- **If it is an annual project, ask who completed the job last time. Then contact that photographer to see what he charged.**

- **Find out who you are bidding against and contact those people to make sure you received the same information about the job. While agreeing to charge the same price is illegal, sharing information on prices is not.**

- **Talk to photographers not bidding on the project and ask them what they would charge.**

- **Finally, consider all aspects of the shoot, including preparation time, fees for assistants and stylists, rental equipment and other material costs. Don't leave anything out.**

For more on pricing your work, turn to page 21.

1996 Photographer's Market

Distributed in Canada by McGraw-Hill, Ryerson,
300 Water Street,
Whitby Ontario L1N 9B6.
Also distributed in Australia by Kirby Books, Pri-
vate Bag No. 19, P.O. Alexandria NSW 2015.

Managing Editor, Market Books Department:
Constance J. Achabal.
Production Editor: Richard D. Muskopf.
Cover Illustration: Mercedes McDonald

This 1996 hardcover edition of Photographer's
Market *features a "self-jacket" that eliminates the*
need for a separate dust jacket. It provides sturdy
protection for your book while it saves paper, trees
and energy.

International Standard Serial Number
0147-247X
International Standard Book Number
0-89879-709-8

Attention Booksellers: This is an annual directory of F&W Publications. Return deadline for
this edition is December 31, 1996.

1996
Photographer's Market

Where & how to sell your photographs

Edited by
Michael Willins

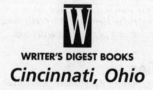

WRITER'S DIGEST BOOKS
Cincinnati, Ohio

Contents

The Markets

© Stephen Hellerstein

Page 71

Page 147

© Robert Holmes

Page 358

© 1995 Patrick Short

©1995 Carol Farneti Foster

Page 491

Resources

From the Editor

I'm a firm believer in fate. Everything happens for a reason. Not all of life's occurrences are pleasant, but each has a purpose. Along the way we learn something and, hopefully, our existence is better as a result.

As photographers, we're learning. We're entering a new period in which CD-ROM, online networks and computer manipulation are changing the ways images are stored and presented. We're uncovering new problems, such as innovative ways to infringe on copyright and unethical manipulation of images. We're taking a quantum leap forward almost daily and the pace in which the photo industry is changing is quite scary. The question is, how will these changes affect photography in the end? Only time will tell.

This year's book contains several exciting feature articles and some important changes from last year. First, the exciting features. If you're a fan of *Life* magazine, as most photographers typically are, you might be familiar with some of the magazine's early shooters. One of the best, **Gordon Parks**, was kind enough to share with me his views of the photo industry. Parks is best known for his documentary images in *Life* and his work with the Farm Security Administration. He also is a noted director, composer and author. Our discussion begins on page 34, and I'm certain you'll enjoy it.

Parks, however, is not the only top professional in this year's *Photographer's Market*. Our Insider Reports feature super advice from several photographers, such as **James Balog** of Boulder, Colorado; **Steve Hellerstein** of New York City; **Alan Brown** of Cincinnati, Ohio; and **John Gerlach** of Chatham, Michigan. We also present insightful conversations with gallery director/photographer **Ron Terner** of Focal Point Gallery in New York City; **Craig Aurness**, owner of Westlight stock agency in Los Angeles, California; New York City photo rep/consultant **Elyse Weissberg**; **Chris Guirlinger** of Landmark General Corporation; and Photo Editor **Deborah Burnett Stauffer** of *Backpacker* magazine.

Before you reach the first section of market listings on page 39, you will encounter a handful of articles that explain the do's and don'ts of working as a professional photographer. We've tried to concentrate on the most important aspects of the business—pricing your work, copyright, packaging your submissions and organizing your office/studio. These articles can give you a solid understanding of the business basics and, therefore, help you make sales.

From calls we get and questions we hear at trade shows and seminars, we can tell many of you are uncomfortable pricing your images. Unfortunately, that's a key part to "being a professional." For this reason we thought it would be a good idea to offer some negotiating tips from photographers, editors, reps and consultants. We hope the advice in the article How Do You Talk Money?, by Allen Rabinowitz, beginning on page 27, can make negotiating an easier process for you.

There are two other articles you won't want to miss. The first, beginning on page 5, Self-Promotion: Putting Your Best Photos Forward, by Sam Marshall, is a discussion with editors and photographers about impressive forms of self-promotion—they tell you what works best and what doesn't. The other article is a first-hand account of how photographers can benefit from new technology. In the article Leading the Charge into the Digital Revolution, well-known travel photographer Carl Purcell explains how he

and his wife, Ann, have capitalized on CD-ROM and online network presentation of their images. Their story begins on page 17.

Now that I've told you about the exciting feature articles, it's time to fill you in on some key changes. First, we have over 500 new listings this year. A couple dozen of those markets come from the best advertising firms in the world—companies like Ammirati & Puris/Lintas, TBWA Advertising and Chiat-Day. In our Consumer Publications section, we've added the likes of *Vanity Fair*, and among our Stock Agencies you'll find The Image Bank and Archive Photos. All of these markets are new in this edition and searching for top-notch photographers.

Throughout *Photographer's Market* you also will find new information about technological changes affecting the photo markets. We asked each buyer how products like CD-ROM, online networks and digital imaging software are changing the way images are stored, purchased and used. This information can be found inside the bulleted (●) editorial comments throughout the book. We also inserted e-mail addresses you can use to directly contact editors.

In our advertising and design studio sections, take note of information on annual billing and staff sizes. While researching for this book we found that many readers like this data in order to estimate the size and professionalism of advertising agencies and design studios.

So what will you do with the knowledge you gain from this book? Will it inspire a lucrative photography career or will you bow out of the business, deciding there's too much to do as a professional? Here's hoping for inspiration.

Michael W.

How to Use Your
Photographer's Market

Photographer's Market is a resource that's only as good as you make it. The book provides information that can help you sell, exhibit or market your work to numerous outlets. The catch is that you must closely examine the listings to know what buyers want.

How should you go about this examination process? Start with what you like to photograph. Your interests may lie in wildlife and landscape photography, or you might enjoy shooting in the controlled environment of a studio. Perhaps you like to travel and, therefore, have thousands of slides from all over the world. Whatever your situation, the subject matter strongly affects who you approach.

After you've determined what you like to shoot, it's time to figure out who might be interested in your work. There are more than 2,000 listings in this edition and roughly 25 percent are new this year. The Table of Contents at the beginning of this book spells out the various markets that are covered, such as Art/Design Studios, Stock Photo Agencies and Record Companies.

The largest section is Publications, which contains more than 850 trade magazines, consumer publications, newspapers and special interest magazines. If you plan to approach these markets, check out the Subject Index at the back of this book. This index lists potential buyers in 24 different categories. If, for example, you're a fashion photographer searching for periodicals that publish such images, look under Fashion in the index.

For all newer or lesser-known photographers, we have a First Markets Index that is divided by book section. For example, all galleries that want to see work from beginners are listed together.

As you scrutinize the listings you will notice that most explain what subjects they want from photographers and how work should be presented. Some like to receive slides, others prefer larger format transparencies, or even prints. Often they only want self-promotion pieces, tearsheets or stock lists. Whatever the case, follow their suggestions.

One important note, do not submit originals unless a buyer plans to use the work and needs originals for production purposes. And, when sending b&w images, never send the negatives. Duplicate slides, tearsheets and prints are replaceable if an image is damaged or lost. Originals aren't.

While payment is important for any businessperson, don't judge markets solely on the aspect of money. Through negotiations you may find that those payments are not set in stone. You also may discover that one buyer who pays $500 for a magazine cover photo only buys one or two shots each year. On the other hand, a buyer who pays $35 for a magazine cover shot might buy 50 images annually. Obviously the odds of selling your work are greater if you contact markets that buy lots of images. When reviewing the listings it is important to know how many photos a buyer purchases from freelancers each year. This usually is stated in this manner: "Uses 80 photos/issue; 80 percent supplied by freelancers." The numbers will change, but you get the idea. Some markets

did not provide any payment information and those listings contain the code "NPI," which stands for "No payment information given."

As you move through this book, you will come across helpful feature articles from various professionals in the photo industry. Known as Insider Reports, these articles are meant to help you in your quest to become a successful photographer.

You also will find articles at the beginning of this book that explain photography's business basics. It's important that you understand this information. Articles on copyright, taxes, insurance, pricing and negotiating, setting up an office, and submitting work can all be found in the first 37 pages.

At the back of this book there are numerous helpful resources. We've listed many of the top photo industry organizations as well as schools that specialize in photography. In the Resources section you will find dozens of art/photo representatives who can help you package your skills and market yourself to potential clients. There also are contests and workshops, through which you can measure or improve your photographic skills.

Self-Promotion: Putting Your Best Photos Forward

by Sam A. Marshall

There's real wisdom in the phrase "You never get a second chance to make a good first impression."

While few photographers ever get work by simply sending out a single self-promo piece, a series of strong pieces—ones that speak the language of the marketplace—can help break the ice with potential clients.

"Work can't happen until an exchange takes place," says Deanne Delbridge, a San Francisco-based creativity consultant and photo rep. "When people don't know you, they don't trust you. But sending direct mail pieces can open the door for showing your portfolio."

However, an effective self-promotion piece doesn't stand alone. It grows out of personal creativity and a well-thought-out promotional strategy. So photographers should resist the temptation to knock out a postcard or brochure just to have something out there.

"The needs of art directors change daily, and they're looking for photographers who communicate an understanding of those needs in their images," says Delbridge. She claims that careful image selection and an imaginative design concept for a mailing campaign "will grab an art director's attention."

Strive for consistency

Opening doors and building trust take time, and require strategic follow-up, says Steven Liska, owner/creative director of the Chicago design firm, Liska & Associates.

"Advertising is a repetitive industry," says Liska. "It's necessary to mirror the industry you're working in. You can't just send out one promo piece and expect to generate lots of inquiries."

Delbridge adds that since art directors have a natural wariness of working with unknowns, photographers also must develop distinctive personal themes or concepts to reach prospective clients. "Not only do you need to show that you have an original, creative vision, but also, your vision must be consistent between your promo pieces and your portfolio," she says.

She warns that when a photographer shows a bad portfolio after sending a great promo, the art director will "never call that photographer again. It tells the art director that the photographer doesn't know what he or she is doing."

Sam A. Marshall *is a Cincinnati-based journalist, photographer and editor, specializing in the photography and design industries. Formerly editor of* Photographer's Market, *he has contributed extensively to the Ohio Valley Chapter of the ASMP as a writer and magazine editor. He has written on such subjects as photographic marketing, copyright, and stock photography for various news publications and trade journals, including* HOW, Photo District News, Earthtreks Digest, *and* Cincinnati Exec. *His article, "To Promo or Not to Promo," published in the* Ohio Valley ASMP News, *received a First Place award from the Cincinnati Editors Association.*

Mix and match methods

Working photographers typically mix and match various promotion methods to suit their personal goals, styles, work schedules and budgets. Traditional methods involve almost everything—creating slick business cards and stationery, developing direct mail pieces, phone calling to set up portfolio reviews, dropping off portfolios and meeting art directors face-to-face, buying ad space, and working with photo reps.

There also are not-so-traditional methods of self promotion, such as the creation of multimedia image portfolios on floppy disks and CD-ROM. This type of presentation has recently grown in popularity among serious professionals.

Among mainstream commercial photographers who work with advertising, design, and corporate clientele, a primary promotion method has been advertising in creative directories. Also known as sourcebooks, these directories are mailed free to art buyers worldwide. Three of the more popular sourcebooks are *The Workbook*, *Creative Black Book* and *American Showcase*. (All of these resources can be found in the list of Recommended Books and Publications at the back of this book.)

One drawback to sourcebook ads is their high cost—about $1,800 to $5,000 for a one-time, full-page, four-color insert in an annual directory (with similar rates for inclusion on the new multimedia disk versions). As a result, many photographers have phased out their ads in favor of direct mail and other less costly methods of promotion.

A spur to creativity

Although direct mail can be quite costly because of design, printing, mailing lists, and postage, many photographers around the country find it more flexible and economical. And some have found that direct mail spurs their creativity.

For instance, Columbus, Ohio, photographer/designer John Weber, who works primarily with computer-manipulated images, developed a set of 12 postcards for resale and self-promotion. Initially, he created two direct mail cards. Then, with the encouragement of the computer-design magazine, *Emigre*, he expanded the number to 12 so he could also sell the complete set through the magazine.

Weber says the highly-manipulated, computer-based images that he used for the postcards were created through experimentation. "Unfortunately, many photographers don't have the time to play with their portfolios. But I found [the postcard collection] was a good way to develop and promote my personal work."

In 1994 the concept was entered into the annual *Photo District News*/Nikon Self Promotion Awards and earned him third place honors in the Best Ongoing Campaign, New Talent division.

"There's been a change in the last [several] years in what art directors want to see," says Weber. He notes a growing interest among art directors who prefer personal work from photographers in place of stylized commercial images.

Some fine-art-oriented photographers say they follow the work of particular designers and mail custom prints or Polaroid transfer images to designers with whom they want to work. This lets the photographers choose their clients rather than the other way around.

When designing a direct mail piece photographers should make sure it fits into a drawer or file folder, a feature that's reportedly preferred among art directors and photo editors. While some posters and other large pieces are acceptable if they feature dynamic images and are no larger than 12 × 18 inches, most observers advise against them because they are often thrown out.

"Posters are so beyond passe it's ridiculous," says Deanne Delbridge. "They're an

idea left over from the seventies, when the philosophy was, 'Bigger is better.' Now the rule is, 'Less is more.' "

Exceptions to the rule

However, there have been some notable exceptions. For instance, a poster-sized booklet, which Steven Liska's firm designed for the top-gun New York commercial photographer Stephen Wilkes in 1993, gathered numerous awards in the photo/design industry.

"I generally hate posters but it's only because we don't usually get good quality," Liska says. "But if the caliber is there, then [a photographer] should make it big rather than something fileable. It definitely belongs up where people can see it."

Similarly, in 1991 Cincinnati, Ohio, photographer Todd Joyce gambled with a poster for his first self-promotion effort and was recognized nationally for his efforts. The 18×22-inch poster featured a photo of Union Terminal, an art deco train station considered to be a Cincinnati architectural landmark. The poster earned him awards from *Studio Magazine*, Kodak and the Advertising Photographers of America, as well as several Addy Awards from the American Advertising Federation.

"Many direct-mail pieces are basically throw-away items, and I didn't like the idea of not getting the buyer's attention," says Joyce. He adds that it's "amazing" to still see the poster on the walls in art directors' offices nearly five years after the initial promotion. In addition to his promo use, Joyce reprinted the poster for local retail sale. The piece "still brings in about $1,000 a year," he notes.

A similar desire to separate his work from the competition's led Hartford, Connecticut photographer Frank Marchese in 1994 to publish an oversized, limited-edition book of his portraiture. The $9\frac{1}{2} \times 12$, spiral-bound promotion, titled *Different People*, was spotlighted in a 1994 article in *Photo District News* for its fresh approach.

As the former tabletop photographer explained in that article, he had two motivations for the oversized format: he wanted a substantial promotion piece that stood out from the "small stuff" other photographers have done, and, perhaps more important, he wanted to steer his career in a new direction, namely portraiture.

By bartering his photography services in exchange for design, printing and materials, Marchese was able to print 2,500 copies for far less than the cost of a sourcebook ad.

A hidden opportunity

Self-published books and calendars also are popular promotional outlets. For instance, as various observers report, producing a high-quality book product or calendar containing personal work can help photo buyers visualize how a photographer approaches a project.

However, in the case of editorial/commercial shooter Robert Flischel, the opportunity to publish a collection of his images did not begin as a self-promotion project. As the Cincinnati photographer recalls, a corporate client approached him about producing a set of 46 mural prints to be displayed in its headquarters. Since its offices are based in Cincinnati, the company wanted distinctive images of the community.

While negotiating the project, the company also suggested publishing a book of the collection to send to its clients. And, says Flischel, that's when he recognized the self-promotion angle and suggested having an additional printing for his personal use. The company and Flischel later decided to sell extra copies of the book in local bookstores.

"About five to six years ago, I started thinking about how to improve my quality of service, and I realized I should help clients at all stages of a project," says Flischel. As he sees it, self-promotion isn't just a one-way process to generate more business. It also involves a creative philosophy and a commitment to professionalism. "As the

project took shape, we . . . created something [together] that effectively sells, not only me, but also everyone involved."

Reinventing portfolios

In recent years, an increasing number of photographers, such as San Francisco-based editorial/corporate photographer Scott Peterson, have chosen to redefine the portfolio concept by constructing three-dimensional packages for their matted prints. These packages, which can either be mailed or taken to a client, often include alternative photographic media, found objects, and other materials that support an overall motif.

In Peterson's case, going with a high-concept proved to be a very cool move. His package—a self-made wooden box with a wrench fastened to the lid and matted Polaroid transfer prints wrapped in wrinkled, handmade paper—received the Gold Award for Self Promotion in *Photo/Design* magazine's Eighth Annual Awards in 1994.

The digital revolution is also helping photographers reposition their portfolios for the emerging electronic imaging market. Since early 1994, the photo industry has been buzzing about the DeskTop Disk Portfolio, a product of Eastern Light Interactive Communications, Ltd. (ELI).

As ELI owner Paul Runyon explains, the company initially developed leads among photographers attending seminars throughout the U.S. Out of more than 1,000 follow-up mailings to these photographers, some 30 percent inquired about having digital portfolios produced, says Runyon.

Interestingly, of those who have tried the more limited floppy disk version, many want to upgrade, says Runyon. "Photographers start out conservatively, but once they work with it a bit they say, 'We love the floppy, but we want to do more.' "

The floppy disk version, which costs about $1,800, can hold up to ten color images, as well as text insertions, a photographer's bio, and a music/voice soundtrack. It also offers two types of presentation to the viewer, self-driven and interactive. Multiple-disk versions are also available.

With the self-driving feature, the disk runs automatically, showing the photographer's portfolio in a preset sequence. Then, with the interactive feature, the viewer can use the click-on menu to access various windows which branch into 6-8 different categories. For instance, editorial, tabletop, fashion, people, architectural, and personal work.

Obviously, the CD-ROM version, with its greater capacity, has much more flexibility. For instance, says Runyon, it can hold up to 300 color photos, plus "a significant amount" of music, supportive information, and special effects. Depending on how elaborate a photographer wants to get, this version can cost $10,000 to $250,000.

As a self-promotion tool, this innovation has great potential, Runyon claims. "The floppy can function almost as a mail card," he points out. "You won't get the job [by just sending in the disk], but it can motivate the art director to call in your portfolio. With the increased competition in today's marketplace, it's a real cutting-edge tool."

Acknowledging some of these benefits, Deanne Delbridge also sees some drawbacks with the digital portfolio. "It's really as random as advertising in a sourcebook," she points out. "In the future, as the price comes down, people will send out a new floppy every three to four months, just as they do now with a direct mail card. But right now, it's very expensive. And since not all art directors work with computers or are comfortable with them, you're not going to connect with everyone. If you're on a tight budget, you have to ask yourself if the expense is justified."

Presentation counts

Pointing out that effective self-promotion begins with a thoroughly professional image, New York-based photo marketing expert Elyse Weissberg, advises photographers to do their "homework" when developing a strategy.

Weissberg, a photo agent/consultant, says photographers should carefully choose their company names, have all promo materials (including business cards and stationery) professionally designed, and strive to present themselves in the most polished, professional manner possible. "How you conduct business tells others how professional you are," she says.

"Of course photographers use their design sense in composing images, but they should still get the best design possible," Weissberg stresses. "Barter with your talent. The best thing to do is barter with a designer whose work you like and with whom you have a good rapport. Maybe you've worked with that person and they know your work. So it's easy to offer to do a job for a person like that, and you'll get a totally professional look."

As for image selection for promo materials, photographers and other observers suggest a number of "research and development" strategies. Several observers recommend going to design and photography awards events to locate top designers and photographers. Not only will a photographer see the types of work designers prefer, but they can get to know the designers or, at least, start a target list for sending promo pieces.

Photographers also should enter competitions and use award-winning images in self promotions. Todd Joyce says award-winning pieces lend even more credibility to your effort. "When you produce an award-winning piece, people are going to take a longer look at you. It helps, especially when a prospect is vacillating on whether to use [you] or not. It's easier for them to justify using you when they're selling their project to management," he says.

Regardless of how technically good a photographer may be, or of how much money he has to invest in producing materials, self-promotion is ultimately unproductive without the ability to communicate creatively, says Deanne Delbridge.

"Personal work is what sells now. And when you can combine that with the language of the marketplace, you get power in your images," she says.

Minding Your Own Business

What is it that makes some photographers fail, while other, less-talented shooters succeed? The answer: business knowledge.

Countless people know how to set exposures and compose images. And if photographers don't have the technical skills, the cameras of today can make it easy for them to create publishable photos. But understanding business basics and having a knack for marketing your talent can mean the difference between success and failure.

You also must create a plan of attack. Spend time developing an overall business strategy that spells out where you want to go with your work. How much money do you want to make? What types of subjects excite you and what do you do best? What subjects do you hate? What kind of financial commitment do you want to make toward your business in the way of self-promotion and/or equipment? What markets are you most interested in?

After answering the aforementioned questions and reading this article, you will understand the finer points of operating a business. You will know how to store images and submit work. You will know how to properly organize your photo archives and file documents. Basically, you will know what it takes to succeed.

Storing images

There is no magic formula for filing prints and transparencies. Everyone has his own way of doing things and a system that works for one person may not work for another. The key is to easily locate images for clients so requests can be quickly serviced. Nothing is more frustrating than losing a sale because an image can't be located.

If you have paid close attention to the trade journals in recent years you have noted the influence of computer technologies on the photo industry. Some of these changes revolve around the new digital manipulation software packages that are available, such as Adobe Photoshop. However, numerous software packages have been developed that can enhance your day-to-day business practices.

One of the most tedious and time-consuming tasks for any photographer is labeling slides once they have been created. Every slide mount should contain your copyright notice and a file coding system of your choice. Also, indicate whether the slide is an original or duplicate. You also might want to caption or place titles on each slide. Adding all this information by hand can take hours (and give you a cramp), but slide labeling software exists. These programs can save you time in the office and make your submissions look more professional.

If you have large numbers of photographs and often hire others to put together submissions, you might want to consider storing them on SyQuest cartridges or CD-ROM. Stock photo houses have begun archiving images using these technologies because they simplify the task of researching large files. If you decide to store material in a digital format it is important to have good image retrieval software, such as Shoebox by Kodak or Aldus Fetch. These packages use subject keywords to quickly seek and find images.

Such storage systems are costly, so make sure the investment is worthwhile. Typically, the cost of scanning slides onto compact disc is $1-3 per image. You also must pay for the disc. Larger formats are more expensive, although discounts are sometimes given depending on the number of scans.

If you decide not to store images digitally you can easily set up a good 3×5 index card system that catalogs photos by subject matter. Transparencies can be assigned numbers and letter codes that signify topics, such as an "A" for Aviation, "C" for Children, or "W" for Wildlife. It will be much easier to find requested photos by referring to your index cards, rather than rifling through large numbers of images.

Once your images are properly labeled, they should be properly stored. Prints can be kept in large manila folders and labeled according to your cataloging system. Negatives for b&w prints should be put in protective plastic sleeves. Transparencies also should be stored in this manner. For more on filing and retrieving work, refer to the book *Sell & Re-Sell Your Photos*, by Rohn Engh (Writer's Digest Books).

Business forms

Just as labels will make you appear more professional in the eyes of potential clients, so, too, will business forms. Most forms can be reproduced quickly and inexpensively at most quick-print services. If you have a computer system with some graphic capabilities you can design several simple and fairly attractive forms that can be used every day.

When producing some of the more detailed contracts, remember that proper wording is imperative. You want to protect your copyright (see more copyright information on page 31) and, at the same time, be fair to clients. Therefore, it might be a good idea to have a lawyer examine your contracts before using such forms.

Several photography books include sample forms if you want to get an idea what should be included in your documents. Check your local library or bookstore for these resources. You also might want to order FORMS, a booklet of sample forms that was produced by the American Society of Media Photographers. To order copies of FORMS write to ASMP, Washington Park, Suite 502 Washington Rd., Princeton Junction NJ 08550-1033. (609)799-8300. The price is $19.95 plus $2 shipping and handling.

The following forms are useful when selling stock photography, as well as when shooting on assignment:

Delivery Memo—This document should be mailed to potential clients along with a cover letter when an initial submission is made. A delivery memo provides an accurate count of the images that are being submitted and it provides rules of usage. Ask clients to sign and return a copy of this form if they agree to the terms you've spelled out.

Terms & Conditions—Also known as a boilerplate, this form outlines in fine detail all aspects of usage, including copyright, client liability and a sales agreement. You also should include a statement that protects you from having your work digitally stored and/or manipulated. Often this form is placed on the back of a delivery memo.

Invoice—This is the form you want to send more than any of the others, because mailing it means you have made a sale. The invoice should provide clients with your mailing address, an explanation of usage and amount due (include a due date for payment). You also should include a business tax identification number or social security number.

Model/Property Releases—Get into the habit of obtaining releases from anyone you photograph. They increase the sales potential for images and can protect you from liability. A model release is a short form, signed by the person/people in the photo, that allows you to sell the image for commercial or editorial purposes. The property release does the same thing for photos of personal property. When photographing children, remember that a parent or guardian must sign before the release is legally binding. In exchange for signed releases some photographers give their subjects copies of the photos, others pay the models. Figure out a system that works best for you. Once you obtain a release, keep it on file.

You do not need a release if the image is being sold editorially. However, some magazine editors are beginning to require such forms in order to protect themselves. You always need a release for advertising purposes or for purposes of trade and promotion. There are times when it is impossible to get a release. In those cases, remember that the image only can be used editorially.

If you shoot photographs of private property, and you want to use these photographs for commercial purposes, secure a property release from the owner of the property. If in doubt, check it out! The *Volunteer Lawyers for the Arts* (VLA) is a nonprofit, tax-exempt organization based in New York City, and it is dedicated to providing all artists, including photographers, with sound legal advice. The VLA can be reached at (212)319-2787 or write to: Volunteer Lawyers for the Arts, 1 E. 53rd St. (6th Floor), New York NY 10022.

Finally, if you are traveling in a foreign country it is a good idea to carry releases written in that country's native language. To translate releases into a foreign language, check with embassies or professors at a college near you.

Submissions

When submitting images to potential clients you want to cater your submission to the needs of the market. Make it simpler for them to buy your work than reject it. Now, how can you do that?

First, don't give editors a sloppy mess. Editors are constantly complaining about the unprofessional manner in which images are submitted. Some photographers, for example, mail photos with no explanations as to what they are or why they are being sent. Others send cover letters written in illegible script on crumpled paper. When an editor receives these types of submissions he will invariably reject them on the basis of appearance.

Invest in a professional appearance—and not just in the form of money, but in time, too. If you have a typewriter or computer, use it when putting together cover letters or query letters. If you don't have a typewriter, visit a local library which lends office equipment to the public. For a more polished look, purchase your own stationery and business cards and use them when putting together submissions.

What should you include in your submission? We've already mentioned several pieces of the marketing puzzle, but let's break it down:

Cover Letters and Query Letters—These are slightly different approaches to the same goal—making a sale. They are used to convince photo buyers that your photography will enhance their products or services. Both of these letters are excellent opportunities to provide more information about your photographic abilities. Cover letters should include an itemized list of what photos you are submitting and caption information pertinent to each image. Keep it brief.

In publishing, query letters are used to propose photo story ideas or photo/text packages. Ideas must sound exciting to interest buyers in your work. In the query letter you can either request permission to shoot an assignment for further consideration, submit stock photos, or ask to be considered for upcoming assignments.

Résumé and Client List—Résumés provide clients with more information about your skills and previous experience. Include job experience, photo-related education and any professional trade association memberships you have. A client list is simply a list of credits, past buyers of your work. You also should include any awards you've won and shows or exhibits you've been in.

Self-Promotion Piece—Art directors and photo editors love to keep self-promotion pieces on file as references for future assignments. Tearsheets or postcards show your style and area of expertise and should be included in any direct mail to potential buyers.

Make sure you include your address and phone directly on the piece.

Stock Photo List—This is a detailed description of the subjects you have available. You also should include whether the images are color or b&w. A travel photographer, for example, might want to outline what countries he has photographed. Editors like to keep such resources in their files for future reference.

The package

To ensure your images' safe arrival and return, pay attention to the way you package them. Insert 8×10 b&w photos into an $8\frac{1}{2} \times 11$ plastic jacket; transparencies should be shipped in protective vinyl pages. *Do not send original transparencies unless they are requested by the client.* You do not want to risk losing or damaging originals. Slides can be duplicated at a relatively low cost and if they are damaged or lost, there is no real harm done.

To further protect your submissions it's a good idea to send your work via certified mail. That way a client must sign for the package when it is delivered. You also can use delivery services, such as UPS or Federal Express, which track packages.

When submitting material, include the following items: a cover letter or query letter, a résumé and client list, a delivery memo with terms and conditions attached, a self-addressed, stamped envelope, and, of course, your work. For proper protection of your prints and transparencies, sandwich all images between two pieces of cardboard. You also can try insulated envelopes. *Note: When mailing to countries other than your own you will need International Reply Coupons instead of stamps. Check with your local post office for IRCs.*

Finally, before you submit work, find out what editors want in the way of submissions. Most markets in this book explain their likes and dislikes when it comes to submissions. Some prefer tearsheets and self-promotion pieces instead of slides, others only want stock photo lists. Many review portfolios and want you to drop off your work on specific days. By doing a little legwork you can sell more photos.

Tracking Down the Tax Picture

The financial concerns that go along with freelancing are demanding. You are the sole proprietor of your business and, therefore, must tend to tasks such as recording expenses and income. These tasks are time consuming, but necessary if you plan to be successful and avoid legal troubles down the road.

Every photographer is in a different situation. You may make occasional sales from your work or your entire livelihood may derive from your photography skills. Whatever the case, it is a good idea to consult with a tax professional. If you are just starting out, an accountant can give you solid advice for organizing financial records. If you are an established professional, an accountant can double check your system and possibly find a few more deductions.

When consulting with a tax professional, it is best to see someone who is familiar with the needs and concerns of small business people, particularly photographers. You also can conduct your own tax research by contacting the Internal Revenue Service. The IRS has numerous free booklets that provide specific information, such as allowable deductions and tax rate structures. These include: Publication 334: Tax Guide for Small Business; Publication 463: Travel, Entertainment and Gift Expense; Publication 505: Tax Withholding and Estimated Tax; Publication 525: Taxable and Nontaxable Income; Publication 533: Self-Employment Tax; Publication 535: Business Expenses; Publication 538: Accounting Periods and Methods; Publication 587: Business Use of Your Home; Publication 910: Guide to Free Tax Services. To order any of these booklets, phone the IRS at (800)829-3676.

Self-employment tax

As a freelancer it's important to be aware of tax rates on self-employment income. All income you receive without taxes being taken out by an employer qualifies as self-employment income. Normally, when you are employed by someone else, your income is taxed at a lower rate and the employer shares responsibility for the taxes due. However, when you are self-employed, even if only part-time, you are taxed at a higher rate on that income, and you must pay the entire amount yourself.

Freelancers frequently overlook self-employment taxes and fail to set aside a sufficient amount of money. They also tend to forget state and local taxes are payable on self-employment income. If the volume of your photo sales reaches a point where it becomes a substantial percentage of your income, then you are required to pay estimated tax on a quarterly basis. This requires you to project what amount of sales you expect to generate in a three-month period. However burdensome this may be in the short run, it works to your advantage in that you plan for and stay current with the various taxes you are required to pay.

Deductions

Many deductions can be claimed by self-employed photographers. It's in your best interest to be aware of them. Examples of 100 percent deductible claims include production costs of résumés, business cards and brochures; photographer's rep commissions; membership dues; costs of purchasing portfolios and education/business-related magazines and books; insurance, legal and professional services; and office expenses.

Additional deductions may be taken if your office or studio is home-based. The catch here is that your work area must be used only on a professional basis; your office can't double as a family room after hours. The IRS also wants to see evidence that you use the work space on a regular basis via established business hours and proof of actively marketing your work. If you can satisfy these criteria then a percentage of mortgage interests, real estate taxes, rent, maintenance costs, utilities, and homeowner's insurance, plus office furniture and equipment, can be claimed on your tax form at year's end.

Some of the aforementioned deductions are available to hobbyists as well as professionals. If you are working out of your home, keep separate records and bank accounts for personal and business finances, as well as a separate business phone. Since the IRS can audit tax records as far back as seven years, it's vital to keep all paperwork related to your business. This includes invoices, vouchers, expenditures and sales receipts, canceled checks, deposit slips, register tapes and business ledger entries for this period. The burden of proof will be on you if the IRS questions any deductions claimed. To maintain professional status in the eyes of the IRS, you will need to show a profit for three years out of a five-year period.

Sales tax

Sales taxes are deceptively complicated and need special consideration. For instance, if you work in more than one state, use models or work with reps in one or more states, or work in one state and store equipment in another, you may be required to pay sales tax in each of the states that apply. In particular, if you work with an out-of-state stock photo agency which has clients over a wide geographic area, you should explore your tax liability with a tax professional.

As with all taxes, sales taxes must be reported and paid on a timely basis to avoid audits and/or penalties. In regard to sales tax, you should:

1) Always register your business at the tax offices with jurisdiction in your city and state.

2) Always charge and collect sales tax on the full amount of the invoice, unless an exemption applies.

3) If an exemption applies because of resale, you must provide a copy of the customer's resale certificate.

4) If an exemption applies because of other conditions (e.g., selling one-time reproduction rights or working for a tax-exempt, nonprofit organization) you must also provide documentation.

Protect Your Livelihood

We've all heard the expression "Better safe than sorry," and if you plan to build a business this phrase goes doubly for you. What would happen to your business if a fire swept through your office? What if someone stole your computers? Maybe you were injured and couldn't work. Could your business withstand these setbacks?

Photographer Laurance Auippy, of Livingston, Montana, says proper financial planning and insurance helped him withstand just such a dilemma. He was driving to a shoot several years ago when his car went off the road and rolled over. The wreck destroyed thousands of dollars worth of equipment, put him in the hospital for a week and kept him from shooting for two months.

"I know you can loose five, six, seven thousand dollars worth of equipment in the blink of an eye," says Auippy. "Unless you can be down for six months and not take a major hit financially, I don't think you're a successful photographer."

Proper planning can keep you from taking that "major hit." Talk with financial planners and insurance agents about protecting your livelihood. From an insurance standpoint, here are a few points to consider:

• Devise an apt system of storage for transparencies, valuable papers and backup computer disks. Consider opening a safety deposit box for duplicate transparencies and other irreplaceable information. Then if disaster strikes in the office you won't be totally devastated. Some professionals place transparencies in fireproof safes. (Auippy swears by old refrigerators that he picks up for free and converts into image storage containers. He says he asked firefighters about the idea and they agree that refrigerators offer as much protection as fireproof safes.)

• Make sure you have adequate liability coverage and worker's compensation. If someone is injured, perhaps a model who is hit by a falling studio light, you must be insured.

• Make sure you have adequate health/disability coverage. If you are injured or become ill and can't work, the effects on your business could be devastating. In the case of disability insurance, however, take a close look to see if you will be suitably covered. A disabled stock photographer, for example, who has a large file of images, could draw an income from stock sales even though he is unable to shoot. By selling stock he might be ineligible for disability benefits.

• Unfortunately, most insurance companies will only pay for the cost of replacing film if images are destroyed or lost. They consider the market value of an image "intangible," and, therefore, uninsurable.

• When acquiring property insurance make sure you are covered if you shoot on location. You don't want to drop a camera during an aerial shoot, for example, and then discover that your insurance only covers equipment in your studio.

• Finally, consider joining trade organizations that offer members group insurance packages. The cost of membership could be worth the insurance benefits you receive.

Leading the Charge into the Digital Revolution

by Carl Purcell

A professional photographer's life is divided into chapters. Now, more than halfway through the book of my career, I find myself in the digital chapter.

In the words of Charles Dickens, "It is the best of times and the worst of times." Our profession is certainly in the throes of transition and there is little doubt that computers threaten the traditional way we handle our business. At the same time, computers empower photographers to enhance, manipulate and market images in ways that would have dazzled photographic pioneers. Some have even dared to compare the computer to the Gutenberg printing press, but in fact, a computer has even more significance as it reaches out around the world and binds us together in a vast global village.

My wife Ann and I first became aware of the digital revolution when we read an article by David Walker about CD-ROM some five years ago in *Photo District News*. He described discs which could hold thousands of color pictures. He accurately predicted that these discs would be commercially produced, flooding the market with cheap photo clip art. For us, this concept was a nightmare.

We had about 650,000 color slides from 97 countries accumulated during our world travels. New technology could well destroy their value. After two sleepless nights, we wisely concluded that there was nothing we could do to stop the technology and that, for the sake of survival, it was crucial to find out how we could benefit from computer imagery. We did not want to be like the farmer behind the plow muttering that a tractor was a contraption that would never work.

Accepting change and forging ahead

There were several factors in our favor. Our talent and energy were combined with a giant picture file made up of images bearing our copyright. For many CD-ROM publishers, a major problem would be purchasing electronic rights from multiple sources. We contacted these companies to find out ways we might work together. Remember, we knew were entering new territory for photographers and knew nothing about what we were doing.

Some of our colleagues wrung their hands, predicting disaster, but we moved ahead and cut a deal with a software company in California. They would produce four CD-ROM discs, each containing about 200 of our images at what was considered to be a medium level resolution. The company predicted we would become rich from the sale of these discs. Their projections were strong motivation, but we were also eager to learn from experience. We insisted that strong restrictions be placed on the use of our

Carl Purcell is a travel writer/photographer from Alexandria, Virginia. He and his wife, Ann, have over 650,000 stock images from over 97 countries. Thousands of their photos can be found online through America Online, Photo Network International and eWorld. Both lecture extensively on travel photography and conducting business in the digital era. They are co-authors of the books The Traveling Photographer, A Guide to Travel Writing and Photography, *and* Stock Photography: The Complete Guide.

images, allowing only a 10,000 print run for published pictures, size limitations and a total ban on other specific uses. This was carefully spelled out in a "read me" file on each disc.

We were happily doing word processing and simple record keeping on our beloved Mac Plus, but sensed correctly that we needed color and more power. The solution was a Macintosh Quadra 950 with 32 megabytes of RAM, at that time the top of the line. Ann was the one who pushed for the 950, saying "You don't want your computer to be obsolete six months after you buy it."

The initial investment was about $10,000 and included a CD-ROM player, a SyQuest drive, a 14,400 modem, and a wonderful program called Adobe PhotoShop, a software for altering and manipulating images. Later, we added a desktop slide scanner and an optical drive at an additional cost of about $5,000. Needless to say, we did not have an extra $15,000 sitting idle in our bank account, so we took out an equity loan on our house to purchase this hardware. We fully realized that having this new equipment was not going to create an instant flow of cash.

About this time, Eastman Kodak introduced its Photo CD and scanning stations opened throughout North America. This put high resolution scans within reach of any photographer at a reasonable cost, ranging from $1-3 per scan. Kodak Photo CD soon became the standard of the industry and guaranteed the proliferation and success of digital imagery. Kodak designed their discs to be dual platform, readable by both Macintosh and IBM computers.

Meanwhile, computer magazine reviews of our CD-ROMs were very complimentary. One report listed them among the top 10 in the country. However, sales were falling far below original projections. We came to the sad conclusion that CD-ROMs did not offer us the path to riches, but we were still convinced that the digital format would eventually dominate photography.

Spreading the word

As an active member of both the Society of American Travel Writers and American Society of Media Photographers, I was frequently asked to lecture at professional meetings about digital imagery. To some extent, I became the Paul Revere of this technology. My call to arms was "Digital photography is coming!" instead of "The British are coming!" While I acknowledged that this revolution had a dark side, I also asserted that it offered opportunities to those with foresight.

Some listeners immediately recognized the potential, but many simply could not believe that a flimsy golden disc could deliver the quality of an original color transparency. Others, more convinced of the quality, reacted with anxiety. Would this technology replace film? At first I doubted it, but a small voice inside told me that it eventually would.

Some colleagues wonder why we speak so openly about our professional knowledge and experience in the digital arena. They ask, "Aren't you concerned with competition?" Frankly, it is to our advantage to spread the word about this technology. The more photographers and editors who use it, the more all of us will benefit.

Jumping online

Back at the ranch, we and our two-person staff were filling picture requests in the same way we had done it for years. A picture buyer would call or fax a request and we would check our files to see if we had the needed subject. If so, we would make a selection and insert the slides into plastic sleeves. We would then Xerox the sleeves for our records, fill out a submission form, package everything with double cardboard protectors, and ship the package by Federal Express (hopefully on the client's number).

The client obviously assumed an awesome financial responsibility for the original color slides in his possession. From our standpoint, we also risked potential loss or damage of our valuable originals and we figured that it cost us about $75 in labor and postage to make a single submission. When the slides were returned they had to be refiled. The process was straight out of the stone age. There had to be a better way.

Out of the blue, I received a call from Wieck Photo Database in Dallas. They were about to establish a special travel forum on their database and wanted to feature about 1,200 of our best travel images. We agreed immediately.

The concept was simple. The image files were JPEG compressed and high resolution pictures could be downloaded from the travel forum in about four minutes. They would be ready to publish and save editors money on research time and color separations. Thumbnails of the images could be previewed online along with full identification and captions. The Wieck mother computer recorded every download with the name of each editor and his or her publication. Usage fees were based on the circulation of the magazine or newspaper and we would receive a monthly report. We were ecstatic. This was the better way!

Wieck wanted our images as the base for what they hoped would soon be a much larger collection. Their goal was to attract the PR managers of tourist boards and travel destinations to place onto the database the images they normally provide free to travel editors. The only catch was that we needed to provide Wieck with 1,200 high quality Kodak Photo CD scans. At about $2 per scan, this was going to seriously deplete our bank account, but we bit the bullet and did it.

In addition to the money, we invested a staggering amount of time in compiling and typing captions and other information needed by Wieck. It took them months to tabulate these, transfer the images into their computers, compress the files and integrate them into their system. Finally, the new travel forum was launched.

If we expected to be flooded with downloads (use sales), we were doomed to disappointment, but in a few weeks we started getting reports from Wieck that downloads were being made. As editors discovered this new resource, the number of downloads gradually grew and finally we were making close to one sale per day. (That number still fluctuates.) We had created an important new market for ourselves. Even better, we didn't need to research, pull and ship slides. While the editors did our work for us, they were delighted at the convenience and savings at their end. We were all reaping the benefits of the digital revolution.

Expanding into cyberspace

The by-product of our efforts was a stack of Kodak Photo CDs, which sat on a book shelf like a block of glowing Kryptonite. How could we use these to our advantage? Several months earlier we had written to America Online (AOL) to explore their possible interest in our travel articles and pictures. In spite of having mailed several of our books with a carefully worded cover letter, there had been no response.

At the same time, we had posted some of our travel material with a locally-based electronic bulletin board called digitalNATION (sic) and periodically checked the names and résumés of the people who had read the stories. The résumé of Craig Mayo indicated that he worked for AOL and I shot him an e-mail message explaining my interest in his company. He passed this on to his supervisor, who called me the next day and said that they were equally interested in us. We met and reached a working agreement within a few days.

Using our stack of Photo CDs, we began our second big database project. However, there were some major differences. AOL was designed primarily for home users, not editors. We were deeply concerned about people publishing or commercially using our

images without permission. AOL wanted the images to be dual platform (IBM & Mac) GIF file format in 256 colors. This looked great on the screen, but was not high enough resolution for decent reproduction. The problem was that someone had to convert the PICT files from the Kodak Photo CDs to GIF files and it would take forever to do them one at a time.

The AOL staff provided us with software that automatically converted 100 images while I took a nap. The hard part was cutting and pasting the captions while connected to the database, a repetitious action capable of inflicting a severe case of carpel tunnel syndrome. This required working at night to avoid tying up our office telephone during the day, a task that fell to Ann as the night owl in the family. When finally completed, everything was merged together with a stunning splash window designed by the graphics staff at AOL showing a camera and pencil superimposed against a globe of the world.

Once we went online at AOL, we were swamped with e-mail messages from all over North America. Our first day, there were over 25,000 connects into our forum. We had launched ourselves into cyberspace. Users of the database were enthusiastic, but some of their comments indicated a need for subject names to replace the number file names we were using for our collection. Within five days we had made the changes and the operation was going smoothly.

Before getting started with Wieck, I had been dabbling in Adobe PhotoShop. It was mind-blowing to take one of our images and change the sky from washed-out white to Ektachrome blue in less than a minute. With equal ease, I could eliminate telephone wires from a landscape scenic with the cloning tool. I could trace an object or a person, copy the enclosed area and paste the image into another color picture, feathering the edges to give the new image a natural look. It was possible to enlarge an image up to ten times, until I could work with each individual pixel on the screen. In some instances I integrated large type into a photo composition. With this medium I was able to create composite images of a scuba diver swimming with a shark, a marble hand holding the globe of the world and the Venus de Milo standing in the middle of the Champs Elysees in Paris. This was an awesome dimension of digital technology, fraught with problems of ethics and copyright, but literally creating a new medium of creative expression.

Concurrent with our multiple efforts in the digital field, Aldus and Kodak introduced cataloging software (Aldus Fetch and Kodak Shoebox), which allows a photographer or photo librarian to create a meticulously captioned photo library with a sophisticated search system for images. In a single stroke, the 3×5 card catalogs of many picture agencies have become obsolete. Those agencies that have not moved toward digital imagery, electronic catalogs and digital distribution are dead in the water.

The skeptical editors and photographers who questioned the viability of this technology two years ago have become soberly quiet. They realize that their craft and their business have changed forever and that they need to change if they want to survive. In fact, it is a brave new world we are entering with exciting possibilities. We are glad to have been two of the pioneers.

Pricing Your Photos in Today's Market

Frequently we get calls from people who are searching for an easy answer to the question, "What should I charge for my photographs?" The reality is that there are no easy answers. Accurately pricing your photography takes time and it depends on numerous factors.

Before you begin to price images, first figure out how much profit you want to make. After all, you're in business to make money. What does it cost you to be in business every day? Do you rent or own a studio that requires insurance, utilities, office help and equipment, or do you work out of a spare room in your house? How much do you want to spend on self-promotion each year? What about retirement?

It's important that you answer these and similar questions. Many photographers fail as businessmen because they don't study their financial picture. They don't know what they need to make to stay in business and, as a result, they aren't in business long.

Establish photo usage

When pricing a photo or job, the first thing you must do is consider the usage: "What is going to be done with the photo?" Too often, photographers shortchange themselves in negotiations because they do not understand how images will be used. Instead, they allow clients to set prices and prefer to accept lower fees rather than lose sales. Photographers argue that they would rather make the sale than lose it because they refused to lower their price.

Unfortunately, those photographers who look at short-term profits are actually bringing down the entire industry. Clients realize, if they shop around, they can find photographers willing to shoot assignments or sell image rights at very low rates. Therefore, prices stay depressed because buyers, not photographers, are setting usage fees.

However, there are ways to combat low prices. First, educate yourself about a client's line of work. This type of professionalism helps during negotiations because it shows buyers that you are serious about your work. The added knowledge also gives you an advantage when settling on fees because photographers are not expected to understand a client's profession.

For example, if most of your clients are in the advertising field, acquire advertising rate cards for magazines so that you know what a client pays for ad space. You also can find ad rates in the *Standard Rate and Data Service* directory, which can be found at your local library. During negotiations it's good to know what clients pay for ads. Businesses routinely spend well over $100,000 on advertising space in national magazines. They establish budgets for such advertising campaigns, keeping the high ad rates in mind, but often restricting funds for photography. Ask yourself, "What's fair?" If the image is going to anchor a national advertisement and it conveys the perfect message for the client, don't settle for a low fee. Your image is the key to the campaign.

Some photographers, at least in the area of assignment work, operate on day rates or half-day rates. Editorial photographers will typically quote fees in the low hundreds, while advertising and corporate shooters may quote fees in the low thousands. However, all photographers are finding that day rates by themselves are incomplete. Day rates

only account for time and don't substantiate numerous other pricing variables. In place of day rates, photographers are assessing "creative fees," which include overhead costs, profit and varying expenses, such as assignment time, experience and image value. They also bill clients for the number of finished pictures and rights purchased, as well as additional expenses, such as equipment rental and hiring assistants.

Keep in mind that there are all sorts of ways to negotiate sales. Some clients, such as paper product companies, prefer to pay royalties on the number of times a product is sold. Special markets, such as galleries and stock agencies, typically charge photographers a commission, from 20 to 50 percent, for displaying or representing their images. In these markets, payment on sales comes from the purchase of prints by gallery patrons, or from commission on the rental of photos by clients of stock agencies. Pricing formulas should be developed depending on your costs and current price levels in those markets, as well as on the basis of submission fees, commissions and other administrative costs charged to you.

The accompanying charts were reprinted with permission from *Stock Photography: The Complete Guide*, by Carl and Ann Purcell (Writer's Digest Books). These charts should give you a starting point for negotiating fees for magazines, newsletters, book publishers and advertisements. However, only use them as guides and adjust your prices according to your experience and photographic skills.

Bidding a job

As you build your business you will encounter another aspect of pricing and negotiating that can be very difficult. Like it or not, clients often ask photographers to supply "bids" for jobs. In some cases, the bidding process is merely procedural and the assignment will go to the photographer who can best complete the assignment. In other instances, the photographer who submits the lowest bid will earn the job. When contacted, it is imperative to find out which bidding process is being used. Putting together an accurate estimate takes time and you do not want to waste a lot of effort if your bid is being sought merely to meet some quota.

However, correctly working through the steps is necessary if you want to succeed. You do not want to bid too much on a project and repeatedly get turned down, but you also don't want to bid too low and forfeit income. When a potential client calls to ask for a bid there are several dos and don'ts to consider:

• Always keep a list of questions by the telephone, so that you can refer to it when bids are requested. The questions should give you a solid understanding of the project and help you in reaching a price estimate.

• Never quote a price during the initial conversation, even if the caller pushes for a "ballpark figure." A spot estimate can only hurt you in the negotiating process.

• Immediately find out what the client intends to do with the photos and ask who will own copyrights to the images after they are produced. It is important to note that many clients believe, if they hire you for a job, they own all rights to the images you create. If they want all rights make sure the price they pay is worth it to you.

• If it is an annual project, ask who completed the job last time. Then contact that photographer to see what they charged.

• Find out who you are bidding against and contact those people to make sure you received the same information about the job. While agreeing to charge the same price is illegal, sharing information on prices is not.

• Talk to photographers not bidding on the project and ask them what they would charge.

• Finally, consider all aspects of the shoot, including preparation time, fees for assistants and stylists, rental equipment and other material costs. Don't leave anything out.

These charts were reprinted from *Stock Photography: The Complete Guide*, by Carl and Ann Purcell. You will notice the phrasing "we" because the charts were created by the Purcells. Their charts should be used as guides and your prices should be adjusted according to your experience and skill level.

Editorial Use—Magazines, House Organs & Newsletters

We use the numbers below when we start to negotiate for *editorial use in consumer magazines* and *internal house organs* (a term used for magazines published within an organization, company or corporation for internal distribution to the employees or membership).

- We charge 50 percent (multiply the numbers below by 0.5) when negotiating for *internal house newsletters* that will be used for internal distribution only.

- We charge 75 percent (multiply the numbers below by 0.75) when negotiating for editorial use in *consumer newsletters* that will be distributed or sold to the public at large.

- We charge 170 percent (multiply the numbers below by 1.7) when negotiating for *editorial use in external house organs* (a term used for magazines published within an organization, company or corporation for both internal and external distribution to its membership).

- If the client is using the photograph as an interior shot plus a spot insertion on the Page of Contents, we charge the space fee plus 25 percent (multiply the space fee by 1.25). If the spot insertion is on the cover, we charge the space fee plus 50 percent (multiply by 1.5).

Magazines, House Organs and Newsletters—Editorial Use

Circulation	¼ page	½ page	¾ page	full page	double page	cover
Over 3M	$425	$495	$565	$700	$1,150	$1,235
1-3M	385	445	510	635	1,050	1,115
500,000-1M	345	400	460	575	945	1,000
250,000-500,000	265	310	350	445	735	775
100,000-250,000	240	280	320	400	675	710
50,000-100,000	220	250	290	365	600	640
20,000-50,000	200	235	275	350	550	625

Advertising in Magazines, House Organs or Newsletters

Advertising in magazines can be local, regional, national or specialized editions. Most of our invoices specify that we are granting the rights for one year. We charge an additional fee for longer use or repeated use and we base it on a percentage of the original billing.

- In the chart below are the prices we charge for *advertisements in consumer magazines—national exposure.*
- We charge 80 percent (multiply by 0.8) of the fees below for *regional exposure.*
- We charge 60 percent (multiply by 0.6) of the fees listed below for *local exposure.*
- We charge the same fee for *advertisements in trade magazines* as we charge for *regional advertisements in consumer magazines.*
- We charge 75 percent (multiply the numbers below by 0.75) when negotiating for *advertisements in newsletters* that will be distributed or sold to the public.

ADDITIONAL FEES:

Rights: One Year Exclusive: Subtotal plus 100 percent
 Five Year Exclusive: Subtotal plus 200 percent
 Unlimited use—1 year—Subtotal plus 250 percent

Insertions: 2-4: Space fee plus 25 percent
 5-10: Space fee plus 50 percent

Inside Cover: We usually start negotiations halfway between the full page price and back cover price.

Advertising in Magazines—National Exposure

Circulation	¼ page	½ page	¾ page	full page	double page	back cover
Over 3M	$1,300	$1,750	$2,200	$2,600	$4,200	$3,500
1-3M	780	1,020	1,250	1,575	2,575	2,080
500,000-1M	625	810	990	1,250	2,050	1,675
250,000-500,000	520	675	835	1,050	1,720	1,400
100,000-250,000	475	625	775	950	1,550	1,280
50,000-100,000	400	525	650	750	1,200	1,000
20,000-50,000	375	440	540	675	1,125	925

Books—Textbooks, Encyclopedias, Trade Books & Paperbacks

Photo use in books is usually considered strictly editorial unless the book is a single destination promotional piece. For textbooks, guidebooks and encyclopedias, we offer a special rate if multiple sales are made.

The normal run for a book is around 10,000 copies. Rarely are books published in runs over 40,000, unless they are paperbacks. We have divided out the pricing for books, therefore, into two categories: under 40,000 and over 40,000.

If the run is for 5,000 copies, we will usually negotiate a price of approximately 80 percent (multiply by 0.8) of the under 40,000 fee.

Press Run	¼ page	½ page	¾ page	full page	double page	jacket or cover
TEXTBOOKS						
Over 40,000	$185	$200	$225	$270	$550	$550-820
Under 40,000	145	170	195	225	450	450-650
ENCYCLOPEDIAS						
Over 40,000	215	270	300	325	650	825-1,075
Under 40,000	190	215	250	275	550	435-650
TRADE BOOKS						
Over 40,000	185	200	225	270	550	550-825
Under 40,000	145	170	195	225	450	450-675
PAPERBACKS						
Over 40,000	200	220	250	285	565	510-780
Under 40,000	175	200	235	260	525	425-650

ADDITIONAL FEES:

* Reuse or revisions: We usually charge 50 percent of the original price each time a new edition comes out or the photo is reused in a foreign edition. If world rights are requested during initial negotiations, we charge 150 percent of the price listed above for a book being published in one language. We charge 200 percent for world rights for a book being published in several languages.

* For chapter openers, we usually charge 125 percent (multiply by 1.25) plus the space fee listed above.

* For wraparound covers, we start negotiations at the top listed price for covers.

* We usually charge $350 for an author head shot, plus traveling costs to get it and $15 per roll of film taken.

Other pricing resources

If you are a newcomer to negotiating, there are some extraordinary resources available that can help you when establishing usage fees. One of the best tools available is a software package called fotoQuote, produced by the CRADOC Corporation. This software is ideal for beginners and established photographers who want to earn the most money for their work.

Written by lecturer/photographer Cradoc Bagshaw, the software walks you through pricing structures in numerous fields, such as advertising markets, calendar companies and puzzle producers, and then provides negotiating tips that help you establish fees. For example, if you want to sell an editorial image to a consumer magazine, a preliminary usage fee is given. The fee changes as you adjust factors that affect the sale price. In this case, prices increase when selling to magazines with higher circulations; common images pay less than unique photos; an aerial shot warrants higher fees than normal images.

Whatever the circumstances, you can input them and receive an estimated photo value. The pricing structures in fotoQuote also can be adapted to fit your negotiating style of sales history. For example, you may sell to companies in major metropolitan areas and find that these markets pay more than the software indicates. After a few modifications the program will operate based on your fee structures.

FotoQuote also provides coaching tips from stock photographer Vince Streano, former president of the American Society of Media Photographers. The tips give you negotiating advice. You also will find scripted telephone conversations. The cost of the software is $129.95 plus $5 shipping and handling. Washington residents are required to pay sales tax and the program is not available in stores. For information, call or write the CRADOC Corporation, 1574 Gulf Rd., Suite 1552, Point Roberts WA 98281. (800)679-0202.

Besides fotoQuote, there are several books that can help with pricing. Two of the more useful resources are *Pricing Photography: The Complete Guide to Assignment & Stock Prices*, by Michal Heron and David MacTavish (Allworth Press) and *Negotiating Stock Photo Prices*, by Jim Pickerell. To order, see our list of Recommended Books & Publications at the back of this book.

How Do You Talk Money?

By Allen Rabinowitz

While most photographers prefer to be known for creativity and taste rather than their business acumen, knowing how to conduct commerce is as important as learning how to make a winning image. No matter how good a shooter's eye may be or how vast his knowledge of light and lenses, a photographer who has difficulty handling the business end of photography may soon be exploring other career options.

Perhaps no aspect of business is more crucial to a photographer's success than an ability to negotiate with clients. Knowing how to talk about money and related issues can make the difference between struggling and success.

"It's important to remember that photographers are more artists than business people," says New Orleans shooter David Spielman. "Subsequently, they fall short when it comes to learning about negotiating. In many cases, photographers don't know their cost of operation. When that happens, they go into negotiating sessions in weaker positions. In many cases, [potential clients] are probably more knowledgeable than the photographers."

Going into a negotiation for a particular image, an assignment or a whole campaign requires a business mindset that many shooters have difficulty achieving. Emily Vickers, director of education for the American Society of Media Photographers, says negotiating has been described as "nothing more than asking the right questions and having enough knowledge of the industry and enough common sense to know when you're getting the right answers."

Photographer Terry Pagos of Seattle, Washington, calls negotiation a "discovery process." While it may be difficult for some, "you have to have that confidence of what you're worth. That's what it's all about," she says.

Along with reaching some inner truth, Pagos adds that photographers must understand that losing some negotiating sessions may be as important as winning. "You're not always going to win," she explains. "If you do win all your negotiations, it could be you're doing something wrong. If you get the clients to lay down to all your demands, maybe you're not asking enough to begin with."

There are a number of common mistakes photographers make during negotiations. "A lot of photographers don't negotiate from a position of perceived power," says photographer Jim Cavanaugh of Tonawanda, New York. "They seem to think the client holds all the marbles. One of the things I try to remember is when a client is coming to you, it's because they're seeking your expertise. They have a problem that needs to be solved and they need your guidance."

Morgan Shorey, a creative services consultant from Atlanta, Georgia, says the client often is as uncomfortable talking about money as the photographer. "Creative people

Allen Rabinowitz *is a freelance writer from Atlanta, Georgia, who specializes in advertising, media and visual communications. His work has appeared in top trade publications, such as* Photo District News, Professional Photographer, Communication Arts, HOW, American Advertising, Folio *and* Photo Electronic Imaging. *He also served as an advisor to the Atlanta/ Southeast Chapter of the Advertising Photographers of America and contributed two chapters to* The ASMP Business Bible, *published by the American Society of Media Photographers.*

tend to be embarrassed to talk about money," she explains. "They apologize that it has to cost anything. Backing into the situation timidly by being scared to discuss finances is only going to make them feel as awkward as you feel. I've found the best thing to do is be very upfront, be very straightforward and pretend that nothing is wrong."

Vickers says immediately giving a price over the phone without thinking things through is another common miscue. "(Some photographers) don't get enough information and they don't ask the right questions," she says. "People jump the gun on giving a price before they've gotten enough information to be able to successfully and fairly value the work they're negotiating for."

Photo rep Susan Miller of New York City says that too many photographers—and reps—mistakenly ask what the budget is for a job. "The translation of that is, 'I'm too afraid to ask for money, so please do all the thinking for me and tell me what to ask for,' " says Miller. "If they do have a budget and they're smart business people, they shouldn't tell you what it is."

Sometimes, negotiations break down because it seems that the photographer and client are speaking different languages. According to photographer Jay Asquini of Detroit, Michigan, clients don't always express their needs in terms photographers can easily comprehend. "They don't say, 'I'm going to need non-exclusive, North American rights.' They say, 'I'm going to use this a lot of different ways.' Right away, photographers jump to the conclusion that it's a buyout and they panic."

Defining usage and estimating value

Defining usage is the first step toward better negotiations. As Asquini points out, the photographer and client must agree how the photo will be used. When a client asks Asquini for endless usage rights, the photographer intentionally quotes a rather high price that covers all possible uses. This forces the client to be more specific. Then Asquini can give a specific price that's more reasonable and fairer to both parties.

When negotiating usage, the photographer should ask specific questions, keeping in mind that different markets—such as editorial, corporate or advertising—have diverse photo needs. Some questions to consider:
- How will the photo be used?
- For what length of time will the client need the photo?
- Where will the photo appear—locally, regionally, nationally or internationally?

"Too many photographers just think of what they're doing as selling their time," says Vickers. "That's why the idea of a day rate is something I'd like to see obliterated. Photographers are not just selling their time, they're selling their creative expertise and the right to reproduce the product of that expertise in a particular context—and that context is what we call usage."

Wendy Ledis, photography sales manager for the *Palm Beach Post* Photo Sales Department (the newspaper's in-house stock agency), says along with usage, photographers should determine the exclusivity of the image and, if selling to a newspaper or magazine, the circulation of the publication.

More than anything, photographers should know the value of their work. Pagos says, "Not knowing what your work is worth is a real hallmark of inexperience and unprofessionalism. Figure out what you want, what you're willing to give up and what your bottom line is. From there, make it as amicable and as 'win-win' as possible."

To better determine the worth of a job, photographers are encouraged to talk to other shooters, reps or agents to learn what other clients have paid for similar assignments. "Until we know what other people are charging, we won't know the value of the work we're pursuing," says Vickers.

To compete successfully, Spielman advises photographers to study potential clients.

For example, if called for a corporate job, Spielman tries to get the company's annual report, brochures or other printed pieces. "By looking at the final pieces you can see how elaborate the projects are. If they're just grin-and-grip type shots, you'll take a different negotiating stance because they won't understand assistants, make-up artists, set designers, location scouts, etc. But, if they have an elaborate project where all of these things were used previously, you need to be prepared to discuss those things," says Spielman.

When presenting a bid or estimate, it's to the shooter's benefit to make a detailed presentation, one which covers conceivable costs and contingencies. Shorey says the goal is to convey value for the dollars the client will spend. "The person you're bidding against may not have as much production value in his estimate," she explains, "and when you present your bid and discuss what you're going to do for the money, it sometimes becomes apparent to the client that, even though the other person is less expensive than you, they're not going to get as much for their money."

Negotiating with trade-outs

During a negotiation, when the client and photographer are close, but can't agree on terms, the shooter may want to discuss "non-cash" payments. These can range from such things as credit lines and extra copies of the finished piece for the photographer's own promotional purposes to computers, software or other merchandise.

Maria Piscopo, a rep and creative services consultant based in Costa Mesa, California, recommends trading some cash for potential promotional pieces. "Marketing materials are becoming more complex and expensive," she explains, "and trading out what it costs to make this photograph for some kind of promotional consideration is very negotiable."

Though trade-outs may move a negotiation along, photographers say such tactics should be used sparingly. "Trade-outs can be a very dangerous approach to negotiating," warns Pagos. "Very often you don't always get exactly what you want. That's one of the errors a young photographer makes."

One thing photographers should be wary of is the promise of future work in exchange for lower fees. Unless the shooter has worked with the client before and trusts the client, more often than not, that future work will never appear and the photographer will be branded as a low-cost shooter.

When presented with that promise of better-paying work down the road, Asquini says, "It's appropriate at that point to offer to write a deal that says you'll be more than happy to discount the second job or do the tenth job for free. There's no reason to discount your first job for someone who is not a customer, but rather a prospect at that time."

Walking away from a deal

Perhaps one of the major challenges during negotiations is being able to walk away from the table when the price isn't right, while at the same time remaining in the client's mind as a candidate for future assignments. Shorey says the time to walk is when "you reach that moment where you feel you can't do a good job for that bid. You don't feel bad about it and you move on. If you're going to do a job that stinks because you didn't have enough money, a year from now [the client] is not going to remember they beat you down on the bid. They'll remember the picture stank and you did it."

"First of all," says Piscopo, "know your break-even point and profit margins, so you know what you're dealing with. With that information, you'll know when to walk away."

Cavanaugh says when a client takes a hard line, doesn't deal straight or makes

irrational demands, it is a good time to walk away. However, if the issue is just a difference in dollars, he says shooters should see that as an opportunity. He suggests following up by calling the client at a later time and asking how the job went and what assignments may be on the horizon. "Our negotiation strategy is never adversarial," he explains. "If we're not right for this job, we'll call back the next time, and maybe the parameters in terms of style, budget or availability will be different."

Though some shooters look forward to a negotiating session as much as they do a trip to the dentist, Miller says if they concentrate on the task at hand and pursue the job with confidence, the outcome will be positive. "You shouldn't be afraid to ask for what you're worth," she says. "It's a hard thing, but if you muster up your courage, you'll find it gets easier in time."

Understanding the Basics of Copyright

In order to understand the importance of copyright, take a look at the various trade journals that cover the photo industry. Almost every issue has an article about a photographer who had an image stolen. Sometimes it's a publisher who swiped an image thinking the photographer would never find out. More and more frequently the cases involve digitally manipulated images, where several photos have been combined into one. Some of the infringers are pursued vigorously, but often these cases don't make it to court. The infringers admit wrongdoing and pay under-the-table settlements, or photographers don't have the financial resources to pursue legal battles.

There are several steps you should take to protect your copyright. First, mark each of your images with a copyright notice—copyright, copr. or ©—plus the year of creation as well as the name of the owner, which in most cases is the creator. Since the © symbol is accepted in most countries and it is becoming more common for photographers to work with clients overseas, it is best to settle on this designation as you establish your routine practices.

According to the Buenos Aires Convention, which covers many Western Hemisphere countries, copyright notices should also include the notation "All rights reserved." However, all rights are automatically reserved under U.S. copyright law. For convenience, you can have rubber stamps made or use a computer software package to create labels for your images. Such labeling is preferable to handmarking, since handwritten notices—especially those done in ink—can sometimes become unreadable or bleed through into printed images. If clients ever advise you not to include copyright information on your slides or prints, take this as a warning sign and do not do business with them.

Another safeguard you should take is to register your images with the Copyright Office in Washington DC. First, understand you *do not* have to register in order to own the copyright to something you've created. As long as it was not a work for hire agreement with someone else, you own the copyright once you've taken the photo. But, registration is necessary in order to sue for attorney's fees and statutory damages when an image is used illegally.

Many photographers who have not registered their images don't pursue infringement cases because the attorney's fees are too costly. Therefore, infringers are not held accountable for their actions. Don't let this happen to you!

The process of registering your work is simple. Write to the Register of Copyrights, Library of Congress, Washington DC 20559, and ask for Form VA (works of visual arts). Registration costs $20, but a recent amendment to the copyright laws makes it possible to easily group register your images. Unpublished works can actually be videotaped and sent with the registration form and $20 fee to the Copyright Office. You also can send duplicate slides packaged in protective sheets. Published works also can be registered, but depending on when an infringement takes place and when you register, you might not be able to recover statutory damages and attorney's fees. Therefore, group registration of unpublished works affords you the best protection. Check with the Copyright Office for more details.

Knowing your rights

As mentioned before, the digital era is making copyright protection more difficult. Often images are manipulated so much that it becomes nearly impossible to recognize the original version. As this technology grows, more and more clients will want digital versions of your photos. Don't be alarmed, just be careful. Not every client wants to steal your work. They often need digital versions to conduct color separations or place artwork for printers.

So, when you negotiate the usage of your work, consider adding a phrase to your contract that limits the rights of buyers who want digital versions of your photos. You might want them to guarantee that images will be removed from computer files once the work appears in print. You might say it's OK to do limited digital manipulation, and then specify what can be done. The important thing is to discuss what the client intends to do with the image and spell it out in writing.

Even a knowledgeable photographer will find himself at risk when dealing with a misinformed or intentionally deceptive client. So, it's essential not only to know your rights under the Copyright Law, but also to make sure that every photo buyer you deal with understands them. The following list of typical image rights should help you in your dealings with clients:

● **One-time rights.** These photos are "leased" on a one-time basis; one fee is paid for one use.

● **First rights.** This is generally the same as purchase of one-time rights, though the photo buyer is paying a bit more for the privilege of being the first to use the image. He may use it only once unless other rights are negotiated.

● **Serial rights.** The photographer has sold the right to use the photo in a periodical. It shouldn't be confused with using the photo in "installments." Most magazines will want to be sure the photo won't be running in a competing publication.

● **Exclusive rights.** Exclusive rights guarantee the buyer's exclusive right to use the photo in his particular market or for a particular product. A greeting card company, for example, may purchase these rights to an image with the stipulation that it not be sold to a competing company for a certain time period. The photographer, however, may retain rights to sell the image to other markets. Conditions should always be in writing to avoid any misunderstandings.

● **Promotion rights.** Such rights allow a publisher to use the photographer's photo for promotion of a publication in which the photo appeared. The photographer should be paid for promotional use in addition to the rights first sold to reproduce the image. Another form of this—agency promotion rights—is common among stock photo agencies. Likewise, the terms of this need to be negotiated separately.

● **Work for hire.** (See sidebar in this section for detailed definition.)

● **All rights.** This involves selling or assigning all rights to a photo for a specified period of time. This differs from work for hire, which always means the photographer permanently surrenders all rights to a photo and any claims to royalties or other future compensation. Terms for all rights—including time period of usage and compensation—should only be negotiated and confirmed in a written agreement with the client.

It is understandable for a client not to want a photo he used to appear in a competitor's ad. Skillful negotiation usually can result in an agreement between the photographer and the client that says the image(s) will not be sold to a competitor, but could be sold to other industries, possibly offering regional exclusivity for a stated time period as well.

Work for hire definition

Under the Copyright Act of 1976, section 101, a "work for hire" is defined as:

"(1) a work prepared by an employee within the scope of his or her employment; or (2) a work . . .

- *specially ordered or commissioned for use as a contribution to a collective work**
- *as part of a motion picture or audiovisual work**
- *as a translation*
- *as a supplementary work**
- *as a compilation*
- *as an instructional text*
- *as a test*
- *as answer material for a test*
- *or as an atlas*

. . . if the parties expressly agree in a written instrument signed by them that the work shall be considered a work made for hire."

NOTE: The asterisk () denotes categories within the Copyright Law which apply to photography.*

Finally, a valuable tool for any photographer dealing with the copyright language and various forms of the photography business is the *SPAR* Do-It-Yourself Kit.* This survival package includes sample forms, explanations and checklists of all terms and questions a photographer should ask himself when negotiating a job and pricing it. It's available from SPAR, the Society of Photographer and Artist Representatives, Inc., 60 E. 42nd St., Suite 1166, New York NY 10165, (212)779-7464. Price $53 plus $3 shipping and handling. New York state residents pay in-state tax of $4.37.

An Interview with Gordon Parks

by Michael Willins

In his book *Arias in Silence* (Bulfinch Press, 1994), Gordon Parks writes of a boy who visits a tree for guidance. The tree tells the boy that, in life, he can be whatever he wishes. In his later years, the boy returns, discouraged by his inability to gain wisdom. He blames his lack of wisdom on a lack of "common sense and good reason."

Gordon Parks

© Toni Parks

"Wisdom is not common sense,
nor is it reason.
It is a bit of one;
a bit of the other —
with a dash of egotism tossed in."
"I lacked strength?"
The tree swayed
to a spring breeze.
"No, you lacked will.
Go back. Try again."

The poem epitomizes Parks's attitude about life and photography. As long as you have the will to succeed nothing can hold you back. "Nobody can set limitations for you. You set your own limits," says Parks, from his home in New York City. "I'm finding out every day of my life . . . you experiment and go beyond the norm. If you're going to do the same pictures that everybody else does you're going to be pretty ordinary."

Parks's life has been far from ordinary. He's gone from being a teenager living on trolley cars in St. Paul, Minnesota, just before the Great Depression, to being a world renowned photographer, composer, director and writer. He spent decades as a photographer documenting poverty in America for the Farm Security Administration and *Life* magazine. He authored *The Learning Tree* (Harper & Row, 1963), and directed a film by the same name. In 1989 the film was one of 25 selected for the National Film Registry of the Library of Congress. He also directed the movie *Shaft*, a 1971 blockbuster.

The list of his accomplishments goes on and on, with honorary degrees, various awards and books he's written, but Parks, now 82, still presses forward. "I'm just trying everything before I die," says Parks, chuckling. "I don't want to be cheated out of anything."

Gordon Parks spent decades documenting poverty for the Farm Security Administration and Life *magazine. He says the key to taking powerful, story-telling images is to research every project and really get to know each subject before shooting any photos. This approach establishes trust with subjects and produces some extremely intimate opportunities, such as this 1967 photo of a boy and his mother the morning after she scalded her husband with boiling water.*

Take, for instance, his work on *Arias in Silence*. Parks used everyday objects, such as leaves, shells, rocks and flowers, to create stunning still life images. All of the photos were created at his home and contain watercolor backgrounds painted by Parks. In the forward to *Arias in Silence*, he points to things that are dear to him—"poetry, music and the magic of watercolor. Each visited my thoughts night and day—helped to extend my vision beyond plateaus I didn't know existed."

What made the project such an eye-opener for Parks? "It made me take a closer look at the world, little things that people everyday pass up and don't actually see," he says. "A crumbled flower can be very beautiful. A rotting piece of wood can be very beautiful, but people throw it in the garbage can. But if you take a close look at it you find out there's something beautiful. I'm just taking a look at things now that I never looked at that way before." Parks says the book also gave him relief from the poverty and crime he shot most of his career.

Oddly enough, the telling images of poverty shown by photographers like Dorothea Lange, Walker Evans and Jack Delano were what attracted Parks to photography. He liked the directness of their images—"The fact that they were saying something important that they felt about the rest of the world. And trying to educate people about the needs of others around them."

He says his early years as a photographer at the FSA and *Life* taught him a lot about valuing and respecting his subjects. "The people who you photographed were the most important people in the world. You were just a little fly on the wall. You weren't the great *Life* photographer or the great FSA photographer. You were just an ordinary human being who had been sent to photograph people and their problems. . . . You tried to say what you felt through them."

Titled "American Gothic," this portrait of a cleaning woman at the Farm Security Administration was taken by Gordon Parks in 1942. Parks began his photography career as a documentary photographer with the FSA. The image expressed his outrage over blatant bigotry in Washington DC. "I expected to find a broader outlook on life, people living in the seat of government who were nicer people. But that wasn't so."

For Parks, understanding the problems of his subjects was easy. He's an African-American who had to survive in America before the push for civil rights. Often this meant encountering ridicule and hatred from strangers and co-workers. "I had a mother and father who taught me that love was the most important thing in the world. I had 14 brothers and sisters who loved me. I was the youngest in the clan. If I wanted to succeed I would succeed. . . . I couldn't let discrimination, poverty, bigotry or anything else be an excuse for not succeeding. That's what I tell young people now. . . . You're going to be discriminated against. If you are a pretty blonde with blue eyes, somebody is not going to like those blue eyes and blonde hair."

Parks says when shooting documentary work he always tried to research and understand his subjects before he captured anything on film. This is something he learned from Roy Stryker, Parks's boss at the FSA. "You don't have a chance to really fulfill a story unless you've had a chance to meet the family first without taking the camera in. You first must become a friend of the family. Then you're able to get pictures that are most unusual because they trust you and they're beginning to like you as an uncle or a brother."

Unfortunately for today's photographers, times have changed. Most photo editors don't have the budgets for extended assignments, and, therefore, photographers aren't given carte blanche to conduct a project. Parks feels this hurts the photos in the end. "At *Life*, if it took you three months to do an assignment, you did the assignment and they would say, 'Take your time.' Today when you go out, you've got three days to do it. Sometimes, for instance, when I did a story on poverty, I didn't even take a camera into a family for three days."

Regardless of the time limitations on projects, Parks says photographers must explore their own vision. They must think about what they want to say and the best way to say it. "Don't just put yourself in a cubbyhole with photography alone," he says. "Photography is only part of it. Beethoven can say something to you. Bach can say something to you. [Poets] can say something to you. Great writers of our time—Hemingway, Richard Wright or Ralph Ellison.

"You get something out of those works and apply them to your work. You try to become as imaginative with a camera as they are with a pen, or piano, or orchestra or whatever device they use to express themselves."

Parks also warns photographers not to allow cameras to dictate the creation of images. "The new cameras today with all the new gadgets are wonderful for photographers. They make it easy. But they also decrease the photographers' senses of imagination to do things on their own, the way they want to do them. The camera is telling them what to do. They're not telling the camera what to do."

Throughout his career, Parks has found numerous ways to express himself. The most important thing was that each project had some depth and communicated a message. "It must be something that taxes my imagination and something that gives me a chance to say something important." It never mattered to him how that message was presented. Poetry, photography, movies, music—they all help him communicate.

Currently, Parks is working on a retrospective of his work for the Corcoran Gallery of Art in Washington D.C. The show will take place within the next two years and will showcase some of his music and all of his films. Parks says he's doing a photo book for Little, Brown and Company that will accompany the show as it travels around the world.

"If you're going to go into photography give it your heart. Give it your best. But the important thing is have something to say. If you don't have anything to say, your photographs aren't going to have much to say."

Important Information on Market Listings

- *The majority of markets listed in this book are those which are actively seeking new freelance contributors. Some important, well-known companies which have declined complete listings are included within their appropriate section with a brief statement of their policies. In addition, firms which for various reasons have not renewed their listings from the 1995 edition are listed in the " '95-'96 Changes" lists at the end of each section.*
- *Market listings are published free of charge to photography buyers and are not advertisements. While every measure is taken to ensure that the listing information is as accurate as possible, we cannot guarantee or endorse any listing.*
- Photographer's Market *reserves the right to exclude any listing which does not meet its requirements.*
- *Although every buyer is given the opportunity to update his listing information prior to publication, the photography marketplace changes constantly throughout the year and between editions. Therefore it is possible that some of the market information will be out of date by the time you make use of it.*
- *This book is edited (except for quoted material) in the masculine gender because we think "he/she," "she/he," "he or she," "him or her" is distracting.*

Key to Symbols and Abbreviations

✦	*Canadian Markets*
‡	*Markets located outside the United States and Canada*
■	*Audiovisual Markets*
*	*New Markets*
●	*Introduces special comments that were inserted by the editor of* Photographer's Market.
NPI	*No payment information given*
SASE	*Self-addressed stamped envelope*
IRC	*International Reply Coupon, for use on reply mail in markets outside of your own country*
Ms, Mss	*Manuscript(s)*
©	*Copyright*
Fax	*Facsimile transmission*

(For definitions and abbreviations relating specifically to the photographic industry, see the Glossary in the back of the book.)

The Markets

Advertising, Public Relations and Audiovisual Firms

When examining most ads today it becomes obvious that creativity and technical excellence are musts for photographers wanting to crack the advertising market. Ads that sport digitally manipulated images are common, as are beautiful black and white photos. There also has been a rise in "realistic" images—those taken of events or situations involving real people rather than models. Much of this realism comes from the cameras of editorial photographers who are being hired by art directors for advertising assignments. Photojournalists are appealing to art directors because they can create believable scenes and tell stories.

Many of the people who produce cutting-edge concepts can be found in the 241 markets in this section. Of these listings, 75 are new to this edition. They range in stature from the very small, one- or two-person operations to the big boys on the block, such as Chiat-Day in Chicago, and New York City agencies TBWA Advertising Inc. and Ammirati & Puris/Lintas.

This year we have done our best to add some very important information that will help you when approaching these companies. In some listings you will notice figures for annual billing and total employees. While researching we found that readers appreciate this type of information when assessing the quality of markets. If you are a beginning photographer trying to get your feet wet in the advertising arena, consider approaching smaller houses. They may be more willing to work with newcomers. (The First Markets Index, which lists buyers interested in working with newer, lesser-known photographers, can be found in the back of this book.) On the flip side, if you have a sizable list of advertising credits, larger firms might be receptive to your work.

We've also added information about changes that are taking place as a result of new technologies. Many of the art directors/creative directors we contacted said they are now digitally storing and manipulating photos. They also are beginning to search online networks for stock images. Any technological changes of note have been mentioned inside the listings after a bullet (●).

Along with advertising and public relations firms you will find audiovisual companies listed in this section. Markets with audiovisual, film or video needs have been designated with a solid, black square (■) before them. These listings also contain detailed information under the subhead "Audiovisual Needs."

Whatever your skill level, be professional in the way you present yourself. Take some extra time to organize your portfolio into an attractive showpiece. Also create some innovative self-promotion pieces that can be given to art directors once your portfolio presentations are over.

One person who has had success in advertising is Steve Hellerstein of New York

City. Hellerstein has done assignments for many of the major advertising houses and has won numerous awards for his work. He also has a unique approach to self-promotion that is discussed in our Insider Report on page 70.

Finally, some markets that were in the 1995 edition of *Photographer's Market* are not in this year's issue. These markets were omitted for a variety of reasons which can be found under '95-'96 Changes at the end of this section.

Alabama

■**HUEY, COOK & PARTNERS**, 3800 Colonnade Pkwy., Fourth Floor, Birmingham AL 35243. (205)969-3200. Fax: (205)969-3136. Art Directors: Mike Macon/Gracey Tillman. Estab. 1972. Ad agency. Types of clients: retail, food and sporting goods. Client list provided on request.
Needs: Works with 6-10 freelance photographers/month. Uses photos for consumer magazines, trade magazines, P-O-P displays, catalogs, posters and audiovisuals. Subjects include: fishing industry, water sports, can food products and golf equipment. Model release preferred. Captions preferred.
Audiovisual Needs: Uses AV for product introductions, seminars and various presentations.
Specs: Uses 5×7 b&w prints; 35mm, 2¼×2¼, 4×5 and 8×10 transparencies.
Making Contact & Terms: Submit portfolio for review. Provide résumé, business card, brochure, flier or tearsheets to be kept on file for possible future assignments. Works on assignment basis only. Pays $50-400/b&w photo; $85-3,000/color photo; $500-1,600/day; $150-20,000/job. Payment is made on acceptance plus 90 days. Buys all rights.
Tips: Prefers to see "table top product with new, exciting lighting."

■**J.H. LEWIS ADVERTISING, INC.**, 1668 Government St., Mobile AL 36604. (205)476-2507. President; Mobile Office: Emil Graf; Birmingham Office: Larry Norris. Creative Director; Birmingham Office: Spencer Till. Senior Art Directors; Mobile Office: Ben Jordan and Helen Savage. Ad agency. Uses photos for billboards, consumer and trade magazines, direct mail, foreign media, newspapers, P-O-P displays, radio and TV. Serves industrial, entertainment, financial, agricultural, medical and consumer clients. Commissions 25 photographers/year.
Specs: Uses b&w contact sheet and 8×10 b&w glossy prints; uses 8×10 color prints and 4×5 transparencies; produces 16mm documentaries.
Making Contact & Terms: NPI. Pays per job, or royalties on 16mm film sales. Buys all rights. Model release preferred. Arrange a personal interview to show portfolio; submit portfolio for review; or send material, "preferably slides we can keep on file," by mail for consideration. SASE. Reports in 1 week.

■**TOWNSEND, BARNEY & PATRICK**, 300 St. Francis St., Mobile AL 36602. (205)433-0401. Ad agency. Vice President/Creative Services: Barbara Spafford. Types of clients: industrial, financial, medical, retail, fashion, fast food, tourism, packaging, supermarkets and food services.
Needs: Works with 1-3 freelance photographers/month. Uses photos for consumer magazines, trade magazines, direct mail, brochures, P-O-P displays, audiovisuals, posters and newspapers. Model release required.
Audiovisual Needs: Works with freelance filmmakers to produce audiovisuals.
Specs: Uses 8×10 and 11×17 glossy b&w prints; 35mm, 2¼×2¼, 4×5 and 8×10 transparencies; 16mm, 35mm film and videotape.
Making Contact & Terms: Arrange a personal interview to show portfolio or query with samples and list of stock photo subjects. Provide résumé, business card, brochure, flier or tearsheets to be kept on file for possible future assignments. Does not return unsolicited material. Reports as needed. NPI; payment "varies according to budget." Pays net 30. Buys all rights.

Alaska

THE NERLAND AGENCY, 808 E St., Anchorage AK 99501. (907)274-9553. Ad agency. Contact: Curt Potter. Types of clients: retail, hotel, restaurant, fitness, healthcare. Client list free with SASE.

The solid, black square before a listing indicates that the market uses various types of audiovisual materials, such as slides, film or videotape.

Needs: Works with 1 freelance photographer/month. Uses photos for consumer magazines, trade magazines, direct mail and brochures and collateral pieces. Subjects include Alaskan scenic shots.
Specs: Uses 11×14 matte b&w prints; 35mm, 2¼×2¼ and 4×5 transparencies.
Making Contact & Terms: Query with samples. Provide résumé, business card, brochure, flier or tearsheets to be kept on file for possible future assignments. Does not return unsolicited material. Pays $500-700/day or minimum $100/job (depends on job). **Pays on receipt of invoice.** Buys all rights or one-time rights. Model release and captions preferred.
Tips: Prefers to see "high technical quality (sharpness, lighting, etc). All photos should capture a mood. Simplicity of subject matter. Keep sending updated samples of work you are doing (monthly). We are demanding higher technical quality and looking for more 'feeling' photos than still life of product."

Arizona

■**ARIZONA CINE EQUIPMENT INC.**, 2125 E. 20th St., Tucson AZ 85719. (602)623-8268. Estab. 1972. AV firm. Types of clients: industrial and retail.
Needs: Works with 6 photographers, filmmakers and/or videographers/month. Uses photos for audiovisual. Model/property release required. Captions preferred.
Audiovisual Needs: Uses slides, film and videotape.
Specs: Uses color prints; 35mm, 4×5 transparencies.
Making Contact & Terms: Query with résumé of credits. Query with list of stock photo subjects. Send unsolicited photos by mail for consideration. Query with samples. Works with freelancers on assignment only. Keeps samples on file. SASE. Reports in 3 weeks. Pays $15-30/hour; $250-500/day; or per job. **Pays on receipt of invoice.** Buys all rights; negotiable. Credit line sometimes given.

*****EMERALD MARKETING CONCEPTS**, 5515 N. Seventh St., Suite 5-170, Phoenix AZ 85014. (602)650-7852. Fax: (602)279-3617. Director of Marketing: Sarah Colman. Estab. 1990. Ad agency. Approximate annual billing: $1 million. Number of employees: 12. Types of clients: adult services.
Needs: Works with 1-5 freelancers/month. Uses photos for consumer magazines, direct mail and catalogs. Subjects include: nude/semi-nude female models. Reviews stock photos of landscapes, sports pictures, semi-nude and/or nude women. Model release required. Property release preferred. "All model work requires a release and 2 forms of identification." Captions preferred; include location where picture was shot.
Specs: Uses 35mm slides.
Making Contact & Terms: Interested in receiving work from newer, lesser-known photographers. Contact through rep. Query with samples. Does not keep samples on file. SASE. Reports in 1-2 weeks. Pays $25-100/hour; $800-1,000/day; $10-200/color photo. Pays on receipt of invoice. Credit line not given. Buys all rights.
Tips: Provide clear shots with good eye contact and interesting angles. The "retro" look is very fashionable at the moment.

■**FARNAM COMPANIES, INC.**, Dept. PM, 301 W. Osborn, Phoenix AZ 85013-3928. Fax: (602)285-1803. Creative Director: Trish Spencer. Types of clients: animal health products, primarily for horses and dogs, some cattle, cats and birds.
 ● This company has an in-house ad agency called Charles Duff Advertising.
Needs: Works with 2 freelance photographers/month. Uses photos for direct mail, catalogs, consumer magazines, P-O-P displays, posters, AV presentations, trade magazines and brochures. Subject matter includes horses, dogs, cats, birds, farm scenes, ranch scenes, cowboys, cattle and horse shows. Occasionally works with freelance filmmakers to produce educational horse health films and demonstrations of product use.
Specs: Uses 8×10 glossy b&w and color prints; 35mm, 2¼×2¼ and 4×5 transparencies; 16mm and 35mm film and videotape.
Making Contact & Terms: Arrange a personal interview to show portfolio. Query with samples. Send unsolicited photos by mail for consideration. Provide résumé, business card, brochure, flier or

The asterisk before a listing indicates that the market is new in this edition. New markets are often the most receptive to freelance submissions.

tearsheets to be kept on file for possible future assignments. Works with freelance photographers on assignment basis only. SASE. Pays $25-100/b&w photo; $50-350/color photo. Pays on publication. Buys one-time rights. Model release required. Credit line given whenever possible.

Tips: "Send me a number of good, reasonably priced for one-time use photos of dogs, horses or farm scenes. Better yet, send me good quality dupes I can keep on file for *rush* use. When the dupes are in the file and I see them regularly, the ones I like stick in my mind and I find myself planning ways to use them. We are looking for original, dramatic work. We especially like to see horses, dogs, cats and cattle captured in artistic scenes or poses. All shots should show off quality animals with good conformation. We rarely use shots if people are shown and prefer animals in natural settings or in barns/stalls."

JOANIE L. FLATT AND ASSOC. LTD, 623 W. Southern Ave, Suite 2, Mesa AZ 85210. (602)835-9139. Fax: (602)835-9597. PR firm. President: Joanie L. Flatt. Types of clients: health care, pharmaceuticals, service, educational, insurance companies, developers, builders and finance.
Needs: Works with 2-3 photos/month. Uses photos for consumer magazines, brochures and group presentations. Subject matter varies.
Specs: Vary depending on client and job.
Making Contact & Terms: Query with list of stock photo subjects. Provide résumé, business card, brochure, flier or tearsheets to be kept on file for possible future assignments. Works with local freelance photographers only. Does not return unsolicited material. Reports in 3 weeks. NPI. Photographer bids a job in writing. Payment is made 30 days after invoice. Buys all rights and sometimes one-time rights. Model release required. Captions preferred. Credit line given if warranted depending on job.

■PAUL S. KARR PRODUCTIONS, 2925 W. Indian School Rd., Phoenix AZ 85017. (602)266-4198. Contact: Kelly Karr. Film and tape firm. Types of clients: industrial, business and education. Works with freelancers on assignment only.
Needs: Uses filmmakers for motion pictures. "You must be an experienced filmmaker with your own location equipment, and understand editing and negative cutting to be considered for any assignment." Primarily produces industrial films for training, marketing, public relations and government contracts. Does high-speed photo instrumentation. Also produces business promotional tapes, recruiting tapes and instructional and entertainment tapes for VCR and cable. "We are also interested in funded co-production ventures with other video and film producers."
Specs: Uses 16mm films and videotapes. Provides production services, including sound transfers, scoring and mixing and video production, post production, and film-to-tape services.
Making Contact & Terms: Query with résumé of credits and advise if sample reel is available. NPI. Pays/job; negotiates payment based on client's budget and photographer's ability to handle the work. Pays on production. Buys all rights. Model release required.
Tips: Branch office in Utah: Karr Productions, 1045 N. 300 East, Orem UT 84057. (801)226-8209. Contact: Mike Karr.

Arkansas

BLACKWOOD, MARTIN, AND ASSOCIATES, 3 E. Colt Square Dr., P.O. Box 1968, Fayetteville AR 72703. (501)442-9803. Ad agency. Creative Director: Gary Weidner. Types of clients: food, financial, medical, insurance, some retail. Client list provided on request.
Needs: Works with 3 freelance photographers/month. Uses photos for direct mail, catalogs, consumer magazines, P-O-P displays, trade magazines and brochures. Subject matter includes "food shots—fried foods, industrial."
Specs: Uses 8×10 high contrast b&w prints; 35mm, 4×5 and 8×10 transparencies.
Making Contact & Terms: Arrange a personal interview to show portfolio; query with samples; provide résumé, business card, brochure, flier or tearsheets to be kept on file for possible future assignments. Works with freelance photographers on assignment basis only. Does not return unsolicited material. Reports in 1 month. NPI. Payment depends on budget—"whatever the market will bear." Buys all rights. Model release preferred.
Tips: Prefers to see "good, professional work, b&w and color" in a portfolio of samples. "Be willing to travel and willing to work within our budget. We are using less b&w photography because of newspaper reproduction in our area. We're using a lot of color for printing."

■CEDAR CREST STUDIO, P.O. Box 28, Mountain Home AR 72653. (501)425-9377. Fax: (501)424-9648. Owner: Bob Ketchum. Estab. 1972. AV firm. Types of clients: industrial, financial, fashion, retail, food. Examples of recent projects: High School Seniors, Michael Timmons, photographer (videotape presentation); H.S. portraits, Stover Photography (videotape presentation); Reunion, USMC Helo pilots/Vietnam (video documentation).

Needs: Works with 4 freelancers/month. Uses photos for covers on CDs and cassettes.
Audiovisual Needs: Uses slides, film and videotape.
Specs: Uses ½", 8mm and ¾" videotape.
Making Contact & Terms: Works with local freelancers only. Does not keep samples on file. Cannot return material. NPI. Pays on publication. Credit line sometimes given. Rights negotiable.

***■WILLIAMS/CRAWFORD & ASSOCIATES, INC.,** (formerly Williams/Crawford/Perry & Associates, Inc.), P.O. Box 789, Ft. Smith AR 72901. (501)782-5230. Fax: (501)782-6970. Creative Director: David Turner. Estab. 1983. Types of clients: financial, health care, manufacturing, tourism. Examples of ad campaigns: Touche-Ross, 401K and Employee Benefits (videos); Cummins Diesel engines (print campaigns); and Freightliner Trucks (sales promotion and training videos).
Needs: Works with 2-3 freelance photographers—filmmakers—videographers/month. Uses photos for consumer magazines, trade magazines, direct mail, P-O-P displays, catalogs, posters, newspapers and audiovisual uses. Subjects include: people, products and architecture. Reviews stock photos, film or video of healthcare and financial.
Audiovisual Needs: Uses photos/film/video for 30-second video and film TV spots, 5-10-minute video sales, training and educational.
Specs: Uses 5×7, 8×10 b&w prints; 35mm, 2¼×2¼ and 4×5 transparencies.
Making Contact & Terms: Query with samples, provide résumé, business card, brochure, flier or tearsheets to be kept on file for possible future assignments. Works with freelancers on assignment basis only. Cannot return material. Reports in 1-2 weeks. Pays $500-1,200/day. Pays on receipt of invoice and client approval. Buys all rights (work-for-hire). Model release required; captions preferred. Credit line given sometimes, depending on client's attitude (payment arrangement with photographer).
Tips: In freelancer's samples, wants to see "quality and unique approaches to common problems." There is "a demand for fresh graphics and design solutions." Freelancers should "expect to be pushed to their creative limits, to work hard and be able to input ideas into the process, not just be directed."

California

***ADVANCE ADVERTISING AGENCY,** 606 E. Belmont, #202, Fresno CA 93701. (209)445-0383. Manager: Martin Nissen. Ad and PR agency and graphic design firm. Types of clients: industrial, commercial, retail, financial. Examples of recent projects: Investors Thrift (direct mail); Windshield Repair Service (radio, TV, newspaper); and Mr. G's Carpets (radio, TV, newspaper); Fresno Dixieland Society (programs and newsletters).
Needs: Model release required.
Specs: Uses color and b&w prints.
Making Contact & Terms: Send unsolicited photos by mail for consideration. Provide business card, brochure, flier to be kept on file for possible future assignments. Keeps samples on file. Reports in 1-2 weeks. NPI; payment negotiated per job. Pays 30 days from invoice. Credit line given. Buys all rights.
Tips: In samples, looks for "not very abstract or overly sophisticated or 'trendy.' Stay with basic, high quality material." Advises that photographers "consider *local* market target audience."

■AIRLINE FILM & TV PROMOTIONS, 13246 Weidner, Pacoima CA 91331. (818)899-1151. President: Byron Schmidt. Types of clients: major film companies.
Audiovisual Needs: Works with 4-5 freelance photographers/month. Uses freelance photos for films and videotapes. Subjects include publicity and advertising.
Specs: "Specifications vary with each production." Uses 8×10 color prints; 35mm transparencies; VHS videotape.
Making Contact & Terms: Provide résumé, business card, self-promotion piece or tearsheets to be kept on file for possible future assignments. Works on assignment only. Does not return unsolicited material. Payment varies per assignment and production: pays $250-500/b&w photo; $500-1,000/job. **Pays on acceptance.** Buys all rights. Model release required. Credit line sometimes given. Looks for work that shows "imagination."

***■AMERTRON-AMERICAN ELECTRONIC SUPPLY,** 1200 N. Vine St., Hollywood CA 90038-1600. (213)462-1200. Fax: (213)871-0127. General Manager: Fred Rosenthal. Estab. 1953. AV firm. Approximate annual billing: $5 million. Number of employees: 35. Types of clients: industrial, financial, fashion and retail.
Needs: Most photos used for advertising purposes.
Audiovisual Needs: Uses slides, film and videotape.
Making Contact & Terms: Interested in receiving work from newer, lesser-known photographers. Query with samples. Provide résumé, business card, brochure, flier or tearsheets to be kept on file for possible future assignments. Cannot return material. Reports in 6 months. NPI.

***AUSTIN ASSOCIATES**, 160 W. Santa St., Suite 1300, San Jose CA 95113. (408)295-1313. Ad agency. Art Director: Stuart Morgan. Serves high technology clients.

Needs: Works with 3 photographers/month. Uses work for billboards, consumer magazines, trade magazines, direct mail, P-O-P displays, newspapers. Subject matter of photography purchased includes: table top (tight shots of electronics products).

Specs: Uses 8×10 matte b&w and color prints; 35mm, 2¼×2¼, 4×5 or 8×10 transparencies.

Making Contact & Terms: Arrange a personal interview to show portfolio, send unsolicited photos by mail for consideration; provide résumé, business card, brochure, flier or tearsheets to be kept on file for possible future assignments. Works on assignment basis only. Does not return unsolicited material. Reports in 3 weeks. Pays $500-2,500/job. Pays on receipt of invoice. Buys all rights (work-for-hire). Model release required, captions preferred.

Tips: Prefers to see "originality, creativity, uniqueness, technical expertise" in work submitted. There is more use of "photo composites, dramatic lighting, and more attention to detail" in photography.

***BEAR ADVERTISING**, 32121 Lindero Canyon Rd., Suite 200, Westlake Village CA 91361-4207. (213)466-6464. Vice President: Bruce Bear. Ad agency. Uses photographs for consumer magazines, direct mail, foreign media, P-O-P displays and trade magazines. Serves sporting goods, fast foods and industrial clients.

Needs: Works with 4 freelance photographers/month on assignment only. Prefers to see samples of sporting goods, fishing equipment, outdoor scenes, product shots with rustic atmosphere of guns, rifles, fishing reels, lures, camping equipment, etc.

Specs: Uses b&w and color photos.

Making Contact & Terms: Call to arrange interview to show portfolio. Provide business card and tearsheets to be kept on file for possible future assignments. SASE. Reports in 1 week. Pays $150-250/b&w photo; $200-350/color photo. Pays 30 days after billing to client. Buys all rights.

***CHIAT-DAY**, 320 Hampton Dr., Venice CA 90291. (310)314-5000. Contact: Art Buyer. Types of clients: industrial, financial, fashion, retail, food. Examples of recent projects: Nissan, Sony, Jack-in-the-Box and Eveready Battery Company.

Needs: Works with 10-50 freelancers/month. Uses photos for billboards, consumer and trade magazines, direct mail, P-O-P displays, catalogs, posters, newspapers, signage and audiovisual uses. Subjects used depend on the company. Model/property release required.

Specs: Uses 8x10 and 11x14 matte b&w prints; 35mm, 2¼×2¼, 4×5, 8×10 transparencies (prefers 4×5 and 8×10).

Making Contact & Terms: Interested in receiving work from newer, lesser-known photographers. Contact through rep. Arrange personal interview to show portfolio. Submit portfolio for review. Query with samples. Leave promo sheet. Provide résumé, business card, brochure, flier or tearsheets to be kept on file for possible future assignments. Reporting time depends; can call for feedback. NPI. Pays on receipt of invoice. Rights purchased vary; negotiable.

■EVANS & PARTNERS, INC., 1961 Oxford Ave., Cardiff by the Sea CA 92007. (619)944-9400. Fax: (619)944-9422. President/Creative Director: David R. Evans. Estab. 1989. Ad agency. Types of clients: industrial, financial, medical. Examples of recent projects: Novus Technologies (brochures, convention booth, videos); Ortho Organizers (ads, brochures, catalogs); Procare (brochures, catalogs, videos, international).

● This agency is utilizing photo manipulation technologies, which gives photographers the latitude to create.

Needs: Works with 2-3 freelance photographers, 1-6 videographers/month. Uses photos for billboards, trade magazines, direct mail, P-O-P displays, catalogs, posters, newspapers, signage and audiovisual uses. Subjects include: medical, medical high tech, real estate. Reviews stock photos. Model release required for people. Property release preferred. Captions preferred; include name of photographer.

Audiovisual Needs: Uses slides and video for presentations, educational.

Specs: Uses 35mm, 2¼×2¼, 4×5 transparencies; ½" VHS-SVHS videotape.

Making Contact & Terms: Interested in receiving work from newer, lesser-known photographers. Query with stock photo list and samples. Provide résumé, business card, brochure, flier or tearsheets to be kept on file for possible future assignments. Works with local freelancers on assignment only. Keeps samples on file. SASE. Will notify if interested. Pays $700-2,000/day; $175 and up/job. Pays

A bullet has been placed within some listings to introduce special comments by the editor of **Photographer's Market.**

upon receipt of payment from client. Credit line given depending upon nature of assignment, sophistication of client. Buys first, one-time and all rights; negotiable.

Tips: Looking for "ability to see structure, line tensions, composition innovation; finesse in capturing people's energy; ability to create visuals equal to the level of sophistication of the business or product."

***■KEN FONG ADVERTISING, INC.,** 178 W. Adams St., Stockton CA 95204-5338. (209)466-0366. Fax: (209)466-0387. Art Director: Donna Yee. Estab. 1953. Ad agency. Number of employees: 9. Types of clients: industrial, financial, fashion, retail and food.

Needs: Uses photos for billboards, consumer and trade magazines, direct mail, P-O-P displays, catalogs, posters, newspapers, signage and audiovisual. Subject matter varies. Reviews stock photos of diverse, "real" and business-type people, lifestyle/leisure, nature, commerce, sports/recreation. Model/property release required.

Audiovisual Needs: Uses slides and video.

Specs: Uses 8×10 and larger glossy color and b&w prints; 35mm, 2¼×2¼, 4×5 transparencies; ½″ VHS videotape.

Making Contact & Terms: Interested in receiving work from newer, lesser-known photographers. Provide résumé, business card, brochure, flier or tearsheets to be kept on file for possible future assignments. Works on assignment only. Keeps samples on file. SASE. Reports in 1 month. Pays on receipt of invoice. Credit line not given. Buys one-time and all rights; negotiable.

■HAYES ORLIE CUNDALL INC., 46 Varda Landing, Sausalito CA 94965. (415)332-7414. Fax: (415)332-5924. Executive Vice President and Creative Director: Alan W. Cundall. Estab. 1991. Ad agency. Uses all media except foreign. Types of clients: industrial, retail, fashion, finance, computer and hi-tech, travel, healthcare, insurance and real estate.

Needs: Works with 1 freelance photographer/month on assignment only. Model release required. Captions preferred.

Making Contact & Terms: Provide résumé, business card and brochure to be kept on file for future assignments. "Don't send anything unless it's a brochure of your work or company. We keep a file of talent—we then contact photographers as jobs come up." NPI. Pays on a per-photo basis; negotiates payment based on client's budget, amount of creativity required and where work will appear. "We abide by local photographer's rates."

Tips: "Most books are alike. I look for creative and technical excellence, then how close to our offices; cheap vs. costly; personal rapport; references from friends in agencies who've used him/her. Call first. Send samples and résumé if I'm not able to meet with you personally due to work pressure. Keep in touch with new samples." Produces occasional audiovisual for industrial and computer clients; also produces a couple of videos a year.

THE HITCHINS COMPANY, 22756 Hartland St., Canoga Park CA 91307. Phone/fax: (818)715-0510. President: W.E. Hitchins. Estab. 1985. Ad agency. Approximate annual billing: $350,000. Number of employees: 2. Types of clients: industrial, retail (food) and auctioneers. Examples of recent projects: Electronic Expediters (brochure showing products).

Needs: Uses photos for trade magazines, direct mail and newspapers. Model release required.

Specs: Uses b&w and color prints. "Copy should be flexible for scanning."

Making Contact & Terms: Provide résumé, business card, brochure, flier or tearsheets to be kept on file for possible future assignments. Works on assignment only. Cannot return material. NPI; payment negotiable depending on job. Pays on receipt of invoice (30 days). Rights purchased negotiable; "varies as to project."

Tips: Wants to see shots of people and products in samples.

***■IMAGE INTEGRATION,** 2418 Stuart St., Berkeley CA 94705. (510)841-8524. Owner: Vince Casalaina. Estab. 1971. Specializes in material for TV productions. Approximate annual billing: $100,000. Examples of recent projects: "Ultimate Subscription" for *Sailing World* (30 second spot); "Road to America's Cup" for ESPN (stock footage); and "Sail with the Best" for US Sailing (promotional video).

Needs: Works with 1 freelance photographer and 1 videographer/month. Reviews stock photos of sailing. Property release preferred. Captions required; include regatta name, regatta location, date.

Audiovisual Needs: Uses videotape. Subjects include: sailing.

Specs: Uses 4×5 or larger matte color or b&w prints; 35mm transparencies; 16mm film and Betacam videotape.

Making Contact & Terms: Interested in receiving work from newer, lesser-known photographers. Send unsolicited photos by mail for consideration. Works on assignment only. Keeps samples on file. SASE. Reports in 1-2 weeks. NPI; payment depends on distribution. Pays on publication. Credit line sometimes given, depending upon whether any credits included. Buys non-exclusive rights; negotiable.

KRESSER/CRAIG, 2501 Colorado Ave., Santa Monica CA 90404. Prefers not to share information.

***RICHARD BOND LEWIS & ASSOCIATES**, 1112 W. Cameron Ave., West Covina CA 91790. (818)962-7727. Creative Director: Dick Lewis. Estab. 1971. Ad agency. Types of clients: industrial, consumer products manufacturer, real estate, autos. Client list free with SASE.
Needs: Works with 1-2 freelance photographers/month. Uses photos for billboards, consumer and trade magazines, direct mail, catalogs and newspapers. Subjects include: product photos. Model release required. Captions preferred.
Specs: Uses 4×5 color prints and 4×5 transparencies.
Making Contact & Terms: Arrange a personal interview to show portfolio. Provide résumé, business card, brochure, flier or tearsheets to be kept on file for possible future assignments. Works on assignment only. Cannot return material. "Will return upon request." NPI; payment negotiable. Pays "usually 10 days from receipt of invoice—no later than 30 days." Credit line given "if client approves." Buys all rights; "we request negatives on completion of job."
Tips: Prefers to see a variety—people, industrial, product, landscape, some fashion. "Bring in portfolio and leave some samples which best describe your capabilities."

■LINEAR CYCLE PRODUCTIONS, Box 2608, Sepulveda CA 91393-2608. (818)895-8921. Production Manager: R. Borowy. Estab. 1980. Member of Internation United Photographer Publishers, Inc. Ad agency, PR firm. Types of clients: industrial, commercial, advertising. Examples of recent projects: Blo-Owt, Blo-Owt Clothing; GRO-PUPe, GRO-PUPe pet food; Bug-B-Goaway, Bug-B-Goaway pest spray (all ad campaigns).
Needs: Works with 7-10 freelance photographers, 8-12 filmmakers, 8-12 videographers/month. Uses photos for billboards, consumer magazines, direct mail, P-O-P displays, posters, newspapers, audiovisual uses. Subjects include: candid photographs. Reviews stock photos, archival. Model/property release required. Captions required; include description of subject matter.
Audiovisual Needs: Uses slides and/or film or video for television/motion pictures. Subjects include: archival-humor material.
Specs: Uses 8×10 color and b&w prints; 35mm, 8×10 transparencies; 16mm-35mm film; ½-¾"-1" videotape.
Making Contact & Terms: Interested in receiving work from newer, lesser-known photographers. Submit portfolio for review. Query with résumé of credits. Query with stock photo list. Send unsolicited photos by mail for consideration. Provide résumé, business card, brochure, flier or tearsheets to be kept on file for possible future assignments. Works with local freelancers on assignment only. Keeps samples on file. Reports in 1 month. Pays $5-1,000/b&w photo; $7-1,500/color photo; $4.35-30/hour; $40-500/day; $20-3,500/job. Prices paid depend on position. Pays on publication. Credit line given. Buys one-time, exclusive product rights and all rights. Rights negotiable.
Tips: "Send a good portfolio with pix shot in color in color (not b&w of color). No sloppy pictures or portfolios!! The better the portfolio is set up, the better the chances that we would consider it . . . let alone look at it!!" Seeing a trend toward "more archival/vintage, and a lot of humor pieces!!!"

■MARKEN COMMUNICATIONS, 3600 Pruneridge, Suite 130, Santa Clara CA 95051. (408)296-3600. Fax: (408)296-3803. President: Andy Marken. Production Manager: Leslie Posada. Estab. 1977. Ad agency and PR firm. Types of clients: furnishings, electronics and computers. Examples of recent ad campaigns include: Burke Industries (resilient flooring, carpet); Boole and Babbage (mainframe software); Maxar (PCs).
Needs: Works with 3-4 freelance photographers/month. Uses photos for trade magazine, direct mail, publicity and catalogs. Subjects include: product/applications. Model release required.
Audiovisual Needs: Slide presentations and sales/demo videos.
Specs: Uses color and b&w prints; 35mm, 2¼×2¼ and 4×5 transparencies.
Making Contact & Terms: Arrange a personal interview to show portfolio. Query with samples. Submit portfolio for review. "Call." Works with freelancers on an assignment basis only. SASE. Reports in 1 month. Pays $50-1,000/b&w photo; $100-1,800/color photo; $50-100/hour; $500-1,000/day; $200-2,500/job. Pays 30 days after receipt of invoice. Credit line given "sometimes."

■NEW & UNIQUE VIDEOS, 2336 Sumac Dr., San Diego CA 92105. (619)282-6126. Fax: (619)283-8264. Director of Acquisitions: Candace Love. Estab. 1981. AV firm. Types of clients: industrial, financial, fashion, retail and special interest video distribution. Examples of recent projects: "Full-Cycle: A World Odyssey" (special-interest video); "Ultimate Mountain Biking," Raleigh Cycle Co. of America (special interest video); "John Howard's Lessons in Cycling," John Howard (special interest video); and "Battle at Durango: First-Ever World Mountain Bike Championships," *Mountain & City Biking Magazine* (special interest video).
Needs: Works with 8-10 photographers and/or videographers/year. Subjects include "new and unique" special interest, such as cycling and sports. Reviews stock footage: cycling, sports, comedy, romance, "new and unique." Model/property release preferred.

Audiovisual Needs: Uses VHS videotape, Hi-8 and Betacam SP.
Making Contact & Terms: Query with list of video subjects. Works on assignment only. Keeps samples on file. SASE. Reports in 3 weeks. NPI; "payment always negotiated." **Pays on acceptance.** Credit line given. Buys exclusive and nonexclusive rights.
Tips: In samples looks for "originality, good humor and timelessness. We are seeing an international hunger for action footage; good wholesome adventure; comedy, educational, how-to—special interest. The entrepreneurial, creative and original video artiste—with the right attitude—can always feel free to call us."

NORTON-WOOD PR SERVICES, 1430 Tropical Ave., Pasadena CA 91107-1623. (818)351-9216. Fax: (818)351-9446. PR firm. Partner-owner: Nat Wood. Types of clients: industrial/manufacturing/ computers/aerospace.
Needs: Works with 1 freelance photographer/month. Uses freelance photographers for trade magazines, catalogs and brochures. Model release required; property release preferred. Captions required.
Making Contact & Terms: Interested in receiving work from newer, lesser-known photographers if industrial oriented. Query with résumé of credits, query with list of stock photo subjects. Works with local freelancers only. Reports in 2 weeks. Pays $20-250/b&w photo; $35-75/color photo; $40-60/ hour; $500-750/day; $500-1,000/job. Pays on receipt of invoice. Buys one-time rights; negotiable. Credit line sometimes given.
Tips: Prefer to see industrial products, in-plant shots, personnel, machinery in use. "Be available for Western states assignments primarily. Use other than 35mm equipment."

■ON-Q PRODUCTIONS INC., 618 E. Gutierrez St., Santa Barbara CA 93103. (805)963-1331. President: Vincent Quaranta. Estab. 1984. Producers of multi-projector slide presentations and computer graphics. Types of clients: industrial, fashion and finance.
Needs: Buys 100 freelance photos/year; offers 50 assignments/year. Uses photos for brochures, posters, audiovisual presentations, annual reports, catalogs and magazines. Subjects include: scenic, people and general stock. Model release required. Captions required.
Specs: Uses 35mm, 2¼ × 2¼ and 4 × 5 transparencies.
Making Contact & Terms: Provide stock list, business card, brochure, flier or tearsheets to be kept on file for possible future assignments. Pays $100 minimum/job. Buys rights according to client's needs.
Tips: Looks for stock slides for AV uses.

***■BILL RASE PRODUCTIONS, INC.,** 955 Venture Court, Sacramento CA 95825. (916)929-9181. Manager/Owner: Bill Rase. Estab. 1965. AV firm. Types of clients: industry, business, government, publishing and education. Produces slide sets, multimedia kits, motion pictures, sound-slide sets, videotapes, mass cassette, reel and video duplication. Photo and film purchases vary.
Needs: "Script recording for educational clients is our largest need, followed by industrial training, state and government work, motivational, video transfer, etc." Freelance photos used sometimes in motion pictures. No nudes. Color only. Vertical format for TV cutoff only. Sound for TV public service announcements, commercials, and industrial films. Uses stock footage of hard-to-find scenes, landmarks in other cities, shots from the 1920s to 1980s, etc. Special subject needs include 35mm and ¾-inch video shot of California landmark locations, especially San Francisco, Napa Valley Wine Country, Gold Country, Lake Tahoe area, Delta area and Sacramento area. "We buy out the footage—so much for so much," or ¾-inch video or 35mm slides. Uses 8 × 10 prints and 35mm transparencies.
Making Contact & Terms: NPI. Payment depends on job, by bid. Pays 30 days after acceptance. Buys one-time rights or all rights; varies according to clients' needs. Model release required. Query with samples and résumé of credits. Freelancers within 100 miles only. Does not return samples. SASE. Reports "according to the type of project. Sometimes it takes a couple of months to get the proper bid info."
Tips: "Video footage of the popular areas of this country and others is becoming more and more useful. Have price list, equipment list and a few slide samples in a folder or package available to send."

■RED HOTS ENTERTAINMENT, 634 N. Glenoaks Blvd., Suite 374, Burbank CA 91502-2024. (818)954-0092. President/Creative Director: Chip Miller. Estab. 1987. Motion picture, music video, commercial, and promotional trailer film production company. Types of clients: industrial, fashion, entertainment, motion picture, TV and music.
Needs: Works with 2-6 freelance photographers/month. Uses freelancers for TV, music video, motion picture stills and production. Model release required. Property release preferred. Captions preferred.
Making Contact & Terms: Provide business card, résumé, references, samples or tearsheets to be kept on file for possible future assignments. NPI; payment negotiable "based on project's budget." Rights negotiable.

Tips: Wants to see minimum of 2 pieces expressing range of studio, location, style and model-oriented work. Include samples of work published or commissioned for production.

■VISITORS AID MARKETING/VISAID MARKETING/PASSENGERS AID, Box 4502, Inglewood CA 90309-4502. (310)473-0286. Manager: Lee Clapp. Estab. 1961. Ad agency, PR firm. Types of clients: industrial, fashion, retail, food, travel hospitality. Examples of recent projects: "Robot Show, Tokyo" (magazine story) and "American Hawaii Cruise" (articles).
Needs: Works with 1 freelance photographer, 1 filmmaker and 1 videographer/month. Uses photos for billboards, consumer magazines, trade magazines, direct mail, P-O-P displays, catalogs, posters, newspapers, signage. Model/property release required for models, printed matter (copyrighted). Captions required; include who, what, where, when.
Audiovisual Needs: Uses slides and/or film or video for presentations to prospective clients. Subjects include: use in brochures enforcement (presentations).
Specs: Uses 8×10, glossy color and b&w prints; 35mm, 2¼×2¼, 4×5, 8×10 transparencies.
Making Contact & Terms: Interested in receiving work from newer, lesser-known photographers. Contact through rep. Query with résumé of credits. Provide résumé, business card, brochure, flier or tearsheets to be kept on file for possible future assignments. "Never send originals." Keeps samples on file. SASE. Reports in 1-2 weeks. NPI. Pays on acceptance, publication or receipt of invoice. Credit line given depending upon origination of subject matter. Buys first, one-time and all rights (discuss); negotiable.

■DANA WHITE PRODUCTIONS, INC., 2623 29th St., Santa Monica CA 90405. (310)450-9101. Full-service audiovisual, multi-image, photography and design, video/film production studio. President: Dana White. Estab. 1977. Types of clients: corporate, government and educational. Examples of recent productions: Southern California Gas Company/South Coast AQMD (Clean Air Environmental Film Trailers in 300+ LA-based motion picture theaters); Glencoe/MacMillan/McGraw-Hill (textbook photography and illustrations, slide shows); Pepperdine University (Awards Banquets Presentations, Fund-Raising, Biographical Tribute Programs); US Forest Service (slide shows and training programs); Venice Family Clinic (Newsletter photography); Johnson & Higgins (brochure photography).
Needs: Works with 2-3 freelance photographers/month. Uses photos for catalogs, audiovisual and books. Subjects include: people, products, still life and architecture. Interested in reviewing 35mm stock photos, by appointment. Signed model release for people and companies photographed is required.
Audiovisual Needs: Uses all AV formats; also slides for multi-image presentations using 1-9 projectors.
Specs: Uses color and b&w; 35mm, 2¼×2¼ transparencies.
Making Contact & Terms: Interested in receiving work from newer, lesser-known photographers. Arrange a personal interview to show portfolio and samples. Works with freelancers on assignment only. Will assign certain work on spec. Do not submit unsolicited material. Will not return material. Pays when images are shot to White's satisfaction—never delays until acceptance by client. Pays according to job: $25-100/hour, up to $500/day; $20-50/shot; or fixed fee based upon job complexity and priority of exposure. Hires according to work-for-hire and will share photo credit when possible.
Tips: In freelancer's portfolio or demo, Mr. White wants to see "quality of composition, lighting, saturation, degree of difficulty and importance of assignment." The trend seems to be toward "more video, less AV." Clients are paying less and expecting more. To break in, freelancers should "diversify, negotiate, be flexible, go the distance to get and keep the job. Don't get stuck in thinking things can be done just one way. Support your co-workers."

*■WORLDWIDE MARKETING GROUP, 1874 S. Pacific Coast Hwy., #906, Redondo Beach CA 90277. (310)540-5374. Fax: (310)543-3081. President: Anne-Marie Fahrenkrug-Ortiz. Ad agency. Approximate annual billing: $6 million. Number of employees: 10. Types of clients: Audiotext. Examples of recent clients: Interwest Communications (London/Santa Monica, California); 3-Net Communications (Sweden); Telecard (Norway).
Needs: Uses photos for consumer magazines, direct mail and newspapers. Subjects include: adult audiotext services. Reviews seductive—adult photos—of Western and Asian women with and without nudity—cleavage and lingerie stock photos. Model release required. Captions should include photo identification.
Audiovisual Needs: Uses videotape for adult commercials on late night TV.
Specs: Uses color and b&w prints (color preferred); 2¼×2¼ transparencies.
Making Contact & Terms: Interested in receiving work from newer, lesser-known photographers. Query with stock photo list. Send unsolicited photos by mail for consideration. Query with samples. Works on assignment only. Keeps samples on file. SASE. Reports in 1-2 weeks. Usually pays from $125/photo (full buyout). **Pays on acceptance**. Credit line not given. Buys all rights.
Tips: "We book space and create ads for clients in the adult audiotext industry. We prefer full buyouts of material with model releases."

Los Angeles

■**BRAMSON + ASSOCIATES**, 7400 Beverly Blvd., Los Angeles CA 90036. (213)938-3595. Fax: (213)938-0852. Principal: Gene Bramson. Estab. 1970. Ad agency. Types of clients: industrial, financial, food, retail, healthcare.
Needs: Works with 2-5 freelance photographers and 1 videographer/month. Uses photos for trade magazines, direct mail, catalogs, posters, newspapers, signage. Subject matter varies. Reviews stock photos. Model/property release required. Captions preferred.
Audiovisual Needs: Uses slides and/or videotape for industrial, product.
Specs: Uses 11 × 15 color and b&w prints; 35mm, 2¼ × 2¼, 4 × 5, 8 × 10 transparencies.
Making Contact & Terms: Interested in receiving work from newer, lesser-known photographers. Submit portfolio for review. Send unsolicited photos by mail for consideration. Provide résumé, business card, brochure, flier or tearsheet to be kept on file for possible future assignments. Works with local freelancers on assignment only. Keeps samples on file. SASE. Reports in 3 weeks. NPI. Pays on receipt of invoice. Payment varies depending on budget for each project. Credit line not given. Buys all rights.
Tips: "Innovative—crisp—dynamic—unique style—different—otherwise we'll stick with our photographers. If it's not great work don't bother."

*■**HALLOWES PRODUCTIONS & ADVERTISING**, 11260 Regent St., Los Angeles CA 90066-3414. (310)390-4767. Fax: (310)397-2977. Creative Director/Producer-Director: Jim Hallowes. Estab. 1984. Produces TV commercials, corporate films and print advertising.
Needs: Buys 8-10 photos annually. Uses photos for magazines, posters, newspapers and brochures. Reviews stock photos; subjects vary.
Audiovisual Needs: Uses film and video for TV commercials and corporate films.
Specs: Uses 35mm, 4 × 5 transparencies; 35mm/16mm film; Beta SP videotape.
Making Contact & Terms: Interested in receiving work from newer, lesser-known photographers. Query with résumé of credits. Do not fax unless requested. Keeps samples on file. SASE. Reports if interested. NPI. Pays on usage. Credit line sometimes given, depending upon usage, usually not. Buys first and all rights; rights vary depending on client.

■**BERNARD HODES ADVERTISING**, 11755 Wilshire Blvd., Suite 1600, Los Angeles CA 90025. (310)575-4000. Ad agency. Creative Directors: Steve Mitchell and Morris Hertz. Produces "recruitment advertising for all types of clients."
Needs: Uses photos for billboards, trade magazines, direct mail, brochures, catalogs, posters, newspapers and internal promotion. Model release required.
Making Contact & Terms: Query with samples "to be followed by personal interview if interested." Does not return unsolicited material. Reporting time "depends upon jobs in house; I try to arrange appointments within 3-4 weeks." NPI. Payment "depends upon established budget and subject." **Pays on acceptance** for assignments; on publication per photo. Buys all rights.
Tips: Prefers to see "samples from a wide variety of subjects. No fashion. People-oriented location shots. Nonproduct. Photos of people and/or objects telling a story—a message. Eye-catching." Photographers must have "flexible day and ½-day rates, work fast and be able to get a full day's (or ½) work from a model or models. Excellent sense of lighting. Awareness of the photographic problems with newspaper reproduction."

LEVINSON ASSOCIATES, 1440 Veteran Ave., Suite 650, Los Angeles CA 90027. (213)460-4545. Fax: (213)663-2820. Assistant to President: Jed Leland, Jr. Estab. 1969. PR firm. Types of clients: industrial, financial, entertainment. Examples of recent projects: Cougar Records; Steve Yeager's Stars of Sports; the Boyce & Hart Project.
Needs: Works with varying number of freelancers/month. Uses photos for trade magazines and newspapers. Subjects vary. Model release required. Property release preferred. Captions preferred.
Making Contact & Terms: Works with local freelancers only. Keeps samples on file. Cannot return material. NPI.

■**MYRIAD PRODUCTIONS**, 1314 N. Hayworth Ave., Suite 402, Los Angeles CA 90046. (213)851-1400. President: Ed Harris. Estab. 1965. Primarily involved with sports productions and events. Works with freelance photographers on assignment only basis.
Needs: Uses photos for portraits, live-action and studio shots, special effects, advertising, illustrations, brochures, TV and film graphics, theatrical and production stills. Model/property release required. Captions preferred; include name(s), location, date, description.
Specs: Uses 8 × 10 b&w glossy prints, 8 × 10 color prints and 2¼ × 2¼ transparancies.
Making Contact & Terms: Provide brochure, résumé and samples to be kept on file for possible future assignments. Send material by mail for consideration. Cannot return material. Reporting time "depends on urgency of job or production." NPI. Credit line sometimes given. Buys all rights.

Tips: "We look for an imaginative photographer; one who captures all the subtle nuances, as the photographer is as much a part of the creative process as the artist or scene being shot. Working with us depends almost entirely on the photographer's skill and creative sensitivity with the subject. All materials submitted will be placed on file and not returned, pending future assignments. Photographers should not send us their only prints, transparencies, etc., for this reason."

OGILVY & MATHER DIRECT, 11766 Wilshire Blvd., Suite 1100, Los Angeles CA 90025. Prefers not to share information.

San Francisco

GOODBY SILVERSTEIN & PARTNERS, 915 Front St., San Francisco CA 94111. Prefers not to share information.

PURDOM PUBLIC RELATIONS, 395 Oyster Point Blvd., Suite 319, San Francisco CA 94080. Fax: (415)588-1643. E-mail: purcom@netcom.com. President: Paul Purdom. Estab. 1965. Member of International Public Relations Exchange, Public Relations Society of America. Number of employees: 15. PR firm. Types of clients: computer manufacturers, software, general high-technology products. Examples of recent PR campaigns: Sun Microsystems, Apple, Acuron Corporation (all application articles in trade publications).
Needs: Works with 4-6 freelance photographers/month. Uses photos for trade magazines, direct mail and newspapers. Subjects include: high technology and scientific topics. Model release preferred.
Specs: Uses 35mm and 2¼×2¼ transparencies; film: contact for specs.
Making Contact & Terms: Query with résumé of credits, list of stock photo subjects. Provide résumé, business card, brochure, flier or tearsheets to be kept on file for possible future assignments. Works on assignment only. Does not return material. Reports as needed. Pays $50-150/hour, $400-1,500/day. Pays on receipt of invoice. Buys all rights; negotiable.

REDGATE COMMUNICATIONS CORPORATION, 221 Main St., Suite 480, San Francisco CA 94105-1913. Associate Creative Director: Judi Muller. Estab. 1987. Marketing communications agency. Types of clients: high tech and healthcare.
Needs: Works with 1-6 photographers/month. Uses photos for brochures and corporate magazines. Subjects include: portraits and conceptual still life. Model release required.
Specs: Uses b&w prints; 35mm, 2¼×2¼, 4×5 transparencies.
Making Contact & Terms: Interested in receiving work from newer, lesser-known photographers. Provide business card and tearsheets to be kept on file for possible future assignments. Keeps samples on file. SASE. "We call when something applicable comes up." NPI. Pays on receipt of invoice (+60 days). Credit line sometimes given: "corporate magazine, yes, otherwise no." Rights negotiable (depends on project).
Tips: "I am looking for interesting, conceptual, unique photography. We already have reliable people we use for standard shots."

HAL RINEY & PARTNERS INC., 735 Battery St., San Francisco CA 94111. Prefers not to share information.

■**VARITEL VIDEO**, One Union, San Francisco CA 94111. (415)693-1111. Vice President of Marketing and Sales: Lori Anderson. Production Manager: Blake Padilla. Types of clients: advertising agencies.
Needs: Works with 10 freelance photographers/month. Uses freelance photos for filmstrips, slide sets and videotapes. Also works with freelance filmmakers for CD-ROM, Paint Box.
Specs: Uses color prints; 35mm transparencies; 16mm, 35mm film; VHS, Beta, U-matic ¾″ or 1″ videotape. Also, D2.
Making Contact & Terms: Provide résumé, business card, self-promotion piece or tearsheets to be kept on file for possible future assignments. Does not return unsolicited material. Reports in 1 week. Pays $50-100/hour; $200-500/day. **Pays on acceptance.** Rights vary.
Tips: Apply with résumé and examples of work to Julie Resing.

Colorado

EVANSGROUP, 1050 17th St., Suite 700, Denver CO 80202. (303)534-2343. Creative Director: Gary Christlieb. Ad agency. Types of clients: consumer, franchises, financial, health care, brewing, business-to-business.

Needs: Works with approximately 25 freelance photographers/year on assignment only basis. Uses photos for consumer and trade magazines, direct mail, P-O-P displays, brochures, catalogs, posters, newspapers, AV presentations and TV.
Making Contact & Terms: Arrange interview to show portfolio. NPI; negotiates payment according to job.

■**FRIEDENTAG PHOTOGRAPHICS**, 356 Grape St., Denver CO 80220. (303)333-7096. Manager: Harvey Friedentag. Estab. 1957. AV firm. Serves clients in business, industry, government, trade and union organizations. Produces slide sets, motion pictures and videotape.
Needs: Works with 5-10 freelancers/month on assignment only. Buys 1,000 photos and 25 films/year. Reviews stock photos of business, training, public relations and industrial plants showing people and equipment or products in use. Model release required.
Audiovisual Needs: Uses freelance photos in color slide sets and motion pictures. No posed looks. Also produces mostly 16mm Ektachrome and some 16mm b&w; ¾" and VHS videotape. Length requirement: 3-30 minutes. Interested in stock footage on business, industry, education and unusual information. "No scenics please!"
Specs: Uses 8×10 glossy b&w and color prints; transparencies; 35mm, 2¼×2¼ or 4×5 color transparencies.
Making Contact & Terms: Send material by mail for consideration. Provide flier, business card and brochure and nonreturnable samples to show clients. SASE. Reports in 3 weeks. Pays $400/day for still; $600/day for motion picture plus expenses, or $35/b&w photo or $75/color photo. **Pays on acceptance.** Buys rights as required by clients.
Tips: "More imagination needed, be different, and above all, technical quality is a must. There are more opportunities now than ever, especially for new people. We are looking to strengthen our file of talent across the nation."

■**WARREN MILLER ENTERTAINMENT**, 2540 Frontier Ave., Unit #104, Boulder CO 80301. (303)442-3430. Fax: (303)442-3402. Production Manager: Don Brolin. Motion picture production house. Buys 5 films/year.
Needs: Works with 5-20 freelance photographers/month. Uses photographers for outdoor cinematography of skiing (snow) and other sports. Also travel, documentary, promotional, educational and indoor studio filming. "We do everything from TV commercials to industrial films to feature length sports films."
Audiovisual Needs: Uses 16mm film. "We purchase exceptional sport footage not available to us."
Making Contact & Terms: Filmmakers may query with résumé of credits and sample reel. "We are only interested in motion picture-oriented individuals who have practical experience in the production of 16mm motion pictures." Works on assignment only. SASE. Reports in 1 week. Pays $150-200/day. Also pays by the job. Pays on receipt of invoice. Buys all rights. Credit line given.
Tips: Looks for technical mastering of the craft and equipment—decisive shot selection. "Make a hot demo reel and be a hot skier; be willing to travel."

Connecticut

*■**DONAHUE ADVERTISING & PUBLIC RELATIONS, INC.**, 227 Lawrence St., Hartford CT 06106. (203)728-0000. Fax: (203)247-9247. Ad agency and PR firm. Creative Director: Jim Donahue. Estab. 1980. Types of clients: industrial and high-tech.
Needs: Works with 1-2 photographers and/or videographers/month. Uses photos for trade magazines, catalogs and posters. Subjects include: products.
Audiovisual Needs: Uses videotape—infrequently.
Specs: Uses 8×10 matte and glossy color or b&w prints; 4×5 transparencies.
Making Contact & Terms: Contact through rep. Arrange personal interview to show portfolio. Send unsolicited photos by mail for consideration. Provide résumé, business card, brochure, flier or tearsheets to be kept on file for possible future assignments. Keeps samples on file. Cannot return material. Reports in 1-2 weeks. Pays $1,200-1,500/day. **Pays on receipt of invoice with purchase order.** Buys all rights. Model/property release required. Credit line not given.

*■**GUILFORD MARKETING**, 6 Paddock Lane, Suite 201, Guilford CT 06437-2809. Phone/fax: (203)453-6261. Owner/Creative Director: R.S. Eaton. Estab. 1990. Ad/PR agency and public affairs. Number of employees: 1 fulltime, 1 part time. Types of clients: industrial, fast food, professions and financial. Examples of recent projects: new store launch for Dunkin' Donuts; integrated condo marketing for Contracting Advisors; and newsletter for the Board of Realtors.
Needs: Works with 1-2 freelancers/month. Connecticut/New York area photographers only. Uses photos for billboards, consumer magazines, direct mail, P-O-P displays, posters, newspapers, signage, brochures and other collateral, TV. Subjects include: people, scenes, products (heavy real estate).

Reviews stock photos. Model release required. Property release preferred. Caption preferred; include location, subject, date, file code/source/photographer credit.
Audiovisual Needs: Uses slides and video for meetings, sales promotion and TV. Subjects include: real estate products, low-cost PR shots, some head and shoulder portraits, some situational.
Specs: Uses color and b&w prints; 35mm, 2¼×2¼, 4×5 transparencies.
Making Contact & Terms: Interested in receiving work from newer, lesser-known photographers. Query with stock photo list. Query with samples. Works on assignment only. Keeps samples on file. SASE. Will contact if future work is anticipated or if need is immediate. Otherwise, will not contact. NPI. Prefer fee for job. Pays within 30 days of invoice. Credit line sometimes given depending on job, client and, sometimes, available space or other design criteria. Buys first, one-time and all rights; negotiable.
Tips: "No kinky, off-beat material. Generally, sharp focus, good depth of field, good use of light. In real estate, most have swing back camera to correct distortions. Retouch capability is a plus. For PR, need extremely fast turn-around and low pricing schedule."

THE MORETON AGENCY, P.O. Box 749, East Windsor CT 06088. (203)627-0326. Art Director: Keith Malone. Ad agency. Types of clients: industrial, sporting goods, corporate and consumer.
Needs: Works with 3-4 photographers/month. Uses photos for consumer and trade magazines, direct mail, catalogs, newspapers and literature. Subjects include: people, sports, industrial, product and fashion. Model release required.
Specs: Uses b&w prints; 35mm, 2¼×2¼, 4×5 and 8×10 transparencies.
Making Contact & Terms: Provide business card, brochure, flier or tearsheets to be kept on file for possible future assignments. Works with freelance photographers on assignment only. Cannot return material. NPI. Credit line negotiable. Buys all rights.

Delaware

■**LYONS MARKETING COMMUNICATIONS,** 715 Orange St., Wilmington DE 19801. (302)654-6146. Ad agency. Creative Director: Erik Vaughn. Types of clients: consumer, corporate and industrial.
Needs: Works with 6 freelance photographers/month. Uses photos for consumer and trade magazine ads, direct mail, P-O-P displays, catalogs, posters and newspaper ads. Subjects vary greatly. Some fashion, many "outdoor-sport" type of things. Also, high-tech, business-to-business. Model release required. Captions preferred.
Specs: Format varies by use.
Making Contact & Terms: Query with résumé of credits and list of stock photo subjects. Provide résumé, business card, brochure, flier or tearsheets to be kept on file for possible future assignments. SASE. Reports in 3 weeks. NPI. Payment varies based on scope of job, abilities of the photographer. Pays on publication. Credit line given depending on job. Rights purchased vary.
Tips: "We consider the subjects, styles and capabilities of the photographer. Rather than guess at what we're looking for, show us what you're good at and enjoy doing. Be available on a tight and changing schedule; show an ability to pull together the logistics of a complicated shoot."

District of Columbia

■**HILLMANN & CARR INC.,** 2121 Wisconsin Ave. NW, Washington DC 20007. (202)342-0001. Art Director: Michal Carr. Estab. 1975. Types of clients: museums, corporations, industrial, government and associations.
Needs: Model releases required. Captions preferred.
Audiovisual Needs: Uses slides, films and videotapes for multimedia productions. "Subjects are extremely varied and range from the historical to current events. We do not specialize in any one subject area. Style also varies greatly depending upon subject matter."
Specs: Uses 35mm transparencies; video, 16mm and 35mm film.
Making Contact & Terms: Provide résumé, business card, self-promotion pieces, tearsheets or video samples to be kept on file for possible future assignments. Works on assignment only. Cannot return

Market conditions are constantly changing! If you're still using this book and it's 1997 or later, buy the newest edition of Photographer's Market *at your favorite bookstore or order directly from Writer's Digest Books.*

material. "If material has been unsolicited and we do not have immediate need, material will be filed for future reference." NPI; payment negotiable. Rights negotiable.
Tips: Looks for photographers with artistic style. "Quality reproduction of work which can be kept on file is extremely important."

■**WORLDWIDE TELEVISION NEWS (WTN)**, 1705 DeSales St. NW, Suite 300, Washington DC 20036. (202)835-0750. Fax: (202)887-7978. Bureau Manager, Washington: Paul C. Sisco. Estab. 1952. AV firm. "We basically supply TV news on tape for TV networks and stations. At this time, most of our business is with foreign nets and stations."
Needs: Buys dozens of "news stories per year, especially sports." Works with 6 freelance photographers/month on assignment only. Generally hard news material, sometimes of documentary nature and sports.
Audiovisual Needs: Produces motion pictures and videotape.
Making Contact & Terms: Send name, phone number, equipment available and rates with material by mail for consideration. Provide business card to be kept on file for possible future assignments. Fast news material generally sent counter-to-air shipment; slower material by air freight. SASE. Reports in 2 weeks. Pays $100 minimum/job. Pays on receipt of material; nothing on speculation. Video rates about $500/half day, $900/full day or so. Negotiates payment based on amount of creativity required from photographer. Buys all video rights. Dupe sheets for film required.

Florida

CREATIVE RESOURCES, INC., 2000 S. Dixie Highway, Miami FL 33133. Fax: (305)856-3151. Chairman and CEO: Mac Seligman. Estab. 1970. PR firm. Handles clients in travel (hotels, resorts and airlines).
Needs: Works with 1-2 freelance photographers/month on assignment only. Buys 10-20 photos/year. Photos used in PR releases. Model release preferred.
Specs: Uses 8×10 glossy prints; contact sheet OK. Also uses 35mm or 2¼×2¼ transparencies and color prints.
Making Contact & Terms: Provide résumé to be kept on file for possible future assignments. Query with résumé of credits. No unsolicited material. SASE. Reports in 2 weeks. Pays $50 minimum/hour; $200 minimum/day; $100/color photo; $50/b&w photo. Negotiates payment based on client's budget. For assignments involving travel, pays $60-200/day plus expenses. **Pays on acceptance.** Buys all rights.
Tips: Most interested in activity shots in locations near clients.

*****HACKMEISTER ADVERTISING & PUBLIC RELATIONS, INC.**, 2631 E. Oakland, Suite 204, Ft. Lauderdale FL 33306. (305)568-2511. President: Dick Hackmeister. Estab. 1979. Ad agency and PR firm. Serves industrial, electronics manufacturers who sell to other businesses.
Needs: Works with 1 freelance photographer/month. Uses photos for trade magazines, direct mail, catalogs. Subjects include: electronic products. Model release and captions required.
Specs: Uses 8×10 glossy b&w and color prints and 4×5 transparencies.
Making Contact & Terms: "Call on telephone first." Does not return unsolicited material. Pays by the day and $200-2,000/job. Buys all rights.
Tips: Looks for "good lighting on highly technical electronic products—creativity."

*****■INTRAVUE**, 6 E. Bay St., 5th Floor, Jacksonville FL 32202. (904)353-8755. Fax: (904)353-8778. Art Director: Kim Tindol. Estab. 1988. Member of ASI, Jacksonville Ad Federation, Florida Chamber of Commerce, Jacksonville Chamber of Commerce. Ad agency. Approximate annual billing: $4 million. Number of employees: 12. Types of clients: industrial, financial, fashion, retail and food. Examples of recent projects: "Aeroglove" for Aerobic Glove, Inc. (broadcst/print/trade magazine); "Isabelle Water" for InterNatural Beverage Group (print).
Needs: Works with 2-5 freelance photographers, 1 videographer/month. Uses photos for consumer and trade magazines, direct mail, P-O-P displays, catalogs, posters, newspapers and audiovisual. Subjects vary per client (specific subjects are selected by creative/art director). Reviews stock photos; all subjects. Model/property release required. Captions preferred.
Audiovisual Needs: Uses slides, film and videotape for all print work.
Specs: Uses 5×7, 8×10 glossy or matte color or b&w prints; 35mm, 2¼×2¼, 4×5 transparencies.
Making Contact & Terms: Interested in receiving work from newer, lesser-known photographers. Arrange personal interview to show portfolio. Send unsolicited photos by mail for consideration. Provide résumé, business card, brochure, flier or tearsheets to be kept on file for possible future assignments. Works on assignment only. Keeps samples on file. SASE. Reports in 1-2 weeks (if interested). NPI. Pays on receipt of client payment. Credit line sometimes given, depending on client, usage. Buys all rights.

Tips: Mixture of styles is a plus. Show an ability to do studio stills and avant garde work as well.

■**MYERS, MYERS & ADAMS ADVERTISING, INC.**, 938 N. Victoria Park Rd., Ft. Lauderdale FL 33304. (305)523-0202. Creative Director: Virginia Sours-Myers. Estab. 1986. Member of Ad Federation of Fort Lauderdale, Marine Industries Assoc. Ad agency. Approximate annual billing: $2 million. Number of employees: 6. Types of clients: industrial, manufacturing, marine and healthcare. Examples of recent projects: Music Marketing Network (direct mail campaign); Advanced Games & Engineering (trade ad); The Landis Group (corporate brochure).
Needs: Works with 3-5 photographers, filmmakers and/or videographers/month. Uses photos for billboards, consumer and trade magazines, direct mail, P-O-P displays, catalogs, newspapers and audiovisual. Subjects include: marine, food, real estate, medical and fashion. Wants to see "all subjects" in stock images and footage.
Audiovisual Needs: Uses photos/film/video for slide shows, film and videotape.
Specs: Uses all sizes b&w/color prints; 35mm, 2¼×2¼, 4×5 transparencies; 35mm film; 1", ¾", but to review need ½".
Making Contact & Terms: Provide résumé, business card, brochure, flier or tearsheets to be kept on file for possible future assignments. Works with freelancers on assignment basis only. Cannot return material. Reports as needed. Pays $50-400/b&w photo; $100-800/color photo; $50-250/hour; $200-1,200/day; $50-30,000/job. Credit line given sometimes, depending on usage. Buys all rights (work-for-hire) and 1 year's usage; negotiable.
Tips: "We're not looking for arty-type photos or journalism. We need photographers who understand an advertising sense of photography: good solid images that sell the product." Sees trend in advertising toward "computer-enhanced impact and color effects. Send samples, tearsheets and be patient. Please don't call us. If your work is good we keep it on file and as a style is needed we will contact the photographer. Keep us updated with new work. Advertising is using a fair amount of audiovisual work. We use a lot of stills within our commercials. Make portfolio available to production houses."

PRODUCTION INK, 2826 NE 19 Dr., Gainesville FL 32609. (904)377-8973. Fax: (904)373-1175. President: Terry Van Nortwick. Ad agency, PR firm. Types of clients: hospital, industrial, computer.
Needs: Works with 1 freelance photographer/month. Uses photos for ads, billboards, trade magazines, catalogs and newspapers. Reviews stock photos. Model release required.
Specs: Uses b&w prints and 35mm, 2¼×2¼ and 4×5 transparencies.
Making Contact & Terms: Arrange personal interview to show portfolio. Submit portfolio for review. Provide résumé, business card, brochure, flier or tearsheets to be kept on file for possible future assignments. Keeps samples on file. NPI. Pays on receipt of invoice. Credit line sometimes given; negotiable. Buys all rights.

SARTORY O'MARA, 5840 Corporate Way, Suite 100, West Palm Beach FL 33407. (407)683-7500. Fax: (407)683-1806. Ad agency. Art Director: Christine Christianson. Types of clients: various.
Needs: Works with 2-3 photographers/month. Uses photos for trade magazines, newspapers, brochures. Subjects include residential, pertaining to client.
Specs: Uses b&w and color prints; 35mm, 2¼×2¼ and 4×5 transparencies.
Making Contact & Terms: Arrange a personal interview to show portfolio. Submit portfolio for review. Provide résumé, business card, brochure, flier or tearsheets to be kept on file for possible future assignments. Works with local freelance photographers on assignment only. Pays $50-100/hour and $250-1,000/day. Pays on receipt of invoice. Buys all rights. Model release required.

Georgia

■**FRASER ADVERTISING**, 1201 George C. Wilson Dr. #B, Augusta GA 30909. (706)855-0343. President: Jerry Fraser. Estab. 1980. Ad agency. Types of clients: automotive, industrial, manufacturing, residential.
Needs: Works with "possibly one freelance photographer every two or three months." Uses photos for consumer and trade magazines, catalogs, posters and AV presentations. Subject matter: "product and location shots." Also works with freelance filmmakers to produce TV commercials on videotape. Model release required. Property release preferred.
Specs: Uses glossy b&w and color prints; 35mm, 2¼×2¼ and 4×5 transparencies; videotape and film. "Specifications vary according to the job."
Making Contact & Terms: Interested in receiving work from newer, lesser-known photographers. Provide résumé, business card, brochure, flier or tearsheets to be kept on file for possible future assignments. Works with freelance photographers on assignment only. Cannot return unsolicited material. Reports in 1 month. NPI; payment varies according to job. Pays on publication. Buys exclusive/product and other rights; negotiable.

Tips: Prefers to see "samples of finished work—the actual ad, for example, not the photography alone. Send us materials to keep on file and quote favorably when rate is requested."

■**PAUL FRENCH & PARTNERS, INC.**, 503 Gabbettville Rd., LaGrange GA 30240. (706)882-5581. Contact: Charles Hall. Estab. 1969. AV firm. Types of clients: industrial, corporate.
Needs: Works with freelance photos on assignment only basis. Uses photos for filmstrips, slide sets, multimedia. Subjects include: industrial marketing, employee training and orientation, public and community relations.
Specs: Uses 35mm and 4×5 color transparencies.
Making Contact & Terms: Query with résumé of credits to be kept on file for possible future assignments. Pays $75-150 minimum/hour; $600-1,200/day; $150 minimum/job, plus travel and expenses. **Payment on acceptance.** Buys all rights, but may reassign to photographer after use.
Tips: "We buy photojournalism . . . journalistic treatments of our clients' subjects. Portfolio: industrial process, people at work, interior furnishings, product, fashion. We seldom buy single photos."

■**GRANT/GARRETT COMMUNICATIONS**, P.O. Box 53, Atlanta GA 30301. Phone/fax: (404)755-2513. President/Owner: Ruby Grant Garrett. Estab. 1979. Ad agency. Types of clients: technical. Examples of ad campaigns: Simons (help wanted); CIS Telecom (equipment); Anderson Communication (business-to-business).
Needs: Uses photos for trade magazines, direct mail and newspapers. Interested in reviewing stock photos/video footage of people at work. Model/property release required. Photo captions preferred.
Audiovisual Needs: Uses stock video footage.
Specs: Uses 4×5 b&w prints; VHS videotape.
Making Contact & Terms: Interested in receiving work from newer, lesser-known photographers. Query with résumé of credits. Query with list of stock photo subjects. Provide résumé, business card, brochure, flier or tearsheets to be kept on file for possible future assignments. Works with freelancers on an assignment basis only. SASE. Reports in 1 week. NPI; pays per job. **Pays on receipt of invoice.** Credit line sometimes given, depending on client. Buys one-time and other rights; negotiable.
Tips: Wants to see b&w work in portfolio.

Idaho

CIPRA AD AGENCY, 314 E. Curling Dr., Boise ID 83702. (208)344-7770. President: Ed Gellert. Estab. 1979. Ad agency. Types of clients: agriculture (regional basis) and gardening (national basis).
Needs: Works with 1 freelance photographer/month. Uses photos for trade magazines. Subjects include: electronic, agriculture and garden. Reviews general stock photos. Model release required.
Specs: Uses 4×5, 8×10, 11×14 glossy or matte, color, b&w prints; also 35mm and 4×5 transparencies.
Making Contact & Terms: Provide résumé, business card, brochure, flier or tearsheets to be kept on file for possible future assignments. Usually works with local freelancers only. Keeps samples on file. Cannot return material. Reports as needed. Pays $75/hour. Pays on publication. Buys all rights.

Illinois

BRAGAW PUBLIC RELATIONS SERVICES, 800 E. Northwest Hwy., Suite 1040, Palatine IL 60067. (708)934-5580. Contact: Richard S. Bragaw. Estab. 1981. PR firm. Types of clients: professional service firms, high-tech entrepreneurs.
Needs: Works with 1 freelance photographer/month. Uses photos for trade magazines, direct mail, brochures, newspapers, newsletters/news releases. Subjects include: "products and people." Model release preferred. Captions preferred.
Specs: Uses 3×5, 5×7 and 8×10 glossy prints.
Making Contact & Terms: Provide résumé, business card, brochure, flier or tearsheets to be kept on file for possible future assignments. Works with freelance photographers on assignment basis only. SASE. Pays $25-100/b&w photo; $50-200/color photo; $35-100/hour; $200-500/day; $100-1,000/job. Pays on receipt of invoice. Credit line "possible." Buys all rights; negotiable.
Tips: "Execute an assignment well, at reasonable costs, with speedy delivery."

JOHN CROWE ADVERTISING AGENCY, 2319½ N. 15th St., Springfield IL 62702-1226. (217)528-1076. President: Bryan J. Crowe. Ad agency. Serves clients in industry, commerce, aviation, banking, state and federal government, retail stores, publishing and institutes.
Needs: Works with 1 freelance photographer/month on assignment only. Uses photos for billboards, consumer and trade magazines, direct mail, newspapers and TV. Model release required.

Specs: Uses 8 × 10 glossy b&w prints; also uses color 8 × 10 glossy prints and 2¼ × 2¼ transparencies.
Making Contact & Terms: Send material by mail for consideration. Provide letter of inquiry, flier, brochure and tearsheet to be kept on file for future assignments. SASE. Reports in 2 weeks. Pays $50 minimum/job or $18 minimum/hour. Payment negotiable based on client's budget. Buys all rights.

■**EGD & ASSOCIATES, INC.**, 4300 Lincoln Ave., Suite K, Rolling Meadows IL 60008. (708)991-1270. Fax: (708)991-1519. Vice President: Kathleen Williams. Estab. 1970. Ad agency. Types of clients: industrial, retail, finance, food. Examples of ad campaigns: National ads for Toshiba and Sellstrom, packaging for Barna.
Needs: Works with 7-8 freelance photographers—videographers/month. Uses photos for billboards, consumer and trade magazines, direct mail, P-O-P displays, catalogs and audiovisual. Subjects include: industrial products and facilities. Reviews stock photos/video footage of "creative firsts." Model release required. Captions preferred.
Audiovisual Needs: Uses photos/video for slide shows and videotape.
Specs: Uses 5 × 7 b&w/color prints; 35mm, 2¼ × 2¼, 4 × 5, 8 × 10 transparencies; videotape.
Making Contact & Terms: Interested in receiving work from newer, lesser-known photographers. Arrange personal interview to show portfolio. Provide résumé, business card, brochure, flier or tearsheets to be kept on file for possible future assignments. Works on assignment basis only. Cannot return material. Reports in 3 weeks. NPI; pays according to "client's budget." Pays within 30 days of invoice. Credit line sometimes given; credit line offered in lieu of payment. Buys all rights.
Tips: Sees trend toward "larger budget for exclusive rights and creative firsts. Contact us every six months."

DAN GLAUBKE, INC., (formerly Fensholt Incorporated), 189 Lowell, Glen Ellyn IL 60137. (708)953-2300. Creative Director: Dan Glaubke. Estab. 1995. Ad agency. Types of clients: industrial, travel.
Needs: Uses photos for trade magazines, direct mail, catalogs, posters, newspapers, signage. Subjects include: furnace installations. Reviews stock photos. Model release required. Captions required; include brief description of job.
Specs: Uses 8 × 7 or 8 × 10 color and b&w contact prints; 35mm, 2¼ × 2¼ transparencies.
Making Contact & Terms: Works on assignment only. Keeps samples on file. NPI; pays by the hour. Credit line sometimes given. Buys all rights.

OMNI ENTERPRISES, INC., 430 W. Roosevelt Rd., Wheaton IL 60187. (708)653-8200. Fax: (708)653-8218. Contact: Steve Jacobs. Estab. 1962. Ad agency and consultants. Types of clients: business, industrial, area development, economic development and financial. Examples of recent projects: capabilities brochure, Schweppes; brochure, Viking Travel Services; technical folders, ads, Thomas Engineering, Inc.
Needs: Works with an average of 3 freelance photographers/month on assignment only. Uses photos for consumer and trade magazines, direct mail, newspapers and P-O-P displays. Buys 100 photos annually. Prefers to see composites in b&w and color. Needs photos of "all varieties—industrial and machine products and human interest." Model release required.
Specs: Uses 5 × 7 and 8 × 10 glossy b&w prints; 8 × 10 glossy color prints. Uses 2¼ × 2¼, 4 × 5 and 8 × 10 transparencies. Rarely uses 35mm.
Making Contact & Terms: Provide résumé, flier, business card, brochure, composites and list of equipment to be kept on file for possible future assignments. Call for an appointment. Pays $50-500/ b&w photo; $100-750/color photo; $50-200/hour; $400-2,000/day. Buys one-time, second (reprint) rights or all rights.
Tips: In portfolio or samples, wants to see "creative composition; technical abilities, (i.e., lighting, color balance, focus and consistency of quality). We need to see samples and have an idea of rates. Because we are loyal to present suppliers, it sometimes takes up to 6 months or longer before we begin working with a new photographer."

QUALLY & COMPANY, INC., Suite 3, 2238 Central St., Evanston IL 60201-1457. (708)864-6316. Creative Director: Robert Qually. Ad agency and graphic design firm. Types of clients: finance, package goods and business-to-business.
Needs: Works with 4-5 freelance photographers/month. Uses photos for billboards, consumer and trade magazines, direct mail, P-O-P displays, posters and newspapers. "Subject matter varies, but is always a 'quality image' regardless of what it portrays." Model release required.
Specs: Uses b&w and color prints; 35mm, 2¼ × 2¼, 4 × 5 and 8 × 10 transparencies.
Making Contact & Terms: Query with samples or submit portfolio for review. Provide résumé, business card, brochure, flier or tearsheets to be kept on file for possible future assignments. Works with local freelance photographers on assignment only. Cannot return material. Reports in 2 weeks. NPI; payment depends on circumstances. Pays on acceptance or net 45 days. Credit line sometimes given, depending on client's cooperation. Rights purchased depend on circumstances.

S.C. MARKETING, INC., 694 E. Grandview, Lake Forest IL 60045. Phone/fax: (312)266-9421. President: Susie Cohn. Estab. 1990. Ad agency. Types of clients: food. Has completed projects for Keebler Company, Golden Tiger, Bernardi Italian Foods, Original Chili Bowl, Cripple Creek, Bri-al Inc.
Needs: Works with 1 freelancer/month. Uses photos for trade magazines, direct mail, P-O-P displays, catalogs, posters.
Specs: Uses 5×7 b&w prints; 4×5, 8×10 transparencies. Prefers Fuji film.
Making Contact & Terms: Interested in receiving work from newer, lesser-known photographers. Submit portfolio for review. Provide résumé, business card, brochure, flier or tearsheets to be kept on file for possible future assignments. Works on assignment only. Keeps samples on file. SASE. Reports in 1 month. Pays net 30. Credit line not given. Buys all rights.

■**VIDEO I-D, INC.**, 105 Muller Rd., Washington IL 61571. (309)444-4323. President: Sam B. Wagner. Types of clients: health, education, industry, cable and broadcast.
Needs: Works with 5 freelance photographers/month to shoot slide sets, multimedia productions, films and videotapes. Subjects "vary from commercial to industrial—always high quality." "Somewhat" interested in stock photos/footage. Model release required.
Specs: Uses 35mm transparencies; 16mm film; U-matic ¾" and 1" videotape, Beta SP.
Making Contact & Terms: Provide résumé, business card, self-promotion piece or tearsheets to be kept on file for possible future assignments; "also send video sample reel." Works with freelancers on assignment only. SASE. Reports in 3 weeks. Pays $8-25/hour; $65-250/day. **Pays on acceptance.** Credit line sometimes given. Buys all rights.
Tips: Sample reel—indicate goal for specific pieces. "Show good lighting and visualization skills. Be willing to learn. Show me you can communicate what I need to hear — and willingness to put out effort to get top quality."

Chicago

***LEO BURNETT COMPANY, INC.**, 35 W. Wacker Dr., Chicago IL 60601. (312)220-5959. Contact: Art Buyer. Types of clients: industrial, financial, fashion, retail, food, auto. Examples of recent projects: Philip Morris, McDonald's, Procter & Gamble.
Needs: Works with 80 freelancers/month. Uses photos for billboards, consumer and trade magazines, direct mail, P-O-P displays, catalogs, posters, newspapers, signage and audiovisual uses. Subject matter varies. Reviews stock photos. Model/property release required. Captions required.
Specs: Uses prints, transparencies, film and videotape.
Making Contact & Terms: Interested in receiving work from newer, lesser-known photographers. Contact through rep. Arrange personal interview to show portfolio. Submit portfolio for review. Query with samples. Provide résumé, business card, brochure, flier or tearsheets to be kept on file for possible future assignments. Does not report back. NPI. Pays 30 days from invoice date. Rights negotiable.

■**DARBY GRAPHICS, INC.**, (formerly Darby Media Group), 4015 N. Rockwell St., Chicago IL 60618. (312)583-5090. Production Manager: Dennis Cyrier. Types of clients: corporate and agency.
Needs: Uses photographers for filmstrips, slide sets, multimedia productions, videotapes, print and publication uses.
Making Contact & Terms: Provide résumé, business card, self-promotion piece or tearsheets to be kept on file for possible future assignments. Works on assignment only; interested in stock photos/footage. NPI. Payment is made to freelancers net 30 days. Captions preferred; model release required.

DEFRANCESCO/GOODFRIEND, 444 N. Michigan Ave., Suite 1000, Chicago IL 60611. (312)644-4409. Fax: (312)644-7651. Partner: John DeFrancesco. Estab. 1985. PR firm. Types of clients: industrial, consumer products. Examples of recent projects: publicity campaigns for Promotional Products Association International and S-B Power Tool Company, and a newsletter for Teraco Inc.
Needs: Works with 1-2 freelancers/month. Uses photos for consumer magazines, trade magazines, direct mail, newspapers, audiovisual. Subjects include: people, equipment. Model/property release required. Captions preferred.

The First Markets Index preceding the General Index in the back of this book provides the names of those companies/ publications interested in receiving work from newer, lesser-known photographers.

Audiovisual Needs: Uses slides and video for publicity, presentation and training.

Specs: Uses 5×7, 8×10, glossy color and b&w prints; 35mm transparencies; ½″ VHS videotape.

Making Contact & Terms: Interested in receiving work from newer, lesser-known photographers. Query with résumé of credits. Provide résumé, business card, brochure, flier or tearsheets to be kept on file for possible future assignments. Works with freelancers on assignment only. Keeps samples on file. SASE. Reports in 1-2 weeks. Pays $25-100/hour; $100-1,000/day; $250/job; payment negotiable. Pays on receipt of invoice. Credit line sometimes given.

Tips: "Because most photography is used in publicity, the photo must tell the story. We're not interested in high-style, high-fashion techniques."

***FOOTE CONE & BELDING COMMUNICATIONS**, 101 E. Erie St., Chicago IL 60611. (312)751-7000. Contact: Art Director. Types of clients: industrial, financial, fashion, retail and food. Examples of recent projects: Citibank, Kraft, Payless.

Needs: Uses photos for billboards, consumer and trade magazines, direct mail, P-O-P displays, catalogs, posters, newspapers, signage, audiovisual uses. Subjects include: industrial, financial, fashion, retail, food. Reviews stock photos. Model/property release required.

Specs: Uses 35mm, 2¼×2¼, 4×5 and 8×10 transparencies.

Making Contact & Terms: Interested in receiving work from newer, lesser-known photographers. Contact through rep. Reports in 1-2 weeks. NPI. Pays on receipt of invoice. Rights purchased depend on advertisement and advertisement form.

***GARFIELD-LINN & COMPANY**, 142 E. Ontario Ave., Chicago IL 60611. (312)943-1900. Creative Director: Mr. Terry Hackett. Associate Creative Director: Ralph Woods. Art Director: Brian Harke. Ad agency. Types of clients: Serves a "wide variety" of accounts; client list provided upon request.

Needs: Number of freelance photographers used varies. Works on assignment only. Uses photographs for billboards, consumer and trade magazines, direct mail, brochures, catalogs and posters.

Making Contact & Terms: Arrange interview to show portfolio and query with samples. NPI. Payment is by the project; negotiates according to client's budget.

■MSR ADVERTISING, INC., P.O. Box 10214, Chicago IL 60610-0214. (312)573-0001. Fax: (312)573-1907. President: Marc S. Rosenbaum. Vice President: Barry Waterman. Creative Director: Indiana Wilkins. Estab. 1983. Ad agency. Types of clients: industrial, financial, retail, food, aerospace, hospital and medical. Examples of recent projects: "Back to Basics," MPC Products; and "Throw Mother Nature a Curve," New Dimensions Center for Cosmetic Surgery.

Needs: Works with 4-6 freelance photographers, 1-2 videographers/month. Uses photos for billboards, consumer and trade magazines, direct mail, P-O-P displays, catalogs, posters and signage. Subject matter varies. Reviews stock photos. Model/property release required.

Audiovisual Needs: Uses slides and videotape for business-to-business seminars, consumer focus groups, etc. Subject matter varies.

Specs: Uses 35mm, 2¼×2¼, 4×5 and 8×10 transparencies.

Making Contact & Terms: Interested in receiving work from newer, lesser-known photographers. Submit portfolio for review. Send unsolicited photos by mail for consideration. Query with samples. Provide résumé, business card, brochure, flier or tearsheets to be kept on file for possible future assignments. Works on assignment only. Keeps samples on file. SASE. Reports in 1-2 weeks. NPI. Payment terms stated on invoice. Credit line sometimes given. Buys all rights; negotiable.

RUDER FINN, 444 N. Michigan Ave., Chicago IL 60611. (312)644-8600. Executive Vice President: Hal Bergen. Estab. 1948. PR firm. Handles accounts for corporations, trade and professional associations, institutions and other organizations.

Needs: Works with 4-8 freelance photographers/month nationally on assignment only. Buys over 100 photos/year. Uses photos for publicity, AV presentations, annual stockholder reports, brochures, books, feature articles and industrial ads. Uses industrial photos to illustrate case histories; commercial photos for ads; and consumer photos—food, fashion, personal care products. Present model release on acceptance of photo.

Making Contact & Terms: Provide résumé, flier, business card, tearsheets and brochure to be kept on file for possible future assignments. Query with résumé of credits or call to arrange an appointment. Pays $25 minimum/hour, or $200 minimum/day. Negotiates payment based on client's budget and photographer's previous experience/reputation.

Tips: Prefers to see publicity photos in a portfolio. Will not view unsolicited material.

***SANDRA SANOSKI COMPANY, INC.**, 166 E. Superior St., Chicago IL 60611. (312)664-7795. President: Sandra Sanoski. Estab. 1974. Ad agency specializing in display and publication design, packaging. Types of clients: retail and consumer goods.

Needs: Works with 3-4 freelancers/month. Uses photos for catalogs and packaging. Subject matter varies. Reviews stock photos. Model/property release required.

Specs: Uses 35mm, 2¼×2¼, 4×5, 8×10 transparencies.
Making Contact & Terms: Interested in receiving work from newer, lesser-known photographers. Arrange personal interview to show portfolio. Works on assignment only. Keeps samples on file. SASE. NPI. Pays net 30 days. Credit line not given. Buys all rights.

Indiana

■**KELLER CRESCENT COMPANY**, 1100 E. Louisiana, Evansville IN 47701. (812)426-7551 or (812)464-2461. Manager Still Photography: Cal Barrett. Ad agency, PR and AV firm. Serves industrial, consumer, finance, food, auto parts and dairy products clients. Types of clients: Old National Bank, Fruit of The Loom and Eureka Vacuums.
Needs: Works with 2-3 freelance photographers/month on assignment only basis. Uses photos for billboards, consumer and trade magazines, direct mail, newspapers, P-O-P displays, radio and TV. Model release required.
Specs: Uses 8×10 b&w prints; 35mm, 4×5 and 8×10 transparencies.
Making Contact & Terms: Query with résumé of credits, list of stock photo subjects. Send material by mail for consideration. Provide business card, tearsheets and brochure to be kept on file for possible future assignments. Prefers to see printed samples, transparencies and prints. Cannot return material. Pays $200-2,500/job; negotiates payment based on client's budget, amount of creativity required from photographer and photographer's previous experience/reputation. Buys all rights.

■**B.J. THOMPSON ASSOCIATES**, 201 S. Main, Mishawaka IN 46544. Senior Art Director: David J. Marks. Estab. 1979. Ad agency. Types of clients: industrial, retail, RV. Examples of previous projects: "Welcome Home" Friendly People Campaign, Jayco Inc. (brochure campaign); annual report for Valley American Bank (sent to stock holders); "The Grand Vienna Ball" Germany trip, Mark IV Audio (incentive trip campaign).
Needs: Works with 2-3 freelance photographers, 1 videographer/month. Uses photos for consumer magazines, trade magazines, direct mail, P-O-P displays, catalogs, posters. Subjects vary. Reviews background, landscape, scenic stock photos. Model/property release required for property (locations), models.
Audiovisual Needs: Uses slides and video for TV spots, informational videos. Subjects vary.
Specs: Uses 35mm, 2¼×2¼, 4×5 transparencies; videotape.
Making Contact & Terms: Arrange personal interview to show portfolio. Provide résumé, business card, brochure, flier or tearsheets to be kept on file for possible future assignments. Works with local freelancers on assignment only. Keeps samples on file. SASE. Reports in 1-2 weeks. Payment varies per job (quotes based on per job). Pays on receipt of invoice. Credit line not given. Buys all rights; negotiable.
Tips: Portfolios "need recreational vehicles, automotive and table top. Freelancers must work well on location and have a good knowledge of interior lighting."

Iowa

*■**PHOENIX ADVERTISING CO.**, W. Delta Park, Hwy. 18 W., Clear Lake IA 50428. (515)357-9999. Fax: (515)357-5364. Ad agency. Estab. 1986. Types of clients: industrial, financial and consumer. Examples of recent projects: "Western Tough," Bridon (print/outdoor/collateral); "Blockbuster," Video News Network (direct mail, print); and "Blue Jeans," Clear Lake Bank & Trust (TV/print/newspaper).
Needs: Works with 2-3 photographers or videographers/month. Uses photos for billboards, consumer and trade magazines, direct mail, P-O-P displays, catalogs, posters, newspapers, signage, audiovisual uses. Subjects include: people/products. Reviews stock photos and/or video.
Audiovisual Needs: Uses slides and videotape.
Specs: Uses 8×10 color and b&w prints; 35mm, 2¼×2¼, 4×5, 8×10 transparencies; ½" or ¾" videotape.
Making Contact & Terms: Contact through rep. Submit portfolio for review. Provide résumé, business card, brochure, flier or tearsheets to be kept on file for possible future assignments. Works on assignment only. Keeps samples on file. SASE. Reports in 3 weeks. Pays $1,000-10,000/day. **Pays on receipt of invoice.** Buys first rights, one-time rights, all rights and others; negotiable. Model/property release required. Credit line sometimes given; no conditions specified.

Kansas

MARKETAIDE, INC., Dept. PM, 1300 E. Iron, P.O. Box 500, Salina KS 67402-0500. (913)825-7161. Fax: (913)825-4697. Production Manager: Steve Wilson. Copy Chief: Ted Hale. Graphic Designer:

Michael Siverling. Ad agency. Uses all media. Serves industrial, retail, financial, nonprofit organizations, political, agribusiness and manufacturing clients.

Needs: Needs industrial photography (studio and on site), agricultural photography, and photos of banks, people and places.

Making Contact & Terms: Call to arrange an appointment. Provide résumé and tearsheets to be kept on file for possible future assignments. Reports in 3 weeks. SASE. Buys all rights. "We generally work on a day rate ranging from $200-1,000/day." Pays within 30 days of invoice.

Tips: Photographers should have "a good range of equipment and lighting, good light equipment portability, high quality darkroom work for b&w, a wide range of subjects in portfolio with examples of processing capabilities." Prefers to see "set-up shots, lighting, people, heavy equipment, interiors, industrial and manufacturing" in a portfolio. Prefers to see "8 × 10 minimum size on prints, or 35mm transparencies, preferably unretouched" as samples.

***PATON & ASSOCIATES, INC./PAT PATON PUBLIC RELATIONS**, P.O. Box 7350, Leawood KS 66207. (913)491-4000. Contact: N.E. (Pat) Paton, Jr. Estab. 1956. Ad agency. Clients: medical, financial, home furnishing, professional associations, vacation resorts, theater and entertainment.

Needs: Uses photos for billboards, consumer and trade magazines, direct mail, newspapers, P-O-P displays and TV. Model release required. Captions required.

Making Contact & Terms: Interested in receiving work from newer, lesser known photographers. Call for personal appointment to show portfolio. Works on assignment only. NPI. Payment negotiable according to amount of creativity required from photographer.

Kentucky

■BARNEY MILLERS INC., 232 E. Main St., Lexington KY 40507. (606)252-2216. Fax: (606)253-1115. Chairman: Harry Miller. Estab. 1922. Types of clients: retail, fashion, industrial, legal and government. Examples of recent projects: Bluegrass AAA (internal training); Bank One (internal training); and Renfro Valley (television promotion).

Needs: Works with 3-4 freelance photographers/month. Uses photos for video transfer, editing and titling. Reviews stock photos/footage. Captions preferred.

Specs: Uses b&w and color prints; 35mm transparencies; 8mm, super 8, 16mm and 35mm film. "We are very proficient in converting to video."

Making Contact & Terms: Interested in receiving work from newer, lesser-known photographers. Arrange a personal interview to show portfolio or submit portfolio by mail. Provide résumé, business card, self-promotion piece or tearsheets to be kept on file for possible future assignments. Works with local freelancers only. SASE. Reports in 1 week. Pays $35-200/hour. **Pays on acceptance.** Credit line given if desired. Rights negotiable.

■KINETIC CORPORATION, 240 Distillery Commons, Louisville KY 40206. (502)583-1679. Fax: (502)583-1104. Director of Creative Service: Stephen Metzger. Estab. 1968. Types of clients: industrial, financial, fashion, retail and food.

Needs: Works with freelance photographers and/or videographers as needed. Uses photos for audiovisual and print. Subjects include: location photography. Model and/or property release required.

Audiovisual Needs: Uses photos for slides and videotape.

Specs: Uses varied sizes and finishes color and b&w prints; 35mm, 2¼ × 2¼, 4 × 5, 8 × 10 transparencies; and ¾" Beta SP videotape.

Making Contact & Terms: Provide résumé, business card, brochure, flier or tearsheets to be kept on file for possible future assignments. Works with local freelancers only. Keeps samples on file. SASE. Reports only when interested. NPI. Pays within 30 days. Buys all rights.

Louisiana

RICHARD SACKETT EXECUTIVE CONSULTANTS, 101 Howard Ave., Suite 3400, New Orleans LA 70113-2036. (504)522-4040. Fax: (504)524-8839. Creative Director: Andrea Pescheret. Ad agency. Approximate annual billing: $2 million. Number of employees: 14. Types of clients: legal, retail and gaming. Examples of recent projects: "One call, that's all" outdoor ad campaign for Morris Bart attorneys; "LA Everything" advertising campaign for LA Auto; brochure and ads for a Las Vegas casino. Client list free with SASE.

Needs: Works with 3 photographers/month. Uses photographers for billboards, consumer and trade magazines, direct mail, P-O-P displays, posters, newspapers. Subject matter includes portraits, merchandise, scenery of the cities, scenery of construction sites, mood photos and food. Model release required.

Specs: Uses 35mm, 4×5 and 8×10 transparencies.
Making Contact & Terms: Arrange a personal interview to show portfolio. Send unsolicited photos by mail for consideration. Works with freelance photographers on an assignment basis only. SASE. Reports in 1 week. Pays $600-1,000/day and $3,000-40,000/job. Pays on publication or on receipt of invoice. Credit line given when appropriate. Buys one-time and all rights; negotiable.

Maryland

■**MARC SMITH COMPANY, INC.**, P.O. Box 5005, Severna Park MD 21146. (410)647-2606. Art Director: Ed Smith. Estab. 1963. Ad agency. Types of clients: industrial. Client list on request with SASE.
Needs: Uses photos for trade magazines, direct mail, catalogs, slide programs and trade show booths. Subjects include: products, sales literature (still life), commercial buildings (interiors and exteriors). Model release required for building owners, designers, incidental persons. Captions required.
Specs: Vary: b&w and color prints and transparencies.
Making Contact & Terms: Provide résumé, business card, brochure, flier or tearsheets to be kept on file for possible future assignments. Works with freelance photographers on assignment only. Cannot return material. Reports in 1 month. NPI; pays by the job. Pays when client pays agency, usually 30-60 days. Buys all rights.
Tips: Wants to see "proximity, suitability, cooperation and reasonable rates."

Massachusetts

*****BERENSON, ISHAM & PARTNERS**, 31 Milk St., Boston MA 02109. (617)423-1120. Fax: (617)423-4597. Art Director: Jeannie Albaneje. Estab. 1971. Member of Art Directors Club—Boston, New England Direct Marketing Association. Direct marketing firm. Types of clients: financial and communications. Examples of recent projects: "Teachers Insurance Long-Term Care" for TIAA-CREF (promo materials); "Call Answering" for NYNEX (direct marketing promo); and "Shining Star Awards" for Club Med (direct mail, business-to-business).
Needs: Works with 1-2 freelancers/month. Uses photos for direct mail. Subjects include: tabletop/still life shots, some people, electronic imaging. Model/property release required. Captions preferred.
Specs: Uses 8×10 b&w prints; 35mm transparencies.
Making Contact & Terms: Query with samples. Provide résumé, business card, brochure, flier or tearsheets to be kept on file for possible future assignment. Works on assignment only. Keeps samples on file. SASE. Reports in 1-2 weeks. NPI. Pays on receipt of invoice. Credit line not given. "We will negotiate either limited use or complete buyout of images depending on job."

*****BUYER ADVERTISING AGENCY, INC.**, 85 Wells Ave., Newton MA 02159. (617)969-4646. Production Manager: Marion Buyer. Ad agency. Uses all media. Serves clients in food and industry.
Needs: Needs photos of food, fashion and industry; and candid photos. Buys up to 10 photos/year.
Making Contact & Terms: Call to arrange an appointment, submit portfolio, or send mailer. Reports in 1 week. SASE. Pays $25 minimum/hour.
Specs: Uses 5×7, 8×10 semigloss b&w prints; contact sheet OK. Also uses color prints; and 35mm, 2¼×2¼, 4×5 and 11×14 transparencies.

*■**CRAMER PRODUCTION CENTER**, Dept. PM, 355 Wood Rd., Braintree MA 02184. (617)849-3350. Fax: (617)849-6165. Film/video production company. Operations Manager: Maura MacMillan. Estab. 1982. Types of clients: industrial, financial, fashion, retail and food. Examples of recent projects: 3-D music video for Meditech; "Walktoberfest," National Diabetes (PSA broadcast); and New England Chevy campaign, Cuneo Sullivan Dolabany Wilgus (broadcast spot).
Audiovisual Needs: Works with 3-8 freelance filmmakers and/or videographers/month for P-O-P displays and audiovisual. Subjects include: industrial to broadcast/machines to people. Reviews stock film or video footage. Uses film and videotape.
Making Contact & Terms: Send demo of work, ¾" or VHS videotape. Query with résumé of credits. Works on assignment only. Keeps samples on file. Reports in 1 month. Pays $175-560/day, depending on job and level of expertise needed. Pays 30 days from receipt of invoice. Buys all rights. Model/property release required. Credit line sometimes given, depending on how the program is used.
Tips: Looks for experience in commercial video production. "Don't be discouraged if you don't get an immediate response. When we have a need, we'll call you."

The solid, black square before a listing indicates that the market uses various types of audiovisual materials, such as slides, film or videotape.

FUESSLER GROUP INC., 324 Shawmut Ave., Boston MA 02118. (617)262-3964. Fax: (617)266-1068. E-mail: 73060.1611@compuserve.com. President: Rolf Fuessler. Estab. 1984. Member of Society for Marketing Professional Services, Public Relations Society of America. Marketing communications firm. Types of clients: industrial, professional services. Has done work for Ogden Yorkshire, Earth Tech Inc.
Needs: Works with 2 freelancers/month; rarely works with videographers. Uses photos for trade magazines, collateral advertising and direct mail pieces. Subjects include: industrial and environmental. Reviews stock photos. Model/property release required, especially with hazardous waste photos. Captions preferred.
Specs: Uses 35mm transparencies.
Making Contact & Terms: Interested in receiving work from newer, lesser-known photographers. Query with résumé of credits. Query with samples. Works with local freelancers on assignment only. Keeps samples on file. SASE. Reports in 3 weeks. NPI. Pays on receipt of invoice. Credit line given. Buys first rights, one-time rights, all rights and has purchased unlimited usage rights for one client; negotiable.

HILL HOLLIDAY CONNORS COSMOPULOS INC., John Hancock Tower, 200 Clarendon St., Boston MA 02116. Prefers not to share information.

■JEF FILMS INC, 143 Hickory Hill Circle, Osterville MA 02655-1322. (508)428-7198. Fax: (508)428-7198. President: Jeffrey H. Aikman. Estab. 1973. AV firm. Member of American Film Marketing Association, National Association of Television Programmers and Executives. Types of clients: retail. Examples of recent projects: "Yesterday Today & Tomorrow," JEF Films (video box); "M," Aikman Archive (video box).
Needs: Works with 5 freelance photographers, 5-6 filmmakers and 5-6 videographers/month. Uses photos for billboards, consumer magazines, trade magazines, direct mail, P-O-P displays, catalogs, posters, newspapers and audiovisual. Subjects include glamour photography. Reviews stock photos of all types. Model release preferred. Property release required. Captions preferred.
Audiovisual Needs: Uses slides, films and/or video for videocassette distribution at retail level.
Specs: Uses 35mm transparencies.
Making Contact & Terms: Interested in receiving work from newer, lesser-known photographers. Submit portfolio for review. Works on assignment only. Keeps samples on file. Cannot return material. Reports in 1 month. Pays $25-300/job. Pays on publication. Credit line is not given. Buys all rights.

■TR PRODUCTIONS, 1031 Commonwealth Ave., Boston MA 02215. (617)783-0200. Executive Vice President: Ross P. Benjamin. Types of clients: industrial, commercial and educational.
Needs: Works with 1-2 freelance photographers/month. Uses photographers for slide sets and multimedia productions. Subjects include: people shots, manufacturing/sales and facilities.
Specs: Uses 35mm transparencies.
Making Contact & Terms: Provide résumé, business card, self-promotion piece or tearsheets to be kept on file for possible future assignments. Works with local freelancers by assignment only; interested in stock photos/footage. Does not return unsolicited material. Reports "when needed." Pays $600-1,500/day. Pays "14 days after acceptance." Buys all AV rights.

Michigan

■CREATIVE HOUSE ADVERTISING, INC., 30777 Northwestern Hwy., Suite 301, Farmington Hills MI 48334. (810)737-7077. Executive Vice President/Creative Director: Robert G. Washburn. Ad agency. Types of clients: retail, industry, finance and commercial products.
Needs: Works with 4-5 freelance photographers/year on assignment only. Also produces TV commercials and demo film. Uses photos for brochures, catalogs, annual reports, billboards, consumer and trade magazines, direct mail, newspapers, P-O-P displays, radio and TV. Model release required.
Audiovisual Needs: Uses 35mm and 16mm film.
Specs: Uses b&w and color prints; transparencies.
Making Contact & Terms: Arrange personal interview to show portfolio. Query with résumé of credits, samples or list of stock photo subjects. Submit portfolio for review. "Include your specialty and show your range of versatility." Send material by mail for consideration. Provide résumé, business card, brochure, flier and anything to indicate the type and quality of photos to be kept on file for future assignments. Local freelancers preferred. SASE. Reports in 2 weeks. Pays $100-200/hour or $800-1,600/day; negotiates payment based on client's budget and photographer's previous experience/reputation. Pays in 1-3 months, depending on the job. Does not pay royalties. Buys all rights.

＊HEART GRAPHIC DESIGN, 501 George St., Midland MI 48640. (517)832-9710. Owner: Clark Most. Estab. 1982. Ad agency. Approximate annual billing: $250,000. Number of employees: 3. Types of clients: industrial.

Needs: Works with 1 freelancer/month. Uses photos for consumer magazines, catalogs and posters. Subjects include: product shots. Reviews stock photos. Model/property release preferred. Captions preferred.

Specs: Uses 8×10, 11×14 color and b&w prints; 2¼×2¼, 4×5 and 8×10 transparencies.

Making Contact & Terms: Interested in receiving work from newer, lesser-known photographers. Send unsolicited photos by mail for consideration. Provide résumé, business card, brochure, flier or tearsheets to be kept on file for possible future assignments. Works with local freelancers only. Keeps samples on file. SASE. Reports in 1-2 weeks. Pays $200-2,500/job. Pays on receipt of invoice. Credit line not given. Rights negotiated depending on job.

Tips: Display an innovative eye, ability to creatively compose shots and have interesting techniques.

***■MESSAGE MAKERS**, 1217 Turner St., Lansing MI 48906. (517)482-3333. Fax: (517)482-9933. Executive Director: Terry Terry. Estab. 1977. Member of LRCC, NSPI, AIVF, ITVA. AV firm. Number of employees: 4. Types of clients: broadcast, industrial and retail.

Needs: Works with 2 freelance photographers, 1 filmmaker and 2 videographers/month. Uses photos for direct mail, posters and newspapers. Subjects include: people or products. Model release preferred. Property release required. Captions preferred.

Audiovisual Needs: Uses slides, film, video and CD.

Specs: Uses 4×5 color and b&w prints; 35mm, 2¼×2¼ transparencies; Beta SP videotape.

Making Contact & Terms: Interested in receiving work from newer, lesser-known photographers. Provide résumé, business card, brochure, flier or tearsheets to be kept on file for possible future assignments. Keeps samples on file. Cannot return material. Reports only if interested. NPI. Pays on receipt of invoice. Credit line sometimes given depending upon client. Buys all rights; negotiable.

■SOUNDLIGHT PRODUCTIONS, 1915 Webster, Birmingham MI 48009-7814. (810)642-3502. Fax: (810)642-3502. Contact: Keth Luke. Estab. 1972. Types of clients: corporations, industrial, businesses, training institutions, astrological and spiritual workshops, books, calendars, fashion, magazines. Examples of productions: "Heavytruck Computer Stories," Rockwell International; and "What Can It Do?," Arcade Machine.

Needs: Works with 1 freelance photographer/2 months. Subjects include: people in activities, industrial, scenic landscapes, animals, travel sites and activities, dance and models (glamour and nude). Reviews stock photos, slides, computer images or video. Model release preferred for models and advertising people. Captions preferred; include "who, what, where."

Audiovisual Needs: Uses freelance photographers for slide sets, multimedia productions and videotapes.

Specs: Uses 4×6 prints and 8×10 glossy color prints, 35mm color slides; VHS, U-matic ¾" and SVHS videotape.

Making Contact & Terms: Interested in receiving work from newer, lesser-known photographers. Query with résumé. Send stock photo list. Provide prints, slides, business card, contact sheets, self-promotion piece or tearsheets to be kept on file for possible future assignments. Works on assignment; sometimes buys stock model photos. May not return unsolicited material. Reports in 3 weeks. Pays $5-100/b&w and color photo; $10-100/hour; $50-750/day; $2,500 maximum/job; sometimes also pays in "trades." Pays on publication. Credit line sometimes given. Buys one-time rights, all rights and various negotiable rights; depends on use.

Tips: In portfolios or demos, looks for "unique lighting, style, emotional involvement, beautiful, artistic, sensual viewpoint." Sees trend toward "more use of video, and manipulated computer images." To break into AV work, "join AV organizations, shoot stills of productions, volunteer your help, etc."

VARON & ASSOCIATES, INC., 31333 Southfield Rd., Beverly Hills MI 48025. (810)645-9730. Fax: (810)642-1303. President: Jerry Varon. Estab. 1963. Ad agency. Types of clients: industrial and retail.

Needs: Uses photos for trade magazines, catalogs and audiovisual. Subjects include: industrial. Reviews stock photos. Model/property release required. Captions preferred.

Audiovisual Needs: Uses slides and videotape for sales and training. Subjects include: industrial.

Specs: Uses 8×10 color prints; 4×5 transparencies.

Making Contact & Terms: Interested in receiving work from newer, lesser-known photographers. Arrange personal interview to show portfolio. Works with freelancers on assignment only. Keeps samples on file. Cannot return material. Reports in 1-2 weeks. Pays $1,000/day. **Pays on acceptance.** Credit line sometimes given. Buys all rights.

Minnesota

FALLON MCELLIGOTT, 704 Fourth Ave. S., Minneapolis MN 55415. Prefers not to share information.

MARTIN-WILLIAMS ADVERTISING INC., 60 South Sixth St., Suite 2800, Minneapolis MN 55402. (612)340-0800. Fax: (612)342-9716. Production Coordinator/Buyer: Lyle Studt. Estab. 1947. Ad agency. Types of clients: industrial, retail, fashion, finance, agricultural, business-to-business and food. Client list free with SASE.
• This agency negotiates with photographers to establish time periods for "unlimited uses" of material.
Needs: Works with 6-12 photographers/month. Uses photos for billboards, consumer and trade magazines, direct mail, catalogs, posters and newspapers. Subject matter varies. Model/property release required.
Specs: Uses 8×10 and larger b&w and color prints; 35mm, 2¼×2¼, 4×5 and 8×10 transparencies.
Making Contact & Terms: Arrange a personal interview to show portfolio. Provide résumé, business card, flier or tearsheets to be kept on file for possible future assignments. Works with freelance photographers on an assignment basis only. SASE. Reports in 2 weeks. Payment individually negotiated. Pays $700-3,500/b&w or color photo; $100-475/hour; $1,000-3,500/day; $1,000-14,500/complete job. Pays on receipt of invoice. Buys one-time rights or all rights.
Tips: Looks for "high quality work, imagination."

■**EDWIN NEUGER & ASSOCIATES**, 1221 Nicollet Mall, #320, Minneapolis MN 55403. (612)333-6621. Fax: (612)344-1809. PR firm. President: Ed Neuger. Types of clients: General, including industrial, retail and finance. Examples of projects: Washington Scientific Industries, Sheldahl, Inc., Barrett Moving & Storage, Metropolitan Financial Corp., Aequitron Medical Corp.
Needs: Works with 10 photographers—filmmakers—videographers/year. Uses photos for trade magazines, direct mail, catalogs and audiovisual. Subjects include: people.
Audiovisual Needs: Slide shows (single projector and multi-image) and videotape.
Specs: Uses color prints and transparencies.
Making Contact & Terms: Query with samples. Works with local freelancers on assignment only. Reports in 6 weeks. Usually pays $1,000-2,000/day. Pays on receipt of invoice. Buys all rights; sometimes negotiable. Model release preferred. Credit line given.

Missouri

*■**ANGEL FILMS NATIONAL ADVERTISING**, 967 Highway 40, New Franklin MO 65274-9778. Phone/fax: (314)698-3900. Vice President Marketing & Advertising: Linda G. Grotzinger. Estab. 1980. Ad agency, AV firm. Approximate annual billing: $10 million. Number of employees: 29. Types of clients: fashion, retail, film, TV and records. Examples of recent projects: swimwear/lingerie campaign for MESN; record promotions for Angel One; and cosmetics ads for Rising Sun. "Rising Sun and MESN are both Asian companies trying to get a toehold here in the Asian-American and Canadian marketplace."
Needs: Works with 4 freelance photographers, 1 filmmaker and 1 videographer/month. Uses photos for billboards, consumer and trade magazines, direct mail, catalogs, posters, newspapers and audiovisual uses. Subjects include: attractive women in swimwear and lingerie. Glamour type shots of both Asian and non-Asian women needed. Reviews stock photos of attractive women and athletic men with attractive women. Model release required.
Audiovisual Needs: Uses slides and video for fill material in commercial spots.
Specs: Uses all sizes color and b&w prints; 35mm transparencies; 16mm film; ½" videotape.
Making Contact & Terms: Interested in receiving work from newer, lesser-known photographers. Provide résumé, business card, brochure, flier or tearsheets to be kept on file for possible future assignments. Works on assignment only. Keeps samples on file. SASE. Reports in 1 month. NPI. Pay is based upon budget of project. Pays within 30 days of receipt of invoice. Credit line sometimes given depending upon the project. Buys all rights.
Tips: "Our company does business both here and in Asia. We do about six record covers a year and accompanying posters using mostly glamour photography."

*■**GEILE/REXFORD CREATIVE ASSOCIATES**, 135 N. Meramec, St. Louis MO 63105. (314)727-5850. Fax: (314)727-5819. Creative Director: David Geile. Estab. 1989. Member of American Market-

The asterisk before a listing indicates that the market is new in this edition. New markets are often the most receptive to freelance submissions.

ing Association, BPAA. Ad agency. Approximate annual billing: $3 million. Number of employees: 12. Types of clients: industrial and financial. Recent clients include: Texas Boot Company; First Bank; and Monsanto.

Needs: Works with 2-3 freelance photographers/month, 3 filmmakers and 5 videographers/year. Uses photos for billboards, consumer and trade magazines, direct mail, P-O-P displays, catalogs, posters and newspapers. Subjects include: product shots. Model/property release preferred.

Audiovisual Needs: Uses slides and video for sales meetings.

Specs: Uses color and b&w prints; 35mm, 2¼×2¼, 4×5 transparencies; 16mm film; 1″ videotape.

Making Contact & Terms: Interested in receiving work from newer, lesser-known photographers. Provide résumé, business card, brochure, flier or tearsheets to be kept on file for possible future assignments. Keeps samples on file. Cannot return material. Reports when approval is given from client. Pays $800-1,200/day; $300-500/b&w photo; also accepts bids for jobs. Pays net 30-45 days. Buys one-time and all rights.

KUPPER PARKER COMMUNICATIONS INC., 8301 Maryland Ave., St. Louis MO 63105. (314)727-4000. Fax: (314)727-3034. Advertising, public relations and direct mail firm. Creative Director: Peter A.M. Charlton. Senior Art Directors: Deborah Boggs, William Tuttle and Joe Geis. Art Directors: Jeff Twardoski and John Mank. Estab. 1992. Types of clients: retail, fashion, automobile dealers, consumer, broadcast stations, health care marketing, sports and entertainment, business-to-business sales and direct marketing.

Needs: Works with 12-16 freelance photographers/month. Uses photos for billboards, consumer and trade magazines, direct mail, P-O-P displays, catalogs, posters, signage and newspapers. Model release required; captions preferred.

Making Contact & Terms: Query with résumé of credits or with list of stock photo subjects. Provide résumé, business card, brochure, flier or tearsheets to be kept on file for possible future assignments. Works on assignment only. Does not return unsolicited material. Reports in 2 weeks. Pays $50-2,500/b&w photo; $250-5,000/color photo; $50-300/hour; $400-2,500/day. Buys one-time rights, exclusive product rights, all rights, and limited-time or limited-run usage. Pays upon receipt of client payment.

Montana

■**CONTINENTAL PRODUCTIONS**, 118 Sixth St. S., Great Falls MT 59405. (406)761-5536. Executive in Charge of Production: Cheryl Cordeiro. Types of clients: industrial, educational, retail and broadcast.

Needs: Works with 3-15 videographers/month. Uses video for films and videotapes. Subjects include: television commercials, educational/informational programs. All video is shot "film-style" (lighted for film, etc.). Reviews stock photos/footage. Model release required.

Specs: Uses U-matic ¾″ SP, prefers 1″ C-format or Beta SP.

Making Contact & Terms: Provide résumé, business card, self-promotion piece or tearsheets to be kept on file for possible future assignments. Works with freelancers on assignment only. SASE. Reports in 1 month. NPI. Pays upon completion of final edit. Credit line not given. Buys all rights.

Tips: "Send the best copy of your work on ¾″ cassette. Describe your involvement with each piece of video shown."

Nebraska

■**J. GREG SMITH**, 1004 Farnam, Suite 102, Burlington on the Mall, Omaha NE 68102. (402)444-1600. Art Director: Karen Gehrki. Ad agency. Types of clients: finance, banking institutions, national and state associations, agriculture, insurance, retail, travel.

Needs: Works with 10 freelance photographers/year on assignment only basis. Uses photographers for consumer and trade magazines, brochures, catalogs and AV presentations. Special subject needs include outer space, science and forest scenes, also high tech.

Making Contact & Terms: Arrange interview to show portfolio. Looks for "people shots (with expression), scenics (well known, bright colors)." Pays $500/color photo; $60/hour; $800/day; varies/job. Buys all rights, one-time rights or others, depending on use.

Tips: Considers "composition, color, interest, subject and special effects when reviewing a portfolio or samples."

■**SWANSON, RUSSELL AND ASSOCIATES**, 1222 P St., Lincoln NE 68508. (402)475-5191. Creative Director: John Kloefkorn. Ad agency. Types of clients: primarily industrial, outdoor recreation and agricultural; client list provided on request.

Needs: Works with 10 freelance photographers/year on assignment only basis. Uses photos for consumer and trade magazines, direct mail, brochures, catalogs, newspapers and AV presentations.

Making Contact & Terms: Query first with small brochure or samples along with list of clients freelancer has done work for. NPI. Negotiates payment according to client's budget. Rights are negotiable.

Nevada

■**DAVIDSON & ASSOCIATES**, 3940 Mohigan Way, Las Vegas NV 89119. (702)871-7172. President: George Davidson. Full-service ad agency. Types of clients: beauty, construction, finance, entertainment, retailing, publishing, travel.
Needs: Photos used in brochures, newsletters, annual reports, PR releases, AV presentations, sales literature, consumer and trade magazines.
Making Contact & Terms: Arrange a personal interview to show portfolio. Query with samples or submit portfolio for review. Provide résumé, brochure and tearsheets to be kept on file for possible future assignments. Offers 150-200 assignments/year. Pays $15-50/b&w photo; $25-100/color photo; $15-50/hour; $100-400/day; $25-1,000 by the project. Pays on production. Buys all rights. Model release required.

New Hampshire

*■**PORRAS & LAWLOR ASSOCIATES**, 15 Lucille Ave., Salem NH 03079. (603)893-3626. Fax: (603)898-1657. Ad agency, PR and AV firm. Contact: Alix Lawlor. Estab. 1980. Types of clients: industrial, educational, financial and service. Examples of recent projects: "You Can Get There from Here," MBTA; "Annual Giving," N.E. Telephone.
Needs: Works with 1-2 freelance photographers/month. Uses photographs for direct mail, catalogs, posters, signage and audiovisual uses. Subjects include: people and studio photography.
Specs: Uses all glossy and matte color and b&w prints; 35mm transparencies.
Making Contact & Terms: Interested in receiving work from newer, lesser-known photographers. Query with résumé of credits, list of stock photo subjects and samples. Provide résumé, business card, brochure, flier or tearsheets to be kept on file for possible future assignments. Works with local freelancers on assignment only. Pays $800-1,500/day; $200-800/color photo; $150-500/b&w photo. **Pays on receipt of invoice.** Buys one-time and exclusive product rights; negotiable. Model release and captions preferred.
Tips: In sample, looks for "product photography, people, architectural, landscape, or other depending on brochure or promotion we are working on. We don't buy photos too often. We use photographers for product, architectural or diverse brochure needs. We buy stock photography for interior graphic projects and others—but less often." To break in with this firm, "stay in touch, because timing is essential."

New Jersey

■**AM/PM ADVERTISING, INC.**, 196 Clinton Ave., Newark NJ 07108. (201)824-8600. Fax: (201)824-6631. President: Robert A. Saks. Estab. 1962. Ad agency. Types of clients: food, pharmaceuticals and health and beauty aids.
Needs: Works with 6 freelance photographers/month. Uses photos for consumer and trade magazines, direct mail, P-O-P displays, catalogs, posters, newspapers and audiovisual. Subjects include: fashion, still life and commercials. Reviews stock photos of food and beauty products. Model release required. Captions preferred.
Audiovisual Needs: "We use multimedia slide shows and multimedia video shows."
Specs: Uses 8×10 color and/or b&w prints; 35mm, 2¼×2¼, 4×5, 8×10 transparencies; 8×10 film; broadcast videotape.
Making Contact & Terms: Arrange personal interview to show portfolio. Send unsolicited photos by mail for consideration. Provide résumé, business card, brochure, flier or tearsheets to be kept on file for possible future assignments. Works on assignment only. Keeps samples on file. Reports in 1-2 weeks. Pays $150/hour; $1,000-2,000/day; $1,000-2,000/job; $1,000/color photo; $500/b&w photo. Pays on receipt of invoice. Credit line sometimes given, depending upon client and use. Buys one-time rights.
Tips: In portfolio or samples, wants to see originality. Sees trend toward more use of special lighting.

*■**CREATIVE ASSOCIATES**, 44 Park Ave., Madison NJ 07940. (201)377-4440. Producer: Harrison Feather. Estab. 1975. AV firm. Types of clients: industrial, cosmetic and pharmaceutical.
Needs: Works with 1-2 photographers, filmmakers and/or videographers/month. Uses photos for trade magazines and audiovisual uses. Subjects include product and general environment. Reviews stock

photos or videotape. Model release required. Property release preferred. Captions preferred.

Audiovisual Needs: Uses photos/video for slides and videotape.

Specs: Uses 35mm, 4×5 and 8×10 transparencies; videotape.

Making Contact & Terms: Provide résumé, business card, brochure, flyer or tearsheets to be kept on file for possible future assignments. Works on assignment only. SASE. Reports as needed. Pays $500-1,000/day; $1,500-3,000/job. Pays on publication. Credit line sometimes given, depending on assignment. Rights negotiable; "depends on budget."

***■CREATIVE PRODUCTIONS, INC.**, 200 Main St., Orange NJ 07050. (201)676-4422. Contact: Gus Nichols. AV producer. Types of clients: industry, advertising, pharmaceuticals and business. Produces film, video, slide presentations, multimedia programs and training programs. Works with freelance photographers on assignment basis only. Provide résumé and letter of inquiry to be kept on file for future assignments.

Subject Needs: Subjects include: sales training, industrial and medical topics. No typical school portfolios that contain mostly artistic or journalistic subject matter. Must be 3:4 horizontal ratio for film, video and filmstrips; 2:3 horizontal ratio for slides.

Specs: Uses color prints, slides and transparencies. Produces video and 16mm industrial, training, medical and sales promotion films. Possible assignments include shooting "almost anything that comes along—industrial sites, hospitals, etc." Interested in some occasional stock footage.

Making Contact & Terms: Query first with résumé of credits and rates. SASE. Reports in 1 week. NPI. Payment negotiable based on photographer's previous experience and client's budget. **Pays on acceptance.** Buys all rights. Model release required.

Tips: "We would use freelancers out-of-state for part of a production when it isn't feasible for us to travel, or locally to supplement our people on overload basis."

DIEGNAN & ASSOCIATES, Box 343 Martens, Lebanon NJ 08833. President: N. Diegnan. Ad agency/ PR firm. Types of clients: industrial, consumer.

Needs: Commissions 15 photographers/year; buys 20 photos/year from each. Uses photos for billboards, trade magazines, and newspapers. Model release preferred.

Specs: Uses b&w contact sheet or glossy 8×10 prints. For color, uses 5×7 or 8×10 prints; also 2¼×2¼ transparencies.

Making Contact & Terms: Arrange a personal interview to show portfolio. Local freelancers preferred. SASE. Reports in 1 week. NPI. Negotiates payment based on client's budget and amount of creativity required from photographer. Pays by the job. Buys all rights.

***■INFINITY FOUR VIDEO, INC.**, 846 Riverside Ave., Lyndhurst NJ 07071. Phone/fax: (201)507-1227. President: John T. Chow. Estab. 1988. AV firm. Approximate annual billing: $100,000. Number of employees: 3. Types of clients: industrial, financial, fashion, retail and broadcast TV. Examples of recent projects: "Corporate Sports Challenge," Andersen Consulting (in-house project); new Met Life sign, for Met Life; and Self Help project for Dr. Joyce Brothers.

Needs: Works with 6-8 videographers/month. Uses photos for audiovisual uses. Model release required; photo captions preferred.

Audiovisual Needs: Uses videotape. Subject matter varies.

Specs: Uses Betacam SP 1″ videotape.

Making Contct & Terms: Query with résumé of credits. Query with samples. Provide résumé, business card, brochure, flier or tearsheets to be kept on file for possible future assignments. Keeps samples on file. SASE. NPI. Pays on receipt of invoice. Credit line sometimes given. Buys all rights.

■INSIGHT ASSOCIATES, 149 Rita Lane, Oak Ridge NJ 07438. (201)697-0880. Fax: (201)697-6904. President: Raymond Valente. Types of clients: major industrial companies.

Needs: Works with 4 freelancers/month. Uses freelancers for slide sets, multimedia productions, videotapes and print material—catalogs. Subjects include: industrial productions. Examples of clients: Matheson (safety), Witco Corp. (corporate image), Volvo (sales training), P.S.E.&G., Ecolab Inc. Interested in stock photos/footage. Model release preferred.

Specs: Uses 35mm, 2¼×2¼ and 4×5 transparencies.

Making Contact & Terms: Arrange a personal interview to show portfolio. SASE. Reports in 1 week. Pays $450-750/day on acceptance. Credit line given. Buys all rights.

Tips: "Freelance photographers should have knowledge of business needs and video formats. Also, versatility with video or location work. In reviewing a freelancer's portfolio or samples we look for content appropriate to our clients' objectives. Still photographers interested in making the transition into film and video photography should learn the importance of understanding a script."

***■INTERNATIONAL MEDIA SERVICES, INC.**, 718 Sherman Ave., Plainfield NJ 07060. (908)756-4060. AV firm/independent film and tape production company/media consulting firm. President/General Manager: Stuart Allen. Types of clients: industrial, advertising, print, fashion, broadcast and CATV.

Needs: Works with 0-25 freelance photographers/month; "depending on inhouse production at the time." Uses photographers for billboards, direct mail, catalogs, newspapers, consumer magazines, P-O-P displays, posters, AV presentations, trade magazines, brochures, film and tape. Subjects range "from scenics to studio shots and assignments"—varies with production requirements. Also works with freelance filmmakers to produce documentaries, commercials and training films.
Specs: Uses 8×10 glossy or matte b&w and color prints; 35mm, 2¼×2¼ and 8×10 transparencies; 16mm, 35mm film and ¾-1″ videotape.
Making Contact & Terms: Provide résumé, business card, brochure, flier or tearsheets to be kept on file for possible future assignments. Query with résumé of credits. Query with list of stock photo subjects. Arrange a personal interview to show portfolio. SASE. Reporting time "depends on situation and requirements. We are not responsible for unsolicited material and do not recommend sending same. Negotiated rates based on type of work and job requirements." Usually pays $100-750/day, $25-2,500/job. Rights negotiable, generally purchases all rights. Model release required; captions preferred. Credit line given.
Tips: "Wants to see a brief book containing the best work of the photographer, representative of the type of assignment sought. Tearsheets are preferred but must have either the original or a copy of the original photo used, or applicable photo credit. Send résumé and sample for active resource file. Maintain periodic contact and update file."

■**JANUARY PRODUCTIONS**, P.O. Box 66, 210 Sixth Ave., Hawthorne NJ 07507. (201)423-4666. Fax: (201)423-5569. Art Director: Karen Neulinger. Estab. 1973. AV firm. Types of clients: schools, teachers and public libraries. Audience consists of primary, elementary and intermediate-grade school students. Produces children's books and videos. Subjects are concerned with elementary education—science, social studies, math and conceptual development.
Audiovisual Needs: Uses 35mm color transparencies and/or b&w photographs of products for company catalogs.
Making Contact & Terms: Interested in receiving work from newer, lesser-known photographers. Call or send résumé/samples of work "for us to keep on file." SASE. NPI. Payment amounts "depend on job." Buys all rights.
Tips: Wants to see "clarity, effective use of space, design, etc. We need clear photographs of our products for catalog use. The more pictures we have in the catalogs, the better they look and that helps to sell the product."

■**KJD TELEPRODUCTIONS, INC.**, 30 Whyte Dr., Voorhees NJ 08043. (609)751-3500. Fax: (609)751-7729. President: Larry Scott. Estab. 1989. AV firm. Types of clients: industrial, fashion, retail and food. Examples of recent projects: Marco Island Florida Convention, ICI Americas (new magazine show); "More Than Just a Game" (TV sports talk show); and "Rukus," Merv Griffin Productions (TV broadcast).
Needs: Works with 2 photographers, filmmakers and/or videographers/month. Uses photos for trade magazines and audiovisual. Model/property release required.
Audiovisual Needs: Primarily videotape, also slides and film.
Specs: Uses ½″, ¾″, Betacam/SP 1″ videotape.
Making Contact & Terms: Send unsolicited photos by mail for consideration. Works on assignment only. Keeps samples on file. Reports in 1 month. Pays $50-300/day. **Pays on acceptance.** Credit lines sometimes given. Buys first rights.
Tips: "We are seeing more use of freelancers, less staff. Be visible!"

*■**KOLLINS COMMUNICATIONS, INC.**, 425 Meadowlands Pkwy., Secaucus NJ 07094. (201)617-5555. Fax: (201)319-8760. Manager: R.J. Martin. Estab. 1992. Types of clients: Fortune 1000 pharmaceuticals, consumer electronics. Examples of projects: Sony (brochures); CBS Inc. (print ads); TBS Labs (slides).
Needs: Works with 2-4 freelance photographers/month. Uses photos for product shots, multimedia productions and videotapes. Subjects are various. Model release required.
Specs: Uses 35mm, 2¼×2¼, 4×5, 8×10 transparencies; Hi 8, ½″ Betacam and 1″ videotape.
Making Contact & Terms: Interested in receiving work from newer, lesser-known photographers. Submit portfolio by mail. Provide résumé, business card, self-promotion piece or tearsheets to be kept on file for possible future assignments. Works on assignment only. Cannot return material. Reports in 2 weeks. NPI. Pays per day or per job. Pays by purchase order 30 days after work completed. Credit line given "when applicable." Buys all rights.
Tips: "Be specific about your best work (what areas), be flexible to budget on project—represent our company when on business."

***LOHMEYER SIMPSON COMMUNICATIONS**, 14 Pine St., Morristown NJ 07960. (201)267-0400. Owner: Dick Lohmeyer. Ad agency. Uses all media. Types of clients: automotive, electronic and industrial.

Needs: Works with freelance photographers on assignment only basis. Uses photos for cars, people, fashion and still life.

Specs: Uses semigloss prints and transparencies. Model release required.

Making Contact & Terms: Provide business card and tearsheets to be kept on file for possible future assignments. Model release required. Buys all rights, but may reassign to photographer. Negotiates payment based on client's budget, amount of creativity required, where the work will appear and photographer's previous experience and reputation. Pays $1,000/b&w photo; $2,000/color photo; or $2,000/day. Call to arrange an appointment. "Show samples of your work and printed samples." Reports in 2 weeks.

Tips: "Interested in cars (location/studio), still life (studio), location, editorial and illustration."

***■SORIN PRODUCTIONS, INC.**, 4400 Rt. 9 South, Freehold NJ 07728. (908)462-1785. President: David Sorin. Type of client: corporate.

Needs: Works with 2 freelance photographers/month. Uses photographers for slide sets, multimedia productions, films and videotapes. Subjects include people and products.

Specs: Uses b&w and color prints; 35mm and 2¼×2¼ transparencies.

Making Contact & Terms: Query with stock photo list. Provide résumé, business card, self-promotion piece or tearsheets to be kept on file for possible future assignments. Works with freelancers by assignment only; interested in stock photos/footage. Does not return unsolicited material. Reports in 2 weeks. NPI. Pays per piece or per job. **Pays on acceptance.** Buys all rights. Captions and model releases preferred. Credit line given by project.

New Mexico

■FOCUS ADVERTISING, 4002 Silver Ave. SE, Albuquerque NM 87108. (505)255-4355. Fax: (505)266-7795. President: Al Costanzo. Ad agency. Types of clients: retail, industry, politics, government, law. Produces overhead transparencies, slide sets, motion pictures, sound-slide sets, videotape, print ads and brochures.

Needs: Works with 1-2 freelance photographers/month on assignment only basis. Buys 70 photos and 5-8 films/year: health, business, environment and products. No animals or flowers. Length requirements: 80 slides or 15-20 minutes, or 60 frames, 20 minutes.

Specs: Produces ½″ and ¾″ video for broadcasts; also b&w photos or color prints and 35mm transparencies, "and a lot of 2¼ transparencies and some 4×5 transparencies."

Making Contact & Terms: Arrange personal interview or query with résumé. Provide résumé, flier and brochure to be kept on file for possible future assignments. Prefers to see a variety of subject matter and styles in portfolio. Does not return unsolicited material. Pays $40-60/hour, $350-750/day, $40-800/job. Negotiates payment based on client's budget and photographer's previous experience/reputation. Pays on job completion. Buys all rights. Model release required.

New York

***■A-1 FILM AND VIDEO WORLD WIDE DUPLICATION**, 4650 Dewey Ave., Rochester NY 14612. (716)663-1400. Fax: (716)663-0246. President: Michael Gross Ordway. Estab. 1976. AV firm. Approximate annual billing: $1 million. Number of employees: 7. Types of clients: industrial and retail.

Needs: Works with 4 freelance photographers, 1 filmmaker and 4 videographers/month. Uses photos for trade magazines, direct mail, catalogs and audiovisual uses. Reviews stock photos or video. Model release required.

Audiovisual Needs: Uses slides, film and video.

Specs: Uses color prints; 35mm transparencies; 16mm film and all types of videotape.

Making Contact & Terms: Fax or write only. Works with local freelancers only. Pays $12/hour; $96/day. Pays on receipt of invoice. Credit line not given. Buys all rights.

■CL&B ADVERTISING, INC., 100 Kinloch Commons, Manlius NY 13104-2484. (315)682-8502. Fax: (315)682-8508. President: Richard Labs. Creative Director: Adam Rozum. Estab. 1937. Advertising,

Can't find a listing? Check at the end of each market section for the " '95-'96 Changes" lists. These lists include any market listings from the '95 edition which were either not verified or deleted in this edition.

"Pretty Pictures" Must Communicate

It isn't easy to understand what made Steve Hellerstein photograph a frog wearing fake eyelashes. Or how he thought of placing a Harley-Davidson style tattoo, with his name on it, on the backside of a pig and then taking a picture of the walking advertisement. And it's not easy to grasp how he captured an image of a butterfly with "Hellerstein" scripted in the creature's wing.

What is easy to understand is that such deft, off-the-wall ideas have won him awards and praise from art directors and creative directors who regularly hire him for advertising jobs. "Our job is to communicate, not just make pretty pictures," says Hellerstein. And for photographers wanting to work with advertising firms, this concept is worth remembering.

Steve Hellerstein

A 1983 graduate of the Art Center College of Design in Pasadena, California, Hellerstein's client list includes top agencies like Ogilvy & Mather, Chiat Day, DDB Needham and McCann-Erickson. He has won awards from the Art Directors Club, *Creative Black Book* and the American Advertising Federation, and is a 1993 winner of The One Show in New York City. He and his nine-person staff currently work out of a 5,000-square-foot studio in New York City.

When putting together a self-promotion piece, it is essential to know the audience you are trying to reach, Hellerstein says. Make sure you have a concept behind the piece and don't just send out the last good photo you've taken, he says. "I like people to see my work as upscale, sophisticated, clever and beautiful. A lot of photographers create self-promotion pieces for people who aren't even out there."

One of his favorite self-promo pieces was of the aforementioned frog with eyelashes. Hellerstein says he struggled with ways to keep the lashes atop the frog's bulging eyes because he didn't want to use actual glue. He had to find a substitute that wouldn't harm the animal. As luck would have it, Hellerstein was ill and drinking some chamomile tea to soothe his throat. When dipped in tea, the lashes held onto the frog's eyes beautifully. The image won the *Creative Black Book* Award and received honors from *Photo District News* in the 1994 Photo/Design Awards. "If you can put a smile on someone's face, I think you're that much ahead of the game," he says.

He estimates that ten percent of his annual budget is spent on self-promotion through various media, such as direct mail, sourcebooks and magazine ads.

Hellerstein maintains a mailing list of about 2,500 buyers. His goal with eachpromotion piece is to separate himself from the pack and get art directors interested in seeing his portfolio. This has become less of a problem for Hellerstein over the years as his name recognition builds.

Hellerstein also warns other photographers not to expect the phone to start ringing once a direct mail piece is out. It often takes months for art directors to respond because they typically file self-promo cards for future reference. "Remember that you're not going to appeal to everyone, so don't even try."

Once you are assigned advertising work, the next step is to give art directors what they want. Show them that you can solve problems and provide outstanding images on a regular basis. "The ad world constantly evolves and changes. We as image producers must constantly evolve and change in order to succeed."

Through his desire to evolve, Hellerstein has been able to outlast many of his competitors. "I don't want to be known as the flavor of the week."
—*Michael Willins*

If you look closely you'll see "Hellerstein" scripted in this butterfly's wing. Steve Hellerstein worked with a designer to digitally create the witty self-promotion piece. "I believe in using computer imaging techniques as tools to enhance the communication, but not as something that calls attention to itself," he says.

© Stephen Hellerstein

PR and research. Types of clients: industrial, fashion, finance and retail. Examples of recent projects: "Charges, Choices and Familiar Faces," (ads and literature); "Girl, dogs, Volvo, fall foliage classics," (posters for retail); and "Glamor shots of donuts," (point of purchase).

Needs: Works with 4-6 freelance photographers/year. Uses photos for billboards, consumer and trade magazines, P-O-P displays, catalogs and newspapers. Subjects include: industrial, consumer, models, location and/or studio. Model/property release required.

Audiovisual Needs: "Wish we could find low cost, high quality 35mm panavision film team."

Specs: Uses all formats.

Making Contact & Terms: "Send bio and proof sheet (if available) first; we will contact you if interested." Works on assignment only. Also uses stock photos. Does not return unsolicited material. Pays $10-1,000/b&w photo; $10-2,500/color photo; $10-100/hour; $200-3,000/day; $100-10,000/job. Pays in 30 days. Credit line seldom given. Buys all rights.

Tips: "We review your work and will call if we think a particular job is applicable to your talents."

■**FINE ART PRODUCTIONS**, 67 Maple St., Newburgh NY 12550. (914)561-5866. Director: Richie Suraci. Estab. 1989. Ad agency, PR firm and AV firm. Types of clients: industrial, financial, fashion, retail, food—all industries. Examples of previous projects: "Great Hudson River Revival," Clearwater, Inc. (folk concert, brochure); feature articles, Hudson Valley News (newspaper); and "Wheel and Rock to Woodstock," MS Society (brochure).

Needs: Uses photos for billboards, consumer and trade magazines, direct mail, P-O-P displays, catalogs, posters, newspapers, signage and audiovisual. Reviews stock photos. Model/property release required. Captions required; include basic information.

Audiovisual Needs: Uses slides, film (all formats) and videotape.

Specs: Uses color and b&w prints, any size or finish; 35mm, 2¼×2¼, 4×5, 8×10 transparencies; film, all formats; and ½″, ¾″ or 1″ Beta videotape.

Making Contact & Terms: Submit portfolio for review. Query with résumé of credits. Query with list of stock photo subjects. Send unsolicited photos by mail for consideration. Query with samples. Provide résumé, business card, brochure, flier or tearsheets to be kept on file for possible future assignments. Keeps samples on file. SASE. Reports in 1 month or longer. NPI: "All payment negotiable relative to subject matter." Pays on acceptance, publication or on receipt of invoice; "varies relative to project." Credit line sometimes given, "depending on project or if negotiated." Buys first, one-time and all rights; negotiable.

Tips: Looks for "all subjects, styles and capabilities."

HARRINGTON ASSOCIATES INC., 57 Fairmont Ave., Kingston NY 12401-5221. (914)331-7136. Fax: (914)331-7168. President: Gerard Harrington. Estab. 1988. PR firm. Types of clients: industrial, high technology, retail, fashion, finance, transportation, architectural, artistic and publishing. Examples of recent clients include: Plato Software Systems (product/service brochure); Ulster Performing Arts Center (PR, brochures, advertising).

● This company has received the Gold Eclat Award, Hudson Valley Area Marketing Association, for best PR effort.

Needs: Number of photographers used on a monthly basis varies. Uses photos for consumer and trade magazines, P-O-P displays, catalogs and newspapers. Subjects include: general publicity including head shots and candids. Also still lifes. Model release required.

Specs: Uses b&w prints, any size and format. Also uses 4×5 color transparencies; and ¾″ videotape.

Making Contact & Terms: Interested in receiving work from newer, lesser-known photographers. Provide résumé, business card, brochure, flier or tearsheets to be kept on file for possible future assignments. Works with freelancers on assignment only. Cannot return material. Reports only when interested. NPI; payment negotiable. Pays on receipt of invoice. Credit line given whenever possible, depending on use. Buys all rights; negotiable.

■**MCANDREW ADVERTISING CO.**, 2125 St. Raymond Ave., P.O. Box 254, Bronx NY 10462. Phone/fax: (718)892-8660. Contact: Robert McAndrew. Estab. 1961. Ad agency, PR firm. Types of clients: industrial and technical. Examples of recent projects: trade advertising and printed material illustrations. Trade show photography.

Needs: Works with 1 freelance photographer/month. Uses photos for trade magazines, direct mail, brochures, catalogs, newspapers, audiovisual. Subjects include: technical products. Reviews stock photos of science subjects. Model release required for recognizable people. Property release required.

Audiovisual Needs: Uses slides and videotape.

Specs: Uses 8×10 glossy b&w or color prints; 35mm, 4×5 transparencies.

Making Contact & Terms: Interested in working with newer, lesser-known photographers. Query with résumé of credits. Provide résumé, business card, brochure, flier, tearsheets or non-returnable samples to be kept on file for possible future assignments. Works with local freelancers only. SASE. Reports in 1 month. Pays $65/b&w photo; $150/color photo; $700/day. "Prices dropping because business is bad." Pays 30 days after receipt of invoice. Credit line sometimes given. Buys all rights.

Tips: Photographers should "let us know how close they are, and what their prices are. We look for photographers who have experience in industrial photography." In samples, wants to see "sharp, well-lighted" work.

***MCCUE ADVERTISING & PR INC.**, 91 Riverside Dr., Binghamton NY 13905. (607)723-9226. President: Donna McCue. Ad agency and PR firm. Types of clients: industrial, retail, all types.
Needs: Works with 5 freelance photographers/month. Uses photos for consumer and trade magazines, direct mail, P-O-P displays, catalogs, signage and newspapers. Model release required.
Specs: Uses 8×10 prints; 35mm, 4×5 transparencies.
Making Contact & Terms: Provide résumé, business card, brochure, flier or tearsheets to be kept on file for possible future assignments. Cannot return material. Reports when assignment comes up. NPI; payment negotiable. Pays in 30 days. Credit line sometimes given. Buys all rights.

■ROGER MALER, INC., 264 North Hwy., South Hampton NY 11968. Ad agency. President: Roger Maler. Types of clients: industrial, pharmaceutical.
Needs: Works with 3 freelance photographers/month. Uses photographers for trade magazines, direct mail, P-O-P displays, brochures, catalogs, newspapers and AV presentations.
Audiovisual Needs: Works with freelance filmmakers.
Making Contact & Terms: Send résumé, business card, brochure, flier or tearsheets to be kept on file for possible future assignments. Works with freelance photographers on assignment only. Does not return unsolicited material. NPI. Pays on publication. Model release required. Credit line sometimes given.

***■NATIONAL TEACHING AIDS, INC.**, 1845 Highland Ave., New Hyde Park NY 11040. (516)326-2555. Fax: (516)326-2560. President: A. Becker. Estab. 1960. AV firm. Types of clients: schools. Produces filmstrips.
Needs: Buys 20-100 photos/year. Science subjects; needs photomicrographs and space photography.
Specs: Uses 35mm transparencies.
Making Contact & Terms: Cannot return material. Pays $50 minimum. Buys one-time rights; negotiable.

***■PARAGON ADVERTISING**, 220 Delaware Ave., Suite 510, Buffalo NY 14202. (716)854-7161. Fax: (716)854-7163. Senior Art Director: Leo Abbott. Estab. 1988. Ad agency. Types of clients: industrial, retail, food and medical.
Needs: Works with 0-5 photographers, 0-1 filmmakers and 0-1 videographers/month. Uses photos for billboards, consumer and trade magazines, P-O-P displays, catalogs, posters, newspapers, signage and audiovisual. Subjects include: location. Reviews stock photos. Model release required. Property release preferred.
Audiovisual Needs: Uses film and videotape for on air.
Specs: Uses 8×10 prints; 2¼×2¼ or 4×5 transparencies; 16mm film; and ¾", 1" Betacam videotape.
Making Contact and Terms: Interested in receiving work from newer, lesser-known photographers. Submit portfolio for review. Query with stock photo list. Send unsolicited photos by mail for consideration. Works on assignment only. Keeps samples on file. SASE. Reports in 1-2 weeks. Pays $500-2,000 day; $100-5,000 job. Pays on receipt of invoice. Credit line sometimes given. Buys all rights; negotiable.

PRO/CREATIVES, 25 W. Burda Pl., New City NY 10956-7116. President: David Rapp. Ad agency. Uses all media except billboards and foreign. Types of clients: package goods, fashion, men's entertainment and leisure magazines, sports and entertainment.
Specs: Send any size b&w prints. For color, send 35mm transparencies or any size prints.
Making Contact & Terms: Submit material by mail for consideration. Reports as needed. SASE. NPI. Negotiates payment based on client's budget.

■TOBOL GROUP, INC., 14 Vanderventer Ave., Port Washington NY 11050. (516)466-0414. Fax: (516)466-0776. Ad agency/design studio. President: Mitch Tobol. Estab. 1981. Types of clients: high-tech, industrial, business-to-business and consumer. Examples of ad campaigns: Weight Watchers (in-store promotion); Eutectic & Castolin; Mainco (trade ad); and Light Alarms.
Needs: Works with up to 4 photographers/videographers/month. Uses photos for billboards, consumer and trade magazines, direct mail, P-O-P displays, catalogs, posters, newspapers and audiovisual. Subjects are varied; mostly still-life photography. Reviews business-to-business and commercial video footage. Model release required.
Audiovisual Needs: Uses videotape.
Specs: Uses 4×5, 8×10, 11×14 b&w prints; 35mm, 2¼×2¼ and 4×5 transparencies; and ½" videotape.

Making Contact & Terms: Send unsolicited photos by mail for consideration. Query with samples. Provide résumé, business card, brochure, flier or tearsheets to be kept on file for possible future assignments: follow-up with phone call. Works on assignment only. SASE. Reports in 3 weeks. Pays $100-10,000/job. Pays net 30. Credit line sometimes given, depending on client and price. Rights purchased depend on client.

Tips: In freelancer's samples or demos, wants to see "the best they do—any style or subject as long as it is done well. Trend is photos or videos to be multi-functional. Show me your *best* and what you enjoy shooting. Get experience with existing company to make the transition from still photography to audiovisual."

■**VISUAL HORIZONS**, 180 Metro Park, Rochester NY 14623. (716)424-5300. Fax: (716)424-5313. E-mail: 73730.2512@compuserve.com. President: Stanley Feingold. AV firm. Types of clients: industrial.
Audiovisual Needs: Works with 2 freelance photographers/month. Uses photos for AV presentations. Also works with freelance filmmakers to produce training films. Model release required. Captions required.
Specs: Uses 35mm transparencies and videotape.
Making Contact & Terms: Provide résumé, business card, brochure, flier or tearsheets to be kept on file for possible future assignments. Works on assignment only. Reports as needed. NPI. Pays on publication. Buys all rights.

New York City

*****ALLY & GARGANO**, 805 Third Ave., New York NY 10022. (212)688-5300. Senior Vice President of Broadcast Operations: Tony Shor. Types of clients: financial, fashion, retail, food, automotive, health care. Examples of recent projects: Dunkin' Donuts, World Gold Council, Bank of New York.
Needs: Number of freelancers used/month varies. Uses photos for billboards, consumer and trade magazines, catalogs, posters, newspapers, signage. Subjects used depend on product. Model/property release required for all subjects.
Making Contact & Terms: Interested in receiving work from newer, lesser-known photographers. Contact through rep. Submit portfolio for review. Query with résumé of credits and portfolio. Query with stock photo list. Reports in 1-2 weeks, but only when looking for that specific material. NPI. Payment depends on contract. Rights purchased depend on contract.

*****AMMIRATI & PURIS/LINTAS**, 100 Fifth Ave., New York NY 10011. (212)206-5000. Art Buyers: Jean Wolff, Karen Meenaghan, Betsy Thompson, Jose Pouso, Helaina Buzzeo. Member of AAAA. Ad agency. Approximate annual billing: $500 million. Number of employees: 750. Types of clients: financial, food, consumer goods. Examples of recent projects: Four Seasons Hotels, Compaq Computers, RCA, Burger King.
Needs: Works with 50 freelancers/month. Uses photos for billboards, trade magazines, direct mail, P-O-P displays, catalogs, posters, newspapers. Reviews stock photos. Model/property release required for all subjects.
Making Contact & Terms: Interested in receiving work from newer, lesser-known photographers. Contact through rep. Arrange personal interview to show portfolio. Submit portfolio for review. Provide résumé, business card, brochure, flier or tearsheets to be kept on file for possible future assignments. Works on assignment only. Keeps samples on file. SASE. Reports in 1-2 weeks. NPI; open. **Pays on receipt of invoice.** Credit line not given. Buys all rights.

AVRETT FREE & GINSBURG, 800 Third Ave., New York NY 10022. Prefers not to share information.

*****NW AYER INC.**, Worldwide Plaza, 825 Eighth Ave., New York NY 10019. (212)474-5000, ext. 5959. Vice President/Manager Art Buying Dept.: Gloriana Palancia. Types of clients: industrial, fashion, retail, food. Examples of recent projects: AT&T, General Motors, De Beers Diamonds.
Needs: Works with 0-15 freelancers/month. Uses photos for billboards, consumer and trade magazines, direct mail, P-O-P displays, catalogs, posters, newspapers, audiovisual uses. Subjects include: fashion, people, still life. Reviews stock photos; various subjects. Model/property release required for anyone recognizable.
Specs: Uses 35mm, 8×10 transparencies.
Making Contact & Terms: Interested in receiving work from newer, lesser-known photographers. Contact through rep. Arrange personal interview to show portfolio. Submit portfolio for review. Query with résumé of credits. Query with stock photo list. Send unsolicited photos by mail for consideration. Query with samples. Reporting time varies. NPI. **Pays on receipt of invoice.** Rights purchased vary.

‡**BACKER SPIELVOGEL BATES**, 405 Lexington Ave., New York NY 10174. Prefers not to share information.

***BBDO WORLDWIDE INC.**, 1285 Avenue of the Americas, 6th Floor, New York NY 10019-6095. (212)459-5000. Photograph Buyer: Andrea Kaye. Films: Kate Donovan. Types of clients: industrial, financial, fashion, retail, food. Examples of recent projects: Pepsi, General Electric.
Needs: Works with 5 freelancers/month. Uses photos for billboards, consumer and trade magazines, direct mail, P-O-P displays, catalogs, posters, newspapers, signage. Subjects include: "everything." Model/property release required.
Specs: Uses any size or finish prints; 35mm, 2¼×2¼, 4×5, 8×10 transparencies.
Making Contact & Terms: Interested in receiving work from newer, lesser-known photographers. Contact by phone. NPI. **Pays on receipt of invoice**. Rights purchased: "depends."

BOZELL, 40 W. 23rd St., New York NY 10010. Prefers not to share information.

■ANITA HELEN BROOKS ASSOCIATES, 155 E. 55th St., New York NY 10022. (212)755-4498. Contact: Anita Helen Brooks. PR firm. Types of clients: beauty, entertainment, fashion, food, publishing, travel, society, art, politics, exhibits and charity events.
Needs: Photos used in PR releases, AV presentations and consumer and trade magazines. Buys "several hundred" photos/year. Most interested in fashion shots, society, entertainment and literary celebrity/personality shots. Model release preferred.
Specs: Uses 8×10 glossy b&w or color prints; contact sheet OK.
Making Contact & Terms: Provide résumé and brochure to be kept on file for possible future assignments. Query with résumé of credits. No unsolicited material; cannot return unsolicited material. Works on assignment only. Pays $50 minimum/job; negotiates payment based on client's budget. Credit line given.

THE EARLE PALMER BROWN CO., 345 Hudson St., New York NY 10014. Prefers not to share information.

***■COX & MARSHALL ADVERTISING**, (formerly Cox Advertising), 379 W. Broadway, New York NY 10012. (212)334-9141. Fax: (212)334-9179. Ad agency. Associate Creative Director: Marc Rubin. Types of clients: industrial, retail, fashion and travel.
Needs: Works with 2 freelance photographers—videographers/month. Uses photographers for billboards, consumer magazines, trade magazines, direct mail, P-O-P displays, catalogs, posters, newspapers, signage and audiovisual. Reviews stock photos or video.
Audiovisual Needs: Uses photos for slide shows; also uses videotapes.
Specs: Uses 16×20 b&w prints; 35mm, 2¼×2¼, 4×5 and 8×10 transparencies.
Making Contact & Terms: Arrange personal interview to show portfolio. Works on assignment only. Cannot return material. Reports in 1-2 weeks. Pays minimum of $1,500/job; higher amounts negotiable according to needs of client. Pays within 30-60 days of receipt of invoice. Buys all rights when possible. Model release required. Credit line sometimes given.

■D.C.A./DENTSU CORPORATION OF AMERICA, 666 Fifth Ave., New York NY 10103. (212)397-3333. Fax: (212)397-3322. Art Buyer: Rachel Pincus. Estab. 1971. Ad agency. Types of clients: Canon, U.S.A., Shiseido and Sanyo.
Needs: Works with 5-10 freelance photographers, 1-2 filmmakers. Uses photos for billboards, consumer magazines, trade magazines, direct mail, P-O-P displays, catalogs, posters, newspapers, signage for annual reports, sales and marketing kits. Reviews stock photos. All subjects with a slant on business and sports. Model/property release required. Captions preferred; include location, date and original client.
Audiovisual Needs: Uses slides and videotape for presentations.
Specs: Uses 8×10 to 16×20 color and b&w prints; 35mm, 4×5, 8×10 transparencies.
Making Contact & Terms: Interested in receiving work from newer, lesser-known photographers. Query with samples. Provide résumé, business card, brochure, flier or tearsheets to be kept on file for possible future assignments. Works with local freelancers on assignment only. Keeps samples on file. Reporting time depends on the quality of work; calls will be returned as they apply to ongoing projects. NPI. Pays 60 days from assignment completion. Credit line sometimes given depending on placement of work. Buys one-time and all rights.
Tips: "Your capabilities must be on par with top industry talent. We're always looking for new techniques."

D'ARCY MASIUS BENTON & BOWLES INC., 1675 Broadway, New York NY 10019. Prefers not to share information.

DDB NEEDHAM WORLDWIDE INC., 437 Madison Ave., 5th Floor, New York NY 10022. Prefers not to share information.

***∎DEUTSCH, INC.**, 215 Park Ave. S., New York NY 10014. (212)995-7500. Fax: (212)353-1506. Estab. 1969. Approximate annual billing: $250 million. Number of employees: 125. Types of clients: financial, retail, liquor. Examples of recent projects: Ikea, Tanqueray, Lenscrafters.
Needs: Uses photos for billboards, consumer and trade magazines, direct mail, P-O-P displays, catalogs, posters, newspapers, signage, audiovisual uses. Model/property release preferred.
Audiovisual Needs: Uses video for review.
Specs: Uses color and b&w prints; 35mm, 2¼×2¼, 4×5 transparencies.
Making Contact & Terms: Interested in receiving work from newer, lesser-known photographers. Submit portfolio for review. Send unsolicited photos by mail for consideration. Works on assignment only. Keeps samples on file. Reports in 3 weeks. NPI. **Pays on receipt of invoice.** Buys all rights; negotiable.
Tips: "No fashion."

∎RICHARD L. DOYLE ASSOC., INC., RLDA COMMUNICATIONS, 15 Maiden Lane, New York NY 10038. (212)349-2828. Fax: (212)619-5350. Ad agency. Client Services: R.L. Stewart, Jr. Estab. 1979. Types of clients: primarily insurance/financial services and publishers. Client list free with SASE.
Needs: Works with 3-4 freelance photographers/month. Uses photographers for consumer and trade magazines, direct mail, newspapers, audiovisual, sales promotion and annual reports. Subjects include people—portrait and candid. Model release required. Captions required.
Audiovisual Needs: Typically uses prepared slides—in presentation formats, video promotions and video editorials.
Specs: Uses b&w and color prints; 35mm and 2¼×2¼ transparencies.
Making Contact & Terms: Query with résumé of credits and samples. Prefers résumé, business card, brochure, flier or tearsheets to be kept on file for possible future assignments. SASE. Reports in 2 weeks. NPI. **Pays on acceptance** or receipt of invoice. Buys all rights.
Tips: Prefers to see photos of people; "good coverage/creativity in presentation. Be perfectly honest as to capabilities; be reasonable in cost and let us know you'll work *with us* to satisfy the client."

***∎EMMERLING POST INC., ADVERTISING**, 415 Madison Ave., New York NY 10017-1163. (212)753-4700. Executive Vice President/Associate Creative Director: Art Gilmore. Senior Vice President/Associate Creative Director: Stuart Cohen. Vice President/Art Director: Paul Shields. Types of clients: magazines, banks, aviation and computers. Current clients: *Readers' Digest*, IBM, Jet Aviation, Magazine Publishers of America and New York Eye Surgery Center.
Needs: Works with 5 photographers and videographers/month. Uses photographs for billboards, consumer and trade magazines, direct mail, P-O-P displays, posters, newspapers, audiovisual and other. Subjects include: reportage, people, still life.
Audiovisual Needs: Uses slides, film and videotape.
Specs: Uses b&w prints; 35mm, 2¼×2¼, 4×5 and 8×10 transparencies; 35mm film; 1″, ¾″, ½″ videotape.
Making Contact & Terms: Mail samples. Local freelancers may call to arrange personal interview to show portfolio. Submit portfolio for review. Provide business card, brochure, flier or tearsheets to be kept on file for possible future assignments. Keeps samples on file. Cannot return material. Reports only as needed. NPI. **Pays on receipt of invoice.** Rights negotiable. Model release required. Credit line sometimes given depending upon fee schedule.
Tips: Looks for original work.

***GREY ADVERTISING**, 777 Third Ave., New York NY 10017. (212)546-2000. Vice President Art Buying Manager: Patti Harris. Types of clients: food, beauty and telecommunications. Examples of recent projects: Procter & Gamble, Panasonic, Sprint.
Needs: Works with 10 freelancers/month. Uses photos for billboards, consumer and trade magazines, direct mail, P-O-P displays, catalogs, posters, newspapers, signage, audiovisual uses. Subjects include: still life, food, people. Model/property release required. Captions required.
Specs: Uses all prints; 35mm, 2¼×2¼, 4×5, 8×10 transparencies.
Making Contact & Terms: Interested in receiving work from newer, lesser-known photographers. Contact through rep. Arrange personal interview to show portfolio. Submit portfolio for review. Query with stock photo list. Query with samples. Provide résumé, business card, brochure, flier or tearsheets to be kept on file for possible future assignments. Does not report back. NPI. Pays 30 days after receipt of invoice. Buys all rights.

∎IMAGE ZONE, INC., 101 Fifth Ave., New York NY 10003. (212)924-8804. Fax: (212)924-5585. Managing Director: Doug Ehrlich. Estab. 1986. AV firm. Types of clients: industrial, financial, fashion. Examples of recent projects: Shearson Lehman Brothers (conference); Pfizer (exhibit); Bristol Myers (product launch).

Needs: Works with 1 freelance photographer, 2 filmmakers and 3 videographers/month. Uses photos for audiovisual projects. Subjects vary. Reviews stock photos. Model/property release preferred. Captions preferred.
Audiovisual Needs: Uses slides, film and videotape. Subjects include: "original material."
Specs: Uses 35mm transparencies; ¾" or ½" videotape.
Making Contact & Terms: Query with résumé of credits. Provide résumé, business card, brochure, flier or tearsheets to be kept on file for possible future assignments. Works with local freelancers on assignment only. Keeps samples on file. Cannot return material. Reports when needed. Pays $500-1,500/job; also depends on size, scope and budget of project. Pays within 14 days of receipt of invoice. Credit line not given. Buys one-time rights; negotiable.

***CAROLINE JONES INC.**, 415 Madison Ave., New York NY 10017-1111. (212)754-9191. Fax: (212)754-9105. Contact: Production Manager. Estab. 1987. Member of AAAA. Ad agency, PR firm. Approximate annual billing: $10 million. Number of employees: 10. Types of clients: financial, food. Has worked on campaigns for McDonald's and Anheuser-Busch.
Needs: Uses photos for billboards, consumer and trade magazines, direct mail, P-O-P displays, posters and newspapers. Subjects vary according to assignment; usually people. Reviews stock photos. Model/property release required. Captions preferred.
Specs: Uses 8 × 10 or smaller prints; 35mm transparencies.
Making Contact & Terms: Interested in receiving work from new and known photographers. Contact through rep. Works on assignment only. Keeps samples on file. Cannot return material. Reports in 1 month. NPI. Pays on receipt of invoice. Credit line sometimes given depending upon client approval. Buys all rights.
Tips: Interested in multiracial subjects when people are shown.

***JORDAN, MCGRATH, CASE & TAYLOR/DIRECT**, 445 Park Ave., New York NY 10022. (212)326-9600. Contact: Karen Hochman. Ad agency. Uses all media. Types of clients: financial services, technology, package goods.
Needs: Still lifes and product photos. Buys 5-10 annually.
Specs: Uses b&w contact sheets for selection, then double-weight glossy or matte prints. Also uses transparencies. Determines specifications at time of assignment.
Making Contact & Terms: "Please do not call. Send promotional materials, which will be retained. Agency will call photographer or rep as appropriate assignments surface."

■KEYSTONE PRESS AGENCY, INC., 202 East 42nd St., New York NY 10017. (212)924-8123. Managing Editor: Brian F. Alpert. Types of clients: book publishers, magazines and major newspapers.
Needs: Uses photos for slide sets. Subjects include: photojournalism. Reviews stock photos/footage. Captions required.
Specs: Uses 8 × 10 glossy b&w and color prints; 35mm and 2¼ × 2¼ transparencies.
Making Contact & Terms: Cannot return material. Reports upon sale. NPI; payment is 50% of sale per photo. Credit line given.

***■MCCABE AND COMPANY**, 101 E. 52nd St., New York NY 10022. (212)308-3434. Fax: (212)308-3502. Creative Director: Simon Bowden. Estab. 1990. Ad agency. Types of clients: financial, retail and food. Examples of recent projects: Rally's Hamburgers, Maxell audiotapes and Mills Pride Kitchens.
Needs: Works with 2 freelance photographers, 1 filmmaker/month. Uses photos for billboards, consumer and trade magazines, direct mail, newspapers and audiovisual uses. Model/property release required.
Audiovisual Needs: Uses film and videotape.
Making Contact & Terms: Interested in receiving work from newer, lesser-known photographers. Arrange personal interview to show portfolio. Submit portfolio for review. Keeps samples on file. NPI.
Pays on acceptance or publication. Credit line sometimes given. Buys all rights.

McCANN-ERICKSON WORLDWIDE, 750 Third Ave., 17th Floor, New York NY 10017. Prefers not to share information.

***■MARSDEN**, 30 E. 33rd St., New York NY 10016. (212)725-9220. Vice President/Creative Director: Stephen Flores. Types of clients: corporate, nonprofit, Fortune 500.
Needs: Works with 2-3 photographers/month. Uses photographers for filmstrips, slide sets, multimedia productions, films and videotapes. Subjects include industrial, technical, office, faces, scenics, special effects, etc.
Specs: Uses 35mm, 2¼ × 2¼, 4 × 5 and 8 × 10 transparencies; 16mm film; U-matic ¾", 1" and 2" videotapes.
Making Contact & Terms: Query with samples or a stock photo list. Provide résumé, business card, self-promotion piece or tearsheets to be kept on file for possible future assignments. Works with local

freelancers only; interested in stock photos/footage. "We call when we have a need—no response is made on unsolicited material." Pays $25-1,000/color photo; $150-600/day. **Pays on acceptance.** Buys one-time rights. Model release preferred. Credit line rarely given.

***■MOLINO + ASSOCIATES, INC.**, 245 Fifth Ave., Suite 2404, New York NY 10016. (212)689-7370. Fax: (212)689-7448. PR firm. Production Manager: John Corrigan. Estab. 1989. Types of clients: nonprofit health care. Recent projects include General Motors Cancer Research Foundation, The Hebrew Home for the Aged at Riverdale and American Association for Cancer Research.
Needs: Works with 1-2 freelancers/month. Uses photos for direct mail, posters, newspapers and audiovisual. Subjects include: health care for the elderly.
Audiovisual Needs: Uses slides, film and videotape—"all, but not too often—once or twice a year."
Specs: Uses 5×7 and 8×10 color and b&w prints; 35mm transparencies.
Making Contact & Terms: Interested in receiving work from newer, lesser-known photographers. Submit portfolio for review. Provide résumé, business card, brochure, flier or tearsheets to be kept on file for possible future assignments. Works with local freelancers only. Keeps samples on file. SASE. Reports in 1-3 weeks. Pays $500-1,000/day; $12-16/b&w photo. Pays on receipt of invoice. Buys all rights and others; negotiable. Model release required for caregivers and patients. Captions preferred. Credit line sometimes given: "If the photo is used on an invitation, no; if in a brochure, yes."
Tips: Wants to see "subjects—people, styles—realistic. Capabilities: showing personality of subjects through lighting, etc. Mainly photos are used for fundraising and/or informational brochures. Photographer has to be good with people he/she's photographing—especially old people, have a good eye for composition and lighting."

OMNICOM GROUP INC., 437 Madison Ave., 9th Floor, New York NY 10022. Prefers not to share information.

PETER ROTHHOLZ ASSOCIATES, INC., 380 Lexington Ave., New York NY 10168. (212)687-6565. Contact: Peter Rothholz. PR firm. Types of clients: pharmaceuticals (health and beauty), government, travel.
Needs: Works with 2 freelance photographers/year, each with approximately 8 assignments. Uses photos for brochures, newsletters, PR releases, AV presentations and sales literature. Model release required.
Specs: Uses 8×10 glossy b&w prints; contact sheet OK.
Making Contact & Terms: Provide letter of inquiry to be kept on file for possible future assignments. Query with résumé of credits or list of stock photo subjects. Local freelancers preferred. SASE. Reports in 2 weeks. NPI; negotiates payment based on client's budget. Credit line given on request. Buys one-time rights.
Tips: "We use mostly standard publicity shots and have some 'regulars' we deal with. If one of those is unavailable we might begin with someone new—and he/she will then become a regular."

***SAATCHI & SAATCHI ADVERTISING**, 375 Hudson St., 15th Floor, New York NY 10014-3660. (212)463-2000. Art Buyers: Joanne DeCarlo (Senior Manager), Marity Brody, Jim Hushon, Amy Salzman, Francis Timoney.
• This market says its photo needs are so varied that photographers should contact individual art buyers about potential assignments.

***■SPENCER PRODUCTIONS, INC.**, 234 Fifth Ave., New York NY 10001. General Manager: Bruce Spencer. Estab. 1961. PR firm. Types of clients: business, industry. Produces motion pictures and videotape.
Needs: Works with 1-2 freelance photographers/month on assignment only. Buys 2-6 films/year. Satirical approach to business and industry problems. Freelance photos used on special projects. Length: "Films vary—from a 1-minute commercial to a 90-minute feature." Model/property release required. Captions required.
Specs: 16mm color commercials, documentaries and features.
Making Contact & Terms: Interested in receiving work from newer, lesser-known photographers. Provide résumé and letter of inquiry to be kept on file for possible future assignments. Query with

Market conditions are constantly changing! If you're still using this book and it's 1997 or later, buy the newest edition of Photographer's Market at your favorite bookstore or order directly from Writer's Digest Books.

samples and résumé of credits. "Be brief and pertinent!" SASE. Reports in 3 weeks. Pays $50-150/ color and b&w photos (purchase of prints only; does not include photo session); $5-15/hour; $500-5,000/job; negotiates payment based on client's budget. Pays a royalty of 5-10%. **Pays on acceptance.** Buys one-time rights and all rights; negotiable.

Tips: "Almost all of our talent was unknown in the field when hired by us. For a sample of our satirical philosophy, see paperback edition of *Don't Get Mad . . . Get Even* (W.W. Norton), by Alan Abel which we promoted, or *How to Thrive on Rejection* (Dembner Books, Inc.) or rent the home video *Is There Sex After Death?*, an R-rated comedy featuring Buck Henry."

■**TALCO PRODUCTIONS**, 279 E. 44th St., New York NY 10017. (212)697-4015. Fax: (212)697-4827. President: Alan Lawrence. Vice President: Marty Holberton. Estab. 1968. Public relations agency and TV, film, radio and audiovisual production firm. Types of clients: industrial, legal, political and nonprofit organizations. Produces motion pictures, videotape and radio programs.

Needs: Works with 1-2 freelancers/month. Model/property release required.

Audiovisual Needs: Uses 16mm and 35mm film. Beta videotape. Filmmaker might be assigned "second unit or pick-up shots."

Making Contact & Terms: Query with résumé of credits. Provide résumé, flier or brochure to be kept on file for possible future assignments. Prefers to see general work or "sample applicable to a specific project we are working on." Works on assignment only. SASE. Reports in 3 weeks. Payment negotiable according to client's budget and where the work will appear. Pays on receipt of invoice. Buys all rights.

Tips: Filmmaker "must be experienced—union member is preferred. We do not frequently use freelancers except outside the New York City area when it is less expensive than sending a crew." Query with résumé of credits only—don't send samples. "We will ask for specifics when an assignment calls for particular experience or talent."

*■**TBWA ADVERTISING**, 292 Madison Ave., New York NY 10017. (212)725-1150. Fax: (212)481-8053. Estab. 1977. Member of Art Buyers Club of New York, International Photographer's Club. Ad agency. Number of employees: 123. Types of clients: financial, retail. Examples of recent projects: Absolut Vodka, for Seagrams (magazine, bus shelter); Evian water, for Grand Brands of Europe (magazine, bus shelter); Woolite carpet cleaner, for Reckitt & Colman (TV).

Needs: Works with 5-6 freelance photographers and 3-5 filmmakers/month. Uses photos for billboards, consumer and trade magazines, direct mail, P-O-P displays, catalogs, posters, newspapers and signage. Subjects include: "Everything and anything. It's all according to the art director's concepts." Reviews stock photos. Model/property release preferred for people, models, famous deceased stars.

Audiovisual Needs: Uses slides and/or videotape. Subjects include: "all types."

Specs: Uses 11 × 14 color and b&w prints; 35mm, 2¼ × 2¼, 4 × 5, 8 × 10 transparencies.

Making Contact & Terms: Interested in receiving work from newer, lesser-known photographers. Contact through rep. Arrange personal interview to show portfolio. Submit portfolio for review. Query with samples. Works on assignment only. Keeps samples on file. SASE. Reports in 1-2 weeks. NPI; depends on the job and client's budget. Credit line sometimes given, depending on agreement between photographer/agency and client. Rights negotiable.

*■**TELE-PRESS ASSOCIATES, INC.**, 321 E. 53rd., New York NY 10022. (212)688-5580. President: Alan Macnow. Project Director: Devin Macnow. PR firm. Uses brochures, annual reports, press releases, AV presentations, consumer and trade magazines. Serves beauty, fashion, jewelry, food, finance, industrial and government clients.

Needs: Works with 3 freelance photographers/month on assignment only.

Specs: Uses 8 × 10 glossy b&w prints; 35mm, 2¼ × 2¼, 4 × 5 or 8 × 10 transparencies. Works with freelance filmmakers in production of 16mm documentary, industrial and educational films.

Making Contact & Terms: Provide résumé, business card and brochure to be kept on file for possible future assignments. Query with résumé of credits or list of stock photo subjects. SASE. Reports in 2 weeks. Pays $100-200/b&w photo; $100-200/color photo; $800-1,500/day; negotiates payment based on client's budget. Buys all rights. Model release and captions required.

Tips: In portfolio or samples, wants to see still life, and fashion and beauty, shown in dramatic lighting. "Send intro letter, do either fashion and beauty or food and jewelry still life."

J WALTER THOMPSON COMPANY, 466 Lexington Ave., New York NY 10017. Prefers not to share information.

WARWICK BAKER & FIORE, 100 Avenue of the Americas, New York NY 10013. Prefers not to share information.

AL WASSERMAN COMPANY, % TMP Worldwide, 1633 Broadway, New York NY 10019. Owner: Al Wasserman. Estab. 1991. Ad and design agency. Types of clients: industrial, finance, business-to-business, real estate and fitness.

Needs: Uses photos for consumer and trade magazines, direct mail, catalogs, posters and newspapers. Subjects include: fitness and sports. Model release required. Captions preferred.
Specs: Uses 8×10 glossy b&w prints; 35mm, 2¼×2¼, 4×5, 8×10 transparencies.
Making Contact & Terms: Query with photocopies of samples. Provide résumé, business card, brochure, flier or tearsheets to be kept on file for possible future assignments. Works on assignment only. Cannot return material. Reports in 1 week. Pays $350-900/b&w photo; $350-900/color photo; $500-1,500/day; and $750-5,000/job. **Pays on acceptance and receipt of invoice**. Credit line sometimes given. Buys one-time rights or all rights.
Tips: Looks for originality. Send nonreturnable samples such as photocopies.

YOUNG & RUBICAM INC., 285 Madison Ave., New York NY 10017. Prefers not to share information.

North Carolina

■**EPLES ASSOCIATES**, 4819 Park Rd., Charlotte NC 28209. (704)522-1220. Vice President: Lamar Gunter. Estab. 1968. Types of clients: industrial and others.
Needs: Works with 1-2 freelance photographers and/or videographers/month. Subjects include: photojournalism. Model/property release required.
Audiovisual Needs: Uses slides and videotape.
Specs: "Specifications depend on situation."
Making Contact & Terms: Works on assignment only. NPI. **Pays on receipt of invoice**. Buys various rights. Credit line sometimes given, "depends on client circumstance."

■**FERN-WOOD DESIGNS & PHOTO MARKETING AGENCY**, P.O. Box 948, Wrightsville Beach NC 28480. (910)256-2897. Fax: (910)256-3299. President: Carol G. Wood. Estab. 1989. Ad agency, PR firm, AV firm. Types of clients: industrial, financial, retail, food. Examples of recent projects: direct mail pieces for Ocean Aire Products, Inc. and Musser Company, and promotional headshots of models for Maultsby Models.
Needs: Works with 30-40 freelancers and 1 videographer/month. Uses photos for billboards, consumer magazines, trade magazines, direct mail, newspapers. Subjects include: people, unique fine art and landscapes. Reviews stock photos. Model/property release required. Captions required, include where, when and what is taking place.
Audiovisual Needs: Uses slides and videotape for creation of training films.
Specs: Uses 3×5 and larger glossy or matte, color or b&w prints; 35mm, 2¼×2¼, 4×5 and 8×10 transparencies. Also uses ¾" to 1" film.
Making Contact & Terms: Interested in receiving work from newer, lesser-known photographers. Query with résumé of credits. Provide business card, brochure, flier or tearsheets to be kept on file for possible future assignments. Submission guidelines furnished with SASE. Keeps samples on file. SASE. Reports in 3 weeks. NPI. Pays on publication. Credit line sometimes given depending on client and usage. Buys one-time rights and negotiates additional rights.
Tips: Pay attention to detail and display an eye for composition.

■**HODGES ASSOCIATES, INC.**, P.O. Box 53805, 912 Hay St., Fayetteville NC 28305. (910)483-8489. Fax: (910)483-7197. Creative Director: Larry Lynn. Estab. 1974. Ad agency. Types of clients: industrial, financial, retail, food. Examples of recent projects: 3 videos for Public Works Commission (community awareness on cable channel); House of Raeford Farms (numerous food packaging/publication ads); The Esab Group, welding equipment (publication ads/collateral material).
Needs: Works with 1-2 freelancers/month. Uses photos for consumer magazines, trade magazines, direct mail, P-O-P displays, catalogs, posters, newspapers, signage, audiovisual uses. Subjects include: food, welding equipment, welding usage, financial, health care, industrial fabric usage, agribusiness products, medical tubing. Reviews stock photos. Model/property release required.
Audiovisual Needs: Uses slides and video. Subjects include: slide shows, charts, videos for every need.
Specs: Uses 4×5, 11×14, 48×96 color and b&w prints; 35mm, 2¼×2¼, 4×5, 8×10 transparencies.
Making Contact & Terms: Interested in receiving work from newer, lesser-known photographers. Submit portfolio for review. Keeps samples on file. SASE. Reports in 1-2 weeks. Pays $100/hour; $800/day. Pays on receipt of invoice. Credit line given depending upon usage PSAs, etc. but not for industrial or consumer ads/collateral. Buys all rights; negotiable.
Tips: Looking for "all subjects and styles." Also, the "ability to shoot on location in adverse conditions (small cramped spaces). For food photography a kitchen is a must, as well as access to food stylist. Usually shoot both color and b&w on assignment. For people shot . . . photographer who works well with talent/models." Seeing "less concern about getting the 'exact' look, as photo can be 'retouched' so easily in Photoshop or on system at printer. Electronic retouching has enabled art director to 'paint'

the image he wants. But by no means does this mean he will accept mediocre photographs."

***HOWARD, MERRELL & PARTNERS ADVERTISING, INC.**, 8521 Six Forks Rd., Raleigh NC 27615. (919)848-2400. Fax: (919)676-1035. Art Buyer/Broadcast Business Supervisor: Jennifer McFarland. Estab. 1976. Member of Affiliated Advertising Agencies International, American Association of Advertising Agencies, American Advertising Federation. Ad agency. Approximate annual billing: $52 million. Number of employees: 59. Types of clients: various.
Needs: Works with 6-10 freelancers/month. Uses photos for consumer and trade magazines, direct mail, catalogs and newspapers. Reviews stock photos. Model/property release required.
Specs: Uses 8×10 glossy b&w prints; 35mm, 2¼×2¼, 4×5, 8×10 transparencies.
Making Contact & Terms: Interested in receiving work from newer, lesser-known photographers. Arrange personal interview to show portfolio. Provide résumé, business card, brochure, flier or tearsheets to be kept on file for possible future assignments. Works on assignment only. Keeps samples on file. SASE. Reports in 3 weeks. NPI; payment individually negotiated. Pays on receipt of invoice. Buys one-time and all rights (1-year or 2-year unlimited use); negotiable.

■IMAGE ASSOCIATES, 4909 Windy Hill Dr., Raleigh NC 27609-4929. (919)876-6400. Fax: (919)876-7064. AV firm. Estab. 1984. Creative Director: John Wigmore. Types of clients: industrial, financial and corporate. Examples of recent projects: "The American Dream," GECAP (multi-image); CTT (multi-image); and Exide Electronics (print).
Needs: Works with 3 freelance photographers/month for audiovisual uses. Interested in reviewing stock photos. Model/property release and captions required.
Audiovisual Needs: Uses photos for multi-image slide presentation and multimedia.
Making Contact & Terms: Interested in receiving work from newer, lesser-known photographers. Provide résumé, business card, brochure, flier or tearsheets to be kept on file for possible future assignments. Works with freelancers on assignment only. Cannot return material. Reports in 1 month. Pays $100 maximum/hour; $800 minimum/day; $50/color photo; $100/stock photo. Pays within 30 days of invoice. Buys all rights; negotiable. Credit line given sometimes; negotiable.
Tips: "We have a greater need to be able to scan photos for multimedia computer programs."

■SMITH ADVERTISING & ASSOCIATES, P.O. Drawer 2187, Fayetteville NC 28302. (910)323-0920. Fax: (910)323-3328. Creative Director: Ron Sloan. Estab. 1974. Ad agency, PR firm. Types of clients: industrial, medical, financial, retail, tourism, resort, real estate. Examples of recent projects: mild side-image, Sarasota Convention & Visitors Bureau, (newspaper/magazine/brochure); collateral-image, NC Ports Authority, (brochure); 401-K sign-ups, BB&T, (posters).
Needs: Works with 0-10 photographers, 0-3 filmmakers, 0-3 videographers/month. Uses photos for billboards, consumer and trade magazines, direct mail, P-O-P displays, catalogs, posters, newspapers, signage, audiovisual. Subjects include: area, specific city, specific landmark. Model release preferred for identifiable people in photos for national publications. Property release preferred. Photo captions preferred.
Audiovisual Needs: Uses slides, film, videotape for slide shows, TVC. Subjects include: archive, early years.
Specs: Uses 5×7 glossy color and b&w prints; 35mm, 2¼×2¼, 4×5 transparencies; ½" VHS film; ½"VHS videotape.
Making Contact & Terms: Interested in receiving work from newer, lesser-known photographers. Provide résumé, business card, brochure, flier or tearsheets to be kept on file for possible future assignments. Samples are kept on file "for limited time." SASE. Reports in 1-2 weeks. NPI; payment negotiable according to client's budget. Pays on publication. Credit lines sometimes given depending on subject and job. Buys all rights; negotiable.

North Dakota

■KRANZLER, KINGSLEY COMMUNICATIONS LTD., P.O. Box 693, Bismarck ND 58502. (701)255-3067. Ad agency. Contact: Art Director. Types of clients: wide variety.
Needs: Works with 1 freelance photographer/month. Uses photos for consumer and trade magazines, direct mail, P-O-P displays, catalogs, posters and newspapers. Subjects include local and regional. Model release required. Captions preferred.
Audiovisual Needs: Uses "general variety" of materials.
Specs: Uses 8×10 glossy b&w/color prints; 35mm, 2¼×2¼ and 4×5 transparencies.
Making Contact & Terms: Interested in receiving work from newer, lesser-known photographers. Query with list of stock photo subjects. Provide résumé, business card, brochure, flier or tearsheets to be kept on file for possible future assignments. Works with freelance photographers on assignment basis only. 90% local freelancers. SASE. Reports in 2 weeks. Pays $50/b&w photo; $50/color photo;

$40/hour; $100/day. Pays on publication. Credit line given. Buys exclusive product and one-time rights; negotiable.
Tips: In reviewing a photographer's portfolio or samples, prefers to see "people—working, playing—various views of each shot, including artistic angles, etc., creative expressions using emotions." Looking for "small clean portfolio; basic skills; no flashy work. We are exclusively using photos in an electronic mode—all photos used are incorporated into our desktop publishing system."

Ohio

■**AD ENTERPRISE ADVERTISING AGENCY,** 6671 Maplewood Dr., Suite 203, Cleveland OH 44124. (216)461-5566. Fax: (216)461-8139. Art Director: Jim McPherson. Estab. 1953. Ad agency and PR firm. Types of clients: industrial, financial, retail and food.
Needs: Works with 1 freelance photographer, 1 filmmaker and 1 videographer/month. Uses photos for consumer and trade magazines, direct mail, P-O-P displays, catalogs and newspapers. Subjects vary to suit job. Reviews stock photos. Model release required with identifiable faces. Captions preferred.
Audiovisual Needs: Uses slides, film and videotape.
Specs: Uses 4×5, 8×10 glossy color/b&w prints; 35mm, 2¼×2¼ and 4×5 transparencies.
Making Contact & Terms: Interested in receiving work from newer, lesser-known photographers. Provide résumé, business card, brochure, flier or tearsheets to be kept on file for possible future assignments. Works with freelancers on assignment only. Keeps samples on file. SASE. Reports in 1-2 weeks. Pays $50-100/hour; $400-1,000/day. Pays after billing client. Credit line sometimes given, depending on agreement. Buys one-time rights and all rights; negotiable.
Tips: Wants to see industrial, pictorial and consumer photos.

■**BARON ADVERTISING, INC.,** 1422 Euclid Ave., Suite 645, Cleveland OH 44115-1901. (216)621-6800. President: Selma Baron. Incorporated 1973. Ad agency. Types of clients: food, industrial, electronics, telecommunications, building products, architectural. In particular, serves various manufacturers of tabletop and food service equipment.
Needs: Uses 20-25 freelance photographers/month. Uses photos for direct mail, catalogs, newspapers, consumer magazines, P-O-P displays, posters, trade magazines, brochures and signage. Subject matter varies. Model/property release required.
Audiovisual Needs: Works with freelance filmmakers for AV presentations.
Making Contact & Terms: Arrange a personal interview to show portfolio. Query with list of stock photo subjects. Provide résumé, business card, brochure, flier or tearsheets to be kept on file for possible future assignments. Works with freelancers on assignment only. Cannot return material. NPI. Payment "depends on the photographer." Pays on completion. Buys all rights.
Tips: Prefers to see "food and equipment" photos in the photographer's samples. "Samples not to be returned."

■**BRIGHT LIGHT PRODUCTIONS,** 602 Main St., Suite 810, Cincinnati OH 45202. (513)721-2574. Fax: (513)721-3329. President: Linda Spalazzi. Film and videotape firm. Types of clients: national, regional and local companies in the governmental, educational, industrial and commercial categories. Examples of productions: Health Power (image piece); Procter & Gamble (quarterly video); and Martiny & Co. (corporate image piece). Produces 16mm and 35mm films and videotape, including Betacam.
Needs: Model/property release required. Captions preferred.
Audiovisual Needs: 16mm and 35mm documentary, industrial, educational and commercial films.
Making Contact & Terms: Interested in receiving work from newer, lesser-known photographers. Provide résumé, flier and brochure to be kept on file for possible future assignments. Call to arrange appointment or query with résumé of credits. Works on assignment only. Pays $100 minimum/day for grip; negotiates payment based on photographer's previous experience/reputation and day rate (10 hours). Pays within 30 days of completion of job. Buys all rights.
Tips: Sample assignments include camera assistant, gaffer or grip. Wants to see sample reels or samples of still work. Looking for sensitivity to subject matter and lighting. "Show a willingness to work hard. Every client wants us to work smarter and provide quality at a good value."

■**ELITE VIDEO, INC.,** P.O. Box 14498, Toledo OH 43614. Fax: (419)867-3639. Director: David Thompson. Types of clients: advertising agencies, audiovisual firms, cable companies, home video distributors, closed circuit television firms, both domestic and international.
Needs: Works with 6-7 freelance photographers/month. Uses photos for audiovisual. Needs glamour, erotic, nude, bikini and humorous videos from snippets to full blown and edited features.
Specs: Needs clear VHS tape for initial samples. "The master should be professional quality."
Making Contact & Terms: Send sample footage via certified mail with a SASE. Keeps samples on file. Reports in 3 weeks. "Don't send a résumé or listing of education. You can either produce this

material, or you can't. If you can, we will call you quickly." Pays 50-67% commission for domestic sales and 50% for international sales. "We offer whatever rights the producer/videographer is willing to sell."

Tips: "This market is exploding. Don't sit on good material. Send it to us. If we return it, it will usually be with suggestions. If we like it, you will get a contract sent out and we will begin to aggressively market you and your work. In addition, we will happily make suggestions to help you improve the saleability of your future work. Be professional."

■FUNK/LUETKE, INC., Dept. PM, 405 Madison Ave., 12th Floor, Toledo OH 43604. (419)241-1244. Fax: (419)241-5210. PR firm. Contact: Janet Gray. Estab. 1985. Types of clients: corporate, industrial, finance, health/hospitals.
Needs: Works with 20 freelance photographers. Uses photos for newspapers, audiovisual, employee newsletter. Subjects include: photojournalism (b&w), hospitals, corporate communications, industrial, location assignments and video newsletters.
Audiovisual Needs: Uses photos and/or film or video for broadcast quality videotape.
Specs: Uses 8×10, b&w prints; 35mm transparencies; BetaCam SP/broadcast quality.
Making Contact & Terms: Provide résumé, business card, brochure, flier or tearsheets to be kept on file for possible future assignments. Works with freelancers on assignment only. Reports in 1-2 weeks. Pays $50-100/hour; $500-1,000/day; $50-1,500/job; $100/color photo; $75/b&w photo. Pays 45 days after receipt of invoice. Model release required or preferred depending on project. Credit line sometimes given depending upon project.
Tips: In samples and queries, wants to see "photojournalism (b&w), ability to cover location assignments, ability to work independently and represent firm professionally, enthusiasm for work, service-oriented, deadline oriented, available on short notice and willing to travel." Sees trend toward "more use of freelancers because of the need to match the right person with the right job." To break in with this firm, "be enthusiastic, eager to work and flexible. Be willing to research the client. Be a part of the assignment. Make suggestions; go beyond the assignment given. Be a partner in the job."

GRISWOLD INC., 101 Prospect Ave. W., Cleveland OH 44115. (216)696-3400. Creative Director: Joe McNeil. Ad agency. Types of clients: Consumer and industrial firms; client list provided upon request.
Needs: Works with freelance photographers on assignment only basis. Uses photographers for billboards, consumer and trade magazines, direct mail, P-O-P displays, brochures, catalogs, posters, newspapers and AV presentations.
Making Contact & Terms: Provide brochure to be kept on file for possible future assignments. Works primarily with local freelancers but occasionally uses others. Arrange interview to show portfolio. NPI. Payment is per day or project; negotiates according to client's budget. Pays on production.

***■INSTRUCTIONAL VIDEO**, P.O. Box 21, Maumee OH 43537. (419)865-7670. Fax: (419)866-3718. Director: Laurence Jankowski. Estab. 1983. Member of Radio-Television News Directors Association. AV firm. Approximate annual billing: $200,000. Number of employees: 3. Types of clients: industrial and food. Examples of recent projects: "Quality Assurance" for Campbell Soup Co. (employee video); "When is Michigan?" for Midland Art Museum (museum display); and "Weathering & Erosion" for Scott Resources (educational video).
Needs: Works with 2 freelance photographers and 2 videographers/month. Uses photos for audiovisual uses and computer animation. Subjects include computer animation.
Audiovisual Needs: Uses film and video for producing educational videotapes for instruction.
Specs: Uses 16mm film and ¾″ videotape.
Making Contact & Terms: Interested in receiving work from newer, lesser-known photographers. Query with résumé of credits. Query with stock photo list. Works on assignment only. Does not keep samples on file. SASE. Reports in 1 month. Pays $1.50-2/second of video. Pays on receipt of invoice. Credit line given. Buys all rights; negotiable.

■THE JAYME ORGANIZATION, One Corporate Exchange, 25825 Science Park Dr., Cleveland OH 44122. (216)831-0110. Fax: (216)464-2308. Contact: Associate Creative Director or Senior Art Director. Estab. 1947. Ad agency. Clients include: industrial, financial, food, pet food and business-to-business. Examples of recent campaigns: Dow Chemical (new business direct mail); Sherwin Williams (new business direct mail); and Hess & Clark (pet food introduction).
Needs: Works with 5-10 freelancers/year. Uses photos for trade magazines, direct mail, P-O-P displays, catalogs and audiovisual uses. Subject matter varies. Reviews stock photos and videotape footage. Model and property release required.
Audiovisual Needs: Uses slides and videotape as needed.
Specs: Uses 8×10 and 16×20 color and b&w prints; also uses 35mm, 2¼×2¼ and 4×5 transparencies. Occasionally uses videotape; formats not specified.

Making Contact & Terms: Submit portfolio for review. Provide résumé, business card, brochure, flier or tearsheets to be kept on file for possible future assignments. Works on assignment only. Keeps samples on file. Cannot return materials. Reports as needed; "we'll only call if interested in using them." NPI; payment determined by project budget. **Pays on receipt of invoice.** Credit lines sometimes given according to "project/client." Most rights negotiable; cases of buying all rights are negotiable, "depending upon client."
Tips: "We need to see a dynamite book."

***■JONES, ANASTASI, BIRCHFIELD ADVERTISING INC.**, 6065 Frantz Rd., Dublin OH 43017. (614)764-1274. Creative Director/VP: Joe Anastasi. Ad agency. Types of clients: telecommunications, hospitals, insurance, colleges, food and restaurants and industrial.
Needs: Works on assignment basis only. Uses photographers for billboards, consumer and trade magazines, brochures, posters, newspapers and AV presentations.
Making Contact & Terms: Arrange interview to show portfolio. NPI. Payment is per hour, per day, and per project; negotiates according to client's budget.

***■LAUERER MARKIN GROUP, INC.**, 1725 Indian Wood Circle, Maumee OH 43537. (419)893-2500. Fax: (419)893-1050. Associate Creative Director: Mike Roberts. Estab. 1971. Ad agency and PR firm. Types of clients: industrial, financial and retail.
Needs: Works with 3-10 freelance photographers, 1 filmmaker and 1 videographer/month. Uses photos for consumer and trade magazines, direct mail, P-O-P displays and newspapers. Subject matter varies. Model/property release required.
Audiovisual Needs: Uses film and videotape for television and corporate videos.
Specs: Uses color and b&w prints; 35mm, 2¼×2¼, 4×5 and 8×10 transparencies; 16mm, 35mm film; and Beta ¾" videotape.
Making Contact & Terms: Interested in receiving work from newer, lesser-known photographers. Provide résumé, business card, brochure, flier or tearsheets to be kept on file for possible future assignments. Works on assignment only. Does not keep samples on file. Cannot return material. Reporting time varies. Pays on receipt of invoice or net 30 days. Buys all rights; negotiable.

■LIGGETT STASHOWER ADVERTISING, INC., 1228 Euclid Ave., Cleveland OH 44115. (216)348-8500. Fax: (216)736-8113. Contact: Kelly McNamara. Estab. 1932. Ad agency. Types of clients: full service agency. Examples of recent projects: Sears Optical, Babcock and Wilcox, and Evenflo.
Needs: Works with 50 freelance photographers, filmmakers and/or videographers/month. Uses photos for billboards, consumer and trade magazines, direct mail, P-O-P displays, catalogs, posters, newspapers, signage and audiovisual. Interested in reviewing stock photos/film or video footage. Model/property release required.
Audiovisual Needs: Uses photos/film/commercials.
Specs: Uses b&w/color prints (size and finish varies); 35mm, 2¼×2¼, 4×5, 8×10, 16mm film; ¼-¾" videotape.
Making Contact & Terms: Interested in receiving work from newer, lesser-known photographers. Send unsolicited photos by mail for consideration. Query with samples. Provide résumé, business card, brochure, flier or tearsheets to be kept on file for possible future assignments. Works with local freelancers only. SASE. Reports in 1-2 weeks. Pays $100/b&w photo; $50-200/hour; $800-2,500/day. Pays within 45 days of acceptance. Credit line sometimes given, depending on usage. Buys one-time, exclusive product, all rights; negotiable.

***LOHRE & ASSOCIATES INC.**, 2330 Victory Pkwy., Suite 701, Cincinnati OH 45206. (513)961-1174. Ad agency. President: Charles R. Lohre. Types of clients: industrial.
Needs: Works with 1 photographer/month. Uses photographers for trade magazines, direct mail, catalogs and prints. Subjects include: machine-industrial themes and various eye-catchers.
Specs: Uses 8×10 glossy b&w and color prints; 4×5 transparencies.
Making Contact & Terms: Query with résumé of credits. Provide résumé, business card, brochure, flier or tearsheets to be kept on file for possible future assignments. Works with local freelancers only. SASE. Reports in 1 week. Pays $60/b&w photo; $250/color photo; $60/hour; $275/day. Pays on publication. Buys all rights.
Tips: Prefers to see eye-catching and thought-provoking images/non-human. Need someone to take 35mm photos on short notice in Cincinnati plants.

■OLSON AND GIBBONS, INC., 1501 Euclid Ave., Suite 518, Cleveland OH 44115-2108. (216)623-1881. Fax: (216)623-1884. Executive Vice-President/Creative Director: Barry Olson. Estab. 1991. Ad agency, PR/marketing firm. Types of clients: industrial, financial, retail and food. Examples of recent projects: Home Federal Savings Bank (newspaper ads, direct mail, P-O-P, collateral); Longo's Pizza Restaurants (newspaper, P-O-P, direct mail, magazine ads); Daewoo Lift Trucks (trade ads, collateral, direct mail); Collins, Rimer & Gordon (collateral); SVO Specialty Products (trade ads and collateral).

Needs: Works with 6 freelancers/month. Uses photos for billboards, trade magazines, consumer newspapers and magazines, direct mail and P-O-P displays. Model/property release required.
Audiovisual Needs: Uses film and videotape.
Specs: Uses color and/or b&w prints; 35mm, 2¼×2¼, 4×5, 8×10 transparencies; 16mm, 35mm film.
Making Contact & Terms: Interested in receiving work from newer, lesser-known photographers. Arrange personal interview to show portfolio. Provide résumé, business card, brochure, flier or tearsheets to be kept on file for possible future assignments. Work with local freelancers on assignment only. Keeps samples on file. SASE. Reports in 1-2 weeks. NPI. Pays on receipt on invoice, payment by client. Credit line not given. Buys one-time or all rights; negotiable.

SMILEY/HANCHULAK, INC., 47 N. Cleveland-Massillon Rd., Akron OH 44333. (216)666-0868. Ad agency. V.P./Associate Creative Director: Dominick Sorrent, Jr. Clients: all types.
Needs: Works with 1-2 photographers/month. Uses freelance photos for consumer and trade magazines, direct mail, P-O-P displays, catalogs, posters and sales promotion. Model release required. Captions preferred.
Specs: Uses 11×14 b&w and color prints, finish depends on job; 35mm or 2¼×2¼ (location) or 4×5 or 8×10 (usually studio) transparencies, depends on job.
Making Contact & Terms: Arrange a personal interview to show portfolio. Query with résumé of credits, list of stock photo subjects or samples. Send unsolicited photos by mail for consideration or submit portfolio for review. Provide résumé, business card, brochure, flier or tearsheets to be kept on file for possible future assignments. If a personal interview cannot be arranged, a letter would be acceptable. Works with freelance photographers on assignment basis only. SASE. Report depends on work schedule. NPI. Pays per day or per job. Buys all rights unless requested otherwise.
Tips: Prefers to see studio product photos. "Jobs vary—we need to see all types with the exception of fashion. We would like to get more contemporary, but photo should still do the job."

WATT, ROOP & CO., 1100 Superior Ave., Cleveland OH 44114. (216)566-7019. Fax: (216)566-0857. Vice President/Manager of Design Operations: Thomas Federico. Estab. 1981. Member of AIGA, PRSA, Press Club of Cleveland, Cleveland Ad Club. PR firm. Approximate annual billing: $3.5 million. Number of employees: 30. Types of clients: industrial, financial, retail and medical. Examples of recent projects: AT&T (magazine insert); City of Cleveland Division of Water (annual report).
Needs: Works with 4 freelance photographers/month. Uses photos for magazines and corporate/capabilities brochures, annual reports, catalogs and posters. Subjects include: corporate. Reviews stock photos. Model/property release required. Captions preferred.
Specs: Uses 35mm, 2¼×2¼, 4×5 transparencies.
Making Contact & Terms: Interested in receiving work from newer, lesser-known photographers. Provide résumé, business card, brochure, flier or tearsheets to be kept on file for possible future assignments. Works with local freelancers on assignment only. Reports "as needed." Pays $100-1,500/b&w photo; $400-2,000/color photo; $50-75/hour; $400-1,500/day. **Pays on receipt of invoice.** Credit line sometimes given. Buys all rights (work-for-hire); one-time rights; negotiable.
Tips: Wants to see "variety, an eye for the unusual. Be professional."

Oregon

■ADFILIATION ADVERTISING, 323 W. 13th, Eugene OR 97401. (503)687-8262. Fax: (503)687-8576. Creative Director: Gary Schubert. Estab. 1976. Ad agency. Types of clients: industrial, food, computer, medical.
Needs: Works with 2 freelance photographers, filmmakers and/or videographers/month. Uses photos for billboards, consumer and trade magazines, P-O-P displays, catalogs and posters. Interested in reviewing stock photos/film or video footage. Model/property release required. Captions preferred.
Audiovisual Needs: Uses slides, film and videotape.
Specs: Uses color and b&w prints and 35mm transparencies.
Making Contact & Terms: Submit portfolio for review. Query with résumé of credits. Query with stock photo list. Provide résumé, business card, brochure, flier or tearsheets to be kept on file for possible future assignments. Works on assignment only. Keeps samples on file. SASE. Reports in 1-2 weeks. NPI; depends on job and location. Pays on receipt of invoice. Credit line sometimes given, depending on project and client. Rights purchased depends on usage; negotiable.

BEAR CREEK DIRECT, P.O. Box 906, Medford OR 97501. (503)776-2121, ext. 3416. Fax: (503)734-2901. Executive Art Director: Barbara Mount. Inhouse ad agency for mail order companies. Types of clients: mail order fruit, food, bakery, floral, gardening and gifts. Examples of recent projects: Harry & David and Jackson & Perkins Co. (catalogs, promotional literature and ads).

Needs: Works with 3 freelance photographers/month. Uses photos for direct mail, catalogs and brochures. Model/property release required for anything with identifiable people or locations.
Specs: Uses 35mm, 120mm and 4×5 transparencies.
Making Contact & Terms: Interested in receiving work from newer, lesser-known photographers. Provide résumé, business card, brochure, flier or tearsheets to be kept on file for possible future assignments. Cannot return material. Reports in 4 weeks. Pays $500-1,500/day; or $150-300/shot. Pays upon use. Buys one-time and all rights; negotiable.
Tips: "I want to see 'perfect' gardens with spectacular color, romantic feeling. Food shots must be warm and friendly—no blemishes or unsightly areas. Be able to provide large quantities of photography to choose from. We are very particular with all of the details of the shots. Look at our catalogs to see the kinds of photography we use."

■**CREATIVE COMPANY**, 3276 Commercial St. SE, Salem OR 97302. (503)363-4433. Fax: (503)363-6817. President/Creative Director: Jennifer L. Morrow. Estab. 1978. Ad agency. Types of clients: food products, health care, tourism, miscellaneous. Examples of recent projects: Supra Products, Oregon Fruit Products and Cherriots.
Needs: Works with 1-2 freelancers/month. Uses photos for direct mail, P-O-P displays, catalogs, posters, audiovisual and sales promotion packages. Model release preferred.
Specs: Uses 5×7 and larger glossy color or b&w prints; 2¼×2¼, 4×5 transparencies.
Making Contact & Terms: Arrange personal interview to show portfolio. Provide résumé, business card, brochure, flier or tearsheets to be kept on file for possible future assignments. Works with local freelancers only. SASE. Reports "when needed." Pays $50-300/b&w photo; $100-400/color photo; $20-75/hour; $400-1,200/day. Pays on publication or "when client pays." Credit line not given. Buys all rights.
Tips: In freelancer's portfolio, looks for "product shots, lighting, creative approach, understanding of sales message and reproduction." Sees trend toward "more special effect photography, manipulation of photos in computers." To break in with this firm, "do good work, be responsive and understand what color separations and printing will do to photos."

WIEDEN & KENNEDY INC., 320 SW Washington, Portland OR 97204. Prefers not to share information.

Pennsylvania

KEENAN-NAGLE ADVERTISING, 1301 S. 12th St., Allentown PA 18103-3814. (610)797-7100. Fax: (215)797-8212. Ad agency. Art Director: Donna Lederach. Types of clients: industrial, retail, finance, health care and high-tech.
Needs: Works with 7-8 freelance photographers/month. Uses photos for billboards, consumer magazines, trade magazines, direct mail, posters, signage and newspapers. Model release required.
Specs: Uses b&w and color prints; 35mm, 2¼×2¼, 4×5 and 8×10 transparencies.
Making Contact & Terms: Query with samples. Provide résumé, business card, brochure, flier or tearsheets to be kept on file for possible future assignments. Does not return unsolicited material. NPI. Pays on receipt of invoice. Credit line sometimes given.

KETCHUM COMMUNICATIONS INC., 6 PPG Place, Pittsburgh PA 15222. Prefers not to share information.

*■**MUDERICK MEDIA**, 101 Earlington Rd., Havertown PA 19083. (610)449-6970. Owner: Michael Muderick. Estab. 1984. Types of clients: industrial and financial.
Needs: Works with 4 photographers and/or videographers/month. Uses photos for audiovisual.
Audiovisual Needs: Uses slides and videotape.
Specs: Uses Betacam/¾" videotape, VHS for demo.
Making Contact & Terms: Provide résumé, business card, brochure, flier or tearsheets to be kept on file for possible future assignments. Works with local freelancers only. Keeps samples on file. Does not report on unsolicited material. NPI; "payment depends on budget." Pays on acceptance or receipt of invoice. Buys all rights; negotiable. Model/property release required. Credit line not given.

> *The code NPI (no payment information given) appears in listings that have not given specific payment amounts.*

ROSEN-COREN AGENCY, 2381 Philmont Ave., Suite 117, Huntingdon PA 19006. (215)938-1017. Fax: (215)938-7634. Office Administrator: Ellen R. Coren. PR firm. Types of clients: industrial, retail, fashion, finance, entertainment.
Needs: Works with 4 freelance photographers/month. Uses photos for PR shots.
Specs: Uses b&w prints.
Making Contact & Terms: "Follow up with phone call." Works with local freelancers only. Reports when in need of service. Pays $35-85/hour for b&w and color photos. Pays when "assignment completed and invoice sent—45 days."

SCEPTER SIGNS INC., (formerly Marketing Partners Inc.), P.O. Box 411, Douglasville PA 19518-0411. (215)286-6020. Ad agency. Art Director: Bruce Becker. Types of clients: industrial, retail, financial.
Needs: Works with 3-5 freelance photographers/month. Uses photos for consumer and trade magazines, P-O-P displays, catalogs and newspapers. Subjects include people and products. Model release required.
Specs: Uses 8×10 glossy prints; 2¼×2¼ and 4×5 transparencies.
Making Contact & Terms: Arrange a personal interview to show portfolio. Send unsolicited photos by mail for consideration. Does not return unsolicited material. Pays $500-2,000/day. Pays on receipt of invoice. Rights negotiable.
Tips: Looks for "creativity, good product, situation, flair. Send samples, contact by phone."

■**STEWART DIGITAL VIDEO**, 525 Mildred Ave., Primos PA 19018. (610)626-6500. Fax: (610)626-2638. Studio and video facility. Director of Sales: David Bowers. Estab. 1970. Types of clients: corporate, commercial, industrial, retail.
Audiovisual Needs: Uses 15-25 freelancers/month for film and videotape productions.
Specs: Reviews film or video of industrial and commercial subjects. Uses various film and videotape (specs).
Making Contact & Terms: Provide résumé, business card, brochure, to be kept on file for possible future assignments. Works with freelancers on assignment basis only. Reports as needed. Pays $250-800/day; also pays "per job as market allows and per client specs." Photo captions preferred.
Tips: "The industry is really exploding with all types of new applications for film/video production." In freelancer's demos, "looks for a broad background with particular attention paid to strong lighting and technical ability." To break in with this firm, "be patient. We work with a lot of freelancers and have to establish a rapport with any new ones that we might be interested in before we will hire them." Also, "get involved on smaller productions as a 'grip' or assistant, learn the basics and meet the players."

■**DUDLEY ZOETROPE PRODUCTIONS**, 19 E Central Ave., Paoli PA 19301. (610)644-4991. Producer: David Speace. Types of clients: corporate.
Needs: Works with 1-2 photographers/month. Uses freelance photographers for slide sets, multi-image productions, films and videotapes. Subject depends on client.
Specs: Uses 35mm transparencies; videotape; 16mm and 35mm film.
Making Contact & Terms: Arrange a personal interview to show portfolio. Provide résumé, business card, self-promotion piece or tearsheets to be kept on file for possible future assignments. Works with freelancers on assignment only. Cannot return material. Reports in 1 week. NPI. Pays per day. **Pays on acceptance.** Credit line sometimes given. Buys all rights.
Tips: "Make your approach straight forward. Don't expect an assignment because someone looked at your portfolio. We are interested in photographers who can shoot for AV. They must be able to shoot from varied angles and present sequences that can tell a story."

Rhode Island

■**MARTIN THOMAS, INC.**, Advertising & Public Relations, One Smith Hill, Providence RI 02903. (401)331-8850. Fax: (401)331-3750. President: Martin K. Pottle. Estab. 1987. Ad agency, PR firm. Types of clients: industrial and business-to-business. Examples of ad campaigns: D&S Plastics International (brochures, PR); Battenfeld of America (ad series); Hysol Adhesives (direct mail).
Needs: Works with 3-5 freelance photographers/month. Uses photos for trade magazines. Subjects include: location shots of equipment in plants and some studio. Model release required.
Audiovisual Needs: Uses videotape for 5-7 minute capabilities or instructional videos.
Specs: Uses 8×10 color and b&w prints; 35mm and 4×5 transparencies.
Making Contact & Terms: Send stock photo list. Provide résumé, business card, brochure, flier or tearsheets to be kept on file for possible future assignments. Send materials on pricing, experience. Works with local freelancers on assignment only. Cannot return material. Pays $1,000/day. Pays 30 days following receipt of invoice. Buys exclusive product rights; negotiable.

Tips: To break in, demonstrate you "can be aggressive, innovative, realistic and can work within our parameters and budgets. Be responsive, be flexible."

South Carolina

■**BROWER, LOWE & HALL ADVERTISING, INC.**, 215 W. Stone Ave., P.O. Box 3357, Greenville SC 29602. (803)242-5350. President: Ed Brower. Estab. 1945. Ad agency. Uses photos for billboards, consumer and trade magazines, direct mail, newspapers, P-O-P displays, radio and TV. Types of clients: consumer and business-to-business.
Needs: Commissions 6 freelancers/year; buys 50 photos/year. Model release required.
Specs: Uses 8 × 10 b&w and color semigloss prints; also videotape.
Making Contact & Terms: Interested in receiving work from newer, lesser-known photographers. Arrange personal interview to show portfolio or query with list of stock photo subjects; will review unsolicited material. SASE. Reports in 2 weeks. NPI. Buys all rights; negotiable.

LESLIE ADVERTISING AGENCY, 874 S. Pleasantburg Dr., Greenville SC 29607. (803)271-8340. Broadcast Producer: Marilyn Neves. Ad agency. Types of clients: industrial, retail, finance, food and resort.
Needs: Works with 1-2 freelance photographers/month. Uses photos for consumer and trade magazines and newspapers. Model release preferred.
Specs: Varied.
Making Contact & Terms: Query with résumé of credits, list of stock photo subjects and samples. Submit portfolio for review "only on request." Provide résumé, business card, brochure, flier or tearsheets to be kept on file for possible future assignments. Occasionally works with freelance photographers on assignment basis only. SASE. Reports ASAP. Pays $150-3,000/b&w photo; $150-3,000/ color photo; $500-3,000/day. **Pays on receipt of invoice.** Buys all rights or one-time rights.
Tips: "We always want to see sensitive lighting and compositional skills, conceptual stengths, a demonstration of technical proficiency and proven performance. Send printed promotional samples for our files. Call or have rep call for appointment with creative coordinator. Ensure that samples are well-presented and that they demonstrate professional skills."

■**SOUTH CAROLINA FILM OFFICE**, P.O. Box 7367, Columbia SC 29202. (803)737-0490. Director: Isabel Hill. Types of clients: motion picture and television producers.
Needs: Works with 8 freelance photographers/month. Uses photos to recruit feature films/TV productions. Subjects include: location photos for feature films, TV projects, and national commercials.
Specs: Uses 3 × 5 color prints; 35mm film.
Making Contact & Terms: Submit portfolio by mail. Provide résumé, business card, self-promotion piece or tearsheets to be kept on file for possible future assignments. Works with local freelancers on assignment only. Does not return unsolicited material. NPI. Pays per yearly contract, upon completion of assignment. Buys all rights.
Tips: "Experience working in the film/video industry is essential. Ability needed to identify and photograph suitable structures or settings to work as a movie location."

South Dakota

*****LAWRENCE & SCHILLER**, 3932 S. Willow Ave., Sioux Falls SD 57106. (605)338-8000. Ad agency. Senior Art Director: Dan Edmonds. Types of clients: industrial, financial, manufacturing, medical.
Needs: Works with 3-4 freelance photographers/month. Uses photographers for consumer and trade magazines, direct mail, P-O-P displays, catalogs, posters and newspapers.
Specs: Uses 8 × 10 b&w prints; 35mm, 2¼ × 2¼ and 4 × 5 transparencies.
Making Contact & Terms: Arrange a personal interview to show portfolio; submit portfolio for review. Provide résumé, business card, brochure, flier or tearsheets to be kept on file for possible future assignments. Works with freelance photographers on assignment basis only. Cannot return material. Reports as needed. Pays $500 maximum/day plus film and processing. **Pays on acceptance.** Buys all rights. Model release required. Captions preferred.
Tips: In reviewing photographer's portfolios wants to see a "good selection of location, model, tabletop/studio examples—heavily emphasizing their forté. The best way for freelancers to begin working with us is to fill a void in an area in which we have either underqualified or overpriced talent—then handle as many details of production as they can. We see a trend in using photography as a unique showcase for products—not just a product (or idea) display."

Tennessee

■**ARNOLD & ASSOCIATES PRODUCTIONS, INC.**, 1204 16th Ave. S., Nashville TN 37212. (615)329-2800. President: John Arnold. Produces TV commercials. Types of clients: Fortune 500. Examples of recent projects: TV spots for "Saladshooter," National Presto Industries; "Nescafe" Nestle; and Safeway.
Needs: Works with 3 freelance photographers, 3 filmmakers and 3 videographers/month. Uses photos for multimedia productions and posters. Subjects include: people, food and interior locations. Reviews stock photos. Model release required. Captions required.
Audiovisual Needs: Uses 35mm transparencies; 35mm film; ¾" VHS demo reels.
Making Contact & Terms: Interested in receiving work from newer, lesser-known photographers. Query with résumé. Works with freelancers on assignment only. Keeps samples on file. SASE. Reports in 1 month. Pays $300-1,200/day. Pays net 20 days. Buys one-time rights.
Tips: "We produce top-quality, award-winning productions working with top professionals able to provide highest quality work." Wants to see dramatic lighting, creative composition and sense of style in photos submitted.

■**K.P. PRODUCTIONS**, 3369 Joslyn St., Memphis TN 38128. (901)726-1928. AV firm. Creative Director: Michael Porter. Estab. 1990. Types of clients: industrial. Examples of recent projects: "Powership," for Federal Express, (training video); Redwing Grain Nozzle, for Redwing Technical Systems, (sales video); and Big Bend Ranch, for Kossman/Klein Advertising, (sales video).
Needs: Occasionally works with freelance filmmaker or videographer. Model/property release required.
Audiovisual Needs: Uses film and videotape.
Specs: Uses 35mm motion picture film and Betacam videotape.
Making Contact & Terms: Arrange personal interview to present demo reels or cassettes. Works on assignment only. Keeps samples on file. SASE. Reports in 1-2 weeks. Pays $350-400/day. **Pays on acceptance or receipt of invoice.** Buys all rights; negotiable. Credit line sometimes given.
Tips: Primarily looks for good composition and a "leading edge look." To break in with this firm, "have a good attitude and work within budget."

■**LAVIDGE AND ASSOCIATES**, 409 Bearden Park Circle, Knoxville TN 37919. (615)584-6121. Fax: (615)584-6756. President: Arthur Lavidge. Estab. 1950. Ad agency. Types of clients: tourism, finance, food, resort, transportation, home furnishing. Examples of projects: Great Smoky Mountains (tourist brochure); Oldsmobile Dealer Association (ad campaign).
Needs: Works with freelancers "when need applies." Subjects include scenics and people. Interested in reviewing stock photos/video footage of people. Model release required. Captions preferred.
Audiovisual Needs: Uses slides and videotape.
Specs: Uses 35mm transparencies; videotape.
Making Contact & Terms: Provide résumé, business card, brochure, flier or tearsheets to be kept on file for possible future assignments. Works with freelancers on assignment only. Cannot return material. Reports in 1-2 weeks. Pays $50 minimum/b&w photo; $90 minimum/color photo; $95 minimum/hour; $490 minimum/day. Pays according to job and client's budget. Pays on publication **or receipt of invoice.** Credit line given sometimes, depending on client. Buys all rights (work-for-hire).

Texas

■**DYKEMAN ASSOCIATES INC.**, 4115 Rawlins, Dallas TX 75219. (214)528-2991. Fax: (214)528-0241. Contact: Alice Dykeman. Estab. 1974. PR and AV firm. Types of clients: industrial, financial, sports, varied.
Needs: Works with 4-5 photographers and/or videographers. Uses photos for publicity, billboards, consumer and trade magazines, direct mail, P-O-P displays, catalogs, posters, newspapers, signage, and audiovisual uses. Subjects include: photojournalism, brochures, PSAs. Reviews stock photos. "We handle model and/or property releases."
Audiovisual Needs: Uses photos for slides and videotape. "We produce and direct video. Just need crew with good equipment and people and ability to do their part."
Specs: Uses 8½×11 and glossy b&w or color prints; ¾" or Beta videotape.
Making Contact & Terms: Arrange personal interview to show portfolio. Provide résumé, business card, brochure, flier or tearsheets to be kept on file for possible future assignments. Works on assignment only. Cannot return material. Pays $800-1,200/day; $250-400/1-2 days. "Currently we work only with photographers who are willing to be part of our trade dollar network. Call if you don't understand this term." Pays 30 days after receipt of invoice. Credit line sometimes given, "maybe for lifestyle publications—especially if photographer helps place." Buys exclusive product rights.

Tips: Reviews portfolios with current needs in mind. "If PSA, we would want to see examples. If for news story, we would need to see photojournalism capabilities. Show portfolio, state pricing, remember that either we or our clients will keep negatives or slide originals."

■EDUCATIONAL VIDEO NETWORK, 1401 19th St., Huntsville TX 77340. (409)295-5767. Fax: (409)294-0233. Chief Executive Officer: George H. Russell. Estab. 1953. AV firm. Types of clients: "We produce for ourselves in the education market."
Needs: Works with 2-3 videographers/month.
Audiovisual Needs: Uses videotape for all projects; slides.
Specs: Uses ½" videotape.
Making Contact & Terms: Query with program proposal. SASE. Reports in 3 weeks. NPI. Pays in royalties or flat fee based on length, amount of post-production work and marketability; royalties paid quarterly. Credit line given. Buys all rights; negotiable.
Tips: In freelancer's demos, looks for "literate, visually accurate, curriculum-oriented video programs that could serve as a class lesson in junior high, high school or college classroom. The switch from slides and filmstrips to video is complete. The schools need good educational material."

***■GK&A ADVERTISING, INC.,** 8200 Brookriver Dr., Suite 510, Dallas TX 75247. (214)634-9486. Fax: (214)634-9490. Production Manager: Kelly Crane. Estab. 1982. Member of AAAA. Ad agency, PR firm. Approximate annual billing: $3 million. Number of employees: 5. Types of clients: financial, retail.
Needs: Works with 1 freelance photographer, 2 filmmakers and 2 videographers/month. Uses photos for billboards, direct mail, P-O-P displays, posters, newspapers, audiovisual uses. Reviews stock photos. Model/property release required. Captions preferred.
Audiovisual Needs: Uses slides, film and video.
Specs: Uses 35mm transparencies; ½" VHS videotape.
Making Contact & Terms: Submit portfolio for review. Works on assignment only. Keeps samples on file. Cannot return material. Reports in 3 weeks. NPI. Pays net 30 days. Credit line not given. Buys all rights.

■HEPWORTH ADVERTISING CO., 3403 McKinney Ave., Dallas TX 75204. (214)220-2415. Fax: (214)220-2416. President: S.W. Hepworth. Estab. 1952. Ad agency. Uses all media except P-O-P displays. Types of clients: industrial, consumer and financial. Examples of recent projects: Houston General Insurance, Holman Boiler, Hillcrest State Bank.
Needs: Uses photos for trade magazines, direct mail, P-O-P displays, newspapers and audiovisual. Model/property release required. Captions required.
Specs: Uses 8×10 glossy color prints, 35mm transparencies.
Making Contact & Terms: Submit portfolio by mail. Works on assignment only. Cannot return material. Reports in 1-2 weeks. Pays $350 minimum/job; negotiates payment based on client's budget and photographer's previous experience/reputation. **Pays on acceptance.** Credit line sometimes given. Buys all rights.
Tips: "For best relations with the supplier, we prefer to seek out a photographer in the area of the job location." Sees trend toward machinery shots. "Contact us by letter or phone."

***■CARL RAGSDALE ASSOC., INC.,** 4725 Stillbrooke, Houston TX 77035. (713)729-6530. President: Carl Ragsdale. Types of clients: industrial and documentary film users.
Needs: Uses photographers for multimedia productions, films, still photography for brochures. Subjects include: industrial subjects—with live sound—interiors and exteriors.
Specs: Uses 35mm, 2¼×2¼, 4×5 transparencies; 16mm, 35mm film.
Making Contact & Terms: Provide résumé to be kept on file for possible future assignments. Works on assignment only. Does not return unsolicited material. Reports as needed. Pays $350-800/day; negotiable. Pays upon delivery of film. Buys all rights.
Tips: "Do not call. We refer to our freelance file of résumés when looking for personnel. Swing from film to video is major change—most companies are now hiring inhouse personnel to operate video equipment. Resurgence of oil industry should improve the overall use of visuals down here." Photographer should have "ability to operate without supervision on location. Send samples of coverage of the same type of assignment for which they are being hired."

***■SANDERS, WINGO, GALVIN & MORTON ADVERTISING,** 4050 Rio Bravo, Suite 230, El Paso TX 79902. (915)533-9583. Creative Director: Kerry Jackson. Ad agency. Uses photos for billboards, consumer and trade magazines, direct mail, foreign media, newspapers, P-O-P displays, radio and TV. Types of clients: retailing and apparel industries. Free client list.
Needs: Works with 5 photographers/year. Model release required.
Specs: Uses b&w photos and color transparencies. Works with freelance filmmakers in production of slide presentations and TV commercials.

Making Contact & Terms: Query with samples, list of stock photo subjects. Send material by mail for consideration. Submit portfolio for review. SASE. Reports in 1 week. Pays $65-500/hour, $600-3,500/day, negotiates pay on photos. Buys all rights.

***TRACY-LOCKE/A DDB NEEDHAM AGENCY**, 200 Crescent Ct., Dallas TX 75201. (214)969-9000. Ad agency. Manager, Art Buying: Susan McGrane. Estab. 1913. Serves diverse client base.
Needs: Works with 50 freelance photographers/month. Uses photographs for consumer and trade magazines, newspapers, outdoor signage, point of purchase, direct mail and collateral. General subject matter according to client needs.
Making Contact & Terms: Mail promotional pieces. Portfolio showings arranged per approval of Art Buying Department. Personal interviews arranged by phone. Works with freelance photographers on assignment only. Pays after receipt of invoice. Rights negotiated per job. Model release required. No credit line given.

■EVANS WYATT ADVERTISING & PUBLIC RELATIONS, 346 Mediterranean Dr., Corpus Christi TX 78418. (512)939-7200. Fax: (512)939-7999. Owner: E. Wyatt. Estab. 1975. Ad agency, PR firm. Types of clients: industrial, financial, healthcare, automotive, educational and retail.
Needs: Works with 3-5 freelance photographers and/or videographers/month. Uses photos for consumer and trade magazines, direct mail, catalogs, posters and newspapers. Subjects include: people and industrial. Reviews stock photos/video footage of any subject matter. Model release required. Captions preferred.
Audiovisual Needs: Uses slide shows and videos.
Specs: Uses 5×7 glossy b&w/color prints; 35mm, 2¼×2¼ transparencies; ½" videotape (for demo or review) VHS format.
Making Contact & Terms: Query with résumé of credits, list of stock photo subjects and samples. Submit portfolio for review. Provide résumé, business card, brochure, flier or tearsheets to be kept on file for possible future assignments. Works on assignment only. Reports in 1 month. Pays $400-1,000/day; $100-500/job; negotiated in advance of assignment. Pays on receipt of invoice. Credit line sometimes given, depending on client's wishes. Buys all rights.
Tips: Resolution and contrast are expected. Wants to see "sharpness, clarity and reproduction possibilities." Also, creative imagery (mood, aspect, view and lighting). Advises freelancers to "do professional work with an eye to marketability. Pure art is used only rarely."

■ZACHRY ASSOCIATES, INC., 709 N. 2nd, Box 1739, Abilene TX 79604. (915)677-1342. Creative Director: Bob Nutt. Types of clients: industrial, institutional, religious service, commercial.
Needs: Works with 2 photographers/month. Uses photos for slide sets, videotapes and print. Subjects include: industrial location, product, model groups, lifestyle. Model release required.
Specs: Uses 5×7, 8×10 b&w prints; 8×10 color prints; 35mm, 2¼×2¼, 4×5 transparencies; VHS videotape.
Making Contact & Terms: Query with samples and stock photo list. Provide résumé, business card, self-promotion piece or tearsheets to be kept on file for possible future assignments. Works with freelancers on assignment only; interested in stock photos/footage. SASE. Reports as requested. NPI; payment negotiable. **Pays on acceptance.** Buys one-time and all rights.

Utah

EVANSGROUP, 110 Social Hall Ave., Salt Lake City UT 84111. (801)364-7452. Ad agency. Art Director: Michael Cullis. Types of clients: industrial, finance.
Needs: Works with 2-3 photographers/month. Uses photos for billboards, consumer and trade magazines, direct mail, P-O-P displays, posters and newspapers. Subject matter includes scenic and people. Model release required; captions preferred.
Specs: Uses color prints and 35mm, 2¼×2¼ and 4×5 transparencies.
Making Contact & Terms: Query with list of stock photo subjects. Submit portfolio for review. Provide résumé, business card, brochure, flier or tearsheets to be kept on file for possible future assignments. Works with freelance photographers on assignment only. SASE. Reports in 1-2 weeks. NPI; payment negotiable. **Pays on receipt of invoice.** Credit live given when possible. Buys one-time rights.

■HARRIS & LOVE, INC., 136 E. S. Temple, Suite 1800, Salt Lake City UT 84111. (801)532-7333. Fax: (801)532-6029. Senior Art Director: Preston Wood. Art Directors: Kathy Leach and Heather Hall. Estab. 1938. Types of clients: industrial, retail, tourism, finance and winter sports.
Needs: Works with 4 freelance photographers—filmmakers—videographers/month. Uses photos for billboards, consumer magazines, trade magazines, newspapers and audiovisual. Needs mostly images

of Utah (travel and winter sports) and people. Interested in reviewing stock photos/film or video footage on people, science, health-care and industrial.

Audiovisual Needs: Contact Creative Director, Bob Wassom, by phone or mail.

Specs: Uses 35mm, 2¼×2¼, 4×5 transparencies.

Making Contact & Terms: Interested in receiving work from newer, lesser-known photographers. Send unsolicited photos by mail for consideration. Submit portfolio for review. Provide résumé, business card, brochure, flier or tearsheets to be kept on file for possible future assignments. Works with freelancers on assignment basis only. NPI. Buys all rights (work-for-hire); rights negotiable. Model and property releases required. Credit line given sometimes, depending on client, outlet or usage.

Tips: In freelancer's portfolio or demos, wants to see "craftsmanship, mood of photography and creativity." Sees trend toward "more abstract" images in advertising. "Most of our photography is a total buy out (work-for-hire). Photographer can only reuse images in his promotional material."

***■PAUL S. KARR PRODUCTIONS, UTAH DIVISION,** 1024 N. 250 East, Orem UT 84057. (801)226-8209. Vice President & Manager: Michael Karr. Types of clients: education, business, industry, TV-spot and theatrical spot advertising. Provides inhouse production services of sound recording, looping, printing and processing, high-speed photo instrumentation as well as production capabilities in 35mm and 16mm.

Needs: Same as Arizona office but additionally interested in motivational human interest material—film stories that would lead people to a better way of life, build better character, improve situations, strengthen families.

Making Contact & Terms: Query with résumé of credits and advise if sample reel is available. NPI. Pays per job, negotiates payment based on client's budget and ability to handle the work. Pays on production. Buys all rights. Model release required.

■SOTER ASSOCIATES INC., 209 N. 400 West, Provo UT 84601. (801)375-6200. Fax: (801)375-6280. Ad agency. President: N. Gregory Soter. Types of clients: industrial, financial, hardware/software and other. Examples of recent projects: boating publications ad campaign for major boat manufacturer; consumer brochures for residential/commercial mortgage loan company; private school brochure; software ads for magazine use; various direct mail campaigns.

Needs: Uses photos for consumer and trade magazines, direct mail and newspapers. Subjects include: product, editorial or stock. Reviews stock photos/videotape. Model/property release required.

Audiovisual Needs: Uses photos for slides and videotape.

Specs: Uses 8×10 b&w prints; 2¼×2¼, 4×5 transparencies; videotape.

Making Contact & Terms: Arrange personal interview to show portfolio. Query with samples. Provide résumé, business card, brochure, flier or tearsheets to be kept on file for possible future assignments. Works on assignment only. Keeps samples on file. SASE. Reports in 1-2 weeks. NPI; payment negotiable. **Pays on receipt of invoice.** Credit line not given. Buys all rights; negotiable.

Virginia

***■AMERICAN AUDIO VIDEO,** 2872 Hartland Rd., Falls Church VA 22043. (703)573-6910. Fax: (703)573-3539. President: John Eltzroth. Estab. 1972. Member of ICIA and MPI. AV firm. Types of clients: industrial and financial.

Needs: Works with 1 freelance photographer and 2 videographers/month. Uses photos for catalogs and audiovisual uses. Subjects include: in-house photos for our catalogs and video shoots for clients. Reviews stock photos.

Audiovisual Needs: Uses slides and videotape.

Specs: Uses 35mm transparencies; ¾″ Beta videotape.

Making Contact & Terms: Interested in receiving work from newer, lesser-known photographers. Arrange personal interview to show portfolio. Send unsolicited photos by mail for consideration. Provide résumé, business card, brochure, flier or tearsheets to be kept on file for possible future assignments. SASE. Reports in 1 month. NPI. **Pays on acceptance and receipt of invoice.** Credit line not given. Buys all rights; negotiable.

■BARKSDALE BALLARD & CO., 8027 Leesburg Pike, #200, Vienna VA 22182. (703)827-8771. Fax: (703)827-0783. Estab. 1987. PR and Special Events firm. Types of clients: food. Examples of recent projects: Virginia Wineries Festival, Virginia Wineries Association (press materials and service); and Congressional Hearings (press service).

Needs: Uses photos for posters, newspapers and audiovisual.

Audiovisual Needs: Uses slides and film.

Making Contact & Terms: Interested in receiving work from newer, lesser-known photographers. Contact through rep. Provide résumé, business card, brochure, flier or tearsheets to be kept on file for possible future assignments. Works with local freelancers only. Keeps samples on file. Reports in 1-2

weeks. NPI; cost depends on job and negotiation with photographer. **Pays on receipt of invoice.** "When possible we credit photos to photographer." Buys all rights; negotiable.
Tips: Photographers should have "good eye for true candid photography and be capable of staging 'natural' shots." Sees growth in "flat, computer-generated/manipulated artwork." Experience with special events a plus.

Washington

MATTHEWS ASSOC. INC., 603 Stewart St., Suite 1018, Seattle WA 98101. (206)340-0680. PR firm. President: Dean Matthews. Types of clients: industrial.
Needs: Works with 0-3 freelance photographers/month. Uses photographers for trade magazines, direct mail, P-O-P displays, catalogs and public relations. Frequently uses architectural photography; other subjects include building products.
Specs: Uses 8×10 b&w and color prints; 35mm, 2¼×2¼ and 4×5 transparencies.
Making Contact & Terms: Arrange a personal interview to show portfolio if local. If not, provide résumé, business card, brochure, flier or tearsheets to be kept on file for possible future assignments. SASE. Works with freelance photographers on assignment only. NPI. Pays per hour, day or job. Pays on receipt of invoice. Buys all rights. Model release preferred.
Tips: Samples preferred depends on client or job needs. "Be good at industrial photography."

West Virginia

■**CAMBRIDGE CAREER PRODUCTS**, 90 MacCorkle Ave., SW, South Charleston WV 25303. (800)468-4227. Fax: (304)744-9351. President: E.T. Gardner, Ph.D. Managing Editor: Amy Pauley. Estab. 1981.
Needs: Works with 2 still photographers and 3 videographers/month. Uses photos for multimedia productions, videotapes and catalog still photography. "We buy b&w prints and color transparencies for use in our 11 catalogs." Reviews stock photos/footage on sports, hi-tech, young people, parenting, general interest topics and other. Model release required.
Specs: Uses 5×7 or 8×10 b&w prints; 35mm, 2¼×2¼, 4×5, and 8×10 transparencies and video-tape.
Making Contact & Terms: Interested in receiving work from newer, lesser-known photographers. Video producers arrange a personal interview to show portfolio. Still photographers submit portfolio by mail. SASE. Reports in 2 weeks. Pays $20-80/b&w photo, $250-850/color photo and $8,000-45,000 per video production. Credit line given. "Color transparencies used for catalog covers and video production, but not for b&w catalog shots." Buys one-time and all rights (work-for-hire); negotiable.
Tips: "Still photographers should call our customer service department and get a copy of *all* our educational catalogs. Review the covers and inside shots, then send us appropriate high-quality material. Video production firms should visit our headquarters with examples of work. For still color photographs we look for high-quality, colorful, eye-catching transparencies. Black & white photographs should be on sports, home economics (cooking, sewing, child rearing, parenting, food, etc.), and guidance (dating, sex, drugs, alcohol, careers, etc.). We have stopped producing educational film-strips and now produce only full-motion video. Always need good b&w or color still photography for catalogs."

Wisconsin

BIRDSALL-VOSS & KLOPPENBURG, INC., 1355 W. Towne Square Rd., Mequon WI 53209. (414)241-4890. Ad agency. Art Director: Scott Krahn. Estab. 1984. Types of clients: travel, health care, financial, industrial and fashion clients such as U.S. Air Vacations, Flyjet Vacations, Robert W. Baird, Covenant HealthCare, Waukesha Memorial Hospital, Care Network Inc., Cousins Subs and Alverno College.
Needs: Uses 5 freelance photographers/month. Uses photos for billboards, consumer magazines, trade magazines, direct mail, catalogs, posters and newspapers. Subjects include: travel and health care. Interested in reviewing stock photos of travel scenes in Carribean, California, Nevada, Mexico and Florida. Model release required.
Specs: Uses 35mm, 2¼×2¼, 4×5, 8×10 transparencies.
Making Contact & Terms: Arrange a personal interview to show portfolio or query with résumé of credits or list of stock photo subjects. Provide résumé, business card, brochure, flier or tearsheets to be kept on file for possible future assignments. Cannot return material. NPI. Pays 30 days on receipt of invoice. Buys all rights.

Tips: Looks for "primarily cover shots for travel brochures; ads selling Florida, the Caribbean, Mexico, California and Nevada destinations."

***■GREINKE, EIERS AND ASSOCIATES**, 2557C N. Terrace Ave., Milwaukee WI 53211-3822. (414)962-9810. Fax: (414)352-3233. CEO: Arthur Greinke. Estab. 1984. Member of Public Relations Society of America, International Association of Business Communicators, Society of Professional Journalists. Ad agency, PR firm and marketing. Types of clients: retail, special events, entertainment. Examples of recent projects: full service jobs for IBM (Milwaukee), Reinhart, Boerner, Van Duren et.al., and Eastside Compact Disc.
Needs: Works with 6-12 freelance photographers, 2 filmmakers, 4-8 videographers/year. Uses photos for billboards, direct mail, P-O-P displays, posters, newspapers, signage, audiovisual. Most photos come from special events. Reviews stock photos of anything related to entertainment/music industry, model photography. Model/property release preferred. Captions preferred; include who, what, where, why, how.
Audiovisual Needs: Uses slides, film, videotape. Subjects include: special events and model work.
Specs: Uses 5×7 or 8×10 color and b&w prints; 2¼×2¼, 4×5 transparencies; 16mm and 35mm film; ½" and ¾" videotape.
Making Contact & Terms: Interested in receiving work from newer, lesser-known photographers. Query with résumé of credits. Query with stock photo list. Query with samples. Provide résumé, business card, brochure, flier or tearsheets to be kept on file for possible future assignments. Keeps samples on file. Cannot return material. "We respond when we need a photographer or a job becomes available for their special skills." NPI. **Pays on acceptance.** Credit line sometimes given depending on client. Buys all rights; negotiable.
Tips: "Search for a specific style or look, and make good use of light and shade."

■NELSON PRODUCTIONS, INC., 1533 N. Jackson St., Milwaukee WI 53202. (414)271-5211. Fax: (414)271-5235. President: David Nelson. Estab. 1968. Produces motion pictures, videotapes, and slide shows. Types of clients: industry, advertising.
Needs: Industrial, graphic art and titles.
Audiovisual Needs: Video stock, slides, computer graphics.
Specs: Uses transparencies, computer originals.
Making Contact & Terms: Interested in receiving work from newer, lesser-known photographers. Query with résumé of credits or send material by mail for consideration. "We're looking for high quality photos with an interesting viewpoint." Pays $250-1,200/day. Buys one-time rights. Model release required. Captions preferred.
Tips: Send only top quality images.

WALDBILLIG & BESTEMAN, INC., 6225 University Ave., Madison WI 53705. (608)238-4767. Creative Director: Tom Senatori. Types of clients: industrial, financial and health care.
Needs: Works with 4-8 freelance photographers/month. Uses photos for consumer and trade magazines, direct mail, P-O-P displays, catalogs, posters, newspapers, brochures and annual reports. Subject matter varies. Model release required. Captions required.
Specs: Uses 8×9 glossy b&w and color prints; 35mm, 2¼×2¼, 4×5 transparencies.
Making Contact & Terms: Provide résumé, business card, brochure, flier or tearsheets to be kept on file for possible future assignments. Works with freelance photographers on assignment basis only. Reports in 2 weeks. Pays $100-200/b&w photo; $200-400/color photo. **Pays on receipt of invoice.** Buys all rights.
Tips: "Send unsolicited samples that do *not* have to be returned. Indicate willingness to do *any* type job. Indicate if you have access to full line of equipment."

Canada

■♣CABER COMMUNICATIONS, 160 Wilkinson Rd., Unit #39, Brampton, Ontario L6T 4Z4 Canada. (905)454-5141. Fax: (905)454-5936. Producer: Chuck Scott. Estab. 1988. AV firm, film and video producer. Types of clients: industrial, financial, retail. Examples of recent projects: Inhaled Steroids, Glaxo Canada (educational); Access Control, Chubb Security (sale promotion).
Needs: Works with 2-3 freelance photographers and 3-5 videographers/month. Uses photos for posters, newsletters, brochures. Model/property release required.
Audiovisual Needs: Uses film or video. "We mainly shoot our own material for our projects."
Specs: 35mm, 2¼×2¼, 4×5 transparencies; videotape (Betacam quality or better).
Making Contact & Terms: Interested in receiving work from newer, lesser-known photographers. Contact through rep. Query with résumé of credits. Provide résumé, business card, brochure, flier or tearsheets to be kept on file for possible future assignments. Works with local freelancers on assignment only. Keeps samples on file. SASE. Reports in 1-2 weeks. Pays $250/3-hour day. **Pays on receipt of**

invoice. Credit line sometimes given depending upon project. Rights vary; negotiable.

■❋**JACK CHISHOLM FILM PRODUCTIONS LTD.**, 99 Atlantic Ave., #50, Toronto, Ontario M6J 3J8 Canada. (416)588-5200. Fax: (416)588-5324. President: Mary Di Tursi. Estab. 1956. Production house and stock shot, film and video library. Types of clients: finance, industrial, government, TV networks and educational TV.
Needs: Supplies stock film and video footage on consignment.
Making Contact & Terms: Works with freelancers on an assignment basis only. Rights negotiable.
Tips: Starting to see more CD-ROM and multimedia applications.

■❋**WARNE MARKETING & COMMUNICATIONS**, 111 Avenue Rd., Suite 810, Toronto, Ontario M5R 3J8 Canada. (416)927-0881. Fax: (416)927-1676. President: Keith Warne. Estab. 1979. Ad agency. Types of clients: business-to-business.
Needs: Works with 5 photographers/month. Uses photos for trade magazines, direct mail, P-O-P displays, catalogs and posters. Subjects include: in-plant photography, studio set-ups and product shots. Special subject needs include in-plant shots for background use. Model release required.
Audiovisual Needs: Uses both videotape and slides for product promotion.
Specs: Uses 8×10 glossy b&w; 4×5 transparencies and color prints.
Making Contact & Terms: Send letter citing related experience plus 2 or 3 samples. Works on assignment only. Cannot return material. Reports in 2 weeks. Pays $1,000-1,500/day. Pays within 30 days. Buys all rights.
Tips: In portfolio/samples, prefers to see industrial subjects and creative styles. "We look for lighting knowledge, composition and imagination." Send letter and 3 samples, and wait for trial assignment.

Advertising, Public Relations and Audiovisual Firms/'95-'96 changes

The following markets appeared in the 1995 edition of *Photographer's Market*, but are not listed this year. The majority did not respond to our request to update their listings. If a reason was given for a market's exclusion it appears in parentheses below.

Advertising in Three-Dimension (out of business)
Alden Group-Public Relations
Authenticated News International
Beber Silverstein & Partners
Michael D. Beckerman & Associates
Bell & Roberts, Inc.
Bennett, Aleon, and Associates (phone disconnected)
Butwin & Associates Advertising, Inc.
Carmichael-Lynch, Inc.
Steven Cohen Motion Picture Production
Data Command Inc.
Discovery Productions (phone disconnected)
Drucilla Handy Co.
Educational Images Ltd.
Electric Paint and Design (no longer needs freelance work)
Epstein & Walker Associates
Everett, Klamp & Bernauer, Inc.
Rich Field Advertising Agency
Foremost Photography
Judy Ganulin Public Relations (uses local photographers)
Gateways Institute

Gordon Gelfond Associates, Inc.
GGH&M Advertising
Goldsholl Design and Film
Group 400 Advertising
Hancock Advertising Agency
HP Communications
HP Direct
Robert Hund Inc.
Koehler Iversen Advertising
Kopf, Zimmermann, Schultheis
Leon Shaffer Golnick Advertising, Inc.
Ronald Levitt Assoc. Inc.
Lippservice
Matthew-Lawrence Advertising & Sales Promotion Inc.
Mediawerks
J.W. Messner, Inc.
Miller Communications, Inc.
Mizerek Advertising
Ruth Morrison Associates
National Television News, Inc. (requested deletion)
Nostradamus Advertising
Omni Productions
Organization Management
Penny & Speier (phone disconnected)

Photec
Photo Communication Services
Prather & Associates Inc. (phone disconnected)
Ted Roggen Advertising and Public Relations
Ross Roy Communications, Inc.
RY & P Moss
Schorr, Howard and Megill
Selz, Seabolt and Associates
Ron Smiley Visual Productions
Ron Tansky Advertising Co.
The Atkins Agency
The Garin Agency
The Market Connection
Thomas & James Advertising
V-graph Inc.
Walker Agency
Waller, Cook & Misamore Advertising & Public Relations
Harold Warner Advertising, Inc.
Weber, Cohn & Riley
Sherry Wheatley Sacino, Inc.
Wolff Associates
World Wide Pictures (requested deletion)
Wunderman Cato Johnson/Chicago
Zelman Studios, Ltd.

Art/Design Studios

Image is everything for corporations in need of design work for annual reports, inhouse publications, catalogs, package design, brochures and other collateral pieces. Company CEOs know that a positive image portrayed to shareholders, employees or clients can stem from the visual appeal of a well-thought out design. Therefore, many companies hire top studios to conceptualize and execute projects.

For photographers this opens doors to a lot of design jobs. But if you intend to work in the design field, it is important to understand how the industry operates. For example, many designers perform tasks, such as buying media space, that used to be in the domain of ad agencies. The practice has created a rivalry for jobs and removed boundary lines between the two industries. It used to be that the two industries worked hand-in-hand with each other on projects.

Trade magazines such as *HOW*, *Print*, *Communication Arts* and *Graphis* are good places to start when learning about design firms. These magazines not only provide information about how designers operate, but they also explain how creatives use photography. You can find these magazines in bookstores or flip to the section Recommended Books & Publications in the back of this book. The section provides addresses for all of these periodicals if you wish to order them.

Concentrate on strengths

For photographers, finding work with studios is much like seeking work with advertising agencies. When preparing your portfolio, concentrate on strengths and find those studios which have an interest in your area of expertise. Photographers who have mastered computer software, such as Adobe Photoshop or programs involving 3-D imaging, also should seriously consider approaching design firms. Studios are quickly adapting these image manipulating programs to their everyday jobs and freelancers can benefit greatly from such computer knowledge.

One photographer who benefited from his computer knowledge is Alan Brown of Cincinnati, Ohio. As our interview subject on page 104, Brown discusses digital imaging and its effect on his business.

ELIE ALIMAN DESIGN, INC., 134 Spring St., New York, NY 10012. (212)925-9621. Fax: (212)925-9621. Creative Director: Elie Aliman. Estab. 1981. Design firm. Specializes in annual reports, publication design, display design, packaging, direct mail. Types of clients: industrial, financial, publishers, nonprofit. Examples of recent projects: First Los Angeles Bank, Equitable Capital Investment and NYU State Business School.
Needs: Works with 4 freelancers/month. Uses photos for annual reports, consumer and trade magazines, direct mail, posters. Model release required. Property release preferred. Photo captions preferred.
Specs: Uses 35mm, 2¼×2¼, 4×5, 8×10 color transparencies.
Making Contact & Terms: Interested in receiving work from newer, lesser-known photographers. Query with résumé of credits. Provide résumé, business card, brochure, flier or tearsheets to be kept on file for possible future assignments. Keeps samples on file. Cannot return material. Reports in 1-2 weeks. NPI. Pays on receipt of invoice. Credit line sometimes given. Buys first rights, one-time rights and all rights; negotiable.
Tips: Looking for "creative, new ways of visualization and conceptualization."

ART ETC., 316 W. 4th St., Cincinnati OH 45202. (513)621-6225. Fax: (513)621-6316. Art Studio. Art Director: Doug Carpenter. Estab. 1971. Specializes in industrial, financial, food and OTC drugs.
Needs: Works with 1-2 freelance photographers/month. Uses photos for consumer and trade magazines, direct mail, P-O-P displays, catalogs and posters. Subjects include: musical instruments, OTC

drugs, pet food, people and skin products. Reviews stock photos. Model/property release required; photo captions preferred.
Specs: Uses 4×5, 8×10 color and b&w prints; 35mm, 2¼×2¼, 4×5, 8×10 transparencies.
Making Contact & Terms: Contact through rep. Arrange personal interview to show portfolio. Query with list of stock photo subjects. Provide résumé, business card, brochure, flier or tearsheets to be kept on file for possible future assignments. Works with local freelancers on assignment only. Keeps samples on file. SASE. Reports in 1-2 weeks. Pays $40-250/hour; $600-2,000/day; $150-3,500/job;$150/color photo; $50/b&w photo. Pays on receipt of invoice. Buys all rights; negotiable. Credit line sometimes given depending upon marketing target.
Tips: Wants to see food, people and product shots.

***BACHMAN DESIGN GROUP**, 6001 Memorial Dr., Dublin OH 43017. (614)793-9993. Fax: (614)793-1607. Principal: Deb Miller. Estab. 1988. Design firm. Specializes in display design, packaging, retail environments. Types of clients: financial, retail. Examples of recent projects: Corestates Financial Corp., Bancohio National Bank and Commonwealth Federal Savings Bank.
Needs: Works with 1 freelancer/month. Uses photos for P-O-P displays, posters. Subjects include: lifestyle, still. Reviews stock photos. Model/property release required. Photo captions preferred.
Specs: Uses color and/or b&w prints; 2¼×2¼, 4×5 transparencies.
Making Contact & Terms: Interested in receiving work from newer, lesser-known photographers. Query with résumé of credits and samples. Provide résumé, business card, brochure, flier or tearsheets to be kept on file for possible future assignments. Works on assignment only. Keeps samples on file. Cannot return material. Reports in 1-2 weeks. NPI. Pays on receipt of invoice. Credit line sometimes given depending on clients' needs/requests. Purchases one-time rights and all rights.

***■AUGUSTUS BARNETT DESIGN & CREATIVE SERVICES**, 632 St. Helens Ave. S., Tacoma WA 98402. (206)627-8508. Fax: (206)593-2116. President: Charlie Barnett. Estab. 1981. Ad agency, design firm. Specializes in industrial, business to business, retail, food and package design. Examples of recent projects: "Flavor of the Great Northwest," Bernstein's Salad Dressing, Light Fantastic (introduction), Tree Top Food Service (product expansion).
Needs: Works with 1-2 freelance photographers/month. Uses photos for consumer and trade magazines, direct mail, P-O-P displays, newspapers and audiovisual. Subjects include: industrial, food-related, product photography. Model release required. Property release preferred for vine art, vintage cars, boats and documents. Captions preferred.
Audiovisual Needs: Reviews stock photos, slides and videotape. Uses "combo of 35mm (either simple or complex up to 15 projectors) plus either ¾″ or ½″ video, large projection system and some other special effects on occasion." Subjects include: "corporate video and slide shows for sales force and brokers."
Specs: Uses 5×7, 8×10, color and b&w glossy prints; 35mm, 2¼×2¼, 4×5 transparencies; VHS ½″ videotape and some ¾″ format, Betacam.
Making Contact & Terms: Call for interview or drop off portfolio. Works on assignment only. Keeps samples on file. SASE. Reports in 1-2 weeks. Pays $90-150/hour; $600-1,500/day; negotiable. **Pays on receipt of invoice**. Credit line sometimes given "if the photography is partially donated for a nonprofit organization." Buys one-time and exclusive product rights; negotiable.
Tips: To break in "make appointment to leave portfolio and references/résumé to meet face-to-face."

BOB BARRY ASSOCIATES, Box H, Newtown Square PA 19073. Phone: (610)353-7333. Fax: (610)356-5759. Contact: Bob Barry. Estab. 1964. Design firm. Specializes in annual reports, publication design, displays, packaging, direct mail, signage, interiors and audiovisual installations. Types of clients: industrial, financial, commercial and government. Examples of recent projects: corporate profile brochure, Zerodec 1 Corporation (text illustration); marketing program, Focht's Inc. (ads, brochures and direct mail); and Mavic Inc. exhibit (large color transparencies in display installations).
Needs: Works with 2-3 freelancers per month. Uses photos for annual reports, consumer and trade magazines, direct mail, P-O-P displays, catalogs, posters, packaging and signage. Subjects include: products, on-site installations, people working. Reviews stock images of related subjects. Model release preferred for individual subjects.

The asterisk before a listing indicates that the market is new in this edition. New markets are often the most receptive to freelance submissions.

Specs: Uses matte b&w and color prints, "very small to cyclorama (mural) size;" 35mm, 2¼×2¼, 4×5, 8×10 transparencies.

Making Contact & Terms: Provide résumé, business card, brochure, flier or tearsheets to be kept on file for possible future assignments. Works on assignment only. Keeps samples on file. SASE. Reports as needed; can be "days to months." Pays $50-150/hour; $600-1200/day; other payment negotiable. Pays on variable basis, according to project. Credit lines sometimes given, depending upon "end use and client guidelines." Buys all rights; negotiable.

Tips: Wants to see "creative use of subjects, color and lighting. Also, simplicity and clarity. Style should not be too arty." Points out that the objective of a photo should be readily identifiable. Sees trend toward more use of photos within the firm and in the design field in general. To break in, photographers should "understand the objective" they're trying to achieve. "Be creative within personal boundaries. Be my eyes and ears and help me to see things I've missed. Be available and prompt."

BERSON, DEAN, STEVENS, 65 Twining Lane, Wood Ranch CA 93065. (805)582-0898. Owner: Lori Berson. Estab. 1981. Design firm. Specializes in annual reports, display design, packaging and direct mail. Types of clients: industrial, financial and retail.
Needs: Works with 1 freelancer/month. Uses photos for billboards, trade magazines, direct mail, P-O-P displays, catalogs, posters, packaging and signage. Subjects include: product shots and food. Reviews stock photos. Model/property release required.
Specs: Uses 8×10 b&w prints; 35mm, 2¼×2¼, 4×5, 8×10 transparencies.
Making Contact & Terms: Interested in receiving work from newer, lesser-known photographers. Provide résumé, business card, brochure, flier or tearsheets to be kept on file for possible future assignments. Works on assignment only. Keeps samples on file. SASE. Reports in 1-2 weeks. NPI. Pays within 30 days after receipt of invoice. Credit line not given. Rights negotiable.

BOB BOEBERITZ DESIGN, 247 Charlotte St., Asheville NC 28801. (704)258-0316. Owner: Bob Boeberitz. Estab. 1984. Graphic design studio. Types of clients: realtors, developers, retail, recording artists, mail-order firms, industrial, restaurants, hotels and book publishers.
Needs: Works with 1 freelance photographer every 2 or 3 months. Uses photos for consumer and trade magazines, direct mail, brochures, catalogs and posters. Subjects include: studio product shots, some location, some stock photos. Model/property release required.
Specs: Uses 8×10 b&w glossy prints; 35mm or 4×5 transparencies.
Making Contact & Terms: Interested in receiving work from newer, lesser-known photographers. Provide résumé, business card, brochure, flier or tearsheets to be kept on file for possible future assignments. Cannot return unsolicited material. Reports "when there is a need." Pays $50-200/b&w photo; $100-500/color photo; $50-100/hour; $350-1,000/day. Pays on per-job basis. Buys one-time and all rights.
Tips: "I usually look for a specific specialty. No photographer is good at everything. I also consider studio space and equipment. Show me something different, unusual, something that sets you apart from any average local photographer. If I'm going out of town for something it has to be for something I can't get done locally."

BRAINWORKS DESIGN GROUP, 2 Harris Court, Suite A-7, Monterey CA 93940. (408)657-0650. Fax: (408)657-0750. President: Al Kahn. Estab. 1986. Design firm. Specializes in publication design and direct mail. Types of clients: education.
Needs: Works with 2 freelancers/month. Uses photographs for direct mail, catalogs and posters. Wants conceptual images. Model release required.
Specs: Uses 35mm, 4×5 transparencies.
Making Contact & Terms: Interested in receiving work from newer, lesser-known photographers. Arrange personal interview to show portfolio. Send unsolicited photos by mail for consideration. Works with freelancers on assignment only. Keeps samples on file. Cannot return material. Reports in 1 month. Pays $500/day; $750/job. Pays on receipt of invoice. Credit line sometimes given, depending on client. Buys first rights, one-time rights and all rights; negotiable.

***CAREW DESIGN,** 200 Gate 5 Rd., Sausalito CA 94965. (415)331-8222. Fax: (415)331-7351. President: Jim Carew. Estab. 1977. Design firm. Specializes in publication design, packaging, direct mail and signage. Types of clients: industrial, publishers.
Needs: Works with 2 freelancers/month. Uses photos for consumer and trade magazines, catalogs and packaging. Reviews stock photos. Model/property release required. Captions preferred.
Specs: Uses 8×10, 11×17 semigloss color and/or b&w prints; 2¼×2¼, 4×5 transparencies.
Making Contact & Terms: Interested in receiving work from newer, lesser-known photographers. Provide résumé, business card, brochure, flier or tearsheets to be kept on file for possible future assignments. Works with local freelancers only. Keeps samples on file. SASE. Responds in 3 weeks. NPI. Credit line sometimes given depending on use. Buys first rights; negotiable.

JANN CHURCH PARTNERS ADVERTISING & GRAPHIC DESIGN, INC., #160, 110 Newport Center Dr., Newport Beach CA 92660. (714)640-6224. Fax: (714)640-1706. President: Jann Church. Estab. 1973. Design firm. Specializes in annual reports, publication design, display design, packaging, direct mail, signage, identity, corporate communications. Types of clients: industrial, financial, retail, publishers, nonprofit, health care, manufacturing, high tech, real estate. Examples of recent projects: annual report for Nichols Institute.
Needs: Works with 2 freelancers/month. Uses photos for annual reports, billboards, consumer magazines, trade magazines, direct mail, P-O-P displays, catalogs, posters, packaging, signage. Reviews stock photos. Model/property release required.
Making Contact & Terms: Interested in receiving work from newer, lesser-known photographers. Provide résumé, business card, brochure, flier or tearsheets to be kept on file for possible future assignments. NPI.

CSOKA/BENATO/FLEURANT, INC., 134 W. 26th St., Room 903, New York NY 10001. (212)242-6777. President: Bob Fleurant. Estab. 1969. Design firm. Specializes in annual reports, packaging and direct mail. Types of clients: industrial, financial and music. Examples of recent projects: "Wonders of Life," Met Life (Epcot Center souvenir); "Power of Music," RCA/BMG (sales kit); and "Booster Cables," Standard Motor Products (package design).
Needs: Uses photos for direct mail, packaging, music packages. Subjects include: still life, holidays, memorabilia, lifestyles and health care. Interested in reviewing stock photos of still life, holidays, memorabilia, lifestyles and health care. Model release required for families, lifestyle, business and health care. Property release preferred.
Specs: Uses 8 × 10 or larger color b&w prints; 35mm, 2¼ × 2¼, 4 × 5, 8 × 10 transparencies.
Making Contact & Terms: Interested in receiving work from newer, lesser-known photographers. Query with stock photo list. Provide résumé, business card, brochure, flier or tearsheets to be kept on file for possible future assignments. "Only select material is kept on file." Works on assignment only. Keeps samples on file. Cannot return material. Reports only when interested. NPI. Pays 30 days from receipt of invoice. Credit line sometimes given depending on client requirements, usage. Rights purchased depend on assignment; negotiable.

***DAVIES & ASSOCIATES, INC.**, 1440 Terrace Dr., Tulsa OK 74104. (918)744-1101. (918)747-0575. President: Jim Davies. Estab. 1984. Member of AIGA, Tulsa Advertising Federation, Art Directors Club of Tulsa. Design firm. Approximate annual billing: $800,000. Number of employees: 7. Specializes in publication design, display design, packaging and direct mail. Types of clients: industrial, financial and retail. Examples of recent projects: Brochure for Price Waterhouse; direct mail for Phillips Petroleum Co.; and package design for Kidquest (children's video sleeve).
Needs: Works with 1-2 freelancers/month. Uses photos for trade magazines, direct mail, P-O-P displays, catalogs, posters and packaging. Reviews oil- and gas-related stock photos. Model release required. Property release preferred.
Specs: Uses 35mm, 2¼ × 2¼ and 4 × 5 transparencies.
Making Contact & Terms: Interested in receiving work from newer, lesser-known photographers. Query with stock photo list. Query with samples. Keeps samples on file. SASE. Reports in 1-2 weeks. NPI; negotiable. **Pays on receipt of invoice.** Credit line sometimes given depending upon negotiation and/or client policies. Buys one-time rights usually, sometimes all rights; negotiable.
Tips: "Our clients are mostly industrial, midwest and conservative. We are always looking for good oil and gas stock."

***DESIGN & MORE**, 1222 Cavell, Highland Park IL 60035. (708)831-4437. Fax: (708)831-4462. Creative Director: Burt Bentkover. Estab. 1989. Design and marketing firm. Approximate annual billing: $300,000. Number of employees: 2. Specializes in annual reports, publication design and food brochures and promotions. Types of clients: industrial and food service.
Needs: Works with 1 freelancer/month. Uses photos for annual reports, trade magazines and sales brochures. Subjects include: abstracts and food. Reviews stock photos of concepts and food. Property release required.
Specs: Uses 4 × 5 and 8 × 10 transparencies.
Making Contact & Terms: Interested in receiving work from newer, lesser-known photographers. Arrange personal interview to show portfolio. Provide résumé, business card, brochure, flier or tearsheets to be kept on file for possible future assignments. Never send originals. Keeps samples on file. Cannot return material. Reports in 1-2 weeks. Pays $800-1,000/day. Pays in 30-45 days. Cannot offer photo credit. For stock, buys one-time rights; original work, all rights; negotiable.

✤DUCK SOUP GRAPHICS, INC., 257 Grandmeadow Crescent, Edmonton, Alberta T6L 1W9 Canada. (403)462-4760. Fax: (403)463-0924. Creative Director: William Doucette. Estab. 1980. Design firm. Specializes in annual reports, publication design, corporate literature/identity, packaging and direct mail. Types of clients: industrial, government, institutional, financial and retail.

Needs: Works with 2-4 freelancers/month. Uses photos for annual reports, billboards, consumer and trade magazines, direct mail, posters and packaging. Subject matter varies. Reviews stock photos. Model release preferred.
Specs: Uses color and b&w prints; 35mm, 4×5, 8×10 transparencies.
Making Contact & Terms: Interested in receiving work from newer, lesser-known photographers. Provide résumé, business card, brochure, flier or tearsheets to be kept on file for possible future assignments. Works on assignment only. Keeps samples on file. SAE and IRC. Reports in 1-2 weeks. Pays $90-130/hour; $600-900/day; $500-6,000/job. **Pays on receipt of invoice.** Credit line sometimes given depending on number of photos in publication. Buys first rights; negotiable.

FRANZ DESIGN GROUP, (formerly Franz-Hatlem Design Group, Inc.), 110 N. 17th St., First Floor, LaCrosse WI 54601. (608)791-1020. Fax: (608)791-1021. Design firm. Creative Director: Alan Franz. Estab. 1990. Specializes in publication design, display design and packaging. Types of clients: industrial, retail. Examples of recent projects: "In Line in Life" video, Rollerblade, Inc. (cover photo for video); Schmidt Loon Search, G. Heileman Brewing Co. (point of purchase display); and Burros Promotional Products (catalog).
Needs: Works with 2 freelance photographers/month. Uses photos for trade magazines, P-O-P displays, catalogs and packaging. Subjects include: models, products and food. Reviews stock photos of studio-food and location-models. Model/property release preferred; usually needs model shots. Captions preferred.
Specs: Uses 2¼×2¼, 4×5 transparencies.
Making Contact & Terms: Provide tearsheets to be kept on file for possible future assignments. Works with freelancers on assignment only. Keeps samples on file. SASE. Reports in 1-2 weeks. Pays $100-3,500/job. **Pays on receipt of invoice.** Credit lines sometimes given depending on the project; "yes, if we can make the decision." Buys all rights; negotiable.
Tips: Interested in "general quality of portfolio and specifically the design and styling of each photo. We like to work with photographers who can suggest solutions to lighting and styling problems—no 'yes' men/women!"

ERIC GLUCKMAN DESIGN OFFICE, 24 E. Parkway, Scarsdale NY 10583. (914)723-0088. Fax: (914)472-9854. Graphic design firm. President: Eric Gluckman. Estab. 1973. Types of clients: industrial, finance and editorial work; antique and collectibles market. Examples of recent projects: Group W Cable (sales presentation book); American Express (employee magazine); and GTE Telenet (sales brochures).
Needs: Works with 2 freelance photographers/month. Uses photos for consumer magazines, trade magazines, direct mail, catalogs, posters and editorial. Subjects include: "now mostly location still life." Model/property release required for models—antiques and collectibles.
Specs: Uses 8×10 color and b&w prints; 35mm, 2¼×2¼, 4×5, 8×10 transparencies.
Making Contact & Terms: Interested in receiving work from newer, lesser-known photographers. Arrange personal interview to show portfolio. Send unsolicited photos by mail for consideration. Query with samples. Provide résumé, business card, brochure, flier or tearsheets to be kept on file for possible future assignments. Works with freelancers on assignment only. Does not return unsolicited material. Reports in 3 weeks. Pays $1,000/day; $1,000/job; page rate—magazine. **Pays on receipt of invoice.** Buys all rights; negotiable, but prefers all rights.
Tips: In portfolio or samples, wants to see "exciting different views of everyday objects (still life). Unfortunately, trends are not creative—still they're economic. There's a much tighter financial squeeze all around." To break in with this firm, "be patient, persevere."

GRAPHIC DESIGN CONCEPTS, 4123 Wade St., Suite 2, Los Angeles CA 90066. (310)306-8143. President: C. Weinstein. Estab. 1980. Design firm. Specializes in annual reports, publication design, display design, packaging, direct mail and signage. Types of clients: industrial, financial retail, publishers and nonprofit. Examples of recent projects: Cosmo Package, Amboy, Inc. (product/package photo); Aircraft Instruments, General Instruments, Inc. (product/package photo); and Retirement Residence, Dove, Inc. (pictorial brochure).
Needs: Works with 10 freelancers/month. Uses photos for annual reports, billboards, consumer and trade magazines, direct mail, P-O-P displays, catalogs, posters, packaging and signage. Subjects include: pictorial, scenic, product and travel. Reviews stock photos of pictorial, product, scenic and

The maple leaf before a listing indicates that the market is Canadian.

travel. Model/property release required for people, places, art. Captions required; include who, what, when, where.

Specs: Uses 8 × 10 glossy, color and b&w prints; 35mm, 2¼ × 2¼, 4 × 5, 8 × 10 transparencies.

Making Contact & Terms: Interested in receiving work from newer, lesser-known photographers. Provide résumé, business card, brochure, flier or tearsheets to be kept on file for possible future assignments. Works with freelancers on assignment only. Keeps samples on file. SASE. Reports as needed. Pays $15 minimum/hour; $100 minimum/day; $100 minimum/job; $50 minimum/color photo; $25 minimum/b&w photo. Pays on receipt of invoice. Credit line sometimes given depending upon usage. Buys rights according to usage.

Tips: In samples, looks for "composition, lighting and styling." Sees trend toward "photos being digitized and manipulated by computer."

HAMMOND DESIGN ASSOCIATES, 79 Amherst St., Milford NH 03055. (603)673-5253. Fax: (603)673-4297. President: Duane Hammond. Estab. 1969. Design firm. Specializes in annual reports, publication design, display design, packaging, direct mail, signage and non-specialized. Types of clients: industrial, financial, publishers and nonprofit. Examples of recent projects: Resonetics Capabilities Brochure, Micro Lasering (product photos, cover and inside); Christmas card, Transnational Travel (front of card); and Lester Lab brochure, Lester Labs (electronics).

Needs: Works with 1 freelancer/month. Uses photos for annual reports, trade magazines, direct mail, catalogs and posters. Subject matter varies. Reviews stock photos. Model release required. Property release preferred. Captions preferred.

Specs: Uses 8 × 10 and 4 × 5 matte or glossy, color and b&w prints; 35mm, 2¼ × 2¼, 4 × 5 transparencies.

Making Contact & Terms: Interested in receiving work from newer, lesser-known photographers. Send unsolicited photos by mail for consideration. Provide résumé, business card, brochure, flier or tearsheets to be kept on file for possible future assignments. Works with freelancers on assignment only. Cannot return unsolicited material. Pays $25-100/hour; $450-1,000/day; $25-2,000/job; $50-100/ color photo; $25-75/b&w photo. Pays on receipt of invoice net 30 days. Credit line sometimes given. Rights negotiable.

Tips: Wants to see creative and atmosphere shots, "turning the mundane into something exciting."

***HEIDEMAN DESIGN**, 9301 Brunson Run, Indianapolis IN 46256. (317)845-4064. Fax: (317)841-0943. Estab. 1986. Member of Art Directors Club of Indiana. Design firm. Number of employees: 2. Specializes in annual reports, publication design, display design, packaging, direct mail and vehicles. Types of clients: industrial, financial and nonprofit. Examples of recent projects: Marburger Foods (sell sheets); Bloomington Transit (vehicle graphics); and Cornish Royal Farms (table tents).

Needs: Works with 2-3 freelancers/year. Uses photos for annual reports, trade magazines, direct mail, P-O-P displays, catalogs, posters, packaging and vehicles. Reviews stock photos. Model/property release required. Captions preferred.

Specs: Uses 5 × 7 and 8 × 10 prints; 35mm, 2¼ × 2¼ and 4 × 5 transparencies.

Making Contact & Terms: Interested in receiving work from newer, lesser-known photographers. Provide résumé, business card, brochure, flier or tearsheets to be kept on file for possible future assignments. Keeps samples on file. SASE. NPI. Pays when payment is received from client. Credit line given.

***DAVID HIRSCH DESIGN GROUP, INC.**, 205 W. Wacker Drive, Chicago IL 60606. (312)329-1500. Art Director: Peter Dugan. Estab. 1976. Design firm. Specializes in annual reports, publication design, direct mail and signage. Types of clients: industrial, financial and nonprofit. Examples of recent projects: employee annual report, Keebler Company; healthy children, Blue Cross/Blue Shield; and annual report, Baker Fentress Management Company.

Needs: Works with a various number of freelancers/month. Uses photos for annual reports and catalogs. Subject matter varies. Model release required; property release preferred. Captions preferred.

Specs: Uses 8 × 10 color/b&w prints; 35mm, 2¼ × 2¼ and 4 × 5 transparencies.

Making Contact & Terms: Interested in receiving work from newer, lesser-known photographers. Send unsolicited photos by mail for consideration. Provide résumé, business card, brochure, flier or tearsheets to be kept on file for possible future assignments. Keeps samples on file. Sometimes returns material. "Reports as soon as we know something." NPI; pays by contract with photographer. **Pays on receipt of invoice.** Credit line not given. Buys all rights; negotiable.

***HULSEY GRAPHICS**, 500 Jesse Jewell Pkwy., Suite 301, Gainesville GA 30501. (404)534-6624. Fax: (404)536-6858. President: Clay Hulsey. Estab. 1989. Design firm. Specializes in annual reports, publication design, packaging, direct mail. Types of clients: industrial, financial, retail.

Needs: Uses photos for annual reports, consumer magazines, trade magazines, direct mail, catalogs, posters, packaging, advertising, newspaper ads. Subject matter varies. Reviews stock photos. Model/ property release required.

Specs: Uses 35mm, 4×5 transparencies.
Making Contact & Terms: Interested in receiving work from newer, lesser-known photographers. Query with résumé of credits. Query with stock photo list. Provide résumé, business card, brochure, flier or tearsheets to be kept on file for possible future assignments. Works with freelancers on assignment. Keeps samples on file. Cannot return material. Reports only if interested. NPI. **Pays on acceptance.** Buys all rights.

***HUTCHINSON ASSOCIATES, INC.**, 1147 W. Ohio St., Apt. 305, Chicago IL 60622-5874. (312)955-9191. Fax: (312)955-9190. Design firm. Contact: Jerry Hutchinson. Estab. 1985. Specializes in annual reports, marketing brochures, etc. Types of clients: industrial, finance, real estate and medical. Examples of recent projects: annual reports (architectural) and capabilities brochures.
Needs: Works with 1 freelance photographer/month. Uses photographs for annual reports, brochures. Subjects include: still life, real estate.
Specs: Uses 4×5, 8×10 color and b&w prints; 35mm, 4×5 transparencies.
Making Contact & Terms: Arrange personal interview to show portfolio. Provide résumé, business card, brochure, flier or tearsheets to be kept on file for possible future assignments. Keeps samples on file. SASE. Reports in 1-2 weeks. NPI; payment rates depend on the client. Pays within 30 days. Buys one-time, exclusive product and all rights (depends); negotiable. Credit line given.
Tips: In samples "quality and composition count." Sees a trend toward "more abstraction."

ELLIOT HUTKIN, 2253 Linnington Ave., Los Angeles CA 90064. (310)475-3224. Fax: (310)446-4855. Art Director: Elliot Hutkin. Estab. 1982. Design firm. Specializes in publication design. Types of clients: industrial, financial, publishers. Examples of previous projects: *Benchmark* for Xerox Corp. (illustration); *Best of Korea* for IDI (illustration, info); and "Take Note!" brochure for Carlsberg Financial (illustration).
Needs: Works with 2-3 freelancers/month. Uses photos for consumer magazines, trade magazines, company magazines, brochures. Subject matter is "eclectic." Reviews stock photos; "eclectic material." Model release required. Property release preferred. Captions preferred; include location, subject (people), equipment shown.
Specs: Uses matte, glossy b&w prints; 35mm, 2¼×2¼, 4×5 transparencies.
Making Contact & Terms: Interested in receiving work from newer, lesser-known photographers. Query with stock photo list. Query with samples. Provide résumé, business card, brochure, flier or tearsheets to be kept on file for possible future assignments. Works on assignment only. Keeps samples on file. SASE. Reports only if assigning work. Pays $250-2,500/job. Pays 30 days after receipt of invoice. Credit line sometimes given (always in magazines; otherwise, depends on client). Rights vary with job/client; negotiable.
Tips: Wants to see an "editorial look; ability to work on the fly with available light, no pro models, very short time frames, and be able to shoot without disturbing ongoing work." Beginning to see more photography work done on computers with four-color separations.

***ICONS**, 76 Elm St., Suite 313, Boston MA 02130. Phone/fax: (617)522-0165. Principal: Glenn Johnson. Estab. 1984. Design firm. Approximate annual billing: $100,000. Number of employees: 2. Specializes in annual reports, publication design, packaging, direct mail and signage. Types of clients: high-tech. Recent clients include: Codex Motorola and Picturetel.
Needs: Works with 1 freelancer/month. Uses photos for annual reports, direct mail and posters. Subjects include: portraits and products. Reviews unusual abstract, non-conventional stock photos. Model/property release preferred for product photography. Captions preferred; include film and exposure information and technique details.
Specs: Uses 8×10 any finish color and b&w prints; 4×5 transparencies.
Making Contact & Terms: Interested in receiving work from newer, lesser-known photographers. Query with samples. Keeps samples on file. SASE. Reports in 1-2 weeks. Pays $1,000-1,500/day; $500-15,000/job. **Pays on receipt of invoice.** Credit line given. Prefers buying all rights, but depends on project; negotiable.

INNOVATIVE DESIGN AND ADVERTISING, 1424 Fourth St., #402, Santa Monica CA 90401. (310)395-4332. Fax: (310)394-9633. Design firm. Partners: Susan Nickey and Kim Crossett. Estab. 1991. Specializes in annual reports, publication design, corporate identity. Types of clients: industrial, financial, retail, nonprofit and corporate. Examples of recent projects: Art/LA '93, Children's Hospital, AQMD, Supercuts, First Interstate, Killer Tracks.
Needs: Works with less than 1 freelance photographer/month. Uses photographs for annual reports, trade magazines, direct mail and brochures. Subjects include: people and studio. Reviews stock photos on a per-assignment basis. Model/property release required for models, any famous works.
Specs: Uses 35mm, 2¼×2¼, 4×5 transparencies.
Making Contact & Terms: Provide résumé, business card, brochure, flier or tearsheets to be kept on file for possible future assignments. Works with freelancers on assignment only. Keeps samples on

file. SASE. Reports in 1 month. "When we receive a job in-house we request photographers." NPI; payment "on a per-job basis as budget allows." Pays within 30 days. Credit lines sometimes given depending on client. "We like to give credit where credit is due!" Rights negotiable.
Tips: "Be punctual and willing to work within our client's budget."

***JENSEN COMMUNICATIONS GROUP, INC.**, 145 Sixth Ave., Penthouse, New York NY 10013. (212)645-3115. Fax: (212)645-6232. Designer: Ken Echevarria. Estab. 1986. Design firm. Specializes in annual reports, publication design, direct mail. Types of clients: Fortune 500. Has done work for Philip Morris, The O'Connor Group and Warner-Lambert Co.
Needs: Works with 4 freelancers/year. Uses photos for annual reports, direct mail, posters. Subjects include: still lifes. Reviews stock photos; subjects are "broad, based on project need."
Specs: Vary based on project needs.
Making Contact & Terms: Interested in receiving work from newer, lesser-known photographers. Submit portfolio for review. Provide résumé, business card, brochure, flier or tearsheets to be kept on file for possible future assignments. Works on assignment only. Keeps samples on file. Cannot return material. Does not report; normally "up to photographer to follow-up." Pays by day rates based on project. Pays within 30 days of receipt of invoice. Credit line given sometimes, depending on project/client and use. Buys one-time rights most frequently.

***BRENT A. JONES DESIGN**, 328 Hayes St., San Francisco CA 94102. Phone: (415)626-8337. Contact: Brent A. Jones. Estab. 1983. Design firm. Specializes in annual reports and publication design. Types of clients: industrial, financial, retail, publishers and nonprofit.
Needs: Works with 1 freelancer/month. Uses photos for annual reports, consumer magazines, catalogs and posters. Reviews stock photos as needed. Model/property release required. Captions preferred.
Specs: Uses color and b&w prints; no format preference. Also uses 35mm, 4×5, 8×10 transparencies.
Making Contact & Terms: Query with résumé of credits. Query with samples. Provide résumé, business card, brochure, flier or tearsheets to be kept on file for possible future assignments. Works with local freelancers only. Keeps samples on file. Cannot return material. Reports in 1 month. NPI; pays on per hour basis. **Pays on receipt of invoice.** Credit line sometimes given. Buys one-time rights; negotiable.

LIEBER BREWSTER CORPORATE DESIGN, 324 W. 87th St., #2F, New York NY 10024. (212)874-2874. Principal: Anna Lieber. Estab. 1988. Design firm. Specializes in corporate communications and marketing promotion. Types of clients: healthcare, financial, publishers and nonprofit.
Needs: Works with freelancers on a per project basis. Uses photos for direct mail, catalogs, brochures, annual report and ads. Subjects include: food and wine, people, location, still life and corporate.
Specs: Uses 8×10 b&w prints; 35mm, 2¼×2¼, 4×5, 8×10 transparencies.
Making Contact & Terms: Interested in receiving work from newer, lesser-known photographers. Provide résumé, business card, brochure, flier or tearsheets to be kept on file for possible future assignments. Works with freelancers on assignment only. Keeps samples on file. SASE. Reports only on solicited work. Pays $75-150/hour; $250-700/day; $500-2,000/job. **Pays on acceptance or receipt of invoice.** Credit line given. Rights negotiable.
Tips: Wants to see an "extremely professional presentation, well-defined style and versatility. Send professional mailers with actual work for clients, as well as creative personal work."

McGUIRE ASSOCIATES, 1234 Sherman Ave., Evanston IL 60202. (708)328-4433. Fax: (708)328-4425. Owner: James McGuire. Estab. 1979. Design firm. Specializes in annual reports, publication design, direct mail, corporate materials. Types of clients: industrial, retail, nonprofit.
Needs: Uses photos for annual reports, consumer magazines, trade magazines, direct mail, catalogs, brochures. Reviews stock photos. Model release required.
Specs: Uses color, b&w prints; 35mm, 2¼×2¼, 4×5, 8×10 transparencies.
Making Contact & Terms: Interested in receiving work from newer, lesser-known photographers. Provide résumé, business card, brochure, flier or tearsheets to be kept on file for possible future assignments. Works on assignment only. Keeps samples on file. Cannot return material. Pays $600-1,800/day. Pays on receipt of invoice. Credit line sometimes given depending upon client or project. Buys all rights; negotiable.

***MASI GRAPHICA LTD.**, 4244 N. Bell, Chicago IL 60618. (312)478-6337. Fax: (312)478-6973. Designer: Eric or Kevin Masi. Estab. 1989. Design firm. Approximate annual billing: $200,000-300,000. Number of employees: 2. Specializes in publication design and direct mail. Types of clients: industrial, retail and publishers. Recent clients include: Budget, Sears and Mac Medical.
Needs: Works with 1-2 freelancers/month. Uses photos for direct mail, catalogs, posters and corporate collateral. Reviews stock photos. Model/property release preferred. Captions preferred.

INSIDER REPORT

Complex Role Suits "Illusographer" Just Fine

Alan Brown

When you enter Alan Brown's studio, Photonics, you begin to suspect that he's no longer a photographer. The decor is more like that of a design firm or a fine artist. This is true whether you're viewing the multi-colored, paint-splattered console TV that serves as a conference room end table or the wooden reception desk that looks like an old 35mm Leica fused with a pipe organ. To confuse you even more is a computer room filled with Macintosh systems and numerous image manipulating software, including Adobe Photoshop, Adobe Illustrator and several 3-D imaging programs. The only obvious signs of this Cincinnatian's photographic roots are the dozens of antique cameras that line office shelves throughout the studio.

In fact, Brown no longer considers himself a photographer. Instead, he prefers the term "illusographer," a word he devised to explain his complex role on clients' projects. The title calls for him to serve as photographer, illustrator and facilitator.

One common thread to his numerous tasks is that computers have become an integral part of his business. He has a staff of eight, including two photographers, two computer illustrators, a sales rep, one multimedia specialist, an office manager and himself. His clients include various book publishers, design studios, advertising agencies, corporations and non-profit organizations.

A fine art/commercial photographer for more than 15 years, Brown knows that many photographers are fighting the digital revolution. That's something he advises against. "The reality of it is that if I'm not interested in computer technology I might as well close my doors. In the next five or ten years, whether we like it or not as image creators, the process of image creation is going to change," says Brown.

He believes it is imperative for commercial photographers to embrace the changing technology if they plan to stay in the mainstream. "We have a choice. We can either become suppliers of parts or we can control the whole process." To emphasize his point, Brown takes a strong stance against stock clip art discs that allow clients to endlessly use images. These discs give clients the ability to use inexpensive "photographic parts" to create new images.

He and his clients have gone through learning curves to understand the capabilities of the equipment. Brown estimates that it wasn't until 1993 when he noticed a change in clients' attitudes. "They were more accepting that this was a viable means of producing visuals," he says.

Although Brown is an advocate of new technology, this is not to say he has adopted a digital camera for his everyday work. In fact, most of his images are still produced on film in his 3,100 square foot studio. Brown says he experimented with digital cameras, but he felt the high cost of equipment and image storage made digital cameras impractical.

He encourages other photographers to jump feet first into the new technology. Study the various types of hardware and software that exist, and expect a large learning curve to master computer programs. Also, don't be afraid to experiment. "There's a tendency among a lot of photographers who feel that the only way you can use a visual tool is to make images look like photographs. . . . They say, 'I'm a photographer and what I give the client must look like a photograph.' I don't buy into that," he says.

Photographers who feel final images must look like photos "have already decided that they aren't going to explore." And, therefore, they are limiting their creative vision. Brown says the beauty of digital manipulation is being able to experiment with "what ifs." He can flop or combine images, fiddle with color combinations and morphing effects, and if he doesn't like the changes he can always start again.

Afterall, what's most important to Brown is the client. "In the end, all we care about is that we have created striking images that solve our clients' problems," says Brown.

—*Michael Willins*

This poster, created for the Cincinnati Ballet, epitomizes the evolving style of Alan Brown. Even though he photographed the ballerina's leg, he says his role on the project was as a "facilitator." He pulled in out-of-house designer Paul Neff and worked with in-house staffers Angie Zawatsky and Erik Von Fischer to digitally create various effects, such as rippling water and the swan's reflection.

© Photonics Graphics

Specs: Uses 4×5 and 8×10 transparencies.
Making Contact & Terms: Interested in receiving work from newer, lesser-known photographers. Query with samples. Provide résumé, business card, brochure, flier or tearsheets to be kept on file for possible future assignments. Works on assignment only. Keeps samples on file. Cannot return material. Reports generally in 1 month. Pays $1,000-1,800/day. Pays on receipt of invoice. Credit line sometimes given. Buys one-time rights; negotiable.
Tips: Wants to see conceptual content in the photographer's work. "Style can be just about anything. We're looking for a mind behind the lens."

***MAUCK & ASSOCIATES**, 303 Locust, Suite 200, Des Moines IA 50309. (515)243-6010. Fax: (515)243-6011. President: Kent Mauck. Estab. 1986. Design firm. Specializes in annual reports and publication design. Types of clients: industrial, financial, retail, publishers and nonprofit. Examples of recent projects: Meredith Corporation, annual report; Blue Cross Blue Shield, annual report; and Allied Group Insurance, annual report.
Needs: Works with 3 freelancers/month. Uses photos for annual reports, billboards, consumer and trade magazines and posters. Subject matter varies. Reviews stock photos. Model release required.
Specs: Uses 35mm, 2¼×2¼, 4×5 transparencies.
Making Contact & Terms: Interested in receiving work from newer, lesser-known photographers. Arrange personal interview to show portfolio. Query with stock photo list. Query with samples. Provide résumé, business card, brochure, flier or tearsheets to be kept on file for possible future assignments. Keeps samples on file. SASE. Reports only when interested. Pays $700-900/day. **Pays on receipt of invoice.** Credit line given. Rights negotiable.

MITCHELL STUDIOS DESIGN CONSULTANTS, 1111 Fordham Lane, Woodmere NY 11598. (516)374-5620. Fax: (516)374-6915. Principal: Steven E. Mitchell. Estab. 1922. Design firm. Types of clients: corporations with consumer products. Examples of recent clients: Lipton Cup-A-Soup, Thomas J. Lipton, Inc.; Colgate Toothpaste, Colgate Palmolive Co.; and Chef Boy-Ar-Dee, American Home Foods—all three involved package design.
Needs: Works with variable number of freelancers/month. Uses photographs for direct mail, P-O-P displays, catalogs, posters, signage and package design. Subjects include: still life/product. Reviews stock photos of still life/people. Model release required. Property release preferred. Captions preferred.
Specs: Uses all sizes and finishes of color and b&w prints; 35mm, 2¼×2¼, 4×5, 8×10 transparencies.
Making Contact & Terms: Interested in receiving work from newer, lesser-known photographers. Submit portfolio for review. Provide résumé, business card, brochure, flier or tearsheets to be kept on file for possible future assignments. Cannot return material. Reports as needed. Pays $35-75/hour; $350-1,500/day; $500 and up/job. Pays on receipt of invoice. Credit line sometimes given depending on client approval. Buys all rights.
Tips: In portfolio, looks for "ability to complete assignment." Sees a trend toward "tighter budgets." To break in with this firm, keep in touch regularly.

***MORRIS BEECHER LORD**, 1000 Potomac St. NW, Washington DC 20007. (202)337-5300. Fax: (202)333-2659. Contact: Diane Beecher. Estab. 1983. Ad agency. Specializes in publications, P-O-P, display design, direct mail, signage, collateral, ads and billboards. Types of clients: sports, health and nutrition, the environment, real estate, resorts, shopping centers and retail.
Needs: Works with 3-4 freelancers/month. Uses photos for billboards, direct mail, posters, signage, ads and collateral materials. Subjects include real estate, fashion and lifestyle. Reviews stock photos. Model release required. Captions preferred.
Specs: Uses any size or finish of color and b&w prints; 35mm transparencies.
Making Contact & Terms: Arrange personal interview to show portfolio. Provide business card, brochure, flier or tearsheets to be kept on file for possible future assignments. Works on assignment only. Keeps samples on file. SASE. Usually pays per job. Credit line not given. Buys all rights.
Tips: Wants to see "very high quality work." Uses a lot of stock.

***■LOUIS NELSON ASSOCIATES INC.**, 80 University Place, New York NY 10003. (212)620-9191. Fax: (212)620-9194. Design firm. Estab. 1980. Types of clients: corporate, retail, not-for-profit and government agencies.
Needs: Works with 3-4 freelance photographers/year. Uses photographs for consumer and trade magazines, catalogs and posters. Reviews stock photos only with a specific project in mind.
Audiovisual Needs: Occasionally needs visuals for interactive displays as part of exhibits.
Making Contact & Terms: Submit portfolio for review. Provide résumé, business card, brochure, flier or tearsheets to be kept on file for possible future assignments. Works on assignment only. Cannot return material. Does not report; call for response. NPI. Pays on receipt of invoice. Credit line sometimes given depending upon client needs.

Tips: In portfolio, wants to see "the usual . . . skill, sense of aesthetics that doesn't take over and ability to work with art director's concept." One trend is that "interactive videos are always being requested."

■**TOM NICHOLSON ASSOCIATES INC.**, 295 Lafayette St., 8th Floor, New York NY 10012. (212)274-0470. Fax: (212)274-0380. President: Tom Nicholson. Estab. 1987. Design firm. Specializes in interactive multimedia. Types of clients: industrial and publishers. Examples of recent projects: "History of Sailing," IBM (interactive multimedia); "Worldview," (educational, physical sciences CD-ROM), and "Shopper's Express," Whittle Communications (interactive multimedia).
Needs: Works with 0-3 freelancers/month. Uses photos for CD-ROM multimedia. Subjects include: nature and sciences. Reviews stock photos of nature and sciences.
Specs: Uses various formats.
Making Contact & Terms: Interested in receiving work from newer, lesser-known photographers. Query with stock photo list. Provide résumé, business card, brochure, flier or tearsheets to be kept on file for possible future assignments. Cannot return material. NPI. Pays on publication. Credit line given. Buys one-time, exclusive product and all rights; negotiable.
Tips: "The industry is moving toward electronic usage. Need realistic pricing to address this market."

*****NOVUS VISUAL COMMUNICATIONS, INC.**, 18 W. 27th St., New York NY 10001-6904. (212)689-2424. Fax: (212)696-9676. President: Robert Antonik. Estab. 1988. Creative marketing and communications firm. Specializes in advertising, annual reports, publication design, packaging, direct mail and signage. Types of clients: industrial, financial, retail, publishers and nonprofit.
Needs: Uses photos for annual reports, billboards, consumer and trade magazines, direct mail, P-O-P displays, catalogs, posters, packaging and signage. Model/property release preferred. Captions preferred.
Specs: Uses color and b&w prints; 35mm, 2¼×2¼, 4×5, 8×10 transparencies.
Making Contact & Terms: Interested in receiving work from newer, lesser-known photographers. Arrange personal interview to show portfolio. Submit portfolio for review. Works on assignment only. Keeps samples on file. SASE. Reports in 1-2 weeks. NPI. Pays upon client's payment. Credit line sometimes given, depending upon client. Buys first rights; negotiable.

*****O'MARA DESIGN GROUP, INC.**, 1551 16th St., Unit D, Santa Monica CA 90404. (310)315-0460. Fax: (310)315-0459. Contact: Dan O'Mara or Wil Conerly. Estab. 1983. Design firm. Specializes in annual reports, publication design and direct mail. Types of clients: industrial and financial.
Needs: Works with 2-3 freelancers/month. Uses photos for annual reports and catalogs. Reviews stock photos. Model release required.
Specs: Uses 35mm, 2¼×2¼, 4×5 transparencies.
Making Contact & Terms: Interested in receiving work from newer, lesser-known photographers. Send unsolicited photos by mail for consideration. Provide résumé, business card, brochure, flier or tearsheets to be kept on file for possible future assignments. Works with local freelancers only. Keeps samples on file. Cannot return material. Reports in 3-4 weeks. Pays $500-1,000/day. **Pays on acceptance.** Credit line sometimes given. Buys all rights.
Tips: Looks for "good working attitude, no prima donnas."

THE PHOTO LIBRARY, INC., (formerly Canetti Design Group The Photo Library), P.O. Box 606, Chappaqua NY 10514. (914)238-1076. Fax: (914)238-3177. Vice President: M. Berger. Estab. 1982. Member of ISDA, NCA, ASI. Photography. Specializes in publication design, display design, packaging, direct mail and product design. Types of clients: industrial, retail. Examples of recent projects: design of new pager for Infomobile; self-promotion catalog for Canetti Design Group.
Needs: Works with 1-2 freelancers/month. Uses photos for annual reports, trade magazines and catalogs. Model/property release required. Captions required.
Making Contact & Terms: Interested in receiving work from newer, lesser-known photographers. Provide résumé, business card, brochure, flier or tearsheets to be kept on file for possible future assignments. Works with local freelancers only. NPI. Buys all rights.

*****PIKE AND CASSELS, INC.**, 300 S. Liberty St., Suite 100, Winston-Salem NC 27101. (910)723-9219. Fax: (919)723-9249. Art Director: Keith Vest. Estab. 1985. Design and advertising firm. Specializes in

 The solid, black square before a listing indicates that the market uses various types of audiovisual materials, such as slides, film or videotape.

publication design, display design, packaging, graphic standards and fashion. Types of clients: industrial, financial, retail and nonprofit.

Needs: Works with 1 freelancer/month. Uses photos for consumer and trade magazines, direct mail, P-O-P displays, catalogs, posters and packaging. Subjects include: tabletop-food and product. Model release preferred. Property release required. Captions preferred; include technique.

Specs: Uses color 35mm, 2¼×2¼, 4×5 transparencies.

Making Contact & Terms: Interested in receiving work from newer, lesser-known photographers. Provide résumé, business card, brochure, flier or tearsheets to be kept on file for possible future assignments. Works with freelancers on assignment only. Keeps samples on file. SASE. Reports in 1 month. NPI. **Pays on receipt of invoice.** Credit line not given. Buys all rights; negotiable.

Tips: Wants to see "flexibility in subjects and technique, fashion photography, processing control and organization of shoots."

***RICHARD PUDER DESIGN**, 2 W. Blackwell St., P.O. Box 1520, Dover NJ 07801. (201)361-1310. Fax: (201)361-1663. Assistant Designer: Suzanne Kersten. Estab. 1985. Member of Type Directors Club. Design firm. Approximate annual billing: $200,000. Number of employees: 2. Specializes in annual reports, publication design, packaging and direct mail. Types of clients: publishers, nonprofit, communication companies. Examples of recent projects: AT&T (cover head shots); and Prentice Hall (desk shots).

Needs: Works with 1 freelancer/month. Uses photos for annual reports, trade magazines, direct mail, posters and packaging. Subjects include: corporate situations and executive portraits. Reviews stock photos. Model/property release preferred.

Specs: Uses 8×10 glossy color and b&w prints; 2¼×2¼, 4×5 transparencies.

Making Contact & Terms: Interested in receiving work from newer, lesser-known photographers. Send unsolicited photos by mail for consideration. Provide résumé, business card, brochure, flier or tearsheets to be kept on file for possible future assignments. Works on assignment only. Keeps samples on file. Cannot return material. "We reply on an as needed basis." Pays $500-1,200/day. Pays on receipt of invoice. Credit line sometimes given depending upon client needs and space availability. Buys first rights; negotiable.

MIKE QUON DESIGN OFFICE, INC., 568 Broadway, #703, New York NY 10012. (212)226-6024. Fax: (212)219-0331. President: Mike Quon. Estab. 1982. Design firm. Specializes in packaging, direct mail, signage, illustration. Types of clients: industrial, financial, retail, publishers, nonprofit.

Needs: Works with 1-3 freelancers/month. Uses photos for direct mail, P-O-P displays, packaging, signage. Model/property release preferred. Captions required; include company name.

Specs: Uses color, b&w prints; 2¼×2¼, 4×5 transparencies.

Making Contact & Terms: Interested in receiving work from newer, lesser-known photographers. Submit portfolio for review. Send unsolicited photos by mail for consideration. Works on assignment only. Keeps samples on file. Cannot return material. Reports only when interested. Pays $1,000-3,000/day. Pays net 30 days. Credit line given when possible. Buys first rights, one-time rights; negotiable.

PATRICK REDMOND DESIGN, P.O. Box 75430-PM, St. Paul MN 55175-0430. (612)646-4254. Designer/Owner/President: Patrick Michael Redmond, M.A. Estab. 1966. Design firm. Specializes in publication design, book covers, books, packaging, direct mail, posters, logos, trademarks, annual reports. Number of employees: 1. Types of clients: publishers, financial, retail, advertising, marketing, education, nonprofit; arts; industrial. Examples of recent projects: numerous book designs, ads, catalogs for Dos Tejedoras Fiber Arts Publications (fiber arts weaving; knitting; textiles); advertising, Hauser Artists (brochures and posters); numerous book cover designs for Mid-List Press (fiction, poetry, nonfiction); Midwest College Placement Association, '95 Conference (graphic image development).

 • Books designed by Patrick Redmond Design won awards from Midwest Independent Publishers Association, Midwest Book Achievement, Publishers Marketing Association and the Benjamin Franklin Awards.

Needs: Uses photos for books and book covers, direct mail, P-O-P displays, catalogs, posters, packaging, annual reports. Subject varies with client—may be editorial, product, how-to, etc. May need custom b&w photos of authors (for books/covers designed by PRD). "Poetry book covers provide unique opportunities for unusual images (but typically have miniscule budgets)." Reviews stock photos; subject matter varies with need—like to be aware of resources. Model/property release required; varies with assignment/project. Captions required; include correct spelling and identification of all factual matters, re: images; i.e., names, locations, etc.—to be used optionally—if needed.

Specs: Uses 5×7, 8×10 glossy prints; 35mm, 2¼×2¼, 4×5 transparencies.

Making Contact & Terms: Interested in receiving work from newer, lesser-known photographers, as well as leading, established talent. "Non-returnable—no obligation." Contact through rep. Arrange personal interview to show portfolio. Query with résumé of credits. Query with stock photo list. Provide résumé, business card, brochure, flier, or tearsheets to be kept on file for possible future assignments. "Patrick Redmond Design will not reply unless specific photographer may be needed for respective

project." Works with local freelancers on assignment only. Keeps samples on file. Cannot return material. NPI. "Client typically pays photographer directly even though PRD may be involved in photo/photographer selection and photo direction." Payment depends on client. Credit line sometimes given depending upon publication style/individual projects. Rights purchased vary with project; negotiable.

Tips: Needs are "open—vary with project . . . location work; studio; table-top; product; portraits; travel; etc." Seeing "use of existing stock images when image/price are right for project and use of b&w how-to photos in low-to-mid budget/price books."

ARNOLD SAKS ASSOCIATES, 350 E. 81st St., New York NY 10028. (212)861-4300. Fax: (212)535-2590. Photo Librarian: Martha Magnuson. Estab. 1968. Member of AIGA. Graphic design firm. Number of employees: 15. Types of clients: industrial, financial, legal, pharmaceutical and utilities. Clients include: 3M, Siemens, Alcoa, Goldman Sachs and MCI.
● This firm conducts many stock photo searches using computer networks. They also scan images onto CD-ROM.

Needs: Works with approximately 15 photographers during busy season. Uses photos for annual reports and corporate brochures. Subjects include: corporate situations and portraits. Reviews stock photos; subjects vary according to the nature of the annual report. Model release required. Captions preferred.

Specs: Uses b&w prints; 35mm, 2¼×2¼, 4×5, 8×10 transparencies.

Making Contact & Terms: Interested in receiving work from newer, lesser-known photographers. "Appointments are set up during the spring for summer review on a first-come only basis. We have a limit of approximately 30 portfolios each season." Call Martha Magnuson to arrange an appointment. Works on assignment only. Reports as needed. Payment negotiable, "based on project budgets. Generally we pay $1,250-2,250/day." Pays on receipt of invoice and payment by client; advances provided. Credit line sometimes given depending upon client specifications. Buys one-time and all rights; negotiable.

Tips: "Ideally a photographer should show a corporate book indicating his success with difficult working conditions and establishing an attractive and vital final product." This "company is well known in the design community for doing classic graphic design. We look for solid, conservative, straightforward corporate photography that will enhance these ideals."

JACK SCHECTERSON ASSOCIATES, 5316 251 Place, Little Neck NY 11362. (718)225-3536. Fax: (718)423-3478. Principal: Jack Schecterson. Estab. 1962. Design firm. Specializes in product, packaging and graphic design. Types of clients: industrial, consumer product manufacturers.

Needs: "Depends on work in-house." Uses photos for annual reports, consumer and trade magazines, direct mail, P-O-P displays, catalogs and packaging. Subjects include: "depends on work in-house." Reviews stock photos. Model/property release required. Captions preferred.

Specs: Variety of size color/b&w prints; 35mm, 2¼×2¼, 4×5 and 8×10 transparencies.

Making Contact & Terms: Interested in receiving work from newer, lesser-known photographers. Works with local freelancers on assignment only. Cannot return material. Reports in 3 weeks. NPI; "depends upon job." Credit line sometimes given. Buys all rights.

Tips: Wants to see creative and unique images.

***CLIFFORD SELBERT DESIGN COLLABORATIVE**, 2067 Massachusetts Ave., Cambridge MA 02140. (617)497-6605. Fax: (617)661-5772. Estab. 1982. Member of AIGA, SEGD. Design firm. Number of employees: 30. Specializes in annual reports, publication design, display design, packaging, direct mail, signage and environmental graphics. Types of clients: industrial, financial, retail, publishers and nonprofit. Examples of current clients: Stride Rite; Reebok; and Laura Ashley.

Needs: Number of photos bought each month varies. Uses photos for annual reports, billboards, consumer and trade magazines, direct mail, P-O-P displays, catalogs, posters, packaging and signage. Reviews stock photos.

Making Contact & Terms: Interested in receiving work from newer, lesser-known photographers. Submit portfolio for review. Provide résumé, business card, brochure, flier or tearsheets to be kept on file for possible future assignments. "We have a drop off policy." Keeps samples on file. SASE. NPI. Credit line given.

STEVEN SESSIONS, INC., 5177 Richmond Ave, Suite 500, Houston TX 77056. Phone: (713)850-8450. Fax: (713)850-9324. President: Steven Sessions. Estab. 1982. Design firm. Specializes in annual reports, packaging and publication design. Types of clients: industrial, financial, women's fashion, cosmetics, retail, publishers and nonprofit.

Needs: Always works with freelancers. Uses photos for annual reports, consumer and trade magazines, P-O-P displays, catalogs and packaging. Subject matter varies according to need. Reviews stock photos. Model/property release preferred.

Specs: Uses b&w and color prints; no preference for format or finish. Prefers 35mm, 2¼×2¼, 4×5, 8×10 transparencies.
Making Contact & Terms: Submit portfolio for review. Send unsolicited photos by mail for consideration. Provide résumé, business card, brochure, flier or tearsheets to be kept on file for possible future assignments. Keeps samples on file. SASE. Reports in 1-2 weeks. Pays $1,800-5,000/day. **Pays on receipt of invoice.** Credit line given. Sometimes buys all rights; negotiable.

SIGNATURE DESIGN, 2101 Locust St., St. Louis MO 63103. (314)621-6333. Fax: (314)621-0179. Partners: Therese McKee and Sally Nikolajevich. Estab. 1988. Design firm. Specializes in print graphics and exhibit design and signing. Types of clients: corporations, museums, botanical gardens and government agencies. Examples of recent projects: Center for Biospheric Education and Research exhibits, Huntsville Botanical Garden; walking map of St. Louis, AIA, St. Louis Chapter; Flood of '93 exhibit, U.S. Army Corps of Engineers; brochure, U.S. Postal Service; Center for Home Gardening exhibits, Missouri Botanical Garden; Hawaii exhibits, S.S. Independence, Delta Queen Steamboat Development Co.
Needs: Works with 1 freelancer/month. Uses photos for posters, copy shots, brochures and exhibits. Reviews stock photos.
Specs: Uses prints and 35mm, 2¼×2¼ and 4×5 transparencies.
Making Contact & Terms: Interested in receiving work from newer, lesser-known photographers. Arrange personal interview to show portfolio. Send unsolicited photos by mail for consideration. Provide résumé, business card, brochure, flier or tearsheets to be kept on file for possible future assignments. Keeps samples on file. Reports in 1-2 weeks. NPI. Pays 30 days from receipt of invoice. Credit line sometimes given. Buys all rights; negotiable.

SMART ART, 1077 Celestial St., Cincinnati OH 45202. (513)241-9757. President: Fred Lieberman. Estab. 1979. Design firm, advertising art. Specializes in annual reports, display design, packaging, direct mail, signage and advertising art. Types of clients: industrial, retail and health. Examples of recent projects: Western Produce Sales Annual (Chiquita); Jennite Corporate Sales Brochure (Neyra Industries); and Corporate Capabilities Brochure (Leonard Insurance).
Needs: Uses photographs for consumer and trade magazines, direct mail, P-O-P displays, catalogs, posters, packaging and signage for a wide diversity of clients. Reviews stock photos "on a variety of subjects; client list varies." Model/property release required. Captions preferred.
Specs: Uses 8×10 color and b&w prints; 2¼×2¼, 4×5, 8×10 transparencies.
Making Contact & Terms: Query with list of stock photo subjects. Provide résumé, business card, brochure, flier or tearsheets to be kept on file for possible future assignments. Works with local freelancers only. Keeps samples on file. Cannot return material. Reporting time "depends entirely on kinds of projects planned." Pays $50-200/hour; $350-1,500/day. Pays on receipt of invoice. "Generally client pays directly upon receipt of invoice." Buys all rights; negotiable. Credit lines sometimes given depending on what might be negotiated.

***STAHL DESIGN INC.**, 116 E. 48th St., Indianapolis IN 46205. (317)283-5000. Fax: (317)580-0545. President: David Stahl. Estab. 1991. Member of AIGA. Design firm. Number of employees: 2. Specializes in annual reports, publication design, display design, direct mail, signage and I.D. Types of clients: industrial, financial, retail, publishers and consumer. Examples of recent projects: annual reports for ATA, Twin Disc, Inc. and ALLtrista Corp.
Needs: Works with 2 freelancers/month. Uses photos for annual reports, direct mail, catalogs and posters. Subjects vary. Reviews stock photos. Model release required. Property release preferred. Captions preferred.
Specs: Uses color and b&w; 35mm, 2¼×2¼, 4×5 and 8×10 transparencies.
Making Contact & Terms: Interested in receiving work from newer, lesser-known photographers. Contact through rep. Query with samples. Send unsolicited photos by mail for consideration. Provide résumé, business card, brochure, flier or tearsheets to be kept on file for possible future assignments. Works on assignment only. Keeps samples on file. NPI; pay varies. Pays on receipt of invoice. Credit line sometimes given. Rights negotiable.

STUDIO WILKS, 8800 Venice Blvd., Los Angeles CA 90034. (310)204-2919. Fax: (310)204-2918. Owners: Teri and Richard Wilks. Estab. 1991. Design firm. Specializes in annual reports, publication design, packaging, signage. Types of clients: corporate.
Needs: Works with 1-2 freelancers/month. Uses photos for annual reports, trade magazines, catalogs, packaging, signage. Reviews stock photos.
Specs: Uses 8×10 prints.
Making Contact & Terms: Interested in receiving work from newer, lesser-known photographers. Provide résumé, business card, brochure, flier or tearsheets to be kept on file for possible future assignments. Works with local freelancers only. Keeps samples on file. SASE. Reports in 3 weeks. Pays $300-750/day. Pays on receipt of invoice. Credit line given. Buys all rights; negotiable.

Tips: Looking for "interesting, conceptual, experimental."

TRIBOTTI DESIGNS, 22907 Bluebird Dr., Calabasas CA 91302. (818)591-7720. Fax: (818)591-7910. Contact: Bob Tribotti. Estab. 1970. Design firm. Specializes in annual reports, publication design, display design, packaging, direct mail and signage. Types of clients: educational, industrial, financial, retail, publishers and nonprofit. Examples of recent projects: school catalog, SouthWestern University School of Law; magazine design, *Knitking*; signage, city of Calabasas.
Needs: Uses photos for annual reports, consumer and trade magazines, direct mail, catalogs and posters. Subjects vary. Reviews stock photos. Model/property release required. Captions preferred.
Specs: Uses 8×10, glossy, color and b&w prints; 35mm, 2¼×2¼, 4×5, 8×10 transparencies.
Making Contact & Terms: Interested in receiving work from newer, lesser-known photographers. Contact through rep. Query with résumé of credits. Provide résumé, business card, brochure, flier or tearsheets to be kept on file for possible future assignments. Works with local freelancers only. Keeps samples on file. Cannot return material. Reports in 3 weeks. Pays $400-1,000/day; $150-1,000/job. Pays on receipt of invoice. Credit line sometimes given. Buys one-time rights; negotiable.

UNIT ONE, INC., 950 S. Cherry St., Suite G-16, Denver CO 80222. (303)757-5690. Fax: (303)757-6801. President: Chuck Danford. Estab. 1968. Design firm. Number of employees: 4. Specializes in annual reports, publication design, display design, corporate identity, corporate collateral and signage. Types of clients: industrial, financial, nonprofit and construction/architecture. Examples of recent projects: Bonfils Blood Center (corporate identity); Western Mobile (plant signage); corporate brochures and marketing materials for companies in the construction industry, fundraising campaign for medical center.
Needs: Works with 1-2 freelancers/month. Uses photos for annual reports, trade magazines, direct mail, P-O-P displays, catalogs, posters and corporate brochures/ads. Subjects include: construction, architecture, engineering, people and oil and gas. Reviews stock photos "when needed." Model/property release required.
Specs: Reviews 2¼×2¼, 4×5 transparencies.
Making Contact & Terms: Interested in receiving work from newer, lesser-known photographers. Query with résumé of credits. Provide résumé, business card, brochure, flier or tearsheets to be kept on file for possible future assignments. Works with local freelancers only. Keeps samples on file. SASE. Reports as needed. Pays $500-1,500/day; $300-450/location for 4×5 building shots. Pays within 30-45 days of completion. Credit line sometimes given, depending on the job, client and price. Buys all rights; negotiable.
Tips: Looks for "quality, style, eye for design, color and good composition."

VISUAL CONCEPTS, 5410 Connecticut Ave., Washington DC 20015. (202)362-1521. Owner: John. Estab. 1980. Design firm, 3-D. Specializes in display design, signage. Types of clients: industrial, retail.
Needs: Works with 5 freelancers/month. Uses photos for annual reports, P-O-P displays, catalogs, posters. Subjects include: fashion and objects. Reviews stock photos of vintage, fashion, b&w. Model release preferred.
Specs: Uses prints and transparencies.
Making Contact & Terms: Interested in receiving work from newer, lesser-known photographers. Query with stock photo list. Provide résumé, business card, brochure, flier or tearsheets to be kept on file for possible future assignments. Works on assignment only. Keeps samples on file. Cannot return material. NPI. Pays on receipt of invoice. Credit line not given. Rights negotiable.
Tips: Looking for "people, building, postcard style photos fun. NO landscapes, NO animals."

WEYMOUTH DESIGN INC., 332 Congress St., Boston MA 02210. (617)542-2647. Fax: (617)451-6233. Office Manager: Judith Hildebrandt. Estab. 1973. Design firm. Specializes in annual reports, publication design, packaging and signage. Types of clients: industrial, financial, retail and nonprofit.
Needs: Uses photos for annual reports and catalogs. Subjects include executive portraits, people pictures or location shots. Subject matter varies. Model/property release required. "Photo captions are written by our corporate clients."
Specs: Uses 35mm, 2¼×2¼, 4×5 transparencies.
Making Contact & Terms: Interested in receiving work from newer, lesser-known photographers. Submit portfolio for review. Portfolio reviews only April-June; otherwise send/drop off portfolio for review. Works with freelancers on assignment only. "Mike Weymouth shoots most of the photographs for our clients." Keeps samples on file. SASE. Pays $125-200/hr.; $1,250-2,000/day. "We give our clients 10 hour days on our day-rate quotes." **Pays on receipt of invoice.** Buys one-time rights; negotiable.

***CLARENCE ZIERHUT, INC.**, 2014 Platinum, Garland TX 75042. Phone: (214)276-1722. Fax: (214)272-5570. President: Clarence Zierhut. Estab. 1956. Design firm. Specializes in displays, packaging and product design. Types of clients: industrial.

Needs: Uses photos for direct mail, catalogs and packaging. Subjects usually are "prototype models." Model/property release required.

Specs: Uses 8×10 color prints, matte finish; 35mm transparencies.

Making Contact & Terms: Provide résumé, business card, brochure, flier or tearsheets to be kept on file for possible future assignments. Works with local freelancers only. Keeps samples on file. Cannot return material. Reports in 1-2 weeks. NPI; payment negotiable on bid basis. **Pays on receipt of invoice.** Credit line sometimes given depending upon client. Buys all rights.

Tips: Wants to see product photos showing "color, depth and detail."

Art/Design Studios/'95-'96 changes

The following markets appeared in the 1995 edition of *Photographer's Market*, but are not listed this year. The majority did not respond to our request to update their listings. If a reason was given for a market's exclusion it appears in parentheses below.

A.T. Associates (requested deletion)
Carla S. Burchett Design Concept
Cliff and Associates
Designworks, Inc. (requested deletion)
Fusion International
Graphic Art Resource Associates
Ligature, Inc.
Miranda Designs Inc.
Deborah Shapiro Designs (no longer needs photos)
Studio Graphics

Book Publishers

The book publishing market for photography can be roughly divided into two sectors. In the first sector, publishers buy individual or groups of photographs for cover art and to illustrate books, especially textbooks, travel books and nonfiction subject books.

For illustration, photographs may be purchased from a stock agency or from a photographer's stock or the publisher may make assignments. Publishers usually pay for photography used in book illustration or on covers on a per-image or per-project basis. Some pay photographers on hourly or day rates. No matter how payment is made, however, the competitive publishing market requires freelancers to remain flexible.

To approach book publishers for illustration jobs, send a query letter and photographs or slides and a stock photo list with prices, if available. If you have published work, tearsheets are very helpful in showing publishers how your work translates to the printed page.

The second sector is created by those publishers who produce photography books. These are usually themed and may feature the work of one or several photographers. It is not always necessary to be well-known to publish your photographs as a book. What you do need, however, is a unique perspective, a saleable idea and quality work.

For entire books, publishers may pay in one lump sum or with an advance plus royalties (a percentage of the book sales). When approaching a publisher for your own book of photographs, query first with a brief letter describing the project and samples. If the publisher is interested in seeing the complete proposal, photographers can send additional information in one of two ways depending on the complexity of the project.

Prints placed in sequence in a protective box, along with an outline, will do for easy-to-describe, straight-forward book projects. For more complex projects, you may want to create a book dummy. A dummy is basically a book model with photographs and print arranged as they will appear in finished book form. Book dummies show exactly how a book will look including the sequence, size, format and layout of photographs and accompanying text. The quality of the dummy is important, but keep in mind the expense can be prohibitive.

To find the right publisher for your work, read the listings in this section carefully. Send for catalogs and guidelines for those publishers that interest you. Also, become familiar with your local bookstore. By examining the books already published, you can find those publishers who produce your type of work. Check for both large and small publishers. While smaller firms may not have as much money to spend, they are often more willing to take risks, especially on the work of new photographers.

What's ahead?

Overall, the book publishing industry is looking forward (cautiously) to better times. Yet the changes instituted during the past decade will remain in effect for a long time. Some of these changes have had a direct impact on how publishers buy and use freelance photography.

"We are buying down, negotiating harder, shopping around, anything to save money," says Ruth Mandel, photo editor for W.W. Norton. Many publishers say they are seeking photographers willing to negotiate payment. Whether publishers deal directly with photographers or with stock agencies, the bottom line is they are looking for more ways to stretch their purchasing dollars.

Publishers also are cutting costs by buying less photography or opting for smaller photo sizes, says Harvey Stein, a New York City-based freelance photographer who frequently lectures on the book publishing market. "Publishers may be buying the same number of photos, but making them smaller because photographers often are paid by photo size," he explains.

Stein has noticed other changes in the market. "Risk taking has declined," he says. "The trend is toward publishing safer books, avoiding difficult topics." Photography books with complicated or sophisticated themes, popular in the 1970s, have become increasingly difficult to sell to larger publishers, he says.

On the other hand, publishers are paying more attention to cover photography, because they've discovered covers are important selling tools. Thanks to this new awareness of the role visuals play in selling a book and to recent improvements in technology, publishers are using more color photography as both illustration and cover art.

***ABBEVILLE PRESS**, 488 Madison Ave., New York NY 10022. (212)888-1969. Fax: (212)644-5085. Director of Photography: Laura Straus. Publishes art books, travel book, cookbooks, children's books, calendars, notecards, giftwrap, stylebooks. Photos used for text illustration, promotional materials, book covers, dust jackets. Examples of recently published titles: *History of Women in Photography* (illustrations); *Empire* (interior illustrations). Photo guidelines free with SASE.
Needs: Buys 500-5,000 photos annually; offers 5-10 freelance assignments annually. Wants focused material that is well-lit. Prefers large format. Reviews stock photos of cats and wildflowers (North American). Model/property release required for people or artwork. Captions required.
Making Contact & Terms: Interested in receiving work from newer, lesser-known photographers. Provide résumé, business card, brochure, flier or tearsheets to be kept on file for possible future assignments. Uses up to 11 × 14 matte or glossy b&w prints; "2¼ × 2¼, 4 × 5 and 8 × 10 transparencies preferred, but we will take 35mm." Keeps samples on file. SASE. Reports in 1 month. Pays per picture rated range from $25-150. Pays on receipt of invoice. Credit line given. Rights purchased depends upon project and whether there was a work-for-hire arrangement; negotiable.
Tips: "We prefer not to review portfolios (except food photography and some specific product work for fashion or objects). We love to receive good ideas for books or gift products. Otherwise, you can submit materials on the following subjects: nature, food, animals. We are turning toward using stock photography for better rates on larger deals. We love to use one photographer for a whole package."

***ADAMS-BLAKE PUBLISHING**, 8041 Sierra St., Fair Oaks CA 95628. Phone/fax: (916)962-9296. Editorial Assistant: Monica Blane. Estab. 1992. Publishes business, career and reference material. Photos used for text illustration, promotional materials and book covers. Examples of recently published titles: *Computer Money* (promo); *Core 911* (cover/promo); and *Complete Guide to TV Movies* (promo).
Needs: Buys 10-15 photos annually; offers 5 freelance assignments annually. Wants photos of people in office situations. Model/property release required. Captions required; include where and when.
Making Contact & Terms: Interested in receiving work from newer, lesser-known photographers. Query with résumé of credits. Provide résumé, business card, brochure, flier or tearsheets to be kept on file for possible future assignments. Uses 5 × 7 and 8 × 10 glossy b&w prints; 35mm transparencies. Keeps samples on file. SASE. Reports in 1 month. Pays $50-100/color photo; $50-100/b&w photo. **Pays on acceptance**. Credit line given. Buys one-time and book rights; negotiable. Simultaneous submissions and previously published work OK.
Tips: "We publish business books and look for subjects using office equipment in meetings and at the desk/work site. Don't send a whole portfolio. We only want your name, number and a few samples. Having an e-mail address and fax number will help you make a sale. Don't phone or fax us. We also look for b&w book covers. They are cheaper to produce and, if done right, can be more effective than color."

AERIAL PHOTOGRAPHY SERVICES, 2511 S. Tryon St., Charlotte NC 28203. (704)333-5143. Fax: (704)333-5148. Photography/Lab Manager: Joe Joseph. Estab. 1960. Publishes pictorial books, calendars, postcards, etc. Photos used for text illustration, book covers. Examples of recently published titles: *Blue Ridge Parkway Calendar, Great Smoky Mountain Calendar, North Carolina Calendar*, all depicting the seasons of the year. Photo guidelines free with SASE.
Needs: Buys 100 photos annually. Landscapes, scenics, mostly seasons (fall, winter, spring). Reviews stock photos. Model/property release preferred. Captions required; include location.
Making Contact & Terms: Interested in receiving work from newer, lesser-known photographers. Send unsolicited photos by mail for consideration. Works with local freelancers on assignment only.

Uses 5×7, 8×10 matte color prints; 35mm, 2¼×2¼, 4×5 transparencies; c-41 120mm film mostly. SASE. Reports in 3 weeks. NPI. **Pays on acceptance.** Credit line given. Buys all rights; negotiable. Simultaneous submissions OK.
Tips: Looking for "fresh looks, creative, dynamic, crisp images. We use a lot of nature photography, scenics of the Carolinas area including Tennessee and the mountains. We like to have a nice variety of the four seasons. We also look for good quality chromes good enough for big reproduction. Only submit images that are very sharp and well exposed. We get a lot of useless photos and that takes a lot of our time, so please be considerate on that particular aspect. Seeing large format photography the most (120mm-4×5). If you would like to submit images in a CD, that is acceptable too. The industry is looking for fast action/response and computers are promising a lot."

***AGRITECH PUBLISHING GROUP**, P.O. Box 950553, Mission Hills CA 91395-0553. (818)361-8889. Executive Vice President: Eric C. Lightin' Horse. Estab. 1988. Publishes adult trade, juvenile, textbooks. Subject matter includes horses, pets, farm animals/materials, gardening, western art/Americana and agribusiness. Photos used for text illustration, promotional materials, book covers and dust jackets.
Needs: Number of purchases and assignments varies. Reviews stock photos. Model/property release required. Captions preferred.
Making Contact & Terms: Interested in receiving work from newer, lesser-known photographers. Submit portfolio for review. Query with samples. Provide résumé, business card, brochure, flier or tearsheets to be kept on file for possible future assignments. Keeps samples on file. SASE. Subject matter varies. NPI. Pays on publication. Credit line sometimes given depending upon subject and/or photo. Buys book rights and all rights.
Tips: Limit queries to what we look for and need.

ALLYN AND BACON PUBLISHERS, 160 Gould St., Needham MA 02194. (617)455-1265. Fax: (617)455-1294. Photo Researcher: Susan Duane. Textbook publisher (college). Photos used in textbook covers and interiors.
Needs: Offers 4 assignments plus 80 stock projects/year. Multiethnic photos in education, business, social sciences and good abstracts. Reviews stock photos. Model/property release required.
Making Contact & Terms: Provide self-promotion piece or tearsheets to be kept on file for possible future assignments. "Do not call or send stock lists." Uses 8×10 or larger, matte b&w prints; 35mm, 2¼×2¼, 4×5, 8×10 transparencies. Keeps samples on file. Cannot return material. Reports back in "24 hours to 4 months." Pays $100-500/job; $300-500/color photo; $50-200/photo. Pays on usage. Credit line given. Buys one-time rights; negotiable.
Tips: "Watch for our photo needs listing in photo bulletin. Send tearsheet and promotion pieces. Need bright, strong, clean abstracts and unstaged, nicely lit people photos."

***AMERICAN & WORLD GEOGRAPHIC PUBLISHING**, P.O. Box 5630, Helena MT 59604. (406)443-2842. Fax: (406)443-5480. Photo Editor: Mary Bell. Estab. 1973. Publishes material relating to geography, weather, photography—scenics and adults and children at work and play. Photos used for text illustration, promotional materials, book covers and dust jackets (inside: alone and with supporting text). Examples of recently published titles: *Wisconsin from the Sky* (aerial coffee table book); *The Quad-Cities and the People* (text, illustration); and *Oklahoma: The Land and Its People* (text, illustration). Photo guidelines free with SASE.
Needs: Buys 1,000 photos annually; offers 1-10 freelance assignments annually. Looking for photos that are clear with strong focus and color—scenics, wildlife, people, landscapes. Captions required; include name and address on mount. Package slides in individual protectors, then in sleeves.
Making Contact & Terms: Interested in receiving work from newer, lesser-known photographers. Query with samples. Query with stock photo list. Uses 35mm, 2¼×2¼, 4×5 and 8×10 transparencies. SASE. Reporting time depends on project. Pays $75-350/color photo. Pays on publication. Buys one-time rights. Simultaneous submissions and/or previously published work OK.
Tips: "We seek bright, heavily saturated colors. Focus must be razor sharp. Include strong seasonal looks, scenic panoramas, intimate close-ups. Of special note to *wildlife* photographers, specify shots taken in the wild or in a captive situation (zoo or game farm). We identify shots taken in the wild."

Market conditions are constantly changing! If you're still using this book and it's 1997 or later, buy the newest edition of Photographer's Market *at your favorite bookstore or order directly from* Writer's Digest Books.

***AMERICAN ARBITRATION ASSOCIATION,** 140 W. 51st St., New York NY 10020-1203. (212)484-4000. Editorial Director: Jack A. Smith. Publishes law-related materials on all facets of resolving disputes in the labor, commercial, construction and insurance areas. Photos used for text illustration. Examples of recently published titles: *Dispute Resolution Journal*, cover and text; *Dispute Resolution Times*, text; and *AAA Annual Report*, text.
Needs: Buys 10 photos annually; assigns 5 freelance projects annually. General business and industry-specific photos. Reviews stock photos. Model release and photo captions preferred.
Making Contact & Terms: Provide résumé, business card, brochure, flier or tearsheets to be kept on file for possible future assignments. Uses 8×10 glossy b&w prints; 35mm transparencies. SASE. Reports "as time permits." Pays $250-400/color photo, $75-100/b&w photo, $75-100/hour. Credit lines given "depending on usage." Buys one-time rights. Also buys all rights "if we hire the photographer for a shoot." Simultaneous submissions and previously published work OK.

AMERICAN BAR ASSOCIATION PRESS, 750 N. Lake Shore Dr., Chicago IL 60611. (312)988-6094. Fax: (312)988-6081. Photo Service Coordinator: Craig Jobson. "The ABA Press publishes 10 magazines, each addressing various aspects of the law. Readers are members of the sections of the American Bar Association." Photos used for text illustration, promotional materials, book covers. Examples of recently published titles: *Business Law Today*, portrait shot of subject of story; *Family Advocate*, stock of elderly women on cover; *Criminal Justice*, photo for story on crack. Photo guidelines free with SASE.
Needs: Buys 3-5 photos/issue. Rarely gives freelance assignments. "We are looking for serious photos that illustrate various aspects of the law, including courtroom scenes and still life law concepts. Photos of various social issues are also needed, e.g., crime, AIDS, homeless, families, etc. Photos should be technically correct. Photos should show emotion and creativity. Try not to send any gavels or Scales of Justice. We have plenty of those." Reviews stock photos. Model/property release preferred; "required for sensitive subjects." Photo captions preferred.
Making Contact & Terms: Interested in receiving work from newer, lesser-known photographers. Query with stock photo list. Send unsolicited photos by mail for consideration. Provide résumé, business card, brochure, flier or tearsheets with SASE to be kept on file for possible future assignments. Uses 5×7, 8×10 b&w prints; 35mm, 2¼×2¼, 4×5, 8×10 transparencies. Keeps samples on file. Reports in 4-6 weeks. Pays $100-350. Assignment fees will be negotiated. When photos are given final approval, photographers will be notified to send an invoice. Credit line given. Buys one-time and all rights; negotiable. Simultaneous submissions and/or previously published works OK.
Tips: "Be patient, present only what is relevant."

AMERICAN BIBLE SOCIETY, 1865 Broadway, New York NY 10023. (212)408-1441. Fax: (212)408-1435. Product Development: Christina Murphy. Estab. 1816. Publishes Bibles, New Testaments and illustrated scripture booklets and leaflets on religious and spiritual topics. Photos used for text illustration, promotional materials and book covers. Examples of recently published titles: *Hospital Scripture Tray Cards*, series of 7 (covers); *God Is Our Shelter and Strength* (booklet on natural disasters); and *God's Love for Us Is Sure and Strong* booklet on Alzheimer's disease (cover and text).
Needs: Buys 10-25 photos annually; offers 10 freelance assignments annually. Needs scenic photos, people (multicultural), religious activities. Reviews stock photos. Model release required. Property release preferred. Releases needed for portraits and churches. Captions preferred; include location and names of identifiable persons.
Making Contact & Terms: Interested in receiving work from newer, lesser-known photographers. Query with samples. Provide résumé, business card, brochure, flier or tearsheets to be kept on file for possible future assignments. Uses any size glossy color and/or b&w prints; 35mm, 2¼×2¼, 4×5, 8×10 transparencies. Keeps samples on file. SASE. Reports within 2 months. Pays $100-800/color photo; $50-500/b&w photo. Pays on receipt of invoice. Credit line sometimes given depending on nature of publication. Buys one-time and all rights; negotiable. Simultaneous and/or previously published work OK.
Tips: Looks for "special sensitivity to religious and spiritual subjects; contemporary, multicultural people shots are especially desired."

***AMHERST MEDIA INC.,** 418 Homecrest Dr., Amherst NY 14226. (716)874-4450. Fax: (716)874-4508. Publisher: Craig Alesse. Estab. 1979. Publishes how-to photography and videography books. Photos used for text illustration and book covers. Examples of recently published titles: *The Freelance Photographer's Handbook*; *Basic Camcorder Guide* (illustration); and *Lighting for Imaging* (illustration).
Needs: Buys 25 photos annually; offers 6 freelance assignments annually. Model release required. Property release preferred. Captions preferred.
Making Contact & Terms: Interested in receiving work from newer, lesser-known photographers. Query with résumé of credits. Uses 5×7 prints; 35mm transparencies. Does not keep samples on file. SASE. Reports in 1 month. Pays $30-100/color photo; $30-100/b&w photo. Pays on publication. Credit

line sometimes given depending on photographer. Rights negotiable. Simultaneous submissions OK.

***AMPHOTO BOOKS**, 1515 Broadway, New York NY 10036. (212)764-7300. Senior Editor: Robin Simmen. Publishes instructional and how-to books on photography. Photos usually provided by the author of the book.
Needs: Submit model release with photos. Photo captions explaining photo technique required.
Making Contact & Terms: Query with résumé of credits and book idea, or submit material by mail for consideration. SASE. Reports in 1 month. NPI. Pays on royalty basis. Buys one-time rights. Simultaneous submissions and previously published work OK.
Tips: "Submit focused, tight book ideas in form of a detailed outline, a sample chapter, and sample photos. Be able to tell a story in photos and be aware of the market."

***ARDSLEY HOUSE PUBLISHERS INC.**, 320 Central Park West, New York NY 10025. (212)496-7040. Fax: (212)496-7146. Publishing Assistant: Linda Jarkesy. Estab. 1981. Publishes college textbooks—music, film, history, philosophy, mathematics. Photos used for text illustration and book covers. Examples of recently published titles: *Ethics in Thought and Action* (text illustration); *Music Melting Round* (text illustration, book cover); and *Greek & Latin Roots of English* (text illustration).
Needs: Buys various number of photos annually; offers various freelance assignments annually. Needs photos that deal with music, film and history. Reviews stock photos. Model/property release preferred.
Making Contact & Terms: Interested in receiving work from newer, lesser-known photographers. Query with samples. Query with stock photo list. Provide résumé, business card, brochure, flier or tearsheets to be kept on file for possible future assignments. Uses color and b&w prints. Keeps samples on file. SASE. Reports in 1 month. Pays $25-50/color photo; $25-50/b&w photo. **Pays on acceptance**. Credit line given. Buys book rights; negotiable.

ARJUNA LIBRARY PRESS, 1025 Garner St., D, Space 18, Colorado Springs CO 80905. Director: Prof. Joseph A. Uphoff, Jr. Estab. 1979. Publishes proceedings and monographs, surrealism and metamathematics (differential logic, symbolic illustration) pertaining to aspect of performance art (absurdist drama, martial arts, modern dance) and culture (progressive or mystical society). Photos used for text illustration and book covers. Example of recently published titles: *English is a Second Language*.
Needs: Surrealist (static drama, cinematic expressionism) suitable for a general audience, including children. Model release and photo captions preferred.
Making Contact & Terms: Interested in receiving work from newer, lesser-known photographers. Query with samples. Send unsolicited photos by mail for consideration. Submit portfolio for review. Provide résumé, business card, brochure, flier or tearsheets to be kept on file for possible future assignments. Uses 5×7 glossy (maximum size) b&w and color prints. Cannot return material. Reports in "one year." Payment is one copy of published pamphlet. Credit line given. Rights dependent on additional use. Simultaneous submissions and previously published work OK.
Tips: "Realizing that photography is expensive, it is not fair to ask the photographer to work for free. Nevertheless, it should be understood that, if the publisher is operating on the same basis, a trade might establish a viable business mode, that of advertising through contributions of historic significance. We are not soliciting the stock photography market. We are searching for examples that can be applied as illustrations to conceptual and performance art. These ideas can be research in the contemporary context, new media, unique perspectives, animate (poses and gestures), or inanimate (landscapes and abstracts). Our preference is for enigmatic, obscure or esoteric compositions. This material is presented in a forum for symbolic announcements, *The Journal of Regional Criticism*. We prefer conservative and general audience compositions." It's helpful "to translate color photographs in order to examine the way they will appear in black and white reproduction of various types. Make a photocopy. It is always a good idea to make a photocopy of a color work for analysis."

ART DIRECTION BOOK CO., 6th Floor, 10 E. 39th St., New York NY 10016. (212)889-6500. Fax: (212)889-6504. Contact: Art Director. Estab. 1939. Publishes advertising art, design, photography. Photos used for dust jackets.
Needs: Buys 10 photos annually. Needs photos for advertising.
Making Contact & Terms: Submit portfolio for review. Works on assignment only. SASE. Reports in 1 month. Pays $200 minimum/b&w photo; $500 minimum/color photo. Credit line given. Buys one-time and all rights.

***ASSOCIATION OF AMERICAN COLLEGES AND UNIVERSITIES**, 1818 R St., NW, Washington DC 20009. (202)387-3760. Fax: (202)265-9532. Production Editor: Cindy Olson. Estab. 1915. Publishes higher education journal: subject matter—educational trends focusing on curriculum, teaching and learning; research reports and monographs. Photos used for text illustration and book covers. Examples of recently published titles: *Liberal Education* (journal), *On Campus with Women* (newsletter), text illustration.

Needs: Buys 15-25 photos annually; offers 1-5 freelance assignments annually. Needs photographs depicting American college life, especially interaction between students, and students and professors, also architecture, cultural events, etc. Reviews stock photos. Model/property release required. Captions required; include name of person, event and/or location.
Making Contact & Terms: Interested in newer, lesser-known photographers. Provide résumé, business card, brochure, flier or tearsheets to be kept on file for possible future assignments. Do not send unsolicited work. Uses 5×7, 8×10 b&w prints; b&w or color transparencies. Keeps samples on file. Reports in 1 month. Pays $25-200/color photo; $25-200/b&w photo; negotiable. Pays on publication. Credit line given. Buys one-time rights. Simultaneous submissions and previously published work OK.
Tips: "We look for close-up, expressive photographs of people, and crisp, detailed shots of architecture, events. We are a small, nonprofit organization primarily interested in working with photographers who have some flexibility in their rates."

ASSOCIATION OF BREWERS, INC., 736 Pearl St., Boulder CO 80302. (303)447-0816. Fax: (303)447-2825. Graphic Production Director: Tim Sposato. Art Director: Vicki Hopewell. Estab. 1978. Publishes how-to, cooking, adult trade, hobby, brewing and beer-related books. Photos used for text illustration, promotional materials, book covers, magazines. Examples of recently published titles: *Great American Beer Cook Book* (front/back covers and inside); *Scotch Ale* (cover front/back).
Needs: Buys 15-50 photos annually; offers 8 freelance assignments annually. Needs still lifes and events. Reviews stock photos. Model/property release preferred.
Making Contact & Terms: Interested in receiving work from newer, lesser-known photographers. Submit portfolio for review. Query with samples. Provide résumé, business card, brochure, flier or tearsheets to be kept on file for possible future assignments. Uses color and b&w prints, 35mm transparencies. Keeps samples on file. SASE. Reports in 1-2 weeks. NPI; all jobs done on a quote basis. Pays on receipt of invoice. Credit line given. Preferably buys all rights, but negotiable. Simultaneous submissions and previously published works OK.
Tips: Looking for "still lifes, food and beer, equipment, event photography. Be flexible on price."

***ATRIUM PUBLISHERS GROUP**, 3356 Coffey Lane, Santa Rosa CA 95403. (707)542-5400. Fax: (707)542-5444. Production Manager: Viki Marugg. Estab. 1983. Publishes trade books for audio outlets and wholesalers.
Needs: Works with 4-5 freelancers/year, 1 videographer/year. Looking for nature, landscape, food, abstract and artistic. Reviews stock photos.
Making Contact & Terms: Interested in receiving work from newer, lesser-known photographers. Provide résumé, business card, brochure, flier or tearsheets to be kept on file for possible future assignments. Uses 4×5 transparencies. Keeps samples on file. SASE. Reports in 3 weeks. Pays $500-1,000/color photo. Pays on receipt of invoice. Credit line given. Buys one-time rights and all rights; negotiable.
Tips: "We purchase 12 or more original photos per year for use as catalog covers. We look for creative, even abstract, images that relate to the areas of food, health and fitness, religion and sacred places, nature or landscapes, animals. We prefer to work with individual photographers whose unique styles will draw attention to our catalogs—rather than choosing stock photos. We like to brainstorm with an artist and give an assignment for a mutually agreed-upon subject area."

AUGSBURG FORTRESS, PUBLISHERS, P.O. Box 1209, Minneapolis MN 55440. (612)330-3300. Fax: (612)330-3455. Contact: Photo Secretary. Publishes Protestant/Lutheran books (mostly adult trade), religious education materials, audiovisual resources and periodicals. Photos used for text illustration, book covers, periodical covers and church bulletins. Guidelines free with SASE.
Needs: Buys 1,000 color photos and 250 b&w photos annually. No assignments. People of all ages, variety of races, activities, moods and unposed. "Always looking for church scenarios—baptism, communion, choirs, acolites, ministers, Sunday school, etc." In color, wants to see nature, seasonal, church year and mood. Model release required.
Making Contact & Terms: Send material by mail for consideration. "We are interested in stock photos." Provide tearsheets to be kept on file for possible future assignments. Uses 8×10 glossy or semiglossy b&w prints, 35mm and 2¼×2¼ color transparencies. SASE. Reports in 6-8 weeks. "Write for guidelines, then submit on a regular basis." Pays $25-75/b&w photo; $40-125/color photo. Credit line nearly always given. Buys one-time rights. Simultaneous submissions and previously published work OK.

***BEACON PRESS**, 25 Beacon St., Boston MA 02108. (617)742-2110. Fax: (617)742-2290. Art Director: Sara Eisenman. Estab. 1854. Publishes adult nonfiction trade and scholarly books; African-American, Jewish, Asian, Native American, gay and lesbian studies; anthropology; philosophy; women's studies; environment/nature. Photos used for book covers and dust jackets. Examples of recently published titles: *Straight Talk about Death for Teenagers* (½-page cover photo, commissioned); *The Glory and the Power* (full-bleed cover photo, stock); and *Finding Home* (full-bleed cover photo, stock).

Needs: Buys 5-6 photos annually; offers 1-2 freelance assignments annually. "We look for photos for specific books, not any general subject or style." Model/property release required. Captions preferred.
Making Contact & Terms: Interested in receiving work from newer, lesser-known photographers. Provide résumé, business card, brochure, flier or tearsheets to be kept on file for possible future assignments. Uses 8×10 glossy b&w prints; 35mm, 2¼×2¼ transparencies. Keeps samples on file. SASE. Reports in 1 month. Pays $500-750/color photo; $150-250/b&w photo. Pays on receipt of invoice. Credit line given. Buys English-language rights for all (paperback & hardcover) editions; negotiable. Previously published work OK.
Tips: "I only contact a photographer if their area of expertise is appropriate for particular titles for which I need a photo. I do not 'review' portfolios because I'm looking for specific images for specific books. Be willing to negotiate. We are a nonprofit organization, so our fees are not standard for the photo industry."

BEAUTIFUL AMERICA PUBLISHING COMPANY, 9725 SW Commerce Circle, P.O. Box 646, Wilsonville OR 97070. (503)682-0173. Librarian: Jaime Thoreson. Estab. 1986. Publishes nature, scenic, pictorial and history. Photos used for text illustration, pictorial. Examples of recently published titles: *Entertaining with Betsy Bloomingdale* (cover); *Fishing with Peter*, children's book (cover and text); and calendars (regional scenic).
Needs: Assigns 4-8 freelance projects annually; buys small number of additional freelance photos. Nature and scenic. Model release required. Captions required; include location, correct spelling of topic in caption.
Making Contact & Terms: Interested in receiving work from newer, lesser-known photographers. Provide résumé, business card, brochure, flier or tearsheets to be kept on file for possible future assignments. Uses 35mm, 2¼×2¼, 4×5, and 8×10 transparencies. Payment varies based on project; $100 minimum/color photo. Credit line given. Buys one-time rights. Simultaneous submissions and previously published work OK.
Tips: "Do not send unsolicited photos!! Please do not ask for guidelines. We are using very little freelance, other than complete book or calendar projects."

BEDFORD BOOKS OF ST. MARTIN'S PRESS, 75 Arlington St., Boston MA 02116. (617)426-7440. Fax: (617)426-8582. Advertising and Promotion Manager: Donna Lee Dennison. Estab. 1981. Publishes college textbooks (freshman composition, literature and history). Photos used for text illustration, promotional materials and book covers. Examples of recently published titles: *Comparing Cultures: Readings on Contemporary Japan for American Writers*; *Our Times: Readings for Recent Periodicals*, fourth edition; *Signs of Life in the U.S.A.: Readings on Popular Culture for Writers*; and *Elements of Argument: A Text and Reader*, fourth edition.
Needs: Buys 12 photos annually; offers 2 freelance assignments annually. "We use photographs editorially, tied to the subject matter of the book (generally historic period pieces)." Also artistic, abstract, conceptual photos; nature or city; people—America or other cultures, multiracial often preferred. Also uses product shots for promotional material. Reviews stock photos. Model/property release required.
Making Contact & Terms: Interested in receiving work from newer, lesser-known photographers. Query with samples. Query with list of stock photo subjects. Provide résumé, business card, brochure, flier or tearsheets to be kept on file for possible future assignments. Prefers artwork, such as promo cards, that doesn't need to be returned. Works with local freelancers only for product shots. Uses 8×10 b&w and color prints; 35mm, 2¼×2¼, 4×5 transparencies. SASE. Reports in 3 weeks. Pays $50-500/color photo; $50-500/b&w photo; $250-1,000/job; $500-1,800/day. Credit line sometimes given; "always covers, never promo." Buys one-time rights and all rights; depends on project; negotiable. Simultaneous submissions and/or previously published work OK.
Tips: "We are always looking for multicultural works that are nonviolent and nonsexist. We also want artistic, abstract, conceptual photos, computer-manipulated works, collages, etc."

***BEHRMAN HOUSE INC.**, 235 Watchung Ave., West Orange NJ 07052. (201)669-0447. Editor: Ms. Ruby G. Strauss. Estab. 1921. Publishes Judaica textbooks. Photos used for text illustration, promotional materials and book covers.
Needs: Interested in stock photos of Jewish content, particularly holidays, with children. Model/property release required.
Making Contact & Terms: Interested in receiving work from newer, lesser-known photographers. Query with résumé of credits. Query with samples. Provide résumé, business card, brochure, flier or tearsheets to be kept on file for possible future assignments. Interested in stock photos. SASE. Reports in 3 weeks. Pays $50-500/color photo; $20-250/b&w photo. Credit line given. Buys one-time rights; negotiable.
Tips: Company trend is increasing use of photography.

ROBERT BENTLEY, PUBLISHERS, 1033 Massachusetts Ave., Cambridge MA 02138. (617)547-4170. Fax: (617)876-9235. President: Michael Bentley. Estab. 1950. Publishes professional, technical, consumer how-to books. Photos used for text illustration, promotional materials, book covers, dust jackets. Examples of published titles: *How to Understand, Service and Modify Ford Fuel Injection*; *Jeep Owner's Bible*; *Sports Car and Competition Driving*.
Needs: Buys 50-100 photos annually; offers 5-10 freelance assignments annually. Looking for motorsport, automotive technical and engineering photos. Reviews stock photos. Model/property release required. Captions preferred.
Making Contact & Terms: Interested in receiving work from newer, lesser-known photographers. Query with samples. Send unsolicited photos by mail for consideration. Provide résumé, business card, brochure, flier or tearsheets to be kept on file for possible future assignments. Works on assignment only. SASE. Reports in 1 month. NPI. Payment negotiable. Credit line given. Buys book rights. Simultaneous submissions OK.

BLACKBIRCH GRAPHICS, INC., One Bradley Rd., Woodbridge CT 06525. Contact: Sonja Glassman. Estab. 1979. Publishes juvenile nonfiction. Photos used for text illustration, promotional materials, book covers and dust jackets. Example of published title: *Everything You Need to Know About Alzheimers*.
Needs: Buys 300 photos annually; offers 50 freelance assignments annually. Interested in set up shots of kids, studio product/catalog photos and location shots. Reviews stock photos of nature, animals and geography. Model release required. Property release preferred. Captions required.
Making Contact & Terms: Interested in receiving work from newer, lesser-known photographers. Query with résumé of credits. Query with samples. Query with stock photo list. Works on assignment only. Uses 35mm, 2¼×2¼/1/4, 4×5 transparencies. Keeps samples on file. Cannot return material. Reports in 1 month. Pays $50-100/hour; $500-800/day; $100-200/color photo; $60-80/b&w photo. Pays on acceptance or publication. Credit line given. Buys one-time, book, all rights; negotiable. Simultaneous submissions and previously published work OK.
Tips: When working with this market you need an ability to work with kids, strong organizational skills, an ability to take charge of a project and art direction skills.

BLUE BIRD PUBLISHING, 1739 E. Broadway, #306, Tempe AZ 85282. (602)968-4088. Publisher: Cheryl Gorder. Estab. 1985. Publishes adult trade books on home education, home business, social issues (homelessness), etc. Photos used for text illustration. Examples of recently published titles: *Homeless: Without Addresses in America* and *Green Earth Resource Guide*. In both, photos used for text illustration.
Needs: Buys 40 photos annually; offers 3 freelance assignments annually. Types of photos "depends on subject matter of forthcoming books." Reviews stock photos. Model release required; photo captions preferred.
Making Contact & Terms: Query with list of stock photo subjects. Provide résumé, business card, brochure, flier or tearsheets to be kept on file for possible future assignments. SASE. Reports in 1 month. Pays $25-150/color photo, $25/150/b&w photo; also pays flat fee for bulk purchase of stock photos. Buys book rights. Simultaneous submissions and previously published work OK.
Tips: "We will continue to grow rapidly in the coming years and will have a growing need for stock photos and freelance work. Send a list of stock photos for our file. If a freelance assignment comes up in your area, we will call."

BLUE DOLPHIN PUBLISHING, INC., P.O. Box 1920, Nevada City CA 95959 or 12428 Nevada City Hwy., Grass Valley CA 95945. (916)265-6925. Fax: (916)265-0787. President: Paul M. Clemens. Estab. 1985. Publishes comparative spiritual traditions, self-help, lay psychology, humor, cookbooks, children's books, natural living and healing. Photos used for text illustration, promotional materials, book covers and dust jackets. Examples of recently published titles: *Mission to Millboro*; *Love, Hope & Recovery*; and *The Way It Is*. All photos used throughout text.
Needs: Buys 1-25 photos annually; offers 1-3 freelance assignments annually. Subject needs New Age, spiritual/psychological or regional. Model release preferred; property release required. Captions preferred.
Making Contact & Terms: Interested in receiving work from newer, lesser-known photographers. Query with a few samples. Provide résumé, business card, brochure, flier or tearsheets to be kept on file for possible future assignments. Works on assignment only. Uses 3×5, 5×7 color and/or b&w prints; 35mm, 2¼×2¼, 4×5, 8×10 transparencies. "We can scan images into our system and output directly to color separations." Keeps samples on file. SASE. Reports in 1 month. Pays $20-200/b&w photo; $20-300/color photo; $20/hour, or by arrangement per project. Pays on receipt of invoice. Credit line given. Buys one-time and book rights; prefers all rights; negotiable. Simultaneous submissions and previously published work OK.
Tips: Looks for "clarity, composition. Do 'different' things in life. Shoot the unique perspective. We're getting more electronic—looking for the unusual perspective."

***✦BOSTON MILLS PRESS**, 132 Main St., Erin, Ontario N0B 1T0 Canada. (519)833-2407. Fax: (519)833-2195. Publisher: John Denison. Estab. 1974. Publishes coffee table books, local guide books. Photos used for text illustration, book covers and dust jackets. Examples of recently published titles: *Georgian Bay* (cover/text); *Credit River Valley* (cover/text); and *Ontario's Heritage Quilts* (cover/text). **Needs:** "We're looking for book length ideas *not* stock. We pay a royalty on books sold plus advance." **Making Contact & Terms:** Interested in receiving work from newer, lesser-known photographers. Query with résumé of credits. Uses 35mm transparencies. Does not keep samples on file. SASE and IRC. Reports in 3 weeks. NPI; payment negotiated with contract. Credit line given. Simultaneous submissions OK.

***BRETHREN PRESS**, 1451 Dundee Ave., Elgin IL 60120. (708)742-5100. Fax: (708)742-6103. Production Assistant: Christopher Paschen. Estab. 1897. Publishes adult, child/juvenile, religious books. Photos used for text illustration, promotional materials and book covers. Examples of recently published titles: *1 Corinthians: A Community Struggles* (cover); *Ephesians* (cover); and *Real Families* (cover).
 • Sample images sent to this listing on disk or CD-ROM (Windows version) will receive preferential treatment at selection time.
Needs: Buys 12-24 photos annually; offer 6-10 freelance assignments annually. Looks for photos of nature, people. Reviews stock photos. Model/property release required.
Making Contact & Terms: Interested in receiving work from newer, lesser-known photographers. Query with samples. Provide résumé, business card, brochure, flier or tearsheets to be kept on file for possible future assignments. Uses 35mm, 2¼×2¼, 4×5 transparencies. Keeps samples on file. Cannot return material. Reports in 1 month. Pays $50-300/color photo; $10-100/b&w photo. Pays on receipt of invoice. Buys books rights. Simultaneous submissions and/or previously published work OK.

CASCADE GEOGRAPHIC SOCIETY, P.O. Box 294, Rhododendron OR 97049. (503)622-4798. Curator: Michael P. Jones. Estab. 1979. "Our photographs are for exhibits, educational materials, fliers, posters, etc., including historical artifact catalogs. We are a nonprofit organization." Photo guidelines free with SASE.
Needs: Buys 20 photos annually; offers 20 freelance assignments annually. American history, wildlife, old buildings, Civil War, Revolutionary War, Indian Wars, Oregon Trail, pioneer history, living history, nature and environmental. Reviews stock photos of American history and nature subjects. Model release preferred. Captions preferred.
Making Contact & Terms: Interested in receiving work from newer, lesser-known photographers. Query with résumé of credits. Send unsolicited photos by mail for consideration. Submit portfolio for review. Provide résumé, business card, brochure, flier or tearsheets to be kept on file for possible future assignments. Works on assignment only. Uses 5×7, 8×10 b&w or color prints; 35mm, 2¼×2¼, 4×5, 8×10 transparencies; videotape. Keeps samples on file. SASE. Reports in 3 weeks. Offers copies of published images in place of payment. Credit line given. Buys one-time rights. Simultaneous submissions and previously published work OK.
Tips: "We want photos that bond people to the earth and history. Send us enough samples so that we can get a good idea of your talent. Be patient."

***CHATHAM PRESS**, Box A, Old Greenwich CT 06870. (203)531-7807. Editor: Roger Corbin. Estab. 1971. Publishes New England and ocean-related topics. Photos used for text illustration, book covers, art and wall framing.
Needs: Buys 25 photos annually; offers 5 freelance assignments annually. Preferably New England and ocean-related topics. Model release preferred; photo captions required.
Making Contact & Terms: Query with samples. Uses b&w prints. SASE. Reports in 1 month. NPI. Credit line given. Buys all rights.
Tips: To break in with this firm, "produce superb b&w photos. There must be an Ansel Adams-type of appeal—which is instantaneous to the viewer!"

CLEANING CONSULTANT SERVICES, P.O. Box 1273, Seattle WA 98111. (206)682-9748. Fax: (206)622-6876. Publisher: William R. Griffin. "We publish books on cleaning, maintenance and self-employment. Examples are related to janitorial, housekeeping, maid services, window washing, carpet cleaning, etc." Photos are used for text illustration, promotional materials, book covers and all uses related to production and marketing of books. Photo guidelines free with SASE. Sample issue $3.

The maple leaf before a listing indicates that the market is Canadian.

Needs: Buys 20-50 freelance photos annually; offers 5-15 freelance assignments annually. Photos of people doing cleaning work. Reviews stock photos. Model release preferred. Captions preferred.
Making Contact & Terms: Query with résumé of credits, samples, list of stock photo subjects or send unsolicited photos by mail for consideration. Provide résumé, business card, brochure, flier or tearsheets to be kept on file for possible future assignments. Uses 5×7 and 8×10 glossy b&w and color prints. SASE. Reports in 3 weeks. Pays $5-50/b&w photo; $5/color photo; $10-30/hour; $40-250/job; negotiable depending on specific project. Credit lines generally given. Buys all rights; depends on need and project; rights negotiable. Simultaneous submissions and previously published work OK.
Tips: "We are especially interested in color photos of people doing cleaning work in other countries for use on the covers of our quarterly magazine, *Cleaning Business*. Be willing to work at reasonable rates. Selling two or three photos does not qualify you to earn top-of-the-line rates. We expect to use more photos, but they must be specific to our market, which is quite select. Don't send stock sample sheets. Send photos that fit our needs. Call if you need more information or specific guidance."

COMPASS AMERICAN GUIDES, 6051 Margarido Dr., Oakland CA 94618. (510)547-7233. Fax: (510)547-2145. Creative Director: Christopher C. Burt. Estab. 1990. Publishes travel guide series for every state in the U.S. and 15 major cities, also Canadian provinces and cities. Photos used for text illustration and book covers. Examples of recently published titles: *Compass American Guide to Manhattan*, *Compass American Guide to Texas*, and *Compass American Guide to South Dakota*.
Needs: Buys 1,000-1,500 photos annually; offers 8-10 freelance assignments annually. Reviews stock photos (depends on project). Model release required, especially with prominent people. Property release preferred. Captions required.
Making Contact & Terms: Interested in receiving work from newer, lesser-known photographers as well as seasoned professionals. Provide résumé, business card, brochure, flier or tearsheets to be kept on file for possible future assignments. "Do not phone; fax OK." Works on assignment only. Uses 35mm, 2¼×2¼, 4×5, 8×10 transparencies. Keeps samples on file. Cannot return unsolicited material. Reports in one week to five years. Pays $5,000/job. Pays ⅓ advance, ⅓ acceptance, ⅓ publication. Buys one-time and book rights. Photographer owns copyright to images. Simultaneous submissions and previously published work OK.
Tips: "Our company works only with photographers native to, or currently residing in, the state or city in which we are publishing the guide. We like creative approaches that capture the spirit of the place being covered. We need a mix of landscapes, portraits, things and places."

CONSERVATORY OF AMERICAN LETTERS, P.O. Box 298, Thomaston ME 04861. (207)354-0998. President: Robert Olmsted. Estab. 1986. Publishes "all types of books except porn and evangelical." Photos used for promotional materials, book covers and dust jackets. Examples of recently published titles: *Dan River Anthology* (cover); *After the Light* (cover).
Needs: Buys 2-3 photos annually. Model release required if people are identifiable. Photo captions preferred.
Making Contact & Terms: Uses 3×5 to 8×10 b&w glossy prints, also 5×7 or 6×9 color prints, vertical format. SASE. Reports in 1 week. Pays $5-40/b&w photo; $35-150/color photo; per job payment negotiable. Credit line given. Buys one-time rights; negotiable.
Tips: "We are a small market. We need *few* photos, but can never find them when we do need them."

***CORNERSTONE PRODUCTIONS INC.**, P.O. Box 55229, Atlanta GA 30308. (404)288-8937. President/CEO: Ricardo A. Scott J.D. Estab. 1985. Publishes adult trade, juvenile and textbooks. Photos used for text illustration, promotional materials and book covers. Examples of recently published titles: *A Reggae Education* (illustrative); and *Allied Health Risk-Management* (illustrative).
Needs: Buys 10-20 photos annually; offers 50% freelance assignments annually. Photos should show life in all its human and varied forms—reality! Reviews stock photos of life, nature, medicine, science, the arts. Model/property release required. Captions required.
Making Contact & Terms: Interested in receiving work from newer, lesser-known photographers. Submit portfolio for review. Send unsolicited photos by mail for consideration. Uses 5×7, 10×12 glossy color and b&w prints; 4×5, 8×10 transparencies; VHS videotape. Keeps samples on file. SASE. Reports in 1 month. NPI. Pays on publication. Credit line sometimes given depending upon the particular projects and arrangements, done on an individual basis. Buys all rights; negotiable. Simultaneous submissions and previously published work OK.
Tips: "The human aspect and utility value is of prime importance. Ask 'How can this benefit the lives of others?' Let your work be a reflection of yourself. Let it be of some positive value and purpose towards making this world a better place."

CRABTREE PUBLISHING COMPANY, 350 Fifth Ave., Suite 3308, New York NY 10118. (905)468-4947. Fax: (905)468-5680. Editor: Tammy Everts. Estab. 1978. Publishes juvenile nonfiction, library and trade—natural science, history, geography (including cultural geography), 18th and 19th-century America, ecology. Photos used for text illustration, book covers. Examples of published titles: *Mexico:*

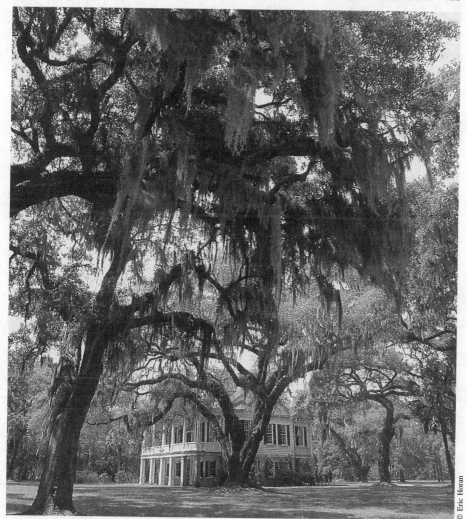

© Eric Horan

Eric Horan of Hilton Head, South Carolina, first approached Compass American Guides after reading about the company in a photo industry trade magazine. Compass was planning to produce a book on South Carolina and Horan submitted work for editorial review. They liked his style and hired him for an assignment which yielded this photo of a plantation house in an oak grove. The shot typifies the Old South and was used as a book cover.

The Land (text illustration, cover); *Fort Life* (text illustration, cover); and *A One-Room School* (text illustration).

Needs: Buys 400-600 photos annually; offers 3-6 freelance assignments annually. Wants photos of children, cultural events around the world, animals (exotic and domestic). Model/property release required for children, photos of artwork, etc. Captions preferred; include place, name of subject, date photographed.

Making Contact & Terms: Interested in receiving work from newer, lesser-known photographers. Send unsolicited photos by mail for consideration. Provide résumé, business card, brochure, flier or tearsheets to be kept on file for possible future assignments. Works with local freelancers only. Uses color prints; 35mm, 2¼×2¼, 4×5, 8×10 transparencies. Keeps samples on file. SASE. Reports in 1-2 weeks. Pays $200-500/job; $40-75/color photo. Pays on publication. Credit line given. Buys all rights. Simultaneous submissions and/or previously published works OK.

Tips: When reviewing a portfolio, this publisher looks for bright, intense color and clarity. "Since books are for younger readers, lively photos of children and animals are always excellent." Portfolio should be "diverse and encompass several subjects, rather than just one or two; depth of coverage of

subject should be intense, so that any publishing company could, conceivably, use all or many of a photographer's photos in a book on a particular subject."

***CROSS CULTURAL PUBLICATIONS, INC.**, P.O. Box 506, Notre Dame IN 46556. (219)272-0889. Fax: (219)273-5973. General Editor: Cy Pullapilly. Estab. 1980. Publishes nonfiction, multicultural books. Photos used for book covers and dust jackets. Examples of recently published titles: *Night Autopsy Room*, *Red Rum Punch*, and *Boots from Heaven*.
Needs: Buys very few photos annually; offers very few freelance assignments annually. Model release preferred. Captions preferred.
Making Contact & Terms: Interested in receiving work from newer, lesser-known photographers. Provide résumé, business card, brochure, flier or tearsheets to be kept on file for possible future assignments. Works on assignment only. Does not keep samples on file. Cannot return material. Reports in 3 weeks. NPI; varies depending on individual agreements. Pays on acceptance. Credit line given. Simultaneous submissions and previously published work OK.

CROSSING PRESS, P.O. Box 1048, Freedom CA 95019. (408)722-0711. Fax: (408)722-2749. Co-Publisher: Elaine Gill. Art Director: Amy Sibiga. Estab. 1971. Publishes adult trade, cooking, calendars, health, humor and New Age books. Photos used for text illustration, book covers. Examples of recently published titles: *Truffles, Candies & Confection*, text illustration; *New Vegetarian Classics—Soups*, text illustration; *Global Grilling*, book cover.
Needs: Buys 70-100 photos annually; offers 3-6 freelance assignments annually. Looking for photos of food, people, how-to steps for health books. Reviews stock photos of food, people, avant-garde material (potential book covers). Model/property release required. Captions preferred.
Making Contact & Terms: Interested in receiving work from newer, lesser-known photographers. Submit portfolio for review. Query with samples. Provide résumé, business card, brochure, flier or tearsheets to be kept on file for possible future assignments. Works on assignment only. Uses color and b&w. Keeps samples on file. SASE. Pays $50-5,000/job. **Pays on acceptance**/comp copies of book. Credit line given. Buys one-time and book rights; negotiable. Simultaneous submissions and/or previously published works OK.
Tips: Looking for photos which are "unique, stylish but not overdone—tight closeups of food—portraits of interesting everyday people—quirky scenes that can be utilized for different reasons. We are a mid-size independent press with limited budgets, but can offer unique opportunities for photographers willing to work closely with us. Increasing rapidly—a desire for style without predictability."

***CRYSTAL CLARITY PUBLISHERS**, 14618 Tyler Foote Rd., Nevada City CA 95959. (916)272-3292 or (919)272-3293. Fax: (916)272-2181. Production Manager: Renée Glenn. Estab. 1968. Publishes adult trade and gift books—all with spiritual, inspirational or metaphysical themes. Topics range from yoga, meditation, marriage, relationships, to creative expression, leadership and health. Photos used for text illustration, promotional materials, book covers, dust jackets, notecards, audio packaging. Examples of recently published titles: *Secrets of Inner Peace* (text illustration/cover); *Secrets for Women* (text illustration/cover); and *Expansive Marriage* (cover).
 ● "We are beginning to use Photo CD in our layout and design stages. This is new to us in the last year."
Needs: Buys 100-200 photos annually; offers 2-5 freelance assignments annually. Needs inspirational landscape, people, scenics with people, health (people doing things—not medical shots), yoga and meditation pictures, and most importantly, images that are inspirational either in beauty or subject. Reviews stock photos. Model/property release required.
Making Contact & Terms: Interested in receiving work from newer, lesser-known photographers. Submit portfolio for review. Send unsolicited photos by mail for consideration. Provide portfolio or tearsheets to be kept on file for possible future assignments. Contact by telephone. Uses 35mm, 2¼×2¼, 4×5 transparencies. Keeps samples on file. SASE. Reports in 1 month. Pays $50-150/inside color or b&w photo (more for cover); for complete book (all photos) "we may negotiate one price." Pays on receipt of invoice. Credit line usually given. Buys books rights; also rights to use on "sideline" products with same title. Simultaneous submissions and previously published work OK.
Tips: "Lighting is most important. Natural photos showing 'God's Beauty' vs. 'man-made beauty.' We prefer unposed, natural looking photos. Don't send high-tech, special effect or photography that looks like 'stock'—with posed images. We are interested in 'artistic' photography, with beautiful lighting and real people."

♣GREEY DE PENCIER BOOKS/OWL COMMUNICATIONS, 179 John St., #500, Toronto, Ontario M5T 3G5 Canada. (416)971-5275. Fax: (416)868-6009. Editor-in-Chief: Sheba Meland. Estab. 1976. "We publish children's books on nature, science and children's activities such as crafts. Our style is highly visual." Photos used for text illustration, book covers. Examples of published titles: *Light Magic and Other Science Activities About Energy*, by Trudy Rising; *Journey Through a Tropical Jungle*, by Adrian Forsyth; *The New Kids' Question & Answer Book*, editor of *Owl Magazine*.

Needs: Buys 50 photos annually. Natural history, science, children. Reviews stock photos. Model/property release required. Captions required.

Making Contact & Terms: Interested in receiving work from newer, lesser-known photographers. Query with samples. Query with stock photo list. Send unsolicited photos by mail for consideration (with SASE). Provide résumé, business card, brochure, flier or tearsheets to be kept on file for possible future assignments. Uses 35mm, 2¼×2¼, 4×5 transparencies. Keeps samples on file (dupes only—nonreturnable). SASE. Reports only when interested. Pays $50-350/color photo. Pays on publication. Credit line given. Buys book rights; negotiable. "Sometimes we require electronic rights, too." Simultaneous submissions and/or previously published work OK.

Tips: Looking for "clarity, striking images and a knowledge of the subject area of the photography. We work with the major stock houses, as well as freelancers, and look for top quality images, both technically and aesthetically." Has noticed "the use of photos to 'tell a story,' particularly in children's creative nonfiction, is growing. I'd like to see such stories myself—science and natural history could work well."

DIAL BOOKS FOR YOUNG READERS, 375 Hudson St., New York NY 10014. (212)366-2803. Fax: (212)366-2020. Senior Editor: Toby Sherry. Publishes children's trade books. Photos used for text illustration, book covers. Examples of recently published titles: *How Many* (photos used to teach children how to count); and *Jack Creek Cowboy.*

Making Contact & Terms: Photos are only purchased with accompanying book ideas. Works on assignment only. Does not keep samples on file. NPI. Credit line given.

DOWN THE SHORE PUBLISHING, 534 Cedar Run Dock Rd., Cedar Run NJ 08092. (609)978-1233. Fax: (609)494-1437. Publisher: Raymond G. Fisk. Estab. 1984. Publishes regional calendars; regional books (specific to the mid-Atlantic shore and New Jersey). Photos used for text illustration, scenic calendars (New Jersey and mid-Atlantic only). Example of recently published titles: *Great Storms of the Jersey Shore* (text illustration). Photo guidelines free with SASE.

Needs: Buys 30-50 photos annually. Scenic coastal shots, photos of beaches and New Jersey lighthouses (New Jersey and mid-Atlantic region). Reviews stock photos. Model release required. Property release preferred. Captions preferred; *specific location* identification essential.

Making Contact & Terms: Interested in receiving work from newer, lesser-known photographers. Query with stock photo list. Provide résumé, business card, brochure, flier or tearsheets to be kept on file for possible future assignments. "We have a very limited use of prints." 35mm, 2¼×2¼, 4×5 transparencies, preferred. Does not keep samples on file. SASE. Reports in 2-6 weeks. Pays $10-150/b&w photo; $20-175/color photo. Pays 90 days from publication. Credit line given. Buys one-time or book rights; negotiable. Previously published work OK.

Tips: "We are looking for an honest depiction of familiar scenes from an unfamiliar and imaginative perspective. Images must be specific to our very regional needs. Limit your submissions to your best work. Edit your work very carefully."

DUSHKIN PUBLISHING GROUP, INC., Sluice Dock, Guilford CT 06437. (203)453-4351. Art Editor: Pamela Carley. Estab. 1971. Publishes college textbooks. Photos used for text illustration, book covers. Examples of recently published titles: *Sexuality Today, Cultural Anthropology, International Politics on the World Stage.*

Needs: Varies according to subject. "I tend to use the work of freelance photographers I see in other sources and in some cases, the work of those who contact me." Reviews stock photos. Model release preferred. Captions preferred.

Making Contact & Terms: Interested in receiving work from newer, lesser-known photographers. Query with stock photo list. Send unsolicited photocopies or tearsheets by mail for consideration. Provide résumé, business card, brochure, flier or tearsheets to be kept on file for possible future assignments. Uses 8×10 glossy b&w prints; 35mm, 2¼×2¼, 4×5, 8×10 transparencies. Keeps samples on file. Reporting time "varies from project to project. Often takes 2-3 months if we seriously consider. If not interested we can respond quickly." NPI. Pays on publication. Credit line given. Buys one-time rights; negotiable. Previously published works OK.

Tips: "Subjects include: psychology, anthropology, education, human sexuality, international politics, American government, health. Looking for good quality current material. Mostly b&w, but some color. Looking especially for good, recent people shots that relate to the above subjects. Ethnic variety."

A bullet has been placed within some listings to introduce special comments by the editor of **Photographer's Market.**

© Judie Lynn

Down the Shore Publishing loved this shot by Judie Lynn of Brick, New Jersey, because it captures a "sense of season" along the New Jersey coast. They used the photo for a calendar. When creating the image, Lynn wanted something more than a typical beach scene— "sunshine and vacationers."

EASTERN PRESS, INC., P.O. Box 881, Bloomington IN 47402. Publisher: Don Lee. Estab. 1981. Publishes university-related Asian subjects: language, linguistics, literature, history, archaeology. Teaching English as Second Language (TESL); Teaching Korean as Second Language (TKSL); Teaching Japanese as Second Language (TJSL); Chinese, Arabic. Photos used for text illustration. Examples of recently published titles: *Kabuki: Japanese Drama* (recently produced).
Needs: Depends upon situation. Looking for higher academic. Captions for photos related to East Asia/Asian higher academic.
Making Contact & Terms: Interested in receiving work from newer, lesser-known photographers. Provide résumé, business card, brochure, flier or tearsheets to be kept on file for possible future assignments. Uses 6×9 book b&w prints. Keeps samples on file. Reports in 1 month (sometimes 1-2 weeks). Payment negotiable. Pays on acceptance. Credit line sometimes given. Rights negotiable.
Tips: Looking for "East Asian/Arabic textbook-related photos. However, it depends on type of book to be published. Send us résumé and about two samples. We keep them on file. Photos on, for example, drama, literature or archaeology (Asian) will be good, also TESL."

‡EDITORIAL PLAZA MAYOR, INC., Avenida Ponce de León 1527—El Cinco, Rio Piedras, Puerto Rico 00927. (809)764-0455. Fax: (809)764-0465. President: Patricia Gutiérrez. Estab. 1990. Publishes textbooks. 90% of our books are aimed at humanities courses. All levels: elementary, high school and university. Photos used for text illustration, book covers. Examples of recently published titles: *Historia Universal*, illustration; *Pensamiento y Communicación: Grades 7-12*, illustration; *Géneros Literarios*, book cover.
Needs: Offers 1-4 freelance assignments annually. Looking for photos of architecture, art, authors, faces, technology. Reviews stock photos. Model/property release preferred.
Making Contact & Terms: Interested in receiving work from newer, lesser-known photographers. Submit portfolio for review. Query with stock photo list. Provide résumé, business card, brochure, flier or tearsheets to be kept on file for possible future assignments. Uses color and b&w prints; 2¼×2¼ transparencies. SASE. Reports in 1 month. NPI. Pays on receipt of invoice. Credit line sometimes given depending upon the amount of photographs used from how many sources in a particular textbook. Buys book rights and all rights; negotiable. Simultaneous submissions and/or previously published works OK.
Tips: Subjects sought "Depends on the textbook's subject matter and level of use. If it is aimed at young children we prefer a modern style (so children can relate to their realities). In college level books this varies according to the subject matter. A lot of small publishers, like myself, cater to our

population. Sometimes we want to build an inhouse picture library with a mix of subjects so that we can have them easily at hand to fill spaces throughout a book. We would love to be able to purchase rights, at a reasonable price, for many pictures. This isn't easily available. My advice to young photographers would be to sell these 'packages' rather than just store them. They would increase their income and their personal information in their résumés; while at the same time begin receiving credits. We are going back to basics. Family values, flora, fauna, conservation of the environment etc."

ELLIOTT & CLARK PUBLISHING, 1745 Kalorama St. NW, Suite B1, Washington DC 20009. (202)387-9805. Fax: (202)483-0355. Vice President: Carolyn Clark. Estab. 1991. Looking for illustrated book projects, not single stock images.
Needs: Interested in natural history, Americana, history and music. Does not want to see "cute and fuzzy" subjects. Model/property release preferred. Captions preferred.
Making Contact & Terms: Interested in receiving work from newer, lesser-known photographers. Query with samples. Provide résumé, business card, brochure, flier or tearsheets to be kept on file for possible future assignments. Uses 35mm, 2¼×2¼, 4×5 transparencies. Keeps samples on file. SASE. Reports in 4-6 weeks. Royalties paid on gross sales of books. Single photographers get cover credit. Buys one-time rights and rights for hard and soft covers, and foreign language editions; negotiable.
Tips: "We like to feature one photographer's work. The photography must tell a story and the photographer must be able to relay the concept and know possible markets."

ELYSIUM GROWTH PRESS, 700 Robinson Rd., Topanga CA 90290. (310)455-1000. Fax: (310)455-2007. Editor: Ed Lange. Estab. 1961. Publishes adult trade books on nudist/naturist/clothing-optional resorts, parks and camps. Photos used for text illustration, promotional, book covers and dust jackets. Examples of recently published titles: *Nudist Nudes*, *Shameless Nude* and *Fun in the Sun Book III*. Photos used for cover and text in all three. Photo guidelines free with SASE; catalog, with SASE, 45¢ postage.
Needs: Buys 50 photos annually. Reviews stock photos. Model release required. Captions required.
Making Contact & Terms: Provide résumé, business card, brochure, flier or tearsheets to be kept on file for possible future assignments. Uses 5×7 glossy b&w and color prints; 35mm and 2¼×2¼ transparencies. SASE. Reports in 2 weeks. Pays $50-100/color photo, $35-50/b&w photo. Credit line given. Buys all rights; negotiable. Simultaneous submissions OK.
Tips: In samples, looking for "nudist/naturist lifestyle photos only."

***ENCYCLOPAEDIA BRITANNICA**, 310 S. Michigan Ave., 3rd Floor, Chicago IL 60604. (312)347-7000. Fax: (312)347-7914. Art Director: Bob Ciano. Estab. 1768. Publishes encyclopedia/yearbooks. Photos used for text illustration, promotional materials. Examples of recently published titles: *Encyclopedia Britannica* (text illustration); *Britannica Book of the Year* (text illustration); *Yearbook of Science and the Future* (text illustration); *Medical & Health Annual*; Britannica On-Line; Britannica CD.
Needs: Buys hundreds of photos annually. Needs photos of natural history, personalities, breakthroughs in science and medicine, art, geography, history, architecture. Reviews stock photos. Captions required. "This is very important to us! Captions must be very detailed."
Making Contact & Terms: Interested in receiving work from newer, lesser-known photographers. Query only with stock photo list. Uses any size or finish color and b&w prints; 35mm, 2¼×2¼, 4×5, 8×10 transparencies. Keeps samples on file. Cannot return unsolicited material. "We only contact when needed." NPI. Pays on receipt of invoice. Credit line given. Buys one-time world rights; negotiable.
Tips: "Photos must be well-lighted and sharply focused. The subject must be clearly visible. We prefer photographers who have a solid knowledge of their subject matter. Submissions should be tightly edited. Loosely edited submissions take up valuable time! Ultimately, the photos must be informative. Space is limited, so pictures must literally speak a thousand words! Stock lists and samples will be routed through the department. We are always looking for new sources of material."

ENTRY PUBLISHING, INC., 27 W. 96th St., New York NY 10025. (212)662-9703. President: Lynne Glasner. Estab. 1981. Publishes education/textbooks, secondary market. Photos used for text illustrations.
Needs: Number of freelance photos bought and freelance assignments given vary. Often looks for shots of young teens in school settings. Reviews stock photos. Model release required. Captions preferred.

The double dagger before a listing indicates that the market is located outside the United States and Canada.

Making Contact & Terms: Interested in receiving work from newer, lesser-known photographers. Query with list of stock photo subjects. Provide résumé, business card, brochure, flier or tearsheets to be kept on file for possible future assignments. Uses b&w prints. SASE. Reports in 3 weeks. NPI; payment depends on job requirements. Credit line given if requested. Buys one-time rights; negotiable. Simultaneous submissions and previously published work OK.

Tips: "Have wide range of subject areas for review and use. Stock photos are most accessible and can be available quickly during production of book."

J.G. FERGUSON PUBLISHING CO., 200 West Madison, Suite 300, Chicago IL 60606. (312)580-5480. Editorial: Holli Cosgrove. Publishes vocational guidance works for high school and college, subscriptions, reference books and corporate histories. Photos used for text illustration. Examples of published titles: *Career Discovery Encyclopedia*, elementary school 6 volume set with jobs explained and illustrated by b&w photos and *Encyclopedia of Careers and Vocational Guidance*, high school/college level.

Needs: Buys several hundred freelance photos biannually. Persons at work in various occupational settings only. Reviews stock lists. Model release and captions preferred.

Making Contact & Terms: Send stock list and résumé. Do not send unsolicited photos. Uses 8×10 glossy b&w prints; 35mm transparencies. NPI; payment negotiable. Credit line given. Buys book rights. Simultaneous submissions and previously published work OK.

Tips: Wants to see "encyclopedia-style b&w photos of people in their jobs with good caption information. We search mainly for specific career images, so a list indicating what a photographer has that may fulfill our needs is the single best method of getting work with us."

FINE EDGE PRODUCTIONS, Box 303, Route 2, Bishop CA 93514. (619)387-2412. Fax: (619)387-2286. Contact: Don Douglass. Estab. 1986. Publishes outdoor guide and how-to books; custom topographic maps—mostly mountain biking and sailing. Photos used for text illustration, promotional materials, book covers. Examples of recently published titles: *Mountain Biking Southern California's Best 100 Trails*; *Mountain Biking The San Bernadino Mountains*; *Eastern High Sierra Recreation Topo Map*. "Call to discuss" photo guidelines.

Needs: Buys 200 photos annually; offers 1-2 freelance assignments annually. Looking for area-specific mountain biking (trail usage), northwest cruising photos. Model release required. Captions preferred with place and activity.

Making Contact & Terms: Interested in receiving work from newer, lesser-known photographers. Query with samples. Uses 3×5, 4×6 glossy b&w prints; color for covers. SASE. Reports in 1-2 months. Pays $150-500/color photo; $10-50/b&w photo. Pays on publication. Credit line given. Rights purchased vary. Simultaneous submissions and/or previously published works OK.

Tips: Looking for "photos which show activity in realistic (not artsy) fashion—want to show sizzle in sport. Increasing—now going from disc directly to film at printer."

✤FITZHENRY & WHITESIDE LIMITED, 195 Allstate Parkway, Markham, Ontario L3R 4T8 Canada. (416)477-9700. Fax: (416)477-9179. Senior Vice President: Robert W. Read. Estab. 1966. Publishes general text and trade, nonfiction. Photos used for text illustration and book covers. Examples of recently published titles: *Canada Exploring New Directions*, *Fred Penner Treasury* and *Art for Enlightenment*.

Needs: Buys 50-100 photos annually; offers 5-10 freelance assignments annually. Interested in photos of people and places, narratives. Reviews stock photos. Model release preferred. Captions preferred.

Making Contact & Terms: Interested in receiving work from newer, lesser-known photographers. Query with samples. Query with stock photo list. Provide résumé, business card, brochure, flier or tearsheets to be kept on file for possible future assignments. Offers some assignments for product shots, mostly stock photos. Uses 8×10 b&w prints; 35mm transparencies. Keeps samples on file. SASE. Reports in 1 month. NPI, "varies too greatly." Pays on publication. Credit line given. Buys one-time and book rights; negotiable. Simultaneous submissions and previously published work OK.

MICHAEL FRIEDMAN PUBLISHING GROUP, INC., 15 W. 26th St., New York NY 10010. (212)685-6610. Photography Director: Christopher Bain. Estab. 1979. Publishes adult trade: science and nature series; sports; food and entertainment; design; and gardening. Photos used for text illustration, promotional materials, book covers and dust jackets.

Needs: Buys 7,500 freelance photos annually; offers 20-30 freelance assignments annually. Reviews stock photos. Captions preferred.

Making Contact & Terms: Query with specific list of stock photo subjects. Uses 35mm, 120, 4×5 and 8×10 transparencies. Pays $50-100/color stock photo; $350-500/day. Payment upon publication of book for stock photos; within 30-45 days for assignment. Credit line always given. Buys rights for all editions. Simultaneous submissions and previously published work OK.

***GLENCOE PUBLISHING/MACMILLAN/MCGRAW HILL**, 15319 Chatsworth St., Mission Hills CA 91345. Attention: Photo Editor. Publishes elementary and high school textbooks, religion, careers,

business, office automation, social studies and fine arts. Photos used for text illustration and book covers. Recently published titles: *Art Talk, Career Skills* and *Marketing Essentials.*
Needs: Buys 500 photos annually. Occasionally offers assignments. Children and teens at leisure, in school, in Catholic church; interacting with others: parents, siblings, friends, teachers; Catholic church rituals; young people (teens, early 20s) working, especially in jobs that go against sex-role stereotypes. Model release preferred.
Making Contact & Terms: Send stock photo list. List kept on file for future assignments. Uses 8×10 glossy b&w prints and 35mm slides. Pays $50/b&w photo, $100/color photo (¼ page). Buys one-time rights, but prefers to buy all rights on assignment photography with some out takes available to photographer. Simultaneous submissions and previously published work OK.
Tips: "A good ethnic mix for models is important. We look for a contemporary, unposed look."

GRAPHIC ARTS CENTER PUBLISHING COMPANY, P.O. Box 10306, Portland OR 97210. (503)226-2402. Fax: (503)223-1410. Editorial Director: Douglas A. Pfeiffer. Publishes adult trade photographic essay books. Photos used for photo essays.
Needs: Offers 5 freelance assignments annually. Landscape, nature, people, historic architecture and other topics pertinent to the essay. Captions preferred.
Making Contact & Terms: Uses 35mm, 2¼×2¼ and 4×5 transparencies (35mm as Kodachrome 25 or 64). NPI; pays by royalty—amount varies based on project; minimum, but advances against royalty are given. Credit line given. Buys book rights. Simultaneous submissions OK.
Tips: "Photographers must be previously published in book form, and have a minimum of five years full-time professional experience to be considered for assignment. Prepare an original idea as a book proposal. Full color essays are expensive to publish, so select topics with strong market potential."

GRAPHIC ARTS PUB INC., 3100 Bronson Hill Rd., Livonia NY 14487. (716)346-2776. Fax: (716)346-2276. Estab. 1979. Publishes textbooks, adult trade—how-to quality and reproduction of color for printers and publishers. Photos used for text illustration, promotional materials, book covers. Examples of recently published titles: *Color Separation on the Desktop,* cover and illustrations; *Quality & Productivity in the Graphic Arts.*
Needs: Varies; offers 1-2 freelance assignments annually. Looking for technical photos. Model release preferred.
Making Contact & Terms: Works on assignment only. Uses color prints; 35mm transparencies.

***GREAT QUOTATIONS PUBLISHING CO.,** 1967 Quincy Ct., Glendale Heights IL 60139. (708)582-2800. Fax: (708)582-2813. President: Ringo Suek. Estab. 1985. Publishes gift books.
Needs: Buys 10-20 photos annually; offers 10 freelance assignments annually. Looking for inspirational or humorous. Reviews stock photos of inspirational, humor, family. Model/property release preferred.
Making Contact & Terms: Interested in receiving work from newer, lesser-known photographers. Provide résumé, business card, brochure, flier or tearsheets to be kept on file for possible future assignments. Works on assignment only. Uses color and b&w prints; 35mm, 2¼×2¼, 4×5 transparencies. Keeps samples on file. SASE. "We prefer to maintain a file of photographers and contact them when appropriate assignments are available." NPI. Pays on publication. "We will work with artist on rights to reach terms all agree on." Simultaneous submissions and previously published work OK.
Tips: "We intend to introduce 30 new books per year. Depending on the subject and book format, we may use photographers or incorporate a photo image in a book cover design. Unfortunately, we decide on new product quickly and need to go to our artist files to coordinate artwork with subject matter. Therefore, the more material and variety of subjects on hand is most helpful to us."

GROLIER, INC., Sherman Turnpike, Danbury CT 06816. (203)797-3500. Fax: (203)797-3197. Chief Photo Researcher: Lisa Grize. Estab. 1829. Publishes encyclopedias and yearbooks. Photos used for text illustration. Examples of published titles: *The New Book of Knowledge Annual*; *Academic American Encyclopedia*; and *Health and Medicine Annual* (all photos used for text illustration). All photo use is text illustration unless otherwise negotiated. (Other uses are very rare!)
● This publisher is using more color images, but they also see a decrease in quality news photos as a result of digital transmission of images. "We also are saddled with shorter deadlines and therefore we rely on those photographers and agencies who put together tight edits in no time. We have less time to track down specialists."
Needs: Buys 2,000 freelance photos/year; offers 5 assignments/year. "Encyclopedic." Interested in unposed photos, of the subject in its natural habitat that are current and clear. Model/property release preferred for any photos used in medical articles, education articles, etc. Captions required; include dates, specific locations and natural history subjects should carry Latin identifications.
Making Contact & Terms: Interested in working with newer, lesser-known photographers. Query with list of stock photo subjects. Provide résumé, business card, brochure, flier or tearsheets to be kept on file for possible future assignments. Uses 8×10 glossy b&w/color prints; 35mm, 2¼×2¼, 4×5,

8 × 10 (originals preferred) transparencies. Cannot return unsolicited material. "Will contact when needed." Pays $65-100/b&w photo; $150-200/color photo; $700-1,000/day. Very infrequent freelance photography is negotiated by the job. Credit line given "either under photo or on illustration credit page." Buys one-time and foreign language rights; negotiable. Occasional foreign language rights. Simultaneous submissions and previously published work OK.

Tips: "Send subject lists and small selection of samples for file. Photocopy or printed samples *only* please. In reviewing samples we consider the quality of the photographs, range of subjects and editorial approach. Keep in touch but don't overdo it. Keep us notified of recent assignments/coverage by sending stock lists or printed samples. We continue to use about 50% b&w photos but have an increasingly hard time finding good photos in our price range. Quality often looks like bad conversions from color instead of good b&w original. Color use will increase and we see a trend toward increasing use of computerized images."

✦GUERNICA EDITIONS, INC., P.O. Box 117, Station P, Toronto, Ontario M5S 2S6 Canada. (416)657-8885. Editor: Antonio D'Alfonso. Estab. 1978. Publishes adult trade (literary). Photos used for book covers. Examples of recently published titles: *Approaches to Absence* (cover); *Breaking the Mould* (cover).

Needs: Buys various number of photos annually; "often" assigns work. Life events, including characters; houses. Photo captions required. "We use authors' photo everywhere."

Making Contact & Terms: Interested in receiving work from newer, lesser-known photographers. Query with samples. Uses color and/or b&w prints. Sometimes keeps samples on file. Cannot return material. Reports in 1-2 weeks. Pays $100-150 for cover. Pays on publication. Credit line given. Buys book rights. "Photo rights go to photographers. All we need is the right to reproduce the work."

HARMONY HOUSE PUBLISHERS, P.O. Box 90, Prospect KY 40059 or 1008 Kent Rd., Goshen KY 40026. (502)228-4446. Fax: (502)228-2010. Owner: William Strode. Estab. 1984. Publishes photographic books on specific subjects. Photos used for text illustration, promotion materials, book covers and dust jackets. Recent book titles: *Country U.S.A.*, *Emblems of Southern Valor*, *Georgia Tech* and *Farming Comes of Age*.

Needs: Number of freelance photos purchased varies. Assigns 30 shoots each year. Captions required.

Making Contact & Terms: Query with résumé of credits along with business card, brochure, flier or tearsheets to be kept on file for possible future assignments. Query with samples or stock photo list. Submit portfolio for review. Works on assignment mostly. Uses 35mm, 2¼ × 2¼, 4 × 5 or 8 × 10 transparencies. NPI; payment negotiable. Credit line given. Buys one-time rights and book rights. Simultaneous submissions and previously published work OK.

Tips: To break in, "send in book ideas to William Strode, with a good tray of slides to show work."

D.C. HEATH AND COMPANY, 125 Spring St., Lexington MA 02173. (617)860-1468. Fax: (617)860-1259. Art and Photo Coordinator: Billie L. Porter. Estab. 1875. Publishes college texts—all disciplines, but the majority are in hard sciences, history, politics, foreign language, English and math. Photos used for text illustration and book covers. Examples of recently published college texts: *Come se Dice?*, *Biology: Discovering Life* and *The American Pageant* (all photos used inside). Photo guidelines available.

Needs: Buys "several hundred" photos annually; offers 20 freelance assignments annually. Wants editorial photos for all disciplines, plus artistic photos for covers. Reviews stock photos. Model release preferred, particularly for texts dealing with social sciences. Captions required "if subject matter is from field of hard sciences."

Making Contact & Terms: Interested in receiving work from newer, lesser-known photographers. Query with résumé of credits. Query with stock photo list. Provide résumé, business card, brochure, flier or tearsheets to be kept on file for possible future assignments. Uses 8 × 10 b&w prints; 35mm, 2¼ × 2¼, 4 × 5 and 8 × 10 transparencies. Keeps samples on file. SASE. Reporting time depends on project. NPI. "We are constrained by low budgets and must keep costs down." Pays on receipt of invoice. Credit line given. Buys one-time rights. Simultaneous and/or previously published work OK.

Tips: "We use stock almost exclusively but do occasional set-up or assignment shots. I want original photos with good contrast and composition. Interested in imaginative treatment of abstracts for math texts, computer texts and economics texts. We are not using more photos, but are using them in more ways as we move toward production of more supplements and alternative text presentations, such as slide sets, videocassettes, video discs and CD-ROM interactive software."

 The asterisk before a listing indicates that the market is new in this edition. New markets are often the most receptive to freelance submissions.

HERALD PRESS, 616 Walnut Ave., Scottdale PA 15683. (412)887-8500. Fax: (412)887-3111. Contact: James Butti. Estab. 1908. Photos used for book covers and dust jackets. Examples of recently published titles: *Lord, Teach Us to Pray, Starting Over* and *Amish Cooking* (all cover shots).
Needs: Buys 5 photos annually; offers 10 freelance assignments annually. Subject matter varies. Reviews stock photos of people and other subjects. Model/property release required. Captions preferred (identification information).
Making Contact & Terms: Interested in receiving work from newer, lesser-known photographers. Query with samples. Provide résumé, business card, brochure, flier or tearsheets to be kept on file for possible future assignments. Works on assignment only or select from file of samples. Uses varied sizes of glossy color and/or b&w prints; 35mm transparencies. Keeps samples on file. SASE. Reports in 1 month. Pays $150-200/color photo. **Pays on acceptance.** Credit line given. Buys book rights; negotiable. Simultaneous submissions and previously published work OK.
Tips: "Put your résumé and samples on file."

HOLLOW EARTH PUBLISHING, P.O. Box 1355, Boston MA 02205-1355. Phone/fax: (603)433-8735. President/Publisher: Helian Yvette Grimes. Publishes adult trade, mythology, computers (Macintosh), science fiction and fantasy. Photos used for text illustration, promotional materials, book covers, dust jackets and magazines. Examples of recently published titles: *Complete Guide to B&B's and Country Inns (USA), Complete Guide to B&B's and Country Inns (worldwide),* and *Software Guide for the Macintosh Power Book.* Photo guidelines free with SASE.
Needs: Buys 150-300 photos annually. Needs photos of bed & breakfasts, country inns, Macintosh Powerbook and computer peripherals. Reviews stock photos of bed & breakfasts, country inns, Macintosh Powerbook and computer peripherals. Model/property release required. Captions required; include what it is, where and when.
Making Contact & Terms: Interested in receiving work from newer, lesser-known photographers. Query with samples. No unsolicited photographs. Works with local freelancers on assignment only. Uses 5×7, 8½×11 glossy or matte color and/or b&w prints; 35mm, 2¼×2¼, 4×5 transparencies. Also accepts images on disk in EPS, Tiff, or Adobe Photoshop formats. Keeps samples on file. SASE. Reports in 1 month. Pays $50-600/color photo; $50-600/b&w photo. Pays on acceptance. Credit line given. Buys all rights "but photographer can use photographs for other projects after contacting us." Rights negotiable. No simultaneous submissions.
Tips: Wants to see portfolios with strong content, impact, graphic design. "Be unique and quick in fulfilling assignments, and pleasant to work with."

HOLT, RINEHART AND WINSTON, 1120 Capital of Texas Hwy. S., Austin TX 78746. (512)314-6500. Fax: (512)314-6590. Manager of Photo Research: Tim Taylor. Estab. 1866. "The Photo Research Department of the HRW School Division in Austin obtains photographs for textbooks in subject areas taught in secondary schools." Photos are used for text illustration, promotional materials and book covers. Examples of published titles: *Elements of Writing, Science Plus, People and Nations, World Literature, Biology Today* and *Modern Chemistry.*
Needs: Buys 3,500 photos annually. Photos to illustrate mathematics, the sciences—life, earth and physical—chemistry, history, foreign languages, art, English, literature, speech and health. Reviews stock photos. Model/property releases preferred. Photo captions required that include scientific explanation, location and/or other detailed information.
Making Contact & Terms: Interested in receiving work from newer, lesser-known photographers. Query with résumé of credits. Query with stock photo list. Query with samples. Send a letter and printed flier with a sample of work and a list of subjects in stock. Do not call! Uses any size glossy b&w prints and color transparencies. Cannot return unsolicited material. Reports as needed. Pays $125-180/b&w photo; $150-225/color photo; $75-125/hour and $700-1,000/day. Credit line given. Buys one-time rights.
Tips: "We use a wide variety of photos, from portraits to studio shots to scenics. We like to see slides displayed in sheets. We especially like photographers who have specialties . . . limit themselves to one/two subjects." Looks for "natural looking, uncluttered photographs, labeled with exact descriptions, technically correct, and including no evidence of liquor, drugs, cigarettes or brand names." Photography should be specialized, with photographer showing competence in 1 or more areas.

HOME PLANNERS, INC., 3275 W. Ina Road, Suite 110, Tucson, AZ 85741. (602)297-8200. Fax: (602)297-6219. Art Director: Cindy J. Coatsworth. Estab. 1946. Publishes material on home building and planning and landscape design. Photos used for text illustration, promotional materials and book covers. Examples of recently published titles: *Yard & Garden Structures, Expandable Home Plans* and *Empty-Nester Homes.* In all three, photos used for cover and text illustrations.
Needs: Buys 25 freelance photos; offers 10 freelance assignments annually. Homes/houses—"but for the most part, it must be a specified house built by one of our plans." Property release preferred.
Making Contact & Terms: Provide résumé, business card, brochure, flier or tearsheets to be kept on file for possible assignments. Works on assignment only. Uses 4×5 transparencies. SASE. Reports

in 1 month. Pays $25-100/color photo; $500-750/day; maximum $500/4-color cover shots. Credit line given. Buys all rights. Simultaneous submissions and previously published work OK.

Tips: Looks for "ability to shoot architectural settings and convey a mood. Looking for well-thought, professional project proposals."

HOMESTEAD PUBLISHING, Box 193, Moose WY 83012. Editor: Carl Schreier. Publishes 7-10 titles per year in adult and children's trade, natural history, Western American and art. Photos used for text illustration, promotional, book covers and dust jackets. Examples of recently published titles: *Yellowstone: Selected Photographs, Field Guide to Yellowstone's Geysers, Hot Springs and Fumaroles, Field Guide to Wildflowers of the Rocky Mountains, Rocky Mountain Wildlife* and *Grand Teton Explorers Guide.*

Needs: Buys 100-200 photos annually; offers 3-4 freelance assignments annually. Natural history. Reviews stock photos. Model release preferred. Photo captions required; accuracy very important.

Making Contact & Terms: Query with samples. Provide résumé, business card, brochure, flier or tearsheets to be kept on file for possible future assignments. Uses 8×10 glossy b&w prints; 35mm, 2¼×2¼, 4×5 and 6×7 transparencies. SASE. Reports in 3-4 weeks. Pays $70-300/color photo, $50-300/b&w photo. Credit line given. Buys one-time and all rights; negotiable. Simultaneous submissions and previously published work OK.

Tips: In freelancer's samples, wants to see "top quality—must contain the basics of composition, clarity, sharp, in focus, etc. Looking for well-thought out, professional project proposals."

***HOWELL PRESS, INC.**, 1147 River Road, Suite 2, Charlottesville VA 22901. (804)977-4006. Fax: (804)971-7204. President: Ross A. Howell, Jr. Estab. 1986. Publishes illustrated books, calendars and posters. Examples of recently published titles: *Sunday Drivers: NASCAR Winston Cup Stock Car Racing, The Lady: B-17 Flying Fortress* and *The Soldier* (photos used for illustration, jackets and promotions for all books).

Needs: Aviation, military history, gardening, maritime history, motorsports, cookbooks only. Model/property release preferred. Captions required; clearly identify subjects.

Making Contact & Terms: Interested in receiving work from newer, lesser-known photographers. Query. Uses b&w and color prints. Keeps samples on file. SASE. Reports in 1 month. NPI; payment varies. Buys one-time rights. Simultaneous submissions and previously published work OK.

Tips: When submitting work, please "provide a brief outline of project, including cost predictions and target market for project. Be specific in terms of numbers and marketing suggestions."

❦I.G. PUBLICATIONS LTD., 999-8 St. SW, Suite 222, Calgary, Alberta T2R 1J5 Canada. (403)244-7343. Fax: (403)229-2470. Property Coordinator: Elizabeth Hrappstead. Estab. 1977. Publishes travel magazines/books of local interest to include areas/cities of Vancouver, Victoria, Banff/Lake Louise, Calgary, Edmonton. Photos used for text illustration, book covers. Examples of published titles: *International Guide* and *Visitor's Choice*, text illustration and covers. Photo guidelines free with SASE.

Needs: Buys 50-100 photos annually. Looking for photos of mountains, lakes, views, lifestyle, buildings, festivals, people, sports and recreation, specific to each area as mentioned above. Reviews stock photos. Model release required. Property release is preferred. Captions required "detailed but brief."

Making Contact & Terms: Interested in receiving work from newer, lesser-known photographers. Query with samples. Works with local freelancers only. Uses 4×5 to 8×10 color prints; 35mm transparencies. Keeps samples on file. SASE. Reports in 3 weeks. Pays $35-65/color photo. Pays on publication. Credit line given. Previously published works OK.

Tips: "Please submit photos that are relative to our needs only. Photos should be specific, clear, artistic, colorful."

ILR PRESS, NY State School of Industrial and Labor Relations, Cornell University, Ithaca NY 14853-3901. (607)255-3061. Fax: (607)255-2755. Marketing and Promotion Manager: Andrea Fleck Clardy. Publishes books about all aspects of work and labor relations for academics, practitioners and the general public. Photos used for book covers and catalog of publications. Examples of recently published titles: *Grand Designs: The Impact of Corporate Strategies on Workers, Unions, and Communities; Women & Unions: Forging a Partnership*, and *Gender & Racial Inequality at Work* (all photos used for covers).

Needs: Buys 5-10 freelance photos annually. People at work in a wide variety of contexts, with high human interest and excellence in photo design. Reviews stock photos. Model/property release preferred for cover shots.

Making Contact & Terms: Interested in receiving work from newer, lesser-known photographers. Query with samples. Uses b&w prints. SASE. Reports in 1 month. Pays $35-100/b&w photo. Credit line given. Buys one-time rights or book rights; negotiable. Simultaneous submissions and previously published work OK.

Tips: Prefers to see "b&w prints of high human interest, images of people in the workforce. Particularly interested in photos that include women and people of color, high-tech professions and worker/manager groups."

JAMESTOWN PUBLISHERS, P.O. Box 9168, Providence RI 02940. Courier Delivery: 544 Douglas Ave., Providence RI 02908. (401)351-1915. Fax: (401)331-7257. Art Director: Thomas E. Malloy. Estab. 1969. Publishes reading developmental textbooks. "We need photos to illustrate covers and text material, covering a wide range of photo matter." Examples of published titles: *Calamities* (cover and text); *Aliens & UFOs* (text); *The College Student* (cover and text).
Needs: Buys 10-20 photographs annually. "We use a wide variety of photos: biographical subjects, illustrative photos for covers, historical photos, nature, science, people, etc." Model release required. Captions preferred; include date, location, subject identification.
Making Contact & Terms: Interested in receiving work from newer, lesser-known photographers. Query with list of stock photo subjects. Provide résumé, business card, brochure, flier or tearsheets to be kept on file for possible future assignments. Uses 8 × 10 glossy b&w prints; 35mm, 4 × 5 transparencies. Does not return unsolicited material. Reports in 1 month. Pays $100-150/b&w photo; $135-350/color photo; $10-50/hour; $100-300/day. Credit line given. Buys one-time rights. Previously published work OK.
Tips: Looks for "creativity, high contrast (for our b&w texts), plus diversity. Send stock lists. I keep all stock sources on a computer file. Keep sending updated lists." Provide complete listing of subject matter and location, printed samples of work limited to one 8½ × 11 sheet. Sees an increased need of contemporary photos of historical events.

KALEIDOSCOPIX, INC., P.O. Box 389, Franklin MA 02038. (508)528-3242. Art Director: Jason Kruz. Estab. 1982. Publishes children's New Englandiana, historical, nautical, cooking. Photos used for text illustration, book covers and dust jackets. Photo guidelines free with SASE.
Needs: Subjects depend upon manuscript needs. For example, *ABC's of Covered Bridges* will require action-type photos of specific New England and Ohio covered bridges. Model release required. Captions preferred.
Making Contact & Terms: Query with samples. Works on assignment only. Uses 7 × 10 b&w prints; 11 × 14 color prints; 35mm transparencies. SASE. Reports in 1 month. Pays $50/color photo; $25/b&w photo. Credit line given. Buys all rights; usually reassigns rights after 1 year of publication. Previously published work OK.
Tips: In samples, wants to see contact sheet of related subjects or 3 × 5 prints, not original slides or full size prints. Show some samples or brochure of style and techniques.

✤**KEY PACIFIC PUBLISHERS CO. LTD.**, 1001 Wharf St., Third Floor, Victoria, British Columbia V8W 1T6 Canada. (604)388-4324. Fax: (604)388-6166. Editor: Kirsten Meincke. Estab. 1986. Publishes travel/Victoria visitor information. Photos used for text illustration. Examples of recently published titles: *Essential Victoria*, text illustration and covers; *Where Victoria*, text illustration.
Needs: Buys 30-40 photos annually. Looking for photos of Victoria sights, attractions, shops, restaurants, city life. Reviews stock photos of Victoria scenes only. Model release required. Property release preferred. Restaurant with people need model release. Captions preferred; include what and where.
Making Contact & Terms: Interested in receiving work from newer, lesser-known photographers. Arrange personal interview to show portfolio. Query with stock photo list. Works with local freelancers only. Uses any glossy/flat color b&w prints; 35mm, 4 × 5 transparencies. Keeps samples on file. SASE. Reports in 3 weeks. Pays $0-400/color photo; $0-100/b&w photo; photo credit when demanded. Pays on publication, receipt of invoice. Buys one-time rights; negotiable. Simultaneous submissions and/or previously published works OK.
Tips: Looking for "generic shopping—someone/couple shopping; generic dining—shot of food/table settings; Victoria sights—coastal scenes; Victoria attractions—museums, gardens, etc. Pick up magazines to see what we use. Tend to use photos for summer issues more than winter." Accepting artist submissions for covers.

*****B. KLEIN PUBLICATIONS.**, P.O. Box 8503, Coral Springs FL 33075. (305)752-1708. Fax: (305)752-2547. President: Bernard Klein. Estab. 1953. Publishes adult trade, reference and who's who. Photos used for text illustration, promotional materials, book covers, dust jackets. Examples of recently published titles: *1933 Chicago World's Fair*, *1939 NY World's Fair* and *Presidential Ancestors*.
Needs: Reviews stock photos.
Making Contact & Terms: Interested in receiving work from newer, lesser-known photographers. Query with résumé of credits. Query with samples. Send unsolicited photos by mail for consideration. Works on assignment only. Cannot return material. Reports in 1-2 weeks. NPI.

KREGEL PUBLICATIONS, P.O. Box 2607, Grand Rapids MI 49501-2607. (616)451-4775. Fax: (616)459-9330. Director of Graphic & Print Production: Alan G. Hartman. Publishes books for Christian and Bible colleges, reference works and commentaries, sermon helps and adult trade books. Photos used for book covers and dust jackets. Examples of recently published titles: *Religion or Christ* (full-bleed photo); *His Deeper Work In Us* (accent box); and *NT In Modern Speech* (accent with 35% ghost effect).
Needs: Buys 12-40 photos annually. Scenic and/or biblical. Holy Land, scenery and inhabitants sometimes used; religious symbols, stained glass and church activities of non-Catholic origin should be submitted. Reviews stock photos. Model release preferred.
Making Contact & Terms: Query with phone call to approve photo submission before sending. Uses 35mm, 2¼×2¼ and 4×5 transparencies. Keeps duplicates on file. SASE. Reports in 1 month. Pays $100-400/color photo. Credit line given. Buys book rights and one-time rights with allowances for reproductions. Previously published work OK.
Tips: "We are tending to use more color photos on covers. Prior submission approval a must!"

LAYLA PRODUCTION INC., 340 E. 74, New York NY 10021. (212)879-6984. Fax: (212)879-6399. Manager: Lori Stein. Estab. 1980. Publishes adult trade, how-to gardening and cooking books. Photos used for text illustration and book covers. Examples of recently published titles: *American Garden Guides* (commissioned 3,000 new editorial photos); *50 Greatest Cartoons* (assigned shooting of artwork and memorabilia).
Needs: Buys over 150 photos annually; offers 6 freelance assignments annually. Gardening and cooking. Buys all rights.
Making Contact & Terms: Provide résumé, business card, brochure, flier or tearsheets to be kept on file for possible future assignments. Specifications for submissions are very flexible. SASE. Reports in 1 month; prefers no unsolicited material. Pays $20-200/color photo; $10-100/b&w photo; $25-100/ hour; $250-400/day. Other methods of pay depends on job, budget and quality needed. Simultaneous submissions and previously published work OK.
Tips: "We're usually looking for a very specific subject. We *do* keep all résumés/brochures received on file—but our needs are small, and we don't often use unsolicited material. We will be working on a series of gardening books through 1997."

LERNER PUBLICATIONS COMPANY, 241 First Ave. North, Minneapolis MN 55401. (612)332-3344. Fax: (612)332-7615. Senior Photo Researcher: Lynn Olsen. Estab. 1959. Publishes educational books for young people covering a wide range of subjects, including animals, biography, ecology, geography and sports. Photos used for text illustration, promotional materials, book covers, dust jackets. Examples of recently published titles: *Bonnie Blair*; *Idaho*; and *Caves* (all text and cover).
Needs: Buys over 1,000 photos annually; rarely offers assignments. Model/property release preferred when photos are of social issues (i.e., the homeless). Captions required; include who, where, what and when.
Making Contact & Terms: Interested in receiving work from newer, lesser-known photographers. Query with stock photo list. Provide résumé, business card, brochure, flier or tearsheets to be kept on file. Uses any size glossy color and b&w prints; 35mm, 2¼×2¼, 4×5 transparencies. Cannot return material. Reports only when interested. Pays $50/color photo; $35/b&w photo; negotiable. Pays on receipt of invoice. Credit line given. Buys one-time rights. Previously published works OK.
Tips: Prefers crisp, clear images that can be used editorially. "Send in as detailed a stock list as you can, and be willing to negotiate use fees. We are using freelance photographers more and more."

LITTLE, BROWN & CO., 41 Mt. Vernon St., Boston MA 02108. (617)227-0730. Art Assistant: Kelly Gagnon. Publishes adult trade. Photos used for book covers and dust jackets.
Needs: Reviews stock photos. Model release required.
Making Contact & Terms: Provide tearsheets to be kept on file for possible future assignments. "Samples should be nonreturnable." SASE. Reporting time varies. NPI. Credit line given. Buys one-time rights.

***LITURGY TRAINING PUBLICATIONS**, 1800 N. Hermitage, Chicago IL 60622. (312)486-8970 ext. 43. Fax: (312)486-7094. Prepress Director: Diana Kodner. Estab. 1964. Publishes materials that assist parishes, institutions and households in the preparation, celebration and expression of liturgy in Christian life. Photos used for text illustration, book covers. Examples of recently published titles: *Infant Baptism, a Parish Celebration* (text illustration); *The Postures of the Assembly During the Eucharistic Prayer* (cover); and *Teaching Christian Children about Judaism* (text illustration).
Needs: Buys 30 photos annually; offers 5 freelance assignments annually. Needs photos of processions, assemblies with candles in church, African-American worship, sacramental/ritual moments.

Reviews stock photos. Model/property release preferred. Captions preferred.
Making Contact & Terms: Interested in receiving work from newer, lesser-known photographers. Arrange personal interview to show portfolio. Submit portfolio for review. Query with résumé of credits. Query with samples. Query with stock photo list. Send unsolicited photos by mail for consideration. Provide résumé, business card, brochure, flier or tearsheets to be kept on file for possible future assignments. Uses 5×7 glossy b&w prints; 35mm transparencies. Keeps samples on file. SASE. Reports in 1-2 weeks. Pays $50-225/color photo; $25-200/b&w photo. Pays on publication. Credit line given. Buys one-time rights; negotiable. Simultaneous submissions; previously published work.
Tips: "Please realize that we are looking for very specific things—people of mixed age, race, socio-economic background; shots in focus; post-Vatican II liturgical style; candid photos; photos that are not dated. We are not looking for generic religious photography. We're trying to use more photos, and will if we can get good ones at reasonable rates."

LLEWELLYN PUBLICATIONS, P.O. Box 64383, St. Paul MN 55164. (612)291-1970. Fax: (612)291-1908. Art Director: Lynne Mentorweck. Publishes consumer books (mostly adult trade paperback) with astrology, psychology, mythology and New Age subjects, geared toward an educated audience. Also publishes book catalogs. Uses photos for book covers. Examples of recently published titles: *Crystal Balls & Crystal Bowls, 1995 Daily Planning Guide* (covers).
Needs: Buys 5-10 freelance photos annually. Science/fantasy, sacred sites, gods and goddesses (statues, etc.), high-tech and special effects. Reviews stock photos. Model release preferred.
Making Contact & Terms: Query with samples. Uses 8×10 glossy color prints; 35mm or 4×5 transparencies. Provide slides, brochure, flier or tearsheets to be kept on file for possible future assignments. SASE. Reports in 5 weeks. Pays $125-600/color cover photo. Pays on publication. Credit line given. Buys all rights.
Tips: "Send materials that can be kept on file."

LOOMPANICS UNLIMITED, P.O. Box 1197, Port Townsend WA 98368. (360)385-5087. Fax: (360)385-7785. E-mail: loompanx@olympus.net. Editorial Director: Dennis P. Eichhorn. Estab. 1975. Publishes how-to and nonfiction for adult trade. Photos used for book covers. Examples of recently published titles: *Free Space!* (color photos on cover and interior); *Secrets of a Superhacker* (photo collage on cover); and *Stoned Free* (interior photos used as line-drawing guide).
Needs: Buys 2-3 photos annually; offers 1-2 freelance assignments annually. "We're always interested in photography documenting crime and criminals." Reviews stock photos. Model/property release preferred. Captions preferred.
Making Contact & Terms: Query with samples. Query with stock photo list. Provide tearsheets to be kept on file for possible future assignments. Uses b&w prints. Samples kept on file. SASE. Reports in 1 month. Pays $10-250 for cover photo; $5-20 interior photo. Credit lines given. Buys all rights. Simultaneous submissions and previously published work OK.
Tips: "We look for clear, high contrast b&w shots that *clearly* illustrate a caption or product. Find out as much as you can about what we are publishing and tailor your pitch accordingly."

LOST RIVER PRESS, INC., P.O. Box 620, Boulder Junction WI 54512. Phone/fax: (715)358-2500. Production Manager: Mary Shafer. Estab. 1993. Publishes nature/outdoor/environmental. Photos used for text illustration, book covers, dust jackets, posters, notecards, audio packaging. Example of published title: *Harvest Moon* (jacket). Photo guidelines free with SASE.
 ● This publisher notes an increase in photo CD/SyQuest cartridge submissions, which make pre-press easier since scanned photos are not needed.
Needs: Buys "hundreds" of photos annually; offers all freelance assignments annually. Needs photos of nature (North America); wildlife; hunting/fishing; landscapes. Reviews stock photos. Model/property release required for people/identifiable locations. Captions preferred for location.
Making Contact & Terms: Interested in receiving work from newer, lesser-known photographers. Query with samples. Query with stock photo list. Provide résumé, business card, brochure, flier or tearsheets to be kept on file for possible future assignments. Works on assignment only. Uses 5×7, 8×10 glossy b&w prints; 35mm, 2¼×2¼, 4×5, 8×10 transparencies; photo CD (digital). Keeps samples on file. SASE. Reports in 1 month "sooner if possible." Pays $25-300/color photo; $25-100/b&w photo. Payment negotiable for job rates. Pays on publication. Credit line given. "We believe all contributors deserve credit for all work." Buys one-time, book and all rights. "Usually one-time for ad material, book rights for most books; others negotiable." Simultaneous and previously published work OK.
Tips: "We look for clear, very sharp-focus work in wildlife shots. Natural history behavior-type shots are very desirable. Landscapes can be soft-focus, since beauty is usually more important here. Be flexible in rates—we're new and growing. We actively seek lesser-known talents, believing your work will sell our product, not your name. Be patient. We reply to submissions as soon as possible."

***LUCENT BOOKS**, 10911 Technology Pl., San Diego CA 92127. (619)485-7424. Fax: (619)485-9549. Production Coordinator: Jill Karson. Estab. 1987. Publishes juvenile nonfiction—social issues, biographies and histories. Photos used for text illustration and book covers. Examples of recently published titles: *The Importance of Winston Churchill*, *The Ancient Near East* and *Child Abuse*.
Needs: Buys hundreds of photos annually, including many historical and biographical images, as well as controversial topics such as euthanasia. Reviews stock photos. Model/property release required; photo captions required.
Making Contact & Terms: Submit portfolio for review. Query with résumé of credits. Query with samples. Uses 5×7, 8½×11 b&w prints. Provide résumé, business card, brochure, flier or tearsheets to be kept on file for possible future assignments. Keeps samples on file. SASE. Reports in 1 month. Pays $25-75/b&w photo. Credit lines given on request. Simultaneous submissions and previously published work OK.

McKINZIE PUBLISHING COMPANY, 11000 Wilshire Blvd., P.O. Box 241777, Los Angeles CA 90024-9577. (213)968-1195. Fax: (213)931-7217. Personnel Manager: Samuel P. Elliott. Estab. 1969. Publishes adult trade, "how-to," description and travel, sports, adventure, fiction and poetry. Photos used for text illustration, promotional materials and book covers.
Needs: Offers 4 or 5 freelance assignments annually. Shots of sports figures and events. Reviews stock photos. Model/property release required.
Making Contact & Terms: Interested in receiving work from newer, lesser-known photographers. Arrange personal interview to show portfolio. Query with samples. Uses 3×5 glossy b&w/prints. SASE. Reports in 3 weeks. Pays $10-50/b&w photo; $50/hour. Credit line may be given. Buys all rights; negotiable.

METAMORPHOUS PRESS, Box 10616, Portland OR 97210. (503)228-4972. Editor: Lori Stephens. "We publish books and tapes in the subject areas of communication, health and fitness, education, business and sales, psychology, women and children. Photos used for text illustration, promotional materials, book covers and dust jackets. Examples of recently published titles: *The Challenge of Excellence*; *Re-Creating Your Self*; and *The Professional ACT: Acting, Communication, Technique*. Photos used for cover and/or text illustration.
Needs: Reviews stock photos.
Making Contact & Terms: Query with list of stock photo subjects. Provide résumé, business card, brochure, flier or tearsheets to be kept on file for possible future assignments. Works on assignment only. Cannot return material. Reports as soon as possible. NPI; payment negotiable. Credit line given. Buys one-time and book rights. Also buys all rights, but willing to negotiate. Simultaneous submissions and previously published work OK.
Tips: "Let us have samples of specialties so we can match contents and styles to particular projects."

MILKWEED EDITIONS, 430 First Ave., Suite 400, Minneapolis MN 55401-1743. (612)332-3192. Managing Editor: B. Olson. Estab. 1979. Publishes fiction (adult and children), nonfiction and poetry. Photos used for text illustration, book covers and dust jackets. Examples of recently published titles: *Confidence of the Heart*, *A Keeper of Sheep*, *Homestead* (color photos for cover illustrations).
Needs: Interested in high-quality photos, able to stand on own; "should not be journalistic." Model release required; photo captions preferred.
Making Contact & Terms: Query with samples. Provide résumé, business card, brochure, book list, flier or tearsheets to be kept on file. Uses b&w glossy prints and color transparencies. SASE. Reports in 1 month. Pays $10-500/b&w photo; $50-600/color photo; $10-650/job. "We buy piece work. We are a nonprofit publisher of poetry, fiction, children's fiction, and adult nonfiction. Photographers who are willing to work with us in keeping down our costs and in reviewing a manuscript to determine the best possible cover image are welcome to send a letter and book list." Credit line given. Buys one-time rights. Simultaneous submissions and previously published work OK. May arrange personal interview to show portfolio.
Tips: Would like to see series works. "Look at our books for use. Then send in a fairly good color copy to keep on file."

MOON PUBLICATIONS, INC., P.O. Box 3040, Chico CA 95927-3040. (916)345-5473. Fax: (916)345-6751. Photo Buyer: Carey Wilson. Estab. 1973. Publishes travel material. Photos used for text illustration, promotional materials and book covers. Examples of recently published titles: *Japan Handbook (1st Ed.)*, *Cancun Handbook (3rd Ed.)* and *Texas Handbook (2nd Ed.)*. All photos used for cover and text illustration. Photo guidelines free with SASE.
Needs: Buys 25-30 photos annually. People, clothing and activity typical of area being covered, landscape or nature. Reviews stock photos. Photo captions preferred; include location, description of subject matter.
Making Contact & Terms: Interested in receiving work from newer, lesser-known photographers. Query with stock photo list. Provide résumé, business card, brochure, flier or tearsheets to be kept on

file for possible future assignments. Uses 35mm, 2¼ × 2¼, 4 × 5, 8 × 10 transparencies. Keeps samples on file. SASE. Reports in 1 month. Pays $200-300/cover photo. Pays on publication. Credit line given. Buys book rights; negotiable. Previously published work OK.

Tips: Wants to see "sharp focus, visually interesting (even unusual) compositions portraying typical activities, styles of dress and/or personalities of indigenous people of area covered in handbook. Unusual land or seascapes. Don't send snapshots of your family vacation. Try to look at your own work objectively and imagine whether the photograph you are submitting really deserves consideration for the cover of a book that will be seen worldwide. We continue to refine our selection of photographs that are visually fascinating, unusual."

***MOREHOUSE PUBLISHING**, 871 Ethan Allen Hwy., Ridgefield CT 06877. (203)431-3927. Fax: (203)431-3964. Production/Promotion Director: Gail Eltringham. Estab. 1884. Publishes adult trade, some juvenile, some gift, some reference—all "religious" (Christian). Photos used for text illustration, book covers.

Needs: Buys 4-5 photos annually; offers 4 freelance assignments annually. Reviews stock photos of any subject with spiritual/contemplative overtones.

Making Contact & Terms: Interested in receiving work from newer, lesser-known photographers. Query with samples. Query with stock photo list. Works with local freelancers only. Uses 5 × 7, 8 × 10 glossy or matte color and b&w prints; 35mm, 2¼ × 2¼, 4 × 5 transparencies. Keeps samples on file. SASE. Reports in 3 weeks. Pays $200-300/job; $100-250/color photo; $50-150/b&w photo. Pays on receipt of invoice. Credit line given. Buys one-time and book rights. Simultaneous submissions OK.

Tips: "Be creative when keeping up with contemporary religious trends. Concentrate on subjects that reflect concerns, questions in today's society."

MOTORBOOKS INTERNATIONAL, 275 South Third St., Stillwater MN 55082. (612)439-6001. Fax: (612)439-5627. Estab. 1965. Publishes trade and specialist and how-to, automotive, aviation and military. Photos used for text illustration, book covers and dust jackets. Examples of recently published titles: *The American Drive-In, Fire Trucks in Action* and *How to Restore Your Harley-Davidson* (photos used for text illustration and covers).

• Motorbooks International has begun using Photo CD and SyQuest storage of images and the company is performing image manipulation inhouse.

Needs: Buys 30 freelance photos and offers 12 assignments annually. Anything to do with transportation (not sailboats), tractors, cycles or airplanes. Reviews stock photos. Model release preferred. Captions preferred.

Making Contact & Terms: Works mostly on assignment. "Present a résumé and cover letter first, and we'll follow up with a request to see samples." Unsolicited submissions of original work are discouraged. Any size prints or transparencies. SASE. Reports in 2 weeks. NPI; payment negotiable. Credit line given. Rights negotiable. Simultaneous submissions and previously published work OK.

MOUNTAIN AUTOMATION CORPORATION, P.O. Box 6020, Woodland Park CO 80866. (719)687-6647. President: Claude Wiatrowski. Estab. 1976. Publishes souvenir books. Photos used for text illustration, promotional materials and book covers. Examples of recently published titles: *Colorado's Black Canyon* (throughout); *Pike's Peak By Rail* (extra illustrations in video) and *Georgetown Loop RR* (extra illustrations in video).

Needs: Complete projects for illustrated souvenir books, not individual photos. Model release required. Property release preferred. Captions required.

Making Contact & Terms: Interested in receiving work from newer, lesser-known photographers. Query with book project. Uses 35mm, 2¼ × 2¼, 4 × 5 transparencies. "Although we will deal with larger formats if necessary, we prefer 35mm for transfer to Kodak Photo CD." Keeps samples on file. SASE. Reports in 1 month. NPI; royalty on complete book projects. Credit lines given. Buys all rights. Simultaneous submissions OK.

Tips: "Provide a contact with a tourist attraction, chamber of commerce or other entity willing to purchase souvenir books. We *only* are interested in complete illustrated book projects for the souvenir market with very targeted markets."

***JOHN MUIR PUBLICATIONS**, P.O. Box 613, Santa Fe NM 87504. (505)982-4078. Fax: (505)988-1680. Design and Production Manager: Kathryn Lloyd-Strongin. Estab. 1969. Publishes adult travel (trade), juvenile nonfiction (science, inter-cultural). Photos used for text illustration and book covers. Examples of recently published titles: *101 Crafty Creatures in the Wetlands*, *Sacred Sites* and *Unique Washington*.

• This publisher scans photos and places them electronically, to be output from disk.

Needs: Buys "hundreds" of photos annually. Reviews stock photos. Model/property release preferred.

Making Contact & Terms: Query with samples. Query with stock photo list. Uses 35mm, 4 × 5 transparencies. Provide résumé, business card, brochure, flier or tearsheets to be kept on file for possible future assignments. Keep samples on file. SASE. Reports back "only if we wish to use material or

photographer." NPI. Credit line given. Buys one-time rights; rights negotiable. Simultaneous submissions and previously published work OK.

Tips: "After sending list or samples follow up regularly."

MUSIC SALES CORP., 257 Park Ave. S., New York NY 10010. (212)254-2100. Contact: Daniel Earley. Publishes instructional music books, song collections and books on music. Recent titles include: *Bob Dylan 30th Anniversary Concert Celebration*; *Stone Temple Pilots: Purple*; and *10,000 Maniacs: MTV Unplugged*. Photos used for cover and/or interiors.

Needs: Buys 200 photos annually. Present model release on acceptance of photo. Captions required.

Making Contact & Terms: Query first with résumé of credits. Provide business card, brochure, flier or tearsheet to be kept on file for possible future assignments. Uses 8×10 glossy prints; 35mm, 2×2 or 5×7 transparencies. SASE. Reports in 2 months. Pays $50-75/b&w photo, $250-750/color photo. Simultaneous submissions and previously published work OK.

Tips: In samples, wants to see "the ability to capture the artist in motion with a sharp eye for framing the shot well. Portraits must reveal what makes the artist unique. We need rock, jazz, classical—on stage and impromptu shots. Please send us an inventory list of available stock photos of musicians. We rarely send photographers on assignment and buy mostly from material on hand." Send "business card and tearsheets or prints stamped 'proof' across them. Due to the nature of record releases and concert events, we never know exactly when we may need a photo. We keep photos on permanent file for possible future use."

W.W. NORTON AND COMPANY, 500 Fifth Ave., New York NY 10110. (212)354-5500. Fax: (212)869-0856. Trade and College Department: Ms. Ruth Mandel and Kate Brewster. Estab. 1923. Photos used for text illustration, book covers and dust jackets. Examples of recently published titles: *Biology: An Exploration of Life, 4th Edition*, and *Abnormal Psychology, 3rd Edition*.

Needs: Variable. Photo captions preferred.

Making Contact & Terms: Interested in receiving work from newer, lesser-known photographers. Send stock photo list. Do not enclose SASE. Reports as needed. NPI. Credit line given. Buys one-time rights; negotiable. Simultaneous submissions and previously published work OK.

Tips: Views photo rates as too high. "We are buying down, negotiating harder, shopping around—anything to save money."

***THE OLIVER PRESS**, Charlotte Square, 5707 W. 36th St., Minneapolis MN 55416-2510. (612)926-8981. Fax: (612)926-8965. Editor: James Satter. Estab. 1991. Publishes history books and collective biographies for the school and library market. Photos used for text illustration, promotional materials and book covers. Examples of recently published titles: *Women of the U.S. Congress* (9 freelance photos in the book, 1 on the back cover); *Women who Reformed Politics* (7 freelance photos in the book); and *Amazing Archaeologists and Their Finds* (8 freelance photos in the book, 3 on the front cover).

Needs: Buys 15 freelance photos annually, but we would like to increase this number. Photographs of people in the public eye: politicians, business people, activists, etc. Reviews stock photos. Captions required; include the name of the person photographed, the year, and the place/event at which the picture was taken.

Making Contact & Terms: Interested in receiving work from newer, lesser-known photographers. Query with stock photo list. Uses 8×10 glossy b&w prints. Keeps samples on file. SASE. Reports in 1 month. Pays $35-50/b&w photo. Pays on publication. Credit line given. Buys book rights, including the right to use photos in publicity materials; negotiable. Simultaneous submissions and previously published work OK.

Tips: "We are primarily interested in photographs of public officials, or people in other fields (science, business, law, etc.) who have received national attention. We are not interested in photographs of athletes and entertainers. Do not send unsolicited photos. Instead, send us a list of the major subjects you have photographed in the past."

C. OLSON & CO., P.O. Box 100-PM, Santa Cruz CA 95063-0100. (408)458-3365. Editor: C. L. Olson. Estab. 1977. Examples of recently published titles: *World Health, Carbon Dioxide & the Weather* (cover).

Needs: Uses 2 photos/year—b&w or color; all supplied by freelance photographers. Photos of well-known natural hygienists. Also, photos of fruit and nut trees (in blossom or with fruit) in public access locations like parks, schools, churches, streets, businesses. You should be able to see the fruits up close with civilization in the background." Also needs photos of people under stress from loud noise, photos relating to male circumcision, photos showing people (children and/or adults) wounded in war. Model/property release required for posed people and private property. Captions preferred.

Making Contact & Terms: Interested in receiving work from newer, lesser-known photographers. Query with samples. SASE, plus #10 window envelope. Reports in 2 weeks. NPI; "all rates negotia-

ble." Pays on acceptance or publication. Credit line given on request. Buys all rights. Simultaneous submissions and previously published work OK.

Tips: Open to both amateur and professional photographers. "To ensure that we buy your work, be open to payment based on a royalty for each copy of a book we sell."

OUR SUNDAY VISITOR, INC., 200 Noll Plaza, Huntington IN 46750. (219)356-8400. Fax: (219)356-8472. Managing Editor: Richard G. Beemer. Estab. 1912. Publishes religious (Catholic) periodicals, books and religious educational materials. Photos used for text illustration, promotional materials, book covers and dust jackets. Examples of recently published titles: *The Making of Saints* (b&w on cover); *Spanish Roots of America* (color on cover); and *Operation Rescue* (color on cover).

Needs: Buys 15-20 photos annually; offers 10-15 freelance assignments annually. Interested in family settings, "anything related to Catholic Church." Reviews stock photos. Model/property release required. Captions preferred.

Making Contact & Terms: Interested in receiving work from newer, lesser-known photographers. Query with samples. Works with freelancers on assignment only. Uses 8×10 glossy, color and/or b&w prints; 35mm transparencies. Keeps samples on file. SASE. Reports in 1 month. NPI. Pays on acceptance, receipt of invoice. Credit line given. Buys one-time rights.

***OUTDOOR EMPIRE PUBLISHING, INC.**, Box C-19000, Seattle WA 98109. (206)624-3845. Human Resource Director: Margaret Durante. Publishes how-to, outdoor recreation and large-sized paperbacks. Photos used for text illustration, promotional materials, book covers and newspapers.

Needs: Buys 6 photos annually; offers 2 freelance assignments annually. Wildlife, hunting, fishing, boating, outdoor recreation. Model release preferred. Captions preferred.

Making Contact & Terms: Query with samples or send unsolicited photos by mail for consideration. Provide résumé, business card, brochure, flier or tearsheets to be kept on file for possible future assignments. Works on assignment only. Uses 8×10 glossy b&w and color prints; 35mm, $2\frac{1}{4} \times 2\frac{1}{4}$ and 4×5 transparencies. SASE. Reports in 3 weeks. NPI; payment "depends on situation/publication." Credit line given. Buys all rights. Simultaneous submissions and previously published work OK.

Tips: Prefers to see slides or contact sheets as samples. "Be persistent; submit good quality work. Since we publish how-to books, clear informative photos that tell a story are very important."

RICHARD C. OWEN PUBLISHERS, INC., P.O. Box 585, Katonah NY 10536. (914)241-2997. Fax: (914)241-2878. Editor (Children's Books): Janice Boland. Editor (Professional Books): Amy Haggblom. Publishes picture/storybook fiction and nonfiction for 5- to 7-year-olds; author autobiographies for 7- to 10-year-olds; professional books for educators. Photos used for text illustration, promotional materials, and book covers of professional books. Examples of recently published titles: *Fire Talking* (photos used on cover and as illustrations for each page, promotional shot of author); *Haukola Hello Friend, Playing with Words* (page and cover).

Needs: Number of photos bought annually varies; offers 3-10 freelance assignments annually. Needs unposed people shots. "For children's books, must be child-appealing with rich, bright colors and scenes, no distortions or special effects. For professional books, similar, but often of classroom scenes, including teachers. Nothing posed, should look natural and realistic." Reviews stock photos of children involved with books and classroom activities, age ranging from kindergarten to sixth grade, "not posed or set up, not portrait type photos. Realistic!" Model release required for children and adults. Children (under the age of 21) must have signature of legal guardian. Property release preferred. Captions required. Include "any information we would need for acknowledgements, including if special permission was needed to use a location."

Making Contact & Terms: Interested in receiving work from newer, lesser-known photographers. Submit portfolio by mail for review. Provide résumé, business card, brochure, flier, or tearsheets to be kept on file for possible future assignments. Include a cover letter with name, address, and daytime phone number, and indicate *Photographer's Market* as a source for correspondence. Works with freelancers on assignment only. "For samples, we like to see any size color prints. For materials that are to be used, we need 35mm mounted transparencies. We usually use full-color photos." Keeps samples on file "if appropriate to our needs." Reports in 1 month. Pays $800-1,800/job. "Each job has its own payment rate and arrangements." Pays on acceptance. Credit line given sometimes, depending on the project. "Photographers' credits appear in children's books, and in professional books, but not in promotional materials for books or our company." For children's books, publisher retains ownership, possession and world rights, and applies to first and all subsequent editions of a particular title, and to all promotional materials. Simultaneous submissions OK.

Tips: Wants to see "real people in natural, real life situations. No distortion or special effects. Bright, clear images with jewel tones and rich colors. Try to think about what would appeal to children. Be familiar with what the publishing company has already done. Listen to the needs of the company."

PAPIER-MACHÉ PRESS, 135 Aviation Way, #14, Watsonville CA 95076. (408)763-1420. Fax: (408)763-1421. Editor: Sandra Haldeman Martz. Estab. 1984. Publishes adult trade paperbacks and

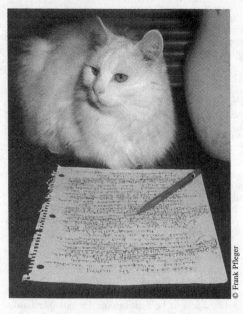

Janice Boland, children's book editor for Richard C. Owen Publishers Inc., says this image, taken by Frank Pfleger of Monroe, New York, was used on the dedication page in an autobiography by Pfleger's wife, Jean Fritz. The cat in the photo is "revising" one of Fritz's manuscripts. Boland liked the playful approach because it would appeal to kids.

© Frank Pfleger

hardcovers focusing on issues of interest to midlife and older women and for men and women on aging. Photos used for text illustration and promotional materials. Examples of published titles: *Why Flowers Bloom* (13 photos); *When I Am an Old Woman I Shall Wear Purple* (19 photos), and *If I Had My Life to Live Over I Would Pick More Daisies* (17 photos). "Guidelines for current theme anthologies are available with #10 SASE."

Needs: Buys 60-80 photos annually; offers 2-3 freelance assignments annually. Human interest, usually women in "doing" role; sometimes couples, families, etc. Sometimes reviews stock photos. Model/property release preferred. "Generally we do not caption photos except for photographer's name."

Making Contact & Terms: Interested in receiving work from newer, lesser-known photographers. Query with samples (including photocopies). Provide résumé, business card, brochure, flier or tearsheets to be kept on file for possible future assignments. Uses 8 × 10 glossy b&w prints. Keeps samples on file. SASE. Reports in 3-6 months. "Guidelines for current theme anthologies are available with #10 SASE." Pays $25-50/b&w photo; $300-500/job; photographers also receive "copies of books, generous discount on books." Credit line given. Buys one-time rights and rights to use photos in promo material for books, e.g. fliers, ads, etc.; negotiable. Simultaneous submissions and previously published work OK.

Tips: "We are generally looking for photos to complement a specific theme anthology or poetry collection. It is essential for photographers to know what those current themes are."

PEANUT BUTTER PUBLISHING, 226 2nd Ave. W., Seattle WA 98119. (206)281-5965. Publisher: Elliott Wolf. Estab. 1971. Publishes cookbooks (primarily gourmet); restaurant guides; novels, children's books, assorted adult trade books. Photos used for promotional materials and book covers.

Needs: Buys 24-36 photos/year; offers up 5 freelance assignments/year. "We are primarily interested in shots displaying a variety of foods in an appealing table or buffet setting. Good depth of field and harmonious color are important. We are also interested in cityscapes that capture one or another of a city's more pleasant aspects. No models." Reviews stock photos.

Making Contact & Terms: Arrange a personal interview to show portfolio. Query with samples or send unsolicited photos by mail for consideration. Uses 2¼ × 2¼ or 4 × 5 slides. SASE. Reports in 2 weeks. Pays $50-300/color photo. Credit line given. Buys one-time, exclusive product and all rights. Simultaneous submissions and previously published work OK.

PELICAN PUBLISHING CO., 1101 Monroe St., Gretna LA 70053. (504)368-1175. Fax: (504)368-1195. Production Manager: Dana S. Bilbray. Publishes adult trade, juvenile, textbooks, how-to, cooking, fiction, travel, science and art books. Photos used for book covers. Examples of recently published titles: *Maverick Hawaii* (cover), *Maverick Berlin* and *Coffee Book.*

Needs: Buys 8 photos annually; offers 3 freelance assignments annually. Wants to see travel (international) shots of locations and people and cooking photos of food. Reviews stock photos of travel subjects. Model/property release required. Captions required.

Making Contact & Terms: Interested in receiving work from newer, lesser-known photographers. Query with stock photo list. Provide résumé, business card, brochure, flier or tearsheets to be kept on file for possible future assignments. Uses 8 × 10 glossy color prints; 35mm, 4 × 5 transparencies. Keeps samples on file. SASE. Reports as needed. Pays $100-500/color photo; negotiable with option for books as payment. **Pays on acceptance.** Credit line given. Buys one-time rights and book rights; negotiable.
Tips: "Be flexible on price. Keep publisher up on new materials."

THE PHOTOGRAPHIC ARTS CENTER, 163 Amsterdam Ave., #201, New York NY 10023. (212)838-8640. Fax: (212)873-7065. Publisher: Robert S. Persky. Estab. 1980. Publishes books on photography and art, emphasizing the business aspects of being a photographer, artist and/or dealer. Photos used for book covers. Examples of recently published titles: *Publishing Your Art as Cards, Posters & Calendars* (cover illustration); and *The Photographer's Complete Guide to Exhibition & Sales Spaces* (text illustration).
Needs: Business of photography and art. Model release required.
Making Contact & Terms: Query with samples and text. Uses 5 × 7 glossy b&w or color prints; 35mm transparencies. SASE. Reports in 3 weeks. Pays $25-100/b&w and color photos. Credit line given. Buys one time rights.
Tips: Sees trend in book publishing toward "books advising photographers how to maximize use of their images by finding business niches such as gallery sales, stock and cards and posters." In freelancer's submissions, looks for "manuscript or detailed outline of manuscript with submission."

PLAYERS PRESS INC., P.O. Box 1132, Studio City CA 91614. (818)789-4980. Vice President: David Cole. Estab. 1965. Publishes entertainment books including theater, film and television. Photos used for text illustration, promotional materials, book covers and dust jackets. Examples of published titles: *Corrugated Cardboard Scenery* (text/cover illustration); *Stage Make-up Techniques* (text illustration); *Scenes for Acting & Directing V2* (text illustration).
Needs: Buys 50-1,000 photos annually. Needs photos of entertainers, actors, directors, theaters, productions, actors in period costumes, scenic designs and clowns. Reviews stock photos. Model release required for actors, directors, productions/personalities. Photo captions preferred for names of principals and project/production.
Making Contact & Terms: Interested in receiving work from newer, lesser-known photographers. Query with list of stock photo subjects. Send unsolicited photos by mail for consideration. Uses 8 × 10 glossy or matte b&w prints; 5 × 7 glossy color prints; 35mm, 2¼ × 2¼ transparencies. SASE. Reports in 3 weeks. Pays $5-500/color photo; $1-200/b&w photo; $25-500/job. Credit line sometimes given, depending on book. Buys all rights; negotiable in "rare cases." Simultaneous submissions and previously published work OK.
Tips: Wants to see "photos relevant to the entertainment industry. Do not telephone; submit only what we ask for."

PRAKKEN PUBLICATIONS, INC., 275 Metty Dr., Suite 1, P.O. Box 8623, Ann Arbor MI 48107. (313)769-1211. Fax: (313)769-8383. Production & Design Manager: Sharon K. Miller. Estab. 1934. Publishes *The Education Digest* (magazine), *Tech Directions* (magazine for technology and vocational/technical educators), text and reference books for technology and vocational/technical education and general education reference. Photos used for text illustration, promotional materials, book covers, magazine covers and text. Examples of published titles: *Chisels on a Wheel: Modern Woodworking Tools and Materials* (cover and text, marketing), *Managing the Occupational Education Laboratory* (text and marketing); and *The Education Digest, Tech Directions* (covers and marketing). No photo guidelines available.
Needs: Education "in action" and especially technology and vocational-technical education. Photo captions necessary; scene location, activity.
Making Contact & Terms: Query with samples. Send unsolicited photos by mail for consideration. Uses any size image and all media. Keeps sample on file. SASE. NPI. Methods of payment to be arranged. Credit line given. Rights negotiable.
Tips: Wants to see "experience in education and knowledge of high-tech equipment" when reviewing portfolios. Send inquiry with relevant samples to be kept on file.

***PROSTAR PUBLICATIONS LTD.**, 13468 Beach Ave., Marina del Rey CA 90292. (310)577-1975. Fax: (310)577-9272. Editor: Peter L. Griffes. Estab. 1989. Publishes how-to, nonfiction. Photos used for book covers. Examples of recently published titles: *Pacific Boating Almanac* (aerial shots of marinas); and *Pacific Northwest Edition*. Photo guidelines free with SASE.
Needs: Buys less than 100 photos annually; offers very few freelance assignments annually. Reviews stock photos of nautical (sport). Model/property release required. Captions required.
Making Contact & Terms: Interested in receiving work from newer, lesser-known photographers. Query with stock photo list. Uses color and b&w prints. Does not keep samples on file. SASE. Reports

in 1 month. Pays $10-50/color or b&w photo. Pays on publication. Credit line not given. Buys book rights; negotiable. Simultaneous submissions and previously published work OK.

❧REIDMORE BOOKS INC., 10109 106th St., Suite 1200, Edmonton, Alberta T5J 3L7. (403)424-4420. Fax: (403)441-9919. Contact: Visuals Editor. Estab. 1979. Publishes textbooks for K-12; textbooks published cover all subject areas. Photos used for text illustration and book covers. Examples of published titles: *Greece: Discovering the Past, China: Our Pacific Neighbour* and *Canada's Atlantic Neighbours*. Photo guidelines available.
Needs: Buys 250 photos annually; offers 1-3 freelance assignments annually. "Photo depends on the project, however, images should contain unposed action." Reviews stock photos. Model/property release preferred. Captions required; "include scene description and photographer's control number."
Making Contact & Terms: Interested in receiving work from newer, lesser-known photographers. Arrange personal interview to show portfolio. Submit portfolio for review. Query with résumé of credits. Query with samples. Query with stock photo list. Provide résumé, business card, brochure, flier or tearsheets to be kept on file for possible future assignments. Keeps samples of tearsheets, etc. on file. Cannot return material. Reports in 1 month. Pays $50-200/color photo; $50-200/b&w photo. Credit line given. Buys one-time rights and book rights; negotiable. Simultaneous submissions and previously published work OK.
Tips: "I look for unposed images which show lots of action. Please be patient when you submit images for a project. The editorial process can take a long time and it is in your favor if your images are at hand when last minute changes are made."

SALEM PRESS, 131 N. El Molino, Pasadena, CA 91101. Photo Editor: Valerie Krein. Publishes reference books, encyclopedias, biographies, historical series. Photos used for text illustration, book covers. Examples of recently published titles: *African American Encyclopedia* (b&w, most ¼ page); biographies for middle school students (b&w and color); and *20th Century Events* (b&w).
Needs: Needs people pictures related to American social issues, including many minority and multicultural photos. Model release preferred for famous people.
Making Contact & Terms: Interested in receiving work from newer, lesser-known photographers. Query with stock photo list. "I use small amounts of color stock material from all areas, rare small assignments. We use mostly b&w 8×10 photos, although I sometimes make color transfers to b&w." Pays $75-100/color photo; $45-50/b&w photo. Pays on publication. Credit line given. Buys one-time rights; negotiable ("depends on situation"). Simultaneous submissions and/or previously published work OK.
Tips: Looks for "clarity, composition, unposed, natural looking." Interested in "can-do, responsive photographers with good quality. We use photo researchers also, especially experienced researchers in Washington DC and New York."

SILVER MOON PRESS, 126 Fifth Ave., New York NY 10011. (212)242-6499. Fax: (212)242-6799. Editor: Eliza Booth. Estab. 1991. Publishes juvenile fiction and general nonfiction. Photos used for text illustration, book covers, dust jackets. Examples of published titles: *Police Lab* (interiors); *Drums at Saratoga* (interiors); *A World of Holidays* (interiors).
Needs: Buys 30-40 photos annually; offers 1-2 freelance assignments annually. Looking for general—children, subject-specific photos. Reviews general stock photos. Captions preferred.
Making Contact & Terms: Interested in receiving work from newer, lesser-known photographers. Query with samples. Provide résumé, business card, brochure, flier or tearsheets to be kept on file for possible future assignments. Uses vary greatly. Keeps samples on file. SASE. Reports in 1 month. Pays $25-100/color photo; $25-100/b&w photo. Pays on publication. Credit line given. Buys all rights; negotiable. Simultaneous submissions and/or previously published works OK.

THE SPEECH BIN INC., 1965 25th Ave., Vero Beach FL 32960. (407)770-0007. Fax: (407)770-0006. Senior Editor: Jan J. Binney. Estab. 1984. Publishes textbooks and instructional materials for speech-language pathologists, audiologists and special educators. Photos used for book covers, instructional materials and catalogs. Examples of recently published titles: *Talking Time* (cover); also catalogs.
Needs: Scenics are currently most needed photos. Also needs children; children with adults; school scenes; elderly adults; handicapped persons of all ages. Model release required.
Making Contact & Terms: Interested in receiving work from newer, lesser-known photographers. Provide résumé, business card, brochure, flier or tearsheets to be kept on file for possible future

 The maple leaf before a listing indicates that the market is Canadian.

assignments. Works on assignment plus purchases stock photos from time to time. Uses 8×10 glossy b&w prints. Full-color scenics for catalog. SASE. Reports in 3 weeks. NPI; negotiable. Credit line given. Buys all rights; negotiable. Previously published work OK.

THE SPIRIT THAT MOVES US PRESS, P.O. Box 720820, Jackson Heights NY 11372-0820. (718)426-8788. Editor/Publisher: Morty Sklar. Estab. 1975. Publishes adult trade fiction, poetry and essays. Photos used for book covers, dust jackets, and as art (not as illustrations). Examples of recently published titles: *Editor's Choice III* (in text pages); *Speak to Me* (on cover and in text); and *Men & Women* (on cover and in text).
Needs: Buys 10-20 photos annually; offers 10-20 freelance assignments annually. Subject matter varies with book, but "expressive" images are preferred over formal shots.
Making Contact & Terms: Interested in receiving work from newer, lesser-known photographers. "95% of what we publish is unsolicited." Query with SASE for needs. Uses 8×10 glossy b&w prints. Keeps samples on file if interested. SASE. Reports in 1-2 weeks. Pays $100 for cover; same as writers for text photos and copies of book. Pays on publication. Credit line given. Buys one-time and possible repeat (anthology) rights; negotiable. Simultaneous submissions and previously published work OK "if they let us know at time of submission."
Tips: "Send us what you love best. Don't try to give us what you think we want at the exclusion of your own tastes. We always love and depend on photographs."

STANDARD EDUCATIONAL CORP., 200 W. Madison, Suite 300, Chicago IL 60606. (312)346-7440. Fax: (312)580-7215. Picture Editor: Irene L. Ferguson. Publishes the New Standard Encyclopedia. Photos used for text illustration. To see style/themes used, look at encyclopedias in library, especially New Standard Encyclopedia.
Needs: Buys 300 photos annually (stock photos only). Major cities and countries, points of interest, agricultural and industrial scenes, plants and animals. Model release preferred. Captions required.
Making Contact & Terms: Query with stock photo list. Do not send unsolicited photos. Uses 8×10 glossy b&w prints; contact sheet OK; uses transparencies. SASE. Reports in 1 month. Pays $75-125/b&w photo; $135-300/color photo. Credit line given. Buys one-time rights. Simultaneous submissions and previously published work OK.

***STAR PUBLISHING COMPANY**, 940 Emmett Ave., Belmont CA 94002. (415)591-3505. Managing Editor: Stuart Hoffman. Estab. 1978. Publishes textbooks, regional history, professional reference books. Photos used for text illustration, promotional materials and book covers. Recently published: *Microbiology Techniques* (cover and text illustration); *Keyboarding with Computer Applications* (text illustration); and *Principles and Practices of Anaerobic Bacteriology* (text illlustration).
Needs: Biological illustrations, photomicrographs, business, industry and commerce. Reviews stock photos. Model release required. Captions required.
Making Contact & Terms: Query with samples and list of stock photo subjects. Provide résumé, business card, brochure, flier or tearsheets to be kept on file for possible future assignments. Uses 5×7 minimum b&w and color prints; 35mm transparencies. SASE. Reports within 90 days when a response is appropriate. NPI; payment variable "depending on publication, placement and exclusivity." Credit line given. Buys one-time rights; negotiable. Previously published submissions OK.
Tips: Wants to see photos that are technically (according to book's subject) correct, showing photographic excellence.

❦THISTLEDOWN PRESS LTD., 633 Main St., Saskatoon, Saskatchewan S7H 0J8 Canada. (306)244-1722. Fax: (306)244-1762. Director of Production: A.M. Forrie. Publishes adult/young adult fiction and poetry. Photos used for text illustration, promotional materials, book covers.
Needs: Looking for realistic color or b&w photos.
Making Contact & Terms: Query with samples. Include SASE. "Project oriented—rates negotiable."

***THORSON & ASSOCIATES**, P.O. Box 94135, Washington MI 48094. (810)781-0907. New Product Development: Timothy D. Thorson. Estab. 1988. Technical publisher and book producer creating trade and specialized projects for a variety of clients.
● This publisher is very interested in photographers with multimedia experience such as CD-ROM, Macromedia Director, etc.
Needs: Offers 2-3 freelance assignments annually. Needs aviation/military, automotive and architectural subjects. Reviews stock photos of aviation/military, automotive, architecture and the arts. Captions preferred; include subject, location, rights offered.
Making Contact & Terms: Interested in receiving work from newer, lesser-known photographers. Query with stock photo list. Provide résumé, business card, brochure, flier or tearsheets to be kept on file for possible future assignments. Works on assignment only. Keeps samples on file. SASE. Reports

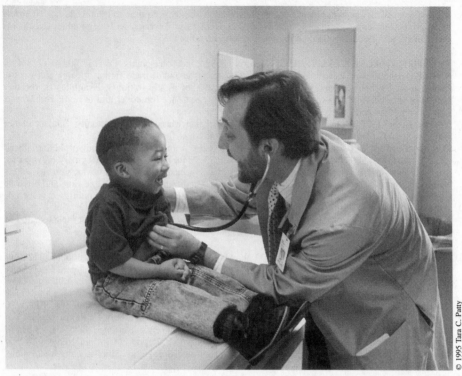

© 1995 Tara C. Patty

The rapport between a doctor and his young patient is obvious in this photo by Chaska, Minnesota, photographer Tara Patty. The image was used in an annual report by the Association for the Care of Children's Health in Bethesda, Maryland, and it sold for $150 to Tyndale House Publishers. Tyndale used the image in a calendar.

in 1 month. NPI; payment negotiable. Pays on usage. Credit line sometimes given depending upon customer. Rights vary based on project; negotiable.

Tips: "We need reliable, self-motivated photographers to provide photos for assigned books in a wide range of fields. Thorson & Associates is also open to original book proposals suggested by a photographer's work or experience; special access to museums or collections, collections of old aircraft, military equipment, classic automobiles, or significant historical buildings. I anticipate a considerable increase in our needs over the next 12-24 months."

TICKNOR & FIELDS BOOKS FOR YOUNG READERS, 215 Park Ave. S., New York NY 10003. (212)420-5800. Art Director: David Saylor. Estab. 1992. Publishes children's trade picture books. Interested in photo essay books on any subject. Photos used for text illustration, book covers. Examples of recently published titles: *A Year on Monhegan Island* (photo essay about life on an island); *A Book of Fruit* (hand-tinted photos of fruit and where they grow); and *The Four Seasons* (photo essay about Amish life).

Needs: The number of photos bought annually varies, as does the number of assignments offered. Prefers photos with a strong personal vision of an interesting subject of the photographer's choice. Model release required. Captions required; include with ms of book after signing contract.

Making Contact & Terms: Interested in receiving work from newer, lesser-known photographers as well as established professionals. Submit portfolio for review on Wednesdays only (9 am-noon; pick-up after 4 pm). Query with samples. Send unsolicited photos by mail for consideration. Provide résumé, business card, brochure, flier or tearsheets to be kept on file for possible future assignments. Do not send original art/photos. Uses 8×10 color and b&w prints; 35mm, 2¼×2¼, 4×5, 8×10 transparencies. Keeps samples on file if interested. SASE. Pays an advance against royalty (half on signing; half on delivery). Credit line given. Buys book rights including electronic rights.

Tips: Looks for a "strong personal style; nothing resembling stock or generic photos. Looking for strong photo/essay books."

***TRAKKER MAPS INC.**, 12027 SW 117th Ct., Miami FL 33186. (305)255-4485. Fax: (305)232-5257. Production Manager: John Forsyth. Estab. 1980. Publishes street atlases and folding maps.

Photos used for covers of folding maps and atlas books. Examples of recently published titles: Florida Folding Map (cover illustration).

Needs: Buys 3 photos annually. Photos that illustrate the lifestyle/atmosphere of a city or region (beach, swamp, skyline, etc.). Reviews stock photos of Florida cities.

Making Contact & Terms: Interested in receiving work from newer, lesser-known photographers. Provide résumé, business card, brochure, flier or tearsheets to be kept on file for possible future assignments. Uses color prints; 35mm, 2¼ × 2¼ transparencies. Keeps samples on file. SASE. Reports in 1 month. Pays $50-200/color photo. Pays on receipt of invoice. Credit line sometimes given depending upon request of photographer. Buys all rights. Simultaneous submissions and previously published work OK.

Tips: "We want to see "clarity at 4 × 4½" (always vertical) and 6 × 8" (always horizontal); colors that complement our red-and-yellow cover style; subjects that give a sense of place for Florida's beautiful cities; scenes that draw customers to them and make them want to visit those cities and, naturally, buy one of our maps or atlases to help them navigate. Have patience. We buy few freelance photos but we do buy them. Let your photos do your talking for you; don't hassle us. *Listen* to what we ask for. More and more, we want eye-grabbing shots that *say* the name of the city. For example, a photo of a polo match on the cover of the West Palm Beach folding map says 'West Palm Beach" better than a photo of palm trees or flamingos."

TRANSPORTATION TRAILS, 9698 W. Judson Rd., Polo IL 61064. (815)946-2343. Editor: Larry Plachno. Estab. 1977. Publishes historical transportation titles. Photos used for text illustration, promotional materials, book covers, dust jackets and condensed articles in magazines. Examples of published titles: *The Longest Interurban Charter* (text and cover); *Sunset Lines—The Story of The Chicago Aurora & Elgin Railroad* (text); *The Steam Locomotive Directory of North America* (text).

Needs: Buys over 500 photos annually. Transportation, mainly bus or interurban, mainly historical.

Making Contact & Terms: Query with samples of historical transportation photos. Uses glossy b&w prints; 35mm transparencies. SASE. Reports in 1 week. Rates vary depending on needs; $2.50-150/ b&w photo. Credit line given. Buys one-time, book and all rights; negotiable. Simultaneous submissions and previously published work OK.

Tips: In photographer's samples, "quality is not as important as location and date." Looks for "historical photos of buses and interurbans. Don't bother us with photos less than 30 years old."

2M COMMUNICATIONS LTD., 121 W. 27 St., New York NY 10001. (212)741-1509. Fax: (212)691-4460. President: Madeleine Morel. Estab. 1982. Publishes adult trade biographies. Photos used for text illustration. Examples of previously published titles: *Diane Keaton, Magic and the Bird* and *The Princess and the Duchess;* all for text illustration.

Needs: Buys approximately 200 photos annually. Candids and publicity. Reviews stock photos. Model release required. Captions preferred.

Making Contact & Terms: Query with stock photo list. Uses b&w prints; 35mm transparencies. Reports in 1 month. Pays $100-200/color photo, $50-100/b&w photo. Credit line given. Buys one-time, book and world English language rights. Simultaneous submissions OK.

TYNDALE HOUSE PUBLISHERS, 351 Executive Dr., Wheaton IL 60189. (708)668-8300. Fax: (708)668-6885. Purchase Agent, Design Dept.: Marlene Muddell. Estab. 1962. Publishes adult trade, children and juvenile fiction, Bibles and Bible reference, calendars and videos for children. Photos used for text illustration, promotional materials, book covers, dust jackets, calendar and video boxes. Examples of recently published titles: *Cool* (text and cover); *His Father Saw Him Coming* (cover); and *Common-sense Parenting* (cover).

● This publisher wants to be able to manipulate photo images with its Macintosh computer system, within ethical boundaries. "We're sometimes ghosting images as backgrounds."

Needs: Buys 25-50 photos annually; offers 10 assignments annually. Nature, conservation and people, especially families of mixed ages and backgrounds, Holy Land. Especially needed are color photos of various ethnics working together. Reviews stock photos. Model/property release required for shots in which faces are identifiable, private property.

Making Contact & Terms: Interested in receiving work from newer, lesser-known photographers. Arrange personal interview to show portfolio. Submit portolio for review. Query with samples. Query

Market conditions are constantly changing! If you're still using this book and it's 1997 or later, buy the newest edition of Photographer's Market at your favorite bookstore or order directly from Writer's Digest Books.

with stock photo list. Works on assignment only. Uses 8×10 glossy b&w or color prints; 35mm; 2¼×2¼, 4×5 transparencies. Keeps samples on file. SASE. Reports in 3 weeks. Pays $250-1,500/ color photo; $75-200/b&w photo. The upper-end figures are offered for high-quality work. **Pays on acceptance**. Credit line given. Buys book and audio rights, world reproduction rights, foreign language rights, unless otherwise negotiated. Simultaneous submissions and/or previously published work OK.
Tips: "We look for people shots which convey as much universality as possible. We want pictures that tell a story, especially of helping and working together situations; marriage and family (must have wedding bands), as well as contemplative scenics; contemporary urban issues. We like ethnic shots. Be concerned about backgrounds. Often it's helpful to have quiet, neutral areas where type can be placed easily. Because of our Christian orientation, Biblical allusions and Holy Land shots are also useful."

ULYSSES PRESS, P.O. Box 3440, Berkeley CA 94703. (510)601-8301. Fax: (510)601-8307. Publisher: Leslie Henriques. Estab. 1983. Publishes trade paperbacks and travel material. Photos used for book covers. Examples of previously published titles: *Hidden Hawaii* (cover photos on front and back); *New Key to Costa Rica* (color signature) and *Hidden Southwest* (cover photos).
Needs: Buys 30 photos annually. Wants scenic photographs of destinations covered in guidebook. Some use of portraits for back cover. Model release required. Property release preferred.
Making Contact & Terms: Interested in receiving work from newer, lesser-known photographers. Query with stock photo list. Provide résumé, business card, brochure, flier or tearsheets to be kept on file for possible future assignments. Uses 35mm, 2¼×2¼ transparencies. Does not keep samples on file. Cannot return material. Reports as needed. Payment depends on placement and size of photo: $150-350 non-agency. Pays on publication. Credit line given. Buys one-time rights. Simultaneous submissions and previously published work OK.

***U.S. NAVAL INSTITUTE**, 118 Maryland Ave., Annapolis MD 21402. (410)268-6110. Fax: (410)269-7940. Picture Editor: Charles L. Mussi. Estab. 1873. Publishes naval and maritime subjects, novels. Photos used for text illustration, promotional materials, book covers and dust jackets. Examples of recently published titles: *The Hunt for Red October* (book cover); *The U.S.N.I. Guide to Combat Fleet* (70% photos); and *A Year at the U.S. Naval Academy* (tabletop picture book). Photo guidelines free with SASE.
Needs: Buys 240 photos annually; offers 12 freelance assignments annually. "We need dynamic cover-type images that are graphic and illustrative. Reviews stock photos. Model release preferred. Captions required.
Making Contact & Terms: Interested in receiving work from newer, lesser-known photographers. Query with résumé of credits. Uses 8×10 glossy color and b&w prints; 35mm, 2¼×2¼, 4×5, 8×10 transparencies. Keeps samples on file. SASE. Reports in 1-2 weeks. Pays $25-200/color and b&w photos. Pays on publication or receipt of invoice. Credit line given. Buys one-time rights; negotiable. Simultaneous submissions and previously published work OK.
Tips: "Be familiar with publications *Proceedings* and *Naval History* published by U.S. Naval Institute."

UNIVELT, INC., P.O. Box 28130, San Diego CA 92198. (619)746-4005. Manager: Robert H. Jacobs. Estab. 1970. Publishes technical books on astronautics. Photos used for text illustration, book covers and dust jackets. Examples of recently published titles: *Men & Women of Space* and *History of Rocketry and Astronautics*.
Needs: Uses astronautics; most interested in photographer's concept of space, and photos depicting space flight and related areas. Reviews stock photos; space related only. Captions required.
Making Contact & Terms: Interested in receiving work from newer, lesser-known photographers. Query with résumé of credits. Provide business card and letter of inquiry to be kept on file for possible future assignments. Uses 6×9 or 4½×6 b&w photos. SASE. Reports in 1 month. Pays $25-100/b&w photo. Credit line given, if desired. Buys one-time rights. Simultaneous submissions and previously published work OK.
Tips: "Photos should be suitable for front cover or frontispiece of space books."

***VERNON PUBLICATIONS INC.**, 3000 Northup Way, Suite 200, Bellevue WA 98004. Fax: (206)822-9372. Editorial Director: Michele A. Dill. Estab. 1960. Publishes travel guides, a travel magazine for RVers, relocation guides, homeowner guides. Photos used for text illustration, promotional materials and book covers. Examples of recently published titles: *The Milepost*; *RV West* (magazine); and *Info Guide* (annual guide). Photo guidelines free with SASE.
● This publisher likes to see high-resolution, digital images.
Needs: Buys 200-300 photos annually. Model release required. Property release preferred. Captions required; include place, time, subject, and any background information.
Making Contact & Terms: Interested in receiving work from newer, lesser-known photographers. Query with samples. Provide résumé, business card, brochure, flier or tearsheets to be kept on file for

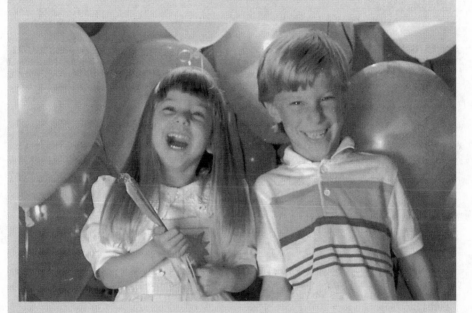

This book cover was shot by photographer Robert Holmes of Mill Valley, California, for Ulysses Press. Leslie Henriques says she frequently assigns work to Holmes because he is easy to work with and he's one of the top local travel photographers.

possible future assignments. Include SASE for return. Uses b&w prints; 35mm, 2¼×2¼ transparencies. SASE. Reporting time varies. NPI. Pays on publication. Credit line given. Buys one-time, book and all rights; negotiable. Simultaneous submissions/previously published work OK; however, it depends on where the images were previously published.

***VISION BOOKS INTERNATIONAL**, 3356A Coffey Lane, Santa Rosa CA 95403. (707)542-1440. Fax: (707)542-1004. Publisher: Kenneth L. Sackett Sr. Estab. 1988. Publishes adult and juvenile; self improvement, health/nutrition, Christian, how-to, cookbooks, art books. Photos used for promotional materials, book covers and dust jackets. Examples of recently published titles: *To Drink or Not to Drink* (cover); *Who's the Affictor* (cover); and *Destroying the Works of the Enemy* (cover).
Needs: Buys 7-20 photos annually. Cover materials. Reviews stock photos of children. Model release required. Property release preferred. Captions preferred; include date, who and where.
Making Contact & Terms: Interested in receiving work from newer, lesser-known photographers. Query with samples. Provide résumé, business card, brochure, flier or tearsheets to be kept on file for possible future assignments. Works on assignment only. Uses 4×5 and 8×10 prints; 8×10 transparencies. Keeps samples on file. Reports in 1-2 months. Pays $25-50/hour; $150-200/day; $150-500/job; $25-100/color photo; royalties. Credit line given. Buys all rights. Simultaneous submissions OK.

J. WESTON WALCH, PUBLISHER, 321 Valley St., P.O. Box 658, Portland ME 04104-0658. (207)772-2846. Fax: (207)772-3105. Contact: Acquisitions. Estab. 1927. Publishes supplementary educational materials for grades 6-12 and adult education. All subject areas. Photos used for text illustration, promotional materials and book covers. Examples of recently published titles: *True Adventure Readers* (3 Art series) (cover photos); *Steps to Good Grammar* (cover photo) and *Science and Social Issues* (text illustration).
Needs: Buys 30-40 or more photos/year; varies widely. Offers up to 5 freelance assignments annually. Black and white and color photos of middle school and high school students, ethnically diverse, in-school, library or real-life situations, historical photos, current events photos, special needs students and chemistry, ecology and biology. Reviews stock photos. Model release required. Captions preferred.
Making Contact & Terms: Interested in receiving work from newer, lesser-known photographers. Provide résumé, business card, brochure, flier or tearsheets to be kept on file for possible future assignments. Uses 8×10 glossy b&w prints; also 35mm, 2¼×2¼, 4×5 and 8×10 transparencies. SASE. Pays $35-100/b&w; $100-500/color photo. Credit line sometimes given depending on photographer's request. Buys one-time rights.
Tips: One trend with this company is a "growing use of b&w and color photos for book covers." Especially wants to see "subjects/styles suitable for use in secondary schools."

***WARNER BOOKS**, 1271 Avenue of the Americas, 9th Floor, New York NY 10020. (212)522-7200. Vice President & Publisher/Warner Treasures, Creative Director/Warner Books: Jackie Merri Meyer. Publishes "everything but text books." Photos used for book covers and dust jackets.
Needs: Buys approximately 20 freelance photos annually; offers approximately 30 assignments annually. People, food still life, glamourous women and couples. Reviews stock photos. Model release required. Captions preferred.
Making Contact & Terms: Send brochure, flier or tearsheets to be kept on file for possible future assignments. Cannot return unsolicited material. Uses color prints/transparencies; also some b&w and hand-tinting. Pays $800 and up/color photo; $1,200 and up/job. Credit line given. Buys one-time rights. Simultaneous submissions and previously published work OK.
Tips: "Printed and published work (color copies are OK, too) are very helpful. Do not call, we do not remember names—we remember samples—be persistent."

***WAVELAND PRESS, INC.**, P.O. Box 400, Prospect Heights IL 60070. (708)634-0081. Fax: (708)634-9501. Photo Editor: Jan Weissman. Estab. 1975. Publishes college textbooks. Photos used for text illustration and book covers. Examples of recently published titles: *Our Global Environment, Fourth Edition* (inside text); *Africa & Africans, Fourth Edition* (chapter openers and cover); and *Principles of Agribusiness Management, Second Edition* (chapter openers).
Needs: Number of photos purchased varies depending on type of project and subject matter. Subject matter should relate to college disciplines: criminal justice, anthropology, speech/communication, sociology, archaeology, etc. Model/property release required. Captions preferred.
Making Contact & Terms: Interested in receiving work from newer, lesser-known photographers. Query with stock photo list. Provide résumé, business card, brochure, flier or tearsheets to be kept on file. Uses 5×7, 8×10 glossy b&w prints. Keeps samples on file. SASE. Reports in 2-4 weeks. Pays $25-200/color photo; $25-100/b&w photo. Pays on publication. Credit line given. Buys one-time and book rights. Simultaneous submissions and previously published work OK.

♣WEIGL EDUCATIONAL PUBLISHERS LIMITED, 1902 11th St. SE, Calgary, Alberta T2G 3G2 Canada. (403)233-7747. Fax: (403)233-7769. Attention: Editorial Department. Estab. 1979. Publishes textbooks and educational resources: social studies, life skills, environment/science studies, multicultural, language arts and geography. Photos used for text illustration and book covers. Example of recently published titles: *Career Connections* (cover and inside) and *Alberta Its People in History* (cover and inside).

Needs: Buys 15-25 photos annually; offers 2-3 freelance assignments annually. Social issues and events, politics, education, technology, people gatherings, multicultural, environment, science, agriculture, life skills, landscape, wildlife and people doing daily activities. Reviews stock photos. Model/property release required. Captions required.

Making Contact & Terms: Interested in receiving work from newer, lesser-known photographers. Query with samples. Query with stock photo list. Provide tearsheets to be kept on file for possible future assignments. Tearsheets or samples that don't have to be returned are best. Keeps samples on file. Uses 5×7, 3×5, 4×6, 8×10 color/b&w prints; 35mm, 2¼×2¼ transparencies. SASE. "We generally get in touch when we actually need photos." Price is negotiable. Credit line given (photo credits as appendix). Buys one-time, book and all rights; negotiable. Simultaneous submissions and previously published work OK.

Tips: Need "clear, well-framed shots that don't look posed. Action, expression, multicultural representation are important, but above all, education value is sought. People must know what they are looking at. Please keep notes on what is taking place, where and when. As an educational publisher, our books use specific examples as well as general illustrations."

SAMUEL WEISER INC., P.O. Box 612, York Beach ME 03910. (207)363-4393. Fax: (207)363-5799. Art Director: Ed Stevens. Estab. 1956. Publishes books on esoterica, Oriental philosophy, alternative health and mystery traditions. Photos used for book covers. Examples of recently published titles: *Modern Mysticism*, by Micheal Gellert (Nicolas Hays imprint); *Foundations of Personality*, by Hamaker-Zondag. Photo guidelines free with SASE.

Needs: Buys 2-6 photos annually. Photos of flowers, abstracts (such as sky, paths, roads, sunsets) and inspirational themes. Reviews stock photos.

Making Contact & Terms: Interested in receiving work from newer, lesser-known photographers. Query with samples. Send unsolicited photos by mail for consideration. Provide résumé, business card, brochure, flier or tearsheets to be kept on file for possible future assignments. "We'll take color snapshots to keep on file, or color copies." Keeps samples on file. Uses color prints, 2¼×2¼ and 4×5 transparencies. SASE. Reports in 1 month. Pays $100-150/color and b&w photos. Credit line given. Buys one-time rights. "We pay once for life of book because we do small runs." Simultaneous submissions and previously published work OK.

Tips: "We don't pay much and we don't ask a lot. We have to keep material on file or we won't use it. Color photocopies, cheap Kodak prints, something that shows us an image that we assume is pristine on a slide and we can call you or fax you for it. We do credit line on back cover, and on copyright page of book, in order to help artist/photographer get publicity. We like to keep inexpensive proofs because we may see a nice photo and not have anything to use it on now. We search our files for covers, usually on tight deadline. We don't want to see goblins and Halloween costumes."

THE WHEETLEY COMPANY, INC., 3201 Old Glenview Rd., Suite 300, Wilmette IL 60091. (708)251-4422. Fax: (708)251-4668. Art Manager: Carol Stutz. Estab. 1986. Produces elementary and high school textbooks in all subjects. Photos used for text illustration and book covers. Examples of recently produced books: *World Geography* (photos used for text and cover illustration, Scholastic); *Mathematics of Money* (photos used for text and cover illustration, South-Western); *Success: Communicating in English* (photos used for text and cover illustration, Addison-Wesley).

Needs: Subject matter depends upon the book being produced. Most photos used are "unposed." Photos frequently call for pictures of school children and young people, including the physically challenged, enjoyably engaged in classroom and school activities. Reviews stock photos. Model release required. Photo captions preferred.

Making Contact & Terms: Interested in receiving work from newer, lesser-known photographers. Query with list of stock photo subjects. Provide résumé, business card, brochure, flier or tearsheets to be kept on file for possible future assignments. Cannot return unsolicited material. Uses glossy b&w prints; 35mm, 2¼×2¼, 4×5 transparencies. Reports in 1 month. Pays $135-165/quarter page of color photos; $60-120/quarter page of b&w photos. Credit line sometimes given depending on the "style established for the book." Buys one-time, exclusive product, North American or world rights; negotiable. Simultaneous submissions and previously published OK.

Tips: Send all information attention: Linda Rogers, Human Resources Manager.

♣WHITECAP BOOKS LTD., 351 Lynn Ave., North Vancouver, British Columbia V7J 2C4 Canada. (604)980-9852. Fax: (604)980-8197. Editorial Director: Robin Rivers. Estab. 1978. Publishes adult

trade, color books, natural history, scenic, gardening; some juvenile nonfiction. Photos used for text illustration, book covers, dust jackets, calendars. Examples of published titles: *Canadian Birds, Canadian Wildlife, Emerald Sea*, all photo essays.

Needs: Buys 500 photos annually. Looking for scenics, wildlife, calendar material. Model release required. Captions required; include basic identification, photographer's name.

Making Contact & Terms: Interested in receiving work from newer, lesser-known photographers. Query with stock photo list. Provide résumé, business card, brochure, flier or tearsheets to be kept on file for possible future assignments. Uses 35mm, 2¼ × 2¼, 4 × 5 transparencies. SASE. $90-100/color photo. Pays on publication. Credit line sometimes given (not usually in text—always a photo credit page). Buys one-time and book rights; negotiable. Simultaneous submissions and/or previously published works OK.

Tips: "We look for wildlife and scenics with good composition, color and a creative approach to conventional subjects. Don't expect to be paid the same rates as in other industries. We are continuing to use freelance photographers on a regular basis."

JOHN WILEY & SONS, INC., 605 Third Ave., New York NY 10158. (212)850-6731. Fax: (212)850-6450. Director, Photo Department: Stella Kupferberg. Estab. 1807. Publishes college texts in all fields. Photos used for text illustration. Examples of recently published titles: *Dynamic Earth*, by Skinner; *Blue Planet*, by Skinner; *Biology*, by Brown (all covers and interior photos).

Needs: Buys 4,000 photos/year; 200 photos used for text and cover illustration. Uses b&w and color photos for textbooks in psychology, business, computer science, biology, physics, chemistry, geography, geology and foreign languages. Captions required.

Making Contact & Terms: Query with list of stock photo subjects. Uses 8 × 10 glossy and semigloss b&w prints; also 35mm and large format transparencies. SASE. "We return all photos securely wrapped between double cardboard by UPS." Pays $100-150/b&w print and $100-225/color transparency. Credit line given. Buys one-time rights. Simultaneous submissions and previously published work OK.

Tips: "Initial contact should spell out the material photographer specializes in, rather than a general inquiry about our photo needs. Tearsheets and fliers welcome."

WORD PUBLISHING, 1501 LBJ Freeway, Suite 650, Dallas TX 75234. (214)488-9673. Senior Art Director: Tom Williams. Estab. 1951. Publishes Christian books. Photos used for book covers, publicity, brochures, posters and product advertising. Examples of recently published titles: *The New World Order*, by Pat Robertson; *Storm Warning*, by Billy Graham; and *Miracle Man: Nolan Ryan Autobiography*. Photos used for covers. "We do not provide want lists or photographer's guidelines."

Needs: Nature, people, studio shots and special effects. Model release required; property release preferred.

Making Contact & Terms: Provide brochure, flier or tearsheets to be kept on file for possible future assignments. Please don't call. SASE. Reports in 1 month. Assignment photo prices determined by the job. Pays for stock $350-900. Credit line given. Rights negotiable.

Tips: In portfolio or samples, looking for strikingly lighted shots, good composition, clarity of subject. Something unique and unpredictable. "We use the same kinds of photos as the secular market. I don't need crosses, church windows, steeples, or wheat waving in the sunset. Don't send just a letter. Give me something to look at, not to read about." Opportunity is quite limited: "We have hundreds of photographers on file, and we use about 5-10% of them."

***✦WUERZ PUBLISHING LTD.**, 895 McMillan Ave., Winnipeg, Manitoba R3M 0T2 Canada. (204)453-7429. Fax: (204)453-6598. Director: Steve Wuerz. Estab. 1989. Publishes university-level, science textbooks, especially in environmental sciences (chemistry, physics and biology). Photos used for text illustration, book covers to accompany textbooks in diskettes or CD-ROM materials. Examples of recently published titles: *Mathematical Biology*; *Energy Physics & the Environment*; and *Environmental Chemistry* (all cover and text illustration). Photo guidelines free with SASE.

Needs: Buys more than 100 photos annually; offers 4 (assignments and research combined). Reviews stock photos. Model/property release "as appropriate." Captions required; include location, scale, genus/species.

Making Contact & Terms: Interested in receiving work from newer, lesser-known photographers. Query with résumé of credits. Query with samples. Query with stock photo list. Provide résumé, business card, brochure, flier or tearsheets to be kept on file for possible future assignments. Works on assignment only. SASE. Reports usually in 1 month. NPI; negotiable. Credit line given. Buys book rights. Simultaneous submissions and previously published work OK.

Tips: "In all cases, the scientific principle or the instrument being displayed must be clearly shown in the photo. In the past year, we have used photos of smog in Los Angeles and Denver, tree frogs from Amazonia, wind turbines from California, a plasma reactor at Harwell United Kingdom, fireworks over London, and about 50 different viruses. Summarize your capabilities. Summarize your collection of 'stock' photos, preferably with quantities. Outline your 'knowledge level,' or how your collection is organized, so that searches will yield answers in reasonable time."

Book Publishers/'95-'96 changes

The following markets appeared in the 1995 edition of *Photographer's Market* but are not listed this year. The majority did not respond to our request to update their listings. If a reason was given for a market's exclusion it appears in parentheses below.

ARCsoft Publishers
Ave Maria Press (too many sub-
 missions)
B&B Publishing
Bonus Book, Inc.
The Bureau for At-Risk Youth
C&T Publishing
Celo Valley Books
Centerstream Publication
Chronicle Books
Dockery House Publishing Inc.
Dunamis House
East Coast Publishing

EMC Publishing
The Feminist Press at the City
 University of New York
Five Corners Publications
J. Flores Publications
Hancock House Publishers
Museum of Northern Arizona
New Leaf Press, Inc.
New Society Publishers (rarely
 uses photos other than those
 supplied by authors)
The Preservation Press, National
 Trust for Historic Preserva-

tion
Quarto Publishing
Redbird Press, Inc.
Resource Publications, Inc.
Alan Sutton Publishing, Inc.
The Trinity Foundation
Universal Publishing Co.
Van Patten Publishing
Wisconsin Trails Books
Writers Publishing Service Co.
Zoland Books

Businesses and Organizations

You will find a wide range of markets in this section, from major corporations such as insurance companies to public interest and trade associations to universities and arts organizations. In all, there are more than 60 markets, and almost half are new this year. The types of photography these listings require overlap somewhat with advertising markets. However, unlike that work which is largely directed toward external media or audiences, the photography for listings in this section tends to be more for specialized applications. Among these are employee or membership commmunications, annual reports, and documentary purposes such as recording meetings, group functions or theatrical presentations.

A fair number of these listings are receptive to stock images, while many have rather specific needs for which they assign photographers. These projects will sometimes require studio-type skills (again similar to the advertising/PR market), particularly in shooting corporate interiors and portraits of executives for annual reports. However, much of the coverage of meetings, events and performances calls for a different set of skills involving use of available light and fill flash. In particular, coverage of sporting events or theatrical performances may require agility with extreme or rapidly changing light conditions.

Unless these businesses and organizations are active at the national level, they typically prefer to work with local freelancers. Rates vary widely depending upon the individual client's budget. We have tried to list current rates of payment where possible, but some listings only indicate "negotiable terms," or a per-shot, per-hour or per-day basis. Listings which have not provided a specific dollar amount include the code NPI, for "no payment information given." When quoting a price, especially for assigned work, remember to start with a basic day rate plus expenses and negotiate for final number of images, types of usage and time period for usage.

In particular, many of these clients wish to buy all rights to the images since they are often assigned for specific needs. In such cases, negotiate so that these clients get all the rights they need but that you ultimately retain copyright.

***ALFRED PUBLISHING CO., INC.**, P.O. Box 10003, Van Nuys CA 91410-0003. Art Director: Ted Engelbart. Estab. 1922.
Needs: Photos of musical instruments. Examples of recent uses: Educational music book covers (4×5); Yamaha Band Student ad campaign (2¼×2¼) and brochures for sales promotions (35mm and 2¼×2¼). Reviews stock photos/footage of musical instruments. Model/property release required for people and music halls.
Making Contact & Terms: Provide résumé, self-promotion piece or tearsheets to be kept on file for possible future assignments. Works on assignment only. Uses 35mm, 2¼×2¼, 4×5, 8×10 transparencies. Does not report back, keeps on file. NPI. Buys all rights (unless stock); negotiable.
Tips: "Send requested profile. Do not call. Provide any price or release requirements." Looks for "graphic or mood presentation of musical instruments; general interest such as fireworks, Americana, landscapes."

***AMATEUR SOFTBALL ASSOCIATION**, 2801 NE 50th St., Oklahoma City OK 73111. (405)424-5266. Director of Communications: Ronald A. Babb. Promotion of amateur softball. Photos used in newsletters, newspapers, association magazine.

Needs: Buys 10-12 photos/year; offers 5-6 assignments annually. Subjects include action sports shots. Model release required. Captions required.
Making Contact & Terms: Contact ASA National office first before doing any work. Uses prints or transparencies. SASE. Reports in 2 weeks. Pays $50 for previously published photo. Assignment fees negotiable. Credit line given. Buys all rights.

■AMERICAN ALLIANCE FOR HEALTH, PHYSICAL EDUCATION, RECREATION AND DANCE, 1900 Association Dr., Reston VA 22091. (703)476-3400. Fax: (703)476-9527. Director of Publications: Debra H. Lewin. Estab. 1885. Photos used in brochures, newsletters, magazines and catalogs.
Needs: Buys 50 photos/year; offers 2-3 assignments/year. Wants photos of sports, recreation, outdoor activities, health practices, physical education and other education-specific settings; also interested in handicapped and special populations. Reviews stock photos. Model/property release preferred, especially for children and handicapped.
Audiovisual Needs: Uses slides.
Making Contact & Terms: Query with stock photo list. Provide résumé, business card, self-promotion piece or tearsheets to be kept on file for possible future assignments. Call. Keeps samples on file. SASE. Reports in 1-2 weeks. Pays $100/color photo; $25/b&w photo. Pays upon usage. Credit line given. Buys one-time rights; negotiable.
Tips: "We are always looking for strong action or emotion. We usually need vertical formats for magazine covers with color work."

AMERICAN FUND FOR ALTERNATIVES TO ANIMAL RESEARCH, 175 W. 12th St., Suite 16-G, New York NY 10011. (212)989-8073. Contact: Dr. E. Thurston. Finances research to develop research methods which will not need live animals. Also informs the public of this and about current methods of experimentation. Photos used in reports, advertising and publications.
Needs: Buys 10 freelance photos/year; offers 5 freelance assignments/year. Needs b&w or color photos of laboratory animal experimentation and animal use connected with fashions (trapping) and cosmetics (tests on animals). Model release preferred.
Making Contact & Terms: Arrange a personal interview to show portfolio. Query with samples and list of stock photo subjects. Provide brochure and flier to be kept on file for possible future assignments. Notifies photographer if future assignments can be expected. Uses 5×7 b&w prints; also uses 16mm film for educational films. SASE. Reports in 2 weeks. Pays $5 minimum/b&w photo; $5 or more/ color photo; $30 minimum/job. Credit line given. Buys one-time rights and exclusive product rights; arranged with photographer.
Tips: In portfolios or samples wants to "see clear pictures of animals in cosmetic tests or testing labs, or fur ranches, and in the wilds."

***AMERICAN MUSEUM OF NATURAL HISTORY LIBRARY, PHOTOGRAPHIC COLLECTION**, Library Services Department, Central Park West, 79th St., New York NY 10024. (212)769-5419. Fax: (212) 769-5009. E-mail: speccol@amnh.org. Manager, Special Collections: Joel Sweimler. Estab. 1869. Provides services for advertisers, authors, film and TV producers, general public, government agencies, picture researchers, publishers, scholars, students and teachers who use photos for brochures, newsletters, posters, newspapers, annual reports, catalogs, magazines, books and exhibits.
Needs: Model release required. Captions required.
Making Contact & Terms: Interested in receiving work from newer, lesser-known photographers. "We accept only donations with full rights (non-exclusive) to use; we offer visibility through credits." Credit line given. Buys all rights.
Tips: "We do not review portfolios. Unless the photographer is willing to give up rights and provide images for donation with full rights (credit lines are given), the museum is not willing to accept work."

AMERICAN SOCIETY FOR THE PREVENTION OF CRUELTY TO ANIMALS (ASPCA), 424 E. 92nd St., New York NY 10128. (212)876-7700, ext. 4441. Fax: (212)534-8888. Art Director: Amber Alliger. Estab. 1866. Photos used in quarterly color magazine, pamphlets, booklets. Publishes *ASPCA Animal Watch Magazine*.
Needs: Photos of animals (domestic and wildlife): farm, domestic, lab, stray and homeless animals, endangered, trapped, injured, fur animals, marine and wildlife, rain forest animals. Example of recent uses: *Traveling With Your Pet* and *ASPCA Animal Watch Magazine*. Model/property release preferred.

The solid, black square before a listing indicates that the market uses various types of audiovisual materials, such as slides, film or videotape.

Making Contact & Terms: Interested in receiving work from newer, lesser-known photographers. Please send a detailed, alphabetized stock list that can be kept on file for future reference. SASE. Reports when needed. Pays $50/b&w photo (inside use); $50/color photo (inside use); $100 for cover use. Prefers color. Credit line given. Buys one-time rights; negotiable.

Tips: "I like exciting pictures: strong colors, interesting angles, unusual light."

AQUINO PRODUCTIONS, P.O. Box 15760, Stamford CT 06901. Phone/fax: (203)967-9952. Publisher: Andres Aquino. Estab. 1983. Publishes posters, magazines and calendars. Photos used in posters, newspapers, magazines and catalogs.

Needs: Uses freelancers for travel, fashion, beauty, glamour, people. Examples of recent uses: Westchester County Limousine (brochure); Bella Magazine (cover). Reviews stock photos. Model/property release required for people and private property. Captions required; include location and year (if applicable).

Making Contact & Terms: Query with stock photo list. Uses 8×10 glossy or matte b&w prints; 35mm, 2¼×2¼, 4×5 transparencies. Keeps samples on file. SASE. Reports in 3 weeks. NPI. "We buy photos in bulk." Credit line given. Buys all rights; negotiable.

Tips: "Become familiar with our publications. We offer a complete set of guidelines, sample photo requests and catalog of publications for $4." Looking for "sharp, well-exposed images from uncommon perspective covering people and places around the world." Sees trend toward more "computer-enhanced images."

ASBO INTERNATIONAL, 11401 N. Shore Dr., Reston VA 22090. (703)478-0405. Fax: (703)478-0205. Production Coordinator: Peggy Gartner. Estab. 1924. Professional association. Photos used in newspapers, magazines, press releases and catalogs.

Needs: Buys 12 photos/year; offers 12 assignments/year. School or business-related photos. Reviews stock photos.

Making Contact & Terms: Interested in receiving work from newer, lesser-known photographers. Query with samples. Works with local freelancers only. Uses 5×7 glossy b&w prints; 2¼×2¼ and 4×5 transparencies. Keeps samples on file. SASE. Reports in 3 weeks. NPI. Pays on acceptance depending upon usage. Buys one-time or all rights; negotiable.

BEDOL INTERNATIONAL GROUP, INC., P.O. Box 2847, Rancho Cucamonga CA 91729-2847. (909)948-0668. President: Mark A. Bedol. Estab. 1982. Produces stationery items, picture frames, calculators, calendars, etc. Photos used in brochures, press releases and picture frames.

Needs: Buys 300 photos/year; offers 6 freelance assignments/year. Uses product photos for catalogs and advertising, photos of female models, female models with children and babies, cars. Examples of recent uses: catalog sheets, frame, product pictures. Reviews stock photos. Model release required. Property release preferred.

Making Contact & Terms: Interested in receiving work from newer, lesser-known photographers. Provide résumé, business card, brochure, flier or tearsheets to be kept on file for possible future assignments. Works on assignment only. Uses various size color, b&w prints; 2¼×2¼ transparencies. Keeps samples on file. Cannot return material. Reports only when needed. Pays $50-85/hour; $50-100/color photo; $50-100/b&w photo. Pays on usage. Credit line not given. Buys all rights.

Tips: "Please send work in for review."

***BERRY & HOMER INC.,** 2035 Richmond St., Philadelphia PA 19125. (215)425-0888. Fax: (215)425-2702. Technical Sales Rep: Lynn Charlton. Estab. 1898. Custom photographic digital imaging lab. Photos used in posters, magazines, catalogs, billboards, direct mail, P-O-P displays, signage.

Needs: Uses 30 photographers/month. Uses freelancers for product shots. Model/property release required. Captions preferred.

Making Contact & Terms: Interested in receiving work from newer, lesser-known photographers. Submit portfolio for review. Works on assignment only. Uses 8½×11 color and b&w prints; 35mm, 2¼×2¼, 4×5, 8×10 transparencies. Keeps samples on file. SASE. Reports in 1 month. NPI; depends on assignment. Pays on receipt of invoice. Credit line sometimes given depending upon subject. Buys all rights; negotiable.

■BETHUNE THEATREDANSE, 8033 Sunset Blvd., Suite 221, Los Angeles CA 90046. (213)874-0481. Fax: (213)851-2078. Managing Director: Beatrice Ballance. Estab. 1979. Dance company. Photos used in posters, newspapers, magazines.

Needs: Number of photos bought annually varies; offers 2-4 freelance assignments annually. Photographers used to take shots of dance productions, dance outreach classes (disabled children's program) and performances, and graphics and scenic. Examples of recent uses: Promotional pieces for the dance production "Cradle of Fire" and for a circus fundraiser performance (all shots in 35mm format). Reviews stock photos if they show an ability to capture a moment. Captions preferred, include company or name of subject, date, and equipment shown in photo.

Audiovisual Needs: Uses slides and videotape. "We are a multimedia company and use videos and slides within our productions. We also use video for archival purposes." Subject matter varies.
Making Contact & Terms: Interested in receiving work from newer, lesser-known photographers. Provide résumé, business card, self-promotion piece or tearsheets to be kept on file for possible future assignments. Uses 8 × 10 color or b&w prints; 35mm transparencies and videotape. Keeps samples on file. Cannot return material. Reports only when in need of work. NPI; payment for each job is negotiated differently. Credit line sometimes given depending on usage. "We are not always in control of newspapers or magazines that may use photos for articles." Buys all rights; negotiable.
Tips: "We need to see an ability to see and understand the aesthetics of dance—its lines and depth of field. We also look for innovative approaches and personal signature to each individual's work. Our productions work very much on a collaborative basis and a videographer's talents and uniqueness are very important to each production. It is our preference to establish ongoing relationships with photographers and videographers."

■**BROWNING**, One Browning Place, Morgan UT 84050. (801)876-2711, ext. 336. Fax: (801)876-3331. Senior Art Director: Brent Evans. Estab. 1878. Photos used in posters, magazines, catalogs. Uses photos to promote sporting good products.
Needs: Works with 2 freelancers/month; 3 filmmakers/year. Outdoor, wildlife, hunting, shooting sports and archery. Reviews stock photos. Model/property release required. Captions preferred; include location, types of props used, especially brand names (such as Winchester and Browning).
Audiovisual Needs: Uses slides and/or film for multimedia and motion presentations.
Making Contact & Terms: Interested in receiving work from newer, lesser-known photographers. Query with samples. Provide résumé, business card, self-promotion piece or tearsheets to be kept on file for possible future assignments. Works on assignment only. Uses 35mm, 2¼×2¼, 4×5, 8×10 transparencies; 16mm film. Keeps samples on file. SASE. Reports in 1 month. NPI. Pays on receipt of invoice. Credit line given depending upon design. Buys one-time rights, all rights; negotiable.
Tips: "We look for dramatic lighting, exceptional settings, preferably masculine but feminine settings at times are desirable. We see more photographers who negotiate terms of photo electronic retouching and imaging."

CALIFORNIA REDWOOD ASSOCIATION, 405 Enfrente Dr., Suite 200, Novato CA 94949. (415)382-0662. Fax: (415)382-8531. Publicity Manager: Pamela Allsebrook. Estab. 1916. "We publish a variety of literature, a small black and white periodical, run color advertisements and constantly use photos for magazine and newspaper publicity. We use new, well-designed redwood applications—residential, commercial, exteriors, interiors and especially good remodels and outdoor decks, fences, shelters."
Needs: Gives 40 assignments/year. Prefers photographers with architectural specialization. Model release required.
Making Contact & Terms: Send query material by mail for consideration for assignment or send finished speculation shots for possible purchase. Uses b&w prints. For color, uses 2¼×2¼ and 4×5 transparencies; contact sheet OK. Reports in 1 month. NPI; payment based on previous use and other factors. Credit line given whenever possible. Usually buys all but national advertising rights. Simultaneous submissions and previously published work OK if other uses are made very clear.
Tips: "We like to see any new redwood projects showing outstanding design and use of redwood. We don't have a staff photographer and work only with freelancers. We generally look for justified lines, true color quality, projects with style and architectural design, and tasteful props. Find and take 'scout' shots or finished pictures of good redwood projects and send them to us."

CHICAGO COMPUTER & LIGHT, INC., 5001 N. Lowell Ave., Chicago IL 60630. (312)283-2749. Fax: (312)283-9972. President: Larry Feit. Estab. 1976. Photos used in newsletters, magazines, catalogs and press releases.
Needs: Offers several freelance assignments/year. New products for special ads in trade journals plus special project needs. Model/property release required.
Making Contact & Terms: Provide résumé, business card, self-promotion piece or samples of work to be kept on file for possible future assignments. **Pays on acceptance.** Credit line sometimes given. All jobs are negotiable.
Tips: In freelancer's samples, looks for simplicity and uniqueness.

CINCINNATI OPERA, Music Hall, 1241 Elm St., Cincinnati OH 45210. (513)621-1919. Fax: (513)621-4310. Contact: Public Relations Director. Estab. 1920. Produces grand opera during 4-week summer season; outreach throughout year. Photos used in newsletters, press releases. "Have a company photographer, but occasionally need photographer for special events, social scene or projects."
Needs: Offers 2-3 assignments/year. Black & white head shots; backstage rehearsal/costume fittings; flash photos at parties. Examples of recent uses: board member photos/head shots release for business

papers; backstage photos of on-stage extras for news release; candids at outdoor party for newsletter/ release to papers.

Making Contact & Terms: Interested in receiving work from newer, lesser-known photographers. Provide résumé, business card, self-promotion piece or tearsheets to be kept on file for possible future assignments. Works with local freelancers on assignment only. Uses 5×7 or 8×10 glossy color or b&w prints (depends on assignment). Does not keep samples on file. SASE. "I will respond if they ask for a response; if it's busy season, better for them to make follow-up call. We ask photographer to tell us normal charges before negotiations. Pay by the hour plus film costs; negotiable—give us a price sheet." Credit line given. Buys all rights.

Tips: "Please keep in mind that we have a company photographer, plus an art photographer with whom we work on brochures and posters. Our need for extra photographers comes up at a moment's notice (if someone is ill or busy, for instance), when we need photos taken at an event or performance during the summer. The best thing to do is send a card, a tearsheet, maybe a short letter for us to keep on file. I do refer back to my files, as often I am looking for a photographer at the last minute. Also, keep in mind: We give only 2-3 assignments/year. Seeing more color shots of on-stage work—almost always get requests from newspapers and agents for color photos of our operas. Also, getting away from the open-mouthed-singer shot, and going for more intense, dramatic facial expressions and body language in our on-stage photos."

***COMPUTER TECHNOLOGY RESEARCH CORPORATION**, 6 N. Atlantic Wharf, Charleston SC 29401. (803)853-6460. Fax: (803)853-7210. Advertising Coordinator: Nancy L. Wagner. Estab. 1979. Publishes guidebooks on information technology. Photos used in brochures and promotional materials.

Needs: Looking for photos of the most current technologies, such as operating systems, networks, the Internet. Reviews stock photos of technical professionals in offices. Model/property release required.

Making Contact & Terms: Interested in receiving work from newer, lesser-known photographers. Query with résumé of credits. Query with samples. Query with stock photo list. Provide résumé, business card, self-promotion piece or tearsheets to be kept on file for possible future assignments. Uses 5×7, 8×10 glossy color and b&w prints. Keeps samples on file. SASE. Reports in 1 month. Pays $25-300/color photo; $25-100/b&w photo. Pays on publication. Credit line sometimes given, depending on whether it fits into the layout. Buys one-time and all rights; negotiable.

Tips: "In the direct mail business, photographers of products yield better results than line drawings."

CREATIF LICENSING®, 31 Old Town Crossing, Mt. Kisco NY 10549. (914)241-6211. Vice President Marketing: Paul Cohen. Estab. 1975. License artwork to manufacturers. Photos of general merchandise in the gift industry.

Needs: Examples of recent uses: t-shirts, posters, bookmarks, address books, picture frames, calendars. Reviews stock photos. Model/property release required for any copyright or protected design. Captions preferred.

Making Contact & Terms: Query with samples and SASE. "Submissions and requests for info will not be returned unless accompanied by a SASE." Uses 35mm, 4×5 transparencies and prints. Samples kept on file. Reports in 3 weeks. NPI. Pays royalties on sales. Pays upon receipt of royalties, advances, guarantees. Rights purchased are "license for contracted time period for specific merchandising categories."

Tips: "We look for designs that would work well on calendars, posters and printed media for the gift and stationery market."

DALOIA DESIGN, P.O. Box 140268, Howard Beach NY 11414. (718)835-7641. Owner/Creative Director: Peter Daloia. Estab. 1983. Design, develop and market novelty and gift products. Photos used in posters, paper, novelty and gift items; display, advertising.

Needs: Use freelancers for humorous, abstract, odd shots, good composition, collage, montage, patterns, religious sentiment, textures. Reviews stock photos. Model/property release required. Captions preferred; include humor, religious, endearing sentiments, etc.

Making Contact & Terms: Interested in receiving work from newer, lesser-known photographers. Query with samples. Provide résumé, business card, brochure, flier or tearsheets to be kept on file for possible future assignments. Works with freelancers on assignment only. Uses 5×7, color and b&w prints; 35mm slides. Keeps samples on file. Cannot return material. Reports only when interested. NPI; pays "prevailing rates or royalties." Pays upon usage. Credit line sometimes given depending on use. Buys one-time rights and exclusive product rights.

Tips: "Let the buyer decide on the best images."

***■DAYTON CONTEMPORARY DANCE COMPANY**, 126 N. Main St., Suite 200, Dayton OH 45402-1710. (513)228-3232. Fax: (513)223-6156. Marketing Director: Gretchen K. Ryan. Estab. 1969. Nonprofit arts organization specializing in modern and contemporary dance. Photos used in brochures, posters, newspapers, press releases, table tents and stickers.

Needs: Number of photos purchased varies. Subjects are always dancers, headshots, dance company photos. Examples of recent uses: season brochure, poster and media requests/performance venue requests.
Audiovisual Needs: Uses videotape for public service announcements.
Making Contact & Terms: Interested in receiving work from newer, lesser-known photographers. Arrange a personal interview to show portfolio. Query with résumé of credits. Query with samples. Provide résumé, business card, self-promotion piece or tearsheets to be kept on file for possible future assignments. Works with local freelancers on assignment only. NPI. Credit line given.

***■DCP COMMUNICATIONS GROUP, LTD.**, 301 Wall St., Princeton NJ 08540-1515. (609)921-3700. Fax: (609)921-3283. Editor: David McKenna. Estab. 1979. Specializes in multimedia production, video production.
Needs: Buys 20 photos/year; offers 10 assignments/year. Uses freelancers for lifestyle, editorial, public relation shots. Examples of recent uses: video montages for manufacturers. Model/property release required. Captions required.
Audiovisual Needs: Uses videotape for multimedia purposes (corporate marketing). Subjects include: lifestyles.
Making Contact & Terms: Interested in receiving work from newer, lesser-known photographers. Query with résumé of credits. Query with samples. Query with stock photo list. Provide résumé, business card, self-promotion piece or tearsheets to be kept on file for possible future assignments. Uses 8 × 10 glossy color and b&w prints; 35mm, 2¼ × 2¼, 4 × 5 transparencies; Betacam SP videotape. Keeps samples on file. SASE. Reports in 1 month. Pays $100-150/hour; $500-1,500/day. **Pays on acceptance**. Credit line given. Buys first, one-time and all rights; negotiable.

FOTOFOLIO, 536 Broadway, New York NY 10012. (212)226-0923. Fax: (212)226-0072. Contact: Editorial Department. Estab. 1976. Photos used in posters, postcards, note cards, T-shirts and calendars. Photo guidelines free with SASE.
Needs: Uses freelancers for all subjects, especially holiday, seasonal, urban and romance. Buys 200-300 images annually. Reviews stock photos. Model release preferred; celebrities, all identifiable subjects; include title, date, place. Captions required, include title and date.
Making Contact & Terms: Interested in receiving work from newer, lesser-known photographers. Query with samples. Submit portfolio for review. Provide résumé, business card, brochure, flier or tearsheets to be kept on file for possible future assignments. Uses any format. Does not keep samples on file. SASE. Reporting time varies. Pays royalties. Pays upon usage and publication. Credit line given. Buys exclusive rights in format purchased.
Tips: "For review, edit tightly. No oversized prints. There is a monthly portfolio review on drop-off basis. Call for next date. Research past products to understand what we publish."

***GARY PLASTIC PACKAGING CORP.**, 530 Old Post Rd., No. 3, Greenwich CT 06830. (203)629-1480. Marketing Director: Marilyn Hellinger. Estab. 1963. Manufacturers of custom injection molding; thermoforming; and stock rigid plastic packaging. Photos used in brochures, catalogs and fliers.
Needs: Buys 10 freelance photos/year; offers 10 assignments/year. Product photography. Model release required.
Making Contact & Terms: Query with résumé of credits or with samples. Follow up with a call to set up an appointment to show portfolio. Prefers to see b&w and color product photography. Solicits photos by assignment only. Provide résumé to be kept on file for possible future assignments. Works with local freelancers only. Uses 8 × 10 b&w and color prints; 2¼ × 2¼ slides; and b&w or color negatives. Notifies photographer if future assignments can be expected. Does not return unsolicited material. Reports in 2 weeks. Pays up to $150/color photo; up to $900/day. Pays by the job and the number of photographs required. Buys exclusive product rights.
Tips: The photographer "has to be willing to work with our designers."

GEI INTERNATIONAL, INC., 100 Ball St., P.O. Box 6849, Syracuse NY 13217. (315)463-9261. Fax: (315)463-9034. Sales Manger: William Parker. Estab. 1988. Manufacturer of stainless steel rulers and graphic accessories. Photos used in brochures, press releases and catalogs.
Needs: Buys 18,000 photos/year. Uses freelancers for photos of "our stocked items."
Making Contact & Terms: Provide résumé, business card, brochure, flier or tearsheets to be kept on file for possible future assignments. Works with local freelancers only. Uses various size glossy b&w photos. Does not keep samples on file. SASE. Reports in 1-2 weeks. NPI. Pays upon usage. Buys all rights.

GREAT SMOKY MOUNTAINS NATURAL HISTORY ASSOCIATION, 115 Park Headquarters Rd., Gatlinburg TN 37738. Fax: (615)436-6884. Publications Specialist: Steve Kemp. Estab. 1953. Produces publications on Great Smokies. Photos used for brochures, newsletters, newspapers and books.

Needs: Buys 150 photos/year; offers 2 freelance assignments/year. Wants to see b&w of people enjoying park. Examples of recent uses: *Smokies Guide* (park newspaper), b&w. Reviews stock photos. Model/property release preferred. Captions preferred; include location of shot.
Making Contact & Terms: Interested in receiving work from newer, lesser-known photographers. Query with stock photo list. Provide résumé, business card, self-promotion piece or tearsheets to be kept on file for possible future assignments. Uses 5×7 b&w prints. Does not keep samples on file. SASE. Reports in 1 month. Pays $30-50/b&w photo; sometimes works on royalties. Pays upon usage. Credit line given. Buys one-time rights.
Tips: "Take b&w photos of people hiking, looking at wildflowers, big trees, waterfalls in Great Smokies. We always need nature b&w's (black bear, wildflowers, deer, fox); nobody shoots b&w."

■**HUBBARD MILLING COMPANY,** 424 N. Riverfront Dr., P.O. Box 8500, Mankato MN 56002. (507)388-9535. Fax: (507)388-9453. Marketing Communications Specialist: Amy Spychalla. Estab. 1878. The Hubbard Feed Division manufactures animal feeds, pet foods and animal health products. Photos used in brochures, newsletters, posters and audiovisual presentations.
Needs: Buys 20 freelance photos/year; offers 10 freelance assignments/year. Livestock—beef cattle, dairy cattle, pigs, horses, sheep, dogs, cats. Model release required.
Making Contact & Terms: Query with samples. Query with list of stock photo subjects. Submit portfolio for review. Provide résumé, business card, brochure, flier or tearsheets to be kept on file for possible future assignments. Works on assignment only. Uses 3×5 and 5×7 matte b&w and color prints; 2¼×2¼ and 4×5 transparencies; and b&w and color negatives. SASE. Reports in 2 weeks. Pays $50-100/b&w photo; $200/color photo; $50-300/job. Buys one-time and all rights; negotiable.
Tips: Prefers "to see the types of work the photographer does and what types of subjects done. We look for lots of agricultural photos in a more serious setting. Keep up with modern farming methods and use confinement shots when deemed necessary. Stay away from 'cutesy' shots."

*■**THE IMAGE MAKERS,** 12 Miliche Lane, New City NY 10956. (914)638-4332. Director: Mark Schimmel. Estab. 1990. Specializes in film making/video production of documentaries, shorts, 30-second spots, public service announcements. Photos used in brochures and press releases.
Needs: Offers 3-6 assignments annually. Uses freelancers for interior shots and portraits. Reviews stock photos. Model/property release required.
Audiovisual Needs: Uses film and videotape as insert footage for a given project.
Making Contact & Terms: Interested in receiving work from newer, lesser-known photographers. Query with samples. Provide business card, self-promotion piece to be kept on file for possible future assignments. Do not call. Keeps samples on file. SASE. Reports when client has made decision. NPI. Pays on usage. Credit line depends on client and usage. Rights purchased depend on client's needs; negotiable.

*■**IMAGETECTS**™, 7200 Bollinger Rd., Suite 802, San Jose CA 95129. (408)252-5487. Fax: (408)252-7409. General Manager: Verdonna K. Ahrens. Estab. 1988. Information publisher specializing in computer graphics. Photos used in digital imagery.
Needs: Wants to see shots of botanical items (trees, shrubs, flowers) and people. Reviews stock photos. Model release required. Captions preferred; include botanical or common name of plant, if known, and film type/speed.
Audiovisual Needs: Uses slides and film for digital imagery.
Making Contact & Terms: Interested in receiving work from newer, lesser-known photographers. Query with samples. Send unsolicited photos by mail for consideration. Call for details. Uses 35mm, 2¼×2¼, 4×5 transparencies. Keeps samples on file. SASE. Reports in 1-2 weeks. NPI; negotiable.
Pays on acceptance. Credit line given. Buys digital rights only.
Tips: Subject should fill the frame. When shooting plants/people "sun should be at 45 degree angle behind right or left shoulder of photographer." Subjects should be in full sunlight. Prefers single subjects per frame, shot against contrasting background (i.e., green leaves against blue sky).

INTERNATIONAL PUBLISHING MANAGEMENT ASSOCIATION, (formerly In-Plant Management Association), 1205 W. College St., Liberty MO 64068-3733. (816)781-1111. (816)781-2790. E-mail: 71674.1647@compuserve.com. Editor: Barbara Schaaf Petty. Membership association for in-house print/mail managers. Photos used in brochures and newsletters.
Needs: Buys 5-10 photos/year. Subject needs: equipment photos, issues (i.e., soy ink, outsourcing), people. Reviews stock photos. Captions preferred (location).
Making Contact & Terms: Interested in receiving work from newer, lesser-known photographers. Query with stock photo list. Provide résumé, business card, brochure, flier or tearsheets to be kept on file for possible future assignments. Uses 5×7 b&w prints. Keeps samples on file. SASE. Reports in 3 weeks. NPI. Pays on usage. Credit line given. Buys one-time rights.

■**INTERNATIONAL RESEARCH & EDUCATION (IRE),** 21098 IRE Control Center, Eagan MN 55121-0098. (612)888-9635. Fax: (612)888-9124. IP Director: George Franklin, Jr. IRE conducts in-

depth research probes, surveys, and studies to improve the decision support process. Company conducts market research, taste testing, brand image/usage studies, premium testing, and design and development of product/service marketing campaigns. Photos used in brochures, newsletters, posters, audiovisual presentations, annual reports, catalogs, press releases, and as support material for specific project/survey/reports.

Needs: Buys 75-110 photos/year; offers 50-60 assignments/year. "Subjects and topics cover a vast spectrum of possibilities and needs." Model release required.

Audiovisual Needs: Uses freelance filmmakers to produce promotional pieces for 16mm or videotape.

Making Contact & Terms: Provide résumé, business card, brochure, flier or tearsheets to be kept on file for possible future assignments. "Materials sent are put on optic disk for options to pursue by project managers responsible for a program or job." Works on assignment only. Uses prints (15% b&w, 85% color), transparencies and negatives. Cannot return material. Reports when a job is available. NPI; pays on a bid, per job basis. Credit line given. Buys all rights.

Tips: "We look for creativity, innovation and ability to relate to the given job and carry out the mission accordingly."

***■JAGUAR PRODUCTIONS INC.**, 235 E. 34th St., New York NY 10016. (212)889-9494. Fax: (212)889-9388. Producer/Director: Ron Jacobs. Estab. 1974. Film and video production house. Photos used in press releases and multimedia.

Needs: Offers 20-40 assignments annually. Reviews stock photos of various subjects for multimedia use. Model/property release required for actors, actresses, privately-owned locations, facilities, etc.

Making Contact & Terms: Interested in receiving work from newer, lesser-known photographers. Arrange a personal interview to show portfolio. Query with stock photo list. Provide résumé, business card, self-promotion piece or tearsheets to be kept on file for possible future assignments. Works with local freelancers on assignment only. Uses 5×7, 8×10, 11×14 matte or glossy b&w prints; 35mm transparencies; 16mm, 35mm; D1, D2, 1″ or ¾″ preferred, Betacam videotape. SASE. Reports in 1-2 weeks. Pays $100-500/day; buyout negotiable. Credit line given if possible. Buys all rights; negotiable.

Tips: "Shoot very wide and very tight. The more dramatic the light, the less an audience will get bored."

***■KOSS CORPORATION**, 4129 N. Port Washington Rd., Milwaukee WI 53212. (414)964-5000. Fax: (414)964-0506. PR Coordinator: Cameryne Roberts. Estab. 1953. Stereophone manufacturer. Photos used in catalogs, direct mail, P-O-P displays, packaging.

Needs: Uses 1 photographer/month. Action shots in which stereophones can be used in activity. Reviews stock photos.

Audiovisual Needs: Uses slides and video for sales presentations. Subjects include: company specific.

Making Contact & Terms: Interested in receiving work from newer, lesser-known photographers. Query with samples. Query with stock photo list. Send unsolicited photos by mail for consideration. Works on assignment only. Media used are project specific. Keeps samples on file. Cannot return material. Reports back as needs arise. NPI.

Tips: Looking for very simple, clean product and action shots.

***■NEAL MARSHAD PRODUCTIONS**, 76 Laight St., New York NY 10013-2046. (212)925-5285. Fax: (212)925-5681. Owner: Neal Marshad. Estab. 1983. Video, motion picture and multimedia production house.

Needs: Buys 20-50 photos/year; offers 5-10 assignments/year. Freelancers used for food, travel, production stills for publicity purposes. Examples of recent uses: Eastern France Multimedia (CD-ROM using 35mm film); France Multimedia (audiovisual show using 35mm film); and IBM Corporation (video 35mm film). Model release required. Property release preferred. Captions preferred.

Audiovisual Needs: Uses slides, film, video, PhotoCD for multimedia CD-ROM. Subjects include: travel and food.

Making Contact & Terms: Provide résumé, business card, self-promotion piece or tearsheets to be kept on file for possible future assignments. "No calls!" Works with local freelancers on assignment only. Uses 35mm, 2¼×2¼, 4×5 prints; 16mm film; Beta SP, 1″ videotape. Keeps samples on file.

SASE. Pays $50-100/hour; $150-300/day; $300-500/job; $10-100/color photo. Pays on usage. Credit line depends on client. Buys all rights; negotiable.

Tips: "Show high quality work, be on time, expect to be hired again if you're good." Expects "explosive growth in photography in the next two to five years as in the past five years."

MASEL INDUSTRIES, 2701 Bartram Rd., Bristol PA 19007. (215)785-1600. Fax: (215)785-1680. Marketing Manager: Richard Goldberg. Estab. 1906. Catalog producer. Photos used in posters, magazines, press releases, catalogs and trade shows.
- This company scans all photos and stores them. Photos are manipulated on PhotoShop.

Needs: Buys over 250 photos/year; offers 15-20 assignments/year. Examples of recent uses: colorful spill shots of products on interesting backgrounds (trade show duratrans, 4×5 format) and teenage football player (catalog cover, 2¼×2¼ format). Reviews stock photos. Needs children and adults with braces on their teeth. Model release required.

Making Contact & Terms: Interested in receiving work from newer, lesser-known photographers. Provide résumé, business card, self promotion piece or tearsheets to be kept on file for possible future assignments. Works with local freelancers on assignment only. Uses 4×5 glossy b&w prints; 35mm, 2¼×2¼, 4×5 transparencies. Keeps samples on file. SASE. Reports in 2 weeks if interested. Pays $100 maximum/color or b&w photo; $250-500/cover shot; $800 maximum/day. Volume work is negotiated. **Pays on acceptance.** Credit line depends on terms and negotiation. Buys all rights.

Tips: "We're an interesting company with great layouts. We are always looking for new ideas. We invite input from our photographers and expect them to get involved."

METALFORMING MAGAZINE/PMA SERVICES, INC., 27027 Chardon Rd., Richmond Heights OH 44143. (216)585-8800. Fax: (216)585-3126. Art Director: Beth Vosmik. Estab. 1942. Publishes trade magazine serving those who give utility to sheet metal by shaping it using tooling in machines. Photos used in brochures and magazine.

Needs: Buys 10 photos/year; offers 4 assignments/year. Photos of stamping presses, press brakes, roll formers, washers, turret presses and items produced by this machinery, product shots and location shots. Reviews stock photos of metalformings—stampings, presses, etc. Model/property release required. Captions required; include details about manufacturers and location.

Making Contact & Terms: Provide résumé, business card, self-promotion piece or tearsheets to be kept on file for possible future assignments. Works on assignment only. Uses 2¼×2¼, 4×5 transparencies. Keeps samples on file. Cannot return material. Reports in 6 months. Pays $150/editorial photo; $750/editorial cover photo. **Pays on acceptance.** Credit line given. Buys all rights. Model/property release required.

***BRUCE MINER POSTER CO. INC.,** Box 709, Peabody MA 01960. (508)741-3800. Fax: (508)741-3880. President: Bruce Miner. Estab. 1971. Photos used in posters.

Needs: Number of photos bought "varies." Wildlife photos. Reviews stock photos of wildlife. Model release preferred.

Making Contact & Terms: Interested in receiving work from newer, lesser-known photographers. Query with stock photo list. Provide résumé, business card, brochure, flier or tearsheets to be kept on file for possible future assignments. Uses 8×10 prints; 2¼×2¼ transparencies. Keeps samples on file. SASE. Reports in 1 month. NPI. Pays advance against royalties. Pays on usage. Credit line given. Buys one-time and all rights; negotiable.

Tips: Looking for "quality" submissions.

NATIONAL BLACK CHILD DEVELOPMENT INSTITUTE, 1023 15th St. NW, Suite 600, Washington DC 20005. (202)387-1281. Fax: (202)234-1738. Deputy Director: Vicki D. Pinkston. Estab. 1970. Photos used in brochures, newsletters, newspapers, annual reports and annual calendar.

Needs: Candid action photos of black children and youth. Reviews stock photos. Model release required.

Making Contact & Terms: Query with samples. Send unsolicited photos by mail for consideration. Uses 5×7 or 8×10 color and glossy b&w prints and color slides or b&w contact sheets. SASE. Reports in 1 month. Pays $25/cover photo and $15/inside photo. Credit line given. Buys one-time rights.

Tips: "Candid action photographs of one black child or youth or a small group of children or youths. Most color photos selected are used in annual calendar and are placed beside an appropriate poem selected by organization. Therefore, photograph should communicate a message in an indirect way. Black & white photographs are used in quarterly newsletter and reports. Obtain sample of publications published by organization to see the type of photographs selected."

***■NORTHERN VIRGINIA YOUTH SYMPHONY ASSOCIATION**, 4026 Hummer Rd., Annandale VA 22003. (703)642-0862. Fax: (703)642-1773. Director of Public Relations: Chris Cohick. Estab.

1964. Nonprofit organization that promotes and sponsors 4 youth orchestras. Photos used in newsletters, posters and audiovisual uses and other forms of promotion.
Needs: Photographers usually donate their talents. Offers 8 assignments annually. Photos taken of orchestras, conductors and soloists. Captions preferred.
Audiovisual Needs: Uses slides and videotape.
Making Contact & Terms: Interested in receiving work from newer, lesser-known photographers. Arrange a personal interview to show portfolio. Works with local freelancers on assignment only. Uses 5×7 glossy color and b&w prints. Keeps samples on file. SASE. NPI. "We're a résumé-builder, a nonprofit that can cover expenses but not service fees." **Pays on acceptance.** Credit line given. Rights negotiable.

NORTHWORD PRESS, INC., 7520 Hwy. 51 S., P.O. Box 1360, Minocqua WI 54548. (715)356-7644. Fax: (715)356-6066. Photo Editor: Larry Mishkar. Estab. 1984. Specializes in nature and wildlife books, calendars, posters, nature audio (CD and tape covers).
Needs: Buys more than 1,000 photos/year. Interested in the following subjects: world nature, wildlife and outdoor related activities. Images must be tack sharp. Model/property releases where needed is photographer's responsibility. Captions required.
Making Contact & Terms: Photo guidelines with SASE. Guidelines require the following: photographer's bio, published credits, stock list, tearsheets (will return, but to photographer's benefit to have here on file). Biz cards not needed. Can read PhotoCD or SyQuest 44 meg type disks. Quick return on outs. Published work is duped for printer use. Uses all transparency formats and 70mm repro-quality dupes. Pays $100-1,000/color photo. Pays within 30 days of publication. Credit line given. Buys one-time rights and project rights. Simultaneous submissions and previously published work OK.
Tips: Do not include multiples. Edit submissions carefully. Credit line on slide. Put slides in Kimac-type sleeves please. Photographers are contacted by mail or phone on upcoming projects. Update your tearsheets and stocklist regularly. "Newer photographers please present a professional, well-packaged submission that is pertinent to our product."

***■OMNI INTERCOMMUNICATIONS, INC.,** 2825 Wilcrest, #400, Houston TX 77042. (713)781-2188. Fax: (713)781-2315. Producer: David Brevard. Estab. 1976. Photos used in audiovisual uses.
Needs: Uses 1-5 photographers, 1-5 filmmakers, 1-5 videographers/month. Industrial footage. Examples of recent uses: Global Resources, for Textneft (environmental protection—Russia); A.C.T., for BFI (Spanish training films). Model/property release preferred. Captions preferred.
Audiovisual Needs: Uses slides, video and interactive CD-ROM for training. Subjects include: industrial footage.
Making Contact & Terms: Interested in receiving work from newer, lesser-known photographers. Provide résumé, business card, self-promotion piece or tearsheets to be kept on file for possible future assignments. Uses 35mm, 2¼×2¼ transparencies; Betacam SP videotape. Keeps samples on file. Cannot return material. Reports in 1-2 weeks. Pays in 30 days. Credit line depends on client. Rights purchased determined on case-by-case basis; negotiable.

***■OPTICOMM CORP.,** 5505 Morehouse Dr., #150, San Diego CA 92121. (619)450-0143. Fax: (619)450-0155. Vice President Market: David Caidar. Estab. 1987. Photos used in posters, magazines, catalogs and P-O-P displays.
Needs: Uses one photographer/month. Fiber optics. Reviews stock photos. Model release required.
Audiovisual Needs: Uses videotape for fiber optic videos.
Making Contact & Terms: Interested in receiving work from newer, lesser-known photographers. Query with samples. Works on assignment only. Uses 35mm, 8×10 transparencies. Keeps samples on file. SASE. Reports in 1-2 weeks. Pays $55/hour; $40/b&w photos. Pays on receipt of invoice. Credit line given. Buys all rights.

PHI DELTA KAPPA, Eighth & Union Sts., P.O. Box 789, Bloomington IN 47402. Design Director: Carol Bucheri. Estab. 1915. Produces *Phi Delta Kappan* magazine and supporting materials. Photos used in magazine, fliers and subscription cards.
Needs: Buys 10 photos/year; offers 1 assignment/year. Education-related subjects: innovative school programs, education leaders at state and federal levels, social conditions as they affect education. Reviews stock photos. Model release required. Photo captions required; include who, what, when, where.
Making Contact & Terms: Query with list of education-related stock photo subjects. Provide photocopies, brochure or flier to be kept on file for possible future assignments. Uses 8×10 b&w prints, b&w contact sheets. SASE. Reports in 3 weeks. Pays $20-100/b&w photo; $30-400/color photo; $30-500/job. Credit line and tearsheets given. Buys one-time rights.
Tips: "Don't send photos that you wouldn't want to hang in a gallery. Just because you do a photo for publications does not mean you should lower your standards. Spots should be touched up (not with

a ball point pen), the print should be good and carefully done, subject matter should be in focus. Send me photocopies of your b&w prints that we can look at. We don't convert slides and rarely use color."

***PHILADELPHIA T-SHIRT MUSEUM**, 235 N. 12th St., Philadelphia PA 19107. (215)625-9230. Fax: (215)625-0740. President: Marc Polish. Estab. 1972. Specializes in T-shirts.
Needs: Number of images bought varies; most supplied by freelancers. Interested in humor, resorts and nature. Model/property release required.
Making Contact & Terms: Interested in receiving work from newer, lesser-known photographers. Query with samples. Uses color and b&w prints. Keeps samples on file. SASE. Reports in 1-2 weeks. Pays 6% royalties on sales. Pays on usage. Credit line given. Buys exclusive product rights; negotiable.

POSEY SCHOOL OF DANCE, INC., Box 254, Northport NY 11768. (516)757-2700. President: Elsa Posey. Estab. 1953. Sponsors a school of dance and a regional dance company. Photos used in brochures and newspapers.
Needs: Buys 10-12 photos/year; offers 4 assignments/year. Special subject needs include children dancing, ballet, modern dance, jazz/tap (theater dance) and classes including women and men. Reviews stock photos. Model release required.
Making Contact & Terms: Interested in receiving work from newer, lesser-known photographers. "Call us." Works on assignment only. Uses 8×10 glossy b&w prints. SASE. Reports in 1 week. NPI; payment negotiable. Pays $25-200/b&w or color photo. Credit line given if requested. Buys one-time rights; negotiable.
Tips: "We need photos of REAL dancers doing, not posing, dance. We need photos of children dancing. We receive 'cute' photos often portraying dancers as shadows!"

***■PROMOTIVISION, INC.**, 5929 Baker Rd., Suite 460, Minnetonka MN 55345. (612)933-6445. Fax: (612)933-7491. President: Daniel G. Endy. Estab. 1984. Photos used in TV commercials, sports, corporate image and industrial.
Audiovisual Needs: Uses film and video. Subjects include legal, medical, industrial and sports.
Making Contact & Terms: Interested in receiving work from professional photographers. Provide résumé, business card, self-promotion piece or tearsheets to be kept on file for possible future assignments. Works with freelancers on occasion. Uses 16mm color neg; Betacam SP videotape. Keeps samples on file. SASE. Pays $500-1,000/day. "We pay immediately. Weekly shows we roll credits." Buys all rights; negotiable.
Tips: "We are only interested in quality work. At times, in markets other than ours, we solicit help and send a producer/director to work with local photo crew. Film is disappearing and video continues to progress. We are only 12 years old and started as an all film company. Now film comprises less than 5% of our business."

THE QUARASAN GROUP, INC., 214 W. Huron, Chicago IL 60610-3616. (312)787-0750. Fax: (312)787-7154. E-mail: quarasan@aol.com. Photography Coordinator: Renee Calabrese. A complete book publishing service and design firm. Offers design of interiors and covers to complete editorial and production stages, art and photo procurement. Photos used in brochures, books and other print products.
Needs: Buys 1,000-5,000 photos/year; offers 75-100 assignments/year. "Most products we produce are educational in nature. The subject matter can vary. For textbook work, male-female/ethnic/handicapped/minorities balances must be maintained in the photos we select to ensure an accurate representation." Reviews stock photos and CD-ROM. Model release required. Captions required.
Making Contact & Terms: Interested in receiving work from new, lesser-known photographers. Query with stock photo list or nonreturnable samples (photocopies OK). Provide résumé, business card, brochure, flier or tearsheets to be kept on file for possible future assignments. Prefers 8×10 b&w glossy prints; 35mm, 2¼×2¼, 4×5, or 8×10 transparencies, or b&w contact sheets. Cannot return material. "We contact once work/project requires photos." NPI; payment based on final use size. Pays on a per photo basis or day rate. Credit line given, but may not always appear on page. Usually buys all rights or sometimes North American rights.
Tips: "Learn the industry. Analyze the products on the market to understand *why* those photos were chosen. Clients still prefer work-for-hire, but this is changing. We are always looking for experienced photo researchers and top-notch photographers local to the Chicago area."

 The asterisk before a listing indicates that the market is new in this edition. New markets are often the most receptive to freelance submissions.

REVERE/LIFEDANCE CO. INC., 3479 NW Yeon Ave., Portland OR 97210. (503)228-9430. Fax: (503)228-5039. President: Morris McClellan. Estab. 1982. Record company and distribution company. Photos used in catalogs, CD and cassette packaging.
Needs: Buys 3-8 photos/year. Uses photos of "nature, mostly." Examples of recent use: annual catalog of recordings (cover), CD/cassette (cover). Reviews stock photos of nature subjects. Photo captions should include: description of subject matter.
Making Contact & Terms: Interested in receiving work from newer, lesser-known photographers. Query with samples. Uses color prints; 35mm, 2¼×2¼, 4×5 transparencies. SASE. Reports only when interested. Pays $300-500/color photo. Pays on usage. Credit line given. Buys one-time rights; negotiable.
Tips: "We require nature photos that reflect relaxation, peace and beauty."

■**RIPON COLLEGE**, P.O. Box 248, Ripon WI 54971. (414)748-8364. Contact: Director of College Relations. Estab. 1851. Photos used in brochures, newsletters, posters, newspapers, audiovisual presentations, annual reports, magazines and press releases.
Needs: Offers 3-5 assignments/year. Formal and informal portraits of Ripon alumni, on-location shots, architecture. Model/property release preferred. Captions preferred.
Making Contact & Terms: Interested in receiving work from newer, lesser-known photographers. Provide résumé, business card, brochure, flier or tearsheets to be kept on file for possible future assignments. Works on assignment only. SASE. Reports in 1 month. Pays $10-25/b&w photo; $10-50/color photo; $30-40/hour; $300-500/day; $300-500/job; negotiable. Buys one-time and all rights; negotiable.

RSVP MARKETING, INC., 450 Plain St., Suite 5, Marshfield MA 02050. President: Edward C. Hicks. Direct marketing consultant/agency. Photos used in brochures, catalogs and magazines.
Needs: Buys 50-100 photos/year; offers 5-10 assignments/year. Industrial equipment, travel/tourism topics and modeled, clothing, sports events. Reviews stock photos. Model release preferred.
Making Contact & Terms: Query with list of stock photo subjects. Provide résumé, business card, brochure, flier or tearsheets to be kept on file for possible future assignments. Works on assignment only. Uses 2×2 and 4×6 b&w and color prints, and transparencies. Reports as needed. NPI; payment negotiable per photo and per job. Buys all rights.
Tips: "We look for photos of industrial and office products, high-tech formats and fashion."

SANGRE DE CRISTO CHORALE, P.O. Box 4462, Santa Fe NM 87502. (505)662-9717. Fax: (505)665-4433. Business Manager: Hastings Smith. Estab. 1978. Producers of chorale concerts. Photos used in brochures, posters, newspapers, press releases, programs and advertising.
Needs: Buys one set of photos every two years; offers 1 freelance assignment every two years. Photographers used to take group shots of performers. Examples of recent uses: Newspaper feature (5×7, b&w); concert posters (5×7, b&w); and group pictures in a program book (5×7, b&w).
Making Contact & Terms: Interested in receiving work from newer, lesser-known photographers. Provide résumé, business card, self-promotion piece or tearsheets to be kept on file for possible future assignments. Works with local freelancers only. Uses 8×10, 5×7 glossy b&w prints. Keeps samples on file. SASE. Reports in 1 month, or sooner. NPI. **Pays on acceptance**. Credit line given. Buys all rights; negotiable.
Tips: "We are a small group—36 singers with a $25,000/year budget. We need promotional material updated about every two years. We prefer photo sessions during rehearsal, to which we can come dressed. We find that the ability to provide usable action photos of the group makes promotional pieces more acceptable."

*****SOUTHWEST SYMPHONY ORCHESTRA**, 5164 W. 95th St., Oaklawn IL 60453. (708)489-5322. Manager: Tom Hawley. Estab. 1964. Puts on 4 classical symphony concerts per season. Photos used in brochures, newsletters, posters, newspapers, annual reports, press releases and concert programs.
Needs: Buys 3 photos/year; offers 3 assignments/year. Freelancers asked to photograph concerts, guest performers and the orchestras. Examples of recent uses: concert programs and press releases. Model/property release preferred. Releases usually needed for guest artists in publicity shots.
Making Contact & Terms: Interested in receiving work from newer, lesser-known photographers. Query with samples. Works on assignment only. Uses 8×10 glossy color and b&w prints. Keeps samples on file. SASE. Reports in 1-2 weeks. Pays $20-50/job. **Pays on acceptance**. Credit line given. Buys all rights; negotiable.
Tips: "We are a small community orchestra with not many financial resources, but would like to establish a relationship with someone we could call for pictures to be taken, etc. We need updated pictures of orchestra for publicity purposes. Would give credit, tickets and pay, but can't afford a lot. Newspapers desperately want publicity shots. So do we!"

■**SPECIAL OLYMPICS INTERNATIONAL**, 1325 G St. NW, Suite 500, Washington DC 20005. (202)628-3630. Fax: (202)824-0200. Media Production Manager: Jill Dixon. Estab. 1968. Provides

sports training/competition to people with mental retardation. Photos used in brochures, newsletters, posters, annual reports, media and audiovisual.

Needs: Buys 500 photos/year; offers 3-5 assignments/year. Sports action and special events. Model/property release preferred for athletes and celebrities.

Audiovisual Needs: Uses slides and videotape.

Making Contact & Terms: Interested in receiving work from newer, lesser-known photographers. Provide résumé, business card, self-promotion piece or tearsheets to be kept on file for possible future assignments. Uses 3×5, 5×7 and 8×10, glossy color or b&w prints; 35mm transparencies; VHS, U-matic, Betacam, 1-inch videotape. Keeps samples on file. SASE. Reports in 1 month. Pays $50-100/hour; $300-500/job. Processing additional. "Many volunteer time and processing because we're a not-for-profit organization." **Pays on acceptance.** Credit line depends on the material it is used on (no credit on brochure/credit in magazines). Buys one-time and all rights; negotiable.

Tips: Specific guidelines can be given upon request. Looking for "good action and close-up shots."

***RICHARD STAFFORD GROUP, INC.**, P.O. Box 735, Miami FL 33144. (305)461-2770. Photo Editor/Researcher: Alex Gonzalez. Estab. 1991. Publisher. Photos used in magazine *Fototeque*.

Needs: Buys 3-6 photos/month. Subjects include fine art, b&w photos. Model/property release preferred. Captions preferred; include technical data (i.e., camera, lens, aperture, film).

Making Contact & Terms: Interested in receiving work from newer, lesser-known photographers. Provide résumé, business card, self-promotion piece or tearsheets to be kept on file for possible future assignments. Do not send unsolicited photos. Uses b&w prints no larger than 8×10. Keeps samples on file. SASE. Reports in 1 month. Pays $35-500/b&w photo. Pays 2 months after publication. Buys one-time rights.

Tips: Wants to see "an artistic sense of design in composition and richness in tonal range. We need critiques, reviews and bios from USA and foreign countries (must be translated). Has a special Portfolio/Gallery section in each issue."

***♥■SUN.ERGOS, A Company of Theatre and Dance**, 2203, 700 Ninth St., SW, Calgary, Alberta T2P 2B5 Canada. (403)264-4621. Fax: (403)269-1896. Artistic and Managing Director: Robert Greenwood. Estab. 1977. Company established in theater and dance, performing arts, international touring. Photos used in brochures, newsletters, posters, newspapers, annual reports, magazines, press releases, audiovisual uses and catalogs.

Needs: Buys 10-30 photos/year; offers 3-5 assignments/year. Performances. Examples of recent uses: souvenir program, performance programs, brochures. Reviews theater and dance stock photos. Property release required for performance photos for media use. Captions required; include subject, date, city, performance title.

Audiovisual Needs: Uses slides, film and videotape for media usage, showcases and international conferences. Subjects include performance pieces/showcase materials.

Making Contact & Terms: Interested in receiving work from newer, lesser-known photographers. Arrange a personal interview to show portfolio. Query with résumé of credits. Provide résumé, business card, self-promotion piece or tearsheets to be kept on file for possible future assignments. Work on assignment only. Uses 8×10, 8½×11 color and b&w prints; 35mm, 2¼×2¼ transparencies; 16mm film; NTSC/PAL/SECAM videotape. Keeps samples on file. SASE. Reporting time depends on project. Pays $100-150/day; $150-300/job; $2.50-10/color photo; $2.50-10/b&w photo. Pays on usage. Credit line given. Buys all rights.

Tips: "You must have experience shooting dance and theater *live* performances."

***TEXAS LOTTERY PLAYERS ASSOCIATION**, P.O. Box 270942, Dallas TX 75227-0942. Operations Manager: Bill Flum. Estab. 1993. Membership organization, advertising, marketing. Photos used in newspapers and magazines.

Needs: Photos of persons who have won reasonable amounts from the Texas lottery. Model/property release required for lottery winners. Captions required.

Making Contact & Terms Interested in receiving work from newer, lesser-known photographers. Send unsolicited photos by mail for consideration. Uses 5×7 glossy color and b&w prints. Keeps samples on file. Reports in 1 month. Pays $10-50/color photo; $15-50/b&w photo; photo credit and copies of publication. Credit line given. Buys all rights; negotiable.

Tips: "Looking for lottery photos about Texas winners of small and large amounts; photos with story lines. Not interested in any other subjects or capabilities. Requests for copy of *T.L.P.A. News* must be

The maple leaf before a listing indicates that the market is Canadian.

accompanied by check/money order of $3.29; no copies will be mailed otherwise. We expect to have a network of photographers in Texas who can get shots/stories (personal) of/from lottery winners, in addition to other lotto info derived from individuals on a creditable basis."

■THIEL COLLEGE, 75 College Ave., Greenville PA 16125. (412)589-2855. Fax: (412)589-2856. Director of Communications: Mark A. Meighen. Estab. 1866. Provides education; undergraduate and community programs. Photos used in brochures, newsletters, newspapers, audiovisual presentations, annual reports, catalogs, magazines and news releases.
Needs: Buys 20-25 photos/year; offers 3-5 assignments/year. "Basically we have an occasional need for photography depending on the job we want done."
Making Contact & Terms: Interested in receiving work from newer, lesser-known photographers. Query with résumé of credits. Works on assignment only. Uses 35mm transparencies. Reports as needed. NPI; payment negotiable. Credit line given depending on usage. Buys all rights; negotiable.

***■UNION INSTITUTE**, 440 E. McMillan St., Cincinnati OH 45206. (513)861-6400. Fax: (513)861-0779. Contact: Anu Mitra. Provides alternative higher education, baccalaureate and doctoral programs. Photos used in brochures, newsletters, magazines, posters, audiovisual presentations, annual reports, catalogs and news releases.
Needs: Uses photos of the Union Institute community involved in their activities. Also, photos that portray themes. Model release required.
Making Contact & Terms: Arrange a personal interview to show portfolio. Uses 5×7 glossy b&w and color prints; b&w and color contact sheets. SASE. Reports in 3 weeks. NPI; payment negotiable. Credit line given.
Tips: Prefers "good closeups and action shots of alums/faculty, etc. Our quarterly alumni magazine reaches an international audience concerned with major issues. Illustrating its stories with quality photos involving our people is our constant challenge. We welcome your involvement."

UNITED AUTO WORKERS (UAW), 8000 E. Jefferson Ave., Detroit MI 48214. (313)926-5291. Fax: (313)331-5120. E-mail: 71112.363@compuserv.com. Editor: David Elsila. Trade union representing 800,000 workers in auto, aerospace, and agricultural-implement industries. Publishes *Solidarity* magazine. Photos used for brochures, newsletters, posters, magazines and calendars.
 • The publications of this organization have won International Labor Communications Association journalism excellence contest and two photography awards.
Needs: Buys 85 freelance photos/year and offers 12-18 freelance assignments/year. Needs photos of workers at their place of work and social issues for magazine story illustrations. Reviews stock photos. Model releases preferred. Captions preferred.
Making Contact & Terms: Arrange a personal interview to show portfolio. In portfolio, prefers to see b&w and color workplace shots. Query with samples and send material by mail for consideration. Prefers to see published photos as samples. Provide résumé and tearsheets to be kept on file for possible future assignments. Uses 8×10 prints; contact sheets OK. Notifies photographer if future assignments can be expected. SASE. Reports in 2 weeks. Pays $50-100/b&w or color photo; $250/half-day; $475/day. Credit line given. Buys one-time rights and all rights; negotiable.

***UNITED STATES SAILING ASSOCIATION**, P.O. Box 209, Newport RI 02840. (401)849-5200. Fax: (401)849-5208. Editor: Dana Marnane. Estab. 1897. *American Sailor Magazine* provided to members of United States Sailing Association. Photos used in brochures, posters and magazines.
Needs: Buys 30-50 photos/year. Examples of recent uses: *American Sailor* (cover, color slide); "US Sailing Directory" (cover); and membership brochure, (b&w and color). Reviews stock photos, action sailing/racing shots; close-up face shots. Captions preferred; include boat type/name, regatta name.
Making Contact & Terms: Prefers slides, accepts prints, color only. Pays $25-100/color cover. Buys one-time rights.

***UNIVERSITY OF NEW HAVEN**, 300 Orange Ave., West Haven CT 06516. (203)932-7243. Public Relations Director: Cynthia Avery. Photos used in brochures, newsletters, newspapers, annual reports, catalogs and news releases.
Needs: Uses University of New Haven campus and student photos.
Making Contact & Terms: Query with résumé "and non-returnable samples for our files. We'll contact to arrange a personal interview to show portfolio." Local freelancers preferred. Uses 5×7 glossy b&w prints; 35mm transparencies; contact sheet OK. SASE. "Can't be responsible for lost materials." Reports in 1 week. Pays $2-9/b&w photo; $10-25/color photo; $30-100/hour; $100-200 and up/day; payment negotiable on a per-photo basis. Buys all rights.
Tips: Looks for good people portraits, candids, interaction, news quality. Overall good versatility in mixed situations. "Call first to see if we need additional photographers. If yes, send samples and rates. Make appointment to show portfolio. Be reasonable on costs (we're a nonprofit institution). Be a

resident in local area available for assignment." Sees a "need for better and better quality photo reproduction."

WILLIAM K. WALTHERS, INC., 5601 W. Florist Ave., Milwaukee WI 53218. (414)527-0770. Fax: (414)527-4423. Creative Services Supervisor: Sandy Ellington. Estab. 1932. Importer/wholesaler of hobby products. Photos used in catalogs, text illustration and promotional materials.
Needs: Buys 50-100 photos/year; offers 20 assignments/year. Interested in any photos relating to historic or model railroading; also photos of industries (i.e., steel mills, nostalgic pictures of train scenes, etc.). Reviews stock photos. Model/property release required. Captions preferred; include brief overview of action, location, any unusual spellings, names of photographer and model builder.
Making Contact & Terms: Interested in receiving work from newer, lesser-known photographers. Send unsolicited photos by mail for consideration. Uses 4×5, 8½×11 color and b&w prints; 35mm, 2¼×2¼ transparencies. Keeps samples on file. SASE. Reports in 1-2 weeks. NPI; payment negotiated based on usage. Pays on publication or receipt of invoice. Credit line given. Buys all rights.
Tips: "Knowledge of railroading is essential since customers consider themselves experts on the subject. With model railroad shots, it should be difficult to see that the subject is a miniature."

***■WORCESTER POLYTECHNIC INSTITUTE**, 100 Institute Rd., Worcester MA 01609. (508)831-5000. Fax: (508)831-5604. University Editor: Michael Dorsey. Estab. 1865. Publishes periodicals and promotional, recruiting and fund-raising printed materials. Photos used in brochures, newsletters, posters, audiovisual presentations, annual reports, catalogs, magazines and press releases.
Needs: On-campus, comprehensive and specific views of all elements of the WPI experience. Relations with industry, alumni. Reviews stock photos. Captions preferred.
Making Contact & Terms: Interested in receiving work from newer, lesser-known photographers. Arrange a personal interview to show portfolio or query with stock photo list. Provide résumé, business card, brochure, flier or tearsheets to be kept on file for possible future assignments. "No phone calls." Uses 5×7 (minimum) glossy b&w prints; 35mm, 2¼×2¼, 4×5 transparencies; b&w contact sheets. SASE. Reports in 2 weeks. NPI. Rates negotiable. Credit line given in some publications. Buys one-time or all rights; negotiable.

***ZOLAN FINE ART STUDIO**, Dept. PM, P.O. Box 656, Hershey PA 17033-2173. (717)534-2446. Fax: (717)534-1095. E-mail: donaldz798@aol.com. President/Art Director: Jennifer Zolan. Commercial and fine art business. Photos used for reference in oil paintings.
Needs: Buys 16-24 photos/year; assignments vary on need. Interested in candid, heart-warming, and endearing photos of children between the ages of two through five capturing the golden moments of early childhood. Reviews stock photos. Model release required.
Making Contact & Terms: Interested in receiving work from newer, lesser-known photographers. Write and send for photo guidelines by mail, fax or America Online. Uses any size color or b&w prints; 35mm, 2¼×2¼, 4×5, 8×10 transparencies. Does not keep samples on file. SASE. Queries on guidelines 2-3 weeks; photo returns or acceptances up to 45 days. Pays $1,000/photo. **Pays on acceptance.** Buys all rights; negotiable.
Tips: "Photos should have high emotional appeal that touch the heart, evoking pleasant and happy memories. Facial expression is important. Photos should look candid. Write for free photo guidelines before submitting your work. We work with amateur and professional photographers."

Businesses and Organizations/'95-'96 changes

The following markets appeared in the 1995 edition of *Photographer's Market*, but are not listed this year. The majority did not respond to our request to update their listings. If a reason was given for a market's exclusion it appears in parentheses below.

Air-Conditioning & Refrigeration Wholesalers
Allright Corporation
American Power Boat Assoc.
American Red Cross
American Souvenir & Novelty Company
Argus Communications
Aristoplay
Bankers Life & Casualty Co.
Blount, Inc.
Dayton Ballet

Scott Evans Productions, Music & Entertainment
General Store Inc.
Green Mountain Power
Icart Vendor Graphics
Imagine Inc.
International Wildlife Association
Juvenile Diabetes Foundation
The Minnesota Opera
Miracle Of Aloe
Overseas Development Council
Palm Springs Desert Resort Con-

vention and Visitors Bureau
Photo Marketing Association
Recreation World Services, Inc. (not buying freelance photos)
San Francisco Conservatory of Music
Save the Children
Schwinn Cycling & Fitness Inc.
Special Report
Through the Opera Glass
Tops News
Yearbook Associates

Galleries

Over the past ten years there has been enormous growth in the popularity of photography as a collectible art form. The reasons for this vary. Prices for outstanding images are not out of reach; the value of limited editions makes photography a worthy investment; and, photographers such as Ansel Adams, Henri Cartier-Bresson and Helmut Newton are becoming well known to collectors.

The fine art photo industry also has benefited from an increase in gallery space, and a sampling of these galleries is in this section. There are 145 galleries listed here, 36 new ones, and all offer exhibition opportunities for new talent.

When trying to rouse interest from collectors and gallery directors, it's important to establish your own style that makes a statement. Purchases are made mainly because a viewer feels something for the work, whether it's a limited edition print or a $10 poster. Even the truly serious collectors are ones who not only recognize the investment value of photos, but also get attached to the beauty of the work.

One photographer who has created his own style is Ron Terner of New York City. Terner is not only a photographer, but he's director of Focal Point Gallery and he discusses his views on the collectibility of fine art in our Insider Report on page 182.

How galleries operate

Although there are a growing number of all-photography galleries, most are still primarily art galleries which may either hold annual photography shows or special solo and group photography exhibits throughout the year. Some also include photography as part of their permanent collections and exhibit photos at all times.

The largest group of galleries are retail, for-profit operations. These galleries usually cater to both private and corporate collectors. Depending on the location, the clientele may include everyone from tourists and first-time buyers, to sophisticated, long-time collectors and professional interior designers. The emphasis is on what sells and these galleries are interested only in work they feel will fit the needs of their clientele. Before approaching a retail gallery, be sure you have a very clear understanding of its clientele's interests and needs.

Art consultancies work primarily with professional art buyers, including interior decorators, interior designers, developers, architects and corporate art collectors. Some include a viewing gallery open to the public, but they are most interested in being able to show their clients a wide variety of work. Consultancies maintain large slide files to match the needs of their clients in almost any situation. Photographers interested in working with consultants must have a body of work readily available.

Nonprofit galleries and alternative spaces offer photographers the most opportunities, especially if their work is experimental. Often sponsored by an educational facility or by a cooperative, the aim of these galleries is to expose the public to a variety of art forms and new artists. Since sales are secondary, profits from sales in these galleries will be lower than in retail outlets. Cooperatives offer artists (and photographers) the opportunity to have a say in how the gallery is operated. Most require a small membership fee and a donation of time. In exchange they take a very low commission on works sold.

Read the listings carefully to determine which galleries interest you most. Some

provide guidelines or promotional information about the gallery's recent exhibits for a self-addressed, stamped envelope. Whenever possible, visit those galleries that interest you to get a real feel for their particular needs and outlook. Do not, however, try to show a portfolio without first making an appointment. Most galleries will look at transparencies, prints, tearsheets, bios, résumés and other material first. If interested, they will request to see a portfolio.

Most galleries operate on a commission basis. Galleries take a percentage commission for works sold. Retail galleries usually take 40-50 percent commission, while nonprofits usually charge 20-30 percent. A few also take a rental fee for space used. Prices may be set by either the gallery or the artist, but quite often by mutual agreement.

Most galleries provide insurance on-site and will handle promotional costs. Shipping costs often are shared with the gallery paying for shipment one-way. Galleries also provide written contracts outlining their expectations. Photographers should study the contract carefully and treat the gallery as any other business partner.

***A.O.I. GALLERY**, 634 Canyon Rd., Santa Fe NM 87501. (505)982-3456. Fax: (505)982-2040. Director: Frank Aoi. Estab. 1992.
Exhibits: Requirements: Must be involved with fine art photography. No students work. Interested in contemporary/avant garde photography or videos. Examples of recent exhibitions: "Recent Work," by Carl Golhagen (photo-emulsion on glass and metal); "Prayer Hands," by Yasu Suzuka (original Polaroids with copper mats); and "Intimate Memories," by Michael Kenna and Masao Yamamoto (silver prints and mixed media). Presents 5 shows/year. Shows last 1 month. Sponsors openings. Photographer's presence at opening and during show preferred.
Making Contact & Terms: Commission varies. Buys photos outright. General price range: $500-15,000. Call for size limits. Call. Cannot return material.
Tips: "Be extremely polite and professional."

A.R.C. GALLERY, 1040 W. Huron, 2nd Floor, Chicago IL 60622. (312)733-2787. President: Julia N. Morrison. Estab. 1973.
Exhibits: Requirements: Must send slides, résumé and statement to gallery for review. All styles considered. Contemporary fine art photography, documentary and journalism. Examples of exhibitions: "Presence of Mind," by Jane Stevens (infrared photographs, b&w); "Take Away the Pictures. . . ," by Barbara Thomas (C-prints); "Watershed Investigations. . . ," by Mark Abrahamson (cibachrome prints). Presents 5-8 shows/year. Shows last 1 month. Sponsors openings. Photographer's presence at opening and during show preferred.
Making Contact & Terms: Interested in receiving work from newer, lesser-known photographers. Charges no commission. General price range: $100-600. Reviews transparencies. Interested in seeing slides for review. No size limits or other restrictions. Send material by mail for consideration. SASE. Reports in 1 month.
Tips: Photographers "should have a consistent body of work. Show emerging and experimental photographer's work."

ANSEL ADAMS CENTER FOR PHOTOGRAPHY, 250 Fourth St., San Francisco CA 94103. (415)495-7000. Fax: (415)495-8517. Attention: Portfolio Review. The Center was established in 1989. The Friends of Photography, the parent organization which runs the center, was founded in 1967.
● The Friends of Photography presents two grants and two Peer awards in Creative Photography. Guidelines for grant application are available every May; applicants must send a SASE for guidelines.
Exhibits: Requirements: "Photographers are welcome to submit exhibition proposals through our portfolio review system. Generally this entails sending 15-26 slides, a brief artist's statement, a brief résumé (optional), and a SASE for return of submission. Call for future info." Interested in all styles and subjects of photography. Examples of exhibitions: "Annie Leibovitz: Photographs 1970-1990" (major retrospective); "Consuming Landscapes: Clearing the Table," by Robin Lasser (multimedia installation); "Clarence John Laughlin: Visionary Photographer" (gelatin silver prints). Presents 15-18 exhibits/year. Shows last 2-2½ months. Sponsors openings; includes informal receptions, refreshments, exhibition preview. Photographer's presence at opening and at show preferred.
Making Contact & Terms: Interested in receiving work from new, lesser-known photographers. NPI. Reviews transparencies. Interested in unframed, mounted or unmounted, matted or unmatted work. Submit portfolio for review. Send material by mail for consideration. Call for details on portfolio review. SASE. Reports back on portfolio reviews in 1-2 weeks; submitted work in 1 month.

Tips: "We are a museum, not a gallery. We don't represent artists, and usually *exhibit* only established artists (locally or nationally). We are, however, very open to seeing/reviewing new work, and welcome exhibition proposals so long as artists follow the guidelines (available if a SASE is sent)."

ADIRONDACK LAKES CENTER FOR THE ARTS, Rt. 28, P.O. Box 205, Blue Mt. Lake NY 12812. (518)352-7715. Fax: (518)352-7333. Program Coordinator: Susan Mitchell. Estab. 1967.
Exhibits: Requirements: send résumé, artist's statement, slides or photos. Interested in all styles and subject matter. Examples of recent exhibitions: "Photos of Wilderness—Adirondacks, Antarctic & Tropics," by Celine Karraker; "Abstract Florals," by Walter Carstens; "Adirondack Park—Exposures of Color," by Brian Morris. Presents 6-8 exhibits/year. Shows last 1 month. Sponsors openings. Provides wine and cheese receptions, bulk mailings of announcements may also be arranged if artist can provide postcard. Photographer's presence at opening preferred.
Making Contact & Terms: Interested in receiving work from newer, lesser-known photographers. Charges 30% commission. General price range: $100-250. "Pricing is determined by photographer. Payment made to photographer at end of exhibit." Reviews transparencies. Interested in framed and matted or unmatted work. Send material by mail for consideration. SASE. Reports in 1 month.
Tips: "Our gallery is open during all events taking place at the Arts Center, including concerts, films, workshops and theater productions. Guests for these events are often customers seeking images from our gallery for their own collections or their places of business. Customers are often vacationers who have come to enjoy the natural beauty of the Adirondacks. For this reason, landscape and nature photographs sell well here."

AKRON ART MUSEUM, 70 E. Market St., Akron OH 44308. (216)376-9185. Curator: Barbara Tannenbaum.
 • This gallery annually awards the Knight Purchase Award to a living artist working with photographic media.
Exhibits: Requirements: To exhibit, photographers must possess "a notable record of exhibitions, inclusion in publications, and/or a role in the historical development of photography. We also feature local photographers (Akron area)." Interested in innovative works by contemporary photographers; any subject matter. Examples of recent exhibitions: "Ralph Eugene Meatyard: An American Visionary"; "The Cuyahoga Valley: Photographs by Robert Glenn Ketchum"; Cibachrome color photographs; "Czech Modernism: Photography," a historical survey of Czechoslovakian photography. Presents 3-5 exhibits/year. Shows last 2 months. Sponsors openings; provides light food, beverages and sometimes entertainment. Photographer's presence at opening preferred. Presence during show is not required, but willingness to give a gallery talk is appreciated.
Making Contact & Terms: NPI; buys photography outright. Will review transparencies. Send material by mail for consideration. SASE. Reports in 1-2 months, "depending on our workload."
Tips: "Prepare a professional looking packet of materials including high-quality slides, and always send a SASE. Never send original prints."

ALBER GALLERIES, 3300 Darby Rd., #5111, Haverford PA 19041. (610)896-9297. Director: Howard Alber. Estab. 1977.
 • This is a private gallery with a very limited operation.
Exhibits: Requirements: Professional presentation, well priced for sales, consistent quality and willingness to deliver promptly. Interested in Philadelphia subjects, land conservation, wetlands, artful treatments of creative presentation. Has shown work by Michael Hogan, Harry Auspitz (deceased), Barry Slavin, Joan E. Rosenstein and Joan Z. Rough. Photographer's presence at opening is not required. "Cooperative show space only. We do not have our own gallery space."
Making Contact & Terms: Charges 40% commission. General price range: $75-1,000. Reviews transparencies; only as requested by us. Not interested in new presentations. Slides only on first presentation.
Tips: "Give us copies of all reproduced photos, calendars, etc., only if we can retain them permanently."

THE ALBUQUERQUE MUSEUM, 2000 Mountain Rd. NW, Albuquerque NM 87104. (505)243-7255. Fax: (505)764-6546. Curator of Art: Ellen Landis. Estab. 1967.

A bullet has been placed within some listings to introduce special comments by the editor of **Photographer's Market.**

Exhibits: Requirements: Send photos, résumé and artist's statement. Interested in all subjects. Examples of recent exhibitions: "Gus Foster," by Gus Foster (panoramic photographs); "Santiago," by Joan Myers (b&w 16×20); and "Frida Kahlo," by Lola Alvaraz Bravo (b&w various sizes). Presents 3-6 shows/year. Shows last 8-12 weeks. Photographer's presence at opening preferred, presence during show preferred.

Making Contact & Terms: Buys photos outright. Reviews transparencies. Interested in framed or unframed work, mounted or unmounted work, matted or unmatted work. Arrange a personal interview to show portfolio. Submit portfolio for review. Send material by mail for consideration. "Sometimes we return material; sometimes we keep works on file." Reports in 1 month.

AMERICAN SOCIETY OF ARTISTS, INC., Box 1326, Palatine IL 60078. (708)991-4748 or (312)751-2500. Membership Chairman: Helen Del Valle.

Exhibits: Members and nonmembers may exhibit. "Our members range from internationally known artists to unknown artists—quality of work is the important factor. We have about 25 shows throughout the year which accept photographic art."

Making Contact & Terms: NPI; price range varies. Interested in framed, mounted or matted work only. Send SASE for membership information and application (state media). Reports in 2 weeks. Accepted members may participate in lecture and demonstration service. Member publication: *ASA Artisan*.

ANN ARBOR ART ASSOCIATION ART CENTER, 117 W. Liberty, Ann Arbor MI 48104. (313)994-8004. Fax: (313)994-3610. Galleries Director: Liz Nelson. Estab. 1909.

Exhibits: Requirements: each artist must be a Michigan resident. Interested in any type of photography. "We are open to new ideas." Examples of exhibitions: "Inner Iconography," by Loralei R. Byatt (enlarged portrait close-ups), and works by Chris Coffey (slice of life photography) and Leslie Adiska (large, landscape scenes). Presents 10-15 shows/year. Shows last 1 month up to 1 year. Sponsors openings. Provides opening reception with refreshments, and "postcards announcing the show to our members as well as artist's mailing list. We also show in our retail gallery shop in addition to our rotating gallery exhibits." Photographer's presence at opening preferred.

Making Contact & Terms: Interested in receiving work from newer, lesser-known photographers. Charges 30% commission for members, 50% for non-members; membership available to everyone. General price range: $200-500. Reviews transparencies. Interested in framed work only. Requires exclusive representation locally. All work must be framed and behind glass or Plexiglas. Arrange a personal interview to show portfolio. SASE for return of slides. Reports in 3 weeks.

Tips: Advises photographers to "become familiar with common business practices. Be prepared. Be prompt. Keep accurate records. Have work professionally framed. Have your b&w promo photos prepared. Update résumé and bio and have them professionally typeset."

***THE ART CENTER**, 125 Macomb Place, Mount Clemens MI 48043. (810)469-8666. Fax: (810)469-4529. Exhibit Coordinator: Colleen Brunton. Executive Director: Jo-Anne F. Wilkie.

Exhibits: Interested in landscapes, still life, portraiture, abstracts, architecture and fashion. Examples of recent exhibitions: works by Steve Jensen and Fernando Diaz (male nudes and nature scenes); Mary Keithan (barns and school houses); and G.L. Klayman (solarized silver prints). Presents 1 show/year. Shows last 3-4 weeks. Sponsors openings. Provides refreshments and food, publicity for opening reception. Photographer's presence at opening and during show preferred.

Making Contact & Terms: Interested in receiving work from newer, lesser-known and well-known photographers. Charges 30% commission. General price range: $175-300. Reviews slides. Interested in framed work only. Large scale submissions accepted based on available gallery space. Query with samples. Send material by mail for consideration. SASE. Reports in 1-2 months.

ART CENTER OF BATTLE CREEK, 265 E. Emmett St., Battle Creek MI 49017. (616)962-9511. Curator: Tim Norris. Estab. 1962.

Exhibits: Interested in "experimentation; technical/compositional skill; originality and personal statement—avoid clichés." Examples of exhibitions: "The Intimate Universe," included experimental photos by Gloria DeFilipps Brush; a solo show of figurative/experimental photos by Felicia Hunt; "The Bridge Club," figurative/experimental photos by numerous artists. Focus '94 State Juried Photo Competition: Ninety-eight artists accepted, 136 works. All subjects, formats and processes represented. Occasionally presents one-person exhibits and 1 competition every other year (on the even years). Shows last 6 weeks. Sponsors openings; press releases are mailed to area and appropriate media. Photographer's presence at opening is preferred.

Making Contact & Terms: Interested in receiving work from newer, lesser-known photographers. Primarily interested in Michigan and Midwestern artists. Charges 33.3% commission. "We also accept gifts of photography by Michigan artists into the collection." General price range: $100-500. Will review transparencies if artist wants a solo exhibit. Interested in seeing framed or unframed, mounted

or unmounted, matted work only. Send material by mail for consideration. SASE. Reports after exhibits committee has met (1-2 months).

Tips: Sees trend toward "experimentation with older formats and processes, use of handtinting and an increase in social commentary. All photographers are invited to apply for exhibitions. The Center has a history of showing the work of emerging artists. Send examples of your best and most recent work. Be honest in your work and in presentation." Traditional landscapes are most popular with buying public.

ART INSTITUTE OF PHILADELPHIA, 1622 Chestnut St., Philadelphia PA 19103. (215)567-7080. Fax: (215)246-3339. Gallery Director: Greg Walker. Estab. 1973.
Exhibits: Requirements: All work must be ready to hang under glass or Plexiglas; no clip frames. Interested in fine art, commercial. Examples of recent exhibitions: George Krause (fine art, b&w); Lisa Goodman (commercial, b&w/color); Enrique Bostelmann (documentary, b&w/color). Presents 4 exhibits/year. Shows last 30 days. Photographer's presence at opening and during show is preferred.
Making Contacts & Terms: Interested in receiving work from newer, lesser-known photographers. Sold in gallery. General price range: $150-2,000. Reviews transparencies. Interested in matted or unmatted work. Query with samples. Include 10-20 slides and a résumé. SASE. Reports in 1 month.
Tips: "The gallery's concern is that artist must demonstrate the ability to present a mature body of work in any photography genre. In this area there are currently very few commercial galleries that show photography. We are open to showing the best photographic work that is submitted."

ARTEMISIA GALLERY, 700 N. Carpenter, Chicago IL 60622. (312)226-7323. Contact: Search Committee. Not-for-profit, cooperative, women artist-run alternative art gallery established in 1973. Interested in innovative, leading edge work and very receptive to newer, lesser-known, fine-art photographers demonstrating quality work and concept.
Exhibits: Examples of photo exhibitions: Cooper Spivey; Sungmi Naylor. Huge gallery with 5 separate spaces, presents 60 shows a year, each lasts 1 month. Approximately 15 exhibits are photography. Concurrently showcases major women artists, sponsors lectures.
Making Contact & Terms: Interested in receiving work from newer, lesser-known photographers. Sells works; does not charge commission. General price range: $150-500. No size limits or restrictions on photography. Sponsors opening reception with cash bar, provides gallery sitters, 1,300 name mailing list. Exhibitor provides announcements and postage, mailing service fee if using the gallery's list, ad fee, rental fee, installs show. Jurying requirements: send 15-20 slides of a consistent body of work, résumé and SASE. Returns in 4-6 weeks.
Tips: Opportunities for photographers in galleries are "fair to good." Photo exhibitions are treated as fine art. Buying public is most interested in work that is "innovative, finely composed, or concerned with contemporary issues. We encourage artists of color and/or members of minority groups, along with those interested in feminist issues, to apply. Please submit professional quality slides marked 'top' of a consistent body of work."

ARTISTS' COOPERATIVE GALLERY, 405 S. 11th St., Omaha NE 68102. (402)342-9617. President: Robin Davis. Estab. 1974.
Exhibits: Requirements: Fine art photography only. Artist must be willing to work 13 days per year at the gallery or pay another member to do so. "We are a member-owned and -operated cooperative. Artist must also serve on one committee." Interested in all types, styles and subject matter. Examples of recent exhibitions: works by Ulla Gallagher (sabattier, hand coloring), Pam King (photograms), and Margie Schimenti (cibachrome prints). Presents 14 shows/year. Shows last one month. Sponsors openings. Gallery sponsors 1 all-member exhibit and outreach exhibits, individual artists sponsor their own small group exhibits throughout the year. Photographer's presence at opening and during show required.
Making Contact & Terms: Interested in receiving work from newer, lesser-known photographers. Charges no commission. General price range: $100-300. Reviews transparencies. Interested in framed work only. Query with résumé of credits. SASE. Reports in 2 months.
Tips: "Write for membership application. Membership committee screens applicants Aug. 1-15 each year. Reports back by Sept. 1. New membership year begins Oct. 1. Members must pay annual fee of $300. Will consider well known artists of regional or national importance for one of our community outreach exhibits. Membership is not required for outreach program and gallery will host one-month exhibit with opening reception."

ASCHERMAN GALLERY/CLEVELAND PHOTOGRAPHIC WORKSHOP, 23500 Mercantile Rd., Suite D, Beachwood OH 44122. (216)464-4944. Fax: (216)464-3188. Director: Herbert Ascherman, Jr. Estab. 1977. Sponsored by Cleveland Photographic Workshop. Subject matter: all forms of photographic art and production. "Membership is not necessary. A prospective photographer must show a portfolio of 40-60 slides or prints for consideration. We prefer to see distinctive work—a signature in the print, work that could only be done by one person, not repetitive or replicative of others."

Exhibits: Presents 5 shows/year. Shows last about 10 weeks. Openings are held for some shows. Photographers are expected to contribute toward expenses of publicity. Photographer's presence at show "always good to publicize, but not necessary."

Making Contact & Terms: Interested in receiving work from newer, lesser-known photographers. Charges 25-40% commission, depending on the artist. Sometimes buys photography outright. Price range: $100-1,000. "Photos in the $100-300 range sell best." Will review transparencies. Matted work only for show.

Tips: "Photographers should show a sincere interest in photography as fine art. Be as professional in your presentation as possible; identify slides with name, title, etc.; matte, mount, box prints. We are a Midwest gallery and for the most part, people here respond to competent, conservative images more so than experimental or trendy work, though we are always looking for innovative work that best represents the artist (all subject matter). This does not mean that every show is landscape. We enjoy a variety of images and subject matters. Know our gallery; call first; find out something about us, about our background or interests. Never come in cold."

***BILL BACE GALLERY**, 39 Wooster St., New York NY 10013. (212)219-0959. Contact: Bill Bace. Estab. 1989.

Exhibits: Requirements: "The artists with whom I work have developed a relationship of respect for my program and my goals. These relationships have developed over time, as do all friendships. Perhaps at some point in the relationship—after the artist has determined that my program and his/hers is on the same course—I will look at work. I am not interested in photojournalism, fashion, etc. I consider photography to be a fine art when the work is a metaphor of human experience which has meaning to the photographer and perhaps the viewer. Work which merely documents the present is of no interest to me." Presents 1 show/year. Shows last 5-6 weeks. Sponsors openings. Photographer's presence at opening and during show required.

Making Contact & Terms: Charges 50% commission. General price range: $500-5,000. Interested in framed work only. Requires exclusive representation locally. SASE. "I don't review unsolicited materials."

BANNISTER GALLERY, Dept. of Art, Rhode Island College, Providence RI 02908. (401)456-9765. Fax: (401)456-8379. Director: Dennis O'Malley. Estab. 1978.

Exhibits: Requirements: Photographer must pass review by Gallery Committee. The committee changes yearly, consequently interests/requirements change. Interested in socio-political documentary/manipulated darkroom images/large format and digital imaging. Examples of recent exhibitions: "Farewell to Bosnia," by G. Pieriess; "Living with AIDS-HIV," by Tom McGovern (photo editor, *Village Voice*). Presents 1/year. Shows last 3 weeks. Sponsors openings; provides modest amount of refreshments, as budget allows. Photographer's presence at opening is preferred, lecture during show preferred.

Making Contact & Terms: Exhibits are for teaching purposes. Reviews transparencies. SASE. Reports 1-3 months, held for review by committee.

***BARLETT FINE ARTS GALLERY**, 77 W. Angela St., Pleasanton CA 94566. (510)846-4322. Owner: Dorothea Barlett. Estab. 1982.

Exhibits: Interested in landscape, dramatic images. Example of recent exhibitions: "Photography 1994," by Al Weber. Show lasts 1 month. Sponsors openings. Artists contribute a fee to cover printing, mailing and reception. Group exhibits keep cost low. Photographer's presence at opening preferred.

Making Contact & Terms: Photography sold in gallery. General price range: $125-500. Reviews transparencies. Interested in matted work only. Requires exclusive representation locally. Works are limited to 8×10 (smallest). Query with samples. Send material by mail for consideration. SASE.

Tips: Submit work that has high marketable appeal, as well as artistic quality."

***BARRON ARTS CENTER**, Dept. PM, 582 Rahway Ave., Woodbridge NJ 07095. (908)634-0413. Director: Stephen J. Kager. Estab. 1975.

Exhibits: Examples of recent exhibitions: "Silver Prints" by Victor Macarol (urban street scenes); "Faces of Maya" by Joseph Macko (color portraits and photo documentary of Mayan tribe); and "Portraits of Artists" by Michael Bergman (black and white portraits). Presents 1-2 shows/year. Shows last 4-5 weeks. Sponsors openings; refreshments (excluding wine). Photographer's presence at opening required.

Making Contact & Terms: Photography sold in gallery. Charges 20% commission. General price range: $150-400. Reviews transparencies but prefers portfolio. Submit portfolio for review. Cannot return material. Reports "depending upon date of review, but in general within a month of receiving materials."

Tips: "Make a professional presentation of work in all pieces matted or treated in a like manner." In terms of the market, we tend to hear that there are not enough galleries existing that will exhibit

photography." One trend is that there is a fair amount of "both representational and art and photography."

BATON ROUGE GALLERY, INC., 1442 City Park Ave., Baton Rouge LA 70808. Phone/fax: (504)383-1470. Director: Kathleen L. Sunderman. Estab. 1966.
● This gallery is the oldest artist co-op in the US.
Exhibits: Professional artists with established exhibition history—must submit 20 slides and résumé to programming committee for approval. Open to all types, styles and subject matter. Examples of recent exhibitions: Italian street photographs by Thomas Neff; "Virtual Vision," by a group of juried regional artists; "Inner-city Churches," by Lori Waselchuck (color). Presents approximately 3 exhibits/year. Shows last 4 weeks. Sponsors openings; provides publicity, liquid refreshments. Photographer's presence at opening is preferred.
Making Contact & Terms: Interested in receiving work from newer, lesser-known photographers. Charges 33.3% commission. General price range: $200-600. Reviews transparencies. Interested in "professional presentation." Send material by mail for consideration. SASE. Reports in 2-3 months. Accepts submissions in March and September.

BENHAM STUDIO GALLERY, 1216 First Ave., Seattle WA 98101. (206)622-2480. Owners: Marita or Lisa. Estab. 1987.
Exhibits: Requirements: Call in August for review appointment in September. Examples of recent exhibitions: works by Michael Gesinger (handcolored nudes); b&w vintage photos by Lucienne Bloch; and abstract manipulated works (group show). Presents 12 shows/year. Shows last 1 month. Photographer's presence at opening preferred.
Making Contact & Terms: Interested in receiving work from newer, lesser-known photographers. Charges 40% commission. General price range: $175-2,000.

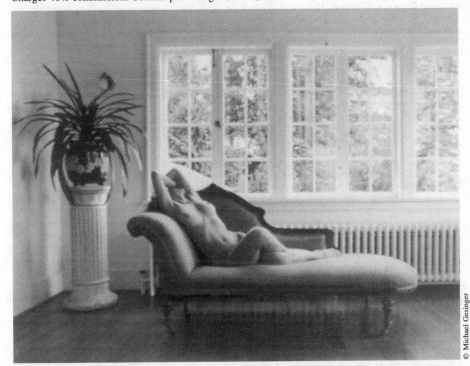

© Michael Gesinger

Michael Gesinger of Bothell, Washington, has been exhibiting work for over 20 years. First shown to Benham Studio Gallery during a portfolio presentation, this piece, "Twisted Nude on Chaise Lounge," has sold approximately a dozen times.

BERKSHIRE ARTISANS GALLERY, located in the Lichtenstein Center for the Arts, 28 Renne Ave., Pittsfield MA 01201. (413)499-9348. Fax: (413)442-8043. Artistic Director: Daniel M. O'Connell. Estab. 1975.

• This gallery was written up in a *Watercolors* magazine article, by Daniel Grant, on galleries that do open-jury selections.

Exhibits: Requirements: Professionalism in portfolio presentation, professionalism in printing photographs, professionalism. Examples of recent exhibitions: "The Other Side of Florida," by Woody Walters (b&w prints); "Radicals," by David Ricci (color prints); "Postcard Invitational," worldwide call for entries. Presents 10 shows/year. Sponsors openings; "we provide publicity announcements, artist provides refreshments." Artists presence at opening and during shows preferred.

Making Contact & Terms: Interested in receiving work from newer, lesser-known photographers. Charges 20% commission. General price range: $50-1,500. Will review transparencies of photographic work. Interested in seeing framed, mounted, matted work only. "Photographer should send SASE with 20 slides or prints and résumé by mail only to gallery." SASE.

Tips: To break in, "Send portfolio, slides and SASE. We accept all art photography. Work must be professionally presented. Send in by March 1, each year. Expect exhibition 4-6 years from submission date. We have a professional juror look at slide entries once a year (usually January-April). Expect that work to be tied up for 6-8 months in jury." Sees trend toward "b&w and Cibachrome architectural photography."

MONA BERMAN FINE ARTS, 78 Lyon St., New Haven CT 06511. (203)562-4720. Fax: (203)787-6855. Director: Mona Berman. Estab. 1979.
• "We are primarily art consultants serving corporations, architects and designers. We also have private clients. We hold very few exhibits, we mainly show work to our clients for consideration and sell a lot of photographs."

Exhibits: Requirements: "Photographers must have been represented by us for over 2 years. Interested in all except figurative, although we do use some portrait work." Examples of previous exhibits: "Suite Juliette," by Tom Hricko (b&w still life). Presents 0-1 exhibits/year. Shows last 1 month. Sponsors openings; provides all promotion. Photographer's presence at opening is required.

Making Contact & Terms: Interested in receiving work from newer, lesser-known photographers. Charges 50% commission. General price range: $300 and up. Reviews 35mm transparencies only. Interested in seeing unframed, unmounted, unmatted work only. Submit portfolio for review (35mm slides only). Query with résumé of credits. Send material by mail for consideration (35mm slides with retail prices and SASE). Reports in 1 month.

Tips: "Have a variety of sizes available and a good amount of work available."

JESSE BESSER MUSEUM, 491 Johnson St., Alpena MI 49707. (517)356-2202. Chief of Resources: Robert Haltiner. Estab. 1965.

Exhibits: Interested in a variety of photos suitable for showing in general museum. Examples of exhibitions: "Ophthalmic Images," extreme color close-ups of the eye and its problems, by Csaba L. Martonyi; "Paper, Paint and Glass," by Bob Grochowski and Carol Dodge Grochowski (b&w photography and photographic oils); "Fall-En Leaves: Primal Maps Home," by David Ochsner (Ilfochrome photography). Presents 1-2 shows/year. Shows last 6-8 weeks.

Making Contact & Terms: Interested in receiving work from newer, lesser-known photographers. Charges 20% sales commission. "However, being a museum, emphasis is not placed on sales, per se." Price range: $25-500. Reviews transparencies. Submit samples to Chief of Resources, Robert Haltiner. Framed work only. SASE for return of slides. Reports in 2 weeks. "All work for exhibit must be framed and ready for hanging. Send *good* slides of work with résumé and perhaps artist's statement. Trend is toward manipulative work to achieve the desired effect."

Tips: Most recently, northern Michigan scenes sell best.

BOOK BEAT GALLERY, 26010 Greenfield, Oak Park MI 48237. (810)968-1190. Fax: (810)968-3102. E-mail: bookbeat@aol.com or caryloren@delphi.com. Director: Cary Lorey. Estab. 1982.

Exhibits: Requirements: Submit résumé, artist's statement, slide sheets and SASE for return of slides. Examples of recent exhibitions: "Recent Work," by Nina Glaser (nudes); "Stills from Andy Warhol," by Billy Name (films); "Mr. Lotus Smiles," by Jeffrey Silverthorne (still life). Presents 6-8 shows/year. Shows last 1-2 months. Sponsors openings, provides inviations, press releases, food and wine. Photographer's presence at opening preferred.

Making Contact & Terms: Interested in receiving work from newer, lesser-known photographers. Charges 50% commission. Buys photos outright. General price range: $200-5,000. Reviews transparencies. Interested in framed or unframed, mounted or unmounted, matted or unmatted work. Arrange a personal interview to show portfolio. Query with samples. Send material by mail for consideration. SASE. Reports in 1-2 months.

Tips: "We have just published our first catalog and are marketing some of our photographers internationally. Photographers should display a solid portfolio with work that is figurative, documentary, surrealistic, off-beat, mythological or theatrical. Photography is in a downswing due to computer and hyper-media phobias. Photography is still in the Mathew Brady mode. There has been little progress. It is a thankless task."

★BOSTON CORPORATE ART, 470 Atlantic Ave., Boston MA 02210. Contact: Assistant to the Gallery Director. Estab. 1987. "The gallery shows group shows and doesn't follow conventional formats. We are an art consulting firm with a large open gallery space that is accessible to the public and our clients." Number of shows varies. Length of shows varies.
Making Contact & Terms: General price range: $150-6,000. "In the event of a sale, the artist will be issued a purchase order which indicates to whom the art was sold. Payment will be issued in full when BCA receives payment from our client." Prefers slides. Send slides by mail for consideration. Provide all necessary information with slides (i.e., sizes you work in and prices). SASE. Reports in 4-6 weeks.
Tips: "We curate some of the largest and most prestigious collections in New England and can provide terrific opportunities for artists." Boston Corporate Art is an advisory and consulting firm working with the corporate community in the areas of acquisition of fine art and commissioning of site-specific work. Boston Corporate Art's client listing is diverse, representing large and small corporate collections, academic, restaurant and healthcare communities, as well as private collectors.

BROMFIELD GALLERY, 107 South St., Boston MA 02111. (617)451-3605. Director: Christina Lanzl. Estab. 1974.
● Bromfield Gallery is Boston's oldest artist-run institution.
Exhibits: Requirements: Usually shows New England artists. Interested in "programs of diversity and excellence." Examples of recent exhibitions: "Process and Product," juried by Barbara Hitchcock and Jim Dow. Presents various number of shows/year. Shows last 1 month. Photographer's presence at opening required.
Making Contact & Terms: Interested in receiving work from newer, lesser-known photographers. Charges 40% commission. General price range: $200-2,000. Reviews transparencies. Interested in framed or unframed, mounted or unmounted, matted or unmatted work. Submit portfolio for review. Send material by mail for consideration. Reports in 1 month.
Tips: "We are looking to expand our presentation of photographers." There is a "small percentage of galleries handling photographers."

J.J. BROOKINGS GALLERY, 669 Mission St., San Francisco CA 94105. (415)546-1000. Director: Timothy C. Duran.
Exhibits: Requirements: Professional presentation, realistic pricing, numerous quality images. Interested in photography created with a painterly eye. Examples of recent exhibitions: Ansel Adams, James Crable, Lisa Gray, Duane Michals, Edward Curtis, Ben Schonzeit, Sandy Skoglund and Todd Watts. Presents rotating group shows. Sponsors openings. Photographer's presence at opening preferred.
Making Contact & Terms: Charges 50% commission. General price range: $500-8,000. Reviews transparencies. Send material by mail for consideration. Reports in 3-5 weeks; "if not acceptable, reports immediately."
Tips: Interested in "whatever the artist thinks will impress me the most. 'Painterly' work is best. No documentary, landscape or politically-oriented work."

C.A.G.E., 1416 Main St., Cincinnati OH 45210-2603. (513)381-2437. Director: Krista Campbell. Estab. 1978.
Exhibits: There is a yearly call for entries; proposals are due in mid-September. Interested in all types of work. Examples of exhibits: "Naked and the Nude," by Sky Bergman (solo show) and solo shows by Kathe Kowalski and Paul Winternitz. Presents 15-20 exhibits/year. Shows last 6 weeks. Sponsors openings; announcements sent to public and media. Photographer's presence at opening is preferred.
Making Contact & Terms: Interested in receiving work from newer, lesser-known photographers. Charges 25% commission. General price range: $100-1,000. Reviews transparencies. Send SASE for prospectus.
Tips: Proposals are considered yearly in September with report to artists in December. "Submit good quality slides with a clear proposal for show. Also, we are a nonprofit gallery and exhibition is more important than sales."

CALIFORNIA MUSEUM OF PHOTOGRAPHY, University of California, Riverside CA 92521. (714)787-4787. Director: Jonathan Green.
Exhibits: The photographer must have the "highest quality work." Presents 12-18 shows/year. Shows last 6-8 weeks. Sponsors openings; inclusion in museum calendar, reception.
Making Contact & Terms: Curatorial committee reviews transparencies and/or matted or unmatted work. Query with résumé of credits. SASE. Reports in 90 days.
Tips: "This museum attempts to balance exhibitions among historical, technology, contemporary, etc. We do not sell photos but provide photographers with exposure. The museum is always interested in newer, lesser-known photographers who are producing interesting work. We can show only a small

percent of what we see in a year. The CMP has moved into a renovated 23,000 sq. ft. building. It is the largest exhibition space devoted to photography in the West."

***WILLIAM CAMPBELL CONTEMPORARY ART**, Dept. PM, 4935 Byers Ave., Ft. Worth TX 76107. (817)737-9566. Owner/Director: William Campbell. Estab. 1974.
Exhibits: Requirements: An established record of exhibitions. "Primarily interested in photography which has been altered or manipulated in some form." Examples of previous exhibitions: A group show, "The Figure In Photography: An Alternative Approach," by Patrick Faulhaber, Francis Merritt-Thompson, Steven Sellars, Dottie Allen and Glenys Quick. Presents 8-10 shows/year. Shows last 5 weeks. Sponsors openings; provides announcements, press releases, installation of work, insurance, cost of exhibition. Photographer's presence during show preferred.
Making Contact & Terms: Charges 50% commission. General price range: $300-1,500. Reviews transparencies. Interested in framed or unframed work; mounted work only. Requires exclusive representation within metropolitan area. Send slides and résumé by mail. SASE. Reports in 1 month.

***THE CANTON MUSEUM OF ART**, (formerly The Canton Art Institute), 1001 Market Ave., Canton OH 44702. (216)453-7666. Executive Director: M.J. Albacete.
Exhibits: Requirements: "The photographer must send preliminary letter explaining desire to exhibit; send samples of work (upon our request); have enough work to form an exhibition; complete *Artist's Form* detailing professional and academic background, and provide photographs for press usage. We are interested in exhibiting all types of quality photography, preferably using photography as an art medium, but we will also examine portfolios of other types of photography work as well: architecture, etc." Presents 2-5 shows/year. Shows last 6 weeks. Sponsors openings. Major exhibits (in galleries), postcard or other type mailer, public reception.
Making Contact & Terms: Charges commission. General price range: $50-500. Interested in exhibition-ready work. No size limits. Query with samples. Submit letters of inquiry first, with samples of photos. SASE. Reports in 2 weeks.
Tips: "We look for photo exhibitions which are unique, not necessarily by 'top' names. Anyone inquiring should have some exhibition experience, and have sufficient materials; also, price lists, insurance lists, description of work, artist's background, etc. Most photographers and artists do little to aid galleries and museums in promoting their works—no good publicity photos, confusing explanations about their work, etc. We attempt to give photographers—new and old—a good gallery exhibit when we feel their work merits such. While sales are not our main concern, the exhibition experience and the publicity can help promote new talents. If the photographer is really serious about his profession, he should design a press-kit type of package so that people like me can study his work, learn about his background, and get a pretty good concept of his work. This is generally the first knowledge we have of any particular artist, and if a bad impression is made, even for the best photographer, he gets no exhibition. How else are we to know? We have a basic form which we send to potential exhibitors requesting all the information needed for an exhibition. My article, 'Artists, Get Your Act Together If You Plan to Take it on the Road,' shows artists how to prepare self-promoting kits for potential sponsors, gallery exhibitors, etc. Copy of article and form sent for $2 and SASE."

CENTER FOR EXPLORATORY AND PERCEPTUAL ART, 700 Main St., Fourth Floor, Buffalo NY 14202. (716)856-2717. Fax: (716)856-2720. Curator: Robert Hirsch. Estab. 1974. "CEPA is an artist-run space dedicated to presenting work that is underrepresented in traditional cultural institutions.
Exhibits: Requirements: slides with detailed and numbered checklist, résumé, artist's statement, project proposal and SASE. The total gallery space is approximately 5,000 square feet. Interested in political, culturally diverse, contemporary and conceptual works. Examples of recent exhibitions: "Rituals: Social Identity," artists explore visual representation; "Keepers of the Western Door," Native American image makers; "Personal Quests," approaches in contemporary color photography. Presents 5-6 shows/year. Shows last 6 weeks. Sponsors openings; reception with lecture.
Making Contact & Terms: Extremely interested in exhibiting work of newer, lesser-known photographers. Charges 20% commission. General price range: $200-3,500. Reviews transparencies. Interested in framed or unframed, mounted or unmounted, matted or unmatted work. Query with résumé of credits. Send material by mail for consideration. SASE. Reports in 3 months.

Photographer Jane Calvin says her image titled "Woman, Window, Chair" was created to portray a sense of chaos and mystery within an interior space. The photo was part of an exhibit at the Center for Exploratory and Perceptual Art in Buffalo, New York, and was used as an illustration in Exploring Color Photography, 2nd edition, *by Robert Hirsch.*

CENTER FOR PHOTOGRAPHY AT WOODSTOCK, 59 Tinker St., Woodstock NY 12498. (914)679-9957. Fax: (914)679-6337. Exhibitions Director: Kathleen Kenyon. Estab. 1977.
Exhibits: Interested in all creative photography. Examples of previous exhibitions: "Social Studies/Public Monument"; "Mirror-Mirror"; and "Picturing Ritual" (all were group shows). Presents 10 shows/year. Shows last 6 weeks. Sponsors openings.
Making Contact & Terms: Interested in receiving work from newer, lesser-known photographers. Charges 25% sales commission. Send 20 slides plus cover letter, résumé and artist's statement by mail for consideration. SASE. Reports in 4 months.
Tips: "We are closed Mondays and Tuesdays. Interested in contemporary and emerging photographers."

CHARLENE'S FRAMING AND GALLERY TEN, (formerly Gallery Ten), 514 E. State St., Rockford IL 61104. (815)963-1113. Partner: Charlene Berg. Estab. 1986.
Exhibits: "We look for quality in presentation; will review any subject or style. However, we are located in a conservative community so artists must consider that when submitting. We may show it, but it may not sell if it is of a controversial nature." Interested in fine art. Example of exhibitions: "Johnson Center Series," by Beth Jersild. Number of exhibits varies. Shows last 6 weeks. Sponsors openings; provides publicity, mailer and opening refreshments. Photographer's presence at opening preferred.
Making Contact & Terms: Very receptive to exhibiting work of newer, lesser-known photographers. Charges 40% commission. General price range: $50-300. Reviews transparencies. Interested in mounted or unmounted work, matted work. "We prefer 20×24 or smaller." Send material by mail for consideration. SASE. Reports in 1 month.
Tips: "Quality in framing and presentation is paramount. We cannot accept work to sell to our clients that will self destruct in a few years."

CLEVELAND STATE UNIVERSITY ART GALLERY, 2307 Chester Ave., Cleveland OH 44114. (216)687-2103. Fax: (216)687-9366. Director: Robert Thurmer. Estab. 1973.

Exhibits: Requirements: Photographs must be of superior quality. Interested in challenging work. Examples of recent exhibitions: "Re-Photo Construct," with Lorna Simpson; "El Salvador," by Steve Cagan; and "In Search of the Media Monster," with Jenny Holzer. Presents 0-1 show/year. Shows last 1 month. Sponsors openings; provides wine and cheese. Photographer's presence at opening and during show preferred.

Making Contact & Terms: Interested in receiving work from newer, lesser-known photographers. Charges 25% commission. General price range: $100-1,000. Reviews transparencies. Interested in framed or unframed, mounted or unmounted, matted or unmatted work. Send material by mail for consideration. SASE. Reports within 3 months.

Tips: "Write us! Do not submit oversized materials. This gallery is interested in new, challenging work—we are not interested in sales (sales are a service to artists and public)."

***COLLECTOR'S CHOICE GALLERY**, 20352 Laguna Canyon Rd., Laguna Beach CA 92651-1164. Phone/fax: (714)494-8215 (call before faxing). Director: Beverly Inskeep. Estab. 1979.
Exhibits: Interested in portraiture: young, old, individual, groups. Examples of recent exhibitions: works by Jennifer Griffiths (hand-tints); Kornelius Schorle (cibachrome); David Richardson (b&w); and Glenn Aaron (b&w).
Making Contact & Terms: Interested in receiving work from newer, lesser-known photographers. Charges 40% commission. Buys photos outright. General price range: $15-2,000. Interested in unframed, unmounted and unmatted work only. Works are limited to unmounted 13' × 16' largest. No minimum restrictions. Send material by mail for consideration. SASE. Reports in 3 weeks.

THE COPLEY SOCIETY OF BOSTON, 158 Newbury St., Boston MA 02116. (617)536-5049. Gallery Manager: Jason M. Pechinski. Estab. 1879.
Exhibits: Requirements: Must apply and be accepted as an artist member. Once accepted, artists are eligible to compete in juried competitions. Guaranteed showing twice a year in small works shows. There is a possibility of group or individual shows, on an invitational basis, if merit exists. Interested in all styles. Examples of exhibitions: portraiture by Al Fisher (b&w, platinum prints); landscape/exotic works by Eugene Epstein (b&w, limited edition prints); and landscapes by Jack Wilkerson (b&w). Presents various number of shows/year. Shows last 2-4 weeks. Sponsors openings for juried shows by providing refreshments. Does not sponsor openings for invited artists. Photographer's presence at opening required. Photographer's presence during show required for invited artists, preferred for juried shows.
Making Contact & Terms: Interested in receiving work from newer, lesser-known photographers. Charges 40% commission. General price range: $100-10,000. Reviews transparencies. Interested in framed work only. Request membership application. Quarterly review deadlines.
Tips: Wants to see "professional, concise and informative completion of application. The weight of the judgment for admission is based on quality of slides. Only the strongest work is accepted."

***CROSSMAN GALLERY**, University of Wisconsin-Whitewater, 800 W. Main St., Whitewater WI 53190. (414)472-5708. Director: Susan Walsh. Estab. 1971.
Exhibits: Requirements: Résumé, artist's statement, list insurance information, 10-20 slides, work framed and ready to mount and have 4 × 5 transparencies available. Interested in all types, especially cibachrome as large format and controversial subjects. Examples of recent exhibitions: "Color Photography Invitational," by Regina Flanagan, Leigh Kane and Janica Yoder. Presents 1 show biannually. Shows last 3-4 weeks. Sponsors openings; provides food, beverage, show announcement, mailing, shipping (partial) and possible visiting artist lecture/demo. Photographer's presence at opening preferred.
Making Contact & Terms: Buys photos outright. General price range: $250-2,800. Reviews transparencies. Interested in framed and mounted work only. Send material by mail for consideration. SASE. Reports in 1 month.
Tips: "The Crossman Gallery's main role is to teach. I want students to learn about themselves and others in alternative ways; about social and political concerns through art."

***CUMBERLAND GALLERY**, 4107 Hillsboro Circle, Nashville TN 37215. (615)297-0296. Director: Carol Stein. Estab. 1980.
Exhibits: Limited editions should not exceed 50. Examples of recent exhibitions: works by Peter Laytin (b&w silver gelatin prints); Jack Spencer (b&w silver gelatin prints); Susan Bryant (hand-colored, silver gelatin prints); and Meryl Truett (hand-colored, silver gelatin prints). Presents 1 photography show/year. Shows last 4-5 weeks. Sponsors openings; provides invitations, mailing list, wine and cheese, publicity. Photographer's presence at opening preferred.
Making Contact & Terms: Interested in receiving work from newer, lesser-known photographers. Charges 50% commission. General price range: $175-1,200. Reviews transparencies. Interested in matted or unmatted work. Requires exclusive representation locally. Send material by mail for consideration. Send résumé and slides. SASE.

Tips: "Please present labeled slides and a professional résumé. Work should be current and readily available. Please do not submit slides of work that is not available. Work should be presented in a professional manner (conservation). Sales in photography are increasing. Due to the high cost of art, photography represents an opportunity for collectors to buy at an affordable price."

***SPANGLER CUMMINGS GALLERY,** 641 N. High, #106, Columbus OH 43215. Estab. 1985-87, 1993-94.
Exhibits: Work must be currently owned by 3-5 museum collections. Sponsors openings; provides formal openings with announcements, press releases and refreshments. Photographer's presence at opening preferred.
Making Contact & Terms: General price range: $250. Reviews transparencies. Interested in framed or unframed, matted or unmatted work. Requires exclusive representation locally. Submit portfolio for review. Query with résumé of credits. Query with samples. Send material by mail for consideration. SASE. Reports in 2 months.

DALLAS VISUAL ART CENTER, (formerly D-Art Visual Art Center), 2917 Swiss Ave., Dallas TX 75204. (214)821-2522. Fax: (214)821-9103. Executive Director: Katherine Wagner. Estab. 1981.
Exhibits: Requirements: a résumé, cover letter, slides and a SASE must be sent to Katherine Wagner, and the photographer must be from Texas. Interested in all types. Examples of recent exhibitions: Mosaics series by Pablo Esparza (b&w/airbrushed). Presents variable number of shows (2-3)/year. Shows last 3 weeks. Sponsorship of openings depends on if artist is selected for a Collector or Mosaic series exhibit (for these, invitations, PR, postage, wine at opening). Rental exhibits: Artist is responsible for all aspects. Photographer's presence at opening required.
Making Contact & Terms: Interested in receiving work from newer, lesser-known photographers. Charges no commission (nonprofit organization). Reviews transparencies. Send material by mail for consideration. SASE. Reports in 1 month.
Tips: "We have funding from Exxon Corporation to underwrite exhibits for artists who have incorporated their ethnic heritage in their work; they should make a note that they are applying for the Mosaics series. (We have a Collector series which we underwrite expenses. All submissions are reviewed by committee.) Rental space is available for nonselected artists at very affordable prices. We have a resource newsletter that is published bi-monthly and contains artist opportunities (galleries, call for entries, commissions) available to member (membership starts at $35)."

DE HAVILLAND FINE ART, 39 Newbury St., Boston MA 02116. (617)859-3880. Fax: (617)859-3973. Gallery Director: Jennifer Gilbert. Estab. 1989.
Exhibits: Interested in mixed media, photo manipulation, Polaroid transfers, etc. Presents 10 shows/year. Shows last 2 weeks. Sponsors openings, artist must be gallery member. Photographer's presence at opening preferred.
Making Contact & Terms: Interested in receiving work from newer, lesser-known photographers. Charges 40% commission. General price range: $100-800. Reviews transparencies. Interested in framed, mounted or matted work. "We prefer work that is matted and framed. Shape and size is of no particular consideration." No documentaries. Submit portfolio for review. SASE. Reports in 1 month.
Tips: "The public is becoming more interested in photography. It must be special to attract attention and that's the type of work we're interested in. Located on first block of Newbury Street—the most exclusive retail block in New England. Therefore, all work must be outstanding."

***RENA DEWEY GALLERY,** 2775 Lombardy, Memphis TN 38111. (901)452-9986. Director: Rena Dewey. Estab. 1968.
Exhibits: Interested in 19th and 20th century works.
Making Contact & Terms: Charges 25-35% commission. Buys photos outright. General price range: $500-3,000. Reviews transparencies. Interested in framed or unframed work; mounted or unmounted work. Submit portfolio for review. Query with résumé of credits. Query with samples. Send material by mail for consideration. SASE. Reports in 1-2 weeks.

PAUL EDELSTEIN GALLERY, 519 N. Highland, Memphis TN 38122-4521. (901)454-7105. Director/Owner: Paul R. Edelstein. Estab. 1985.
Exhibits: Interested in 20th century photography—figurative still life, abstract—by upcoming and established photographers. Examples of recent exhibitions: works by Vincent de Gerlando, Eudora Welty, Lucia Burch Doggrell, Joseph Companiotte, Caldicott Chubb. Shows are presented continually throughout the year.
Making Contact & Terms: Interested in receiving work from newer, lesser-known photographers. Charges 30-40% commission. Buys photos outright. General price range: $400-5,000. Reviews transparencies. Interested in framed or unframed, mounted or unmounted, matted or unmatted work. There are no size limitations. Submit portfolio for review. Query with samples. Cannot return material. Reports in 1 month.

ELEVEN EAST ASHLAND (Independent Art Space), 11 E. Ashland, Phoenix AZ 85004. (602)257-8543. Director: David Cook. Estab. 1986.
Exhibits: Requirements: Contemporary only (portrait, landscape, genre, mixed media in b&w, color, non-silver, etc.); photographers must represent themselves, complete exhibition proposal form and be responsible for own announcements. Interested in "all subjects in the contemporary vein—manipulated, straight and non-silver processes." Example of recent exhibitions: works by John Gipey, Jack Stuber and Eric Kronengold. Presents 13 shows/year. Shows last 3 weeks. Sponsors openings; two inhouse juried/invitational exhibits/year. Photographer's presence during show preferred.
Making Contact & Terms: Very receptive to exhibiting work of newer, lesser-known photographers. Charges 25% commission. General price range: $100-500. Reviews transparencies. Interested in framed or unframed, mounted or unmounted, matted or unmatted work. Shows are limited to material able to fit through the front door and in the space (4' × 8' max.). Query with résumé of credits. Query with samples. SASE. Reports in 2 weeks.
Tips: "Sincerely look for a venue for your art, and follow through. Search for traditional and non-traditional spaces."

ETHERTON GALLERY, (formerly Etherton/Stern Gallery), 135 S. 6th Ave., Tucson AZ 85701. (602)624-7370. Fax: (602)792-4569. Director: Terry Etherton. Estab. 1981.
• Etherton Gallery regularly purchases 19th Century, vintage, Western survey photographs and Native American portraits.
Exhibits: Photographer must "have a high-quality, consistent body of work—be a working artist/photographer—no 'hobbyists' or weekend photographers." Interested in contemporary photography with emphasis on artists in Western and Southwestern US. Examples of exhibitions: "The Sacred and Secular" aerial photography by Marilyn Bridges, photographs by Paul Caponigro and Dick Arentz, and mixed-media photographs by Keith McElroy. Presents 10 shows/year. Shows last 6 weeks. Sponsors openings; provides wine and refreshments, publicity, etc. Photographer's presence at opening and during show preferred.
Making Contact & Terms: Interested in receiving work from newer, lesser-known photographers. Charges 50% commission. Occasionally buys photography outright. General price range: $200-20,000. Reviews transparencies. Interested in matted or unmatted, unframed work. Please send portfolio by mail for consideration. SASE. Reports in 3 weeks.
Tips: "You must be fully committed to photography as a way of life. You should be familiar with the photo art world and with my gallery and the work I show. Please limit submissions to 20, showing the best examples of your work in a presentable, professional format; slides preferred."

FAHEY/KLEIN GALLERY, 148 N. La Brea Ave., Los Angeles CA 90036. (213)934-2250. Fax: (213)934-4243. Co-Director: David Fahey. Estab. 1986.
Exhibits: Requirements: Must be established for a minimum of 5 years; preferably published. Interested in established work. Fashion/documentary/nudes/portraiture/fabricated to be photographed work. Examples of exhibitions: works by Irving Penn (color work), Henri Cartier-Bresson and McDermott & McGough. Presents 10 shows/year. Shows last 5 weeks. Sponsors openings; provides announcements and beverages served at reception. Photographer's presence at opening and during show preferred.
Making Contact & Terms: Charges 50% commission. Buys photos outright. General price range: $600-200,000. Reviews transparencies. Interested in unframed, unmounted and unmatted work only. Requires exclusive representation within metropolitan area. Send material by mail for consideration. SASE. Reports in 2 months. Interested in seeing mature work with resolved photographic ideas and viewing complete portfolios addressing 1 idea.
Tips: "Have a comprehensive sample of innovative work."

***500X GALLERY**, 500 Exposition Ave., Dallas TX 75226. (214)828-1111. President: Tom Sime. Estab. 1978.
Exhibits: Must have slides to submit and be co-op member. (Must live in Dallas/Ft. Worth area or environs to be a member.) "We also sponsor juried exhibits of all media that invariably include photography." Interested in all styles, from straight-forward photography to the extreme and experimental. "We also exhibit other media." Examples of recent exhibitions: works by Dianne Greene (painted photographs); Robert McAn (experimental photography-based prints); and Clint Imboden, Jr. (original and archival photographs and collages). Presents 2-3 shows/year. Shows last 4 weekends. Sponsors openings. "We provide drinks and, sometimes, entertainment. We design and print announcements, with member artists covering costs." Photographer's presence at opening and during show preferred.
Making Contact & Terms: Interested in receiving work from newer, lesser-known photographers. Charges 30% commission. General price range: $100-1,000. Reviews transparencies. Interested in framed or unframed, mounted or unmounted, matted or unmatted work. Send material by mail for consideration. Send slides, not prints. SASE. Reports in 2-3 months.

Tips: "We all cooperatively run the gallery and produce our own exhibits (hence the restriction to area artists). Any artist in the U.S. can participate in our juried exhibits, however; just send us your name and address and tell us you want to be on our artist mailing list. Make sure you control your editions. Buyers want to know how many copies exist, if price is over $50."

FOCAL POINT GALLERY, 321 City Island Ave., New York NY 10464. (718)885-1403. Photographer/ Director: Ron Terner. Estab. 1974.
Exhibits: Open to all subjects, styles and capabilities. Nudes and landscapes sell best. Examples of recent exhibitions: Todd Weinstein, Ron Terner, Ira Wunder, Gordon Smith (winner) 4th annual juried exhibition. Shows last 1 month. 6 photographic shows a year. Photographer's presence at opening preferred.
Making Contact & Terms: Very receptive to exhibiting work of newer, lesser-known photographers. Charges 30% sales commission. General price range: $175-700. Artist should call for information about exhibition policies.
Tips: Sees trend toward more use of alternative processes. "The gallery is geared toward exposure— letting the public know what contemporary artists are doing—and is not concerned with whether it will sell. If the photographer is only interested in selling, this is not the gallery for him/her, but if the artist is concerned with people seeing the work and gaining feedback, this is the place. Most of the work shown at Focal Point Gallery is of lesser-known artists. Don't be discouraged if not accepted the first time. But continue to come back with new work when ready."

FREEPORT ART MUSEUM, 121 N. Harlem Ave., Freeport IL 61032. Phone/fax: (815)235-9755. Director: Becky Connors. Estab. 1976.
Exhibits: Interested in general, especially landscapes, portraits and country life. Examples of recent exhibitions: "Between Black and White: Photographs by Carol House" and "Archie Lieberman: The Corner of My Eye." Presents 1 or 2 shows/year. Shows last 2 months. Sponsors openings on Friday evenings. Pays mileage. Photographer's presence at opening required.
Making Contact & Terms: Exhibits works by established or lesser-known photographers. Charges 20% commission. Reviews transparencies or photographs. Interested in framed work only. Send material by mail for consideration. SASE. Reports in 3 months.

GALERIA MESA, P.O. Box 1466, 155 N. Center, Mesa AZ 85211-1466. (602)644-2242. Contact: Curator. Estab. 1980.
Exhibits: Interested in contemporary photography as part of its national juried exhibitions in any and all media. Presents 7-9 national juried exhibits/year. Shows last 4-6 weeks. Sponsors openings; refreshments and sometimes slide lectures (all free).
Making Contact & Terms: Interested in receiving work from newer, lesser-known photographers. Charges 25% commission. General price range: $300-800. Interested in seeing slides of all styles and aesthetics; wants more shots of everyday life, Hispanic/Native American themes, mixed media. Slides are reviewed by changing professional jurors. Must fit through a standard size door and be ready for hanging. Enter national juried shows; awards total $1,500. SASE. Reports in 1 month.
Tips: "We do invitational or national juried exhibits only. Only submit professional quality work."

THE GALLERY AT CENTRAL BANK, Box 1360, Lexington KY 40590. In U.S. only (800)637-6884. In Kentucky (800)432-0721. Fax: (606)253-6244. Curator: John G. Irvin. Estab. 1987.
Exhibits: Requirements: No nudes and only Kentucky photographers. Interested in all types of photos. Examples of recent exhibitions: "Covered Bridges of Kentucky," by Jeff Rogers; "Portraits of Children in Black and White," by Jeanne Walter Garvey; and "The Desert Storm Series," by Brother Paul of the Abbey of Gethsemane. Presents 2-3 photography shows/year. Shows last 3 weeks. Sponsors openings. "We pay for everything, invitations, receptions and hanging. We give the photographer 100 percent of the proceeds."
Making Contact & Terms: Interested in receiving work from newer, lesser-known photographers. Charges no commission. General price range: $75-1,500. "If you can get it in the door we can hang it." Query with telephone call. Reports back probably same day.

***GALLERY OF ART, UNIVERSITY OF NORTHERN IOWA,** Cedar Falls IA 50614-0362. (319)273-6134. Estab. 1976. Interested in all styles of high-quality contemporary art and photojournalistic works.
Exhibits: Examples of recent exhibitions: Magic Silver Show (juried national show); "Gayburke: Photographs of Guatemala"; and "Kathleen Campbell: Photographs of Widely-Known Non-Existent Beings." Presents average of 4 shows/year. Shows last 1 month. Open to the public.
Making Contact & Terms: Work presented in lobby cases. "We do not often sell work; no commission is charged." Will review transparencies. Interested in framed or unframed work, mounted and matted work. May arrange a personal interview to show portfolio, résumé and samples. Send material by mail for consideration or submit portfolio for review. SASE. Reporting time varies.

INSIDER REPORT

Collectors Brighten Future for Fine Art Photographers

When fine art photographer Ron Terner first approached galleries to sell his work, he found a divided art community. "You had photo galleries and then you had galleries showing paintings and other forms of artwork that did not handle photography," he says. There was little room for new artists and new visions.

In 1975, unhappy with what he saw in galleries, the way he was sometimes treated, and the lack of outlets for new work, he opened Focal Point Gallery. The move gave him the opportunity to show his work and offer space to green, struggling photographers.

Since then Terner has seen an increasing acceptance of photography as art. "Now you have galleries that show both paintings and photography. In fact most painting galleries have a section set aside for photographic art," he says.

© Rajeev Terner

Ron Terner

From a fine art photographer's perspective, the key is to have an educated buying public who understands photographic value. These days more people are collecting photos, partly because they recognize names like Annie Leibovitz, Ansel Adams, Edward Weston and Herb Ritts. "You can really see it at art auctions where photographic prints are selling for big money," says Terner. "People have begun to appreciate and buy fine art photographs. They can enjoy (photos), collect them, have them go up in value—all the things one might look for when investing in art."

Terner receives about 100 submissions a year from photographers seeking exhibition space for their images. Of those artists, eight are showcased during the year. He also features current exhibitors in his publication *The Viewfinder*. The annual publication is mailed to around 3,000 people and many artists garner additional sales from this exposure.

When submitting material to galleries for consideration avoid sending poorly produced images or too many styles. These are two mistakes Terner witnesses all too often. "If you are sending work for a one-person show, which is what I'm seeking, you don't necessarily want to show you can do a landscape, a portrait, a nude, or an experimental piece," he says. "It's better to show interest in a specific area or a particular approach, unless you can demonstrate a connection between those different areas."

Photographers also should experiment with their art, Terner says. For example, Terner has developed a method of creating images called "PhotoTern." The

process calls for painting on photographic prints with a chemical solution. "This was something that happened by accident. I don't really believe there's such a thing as a bad accident because, if you can see what you did wrong, you can learn from it. If it's something you can use, you can explore it. Basically, you just have to be open to allowing accidents to happen and have a good time," he says.

More photographers are taking different approaches to photography, says Terner. "When I started manipulating images in 1975, I found myself relatively alone. Other photographers were working in the zone system or in straight, journalistic style. Yet now I see more people using photography as a flexible material and there's a lot more experimentation going on.

"It's one of the reasons I have such a love affair with photography, because it is so flexible. You can use a straight image or a manipulated one. Once you've created that negative you can print it, collage it, bleach it, reinterpret that image in 100 different ways."

—Robin Gee

In 1975, Gallery Director/Photographer Ron Terner wanted a place to show his own work and that of emerging artists, so he opened Focal Point Gallery. Since then photography has become a more popular fine art medium among collectors who see the value in beautiful photos, like this 1981 portrait taken in Mexico by Terner.

© Ron Terner

GALLERY 1114, 1114 N. Big Spring, Midland TX 79701. (915)685-9944. President: Pat Cowan Harris. Estab. 1983.
Exhibits: Requirements: Work judged by exhibit committee. Interested in "work showing a coherent, innovative direction." Examples of recent exhibitions: "Mixed Metaphors," by Timothy Tracz (incongruities in reality); group show with Michael Banschbach (large format); and "Portraits from the Earth," by Olivia Hill (b&w silver). Presents an average of 1 show/year. Shows last 6 weeks. Sponsors openings; provides publicity, invitations and refreshments. Photographer's presence at opening is preferred.
Making Contact & Terms: Interested in receiving work from newer, lesser-known photographers. Charges 40% commission. General price range: $50-400. Reviews transparencies. Interested in framed work only. Requires exclusive representation within metropolitan area. Send material by mail for consideration. SASE. Reports in 1-3 months.
Tips: "Send work that makes a statement, is formally interesting, shows direction."

GOMEZ GALLERY, 836 Leadenhall St., Baltimore MD 21230. (410)752-2080. Fax: (410)752-2082. Directors: Walter Gomez and Diane DiSalvo. Estab. 1988.
Exhibits: Interested in work exploring human relationships or having psychological dimensions. Provocative work accepted. "We are a full-scope gallery (paintings, prints, sculpture, photography). One specialty is male and female figurative photography. Work must be innovative. We will not accept traditional nude or portraiture work." Photographers represented include: Connie Imboden, Robert Flynt, Jo Brunnenburg, Harry Connolly, Allan Janus, Stephen John Phillips, Jose Villarrubia, Mary Wagner. Presents 3-4 photo shows/year. Shows last 1 month. Sponsors openings; provides advertising, mailings, opening receptions. Photographer's presence at opening is required, presence during show is preferred.
Making Contact & Terms: Interested in reviewing work from newer, lesser-known photographers. Charges 50% commission. General price range: $150-2,000. "Initially will only review transparencies and résumé; may later request to see actual work." Requires exclusive representation within metropolitan area or Mid-Atlantic region." No "walk-ins" please. SASE. Reports 1-2 months.
Tips: "We are looking for new work. If it's already been done, or is traditional nudes, or lacks a focus or purpose, we are not the gallery to contact! We find that more provocative figurative work sells best. For all our top figurative photographers, we are their top selling gallery in the world."

WELLINGTON B. GRAY GALLERY, East Carolina University, Greenville NC 27858. (328)757-6336. Fax: (328)757-6441. Director: Gilbert Leebrick. Estab. 1978.
Exhibits: Requirements: For exhibit review, submit 20 slides, résumé, catalogs, etc., by Nov. 15th annually. Exhibits are booked the next academic year. Work accepted must be framed or ready to hang. Interested in fine art photography. Examples of exhibitions: "A Question of Gender," by Angela Borodimos (color C-prints) and "Photographs from America," by Marsha Burns (gelatin silver prints). Presents 1 show/year. Shows last 1-2 months. Sponsors openings; provides invitations, publicity and a reception. Photographer's presence at opening and during show preferred.
Making Contact & Terms: Interested in receiving work from newer, lesser-known photographers. Charges 20% commission. General price range: $200-1,000. Reviews transparencies. Interested in framed work for exhibitions; send slides for exhibit committee's review. Send material by mail for consideration. SASE. Reports 1 month after slide deadline (Nov. 15th).

***HALLWALLS CONTEMPORARY ARTS CENTER**, 2495 Main St., Suite 425, Buffalo NY 14214. (716)835-7362. Fax: (716)835-7364. Exhibitions Curator: Sara Kellner. Estab. 1974.
Exhibits: Hallwalls is a nonprofit multimedia organization. "While we do not focus on the presentation of photography alone, we present innovative work by contemporary photographers in the context of contemporary art as a whole." Interested in work which expands the boundaries of traditional photography. No limitations on type, style or subject matter. Examples of recent exhibitions: "Feed," by Heidi Kumao (zoetrope, mixed media); "Amendments," including Ricardo Zuiveta (b&w performance stills); and "Consuming Passions," including Annie Lopez (b&w photos of food). Presents 10 shows/year. Shows last 6 weeks. Sponsors openings; provides invitations, brochure and refreshments. Photographer's presence at opening and during show preferred.
Making Contact & Terms: Interested in receiving work from newer, lesser-known photographers. Photography sold in gallery. Reviews transparencies. Send material by mail for consideration. Do not send work. Work may be kept on file for additional review for 6 months.
Tips: "We're looking for photographers with innovative work; work that challenges the boundaries of the medium."

***THE HALSTED GALLERY INC.**, 560 N. Woodward, Birmingham MI 48009. (810)644-8284. Fax: (810)644-3911. Contact: Wendy Halsted or Thomas Halsted.
Exhibits: Interested in 19th and 20th century photographs and out-of-print photography books. Examples of recent exhibitions: "Michael Kenna: A 20 Year Retrospective" (contemporary landscape);

contemporary photography by Jerry Velsmann; and Walter Rosenblum (retrospective, work from the 40s-70s). Sponsors openings. Presents 5 shows/year. Shows last 2 months.

Making Contact & Terms: Charges 50% sales commission or buys outright. General price range: $500-25,000. Call to arrange a personal interview to show portfolio only. Prefers to see 10-15 prints overmatted. Send no slides or samples. Unframed work only.

Tips: This gallery has no limitations on subjects. Wants to see creativity, consistency, depth and emotional work.

HAYDON GALLERY, 335 N. Eighth St., Suite A, Lincoln NE 68508. (402)475-5421. Director: Anne Pagel. Estab. 1987 (part of Sheldon Art & Gift Shop for 20 years prior to that).

Exhibits: Requirements: Must do fine-quality, professional-level art. "Interested in any photography medium or content, so long as the work is of high quality." Example of recent exhibition: photographs by Joel Sartore (a *National Geographic* photographer). Presents 1 or 2 (of 9 solo exhibitions) plus group exhibitions/year. Shows last 1 month. Hors d'oeuvres provided by host couple, cost of beverages split between gallery and artist. (Exhibitions booked through 1998.) Artist presents gallery talk 1 week after the opening. Photographer's presence at opening required.

Making Contact & Terms: Interested in receiving work from newer, lesser-known photographers "if high quality." Charges 45% commission. General price range: $150-500. Reviews transparencies. Interested in seeing framed or unframed, mounted or unmounted, matted or unmatted work. "Photos in inventory must be framed or boxed." Requires exclusive representation locally. Arrange a personal interview to show portfolio. Submit portfolio for review. SASE. Reports in 1 month.

Tips: "Submit a professional portfolio, including résumé, statement of purpose and a representative sampling from a cohesive body of work." Seeing opportunities for photographers through galleries becoming more competitive. "The public is still very conservative in its response to photography. My observation has been that although people express a preference for b&w photography, they purchase color."

HERA EDUCATIONAL FOUNDATION AND ART GALLERY, P.O. Box 336, Wakefield RI 02880. (401)789-1488. Director: Alexandra Broches. Estab. 1974.

Exhibits: Requirements: Must show a portfolio before attaining membership in this co-operative gallery. Interested in innovative contemporary art which explores social and artistic issues. Examples of exhibitions: "Ordinary Places," by Alexandra Broches (b&w photos), and "Digital Imagery," by Patti Fitzmaurice (computer generated). The number of photo exhibits varies each year. Shows last 3-4 weeks. Sponsors openings; provides refreshments and entertainment or lectures, demonstrations and symposia for some exhibits. Photographer's presence at opening required.

Making Contact & Terms: Interested in receiving work from newer, lesser-known photographers. Charges 25% commission. Prices set by artist. Reviews transparencies. Interested in framed or unframed work. Works must fit inside a 6′ 6″ × 2′ 6″ door. Reports in 2-3 weeks. Inquire about membership and shows. Membership guidelines mailed on request.

Tip: Hera exhibits a culturally diverse range of visual artists, particularly women and emerging artists. Hera "seems to be getting more computer-based, digital imagery, and special effects photography."

HUGHES FINE ARTS CENTER, Dept. of Visual Arts, Box 8134, Grand Forks ND 58202-8134. (701)777-2257. Director: Brian Paulsen. Estab. 1979.

Exhibits: Interested in any subject; mixed media photos, unique technique, unusual subjects. Examples of recent exhibitions: works by James Falkofske and Alexis Schaefer. Presents 11-14 shows/year. Shows last 2-3 weeks. "We pay shipping costs."

Making Contact & Terms: Very interested in receiving work of newer, lesser-known photographers. Does not charge commission; sales are between artist-buyer. Reviews transparencies. "Works should be framed and matted." No size limits or restrictions. Send 10-20 transparencies with résumé. SASE. Reports in 2 weeks.

Tips: "Send slides of work . . . we will dupe originals and return ASAP and contact you later." Needs "fewer photos imitating other art movements. Photographers should show their own inherent qualities."

 The asterisk before a listing indicates that the market is new in this edition. New markets are often the most receptive to freelance submissions.

HYDE PARK ART CENTER, 5307 S. Hyde Park Blvd., Chicago IL 60615. (312)324-5520. Contact: Exhibition Committee. Estab. 1939.
Exhibits: Receptive but selective with new work. "The gallery has a history of showing work on the cutting edge—and from emerging artists. Usually works with Chicago-area photographers who do not have gallery representation." Examples of exhibitions: "Humor," curated by C. Thurow and E. Murray; "Private Relations," curated by Jay Boersma. Shows last 4-5 weeks. Photography included in 1-2 shows/year. Exclusively photo shows rare.
Making Contact & Terms: Charges 25% commission. Send up to 6 slides and résumé to exhibition committee. SASE. Reports quarterly.
Tips: "Don't make solicitations by phone; the exhibition committee does not have office hours. Please do not bring work in for review."

ILLINOIS ART GALLERY, 100 W. Randolph, Suite 2-100, Chicago IL 60601. (312)814-5322. Director: Kent Smith. Assistant Administrator: Jane Stevens. Estab. 1985.
Exhibits: Must be an Illinois photographer. Interested in contemporary and historical photography. Examples of recent exhibitions: "Poetic Vision," by Joseph Jachna (landscape, large-format); "New Bauhaus Photographs 1937-1940," by James Hamilton Brown, Nathan Lerner, Gyorgy Kepes, Laszlo Moholy-Nagy and Arthur Siegel (photograms). Presents 2-3 shows/year. Shows last 2 months. Sponsors openings; provides refreshments at reception and sends out announcement cards for exhibitions.
Making Contact & Terms: Interested in receiving work from newer, lesser-known photographers, as well as established photographer. Reviews transparencies. Interested in mounted or unmounted work. Send résumé, artist's statement and slides (10). SASE. Reports in 1 month.

***INDIANAPOLIS ART CENTER**, 820 E. 67th St., Indianapolis IN 46220. (317)255-2464. Fax: (317)254-0486. Exhibitions Curator: Julia Moore. Estab. 1976.
Exhibits: Requirements: Preferably live within 250 miles of Indianapolis. Interested in very contemporary work, preferably unusual processes. Examples of recent exhibitions: works by Nancy Hutchinson (b&w hand-colored: surreal); Yasha Persson (altered using Adobe Photoshop: social commentary); Ken Gray (overprinted: social commentary); and Stephen Marc (documentary/digital montages). Presents 1-2 photography shows/year out of 13-20 shows in a season. Shows last 4-6 weeks. Sponsors openings. Provides food and mailers. "We mail to our list and 50 names from photographer's list. You mail the rest." Photographer's presence at opening and during show preferred.
Making Contact & Terms: Interested in receiving work from newer, lesser-known photographers. Charges 35% commission. General price range: $100-1,000. Reviews transparencies. Interested in framed (or other finished-presentation formatted) work only for final exhibition. Works are limited to 96″ maximum any direction. Send material by mail for consideration. Send minimum 10 slides with résumé, reviews, artist's statement. No wildlife or landscape photography. Interesting color work is appreciated. SASE.

INTERNATIONAL CENTER OF PHOTOGRAPHY, 1130 Fifth Ave., New York NY 10128. Contact: Department of Exhibitions. Estab. 1974.
Making Contact & Terms: Portfolio reviews are held the first Monday of each month. Submit portfolio to the receptionist by noon and pick up the following afternoon. Call Friday prior to drop-off date to confirm. "This is strictly drop-off."

ISLIP ART MUSEUM, 50 Irish Lane, Islip NY 11730. (516)224-5402. Director: M.L. Cohalan. Estab. 1973.
Exhibits: Interested in contemporary or avant-garde works. Has exhibited work by Robert Flynt, Skeet McAuley and James Fraschetti. Shows last 6-8 weeks. Sponsors openings. Photographer's presence at opening preferred.
Making Contact & Terms: Interested in reviewing work from newer, lesser-known photographers. Charges 30% commission. General price range: $200-3,000. Reviews transparencies. Send slides and résumé; no original work. Reports in 1 month.
Tips: "Our museum exhibits theme shows. We seldom exhibit work of individual artists. Themes reflect ideas and issues facing current avant-garde art world. We are a museum. Our prime function is to exhibit, not promote or sell, work."

***KALA INSTITUTE**, 1060 Heinz Ave., Berkeley CA 94710. (510)549-2977. Fax: (510)549-2984. Programs Director: Patrick MacMennamin. Estab. 1974.
Exhibits: Usually required to be an artist in residence at the Kala Institute or part of group showing. Interested in photoetching and alternative photo processes. Examples of recent exhibitions: "Fellowship 1993," by Robin McCloskey (photoetching); "Monthly Salon," by Jan Kaufman (color abstract photography). Presents 1-2 shows/year. Shows last 6 weeks. Sponsors openings; usually provides publicity and installation. Photographer's presence at opening and during show preferred.

Making Contact & Terms: Interested in receiving work from newer, lesser-known photographers. Charges 50% commission. General price range: $100-500. Reviews transparencies. Interested in framed or unframed work, mounted or unmounted work, matted or unmatted work. Query with résumé of credits. SASE. Reports in 1 month.

Tips: "Normally, our gallery presents only work that is produced at our institute. We offer fellowships and artists in residencies to photographers and etchers to produce their work here."

KENT STATE UNIVERSITY SCHOOL OF ART GALLERY, Dept. PM, KSU, 201 Art Building, Kent OH 44242. (216)672-7853. Director: Fred T. Smith.

Exhibits: Interested in all types, styles and subject matter of photography. Photographer must present quality work. Presents 1 show/year. Exhibits last 3 weeks. Sponsors openings; provides hors d'oeuvres, wine and non-alcoholic punch. Photographer's presence at opening preferred.

Making Contact & Terms: Photography can be sold in gallery. Charges 20% commission. Buys photography outright. Will review transparencies. Write a proposal and send with slides. Send material by mail for consideration. SASE. Reports usually in 4 months, but it depends on time submitted.

LA MAMA LA GALLERIA, 6 E. First Street, New York NY 10003. (212)505-2476. Director/Curator: Lawry Smith. Estab. 1982.

Exhibits: Interested in all types of work. Looking for "movement, point of view, dimension." Examples of recent exhibitions: "Jocks in Frocks," by Charles Justina; "Styles & Aesthetics," group show. Presents 2 shows/year. Shows last 3 weeks. Sponsors openings. Photographer's presence at opening required.

Making Contact & Terms: Very receptive to exhibiting work of newer, lesser-known photographers. Charges 20% commission. General price range: $200-2,000. Prices set by agreement between director/ curator and photographer. Reviews transparencies. Interested in framed or unframed, mounted, matted or unmatted work. Requires exclusive representation within metropolitan area. Arrange a personal interview to show portfolio. Send material by mail for consideration. SASE. Reports in 1 month.

Tips: "Be patient; we are continuously booked 18 months-2 years ahead."

J. LAWRENCE GALLERY, 1435 Highland Ave., Melbourne FL 32935. (407)259-1492. Fax: (407)259-1494. Owner: Joseph L. Conneen, Jr. Estab. 1984.

Exhibits: Requirements: Must be original works done by the photographer. Interested in cibachrome; hand-tinted b&w and b&w. Examples of exhibitions: works by Lloyd Behrendt (hand-tinted b&w), Chuck Harris (cibachrome), and Clyde & Nikki Butcher (b&w and hand-tinted b&w). Most shows are group exhibits. Shows last 6 weeks. Sponsors openings; provides invitations, mailings, opening entertainment, etc. Photographer's presence at opening and during show preferred.

Making Contact & Terms: Interested in receiving work from newer, lesser-known photographers. Charges 40% commission. General price range: $200-1,000. Reviews transparencies. Interested in framed or unframed, mounted or unmounted, matted or unmatted work. Requires exclusive representation locally. Arrange a personal interview to show portfolio. Submit portfolio for review. Query with résumé of credits. Query with samples. Send material by mail for consideration. SASE. Reports in 1-2 weeks.

Tips: "The market for fine art photography is growing stronger."

***LBW GALLERY**, Northview Mall, 1724 E. 86th St., Indianapolis IN 46240-2360. (317)848-2787. Director: Linda B. Walsh.

Exhibits: Requirements: Must appeal to clients (homeowners, collectors). Interested in landscapes, flowers, architecture, points and places of interest. Examples of recent exhibitions: "Indiana Scenes," by Robert Cook; "Trees & Flowers," by John and Joan Green; and "Indiana Scenery," by Robert Walls. Presents 10 shows/year. Shows last 1 month. Sponsors openings; provides refreshments, press releases, direct mail. Photographer's presence at opening preferred, but not necessary.

Making Contact & Terms: Interested in receiving work from newer, lesser-known photographers. Charges 50% commission. General price range: $150-250. Reviews transparencies. Interested in framed and matted work only. Works are limited to up to 18×24. Query with résumé of credits. Query with samples. SASE. Reports in 1-2 weeks.

Tips: "Be realistic in dealing with subject matter that would be interesting and sell to the public. Also, be realistic as to the price you desire out of your work."

LEWIS LEHR INC., Box 1008, Gracie Station, New York NY 10028. (212)288-6765. Director: Lewis Lehr. Estab. 1984. Private dealer. Buys vintage photos.

Making Contact & Terms: Charges 50% commission. Buys photography outright. General price range: $500 plus. Reviews transparencies. Interested in mounted or unmounted work. Requires exclusive representation within metropolitan area. Query with résumé of credits. SASE. Member AIPAD.

Tips: Vintage American sells best. Sees trend toward "more color and larger" print sizes. To break in, "knock on doors." Do not send work.

■**THE LIGHT FACTORY PHOTOGRAPHIC ARTS CENTER**, P.O. Box 32815, Charlotte NC 28232. (704)333-9755. Contact: Gallery Manager. Nonprofit. Estab. 1972.
Exhibits: Requirements: Photographer must have a professional exhibition record for main gallery. Interested in contemporary and documentary photography, any subject matter. Presents 8-10 shows/year. Shows last 1-2 months. Sponsors openings; reception (3 hours) with food and beverages, artist lecture following reception. Photographer's presence at opening preferred.
Making Contact & Terms: Photography sold in the gallery. "Artists price their work." Charges 33% commission. Rarely buys photography outright. General price range: $500-12,000. Reviews transparencies. Write for gallery guidelines. Query with résumé of credits and slides. Artist's statement required. SASE. Reports in 2 months.
Tips: Among various trends such as fine art prints and documentary work, "we are seeing more mixed media using photography, painting, sculpture and videos. We have several smaller galleries to show work from up and coming photographers. We are interested in cohesive bodies of work that reflect a particular viewpoint or idea."

*****LIZARDI/HARP GALLERY**, 8678 Melrose Ave., Los Angeles CA 90069. Director: Grady Harp. Estab. 1981.
Exhibits: Requirements: Must have more than one portfolio of subject, unique slant and professional manner. Interested in figurative, nudes, "maybe" manipulated work, documentary and mood landscapes. Examples of recent exhibitions: "The Rome Series," by Christopher James (Diana camera docu-portraits); self portraits, by Robert Stivers (self portraits in staged settings); and "L.A. Gangs," by Della Rossa (documentary on Echo Park). Presents 3-4 shows/year. Shows last 4-6 weeks. Sponsors openings; provides announcements, reception costs. Photographer's presence at opening preferred.
Making Contact & Terms: Interested in receiving work from newer, lesser-known photographers. Charges 50% commission. General price range: $500-4,000. Reviews transparencies. Interested in unframed, unmounted and matted or unmatted work only. Submit portfolio for review. Query with résumé of credits. Query with samples. Send material by mail for consideration. SASE. Reports in 1 month.

*****M.C. GALLERY**, 400 First Ave. N., Minneapolis MN 55401. (612)339-1480. Fax: (612)339-1480. Director: M.C. Anderson. Estab. 1984.
Exhibits: Interested in avant-garde work. Examples of recent exhibitions: works by Gloria Dephilips Brush, Ann Hofkin and Catherine Kemp. Shows last 6 weeks. Sponsors openings; attended by 2,000-3,000 people. Photographer's presence preferred at opening and during show.
Making Contact & Terms: Interested in receiving work from newer, lesser-known photographers. Charges 50% commission. General price range: $300-1,200. Reviews transparencies. Interested in framed or unframed work. Requires exclusive representation within metropolitan area. Submit portfolio for review. Query with résumé of credits. Send material by mail for consideration. Material will be returned, but 2-3 times/year. Reports in 1-2 weeks if strongly interested, or it could be several months.

*****MAINE COAST ARTISTS**, P.O. Box 147, Rockport ME 04856. (207)236-2875. Director: John Chandler. Estab. 1952.
Exhibits: Requirements: Must work part of the year in Maine. Examples of recent exhibitions: "Private Moments: Public Places," by Rudy Burkhardt (urban images); "Elmer Walker: Hermit to Hero," by Tonee Harbert (installation); and solo show by Todd Webb. Number of shots varies. Shows last 1 month. Sponsors openings; provides refreshments. Photographer's presence at opening is preferred.
Making Contact & Terms: Interested in receiving work from newer, lesser-known photographers. Charges 40% commission. General price range: $200-2,000. Reviews transparencies. Query with résumé of credits. Query with samples. Send material by mail for consideration. SASE. Reports in 2 months.
Tips: "A photographer can request receipt of application for our annual juried exhibition (May 27-end of June), as well as apply for solo or group exhibitions." MCA is exhibiting more and more photography.

MARLBORO GALLERY, Prince George's Community College, 301 Largo Road, Largo MD 20772-2199. (301)322-0967. Gallery Curator: John Krumrein. Estab. 1976.
Exhibits: Not interested in commercial work. "We are looking for fine art photos, we need between 10 to 20 to make assessment, and reviews are done every 6 months. We prefer submissions during February-April." Examples of recent exhibitions: "Blues Face/Blues Places," John Belushi's blues collection photos (various photographers); "Blues Face/Blues Places," the David Spitzer collection of blues; and "Greek Influence," photos of Greece by various photographers. Shows last 3-4 weeks. Sponsors openings. Photographer's presence at opening required.
Making Contact & Terms: Interested in receiving work from newer, lesser-known photographers. General price range: $50-5,000. Reviews transparencies. Interested in framed work only. Query with samples. Send material by mail for consideration. SASE. Reports in 3-4 weeks.

Tips: "Send examples of what you wish to display and explanations if photos do not meet normal standards (i.e., in focus, experimental subject matter)."

MARSH ART GALLERY, University of Richmond, Richmond VA 23173. (804)289-8276. Fax: (804)287-6006. E-mail: waller@urvax.urich.edu. Director: Richard Waller. Estab. 1966.
Exhibits: Interested in all subjects. Examples of recent exhibitions: "Mountaineers to Main Streets: The Depression Years 1935-41"; "Builder Levy: Images of Appalachian Coalfields"; "The Encompassing Eye: Photography as Drawing." Presents 8-10 shows/year. Shows last 1 month. Photographer's presence at opening preferred.
Making Contact & Terms: Charges 10% commission. Reviews transparencies. Interested in framed or unframed, mounted or unmounted, matted or unmatted work. Work must be framed for exhibition. Query with résumé of credits. Query with samples. Send material by mail for consideration. Reports in 1 month.
Tips: If possible, submit material which can be left on file and fits standard letter file. "We are a nonprofit university gallery interested in presenting contemporary art."

MORTON J. MAY FOUNDATION GALLERY—MARYVILLE UNIVERSITY, 13550 Conway Rd., St. Louis MO 63141. (314)529-9415. Gallery Director and Art Professor: Nancy N. Rice.
Exhibits: Requirements: Must transcend student work, must have a consistent aesthetic point of view or consistent theme, and must be technically excellent. Examples of recent exhibitions: "Recent Work," by Stacey C. Morse (b&w landscapes). Presents 1-3 shows/year. Shows last 1 month. Sponsors openings; provides wine and soda, exhibit announcements and bulk rate mailings. Photographer's presence at opening required.
Making Contact & Terms: Interested in receiving work from newer, lesser-known photographers. General price range: $25-500. Interested in framed or unframed, mounted or unmounted, matted or unmatted work (when exhibited work must be framed or suitably presented.) Send material by mail for consideration. SASE. Reports in 3-4 months.

ERNESTO MAYANS GALLERIES, 601 Canyon Rd., Santa Fe NM 87501. (505)983-8068. Fax: (505)982-1999. Owner: Ernesto and Leonor Mayans. Estab. 1977.
Exhibits: Examples of recent exhibitions: "Cholos/East L.A.," by Graciela Iturbide (b&w); "Fresson Images," by Doug Keats (Fresson), "Selected Works," by André Kertész (b&w) and Willis Lee: photogravures. Publishes catalogs and portfolios.
Making Contact & Terms: Charges 50% commission. Buys photos outright. General price range: $200-5,000. Reviews transparencies. Interested in framed or unframed, mounted or unmounted work. Requires exclusive representation within area. Shows are limited to up to 16×20. Arrange a personal interview to show portfolio. Send material by mail for consideration. SASE. Reports in 1-2 weeks.
Tips: "Please call before submitting."

R. MICHELSON GALLERIES, 132 Main St., Northampton MA 01060. (413)586-3964. Owner and President: Richard Michelson. Estab. 1976.
Exhibits: Interested in contemporary, landscape and/or figure, generally realistic work. Examples of recent exhibitions: Works by Michael Jacobson-Hardy (landscape), Jim Wallace (landscape), and Robin Logan (still life/floral). Presents 1 show/year. Show lasts 6 weeks. Sponsors openings. Photographer's presence at opening required, presence during show preferred.
Making Contact & Terms: Interested in receiving work from newer, lesser-known photographers. Sometimes buys photos outright. General price range: $100-1,000. Reviews transparencies. Interested in framed or unframed, mounted or unmounted, matted or unmatted work. Requires exclusive representation locally. Send material by mail for consideration. SASE. Reports in 1-2 weeks.

PETER MILLER GALLERY, 401 W. Superior, Chicago IL 60610. (312)951-0252. Fax: (312)951-2628. Director: Peter Miller. Estab. 1979.
Exhibits: "We have not exhibited photography but we are interested in adding photography to the work currently exhibited here." Sponsors openings. Photographer's presence at opening and during show preferred.
Making Contact & Terms: Interested in receiving work from newer, lesser-known photographers. Charges 50% commission. Reviews transparencies. Interested in framed or unframed, mounted or unmounted, matted or unmatted work. Requires exclusive representation locally. Send 20 slides of the most recent work with SASE. Reports in 1-2 weeks.

MINOT ART GALLERY, P.O. Box 325, Minot ND 58701. (701)838-4445. Estab. 1970.
Exhibits: Example of recent exhibition: "Wayne Jansen: Photographs," by Wayne Jansen (buildings and landscapes). Presents 3 shows/year. Shows last about 1 month. Sponsors openings.
Making Contact & Terms: Very receptive to work of newer, lesser-known photographers. Charges 30% commission. General price range: $25-150. Submit portfolio or at least 6 examples of work for review. Prefers transparencies. SASE. Reports in 1 month.

Tips: "Wildlife, landscapes and floral pieces seem to be the trend in North Dakota. We get many slides to review for our three photography shows a year. Do something unusual, creative, artistic. Do not send postcard photos."

***MONTEREY PENINSULA MUSEUM OF ART**, 559 Pacific St., Monterey CA 93940. (408)372-5477. Fax: (408)372-5680. Director: Reilly Rhodes. Estab. 1969.
Exhibits: Interested in all subjects. Examples of recent exhibitions: "Twenty Years of Photography," by John Sexton; "Platinum Prints Clair-Obscur," by Tom Millea; and "Edward Weston: Photographs 1937-1939." Presents 4-6 shows/year. Shows last approximately 6-12 weeks. Sponsors openings.
Making Contact & Terms: "Very receptive" to working with newer, lesser-known photographers. Buys photography outright. NPI. Reviews transparencies. Work must be framed to be displayed; review can be by slides, transparencies, unframed or unmatted. Send material by mail for consideration. SASE. Reports in 1 month.
Tips: "Send 20 slides and résumé at any time to the attention of the museum director."

MONTPELIER CULTURAL ARTS CENTER, 12826 Laurel-Bowie Rd., Laurel MD 20708. (301)953-1993. Director: Richard Zandler. Estab. 1979.
Exhibits: Open to all photography. Examples of exhibitions: Photographs by Jason Horowitz (panoramic b&w); "In The Shadow of Crough Patrick," photos by Joan Rough (color landscapes of Ireland); photographs by Robert Houston (b&ws of urban life). Shows last 1-2 months. Sponsors openings. "We take care of everything." Photographer's presence at opening preferred.
Making Contact & Terms: Interested in receiving work from newer, lesser-known photographers. "We do not sell much." Charges 25% commission. Reviews transparencies. Interested in framed work only. "Send 20 slides, résumé and exhibit proposal for consideration. Include SASE for return of slides. Work must be framed and ready for hanging if accepted." Reports "after scheduled committee meeting/depends on time of year."

***MTSU PHOTOGRAPHIC GALLERY**, P.O. Box 305, Murfreesboro TN 37132. (615)898-2085. Fax: (615)898-5682. Curator: Tom Jimison. Estab. 1971.
Exhibits: Interested in all styles and genres, including landscapes, Americana and figurative work. Presents 6 shows/year. Shows last 5 weeks.
Making Contact & Terms: Interested in receiving work from newer, lesser-known photographers. General price range: $300-2,000. Interested in framed work in any size and matted work in standard sizes (11×14, 14×17, 16×20, 20×24). Query with résumé of credits. Call or write for portfolio review. Reports in 4-6 weeks.

THE MUSEUM OF CONTEMPORARY PHOTOGRAPHY, COLUMBIA COLLEGE CHICAGO, 600 S. Michigan Ave., Chicago IL 60605-1996. (312)663-5554. Fax: (312)360-1656. Director: Denise Miller-Clark. Assistant Director: Ellen Ushioka. Estab. 1984.
Exhibits: Interested in fine art, documentary, photojournalism, commercial, technical/scientific. "All high quality work considered." Examples of exhibitions: "Open Spain/Espana Abierta" (contemporary documentary Spanish photography/group show); "The Duane Michals Show," by Duane Michals (b&w narrative sequences, surreal, directorial); "Irving Penn: Master Images," by Irving Penn (b&w fashion, still life, portraiture). Presents 5 main shows and 8-10 smaller shows/year. Shows last 8 weeks. Sponsors openings, provides announcements.
Making Contact & Terms: "We do exhibit the work of newer and lesser known photographers if their work is of high professional quality." Charges 30% commission. Buys photos outright. General price range: $300-2,000. Reviews transparencies. Interested in reviewing unframed work only, matted or unmatted. Submit portfolio for review. SASE. Reports in 2 weeks. No critical review offered.
Tips: "Professional standards apply; only very high quality work considered."

MUSEUM OF PHOTOGRAPHIC ARTS, 1649 El Prado, Balboa Park, San Diego CA 92101. (619)238-7559. Fax: (619)238-8777. Executive Director: Arthur Ollman. Associate Curator: Diana Gaston. Estab. 1983.
Exhibits: "The criteria is simply that the photography be the finest and most interesting in the world, relative to other fine art activity. MoPA is a museum and therefore does not sell works in exhibitions. There are no fees involved." Examples of recent exhibitions: "Wigs," by Lorna Simpson; "Essential Elements," by Harry Callahan; "Informed by Film," by contemporary photographers simulating appearance of film. Presents 6-8 exhibitions annually from 19th century to contemporary. Each exhibition lasts approximately 2 months. Exhibition schedules planned 2-3 years in advance. The Museum holds a private Members' Opening Reception for each exhibition.
Making Contact & Terms: For space, time and curatorial reasons, there are few opportunities to present the work of newer, lesser-known photographers. Send résumé of credits with a portfolio (unframed photographs) or slides. Portfolios may be submitted for review with advance notification. Files

are kept on contemporary artists for future reference. Send return address and postage. Reports in 2 months.
Tips: "Exhibitions presented by the museum represent the full range of artistic and journalistic photographic works." There are no specific requirements. "The executive director/curator makes all decisions on works that will be included in exhibitions. There is an enormous stylistic diversity in the photographic arts. The Museum does not place an emphasis on one style or technique over another."

MUSEUM OF THE PLAINS INDIAN & CRAFTS CENTER, Junction of Highways 2 and 89, Browning MT 59417. (406)338-2230. Fax: (406)338-7404. Curator: Loretta Pepion. Estab. 1941.
Exhibits: Requirements: Must be a Native American of any tribe within the 50 states, proof required. Shows last 6 weeks. Sponsors openings. Provides refreshments and a weekend opening plus a brochure.
Making Contact & Terms: Interested in receiving work from newer, lesser-known photographers. Charges 25% commission. Reviews transparencies. Interested in framed and matted work. Query with samples. Send material by mail for consideration. SASE.

NEIKRUG PHOTOGRAPHICA LTD., 224 E. 68th St., New York NY 10021. (212)288-7741. Fax: (212)737-3208. Owner/Director: Marjorie Neikrug. Estab. 1970.
Exhibits: Interested in "photography which has a unique way of showing the contemporary world. Special needs include photographic art for our annual Rated X exhibit." Examples of recent exhibitions: "A Guerrilla of Photography," by Stephan Lufino; "Intimate Impressions," by Marie-Claire Montanari. Sponsors openings "in cooperation with the photographer." Photographer's presence preferred.
Making Contact & Terms: Interested in receiving work from newer, lesser-known photographers. Charges 50% commission. Price range: $100-5,000. Requires exclusive representation in metropolitan area. Call to arrange an appointment or submit portfolio in person. SASE. Works are limited to the following sizes: 11×14, 16×20 or 20×30.
Tips: "We are looking for meaningful and beautiful images—images with substance and feeling! Show us themes, organization of work, print interpretation and originality. Edit work carefully and make it easy for the viewer. Have neat presentation." Nudes and color landscapes currently sell best at this gallery.

NEVADA MUSEUM OF ART, 160 W. Liberty St., Reno NV 89501. (702)329-3333. Fax: (702)329-1541). E-mail: 70252.1404@compuserve.com. Chairman of the Collections Committee: Peter Pool. Estab. 1931.
• Peter Pool is now in the process of developing an "Altered Landscape" collection for the museum. That is the primary photographic concern for the museum.
Exhibits: Examples of recent exhibitions: "Contemporary Basque Photography," group show organized in Spain; "Gus Bundy," artist's work from the permanent collection; "Erik Lauritzen: Under Construction." Presents 10-12 shows/year in various media. Shows last 6-8 weeks. Sponsors openings; provides catered reception for up to 400 people, book signings, etc. Photographer's presence at opening preferred.
Making Contact & Terms: General price range: $75-2,000. Reviews work in any form: original prints, work prints, slides. Call for interest and arrangements. Interested in framed or unframed work.
Tips: Museum exhibits "a wide variety of art, including photography. It is a tax-exempt, not-for-profit institution; primarily an art museum and not just a photography museum. We're not a commercial gallery."

NEW ORLEANS MUSEUM OF ART, Box 19123, City Park, New Orleans LA 70179. (504)488-2631. Fax: (504)484-6662. Curator of Photography: Steven Maklansky. Collection estab. 1973.
Exhibits: Requirements: Send thought out images with originality and expertise. Do not send commercial looking images. Interested in all types of photography. Examples of recent exhibitions: "Double Exposure," "Photoglyphs," and "Asserting Equality" (all photos by various photographers). Presents shows continuously. Shows last 1-3 months.
Making Contact & Terms: Buys photography outright; NPI. Present budget for purchasing contemporary photography is very small. Sometimes accepts donations from established artists, collectors or dealers. Query with color photocopies (preferred) or slides and résumé of credits. SASE. Reports in 1-3 months.

A bullet has been placed within some listings to introduce special comments by the editor of Photographer's Market.

***NICOLAYSEN ART MUSEUM & DISCOVERY CENTER**, 400 E. Collins, Casper WY 82601. (307)235-5247. Fax: (307)235-0923. Director: Karen R. Mobley. Estab. 1967.
Exhibits: Requirements: Artistic excellence and work must be appropriate to gallery's schedule. Interested in all subjects and media. Examples of recent exhibitions: works by Gerry Spence (b&w); Devendra Shirkehande (color); and Susan Moldenhauer (color). Presents 2 shows/year. Shows last 2 months. Sponsors openings. Photographer's presence at opening and during show is preferred.
Making Contact & Terms: Interested in receiving work from newer, lesser-known photographers. Charges 40% commission. General price range: $250-1,500. Reviews transparencies. Interested in framed or unframed work. Send material by mail for consideration (slides, vita, proposal). SASE. Reports in 1 month.
Tips: "We have a large children/youth audience and gear some of what we do to them."

NORTHLIGHT GALLERY, School of Art, Arizona State University, Tempe AZ 85287-1505. (602)965-6517. Collections Manager: Mary Anne Laugharn. Estab. 1972.
Exhibits: Requirements: Review by Northlight advisory committee for academic year scheduling. Interested in "any and all" photography. Examples of recent exhibitions: "Family Matters," by Sally Mann, Vince Leo, Melissa Shook, Phillip Lorca DiCorcia; Richard Bolton; Jay Wolke, Paul DaMato, Beaumont Newhall. Presents 6 shows/year. Shows last 1 month. Sponsors openings; provides travel honorarium. Photographer's presence at opening preferred.
Making Contact & Terms: Interested in receiving work from newer, lesser-known photographers. Reviews transparencies. SASE. Reports in 1 month.

***NORTHPORT/B.J. SPOKE GALLERY**, 299 Main Street, Huntington NY 11743. (516)549-5106. Director: Carol L. Davis.
Exhibits: Requirements: juried shows; send for prospectus or deadline. Interested in "all styles and genres, photography as essay, as well as 'beyond' photography." Examples of recent exhibitions: works by Terryl Best (still life) and Neil Scholl (gel-silver print). Shows last 1 month. Sponsors openings. Photographer's presence at opening preferred.
Making Contact & Terms: Interested in receiving work from newer, lesser-known photographers. Charges 25% commission. General price range: $250-900. Reviews transparencies. Interested in framed or unframed, matted or unmatted work. Arrange a personal interview to show portfolio. Query with résumé of credits. Send material by mail for consideration. SASE. Reports back in 2 months.

***THE NOYES MUSEUM**, Lily Lake Rd., Oceanville NJ 08231. (609)652-8848. Fax: (609)652-6166. Curator: Stacy Smith. Estab. 1983.
Exhibits: Works must be ready for hanging, framed preferable. Interested in all styles. Examples of recent exhibitions: "Wind, Water and Sand," by Henry Troup (gelatin silver prints); "Wildlife Photos," by Leonard Balish (color); "Atlantic City," by William Suttle (hand colored). Presents 1 show/year. Shows last 6-12 weeks. Sponsors openings; provides invitation, public relations, light refreshments. Photographer's presence at opening preferred.
Making Contact & Terms: Interested in receiving work from newer, lesser-known photographers. Charges 10% commission. Infrequently buys photos for permanent collection. General price range: $150-1,000. Reviews transparencies. Any format OK for initial review. Send material by mail for consideration, include résumé and slide samples. Reports in 1 month.
Tips: "Send challenging, cohesive body of work. May include photography and mixed media."

O.K. HARRIS WORKS OF ART, 383 W. Broadway, New York NY 10012. (212)431-3600. Director: Ivan C. Karp. Estab. 1969.
● This gallery is closed from mid-July to after Labor Day.
Exhibits: Requirements: "The images should be startling or profoundly evocative. No rock, dunes, weeds or nudes reclining on any of the above or seascapes." Interested in urban and industrial subjects and cogent photojournalism. Examples of exhibitions: "Vernacular Church Architecture of the South," by Dennis O'Kain; "Second Story Windows," by A. Roy Greer; and "Neighbors, 1974-1990," by Noel Jones-Sylvester. Presents 5-8 shows/year. Shows last 3 weeks.
Making Contact & Terms: Charges 40% commission. General price range: $350-1,200. Interested in matted or unmatted work. Appear in person, no appointment: Tuesday-Friday 10-6. SASE. Reports back immediately.
Tips: "Do not provide a descriptive text."

OLIN FINE ARTS GALLERY, Washington & Jefferson College, Washington PA 15301. (412)222-4400. Contact: Paul Edwards. Estab. 1982.
Exhibits: Requirements: Photographer must be at least 18 years old, American citizen and artists assume most show costs. Interested in large format, experimental, traditional photos. Examples of previous exhibitions: one-person show by William Wellman; "The Eighties," by Mark Perrott. Presents

1 show/year. Shows last 3 weeks. Sponsors openings; pays for non-alcoholic reception if artist attends. Photographer's presence at opening preferred.

Making Contact & Terms: Charges 20% commission. General price range: $50-1,500. Reviews transparencies. Interested in framed work only. Shows are limited to works that are no bigger than 6 feet; subject matter that is not for publication. Send material by mail for consideration. SASE. Reports in 1 month.

OLIVER ART CENTER-CALIFORNIA COLLEGE OF ARTS & CRAFTS, 5212 Broadway, Oakland CA 94618. (510)597-3605, ext. 198. Fax: (510)547-8612. Director-Exhibitions/Public Programming: Dyana Curreri-Chadwick. Estab. 1989.

Exhibits: Requirements: must be professional photographer with at least a 2-year exhibition record. Interested in contemporary photography in all formats and genres. Example of exhibition: "Mary Ellen Mark: A Retrospective" (documentary). Presents 1-2 exhibits/year. Shows last 6-8 weeks. Photographer's presence at opening and at show preferred.

Making Contact & Terms: Interested in receiving work from newer, lesser-known photographers. NPI. Reviews transparencies. Query with résumé of credits. SASE. Reports in 1 month.

Tips: "Know the types of exhibitions we have presented and the audience which we serve."

****OPEN SPACE ARTS SOCIETY**, 510 Fort St., Victoria, British Columbia V8W 1E6 Canada. (604)383-8833. Director: Sue Donaldson. Estab. 1972.

Exhibits: Interested in photographs as fine art in an experimental context, as well as interdisciplinary works involving the photograph. No traditional documentary, scenics, sunsets or the like. Examples of recent exhibitions: "Bed of Roses," (sexual imagery); "Compañeras de Mexico," (Mexican women) and "Carnet Photographique," by Joanne Tremblay (female model). Presents 5 shows/year. Shows last 3-4 weeks. Sponsors openings.

Making Contact & Terms: Interested in receiving work from newer, lesser-known photographers. General price range: $100-1,000. Pays the C.A.R.F.A.C. fees; no commission. Query with transparencies of work. SASE. Reports 2 times a year.

Tips: "Submit 10-20 slides and artist statement of what the work is about or how you feel about it. Send for information about Open Space to give you an idea of how large the space is." Sees trend in multimedia installation work where photography is used as part of a larger artwork.

ORGANIZATION OF INDEPENDENT ARTISTS, 19 Hudson St., #402, New York NY 10013. (212)219-9213. Fax: (212)219-9216. Administrative Director: Nan Hall. Estab. 1976.

• OIA is a non-profit organization that helps sponsor exhibitions at the OIA office and in public spaces throughout New York City.

Exhibits: Presents 2 shows/year. Shows last 1 month. Photographer's presence at opening preferred.

Making Contact & Terms: Interested in receiving work from newer, lesser-known photographers. NPI. Reviews transparencies. Submit slides with proposal. Send material by mail for consideration according to guidelines only. Write for information on membership. SASE. "We review 3 times/year."

Tips: "It is not required to be a member to submit a proposal, but interested photographers may want to become OIA members to be included in OIA's active slide file that is used regularly by curators and artists. You must be a member to have your slides in the registry to be considered for exhibits 'Selections from the Slide File' at the OIA office."

ORLANDO GALLERY, Dept. PM, 14553 Ventura Blvd., Sherman Oaks CA 91403. (818)789-6012. Directors: Robert Gino, Don Grant. Estab. 1958.

Exhibits: Interested in photography demonstrating "inventiveness" on any subject. Examples of recent exhibitions: landscapes by Steve Wallace; personal images by Fred Skupenski; platinum prints by Joseph Orsillo. Shows last 1 month. Sponsors openings. Photographer's presence at opening and during show is preferred.

Making Contact & Terms: Very receptive to work of newer photographers. Charges 50% commission. Price range: $600-3,000. Query with résumé of credits. Send material by mail for consideration. SASE. Framed work only. Reports in 1 month. Requires exclusive representation in area.

Tips: Make a good presentation. "Make sure that personality is reflected in images. We're not interested in what sells the best—just good photos."

PACE/MACGILL GALLERY, Dept. PM, 32 E. 57th St., 9th Floor, New York NY 10022. (212)759-7999. Contact: Assistant to the Director. Estab. 1983.

Exhibits: "We like to show original work that changes the direction of the medium." Presents 18 shows/year. Shows last 3-5 weeks. Sponsors openings. Photographer's presence at opening preferred.

Making Contact & Terms: Photography sold in gallery. Commission varies. On occasion, buys photos outright. General price range: $1,000-300,000. Reviews transparencies with a letter of recommendation from an established, reputable third party. Requires exclusive representation. No size limits. Please include SASE. Reports in 3 weeks.

Tips: "Review our exhibitions and ask, 'Does my work make a similar contribution to photography?' If so, seek third party to recommend your work."

PAINTERS ART GALLERY, 30517 St. Rt. 706 East, P.O. Box 106, Ashford WA 98304. (360)569-2644. Owner: Joan Painter.
● This market hangs work for retail sales only.
Exhibits: Interested in subject matter that deals with the Mountain men, Native Americans and Mt. Rainier.
Making Contact & Terms: Interested in receiving work from newer, lesser-known photographers. Charges 30% commission. General price range: $10-400. Reviews transparencies. Interested in framed or unframed, mounted, matted or unmatted work that is shrink-wrapped. Arrange a personal interview to show portfolio. Send material by mail for consideration. Reports in 1-2 weeks and as space is available.
Tips: "Photography should lean towards fine art format. The gallery receives clients world wide and from all walks of life and religions. So keep it conservative and in good taste."

PALO ALTO CULTURAL CENTER, 1313 Newell Rd., Palo Alto CA 94303. (415)329-2366. Contact: Exhibitions Dept. Estab. 1971.
Exhibits: "Exhibit needs vary according to curatorial context." Seeks "imagery unique to individual artist. No standard policy. Photography may be integrated in group exhibits." Shows last 1-3 months. Sponsors openings. Photographer's presence at opening preferred.
Making Contact & Terms: Reviews transparencies. Interested in framed work only. Send material by mail for consideration; include transparencies, slides, bio and artistic statement. SASE.

THE PEORIA ART GUILD, 1831 N. Knoxville Ave., Peoria IL 61603. (309)685-7522. Fax: (309)685-7446. Director: Ann Conver. Estab. 1969.
● The Guild had a successful first annual Digital Photo Competition. Write for details.
Exhibits: Requirements: submit slides, résumé and artist's statement. Examples of recent exhibitions: "Digital Photography '94"; a Fine Art Fair and a Fine Art Show & Sale with photography included. Presents 1-2 shows/year. Shows last 1 month. Sponsors openings; provides food and drink, occasionally live music. Photographer's presence at opening preferred.
Making Contact & Terms: Interested in receiving work from newer, lesser-known photographers. Charges 40% commission. General price range: $75-500. Reviews transparencies. Interested in framed or unframed work. Submit portfolio for review. Query with résumé of credits. Send material by mail for consideration. SASE. Reports in 1 month.

PHOTO GALLERY AT THE MAINE SCHOOL OF ART, (formerly The Photo Gallery at the Portland School of Art), 619 Congress St., Portland ME 04101. (207)775-3052. Head, Photo Department: John Eide. Estab. 1972.
Exhibits: Examples of exhibitions: "Boxers & Brokers," by Larry Fink (b&w photos of boxers and stock brokers); "Recent Photographs," by Paul D'Amato (color images of street gangs); "New Landscapes," by Mark Klett (b&w large format images of Western landscape). Presents 6 shows/year. Shows last 5 weeks.
Making Contact & Terms: Very receptive to newer, lesser-known photographers. General price range: $100-500. Will review transparencies. Interested in unmounted work only. Requires work that has been matted and ready to hang. Submit portfolio for review. SASE. Reporting time varies.

THE PHOTO LOUNGE, Truckee Meadows Community College, 7000 Danoini Blvd, Reno NV 89512. (702)673-7084. Director: Erik Lauritzen. Estab. 1993.
Exhibits: Requirements: Send 15 slides of recent work, résumé, artist's statement and SASE for return of slides. Annual deadline March 15. Examples of recent exhibitions: "Human Conditions," by Alicia Bailey (handtinted b&w photos); "Siberia," by George Vago (b&w photographs); and "The Face of God," by Hal Honigsberg (mixed media photos). Presents 8-9 shows/year. Shows last 1 month. Sponsors openings; provides catered reception—wine, cheese, breads, fruit, etc. Photographer's presence at opening preferred.
Making Contact & Terms: Interested in receiving work from newer, lesser-known photographers. Charges 20% commission. General price range: $150-500. Reviews transparencies. Interested in matted work only. Works are limited to 30×40 maximum. Send material by mail for consideration. SASE. Reports in 2-4 months.
Tips: Slides submitted should be sharp, in focus, color correct and show entire image. "Ours is a nonprofit educational space. Students and community rarely purchase work, but appreciate images shown. In Reno, exposure to art is valuable as the community is somewhat removed from the artworld."

***PHOTOGRAPHIC IMAGE GALLERY,** 240 SW First St., Portland OR 97204. (503)224-3543. Fax: (503)224-3607. Director: Guy Swanson. Estab. 1984.

Exhibits: Interested in primarily mid-career to contemporary Master-Traditional Landscape in color and b&w. Examples of recent exhibitions: "Erotica," by Charles Gatewood; "Group," by Rowell, Neil, Ketchum (landscapes); "Nudes," by Jenny Velsmann. Presents 12 shows/year. Shows last 1 month. Sponsors openings. Photographer's presence at opening preferred.
Making Contact & Terms: Charges 50% commission. General price range: $300-1,500. Reviews transparencies. Requires exclusive representation within metropolitan area. Query with résumé of credits. SASE. Reports in 1 month.
Tips: Current opportunities through this gallery are fair. Sees trend toward "more specializing in imagery rather than trying to cover all areas."

■**PHOTOGRAPHIC RESOURCE CENTER,** 602 Commonwealth Ave., Boston MA 02215. (617)353-0700. Fax: (617)353-1662. Curator: Robert E. Seydel. "The PRC is a nonprofit gallery."
Exhibits: Interested in contemporary and historical photography and mixed-media work incorporating photography. "The photographer must meet our high quality requirements." Examples of recent exhibitions: "The Silence of the Passing Time," by Vistan (Wieslaw Brzoska); "Message Carriers," (Contemporary Native American); "Camera As Weapon: Worker Photography Between the Wars." Presents 5-6 group thematic exhibitions in the David and Sandra Bakalar Gallery and 5-6 one- and two-person shows in the Natalie G. Klebenov Gallery/year. Shows last 6-8 weeks. Sponsors openings; provides receptions with refreshments for the Bakalar Gallery shows.
Making Contact & Terms: Interested in receiving work from newer, lesser-known photographers. Will review transparencies. Interested in matted or unmatted work. Query with samples or send material by mail for consideration. SASE. Reports in 2-3 months "depending upon frequency of programming committee meetings. We are continuing to consider new work, but because the PRC's exhibitions are currently scheduled into 1996, we are not offering exhibition dates."

PHOTOGRAPHY GALLERY, Dept. PM, % Park School of Communications, Ithaca College, Ithaca NY 14850. (607)274-3896. Fax: (607)274-1664. Director and Associate Professor: Danny Guthrie. Estab. 1980.
Exhibitions: "Open to all photo-based work; recent and contemporary work by known and emerging artists. No requirements, but most exhibitors are semi-established artists or artists/academics." Presents 10 shows/years. Shows last 1 month. "We do a national mailing of the annual calendar with one image from each selected photographer."
Making Contact & Terms: Interested in receiving work from newer, lesser-known photographers. Photography is occasionally sold. Does not charge commission. General price range: $300-1,500. "We review slides during the month of September for the next year." Interested in matted work only. No frames. Large unmatted work is OK. 4×8 maximum size. Send material by mail for consideration only in month of September. SASE. Reports in 1 month.
Tips: Send work in September. Submit good quality, labeled slides with statement, vitae and support material.

PHOTO-SPACE AT ROCKLAND CENTER FOR THE ARTS, 27 S. Greenbush Rd., West Nyack NY 10994. (914)358-0877. Executive Director: Julianne Ramos. Estab. 1947.
Exhibits: Requirements: Geographic Limits: Rockland, Westchester and Orange counties in New York and Bergen County in New Jersey. Interested in all types of photos. Examples of recent exhibitions: "Second Thoughts" by Ned Harris and "Photo Structures" by Gordon Rapp. Presents 4-5 shows/year. Shows last 2 months. Photographer's presence at opening preferred.
Making Contact & Terms: Charges 33% commission. General price range: $250-2,500. Reviews transparencies. Interested in matted or unmatted work. Shows are limited to 32×40. Query with samples. Send material by mail for consideration. SASE. Reports in 3 months.

QUAST GALLERIES—TAOS, P.O. Box 1528, Taos NM 87571. (505)758-7160. Fax: (505)751-0706. Director: Elise Waters Olonia. Estab. 1987.
Exhibits: Requirements: fine art orientation, established reputation and technique. Interested in figurative works and landscapes, primarily traditional. Focus on international subject matter. Examples of exhibitions: "Vietnam; The Land and the People," by Kerry Heubec (b&w, 35mm); "Winter's Wisdom," by Dan Ham and Geriant Smith (color, b&w, 35mm, 4×5 and Polaroid transfer). Presents 1 show/year. Show lasts 3 weeks. Sponsors openings; provides marketing and catering. Photographer's presence at opening and during show preferred.
Making Contact & Terms: "We are considering sales of photos in our gallery. We charge 50% commission." Reviews transparencies. Interested in matted or unmatted work. Requires exclusive representation locally. Query with résumé of credits. Make appointment in advance if intending to make a personal presentation. Bring representational body of work with résumé. SASE. Reports in 1 month (or sooner).

QUEENS COLLEGE ART CENTER, Benjamin S. Rosenthal Library, Queens College, Flushing NY 11367-6701. (718)997-3770. Fax: (718)997-3753. E-mail: sbsqc@cunyvm.cuny.edu. Director: Suzanna Simor. Curator: Alexandra de Luise. Estab. 1952.
Exhibits: Requirements: Open to all types, styles, subject matter; decisive factor is quality. Photographer must be ready to deliver all the work in ready-to-be-exhibited condition and is responsible for installation, removal, transportation. Examples of recent exhibitions: "Images of Mexico," by Angela Petruso; photography of monuments by Guillermo Kahlo; photographs of Colombia by Leo Matiz. Presents 2-4 shows/year. Shows last 1 month. Sponsors openings. Photographer is responsible for providing/arranging, refreshments and cleanup. Photographer's presence at opening required, presence during show preferred.
Making Contact & Terms: Charges 40% commission. General price range: $100-500. Interested in framed or unframed, mounted or unmounted, matted or unmatted work. Arrange a personal interview to show portfolio. Query with résumé of credits. Query with samples. Send material by mail for consideration. Submit portfolio for review. SASE. Reports in 2-4 weeks.

RANDOLPH STREET GALLERY, 756 N. Milwaukee Ave., Chicago IL 60622. (312)666-7737. Fax: (312)666-8966. E-mail: randolph@merle.acns.nwu.edu. Exhibitions Director: Paul Brenner. Estab. 1979.
Exhibits: Exhibits work in all media, mostly in group exhibitions dealing with a specific topic, theme, social issue or aesthetic concept. Examples of recent exhibitions: "Telling. . . Stories," group show (photographic autobiography); "Lousy Fear," Andrew Bush, Harlen Wallach, et al. (marketing of fear); and "Minefield of Memory," Rosy Martin (lesbian identity). Presents 7 shows/year. Shows last 5 weeks. Sponsors openings; provides publicity brochure for exhibition. Photographer's presence at opening preferred.
Making Contact & Terms: NPI. Reviews slides. Interested in framed or unframed, mounted or unmounted, matted or unmatted work. Send material by mail for consideration. SASE. Reports in 1-4 months, depending on when the slides are received.
Tips: "We review quarterly and view slides only. We are a nonprofit exhibition space, therefore we do not represent artists, but can facilitate sales through the artist's gallery or directly through artist."

RED MOUNTAIN GALLERY, Truckee Meadows Community College, 7000 Dandini Blvd., Reno NV 89512. (702)673-7084. Gallery Director: Erik Lauritzen. Estab. 1990.
Exhibits: Interested in all styles, subject matter, techniques—less traditional, more innovative and/or cutting edge. Examples of previous exhibits: "Tents," by Wendy Erickson (16×20 cibachrome prints); "Trying to Photograph the Face of God," by Hal Honigbsburg (mixed media constructions). Number of photography exhibits presented each year depends on jury. Shows last 1 month. Sponsors openings; catered through school food service. Photographer's presence at opening is preferred, but not mandatory.
Making Contact & Terms: Interested in reviewing work from known photographers. Possible honorarium. Charges 20% commission. General price range: $100-700. Reviews transparencies. Interested in exhibiting matted work only. Send 15 slides, résumé and SASE for consideration (35mm glassless dupes). Work is reviewed once a year; deadline is March 15th.
Tips: "Slides submitted should be sharp, accurate color and clearly labeled with name, title, dimensions, medium—the clearer the vitae the better. Statements optional." Sees trend toward mixed media concerns and explorations."

ANNE REED GALLERY, P.O. Box 597, 620 Sun Valley Rd., Ketchum ID 83340. (208)726-3036. Fax: (208)726-9630. Director: Jennifer Gately. Estab. 1980.
Exhibits: Requirements: Work must be of exceptional quality. Interested in platinum, palladium prints, landscapes, still lifes and regional material (West). Examples of recent exhibitions: works by Kenro Izu (platinum/palladium) and Bruce Barnbaum (b&w, silver image). Presents 1-2 shows/year. Shows last 1 month. Sponsors openings; provides installation of exhibition, public relations and opening reception. Photographer's presence at opening and during show preferred.
Making Contact & Terms: Interested in receiving work from newer, lesser-known photographers. Charges 50% commission. General price range: $400-4,000. Reviews transparencies. Interested in framed or unframed, mounted or unmounted, matted or unmatted work. Requires exclusive representation locally. Submit portfolio for review. Query with résumé of credits. Query with samples. Send material by mail for consideration. "It helps to have previous exhibition experience." SASE. Reports in 1-3 weeks.
Tips: "We're interested only in fine art photography. Work should be sensitive, social issues are difficult to sell. We want work of substance, quality in execution and uniqueness. Exhibitions are planned one year in advance. Photography is still a difficult medium to sell, however there is always a market for exceptional work!"

REFLECTIONS OF COLOR GALLERY, 18951 Livernois, Detroit MI 48221. (313)342-7595. Director: Marla Wellborn. Estab. 1988.
Exhibits: Requirements: Must be a minority (African-American, Hispanic, Native American). Interested in images expressing lifestyles, living environments; images expressing or capturing individual strengths. (Not interested in depressing subjects). Art exhibits last 30 days. Sponsors openings; provides promotion of event. Photographer's presence at opening preferred.
Making Contact & Terms: Interested in receiving work from newer, lesser-known photographers. Charges 50% commission. Buys photos outright. General price range: $50-300. Reviews transparencies. Interested in framed or unframed, matted work only. Works are limited to 30×36 maximum. Query with samples. SASE. Reports in 3 weeks.
Tips: Images should be creative and interesting, not commercial. "Galleries are realizing that photography is a true art form to be explored as customers demand more unique and fresh expressions of life!"

ROBINSON GALLERIES, 3514 Lake St., Houston TX 77098. (713)526-0761. Fax: (713)526-0763. Director: Thomas V. Robinson. Estab. 1969.
• Robinson Galleries, through Art Travel Studies, has developed various travel programs whereby individual photographers provide their leadership and expertise to travel groups of other photographers, artists, museum personnel, collectors, ecologists and travelers in general. Ecuador is the featured country, however, the services are not limited to any one destination. Artists/photographers are requested to submit biographies and proposals for projects that would be of interest to them, and possibly to others that would pay the expenses and an honorarium to the photographer leader.
Exhibits: Requirements: Archivally framed and ready for presentation. Limited editions only. Work must be professional. Not interested in pure abstractions. Examples of recent exhibitions: Works by Pablo Corral (cibachrome) and Ron English (b&w and hand-colored silver gelatin prints) and Blair Pittman (audiovisual with 35mm slides in addition to cibachrome and b&w framed photographs). Presents 1 show every other year. (Photographs included in all media exhibitions one or two times per year.) Shows last 4-6 weeks. Sponsors openings; provides invitations, reception and traditional promotion.
Making Contact & Terms: Charges 50% commission. General price range $100-400. Reviews transparencies. Interested in framed or unframed, matted or unmatted work. Requires exclusive representation within metropolitan or state area. Arrange a personal interview to show portfolio. Submit portfolio for review. Query with résumé of credits. SASE. Reports in 1-2 weeks.
Tips: "Robinson Galleries is a fine arts gallery first, the medium is secondary."

***ROCKRIDGE CAFE**, 5492 College Ave., Oakland CA 94618. (510)653-1567. Fax: (510)653-6806. Manager: Bill Chung. Estab. 1973.
Exhibits: "Rockridge Cafe is a popular restaurant in North Oakland that has existed for twenty years. We are flexible and willing to work with upstart artists. We show what we like, the only restrictions having to do with the fact that this is a family restaurant." Presents 7 exhibits/year. Shows last 2 months. "We will accommodate a reception."
Making Contact & Terms: Very interested in receiving work from newer, lesser-known photographers. NPI. Reviews transparencies. Interested in framed or unframed, mounted, matted or unmatted work. Accepts photos up to 3×6 feet. Query with samples. Send material by mail for consideration. Submit portfolio for review—"2 or 3 pieces as would be shown plus slides." SASE. Reports after receiving sample. Reports promptly.
Tips: Does not buy photos outright. Interested buyers will be referred to photographers. "Artists are responsible for hanging and taking down their work."

THE ROLAND GALLERY, 601 Sun Valley Rd., P.O. Box 221, Ketchum ID 83340. (208)726-2333. Fax: (208)726-6266. Contact: Roger Roland. Estab. 1990.
Exhibits: Examples of recent exhibitions: Works by Al Wertheimer (1956 original Elvis Presley prints). Presents 5 shows/year. Shows last 1 month. Sponsors openings; provides advertising and reception. Photographer's presence at opening and during show preferred.
Making Contact & Terms: Interested in receiving work from newer, lesser-known photographers. Charges 50% commission. General price range: $100-1,000. Reviews transparencies. Interested in matted or unmatted work. Submit portfolio for review. SASE. Reports in 1 month.

THE ROSSI GALLERY, 2821 McKinney Ave., Dallas TX 75204. (214)871-0777. Fax: (214)871-1343. Owner: Hank Rossi. Estab. 1987.
Exhibits: Pays shipping both ways. Interested in black and white film noir. Challenging work and conceptual are preferred. Examples of recent exhibits: "Visions of the West," by Skeeter Hagler (b&w); photography by Natalie Caudill (mixed media photographs); "Spirit," by David Chasey (b&w). Presents 2 shows/year. Shows last 1 month. Sponsors openings; provides refreshments, invitations. Photographer's presence at opening required.

Making Contact & Terms: Interested in reviewing work from newer, lesser-known photographers. Charges 40% commission. General price range: $400-1,500. Reviews transparencies. Interested in mounted, matted, or unmatted work only. Query with samples. SASE. Reports in 1 month.
Tips: "Be responsible and prompt. Figurative work is very strong."

THE ROTUNDA GALLERY, 33 Clinton St., Brooklyn NY 11201. (718)875-4047. Fax: (718)488-0609. Director: Janet Riker.
Exhibits: Requirements: Must live in, work in or have studio in Brooklyn. Interested in contemporary works. Examples of recent exhibitions: "All That Jazz," by Cheung Ching Ming (jazz musicians); "Undiscovered New York," by Stanley Greenberg (hidden New York scenes); "To Have and to Hold," by Lauren Piperno (ballroom dancing). Presents 1 show/year. Shows last 5 weeks. Sponsors openings. Photographer's presence at opening preferred.
Making Contact & Terms: Interested in receiving work from newer, lesser-known photographers. Charges 20% commission. Reviews transparencies. Interested in framed or unframed, mounted or unmounted, matted or unmatted work. Shows are limited by walls that are 22 feet high. Arrange a personal interview to show portfolio. Send material by mail for consideration. Join artists slide registry, call for form. SASE.

SANGRE DE CRISTO ARTS CENTER, 210 N. Santa Fe Ave., Pueblo CO 81003. (719)543-0130. Fax: (719)543-0134. Curator of Visual Arts: Jennifer Cook. Estab. 1972.
Exhibits: Requirements: Work must be artistically and technically superior; all displayed works must be framed. It is preferred that emerging and mid-career artists be regional. Examples of recent exhibitions: "Photographs by Karsh," by Yousef Karsh (b&w, large format); "Seeing The Unseen," by Harold Edgerton (high speed); "A Legacy of Beauty," by Laura Gilpin (photos of the Southwest). Presents 3 shows/year. Shows last 2 months. Sponsors openings; provides hors d'oeuvres, cash bar and live musical entertainment. Photographer's presence at opening preferred.
Making Contact & Terms: Interested in receiving work from newer, lesser-known photographers, particularly regional. Charges 30% commission. General price range: $200-800. Reviews transparencies. Interested in framed or unframed, matted or unmatted work. Arrange a personal interview to show portfolio. Submit portfolio for review. Query with résumé of credits. Query with samples. Send material by mail for consideration. Reports in 2 months.

MARTIN SCHWEIG STUDIO AND GALLERY, 4658 Maryland Ave., St. Louis MO 63108. (314)361-3000. Gallery Director: Christine Flavin.
Exhibits: Requirements: Photographs must be matted to standard frame sizes. Interested in all types, expecially interested in seeing work that pushes the boundaries of photography, in technique and subject. Examples of recent exhibitions: "Emulsion Media: Pushing the Limits of Photography," a group show of experimental photography. Presents 8 shows/year. Shows last 1 month. Sponsors openings. Photographer's presence at opening preferred.
Making Contact & Terms: Interested in receiving work from newer, lesser-known photographers. Charges 40% commission. General price range: $100-700. Interested in mounted or matted work. Submit portfolio for review. Query with samples. SASE. Reports in 1 month.
Tips: "Our show schedule is decided by a panel of jurors. Usually a portfolio must be submitted twice."

***SCHWEINFURTH ART CENTER**, 205 W. Genesee St., Auburn NY 13021. (315)255-1553. Director: Susan E. Marteney.
● The Schweinfurth is a museum which features exhibitions on a variety of arts topics and media.
Exhibits: Requirements: Have work ready to install (labeled with name, title, price, etc.). Interested in all types (nature, portraits, topic specific, the Holocaust, etc.). Examples of recent exhibitions: works by Nathan Farb and Henry Horenstein. Presents 1-4 shows/year. Shows last 2 months. Sponsors openings. Provides food and drink; invitations to center's members and artist's mailing list. Photographer's presence at opening and during show preferred.
Making Contact & Terms: Interested in receiving work from newer, lesser-known photographers. Charges 20% commission. General price range: $50-700. Reviews transparencies. Interested in framed

Can't find a listing? Check at the end of each market section for the " '95-'96 Changes" lists. These lists include any market listings from the '95 edition which were either not verified or deleted in this edition.

work only. Query with résumé and slide portfolio. SASE. Reports in 2-4 months.

SECOND STREET GALLERY, 201 Second St. NW, Charlottsville VA 22902. Phone/fax: (804)977-7284. Director: Sarah Sargent. Estab. 1973.
Exhibits: Requirements: Request exhibition guidelines. Examples of recent exhibitions: works by Anne Arden McDonald, Patricia Germain and Bill Emory. Presents 2-3 shows/year. Shows last 1 month. Sponsors openings. Photographer's presence at opening preferred.
Making Contact & Terms: Interested in receiving work from newer, lesser-known photographers. Charges 25% commission. General price range: $250-2,000. Reviews transparencies in fall. Submit 10 slides for review. SASE. Reports in 6-8 weeks.

SELECT ART, 10315 Gooding Dr., Dallas TX 75229. (214)353-0011. Fax: (214)350-0027. Owner: Paul Adelson. Estab. 1986.
• This market deals fine art photography to corporations and sells to collectors. Although Adelson has a gallery, he does not exhibit works.
Exhibits: Interested in architectural pieces, landscapes and florals.
Making Contact & Terms: Interested in receiving work from newer, lesser-known photographers. Charges 50% commission. General price range: $250-600. Retail price range: $100-1,000. Reviews transparencies. Interested in unframed and matted work only. Send material by mail for consideration. SASE. Reports in 1 month.
Tips: Make sure the work you submit is fine art photography, not documentary/photojournalistic or commercial photography. No nudes.

SHAPIRO GALLERY, 250 Sutter St., 3rd Floor, San Francisco CA 94108. (415)398-6655. Owners: Michael Shapiro and Heather Shapiro. Estab. 1980.
Exhibits: Interested in "all subjects and styles. Superior printing and presentation will catch our attention." Examples of exhibitions: Aaron Siskind (b&w); Andre Kertesz (b&w); and Vernon Miller (platinum). Shows last 4-6 weeks. Sponsors openings.
Making Contact & Terms: Very interested in receiving work from newer, lesser-known photographers. General price range: $500-50,000. Arrange a personal interview to show portfolio. SASE.
Tips: "Classic, traditional" work sells best.

SPIRIT SQUARE CENTER FOR THE ARTS, 345 N. College St., Charlotte NC 28202. (704)372-9664. Fax: (704)377-9808. Associate Curators: Aida Saul and Alan Prokop. Estab. 1975.
Exhibits: Requirements: must be able to present a cogent body of work and be responsible for effective presentation. Interested in wide ranging work; no tourism. Presents 3-4 shows/year in each of 6 different galleries. Shows last 8-10 weeks. Sponsors openings. Photographer's presence at opening preferred.
Making Contact & Terms: Interested in receiving work from newer, lesser-known photographers. Charges 40% commission. General price range: $80-1,500. Reviews transparencies. Interested in framed or unframed, mounted or unmounted. Submit portfolio for review. Send material by mail for consideration. SASE. Reports quarterly.
Tips: "The work has to be able to maintain its strength within the presence of other media—painting, sculpture, fiber arts. Installation-based work is a plus."

THE STATE MUSEUM OF PENNSYLVANIA, P.O. Box 1026, Third & North Streets, Harrisburg PA 17108-1026. (717)787-4980. Fax: (717)783-1073. Senior Curator, Art Collections: N. Lee Stevens. Museum estab. 1905; Current Fine Arts Gallery opened in 1993.
Exhibits: Requirements: Photography must be created by native or resident of Pennsylvania, or relevant subject matter. Art photography is a new area of endeavor for The State Museum, both collecting and exhibiting. Interested in works produced with experimental techniques. Examples of recent exhibitions: "Art of the State: PA '94," by Bruce Fry (manipulated, sepia-toned, b&w photo), and works by Norinne Betjemann (gelatin silver print with paint), and David Lebe (painted photogram). Number of exhibits varies. Shows last 2 months. Photographer's presence at opening preferred.
Making Contact & Terms: Interested in receiving work from newer, lesser-known photographers. Work is sold in gallery, but not actively. General price range: $50-500. Reviews transparencies. Interested in framed work. Send material by mail for consideration. SASE. Reports in 1 month.

SUNPRINT CAFE & GALLERY, 638 State St., Madison WI 53703. (608)255-1555. Fax: (608)274-0304. Director: Rena Gelman. Estab. 1976.
Exhibits: Interested in all types of photography; 3-4 of 7-8 shows a year feature photography. "We get far more 'nature-photo' submissions than we could ever use. We look for a well-developed eye and a unique voice or statement." Professional quality—but not interested in slick commercially-oriented work. Style and subjects can vary. Do not submit nudes. "We are interested in non-silver, color and/or b&w work." Examples of exhibitions: works by Jim Larson, Ann Schaffer and Dickie Lee Stafford.

Making Contact & Terms: Very receptive to exhibiting the work of newer, lesser-known photographers. Charges 15% commission. General price range: $100-400. Call for more information. Framed work only. "We need 1 month to view each portfolio; expect a follow-up letter from us. Include a SASE for return of slides."
Tips: "We have a restaurant and gallery business which encourages work to be viewed in a relaxed atmosphere. Lots of natural light and track lighting. We schedule 6-week shows. Artists usually sell 0-3 pieces during show. Low-cost work sells more."

***SUNY PLATTSBURGH ART MUSEUM**, SUNY College at Plattsburgh, Plattsburgh NY 12901. (518)564-2813 or (518)564-2178. Director: Edward Brohel. Estab. 1969.
Exhibits: "Professional work only." Presents "about 2 shows per year." Shows last 7 weeks. Sponsors openings. "Generally 4 gallery spaces have openings on the same day. One general reception, or tea, is held. It varies as to which gallery hosts." Photographer's presence at opening preferred.
Making Contact & Terms: Interested in receiving work from newer, lesser-known photographers. General price range: $25-200. Reviews transparencies. Interested in framed work only. Requires exclusive representation to a degree within metropolitan area. Send material by mail for consideration or submit portfolio for review. Returns material "if requested—some are kept on file." Reporting time "varies with gallery pressures."
Tips: "Be serious, be yourself and think."

***URBAN PARK-DETROIT ART CENTER**, 508 Monroe St., Detroit MI 48226-2944. (313)963-5445. Director: Dave Roberts. Estab. 1991.
Exhibits: Requirements: Artist or designate must assist in staffing gallery 32 hours over course of exhibition. Interested in landscape, still life, figurative. Examples of recent exhibitions: works by Ray Rohr (landscape and still life, b&w and color); Michigan Friends of Photography Members Exhibit. Presents 8 shows/year. Shows last 5 weeks. Sponsors openings; provides mailed announcements, refreshments. Photographer's presence at opening preferred; presence during show required.
Making Contact & Terms: Interested in receiving work from newer, lesser-known photographers. Charges 40% commission. General price range: $150-800. Reviews transparencies. Interested in framed work only. Arrange a personal interview to show portfolio. Submit portfolio for review. Query with résumé of credits. Query with samples. SASE. Reports in 1 month.
Tips: "Photographers should present a solid body of work with resolved ideas."

VALENCIA COMMUNITY COLLEGE EAST CAMPUS GALLERIES, P.O. Box 3028, Orlando FL 32802. (407)299-5000 ext. 2298. Fax: (407)299-5000 ext. 2270. Gallery Curator: Robin Ambrose. Estab. 1982.
Exhibits: Interested in innovative, documentary, straight-forward style. Examples of previous exhibitions: "Allan Maxwell: The Manipulated Image," by Allan Maxwell (cibachrome); "Equilibrium," group exhibition including work by Rick Lang (documentary). Shows last 6-8 weeks. Sponsors openings; provides food. Photographer's presence at opening required, presence during show preferred.
Making Contact & Terms: Interested in receiving work from newer, lesser-known photographers. Does not charge commission. General price range: $175-1,500. Reviews transparencies. Interested in matted work only. Send material by mail for consideration. SASE. Reports as needed.
Tips: Photography is usually exhibited with other mediums. "Professional presentation is most helpful; display a willingness to participate in group shows." Sees a renewed interest in documentary photography, also in contemporary materials and methods.

VIRIDIAN GALLERY, 24 W. 57 St., New York NY 10019. (212)245-2882. Director: Joan Krawczyk. Estab. 1968.
Exhibits: Interested in eclectic. Member of Cooperative Gallery. Examples of recent exhibitions: works by Mark Abrahamson, Jennifer Warner, Carol Crawford and Robert Smith. Presents 1-2 shows/year. Shows last 3 weeks. Photographer's presence at opening preferred.
Making Contact & Terms: Is receptive to exhibiting work of newer photographers, but they must pass board acceptance. Charges 30% commission. General price range: $300-600. Will review transparencies only if submitted as membership application. Interested in framed or unframed, mounted, and matted or unmatted work. Request membership application details. Send materials by mail for consideration. SASE. Reports in 3 weeks.
Tips: Opportunities for photographers in galleries are "improving." Sees trend toward "a broad range of styles" being shown in galleries. "Photography is getting a large audience that is seemingly appreciative of technical and aesthetic abilities of the individual artists."

VISION GALLERY INC., 1155 Mission St., San Francisco CA 94103. (415)621-2107. Fax: (415)621-5074. President: Joseph G. Folberg. Interested in contemporary and vintage. Estab. 1980.
Exhibits: Presents 8 shows/year. Shows last 6 weeks. Sponsors openings. Photographer's presence at opening is preferred.

After showing this image at the Second Street Gallery in Charlottesville, Virginia, fine art photographer Patricia Germani of Mahopac, New York, sold one print to a private collector for $450. The image, titled "Quetzacoatal," is a hand-tinted palladium print that appeared in her Ancient Winds show at the gallery.

Making Contact & Terms: Receives 50% commission. Buys photography outright. General price range: $400 and up. Please contact the gallery to request submission guidelines. Reports within 8-10 weeks.

■**WASHINGTON PROJECT FOR THE ARTS**, 400 Seventh St., NW, Washington DC 20004. (202)347-4813. Fax: (202)347-8393. Executive Director: Donald Russell. Estab. 1975.
Exhibits: Interested in still, video, film and installation exhibitions examining contemporary issues, community involvement, emphasizing innovation and risk; with a particular interest in work which

examines the impact of cultural identity on the individual. "WPA primarily assists artists in the early stages of their careers, and gives recognition to talented mid-career artists who have been unable to gain exposure through more traditional venues." Example of recent exhibition: "Shooting Back from the Reservation," photos by Native American youth.presents 4 shows/year. Shows last 6 weeks. Sponsors openings; "Artist honoraria provided to artists participating with WPA's exhibitions. The fees can be used for travel to the opening." Photographer's presence at opening preferred.
Making Contact & Terms: Interested in receiving work from newer, lesser-known photographers. NPI. Reviews transparencies. Send material by mail for consideration. SASE. Reports in 2 months.
Tips: In samples, looks for "good slides, clearly defined concept, unusual approaches, social impact."

***SANDE WEBSTER GALLERY**, 2018 Locust St., Philadelphia PA 19103. (215)732-8850. Fax: (215)732-7850. Gallery Director: Michael Murphy.
• The gallery will review the work of emerging artists, but due to a crowded exhibition schedule, may defer in handling their work.
Exhibits: Requirements: Must be established fine artist with experience exhibiting. Interested in contemporary, fine art photography in limited editions. "We encourage the use of non-traditional materials in the pursuit of expression, but favor quality as the criterion for inclusion in exhibits." Examples of recent exhibitions: "Dust Shaped Hearts," by Don Camp (photo sensitized portraits); works by Norrine Betjenzon (hand-tinted); and Kevin Reilly (documentary landscape and automotive images). Presents 1 show/year. Shows last 1 month. Sponsors openings; covers all costs for the event. The artist is responsible for travel and accommodations. Photographer's presence at opening and during show preferred.
Making Contact & Terms: Interested in receiving work from newer, lesser-known photographers. Charges 50% commission. General price range: $200-2,000. Reviews transparencies. Interested in framed or unframed work. Send material by mail for consideration. SASE. Reports in 1 month.

WESTCHESTER GALLERY, 196 Central Ave., County Center, White Plains NY 10606. (914)684-0094. Fax: (914)684-0608. Gallery Coordinator: Lauren Platt.
Exhibits: Requirements: submit 10 slides or actual work to be juried by panel of artists. Example of exhibition: works by Tim Keating and Alan Rokach. Presents 2 photo shows/year (usually). Shows last 1 month. Sponsors openings; gallery covers cost of space, light, insurance, mailers (printing and small mailing list) and modest refreshments. Photographer's presence at opening preferred.
Making Contact & Terms: Interested in receiving work from newer, lesser-known photographers. Charges 33⅓% commission. General price range $150-5,000. Reviews transparencies. Interested in any presentable format ready to hang. Arrange a personal interview to show portfolio. Submit portfolio for review. Query with résumé of credits. Send material by mail for consideration. SASE. Reports in 1 month.
Tips: "Most sales are at low end, $150. Gallery space is flexible and artists are encouraged to do their own installation."

WHITE GALLERY-PORTLAND STATE UNIVERSITY, Box 751, Portland OR 97207. (503)725-4452. Fax: (503)725-4882. Associate Director: Teresa Tate. Estab. 1969.
Exhibits: Examples of recent exhibitions: "Invisible No More," by Orville Robertson (b&w); "In the City Streets," by Edis Lurchis (b&w); and "Collection of Opera Photographs," by Christine Sale (b&w). Presents 12 shows/year. Exhibits last 1 month. Sponsors openings. Photographer's presence at opening and during show is preferred.
Making Contact & Terms: Charges 20% commission. General price range: $175-400. Interested in framed or unframed, mounted, matted work. "We prefer matted work that is 16×20." Send material by mail for consideration. SASE. Reports in 1 month.
Tips: "Best time to submit is September-October of the year prior to the year show will be held. We only go by what we see, not the name. We see it all and refrain from the trendy. Send slides. Do something different . . . view life upside down."

WYCKOFF GALLERY, 648 Wyckoff Ave., Wyckoff NJ 07481. (201)891-7436. Director: Sherry Cosloy. Estab. 1978.
Exhibits: Requirements: prior exhibition schedule, mid-career level. Interested in all styles except depressing subject matter (e.g. AIDS, homeless). Example of exhibition: Works by Jorge Hernandez (landscapes). Presents 1 exhibit/year. Shows last 1 month. Sponsors openings; arrangements discussed with photographer. Photographer's presence at opening is required, presence during show preferred.
Making Contact & Terms: General price range: $200-2,000. Reviews transparencies. Interested in framed or unframed, mounted or unmounted, matted or unmatted work. Requires exclusive presentation locally. Query with résumé of credits. Query with samples. SASE. Reports in 1-2 weeks.
Tips: "I am predominantly a fine arts (paintings and sculptures) gallery so photography is not the prime focus. People like photography that is hand-colored and/or artistic in composition and clarity."

YESHIVA UNIVERSITY MUSEUM, 2520 Amsterdam Ave., New York NY 10033. (212)960-5390. Fax: (212)960-5406. Director: Sylvia A. Herskowitz. Estab. 1973.
Exhibits: Seeks work focusing on Jewish themes and interest. Examples of recent exhibitions: "A Photographer's Odyssey," by Leni Sonnenfeld (retrospective); "Ruminants," by David Blumenfeld (Jewish life in the former Soviet Union); "The Far Country," by Wendy Joy Kuppermann (photo essay). Presents 3-4 shows/year. Shows last 4-8 months. Sponsors openings; provides invitations and light refreshments. Photographer's presence at opening preferred.
Making Contact & Terms: Interested in receiving work from newer, lesser-known photographers. Photography sold in museum shop. NPI; commission negotiable. General price range: $100 and up. Interested in framed work. Send material by mail for consideration. Reports following meeting of exhibits committee.
Tips: "We exhibit the contemporary art and photography that is based on a Jewish theme. We look for excellent quality; individuality; and especially look for unknown artists who have not widely exhibited either in the New York area or at all. Send a slide portfolio of ten slides, an exhibition proposal, a résumé, and other pertinent information with a SASE. We conduct portfolio reviews three times a year."

Galleries/'95-'96 changes

The following markets appeared in the 1995 edition of *Photographer's Market*, but are not listed this year. The majority did not respond to our request to update their listings. If a reason was given for a market's exclusion it appears in parentheses below.

The Afterimage Photograph
 Gallery
Art Forms
Blanden Memorial Art Museum
Bridgewater/Lustberg
The Broken Diamond
Brookfield Gallery of Fine Arts
Sandy Carson Gallery
Center for Photographic Art
Concept Art Gallery
Core New Art Space
Corporate Art Source, Inc.
Evanston Art Center
Fine Arts Museum of the South
Fleisher Art Memorial, Dene M.

Louchheim Galleries
Foster Goldstrom
Fuller Lodge Art Center and
 Gallery
Galeria San Fronteras
Hughley Gallery & Objects
Intersection for the Arts
Kendall Campus Art Gallery-
 Miami-Dade Community
 College
Kirkland Art Center
La Petite Galerie (closed; may re-
 open in 1997 as Potpourri of
 Vermont)
Leedy-Voulkos Gallery

Lehigh University Art Galleries
Light Impressions Spectrum
 Gallery
Marble House Gallery
Northern Illinois University Art
 Gallery in Chicago (requested
 deletion)
The Silver Image Inc.
South Shore Art Center, Inc.
Union Square Gallery/Ernst Haas
 Viewing Room (no longer in
 business)
Vered Gallery

Paper Products

The greeting card industry is dominated by the big three—American Greetings, Gibson Greetings and Hallmark Cards. These giants consistently corner over 80 percent of the market. But if you are having trouble breaking into these three markets, don't despair. There is plenty of room for photo sales to the smaller players.

There are more than 1,000 greeting card companies in the United States which sell over 7 billion cards annually. Many of these companies produce low-priced cards that fill a niche in the market. Some, such as West Graphics in San Francisco, focus on risqué subjects, while others, like Cardmakers in Lyme, New Hampshire, prefer seasonal topics.

Many of the more than 50 listings in this section produce not only greeting cards, but calendars, posters, games and gift items. Chris Guirlinger, photo resources manager for Landmark General Corporation, says his company is always on the lookout for calendar art. Guirlinger discusses the calendar industry in his Insider Report on page 212.

Building a rapport

The important thing is to research the industry to know what is being bought and sold. After your initial research, query companies you are interested in working with and send a stock photo list. Since these companies receive large volumes of submissions, they often appreciate knowing what is available rather than actually receiving it. This kind of query can lead to future sales even if your stock inventory doesn't meet their immediate needs. Buyers know they can request additional submissions as their needs change. Some listings in this section advise sending quality samples along with your query while others specifically request only a list. As you plan your queries, follow their instructions. It will help you establish a better rapport with companies from the start.

Some larger companies have staff photographers for routine assignments, but also look for freelance images. Usually, this is in the form of stock, and images are especially desirable if they are of unusual subject matter or remote scenic areas for which assignments—even to staff shooters—would be too costly. Freelancers are usually offered assignments once they have established a track record and demonstrate a flair for certain techniques, subject matters or locations. Also, smaller companies are more receptive to working with freelancers, though they are less likely to assign work because of smaller budgets for photography.

The pay in this market can be quite lucrative if you provide the right image at the right time for a client desperately in need of it, or if you develop a working relationship with one or a few of the better paying markets. You should be aware, though, that one reason for higher rates of payment in this market is that these companies may want to buy all rights to images. With changes in the copyright law, many companies are more willing to negotiate sales which specify all rights for limited time periods or exclusive product rights rather than complete surrender of copyright.

Another key consideration is that an image with good market value is effectively taken out of the market during the selection process. Many paper product companies work on lead times of up to two years before products are ready to market. It can be

weeks, months or as much as a year before buyers contact photographers. In addition, some companies will pay only on publication or on a royalty basis after publication. For these reasons, as well as the question of rights, you may want to reconsider selling images with high multiple resale potential in this market. Certainly, you will want to pursue selling to companies which do not present serious obstacles in these ways or which offer exceptionally good compensation when they do.

Keep in mind the varying degrees of professionalism among companies. For instance, some smaller companies can be a source of headaches in a number of ways, including failing to report in a timely manner on submissions, delaying return of submissions or using images without authorization. This sometimes happens with the seemingly more established companies, too, though it's less common. Typically, many smaller companies have started as one- or two-person operations, and not all have acquired adequate knowledge of industry practices which are standard among the more established firms.

***AMERICAN ARTS & GRAPHICS, INC.**, 10915 47th Ave. W., Mukilteo WA 98275. (206)353-8200. Fax: (206)355-0491. Licensing Director: Karen Shepard. Estab. 1948. Specializes in posters. Photo guidelines free with SASE.
Needs: Works with 3-4 freelance photographers/month. Humorous, cute animals, exotic sports cars, male and female models (no nudes), some scenic. "Images that would be appealing to our 12-20-year-old poster market." Submit seasonal material 5 months in advance. Reviews stock photos. Model release required.
Making Contact & Terms: Contact by phone to request guidelines. Uses 2¼×2¼, 4×5, 8×10 transparencies. SASE. Reports in 2 weeks. Pays $500 or more/color photo. **Pays on acceptance.** Credit line given. Buys poster rights only. Simultaneous submissions and previously published work OK (if not posters).
Tips: "Subject and style must appeal to our young, teenage market. A good way to get a feel for what we do is to look at our poster rack in your area."

AMERICAN GREETINGS, 10500 American Rd., Cleveland OH 44144. Prefers not to share information.

ART RESOURCE INTERNATIONAL LTD./BON ART, Fields Lane, Brewster NY 10509. (914)277-8888. Fax: (914)277-8602. Vice President: Robin Bonnist. Estab. 1980. Specializes in posters and fine art prints. Photo guidelines free with SASE.
Needs: Buys 500 images/year. Interested in all types but does not wish to see regional. Accepts seasonal material anytime. Model release required. Captions preferred.
Making Contact & Terms: Interested in receiving work from newer, lesser-known photographers. Send unsolicited photos by mail for consideration. Submit portfolio for review. Works on assignment only. Uses 35mm, 4×5 and 8×10 transparencies. SASE. Reports in 1 month. Pays $50-250/photo. Pays on publication. Credit line given if required. Buys all rights; exclusive reproduction rights. Simultaneous submissions and previously published work OK.
Tips: Looks for "new and exciting material; subject matter with universal appeal."

AVANTI PRESS INC., 134 Spring St., Suite 602, New York NY 10012. (212)941-9000. Fax: (212)941-8008. Attention: Art Submissions. Estab. 1980. Specializes in photographic greeting cards, posters and note cards. Photo guidelines free with SASE.
Needs: Buys approximately 250 images annually; all supplied by freelancers. Offers 75 assignments annually. Interested in humorous, narrative, colorful, simple, to the point; also babies, children, animals (in humorous situations). Has specific deadlines for seasonal material. Does NOT want travel, sunsets, landscapes, nudes, high-tech. Reviews stock photos. Model/property release required. Now have an alternative, multi-occasion line, 4U. Personal, artistic, expressive, friendly, intimate, mysterious are words which describe the types of images needed for this line.
Making Contact & Terms: Interested in receiving work from newer, lesser-known photographers. Arrange personal interview to show portfolio. Query with stock photo list. Please do not submit original material. Will work with all mediums and formats. Reports quarterly. NPI. Pays on license. Credit line given. Buys 5-year worldwide, exclusive card rights.
Tips: "Know our card lines. Stretch the boundaries of creativity."

BEAUTYWAY, Box 340, Flagstaff AZ 86002. (602)526-1812. President: Kenneth Schneider. Estab. 1979. Specializes in postcards, note cards and posters.

Needs: Buys 300-400 freelance photos/year (fee pay and Joint Venture). "Joint Venture is a program within Beautyway in which the photographer invests in his own images and works more closely in overall development. Through Joint Venture, photographers may initiate new lines or subjects with Beautyway." Interested in (1) nationwide landscapes, emphasizes subjects of traveler interest and generic scenes of sea, lake and river; (2) animals, birds and sealife, with particular interest in young animals, eyes and interaction. (3) Air, water and winter sports. (4) The most important attractions and vistas of major cities, emphasizing sunset, storm, cloud and night settings. Model release required.

Making Contact & Terms: Query with samples, stock list and statement of interests or objectives. All transparency formats OK. Ship in protective sleeves with photographer name, title and location of image on frame. SASE. First report averages two weeks, others vary. Pays $45 for up to 2,400 postcards; $70 for up to 4,800 postcards; $120 for up to 9,600 postcards; $8 per 1,200 postcards thereafter. Previously published work OK if not potentially competitive.

Tips: Looks for "very sharp photos with bright colors and good contrast. Subject matter should be easily identified at first glance. We seek straightforward, basic scenic or subject shots. Obvious camera manipulation such as juxtaposing shots or unnatural filter use is almost always rejected. When submitting transparencies, the person's name, address and name and location of subject should be upon each transparency sleeve."

BLUE SKY PUBLISHING, 6395 Gunpark Dr., M, Boulder CO 80301. (303)530-4654. Fax: (303)530-4627. Art Director: Theresa Brown. Estab. 1989. Specializes in greeting cards.

Needs: Buys 24-48 images annually; all supplied by freelancers. Interested in Rocky Mountain winter landscapes, seasonal and Christmas. Submit seasonal material 1 year in advance. Reviews stock photos. Model/property release preferred.

Making Contact & Terms: Interested in receiving work from newer, lesser-known photographers. Submit portfolio for review. Query with samples. Provide résumé, business card, self-promotion piece or tearsheets to be kept on file for possible future assignments. Uses 35mm, 4×5 ("4×5 preferred") transparencies. Keeps samples on file. SASE. "We try to respond within 1 month—sometimes runs 2 months." Pays $150-250/color photo; 3-5% royalties. **Pays on acceptance.** Credit line given. Buys exclusive product rights for 5 years; negotiable. Simultaneous submissions and/or previously published work OK.

CARDMAKERS, (formerly Diebold Designs), High Bridge Rd., P.O. Box 236, Lyme NH 03768. (603)795-4422. Fax: (603)795-4222. Owner: Peter D. Diebold. Estab. 1978. Specializes in greeting cards (Christmas).

• This company expects photo cards to be a growing portion of their business.

Needs: Buys stock and assigns work. Nautical scenes which make appropriate Christmas card illustrations. Model/property release preferred.

Making Contact & Terms: Interested in receiving work from newer, lesser-known photographers. Provide self-promotion piece to be kept on file for possible future assignments. Uses color prints; 35mm, 4×5, 8×10 transparencies. Keeps samples on file. SASE. Reports in 3 weeks. Pays $100/ b&w and color photos. **Pays on acceptance.** Credit line negotiable. Buys exclusive product rights and all rights; negotiable. Simultaneous submissions and previously published work OK.

Tips: "We are seeking photos primarily for our nautical Christmas card line but would also be interested in any which might have potential for business to business Christmas greeting cards. Emphasis is on humorous situations. A combination of humor and nautical scenes is best. Please do not load us up with tons of stuff. We have yet to acquire/publish designs using photos but are very active in the market presently. The best time to approach us is during the first nine months of the year (when we can spend more time reviewing submissions)."

***CEDCO PUBLISHING CO.**, 2955 Kerner Blvd., San Rafael CA 94901. (415)457-3893. Fax: (415)457-3967. Contact: Art Dept. Estab. 1980. Specializes in calendars and picture books. Photo guidelines free with SASE.

Needs: Buys 1,500 images/year; 1,000 supplied by freelancers. Wild animals, domestic animals, America, Ireland, inspirational, beaches, islands, whales, stock general and studio stock. East Coast 4×5 photos especially needed. New ideas welcome. East Coast beaches, music, flowers. Model/property release required. Captions required.

 A bullet has been placed within some listings to introduce special comments by the editor of **Photographer's Market.**

Making Contact & Terms: Interested in receiving work from newer, lesser-known photographers. Query with non-returnable samples and a list of stock photo subjects. "Do not send any returnable material unless requested." Uses 35mm, 2¼×2¼, 4×5, 8×10 transparencies. Keeps samples on file. Reports as needed. Pays royalties on sales if whole calendar done by 1 photographer. Pays $200/b&w photo; $200/color photo; payment negotiable. Pays the December prior to the year the calendar is dated (i.e., if calendar is 1997, photographers are paid in December 1996). Credit line given. Buys one-time rights. Simultaneous submissions and previously published work OK.
Tips: No phone calls.

COMSTOCK CARDS, 600 S. Rock Blvd., #15, Reno NV 89502. Phone/fax: (702)856-9400. Production Manager: David Delacroix. Estab. 1986. Specializes in greeting cards, invitations, notepads, magnets. Photo guidelines free with SASE.
Needs: Buys/assigns 20 photos/year. Wild, outrageous and shocking adult humor only! "Do not waste our time, or yours, submitting hot men or women images." Definitely does not want to see traditional, sweet, cute, animals or scenics. "If it's appropriate to show your mother, we don't want it!" Submit seasonal material 9-10 months in advance. Model/property release required.
Making Contact & Terms: Interested in receiving work from newer, lesser-known photogaphers. Query with samples. Uses 35mm 6cm×6cm, 6cm×7cm, or 4×5 color transparencies. SASE. Reports in 3 weeks. Pays $50-150/color photo. **Pays on acceptance.** Credit line given if requested. Buys all rights; negotiable. Simultaneous submissions OK.
Tips: "Submit with SASE if you want material returned."

DeBOS PUBLISHING COMPANY, P.O. Box 36182, Canton OH 44735. Phone/fax: (216)830-0872. Operations Director: Jennifer F. Rohl. Estab. 1990. Specializes in calendars and posters. Photo guidelines free with SASE.
Needs: Buys 24 images/year. Offers 24 assignments/year. Interested in civilian and military helicopters, in operation, all seasons. "We promote public interest in the helicopter industry." Submit seasonal material 6 months in advance. Reviews stock photos. Any helicopter photo relating to historical or newsworthy events. Model/property release required (owner of the helicopter, property release; pilot of aircraft, model release). Captions preferred; include name and address of operation and pilot; date and location of photograph(s) are recommended. DeBos Publishing Company will supply all releases.
Making Contact & Terms: Interested in receiving work from newer, lesser-known photographers. Provide résumé, business card, self-promotion piece or tearsheets to be kept on file for possible future assignments. Works with freelancers on assignment only. Uses color prints; 35mm 2¼×2¼ and 4×5 transparencies. Keeps samples on file. SASE. Reports in 3 weeks. Pays $35-150/color photo. Pays when proper releases returned. Credit line given. Buys all rights; negotiable.
Tips: "Every company in the market for photography has its own view on what photographs should look like. Their staff photographers have their favorite lens, angle and style. The freelance photographer is their answer to a fresh look at the subject. Shoot the subject in your best point-of-view, and shoot it in a different way, a way people are not used to seeing. Everyone owns a camera, but the one who puts it to use is the one who generates the income. Quantity of money made should not take priority at first, but the quality and amount of work published should be your goal. If your work is good, your client will call on you time and again. Due to today's economy, companies like ours are keeping fewer photographers on staff. *Photographer's Market* allows us to successfully do so, using freelance photographers for our work. This also gives experience and income to photographers who like to work independently and on numerous subjects. This is an essential tool to both employer and employee."

DESIGN DESIGN, INC., P.O. Box 2266, Grand Rapids MI 49501. (616)774-2448. Fax: (616)774-4020. Creative Director: Tom Vituj. Estab. 1986. Specializes in greeting cards, gift wrap, T-shirts, gift bags and invitations.
Needs: Buy stock images from freelancers and assigns work. Specializes in humorous, seasonal and traditional topics. Submit seasonal material one year in advance. Model/property release required.
Making Contact & Terms: Submit portfolio for review. Provide résumé, business card, self-promotion piece or tearsheets to be kept on file for possible future assignments. Uses color prints. Samples kept on file. SASE. Reports in 3 weeks. NPI. Pays royalties. Pays upon sales. Credit line given. Buys exclusive product rights; negotiable.

***ENGLISH CARDS LTD.**, 40 Cutter Mill Rd., Great Neck NY 11021. (510)487-7370. Fax: (510)487-1253. Contact: Douglas Evans. Estab. 1966. Specializes in greeting cards, postcards, stationery.
Needs: Buys over 100 images annually. Interested in humorous, cute animals, nature, seasonal, social point of view (with superior taste), family. Submit seasonal material 6 months in advance. Does not want insulting, rude, X-rated or demeaning black humor. Reviews stock photos. Model/property release required. Captions preferred.
Making Contact & Terms: Interested in receiving work from newer, lesser-known photographers. Mail in photos and résumé. Works with local freelancers only. Uses any size color and b&w prints.

SASE. Reports in 2 weeks. NPI. **Pays on acceptance**. Credit line not given. Buys all rights; negotiable. Simultaneous submissions OK.

***EPCONCEPTS**, P.O. Box 363, Piermont NY 10968. President: Steve Epstein. Estab. 1983. Specializes in greeting cards, calendars, postcards, posters, stationery, gift wrap, prints.
Needs: Buys 20-30 photos/year. Children 2-5 years old and only 1-2 children in each picture. Child's face must be showing and in sharp focus. Child must be looking into the camera and engaged in childhood activity such as playing with a pet or collecting shells on a beach. Child must not be playing with man-made toys. No religious. Submit seasonal material 3-6 months in advance. Reviews stock photos. Model release required. Captions required.
Making Contact & Terms: Interested in receiving work from newer, lesser-known photographers. Query with samples. Send unsolicited photos by mail for consideration. Uses any size glossy or matte b&w or color prints; 35mm, 2¼×2¼ and 4×5 transparencies; b&w or color contact sheets; b&w or color negatives. SASE. Reports in 2 weeks. Pays $50/b&w or color photo. **Pays on acceptance.** Buys one-time rights; negotiable. Previously published work OK.
Tips: Absolute must to include SASE or samples will not be returned.

FERN-WOOD DESIGNS AND PHOTO MARKETING AGENCY (a division of Fern-Wood Enterprises, Inc.), P.O. Box 948, Wrightsville Beach NC 28480. (910)256-2897. Fax: (910)256-3299. President/Treasurer: Carol G. Wood. Vice President/Secretary: Angus L. McLean Jr. Estab. 1990. Specializes in all occasion cards, calendars, postcards, gift wrap, playing cards and advertising.
Needs: Buys stock and assigns work. Buys 50-75 photos/year. Represents photographers worldwide. Variety especially. Beach areas, humorous and "the true-to-life with a uniqueness about it." Prefers natural settings to staged sets. Submit seasonal material 6-12 months in advance. Reviews stock photos. Model/property releases required for photos of full face, recognizable people and personal property. Caption sheet required including location and file number.
Making Contact & Terms: Interested in receiving work from newer, lesser-known photographers. Query with samples. Send stock photo list. Provide résumé, business card, self-promotion piece or tearsheets to be kept on file for possible future assignments. Uses 5×7 glossy color prints; 35mm, 2¼×2¼ and 4×5 transparencies. Keeps samples on file. Guidelines available with SASE. Reports in 3 weeks. Pays $100-250/job; $50-100/color photo. Pays upon usage. Credit line given when possible. Buys one-time and other negotiated rights. Simultaneous submissions OK.

FLASHCARDS, INC., 1136 N. Flagler Dr., Fort Lauderdale FL 33304. (305)467-1141. Photo Researcher: Micklos Huggins. Estab. 1980. Specializes in postcards, greeting cards, notecards and posters.
Needs: Buys 500 images/year. Humorous, human interest, animals in humorous situations, nostalgic looks, male nudes, Christmas material, valentines, children in interesting and humorous situations. No traditional postcard material; no florals or scenic. "If the photo needs explaining, it's probably not for us." Submit seasonal material 8 months in advance. Reviews stock photos. Model release required.
Making Contact & Terms: Interested in receiving work from newer, lesser-known photographers. Query with sample. Send photos by mail for consideration. Provide résumé, business card, brochure, flier or tearsheets to be kept on file for possible future assignments. Uses any size color or b&w prints, transparencies and color or b&w contact sheets. SASE. Reports in 5 weeks. Pays $100 for exclusive product rights. Pays on publication. Credit line given. Buys exclusive product rights. Simultaneous and previously published submissions OK.

***FLAVIA STUDIOS**, 740 State St., 3rd Floor, Santa Barbara CA 93101. (805)564-6905. Fax: (805)966-9175. Production Manager: Sharon Beckett. Estab. 1986. Specializes in greeting cards, calendars, stationery.
Needs: Buys 300 images annually; 50% supplied by freelancers. Offers 10 assignments annually. Interested in nature, seasonal, still life, inspirational, occasion-oriented (wedding, baby, etc.), floral, children. Submit seasonal material 18 months in advance. Reviews stock photos. Model/property release preferred for children.
Making Contact & Terms: Interested in receiving work from newer, lesser-known photographers. Query with samples. Works with local freelancers on assignment only. Uses 2¼×2¼ transparencies. Keeps samples on file. SASE. Reports back in 1 month. Pays royalties on sales. Pays on usage. Credit line given. Buys exclusive product rights; negotiable. Considers previously published work (with sales data).
Tips: Wants to see multiple images that form a theme for general usage.

***GIBSON GREETINGS**, 2100 Section Rd., Cincinnati OH 45222. Senior Art Director: Jennifer Clark. Specializes in greeting cards, calendars, stationery, gift wrap, wall decor.
Needs: Buys 150-200 images annually; all supplied by freelancers. Interested in "everything." Model/property release preferred for "cheesecake," any property that is recognizable. Captions preferred.

Making Contact & Terms: Provide résumé, business card, self-promotion piece or tearsheets to be kept on file for possible future assignments. Not accepting any unsolicited material. 35mm, 2¼×2¼, 4×5, 8×10 transparencies. Keeps samples on file. SASE. Reports in 1 year. NPI.

GLITTERWRAP, INC., 701 Ford Rd., Rockaway NJ 07866. (201)625-4200. Fax: (201)625-9641. Art Director: Danielle Grassi. Estab. 1987. Specializes in gift wrap, tote bags and accessories.
Needs: Buys 30-50 images annually for product design; 80-90% supplied by freelancers. Offers 2 assignments annually. Selection periods are January-March and May-June. Product design shots supplied by freelancers. Offers 2-3 catalog assignments, 2-4 flysheets annually. Interested in seasonal material; currently purchases only product photography; interested in expanding line to include photo subjects (i.e., wedding/Valentine's/Christmas/baby shower). Submit seasonal material 1 year in advance. Does not want to see fashion, landscape, nudes, architectural or industrial shots. Reviews stock photos. Model/property release required.
Making Contact & Terms: Interested in receiving work from newer, lesser-known photographers. Query with samples. Provide résumé, business card, self-promotion piece or tearsheets to be kept on file for possible future assignments. Works on assignment only. Uses 2¼×2¼, 4×5, 8×10 transparencies. Keeps samples on file. SASE. Reports in 3 weeks. Requires estimates based on job for product fliers; and pays $200-500 for product designs. Pays upon usage for totes and wraps; within 30 days for catalog and flysheet work. Credit line given "if used on totes or wrap." Buys all rights; negotiable. Simultaneous submissions and/or previously published work OK.
Tips: "Our product is occasion specific. The best selling area of our line is birthday with baby following as a close second. Valentines and weddings are additional areas where we've had success with photographic images. We're looking for images that evoke an emotional response, tug on the heartstrings. Black and white, sepia, color and slightly handcolored are all considered. In the past few years, we've seen an increase in the use of b&w hand-tinted images on products, not just paper products. Expect growth in this area to continue for at least another one or two years."

***GREETINGS FROM NATURE**™, 2824 International Circle, Colorado Springs CO 80910. (719)475-7100. Fax: (719)475-7107. Art Director: Marco A. Hernandez. Estab. 1989. Specializes in greeting cards, stationery. Photo guidelines free with SASE.
Needs: Buys 300 images annually; all supplied by freelancers. Interested in nature, wildlife and landscape; Christmas and holiday nature shots; nature conservancy preserves. Submit seasonal material 10 months in advance. Does not want to see signs of "man" in nature photos, no b&w. Reviews stock photos of nature, wildlife and landscapes. Captions required. For animals include type and location of habitat and endangered status for landscapes; include location (park, state, country, etc.)
Making Contact & Terms: Query with samples. Provide résumé, business card, self-promotion piece or tearsheets to be kept on file for possible future assignments. Uses 35mm, 2¼×2¼, 4×5, 8×10 transparencies. Keeps samples on file. SASE. Reports in 3 weeks. Pays publication fee and royalties. Pays on usage. Credit line given. Buys exclusive product rights; will negotiate. Simultaneous submissions and previously published work OK.
Tips: "For greeting cards images must evoke an emotion. People buy and send greeting cards to express emotions and communicate feelings. Strong, central images and bright colors catch the consumer's eye the best."

HALLMARK CARDS, INC., 2501 McGee, Drop #152, Kansas City MO 64108. Not accepting freelance submissions at this time.

HEALTHY PLANET PRODUCTS INC., (formerly Carolyn Bean Publishing, Ltd.), 1129 N. McDowell Blvd., Petaluma CA 94954. (707)778-2280. Fax: (707)778-7518. President/Creative Director: Bruce Wilson. Specializes in greeting cards, stationery, and some gift products such as magnets and journals.
Needs: "We have expanded several of our Healthy Planet Products lines. Our Sierra Club line of wildlife and wilderness cards has been a great success and we continue to look for more shots to expand this line. Wildlife in pairs, interacting in a nonthreatening manner are popular, as well as dramatic shots of man in nature. Non-West Coast shots are always in demand, as well as shots that could be used in our boxed Christmas line. Vertical format is preferred but some horizontals will be selected. Our underwater line, Sea Dreams, is comprised of only horizontal shots. Vibrant colors are a real plus. Sea mammals are very popular. Our Humane Society line includes b&w photos only, and features people with animals. The special bond between animal and people is the line focus; emotion is the key. Both vintage and contemporary are accepted." Submit seasonal material 1 year in advance; all-year-round review "include return postage." Publishes Christmas series December; everyday series January and May. Reviews stock photos. Model release required.
Making Contact & Terms: Submit by mail. Provide business card and tearsheets to be kept on file for possible future assignments. "Due to insurance requirements, we cannot accept responsibility for original transparencies so we encourage you to submit dupes. Should we select a shot from your original submission for further review, we will at that time request the original and accept responsibility

for that original up to $1,500 per transparency." Uses 35 mm, 2¼×2¼, 4×5 transparencies. SASE. Reports in 4-6 weeks. Simultaneous submissions and previously published work OK. Pays $300 for 5-year, worldwide greeting card rights, separate fees for other rights. "We do not pay research fees." Credit line given. Buys exclusive product rights.

Tips: "Please hold submissions for our Healthy Planet Products line to your best 100-120 shots. A portion of the proceeds from the sales of our lines goes to the Sierra Club and/or other environmentally conscious organizations."

IMAGE CONNECTION AMERICA, INC., 32 S. Lansdowne Ave., Lansdowne PA 19050. (215)626-7770. President: Michael Markowicz. Estab. 1988. Specializes in postcards and posters.
Needs: Contemporary. Model release required. Captions preferred.
Making Contact & Terms: Query with samples. Send unsolicited photos by mail for consideration. Uses 8×10 b&w prints and 35mm transparencies. SASE. NPI. Pays quarterly or monthly on sales. Credit line given. Rights purchased vary, but usually exclusive.

***IMPACT**, 4961 Windplay Dr., El Dorado Hills CA 95762. (916)939-9333. Fax: (916)939-9334. Estab. 1975. Specializes in calendars, bookmarks, magnets, postcard packets, postcards, posters and books for the tourist industry. Photo guidelines and fee schedule free with SASE.
• This company sells to specific tourist destinations; their products are not sold nationally. They need material that will be sold for at least a 6-8 year period.
Needs: Buys stock and assigns work. Buys 3,000 photos/year. Offers 10-15 assignments/year. Wildlife, scenics, US travel destinations, national parks, theme parks and animals. Submit seasonal material 4-5 months in advance. Model/property release required. Captions preferred.
Making Contact & Terms: Query with samples. Query with stock photo list. Provide résumé, business card, self-promotion piece or tearsheets to be kept on file for possible future assignments. Uses 35mm, 2¼×2¼, 4×5, 8×10 transparencies. Keeps samples on file. SASE. Reports in 1 month. NPI; request fee schedule; rates vary by size. Pays on usage. Credit line and printed samples of work given. Buys one-time and exclusive product rights; negotiable. Simultaneous submissions and previously published work OK.

INTERCONTINENTAL GREETINGS, 176 Madison Ave., New York NY 10016. (212)683-5830. Fax: (212)779-8564. Art Director: Robin Lipner. Estab. 1967. Specializes in greeting cards, calendars, post cards, posters, framing prints, stationery, gift wrap and playing cards. Photo guidelines free with SASE.
Needs: Buys 20-50 photos/year. Graphics, sports, occasions (i.e. baby, birthday, wedding), "soft-touch" romantic themes, graphic studio photography. No nature, landscape or cute children. Accepts seasonal material any time. Model release preferred.
Making Contact & Terms: Interested in receiving work from newer, lesser-known photogaphers. Query with samples. Send unsolicited photos by mail for consideration. Submit portfolio for review. Provide résumé, business card, brochure, flier or tearsheets to be kept on file for possible future assignments. Works with freelancers only. Uses glossy color prints; 35mm, 2¼×2¼, 4×5 and 8×10 transparencies. SASE. Reports in 3 weeks. Pays 20% royalties on sales. Pays on publication. No credit line given. Buys one-time rights and exclusive product rights. Simultaneous submissions and previously published work OK.
Tips: In photographer's portfolio samples, wants to see "a neat presentation, perhaps thematic in arrangement." The trend is toward "modern, graphic studio photography."

JII SALES PROMOTION ASSOCIATES, INC., 545 Walnut St., Coshocton OH 43812. (614)622-4422. Photo Editor: Walt Andrews. Estab. 1940. Specializes in advertising, calendars and greetings. Photo guidelines free with SASE.
Needs: Buys 200 photos/year. Interested in traditional scenics, mood/inspirational scenics, human interest, special interest (contemporary homes [summer and winter], sailboats, hot air balloons), animals, plants. Reviews stock photos. Model release required. Captions with location information only required.
Making Contact & Terms: Query with stock photo list. Send unsolicited photos by mail for consideration. Uses 4×5, 8×10 transparencies. SASE. Reports in 2 weeks. NPI; pays by the job. **Pays on acceptance.** Buys all time advertising, calendar, greeting and direct mail rights, exclusive product rights, some special 1 year rights.
Tips: "Our calendar selections are nearly all horizontal compositions. Greeting photos may be either horizontal or vertical."

ARTHUR A. KAPLAN CO., INC., 460 W. 34th St., New York NY 10001. (212)947-8989. Art Director: Elizabeth Tuckman. Estab. 1956. Specializes in posters, wall decor and fine prints and posters for framing.

Needs: Buys 50-100 freelance photos/year. Flowers, scenics, animals, ballet, still life, Oriental motif, musical instruments, Americana, hand-colored and *unique* imagery. Reviews stock photos. Model release required.

Making Contact & Terms: Send unsolicited photos or transparencies by mail for consideration. Uses any size color prints; 35mm, 2¼×2¼, 4×5 and 8×10 transparencies. Reports in 1-2 weeks. Royalty 5-10% on sales. Offers advances. Pays on publication. Buys exclusive product rights. Simultaneous submissions OK.

Tips: "Our needs constantly change, so we need diversity of imagery. We are especially interested in images with international appeal."

***KOGLE CARDS, INC.**, 1498 S. Lipan St., Denver CO 80223. (303)698-9007. Fax: (303)698-9242. President: Patricia Koller. Send submissions Attn: Photo Director. Estab. 1982. Specializes in greeting cards and postcards for all business occasions.

Needs: Buys about 300 photos/year. Thanksgiving, Christmas and other holidays, also humorous. Submit seasonal material 9 months in advance. Reviews stock photos. Model release required.

Making Contact & Terms: Query with samples. Will work with color only. SASE. Reports in 4 weeks. NPI; works under royalty with no advance. "The photographer makes more that way." Monthly royalty check. Buys all rights; negotiable.

LANDMARK CALENDARS, 51 Digital Dr., P.O. Box 6105, Novato CA 94948-6105. (415)883-1600. Fax: (415)883-6725. Contact: Photo Editor. Estab. 1979. Specializes in calendars. Photo guidelines free with SASE.

● Images for this market must be super quality. In the next two years Landmark plans to implement digital pre-press of images and line art. They encourage freelancers to submit images on CD.

Needs: Buys/assigns 3,000 photos/year. Interested in scenic, nature, travel, sports, automobiles, collectibles, animals, food, people, miscellaneous. No nudes. "We accept *solicited* submissions only, from November through February two years prior to the calendar product year. Photos must be accompanied by our submission agreement, and be sent only within the terms of our guidelines." Reviews stock photos. Model/property release required especially when shooting models and photos containing trademarked property or logos. Captions required; include specific breed of animal, if any; specific location of scene (i.e. gray wolf, Kalispell, Montana).

Making Contact & Terms: Unsolicited submissions are not accepted. Send list of published credits and/or non-returnable samples. Will send guidelines if work fits our needs. Uses transparencies from 35mm to 8×10. Pays $50-200/photo depending on product. Pays in April of year preceding product year (i.e. would pay in April 1996 for 1997 product). Credit line given. Buys one-time and exclusive product rights, plus rights to use photo in sales material and catalogs. Previously published work OK.

Tips: Looks for "tack-sharp focus, good use of color, interesting compositions, correct exposures. Most of our calendars are square or horizontal, so work should allow cropping to these formats. For 35mm slides, film speeds higher than ASA 100 are generally unacceptable due to the size of the final image (up to 12×12)."

LIMITED EDITION PUBLISHING, P.O. Box 5667, Sherman Oaks CA 91413. (310)546-6359. Owner: A. Costello. Estab. 1988. Specializes in calendars, posters, playing cards and keyrings.

Needs: Buys 200 images annually; all supplied by freelancers. Offers 6 freelance assignments annually. Interested in male and female shots, including body shots, swimsuits, lingerie, semi-nude and totally nude (mostly summer or tropical themes). Submit seasonal material throughout the year. Reviews stock photos. Model release required. Captions required, include name and age of model. Models must be over 18 years old.

Making Contact & Terms: Interested in receiving work from newer, lesser-known photographers. Query with samples. Must send sample photos to be returned. Works with local freelancers on assignment only. Uses color prints; 4×5 transparencies and ½" videotape. Keeps samples on file. SASE. Reports in 1 month. Pays $20-50/hour; $500-1,000/day; $5-50/color photo. **Pays on acceptance.** Credit line sometimes given depending on medium. Buys exclusive product rights; negotiable. Previously published work OK.

LOVE GREETING CARDS, INC., 1717 Opa Locka Blvd., Opa Locka FL 33054. (305)685-LOVE. Vice President: Norman Drittel. Specializes in greeting cards, postcards and posters.

Needs: Buys 75-100 photos/year. Nature, flowers, boy/girl (contemporary looks). Submit seasonal material 6 months in advance. Reviews stock photos. Model release preferred.

Making Contact & Terms: Query with samples or stock photo list. Send unsolicited photos by mail for consideration. Provide résumé, business card, brochure, flier or tearsheets to be kept on file for possible future assignments. Uses 5×7 or 8×10 color prints; 35mm, 2¼×2¼ and 4×5 transparencies; color contact sheets, color negatives. SASE. Reports in 1 month. Pays $75-150/color photo. Pays on publication. Credit line given. Buys exclusive product rights. Previously published work OK.

Will Your Photographs "Stop the Rack?"

Chris Guirlinger chuckles when describing some of the wilder submissions he has received. Take the time a photographer sent images of women's legs dressed in shoes of famous movie actresses of the 1940s. The photos were artfully done, but Guirlinger passed on the bizarre concept. "That one was pretty different," he says.

As photo resources manager for Landmark General Corporation, Guirlinger receives more than 1,000 submissions between January and March. His company is the largest calendar producer in the country, both in sales and calendar titles, he says.

"The first thing I look at is the subject matter. Is it appropriate for the gift industry?" And just what kind of buying public is out there? Guirlinger

Chris Guirlinger

says most purchasers of calendars are women between the ages of 18 and 45. And most calendars are bought as gifts, such as Christmas stocking stuffers or birthday presents.

He adds that a photo editor's decision to buy a photo rests on several key factors. "Will it appeal to the highest number of people? Will it make a successful cover? Will it make shoppers stop the rack from spinning at the store?"

For a photographer, meeting these demands requires superb images, both in technical quality and subject matter. Guirlinger advises shooters to use films that provide great color saturation. Two of his favorites are Kodak Lumiere and Fuji Velvia. He also suggests photographers not surpass 100 ASA film speed, in order to provide the best image quality possible when large reproductions are needed. However, he understands that some subjects, such as wildlife and sports, require faster films.

"I think photographers really need to know who they're going to market their images to. For calendar and poster companies, you need slower film with better color saturation. On the other hand, greeting cards are smaller and the format tends to be more forgiving (with poorer image quality)."

When submitting material to a calendar company, photographers also should realize that purchased images may not reach retail outlets for two years. Guirlinger says this is important for stock photographers who want to simultaneously submit great slides to other potential buyers. He suggests shooting in-camera duplicates of subjects to combat the problem of having all your images in the hands of editors who won't return them for several months.

As for subject matter, Guirlinger is open to most ideas. His staff normally

creates a laundry list of calendar topics and then images are acquired from freelancers to fill the calendars. He also hires freelancers for plum assignments, such as photo shoots of top models like Claudia Schiffer, Rachel Hunter and Pamela Anderson.

However, calendar ideas can come from submissions. "Some of these stock calendars we do, we didn't come up with the ideas. We saw trends in the stock photography that's out there and decided that certain subjects would make good calendars," he says. "We also get proposals all the time. Photographers see us being interviewed on TV and they think, 'Hey, I've got something that will work for them.' "

—*Michael Willins*

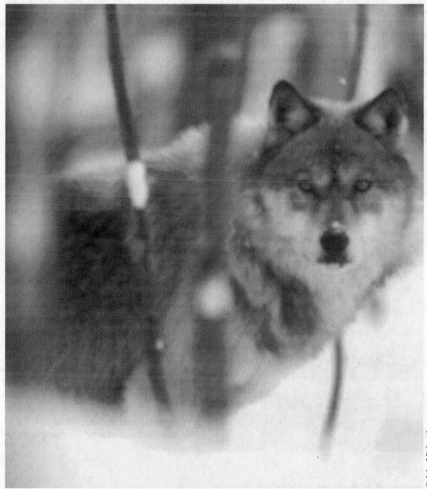

© John Mielcarek

Photographer John Mielcarek of Washington, Michigan, used Photographer's Market to query Landmark General Corporation for guidelines to see what kinds of images the calendar producer wanted from freelancers. Chris Guirlinger, photo resources manager for Landmark, liked Mielcarek's shot of a gray wolf because it portrays the mystery and power of wolves. The image was used on the cover of the 1995 Wolves calendar.

Tips: "We are looking for outstanding photos for greeting cards and new age posters." There is a "larger use of photos in posters for commercial sale."

MARCEL SCHURMAN COMPANY, 2500 N. Watney Way, Fairfield CA 94533. (800)333-6724. Fax: (707)428-0641. Art Director: Christienne de Tournay. Estab. 1950. Specializes in greeting cards, stationery, gift wrap. Guidelines free with SASE; contact: Cathy Van Vessum.
Needs: Buys 75 images annually; all supplied by freelancers. Offers 50 assignments annually. Interested in humorous, seasonal, art/contemporary, some nature, still life. Submit seasonal material 1 year in advance. Does not want technical, medical, or industrial shots. Model/property release required. Captions preferred.
Making Contact & Terms: Interested in receiving work of newer, lesser-known photographers. Submit portfolio for review. Query with samples. Provide résumé, business card, self-promotion piece or tearsheets to be kept on file for possible future assignments. Works with local freelancers only. Uses 8×10, 11×14 matte b&w prints; 35mm, 2¼×2¼, 4×5 transparencies. Keeps samples on file. SASE. Reports in 6 weeks. Pays $300-500/job; $300-500/color photo; $300-500/b&w photo; royalties on sales in some cases. **Pays on acceptance.** Credit line given. Buys 3-5 year worldwide exclusive rights to greeting cards/gift wraps. Simultaneous submissions OK.
Tips: "In terms of greeting cards, I advise any interested artists to familiarize themselves with the company's line by visiting a retailer. It is the fastest and most effective way to know what kind of work the company is willing to purchase or commission. Photography, in all forms, is very marketable now, specifically in different areas of technique, such as hand-colored, sepia/etc. toning, Polaroid transfer, b&w art photography."

This shot is proof that it pays to research. Photographer Daryl Solomon says she approached Marcel Schurman Company after seeing the company's greeting cards in a store. The photo was chosen from a group submission. Christienne de Tournay, art director, liked the image because of its composition and color.

© 1990 Daryl Solomon

***NORTHERN EXPOSURE GREETING CARDS,** 461 Sebastopol Ave., Santa Rosa CA 95401. (707)546-2153. Fax: (707)546-0875. Art Directors: Jack Freed or Bruce Henson. Estab. 1990. Specializes in greeting cards. "Our subjects include children, animals and beautiful florals. We touch upon all types of emotions, from lighthearted to humorous."
Needs: Buys 40-80 images annually; 50 supplied by freelancers. Submit seasonal material 1 year in advance.
Making Contact & Terms: Submit portfolio for review. Query with samples. Uses any size transparencies. Dupes only. Keeps samples on file. Reports in 3 weeks. Pays 6% royalty or buyout. Rights negotiable.

© Veronica Anderton (photographer). © 1993 Northern Exposure Greeting Cards

Talk about bad hair days. Used as a greeting card, this shot has become the top seller for Northern Exposure Greeting Cards. Bruce Henson, of Northern Exposure, says the image was definitely different from all the other cat photos he has received. The image was taken by photographer Veronica Anderton of Peoria, Illinois.

PALM PRESS, INC., 1442A Walnut St., Berkeley CA 94709. (510)486-0502. Assistant Photo Editor: Theresa McCormick. Estab. 1980. Specializes in greeting cards.
Needs: Buys stock images from freelancers. Buys 200 photos/year. Wildlife, humor, nostalgia, unusual and interesting b&w and color, Christmas and Valentine. Does not want abstracts or portraits. Submit seasonal material 1 year in advance. Model/property release required. Captions required.
● Palm Press has received Louie Awards from the Greeting Card Association.
Making Contact & Terms: Query with résumé of credits. Query with samples. Uses b&w and color prints; 35mm transparencies. SASE. Reports in 2-3 weeks. NPI; pays royalty on sales. Credit line given. Buys one-time and exclusive worldwide product rights; negotiable.
Tips: Sees trend in increased use of "occasion" photos.

***PHOTOFILE**, P.O. Box 8138, Springfield MO 65801. Estab. 1994. Specializes in greeting cards, postcards, posters, calendars and photo art. Photo guidelines free with SASE.
Needs: Buys 100 photos/year. Interested in photos of sexy women in swimwear, sportswear, fashion, glamour, lingerie, boudoir, sensuous nude and semi-nude (no porn). Also needs hot car and motorcycle shots that include models; modern military jets, big game animals. Model/property release required.
Making Contact & Terms: Interested in receiving work from newer, lesser-known photographers. Query with samples. Send unsolicited material by mail for consideration. Send duplicate slides or prints. Do not send originals. Uses glossy b&w, color prints; 35mm, 2¼×2¼, 4×5 transparencies. SASE. Reports in 1 month. NPI; payment negotiable. **Pays on acceptance**. Rights negotiable. Simultaneous submissions and previously published work OK.
Tips: "Send as few or as many samples as you wish, but send only good quality material."

Photographer Pete Stone of Seattle, Washington, says this image was first used in an ad for Columbia Sportswear before Palm Press Inc. picked it up as a greeting card. Actually the model, Gert Boyle, is Columbia's CEO. Teresa McCormick, assistant photo editor for Palm Press, says two different greeting cards were made with this image because it was so strong.

© 1994 Pete Stone

PORTAL PUBLICATIONS LTD., Dept. PM, 770 Tamalpais Dr., Suite 400, Corte Madera CA 94925. (415)924-5652. Fax: (415)924-7439. Submissions to: Art Department. Estab. 1954. Specializes in greeting cards, calendars, posters, wall decor, framing prints, gift bags, apparel and note cards. Photo guidelines free with SASE.
Needs: Gives up to 400 or more assignments annually. Contemporary photography (florals, landscapes, b&w and hand-tinted b&w). Nostalgia, nature and wildlife, endangered species, humorous, animal photography, scenic, inspirational, tinted b&w children's photography, still life, garden themes and dance. Sports, travel, food and youth-oriented popular icons such as celebrities, movie posters and cars. Nothing too risqué. Reviews stock photos. Model release required; captions preferred.
Making Contact & Terms: Query with samples. Submit portfolio for review. "Please limit submission to a maximum of 40 images showing the range and variety of work. All slides and transparencies should be clearly labeled and marked." Uses 35mm, 2¼×2¼, 4×5 and 8×10 transparencies. No originals; dupes only. SASE. Reports in 3 months. NPI. Payment determined by the product format. Pays on acceptance or publication. Credit line given. Buys one-time and exclusive product rights. Simultaneous submissions and previously published work OK.
Tips: "Ours is an increasingly competitive business, so we look for the highest quality and most unique imagery that will appeal to our diverse market of customers."

***PREFERRED STOCK, INC.**, 6667 W. Old Shakopee Rd., Suite 112, Bloomington MN 55438. (612)947-9319. Fax: (612)947-9322. Art/Production Director: Kevin Hughes. Estab. 1984. Specializes in gift wrap and gift totes.
Needs: Buys 4-5 images annually; 100% supplied by freelancers. Interested in floral, still life images for seasonal use—very few human and animal images. Does not want to see nudes. Reviews stock photos of still life and natural images. Property release required.
Making Contact & Terms: Interested in receiving work from newer, lesser-known photographers. Query with samples. Provide résumé, business card, self-promotion piece or tearsheets to be kept on file for possible future assignments. Works with local freelancers only. Uses 4×5 transparencies. Does not keep samples on file. SASE. Reports in 1 month. Pays $100-250/color photo. Pays on usage. Buys exclusive product rights; negotiable.
Tips: "Image must create immediate response. We are not interested in 'art' pieces that require thought."

PRODUCT CENTRE-S.W. INC., THE TEXAS POSTCARD CO., P.O. Box 860708, Plano TX 75086. (214)423-0411. Art Director: Susan Hudson. Estab. 1980. Specializes in postcards.
Needs: Buys approximately 100 freelance photos/year. Texas, Oklahoma, Louisiana, Arkansas, Kansas, Missouri, New Mexico and Mississippi towns/scenics; regional (Southwest only) scenics, humor-

ous, inspirational, nature (including animals), staged studio shots—model and/or products. No nudity. Submit seasonal material 1 year in advance. Model release required.
Making Contact & Terms: Interested in receiving work from newer, lesser-known photographers. Send insured samples with return postage/insurance. Include Social Security number and telephone number. Uses "C" print 8×10; 35mm, 2¼×2¼, 4×5 transparencies. SASE. No material returned without postage. Reports in usually 3-4 months, depending on season. Pays $50-100/photo. Pays on publication. Buys all rights.
Tips: "Submit slides only for viewing. Must be in plastic slide sleeves and each labeled with photographer's name and address. Include descriptive material detailing where and when photo was taken. Follow the guidelines—nine out of ten submissions rejected are rejected due to noncompliance with submission guidelines."

RECYCLED PAPER GREETINGS, INC., Art Dept., 3636 N. Broadway, Chicago IL 60613. (312)348-6410. Art Director: Melinda Gordon. Specializes in greeting cards and postcards.
Needs: Buys 30-50 photos/year. "Primarily humorous photos for postcards and greeting cards. Photos must have wit and a definite point of view. Unlikely subjects and offbeat themes have the best chance, but will consider all types." Model release required.
Making Contact & Terms: Send for artists' guidelines. Uses 4×5 b&w and color prints; b&w or color contact sheets. Please do not submit slides. SASE. Reports in 1 month. Pays $250/b&w or color photo. **Pays on acceptance.** Credit line given. Buys all rights; negotiable. Simultaneous submissions OK.
Tips: Prefers to see "up to ten samples of photographer's best work. Cards are printed 5×7 vertical format. Please include messages. The key word for submissions is wit."

ROCKSHOTS, INC., 632 Broadway, New York NY 10012. Fax: (212)353-8756. Art Director: Bob Vesce. Estab. 1978. Specializes in greeting cards.
 • Bob Vesce says Rockshots is buying more freelance photography because of a desire for different points of view. In the past the majority of photos were created inhouse.
Needs: Buys 20-50 photos/year. Sexy (including nudes and semi-nudes), outrageous, satirical, ironic, humorous photos. Submit seasonal material at least 6 months in advance. Model release required.
Making Contact & Terms: Interested in receiving work from newer, lesser-known photographers. Send SASE requesting photo guidelines. Provide flier and tearsheets to be kept on file for possible future assignments. Uses b&w and color prints; 35mm, 2¼×2¼ and 4×5 slides. "Do not send originals!" SASE. Reports in 8-10 weeks. Pays $50-125/b&w, $125-300/color photo; other payment negotiable. **Pays on acceptance.** Rights negotiable. Simultaneous submissions and previously published work OK.
Tips: Prefers to see "greeting card themes, especially birthday, Christmas, Valentine's Day. Remember, nudes and semi-nudes are fantasies. Models should definitely be better built than average folk. Also, have fun with nudity, take it out of the normal boundaries. It's much easier to write a gag line for an image that has a theme and/or props. We like to look at life with a very zany slant, not holding back because of society's imposed standards."

***‡SANTORO GRAPHICS**, 63 Maltings Place, London SW6 2B4 United Kingdom. (171)610-6166. Fax: (171)371-9712. Contact: Art Department. Estab. 1987. Specializes in greeting cards, postcards, posters, stationery and gift wrap.
Needs: Buys 200 images annually; most supplied by freelancers. Interested in humorous, arty, children. Does not want nudes. Reviews stock photos. Model release required. Captions preferred.
Making Contact & Terms: Query with samples. Uses up to 8×10 color and b&w prints; 35mm 2¼×2¼, 4×5. SASE. Reports every 2 months. Pays $150-250/color photo; $150-250/b&w photo. Pays on usage. Credit line depends on product and suitability. Buys exclusive product rights and rights to use photos in sales literature; negotiable. Simultaneous submissions and previously published work OK.
Tips: "We look for unusual imagery that is commercial and appealing. We favor humorous imagery on any subject for cards and high-quality photos for prints and posters."

SCAFA-TORNABENE PUBLISHING CO., 100 Snake Hill Rd., West Nyack NY 10994. (914)358-7600. Contact: Susan Murphy. Specializes in unlimited edition offset reproductions for framers, commercial art trade, and manufacturers worldwide.
Needs: Interested in photography with decorative appeal for the wall decor market. Model release required.
Making Contact & Terms: Query with slides or photos. Call approximately 2 weeks from contact. Uses 35mm, 2¼×2¼, 4×5 and 8×10 camera ready prints. SASE. Reports in 3-4 weeks. Pays $150-250 flat fee for some accepted pieces. Royalty arrangements with advance against 5-10% royalty is standard. Buys only reproduction rights (written contract). Artist maintains ownership of original photograph. Requires exclusive publication rights to all accepted work.
Tips: "Send a good cross sampling of subjects that you shoot. Appropriate subject matter would be: floral still lifes, figuratives, dramatic landscapes, wildlife, domestic animals and automobiles, to name a few. Colored, hand-colored, b&w and sepia tone photography are all considered."

SCANDECOR INC., 430 Pike Rd., Southampton PA 18966. (215)355-2410. Fax: (215)364-8737. Product Manager: Lauren H. Karp. Estab. 1972. Specializes in posters, framing prints, wall decor and calendars.
Needs: Buys stock and assigns work. Buys 300-500 photos/year. Needs studio and wild animals, men and women, cute children, trendy subjects, nature, marine animals, art, humorous. Submit seasonal material 1 year in advance. Model/property release required. Captions preferred.
Making Contact & Terms: Query with samples. Uses color prints; 35mm, 2¼×2¼, 4×5, 8×10 transparencies. Samples not kept on file. SASE. Reports in 1 month. Pays $150 minimum/b&w photo; $250 minimum/color photo; $300 minimum/job. Pays upon usage. Credit line given. Buys exclusive product rights; negotiable. Simultaneous submissions and previously published work OK.

SUNRISE PUBLICATIONS, INC., P.O. Box 4699, Bloomington IN 47402. (812)336-9900. Fax: (812)336-8712. Administrative Assistant: Julia Jensen. Estab. 1974. Specializes in greeting cards, posters, stationery. Photo guidelines free with SASE.
Needs: Buys approximately 30 images/year supplied by freelancers. Interested in interaction between people/children/animals evoking a mood/feeling, nature, endangered species (color or b&w photography). Does not want to see sexually suggestive or industry/business photos. Reviews stock photos. Model release required. Property release preferred.
Making Contact & Terms: Interested in receiving work from newer, lesser-known photographers. Submit portfolio for review. Works on assignment only. Uses 35mm; 4×5 transparencies. Keeps samples on file. Reports in 4-6 weeks. NPI. **Pays on acceptance.** Credit line given. Buys exclusive product rights; negotiable. Simultaneous submissions and previously published work OK.
Tips: "Look for Sunrise cards in stores, familiarize yourself with quality and designs before making a submission."

SUPER-CALLI-GRAPHICS, P.O. Box 66398, Los Angeles CA 90066. (310)677-4171. Fax: (310)677-4911. President: Marcia Miller. Estab. 1978. Specializes in stationery.
Needs: Buys 5-10 images annually; all supplied by freelancers. Offers 5-10 assignments annually. Interested in photos of children, seasonal shots according to need. Submit seasonal material 4-6 months in advance. Model release required. Captions preferred.
Making Contact & Terms: Interested in receiving work from newer, lesser-known photographers. Query with samples. Provide résumé, business card, self-promotion piece or tearsheets to be kept on file for possible future assignments. Works on assignment only. Uses glossy or matte color prints. Keeps samples on file. SASE. Does not report back unless interested. NPI. Pays on usage. Buys all rights, exclusive product rights; negotiable.

SYRACUSE CULTURAL WORKERS, Box 6367, Syracuse NY 13217. (315)474-1132. Research/Development Director: Dik Cool. Art Director: Linda Malik. Specializes in posters, cards and calendars.
Needs: Buys 15-25 freelance photos/year. Images of social content, reflecting a consciousness of peace/social justice, environment, liberation, etc. Model release preferred. Captions preferred.
Making Contact & Terms: Interested in receiving work from newer, lesser-known photographers. Send unsolicited photos by mail for consideration. Uses any size b&w; 35mm, 2¼×2¼, 4×5 or 8×10 color transparencies. SASE. Reports in 2-4 months. Pays $75-100/b&w or color photo plus free copies of item. Credit line given. Buys one-time rights.
Tips: "We are interested in photos that reflect a consciousness of peace and social justice, that portray the experience of people of color, disabled, elderly, gay/lesbian—must be progressive, feminist, nonsexist. Look at our catalog (available for $1)—understand our philosophy and politics. Send only what is appropriate and socially relevant. We are looking for positive, upbeat and visionary work."

TELDON CALENDARS, A Division of Teldon International Inc., Box 8110, 800-250 H St., Blaine WA 98231-2107. (206)945-1211. Fax: (206)945-0555. Photo Editor: Monika Vent. Assistant to the

Photo Editor: Jamie Whittla. Estab. 1968. Publishes high quality scenic and generic calendars. Photos used for one time use in calendars. Examples of recently published titles: calendars for the Amoco Oil Company, NRS National Real Estate Service and Goodyear Tire & Rubber Company. Photo guidelines free with SASE.

Needs: Buys 800-1,000 photos annually. Looking for travel (world), wildlife (North America), classic automobiles, golf, scenic North America photos and much more. Reviews stock photos. Model/property release required for residential houses, people. Photo captions required that include complete detailed description of destination, i.e., Robson Square, Vancouver, British Columbia, Canada. "Month of picture taken also required as we are 'seasonal driven.' "

Making Contact & Terms: Interested in receiving work from newer, lesser-known photographers. Query with stock photo list. Phone call OK to receive guidelines. Works with freelancers and stock agencies. Uses 35mm, 2¼×2¼, 4×5, 6×7, 8×10 horizontal only transparencies. "We are making duplicates of what we think is possible material." SASE. Reports in 1 month, depending on work load. Pays $100 for one time use. Pays in September of publication year. Credit line and complementary calendar copies given. Buys all rights. Simultaneous submissions and/or previously published works OK.

Tips: Horizontal transparencies only, dramatic and colorful nature/scenic/wildlife shots. City shots to be no older than one year. For scenic and nature pictures avoid "man made" objects, even though an old barn captured in the right moment can be quite beautiful. "Examine our catalogs and fliers carefully and you will see what we are looking for. Capture the beauty of nature and wildlife as long as it's still around—and that's the trend."

THAYER PUBLISHING, 150 Kingswood Rd., Mankato MN 56001. (507)388-8647. Fax: (507)388-3076. Product Manager: Sue Anderson. Estab. 1952. Specializes in greeting cards, calendars, postcards. Photo guidelines free with SASE.

Needs: Buys 18 images annually; all from freelancers. Offers 1 assignment annually. Interested in scenic America, holiday scenes. Submit seasonal material by June 1 of each year. Reviews stock photos. Model/property release preferred. Captions preferred; include photo location and time of year.

Making Contact & Terms: Interested in receiving work from newer, lesser-known photographers. Provide résumé, business card, self-promotion piece or tearsheets to be kept on file for possible future assignments. Uses 35mm, 2¼×2¼, 4×5 transparencies. Keeps samples on file. SASE. Reports in 45 days. Pays $75-200/color. Pays on usage. Credit line not given. Buys one-time rights, exclusive product rights; negotiable.

TIDE MARK PRESS, Box 280311, East Hartford CT 06128-0311. Editor: Scott Kaeser. Art Director: C. Cote. Estab. 1979. Specializes in calendars.

Needs: Buys 400-500 photos/year; few individual photos; all from freelance stock. Complete calendar concepts which are unique, but also have identifiable markets; groups of photos which could work as an entire calendar; ideas and approach must be visually appealing and innovative but also have a definable audience. No general nature or varied subjects without a single theme. Submit seasonal material in spring for next calendar year. Reviews stock photos. Model release preferred. Captions required.

Making Contact & Terms: "Contact us to offer specific topic suggestion which reflect specific strengths of your stock." Uses 35mm, 2¼×2¼, 4×5 and 8×10 transparencies. SASE. Reports in 1 month. Pays $125-150/color photo; royalties on sales if entire calendar supplied. Pays on publication or per agreement. Credit line given. Buys one-time rights.

Tips: "We tend to be a niche publisher and we rely on niche photographers to supply our needs."

***❧TYE SIL CORP. LTD.**, 12225 Industrial Blvd., Montreal, Quebec H1B 5M7 Canada. (514)640-9727. Fax: (514)640-6423. Creative Director: Daniel Marcille. Estab. 1960s. Specializes in greeting cards, stationery, gift wrap, gift bags.

Needs: Buys 100-150 images annually. Interested in nature, special occasion, Christmas, people, mood and emotion, animal, collectibles, miscellaneous. Submit seasonal material 6-12 months in advance. Does not want unfocused, grainy, nudes, religious. Model release required.

Making Contact & Terms: Interested in receiving work from newer, lesser-known photographers. Submit portfolio for review. Send work under speculation. Uses 2¼×2¼, 4×5 transparencies. Keeps amples on file. Reports in 3 weeks initially; final approval is done within 6 months. Pays $200/color photo. Pays within 45 days of usage. Buys all rights. Previously published work OK.

 The maple leaf before a listing indicates that the market is Canadian.

VAGABOND CREATIONS, INC., 2560 Lance Dr., Dayton OH 45409. (513)298-1124. President: George F. Stanley, Jr. Specializes in greeting cards.
Needs: Buys 2 photos/year. Interested in general Christmas scenes . . . non-religious. Submit seasonal material 9 months in advance. Reviews stock photos.
Making Contact & Terms: Query with stock photo list. Uses 35mm transparencies. SASE. Reports in 1 week. Pays $100/color photo. **Pays on acceptance.** Buys all rights. Simultaneous submissions OK.

WEST GRAPHICS, 385 Oyster Point Blvd., Unit 7, South San Francisco CA 94080. (800)648-9378. Contact: Production Department. Specializes in humorous greeting cards. Photo guidelines free with SASE.
Needs: Buys 10-20 freelance photos/year. Humorous, animals, people in outrageous situations or anything of an unusual nature; prefers color. Does not want to see scenics. Submit seasonal material 1 year in advance. Model release required. Captions preferred; include model's/photographer's name.
Making Contact & Terms: Interested in receiving work from newer, cutting edge photographers. Query with samples. Send unsolicited photos by mail for consideration. Uses 8 × 10 b&w glossy prints; 35mm, 2¼ × 2¼ and 4 × 5 transparencies. Do not send originals. SASE. Reports in 6 weeks. Pays $50-300/color or b&w photo and/or 5% royalty on sales. Pays 30 days after publication. Buys exclusive product rights; negotiable. Simultaneous submissions and previously published work OK.
Tips: "Our goal is to publish cards that challenge the limits of taste and keep people laughing. Using the latest in computer graphic technology we can creatively combine photographic images with settings and objects from a variety of resources. Computers and scanners have expanded the range of photographs we accept for publication."

WILLIAMHOUSE-REGENCY, INC., 28 W. 23rd St., New York NY 10010. (212)691-2000. Art Director: Vicki Scopinich. Estab. 1955. Specializes in greeting cards, stationery, invitations and announcements. Photo guidelines free with SASE.
Needs: Offers 5 assignments annually.
Making Contact & Terms: Interested in working with photographers who do product shots and are local in Manhattan. Provide résumé, business card, self-promotion piece or tearsheets to be kept on file for possible future assignments. Works with local freelancers on assignment only. Uses 4 × 5 and 8 × 10 transparencies. Keeps samples on file. SASE. Reports in 3 weeks. Pays $500-750/day. **Pays on acceptance.** Credit line not given. Buys all rights.
Tips: "We are interested in photographers who have photographed paper products that use embossing, foil leaf and subtle colors."

Paper Products/'95-'96 changes

The following markets appeared in the 1995 edition of *Photographer's Market*, but are not listed this year. The majority did not respond to our request to update their listings. If a reason was given for a market's exclusion it appears in parentheses below.

Acme Graphics, Inc.
Africa Card Co., Inc.
Alaska Wild Images (not accepting freelance work)
Angel Graphics
Angler's Calendars (submissions by invitation only)
Class Publications, Inc.
Design House, Inc.

Designer Greetings (requested deletion)
Eldorado (has no photo needs)
Glenn Ellen Press (no longer accepting freelance work)
McCleery-Cumming Company, Inc. (overwhelmed with submissions)
Mehron Inc.

Pemberton & Oakes (not accepting freelance work)
Pictura, Inc. (requested deletion)
Reedproductions
Renaissance Greeting Cards, Inc.
Sacred Mountain Ashram
Seabright Press

Publications

There is no doubt that somewhere among the hundreds of listings in this section you can find a publication interested in your work. These magazines, newspapers and newsletters are too far ranging in style and content not to have viable markets for you. Some, such as *Life*, *Playboy* and *Vanity Fair* require more experience from freelancers, but many publications are willing to take a chance on an unknown talent. Your task is to find your niche. Find those markets that fit your style and might be interested in your photographs.

First, do your homework. This section consists of four main categories—Consumer Publications, Newspapers & Newsletters, Special Interest Publications and Trade Publications. Many of these listings offer photo guidelines and sample copies. Send for this information and use it to your advantage. Photo guidelines tell you what editors prefer in the way of formats and content. They might provide tips regarding upcoming needs and tell you when to drop off portfolios. Also, sample copies can give you a better indication of what the publication needs and they can show you how your work is likely to be presented.

Whenever possible try to get feedback regarding your work. If an editor hated the images in your portfolio, ask him why. Also, try not to take a love-it-or-leave-it attitude regarding your work. Be willing to accept criticism and learn from the suggestions of editors. However, if you ask for an assessment of your work and an editor gives you a vague response, be a little suspicious. There are times when editors are too busy and don't look at portfolios. Without being too confrontational, see if you can submit your portfolio again in the near future.

The important thing is to be persistent without being a pest. Sending a new promotional piece often can be enough to keep your name in the mind of an editor. Constant phone calls from freelancers often bother editors who may be working on deadlines and don't have time to talk. If you get on an editor's bad side your chances of making a sale or getting an assignment for that publication drastically decrease.

To make your search for markets easier, there is a Subject Index at the back of this book. This index is divided into 24 topics, and markets are listed according to the types of photographs they want to see. For example, if you shoot environmental photos there are numerous markets wanting to receive this type of material.

Every year we update all our listings to include new information, such as changes in photo needs, adjustments in pay rates, and replacement of old addresses with new ones. However, throughout the year some of this information can be found in photo industry newsletters and trade magazines. Addresses for these and other publications are located in the back of this book under Recommended Books & Publications.

We also have a First Markets Index, which provides the names of those publications interested in receiving work from newer, lesser-known photographers. If you are just getting started this is an excellent place to look for potential markets.

Throughout this section you also will find bullets (●) inside some listings. These comments were written by the editor of *Photographer's Market* and they are designed to provide additional information about listings. The comments usually center on awards won by markets, design changes that have taken place, or specific submission requirements.

Consumer Publications

The consumer publications that follow make up the largest section in *Photographer's Market*. This year there are more than 450 markets, 111 of which are new. If you want to work with these magazines you should realize that some of them are taking a good look at the way information is presented. For example, as the general public gets more acquainted with online networks, publishers are sure to adopt such technology. Photos eventually will be viewed by editors on a computer screen rather than on a light table. Be prepared for such advances and do what you can to protect your copyright.

One magazine already involved with online presentation of images is *Backpacker*. Photo Editor Deborah Burnett Stauffer discusses her company's interest in digital imagery as our Insider Report subject on page 232.

When dealing with editors you will notice that many maintain strict fees. Photographers often consider editorial prices to be fairly low, so newcomers should not anticipate large sums for unsolicited photographs. If you are just beginning to build a client base, expect to pay your dues for awhile. Once you are established you will acquire photo assignments which pay more than standard stock fees.

If you feel an image is unique don't be afraid to ask for more money. Many editors and photographers report that they often see photographers losing income because they don't ask for it.

ABOARD MAGAZINE, 100 Almeria Ave., Suite 220, Coral Gables FL 33134. Fax: (305)441-9739. Circ. 110,000. Estab. 1976. Inflight magazine for 11 separate Latin American national airlines. Bilingual bimonthly. Emphasizes travel through Central and South America. Readers are mainly Latin American businessmen, and American tourists and businessmen. Sample copy free with SASE. Photo guidelines free with SASE.
Needs: Uses 50 photos/issue; 30 supplied by freelance photographers. Needs photos of travel, scenic, fashion, sports and art. Special needs include good quality pictures of Latin American countries, particularly Chile, Guatemala, Ecuador, Bolivia, Rep. Dominicana, El Salvador, Peru, Nicaragua, Honduras, Paraguay, Uruguay. Model/property release preferred. Captions preferred.
Making Contact & Terms: Interested in receiving work from newer, lesser-known photographers. Query with samples. Provide business card, brochure, flier or tearsheets to be kept on file for possible future assignments. SASE. Reports in 1 month. Payment varies; pays $20/color photo; $150 for photo/text package. Pays on publication. Credit line given. Buys one-time rights. Previously published work OK.
Tips: If photos are accompanied by an article, chances are much better of their being accepted.

ACCENT ON LIVING, P.O. Box 700, Bloomington IL 61702. (309)378-2961. Fax: (309)378-4420. Editor: Betty Garee. Circ. 20,000. Estab. 1955. Quarterly magazine. Emphasizes successful disabled young adults (18 and up) who are getting the most out of life in every way and *how* they are accomplishing this. Readers are physically disabled individuals of all ages and socioeconomic levels and professions. Sample copy $3 with 5×7 SAE and 5 first-class stamps. Free photo/writers guidelines; enclose SASE.
Needs: Uses 40-50 photos/issue; 95% supplied by freelancers. Needs photos for Accent on People department, "a human interest photo column on disabled individuals who are gainfully employed or doing unusual things." Also uses occasional photo features on disabled persons in specific occupations: art, health, etc. Manuscript required. Photos depict handicapped persons coping with the problems and situations particular to them: how-to, new aids and assistive devices, news, documentary, human interest, photo essay/photo feature, humorous and travel. "All must be tied in with physical disability. We want essentially action shots of disabled individuals doing something interesting/unique or with a new device they have developed. Not photos of disabled people shown with a good citizen 'helping' them." Model release preferred. Captions preferred.
Making Contact & Terms: Interested in receiving work from newer, lesser-known photographers. Query first with ideas, get an OK, and send contact sheet for consideration. Uses glossy prints and color photos, transparencies preferred. Provide letter of inquiry and samples to be kept on file for possible future assignments. Cover is usually tied in with the main feature inside. SASE. Reports in 3 weeks. Pays $50-up/color cover; pays $15-up/color inside photo; pays $5-up/b&w inside photo. Pays on publication. Credit line given if requested. Previously published work OK.
Tips: "Concentrate on improving photographic skills. Join a local camera club, go to photo seminars, etc. We find that most articles are helped a great deal with *good* photographs—in fact, good photographs

Photographer Robin Hill of Miami Beach, Florida, received $200 from Aboard magazine for this shot of a local hotel. The image also sold to Sky magazine and was used in posters to promote the hotel. Hill says the hotel's owner was so captivated by the shot that he immediately offered Hill several nights free stay along with a complimentary dinner.

© 1994 Robin Hill

will often mean buying a story and passing up another one with very poor or no photographs at all." Looking for *good* quality photos depicting what article is about. "We almost always work on speculation."

ADIRONDACK LIFE, Rt. 9N, P.O. Box 97, Jay NY 12941. (518)946-2191. Art Director: Ann Eastman. Circ. 50,000. Estab. 1970. Bimonthly. Emphasizes the people and landscape of the north country of New York State. Sample copy $4 with 9×12 SAE and 5 first-class stamps. Photo guidelines free with SASE.
Needs: "We use about 40 photos/issue, most supplied by freelance photographers. All photos must be taken in the Adirondacks and all shots must be identified as to location and photographer."
Making Contact & Terms: Send one sleeve (20 slides) of samples. Send b&w prints (preferably 8×10) or color transparencies in any format. SASE. Pays $300/cover photo; $50-200/color or b&w photo; $150/day plus expenses. Pays 30 days after publication. Credit line given. Buys first North American serial rights. Simultaneous submissions OK.
Tips: "Send quality work pertaining specifically to the Adirondacks. In addition to technical proficiency, we look for originality and imagination. We emphasize vistas and scenics. We are using more pictures of people and action."

ADVENTURE WEST MAGAZINE, P.O. Box 3210, Incline Village NV 89450. (702)832-3700. Fax: (702)832-1640. Editor: Marianne Porter. Circ. 165,000. Estab. 1992. Bimonthly magazine. Emphasizes travel and adventure in the 13 western states, including Hawaii, Alaska, Western Canada and Western Mexico. Sample copy free with 10×13 SAE and 11 first-class stamps. Photo guidelines free with SASE.
Needs: Uses 65-70 photos/issue; 100% supplied by freelancers. Needs photos of action, sports, animal/wildlife, scenics. Special photo needs include scuba/underwater, hiking, camping, biking, climbing, kayaking, sailing, caving, skiing. Property release preferred. Captions preferred; include where and what.
Making Contact & Terms: Interested in receiving work from newer, lesser-known photographers. Query with stock photo list. Send unsolicited photos by mail for consideration. Send 35mm color transparencies. Keeps samples on file; "not originals but business cards and stock lists. SASE. Reports in 6 weeks. Pays $300/color cover photo; $35-100/color inside photo. Pays on publication. Credit line given. Buys one-time rights. Simultanous submissions OK.
Tips: "Always ask about payment before agreeing to send photos."

AFRICA REPORT, 833 UN Plaza, New York NY 10017. (212)949-5666. Editor: Margaret A. Novicki. Circ. 12,000. Bimonthly magazine. Emphasizes African political and economic affairs, especially those

significant for US. Readers are Americans with professional or personal interest in Africa. Free sample copy.

Needs: Uses 20 photos/issue. Personality, documentary, photo feature, scenic, spot news, human interest, travel, socioeconomic and political. Photos must relate to African affairs. "We will not reply to 'How I Saw My First Lion' or 'Look How Quaint the Natives Are' proposals." Wants, on a regular basis, photos of economics, African international affairs, development, conflict and daily life. Captions required.

Making Contact & Terms: Provide samples and list of countries/subjects to be kept on file for future assignments. Query on accompanying ms. SASE. Pays $25-35/inside photo; $25-75/cover photo; $150-250/ms. Pays on publication. Credit line given. Buys one-time rights. Reports in 1 month. Simultaneous submissions and previously published work OK. Uses 8 × 10 glossy prints; vertical format preferred for cover.

Tips: "Live and travel in Africa; and make political, economic and social events humanly interesting."

AFTER FIVE MAGAZINE, P.O. Box 492905, Redding CA 96049. (800)637-3540. Publisher: Craig Harrington. Monthly tabloid. Emphasizes news, arts and entertainment. Circ. 32,000. Estab. 1986. Sample copy $1.

Needs: Uses 8-12 photos/issue; 25% supplied by freelance photographers. Needs photos of animal/wildlife shots, travel and scenics of northern California. Model release and captions preferred.

Making Contact & Terms: Provide résumé, business card, brochure, flier or tearsheets to be kept on file for possible assignments. SASE. Reports in 1-2 weeks. Pays $50/color cover photo; $50/b&w cover photo; $20/b&w inside photo; $60/b&w page rate. Pays on publication. Credit line given. Buys one-time rights. Previously published work OK.

Tips: "Need photographs of subjects north of Sacramento to Oregon-California border, plus southern Oregon. Query first."

AIM MAGAZINE, P.O. Box 20554, Chicago IL 60620. (312)874-6184. Editor: Ruth Apilado. Circ. 7,000. Estab. 1974. Quarterly magazine. Magazine dedicated to promoting racial harmony and peace. Readers are high school and college students, as well as those interested in social change. Sample copy for $4 with 9 × 12 SAE and 4 first-class stamps.

Needs: Uses 10 photos/issue. Needs "ghetto pictures, pictures of people deserving recognition, etc." Needs photos of "integrated schools with high achievement." Model release required.

Making Contact & Terms: Send unsolicited photos by mail for consideration. Send b&w prints. SASE. Reports in 1 month. Pays $25/color cover photo; $10/b&w cover photo. **Pays on acceptance.** Credit line given. Buys one-time rights. Simultaneous submissions OK.

Tips: Looks for "positive contributions."

ALABAMA LITERARY REVIEW, 253 Smith Hall, Troy State University, Troy AL 36082. (205)670-3286. Fax: (205)670-3519. Editor: Theron Montgomery. Circ. 800. Estab. 1987. Semi-annual journal. Emphasizes short stories, poetry, essays, short drama, art and photography. Readers are anyone interested in literature and art of all ages. Sample copy for $5/issue and 9 × 12 SASE.

Needs: Uses 5-6 photos/issue; 100% supplied by freelance photographers, 10% on assignment, 90% from stock. Will consider all kinds of photos. Special needs include anything artistic or thought-provoking. Model release required. Property release preferred.

Making Contact & Terms: Interested in receiving work from newer, lesser-known photographers. Send 8 × 10 glossy b&w prints by mail for consideration. SASE. Reports in 3 months. Pays in copies and sometimes honorarium. Pays on publication. Credit line given. Buys first rights; returned upon publication. Simultaneous submissions OK.

Tips: "We take pride in discovering amateur photographers and presenting their work to a serious audience across the U.S. *ALR* is a good place for a new photographer to break in." Looks for "playoff on b&w, people and forms. Also, something that tells a story." The trend is towards b&w art forms. "Think of the completeness, proportion and metaphoric implications of the pictures."

ALABAMA LIVING, P.O. Box 244014, Montgomery AL 36124. (205)215-2732. Fax: (205)215-2733. Editor: Darryl Gates. Circ. 301,000. Estab. 1948. Publication of the Alabama Rural Electric Association. Monthly magazine. Emphasizes rural life and rural electrification. Readers are older males and females living in rural areas and small towns. Sample copy free with 8½ × 11 SASE and 4 first-class stamps.

Needs: Uses 6-12 photos/issue; 1-3 supplied by freelancers. Needs photos of nature/wildlife, travel—southern region, some scenic and Alabama specific. Special photos needs include vertical scenic cover shots. Captions preferred; include place and date.

Making Contact & Terms: Interested in receiving work from newer, lesser-known photographers. Query with stock photo list or transparencies ("dupes are fine") in negative sleeves. Keeps samples on file. SASE. Reports in 1 month. Pays $40-50/color cover photo; $60-75/photo/text package. Pays

on publication. Credit line given. Buys one-time rights; negotiable. Simultaneous submissions OK. Previously published work OK "if previously published out-of-state."

ALASKA, 808 E St., Suite 200, Anchorage AK 99501. Phone/fax: (907)272-2552. Managing Editor: Tricia Brown. Photo Editor: Roy Corral. Circ. 250,000. Estab. 1935. Monthly magazine. Readers are people interested in Alaska. Sample copy $4. Free photo guidelines.

● *Alaska* has received many awards: 1994 Maggie Award for regional/state excellence; three 1994 White Awards for the most interesting cover photo, a black and white feature and an essay; The Alaska Press Club's 1994 awards for best portrait, picture story, scenic photo and profile.

Needs: Buys 500 photos annually, supplied mainly by freelancers. Captions required.

Making Contact & Terms: Interested in receiving work from established and newer, lesser-known photographers. Send carefully edited, captioned submission of 35mm, 2¼ × 2¼ or 4 × 5 transparencies. SASE. Reports in 4 weeks. Pays $50/b&w photo; $75-500/color photo; $300/day; $2,000 maximum/complete job; $300/full page; $500/cover. Buys one-time rights; negotiable.

Tips: "Each issue of *Alaska* features 8- to 10-page photo feature. We're looking for themes and photos to show the best of Alaska. We want sharp, artistically composed pictures. Cover photo always relates to stories inside the issue."

ALASKA GEOGRAPHIC, Dept. PM, P.O. Box 93370, Anchorage AK 99509. (907)562-0164. Editor: Penny Rennick. Quarterly magazine. Covers Alaska and Northwestern Canada only. Readers are professional men and women, ages 30 and up. Circ. 9,000. Estab. 1972. Guidelines free with SASE.

Needs: Uses about 70 photos/issue; most supplied by freelancers. Needs photos of scenics, animals, natural history and people. Each issue covers a special theme. Model release preferred; captions required.

Making Contact & Terms: Interested in receiving work from newer, lesser-known photogaphers. Query with list of stock photo subjects. SASE. "We don't have time to deal with inappropriate submissions, so know the area and subjects very well to avoid wasting time." Pays $300/color cover photo; $100/inside full-page color; $50/inside half-page color. Pays on publication. Credit line given. Buys one-time rights. Simultaneous submissions and previously published work OK.

Tips: Do not send mss, "just photos. Our freelance writing is done by assignment only."

Alive Now! MAGAZINE, 1908 Grand Ave., P.O. Box 189, Nashville TN 37202. (615)340-7218. Assistant Editor: Beth A. Richardson. Circ. 80,000. Estab. 1975. Bimonthly magazine published by The Upper Room. "*Alive Now!* uses poetry, short prose, photography and contemporary design to present material for personal devotion and reflection. It reflects on a chosen Christian concern in each issue. The readership is composed of primarily college-educated adults." Sample copy free with 6 × 9 SAE and 3 first-class stamps. Themes list free with SASE; photo guidelines available.

Needs: Uses about 25-30 b&w prints/issue; 90% supplied by freelancers. Needs b&w photos of "family, friends, people in positive and negative situations, scenery, celebrations, disappointments, ethnic minority subjects in everyday situations—Native Americans, Hispanics, Asian-Americans and African-Americans." Model release preferred.

Making Contact & Terms: Query with samples. Send 8 × 10 glossy b&w prints by mail for consideration. Send return postage with photographs. Submit portfolio for review. SASE. Reports in 6 months; "longer to consider photos for more than one issue." Pays $25-35/b&w inside photo; no color photos. Pays on publication. Credit line given. Buys one-time rights. Simultaneous and previously published submissions OK.

Tips: Looking for high reproduction, quality photographs. Prefers to see "a variety of photos of people in life situations, presenting positive and negative slants, happy/sad, celebrations/disappointments, etc. Use of racially inclusive photos is preferred."

ALOHA, THE MAGAZINE OF HAWAII AND THE PACIFIC, P.O. Box 3260, Honolulu HI 96801. (808)593-1191. Fax: (808)593-1327. Assistant Editor: Joyce Akamine. Circ. 65,000. Estab. 1978. Bimonthly. Emphasizes culture, arts, history of Hawaii and its people. Readers are "affluent, college-educated people from all over the world who have an interest in Hawaii." Sample copy $2.95 with 9 × 11 SAE and 9 first-class stamps. Photo guidelines free with SASE.

Needs: Uses about 50 photos/issue; 90% supplied by freelance photographers. Needs "scenics, travel, people, florals, strictly about Hawaii. We buy primarily from stock. Assignments are rarely given and when they are, they are usually given to one of our regular local contributors. Subject matter must be

The Subject Index, located at the back of this book, can help you find publications interested in the topics you shoot.

Hawaiian in some way. A regular feature is the photo essay, 'Beautiful Hawaii,' which is a 6-page collection of images illustrating that theme." Model release required if the shot is to be used for a cover. Captions required.

Making Contact & Terms: Interested in receiving work from newer, lesser-known photographers. Submit portfolio for review. Query with stock photo list. Send unsolicited photos by mail for consideration. Provide résumé, business card, brochure, flier or tearsheets. SASE. Reports in 3 weeks. Pays $25/b&w photo; $60/color transparency; $125/photo running across a two-page spread; $250/cover shot. Pays on publication. Credit line given. Buys one-time rights.

Tips: Prefers to see "a unique way of looking at things, and of course, well-composed images. Generally, we are looking for outstanding scenic photos that are not standard sunset shots printed in every Hawaii publication. We need to see that the photographer can use lighting techniques skillfully, and we want to see pictures that are sharp and crisp. Many photographers break in by submitting transparencies for "Beautiful Hawaii." Competition is fierce, and it helps if a photographer can first bring in his portfolio to show to our art director. Then the art director can give him ideas regarding our needs."

***❦ALTERNATIVES: PERSPECTIVES ON SOCIETY, TECHNOLOGY & ENVIRONMENT**, Faculty of Environmental Studies, University of Waterloo, Waterloo, Ontario N2L 3G1 Canada. (519)888-4545. Fax: (519)746-0292. E-mail: mruby@watserv1.uwaterloo.ca. Production Coordinator: Marcia Ruby. Circ. 4,200. Estab. 1971. Quarterly magazine. Emphasizes environmental issues. Readers are activists, academics, professionals, policy makers. Sample copy free with 9×12 SASE and 2 first-class stamps.

Needs: Uses 20-30 photos/issue; 4-8 supplied by freelancers. Subjects vary widely depending on theme of each issue. "We often need technically and visually strong action shots of people involved in environmental issues—no models or setups." Reviews photos purchased with or without a ms. "We prefer not to use models." Captions preferred; include who, when, where, environmental significance of shot.

Making Contact & Terms: Interested in receiving work from newer, lesser-known photographers. Send unsolicited photos by mail for consideration. Provide résumé, business card, brochure, fliers or tearsheets to be kept on file for possible assignments. Send 8×10 or 5×7 glossy color and b&w prints; 35mm transparencies. Keeps samples on file. SASE. Reports in 3 weeks. Pays on publication. Credit line given. Buys one-time rights; negotiable. Simultaneous submissions and previously published work OK.

 ● "*Alternatives* is a nonprofit organization whose contributors are all volunteer. We are able to give a small honorarium to artists and photographers, usually $50. This in no way should reflect the value of the work. It symbolizes our thanks to their contribution to *Alternatives*."

Tips: "*Alternatives* covers Canadian and global environmental issues. Strong action photos or topical environmental issues are needed—preferably with people. We also print animal shots. We look for positive solutions to problems and prefer to illustrate the solutions rather than the problems. Freelancers need a good background understanding of environmental issues. You need to know the significance of your subject before you can powerfully present its visual perspective."

***AMBIENCE**, P.O. Box 12134, Berkeley CA 94712. (415)789-8129. Editor: Deborah Fleishman. Estab. 1995. Quarterly magazine. Explores women's vision of romance and sensuality. Readers are women ages 20-45. Photo guidelines free with SASE.

Needs: Uses 50-100 photos/issue; 100% supplied by freelancers. "We invite sensual photography which, like a good aphrodisiac, will leave a woman drunk with anticipation and, in blunter terms, 'turn us on.' Photos should resemble a film—tell a story rather than portray an image, leaving enough ambiguity for the viewer to fill in the gaps. They should involve an encounter between both sexes, and some form of intrigue, with as much emotional and mental foreplay as physical. Nudity should be the afterthought; partially clothed or in the process of being 'unclothed' is preferable to 'no clothes.' Also looking for erotic photos to offset against erotic writing. These need not involve human beings but should be sensual in nature." Reviews photos with or without ms. Model/property release required. Captions required; include who, what, where, when, why.

Making Contact & Terms: Please send for detailed photo guidelines before you submit your material. Work is primarily assignment oriented. "We consider material from both men and women but we are especially interested in works by women and newer, lesser-known photographers." Accept both color and b&w. Send 8×10 glossy prints or 35mm, 2¼×2¼, 4×5, 8×10 transparencies by mail for consideration or query for possible assignments with résumé, business card, brochure, flier or tearsheets to be kept on file for future assignments. SASE. Material returned if accompanied by exact postage. Reports in 2 months. NPI. Pays on publication. Credit line given. Buys one time rights; negotiable. Use for promotional and/or other rights arranged. Simultaneous submissions and previously published work OK.

Tips: *Ambience* is interested in presenting a cornucopia of shapes, faces and colors to reflect the wondrous variety of our species and our sexual relations. Our focus is heterosexual but we appreciate diversity. Make sure your photos capture the essence of a *woman's* sexual experience or fantasy—i.e.

Alive Now *magazine went through a redesign last year, resulting in intriguing covers like this one by Scott Thomas Design of Nashville, Tennessee. Editor George Graham says he wanted an image that represents life's priorities, such as money, time and spirituality. Thomas created the collage using Adobe Photoshop.*

the mood that precedes and provokes desire. We are especially interested in nostalgia and romance—from films like *Gone With The Wind*, and *Streetcar Named Desire*, when sex was seething in the air, not hitting you in the face. Also, we want to see *men* sexualized for women: their bodies, hands, thighs, butts and facial expressions photographed in their natural habitats, (at work, at play . . .) not posed. All themes considered: humor, farce, fantasy, serious, dark, taboo, romance, erotic, both real and imagined."

AMELIA MAGAZINE, 329 "E" St., Bakersfield CA 93304. (805)323-4064. Editor: Frederick A. Raborg, Jr. Circ. 1,250. Quarterly magazine. Emphasizes literary: fiction, non-fiction, poetry, reviews, fine illustrations and photography, etc. "We span all age groups, three genders and all occupations. We are also international in scope. Average reader has college education." Sample copy $8.95 and SASE. Photo guidelines free with SASE.
• Because this is a literary magazine it very seldom uses a lot of photographs. However, the cover shots are outstanding, fine art images.
Needs: Uses 4-6 photos/issue depending on availability; all supplied by freelance photographers. "We look for photos in all areas including male and female nudes and try to match them to appropriate editorial content. We sometimes use photos alone; color photos on cover. We use the best we receive; the photos usually convince us." Model release required. Captions preferred.
Making Contact & Terms: Send unsolicited photos by mail for consideration. Send b&w or color, 5×7 and up, glossy or matte prints; 35mm or 2¼×2¼ transparencies. SASE. Reports in 2 weeks. Pays $100/color cover photo; $50/b&w cover photo; $5-25/b&w inside photo. **Pays on acceptance.** Credit line given. Buys one-time rights or first North American serial rights. "We prefer first North American rights, but one-time is fine." Simultaneous submissions OK.
Tips: In portfolio or samples, looks for "a strong cross-section. We assume that photos submitted are available at time of submission. Do your homework. Examine a copy of the magazine, certainly. Study the 'masters of contemporary' photography, i.e., Adams, Avedon, etc. Experiment. Remember we are looking for photos to be married to editorial copy usually."

AMERICA WEST AIRLINES MAGAZINE, 4636 E. Elmwood St., Suite 5, Phoenix AZ 85040. (602)997-7200. Art Director: Katherine McGee. America West Airlines magazine. Circ. 125,000. Monthly. Emphasizes general interest—including: travel, interviews, business trends, food, etc. Readers are primarily business people and business travelers; substantial vacation travel audience. Photo guidelines free with SASE. Sample copy $3.
Needs: Uses about 60-100 photos/issue; all supplied by freelance photographers. "Each issue varies immensely, we primarily look for stock photography of places, people, subjects such as animals, plants, scenics—we assign some location and portrait shots. We publish a series of photo essays with brief, but interesting accompanying text." Model release required. Captions required.
Making Contact & Terms: Provide résumé, business card, brochure, tearsheets or color samples to be kept on file for possible future assignments. Pays $100-225/color inside photo, depends on size of photo and importance of story; $75-100/hour; $350/day plus film and expenses. Pays on publication. Credit line given. Buys one-time rights. Previously published work OK.
Tips: "We judge portfolios on technical quality, consistency, ability to show us that you can give us what we ask for with a certain uniqueness in style or design, versatility and creativity. Photographers we work with most often are those who are both technically and creatively adept, and who can take the initiative conceptually by providing new approaches or ideas."

AMERICAN HORTICULTURIST, 7931 E. Boulevard Dr., Alexandria VA 22308. (703)768-5700. Fax: (703)768-7533. Editor: Kathleen Fisher. Circ. 25,000. Estab. 1927. Monthly. "Alternate 4-color and 2-color publications." Emphasizes horticulture. Readers are advanced amateur gardeners. Sample copy $3. Photo guidelines free with SASE.
Needs: Uses 30-40 (color/magazine), 2-3 (b&w/news edition) photos/issue; all supplied by freelancers. "Assignments are rare; 2-3/year for portraits to accompany profiles." Needs shots of people gardening, people engaged in horticulture research, public gardens, close-ups of particular plant species showing detail. "We only review photos to illustrate a particular manuscript which has already been accepted." Sometimes uses seasonal cover shots. Model release preferred. Captions required, must include genus, species and/or cultivar names; "tulip" or "rose" is not enough. "We are science-based, not a garden design magazine."
Making Contact & Terms: Interested in receiving work from newer, lesser-known photographers. Query with list of stock photo subjects, photo samples. Provide résumé, business card, brochure, flier or tearsheets to be kept on file for possible future assignments or requests. SASE. Reports in 3 weeks. Pays $50/color inside photo; $80/color cover photo; $25-50/b&w photo. Pays on publication. Buys one-time rights.
Tips: Wants to see "ability to identify precise names of plants, clarity and vibrant color."

AMERICAN SKATING WORLD, 1816 Brownsville Rd., Pittsburgh PA 15210-3908. (412)885-7600. Fax: (412)885-7617. Managing Editor: H. Kermit Jackson. Circ. 15,000. Estab. 1981. Monthly tabloid. Emphasizes ice skating—figure skating primarily, speed skating secondary. Readers are figure skating participants and fans of all ages. Sample copy $2.95 with 8×12 SAE and 3 first-class stamps. Photo guidelines free with SASE.

Needs: Uses 20-25 photos/issue; 4 supplied by freelancers. Needs performance and candid shots of skaters and "industry heavyweights." Reviews photos with or without manuscript. Model/property release preferred for children and recreational skaters. Captions required; include name, locale, date and move being executed (if relevant).

Making Contact & Terms: Interested in receiving work from newer, lesser-known photographers. Query with résumé of credits. Keeps samples on file. SASE. Report on unsolicited submissions could take 3 months. Pays $25/color cover photo; $5/b&w inside photo. Pays 30 days after publication. Buys one-time rights color; all rights b&w; negotiable. Simultaneous submissions and/or previously published work OK.

Tips: "Pay attention to what's new, the newly emerging competitors, the newly developed events. In general, be flexible!" Photographers should capture proper lighting in performances and freeze the action instead of snapping a pose.

AMERICAN SURVIVAL GUIDE, 774 S. Placentia Ave., Placentia CA 92670-6832. (714)572-2255. Fax: (714)572-1864. Editor: Jim Benson. Circ. 43,000. Estab. 1980. Monthly magazine. Emphasizes firearms, military gear, emergency preparedness, survival food storage and self-defense products. Average reader is male, mid-30s, all occupations and with conservative views. Sample copy $3.25 and SAE with 5 first-class stamps. Photo guidelines free with SASE.

Needs: Uses more than 100 photos/issue; 35-45% supplied by freelance photographers. Photos purchased with accompanying manuscript only. Model release required. Captions required.

Making Contact & Terms: Interested in receiving work from newer, lesser-known photographers. Send written query detailing article and photos. Note: Will not accept text without photos or other illustrations. Pays $70/color and b&w page rate. Pays on publication. Credit line given. Buys all rights; negotiable.

Tips: Wants to see "professional looking photographs—in focus, correct exposure, good lighting, interesting subject and people in action. Dramatic poses of people helping each other after a disaster, riots or worn torn area. Wilderness survival too. Look at sample copies to get an idea of what we feature. We only accept photos with an accompanying manuscript (floppy disk with WordPerfect or Microsoft Word files). The better the photos, the better chance you have of being published."

AQUARIUM FISH MAGAZINE, P.O. Box 6050, Mission Viejo CA 92690. (714)855-8822. Fax: (714)855-3045. E-mail: 76107.460@compuserve.com. Editor: Edward Bauman. Circ. 75,000. Estab. 1988. Monthly magazine. Emphasizes aquarium fish. Readers are both genders, all ages. Sample copy $3.50. Photo guidelines free with SASE.

Needs: Uses 30 photos/issue; all supplied by freelance photographers. Needs photos of aquariums and fish, freshwater and saltwater; ponds.

Making Contact & Terms: Query with list of stock photo subjects. Submit portfolio for review. Send 35mm, 2¼×2¼ transparencies by mail for consideration. SASE. Reports in 1 month. Pays $150/color cover photo; $50-75/color inside photo; $25/b&w inside photo; $75/color page rate; $25/b&w page rate. Pays on publication. Credit line given. Buys one-time rights. Previously published work OK.

ASPEN MAGAZINE, Dept. PM, Box G3, Aspen CO 81612. (303)920-4040. Fax: (303)920-4044. Art Director: Marlene Cohen. Circ. 16,000. Estab. 1974. Bimonthly magazine. Emphasizes Aspen—lifestyle, sports, local issues. Readers are "Aspenites, both locals, part-time residents and lovers of the town wherever they live." Sample copy free with 10×12 SAE and 6 first class stamps.

Needs: Uses "35 photos/issue; most supplied by freelancers, usually on assignment." Needs scenics, sports—skiing in winter and other mountain sports in summer—profiles, travel shots, etc. Model release preferred. "We're eager to see work of shooters who are in our area for work or pleasure."

Making Contact & Terms: Provide résumé, business card, brochure, flier or tearsheets. Does not keep samples on file. Cannot return material. Reports in 1 month. NPI. Credit line given. Buys "exclusive rights in our market," one-time rights; negotiable.

Tips: Wants to see "technical proficiency, appropriate subject matter, vision and creative sensibility. We strive for the highest level of photography in all areas and design. Do *not* send inappropriate submissions that are unrelated to Aspen, Colorado. All our photos (and editorial text) are geared to our role as a 'city' magazine. When we do use stock shots they are usually from photographers who have worked extensively in our town, but we still like to see the work of others as long as they have shots *from our area. No general submissions please.*"

ASPIRE, (formerly *Today's Better Life*), Royal Magazine Group, 404 BNA Dr., Suite 600, Building 200, Nashville TN 37217. (615)872-8080. Fax: (615)889-0437. Design & Production Director: Eric T. Jessen. Circ. 200,000. Estab. 1991. Bimonthly magazine. Emphasizes Christian lifestyle and health. Readers are male and female Christians, ages 30-45.
Needs: Uses 25 photos/issue; 10 supplied by freelancers. Needs photos of editorial concepts. Model release required. Property release preferred. Captions preferred.
Making Contact & Terms: Interested in receiving work from newer, lesser-known photographers. Send unsolicited photos by mail for consideration. Provide résumé, business card, brochure, flier or tearsheets to be kept on file for possible assignments. Send 35mm, 2¼×2¼, 4×5, 8×10 transparencies. Keeps samples on file. SASE. Reports in 1-2 weeks. Pays $50-100/hour; $500-800/day; $50-500/job; $250-750/color cover photo; $50-300/b&w cover photo; $200-500/color inside photo; $50-200/b&w inside photo. **Pays on acceptance.** Credit line given. Buys first North American serial rights; negotiable. Simultaneous submissions and/or previously published work OK.

ASTRONOMY, 21027 Crossroads Circle, Waukesha WI 53187. (414)796-8776. Fax: (414)796-1142. Photo Editor: David J. Eicher. Circ. 175,000. Estab. 1973. Monthly magazine. Emphasizes astronomy, science and hobby. Median reader: 40 years old, 85% male, income approximately $68,000/yr. Sample copy $3. Photo guidelines free with SASE.
Needs: Uses approximately 100 photos/issue; 70% supplied by freelancers. Needs photos of astronomical images. Model/property release preferred. Captions required.
Making Contact & Terms: Interested in receiving work from newer, lesser-known photographers. Send unsolicited photos by mail for consideration. Send 8×10 glossy color and b&w photos; 35mm, 2¼×2¼, 4×5, 8×10 transparencies. Keeps samples on file. SASE. Reports in 2 weeks. Pays $100/cover photo; $25 for routine uses. Pays on publication. Credit line given.

ATLANTA HOMES & LIFESTYLES, 5775-B Glenridge Dr., #580, Atlanta GA 30328. (404)252-6670. Fax: (404)252-6673. Editor: Barbara Tapp. Circ. 38,000. Estab. 1983. Magazine published 8 times/year. Covers residential design (home and garden); food, wine and entertaining; people, travel and lifestyle subjects. Sample copy $2.95.
Needs: Needs photos of homes (interior/exterior), people, travel, decorating ideas, products, gardens. Model/property release required. Captions preferred.
Making Contact & Terms: Interested in receiving work from newer, lesser-known photographers. Submit portfolio for review. Send unsolicited photos by mail for consideration. Provide résumé, business card, brochure, flier or tearsheets to be kept on file for possible assignments. Send 35mm, 2¼×2¼ transparencies. SASE. Reports in 2 months. Pays $50-650/job. Pays on publication. Credit line given. Buys one-time rights. Simultaneous submissions and/or previously published work OK.

ATLANTA PARENT, 4330 Georgetown Square II, Suite 506, Atlanta GA 30338. (404)454-7599. Fax: (404)454-7699. Assistant to Publisher: Peggy Middendorf. Circ. 61,000. Estab. 1983. Monthly tabloid. Emphasizes parents, families, children, babies. Readers are parents with children ages 0-14. Sample copy $2.
Needs: Uses 4-8 photos/issue; all supplied by freelancers. Needs photos of babies, children in various activities, parents with kids. Model/property release required. Captions preferred.
Making Contact & Terms: Interested in receiving work from newer, lesser-known photographers. Query with stock photo list. Send unsolicited photos by mail for consideration. Send 3×5 or 4×6 b&w prints. Keeps samples on file. SASE. Reports in 3 months. Pays $20-75/color photo; $20/b&w photo. Pays on publication. Credit line given. Buys one-time rights; negotiable. Simultaneous and/or previously published work OK.

ATLANTIC CITY MAGAZINE, Dept. PM, Box 2100, Pleasantville NJ 08232. (609)272-7900. Art Director: Michael Lacy. Circ. 50,000. Monthly. Sample copy $2 plus 4 first-class stamps.
Needs: Uses 50 photos/issue; all supplied by freelance photographers. Prefers to see b&w and color fashion, product and portraits, sports, theatrical. Model release required. Captions required.
Making Contact & Terms: Query with portfolio/samples. Cannot return material. Provide tearsheets to be kept on file for possible future assignments. Payment negotiable; usually $35-50/b&w photo; $50-100/color; $250-450/day; $175-300 for text/photo package. Pays on publication. Credit line given. Buys one-time rights.
Tips: "We promise only exposure, not great fees. We're looking for imagination, composition, sense of design, creative freedom and trust."

AUDUBON MAGAZINE, 700 Broadway, New York NY 10003. (212)979-3126. Picture Editor: Peter Howe. Bimonthly magazine. Circ. 475,000. Emphasizes wildlife. Sample copy $4. First-class $5.
Needs: Freelancers supply 100% of the photos. Photo essays of nature subjects, especially wildlife, showing animal behavior, unusual portraits with good lighting and artistic composition. Nature photos should be artistic and dramatic, not the calendar or postcard scenic. Uses color covers only; horizontal

wraparound format requires subject off-center. Also uses journalistic and human interest photos. Captions are required. Also seeks articles with accompanying photos on environmental topics, natural areas or wildlife, predominantly North America.

Making Contact & Terms: Important: Query first before sending material; include tearsheets or list previously published credits. SASE. Reports in 1 month. Portfolios should be geared to the magazine's subject matter. Must see original transparencies as samples. Uses 8 × 10 glossy b&w prints; 35mm; 2¼ × 2¼ and 4 × 5 transparencies. Plastic sheets only; no prints, no dupes. Pays $125-300/b&w and color inside; $700/color cover; $450/table of contents. Pays on publication. Credit line given. Buys one-time rights. No simultaneous submissions.

Tips: "Query first. Study recent issues (last six months). Do not send unsolicited material. If you do submit unsolicited material, it should be accompanied by return postage. We cannot assume the cost of sending back unsolicited material. All photos submitted must be accompanied by adequate captions or they will not be considered for publication."

***AUTO SOUND & SECURITY**, 774 S. Placentia Ave., Placentia CA 92670. (714)572-2255. Fax: (714)572-1864. Editor: Rob McPherson. Estab. 1990. Monthly magazine. Emphasizes automotive aftermarket electronics. Readers are largely male students, ages 16-26. Sample copy free with SASE.

Needs: Uses 100 photos/issue; less than half supplied by freelancers. Needs photos of custom installations of aftermarket autosound systems and sub-systems. Model/property release required for vehicle owners and models (cover and full features only).

Making Contact & Terms: Interested in receiving work from newer, lesser-known photographers. Provide résumé, business card, brochure, flier or tearsheets to be kept on file for possible assignments. Deadlines: three months prior to cover date. Keeps samples on file. SASE. Reports in 2 weeks. Pays $300-500/job; $500-750/color cover photo; $100/color page rate. Pays on publication. Credit line given. Rights negotiable.

AWARE COMMUNICATIONS INC., 2720 NW Sixth St., Gainesville FL 32609-2992. (904)331-8422. Vice President-Creative: Scott Stephens. Publishes quarterly and annual magazines and poster. Emphasizes education—medical, pre-natal, sports safety and job safety. Readers are high school males and females, medical personnel, pregnant women, new home owners.

●This company produces numerous consumer publications: *First Baby, Student Aware, Job Search, Technology Education, Sports Safety, Medaware, America Moves, New Homeowner, Help Yourself, Perfect Prom* and *Insect Protect!.*

Needs: Uses 20-30 photos/issue; 90% supplied by freelancers. Needs photos of medical, teenage sports and fitness, pregnancy and lifestyle (of pregnant mothers), home interiors. Model/property release required.

Making Contact & Terms: Interested in reviewing work from newer, lesser-known photographers. Submit portfolio for review. Send unsolicited photos by mail for consideration. Send 35mm, 2¼ × 2¼, 4 × 5, 8 × 10 transparencies. Keeps samples on file. SASE. Reports only when interested. Pays $400/ color cover photo; $100/color inside photo. Pays on publication. Credit line given. Buys one time rights; negotiable. Simultaneous submissions and/or previously published work OK.

Tips: Looks for quality of composition and color sharpness. "Photograph people in all lifestyle situations."

***BABY**, 1700 K. St. NW, Suite 1202, Washington DC 20006. (202)296-4860. Fax: (202)331-1025. Photo Editor: Annette Stenner. Circ. 350,000. Estab. 1995. Bimonthly magazine. Emphasizes cloth diapers, also encourages breast feeding. "No bottles in photos please." Readers are new mothers—childbearing age. Sample copy free with 9 × 12 SASE.

Needs: Uses 3 photos/issue. Needs photos for cover shot—baby up to 8 months old in bright clothing, will crop in on face and shoulders—inside photos specific to articles. Model release required.

Making Contact & Terms: Interested in receiving work from newer, lesser-known photographers. Send unsolicited photos by mail for consideration. Query with stock photo list. Can call for more information on specific articles. Send any size color prints; 35mm, 2¼ × ¼, 4 × 5, 8 × 10 transparencies. Keeps samples on file. SASE. Reports in 3 weeks. NPI. Credit line given. Buys one-time rights. Simultaneous submissions and previously published work OK.

Tips: "Expressions on faces is very important. We prefer brightly colored clothing and simple backgrounds for cover."

BACK HOME IN KENTUCKY, P.O. Box 681629, Franklin TN 37068-1629. (615)794-4338. Fax: (615)790-6188. Editor: Nanci Gregg. Circ. 13,000. Estab. 1977. Bimonthly magazine. Emphasizes subjects in the state of Kentucky. Readers are interested in the heritage and future of Kentucky. Sample copy $2 with 9 × 12 SAE and 5 first-class stamps.

●This publication performs its own photo scans and has stored some images on CD. "We have done minor photo manipulation of photos for advertisers."

Editor-Photographer Relations Change with the Times

Surf the online networks and you'll find them. Magazines of all kinds, including *Time, National Geographic, Elle* and *Smithsonian.* Not only is the digital era revolutionizing the way material is presented, but it's altering the way photographers and photo editors do business.

Deborah Burnett Stauffer, photo editor for *Backpacker* magazine, says her company, Rodale Press Inc., now requests digital rights along with print rights when acquiring images. Such agreements are meant to accommodate *Backpacker's* digital presentation on America Online. However, some photographers are reluctant to sign such contracts. "A lot of stock agencies are wanting us to renegotiate prices. And a lot of photographers see (a digital rights clause) on their contracts and they panic. Then they call ASMP and ask 'What should I do?' " says Burnett Stauffer.

The dominant concern among photographers is that once images are available through networks, publishers, corporations or anyone else will be able to download and use the photos without paying usage fees. Burnett Stauffer says such vexations are unwarranted because online images have poor resolution. "You can scan a copy of the magazine itself and get a better resolution," she says.

Photographers also believe that images are worth more if they are used in print *and* online. This becomes a pricing problem for publishers who are pioneers in the electronic marketplace. Burnett Stauffer says *Backpacker* pays photographers for print usage and offers additional compensation based on the number of times the magazine is accessed online. Other publishers have added flat fees to compensate freelancers for online rights. "We don't know how else to deal with payment for network usage," says Burnett Stauffer. "As far as we're concerned, it's the same image that appeared in the magazine. It's just another version of the magazine, another way of purchasing a copy of *Backpacker.*"

Because the new era creates such contractual dilemmas, Burnett Stauffer has become more selective in the images she acquires. She prefers photographers who are willing to grant rights for online usage.

Burnett Stauffer adds that she is not unfamiliar with the concerns of photographers. A graduate of Kutztown University of Pennsylvania, she spent three years working for New York City advertising photographer John Cooper. Therefore, she understands the plight of freelancers who want top dollar for images in an extremely competitive industry. "I don't want to rip them off because I know how I felt calling up clients and saying, 'Hey, I need to pay my bills this month. I'm not a bank.' "

When approaching magazine editors, Burnett Stauffer advises photographers

to send letters of introduction along with stock lists and some samples. Promo cards and tearsheets are good because they quickly show a photographer's style. Photographers also should make sure submissions are sent directly to the person buying the work. Also, freelancers must never send original work when submitting photos on speculation.

Burnett Stauffer says stock lists are important for her because *Backpacker* covers some very remote wilderness areas and stock agencies don't often have the images she needs. She relies heavily on the 1,600 photographers whose names are stored in her computer database.

The electronic era also makes it possible for photographers to improve their image presentation. Burnett Stauffer says she occasionally receives portfolios on CD-ROM. "I think that type of technology is going to make things easier because you're not going to have to worry about sending your original film. You'll be able to send images on CD-ROM or send them online and editors can request the images they want. And there is less of a chance that images will be lost or damaged."

—*Michael Willins*

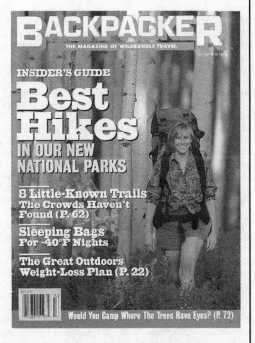

One of the nation's premiere outdoor magazines, Backpacker is now offered through America Online. Photo Editor Deborah Burnett Stauffer says the shift to electronic presentation of the magazine has created some interesting challenges for her when dealing with photographers. Backpacker is now interested in acquiring digital rights to photos, along with traditional print rights.

Needs: Uses 25 photos/issue; all supplied by freelance photographers, less than 10% on assignment. Needs photos of scenic, specific places, events, people. Reviews photos with accompanying ms. Also seeking vertical cover (color) photos. Special needs include holidays in Kentucky; Christmas; the Kentucky Derby sights and sounds. Model release required. Captions required.

Making Contact & Terms: Interested in receiving work from newer, lesser-known photographers. Send any size, glossy b&w and color prints, 35mm transparencies by mail for consideration. Reports in 2 weeks. Pays $10-25/b&w photo; $20-50/color photo; $50 minimum/cover photo; $15-100/text/photo package. Pays on publication. Credit line given. Usually buys one-time rights; also all rights; negotiable. Simultaneous submissions and previously published work OK.

Tips: "We look for someone who can capture the flavor of Kentucky—history, events, people, homes, etc. Have a great story to go with the photo—by self or another."

BACKPACKER MAGAZINE, 135 N. Sixth St., Emmaus PA 18049. (215)967-5171. E-mail: bpeditor @aol.com. Photo Editor: Deborah Burnett Stauffer. Magazine published 9 times annually. Readers are male and female, ages 35-45. Photo guidelines free with SASE.

Needs: Uses 20-25 photos/issue; almost all supplied by freelancers. Needs transparencies of wildlife, scenics, people backpacking. Reviews photos with or without ms. Model/property release required.

Making Contact & Terms: Interested in receiving work from newer, lesser-known photographers. Query with résumé of credits and photo list. Provide résumé, business card, brochure, flier or tearsheets to be kept on file for possible assignments. SASE. NPI; payment varies. Pays on publication. Credit line given. Rights negotiable. Sometimes considers simultaneous submissions and previously published work.

BALL MAGAZINE, Side 'O' Fries Press 0775, Northampton MA 01061. (413)247-9766. Senior Editor: Douglas M. Kimball. Circ. 2,000. Estab. 1992. Semiannual magazine "hand bound." "Ball is interested in experimental, erotic, ethnic and class diversity photos." Readers are progressive, ages 18-40. Photo guidelines free with SASE.

Needs: Uses 2-8 photos/issue; all supplied by freelancers. Needs photos of experimental nature, erotica, grotesque, and in general, work which explores the dark or sinister side of American life. Reviews photos with or without ms. Model/property release preferred. Captions required; include date and format.

Making Contact & Terms: Interested in receiving work from newer, lesser-known photographers. Send unsolicited photos by mail for consideration. Uses b&w prints/transparencies. SASE. Reports in 2 months. Pays in contributor's copies. Pays on publication. Credit line given. Buys one-time rights. Simultaneous submissions OK.

BALLOON LIFE, 2145 Dale Ave., Sacramento CA 95815. (916)922-9648. Fax: (916)922-4730. E-mail: 73232.1112@compuserve.com. Editor: Tom Hamilton. Circ. 4,000. Estab. 1986. Monthly magazine. Emphasizes sport ballooning. Readers are sport balloon enthusiasts. Sample copy free with 9 × 12 SAE and 7 first-class stamps. Photo guidelines free with 9 × 12 SASE.

● 95% of artwork is scanned digitally inhouse by this publication, then color corrected and cropped for placement.

Needs: Uses about 15-20 photos/issue; 90% supplied by freelance photographers on assignment. Needs how-to photos for technical articles, scenic for events. Model/property release preferred. Captions preferred.

Making Contact & Terms: Interested in receiving work from newer, lesser-known photographers. Send b&w or color prints; 35mm transparencies by mail for consideration. "We are now scanning our own color and doing color separations in house. As such we prefer 35mm transparencies above all other photos." SASE. Reports in 1 month. Pays $50/color cover photo; $15-50/b&w or color inside photo. Pays on publication. Credit line given. Buys one-time and first North American serial rights. Simultaneous submissions and previously published work OK.

Tips: "Photographs, generally, should be accompanied by a story. Cover the basics first. Good exposure, sharp focus, color saturation, etc. Then get creative with framing and content. Often we look for one single photograph that tells readers all they need to know about a specific flight or event. We're evolving our coverage of balloon events into more than just 'pretty balloons in the sky.' I'm looking for photographers who can go the next step and capture the people, moments in time, unusual happenings, etc. that make an event unique. Query first with interest in sport, access to people and events, experience shooting balloons or other outdoor special events."

***BALTIMORE**, 16 S. Calvert St., Baltimore MD 21202. (410)752-7375. Fax: (410)625-0280. Associate Art Director: Pattie Gerlach. Circ. 50,000. Estab. 1907. Monthly magazine for Baltimore region. Readers are educated Baltimore denizens, ages 35-60. Sample copy $2.05 with 9 × 12 SASE.

Needs: Uses 200 photos/issue; 200 supplied by freelancers. Needs photos of lifestyle, profile, news, food, etc. Special photo needs include photo essays about Baltimore. Model release required. Captions required; include name, age, neighborhood, reason/circumstances of photo.

Making Contact & Terms: Interested in receiving work from newer, lesser-known photographers. Provide résumé, business card, brochure, flier or tearsheets to be kept on file for possible assignments. Cannot return material. Call for photo essays. Reports in 1 month. Pays $100-350/day. Pays 30 days past invoice. Credit line given. Buys first North American serial rights; negotiable.

BASSIN', Dept. PM, 2448 E. 81st St., 5300 CityPlex Tower, Tulsa OK 74137-4207. (918)366-4441. Managing Editor: Mark Chesnut. Circ. 275,000 subscribers, 100,000 newsstand sales. Published 8 times/year. Emphasizes bass fishing. Readers are predominantly male, adult; nationwide circulation with heavier concentrations in South and Midwest. Sample copy $2.95. Photo guidelines free.
Needs: Uses about 50-75 photos/issue; "almost all of them" are supplied by freelance photographers. "We need both b&w and Kodachrome action shots of freshwater fishing; close-ups of fish with lures, tackle, etc., and scenics featuring lakes, streams and fishing activity." Captions required.
Making Contact & Terms: Query with samples. SASE. Reports in 6 weeks. Pays $400-500/color cover photo; $25/b&w inside photo; $35-200/color inside photo. Pays on publication. Credit line given. Buys first North American serial rights.
Tips: "Send lots of photos and give me a specific deadline in which to send them back. Don't send lists—I can't pick a photo from a grocery list. In the past, we used only photos sent in with stories from freelance writers. However, we would like freelance photographers to participate."

BAY FOOD, 5878 Doyle St., Emeryville CA 94608. (510)652-6115. Fax: (510)652-4845. Art Director: Laura Williams. Circ. 35,000. Estab. 1988. Monthly tabloid. Emphasizes food and wine in Northern California. Send $3.50 for sample copy.
Needs: Uses 1 photo/issue; all supplied by freelancers. Needs photos of local food personalities, interiors and location shots. Model release required. Captions preferred.
Making Contact & Terms: Interested in receiving work from newer, lesser-known photographers. Provide résumé, business card, brochure, flier or tearsheets to be kept on file for possible assignments. Keeps samples on file. SASE. Reports in 3 weeks. Pays $200/color cover photo; $20-50/b&w inside photo. Pays on publication. Credit line given. Buys one-time rights. Simultaneous submissions and previously published work OK.
Tips: "Have portfolio pieces presented well and of the subject matter pertinent to our needs and your skills. Be brief—art directors don't have a lot of time."

♣BC OUTDOORS, 202-1132 Hamilton St., Vancouver, British Columbia V6B 2S2 Canada. (604)687-1581. Fax: (604)687-1925. Editor: Karl Bruhn. Circ. 42,000. Estab. 1945. Emphasizes fishing, both fresh water and salt; hunting; RV camping; wildlife and management issues. Published 8 times/year (January/February, March, April, May, June, July/August, September/October, November/December). Free sample copy with $2 postage.
Needs: Uses about 30-35 photos/issue; 99% supplied by freelance photographers on assignment. "Fishing (in our territory) is a big need—people in the act of catching, or releasing fish. Hunting, canoeing and camping. Family oriented. By far most photos accompany mss. We are always on lookout for good covers—fishing, wildlife, recreational activities, people in the outdoors—vertical and square format, primarily of British Columbia and Yukon. Photos with mss must, of course, illustrate the story. There should, as far as possible, be something happening. Photos generally dominate lead spread of each story. They are used in everything from double-page bleeds to thumbnails. Column needs basically supplied inhouse." Model/property release preferred. Captions or at least full identification required.
Making Contact & Terms: Interested in receiving work from newer, lesser-known photographers. Send by mail for consideration actual 5×7 or 8×10 b&w prints; 35mm, 2¼×2¼, 4×5 or 8×10 color transparencies; color contact sheet. If color negative, send jumbo prints and negatives only on request. Query with list of stock photo subjects. SASE, Canadian stamps. Reports in 1-2 weeks normally. Pays $20-75/b&w photo; $25-200/color photo; and $250-up/cover photo. Pays on publication. Credit line given. Buys one-time rights inside; with covers "we retain the right for subsequent promotional use." Simultaneous submissions not acceptable if competitor; previously published work OK.
Tips: "We see a trend toward more environmental/conservation issues."

***BEAUTY HANDBOOK: NATIONAL WOMEN'S BEAUTY MAGAZINE**, 75 Holly Hill Lane, Third Floor, Greenwich CT 06830. (203)869-5553, ext. 305. Fax: (203)869-3971. Editor-in-Chief: Keri Ann Ammerman. Circ. 1.1 million. Quarterly magazine. Emphasizes beauty, health, fitness, hair, cosmetics, nails. Readers are female, ages 25-45, interested in improving appearance. Sample copy free with 8×10 SAE and 4 first-class stamps.
Needs: Uses 12-14 photos/issue; almost all supplied by freelancers. Needs photos of studio and natural setting shots of attractive young women. Model/property release preferred.
Making Contact & Terms: Interested in receiving work from newer, lesser-known photographers. Send unsolicited photos by mail for consideration. Contact through rep. Query with stock photo list. Send 8×10 glossy b&w or color prints; 35mm, 2¼×2¼, 4×5. Keeps samples on file. SASE. Reports

in 2 weeks. Photographers must be willing to work for tearsheets only. Rights negotiable. Simultaneous submissions and previously published work OK.

***BECKETT BASEBALL CARD MONTHLY**, 15850 Dallas Pkwy., Dallas TX 75248. (214)448-9049. Fax: (214)991-8930. Photo Editor: Gail Docekal. Circ. 701,768. Estab. 1984. Monthly magazine. Emphasizes major league baseball. Readers are 95% male, 5% female; all age groups, mostly 7-17 years old. Sample copy $2.95.
Needs: Uses 10-20 photos/issue; 50-75% supplied by freelancers. Needs photos of sports action and posed subjects.
Making Contact & Terms: Interested in receiving work from newer, lesser-known photographers. Contact photo editor, then send photos for review. Does not keep samples on file. SASE. Reports in 1 month. Pays $200-300/color cover photo; $50-150/color inside photo; $50-150/b&w inside photo. Credit line given. Buys one-time rights. Previously published work OK.

***BECKETT BASKETBALL MONTHLY**, 15850 Dallas Pkwy., Dallas TX 75248. (214)448-9049. Fax: (214)991-8930. Photo Editor: Gail Docekal. Circ. 370,665. Estab. 1990. Monthly magazine. Emphasizes NBA basketball. Readers are 94% male, 6% female; all age groups, mostly 7-17 years old. Sample copy $2.95.
Needs: Uses 10-20 photos/issue; 50-75% supplied by freelancers. Needs photos of sports action and posed subjects.
Making Contact & Terms: Interested in receiving work from newer, lesser-known photographers. Contact photo editor, then send photos for review. Does not keep samples on file. SASE. Reports in 1 month. Pays $200-300/color cover photo; $50-150/color inside photo; $50-150/b&w inside photo. Credit line given. Buys one-time rights. Previously published work OK.

***BECKETT FOCUS ON FUTURE STARS**, 15850 Dallas Pkwy., Dallas TX 75248. (214)448-9049. Fax: (214)991-8930. Photo Editor: Gail Docekal. Circ. 110,000. Estab. 1991. Monthly magazine. Emphasizes baseball, basketball, football and hockey (all sports minor league and college). Readers are 95% male, 5% female; mostly ages 15-25. Sample copy $2.95.
Needs: Uses 10-20 photos/issue; 50-75% supplied by freelancers. Needs photos of sports action and posed subjects.
Making Contact & Terms: Interested in receiving work from newer, lesser-known photographers. Contact photo editor, then send photos for review. Does not keep samples on file. SASE. Reports in 1 month. Pays $200-300/color cover photo; $50-150/color inside photo; $50-150/b&w inside photo. Credit line given. Buys one-time rights. Previously published work OK.

***BECKETT FOOTBALL CARD MONTHLY**, 15850 Dallas Pkwy., Dallas TX 75248. (214)448-9049. Fax: (214)991-8930. Photo Editor: Gail Docekal. Circ. 208,730. Estab. 1989. Monthly magazine. Emphasizes NFL football. Readers are 95% male, 5% female; all age groups, mostly 7-17 years old. Sample copy $2.95.
Needs: 10-20 photos/issue; 50-75% supplied by freelancers. Needs photos of sports action and posed subjects.
Making Contact & Terms: Interested in receiving work from newer, lesser-known photographers. Contact photo editor, then send photos for review. Does not keep samples on file. SASE. Reports in 1 month. Pays $200-300/color cover photo; $50-150/color inside photo; $50-150/b&w inside photo. Credit line given. Buys one-time rights. Previously published work OK.

***BECKETT HOCKEY MONTHLY**, 15850 Dallas Pkwy., Dallas TX 75248. (214)448-9049. Fax: (214)991-8930. Photo Editor: Gail Docekal. Circ. 164,716. Estab. 1990. Monthly magazine. Emphasizes NHL hockey. Readers are 94% male, 6% female; all age groups; mostly 7-34 years old. Sample copy $2.95.
Needs: Uses 10-20 photos/issue; 50-75% supplied by freelancers. Needs photos of sports action and posed subjects.
Making Contact & Terms: Interested in receiving work from newer, lesser-known photographers. Contact photo editor, then send photo for review. Does not keep samples on file. Reports in 1 month. Pays $200-300/color cover photo; $50-150/color inside photo; $50-150/b&w inside photo. Credit line given. Buys one-time rights. Previously published work OK.

***BECKETT RACING MONTHLY**, 15850 Dallas Pkwy., Dallas TX 75248. (214)448-9049. Fax: (214)991-8930. Photo Editor: Gail Docekal. Circ. 120,000. Estab. 1994. Monthly magazine. Emphasizes auto racing. Readers are 90% male, 10% female; mostly ages 18-30. Sample copy $3.95.
Needs: Uses 10-20 photos/issue; 50-75% supplied by freelancers. Needs photos of sports action and posed subjects.
Making Contact & Terms: Interested in receiving work from newer, lesser-known photographers. Contact photo editor, then send photos for review. Does not keep samples on file. SASE. Reports in

1 month. Pays $200-300/color cover photo; $50-150/color inside photo; $50-150/b&w inside photo. Credit line given. Buys one-time rights. Previously published work OK.

***BETTER HEALTH MAGAZINE**. 1384 Chapel St., New Haven CT 06511. (203)789-3972. Assistant Editor: Nora King. Circ. 140,000. Estab. 1979. Bimonthly magazine. Emphasizes health matters. Readers are female, ages 35-55. Sample copy $2.50 with 8½×11 SASE.
Needs: Uses 3-5 photos/issue; 2 supplied by freelancers. "We're interested in working with photographers on their stock." Interested in work that is on SyQuest cartridges. Model/property release required.
Making Contact & Terms: Interested in receiving work from newer, lesser-known photographers. Query with stock photo list. SASE. Pays flat fees for images; $500 for much needed shots, $100 for stock. **Pays on acceptance.** Credit line given. Buys one-time rights. Simultaneous submissions and previously published work OK.

BETTER NUTRITION, Argus Business, 6151 Powers Ferry Rd., Atlanta GA 30339-2941. (404)955-2500. Fax: (404)618-0348. Art Director: Maurice Thompson. Circ. 465,000. Monthly magazine. Emphasizes "health food, healthy people." Readers are 30-60. Sample copy or editorial calendar free with 9×12 SAE and 2 first-class stamps. Free guideline sheet with SASE.
Needs: Uses 8-10 photos/issue; 6 supplied by freelancers. Needs photos of "healthy people exercising (skiing, running, etc.), food shots, botanical shots." Model release preferred.
Making Contact & Terms: Interested in receiving work from newer, lesser-known photographers. Send unsolicited photos by mail for consideration. Send 35mm transparencies. SASE. Reports in 1 month. Pays $400/color cover photo; $150/color inside photo. Pays on publication. Credit line given. Buys one-time rights. Simultaneous submissions and previously published work OK.
Tips: "We are looking for photos of healthy people (all ages) usually in outdoor settings. We work on a limited budget, so do not send submissions if you cannot work within it. Review past issues for photo style."

***BIBLICAL ARCHAEOLOGY SOCIETY**, 4710 41st St. NW, Washington DC 20016. (202)364-3300. Fax: (202)364-2636. Contact: Lisa Josephson. Estab. 1975. Magazine. Emphasizes archaeology, Biblical subjects.
Needs: Needs photos of archaeology, Biblical. Captions preferred.
Making Contact & Terms: Interested in receiving work from newer, lesser-known photographers. Query with samples. Send 35mm, 2¼×2¼, 4×5 transparencies. Does not keep samples on file. SASE. Reports in 3 weeks. Pays $50-250/color inside photo; $25-100/b&w inside photo. Pays on publication. Buys one-time rights.

BIRACIAL CHILD, P.O. Box 12048, Atlanta GA 30355. (404)364-9690. Fax: (404)364-9965. Associate Publisher: Gabe Grosz. Circ. 3,000. Estab. 1994. Quarterly magazine. Emphasizes children, with or without family, of mixed-race heritage, 1 month to 17 years old. Also, transracial adoptees. Readers are parents of biracial/multiracial children; transracial adoption parents. Sample copies $2 with 9×12 SAE and 4 first-class stamps. Photo guidelines free with SASE.
Needs: Uses 15-20 photos/issue; 12-15 supplied by freelancers. Needs photos of children and their families. Must be mixed-race or transracial adoptees. All racial, ethnic background. Special photo needs include children playing, serious shots, schooling, athletes, arts, entertainment. Model/property release preferred. Captions preferred.
Making Contact & Terms: Interested in receiving work from newer, lesser-known photographers. Submit portfolio for review. Query with résumé of credits. Query with stock photo list. Send unsolicited photos by mail for consideration. Provide résumé, business card, brochure, flier or tearsheets to be kept on file for possible assignments. Send 3×5, 8×10 color or b&w prints; any transparencies. Keeps samples on file. SASE. Reports in 1 month or less. Pays $15-25/hour; $15-75/job; $50-75/color cover photo; $50-75/b&w cover photo; $20-35/color inside photo; $15-25/b&w inside photo; $20-35/color page rate. Pays on publication. Credit line given. Buys one-time rights. Simultaneous submissions and/or previously published work OK.
Tips: "We're looking for kids of all ethnic/racial make up. Cute, upbeat kids are a plus. Photos with family are also needed."

BIRD WATCHER'S DIGEST, Dept. PM, Box 110, Marietta OH 45750. (614)373-5285. Editor/Photography and Art: Bill Thompson III. Circ. 99,000. Bimonthly. Emphasizes birds and bird watchers. Readers are bird watchers/birders (backyard and field, veterans and novices). Digest size. Sample copy $3.50.
Needs: Uses 25-35 photos/issue; all supplied by freelance photographers. Needs photos of North American species. For the most part, photos are purchased with accompanying ms.
Making Contact & Terms: Query with list of stock photo subjects and samples. SASE. Reports in 2 months. Pays $50-up/color inside. Pays on publication. Credit line given. Buys one-time rights. Previously published work in other bird publications should not be submitted.

BLUE RIDGE COUNTRY, P.O. Box 21535, Roanoke VA 24018. (703)989-6138. Art Director: Tim Brown. Circ. 70,000. Estab. 1988. Bimonthly magazine. Emphasizes outdoor scenics of Blue Ridge Mountain region. Readers are upscale couples, ages 30-70. Sample copy free with 9×12 SAE and 7 first-class stamps. Photo guidelines free with SASE.

Needs: Uses up to 20 photos/issue; all supplied by freelance photographers; 10% assignment and 90% freelance stock. Needs photos of travel, scenics and wildlife. Seeking more scenics with people in them. Future photo needs include themes of the Blue Ridge region. Model release preferred. Captions required.

Making Contact & Terms: Query with list of stock photo subjects. Send unsolicited photos by mail for consideration. Uses 35mm, 2¼×2¼, 4×5 transparencies. SASE. Reports in 2 months. Pays $100/color cover photo; $25/b&w photo; $25-50/color photo. Pays on publication. Credit line given. Buys one-time rights.

Tips: In photographer's samples looks for "photos of Blue Ridge region, color saturated, focus required and photo abilities. Freelancer should present him/herself neatly and organized."

© David Lorenz Winston

David Lorenz Winston of Philadelphia, Pennsylvania, sold this photo as part of a nine-image, photo-text package to Blue Ridge Country magazine. Normally he works strictly as a photographer, so Winston was excited to provide the entire package which earned him $350.

BODY, MIND & SPIRIT MAGAZINE, P.O. Box 701, Providence RI 02901. (401)351-4320. Fax: (401)272-5767. Publisher: Jim Valliere. Associate Publisher: Jane Kuhn. Circ. 150,000. Estab. 1982. Bimonthly. Focuses on spirituality, meditation, alternative healing, and the body/mind connection. Targeted to all who are interested in personal transformation and growth. Sample copy free with 9×12 SAE.

Needs: Uses 10-15 photos/issue. Photographs for different areas of magazine which includes; natural foods, holistic beauty and skin care, alternative healing, herbs, meditation, spirituality, and the media section which includes; reviews of books, audio tapes, videos and music. Photos should show creativity, depth of feeling, positive energy, imagination and a light heart. Model release required. Captions required.

Making Contact & Terms: Interested in receiving work from newer, lesser-known photographers. Query with samples/portfolio. Provide résumé, business card, brochure, price requirements if available, flier or tearsheets to be kept on file for possible future assignments. SASE. Reports in 3 months. Pays up to $150/b&w photo and up to $400/color photo. Pays on publication. Credit line given. Buys one-time rights. Previously published work OK.

***BODYBOARDING MAGAZINE**, 950 Calle Amanecer, Suite C, San Clemente CA 92672. (714)492-7873. Fax: (714)498-6485. E-mail: surfing@netcom.com. Photo Editor: Scott Winer. Quarterly magazine. Emphasizes hardcore bodyboarding action and bodyboarding beach lifestyle photos and personalities. Readers are 15-16 years old, mostly males (96%). Circ. 40,000. Photo guidelines free with SASE.
Needs: Uses roughly 70 photos/issue; 50-70% supplied by freelancers. Needs photos of hardcore bodyboarding action, surf lineups, beach scenics, lifestyles and bodyboarding personalities. Special needs include bodyboarding around the world; foreign bodyboarders in home waves, local beach scenics.
Making Contact & Terms: Send unsolicited photos by mail for consideration. Uses 35mm and 2¼×2¼ transparencies; b&w contact sheets & negatives. SASE. Reports in 2 weeks. Pays $20-110/b&w photo; $20-575/color photo; $45/color cover photo; $40/b&w page rate; $80/color page rate. Pays on publication. Credit line given. Buys one-time rights.
Tips: "We look for clear, sharp, high action bodyboarding photos preferably on Fuji Velvia 50. We like to see a balance of land and water shots. Be able to shoot in not so perfect conditions. Be persistent and set high standards."

BOSTONIA MAGAZINE, 10 Lenox St., Brookline MA 02146. (617)353-9711. Art Director: Jerrold Hickey. Editor: Keith Botsford. Circ. 150,000. Estab. 1900. Quarterly. Sample copy $3.50.
Needs: Uses 100 photos/issue; many photos are supplied by freelance photographers. Works with freelance photographers on assignment only basis. Needs include documentary photos and international travel photos; photo essay/photo features and human interest; and possibly art photos presented in long portfolio sections. Also seeks feature articles on people and the New England area accompanied by photos. Model releases required. Captions required.
Making Contact & Terms: Provide résumé, brochure and samples to be kept on file for possible future assignments. Call for appointment or send photos by mail for consideration; send actual 5×7 b&w glossies for inside. SASE. Reports in 2 weeks. Pays on acceptance $50-400 for b&w photo; $300-600/color photo; 10¢/word or flat fee (depending on amount of preparation) for feature articles. Credit line given. Buys all rights. No simultaneous submissions or previously published work.

BOW & ARROW HUNTING, 34249 Camino, Box 2429, Capistrano Beach CA 92624. (714)493-2101. Fax: (714)240-8680. Editor: Jack Lewis. Circ. 150,000. Bimonthly magazine. For archers and bowhunters. "We emphasize bowhunting—with technical pieces, how-tos, techniques, bowhunting tips, personality profiles and equipment tests." Writer's guidelines included with photo guidelines.
Needs: "We buy approximately 4 text/photo packages per issue." Technical pieces, personality profiles, humor, tournament coverage, how-to stories, bowhunting stories (with tips), equipment tests and target technique articles. Needs photos of animal (for bowhunting stories); celebrity/personality (if the celebrity is involved in archery); head shot ("occasionally used with personality profiles, but we prefer a full-length shot with the person shooting the bow, etc."); how-to (must be step-by-step); human interest; humorous; nature, travel and wildlife (related to bowhunting); photo essay/photo feature; product shot (with equipment tests); scenic (only if related to a story); sport (of tournaments); and sport news. "No snapshots (particularly color snapshots), and no photos of animals that were not hunted by the rules of fair chase." Photos purchased with accompanying ms; rarely without. Captions required, include location, species and month taken.
Making Contact & Terms: Interested in receiving work from newer, lesser-known photographers. Query with samples OK, but prefers to see completed material by mail on speculation. Uses 5×7 or 8×10 glossy color and b&w prints; 35mm or 2¼×2¼ transparencies. SASE. Reports in 4-6 weeks. Pays $50-300 for text/photo package or on a per-photo basis for photos without accompanying ms. **Pays on acceptance.** Credit line given. Buys one-time rights.
Tips: "Send us a good, clean manuscript with good-quality b&w glossies (our use of color is limited). Most cover shots are freelance. Review the magazine before you submit anything."

BOWHUNTER, 6405 Flank Dr., P.O. Box 8200, Harrisburg PA 17105. (717)657-9555. Editor: M.R. James. Publisher/Editorial Director: Dave Canfield. Managing Editor: Richard Cochran. Circ. 200,000. Estab. 1971. Published 8 times/year. Emphasizes bow and arrow hunting. Sample copy $2. Writer's guidelines free with SASE.
Needs: Buys 50-75 photos/year. Scenic (showing bowhunting) and wildlife (big and small game of North America). No cute animal shots or poses."We want informative, entertaining bowhunting adventure, how-to and where-to-go articles." Photos purchased with or without accompanying ms.
Making Contact & Terms: Send material by mail for consideration. Query with samples. SASE. Reports on queries in 2 weeks; on material in 6 weeks. Uses 5×7 or 8×10 glossy b&w and color prints, both vertical and horizontal format; 35mm and 2¼×2¼ transparencies, vertical format; vertical format preferred for cover. Pays $50-125/b&w photo; $75-250/color photo; $300/cover photo, occasionally "more if photo warrants it." **Pays on acceptance.** Credit line given. Buys one-time publication rights.

Tips: "Know bowhunting and/or wildlife and study several copies of our magazine before submitting any material. We're looking for better quality and we're using more color on inside pages. Most purchased photos are of big game animals. Hunting scenes are second. In b&w we look for sharp, realistic light, good contrast. Color must be sharp; early, late light is best. We avoid anything that looks staged; we want natural settings, quality animals. Send only your best, and if at all possible let us hold those we indicate interest in. Very little is taken on assignment; most comes from our files or is part of the manuscript package. If your work is in our files it will probably be used."

BOWHUNTING WORLD, 601 Lakeshore Pkwy., Suite 600, Minnetonka MN 55305. (612)476-2200. Editor: Mike Strandlund. Circ. 135,000. Estab. 1952. Published 11 times/year. "*Bowhunting World* is the oldest and most respected magazine in print for the hunting archer." It focuses editorially on all aspects of hunting with a bow and arrow in North America. Readers are primarily male, college-educated, avid bowhunters who participate in their sport year-round and who make an above-average income. Photo guidelines available.
Needs: Uses 10-25 photos/issue; most from freelancer stock. "We want to see wildlife subjects commonly hunted as big game species in North America. Also sharp color photos of bowhunters and target archers in action." Special needs include "big game species for cover selections. We're also considering photos of archers and bowhunters for the cover."
Making Contact & Terms: Send 35mm by mail for consideration. SASE. Reports in 2-4 weeks. Pays $250/color cover photo; $40/b&w inside photo; $75-125 color/inside photo; and $200-500/text/ photo package. Pays on publication. Credit line given. Buys one-time rights. Simultaneous submissions and previously published work OK "but please so state in cover letter."
Tips: "We look for technically excellent photos with trophy-class animals and/or unusual and beautiful settings. We're using more color than ever before, far less freelance b&w. And our covers are no longer limited to deer—we're using elk, bear and are open to moose, caribou and antelope as well. Send small, carefully screened submissions—not more than 60 slides. 20 excellent ones will get a far better reception than 20 excellent mixed with 40 average. Be prepared for us to hold your slides on file up to a year, and if there's a limit to the number we should hold, say so."

BOWLING MAGAZINE, 5301 S. 76th St., Greendale WI 53129. (414)423-3232. Fax: (414)421-7977. Editor: Bill Vint. Circ. 150,000. Estab. 1934. Publication of the American Bowling Congress. Bimonthly magazine. Emphasizes ten-pin bowling. Readers are males, ages 30-55, in a cross section of occupations. Sample copy free with 9 × 12 SAE and 5 first-class stamps. Photo guidelines free with SASE.
Needs: Uses 30-40 photos/issue; 5-10 supplied by freelancers. Needs photos of outstanding bowlers or human interest features. Model release preferred. Captions required.
Making Contact & Terms: Interested in receiving work from newer, lesser-known photographers. Provide résumé, business card, brochure, flier or tearsheets to be kept on file for possible assignments. Deadline discussed on case basis. SASE. Reports in 1-2 weeks. Pays $25-50/hour; $100-150/day; $50-150/job; $50-150/color cover photo; $25-50/color inside photo; $20-30/b&w inside photo; $150-300/ photo/text package. **Pays on acceptance**. Credit line given. Buys all rights.

***BOY'S LIFE**, 1325 Walnut Hill Lane, Irving TX 75038. (214)580-2358. Fax: (214)580-2079. Photo Editor: Brian Payne. Circ. 1.3 million. Estab. 1910. Monthly magazine. General interest youth publication. Readers are primarily boys, ages 8-18. Photo guidelines free with SASE.
Needs: Uses 50-80 photos/issue; 99% supplied by freelancers. Needs photos of all categories. Captions required.
Making Contact & Terms: "We're interested in all photographers, but please do not send work." Arrange personal interview to show portfolio. Does not keep samples on file. Cannot return material. Reports in 3 weeks. Pays $350/day minimum. Pays on acceptance or publication. Buys one-time rights. Previously published work OK.
Tips: "A portfolio shows me 20% of a person's ability. We use new people regularly. Show an ability to work quickly with people in tough situations. Learn and read our publications before submitting anything."

❧BRIARPATCH, 2138 McIntyre St., Regina, Saskatchewan S4P 2R7 Canada. (306)525-2949. Fax: (306)565-3430. Managing Editor: George Martin Manz. Circ. 2,000. Estab. 1973. Magazine published 10 times per year. Emphasizes Canadian and international politics, labor, environment, Aboriginal, peace, free trade. Readers are left-wing political activists. Sample copy $3.
Needs: Uses 15-30 photos/issue; 15-30 supplied by freelancers. Needs photos of Canadian and international politics, labor, environment, Aborginal peace, free trade and personalities. Model/property release preferred. Captions preferred; include name of person(s) in photo, etc.
Making Contact & Terms: Interested in receiving work from newer, lesser-known photographers. Query with stock photo list. Send unsolicited photos by mail for consideration. Do not send slides! Provide résumé, business card, brochure, flier or tearsheets to be kept on file for possible assignments.

Send (minimum 3×5) color and b&w prints. Keeps samples on file. SASE. Reports in 1 month. "We cannot pay photographers for their work since we do not pay any of our contributors (writers, photo, illustrators). We rely on volunteer submissions. When we publish photos, etc., we send photographer 5 free copies of magazine." Credit line given. Buys one-time rights. Simultaneous submissions and previously published work OK.

Tips: "We keep photos on file and send free magazines when they are published."

***BRIDE'S & YOUR NEW HOME**, 140 E. 45th St., New York NY 10017. (212)880-8530. Fax: (212)880-8331. Art Director: Phyllis Richard Cox. Produced by Conde Nast Publications. Bimonthly magazine. Emphasizes bridal fashions, home furnishings, travel. Readers are mostly female, newly engaged; ages 21-35.

Needs: Needs photos of home furnishings, tabletop, lifestyle, fashion, travel. Model release required.

Making Contact & Terms: Interested in receiving work from newer, lesser-known photographers. Submit portfolio for review. Provide résumé, business card, brochure, flier or tearsheets to be kept on file for possible assignments. Keeps samples on file. SASE. Reports in 3 weeks. NPI. Pays after job is complete. Credit line given. Buys one-time rights, all rights; negotiable.

BRIGADE LEADER, P.O. Box 150, Wheaton IL 60189. (708)665-0630. Fax: (708)665-0372. Managing Editor: Deborah Christensen. Art Director: Robert Fine. Circ. 9,000. Estab. 1959. Quarterly magazine. For Christian men, age 20 and up. Seeks "to make men aware of their leadership responsibilities toward boys in their families, churches and communities." Sample copy $1.50 with 9×12 SAE and 4 first-class stamps. Photo guidelines free with SASE.

Needs: Buys 2-7 photos/issue; 50% freelance photography/issue comes from assignment and 50% from freelance stock. Needs photos of men at work, camping with their sons, with groups of boys in sports, recreation and hobbies.

Making Contact & Terms: Interested in receiving work from newer, lesser-known photographers. Send 8×10 photos or photocopies for consideration. Reports in 6 weeks. Pays $50/inside b&w photo; $75-100/b&w cover photo. Pays on publication. Buys one-time rights. Simultaneous submissions and previously published work OK.

Tips: "Study the magazine before submitting. Submit sharp photos with good contrast."

BRITISH CAR, Dept. PM, P.O. Box 9099, Canoga Park CA 91309. (818)710-1234. Fax: (818)710-1877. Editor: Dave Destler. Circ. 30,000. Estab. 1985. Bimonthly magazine. Publication for owners and enthusiasts of British motor cars. Readers are U.S. citizens, male, 40 years old and owners of multiple cars. Sample copy $5. Photo guidelines free for SASE.

Needs: Uses 100 photos/issue; 50-75% (75% are b&w) supplied by freelancers. "Photos with accompanied manuscripts required. However, sharp uncluttered photos of different British marques may be submitted for file photos to be drawn on as needed." Photo captions required that include description of vehicles, owner's name and phone number, interesting facts, etc.

Making Contact & Terms: Send unsolicited photos by mail for consideration. Send 5×7 and larger, b&w prints. Does not keep samples on file unless there is a good chance of publication. SASE. "Publisher takes all reasonable precautions with materials, however cannot be held liable for damaged or lost photos." Reports in 6-8 weeks. Pays $25-100/color inside photo; $10-35/b&w inside photo. Payment negotiable, however standard rates will be paid unless otherwise agreed in writing prior to publication." Pays on publication. Buys world rights; negotiable.

Tips: "Find a journalist to work in cooperation with."

***B-SIDE MAGAZINE**, P.O. Box 1860, Burlington NJ 08016. (609)387-9424. Photo Editor: Sandra C. Davis. Circ. 35,000. Estab. 1986. Bimonthly magazine. Emphasizes alternative/college music. Readers are average age 19-31, equal male/female split. Sample copy $5. Photo guidelines free with SASE.

Needs: Uses 50-60 photo/issue; 50% supplied by freelancers. Needs photos of personalities in music groups. Reviews photos purchased with accompanying ms only. Model release preferred for "touchy artists who may demand one."

Making Contact & Terms: Interested in receiving work from newer, lesser-known photographers. Send unsolicited photos by mail for consideration. Provide résumé, business card, brochure, flier or tearsheets to be kept on file for possible assignments. Query with stock photo list. Send 5×7 to 8×10 color b&w prints. SASE. Reports in 1 month. Pays $50-200/color cover photo; $25-75/color inside photo; $10-35/b&w inside photo. Pays on publication. Credit line given. Buys one-time rights.

 The maple leaf before a listing indicates that the market is Canadian.

Tips: "We look for a fresh approach: novel compositions, creative lighting, and, of course, focused shots! We're a good outlet for aggressive, young, photographers needing a fine starting point, since we're very flexible and encourage creativity! Make sure you understand how to supply a proper b&w shot. Publication shots are different than gallery shots."

***BUGLE MAGAZINE**, P.O. Box 8249, Missoula MT 59807-8249. (406)523-4573. Fax: (406)523-4550. Photo Coordinator: Kathy Woodford. Circ. 200,000. Estab. 1984. Publication of the Rocky Mountain Elk Foundation. Quarterly magazine. Nonprofit organization that specializes in elk, elk habitat and hunting. Readers are 98% hunters, both male and female; 54% are 35-54; 48% have income over $50,000. Sample copy $5. Photo guidelines free with SASE.
Needs: Uses 50 photos/issue; all supplied by freelancers. "*Bugle* editor sends out quarterly letter requesting specific images for upcoming issue." Model/property release required. Captions preferred; include name of photographer, location of photo, information on what is taking place.
Making Contact & Terms: Interested in receiving work from newer, lesser-known photographers. Send unsolicited photos by mail for consideration. Send 3 × 5 glossy prints; 35mm, 2¼ × 2¼, 4 × 5 transparencies. Deadlines: February 8 for summer issue; May 3 for fall issue; August 2 for winter issue; November 1 for spring issue. Does not keep samples on file. SASE. Reports in 1-2 weeks. Pays $250/cover photo; $150/spread; $100/full-page; $50/half page. Pays on publication. Credit line given. Rights negotiable. Previously published work OK.
Tips: "We look for high quality, unusual, dramatic and stimulating images of elk and other wildlife. Photos of elk habitat and elk in unique habitat catch our attention, as well as those depicting specific elk behavior. We are also interested in habitat project photos involving trick tanks, elk capture and release, etc. And images showing the effects of human development on elk habitat. Outdoor recreation photos are also welcome. Besides *Bugle* we also use images for billboards, brochures and displays. We work with both amateur and professional photographers, with the bulk of our editorial material donated."

BUSINESS IN BROWARD, P.O. Box 7375, Ft. Lauderdale FL 33338-7375. (305)563-8805. Publisher: Sherry Friedlander. Circ. 20,000. Estab. 1986. Bi-monthly magazine. Emphasizes business. Readers are male and female executives, ages 30-65. Sample copy $4.
• This company also publishes *Business in Palm Beach County.*
Needs: Uses 30-40 photos/issue; 75% supplied by freelancers. Needs photos of local sports, local people, ports, activities and festivals. Model/property release required. Photo captions required.
Making Contact & Terms: Contact through rep. Submit portfolio for review. Reports in 2 weeks. Pays $150/color cover photo; $75/color inside photo. Pays on publication. Buys one-time rights; negotiable. Previously published work OK.
Tips: "Know the area we service."

BUSINESS PHILADELPHIA, 260 S. Broad St., Philadelphia PA 19102. (215)735-6969. Fax: (215)735-6965. Design Director: Nicole Fichera. Monthly magazine. Emphasizes business through the eyes of business people. Readers are CEO's, presidents, vice presidents and other top-level business executives.
Needs: Uses 10-15 photos/issue; 5-10 supplied by freelancers. Needs portrait photos, studio and location shots and still lifes. Reviews photos with or without a manuscript. Model release preferred.
Making Contact & Terms: Interested in receiving work from newer, lesser-known photographers. Submit portfolio for review. Provide résumé, business card, brochure, flier or tearsheets to be kept on file for possible assignments. Keeps samples on file. Reports in 1-2 weeks. Pays $75-200/job; $100-200/feature story, plus expenses. Pays 30 days after acceptance. Credit line given. Buys one-time rights; negotiable. Previously published work OK.
Tips: "Photographers should work well with CEOs, presidents and other executives whose portraits they are taking, while providing unique and avante-garde concepts or styles to their photographs. While we do not offer much monetarily, *Business Philadelphia* offers photographers opportunities to experiment and create more artistic images than most business publications. Photographers should base the worth of an assignment using the amount of artistic control they have, as well as the dollar amounts being offered."

***CAGED BIRD HOBBYIST**, 5400 NW 84th Ave., Miami FL 33166. (305)592-9890. Fax: (305)592-9726. Editorial Director: Elizabeth McKey. Bimonthly magazine plus one special issue printed annually. Emphasizes primarily pet birds, plus some feature coverage of birds in nature. Sample copy $3 and 9 × 12 SASE. Photo guidelines free with SASE.
Needs: Needs photos of pet birds. Special needs arise with story schedule. Write for photo needs list. Common pet birds are always in demand (cockatiels, parakeets, etc.) Captions required; include common and scientific name of bird; additional description as needed.
Making Contact & Terms: Interested in receiving work from newer, lesser-known photographers. Send unsolicited photos by mail for consideration. Query with stock photo list. We cannot assure liability for originals. Photographers may wish to send duplicates. Send 4 × 6, 8 × 10 glossy color prints;

35mm, 2¼×2¼ transparencies. Deadlines: 3 months prior to issue of publication. Keeps samples on file. SASE. Reports in 2 months. Pays $150-250/color cover photo; $25-50/color inside photo. Pays on publication. Buys all rights; negotiable.
Tips: "We are looking for pet birds primarily; although we do feature some wildlife/nature/conservation bird articles. We look for good composition (indoor or outdoor). Photos must be professional and of publication quality—in focus and with proper contrast. We work regularly with a few excellent freelancers, but are always on the lookout for new contributors. Because we are a bimonthly, we do need to retain submissions on file for at least a few months."

CALLIOPE, World History for Young People, Cobblestone Publishing, Inc., 7 School St., Peterborough NH 03458. (603)924-7209. Fax: (603)924-7380. Freelance Picture Editor: Francelle Carapetyan. Circ. 10,500. Estab. 1990. Magazine published 5 times/year, September-May. Emphasis on non-United States history. Readers are children, ages 8-14. Sample copies $4.50 with 7½×10½ or larger SASE and 5 first-class stamps. Photo guidelines free with SASE.
Needs: Uses 40-45 photos/issue; 15% supplied by freelancers. Needs contemporary shots of historical locations, buildings, artifacts, historical reenactments and costumes. Reviews photos with or without accompanying ms. Model/property release preferred. Captions preferred.
Making Contact & Terms: Query with stock photo list. Send unsolicited photos by mail for consideration. Provide résumé, business card, brochure, flier or tearsheets to be kept on file for possible future assignments. Send b&w or color prints; 35mm transparencies. Samples kept on file. SASE. Reports in 1 month. Pays $15-100/inside b&w photo; cover (color) photo negotiated. Pays on publication. Credit line given. Buys one-time rights; negotiable. Simultaneous submissions and/or previously published work OK.
Tips: "Given our young audience, we like to have pictures which include people, both young and old. Pictures must be dynamic to make history appealing. Submissions must relate to themes in each issue."

CAMERA & DARKROOM, 9171 Wilshire Blvd., Suite 300, Beverly Hills CA 90210. (213)651-5400. Fax: (213)651-1289. Editor-in-Chief: Ana Jones. Executive Editor: Dave Howard. Circ. 43,000. Estab. 1979. Monthly publication. Emphasizes darkroom-related and general photographic subjects. Free editorial guide.
Needs: Uses 50% photos from stock; assigns 50%. Any subject if photography related. Model release required for covers, nudes, portraits. Property release preferred. Captions preferred; include camera, film, other technical information, title, date and location.
Making Contact & Terms: Interested in reviewing work from newer, lesser-known photographers. Query with samples. Send 8×10 or 11×14 glossy b&w prints and 35mm, 2¼×2¼, 4×5 or 8×10 color transparencies or 8×10 glossy color prints. Don't submit mounted prints. Uses color covers; vertical format required. SASE. Reports in 4-6 weeks. NPI. Pays on publication. Credit line given. Buys one-time rights.

✿**CAMPUS CANADA**, 287 MacPherson Ave., Toronto, Ontario M4V 1A4 Canada. (416)928-2909. Fax: (416)928-1357. Managing Editor: Sarah Moore. Circ. 125,000. Estab. 1983. Quarterly magazine. Emphasizes from university students to lifestyle magazine. Readers are primarily students 18-25. Free sample copy.
Needs: Uses 10 photos/issue; all supplied by freelancers. Needs photos of entertainment, travel, lifestyle, etc. Model release preferred.
Making Contact & Terms: Interested in receiving work from newer, lesser-known photographers. Query with résumé of credits. Keeps samples on file. SASE. Reports in 2 weeks. Pays on publication. Credit line given. Simultaneous submissions OK.

CAMPUS LIFE, 465 Gundersen Dr., Carol Stream IL 60188. Editor: Harold Smith. Photo Coordinator: Doug Johnson. Circ. 120,000. Estab. 1943. Monthly magazine except May/June and July/August. "*Campus Life* is a magazine for high school and college-age youth. We emphasize balanced living—emotionally, spiritually, physically and mentally." Sample copy $2. Photo guidelines free with SASE.
Needs: Buys 15 photos/issue; 10 supplied by freelancers. Head shots (of teenagers in a variety of moods); humorous, sport and candid shots of teenagers/college students in a variety of settings. "We want to see multiracial teenagers in different situations, and in many moods and expressions, at work, play, home and school. No travel, how-to, still life, travel scenics, news or product shots. Shoot for a target audience of 17-year-olds." Photos purchased with or without accompanying ms. Special needs include "Afro-American males/females in positive shots." Model/property release preferred for controversial stories. Captions preferred.
Making Contact & Terms: Interested in reviewing work from newer, lesser-known photographers. Submit portfolio for review. Query with résumé of credits. Provide résumé, business card, brochure, flier or tearsheets to be kept on file for possible assignments. Uses 6×9 glossy b&w prints and 35mm or larger transparencies. Keeps samples on file. SASE. Reports in 6 weeks. Pays $75-150/b&w photo; $75-300/color photo. Pays on publication. Credit line given. Buys one-time rights; negotiable. Simulta-

neous submissions and previously published work OK if marked as such.

Tips: "Ask for copies of past issues of *Campus Life*. Show work that fits our editorial approach. We choose photos that express the contemporary teen experience. We look for unusual lighting and color. Our guiding philosophy: that readers will 'see themselves' in the pages of our magazine." Looks for ability to catch teenagers in real-life situations that are well-composed but not posed. Technical quality, communication of an overall mood or emotion or action. "Look at a few issues to get a feel for what we choose. We're not interested in posed shots."

✤CANADIAN RODEO NEWS, 2116 27th Ave. NE, #223, Calgary, Alberta T2E 7A6 Canada. (403)250-7292. Fax: (403)250-6926. Editor: P. Kirby Meston. Circ. 4,000. Estab. 1964. Monthly tabloid. Emphasizes professional rodeo in Canada. Readers are male and female rodeo contestants and fans—all ages. Sample copy and photo guidelines free with SASE (9 × 12).
Needs: Uses 20-25 photos/issue; 3 supplied by freelancers. Needs photos of professional rodeo action or profiles. Photo captions are preferred; include identity of contestant/subject.
Making Contact & Terms: Interested in receiving work from newer, lesser-known photographers. Send unsolicited photos by mail for consideration. Phone to confirm if usable. Send any color/b&w print. Keeps samples on file. SASE. Reports in 1 month. Pays $15/color cover photo; pays $10/color inside photo; pays $10/b&w inside photo; pays $60-70/photo/text package. Pays on publication. Credit line given. Rights negotiable. Simultaneous submissions and/or previously published work OK.
Tips: "Photos must be from or pertain to professional rodeo in Canada. Phone to confirm if subject/material is suitable before submitting. *CRN* is very specific in subject."

✤CANADIAN YACHTING, 395 Matheson Blvd. E., Mississauga, Ontario L4Z 2H2 Canada. (905)890-1846. Fax: (905)890-5769. Editor: Graham Jones. Circ. 15,800. Estab. 1976. Bimonthly magazine. Emphasizes sailing (no powerboats). Readers are mostly male, highly educated, high income, well read. Sample copy free with 9 × 12 SASE.
Needs: Uses 28 photos/issue; all supplied by freelancers. Needs photos of all sailing/sailing related (keelboats, dinghies, racing, cruising, etc.). Model/property release preferred. Captions preferred.
Making Contact & Terms: Interested in receiving work from newer, lesser-known photographers. Submit portfolio for review. Query with stock photo list. Send unsolicited photos by mail for consideration. Send transparencies. SASE. Reports in 1 month. Pays $150-250/color cover photo; $30-70/color inside photo; $30-70/b&w inside photo. Pays 60 days after publication. Buys one-time rights. Simultaneous submissions and previously published work OK.

CANOE & KAYAK, Dept. PM, P.O. Box 3146, Kirkland WA 98083. (206)827-6363. Fax: (206)827-1893. Editor: Nancy Harrison Hill. Circ. 63,000. Estab. 1973. Bimonthly magazine. Emphasizes a variety of paddle sports, as well as how-to material and articles about equipment. For upscale canoe and kayak enthusiasts at all levels of ability. Also publishes special projects/posters. Free sample copy with 9 × 12 SASE.
Needs: Uses 30 photos/issue: 90% supplied by freelancers. Canoeing, kayaking, ocean touring, canoe sailing, fishing when compatible to the main activity, canoe camping but not rafting. No photos showing disregard for the environment, be it river or land; no photos showing gasoline-powered, multi hp engines; no photos showing unskilled persons taking extraordinary risks to life, etc. Accompanying mss for "editorial coverage strives for balanced representation of all interests in today's paddling activity. Those interests include paddling adventures (both close to home and far away), camping, fishing, flatwater, whitewater, ocean kayaking, poling, sailing, outdoor photography, how-to projects, instruction and historical perspective. Regular columns feature paddling techniques, conservation topics, safety, interviews, equipment reviews, book/movie reviews, new products and letters from readers." Photos only occasionally purchased without accompanying ms. Model release preferred "when potential for litigation." Property release required. Captions are preferred, unless impractical.
Making Contact & Terms Interested in reviewing work from newer, lesser-known photographers. Query or send material. "Let me know those areas in which you have particularly strong expertise and/or photofile material. Send best samples only and make sure they relate to the magazine's emphasis and/or focus. (If you don't know what that is, pick up a recent issue first, before sending me unusable material.) We will review dupes for consideration only. Originals required for publication. Also, if you have something in the works or extraordinary photo subject matter of interest to our audience, let me know! It would be helpful to me if those with substantial reserves would supply indexes by subject matter." Uses 5 × 7 and 8 × 10 glossy b&w prints; 35mm, 2¼ × 2¼ and 4 × 5 transparencies; for cover uses color transparencies; vertical format preferred. SASE. Reports in 1 month. Pays $300/cover color photo; $150/half to full page color photos; $100/full page or larger b&w photos; $75/quarter to half page color photos; $50/quarter or less color photos; $75/half to full page b&w photos; $50/quarter to half page b&w photos; $25/less than quarter b&w photos. NPI for accompanying ms. Pays on publication. Credit line given. Buys one-time rights, first serial rights and exclusive rights. Simultaneous submissions and previously published work OK, in noncompeting publications.

Tips: "We have a highly specialized subject and readers don't want just any photo of the activity. We're particularly interested in photos showing paddlers' *faces*; the faces of people having a good time. We're after anything that highlights the paddling activity as a lifestyle and the urge to be outdoors." All photos should be "as natural as possible with authentic subjects. We receive a lot of submissions from photographers to whom canoeing and kayaking are quite novel activities. These photos are often clichéd and uninteresting. So consider the quality of your work carefully before submission if you are not familiar with the sport. We are always in search of fresh ways of looking at our sport."

CAPE COD LIFE INCLUDING MARTHA'S VINEYARD AND NANTUCKET, P.O. Box 767, Cataumet MA 02534-0767. (508)564-4466. Fax: (508)564-4470. Publisher: Brian F. Shortsleeve. Circ. 35,000. Estab. 1979. Bimonthly magazine. Emphasizes Cape Cod lifestyle. "Readers are 55% female, 45% male, upper income, second home, vacation homeowners." Sample copy for $3.75. Photo guidelines free with SASE.
Needs: Uses 30 photos/issue; all supplied by freelancers. Needs "photos of Cape and Island scenes, people, places; general interest of this area." Reviews photos with or without a ms. Model release required. Property release preferred. Photo captions required; include location. Reviews photos with or without a ms.
Making Contact & Terms: Interested in receiving work from newer, lesser-known photographers. Submit portfolio for review. Send unsolicited photos by mail for consideration. Send 35mm, 2¼×2¼, 4×5 transparencies. Keeps samples on file. SASE. Pays $200/color cover photo; $25-200/b&w/color photo, depending on size. Pays 30 days after publication. Credit line given. Buys one-time rights; reprint rights for *Cape Cod Life* reprints; negotiable. Simultaneous submissions and previously published work OK.
Tips: Looks for "clear, somewhat graphic slides. Show us scenes we've seen hundreds of times with a different twist and elements of surprise."

THE CAPE ROCK, Southeast Missouri State University, Cape Girardeau MO 63701. (314)651-2156. Editor-in-Chief: Harvey Hecht. Circ. 1,000. Estab. 1964. Emphasizes poetry and poets for libraries and interested persons. Semiannual. Free photo guidelines.
Needs: Uses about 13 photos/issue; all supplied by freelance photographers. "We like to feature a single photographer each issue. Submit 25-30 thematically organized b&w glossies (at least 5×7), or send 5 pictures with plan for complete issue. We favor a series that conveys a sense of place. Seasons are a consideration too: we have spring and fall issues. Photos must have a sense of place: e.g., an issue featuring Chicago might show buildings or other landmarks, people of the city (no nudes), travel or scenic. No how-to or products. Sample issues and guidelines provide all information a photographer needs to decide whether to submit to us." Model release not required "but photographer is liable." Captions not required "but photographer should indicate where series was shot."
Making Contact & Terms: Send by mail for consideration actual b&w photos. Query with list of stock photo subjects. Submit portfolio by mail for review. SASE. Reporting time varies. Pays $100 and 10 copies on publication. Credit line given. Buys "all rights, but will release rights to photographer on request."
Tips: "We don't make assignments, but we look for a unified package put together by the photographer. We may request additional or alternative photos when accepting a package."

CAR CRAFT MAGAZINE, 6420 Wilshire Blvd., Los Angeles CA 90048. (213)782-2320. Fax: (213)782-2263. Editor: Charles Schifsky. Circ. 500,000. Estab. 1953. Monthly magazine. Emphasizes street machines, muscle cars and modern, high-tech performance cars. Readership is mostly males, ages 18-34.
Needs: Uses 100 photos/issue. Uses freelancers occasionally; all on assignment. Model/property release required. Captions preferred.
Making Contact & Terms: Interested in receiving work from newer, lesser-known photographers. Query with résumé of credits. Provide résumé, business card, brochure, flier or tearsheets to be kept on file for possible assignments. Send 35mm and 8×10 b&w prints; 35mm and 2¼×2¼ transparencies by mail for consideration. SASE. Reports in 1 month. Pays $35-75/b&w photo; $75-250/color photo, cover or text; $60 minimum/hour; $250 minimum/day; $500 minimum/job. Payment for b&w varies according to subject and needs. Pays on publication. Credit line given. Buys all rights.
Tips: "We use primarily b&w shots. When we need something special in color or see an interesting color shot, we'll pay more for that. Review a current issue for our style and taste."

CAREER FOCUS, Dept. PM, 250 Mark Twain Tower, 106 W 11th St., Kansas City MO 64105. (816)221-4404. Fax: (816)221-1112. Circ. 250,000. Estab. 1988. Bimonthly magazine. Emphasizes career development. Readers are male and female African-American and Hispanic professionals, ages 21-45. Sample copy free with 9×12 SAE and 4 first class stamps. Photo guidelines free with SASE.
Needs: Uses approximately 40 photos/issue. Needs technology photos and shots of personalities; career people in computer, science, teaching, finance, engineering, law, law enforcement, government,

hi-tech, leisure. Model release preferred. Captions required; include name, date, place, why.
Making Contact & Terms: Query with résumé of credits and list of stock photo subjects. Keeps
samples on file. SASE. Reports in 1 month. Pays $10-50/color photo; $5-25/b&w photo. Pays on
publication. Credit line given. Buys one-time rights. Simultaneous submissions and previously pub-
lished work OK.
Tips: "Freelancer must be familiar with our magazine to be able to submit appropriate manuscripts
and photos."

CAREER WOMAN, Equal Opportunity Publications, Inc., 150 Motor Parkway, Suite 420, Hauppauge
NY 11788-5145. (516)273-8643. Fax: (516)273-8936. Editor: Eileen Nester. Circ. 10,500. Estab. 1973.
Annual publication. Emphasizes career guidance and career opportunities for women. Readers are
college-age and entry-level professional women. Sample copy free with 9×12 SAE and 5 first-class
stamps.
Needs: Uses at least one photo per issue (cover); uses freelance work for covers and editorial; many
photos come from freelance writers who submit photos with their articles. Contact for needs. Model
release preferred. Captions required; include person's name and title.
Making Contact & Terms: Interested in receiving work from newer, lesser-known photographers.
Query with list of photo subjects. Send unsolicited prints or 35mm transparencies by mail for consider-
ation. SASE. Reports in 2 weeks. Pays $75/color and b&w photo; $100/cover shot. Pays on publication.
Credit line given. Buys one-time rights. Simultaneous submissions and previously published work OK,
"but not in competitive career-guidance publications."
Tips: "We are looking for clear color slides of women in a variety of professions and work environ-
ments. We are looking primarily for women (ages 25-35) who represent role models for our readers.
They should be dressed and groomed in a professional manner. We are open to using inside photos,
but freelancers should contact us and discuss upcoming stories before sending photos. Read our maga-
zine to get an idea of the editorial content. Contact us with ideas for cover shots. Cover photos do not
have to tie in to any particular story in the magazine, but they have to be representative of the magazine's
editorial content as a whole."

CAREERS & COLLEGES MAGAZINE, 989 Avenue of Americas, New York NY 10018. (212)563-
4688. Fax: (212)967-2531. Art Director: Michael Hofmann. Circ. 500,000. Estab. 1980. Biannual
magazine. Emphasizes college and career choices for teens. Readers are high school juniors and seniors,
male and female, ages 16-19. Sample copy $2.50 with 9×12 SAE and 5 first-class stamps.
Needs: Uses 4 photos/issue; 80% supplied by freelancers. Needs photos of teen situations, study or
career related, some profiles. Model release preferred. Property release required. Captions preferred.
Making Contact & Terms: Interested in receiving work from newer, lesser-known photographers.
Send tearsheets and promo cards. Keeps samples on file. SASE. Reports in 3 weeks. Pays $800-1,000/
color cover photo; $350-450/color inside photo; $600-800/color page rate. **Pays on acceptance**. Credit
line given. Buys one-time rights; negotiable.
Tips: "Must work well with teen subjects, hip, fresh style, not too corny. Promo cards or packets work
the best, business cards are not needed unless they contain your photography."

CARIBBEAN TRAVEL AND LIFE MAGAZINE, 8403 Colesville Rd., #830, Silver Spring MD 20910.
(301)588-2300. Fax: (301)588-2256. Production Editor: Sara Perez. Circ. 125,000. Estab. 1985. Pub-
lished bimonthly. Emphasizes travel, culture and recreation in islands of Caribbean, Bahamas and
Bermuda. Readers are male and female frequent Caribbean travelers, age 32-52. Sample copy $4.95.
Photo guidelines free with SASE.
Needs: Uses about 100 photos/issue; 90% supplied by freelance photographers: 10% assignment and
90% freelance stock. "We combine scenics with people shots. Where applicable, we show interiors,
food shots, resorts, water sports, cultural events, shopping and wildlife/underwater shots." Special
needs include "cover shots—attractive people on beach; striking images of the region, etc." Captions
preferred. "Provide thorough caption information. Don't submit stock that is mediocre."
Making Contact & Terms: Query with list of stock photo subjects. Uses 4-color photography. SASE.
Reports in 3 weeks. Pays $400/color cover photo; $150/color full page; $125/color ¾ page; $100/color
½ page and $75/color ¼ page; $75-400/color photo; $1,200-1,500 per photo/text package. Pays after
publication. Buys one-time rights. Does not pay research or holding fees.
Tips: Seeing trend toward "fewer but larger photos with more impact and drama. We are looking for
particularly strong images of color and style, beautiful island scenics and people shots—images that
are powerful enough to make the reader want to travel to the region; photos that show people doing
things in the destinations we cover; originality in approach, composition, subject matter. Good composi-
tion, lighting and creative flair. Images that are evocative of a place, creating story mood. Good use
of people. Submit stock photography for specific story needs, if good enough can lead to possible
assignments. Let us know exactly what coverage you have on a stock list so we can contact you when
certain photo needs arise."

CAROLINA QUARTERLY, Greenlaw Hall, CB#3520, University of North Carolina, Chapel Hill NC 27599-3520. Editor: Amber Vogel. Circ. 1,500. Estab. 1948. Emphasizes "current poetry, short fiction." Readers are "literary, artistic—primarily, though not exclusively, writers and serious readers." Sample copy $5.
Needs: Sometimes uses 1-8 photos/issue; all supplied by freelance photographers from stock. Often photos are chosen to accompany the text of the magazine.
Making Contact & Terms: Interested in receiving work from newer, lesser-known photographers. Send b&w prints by mail for consideration. SASE. Reports in 3 months, depending on deadline. NPI. Credit line given. Buys one-time rights.
Tips: "Look at a recent issue of the magazine to get a clear idea of its contents and design."

CASINO PLAYER, Bayport One, 8025 Black Horse Pike, Suite 470, West Atlantic City NJ 08232. Photo Editor: Rick Greco. Circ. 200,000. Estab. 1988. Monthly magazine. Emphasizes casino gambling. Readers are frequent gamblers, age 35 and up. Sample copy free with $8\frac{1}{2} \times 11$ SAE and $2 postage.
Needs: Uses 40-60 photos/issue; 5 supplied by freelancers. Needs photos of casinos, gambling, casino destinations, money, slot machines. Reviews photos with or without ms. Model release required for gamblers. Captions required; include name, hometown, titles.
Making Contact & Terms: Interested in receiving work from newer, lesser-known photographers. Query with résumé of credits. Reports in 3 months. Pays $200/color cover photo; $40/color inside photo; $20/b&w inside photo. Pays on publication. Credit line given. Buys all rights; negotiable.
Tips: "Know the magazine before submission."

CAT FANCY, Fancy Publications, Inc., P.O. Box 6050, Mission Viejo CA 92690. (714)855-8822. Editor-in-Chief: Debbie Phillips-Donaldson. Circ. 303,000. Estab. 1965. Readers are "men and women of all ages interested in all phases of cat ownership." Monthly. Sample copy $5.50. Photo guidelines and needs free with SASE.
Needs: Uses 20-30 photos/issue; all supplied by freelancers. "For purebred photos, we prefer shots that show the various physical and mental attributes of the breed. Include both environmental and portrait-type photographs. We also need good-quality, interesting b&w and color photos of mixed-breed cats for use with feature articles and departments." Model release required.
Making Contact & Terms: Send by mail for consideration actual 8×10 b&w photos; 35mm or $2\frac{1}{4} \times 2\frac{1}{4}$ color transparencies. No duplicates. SASE. Reports in 6 weeks. Pays $35-100/b&w photo; $50-250/color photo; and $50-450 for text/photo package. Credit line given. Buys first North American serial rights.
Tips: "Nothing but sharp, high contrast shots, please. Send SASE for list of specific photo needs. We are using more color photos and prefer more action shots, fewer portrait shots. We look for photos of all kinds and numbers of cats doing predictable feline activities—eating, drinking, grooming, being groomed, playing, scratching, taking care of kittens, fighting, being judged at cat shows and accompanied by people of all ages."

CATHOLIC NEAR EAST MAGAZINE, 1011 First Ave., New York NY 10022-4195. Fax: (212)838-1344. Editor: Michael LaCività. Circ. 100,000. Estab. 1974. Bimonthly magazine. A publication of Catholic Near East Welfare Association, a papal agency for humanitarian and pastoral support. *Catholic Near East* informs Americans about the traditions, faiths, cultures and religious communities of Middle East, Northeast Africa, India and Eastern Europe. Sample copy and guidelines available with SASE.
Needs: 60% supplied by freelancers. Prefers to work with writer/photographer team. Evocative photos of people—not posed—involved in activities; work, play, worship. Also interested in scenic shots and photographs of art objects and the creation of crafts, etc. Liturgical shots also welcomed. Extensive captions required if text is not available.
Making Contact & Terms: Interested in receiving work from newer, lesser-known photographers. Query first. "Please do not send an inventory, rather, send a letter explaining your ideas." SASE. Reports in 3 weeks; acknowledges receipt of material immediately. Credit line given. "Credits appear on page 3 with masthead and table of contents." Pays $50-150/b&w photo; $75-300/color photo; $20 maximum/hour; $60 maximum/day. Pays on publication. Buys first North American serial rights. Simultaneous submissions and previously published work OK, "but neither is preferred. If previously published please tell us when and where."
Tips: Stories should weave current lifestyles with issues and needs. Avoid political subjects, stick with ordinary people. Photo essays are welcomed.

***THE CATHOLIC WORLD**, 997 MacArthur Blvd., Mahwah NJ 07430. (201)825-7300. Fax: (201)825-8345. Managing Editor: Laurie Felknor. Circ. 6,000. Estab. 1865. Bimonthly magazine.
Needs: Buys 5-10 photos/issue. Human interest, some nature, religious (all religions).
Making Contact & Terms: Send material by mail for consideration. Uses 8×10 glossy b&w and color prints. SASE. Reports in 1 month. Pays $25-40/photo. Pays on publication. Credit line given.

Buys one-time rights. Simultaneous submissions and previously published work OK.
Tips: Photos of people must reflect current hairstyles, clothing, etc. Each issue of *The Catholic World* is on a specific theme. Send query as to themes for the 6 issues per year.

CATS MAGAZINE, P.O. Box 290037, Port Orange FL 32129. (904)788-2770. Fax: (904)788-2710. Editor: Tracey Copeland. Circ. 150,000. Estab. 1945. Monthly magazine. For cat enthusiasts of all types. Sample copy $3. Photo guidelines free with SASE.
• In 1994 this magazine received a Charlie award and four bronzes for writing and design excellence from the Florida Magazine Association.
Needs: Buys 50-60 photos/year; 70% of photography per issue is assigned; 30% from freelance. Felines of all types: photos depicting cats in motion and capturing feline expression are preferred; celebrities with their cats; head shots of cats; human interest on cats; humorous cats; feature photography; sport (cat shows); travel with cats; and wildlife (wild cats). No shots of clothed cats or cats doing tricks. Photos must not be over-propped (hats, bows, baskets, flowers etc.). Model/property release preferred. Photo captions preferred.
Making Contact & Terms: Submit sample photos to be kept on file for possible future assignments. Samples are reviewed upon arrival. Photos accepted are kept on file, the rest are returned. Send to Roy Copeland, Art Director. 35mm slides, 2¼×2¼ or 4×5 transparencies are preferred for feature photos and cover. SASE. Reports in 2 months. Pays $200-250/cover; $75/breed of the month; $25-200/various other, depending on size. Pays on publication. Buys first serial rights.
Tips: Label material clearly with name, address, phone, and breed/name of cats. Do not send oversized submissions. If purebred cats are used as subjects, they must be a high quality specimen of their breed. Photos must be clear, well composed and in focus. "Our most frequent causes for rejection: not preferred format; out of focus; cat image too small; backgrounds cluttered; too posed; too many props; uninteresting; poor quality purebred cats; dirty or scruffy cats; shot wrong shape for cover (must be vertical); colors untrue; exposure incorrect. Cats should be portrayed in a realistic manner. Submit your specialty (ie: outdoor cat scenes, portraits or realistic shots)."

***CD REVIEW**, 86 Elm St., Peterborough NH 03458. (603)924-7271. Fax: (603)924-7013. Editor-in-Chief: Lou Waryncia. Circ. 100,000. Estab. 1984. Monthly magazine. Emphasizes music and music/audio industries. Readers are primarily male, 80% college educated, average age 34. Sample copy $3.95.
Needs: Uses 20 photos/issue; 5-10 supplied by freelancers. Needs photos of musicians, recording artists. Special photo needs include greater emphasis on topical, cutting edge musicians. Captions preferred; include names of all appropriate individuals.
Making Contact & Terms: Interested in receiving work from newer, lesser-known photographers. Query with résumé of credits. Send unsolicited photos by mail for consideration. Provide résumé, business card, brochure, flier or tearsheets to be kept on file for possible assignments. Send 35mm, 2¼×2¼, 4×5, 8×10 transparencies. Keeps samples on file. SASE. Reports in 1 month. NPI. Pays on publication. Credit line given. Buys one-time rights; negotiable.

CHARISMA MAGAZINE, 600 Rinehart Rd., Lake Mary FL 32746. (407)333-0600. Design Manager: Mark Poulalion. Circ. 200,000. Monthly magazine. Emphasizes Christians. General readership. Sample copy $2.50.
Needs: Uses approximately 20 photos/issue; all supplied by freelance photographers. Needs editorial photos—appropriate for each article. Model release required. Captions preferred.
Making Contact & Terms: Send unsolicited photos by mail for consideration. Provide brochure, flier or tearsheets to be kept on file for possible assignments. Send color 35mm, 2¼×2¼, 4×5 or 8×10 transparencies. Cannot return material. Reports ASAP. Pays $300/color cover photo; $150/b&w inside photo; $50-150/hour or $400-600/day. Pays on publication. Credit line given. Buys all rights; negotiable. Simultaneous submissions and previously published work OK.
Tips: In portfolio or samples, looking for "good color and composition with great technical ability. To break in, specialize; sell the sizzle rather than the steak!"

THE CHESAPEAKE BAY MAGAZINE, 1819 Bay Ridge Ave., Annapolis MD 21403. (410)263-2662, (DC)261-1323. Art Director: Christine Gill. Circ. 35,000. Estab. 1972. Monthly. Emphasizes boating—Chesapeake Bay only. Readers are "people who use Bay for recreation." Sample copy available.
Needs: Uses "approximately" 32 photos/issue; 60% supplied by freelancers; 40% by freelance assignment. Needs photos that are Chesapeake Bay related (must); vertical powerboat shots are badly needed (color). Special needs include "vertical 4-color slides showing boats and people on Bay."
Making Contact & Terms: Interested in reviewing work from newer, lesser-known photographers. Query with samples or list of stock photo subjects. Send 35mm, 2¼×2¼, 4×5 or 8×10 transparencies by mail for consideration. SASE. Reports in 3 weeks. Pays $250/color cover photo; $25-75/b&w photo; $25-250/color photo; $150-1,000/photo/text package. Pays on publication. Credit line given. Buys one-time rights. Simultaneous submissions OK.

Tips: "We prefer Kodachrome over Ektachrome. Looking for: boating, bay and water-oriented subject matter. Qualities and abilities include: fresh ideas, clarity, exciting angles and true color. We're using larger photos—more double-page spreads. Photos should be able to hold up to that degree of enlargement. When photographing boats on the Bay—keep the 'safety' issue in mind. (People hanging off the boat, drinking, women 'perched' on the bow are a no-no!)"

***CHICAGO BEAR REPORT**, 112 Market St., Sun Prairie WI 53590. (608)837-5161. Fax: (608)825-3053. Managing Editor: Larry Mayer. Circ. 15,000. Estab. 1976. Published by Royal Communications Group. Tabloid published 26 times/year, weekly during NFL season and off-season issues. Emphasizes Chicago Bears and the NFL. Readers are male 25-45, professionals and manufacturers. Sample copy free with 9×12 SASE and 4 first-class stamps.
Needs: Uses 10-12 photos/issue; all supplied by freelancers. Needs photos of NFL games, player action shots, Chicago Bears action and posed shots. Captions preferred; include where, when, who, what.
Making Contact & Terms: Interested in receiving work from newer, lesser-known photographers. Arrange personal interview to show portfolio. Submit portfolio for review. Send unsolicited photos by mail for consideration. Send any size glossy color or b&w prints; 35mm, 2¼×2¼, 4×5, 8×10 transparencies. Keeps samples on file. SASE. Reports in 3 weeks. Pays $50/color cover photo; $50/color inside photo; $15-20/b&w inside photo. Pays on publication. Credit line given. Buys all rights; negotiable. Simultaneous submissions and previously published work OK.

CHICAGO RUNNER MAGAZINE, 7840 N. Lincoln Ave., Suite 204, Skokie IL 60077. (708)675-0200. Fax: (708)675-2903. Publisher: Eliot Wineberg. Circ. 50,000. Estab. 1991. Bimonthly magazine. Emphasizes Chicago running. Readers are male and female, ages 25-55. Sample copies available.
Needs: Uses 40 photos/issue. 90% supplied by freelancers. Needs photos of people running in Chicago. Reviews photos with or without ms. Model/property release is preferred. Captions preferred.
Making Contact & Terms: Interested in reviewing work from newer, lesser-known photographers. Send unsolicited photos by mail for consideration. Send any size b&w prints. Keeps samples on file. SASE. Reports in 1-2 weeks. NPI. **Pays on acceptance**. Credit line given. Simultaneous submissions and/or previously published work OK.

♣CHICKADEE MAGAZINE, 179 John St., Suite 500, Toronto, Ontario M5T 3G5 Canada. (416)971-5275. Fax: (416)971-5294. Photo Researcher: Robin Wilner. Circ. 110,000. Estab. 1979. Published 10 times/year, 1 summer issue. A natural science magazine for children under 9 years. Sample copy for $4.28 with 9×12 SAE and $1.50 money order to cover postage. Photo guidelines free.
Needs: Uses about 3-6 photos/issue; 1-2 supplied by freelance photographers. Needs "crisp, bright, close-up shots of animals in their natural habitat." Model/property release required. Captions required.
Making Contact & Terms: Interested in receiving work from newer, lesser-known photographers. Request photo package before sending photos for review. Send 35mm transparencies. Reports in 6-8 weeks. Pays $325 Canadian/color cover; $200 Canadian/color page; text/photo package negotiated separately. **Pays on acceptance.** Credit line given. Buys one-time rights. Previously published work OK.

CHILDREN'S DIGEST, P.O. Box 567, Indianapolis IN 46206. (317)636-8881. Fax: (317)684-8094. Editor: Sandy Grieshop. Circ. 106,000. Estab. 1950. Magazine published 8 times/year. Emphasizes health and fitness. Readers are preteens—kids 10-13. Sample copy $1.25. Photo guidelines free with SASE.
Needs: "We have featured photos of wildlife, children in other countries, adults in different jobs, how-to projects." *Reviews photos with accompanying ms only.* "We would like to include more photo features on nature, wildlife or anything with an environmental slant." Model release preferred.
Making Contact & Terms: Send complete manuscript and photos on speculation; 35mm transparencies. SASE. Reports in 10 weeks. Pays $50-100/color cover photo; $20/color inside photo; $10/b&w inside photo. Pays on publication. Buys one-time rights.

CHILDREN'S MINISTRY MAGAZINE, % Group Publishing, Inc., 2890 N. Monroe Ave., P.O. Box 481, Loveland CO 80538. (303)669-3836. Fax: (303)669-3269. Photo Editor: Karlin Walddner. Art Director: Rich Martin. Circ. 30,000. Estab. 1991. Bimonthly magazine. Provides ideas and support to adult workers (professional and volunteer) with children in Christian churches. Sample copy $1 with 9×12 SAE. Photo guidelines free with SASE.
 ● This publication is interested in receiving work on PhotoCD.
Needs: Uses 20-25 photos/issue; 1-3 supplied by freelancers. Needs photos of children (infancy—6th grade) involved in family, school, church, recreational activities; with or without adults; generally upbeat and happy. Reviews photos with or without a manuscript. Especially needs good portrait-type shots of individual children, suitable for cover use; colorful, expressive. Model release required when

people's faces are visible and recognizable and could be used to illustrate a potentially embarrassing subject. Captions not needed.

Making Contact & Terms: Interested in reviewing work from newer, lesser-known photographers, "if they meet our stated requirements." Query with list of stock photo subjects. Send unsolicited photos by mail for consideration. Send 8×10 glossy b&w prints; 35mm, 2¼×2¼ transparencies. SASE. Reports in 1 month. Pays minimum $150/color cover photo; minimum $75/color inside photo; $40-60/b&w inside photo. Pays on publication. Credit line given. Buys one-time rights. Simultaneous submissions and previously published work OK.

Tips: Wants to see "sharp, well-composed and well-exposed shots of children from all walks of life; emphasis on the active, upbeat colorful; ethnic mix is highly desirable." To be considered, "photos must appear current and contemporary. Professionalism must be evident in photos and their presentation. No under- or overexposed 'snapshot'-style photos, please."

CHILDREN'S PLAYMATE, Dept. PM, P.O. Box 567, Indianapolis IN 46206. (317)636-8881. Editor: Sandy Grieshop. Circ. 117,820. Published 8 times/year. Emphasizes better health for children. Readers are children between the ages of 6-8. Sample copy $1.25 with 5×7 SASE. Photo guidelines free with SASE.

Needs: Number of photos/issue varies; all supplied by freelancers. *Reviews photos with accompanying ms only.* Model release required. Captions preferred.

Making Contact & Terms: Send unsolicited photos, accompanied by ms. Uses b&w prints and 35mm transparencies. SASE. Reports in 8-10 weeks. Pays $5 minimum/b&w inside photo; $15 minimum/color inside photo. Pays on publication. Credit line given. Buys one-time rights.

CHILE PEPPER, P.O. Box 80780, Albuquerque NM 87198. (505)266-8322. Fax: (505)266-2127. Art Director: Lois Bergthold. Bimonthly magazine. Emphasizes world cuisine, emphasis on hot, spicy foods and chile peppers. Readers are male and female consumers of spicy food, age 35-55. Circ. 70,000. Estab. 1986. Sample copy $3.95. Photo guidelines not available.

Needs: Uses 8-12 photos/issue; 10-20% supplied by freelancers. Needs photos of still life ingredients, location shots specifically of locales which are known for spicy cuisine, shots of chiles. Reviews photos with or without a ms. "We will be doing features on the cuisine of India, Africa, Malaysia, Louisiana, Mexico, Arizona and the Caribbean." Model/property release preferred. Captions required; include location and species of chile (if applicable).

Making Contact & Terms: Query with stock photo list. Send unsolicited photos by mail for consideration. Provide résumé, business card, brochure, flier or tearsheets to be kept on file for possible assignments. Send b&w/color prints; 35mm, 4×5, 8×10 transparencies. Keeps samples on file. SASE. Reports in 3 weeks. Pays $150/color cover photo; $50/color inside photo; $25/b&w inside photo. Pays on publication. Credit line given. Buys one-time rights. Simultaneous submissions and/or previously published work OK.

Tips: "Looking for shots that capture the energy and exotica of locations, and still-life food shots that are not too classical, with a 'fresh eye' and interesting juxtapositions."

THE CHRISTIAN CENTURY, 407 S. Dearborn St., Chicago IL 60605. (312)427-5380. Fax: (708)427-1302. Production Coordinator: Matthew Giunti. Circ. 32,000. Estab. 1884. Weekly journal. Emphasis on religion. Readers are clergy, scholars, laypeople, male and female, ages 40-85. Sample copy $2. Photo guidelines free with SASE.

Needs: Buys 50 photos/year; all supplied by freelancers; 75% comes from stock. People of various races and nationalities; celebrity/personality (primarily political and religious figures in the news); documentary (conflict and controversy, also constructive projects and cooperative endeavors); scenic (occasional use of seasonal scenes and scenes from foreign countries); spot news; and human interest (children, human rights issues, people "in trouble," and people interacting). Photos with or without accompanying ms. For accompanying mss seeks articles dealing with ecclesiastical concerns, social problems, political issues and international affairs. Model/property release preferred. Captions preferred; include name of subject and date.

Making Contact & Terms: Interested in reviewing work from newer, lesser-known photographers. "Send crisp black-and-white images. We will consider a stack of photos in one submission. Send cover letter with prints. Don't send negatives or color prints." Uses 8×10 b&w prints. Does not keep samples on file. SASE. Reports in 1 month. Pays $50/b&w cover photo; $25/b&w inside photo. Pays on publication. Credit line given. Buys one-time rights; negotiable. Simultaneous submissions and previously published work OK.

Tips: Looks for diversity in gender, race, age and religious settings. Photos should reproduce well on newsprint.

CHRISTIAN HISTORY, 465 Gundersen Dr., Carol Stream IL 60188. (708)260-6200. Fax: (708)260-0114. Art Director: Rai Whitlock. Quarterly magazine. Emphasizes history of Christianity. Readers are educated, history buffs. Sample copy $5.50.

Needs: Uses 50 photos/issue; 20% supplied by freelancers. Needs photos of history. Captions required; include site and date, artist, subject.

Making Contact & Terms: Interested in reviewing work from newer, lesser-known photographers. Provide résumé, business card, brochure, flier or tearsheets to be kept on file for possible assignments. Does not keep samples on file. SASE. Reports in 1 month. Pays $100-200/color cover photo; $50-100/b&w cover photo; $50-75/color inside photo; $10-40/b&w inside photo. Pays on publication. Credit line given. Buys one-time rights.

THE CHRONICLE OF THE HORSE, P.O. Box 46, Middleburg VA 22117. (703)687-6341. Fax: (703)687-3937. Editor: John Strassburger. Cir. 23,000. Estab. 1937. Weekly magazine. Emphasizes English horse sports. Readers range from young to old. "Average reader is a college-educated female, middle-aged, well off financially." Sample copy for $2. Photo guidelines free with SASE.

Needs: Uses 10-25 photos/issue; 90% supplied by freelance photographers. Needs photos from competitive events (horse shows, dressage, steeplechase, etc.) to go with news story or to accompany personality profile. "A few stand alone. Must be cute, beautiful or news-worthy. Reproduced in b&w." Prefer purchasing photos with accompanying ms. Special photo needs include good photos to accompany our news stories, especially horse shows. Captions required with every subject identified.

Making Contact & Terms: Interested in receiving work from newer, lesser-known photographers. Query with idea. Send b&w and color prints (reproduced b&w). SASE. Reports in 3 weeks. Pays $15-30/photo/text package. Pays on publication. Credit line given. Buys one-time rights. Prefer first North American rights. Simultaneous submissions and previously published work OK.

Tips: "We do not want to see portfolio or samples. Contact us first, preferably by letter. Know horse sports."

THE CHURCH HERALD, 4500 SE 60th St., Grand Rapids MI 49512-9642. (616)698-7071. Editor: Jeffrey Japinga. Associate Editor: Terry A. DeYoung. Circ. 100,000. Published 11 times/year. Emphasizes current events, family living, evangelism and spiritual growth, from a Christian viewpoint. For members and clergy of the Reformed Church in America. Sample copy $2 with 9 × 12 SAE.

Needs: Buys 1-2 photos/issue; 10% freelance photography/issue and 90% from compact disc. Needs photos of life situations—families, couples, vacations, school; religious, moral and philosophical symbolism; seasonal and holiday themes. Interested in images that depict local church life and the connection of church with culture.

Making Contact & Terms: Send photos for consideration. SASE. Reports in 1 month. Pays $35/b&w inside photo; $70/color inside photo; $150/color cover photo. **Pays on acceptance.** Buys first serial rights, second serial (reprint) rights, first N.A. serial rights or simultaneous rights. Simultaneous submissions and/or previously published work OK.

Tips: Looks for "good photo quality—photos that our readers will relate to in a positive way—a lot of what we get are junk photos we can't use. We use very few nature scenes. Have an understanding of the kinds of articles we run. I want to see interesting photos of good quality that depict real-life situations. We're using more color and commissioning more. Don't send me a list of what you have unless it's accompanied by a selection of photos. I'm happy to look at someone's work, but I'm frustrated by résumés and checklists."

CIRCLE K MAGAZINE, 3636 Woodview Trace, Indianapolis IN 46268. (317)875-8755. Executive Editor: Nicholas K. Drake. Circ. 15,000. Published 5 times/year. For community service-oriented college leaders "interested in the concept of voluntary service, societal problems, leadership abilities and college life. They are politically and socially aware and have a wide range of interests."

Needs: Assigns 0-5 photos/issue. Needs general interest photos, "though we rarely use a nonorganization shot without text. Also, the annual convention requires a large number of photos from that area." Prefers ms with photos. Seeks general interest features aimed at the better-than-average college student. "Not specific places, people topics." Captions required, "or include enough information for us to write a caption."

Making Contact & Terms: Works with freelance photographers on assignment only basis. Provide calling card, letter of inquiry, résumé and samples to be kept on file for possible future assignments. Send query with résumé of credits. Uses 8 × 10 glossy b&w prints or color transparencies. Uses b&w and color covers; vertical format required for cover. SASE. Reports in 3 weeks. Pays up to $225-350 for text/photo package, or on a per-photo basis—$15 minimum/b&w print and $70 minimum/cover. **Pays on acceptance.** Credit line given. Previously published work OK if necessary to text.

CLASSIC AUTO RESTORER, P.O. Box 6050, Mission Viejo CA 92690. (714)855-8822. Fax: (714)855-3045. Editor: Brian Mertz. Circ. 100,000. Estab. 1989. Monthly magazine. Emphasizes restoration of collector cars. Readers are male (98%), professional/technical/managerial, ages 35-55. Sample copy $5.50.

Needs: Uses 100 photos/issue; 95% supplied by freelancers. Needs photos of auto restoration projects and restored cars; related events such as tours, swap meets, auctions and vintage races. Reviews photos

with accompanying ms only. Model/property release preferred. Captions required; include year, make and model of car; identification of people in photo.

Making Contact & Terms: Interested in receiving work from newer, lesser-known photographers. Submit inquiry and portfolio for review. Provide résumé, business card, brochure, flier or tearsheets to be kept on file for possible assignments. Prefers transparencies, mostly 35mm, 2¼×2¼. Does not keep samples on file. SASE. Reports in 1 month. Pays $200-300/color cover photo; $100/color page rate; $100/b&w page rate; $100/page for photo/test package; $30-100/color or b&w photo. Pays on publication. Credit line given. Buys first North American serial rights; negotiable. Simultaneous submissions OK.

Tips: Looks for "technically proficient or dramatic photos of various automotive subjects, auto portraits, detail shots, action photos, good angles, composition and lighting."

***CLASSIC TOY TRAINS**, 21027 Crossroads Circle, Waukesha WI 53187. (414)796-8776. Fax: (414)796-1383. Editor: Roger Carp. Circ. 75,000. Estab. 1987. Magazine published 8 times/year (Jan., Feb., Mar., May, July, Sept., Nov., Dec.). Emphasizes collectible toy trains (O scale, S scale, Standard gauge, G scale) Lionel, American Flyer, Marx, Dorfan. Readers are high-income male professionals, average age mid-40s. Sample copy $3.95 plus shipping and handling. Photo guidelines free with SASE.

Needs: Uses 35 photos/issue; number supplied by freelancers varies. Needs photos of toy train collections and layouts. Captions preferred; include toy train scale, manufacturer, model number, collector's name and address.

Making Contact & Terms: Interested in receiving work from newer, lesser-known photographers. Send unsolicited photos by mail for consideration. Send 5×7 glossy color prints; 35mm, 4×5 transparencies. Does not keep samples on file. SASE. Reports in 1 month. Pays $75/page; $200/cover ($15 minimum). Pays on acceptance. Credit line given. Buys all rights; negotiable.

Tips: "Reviewing a couple back issues of *Classic Toy Trains* will give the best idea of the material we're interested in. Familiarity with toy train subject is very helpful."

CLUB MODÈLE MAGAZINE, (formerly *Model And Performer Magazine*), P.O. Box 15760, Stamford CT 06901-0760. Phone/fax: (203)967-9952. Monthly magazine. Emphasizes modeling, fashion and entertainment. Readers are male and female, ages 18-55 (agents, managers, producers, fashion designers, models, talents, photographers). Sample copy $4. Photo guidelines free with SASE.

Needs: Uses 50 photos/issue; 35-45% supplied by freelancers. Needs photos of personalities, models and entertainers. Model/property release required. Captions required.

Making Contact & Terms: Interested in receiving work from newer, lesser-known photographers. Query with stock photo list. Send unsolicited photos by mail for consideration. Send any size, any finish color and b&w prints; 35mm, 2¼×2¼, 4×5, 8×10 transparencies. Keeps samples on file. SASE. Reports in 1 month. Pays $25-100/b&w inside photo; $25-100/color page rate; purchases of 20-1,000 are negotiated. **Pays on acceptance.** Credit line given. Buys one-time rights, first North American serial rights, all rights; negotiable. Simultaneous submissions OK.

Tips: Make sure your work captures the essence and personality of the model. Send creative images—beauty and glamour with a special touch. Become familiar with the content of the publication and offer better images than those published.

COBBLESTONE: THE HISTORY MAGAZINE FOR YOUNG PEOPLE, Cobblestone Publishing, Inc., 7 School St., Peterborough NH 03458. (603)924-7209. Freelance Photo Editor: Francelle Carapetyan. Circ. 36,000. Estab. 1980. Publishes 10 issues/year, September-June. Emphasizes American history; each issue covers a specific theme. Readers are children 8-14, parents, teachers. Sample copy for $4.50 and 8×11 SAE with 5 first-class stamps. Photo guidelines free with SASE.

Needs: Uses about 40 photos/issue; 5-10 supplied by freelance photographers. "We need photographs related to our specific themes (each issue is theme-related) and urge photographers to request our themes list." Model release required. Captions preferred.

Making Contact & Terms: Query with samples or list of stock photo subjects. Send 8×10 glossy b&w prints, or 35mm or 2¼×2¼ transparencies. SASE. "Photos must pertain to themes, and reporting dates depend on how far ahead of the issue the photographer submits photos. We work on issues 6 months ahead of publication." Cover photo (color) negotiated; $15-100/inside b&w use. Pays on publication. Credit line given. Buys one-time rights. Simultaneous submissions and previously published work OK.

Tips: "In general, we use few contemporary images; most photos are of historical subjects. However, the amount varies with each monthly theme."

COLLAGES & BRICOLAGES, P.O. Box 86, Clarion PA 16214. Editor: Marie-José Fortis. Estab. 1986. Annual magazine. Emphasizes literary works, avant-garde, poetry, fiction, plays and nonfiction. Readers are writers and the general public in the U.S. and abroad. Sample copy $6.

Needs: Uses 5-10 photos/issue; all supplied by freelancers. Needs photos that make a social statement, surrealist photos and photo collages. Reviews photos (only in fall, August-December) with or without

a ms. Photo captions preferred; include title of photo and short biography of artist/photographer.
Making Contact & Terms: Send unsolicited photos by mail for consideration. Send matte b&w prints. SASE. Reports in 3 months. Pays in copies. Simultaneous submissions and/or previously published work OK.
Tips: *"C&B* is primarily meant for writers. It will include photos if: a) they accompany or illustrate a story, a poem or an essay; b) they constitute the cover of a particular issue; or c) they make a statement (political, social, spiritual)."

***COLLECTOR CAR & TRUCK PRICES**, 41 N. Main St., N. Grafton MA 01536-1559. (508)839-6707. Fax: (508)839-6266. Production Director: Kelly Hulitzky. Circ. 20,000. Estab. 1994. Bimonthly magazine. Emphasizes old cars and trucks. Readers are primarily males, ages 30-60. Sample copy free with SASE and 6 first-class stamps.
Needs: Uses 3 photos/issue; all supplied by freelancers. Needs photos of old cars and trucks. Model/property release required. Captions required; include year, make and model. Provide résumé, business card, brochure, flier or tearsheets to be kept on file for possible assignments. Does not keep samples on file. SASE. Reports in 1 month. Pays $150-200/color cover photo; $100-125/b&w inside photo. Pays net 30 days. Buys one-time rights. Previously published work OK.

***COLLECTOR EDITIONS**, 170 Fifth Ave., 12th Floor, New York NY 10010. (212)989-8700. Fax: (212)645-8976. Art Director: Caroline Meyers. Circ. 100,000. Estab. 1973. Magazine published 7 times/year. Emphasizes collectibles: glass, plates, cottages, dolls, figurines, antiques, prints, etc. Readers are females, 45 years old and over. Sample copy $4.
Needs: Uses 200 photos/issue; less than 10% assigned to freelancers. Photo assignments of collectible items (product shots). Model/property release required for interior arrangements with props or on location.
Making Contact & Terms: Interested in assigning work to newer, lesser-known photographers. Provide résumé, business card, brochure, flier or tearsheets to be kept on file for possible assignments. Deadlines discussed at time of assignment. Keeps samples on file. SASE. Reports in 2 weeks. Pays up to $500/day; plus expenses. Pays 4-6 weeks after assignment is completed. Credit line given. Buys first North American serial rights.

COLLEGE PREVIEW, 106 W. 11th St., #250, Kansas City MO 64105-1806. (816)221-4404. Fax: (816)221-1112. Editor: Neoshia Michelle Paige. Circ. 600,000. Bimonthly magazine. Emphasizes college and college-bound African-American and Hispanic students. Readers are African-American, Hispanic, ages 16-24. Sample copy free with 9×12 SAE and 4 first-class stamps.
• This publication is moving its offices, but at *Photographer's Market* press time, it doesn't know where. We recommend calling before querying.
Needs: Uses 30 photos/issue. Needs photos of students in class, at work, in interesting careers, on-campus. Special photo needs include computers, military, law and law enforcement, business, aerospace and aviation, health care. Model/property release required. Captions required; include name, age, location, subject.
Making Contact & Terms: Interested in receiving work from newer, lesser-known photographers. Query with résumé of credits. Query with ideas and SASE. Reports in 1 month, "usually less." Pays $10-50/color photo; $5-25/b&w inside photo. Pays on publication. Buys first North American serial rights. Simultaneous submissions and/or previously published work OK.

COLLISION, (formerly *Wheelings*), P.O. Box M, Franklin MA 02038-0912. (508)528-6211. Editor: J.A. Kruza. Circ. 15,000. Magazine published 9 times a year. Readers are auto dealers, body shops and tow truck operators in northeastern US. Photo guidelines free.
Needs: Uses 100 photos/issue; usually 30% supplied by freelance photographers. "We are looking for feature stories on specific business or technological aspects of work." Captions required.
Making Contact & Terms: Query with samples. SASE. Reports in 2 weeks. Pays $25 first photo; $15 for each additional photo; buys 5-6 photos in a series. **Pays on acceptance.** Credit line given. Reassigns rights to photographer after use. Simultaneous submissions and previously published work OK.

COLORADO HOMES & LIFESTYLES MAGAZINE, 7009 S. Potomac, Englewood CO 80112. (303)397-7600. Fax: (303)397-7619. Art Director: Elaine St. Louis. Circ. 45,000. Estab. 1980. Bimonthly magazine. Emphasizes interior design, architecture of homes and lifestyles of people in Colorado. Primary readers are women, 35-55, the majority of them homeowners. Sample copies available.
Needs: Uses approximately 100 photos/issue; roughly one-third supplied by freelancers. Needs photos of home interiors, architecture, people (by assignment only), travel, food and entertaining, gardening, home products, etc. Reviews photos with accompanying ms only. "We will review photographers' books for possible future assignments." Model/property release required for private homes and people. Captions required; include what and where.

Making Contact & Terms: Interested in receiving work from newer, lesser-known photographers. Arrange personal interview to show portfolio. Send unsolicited photos by mail for consideration with SASE if you would like them returned. Provide résumé, business card, brochure, flier or tearsheets to be kept on file for possible assignments. Send 5×7 or larger prints; 35mm, 2¼×2¼, 4×5, 8×10 transparencies. Keeps samples on file. Reports within 3 months. Pays $75-400/job for a feature story with 5 shots; $50-200/color photo; $50-75/b&w photo. **Pays on acceptance.** Credit line given. Rights negotiable. Simultaneous submissions and/or previously published work OK.

Tips: "Our primary subject matter is homes. With very rare exceptions, subjects must be in Colorado. Particular attention to refined talent with subtle, controlled lighting, both tungsten and daylight/strobe. If you shoot homes for another (Colorado) client—interior designer, architect, etc.—consider submitting to us; that's a good way to break in because we don't have to pay, and we're *very* budget-conscious."

COMBO MAGAZINE, (formerly *Card Collectors Price Guide*), 155 E. Ames Court, Plainview NY 11803. (516)349-9494. Fax: (516)349-9516. Editor-in-Chief: Doug Kale. Circ. 150,000. Estab. 1992. Monthly. Emphasizes movies, outer space, science fiction, super heroes, cartoons, fantasy art. Readers are male and female, ages 9-99. Free sample copy.

Needs: Uses 1-2 photos/issue; all supplied by freelancers. Needs studio shots, graphics (computerized), shots of famous personalities, movie stars, music stars, etc. Special photo needs include studio shots, action shots. Property release required.

Making Contact & Terms: Interested in receiving work from newer, lesser-known photographers. Send unsolicited photos by mail for consideration. Send 8×10 glossy color prints. Cannot return material. Reports in 2 weeks. Pays $75-150/job. Pays on publication. Credit line given. Buys all rights; negotiable. Simultaneous submissions OK.

***COMPLETE WOMAN**, 875 N. Michigan Ave., Suite 3434, Chicago IL 60611-1901. Art Director: Sheri L. Darnall. Estab. 1980. Bimonthly magazine. General interest magazine for women. Readers are "females, 21-40, from all walks of life."

Needs: Uses 50-60 photos/issue. Needs "high-contrast shots of attractive women, how-to beauty shots, women with men, etc." Model release required. Captions preferred.

Making Contact & Terms: Interested in receiving work from newer, lesser-known photographers. Query with list of stock photo subjects. Send unsolicited photos by mail for consideration. Provide résumé, business card, brochure, flier or tearsheets to be kept on file for possible assignments. Send b&w, color prints; 35mm transparencies. SASE. Reports in 1 month. Pays $75/color inside photo; $50/ b&w inside photo. Pays on publication. Credit line given. Buys one-time rights. Simultaneous and previously published work OK.

CONDE NAST TRAVELER, 360 Madison Ave., New York NY 10017. Has very specific needs and contacts a stock agency when seeking shots.

CONFRONTATION: A LITERARY JOURNAL, English Dept., C.W. Post of L.I.U., Brookville NY 11548. (516)299-2391. Fax: (516)299-2735. Editor: Martin Tucker. Circ. 2,000. Estab. 1968. Semiannual magazine. Emphasizes literature. Readers are college-educated lay people interested in literature. Sample copy $3.

Needs: Reviews photos with or without a manuscript. Captions preferred.

Making Contact & Terms: Interested in reviewing work from newer, lesser-known photographers. Query with résumé of credits. Query with stock photo list. Reports in 1 month. Pays $25-100/b&w photo; $50-100/color cover photo; $20-40/b&w page rate; $100-300/job. Pays on publication. Credit line given. Buys first North American serial rights; negotiable. Simultaneous submissions OK.

***THE CONNECTION PUBLICATION OF NJ, INC.**, P.O. Box 2122, Teaneck NJ 07666. (201)692-1512. Fax: (201)692-1655. Editor: Ralph F. Johnson. Weekly tabloid. Readers are male and female executives, ages 18-62. Circ. 25,000. Estab. 1982. Sample copy $1.50 with 9×12 SAE.

Needs: Uses 12 photos/issue; 4 supplied by freelancers. Needs photos of personalities. Reviews photos with accompanying ms only. Photo captions required.

Making Contact & Terms: Send unsolicited photos by mail for consideration. Send b&w prints. Keeps samples on file. SASE. Reports in 2 weeks. NPI; negotiable. Pays on publication. Credit line given. Buys one-time rights; negotiable. Previously published work OK.

Tips: "Work with us on price."

CONSERVATIONIST MAGAZINE, Editorial Office, NYSDEC, 50 Wolf Rd., Albany NY 12233-4502. (518)457-5547. Contact: Photo Editor. Circ. 120,000. Estab. 1946. Bimonthly nonprofit, New York State government publication. Emphasizes natural history, environmental, and outdoor interests pertinent to New York State. Readers are people interested in nature and environmental quality issues. Sample copy $3 and 8½×11 SASE. Photo guidelines free with SASE.

Publications/Consumer 255

Needs: Uses 40 photos/issue; 80% supplied by freelance photographers. Needs wildlife shots, people in the environment, outdoor recreation, forest and land management, fisheries and fisheries management, environmental subjects (pollution shots, a few), effects of pollution on plants, buildings, etc. Model release preferred. Captions required.

Making Contact & Terms: Interested in reviewing work from newer, lesser-known photographers. Query with samples. Send 35mm, 2¼×2¼, 4×5 or 8×10 transparencies by mail for consideration. Submit portfolio for review. Provide résumé, business card, brochure, flier or tearsheets to be kept on file for possible future assignments. Reports in 3 weeks. Pays $15/b&w or color photo. Pays on publication. Buys one-time rights. Simultaneous submissions and previously published work OK.

Tips: Looks for "artistic interpretation of nature and the environment," unusual ways of picturing environmental subjects (even pollution, oil spills, trash, air pollution, etc.); wildlife and fishing subjects at all seasons. Try for unique composition, lighting. Technical excellence a must.

COUNTRY, 5925 Country Lane, Greendale WI 53129. (414)423-0100. Fax: (414)423-1143. Editorial Assistant: Trudi Bellin. Estab. 1987. Bimonthly magazine. "For those who live in or long for the country." Readers are rural-oriented, male and female. "*Country* is supported entirely by subscriptions and accepts no outside advertising." Sample copy $2. Photo guidelines free with SASE.

Needs: Uses 150 photos/issue; 20% supplied by freelancers. Needs photos of scenics—country only. Model/property release required. Captions preferred; include season, location.

Making Contact & Terms: Interested in receiving work from newer, lesser-known photographers. Query with list of stock photo subjects. Send unsolicited photos by mail for consideration. Send 35mm, 2¼×2¼, 4×5 and 8×10 transparencies. Tearsheets kept on file but not dupes. SASE. Reports "as soon as possible; sometimes days, other times months." Pays $200/color cover photo; $50-125/color inside photo; $150/color page (full page bleed); $10-50/b&w photo. Pays on publication. Credit line given. Buys one-time rights. Previously published work OK.

Tips: "Technical quality is extremely important: focus must be sharp, no soft focus; colors must be vivid so they 'pop off the page.' Study our magazine thoroughly—we have a continuing need for sharp, colorful images, and those who can supply what we need can expect to be regular contributors."

COUNTRY JOURNAL, 4 Highridge Park, Stamford CT 06905. (203)321-1709. Art Director: Robin Demougeot. Circ. 166,000. Estab. 1974. Bimonthly magazine. Emphasizes practical concerns and rewards of life in the country. Sample copy for $4. Photo guidelines free with SASE.

Needs: Uses 40 photos/issue; 95% supplied by freelance photographers. Needs photos of animal/wildlife, country scenics, vegetable and flower gardening, home improvements, personality profiles, environmental issues and other subjects relating to rural life. Model release required. Captions required.

Making Contact & Terms: Provide résumé, business card, brochure, flier or tearsheets to be kept on file for possible assignments. Send b&w prints and 35mm, 2¼×2¼, 4×5 and 8×10 prints with SASE by return mail for consideration. Reports in 1 month. Pays $500/color and b&w cover photo; $135/quarter page color and b&w page inside photo; $235/color and b&w page rate; $275-325/day. Pays on publication. Credit line given. Buys one-time rights. Simultaneous submissions OK.

Tips: "Know who you are submitting to. You can waste time, money and a possible opportunity by sending inappropriate samples and queries. If you can't find samples of the publication, call or send for them."

COUNTRY SAMPLERS WEST, 707 Kautz Rd., St. Charles IL 60174. (708)377-8000. Fax: (708)377-1757. Art Director: Dan Masini. Circ. 110,000. Estab. 1990. Bimonthly magazine. Emphasizes western design, homes and interiors. Readers are female homeowners, ages 30-50. Sample copy free with 9×11 SASE.

Needs: Uses 50-100 photos/issue; all supplied by freelancers. Needs photos of travel, personality, scenic. Model release required. Captions required; include who, what, where, when.

Making Contact & Terms: Interested in receiving work from newer, lesser-known photographers. Submit portfolio for review. Query with stock photo list. Provide résumé, business card, brochure, flier or tearsheets to be kept on file for possible assignments. Keeps samples on file. SASE. Reports in 2-3 months. Pays $200-600/day; $50-250/color inside photo; $50-500/photo/text package. **Pays on acceptance.** Credit line given. Buys first and second North American serial rights; negotiable. Simultaneous submissions and previously published work OK.

Tips: Portfolios should show an "ability to capture light, natural-looking people shots, expertise in area of specialization. Customize queries to the publication. Know the market."

COUNTRY WOMAN, Dept. PM, P.O. Box 643, Milwaukee WI 53201. Managing Editor: Kathy Pohl. Emphasizes rural life and a special quality of living to which country women can relate; at work or play in sharing problems, etc. Sample copy $2. Free photo guidelines with SASE.

Needs: Uses 75-100 photos/issue, most supplied by readers, rather than freelance photographers. "We're always interested in seeing good shots of farm, ranch and country women (in particular) and rural families (in general) at work and at play." Uses photos of farm animals, children with farm

animals, farm and country scenes (both with and without people) and nature. Want on a regular basis scenic (rural), seasonal, photos of rural women and their family. "We're always happy to consider cover ideas. Covers are often seasonal in nature and *always* feature a country woman. Additional information on cover needs available." Photos purchased with or without accompanying ms. Good quality photo/text packages featuring interesting country women are much more likely to be accepted than photos only. Captions are required. Work 6 months in advance. "No poor quality color prints, posed photos, etc."

Making Contact & Terms: Send material by mail for consideration. Uses transparencies. Provide brochure, calling card, letter of inquiry, price list, résumé and samples to be kept on file for possible future assignments. SASE. Reports in 3 months. Pays $100-225 for text/photo package depending on quality of photos and number used; pays $200 for front cover; $150 for back cover; partial page inside $50-125, depending on size. Many photos are used at ¼ page size or less, and payment for those is at the low end of the scale. No b&w photos used. **Pays on acceptance.** Buys one-time rights. Previously published work OK.

Tips: Prefers to see "rural scenics, in various seasons; emphasis on farm women, ranch women, country women and their families. Slides appropriately simple for use with poems or as accents to inspirational, reflective essays, etc."

THE COVENANT COMPANION, 5101 N. Francisco Ave., Chicago IL 60625. (312)784-3000. Editor: John E. Phelan, Jr.. Managing Editor: Jane K. Swanson-Nystrom. Art Director: David Westerfield. Circ. 23,500. Monthly denominational magazine of The Evangelical Covenant Church. Emphasizes "gathering, enlightening and stimulating the people of our church and keeping them in touch with their mission and that of the wider Christian church in the world."

Needs: Mood shots of nature, commerce and industry, home life, church life, church buildings and people. Also uses fine art, scenes, city life, etc.

Making Contact & Terms: "We need to keep a rotating file of photos for consideration." Send 5×7 and 8×10 glossy prints; color slides for cover only. SASE. Pays $20/b&w photo; $50-75/color cover. Pays within 2 months of publication. Credit line given. Buys one-time rights. Simultaneous submissions OK.

Tips: "Give us photos that illustrate life situations and moods. We use b&w photos which reflect a mood or an aspect of society—wealthy/poor, strong/weak, happiness/sadness, conflict/peace. These photos or illustrations can be of nature, people, buildings, designs and so on. Give us a file from which we can draw."

THE CREAM CITY REVIEW, University of Wisconsin-Milwaukee, English Dept., Box 413, Milwaukee WI 53201. (414)229-4708. Art Director: Laurie Buman. Circ. 2,000. Estab. 1975. Bienniel magazine. Emphasizes literature. Readers are mostly males and females with Ph.D's in English, ages 18-over 70. Sample copy $5. Photo guidelines free with SASE.

Needs: Uses 6-20 photos/issue; most supplied by freelancers. Needs photos of fine art and other works of art. Captions preferred.

Making Contact & Terms: Interested in reviewing work from newer, lesser-known photographers. Send unsolicited photos by mail for consideration. Send all sizes b&w and color prints; 35mm, 2¼×2¼, 4×5, 8×10 transparencies. SASE. Reports in 2 months. Pays $50/color cover photo; $50/ b&w cover photo; $5/b&w inside photo; $5/b&w page rate. Pays on publication. Credit line given. Buys one-time rights. Simultaneous submissions and/or previously published work OK.

Tips: "We currently receive very few unsolicited submissions, and would like to see more. Though our primary focus is literary, we are dedicated to producing a visually exciting journal. The artistic merit of submitted work is important. We have been known to change our look based on exciting work submitted. Take a look at *Cream City Review* and see how we like to look. If you have things that fit, send them."

CRUISE TRAVEL, 990 Grove St., Evanston IL 60201. (708)491-6440. Managing Editor: Charles Doherty. Circ. 200,000. Estab. 1979. Bimonthly magazine. Emphasizes cruise ships, ports, vacation destinations, travel tips, ship history. Readers are "those who have taken a cruise, plan to take a cruise, or dream of taking a cruise." Sample copy $3.50 with 9×12 SAE and 6 first-class stamps. Photo guidelines free with SASE.

Needs: Uses about 50 photos/issue; 75% supplied by freelance photographers. Needs ship shots, interior/exterior, scenic shots of ports, shopping shots, native sights, etc. Photos rarely purchased without accompanying ms. Model release preferred. Captions required.

Making Contact & Terms: Query with samples. "We are not seeking overseas contacts." Uses color prints; 35mm (preferred), 2¼×2¼, 4×5, 8×10 transparencies. SASE. Reports in 2 weeks. Pays variable rate for color cover; $25-150/color inside photo; $200-500/text/photo package for original work. Pays on acceptance or publication; depends on package. Credit line usually given, depends on arrangement with photographer. Buys one-time rights. Simultaneous submissions and previously published work OK.

Tips: "We look for bright, colorful travel slides with good captions. Nearly every purchase is a photo/ms package, but good photos are key. We prefer 35mm originals for publication, all color."

CRUISING WORLD MAGAZINE, 5 John Clark Rd., Newport RI 02840. (401)847-1588. Fax: (401)848-5048. Photo Editor: Paul F. Mirto. Circ. 130,000. Estab. 1974. Emphasizes sailboat maintenance, sailing instruction and personal experience. For people interested in cruising under sail. Sample copy free for 9 × 12 SAE.
Needs: Buys 25 photos/year. Needs "shots of cruising sailboats and their crews anywhere in the world. Shots of ideal cruising scenes. No identifiable racing shots, please." Also wants exotic images of cruising sailboats, people enjoying sailing, tropical images, different perspectives of sailing, good composition, bright colors. For covers, photos "must be of a cruising sailboat with strong human interest, and can be located anywhere in the world." Prefers vertical format. Allow space at top of photo for insertion of logo. Model release preferred. Property release required. Captions required; include location, body of water, make and model of boat.
Making Contact & Terms: Interested in receiving work from newer, lesser-known photographers "as long as their subjects are marine related." Send 35mm color transparencies. "We rarely accept miscellaneous b&w shots and would rather they not be submitted unless accompanied by a manuscript." For cover, "submit original 35mm slides. *No* duplicates. Most of our editorial is supplied by author. We look for good color balance, very sharp focus, the ability to capture sailing, good composition and action. Always looking for *cover shots*." Reports in 2 months. Pays $50-300/inside photo; $500/cover photo. Pays on publication. Credit line given. Buys all rights, but may reassign to photographer after publication; first North American serial rights; or one-time rights.

CUPIDO, % Red Alder Books, P.O. Box 2992, Santa Cruz CA 95063. (408)426-7082. Photo Representative: David Steinberg. Circ. 60,000. Estab. 1984. Monthly magazine. Emphasizes quality erotica. Sample copy $10 (check payable to Red Alder Books).
Needs: Uses 50 photos/issue. Needs quality erotic and sexual photography, visually interesting, imaginative, showing human emotion, tenderness, warmth, humor OK, sensuality emphasized. Reviews photos only (no manuscripts, please).
Making Contact & Terms: Contact through rep. Arrange personal interview to show portfolio or submit portfolio for review. Query with stock photo list. Send unsolicited photos by mail for consideration. Send 8 × 10 or 11 × 14 b&w, color prints; 35mm, 2¼ × 2¼, 4 × 5, 8 × 10 transparencies. Keeps samples on file. SASE. Reports in 1 month. Pays $500-800/color cover photo; $60/color or b&w inside photo. Pays on publication. Credit line given. Buys one-time rights. Simultaneous submissions and/or previously published work OK.
Tips: "Not interested in standard, porn-style photos. Imagination, freshness, emotion emphasized. Glamor OK, but not preferred."

CYCLE WORLD MAGAZINE, Dept. PM, 1499 Monrovia Ave., Newport Beach CA 92663. (714)720-5300. Editor-in-Chief: David Edwards. VP/Editorial Director: Paul Dean. Monthly magazine. Circ. 350,000. For active motorcyclists who are "young, affluent, educated and very perceptive." For motorcycle enthusiasts.
Needs: "Outstanding" photos relating to motorcycling. Buys 10 photos/issue. Prefers to buy photos with mss. For Slipstream column see instructions in a recent issue.
Making Contact & Terms: Buys all rights. Send photos for consideration. Pays on publication. Reports in 6 weeks. SASE. Send 8 × 10 glossy prints. "Cover shots are generally done by the staff or on assignment." Uses 35mm color transparencies. Pays $50-100/b&w photo; $150-225/color photo.
Tips: Prefers to buy photos with mss. "Read the magazine. Send us something good. Expect instant harsh rejection. If you don't know our magazine, don't bother us."

***DANCING USA**, 10600 University Ave. NW, Minneapolis MN 55448-6166. (612)757-4414. Fax: (612)755-6605. Managing Editor: Patti P. Johnson. Circ. 20,000. Estab. 1982. Bimonthly magazine. Emphasizes romance of ballroom dance and big bands, techniques, personal relationships, dance music reviews. Readers are male and female, all backgrounds, with ballroom dancing and band interest, age over 45. Sample copy free with 9 × 12 SASE and 4 first-class stamps.
Needs: Uses 25 photos/issue; 1-5 supplied by freelancers. Prefer action dancing/band photos. Nondance competitive clothing, showing romance and/or fun of dancing. Model/property release preferred. Captions preferred; include who, what, when, where, how if applicable.
Making Contact & Terms: Interested in receiving work from newer, lesser-known photographers. Send unsolicited photos by mail for consideration. Send 4 × 5 matte color or b&w prints; 35mm, 2¼ × 2¼, 4 × 5 transparencies. Keeps samples on file. SASE. Reports in 1 month. Pays $50-200/color cover photo; $25-70/color inside photo; $10-50/b&w inside photo; $10-150/photo/text package. Pays

on acceptance. Credit line given. Buys one-time rights. Simultaneous submissions and previously published work OK.

DAS FENSTER, 1060 Gaines School Rd., B-3, Athens GA 30605. (706)548-4382. Owner/Business Manager: Alex Mazeika. Circ. 18,000. Estab. 1904. Monthly magazine. Emphasizes general topics written in the German language. Readers are German, ages 35 years plus. Sample copy free with SASE.
Needs: Uses 25 photos/issue; 20-25 supplied by freelancers. Needs photos of German scenics, wildlife and travel. Captions preferred.
Making Contact & Terms: Interested in receiving work from newer, lesser-known photographers. Send unsolicited photos by mail for consideration. Send 4×5 glossy b&w prints. Keeps samples on file. SASE. Reports in 3 weeks. Pays $40/b&w page rate. Pays on publication. Credit line given. Buys one-time rights; negotiable. Previously published work OK.

DEER AND DEER HUNTING, 700 E. State St., Iola WI 54990. (715)445-2214. Editor: Pat Durkin. Distribution 200,000. Estab. 1977. 8 issues/year. Emphasizes white-tailed deer and deer hunting. Readers are "a cross-section of American deer hunters—bow, gun, camera." Sample copy and photo guidelines free with 9×12 SAE with 7 first-class stamps.
Needs: Uses about 25 photos/issue; 20 supplied by freelance photographers. Needs photos of deer in natural settings. Model release and captions preferred.
Making Contact & Terms: Query with résumé of credits and samples. "If we judge your photos as being usable, we like to hold them in our file. It is best to send us duplicates because we may hold the photo for a lengthy period." SASE. Reports in 2 weeks. Pays $500/color cover; $50/b&w inside; $75-250/color inside. Pays within 10 days of publication. Credit line given. Buys one-time rights. Simultaneous submissions and previously published work OK.
Tips: Prefers to see "adequate selection of b&w 8×10 glossy prints and 35mm color transparencies, action shots of whitetail deer only as opposed to portraits. We also need photos of deer hunters in action. We are currently using almost all color—very little b&w. Submit a limited number of quality photos rather than a multitude of marginal photos. Have your name on all entries. Cover shots must have room for masthead."

***DIRT RIDER**, 6420 Wilshire Blvd., Los Angeles CA 90048-5515. (213)782-2390. Fax: (213)782-2372. Moto Editor: Ken Faught. Circ. 185,000. Estab. 1982. Monthly magazine. Off-road motorcycles, specializing in product tests, race coverage and rider interviews. Readers are predominantly male blue-collar/white-collar, between the ages of 20-35 who are active in motorcycling. Sample copy $3.
Needs: Uses 125 photos/issue; 40 supplied by freelancers. "We need everything: technical photos, race coverage and personality profiles. Most subject matter is assigned. Any photo aside from race coverage or interview needs a release." Captions preferred.
Making Contact & Terms: Interested in receiving work from newer, lesser-known photographers. Phone Ken Faught. Deadlines vary from month to month. Keeps samples on file. Cannot return material. Reports in 2 weeks. Pays $200/color cover photo; $200/b&w cover photo; $50/color inside photo; $25/b&w inside photo; $50/color page rate; $25/b&w page rate. Pays on publication. Credit line given. Simultaneous submissions OK.
Tips: "Familiarize yourself with *Dirt Rider* before submitting photos for review or making initial contact. Pay strict attention to deadlines."

THE DIVER, Dept. PM, Box 313, Portland CT 06480. (203)342-4730. Publisher/Editor: Bob Taylor. 6 issues/year. Emphasizes springboard and platform diving. Readers are divers, coaches, officials and fans. Circ. 1,500. Sample copy $2 with SASE and 4 first-class stamps.
Needs: Uses about 10 photos/issue; 30% supplied by freelance photographers. Needs action shots, portraits of divers, team shots and anything associated with the sport of diving. Special needs include photo spreads on outstanding divers and tournament coverage. Captions required.
Making Contact & Terms: Send 4×5 or 8×10 b&w glossy prints by mail for consideration; "simply query about prospective projects." SASE. Reports in 4 weeks. Pays $25/b&w cover photo; $10/b&w inside photo; $50 for text/photo package. Pays on publication. Credit line given. Buys one-

The asterisk before a listing indicates that the market is new in this edition. New markets are often the most receptive to freelance submissions.

time rights. Simultaneous submissions and previously published work OK.
Tips: "Study the field, stay busy."

DOG FANCY, P.O. Box 6050, Mission Viejo CA 92690. Editor: Kim Thornton. Circ. 270,000. Estab. 1970. Monthly. Readers are "men and women of all ages interested in all phases of dog ownership." Sample copy $5.50; photo guidelines available with SASE.
Needs: Uses 20-30 photos/issue, 100% supplied from freelance stock. Specific breed featured in each issue. Prefers "photographs that show the various physical and mental attributes of the breed. Include both environmental and portrait-type photographs. Dogs must be well groomed and, if purebred, good examples of their breed. By good example, we mean a dog that has achieved some recognition on the show circuit and is owned by a serious breeder or exhibitor. We also have a major need for good-quality, interesting photographs of any breed or mixed breed in any and all canine situations (dogs with veterinarians; dogs eating, drinking, playing, swimming, etc.) for use with feature articles." Model release required. Captions preferred (include dog's name and breed and owner's name and address).
Making Contact & Terms: Interested in receiving work from newer, lesser-known photographers. Send by mail for consideration actual 35mm or 2¼×2¼ color transparencies. Present a professional package: 35mm slides in sleeves, labeled, numbered or otherwise identified; a run sheet listing dog's name, titles (if any) and owner's name; and a return envelope of the appropriate size with the correct amount of postage. Reports in 6 weeks. Pays $15-35/b&w photo; $50-200/color photo; $100-400 per text/photo package. Credit line given. Buys first North American serial rights; buys one-time rights.
Tips: "Nothing but sharp, high contrast shots. Send SASE for list of photography needs. We're looking more and more for good quality photo/text packages that present an interesting subject both editorially and visually. Bad writing can be fixed, but we can't do a thing with bad photos. Subjects should be in interesting poses or settings with good lighting, good backgrounds and foregrounds, etc. We are very concerned with sharpness and reproducibility; the best shot in the world won't work if it's fuzzy, and it's amazing how many are. Submit a variety of subjects—there's always a chance we'll find something special we like."

E MAGAZINE, Dept. PM, 28 Knight St., Norwalk CT 06851. (203)854-5559. Fax: (203)866-0602. Assistant Editor: Kristen Quirk. Circ. 70,000. Estab. 1990. Nonprofit consumer magazine. Emphasizes environmental issues. Readers are environmental activists; people concerned about the environment. Sample copy for 9×12 SAE and $5. Photo guidelines free with SASE.
Needs: Uses 42 photos/issue; 55% supplied by freelancers. Needs photos of threatened landscapes, environmental leaders, people and the environment and coverage of when environmental problem figures into background of other news. Model and/or property release preferred. Photo captions required: location, identities of people in photograph, date, action in photograph.
Making Contact & Terms: Query with résumé of credits and list of stock photo subjects. Keeps printed samples on file. Reports in 6 weeks. Pays $75/¼ page color photo; negotiable. Pays several weeks after publication. Credit line given. Buys one-time rights. Simultaneous submissions and previously published work OK.
Tips: Wants to see "straightforward, journalistic images. Abstract or art photography or landscape photography is not used." In addition, "please do not send manuscripts with photographs. These can be addressed as queries to the managing editor."

EARTH MAGAZINE, 21027 Crossroads Circle, Waukesha WI 53187. (414)796-8776. Fax: (414)796-1142. Editorial Assistant: Diane Pinkalla. Circ. 85,000. Estab. 1992. Bimonthly magazine. Emphasizes earth science for general audience. Sample copy $6.95 ($3.95 plus $3 shipping and handling). Photo guidelines free with SASE for amateurs.
Needs: Uses 70 photos/issue; 25% supplied by freelancers. Needs photos of earth science: landforms, air and water phenomena, minerals, fossils, researchers at work, geologic processes. Model/property release preferred. Captions required; include location, feature and date.
Making Contact & Terms: Interested in receiving work from newer, lesser-known photographers. Send stock list and samples for file. Pays $25-200/color or b&w inside photo. Pays on publication. Credit line given. Buys one-time rights. Previously published work OK.
Tips: Wants to see excellent technical quality in photos of real earth science, not just pretty pictures.

***EASYRIDERS MAGAZINE,** Dept. PM, P.O. Box 3000, Agoura Hills CA 91376-3000. (818)889-8740. Fax: (818)889-4726. Editorial Director: Keith R. Ball. Estab. 1971. Monthly. Emphasizes "motorcycles (Harley-Davidsons in particular), motorcycle women, bikers having fun." Readers are "adult men—men who own, or desire to own, custom motorcycles. The individualist—a rugged guy who enjoys riding a custom motorcycle and all the good times derived from it." Free sample copy. Photo guidelines free with SASE.
Needs: Uses about 60 photos/issue; "the majority" supplied by freelance photographers; 70% assigned. Needs photos of "motorcycle riding (rugged chopper riders), motorcycle women, good times

had by bikers, etc." Model release required. Also interested in technical articles relating to Harley-Davidsons.

Making Contact & Terms: Send b&w prints, 35mm transparencies by mail for consideration. SASE. Reports in 2 months. Pays $30-100/b&w photo; $40-250/color photo; $30-2,500/complete package. Other terms for bike features with models to satisfaction of editors. For usage on cover, gatefold and feature. Pays 30 days after publication. Credit line given. Buys all rights. All material must be exclusive.

Tips: Trend is toward "more action photos, bikes being photographed by photographers on bikes to create a feeling of motion." In samples, wants photos "clear, in-focus, eye-catching and showing some emotion. Read magazine before making submissions. Be critical of your own work. Check for sharpness. Also, label photos/slides clearly with name and address."

ELLE, 1633 Broadway, New York NY 10019. Uses very little freelance work.

***ELLERY QUEEN'S MYSTERY MAGAZINE**, 1540 Broadway, New York NY 10036. (212)782-8547. Fax: (212)782-8309. Art Director: Terri Czeczko. Monthly magazine. Readers are female and male, ages 40 and over. Circ. 250,000. Estab. 1941. Photo guidelines free with SASE.

Needs: Uses 1 cover shot/issue. Needs photos of famous authors and personalities. Model/property release required.

Making Contact & Terms: Submit portfolio for review. Keeps samples on file. NPI. Pays on publication. Credit line given. Buys all rights. Rights negotiable.

***ENERGY TIMES**, 548 Broad Hollow Rd., Melville NY 11747. (516)777-7773. Fax: (516)293-0349. Art Director: Ed Canavan. Circ. 575,000. Estab. 1992. Bimonthly magazine. Emphasizes health food industry. Readers are 72% female, 28% male, average age 42.3, interested in supplements and alternative health care, exercise 3.2 times per week. Sample copy $1.25.

Needs: Uses 25 photos/issue; 5 supplied by freelancers. Needs photos of herbs, natural lifestyle, food. Model/property release required. Captions preferred.

Making Contact & Terms: Interested in receiving work from newer, lesser-known photographers. Provide résumé, business card, brochure, flier or tearsheets to be kept on file for possible assignments. Deadlines ongoing. Keeps samples on file. SASE. Reports in 2 weeks. Pays $250/color cover photo; $85/color inside photo; "inside rates negotiable based on size." Pays on publication. Rights negotiable. Previously published work OK.

Tips: "Photos must clearly illustrate the editorial context. Photos showing personal energy are highly regarded. Sharp, high contrast photos are the best to work with. Bright but non-tacky colors will add vibrance to a publication. When shooting people, the emotion captured in the subject's expression is often as important as the composition."

ENTREPRENEUR, Dept. PM, 2392 Morse Ave., Irvine CA 92714. (714)261-2325. Fax: (714)755-4211. Photo Editor: Chrissy Borgatta. Publisher: Jim Fitzpatrick. Editor: Rieva Lesonsky. Design Director: Richard R. Olson. Cir. 360,000. Estab. 1977. Monthly. Emphasizes business. Readers are existing and aspiring small business owners.

Needs: Uses about 30 photos/issue; many supplied by freelance photographers; 60% on assignment; 40% from stock. Needs "people at work: home office, business, situations. I want to see colorful shots in all formats and styles." Model/property release preferred. Captions required; include names of subjects.

Making Contact & Terms: Interested in reviewing work from newer, lesser-known photographers. Arrange a personal interview to show portfolio. Query with sample or list of stock photo subjects. Provide résumé, business card, brochure, flier or tearsheets to be kept on file for possible future assignments; "follow-up for response." Pays $75-200/b&w photo; $125-225/color photo; $125-225/color stock. Pays "depending on photo shoot, per hour or per day. We pay $250-300 plus all expenses for assignments." Pays on publication. Credit line given. Buys one-time rights; negotiable.

Tips: "I am looking for photographers who use the environment creatively; I do not like blank walls for backgrounds. Lighting is also important. I prefer medium format for most shoots. I think photographers are going back to the basics—a good clean shot, different angles and bright colors. I am extremely tired of a lot of motion-blurred effect with gelled lighting. I prefer examples of your work—promo cards and tearsheets along with business cards and résumés. Portfolios are always welcome."

ENVIRONMENT, Dept. PM, 1319 18th St. NW, Washington DC 20036. (202)296-6267. Fax: (202)296-5149. Editor: Barbara T. Richman. Circ. 12,500. Estab. 1958. Graphics/Production Manager: Jennifer Crock. Magazine published 10 times/year. Covers science and science policy from a national, international and global perspective. "We cover a wide range of environmental topics—acid rain, tropical deforestation, nuclear winter, hazardous waste disposal, energy topics and environmental legislation." Readers include libraries, colleges and universities and professionals in the field of environmental science and policy. Sample copy $7.

Needs: Uses 15 photos/issue; varying number supplied by freelance photographers; 90% comes from stock. "Our needs vary greatly from issue to issue—but we are always looking for good photos showing human impact on the environment worldwide—industrial sites, cities, alternative energy sources, pesticide use, disasters, third world growth, hazardous wastes, sustainable agriculture and pollution. Interesting and unusual landscapes are also needed." Model release required. Captions required, include location and subject.

Making Contact & Terms: Interested in receiving work from newer, lesser-known photographers. Query with list of stock photo subjects. Provide business card, brochure, flier or tearsheets to be kept on file for possible future assignments. Pays $50-150/b&w photo; $50-300/color photo; $350/color cover photo. Pays on publication. Credit line given. Buys one-time rights. Simultaneous submissions and previously published work OK.

Tips: "We are looking for international subject matter—especially environmental conditions in developing countries. Provide us with a stock list, and if you are going someplace specific to shoot photos let us know. We might have some specific request."

EQUAL OPPORTUNITY, 150 Motor Pkwy., Suite 420, Hauppauge NY 11788. (516)273-0066. Fax: (516)273-8936. Art Director: Jamie Ctroud. Circ. 10,000. Estab. 1967. Magazine published 3 times/ year. Emphasizes career guidance for members of minority groups at the college and professional levels. Readers are college-age, minority students and young working professionals of all occupations that require a college degree. Sample copy with 9 × 12 SASE and 5 first-class stamps.
Needs: Uses 10 photos per issue; 5 supplied by freelancers. Contact for needs. Model release preferred. Captions preferred.
Making Contact & Terms: Interested in receiving work from newer, lesser-known photographers. Query with list of stock photo subjects or send unsolicited photos by mail for consideration. Send color 35mm transparencies. SASE. Reports in 2 weeks. Pays $25-50/color inside photo; $350-500/ cover photo. Pays on publication. Credit line given. Buys one-time rights. Simultaneous submissions and previously published work OK, "but not in competitive career-guidance publications."
Tips: "We are looking for clear color shots of minority students and young professionals who are involved in activities related to their academic studies or professions. We've decided to use more cover photos than we have in the past. We are also open to using inside photos, but freelancers should contact us and discuss upcoming stories before sending photos. Read our magazine to get an idea of the editorial content. Cover photos do not have to tie in to any one particular story in the issue, but they have to be representative of the magazine's editorial content as a whole."

❧EQUINOX MAGAZINE, 25 Sheppard Ave. W., Suite 100, North York, Ontario M2N 6S7 Canada. Fax: (416)218-3633. Editor: Jim Cormier. Circ. 175,000. Bimonthly. Emphasizes "Canadian subjects of a general 'discovery' nature." Sample copy $5 with 8½ × 14 SAE; photo guidelines free with SAE and IRC.
Needs: Uses 80-100 photos/issue; all supplied by freelance photographers. Needs "photo stories of interest to a Canadian readership as well as occasional stock photos required to supplement assignments. Story categories include wildlife, international travel and adventure, science, Canadian arts and architecture and Canadian people and places." Captions required.
 • *Equinox Magazine* has won numerous national magazine awards (Canadian).
Making Contact & Terms: Query with samples. Submit portfolio for review. "Submit story ideas and complete photo essays rather than vague invitations." SASE. Reports in 6 weeks. "Most stories are shot on assignment basis—average $2,000 price. We also pay expenses for people on assignment. We also buy packages at negotiable prices and stock photography at about $250 a page if only one or two shots used." Pays on publication. Credit line given. Buys first North American serial rights.
Tips: We look for "excellence and in-depth coverage of a subject, technical mastery and an ability to work intimately with people. Many of the photographs we use are of people, so any portfolio should emphasize people involved in some activity. Stick to Kodachrome/Ektachrome transparencies."

***EROTIC X-FILM GUIDE**, P.O. Box 309, Hollywood CA 90078. (213)466-2451. Fax: (213)466-7809. Editorial Director: Marc Medoff. Circ. 100,000. Estab. 1984. Monthly magazine. Emphasizes erotic entertainment. Readers are male, ages 21-35. Sample copy free with 10 × 13 SASE and 10 first-class stamps. Photo guidelines free with SASE.
Needs: Uses 125-150 photos/issue; 25-50 supplied by freelancers. Needs photos of nudes. Model/ property release required. Captions required.
Making Contact & Terms: "We are especially interested in working with photographers who can find and photograph new, never before seen female erotic models." Query with résumé of credits. Send unsolicited photos by mail for consideration. Provide résumé, business card, brochure, flier or tearsheets to be kept on file for possible assignments. Submit portfolio for review. Send 35mm transparencies. Keeps samples on file. SASE. NPI. **Pays on acceptance**. Buys first North American serial rights. Simultaneous submissions and previously published work OK.

EVANGELIZING TODAY'S CHILD, Child Evangelism Fellowship Inc., P.O. Box 348, Warrenton MO 63383. (314)456-4321. Fax: (314)456-2087. Editor: Mrs. Elsie Lippy. Circ. 25,000. Estab. 1975. Bimonthly magazine. Written for people who work with children, ages 5-12, in Sunday schools, Bible clubs and camps. Sample copy for $1. Photo guidelines free with SASE.
Needs: Buys 1-4 photos/issue; 20% from freelance asssignment; 80% from freelance stock. Children, ages 6-11; unique, up-to-date. Candid shots of various moods and activities. If full color, needs to include good color combination. "We use quite a few shots with more than one child and some with an adult, mostly closeups. The content emphasis is upon believability and appeal. Religious themes may be especially valuable." No nudes, scenery, fashion/beauty, glamour or still lifes.
Making Contact & Terms: Interested in receiving work from newer, lesser-known photographers. Prefers to retain good-quality photocopies of selected glossy prints and duplicate slides in files for future use. Send material by mail with SASE for consideration; 8×10 b&w glossy prints or 35mm and larger transparencies. Publication is under no obligation to return materials sent without SASE. Pays on a per-photo basis. Pays $35 minimum/b&w photo; $45 minimum/color inside photo; $125/color cover shot. Credit line given. Buys one-time rights. Simultaneous submissions and previously published work OK.

FACES: The Magazine About People, Cobblestone Publishing Inc., 7 School St., Peterborough NH 03458. (603)924-7209. Fax: (603)924-7380. Freelance Picture Editor: Francelle Carapetyan. Circ. 13,500. Estab. 1984. 9 issues/year, September-May. Emphasizes cultural anthropology for young people ages 8-14. Sample copy $4.50 with 8×11 SASE and 5 first-class stamps. Photo guidelines free with SASE.
Needs: Uses about 30-35 photos/issue; about 75% supplied by freelancers. "Photos (b&w use) for text must relate to themes; cover photos (color) should also relate to themes." Send SASE for themes. Photos purchased with or without accompanying ms. Model release preferred. Captions preferred.
Making Contact & Terms: Query with stock photo list and/or samples. SASE. Reports in 1 month. Pays $15-100/inside b&w use; cover (color) photos negotiated. Pays on publication. Credit line given. Buys one-time rights. Simultaneous submissions and previously published work OK.
Tips: "Photographers should request our theme list. Most of the photographs we use are of people from other cultures. We look for an ability to capture people in action—at work or play. We primarily need photos showing people, young and old, taking part in ceremonies, rituals, customs and with artifacts and architecture particular to a given culture. Appropriate scenics and animal pictures are also needed. All submissions must relate to a specific future theme."

FAMILY MAGAZINE, %Thomas Design Inc., 81 N. Broadway, Hicksville NY 11801. (516)933-8944. Fax: (516)933-8294. Editor: Liz DeFrankel. Art Director: Tom Civitillo. Circ. 500,000. Estab. 1958. Monthly magazine. Emphasizes military housewives, military family life, kids and moms. Readers are female homemakers, age 20-30, with military spouses. Sample copy $1.25 plus 5 first-class stamps and 9×12 envelope. Photo guidelines free with SASE.
Needs: Uses 20 photos/issue; 15 supplied by freelancers. Needs photos that are family-oriented—travel, holidays, homemaking, moving, problem-solving, recreation, schooling, any real life activity. Reviews photos with or without ms. Model release required. Captions required; include names of specific places (travel) or items in shot.
Making Contact & Terms: Interested in receiving work from newer, lesser-known photographers. Send unsolicited photos by mail for consideration. Provide résumé, business card, brochure, flier or tearsheets to be kept on file for possible assignments. Send 35mm color transparencies. Keeps samples on file. Reports in 1 month. Pays $50/color inside photo. Pays on publication. Credit line given. Buys one-time rights; negotiable. Simultaneous submissions and/or previously published work OK.
Tips: "Never send original slides. We want only dupes to keep on file! A written request for return of photos will get your photos back to you. Otherwise, they stay on file. Also, along with written request, send SASE for photos' safe return."

FARM & RANCH LIVING, 5400 S. 60th St., Greendale WI 53129. (414)423-0100. Fax: (414)423-1143. Associate Editor: Trudi Bellin. Estab. 1978. Bimonthly magazine. "Concentrates on farming and ranching as a way of life." Readers are full-time farmers and ranchers. Sample copy $2. Photo guidelines free with SASE.
Needs: Uses about 160 photos/issue; about 23% from freelance stock; 40% assigned. Needs agricultural and scenic photos. "We assume you have secured releases. If in question, don't send the photos." Captions should include season, location.
Making Contact & Terms: Interested in receiving work from newer, lesser-known photographers. Query with samples or list of stock photo subjects. Send 35mm, 2¼×2¼, 4×5, 8×10 transparencies by mail for consideration. SASE. "We only want to see one season at a time; we work one season in advance." Reporting time varies; "ASAP: can be a few days, may be a few months." Pays $200/color cover photo; $50-125/color inside photo; $150/color page (full-page bleed); $10-50/b&w photo. Pays on publication. Buys one-time rights. Previously published work OK.

Tips: "Technical quality extremely important. Colors must be vivid so they pop off the page. Study our magazines thoroughly. We have a continuing need for sharp, colorful images. Those who supply what we need can expect to be regular contributors."

FIELD & STREAM, 2 Park Ave., New York NY 10016. (212)779-5364. Photo Editor: Scott Wm. Hanrahan. Circ. 2 million. This is a broad-based service magazine. The editorial content ranges from very basic "how it's done" filler stories that tell in pictures and words how an outdoor technique is accomplished or device is made, to feature articles of penetrating depth about national conservation, game management, and resource management issues; and recreational hunting, fishing, travel, nature and outdoor equipment. Photographer's guidelines available.
Needs: Photos using action and a variety of subjects and angles in color and occasionally b&w. "We are always looking for cover photographs, in color, which may be vertical or horizontal. Remember: a cover picture must have room at the left for cover lines." Needs photo information regarding subjects, the area, the nature of the activity and the point the picture makes.
Making Contact & Terms: Send 35mm and 2¼ × 2¼ transparencies. Will also consider 4 × 5 transparencies, but "majority of color illustrations are made from 35mm or slides." Submit photos by registered mail. Send slides in 8½ × 11 plastic sheets, and pack slides and/or prints between cardboard. SASE. Pays $75/b&w photo, $450/color photo depending on size used on single page; $700/partial color spread; $900/full-color spread; $1,000/color cover. Buys first North American serial rights returned after publication.

FIFTY SOMETHING MAGAZINE, 8250 Tyler Blvd., Unit #E, Mentor OH 44060. (216)974-9594. Editor: Linda L. Lindeman. Circ. 25,000. Estab. 1990. Bimonthly magazine. Emphasizes lifestyles for the fifty-and-better-reader. Readers are men and women, age 50 and up. Sample copy free with 9 × 12 SAE and 4 first-class stamps. Photo guidelines free with SASE.
Needs—Uses 25-40 photos/issue; 30 supplied by freelancers. Needs "anything pertaining to mature living—travel, education, health, fitness, money, etc." Model release preferred. Captions preferred.
Making Contact & Terms: Interested in receiving work from newer, lesser-known photographers. Query with list of stock photo subjects. Send unsolicited photos by mail for consideration. Submit portfolio for review. Provide résumé, business card, brochure, flier or tearsheets to be kept on file for possible assignments. Send b&w, color prints; 35mm, 2¼ × 2¼, 4 × 5, 8 × 10 transparencies. SASE. Reports in 6 months. Pays $100/color cover photo; $10/color inside photo; $5/b&w inside photo; $25-75/hour; $100-400/day; $25-125/photo/text package. Pays on publication. Credit line given. Buys onetime rights. Simultaneous submissions and previously published work OK.
Tips: "We are an upbeat publication with the philosophy that life begins at 50. Looking for stories/pictures that show this lifestyle. Also, use a lot of travel/photo essays."

FIGHTING WOMAN NEWS, 6741 Tung Ave. W., Theodore AL 36582. Editor: Debra Pettis. Quarterly. Circ. 5,000. Estab. 1975. Quarterly. Covers women's martial arts. Readers are "adult females actively practicing the martial arts or combative sports." Sample copy $4.50 postpaid. Photo guidelines free with SASE.
Needs: Uses several photos/issue; most supplied by freelance photographers. Needs powerful images of female martial artists; "action photos from tournaments and classes/demonstrations; studio sequences illustrating specific techniques and artistic constructions illustrating spiritual values. Obviously, photos illustrating text have a better chance of being used. We have little space for fillers. We are always short of photos suitable to our magazine." Model release preferred. Captions required; include identification information.
Making Contact & Terms: Interested in reviewing work from newer, lesser-known photographers. Query with résumé of credits or with samples. Send 8 × 10 glossy b&w prints or b&w contact sheet by mail for consideration. Provide résumé, business card, brochure, flier or tearsheets to be kept on file for possible future assignments. SASE. Reports "as soon as possible." NPI. Payment for text/photo package "to be negotiated." Pays on publication. Credit line given. Buys one-time rights. Simultaneous submissions and previously published work OK; "however, we insist that we are *told* concerning these matters. We don't want to publish a photo that is in the current issue of another martial arts magazine."
Tips: Prefers to see "technically competent b&w photos of female martial artists in action; good solid images of powerful female martial artists. We don't print color. No glamour, no models; no cute little kids unless they are also skilled. Get someone knowledgeable to caption your photos or at least tell you what you have—or don't have if you are not experienced in the art you are photographing. We are a poor alternative publication chronically short of material, yet we reject 90% of what is sent because the sender obviously never saw the magazine and has no idea what it's about. Five of our last seven covers were live action photos and we are using fewer enhancements than previously. Best to present yourself and your work with samples and a query letter indicating that you have *seen* our publication. The cost of buying sample copies is a lot less than postage these days."

***FINE GARDENING**, 63 S. Main St., P.O. Box 355, Newtown CT 06470. (203)426-8171. Fax: (203)426-3454. Executive Editor: Nancy Beaubaire. Circ. 195,000. Estab. 1988. Bimonthly magazine. Emphasizes gardening. Readers are male and female gardeners, all ages (30-60 mostly). Sample copy $5. Photo guidelines free with SASE.
Needs: Uses 80 photos/issue; 30-40 supplied by freelancers. Needs photos of landscape, gardens, flower close-ups, how-tos. Property release required for private gardens. Captions required, include complete names of plants (common and botanic).
Making Contact & Terms: Interested in receiving work from newer, lesser-known photographers. Send unsolicited photos by mail for consideration. Send color prints; 35mm transparencies. Keeps samples on file. SASE. Reports in 1 month. Pays $300/color cover photo; $50-200/color inside photo; $200/color page rate. Pays on publication. Credit line given. Buys one-time rights. Simultaneous submissions OK.

FINESCALE MODELER, 21027 Crossroads Circle, P.O. Box 1612, Waukesha WI 53187. (414)796-8776. Fax: (414)796-1383. Editor: Bob Hayden. Photo Editor: Paul Boyer. Circ. 85,000. Published 9 times/year. Emphasizes "how-to-do-it information for hobbyists who build nonoperating scale models." Readers are "adult and juvenile hobbyists who build nonoperating model aircraft, ships, tanks and military vehicles, cars and figures." Sample copy $3.50. Photo guidelines free with SASE.
Needs: Uses more than 50 photos/issue; "anticipates using" 10 supplied by freelance photographers. Needs "in-progress how-to photos illustrating a specific modeling technique; photos of full-size aircraft, cars, trucks, tanks and ships." Model release required. Captions required.
Making Contact & Terms: Provide résumé, business card, brochure, flier or tearsheets to be kept on file for possible future assignments. "Phone calls are OK." Reports in 8 weeks. Pays $25 minimum/color cover photo; $5 minimum/b&w inside photo; $7.50 minimum/color inside photo; $30/b&w page; $45/color page; $50-500 for text/photo package. Pays for photos on publication, for text/photo package on acceptance. Credit line given. Buys one-time rights. "Will sometimes accept previously published work if copyright is clear."
Tips: Looking for "clear b&w glossy 5×7 or 8×10 prints of aircraft, ships, cars, trucks, tanks and sharp color positive transparencies of the same. In addition to photographic talent, must have comprehensive knowledge of objects photographed and provide copious caption material. Freelance photographers should provide a catalog stating subject, date, place, format, conditions of sale and desired credit line before attempting to sell us photos. We're most likely to purchase color photos of outstanding models of all types for our regular feature, 'Showcase.' "

FIRST OPPORTUNITY, 106 W. 11th St., #250, Kansas City MO 64105-1806. (816)221-4404. Fax: (816)221-1112. Editor: Neoshia Michelle Paige. Circ. 500,000. Semi-annual magazine. Emphasizes advanced vocational/technical education opportunities, career prospects. Readers are African-American, Hispanic, ages 16-22. Sample copy free with 9×12 SAE with 4 first-class stamps.
Needs: Uses 30 photos/issue. Needs photos of students in class, at work, in vocational/technical training, in health field, in computer field, in technology, in engineering, general interest. Model/property release required. Captions required; include name, age, location, action.
Making Contact & Terms: Interested in receiving work from newer, lesser-known photographers. Query with résumé of credits. Query with ideas and SASE. Reports in 1 month, "usually less." Pays $10-50/color photo; $5-25/b&w inside photo. Pays on publication. Buys first North American serial rights. Simultaneous submissions and/or previously published work OK.

FIRST VISIT, 8003 Old York Rd., Elkins Park PA 19027. (215)635-1700. Fax: (215)635-6455. Project Coordinator: Deana C. Jamroz. Circ. 2,250,000/year. Estab. 1991. Magazine published 3 times/year. Emphasizes postnatal care for infants. Readers are new parents who have just taken baby to first pediatrician visit. Sample copy free with 6×9 SAE and 2 first-class stamps. Photo guidelines free with SASE.
Needs: Uses 2-10 photos/issue; 80% supplied by freelancers. Needs photos of neonates, parents with new babies, grandparents with new babies, baby items/products, babies being fed, babies being bathed, etc. Reviews photo with or without ms. Model/property release required.
Making Contact & Terms: Interested in receiving work from newer, lesser-known photographers. Query with stock photo list. Does not keep samples on file. SASE. Pays $800/half day; $300-600/

Market conditions are constantly changing! If you're still using this book and it's 1997 or later, buy the newest edition of Photographer's Market *at your favorite bookstore or order directly from Writer's Digest Books.*

color inside photo; $100-500/b&w inside photo. **Pays on acceptance.** Credit line not given. Buys all rights.
Tips: "Payment for photos is negotiable depending upon degree of difficulty/technical difficulty of pictures."

***FISHING FACTS**, 312 E. Buffalo, Milwaukee WI 53202. (414)273-0021. Fax: (414)273-0016. Art Director: Philip Schroeder. Circ. 100,000. Published 7 times/year. Emphasizes freshwater fishing. Readers are mostly male sportfishermen or recreational active outdoors persons, ages 14-70. Sample copy free with 9 × 12 SASE and 10 first-class stamps. Photo guidelines available.
Needs: Uses various number of photos. Needs photos of close-up action of freshwater species, some scenics, some how-to, specific wildlife shots. Reviews photos purchased with accompanying ms only. Special photo needs include covers with specific species. Model/property release required. Caption preferred.
Making Contact & Terms: Interested in receiving work from newer, lesser-known photographers. Call first. Provide résumé, business card, brochure, flier or tearsheets to be kept on file for possible assignments. Keeps samples on file. SASE. Reports in 1-2 weeks. Pays $500/hour; $500/color cover photo; $75-100/color inside photo; $75-100/b&w page rate. Pays on publication. Credit line given. Buys one-time rights. Simultaneous submissions OK.
Tips: Prefers underwater shots with good color, clarity, and focus. Familiarize yourself with content and style of the publication.

FLORIDA KEYS MAGAZINE, 3299 SW Ninth Ave., P.O. Box 22748, Ft. Lauderdale FL 33335-2748. (305)764-0604. Fax: (305)760-9949. Art Director: Vivia Aceto. Circ. 10,000. Estab. 1978. Bimonthly magazine. Emphasizes Florida Keys lifestyle. Readers are male and female, Keys residents and frequent visitors, ages 30-55. Sample copy free with 9 × 12 SAE and 3 first-class stamps. Photo guidelines free with SASE.
Needs: Uses 20-30 photos/issue; 20% supplied by freelancers. Needs photos of wildlife, scenic, personalities, food, architecture, sports. Special photo needs include holiday and special event locations in the Keys. Model/property release preferred. Captions required; include location, names of subjects.
Making Contact & Terms: Interested in receiving work from newer, lesser-known photographers. Send unsolicited photos by mail for consideration. Send any size color or b&w prints; 35mm, 2¼ × 2¼, 4 × 5, 8 × 10 transparencies. Keeps samples on file. SASE. Reports in 1 month. Pays $50/color cover photo; $25/color inside photo; $25/b&w inside photo. Pays on publication. Credit line given. Buys one-time rights; negotiable. Simultaneous submissions and/or previously published work OK.
Tips: Wants to see a "fresh viewpoint on familiar subjects."

FLORIDA MARINER, (formerly *Gulf Mariner*), P.O. Box 1220, Venice FL 34284. (813)488-9307. Fax: (813)488-9309. Editor: Thomas Kahler. Circ. 25,000. Estab. 1984. Biweekly tabloid. Readers are recreational boaters, both power and sail. Sample copy free with 9 × 12 SAE and 7 first-class stamps.
Needs: Uses cover photo each issue—24 a year; 100% supplied by freelance photographers. Needs photos of boating related fishing, water skiing, racing and shows. Use of swimsuit-clad model or fisherman with boat preferred. All photos must have *vertical* orientation to match our format. Model release required. Captions preferred.
Making Contact & Terms: Interested in receiving work from newer, lesser-known photographers. Send 35mm transparencies by mail for consideration. SASE. Reports in 2 weeks. Pays $50/color cover photo. **Pays on acceptance.** Credit line optional. Rights negotiable. May use photo more than once for cover. Simultaneous submissions and previously published work OK.
Tips: "We are willing to accept outtakes from other assignments which is why we pay only $50. We figure that is better than letting an unused shot go to waste or collect dust in the drawer."

FLOWER AND GARDEN MAGAZINE, 700 W. 47th St., Suite 310, Kansas City MO 64112. (816)531-5730. Fax: (816)531-5730. Staff Editor: Brent Shepherd. Executive Editor: Kay Melchisedech Olson. Estab. 1957. "We publish 6 times a year and require several months of lead time." Emphasizes home gardening. Readers are male and female homeowners with a median age of 47. Sample copy $3.50. Photo guidelines free with SASE.
Needs: Uses 25-50 photos/issue; 75% supplied by freelancers. "We purchase a variety of subjects relating to home lawn and garden activities. Specific horticultural subjects must be accurately identified."
Making Contact & Terms: Interested in receiving work from newer, lesser-known photographers. To make initial contact, "Do not send great numbers of photographs, but rather a good selection of 1 or 2 specific subjects. We do not want photographers to call. We return photos by certified mail—other means of return must be specified and paid for by the individual submitting them. It is not our policy to pay holding fees for photographs." Pays $25-100/b&w photo; $100-500/color photo. Pays on publication. Buys one-time and non-exclusive reprint rights. Model/property release preferred. Captions preferred, please provide exact name of plant (botanical), variety name and common name.

Tips: Wants to see "clear shots with crisp focus. Also, appealing subject matter—good lighting, technical accuracy, depictions of plants in a home garden setting rather than individual close-ups. Let us know what you've got, we'll contact you when we need it. We see more and more freelance photographers trying to have their work published. In other words, supply is greater than demand. Therefore, a photographer who has too many conditions and provisions will probably not work for us."

FLY FISHERMAN, Cowles Magazines, Inc., 6405 Flank Dr., P.O. Box 8200, Harrisburg PA 17112. (717)657-9555. Editor and Publisher: John Randolph. Managing Editor: Philip Hanyok. Circ. 130,000. Published 6 times/year. Emphasizes all types of fly fishing for readers who are "99% male, 79% college educated, 79% married. Average household income is $62,590 and 55% are managers or professionals; 85% keep their copies for future reference and spend 35 days a year fishing." Sample copy $3.95 with 9×12 SAE and 4 first-class stamps. Photo/writer guidelines for SASE.
Needs: Uses about 45 photos/issue, 80% of which are supplied by freelance photographers. Needs shots of "fly fishing and all related areas—scenics, fish, insects, how-to." Captions required.
Making Contact & Terms: Send 35mm, 2¼×2¼, 4×5 or 8×10 color transparencies by mail for consideration. SASE. Reports in 6 weeks. NPI. Pays on publication. Credit line given. Buys one-time rights.

FLY ROD & REEL: THE MAGAZINE OF AMERICAN FLY-FISHING, Dept. PM, P.O. Box 370, Camden ME 04843. (207)594-9544. Fax: (207)594-5144. Editor: Jim Butler. Magazine published 6 times/year, irregular intervals. Emphasizes fly-fishing. Readers are primarily fly fishermen ages 30-60. Circ. 62,000. Estab. 1979. Free sample copy with SASE. Photo guidelines free with SASE.
Needs: Uses 25-30 photos/issue; 15-20 supplied by freelancers. Needs "photos of fish, scenics (preferrably with anglers in shot), equipment." Photo captions preferred that include location, name of model (if applicable).
Making Contact & Terms: Query with list of stock photo subjects. Send unsolicited photos by mail for consideration. Provide résumé, business card, brochure, flier or tearsheets to be kept on file for possible assignments. Send glossy b&w, color prints; 35mm, 2¼×2¼, 4×5 transparencies. Keeps samples on file. SASE. Reports in 1 month. Pays $600/color cover photo; $75/color inside photo; $75/b&w inside photo; $150/color page rate; $150/b&w page rate. Pays on publication. Credit line given. Buys one-time rights.
Tips: "Photos should avoid appearance of being too 'staged.' We look for bright color (especially on covers), and unusual, visually appealing settings. Trout and salmon are preferred for covers. Also looking for saltwater fly-fishing subjects."

FOOD & WINE, Dept. PM, 1120 Avenue of the Americas, New York NY 10036. (212)382-5600. Contact: Photo Editor. Monthly. Emphasizes food and wine. Readers are an "upscale audience who cook, entertain, dine out and travel stylishly." Circ. 850,000. Estab. 1978.
Needs: Uses about 25-30 photos/issue; freelance photography on assignment basis 85%, 15% freelance stock. "We look for editorial reportage specialists who do restaurants, food on location and travel photography." Model release and captions required.
Making Contact & Terms: Drop-off portfolio on Tuesdays. Call for pickup. Submission of fliers, tearsheets, etc. to be kept on file for possible future assignments and stock usage. Pays $450/color page; $100-450 color photo. **Pays on acceptance.** Credit line given. Buys one-time world rights.

FOR SENIORS ONLY, 339 N. Main St., New City NY 10956. (914)638-0333. Fax: (914)634-9423. Art Director: Randi Wendelkin. Circ. 525,000. Estab. 1970. Biannual publication. Emphasizes career and college guidance—with features on travel, computers, etc. Readers are male and female, ages 16-19. Sample copy free with 6½×9½ SAE and 8 first-class stamps.
Needs: Uses various number of photos/issue; 50% supplied by freelancers. Needs photos of travel, college-oriented shots and youths. Reviews photos with or without ms. Model/property release required.
Making Contact & Terms: Interested in receiving work from newer, lesser-known photographers. Send unsolicited photos by mail for consideration. Send 5½×8½ color prints; 35mm, 8×10 transparencies. SASE. Reports when needed. NPI. Pays on publication. Credit line given. Buys one-time rights; negotiable. Simultaneous submissions and/or previously published work OK.

FORTUNE, Dept. PM, Rockefeller Center, Time-Life Bldg., New York NY 10020. (212)522-3803. Managing Editor: Marshall Loeb. Picture Editor: Michele F. McNally. Picture Editor reviews photographers' portfolios on an overnight drop-off basis. Emphasizes analysis of news in the business world for management personnel. Photos purchased on assignment only. Day rate on assignment (against space rate): $400; page rate for space: $400; minimum for b&w or color usage: $150.

FOUR WHEELER MAGAZINE, 6728 Eton Ave., Canoga Park CA 91303. (818)992-4777. Editor: John Stewart. Circ. 325,000. Monthly magazine. Emphasizes four-wheel drive vehicles and enthusiasts. Photo guidelines free with SASE.
Needs: Uses 100 color/100 b&w photos/issue; 2% supplied by freelance photographers. Needs how-to, travel/scenic/action (off-road 4×4s only) photos. Travel pieces also encouraged. Reviews photos with accompanying ms only. Model release required. Captions required.
Making Contact & Terms: Provide résumé, business card, brochure, flier or tearsheets to be kept on file for possible future assignments. Does not return unsolicited material. Reports in 1 month. Pays $10-50/inside b&w photo; $20-100/inside color photo; $100/b&w and color page; $200-600/text/photo package. Pays on publication. Credit line given. Buys all rights.

‡FRANCE MAGAZINE, Dormer House, The Square, Stow-on-the-Wold, Gloucestershire GL54 1BN England. (0451)831398. Fax: (0451)830869. Assistant Editor: Jon Stackpool. Circ. 34,000. Estab. 1990. Quarterly magazine. Emphasizes France. Readers are male and female, ages over 45; people who holiday in France. Sample copy $9.
Needs: Uses 250 photos/issue; 200 supplied by freelancers. Needs photos of France and French subjects: people, places, customs, curiosities, produce, towns, cities, countryside. Captions required; include location.
Making Contact & Terms: Interested in receiving work from newer, lesser-known photographers. Send unsolicited photos by mail for consideration. Send 35mm, 2¼×2¼ transparencies. Keep samples on file. SASE. Reports in 1 month. Pays £100/color cover photo; £50-100/color page rate. Pays quarterly following publication. Credit line given. Buys one-time rights. Previously published work OK.

FUN IN THE SUN, Dept. PM, 5436 Fernwood Ave., Los Angeles CA 90027. (213)465-7121. Publisher: Ed Lange. Circ. 10,000. Quarterly. Emphasizes nudism/naturism/alternative lifestyles. Photo guidelines free with SASE.
Needs: Uses about 50 photos/issue; 20 supplied by freelance photographers. Needs photos of "nudity; fun in sun (nonsexist)." Nudist, naturist, body self-acceptance. Model release required. Captions required.
Making Contact & Terms: Query with samples. SASE. Reports in 3 weeks. Pays $50/b&w cover photo; $100/color cover photo; $25/b&w or color inside photo. **Pays on acceptance.** Credit line given. Buys one-time or all rights. Previously published work OK.

***FUTURIFIC MAGAZINE**, The Foundation for Optimism, 150 Haven Ave. Terrace 3, New York NY 10032. Editor-in-Chief: Mr. Balint Szent-Miklosy. Monthly. Circ. 10,000. Emphasizes future-related subjects. Readers range from leaders from all walks of life. Sample copy with $10—for postage and handling.
Needs: Uses up to 10 photos/issue; all supplied by freelance photographers. Needs photos showing a positive, upbeat look at what the future will look like. Photos purchased with or without accompanying ms. Captions preferred.
Making Contact & Terms: Send by mail for consideration b&w prints or contact sheets. Reports in 1 month. NPI; payment negotiable. Pays on publication. Buys one-time rights. Simultaneous submissions and/or previously published work OK.
Tips: "Photographs should illustrate what directions society and the world are heading. Optimistic only."

GALLERY MAGAZINE, FOX MAGAZINE, POCKETFOX MAGAZINE, 401 Park Ave. S., New York NY 10016-8802. Photo Editor: Judy Linden. Estab. 1972. Emphasizes men's interests. Readers are male, collegiate, middle class. Photo guidelines free with SASE.
Needs: Uses 80 photos/issue; 10% supplied from freelancers (no assignments). Needs photos of nude women and celebrities, plus sports, adventure pieces. Model release with photo ID required.
Making Contact & Terms: Send at least 100 35mm transparencies by mail for consideration. SASE. Reports in 1 month. Girl sets: pays $1,500 minimum; cover extra. Buys first North American serial rights plus nonexclusive international rights. Also operates Girl Next Door contest: $250 entry photo; $2,500 monthly winner; $25,000 yearly winner (must be amateur!). Photographer: entry photo/receives 1-year free subscription, monthly winner $500; yearly winner $2,500. Send *by mail* for contest information.
Tips: In photographer's samples, wants to see "beautiful models and good composition. Trend in our publication is outdoor settings—avoid soft focus! Send complete layout."

GAME & FISH PUBLICATIONS, 2250 Newmarket Pkwy., Suite 110, Marietta GA 30067. (404)953-9222. Fax: (404)933-9510. Photo Editor: Tom Evans. Editorial Director: Ken Dunwoody. Combined circ. 525,000. Estab. 1975. Publishes 31 different monthly outdoors magazines: *Alabama Game & Fish, Arkansas Sportsman, California Game & Fish, Florida Game & Fish, Georgia Sportsman, Great Plains Game & Fish, Illinois Game & Fish, Indiana Game & Fish, Iowa Game & Fish, Kentucky*

Game & Fish, Louisiana Game & Fish, Michigan Sportsman, Mid-Atlantic Game & Fish, Minnesota Sportsman, Mississippi Game & Fish, Missouri Game & Fish, New England Game & Fish, New York Game & Fish, North Carolina Game & Fish, Ohio Game & Fish, Oklahoma Game & Fish, Pennsylvania Game & Fish, Rocky Mountain Game & Fish, South Carolina Game & Fish, Tennessee Sportsman, Texas Sportsman, Virginia Game & Fish, Washington-Oregon Game & Fish, West Virginia Game & Fish, Wisconsin Sportsman, and *North American Whitetail.* All magazines (except *Whitetail*) are for experienced fishermen and hunters and provide information about where, when and how to enjoy the best hunting and fishing in their particular state or region, as well as articles about game and fish management, conservation and environmental issues. Sample copy $2.50 with 10×12 SAE. Photo guidelines free with SASE.

Needs: 50% of photos supplied by freelance photographers; 5% assigned. Needs photos of live game animals/birds in natural environment and hunting scenes; also underwater game fish photos and fishing scenes. Model release preferred. Captions required; include species identification and location. Number slides/prints. In captions, identify species and location.

Making Contact & Terms: Query with samples. Send 8×10 glossy b&w prints or 35mm transparencies (preferably Kodachrome) with SASE for consideration. Reports in 1 month. Pays $250/color cover photo; $75/color inside photo; $25/b&w inside photo. Pays 75 days prior to publication. Tearsheet provided. Credit line given. Buys one-time rights. Simultaneous submissions not accepted.

Tips: "Study the photos that we are publishing before sending submission. We'll return photos we don't expect to use and hold remainder in-house so they're available for monthly photo selections. Please do not send dupes. Photos will be returned upon publication or at photographer's request."

GARDEN DESIGN, 100 Avenue of the Americas, 7th Floor, New York NY 10013. (212)334-1212. Fax: (212)334-1260. Senior Editor: Susan Goldberger. Bimonthly. Emphasizes residential landscape architecture and garden design. Readers are gardeners, home owners, architects, landscape architects, garden designers and garden connoisseurs. Estab. 1982. Sample copy $5; photo guidelines free with SASE.

• This publication has been completely redesigned.

Needs: Uses about 80 photos/issue; nearly all supplied by freelance photographers; 80% from assignment and 20% from freelance stock. Needs photos of "public and private gardens that exemplify professional quality design." Needs to see both the design intent and how garden subspaces work together. Model release and captions required.

Making Contact & Terms: Interested in receiving work from newer, lesser-known photographers. Submit proposal with résumé and samples. Reports in 2 months or sooner if requested. Publishes color primarily, and uses original transparencies only for separation—do not send dupes. Pays $300/color cover photo; $150/inside photo over ⅓ page; $200/double page special; $75/⅓ page or smaller. Credit line given. Buys one-time first North American magazine publication rights. Previously published work may be acceptable but is not preferred.

Tips: "Show both detailed and comprehensive views that reveal the design intent and content of a garden, as well as subjective, interpretive views of the garden. A letter and résumé are not enough—must see evidence of the quality of your work, in samples or tearsheets. Need excellent depth of field and superior focus throughout. The quality of light, original framing and point of view are important. Our trend is away from the large estate and/or public gardens, to smaller scale, well-conceived and executed residential ones."

***GENERAL LEARNING CORP.,** 60 Revere Dr., Northbrook IL 60062-1563. (708)205-3000. Supervisor/Photography: Candace H. Johnson. Estab. 1969. Publishes four monthly school magazines running September through May. *Current Health I* is for children aged 9-13. *Current Health II, Writing!, Career World* are for high school teens. An article topics list and photo guidelines will be provided free with 9×12 SAE.

Needs: Color photos of children aged 11-13 and teens geared to our topic themes for inside use and cover; 35mm or larger transparencies only. Model release preferred. Captions preferred.

Making Contact & Terms: Interested in receiving work from newer, lesser-known photographers who produce exceptional quality photographs. Label all photos with name and address for easy return. Pays $75/inside photo; $200/cover photo. Pays on publication. Credit line given. Buys one-time rights. Simultaneous submissions and previously published work OK.

Tips: "We are looking for contemporary photos of children and teens, including minorities. Do not send outdated or posed photos. When sending photos for a particular article or magazine be as specific as possible in stating the name of the magazine, issue and title of article (example: *Career World,* March 1996, "Managing Stress")."

GENESIS MAGAZINE, 110 E. 59th St., Suite 3100, New York NY 10022. (212)644-8800. Fax: (212)644-9212. Creative Director: Tony Perrotti Circ. 250,000. Estab. 1973. Monthly magazine. Emphasizes nude women. Readers are male, ages 25-45. Photo guidelines free with SASE.

Alan Detrick sees magazine covers as a chance to showcase his work to numerous buyers. "I spend many hours doing research of markets in libraries, bookstores and newsstands," says Detrick. That's why the Glen Rock, New Jersey photographer was excited when Garden Design chose his shot of daylilies to grace the magazine's cover.

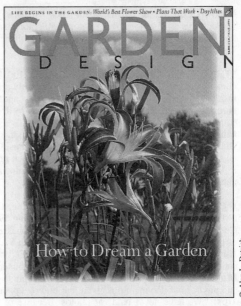

© Alan L. Detrick

Needs: Uses 100 photos/issue. Needs photos of nudes. Special photo needs include surreal photojournalism and artistic nudes. Model release required (2 pieces of identification).
Making Contact & Terms: Interested in receiving work from newer, lesser-known photographers. Send unsolicited photos by mail for consideration. Send 35mm, 2¼×2¼ transparencies. SASE. Reports in 1 month. Pays $300-500/color photo; $1,000-3,000/girl pictorials. Pays 90 days after acceptance. Credit line given.
Tips: "On girl pictorials we need to see very beautiful, vibrant models and great color on flesh tones. We need all indoor sets, no outdoor."

***GENRE**, 8033 Sunset Blvd., #1, Los Angeles CA 90046. (213)896-9778. Publisher: Richard Settles. Circ. 45,000. Estab. 1990. Monthly. Emphasizes gay life. Readers are gay men, ages 24-35. Sample copy $5.
Needs: Uses 140 photos/issue. Needs photos of fashion, celebrities, scenics. Model/property release required. Captions preferred.
Making Contact & Terms: Interested in receiving work from newer, lesser-known photographers. Provide résumé, business card, brochure, flier or tearsheets to be kept on file for possible assignments. Cannot return material. Reports only if interested. "We pay only film processing." Pays on publication. Credit line given. Buys all rights; negotiable.

❧GEORGIA STRAIGHT, 1235 W. Pender St., 2nd Floor, Vancouver, BC V6E 2V6 Canada. (604)681-2000. Fax: (604)681-0272. Managing Editor: Charles Campbell. Circ. 100,000. Estab. 1967. Weekly tabloid. Emphasizes entertainment. Readers are generally well-educated people between 20 and 45 years old. Sample copy free with 10×12 SAE.
Needs: Uses 20 photos/issue; 35% supplied by freelance photographers on assignment. Needs photos of entertainment events and personalities. Captions preferred.
Making Contact & Terms: Query with list of stock photo subjects. Include résumé, business card, brochure, flier or tearsheets to be kept on file for possible assignments. Reports in 1 month. Pays $200/b&w cover photo and $125/b&w inside photo. Pays on publication. Credit line given. Buys one-time rights. Simultaneous submissions and previously published work OK.
Tips: "Almost all needs are for in-Vancouver assigned photos, except for high-quality portraits of film stars."

***GOLF TRAVELER**, 3601 Calle Tecate, Camarillo CA 93012. (805)389-0333. Fax: (805)389-0363. Editor: Valerie Rogers. Bimonthly magazine. Emphasizes golf; senior golfers. Readers are "avid golfers who have played an average of 24 years." Circ. 90,000. Estab. 1976. Sample copy $2.50 and SASE.
Needs: Uses 10-20 photos/issue; all supplied by freelancers. Needs photos of "affiliated golf courses associated with Golf Card; personality photos of Senior Tour golfers. Model release required for cover images. Photo captions preferred that include who and where.

Making Contact & Terms: Send stock list. Does not keep samples on file. SASE. Reports in 2 weeks. Pays $475/color cover photo; $150/color inside ¼ page photo. **Pays on acceptance.** Credit line given. Buys one-time rights. Previously published work OK.

Tips: Looks for "good color-saturated images."

***THE GOLFER**, 42 W. 38th St., New York NY 10018. (212)768-8360. Fax: (212)768-8365. Contact: Gina Falco. Circ. 250,000. Estab. 1994. Bimonthly magazine. Emphasizes golf, resort, travel, sporting fashion. Readers are affluent males and females, ages 35 and up. Sample copy $5.50.

Needs: Uses 30-50 photos/issue; all supplied by freelancers. Needs photos of golf action, resorts, courses, and still life photography.

Making Contact & Terms: Interested in receiving work from newer, lesser-known photographers. Query with résumé of credits. Provide résumé, business card, brochure, flier or tearsheets to be kept on file for possible assignments. Query with stock photo list. Keeps samples on file. SASE. Reports in 1 month. NPI. Pays on publication. Buys one-time rights. Simultaneous submissions and previously published work OK.

♦GOSPEL HERALD, 4904 King St., Beamsville, Ontario L0R 1B6 Canada. (905)563-7503. Fax: (905)563-7503. Editor: Wayne Turner. Managing Editor: Eugene Perry. Circ. 1,420. Estab. 1936. Consumer publication. Monthly magazine. Emphasizes Christianity. Readers are primarily members of the Churches of Christ. Sample copy free with SASE.

Needs: Uses 2-3 photos/issue; percentage supplied by freelancers varies. Needs scenics, shots, especially those relating to readership—moral, religious and nature themes.

Making Contact & Terms: Send unsolicited photos by mail for consideration. Send b&w, any size and any format. Payment not given, but photographer receives credit line.

Tips: "We have never paid for photos. Because of the purpose of our magazine, both photos and stories are accepted on a volunteer basis."

GRAND RAPIDS MAGAZINE, 549 Ottawa Ave. NW, Grand Rapids MI 49503-1444. (616)459-4545. Fax: (616)459-4800. Publisher: John H. Zwarensteyn. Editor: Carole Valade. Estab. 1963. Monthly magazine. Emphasizes community-related material of Western Michigan; local action and local people.

Needs: Animal, nature, scenic, travel, sport, fashion/beauty, photo essay/photo feature, fine art, documentary, human interest, celebrity/personality, humorous, wildlife, vibrant people shots and special effects/experimental. Wants on a regular basis western Michigan photo essays and travel-photo essays of any area in Michigan. Model release required. Captions required.

Making Contact & Terms: Interested in receiving work from newer, lesser-known photographers. Freelance photos assigned and accepted. Provide business card to be kept on file for possible future assignments; "only people on file are those we have met and personally reviewed." Arrange a personal interview to show portfolio. Query with résumé of credits. Send material by mail for consideration. Submit portfolio for review. Send 8×10 or 5×7 glossy b&w prints; contact sheet OK; 35mm, 120mm or 4×5 transparencies or 8×10 glossy color prints; Uses 2¼×2¼ and 4×5 color transparencies for cover, vertical format required. SASE. Reports in 3 weeks. Pays $25-35/b&w photo; $35-50/color photo; $100-150/cover photo. Buys one-time rights, exclusive product rights, all rights; negotiable.

Tips: "Most photography is by our local freelance photographers, so freelancers should sell us on the unique nature of what they have to offer."

GRAND RAPIDS PARENT MAGAZINE, 549 Ottawa NW, Grand Rapids MI 49503. (616)459-4545. Fax: (616)459-4800. Editor: Carole Valade. Circ. 12,000. Estab. 1989. Monthly magazine. Sample copy $2. Photo guidelines free with SASE.

Needs: Uses 20-50 photos/issue; all supplied by freelancers. Needs photos of families, children, education, infants, play, etc. Model/property release required. Captions preferred; include who, what, where, when.

Making Contact & Terms: Interested in receiving work from newer, lesser-known photographers. Query with résumé of credits. Query with stock photo list. Sometimes keeps samples on file. SASE. Reports in 1 month. Pays $200/color cover photo; $35/color inside photo; $25/b&w inside photo; $50 minimum/color page rate. Pays on publication. Credit line given. Buys one-time rights, all rights; negotiable. Simultaneous submissions and/or previously published work OK.

Tips: "We are not interested in 'clip art' variety photos. We want the honesty of photojournalism, photos that speak to the heart, that tell a story, that add to the story told."

GRIT MAGAZINE, 1503 SW 42nd St., Topeka KS 66609. Contact: Editor. Circ. 400,000. Estab. 1882. Biweekly magazine. Emphasizes "people-oriented material which is helpful, inspiring or uplifting. Readership is national." Sample copy $2.

Needs: Buys "hundreds" of photos/year; 70% from assignment. Needs on a regular basis "photos of all subjects, provided they have up-beat themes that are so good they surprise us. Need *short*, unusual stories—heartwarming, inspirational, off-beat, humorous—or human interest with b&w or color pho-

tos. Be certain pictures are well composed, properly exposed and pin sharp. No cheesecake. No pictures that cannot be shown to any member of the family. No pictures that are out of focus or over-or under-exposed. No ribbon-cutting, check-passing or hand-shaking pictures. We use 35mm and up." Photos purchased with accompanying ms. Model release required. Captions required. "Single b&w photo or color slide, that stands alone must be accompanied by 50-100 words of meaningful caption information."

Making Contact & Terms: Interested in receiving work from newer, lesser-known photographers if work is good. Send material by mail for consideration. Prefer b&w glossies or color slides/professional quality. Reports in 6 weeks. Pays $150 for cover photo; $75 minimum/color photo; $40 minimum/ b&w photo. Uses much more color than b&w. Buys one-time rights; negotiable. SASE. Pays on publication.

Tips: Building network of freelance photographers nationwide for assignment. "Good major-holiday subjects seldom come to us from freelancers. For example, Easter, Fourth of July, Christmas or New Year. Remember that *Grit* publishes on newsprint and therefore requires sharp, bright, contrasting colors for best reproduction. Avoid sending shots of people whose faces are in shadows; no soft focus."

***GUEST INFORMANT**, 21200 Erwin St., Woodland Hills CA 91367. (800)275-5885. Contact: Photo Editor. Quarterly and annual city guide books. Emphasizes city-specific photos for use in guide books distributed in upscale hotel rooms in approximately 30 U.S. cities.

Needs: "We review people-oriented, city-specific stock photography that is innovative and on the cutting edge." Categories include: major attractions, annual events, local recreation, lifestyle, pro sports, regional food and cultural color. Captions required; include city, location, event, etc.

Making Contact & Terms: Interested in seeing new as well as established photographers. Provide promo, business card and list of cities covered. Send transparencies with a delivery memo stating the number and format of transparencies you are sending. All transparencies must be clearly marked with photographer's name and caption information. They should be submitted in slide pages with similar images grouped together. Rates: Cover $250. Inside $100-200, depending on size. 50% reuse rate. Pays on publication, which is about 60 days from initial submission. Credit line given.

Tips: Contact photo editor at (800)275-5885 for guidelines and submission schedule before sending your work.

GUIDE FOR EXPECTANT PARENTS, 8003 Old York Rd., Elkins Park PA 19027. (215)635-1700. Fax: (215)635-6455. Project Coordinator: Deana C. Jamroz. Circ. 1,850,000/year. Estab. 1973. Biannual magazine. Emphasizes prenatal care for pregnant women and their partners. Sample copy free with 9×12 SAE and 4 first-class stamps. Photo guidelines free with SASE.

Needs: Uses 2-8 photos/issue; 80% supplied by freelancers. Needs photos of pregnant women with their spouses and physicians, nurses with pregnant women, pregnant women in classroom (prenatal) situations, pictures of new families. Reviews photos with or without ms. Model/property release required.

Making Contact & Terms: Interested in receiving work from newer, lesser-known photographers. Query with stock photo list. Does not keep samples on file. SASE. Reports in 3 weeks. Pays $300-600/color inside photo; $100-500/b&w inside photo. **Pays on acceptance.** Credit line not given. Buys all rights.

GUIDEPOSTS ASSOCIATES, INC., Dept. PM, 16 E. 34th St., 21st Floor, New York NY 10016. (212)251-8124. Fax: (212)684-0679. Photo Editor: Courtney Reid-Eaton. Circ. 4 million. Estab. 1945. Monthly magazine. Emphasizes tested methods for developing courage, strength and positive attitudes through faith in God. Free sample copy and photo guidelines with 6×9 SAE and 3 first-class stamps.

● This company has begun using digital manipulation and retouching when necessary.

Needs: Uses 85% assignment, 15% stock (variable). "Photos mostly used are of an editorial reportage nature or stock photos, i.e., scenic landscape, agriculture, people, animals, sports. We work four months in advance. It's helpful to send stock pertaining to upcoming seasons/holidays. No lovers, suggestive situations or violence." Model release preferred.

Making Contact & Terms: Interested in receiving work from newer, lesser-known photographers. Send photos or arrange a personal interview. Send 35mm transparencies; vertical format required for cover, usually shot on assignment. SASE. Reports in 1 month. Pays by job or on a per-photo basis; pays $150-400/color photo; $750/cover photo; $400-600/day; negotiable. **Pays on acceptance.** Credit line given. Buys one-time rights. Simultaneous submissions OK.

Tips: "I'm looking for photographs that show people in their environment. I like warm, saturated color for portraits and scenics. We're trying to appear more contemporary. We want to stimulate a younger audience and yet maintain a homey feel. For stock—scenics; graphic images with intense color. *Guideposts* is an 'inspirational' magazine. NO violence, nudity, sex. No more than 60 images at a time. Write first and ask for a photo guidelines/sample issue; this will give you a better idea of what we're looking for. I will review transparencies on a light box. I am interested in the experience

as well as the photograph. I am also interested in the photographer's sensibilities—Do you love the city? Mountain climbing? Farm life?"

GUITAR SCHOOL, 1115 Broadway, New York NY 10010. (212)807-7100. Fax: (212)627-4678. Managing Editor: Tom Beaujour. Circ. 127,000. Bimonthly. Emphasizes guitar playing. Readers are male and female fans and students of guitar.
Needs: Uses 25 photos/issue; all supplied by freelancers.
Making Contact & Terms: Interested in receiving work from newer, lesser-known photographers. Query with stock photo list. Cannot return materials. Reports in 1-2 weeks. NPI. Pays on publication. Credit line given. Buys one-time rights.

✦HARROWSMITH, 25 Sheppard Ave. W., Suite 100, North York, Ontario M2N 6S7 Canada. (416)733-7600. Contact: Editorial Assistant. Estab. 1976. Magazine published 6 times/year. Circ. 154,000. Emphasizes self-reliance, energy conservation, organic gardening, solar energy. Sample copy $5 with 8½×14 SASE.
Needs: Buys 400 photos/year, 50 photos/issue; 40% assigned. Animal, how-to, nature, North American rural life, wildlife (North American), horticulture, organic gardening.
Making Contact & Terms: Anyone wishing to submit photographs should contact the Editorial Assistant. "We are interested in seeing portfolios of both published and personal work." NPI. Payment varies with assignment.
Tips: Prefers to see portfolio with credits and tearsheets of published material. Samples should be subject-oriented. In portfolio or samples, wants to see "clarity, ability to shoot people, nature and horticulture photo essays."

***HEALTHY OUTLOOK**, 2601 Ocean Park Blvd., #200, Santa Monica CA 90405. (310)399-9000. Fax: (310)399-1722. Art Director: Howard Maat. Publication of Oxford Health Plans. Quarterly magazine. Emphasizes senior health issues, senior travel, finance, etc. Readers are 65 and older, mostly retired seniors from East Coast.
Needs: Needs photos of healthy/active senior citizens, healthy food preparations/ingredients, East Coast scenics, famous senior personalities. Special photo needs include senior celebrities (60+) with release. Model/property release preferred. Captions required.
Making Contact & Terms: Interested in receiving work from newer, lesser-known photographers. Provide résumé, business card, brochure, flier or tearsheets to be kept on file for possible assignments. Submit portfolio for review. Keeps samples on file. Reports in 1 month. NPI. Pays on publication. Credit line given. Buys one-time rights, all rights. Previously published work OK.
Tips: "Show specific strengths; be upfront with prices; be flexible and responsible with regards to deadlines."

***HEARTLAND BOATING**, P.O. Box 1067, Martin TN 38237. (901)587-6791. Fax: (901)587-6893. Editor: Molly Lightfoot Blom. Circ. 20,000. Estab. 1989. Magazine published 7 times/year (during boating season). Emphasizes recreational boating on the inland lakes and rivers. Readers are recreational boaters, primarily affluent middle-aged males. Sample copy $5. Photo guidelines free with SASE.
Needs: Needs photos of boating—places, people, technical. Model release preferred. Captions preferred.
Making Contact & Terms: Interested in receiving work from newer, lesser-known photographers. Provide résumé, business card, brochure, flier or tearsheets to be kept on file for possible assignments. Keeps samples on file. Reports 2 months. NPI. Pays on publication. Credit line given. Buys one-time rights, first North American serial rights. Previously published work OK.

HIGH SOCIETY MAGAZINE, 801 Second Ave., New York NY 10017. (212)661-7878. Fax: (212)692-9297. Photo Editor: Vivienne Maricevic. Circ. 400,000. Estab. 1976. Monthly magazine. Emphasis on "everything of sexual interest to the American male." Readers are young males, ages 21-40. SASE. Photo guidelines available.
Needs: Uses 300 photos/issue; 50% supplied by freelancers. Needs sexually stimulating, nude photos of gorgeous women, ages 21-35. Reviews photos with or without accompanying ms. Special needs include outdoor and indoor scenes of nude women. Model/property release required. Captions preferred.
Making Contact & Terms: Interested in receiving work from newer, lesser-known photographers. Send color prints; 35mm, 2¼×2¼ transparencies by mail for consideration. Does not keep samples on file. SASE. Pays $300/color cover photo; $150/color inside photo; $100/b&w inside photo; $800/color page rate; $400/b&w page rate; $1,500/photo-text package. **Pays on acceptance.** Credit line given. Buys one-time rights; negotiable. Simultaneous submissions and previously published work OK.

Tips: Looks for "clear, concise color, interesting set preparation and props, strong contrast, backgrounds and settings, and knock-'em-out models. Look at our previous published issues and see what we buy."

HIGHLIGHTS FOR CHILDREN, Dept. PM, 803 Church St., Honesdale PA 18431. (717)253-1080. Photo Essay Editor: Kent L. Brown, Jr. Circ. more than 3 million. Monthly magazine. For children, ages 2-12. Free sample copy.
Needs: Buys 20 or more photos annually. "We will consider outstanding photo essays on subjects of high interest to children." Photos purchased with accompanying ms. Wants no single photos without captions or accompanying ms.
Making Contact & Terms: Interested in receiving work from newer, lesser-known photographers. Send photo essays for consideration. Prefers transparencies. SASE. Reports in 7 weeks. Pays $30 minimum/b&w photo; $55 minimum/color photo. Pays $100 minimum for ms. Buys all rights.
Tips: "Tell a story which is exciting to children. We also need mystery photos, puzzles that use photography/collage, special effects, anything unusual that will visually and mentally challenge children."

HOCKEY ILLUSTRATED, 233 Park Ave. S., New York NY 10003. (212)780-3500. Fax: (212)780-3555. Editor: Stephen Ciacciarelli. Circ. 50,000. Published 4 times/year, in season. Emphasizes hockey superstars. Readers are hockey fans. Sample copy $2.95 with 9 × 12 SASE.
Needs: Uses about 60 photos/issue; all supplied by freelance photographers. Needs color slides of top hockey players in action. Captions preferred.
Making Contact & Terms: Query with action color slides. SASE. Pays $150/color cover photo; $75/color inside photo. **Pays on acceptance.** Credit line given. Buys one-time rights.

HOME EDUCATION MAGAZINE, P.O. Box 1083, Tonasket WA 98855. (509)486-1351. E-mail: homeedmag@aol.com. Managing Editor: Helen Hegener. Circ. 8,900. Estab. 1983. Bimonthly magazine. Emphasizes homeschooling. Readers are parents of children, ages 2-18. Sample copy for $4.50. Photo guidelines free with SASE.
Needs: Number of photos used/issue varies based on availability; 25% supplied by freelance photographers. Needs photos of parent/child or children. Special photo needs include homeschool personalities and leaders. Model/property releases preferred. Captions preferred.
Making Contact & Terms: Interested in receiving work from newer, lesser-known photographers. Send unsolicited b&w prints by mail for consideration. Prefers b&w prints in normal print size (3 × 5). "Enlargements not necessary." Uses 35mm transparencies. SASE. Reports in 1 month. Pays $25/color cover photo; $5/b&w inside photo; $10-50/photo/text package. Pays on publication. Credit line given. Buys first North American serial rights; negotiable.
Tips: In photographer's samples, wants to see "sharp clear photos of children doing things alone, in groups or with parents. Know what we're about! We get too many submissions that are simply irrelevant to our publication."

THE HOME SHOP MACHINIST, P.O. Box 1810, Traverse City MI 49685. (616)946-3712. Fax: (616)946-3289. Editor: Joe D. Rice. Circ. 30,000. Estab. 1982. Bimonthly. Emphasizes "machining and metal working." Readers are "amateur machinists, small commercial machine shop operators and school machine shops." Sample copy free with 9 × 12 SAE and 3 first-class stamps. Photo guidelines free with SASE.
Needs: Uses about 30-40 photos/issue; "most are accompanied by text"; 30% from assignment; 70% from stock." Needs photos of "machining operations, how-to-build metal projects." Special needs include "good quality machining operations in b&w."
Making Contact & Terms: Interested in receiving work from newer, lesser-known photographers. Send 4 × 5 or larger glossy b&w prints by mail for consideration. SASE. Reports in 3 weeks. Pays $40/b&w cover photo; $9/b&w inside photo; $30 minimum for text/photo package ("depends on length"). Pays on publication. Credit line given. Buys one-time rights.
Tips: "Photographer should know about machining techniques or work with a machinist. Subject should be strongly lit for maximum detail clarity."

HORIZONS MAGAZINE, P.O. Box 2639, Bismarck ND 58502. (701)222-0929. Fax: (701)222-1611. Editor: Lyle Halvorson. Estab. 1971. Quality regional magazine. Photos used in magazines, audiovisual and calendars.
Needs: Buys 50 photos/year; offers 25 assignments/year. Scenics of North Dakota events, places and people. Examples of recent uses: "Scenic North Dakota" calendar, *Horizons Magazine* (winter edition) and "North Dakota Bad Lands." Model/property release preferred. Captions preferred.
Making Contact & Terms: Query with samples. Query with stock photo list. Works on assignment only. Uses 8 × 10 glossy b&w prints; 35mm, 2¼ × 2¼, 4 × 5 transparencies. Does not keep samples

on file. SASE. Reports in 2 weeks. Pays $150-250/day; $200-300/job. Pays on usage. Credit line given. Buys one-time rights; negotiable.

Tips: "Know North Dakota events, places. Have strong quality of composition and light."

HORSE ILLUSTRATED, Dept. PM, P.O. Box 6050, Mission Viejo CA 92690. (714)855-8822. Fax: (714)855-3045. Editor: Audrey Pavia. Managing Editor: Moira C. Harris. Readers are "primarily adult horsewomen between 18-40 who ride and show mostly for pleasure and who are very concerned about the well being of their horses." Circ. 180,000. Sample copy $4.50; photo guidelines free with SASE.

Needs: Uses 20-30 photos/issue, all supplied by freelance photographers; 50% from assignment and 50% from freelance stock. Specific breed featured every issue. Prefers "photos that show various physical and mental aspects of horses. Include environmental, action and portrait-type photos. Prefer people to be shown only in action shots (riding, grooming, treating, etc.). We like riders—especially those jumping—to be wearing protective headgear."

Making Contact & Terms: Send by mail for consideration actual 8 × 10 b&w photos or 35mm and 2¼ × 2¼ color transparencies. "We generally use color transparencies and have them converted to b&w as needed." Reports in 2 months. Pays $15-25/b&w photo; $50-150/color photo and $100-350 per text/photo package. Credit line given. Buys one-time rights.

Tips: "Nothing but sharp, high-contrast shots. Looks for clear, sharp color and b&w shots of horse care and training. Healthy horses, safe riding and care atmosphere is the current trend in our publication. Send SASE for a list of photography needs and for photo guidelines and submit work (prefer color transparencies) on spec."

***HORSEPLAY MAGAZINE**, Dept. PM, 11 Park Ave., P.O. Box 130, Gaithersburg MD 20884. (301)840-1866. Fax: (301)840-5722. Managing Editor: Lisa Kiser. Circ. 50,000. Estab. 1972. Monthly magazine. Emphasizes English riding (show jumping, fox hunting, dressage, eventing). Readers are ages 15-35, female, middle to upper-middle class. Sample copy $3. Photo guidelines free with SASE.

Needs: Uses 45 photos/issue; 95% supplied by freelance photographers. Needs photos of horse shows, top riders, training photos and general horse care. Special photo needs include world championship events, major grands prix, major 3-day, major dressage competitions. Propety release required. Captions preferred; must identify horse and rider, show and year taken.

Making Contact & Terms: Interested in receiving work from newer, lesser-known photographers. Send b&w prints and 35mm transparencies by mail for consideration. Pays $200/color cover photo; $45/color inside photo; $22.50/b&w inside photo; $75 assignment fee. SASE. Buys one-time rights; negotiable. "Exclusive or first refusal photos only."

Tips: Wants to see "razor-sharp focus, good b&w contrast, uncluttered and colorful subjects/backgrounds."

HORTICULTURE MAGAZINE, 98 N. Washington St., Boston MA 02114. (617)742-5600. Fax: (617)367-6364. Photo Editor: Tina Schwinder. Circ. 350,000. Estab. 1904. Monthly magazine. Emphasizes gardening. Readers are all ages. Sample copy $2.50 with 9 × 12 SAE with $2 postage. Photo guidelines free with SASE.

Needs: Uses 25-30 photos/issue; 100% supplied by freelance photographers. Needs photos of gardening, individual plants. Model release preferred. Captions required.

Making Contact & Terms: Arrange a personal interview to show portfolio. Query with samples. Send 35mm color transparencies by mail for consideration. Submit portfolio for review. Provide résumé, business card, brochure, flier or tearsheets to be kept on file for possible future assignments. SASE. Reports in 1 month. Pays $500/color cover photo; $50-250/color page. Pays on publication. Credit line given. Buys one-time rights. Simultaneous submissions OK.

Tips: Wants to see gardening images, i.e., plants and gardens.

***HOT BOAT**, 9171 Wilshire Blvd., Suite 300, Beverly Hills CA 90210. (310)858-7155. Editor: Peter MacGilliuray. Circ. 70,000. Estab. 1964. Monthly magazine. Emphasizes performance boating. Readers are mostly male, ages 19-55. Sample copy free with SASE.

Needs: Uses 40 photos/issue; 20 supplied by freelancers. "We use photography to illustrate our tech stories. travel and boat tests, competition, too." Captions required.

Making Contact & Terms: Interested in receiving work from newer, lesser-known photographers "as long as they know the subject." Submit portfolio for review (copies OK). Send color prints; 35mm, 2¼ × 2¼ transparencies. Does not keep samples on file. SASE. Reports in 1-2 weeks. Pays $100-200/color page rate. Pays on publication. Credit line given. Buys first North American serial rights; negotiable. Simultaneous submissions OK.

Tips: "I look for an understanding of performance boating. We aren't interested in sailboats or fishing! The best way to break into this magazine is to shoot a feature (multiple photos—details and overall action) of a 'hot boat.' Check out the magazine if you don't know what a custom performance boat is."

***I LOVE CATS**, 950 Third Ave., 16th Floor, New York NY 10022. (212)888-1855. Fax: (212)838-8420. Editor: Lisa A. Sheets. Circ. 200,000. Bimonthly magazine. Emphasizes cats. Readers are male and female ages 10-100. Sample copy $3. Photo guidelines free with SASE.
Needs: Uses 30-40 photos/issue; all supplied by freelancers. Needs color shots of cats in any environment. "Pay attention to details. Don't let props overplay cat." Model/property release preferred for children. Caption preferred.
Making Contact & Terms: Interested in receiving work from newer, lesser-known photographers. Send unsolicited photos by mail for consideration. Provide résumé, business card, brochure, flier or tearsheets to be kept on file for possible assignments. Send any size, any finish, color and b&w prints; 35mm transparencies. Deadlines: 6 months ahead of any holiday. SASE. Reports in 1 month. Pays $100-400/color cover photo; $10-25/color inside photo; $10/b&w inside photo; $100-200/photo/text package. Pays on publication. Credit line given. Buys all rights but, photos are returned after use.
Tips: Wants to see "crisp, clear photos with cats as the focus. Big eyes on cats looking straight at the viewer for the cover. Inside photos can be from the side with more props, more soft, creative settings. Don't send cats in dangerous situations. Keep the family perspective in mind. Always include a SASE with enough postage. Don't bug an editor, as editors are very busy. Keep the theme, intent and purpose of the publication in mind when submitting material. Be patient and submit material that is appropriate. Get a copy of the magazine."

IDAHO WILDLIFE, P.O. Box 25, Boise ID 83707. (208)334-3748. Fax: (208)334-2148. Editor: Diane Ronayne. Circ. 27,000. Estab. 1978. Bimonthly magazine. Emphasizes wildlife, hunting, fishing. Readers are aged 25-70, 80% male, purchase Idaho hunting or fishing licenses; ⅔ nonresident, ⅓ resident. Sample copy $1. Photo guidelines free with SASE.
 ● Ronayne says her staff began using CD-ROM and Internet in early 1995. The use of these technologies "could facilitate image previews, so originals are only shipped when rights are purchased."
Needs: Uses 20-40 photos/issue; 30-60% supplied by freelancers. Needs shots of "wildlife, hunting, fishing in Idaho; habitat management." Photos of wildlife/people should be "real," not too "pretty" or obviously set up. Model release preferred. Captions required; include species and location.
Making Contact & Terms: Interested in receiving work from newer, lesser-known photographers. Query with list of stock photo subjects. SASE. Reports in 1 month. Pays $80/color cover photo; $40/color or b&w inside photo; $40/color or b&w page rate. Pays on publication. Credit line given. Buys one-time rights. Simultaneous submissions and previously published work OK.
Tips: "Write first for want list. 99% of photos published are taken in Idaho. Seldom use scenics. Love action hunting or fishing images but must look 'real' (i.e., natural light). Only send your *best* work. We don't pay as much as commercial magazines but our quality is as high or higher and we value photography and design as much as text."

IDEALS MAGAZINE, Ideals Publications Incorporated, 565 Marriott Dr., Suite 800, Nashville TN 37214. (615)231-6740. Fax: (615)231-6750. Editor: Lisa Thompson. Circ. 200,000. Estab. 1944. Magazine published 8 times/year. Emphasizes an idealized, nostalgic look at America through poetry and short prose, using "seasonal themes—bright flowers and scenics for Thanksgiving, Christmas, Valentine, Easter, Mother's Day, Friendship, Country and Home—all thematically related material. Issues are seasonal in appearance." Readers are "mostly college-educated women who live in rural areas, aged 50 and up." Sample copy $4. Photo guidelines free with SASE.
Needs: Uses 20-25 photos/issue; all supplied by freelancers. Needs photos of "bright, colorful flowers, scenics, still life, children, pets, home interiors; subject-related shots depending on issue. We regularly send out a letter listing the photo needs for our upcoming issue." Model/property release required. No research fees.
Making Contact & Terms: Submit tearsheets to be kept on file. No color copies. Will send photo needs list if interested. Do not submit unsolicited photos or transparencies. Work only with 2¼×2¼, 4×5, 8×10 transparencies; no 35mm. Keeps samples on file. NPI; rates negotiable. Pays on publication. Credit line given. Buys one-time rights. Simultaneous and previously published work OK.
Tips: "We want to see *sharp* shots. No mood shots, please. No filters. Would suggest the photographer purchase several recent issues of *Ideals* magazine and study photos for our requirements."

ILLINOIS ENTERTAINER, 124 W. Polk, #103, Chicago IL 60605-2069. (312)922-9333. Fax: (312)922-9369. Editor: Michael C. Harris. Circ. 80,000. Estab. 1975. Monthly magazine. Emphasizes

A bullet has been placed within some listings to introduce special comments by the editor of Photographer's Market.

music, video, theater, entertainment. Readers are male and female, 16-40, music/clubgoers. Sample copy $5.

Needs: Uses 20 photos/issue; approximately 5 supplied by freelancers on assignment or from stock. Needs "live concert photos; personality head shots—crisp, clean, high-contrast b&ws." Model/property release required; "releases required for any non-approved publicity photos or pics with models." Captions required.

Making Contact & Terms: Interested in receiving work from newer, lesser-known photographers. Query with résumé of credits and list of stock photo subjects. Send unsolicited photos by mail for consideration. Send 8 × 10 or 5 × 7 b&w prints. Does not keep samples on file. SASE. Reports in 1 month. Pays $100-125/color cover photo; $20-30/b&w inside photo. Pays no sooner than 60 days after publication. Buys one-time rights. Simultaneous submissions and previously published work OK.

Tips: Send high-contrast b&w photos. "We print on newsprint paper. We are seeing some more engaging publicity photos, though still fairly straightforward stuff abounds."

***INCOME OPPORTUNITIES**, 1500 Broadway, 6th Floor, New York NY 10036. (212)642-0600. Art Director: Andrew Bass. Circ. 350,000. Estab. 1956. Monthly magazine. Readers are individuals looking for ways to start low-cost businesses. Sample copy free with 9 × 12 SASE. Photo guidelines free with SASE.

Needs: Uses 10-30 photos/issue; 10-15 supplied by freelancers. Needs editorial shots with people, location shots. Special photo needs include special effect, location, portraiture photos.

Making Contact & Terms: Interested in receiving work from newer, lesser-known photographers. Provide résumé, business card, brochure, flier or tearsheets to be kept on file for possible assignments. Keeps samples on file. Cannot return material. Reports in 2 weeks. Pays maximum prices of $1,700/color cover photo; $1,700/b&w cover photo; $350/color inside photo; $275/b&w inside photo. **Pays on acceptance.** Credit line given. Buys first North American serial rights; negotiable. Previously published work OK.

INDIANAPOLIS BUSINESS JOURNAL, 431 N. Pennsylvania St., Indianapolis IN 46204. (317)634-6200. Fax: (317)263-5060. Picture Editor: Robin Jerstad. Circ. 17,000. Estab. 1980. Weekly newspaper/monthly magazine. Emphasizes Indianapolis business. Readers are male, 28 and up, middle management to CEO's.

Needs: Uses 15-20 photos/issue; 3-4 supplied by freelancers. Needs portraits of business people. Model release preferred. Captions required; include who, what, when and where.

Making Contact & Terms: Interested in receiving work from newer, lesser-known photographers. Query with résumé and credits. Query with stock photo list. Cannot return material. Reports in 3 weeks. Pays $50-75/color inside photo; $25-50/b&w inside photo. Pays on publication. Credit line given. Buys one-time rights. Simultaneous submissions and/or previously published work OK.

Tips: "We generally use local freelancers (when we need them). Rarely do we have needs outside the Indianapolis area."

***INDIANAPOLIS MONTHLY**, Dept. PM, 950 N. Meridian, Suite 1200, Indianapolis IN 46204. Art Director: Craig Arive. Monthly. Emphasizes regional/Indianapolis. Readers are upscale, well-educated. Circ. 50,000. Sample copy for $3.05 and 9 × 12 SASE.

● *Indianapolis Monthly* was a 1994 Gold Medal Winner of the White Award for best city magazine under 50,000 circulation.

Needs: Uses 50-60 photos/issue; 10-12 supplied by freelance photographers. Needs seasonal, human interest, humorous, regional; subjects must be Indiana- or Indianapolis-related. Model release and captions preferred.

Making Contact & Terms: Query with samples; send 5 × 7 or 8 × 10 glossy b&w prints or 35mm or 2¼ × 2¼ transparencies by mail for consideration. SASE. Reports in 1 month. Pays $25/b&w inside photo; $35/color inside photo. Pays on publication. Credit line given. Buys first North American serial rights. Previously published work on occasion OK, if different market.

Tips: "Read publication. Send photo similar to those you see published. If we do nothing like what you are considering, we probably don't want to."

INDIANAPOLIS WOMAN, (formerly *Indy's Woman*), 9000 Keystone Crossing, Suite 939, Indianapolis IN 46240. (317)580-0939. Fax: (317)581-1329. Art Director: Amy Mansfield. Circ. 32,000. Estab. 1994. Monthly magazine. Readers are females, ages 20-55. Sample copy free with 9 × 12 SASE. Photo guidelines free with SASE.

Needs: Uses 48 photos/issue. Needs photos of beauty, fashion, dining out. Model relese preferred. Property release required. Captions preferred; include subject, date, photographer.

Making Contact & Terms: Interested in receiving work from newer, lesser-known photographers. Provide résumé, business card, brochure, flier or tearsheets to be kept on file for possible assignments. Keeps samples on file. SASE. Reports on an as needed basis. NPI. Credit line given. Rights negotiable. Previously published work OK.

***INLINE: THE SKATER'S MAGAZINE**, 2025 Pearl St., Boulder CO 80302. (303)440-5111. Fax: (303)440-3313. Photo Editor: Laurie Jennings. Circ. 40,000. Estab. 1991. Bimonthly tabloid. Emphasizes inline skating (street, speed, vertical, fitness, hockey, basics). Readers are male and female skaters of all ages. Sample copy free with 11 × 14 SASE.
Needs: Uses 20-50 photos/issue; 75% supplied by freelancers. Needs photos of skating action, products, scenics, personalities, how-to. Captions preferred; include location and model.
Making Contact & Terms: Interested in receiving work from newer, lesser-known photographers. Provide résumé, business card, brochure, flier or tearsheets to be kept on file for possible assignments. Keeps samples on file. SASE. Reports in 3 weeks. Pays $50-500/job; 200-300/color cover photo; $50-125/color inside photo; $25-100/b&w inside photo; $100/color page rate; $75/b&w page rate. Pays on publication. Credit line given. Buys one-time rights; negotiable. Simultaneous submissions and previously published work OK.
Tips: "Freelancers should get in touch to arrange any kind of submission before sending it. However, I am always interested in seeing new work from new photographers."

INSIDER MAGAZINE, 4124 Oakton St., Skokie IL 60076-3267. (708)673-3458. Fax: (708)675-0591. Editorial Director: Alex Gordon. Circ. 1 million. Estab. 1984. Monthly magazine. Emphasizes general interest focusing on male and female readers, ages 18-29. Sample copy $1.95.
Needs: Uses 100 photos/issue. Reviews photos purchased with accompanying ms only. Model release required. Captions required.
Making Contact & Terms: Interested in receiving work from newer, lesser-known photographers. Query with résumé of credits. Query with stock photo list. Provide résumé, business card, brochure, flier or tearsheets to be kept on file for possible assignments. Send 8 × 10 color prints; 35mm, 4 × 5 transparencies. Keeps samples on file. SASE. Reports in 1 month. Pays on publication. Credit line given. Buys all rights.

INTERNATIONAL WILDLIFE, 8925 Leesburg Pike, Vienna VA 22184. (703)790-4419. Fax: (703)442-7332. Photo Editor: John Nuhn. Circ. 375,000. Estab. 1970. Bimonthly magazine. Emphasizes world's wildlife, nature, environment, conservation. Readers are people who enjoy viewing high-quality wildlife and nature images, and who are interested in knowing more about the natural world and man's interrelationship with animals and environment on all parts of the globe. Sample copy $3 from National Wildlife Federation Membership Services (same address); do not include order with guidelines request. Photo guidelines free with SASE, Attn: Photo Guidelines, Wildlife Editorial.
 • This photo editor looks for the ability to go one step farther to make a common shot unique and creative.
Needs: Uses about 45 photos/issue; all supplied by freelance photographers; 30% on assignment, 70% from stock. Needs photos of world's wildlife, wild plants, nature-related how-to, conservation practices, conservation-minded people (tribal and individual), environmental damage, environmental research, outdoor recreation. Special needs include single photos for cover possibility (primarily wildlife but also plants, scenics, people); story ideas (with photos) from Canada, Europe, former Soviet republics, Pacific, China; b&w accompanying unique story ideas that have good reason not to be in color. Model release preferred. Captions required.
Making Contact & Terms: Send 35mm, 2¼ × 2¼, 4 × 5, 8 × 10 transparencies (magazine is 95% color) or 8 × 10 glossy b&w prints by mail for consideration. Query with samples, credits and stock listings. SASE. Reports in 1 month. Pays $500-800/color cover photo; $300-750/color and b&w inside photo; negotiable/text photo package. **Pays on acceptance.** Credit line given. Buys one-time rights with limited magazine promotion rights. Previously published work OK.
Tips: Looking for a variety of images that show photographer's scope and specialization, organized in loose slide sheets (no binders), along with tearsheets of previously published work. "Study our magazine; note the type of images we use and send photos equal or better. Think editorially when submitting story queries or photos. Assure that package is complete—sufficient return postage (no checks), proper size return envelope, address inside and do not submit photos in glass slides, trays or small boxes."

INTERRACE MAGAZINE, P.O. Box 12048, Atlanta GA 30355. (404)364-9690. Fax: (404)364-9965. Associate Publisher: Gabe Grosz. Circ. 25,000. Estab. 1989. Bimonthly magazine. Emphasizes interracial couples and families, mixed-race people. Readers are males and females, ages 18-70, of all racial backgrounds. Sample copies $2 with 9 × 12 SAE and 4 first-class stamps. Photo guidelines free with SASE.
Needs: Uses 20-30 photos/issue; 15-20 supplied by freelancers. Needs photos of people/couples/personalities; must be interracial couple or interracially involved; biracial/multiracial people. Model/property release optional. Captions preferred, identify subjects.
Making Contact & Terms: Interested in receiving work from newer, lesser-known photographers. Submit portfolio for review. Query with résumé of credits. Query with stock photo list. Send unsolicited photos by mail for consideration. Provide résumé, business card, brochure, flier or tearsheets to be

kept on file for possible assignments. Send 3×5, 8×10 color or b&w prints; any transparencies. Keeps samples on file. SASE. Reports in 1 month or less. Pays $15-25/hour; $15-100/job; $75-100/ color cover photo; $75-100/b&w cover photo; $20-35/color inside photo; $15-25/b&w inside photo; $20-35/color page rate. Pays on publication. Credit line given. Buys one-time rights. Simultaneous submissions and/or previously published work OK.

Tips: "We're looking for unusual, candid, upbeat, artistic, unique photos. We're looking for not only black and white couples/people. All racial make ups are needed."

THE IOWAN MAGAZINE, 108 Third St., Suite 350, Des Moines IA 50309. (515)282-8220. Fax: (515)282-0125. Editor: Mark Ingelorotsen. Circ. 25,000. Estab. 1952. Quarterly magazine. Emphasizes "Iowa—its people, places, events and history." Readers are over 30, college-educated, middle to upper income. Sample copy $4.50 with 9×12 SAE and 8 first-class stamps. Photo guidelines free with SASE.

Needs: Uses about 50 photos/issue; 95% by freelance photographers on assignment and 5% freelance stock. Needs "Iowa scenics—all seasons." Model/property releases preferred. Captions required.

Making Contact & Terms: Interested in receiving work from newer, lesser-known photographers. Send b&w prints; 35mm, 2¼×2¼ or 4×5 transparencies; or b&w contact sheet by mail for consideration. SASE. Reports in 1 month. Pays $25-50/b&w photo; $50-100/color photo; $200-500/day. Pays on publication. Credit line given. Buys one-time rights; negotiable.

JAZZTIMES, 7961 Eastern Ave., Suite 301, Silver Spring MD 20910. (301)588-4114. Fax: (301)588-2009. Editor: Mike Joyce. Circ. 80,000. Estab. 1969. Monthly glossy magazine (10 times/year). Emphasizes jazz. Readers are jazz fans, record consumers and people in the music industry, ages 15-75.

Needs: Uses about 50 photos/issue; 30 supplied by freelance photographers. Needs performance shots, portrait shots of jazz musicians. Model release required. Captions preferred.

Making Contact & Terms: Interested in receiving work from newer, lesser-known photographers. Send 5×7 b&w prints by mail for consideration. "If possible, we keep photos on file till we can use them." SASE. Reports in 2 weeks. Pays $50/color; $15-20/b&w inside photo. Negotiates fees for cover photo. Pays on publication. Credit line given. Buys one-time or reprint rights; negotiable. Simultaneous submissions and previously published work OK.

Tips: "Send whatever photos you can spare. Name and address should be on back."

***JOTS (Journal of the Senses)**, 814 Robinson Rd., Topanga CA 90290. Photo Editor: Iris Bancroft. Bimonthly journal. Emphasizes nudism: clothing optional lifestyle. Readers are families, couples and singles. Circ. 12,000. Estab. 1961. Sample copy for $1. Photo guidelines sheet available.

Needs: Uses 16 photos/issue; 10% supplied by freelancers. Needs photos of nudists/recreational activities. Model/property release required for all people. Captions required.

Making Contact & Terms: Interested in receiving work from newer, lesser-known photographers. Query with stock photo list. Does not keep samples on file. SASE. Reports in 2 weeks. Pays $100/ color cover photo; $50/b&w cover photo; $50/color inside photo; $25/b&w inside photo. Pays on publication. Credit line given. Buys one-time rights; negotiable. Simultaneous submissions OK.

Tips: "We look for spontaneity, naturalness in poses. Sharp, clear photos. We have little use for single figure studies. We need *nude groups* doing normal recreational things (biking, hiking, playing tennis, running into water, etc.)."

JUNIOR SCHOLASTIC, 555 Broadway, New York NY 10012. (212)343-6295. Editor: Lee Baier. Senior Photo Researcher: Deborah Thompson. Circ. 600,000. Biweekly educational school magazine. Emphasizes middle school social studies (grades 6-8): world and national news, US and world history, geography, how people live around the world. Sample copy $1.75 with 9×12 SAE.

Needs: Uses 20 photos/issue. Needs photos of young people ages 11-14; non-travel photos of life in other countries; US news events. Reviews photos with accompanying ms only. Model release required. Captions required.

Making Contact & Terms: Arrange a personal interview to show portfolio. "Please do not send samples—only stock list or photocopies of photos." Reports in 1 month. Pays $200/color cover photo; $75/b&w inside photo; $150/color inside photo. **Pays on acceptance.** Credit line given. Buys one-time rights. Simultaneous submissions OK.

Tips: Prefers to see young teenagers; in US and foreign countries. "Personal interviews with teenagers worldwide with photos."

KALLIOPE, A Journal of Women's Art, 3939 Roosevelt Blvd., Jacksonville FL 32205. Contact: Art Editor. Circ. 1,000. Estab. 1978. Journal published 3 times/year. Emphasizes art by women. Readers are interested in women's issues. Sample copy $7. Photo guidelines free with SASE.

Needs: Uses 18 photos/issue; all supplied by freelancers. Needs art and fine art that will reproduce well in b&w. Needs photos of nature, people, fine art by excellent sculptors and painters, and shots that reveal lab applications. Model release required. Photo captions preferred. Artwork should be titled.

Making Contact & Terms: Interested in receiving work from newer, lesser-known photographers as well as established photographers. Send unsolicited photos by mail for consideration. Send 5×7 b&w prints. SASE. Reports in 1 month. Pays contributor 3 free issues or free 1-year subscription. Buys one-time rights. Credit line given.
Tips: "Send excellent quality photos with an artist's statement (50 words) and résumé."

KANSAS, 700 SW Harrison, Suite 1300, Topeka KS 66603. (913)296-3479. Editor: Andrea Glenn. Circ. 54,000. Estab. 1945. Quarterly magazine. Emphasizes Kansas scenery, arts, recreation and people. Photos are purchased with or without accompanying ms or on assignment. Free sample copy and photo guidelines.
Needs: Buys 60-80 photos/year; 75% from freelance assignment, 25% from freelance stock. Animal, human interest, nature, photo essay/photo feature, scenic, sport, travel and wildlife, all from Kansas. No nudes, still life or fashion photos. Model/property release preferred. Captions required.
Making Contact & Terms: Interested in receiving work from newer, lesser-known photographers. Send material by mail for consideration. No b&w. Transparencies must be identified by location and photographer's name on the mount. Uses 35mm, 2¼×2¼ or 4×5 transparencies. Photos are returned after use. Pays $50 minimum/color photo; $150 minimum/cover photo. **Pays on acceptance.** Credit line given. Not copyrighted. Buys one-time rights. Previously published work OK.
Tips: Kansas-oriented material only. Prefers Kansas photographers. "Follow guidelines, submission dates specifically. Shoot a lot of seasonal scenics."

***KASHRUS MAGAZINE—The Guide for the Kosher Consumer**, P.O. Box 204, Parkville Station, Brooklyn NY 11204. (718)336-8544. Editor: Rabbi Yosef Wikler. Circ. 10,000. Bimonthly. Emphasizes kosher food and food technology. Readers are kosher food consumers, vegetarians and producers. Sample copy for 9×12 SAE with $1.47 postage.
Needs: Uses 3-5 photos/issue; all supplied by freelance photographers. Needs photos of travel, food, food technology, seasonal nature photos and Jewish holidays. Model release preferred. Captions preferred.
Making Contact & Terms: Send unsolicited photos by mail for consideration. Provide résumé, business card, brochure, flier or tearsheets to be kept on file for possible future assignments. Uses 2¼×2¼, 3½×3½ or 7½×7½ matte b&w prints. SASE. Reports in 1 week. Pays $40-75/b&w cover photo; $25-50/b&w inside photo; $75-200/job; $50-200/text/photo package. Pays part on acceptance; part on publication. Buys one-time rights, first N.A. serial rights, all rights; negotiable. Simultaneous submissions and previously published work OK.

KEYBOARD, 411 Borel Ave., Suite 100, San Mateo CA 94402. (415)358-9500. Editor: Tom Darter. Art Director: Paul Martinez. Monthly magazine. Circ. 82,000. Emphasizes "biographies and how-to feature articles on keyboard players (pianists, organists, synthesizer players, etc.) and keyboard-related material. It is read primarily by musicians to get background information on their favorite artists, new developments in the world of keyboard instruments, etc."
Needs: Buys 10-15 photos/issue. Celebrity/personality (photos of keyboard players at their instruments). Prefers shots of musicians with their instruments. Photos purchased with or without accompanying ms and infrequently on assignment. Captions required for historical shots only.
Making Contact & Terms: Interested in receiving work from newer, lesser-known photographers. Query with list of stock photo subjects. Send first class to Paul Martinez. Uses 8×10 b&w glossy prints; 35mm color, 120mm, 4×5 transparencies for cover shots. SASE. Reports in 1 month. Pays on a per-photo basis. Pays expenses on assignment only. Pays $35-150/b&w inside photo; $300-500/ photo for cover; $75-250/ color inside photo. Pays on publication. Credit line given. Buys rights to one-time use with option to reprint. Simultaneous submissions OK.
Tips: "Send along a list of artist shots on file. Photos submitted for our files would also be helpful—we'd prefer keeping them on hand, but will return prints if requested. Prefer live shots at concerts or in clubs. Keep us up to date on artists that will be photographed in the near future. Freelancers are vital to us."

KIPLINGER'S PERSONAL FINANCE MAGAZINE, 1729 H St. NW, Washington DC 20006. (202)887-6492. Fax: (202)331-1206. Picture Editor: Douglas J. Vann. Circ. 1.2 million. Estab. 1935. Monthly magazine. Emphasizes personal finance.
Needs: Uses 15-25 photos/issue; 90% supplied by freelancers. Needs "business portraits and photo illustration dealing with personal finance issues (i.e. investing, retirement, real estate). Model release required. Property release preferred. Captions required.
Making Contact & Terms: Interested in receiving work from newer, lesser-known photographers. Contact through rep. Arrange personal interview to show portfolio. Query with list of stock photo subjects. Provide résumé, business card, brochure, flier or tearsheets to be kept on file for possible assignments. Keeps samples on file. SASE. Reports in 2 weeks. Pays $1,200/color and b&w cover

photo; $350-1,200/day against space rate per page. **Pays on acceptance.** Credit line given. Buys one-time rights.

KITE LINES, P.O. Box 466, Randallstown MD 21133-0466. Publisher-Editor: Valerie Govig. Circ. 13,000. Estab. 1977. Quarterly. Emphasizes kites and kite flying exclusively. Readers are international adult kiters. Sample copy $5. Photo guidelines free with SASE.

Needs: Uses about 45-65 photos/issue; "up to about 50% are unassigned or over-the-transom—but nearly all are from *kiter*-photographers." Needs photos of "unusual kites in action (no dimestore plastic kites), preferably with people in the scene (not easy with kites). Needs to relate closely to *information* (article or long caption)." Special needs include major kite festivals; important kites and kiters. Captions required. "Identify *kites*, kitemakers and kitefliers as well as location and date."

Making Contact & Terms: Query with samples or send 2-3 b&w 8×10 uncropped prints or 35mm or larger transparencies (dupes OK) by mail for consideration. Provide relevant background information, i.e., knowledge of kites or kite happenings. SASE. Reports in "2 weeks to 2 months (varies with work load, but any obviously unsuitable stuff is returned quickly—in 2 weeks." Pays $0-30/inside photo; $0-50/color photo; special jobs on assignment negotiable; generally on basis of film expenses paid only. "We provide extra copies to contributors. Our limitations arise from our small size. However, *Kite Lines* is a quality showcase for good work." Pays within 30 days after publication. Buys one-time rights; usually buys first world serial rights. Previously published work considered.

Tips: In portfolio or samples wants to see "ability to select important, *noncommercial* kites. Just take a great kite picture, and be patient with our tiny staff. Considers good selection of subject matter; good composition—angles, light, background and sharpness. But we don't want to look at 'portfolios'—just *kite* pictures, please."

© Charlene Blankenship

A kitemaker in Iwakuni, Japan, proved to be a superb subject for Everett, Washington, photographer Charlene Blankenship. The art of hand painting kites is disappearing in Japan. Therefore the subject matter was perfect for Kite Lines magazine, which paid Blankenship $40 for first usage rights.

LADIES HOME JOURNAL, Dept. PM, 100 Park Ave., New York NY 10017. (212)351-3500. Fax: (212)351-3650. Contact: Photo Editor. Monthly magazine. Features women's issues. Readership consists of women with children and working women in 30s age group. Circ. 6 million.

Needs: Uses 90 photos per issue; 100% supplied by freelancers. Needs photos of children, celebrities and women's lifestyles/situations. Reviews photos only without ms. Model release and captions preferred. No photo guidelines available.

Making Contact & Terms: Provide résumé, business card, brochure, flier or tearsheet to be kept on file for possible assignment. "Do not send slides or original work; send only promo cards or disks."

Reports in 3 weeks. Pays $200/b&w inside photo; $200/color page rate. **Pays on acceptance.** Credit line given. Buys one-time rights.

LAKE SUPERIOR MAGAZINE, Lake Superior Port Cities, Inc., P.O. Box 16417, Duluth MN 55816-0417. (218)722-5002. Fax: (218)722-4096. Editor: Paul L. Hayden. Circ. 20,000. Estab. 1979. Bimonthly magazine. "Beautiful picture magazine about Lake Superior." Readers are ages 35-55, male and female, highly educated, upper-middle and upper-management level through working. Sample copy $3.95 with 9×12 SAE and 5 first-class stamps. Photo guidelines free with SASE.
Needs: Uses 30 photos/issue; 70% supplied by freelance photographers. Needs photos of scenic, travel, wildlife, personalities, underwater, all photos Lake Superior-related. Photo captions preferred.
Making Contact & Terms: Interested in receiving work from newer, lesser-known photographers. Send unsolicited photos by mail for consideration. Provide résumé, business card, brochure, flier or tearsheets to be kept on file for possible assignments. Uses b&w prints; 35mm, 2¼×2¼, 4×5 transparencies. SASE. Reports in 3 weeks. Pays $75/color cover photo; $35/color inside photo; $20/b&w inside photo. Pays on publication. Credit line given. Buys first North American serial rights; reserves second rights for future use. Simultaneous submissions OK.
Tips: "Be aware of the focus of our publication—Lake Superior. Photo features concern only that. Features with text can be related. We are known for our fine color photography and reproduction. It has to be 'tops.' We try to use images large, therefore detail quality and resolution must be good. We look for unique outlook on subject, not just snapshots. Must communicate emotionally."

***LAKELAND BOATING MAGAZINE,** 1560 Sherman Ave., Suite 1220, Evanston IL 60201. (708)869-5400. Editor: Randall W. Hess. Circ. 45,000. Estab. 1945. Monthly magazine. Emphasizes powerboating in the Great Lakes. Readers are affluent professionals, predominantly men over 35. Sample copy $6 with 9×12 SAE and 10 first-class stamps.
Needs: Needs shots of particular Great Lakes ports and waterfront communities. Model release preferred. Captions preferred.
Making Contact & Terms: Query with list of stock photo subjects. Provide résumé, business card, brochure, flier or tearsheets to be kept on file for possible assignments. SASE. Pays $20-100/b&w photo; $25-100/color photo. **Pays on acceptance.** Credit line given. Buys one-time rights.

✠LEISURE WORLD, 1253 Ouellette Ave., Windsor, Ontario N8X 1J3 Canada. (519)971-3207. Fax: (519)977-1197. Editor-in-Chief: Doug O'Neil. Circ. 321,214. Estab. 1988. Bimonthly magazine. Emphasizes travel and leisure. Readers are members of the Canadian Automobile Association, 50% male, 50% female, middle to upper middle class. Sample copy $2.
Needs: Uses 9-10 photos/issue; 25-30% supplied by freelance photographers. "*Leisure World* is looking for travel and destination features that not only serve as accurate accounts of real-life experiences, but are also dramatic narratives, peopled by compelling characters. Nonfiction short stories brought home by writers who have gone beyond the ordinary verities of descriptive travel writing to provide an intimate glimpse of another culture." Special needs include exotic travel locales. Model release preferred. Captions required.
Making Contact & Terms: Send unsolicited photos by mail for consideration. Provide business card, brochure, flier or tearsheets to be kept on file for possible assignments. Send b&w or color 35mm, 2¼×2¼, 4×5, or 8×10 transparencies. SASE. Reports in 2 weeks. Pays $100/color cover photo; $50/color inside photo; $50/b&w inside photo; or $150-300/photo/text package. Pays on publication. Credit line given. Buys one-time rights.
Tips: "We expect that the technical considerations are all perfect—frames, focus, exposure, etc. Beyond that we look for a photograph that can convey a mood or tell a story by itself. We would like to see more subjective and impressionistic photographs. Don't be afraid to submit material. If your first submissions are not accepted, try again. We encourage talented and creative photographers who are trying to establish themselves."

***LETTERS,** Dept. PM, 310 Cedar Lane, Teaneck NJ 07666. Associate Editor: Lisa Rosen. Monthly. Emphasizes "sexual relations between people, male/female; male/male; female/female." Readers are "primarily male, older; some younger women." Sample copy $3.
Needs: Uses 1 photo/issue; all supplied by freelance photographers. Needs photos of women in lingerie or scantily attired; special emphasis on shots of semi- or completely nude buttocks. Model release required.

The Subject Index, located at the back of this book, can help you find publications interested in the topics you shoot.

Making Contact & Terms: Query with samples. Send 2¼×2¼ slides by mail for consideration. Provide brochure, flier and tearsheets to be kept on file for possible future assignments. SASE. Reports in 3 weeks. Pays $150/color photo. Pays on publication. Buys all rights.

Tips: Would like to see "material germane to our publication's needs. See a few issues of the publication before you send in photos. Please send slides that are numbered and keep a copy of the list, so if we do decide to purchase we can let you know by the number on the slide. All of our covers are purchased from freelance photographers."

LIFE, Dept. PM, Time-Life Bldg., Rockefeller Center, New York NY 10020. (212)522-1212. Photo Editor: Barbara Baker Burrows. Circ. 1,400,000. Monthly magazine. Emphasizes current events, cultural trends, human behavior, nature and the arts, mainly through photojournalism. Readers are of all ages, backgrounds and interests.

Needs: Uses about 100 photos/issue. Prefers to see topical and unusual photos. Must be up-to-the minute and newsworthy. Send photos that could not be duplicated by anyone or anywhere else. Especially needs humorous photos for last page article "Just One More."

Making Contact & Terms: Send material by mail for consideration. SASE. Uses 35mm, 2¼×2¼, 4×5 and 8×10 slides. Pays $500/page; $1,000/cover. Credit line given. Buys one-time rights.

Tips: "Familiarize yourself with the topical nature and format of the magazine before submitting photos and/or proposals."

LIVE STEAM MAGAZINE, Dept. PM, P.O. Box 629, Traverse City MI 49685. (616)941-7160. Editor-in-Chief: Joe D. Rice. Circ. 13,000. Monthly. Emphasizes "steam-powered models and full-size equipment (i.e., locomotives, cars, boats, stationary engines, etc.)." Readers are "hobbyists—many are building scale models." Sample copy free with 9×12 SAE and 4 first-class stamps. Photo guidelines free with SASE.

Needs: Uses about 80 photos/issue; "most are supplied by the authors of published articles." Needs "how-to-build (steam models), historical locomotives, steamboats, reportage of hobby model steam meets. Unless it's a cover shot (color), we only use photos with ms." Special needs include "strong transparencies of steam locomotives, steamboats or stationary steam engines."

Making Contact & Terms: Query with samples. Send 3×5 glossy b&w prints by mail for consideration. SASE. Reports in 3 weeks. Pays $40/color cover photo; $8/b&w inside photo; $30/page plus $8/photo; $25 minimum for text/photo package (maximum payment "depends on article length"). Pays on publication—"we pay quarterly." Credit line given. Buys one-time rights. Simultaneous submissions OK.

Tips: "Be sure that mechanical detail can be seen clearly. Try for maximum depth of field."

THE LIVING CHURCH, 816 E. Juneau Ave., P.O. Box 92936, Milwaukee WI 53202. (414)276-5420. Fax: (414)276-7483. Managing Editor: John Schuessler. Circ. 9,000. Estab. 1878. Weekly magazine. Emphasizes news of interest to members of the Episcopal Church. Readers are clergy and lay members of the Episcopal Church, predominantly ages 35-70. Sample copies available.

Needs: Uses 8-10 photos/issue; almost all supplied by freelancers. Needs photos to illustrate news articles. Always in need of stock photos—churches, scenic, people in various settings. Captions preferred.

Making Contact & Terms: Interested in receiving work from newer, lesser-known photographers. Send unsolicited photos by mail for consideration. Send 5×7 or larger glossy b&w prints. SASE. Reports in 1 month. Pays $25-50/b&w cover photo; $10-25/b&w inside photo. Pays on publication. Credit line given.

***LOG HOME LIVING**, 4451 Brookfield Corp. Dr., Suite 101, Chantilly VA 22021. (703)222-9411. Fax: (703)222-3209. Managing Editor: Janice Brewster. Circ. 100,000. Estab. 1989. Bimonthly magazine. Emphasizes buying and living in log homes. Sample copy $3.50/issue. Photo guidelines free with SASE.

Needs: Uses over 100 photos/issue; 10 supplied by freelancers. Needs photos of homes—living room, dining room, kitchen, bedroom, bathroom, exterior, portrait of owners, design/decor—tile sunrooms, furniture, fireplaces, lighting, porch and decks, doors. Model release preferred. Caption required.

Making Contact & Terms: Interested in receiving work from newer, lesser-known photographers. Send unsolicited photos by mail for consideration. Keeps samples on file. SASE. Reports back only if interested. Pays $200-300/color cover photo; $50-100/color inside photo; $100/color page rate; $500-600/photo/text package. Pays on acceptance. Credit line given. Buys first North American serial rights; negotiable. Previously published work OK.

LOTTERY PLAYER'S MAGAZINE, 321 New Albany Rd., Moorestown NJ 08057. (609)779-8900. Fax: (609)273-6350. Editor: Denise Dugan. Circ. 130,000. Estab. 1981. Monthly tabloid. Emphasizes all aspects of gaming, especially lottery winners. Readers are male and female lottery players, usually between ages 35-65. Sample copy $2.50.

Needs: Uses 15-20 photos/issue; 1-2 supplied by freelancers. Needs photos of people buying lottery tickets, lottery winners, lottery and gaming activities. Reviews photos with or without ms. Captions required.
Making Contact & Terms: Interested in receiving work from newer, lesser-known photographers. Provide résumé, business card, brochure, flier or tearsheets to be kept on file for possible assignments. "Call with ideas." Keeps samples on file. SASE. Reports in 3 weeks. Pays $20-60/color cover photo; $20/b&w inside photo; rates vary. Pays 2 months after publication. Buys one-time rights, first North American serial rights, all rights; negotiable. Simultaneous submissions and/or previously published work OK.
Tips: "Photos should be clear, timely and interesting, with a lot of contrast."

LUSTY LETTERS, OPTIONS, BEAU, Box 470, Port Chester NY 10573. Photo Editor: Wayne Shuster. Circ. 60,000. Periodical magazines. Emphasizes "sexually oriented situations. We emphasize good, clean sexual fun among liberal-minded adults." Readers are mostly male; ages 18-65. Sample copy $2.95 with 6×9 SAE and 5 first-class stamps.
Needs: Color transparencies of single girls, girl-girl and single boys for cover; present in a way suitable for newsstand display." Model release required.
Making Contact & Terms: Query with samples. Send 35mm, 2¼×2¼, 4×5 transparencies by mail for consideration. SASE. Reports in 2 weeks. Pays $250 maximum/color cover photo. Pays on publication. Buys one-time rights on covers.
Tips: "Please examine copies of our publications before submitting work. In reviewing samples we consider composition of color photos for newsstand display and look for recent b&w photos for inside."

LUTHERAN FORUM, P.O. Box 327, Delhi NY 13753. (607)746-7511. Editor: Leonard Klein. Circ. 3,500. Quarterly. Emphasizes "Lutheran concerns, both within the church and in relation to the wider society, for the leadership of Lutheran churches in North America."
Needs: Uses cover photo occasionally. "While subject matter varies, we are generally looking for photos that include people, and that have a symbolic dimension. We use *few* purely 'scenic' photos. Photos of religious activities, such as worship, are often useful, but should not be 'cliches'—types of photos that are seen again and again." Captions "may be helpful."
Making Contact & Terms: Query with list of stock photo subjects. SASE. Reports in 2 months. Pays $15-25/b&w photo. Pays on publication. Credit line given. Buys one-time rights. Simultaneous submissions or previously published work OK.

THE MAGAZINE ANTIQUES, 575 Broadway, New York NY 10012. (212)941-2800. Fax: (212)941-2819. Editor: Allison E. Ledes. Circ. 56,700. Estab. 1922. Monthly magazine. Emphasizes art, antiques, architecture. Readers are male and female collectors, curators, academics, interior designers, ages 40-70. Sample copy $7.50.
Needs: Uses 60-120 photos/issue; 40% supplied by freelancers. Need photos of interiors, architectural exteriors, objects. Reviews photos with or without ms.
Making Contact & Terms: Interested in receiving work from newer, lesser-known photographers. Submit portfolio for review. Send 8×10 glossy prints; 4×5 transparencies. Does not keep samples on file. SASE. Reports in 2 weeks. NPI; rates negotiated on an individual basis. Pays on publication. Credit line given. Buys one-time rights; negotiable. Previously published work OK.

MAGIC REALISM, P.O. Box 922648, Sylmar CA 91392-2648. Editor: C. Darren Butler. Circ. 1,200. Estab. 1990. Magazine published quarterly. Emphasizes literary fiction, unusual fiction related to fantasy and magic realism. Sample copy $5.95; $4.95 (back issue). General guidelines free with SASE.
Needs: Uses 0-3 photos/issue; all supplied by freelancers. Special photo needs include artistic, bizarre, touched up, multiple exposures. Model/property release preferred. Captions preferred.
Making Contact & Terms: Interested in receiving work from newer, lesser-known photographers. Submit portfolio for review. Query with résumé of credits. Query with stock photo list. Send unsolicited photos by mail for consideration. Provide résumé, business card, brochure, flier or tearsheets to be kept on file for possible assignments. Send color or b&w 5×4 transparencies. Keeps samples on file. SASE. Reports in 1 month on queries; 3 months on submissions. Pays $50/b&w or color cover photo; $2-10/b&w inside photo and contributor's copies. **Pays on acceptance.** Credit line given. Buys one-time, first North American serial, Spanish language edition rights. Simultaneous submissions and previously published work OK.

MAGICAL BLEND, 133½ Broadway, Chico CA 95928. Art Directors: Matthew Courtway and Yuka Hirota. Circ. 57,000. Estab. 1980. Quarterly magazine. Emphasizes New Age consciousness, painting, collage and photography. Readers include people of "all ages interested in an alternative approach to spirituality." Sample copy $5.
Needs: Uses 1-12 photos/issue; 100% supplied by freelance photographers. Looks for creative, visionary and surreal work. Model release preferred if needed.

Making Contact & Terms: Interested in receiving work from newer, lesser-known photographers. Send unsolicited photos by mail for consideration. Send b&w or color prints; 35mm, 2¼×2¼, 4×5 and 8×10 transparencies. SASE. Reports in 6 weeks. Payment not given; credit line only. Buys one-time rights. If desired, print photographer's address with photo so readers can contact for purchases.
Tips: In portfolio or samples, looking for "images that are inspiring to look at that show people in celebration of life. Try to include positive images. The best way to see what we're interested in printing is by sending for a sample copy."

MAINSTREAM, Magazine of the Able-Disabled, 2973 Beech St., San Diego CA 92102. (619)234-3138. Editor: William G. Stothers. Circ.19,400. Estab. 1975. Published 10 times per year. Emphasizes disability rights. Readers are upscale, active men and women who are disabled. Sample copy $5 with 9×12 SAE with 6 first-class stamps.
Needs: Uses 3-4 photos/issue. Needs photos of disabled people doing things, sports, travel, working, etc. Reviews photos with accompanying ms only. Model/property release preferred. Captions required.
Making Contact & Terms: Provide résumé, business card, brochure, flier or tearsheets to be kept on file for possible assignments. Keeps samples on file. SASE. Reports in 2 months. Pays $85/color cover photo; $35/b&w inside photo. Pays on publication. Credit line given. Buys all rights; negotiable. Previously published work OK "if not in one of our major competitors' publications."
Tips: "We definitely look for signs that the photographer empathizes with and understands the perspective of the disability rights movement."

MARLIN MAGAZINE, P.O. Box 2456, Winter Park FL 32790. (407)628-4802. Fax: (407)628-7061. Editor: David Ritchie. Photo Editor: Doug Olander. Circ. 30,000 (paid). Estab. 1981. Bimonthly magazine. Emphasizes offshore big game fishing for billfish, sharks and tuna and other large pelagics. Readers are 94% male, 75% married, average age 43, very affluent businessmen. Free sample copy with 8×10 SAE. Photo guidelines free with SASE.
Needs: Uses 40-50 photos/issue; 98% supplied by freelancers. Needs photos of fish/action shots, scenics and how-to. Special photo needs include big game fishing action and scenics (marinas, landmarks etc.). Model release preferred. Captions preferred.
Making Contact & Terms: Interested in receiving work from newer, lesser-known photographers. Send unsolicited photos by mail for consideration. Send 35mm transparencies. SASE. Reports in 1 month. Pays $500/color cover photo; $50-150/color inside photo; $35-150/b&w inside photo; $150-200/color page rate. Pays on publication. Buys first North American rights. Simultaneous submissions OK.

♣MARQUEE ENTERTAINMENT MAGAZINE, 77 Mowat Ave., #621, Toronto, Ontario M6K 3E3 Canada. (416)538-1000. Fax: (416)538-0201. Managing Editor: Jack Gardner. Circ. 730,000. Estab. 1975. Monthly magazine. Emphasizes movies, music. Sample copy $5.95.
Needs: Uses 25-30 photos/issue. Needs photos of personalities. Captions preferred.
Making Contact & Terms: Interested in receiving work from newer, lesser-known photographers. Contact through rep. Does not keep samples on file. Reports in 3 weeks. Pays on publication. Credit line given. Rights negotiable.
Tips: Looking for "shots that relate to movies/personalities."

MARTIAL ARTS TRAINING, P.O. Box 918, Santa Clarita CA 91380-9018. (805)257-4066. Fax: (805)257-3028. Editor: Douglas Jeffrey. Circ. 40,000. Bimonthly. Emphasizes martial arts training. Readers are martial artists of all skill levels. Sample copy free. Photo guidelines free with SASE.
Needs: Uses about 100 photos/issue; 90 supplied by freelance photographers. Needs "photos that pertain to fitness/conditioning drills for martial artists. Photos purchased with accompanying ms only. Model release required. Captions required.
Making Contact & Terms: Send 5×7 or 8×10 b&w prints; 35mm transparencies; b&w contact sheet or negatives by mail for consideration. SASE. Reports in 1 month. Pays $50-150 for text/photo package. Pays on publication. Credit line given. Buys all rights.
Tips: Photos "must be razor-sharp, b&w. Technique shots should be against neutral background. Concentrate on training-related articles and photos."

MEDIPHORS, P.O. Box 327, Bloomsburg PA 17815. Editor: Eugene D. Radice, MD. Circ. 500. Estab. 1993. Semiannual magazine. Emphasizes literary/art in medicine and health. Readers are male and female adults in the medical fields and literature. Sample copy $5. Photo guidelines free with SASE.
Needs: Uses 5-7 photos/issue; all supplied by freelancers. Needs artistic photos related to medicine and health. Also photos to accompany poetry, essay, and short stories. Special photo needs include single photos, cover photos, and photos accompanying literary work. Releases usually not needed—artistic work. Photographers encouraged to submit titles for their artwork.
Making Contact & Terms: Interested in receiving work from newer, lesser-known photographers. Send unsolicited photos by mail for consideration. Send minimum 3×4 any finish b&w prints. Keeps

samples on file. SASE. Reports in 1 month. Pays on publication 2 copies of magazines. Credit line given. Buys first North American serial rights.
Tips: Looking for "b&w artistic photos related to medicine & health. Our goal is to give new artists an opportunity to publish their work. Prefer photos where people CANNOT be specifically identified. Examples: Drawings on the wall of a Mexican Clinic, an abandoned nursing home, an old doctor's house, architecture of an old hospital."

MENNONITE PUBLISHING HOUSE, 616 Walnut Ave., Scottdale PA 15683. (412)887-8500. Fax: (412)887-3100. Photo Secretary: Debbie Cameron. Publishes *Story Friends* (ages 4-9), *On The Line* (ages 10-14), *Christian Living*, *Gospel Herald*, *Purpose* (adults).
Needs: Buys 10-20 photos/year. Needs photos of children engaged in all kinds of legitimate childhood activities (at school, at play, with parents, in church and Sunday School, at work, with hobbies, relating to peers and significant elders, interacting with the world); photos of youth in all aspects of their lives (school, work, recreation, sports, family, dating, peers); adults in a variety of settings (family life, church, work, and recreation); abstract and scenic photos. Model release preferred.
Making Contact & Terms: Send 8½ × 11 b&w photos by mail for consideration. Provide résumé, business card, brochure, flier or tearsheets to be kept on file for possible assignments. SASE. Reports in 1 month. Pays $20-50/b&w photo. Credit line given. Buys one-time rights. Simultaneous submissions and/or previously published work OK.

***THE MET GOLFER/SPORTS PUBLISHING GROUP**, 2 Park Ave., New York NY 10016. (212)779-5000. Fax: (212)725-4928. Art Director: Louis Cruz. Circ. 100,000. Publication of Metropolitan Golf Association. Bimonthly magazine. Emphasizes golf. Readers are male and female members of golf clubs in metropolitan New York, New Jersey and Connecticut.
Needs: Uses 75-100 photos/issue; 50 supplied by freelancers. Needs photos of golf courses, golf personalities. Model/property release required.
Making Contact & Terms: Interested in receiving work from newer, lesser-known photographers. Submit portfolio for review. Samples kept on file. Cannot return material. Reports in 1 month. NPI. Pays on publication. Credit line given.

MICHIGAN NATURAL RESOURCES MAGAZINE, 30700 Telegraph Rd., Suite 1401, Bingham Farms MI 48025. (810)642-9580. Fax: (810)642-5290. Editor: Richard Morscheck. Creative Director: Kathleen Kolka. Circ. 100,000. Estab. 1931. Bimonthly. Emphasizes natural resources in the Great Lakes region. Readers are "appreciators of the out-of-doors; 15% readership is out of state." Sample copy $4. Photo guidelines free with SASE.
Needs: Uses about 40 photos/issue; freelance photography in given issue—25% from assignment and 75% from freelance stock. Needs photos of Michigan wildlife, Michigan flora, how-to, travel in Michigan, outdoor recreation. Captions preferred.
Making Contact & Terms: Interested in receiving work from newer, lesser-known photographers. Query with samples or list of stock photo subjects. Send original 35mm color transparencies by mail for consideration. SAE. Reports in 1 month. Pays $50-250/color page; $500/job; $800 maximum for text/photo package. Pays on publication. Credit line given. Buys one-time rights.
Tips: Prefers "Kodachrome 64 or 25 or Fuji 50 or 100, 35mm, *razor-sharp in focus!* Send about 20 slides with a list of stock photo topics. Be sure slides are sharp, labeled clearly with subject and photographer's name and address. Send them in plastic slide filing sheets. Looks for unusual outdoor photos. Flora, fauna of Michigan and Great Lakes region. Strongly recommend that photographer look at past issues of the magazine to become familiar with the quality of the photography and the overall content. We'd like our photographers to approach the subject from an editorial point of view. Every article has a beginning, middle and end. We're looking for the photographer who can submit a complete package that does the same thing."

MICHIGAN OUT-OF-DOORS, P.O. Box 30235, Lansing MI 48909. (517)371-1041. Fax: (517)371-1505. Editor: Kenneth S. Lowe. Circ. 130,000. Estab. 1947. Monthly magazine. For people interested in "outdoor recreation, especially hunting and fishing; conservation; environmental affairs." Sample copy $2; free editorial guidelines.
Needs: Use.1-6 freelance photos/issue. Animal, nature, scenic, sport (hunting, fishing and other forms of noncompetitive recreation), and wildlife. Materials must have a Michigan slant. Captions preferred.
Making Contact & Terms: Send any size glossy b&w prints; 35mm or 2¼ × 2¼ transparencies. SASE. Reports in 1 month. Pays $15 minimum/b&w photo; $150/cover photo; $25/inside color photo. Credit line given. Buys first North American serial rights. Previously published work OK "if so indicated."
Tips: Submit seasonal material 6 months in advance. Wants to see "new approaches to subject matter."

***MILITARY LIFESTYLE**, 4800 Montgomery Lane, #710, Bethesda MD 20814. (301)718-7600. Fax: (301)718-7652. Design Director: Judi Connelly. Circ. 100,000. Estab. 1970. Monthly magazine. Em-

phasizes military families and community. Readers are married couples, ages 28-42, with children, moving every 1-3 years. Sample copy $1.50 with 9×12 SASE.
Needs: Uses 30-40 photos/issue; all supplied by freelancers. Needs photos of travel, food, mililtary living. Model release preferred. Caption required.
Making Contact & Terms: Interested in receiving work from newer, lesser-known photographers. Send samples, leave-behinds, tearsheets. Deadlines: middle of every month. Keeps samples on file. Pays $350-400/day; $800/color cover photo.
Tips: "Military references are a must when submitting story ideas."

MONDO 2000, PO Box 10171, Berkeley CA 94708. (510)845-9018. Fax: (510)649-9630. Art Director: Bart Nagel. Circ. 100,000. Estab. 1989. Quarterly magazine. Emphasizes lifestyle, high-tech computer and communication fields. Readers are professionals, 70 percent male, 30 percent female, median age of 29. Sample copies $7.
● This publication lives on bizarre artwork and stories. Creativity is a must when submitting work to this market.
Needs: Uses approximately 25-30 photos/issue; around 70% supplied by freelancers. Needs photos of technology, portraits, fashion. Experimental and fringe art preferred. Reviews photos with or without ms. Model/property release preferred. No captions are necessary, provide description and details if they are not obvious.
Making Contact & Terms: Submit portfolio for review. Provide résumé, business card, brochure, flier or tearsheets to be kept on file for possible assignments. Keeps samples on file. SASE. Reports in 3 weeks to 3 months. NPI. Pays 30 days to 1 year after publication. Also interested in receiving work from newer, lesser-known photographers. Previously unpublished work preferred.
Tips: "Put your name, address and phone number on everything. Call us often and tell us it's OK if we don't have a lot of money to pay." Wants to see sharp images with "disturbing composition and lots of creativity. We seek images from the darker side of the mind."

***MOTHER EARTH NEWS**, 24 E. 23rd St., New York NY 10010. (212)260-3214. Fax: (212)260-7445. Photo Editor: Elisabeth Sinsabaugh. Estab. 1991. Bimonthly magazine. Emphasizes do-it-yourself information and insights on practical aspects of country life. Readers are male and female professionals and working families who have choosen a more natural way of life away from urban centers. Photo guidelines available.
Needs: Uses 20-35 photos/issue; 75% supplied by freelancers. Needs photos of gardening, food, pets, humor. Special photo needs include gardening with people and families. Model/property release preferred. Captions required.
Making Contact & Terms: Interested in receiving work from newer, lesser-known photographers. Submit portfolio for review. Send promo card with photo. Deadlines: call before you drop off portfolio. Keeps samples on file. Reports back if interested. Pays: assignments—$1,000 plus expenses (cover), $250 plus expenses (inside); stock—(b&w or color), $50-150 ¼ page; $200-300 full page .
Tips: "I look for a strong vision. This magazine requires a direct friendly approach. Look at the magazine before you submit your portfolio."

MOTHER JONES, 1663 Mission St., San Francisco CA 94103. Prefers not to share information.

MOTHERING MAGAZINE, P.O. Box 1690, Santa Fe NM 87504. (505)984-8116. Fax: (505)986-8335. Photo Editor: Tara Weiden. Circ. 70,000. Estab. 1976. Quarterly magazine. Emphasizes parenting. Readers are progressive parents, primarily aged 25-40, with children of all ages, racially mixed. Sample copy $3. Free photo guidelines and current photo needs.
Needs: Uses about 40-50 photos/issue; nearly all supplied by freelance photographers. Needs photos of children of all ages, mothers, fathers, breastfeeding, birthing, education. Model/property release required.
Making Contact & Terms: Interested in receiving work from newer, lesser-known photographers. Please send duplicates of slides. Send only 8×10 b&w prints by mail for consideration. "Provide a well-organized, carefully packaged submission following our guidelines carefully. Send SASE please." Reports in 2 months. Pays $500/color cover photo; $100 for full page, $50 for less than full page/ b&w inside photo. Pays on publication. Credit line given. Buys one-time rights.
Tips: "For cover: we want technically superior, sharply focused image evoking a strong feeling or mood, spontaneous and unposed; unique and compelling. Eye contact with subject will often draw in viewer; color slide only. For inside: b&w prints, sharply focused, action or unposed shots; 'doing' pictures—family, breastfeeding, fathering, midwifery, birth, reading, drawing, crawling, climbing, etc. No disposable diapers, no bottles, no pacifiers. We are being flooded with submissions from photographers acting as their own small stock agency—when the reality is that they are just individual freelancers selling their own work. As a result, we are using fewer photos from just one photographer, giving exposure to more photographers."

✤**MOVING PUBLICATIONS LIMITED**, 44 Upjohn Rd., #100, Don Mills, Ontario M3B 2W1 Canada. Administrative Assistant: Anne Laplante. Circ. 225,000. Estab. 1973. Annual magazines. Emphasizes moving to a geographic area. Readers are male and female, ages 35-55.
Needs: Uses 20 photos/issue. Needs photos of housing shots, attractions, leisure. Special photo needs include cover shots. Model/property release required. Captions should include location.
- This publisher produces guides to locations such as Alberta, San Francisco Bay Area and Greater Sacramento; Vancouver & British Columbia; Winnipeg and Manitoba; Montreal; Toronto and Area; Saskatchewan; Ottawa/Hull; Greater Hamilton Area.
Making Contact & Terms: Only free photographs accepted. Do not send unsolicited material. Phone/fax to determine requirements.
Tips: "For front covers, we look for vertical shots with room for a masthead."

✤**MUSCLEMAG INTERNATIONAL**, 6465 Airport Rd., Mississauga, Ontario L4V 1E4 Canada. (905)678-7311. Fax: (905)678-9236. Editor: Johnny Fitness. Circ. 300,000. Estab. 1974. Monthly magazine. Emphasizes male and female physical development and fitness. Sample copy $5.
Needs: Buys 2,000 photos/year; 50% assigned; 50% stock. Needs celebrity/personality, fashion/beauty, glamour, swimsuit, how-to, human interest, humorous, special effects/experimental and spot news. "We require action exercise photos of bodybuilders and fitness enthusiasts training with sweat and strain." Wants on a regular basis "different" pics of top names, bodybuilders or film stars famous for their physique (i.e., Schwarzenegger, The Hulk, etc.). No photos of mediocre bodybuilders. "They have to be among the top 100 in the world or top film stars exercising." Photos purchased with accompanying ms. Captions preferred.
Making Contact & Terms: Send material by mail for consideration; send $3 for return postage. Uses 8 × 10 glossy b&w prints. Query with contact sheet. Send 35mm, 2¼ × 2¼ or 4 × 5 transparencies; vertical format preferred for cover. Reports in 1 month. Pays $85-100/hour; $500-700/day and $1,000-3,000/complete package. Pays $13-35/b&w photo; $25-500/color photo; $300-500/cover photo; $85-300/accompanying ms. **Pays on acceptance.** Credit line given. Buys all rights.
Tips: "We would like to see photographers take up the challenge of making exercise photos look like exercise motion." In samples wants to see "sharp, color balanced, attractive subjects, no grain, artistic eye. Someone who can glamorize bodybuilding on film." To break in, "get serious: read, ask questions, learn, experiment and try, try again. Keep trying for improvement—don't kid yourself that you are a good photographer when you don't even understand half the attachments on your camera. Immerse yourself in photography. Study the best; study how they use light, props, backgrounds, best angles to photograph."

MUSTANG MONTHLY, P.O. Box 7157, Lakeland FL 33807-7157. (813)646-5743. Fax: (813)648-1187. Senior Editor: Rob Reaser. Circ. 80,000. Estab. 1978. Monthly magazine. Emphasizes 1964 through current model Mustangs. Readers are male and female, ages 18-65, who span all occupations and income brackets. They have a deep passion for the preservation, restoration and enjoyment of all Mustangs, from the '60s classics to the current models. Free sample copy. Photo guidelines free.
Needs: 15% of photos supplied by freelancers. Needs technical "how-to" and feature car photography. "Query first." Reviews photos with or without ms. Special photo needs include 1969-73 and 1979-current model Mustangs. Property release required for feature cars. Captions preferred.
Making Contact & Terms: Interested in receiving work from newer, lesser-known photographers. Currently looking to expand our freelance base. Submit portfolio for review. Query with stock photo list. Send unsolicited photos by mail for consideration. "Anything containing automobile subject matter." Send 35mm, 2¼ × 2¼, 4 × 5 transparencies. Does not keep samples on file. SASE. Reports in 1 month. Pays $200-250/color cover photo; $10/b&w inside photo; $150-300/photo/text package. Pays on publication. Credit line given. Buys one-time rights; first North American serial rights.
Tips: Wants to see "command of lighting and composition. *Mustang Monthly* is a showcase of the best Mustangs in the world. Photographer should have a working knowledge of Mustangs and automotive photography skills. We feature only pristine and correctly restored cars. Study past issues for style."

NATIONAL GEOGRAPHIC, Prefers not to share information.

NATIONAL GEOGRAPHIC TRAVELER, 1145 17th St. NW, Washington DC 20036. Contact: Illustration Editors listed on magazine's masthead. Circ. 750,000. Bimonthly. Stories focus primarily on the U.S. and Canada with two foreign articles per issue on high interest, readily accessible areas. Minimal

 The maple leaf before a listing indicates that the market is Canadian.

can Indian/Smithsonian). Sample copy free with SASE. Photo guidelines free with SASE.
Needs: Uses 50-60 photos/edition; 100% supplied by freelancers. Needs Native American lifeways photos. Model/property release preferred. Captions preferred; include names, location and circumstances.
Making Contact & Terms: Interested in receiving work from newer, lesser-known photographers. Submit portfolio for review. Send unsolicited photos by mail for consideration. Send transparencies, all formats. SASE. Reports in 1 month. Pays $250/color cover photo; $250/b&w cover photo; $50-150 color inside photo; $50-150/b&w inside photo. Pays on publication. Buys one-time rights.
Tips: "We prefer to send magazine and guidelines rather than pour over general portfolio."

✦**NATURAL LIFE MAGAZINE**, 7436 Fraser Park Dr., Burnaby, British Columbia V5J 5B9 Canada. (604)435-1919. Photo Editor: Siegfried Gursche. Published 11 times/year. Readers are interested in health and nutrition, lifestyle and fitness. Circ. 110,000. Sample copy $3 (Canadian) and 9½×11 SASE. Photo guidelines free with SASE.
Needs: Uses 12 photos/issue; 50% supplied by freelance photographers. Looking for photos of healthy people doing healthy things. Subjects include environment, ecology, organic farming and gardening, herbal therapies, vitamins, mineral supplements and good vegetarian food, all with a family orientation. Model release required. Captions preferred.
Making Contact & Terms: Send unsolicited photos by mail for consideration with résumé, business card, brochure, flier or tearsheets to be kept on file for possible assignments. Send color 4×5 prints and 35mm, 2¼×2¼, or 4×5 transparencies. SASE. Reports in 2 weeks. Pays $125/color cover photo; $60/color inside photo. Pays on publication. Credit line given. Buys all rights; will negotiate. Simultaneous submissions and previously published work OK.
Tips: "Get in touch with the 'Natural Foods' and 'Alternative Therapies' scene. Observe and shoot healthy people doing healthy things."

NATURE PHOTOGRAPHER, P.O. Box 2037, West Palm Beach FL 33402. (407)586-3491. Photo Editor: Helen Longest-Slaughter. Circ. 20,000. Estab. 1990. Bimonthly 4-color high quality magazine. Emphasizes "conservation-oriented, low-impact nature photography" with strong how-to focus. Readers are male and female nature photographers of all ages. Sample copies free with 10×13 SAE with 6 first-class stamps.
Needs: Uses 25-35 photos/issue; 90% supplied by freelancers. Needs nature shots of "all types—abstracts, animal/wildlife shots, flowers, plants, scenics, environmental images, etc." Shots must be in natural settings; no set-ups, zoo or captive animal shots accepted. Reviews photos with or without ms. Captions required; include description of subject, location, type of equipment, how photographed. "This information published with photos."
Making Contact & Terms: Interested in receiving work from newer, lesser-known photographers. Query with résumé of credits. Send stock photo list. Prefers to see 35mm, 2¼×2¼ and 4×5 transparencies. Does not keep samples on file. SASE. Reports within 4 months, according to deadline. Pays $100/color cover photo; $25-40/color inside photo; $20/b&w inside photo; $75-150/photo/text package. **Pays on acceptance.** Credit line given. Buys one-time rights. Simultaneous submissions and previously published work OK.
Tips: Recommends working with "the best lens you can afford and slow speed slide film." Suggests editing with a 4× or 8× lupe (magnifier) on a light board to check for sharpness, color saturation, etc. Color prints are not used for publication in magazine, except from photographers under the age of 18 for the "Young People's" column.

NATURIST LIFE INTERNATIONAL, P.O. Box 300-F, Troy VT 05868-0300. Editor-in-chief: Jim C. Cunningham. Circ. 2,000. Estab. 1987. Quarterly magazine. Emphasizes nudism. Readers are male and female nudists, age 30-80. Sample copy $5. Photo guidelines free with SASE.
Needs: Uses approximately 45 photos/issue; 80% supplied by freelancers. Needs photos depicting family-oriented, nudist/naturist work and recreational activity. Reviews photos with or without ms. Model release required. Property release preferred for recognizable nude subjects. Captions preferred.
Making Contact & Terms: Interested in receiving work from newer, lesser-known photographers. Query with résumé of credits. Send unsolicited photos by mail for consideration. Provide résumé, business card, brochure, flier or tearsheets to be kept on file for possible assignments. Send 8×10 glossy color and b&w prints; 35mm, 2¼×2¼, 4×5, 8×10 (preferred) transparencies. Does not keep samples on file. SASE. Reports in 2 weeks. Pays $50 color photo; $25/color inside photo; $25/b&w inside photo. Only pays $10 if not transparency or 8×10 glossy. Pays on publication. Credit line given. "Prefer to own all rights but sometimes agree to one-time publication rights."
Tips: "The ideal *NLI* photo shows ordinary-looking people of all ages doing everyday activities, in the joy of nudism."

NEVADA MAGAZINE, Capitol Complex, Carson City NV 89710. (702)687-6158. Fax: (702)687-6159. Art Director: Paul Allee. Estab. 1936. Circ. 100,000. Bimonthly. State tourism magazine devoted

to promoting tourism in Nevada, particularly for people interested in travel, people, history, events and recreation; age 30-70. Sample copy $2.50.

Needs: Buys 40-50 photos/issue; 30-35 supplied by freelance photographers. Buys 10% freelance on assignment, 20% from freelance stock. (Nevada stock photos only—not generic). Towns and cities, scenics, outdoor recreation with people, events, state parks, tourist attractions, travel, wildlife, ranching, mining and general Nevada life. Must be Nevada subjects. Captions required; include place, date, names if available.

Making Contact & Terms: Interested in receiving work from newer, lesser-known photographers. Send samples of Nevada photos. Send 8×10 glossy prints; 35mm, 2¼×2¼, 4×5, 8×10 transparencies; prefers vertical format for cover. Send 35mm slides in 8×10 see-through slide sleeves. Must be labeled with name, address and captions on each. SASE. Reports in 4 months. Pays $20-100/inside photo; $150/cover photo; $50 minimum/job. Pays on publication. Credit line given. Buys first North American serial rights.

Tips: "Send variety of good-quality Nevada photos, well-labeled. Self-edit work to 20-40 slides maximum. Increasing use of events photos from prior years' events. Real need for current casino shots."

NEW MEXICO MAGAZINE, Dept. PM, 495 Old Santa Fe Trail, Santa Fe NM 87503. (505)827-7447. Fax: (505)827-6496. Art Director: John Vaughan. Circ. 123,000. Monthly magazine. For affluent people age 35-65 interested in the Southwest or who have lived in or visited New Mexico. Sample copy $2.95 with 9×12 SAE and 3 first-class stamps. Photo guidelines free with SASE.

Needs: Uses about 60 photos/issue; 90% supplied by freelancers. Needs New Mexico photos only—landscapes, people, events, architecture, etc. "Most work is done on assignment in relation to a story, but we welcome photo essay suggestions from photographers." Cover photos usually relate to the main feature in the magazine. Model release preferred. Captions required; include who, what, where.

Making Contact & Terms: Interested in receiving work from newer, lesser-known photographers. Submit portfolio to John Vaughan; uses transparencies. SASE. Pays $450/day; $300/color cover photo; $300/b&w cover photo; $60-100/color inside photo; $60-100/b&w inside photo. Pays on publication. Credit line given. Buys one-time rights.

Tips: Prefers transparencies submitted in plastic pocketed sheets. Interested in different viewpoints, styles not necessarily obligated to straight scenic. "All material must be taken in New Mexico. Representative work suggested. If photographers have a preference about what they want to do or where they're going, we would like to see that in their work. Transparencies or dupes are best for review and handling purposes."

NEW YORK MAGAZINE, 755 Second Ave., New York NY 10017. (212)880-0700. Editor: Kurt Andersen. Photo Director, Special Projects: Jordan Schaps. Picture Editor: Marjorie Goldberg. Circ. 430,000. Estab. 1968. Weekly magazine. Full service city magazine: national and local news, fashion, food, entertaining, lifestyle, design, profiles, etc. Readers are 28-55 years average with $100,000 average family income. Professional people, family people, concerned with quality of life and social issues affecting them, their families and the community. Sample copy free with SASE.

Needs: Uses about 50 photos/issue; 85% assigned; 15% stock. Needs full range: photojournalism, fashion, food, product still lifes, conceptual and stock (occasionally). Always need great product still life and studio work. "Model release and captions preferred for professional models; require model release for 'real' people." Captions required.

Making Contact & Terms: Submit a portfolio for review by drop-offs, every Thursday; pick up Friday. *Does not return unsolicited material.* Reports ASAP. Pays $1,000/color cover photo; $300/page of color; $125-200/photo spot; $150-300/b&w and color photo; $300/day. Pays on publication and receipt of original invoices. Credit line given. Buys one-time rights. "We reserve the right to reuse photography in context for house ads and self-promotion at no additional charge."

Tips: "We look for strong, high-quality images that work with the text but tell their own story as well. We want the kind of photographer who can deliver images whether on his own or with spirited direction. You need to really get to know the magazine and its various departments ('Intelligencer,' 'Hot Line,' 'Best Bets,' etc.) as well as the way we do fashion, entertaining, lifestyle, etc. *New York* is a great showcase for the talented newcomer looking for prestige exposure, the solid working photojournalist and the well-established advertising specialist looking for the creative freedom to do our kind of work. We lean toward traditional high-quality photographic solutions to our visual needs, but are ever mindful of and sensitive to the trends and directions in which photography is moving."

NEW YORK OUTDOORS, Allsport Publishing Corp., 51 Atlantic Ave., Floral Park NY 11001. (516)352-9700. Fax: (516)437-6841. Publisher/Editor-in-Chief: Scott Shane. Editor: John Tsaousis. Circ. 50,000. Published 8 times annually. Emphasizes technique, locations and products for all outdoor activities including: cycling, paddling, fishing, hiking, camping, climbing, diving, skiing and boating. Also features adventure outdoor locations and destinations in the northeastern U.S. Free sample copy and photo guidelines. "Ask to be placed on our wants list or send us your stock list."

Needs: Buys one color cover and 5-10 inside shots per issue. Photo from freelance stock. Photos purchased with accompanying ms; covers purchased separately. Captions required.
Making Contact & Terms: Interested in receiving work from newer, lesser-known photographers. Send original transparencies. Send photos for consideration. SASE. Reports in 3 weeks. Pays: Covers up to $300; inside b&w quarter—to 2-page spread, up to $200. Pays on publication. Buys first North American serial rights.
Tips: "If it looks like fun, it's for us. Any sport, but background must be or look like Northeast United States, New York state a bonus. We are tabloid size, so pictures need to hold a blow-up. People in sport—including families—are always good."

***NEW YORK SPORTSCENE**, 990 Motor Pkwy., Central Islip NY 11722. (516)435-8890. Fax: (516)435-8925. Editor-in-Chief: Mark Sosna. Circ. 125,000. Estab. April 1995. Monthly magazine. Emphasizes professional and major college sports in New York. Readers are 95% male; median age: 30; 85% are college educated. Sample copy $3.
Needs: Uses 30 photos/issue; all supplied by freelancers. Needs photos of sports action, fans/crowd reaction.
Making Contact & Terms: Interested in receiving work from newer, lesser-known photographers. Send unsolicited photos by mail for consideration. Send color prints; 35mm transparencies. Keeps samples on file. SASE. Reports in 3 weeks. NPI. Pays several weeks after publication.
Tips: "Slides should capture an important moment or event and tell a story. There are numerous sports photographers out there—your work must stand out to be noticed.

NORTHEAST OUTDOORS, P.O. Box 2180, Waterbury CT 06722. (203)755-0158. Editorial Director: John Florian. Circ. 14,000. Estab. 1968. Monthly tabloid. Emphasizes camping in the Northeast. Sample copy free with SASE.
Needs: Reviews photos with accompanying manuscript *only*. Model release required. Photo captions preferred.
Making Contact & Terms: Query with story ideas and résumé. SASE. Reports in approximately 2 weeks. Pays $40-80/photo text package. Pays on publication. Credit line given. Buys one-time rights, first North American serial rights. Previously published work OK if not in competing publication.

NORTHERN OHIO LIVE, Dept. PM, 11320 Juniper Rd., Cleveland OH 44106. (216)721-1800. Art Director: Michael Wainey. Circ. 35,000. Estab. 1980. Monthly magazine. Emphasizes arts, entertainment, lifestyle and fashion. Readers are upper income, ages 25-60, professionals. Sample copy $2 with 9×12 SAE.
Needs: Uses 30 photos/issue; 20-100% supplied by freelance photographers. Needs photos of people in different locations, fashion and locale. Model release preferred. Captions preferred (names only is usually OK).
Making Contact & Terms: Arrange a personal interview to show portfolio. Send b&w and color prints; 35mm or 2¼×2¼ transparencies by mail for consideration. Provide résumé, business card, brochure, flier or tearsheet to be kept on file for possible assignments. Follow up phone call OK. SASE. Reports in 3 weeks. Pays $250/color cover photo; $250/b&w cover photo; $100/color inside photo; $50/b&w inside photo; $30-50/hour; $250-500/day. Pays on publication. Credit line given. Buys one-time rights. Previously published work OK.
Tips: In photographer's portfolio wants to see "good portraits, people on location, photojournalism strengths, quick turn-around and willingness to work on *low* budget. Mail sample of work, follow up with phone call. Portfolio review should be short—only *best quality* work!"

NORTHWEST PARKS AND WILDLIFE, 1525 12th St., P.O. Box 18000, Florence OR 97439. (800)348-8401. Photo Editor: Barbara Grano. Circ. 15,000. Estab. 1991. Bimonthly magazine. Emphasizes state and national parks in Pacific Northwest—Oregon, Washington, Idaho, Alaska and British Columbia (southern). Readers are middle-age male and female, upper income/middle income. Sample copy $4.50 includes postage. Photo guidelines free with SASE.
Needs: Uses 8-12 (full page) vertical photos/issue; all supplied by freelancers. Needs photos of travel, scenics, wildlife. Model release preferred. Photo captions required.
Making Contact & Terms: Send unsolicited photos by mail for consideration. Uses 35mm, 2¼×2¼, 4×5 transparencies. SASE. Reports in 2 weeks; 1 month for photo/text packages. Pays $325/color cover photo; $25-75/color inside photo; $25-50/b&w inside photo; $100-250/photo/text package. Pays on publication. Credit line given. Buys one-time rights.
Tips: "Mainly interested in scenics and wildlife shots. Avoid colored filters. Use only film that can enlarge without graininess."

***NORTHWEST TRAVEL**, 1525 12th St., P.O. Box 18000, Florence OR 97439. (800)348-8401. Photo Editor: Barbara Grano. Circ. 50,000. Estab. 1991. Bimonthly magazine. Emphasizes Pacific Northwest travel—Alaska, Oregon, Washington, Idaho and British Columbia (southern). Readers are middle-age

male and female, upper income/middle income. Sample copy $4.50 includes postage. Photo guidelines free with SASE.

Needs: Uses 8-12 (full page) photos/issue; all supplied by freelancers. Needs photos of travel, scenics. Model release preferred. Photo captions required.

Making Contact & Terms: Send unsolicited photos by mail for consideration. Uses 35mm, 2¼×2¼, 4×5 transparencies. SASE. Reports in 1 month. Pays $325/color cover photo; $25-75/color inside photo; $25-50/b&w inside photo; $100-250/photo/text package. Pays on publication. Credit line given. Buys one-time rights.

Tips: "Mainly interested in scenics. Avoid colored filters. Use only film that can enlarge without graininess."

NORTHWOODS PUBLICATIONS INC., 430 N. Front St., P.O. Box 90, Lemoyne PA 17043. (717)761-1400. Fax: (717)761-4579. Publishes *Pennsylvania Sportsman, New York Sportsman, Michigan Hunting & Fishing.* Associate Publisher: Sherry Ritchey. Circ. 140,000. Estab. 1977. Published eight times/year. Emphasizes outdoor hunting and fishing. Readers are of all ages and backgrounds. Sample copy $2.95. Photo guidelines free with SASE.

Needs: Uses 40-70 photos/issue; 30% supplied by freelancers. Needs photos of wildlife. Special photo needs include deer, turkey, bear, trout, pike, walleye, panfish. Captions preferred.

Making Contact & Terms: Interested in receiving work from newer, lesser-known photographers. Query with stock photo list. Send unsolicited photos by mail for consideration. Send 35mm transparencies. Keeps samples on file. SASE. Pays $150/color cover photo; $25-75/color inside photo; $10-50/b&w inside photo. Pays on publication. Credit line given. Buys first North American serial rights.

Tips: "Look at the magazine to become familiar with needs."

‡NORWAY AT YOUR SERVICE, Drammensveien 40, 0243, Oslo, Norway. (47)22926300. Fax: (47)22926400. Editor: Peggy Schoen. Circ. 35,000-50,000. Estab. 1984. Publication of the Norwegian Trade Council, in cooperation with the Norwegian Tourist Board, the Ministry of Foreign Affairs and other national organizations. Annual magazine. Emphasizes Norwegian business, culture and tourism. Readers are tourists interested in visiting Norway and business/organizations interested in Norwegian products and companies. Sample copy free with European C4 SAE and International postal voucher. Photo guidelines free with SASE.

Needs: Uses 60-80 photos/issue; 50% freelance, 50% photo agency. Needs photos of Norwegian travel destinations (festivals, places, nature); Norwegian culture and lifestyle; Norwegian companies and products; Norwegian personalities. Model/property release preferred. Captions required; include when/where taken, context of photo.

Making Contact & Terms: Interested in receiving work from newer, lesser-known photographers. Query with stock photo list. Send unsolicited photos by mail for consideration. Provide résumé, business card, brochure, flier or tearsheets to be kept on file for possible assignments. "We prefer transparencies but can take 5×7 prints. Keeps samples on file. Returns unsolicited material if SASE is an international postal order. Reports in 2 months. Pays $150-300/color cover photo; $70-200/color inside photo; $275-600/photo/text package. Pays on publication. Credit line given. Buys one-time rights. Simultaneous submissions and previously published work OK.

Tips: "Photos must be professional and high quality. Freelance submissions need to have a specific focus to be considered, as general Norwegian landscape shots, etc., are easily obtained from photo agencies. The magazine markets contemporary Norway, so submissions should have a contemporary, rather than a historical, focus."

NOR'WESTING, 6044 Seaview Ave. NW, Seattle WA 98107. (206)783-8939. Fax: (206)783-9011. Editor: Gloria Kruzner. Monthly magazine. Emphasis on cruising destinations in the Pacific Northwest. Reader are male and female boat owners ages 40-65 (on average) who own 32'-42' boats (mostly powerboats). Sample copy free with SASE. Photo guidelines available.

• By late 1995, this publisher planned to do an electronic version of the magazine.

Needs: Uses 30-40 photo/issue; 100% supplied by freelancers. Interested in scenic Northwest destination shots, boating, slice-of-life nautical views. Model release preferred for anyone under age 18. Captions required; include location, type of boat, name of owner, crew.

Making Contact & Terms: Interested in receiving work from newer, lesser-known photographers. "We're looking for active outdoor photographers in the Pacific Northwest." Send unsolicited photos by mail for consideration. Provide résumé, business card, brochure, flier or tearsheets to be kept on file for possible assignments. Send 3×5 glossy b&w prints; 35mm transparencies. Deadlines: the 10th of each month. Keeps samples on file. SASE. Reports in 2 months. Pays $100-250/color cover photo; $25-50/b&w inside photo. Pays 2 months after publication. Credit line given. Buys first North American rights; negotiable. Simultaneous submissions and/or previously published work OK.

Tips: "We want the Pacific Northwest boating scene to come alive through photography. No posed shots; wait for moment to happen."

NUGGET, 2600 Douglas Rd., Suite 600, Coral Gables FL 33134. (305)443-2378. Editor-in-Chief: Christopher James. Circ. 100,000. Magazine published 9 times a year. Emphasizes sex and fetishism for men and women of all ages. Sample copy $5 postpaid; photo guidelines free with SASE.
Needs: Uses 100 photos/issue. Interested only in nude sets—single woman, female/female or male/female. All photo sequences should have a fetish theme (sadomasochism, leather, bondage, transvestism, transsexuals, lingerie, infantilism, wrestling—female/female or male/female—women fighting women or women fighting men, amputee models, etc.). Also seeks accompanying mss on sex, fetishism and sex-oriented products. Model release required.
Making Contact & Terms: Submit material for consideration. Buys in sets, not by individual photos. No Polaroids or amateur photography. Send 8 × 10 glossy b&w prints, contact sheet OK; transparencies, prefers Kodachrome or large format; vertical format required for cover. SASE. Reports in 2 weeks. Pays $250 minimum/b&w set; $300-400/color set; $200/cover photo; $250-350/ms. Pays on publication. Credit line given. Buys one-time rights or second serial (reprint) rights. Previously published work OK.

ODYSSEY, Science That's Out of This World, Cobblestone Publishing, Inc., 7 School St., Peterborough NH 03458. (603)924-7209. Fax: (603)924-7380. Freelance Picture Editor: Francelle Carapetyan. Circ. 29,000. Estab. 1979. Monthly magazine, September-May. Emphasis on astronomy and space exploration. Readers are children, ages 8-14. Sample copy $4.50 with 8 × 11 or larger SAE and 5 first-class stamps. Photo guidelines free with SASE.
Needs: Uses 30-35 photos/issue. Needs photos of astronomy and space exploration from NASA and observatories, museum shots and others illustrating activities from various organizations. Reviews photos with or without ms. Model/property release required. Captions preferred.
Making Contact & Terms: Query with stock photo list. Send unsolicited photos by mail for consideration. Provide résumé, business card, brochure, flier or tearsheets to be kept on file for possible future assignments. Send color prints or transparencies. Samples kept on file. SASE. Reports in 1 month. Payment negotiable for color cover photo; $25-100/inside color use. Pays on publication. Credit line given. Buys one-time and all rights; negotiable.
Tips: "We like photos that include kids in reader-age range and plenty of action. Each issue is devoted to a single theme. Photos should relate to those themes."

OHIO MAGAZINE, 62 E. Broad St., Columbus OH 43215. (614)461-5083. Contact: Brooke Wenstrup. Estab. 1979. Monthly magazine. Emphasizes features throughout Ohio for an educated, urban and urbane readership. Sample copy $3 postpaid.
Needs: Travel, photo essay/photo feature, b&w scenics, personality, sports and spot news. Photojournalism and concept-oriented studio photography. Model/property releases preferred. Captions required.
Making Contact & Terms: Interested in receiving work from newer, lesser-known photographers. Send material by mail for consideration. Query with samples. Arrange a personal interview to show portfolio. Send 8 × 10 b&w glossy prints; contact sheet requested. Also uses 35mm, 2¼ × 2¼ or 4 × 5 transparencies; square format preferred for covers. SASE. Reports in 1 month. Pays $30-250/b&w photo; $30-250/color photo; $350/day; and $150-350/job. Pays within 90 days after acceptance. Credit line given. Buys one-time rights; negotiable.
Tips: "Please look at magazine before submitting to get an idea of what type of photographs we use." Send sheets of slides and/or prints with return postage and they will be reviewed. Dupes for our files are always appreciated—and reviewed on a regular basis. We are leaning more toward well-done documentary photography and less toward studio photography. Trends in our use of editorial photography include scenics, single photos that can support an essay, photo essays on cities/towns, more use of 180° shots. In reviewing a photographer's portfolio or samples we look for humor, insight, multi-level photos, quirkiness, thoughtfulness; stock photos of Ohio; ability to work with subjects (i.e., an obvious indication that the photographer was able to make subject relax and forget the camera—even difficult subjects); ability to work with givens, bad natural light, etc.; creativity on the spot—as we can't always tell what a situation will be on location."

Can't find a listing? Check at the end of each market section for the " '95-'96 Changes" lists. These lists include any market listings from the '95 edition which were either not verified or deleted in this edition.

OLD WEST, P.O. Box 2107, Stillwater OK 74076. (405)743-3370. Fax: (405)743-3374. Editor: John Joerschke. Circ. 30,000. Estab. 1964. Quarterly magazine. Emphasizes history of the Old West (1830 to 1915). Readers are people who like to read the history of the West, mostly male, age 45 and older. Sample copy free with 9×12 SAE and 7 first-class stamps.
Needs: Uses 100 or more photos/issue; "almost all" supplied by freelance photographers. Needs "mostly Old West historical subjects, some travel, some scenic (ghost towns, old mining camps, historical sites). Prefers to have accompanying ms. Special needs include western wear, cowboys, rodeos, western events. Captions required; include name and location of site.
Making Contact & Terms: Interested in receiving work from newer, lesser-known photographers. Query with samples, b&w only for inside, color covers. SASE. Reports in 1 month. Pays $75-150/ color cover photos; $10/b&w inside photos. **Payment on acceptance**; cover photos on publication. Credit line given. Buys first North American serial rights.
Tips: "Looking for transparencies of existing artwork as well as scenics for covers, pictures that tell stories associated with Old West for the inside. Most of our photos are used to illustrate stories and come with manuscripts; however, we will consider other work (scenics, historical sites, old houses). Scenics should be free of modern intrusions such as buildings, power line, highways, etc."

OMNI MAGAZINE, 277 Park Ave., New York NY 10172. (212)702-6000. Photo Editor/Art Buyer: Hildegard Kron. Quarterly magazine. Emphasizes science. Circ. 850,000. Estab. 1978. Sample copy for contributors only (free). Photo guidelines for SASE.
Needs: Uses 20-30 photos/issue; 100% supplied by freelancers. Needs photos of technology and portraiture. Mostly scientific or special-effect, "surreal" photography. Model/property release required. Captions preferred.
Making Contact & Terms: Send unsolicited photos by mail for consideration. Provide résumé, business card, brochure, flier or tearsheets to be kept on file for possible assignments. Send any format. Keeps samples on file. SASE. Reports in 1-2 weeks. NPI. Pays on publication. Credit line given on opening spreads only. Buys one-time rights. Rights negotiable. Previously published work OK.
Tips: "We are always seeking surreal, graphic images for our covers, which are upbeat and will function well commercially on the newsstand. Have an understanding of our needs. Research our past three issues for an idea of what we commission. We assign a great deal of portraiture of leading scientists."

ON THE LINE, 616 Walnut Ave., Scottdale PA 15683. (412)887-8500. Contact: Editor. Circ. 6,700. Estab. 1875. Weekly magazine. For children, ages 10-14. Free sample copy and editorial guidelines.
Needs: Very little photography from assignment and 95% from freelance stock. "We need quality b&w photos only. Prefers vertical shots, use some horizontal. We need photos of children, age 10-14 representing a balance of male/female, white/minority/international, urban/country. Clothing and hair styles must be contemporary, but not faddish. Wants to see children interacting with each other, with adults and with animals. Some nature scenes as well (especially with kids)."
Making Contact & Terms: Interested in receiving work from newer, lesser-known photographers. Send 8×10 b&w prints for consideration. SASE. Reports in 1 month. Pays $20-50/b&w (cover). **Pays on acceptance.** Buys one-time rights. Simultaneous submissions and previously published work OK.

ON-DIRT MAGAZINE, P.O. Box 6246, Woodland Hills CA 91365. (818)340-5750. Fax: (818)348-4648. Photo Editor: Lonnie Peralta. Circ. 120,000. Estab. 1984. Monthly magazine. Emphasizes all forms of off-roading and racing. Readers are male and female off-road enthusiasts, ages 15-65. Sample copy $3.
Needs: Uses 100-135 photos/issue; 50% supplied by freelancers. Needs photos of off-road action from events, races or fun. Reviews photos with or without a manuscript. Special needs are "fun" drives, "jamborees" and how-to articles with photos. Model/property release preferred. Captions required.
Making Contact & Terms: Send unsolicited photos by mail for consideration. Send 5×7, 8×10 glossy with border b&w, color prints; 35mm transparencies. Keeps samples on file. SASE. Reports as needed. Pays $50/cover photo; $7/b&w inside photo; $7/color page rate; $7/b&w page rate; $7/hour. Pays on publication. Credit line given. Buys all rights; negotiable.

♣ONTARIO OUT OF DOORS MAGAZINE, 227 Front St. E., Toronto, Ontario M5A 1E8 Canada. (416)368-0185. Fax: (416)941-9113. Art Director: Yukio Yamada. Circ. 85,000. Estab. 1968. Monthly magazine. Emphasizes hunting and fishing in Ontario. Readers are male ages 20-65. Sample copies free with SAE, IRC. Photo guidelines free with SAE, IRC.
Needs: Uses 30 photos/issue; 50% supplied by freelancers, half on assignment, half from stock. Needs photos of game and fish species sought in Ontario; also scenics with anglers or hunters. Background must be similar to or Ontario-related. Model/property releases required for photos used in advertising. Captions preferred.
Making Contact & Terms: Interested in receiving work from newer, lesser-known photographers. Query with list of stock photo subjects. Send b&w prints; 35mm transparencies. Keeps samples on

file. Reports in 1 month. Pays $300-500/color cover photo; $100-200/color inside photo; $35-75/ b&w inside photo. **Pays on acceptance.** Credit line given. Buys one-time rights. Previously published work OK.

OREGON COAST MAGAZINE, P.O. Box 18000, Florence OR 97439. (800)348-8401. Photo Editor: Barbara Grano. Circ. 62,000. Estab. 1982. Bimonthly magazine. Emphasizes Oregon coast life. Readers are middle class, middle age. Sample copy $4.50, including postage. Photo guidelines available with SASE with 2 first-class stamps.
Needs: Uses 6-10 photos/issue; all supplied by freelancers. Needs scenics. Especially needs photos of typical subjects—waves, beaches, lighthouses—but from a different angle. Model release required. Captions required; include specific location and description. "Label all slides and transparencies with captions and photographer's name."
Making Contact & Terms: Interested in receiving work from newer, lesser-known photographers. Send unsolicited 35mm, 2¼×2¼, 4×5 transparencies by mail for consideration. SASE. Reports in 2 weeks; 1 month for photo-text package. Pays $325/color cover photo; pays $100 for calendar usage; pays $25-75/color inside photo; $25-50/b&w inside photo; $100-250/photo/text package. Credit line given. Buys one-time rights.
Tips: "Send only the very best. Use only slide film that can be enlarged without graininess. An appropriate submission would be 20-60 slides. Don't use color filters. Protect slides with sleeves— put in plastic holders. Don't send in little boxes."

THE OTHER SIDE, 300 W. Apsley St., Philadelphia PA 19144. (215)849-2178. Art Director: Cathleen Benberg. Circ. 12,000. Estab. 1965. Bimonthly magazine. Emphasizes social justice issues from a Christian perspective. Sample copy $2.
• This publication is an Association Church Press and Evangelical Press Association award winner.
Needs: Buys 6 photos/issue; 95-100% from stock, 0-5% on assignment. Documentary, human interest and photo essay/photo feature. "We're interested in human-interest photos and photos that relate to current social, economic or political issues, both here and in the Third World." Model/property release preferred. Captions preferred.
Making Contact & Terms: Interested in receiving work from newer, lesser-known photographers. Send samples of work to be photocopied for our files and/or photos; a list of subjects is difficult to judge quality of work by. Send 8×10 glossy b&w prints; transparencies for cover, vertical format required. Materials will be returned on request. SASE. Pays $20-30/b&w photo; $50-100/cover photo. Credit line given. Buys one-time rights. Simultaneous submissions and previously published work OK.
Tips: In reviewing photographs/samples, looks for "sensitivity to subject, creativity, and good quality darkroom work."

✦**OUR FAMILY**, P.O. Box 249, Battleford, Sasketchewan, S0M 0E0 Canada. Fax: (306)937-7644. Editor: Nestor Gregoire. Circ. 10,000. Estab. 1949. Monthly magazine. Emphasizes Christian faith as a part of daily living for Roman Catholic families. Sample copy $2.50 with 9×12 SAE and $1.10 Canadian postage. Free photo and writer's guidelines with SAE and 49¢ Canadian postage.
Needs: Buys 5 photos/issue; cover by assignment; contents all freelance. Head shot (to convey mood); human interest ("people engaged in the various experiences of living"); humorous ("anything that strikes a responsive chord in the viewer"); photo essay/photo feature (human/religious themes); and special effects/experimental (dramatic—to help convey a specific mood). "We are always in need of the following: family (aspects of family life); couples (husband and wife interacting and interrelating or involved in various activities); teenagers (in all aspects of their lives and especially in a school situation); babies and children; any age person involved in service to others; individuals in various moods (depicting the whole gamut of human emotions); religious symbolism; and humor. We especially want people photos, but we do not want the posed photos that make people appear 'plastic,' snobbish or elite. In all photos, the simple, common touch is preferred. We are especially in search of humorous photos (human and animal subjects). Stick to the naturally comic, whether it's subtle or obvious." Photos are purchased with or without accompanying ms. Model release required if editorial topic might embarrass subject. Captions required when photos accompany ms.
Making Contact & Terms: Send material by mail for consideration or query with samples after consulting photo spec sheet. Provide letter of inquiry, samples and tearsheets to be kept on file for possible future assignments. Send 8×10 glossy b&w prints; transparencies or 8×10 glossy color prints are used on inside pages, but are converted to b&w. SAE and IRC. (Personal check or money order OK instead or IRC.) Reports in 1 month. Pays $35/b&w photo; 7-10¢/word for original mss; 5¢/word for nonoriginal mss. **Pays on acceptance.** Credit line given. Buys one-time rights and simultaneous rights. Simultaneous submissions or previously published work OK.
Tips: "Send us a sample (20-50 photos) of your work after reviewing our Photo Spec Sheet. Looks for "photos that center around family life—but in the broad sense — i.e., our elderly parents, teenagers,

young adults, family activities. Our covers (full color) are a specific assignment. We do not use freelance submissions for our cover."

OUT MAGAZINE, 110 Greene St., Suite 600, New York NY 10012. (212)334-9119. Fax: (212)334-9227. E-mail: outmag@aol.com. Art Director: James Conrad. Photo Editor: Amy Steiner. Circ. 150,000. Estab. 1992. Published 10 times/year. Emphasizes gay and lesbian lifestyle. Readers are gay men and lesbians of all ages.
 • 1994 saw *Out Magazine* receive a bronze "Ozzie" from *Folio*; win a first place for editorial excellence from *Folio*; and receive a certificate of distinction for creativity from *Art Direction Magazine*.
Needs: Uses 100 photos/issue; 50 supplied by freelancers. Needs photos of portraits, fashion, photojournalism. Reviews photos with or without ms. Model release required. Captions preferred.
Making Contact & Terms: Submit portfolio for review. Reports in 1 month. NPI. Pays on publication. Credit line given. Buys all rights; negotiable. Simultaneous submissions and/or previously published work OK.
Tips: "Don't ask to see layout. Don't call every 5 minutes. Turn over large portion of film."

✦OUTDOOR CANADA, 703 Evans Ave., Suite 202, Toronto, Ontario M9C 5E9 Canada. (416)695-0311. Fax: (416)695-0381. Editor: Teddi Brown. Circ. 102,000. Estab. 1972. Magazine published 8 times a year. Free writers' and photographers' guidelines "with SASE or SAE and IRC only."
Needs: Buys 70-80 photos annually. Needs Canadian photos of people fishing, hunting, hiking, wildlife, camping, ice-fishing, action shots. Captions required including identification of fish, bird or animal.
Making Contact & Terms: Interested in receiving work from newer, lesser-known photographers. Send transparencies for consideration. No phone calls, please. For cover allow undetailed space along left side of photo for cover lines. SAE and IRC for American contributors, SASE for Canadians *must* be sent for return of materials. Reports in 3 weeks; "acknowledgement of receipt is sent the same day material is received." Pays $400 maximum/cover photo; $30-225/inside color photo depending on size used. Pays on publication. Buys first serial rights.
Tips: "Study the magazine and see the type of articles we use and the types of illustration used" and send a number of pictures to facilitate selection. "We are using more photos. We are looking for pictures that tell a story. We especially need photos of people in the outdoors. A photo that captures the outdoor experience and shows the human delight in it. Take more fishing photos. It's the fastest-growing outdoor pastime in North America."

OUTDOOR LIFE MAGAZINE, Dept. PM, 2 Park Ave., New York NY 10016. (212)779-5000. Contact: Art Director. Circ. 1.5 million. Monthly. Emphasizes hunting, fishing, shooting, camping and boating. Readers are "outdoorsmen of all ages." Sample copy "not for individual requests." Photo guidelines for SASE.
Needs: Uses about 50-60 photos/issue; 75% supplied by freelance photographers. Needs photos of "all species of wildlife and fish, especially in action and in natural habitat; how-to and where-to." Captions preferred.
Making Contact & Terms: Send 5×7 or 8×10 b&w glossy prints; 35mm or 2¼×2¼ transparencies; b&w contact sheet by mail for consideration. No color prints—preferably Kodachrome 35mm slides." Prefers dupes. SASE. Reports in 1 month. Pays $35-275/b&w photo, $50-700/color photo depending on size of photos; $800-1,000/cover photo. Rates are negotiable. Pays on publication. Credit line given. Buys one-time rights.
Tips: "Have name and address clearly printed on each photo to insure return, send in 8×10 plastic sleeves. Multi subjects encouraged."

OUTDOOR TRAVELER MID-ATLANTIC, P.O. Box 2748, Charlottesville VA 22902. (804)984-0655. Fax: (804)984-0656. Editor: Marianne Marks. Circ. 30,000. Estab. 1993. Quarterly magazine. Emphasizes outdoor recreation, travel, nature—all in the mid-Atlantic region. Readers are male and female outdoor enthusiasts and travelers, ages 20-50. Sample copy $4.
Needs: Uses 20-25 photos/issue; 95% supplied by freelancers. Needs photos of outdoor recreation, nature/wildlife, travel, scenics—all in the region. Reviews photos with or without ms. Special photo needs include seasonal photos related to outdoor recreation and scenery. Model release required. Property release is preferred. Captions preferred.
Making Contact & Terms: Interested in receiving work from newer, lesser-known photographers. Query with résumé of credits, slides or printed samples and a stock list. Keeps samples on file. SASE. Reports in 2 months. Pays $250/color cover photo; $50/color quarter-page; $75/color half page; $100/color full page; $150/color spread. Pays on publication. Credit line given. Buys one-time rights. Simultaneous submissions and previously published work OK.
Tips: Interested in "action-oriented, scenic photos of people engaged in outdoor recreation (hiking, bicycling, skiing, rafting, canoeing, rock climbing, etc.)."

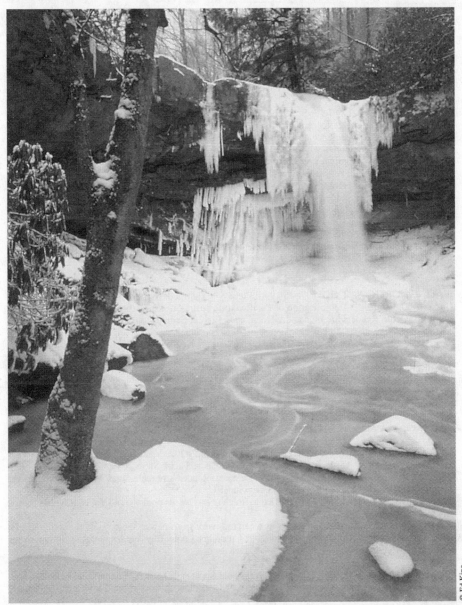

© Ed King

Photographer Ed King of Greensburg, Pennsylvania, initially contacted Outdoor Traveler Mid-Atlantic *magazine by sending editors tearsheets and a copy of his stock list. Subsequently he was asked to provide vertical scenics for a winter issue of the magazine. This image of a waterfall garnered $100 for use as a* Last Page *feature.*

***OVER THE BACK FENCE**, P.O. Box 756, Chillicothe OH 45601. (614)772-2165. Fax: (614)773-7626. Contact: Photo Editor. Estab. 1994. Quarterly magazine. "This is a regional magazine serving South Central Ohio. We are looking for photos of interesting people, events, and history of our area." Sample copy $4. Photo guidelines free with SASE.

Needs: Uses 50-70 photos/issue; 80% supplied by freelance assignment; 20% by freelance stock. Needs photos of scenics, attractions, food (specific to each issue), historical locations in our region (call for specific counties). Model release required for identifiable people. Captions preferred; include locations, description, names, date of photo (year); and if previously published, where and when.

Making Contact & Terms: Interested in receiving work from newer, lesser-known photographers. Provide résumé, business card, brochure, flier or tearsheets to be kept on file for possible assignments.

Query with stock photo list and résumé of credits. Deadlines: 6 months minimum before each issue. SASE. Reports in 3 months. Pays $100/color cover photo; $100/b&w cover photo; $25-100/color inside photo; $25-100/b&w inside photo. Pays on publication. Credit line given except in the case of ads, where it may or may not appear. Buys one-time rights. Simultaneous submissions and previously published work OK, "but must identify photos used in other publications."
Tips: "We use a high percentage of black and white photos."

✿OWL MAGAZINE, 179 John St., Suite 500, Toronto, Ontario M5T 3G5 Canada. (416)971-5275. Fax: (416)971-5294. Photo Researcher: Robin Wilner. Circ. 110,000. Estab. 1976. Published 10 times/year; 1 summer issue. A science and nature magazine for children ages 8-13. Sample copy $4.28 and 9×12 SAE. Photo guidelines with SAE.
Needs: Uses approximately 15 photos/issue; 10% supplied by freelancers. Needs photos of animals/wildlife. Model/property release preferred. Captions required.
Making Contact & Terms: Interested in receiving work from newer, lesser-known photographers. Request photo package before sending photos for review. Send 35mm transparencies. Keeps samples on file. SAE and IRCs. Reports in 6-8 weeks. Pays $325 Canadian/color cover photo; $100 Canadian/color inside photo; $200 Canadian/color page rate. **Pays on acceptance.** Credit line given. Buys one-time rights. Previously published work OK.
Tips: "Photos should be sharply focused with good lighting showing animals in their natural environment. It is important that you present your work as professionally as possible. Become familiar with the magazine—study back issues."

***PACIFIC NORTHWEST GOLF**, 7826 193rd Place SW, Edmonds WA 98026. Editor: Dick Stephens. Circ. 40,000. Estab. 1994. Publication of Pacific Northwest Golf Association. Published twice a year. Emphasizes golf. Readers are men and women, ages 12-112. Sample copy free with SASE and 7 first-class stamps.
Needs: Uses 25 photos/issue; 50% supplied by freelancers. Needs photos of landscape, action, instructional, still, artistic. Model/property release preferred for professionals, golf courses. Captions required.
Making Contact & Terms: Send unsolicited photos by mail for consideration. Provide résumé, business card, brochure, flier or tearsheets to be kept on file for possible assignments. Send all sizes and finishes color and b&w prints; 35mm transparencies. Deadlines: June 1, February 1. Keeps samples on file. SASE. Reports in 1 month. Pays $20-200/photo. Rights negotiable. Simultaneous and previously published work OK.
Tips: "Keep us current on your professional status and work schedule."

✿PACIFIC YACHTING MAGAZINE, 1132 Hamilton St., #202, Vancouver, British Columbia V6B 2S2 Canada. (604)687-1581. Fax: (604)687-1925. Editor: Duart Snow. Circ. 25,000. Estab. 1968. Monthly magazine. Emphasizes boating on west coast. Readers are male, ages 35-60, boaters, power and sail. Sample copy free with 8½×11 SAE with IRC.
Needs: Uses 125 photos/issue; 125 supplied by freelancers. Needs photos of all kinds. Reviews photos with accompanying ms only.
Making Contact & Terms: Interested in receiving work from newer, lesser-known photographers. Keeps samples on file. NPI. Payment negotiable. Credit line given. Buys one-time rights. Simultaneous submissions and/or previously published work OK.

***PADDLER MAGAZINE**, P.O. Box 5450, Steamboat Springs CO 80477. Phone/fax: (303)879-1450. Editor: Eugene Buchanan. Circ. 85,000. Estab. 1990. Bimonthly magazine. Emphasizes kayaking, rafting, canoeing and sea kayaking. Sample copy $3.50. Photo guidelines free with SASE.
Needs: Uses 30-50 photos/issue; 90% supplied by freelancers. Needs photos of scenics and action. Model/property release preferred. Captions preferred; include location.
Making Contact & Terms: Interested in receiving work from newer, lesser-known photographers. Query with stock photo list. Send unsolicited photos by mail for consideration. Send 35mm transparencies. Keeps samples on file. SASE. Reports in 2 months. Pays $25-150/color photo; $150/color cover photo; $75/color full page inside photo. Pays on publication. Credit line given. Buys first North American serial rights; negotiable.
Tips: "Send dupes and let us keep them on file."

PALM BEACH ILLUSTRATED MAGAZINE, 1016 N. Dixie Hwy., West Palm Beach FL 33401. (407)659-0210. Fax: (407)659-1736. Editor: Judy Di Edwardo. Circ. 30,000. Estab. 1952. Magazine published 10 times a year. Emphasizes upscale, first-class living. Readers are highly influential, established people, ages 35-54.
Needs: Needs photos of travel. Reviews photos with or without a ms. Model/property release required. Captions preferred.

Making Contact & Terms: Send color prints; 35mm, 2¼×2¼ transparencies. SASE. Reports in 1 month. NPI; payment made on individual basis. Pays on publication. Credit line given. Buys one-time rights. Simultaneous submissions OK.
Tips: Looks for "travel and related topics such as resorts, spas, yacht charters, trend and lifestyle topics. Materials should appeal to affluent readers: e.g., budget travel is not of interest. Editorial material on the latest best investments in the arts would be appropriate; editorial material on investing in a mobile home would not."

PALM SPRINGS LIFE MAGAZINE, P.O. Box 2724, 303 N. Indian Canyon Ave., Palm Springs CA 92263. (619)325-2333. Fax: (619)325-7008. Art Director: Bill Russom. Editor: Stewart Weiner. Circ. 20,000. Estab. 1957. Monthly magazine. Emphasizes Palm Springs/California desert area upscale resort living. Readers are extremely affluent, 35 years and older. "Primarily for our readers, Palm Springs may be second/vacation home." Sample copy $6. Photo guidelines free with SASE.
Needs: Uses 100 photos/issue; 30% supplied by freelance photographers; 70% from assignment. Needs desert photos, scenic wildlife, gardening, fashion, beauty, interior design, travel, personalities and people (all local). Special needs include photo essays, art photography. Model release preferred. Property release required. Captions preferred; include who, what, when, where, why.
Making Contact & Terms: Interested in receiving work from newer, lesser-known photographers. Arrange personal interview to show portfolio. Submit portfolio for review. Query with résumé of credits. Query with stock photo list. Uses 35mm, 2¼×2¼, 4×5 or 8×10 transparencies. Deadlines: 3 months prior to publication. SASE. Reports as soon as possible. Pays $300-500/color cover photo; $25-200/color inside photo; $125/color page; $25-100/b&w photo; $50-325/color photo; payment/job, negotiable. Pays on publication. Credit line given. Buys all rights; negotiable. Simultaneous submissions and previously published work OK.
Tips: In reviewing photographer's portfolio, looking for published photographs. The "unusual" bend to the "usual" subject. "We will try anything new photographically as long as it's gorgeous! Must present professional-looking portfolio. Please don't submit photos of subjects I'd never use. Know your market!"

***PARENTING**, 301 Howard St., 17th Floor, San Francisco CA 94105. (415)546-7575. Fax: (415)546-0578. Picture Editor: Tripp Mikich. Circ. 925,000. Estab. 1987. Monthly magazine. Emphasizes parenting skills and child rearing, pregnancy through pre-teen. Readers are primarily female approximately 22-35 years old, middle to upper-middle income. Sample copy $3. Photo guidelines free with SASE.
Needs: Uses 75-100 photos/issue; 90% supplied by freelancers. Needs photos of all subject areas related to parents, families and children. Model release required for anything of a potentially controversial subject, or which might be used in a controversial context. Captions preferred; include when shot, context of photo, etc. Primarily a concern with journalistic work.
Making Contact & Terms: Interested in receiving work from newer, lesser-known photographers. Arrange personal interview to show portfolio. Submit portfolio for review. Provide résumé, business card, brochure, flier or tearsheets to be kept on file for possible assignments. Reports in 3 weeks depending on interest in material, etc. Pays $300-500/day; other payment varies. Pays on acceptance. Credit line given. Buys one-time rights, first North American serial rights. Simultaneous submissions and previously published work OK.
Tips: "Subject area is not always most important, but 'how' a photographer approaches any subject and how well the photographer captures an original or creative image (is important). Technique is secondary often to 'vision.' Submit good samples and portfolio. Try to show quality, not the 'I can shoot anything/everything' type of book. Know who you're submitting your work to. Look at the publication and have some knowledge of how we use photography, and how your work might apply."

***PASSENGER TRAIN JOURNAL**, P.O. Box 379, Waukesha WI 53187. (414)542-4900. Fax: (414)542-7595. E-mail: 76307.1175@compuserve.com. Editor: Carl Swanson. Circ. 14,000. Estab. 1968. Monthly magazine. Emphasizes rail passenger equipment and travel. Readers are mostly male, well-educated, ages 35-60. Photo guidelines free with SASE.
Needs: Uses 12-15 photos/issue; all supplied by freelancers. Needs photos of North American passenger trains, depots and rail transit systems in the United States. Reviews photos with or without ms. Special photo needs include general photos of Amtrak long-distance trains. Model/property release preferred for any recognizable person in the photo. Captions required; include name of train, direction of travel, date, location.
Making Contact & Terms: Interested in receiving work from newer, lesser-known photographers. Send unsolicited photos by mail for consideration. Send 5×7 glossy b&w prints; 35mm, 2¼×2¼ transparencies. Does not keep samples on file. SASE. Reports in 1 month. Pays $50/color cover photo; $50/b&w cover photo; $10-50/color inside photo; $10-50/b&w inside photo. Pays on publication. Credit line given. Buys one-time rights.

Tips: "We look for people who can convey the drama of passenger railroading through their pictures. Although our payment rates are fairly low, we feel this magazine is a good way for unknown photographers to see their work in print and get their name before the public."

PENNSYLVANIA, P.O. Box 576, Camp Hill PA 17011. (717)761-6620. Editor: Albert E. Holliday. Circ. 40,000. Bimonthly. Emphasizes history, travel and contemporary issues and topics. Readers are 40-60 years old, professional and retired; average income is $46,000. Sample copy $2.95. Photo guidelines free with SASE.
• If you want to work with this publication make sure you review several past issues and obtain photo guidelines.
Needs: Uses about 40 photos/issue; most supplied by freelance photographers. Needs include travel and scenic. All photos must be in Pennsylvania. Reviews photos with or without accompanying ms. Captions required.
Making Contact & Terms: Query with samples and list of stock photo subjects. Send 5×7 and up b&w and color prints; 35mm and 2¼×2¼ transparencies (duplicates only, no originals) by mail for consideration. SASE. Reports in 2 weeks. Pays $100-150/color cover photo; $15-25/inside photo; $50-400/text/photo package. Credit line given. Buys one-time rights. Simultaneous submissions and previously published work OK.

***PENNSYLVANIA GAME NEWS**, 2001 Elmerton Ave., Harrisburg PA 17110-9797. (717)787-3745. Editor: Bob Mitchell. Circ. 150,000. Monthly magazine. Published by the Pennsylvania Game Commission. For people interested in hunting, wildlife management and conservation in Pennsylvania. Free sample copy with 9×12 SASE. Free editorial guidelines.
Needs: Considers photos of "any outdoor subject (Pennsylvania locale), except fishing and boating." Photos purchased with accompanying ms.
Making Contact & Terms: Submit seasonal material 6 months in advance. Send 8×10 glossy b&w prints. SASE. Reports in 2 months. Pays $5-20/photo. **Pays on acceptance.** Buys all rights, but may reassign after publication.

***PENNSYLVANIA SPORTSMAN**, P.O. Box 90, Lemoyne PA 17043. (717)761-1400. Associate Publisher: Sherry Ritchey. Regional magazine, published 8 times/year. Features fiction, nonfiction, how-to's, where-to's, various game and wildlife in Pennsylvania. Readers are men and women of all ages and occupations.Circ. 68,000. Estab. 1971. Sample copy for $2. Photo guidelines free with SASE.
Needs: Uses 40 photos/issue; 5 supplied by freelancers. Primarily needs animal/wildlife shots. Especially interested in shots of deer, bear, turkeys and game fish such as trout and bass. Photo captions preferred.
Making Contact & Terms: Query with list of stock photo subjects. SASE. Reports in 1 month. NPI; negotiable. **Pays on acceptance.** Credit line given. Buys one-time rights. Simultaneous submissions OK.
Tips: "Read the magazine to determine needs."

PENTHOUSE, 1965 Broadway, New York NY 10023. Prefers not to share information.

PEOPLE MAGAZINE, Time & Life Bldg., Rockefeller Center, New York NY 10024. (212)522-2606. Photo Editor: M.C. Marden. Circ. 1.9 million subscribers; 1.5 million newsstand buyers. Estab. 1974. Weekly. "We are concerned with people, from the celebrity to the person next door. We have a dual audience, men and women, primarily under 40."
Needs: Uses approximately 100 photos/issue. "We have no staff photographers, therefore all work in *People* is done by freelancers. About 75% is from assignments, the rest of the material is from photo agencies and pickups from freelancers, movie companies, and networks, record companies and publishers. We are always looking for recent *lively* photojournalistic photos. We are less interested in studio portraits than in photo reportage. Our needs are specific people rather than generic people." Model release and captions required.
Making Contact & Terms: "*People* has a portfolio drop-off system. This enables them to let *People* see their work. They should call and make a drop-off apointment. Pays $1,250/b&w or color cover photo; "space rates: minimum $125 to $350 for full page"; $400-500/day. Pays on publication. Credit line given.
Tips: "Our photographs must tell a story. I have to see reportage, not portraits. I am looking for pictures with impact, pictures that move one, make one laugh. It is valuable to include contact sheets and color to show how the photographer really works a story. It is also important to have a portfolio that relates to the appropriate market, i.e. advertising for advertising, editorial for editorial. Submit newsworthy recent photos. They really should be timely and exclusive."

PETERSEN'S PHOTOGRAPHIC, 6420 Wilshire Blvd., Los Angeles CA 90048-5515. (213)782-2200. Fax: (213)782-2465. Editor: Jenni Bidner. Circ. 225,000. Estab. 1972. Monthly magazine. Emphasizes

photography. Sample copies available on newsstands. Photo guidelines free with SASE.

Needs: No assignments. All queries, outlines and mss must be accompanied by a selection of images that would illustrate the article.

Making Contact & Terms: Interested in receiving work from newer, lesser-known photographers as well as established pros. Submit portfolio for review. Send unsolicited photos by mail for consideration. Send unmounted glossy color or b&w prints no larger than 8×10; 35mm, 2¼×2¼, 4×5, 8×10 transparencies preferred. All queries and mss must be accompanied by sample photos for the article. Deadlines: 6 months in advance for seasonal photos. SASE. Reports in 2 months. NPI. Pays per published page (text and photos). Pays on publication. Credit line given. Buys one-time rights. Previously published work OK.

Tips: "We need images that are visually exciting and technically flawless. The articles mostly cover the theme 'We Show You How.' Send great photographs with an explanation of how to create them."

PHOENIX MAGAZINE, 5555 N. Seventh Ave., Suite B-200, Phoenix AZ 85013. (602)207-3750. Executive Editor/Publisher: Dick Vonier. Art Director: James Forsmo. Monthly magazine. Circ. 50,000. Emphasizes "subjects that are unique to Phoenix: its culture, urban and social achievements and problems, its people and the Arizona way of life. We reach a professional and general audience of well-educated, affluent visitors and long-term residents."

Needs: Buys 10-35 photos/issue. Wide range, all dealing with life in metro Phoenix. Generally related to editorial subject matter. Wants on a regular basis photos to illustrate features, as well as for regular columns on arts. No "random shots of Arizona scenery, etc. that can't be linked to specific stories in the magazine." Photos purchased with or without an accompanying ms.

Making Contact & Terms: Query. Works with freelance photographers on assignment only basis. Provide résumé, samples, business card, brochure, flier and tearsheets to be kept on file for possible future assignments. SASE. Reports in 3-4 weeks. Black and white: $25-75; color: $50-200; cover: $400-1,000. Pays within 2 weeks of publication. Payment for manuscripts includes photos in most cases. Payment negotiable for covers and other photos purchased separately.

Tips: "Study the magazine, then show us an impressive portfolio."

***PHOTO EDITORS REVIEW**, 1201 Montego #4, Walnut Creek CA 94598-2819. Phone/fax: (510)935-7406. Photo Editor: Robert Shepherd. Circ. 4,200. Estab. 1994. Bimonthly journal. Emphasis on photo editing. Readers are mostly professional photo editors and magazine photographers. Sample copies $3 with 9×12 envelope and 4 first-class stamps. Photo guidelines free with SASE.

Needs: Uses 6-10 photos/issue; almost all supplied by photo editors and professional photographers. About 25% supplied by talented amateur photographers. Needs all kinds of photos, but photos must meet criteria listed under Tips, below. Special photo needs include photographic illustrations with universal themes. Model/property release required for identifiable private property and portraits. Captions required; include camera model, lens used, shutter speed; f-stop and lighting information if applicable.

Making Contact & Terms: Always interested in receiving work from newer, lesser-known photographers. Query with résumé of credits. Query with stock photo list. Send 3×5 to 8×10 glossy b&w prints by mail for consideration. Provide return envelope and postage if photos are to be returned. Provide résumé, business card, brochure, flier or tearsheets to be kept on file for possible assignments. Keeps photo samples on file. SASE. Reports in 1 month. Pays $50/b&w photo; up to $200 for photo assignment. **Pays on acceptance**. Credit line given and portrait of photo editor or photographer published. Buys one-time rights; negotiable. Simultaneous submissions and previously published work OK.

Tips: "We are a trade publication that caters to the needs of professional photo editors; therefore, marketable photos that exhibit universal themes will be given top priority. We look for five basic characteristics by which we judge photographic materials: sharp exposures (unless the image was intended as a soft-focus shot), impact, easily identifiable theme or subject, emphasis of the theme or subject, and simplicity."

❖PHOTO LIFE, 130 Spy Court, Markham, Ontario L3R 5H6 Canada. (905)475-8440. Fax: (905)475-9560. Editor: Jerry Kobalenko. Circ. 55,000. Magazine published 8 times/year. Readers are advanced amateur and professional photographers. Sample copy or photo guidelines free with SASE.

Needs: Uses 50 photos/issue; 80% supplied by freelance photographers. Needs animal/wildlife shots, travel, scenics and so on. Only by Canadian photographers on Canadian subjects.

Making Contact & Terms: Query with résumé of credits. SASE. Reports in 1 month. Pays $60/b&w photo; $75-100/color photo; $400 maximum/complete job; $700 maximum/photo/text package. **Pays on acceptance**. Buys first North American serial rights and one-time rights.

Tips: "Looking for good writers to cover any subject interesting to the advanced photographer. Fine art photos should be striking, innovative. General stock, outdoor and travel photos should be presented with a strong technical theme."

PHOTOGRAPHER'S MARKET, 1507 Dana Ave., Cincinnati OH 45207. (513)531-2690 ext. 286. Editor: Michael Willins. Circ. 30,000. Annual hardbound directory for freelance photographers.
Needs: Publishes 35-40 photos per year. Uses general subject matter. Photos must be work sold to listings in *Photographer's Market*. Photos are used to illustrate to readers the various types of images being sold to photo buyers listed in the book. "We receive a lot of photos for our Publications section. Your chances of getting published are better if you can supply images for sections other than Publications." Captions should explain how the photo was used by the buyer, why it was selected, how the photographer sold the photo or got the assignment, how much the buyer paid the photographer, what rights were sold to the buyer and any self-marketing advice the photographer can share with readers. Look at book for examples.
Making Contact & Terms: Interested in receiving work from newer, lesser-known photographers. Submit photos for inside text usage in fall and winter to ensure sufficient time to review them by spring deadline (late February to early March). All photos are judged according to subject uniqueness in a given edition, as well as technical quality and composition within the market section in the book. Photos are held and reviewed at close of deadline. Uses b&w glossy prints, any size and format; 5×7 or 8×10 preferred. Also uses tearsheets and transparencies, all sizes. Reports are immediate if a photo is selected; photos not chosen are returned within 2 months of selection deadline. Pays $50 plus complimentary copy of book. Pays when book goes to printer (June). Book forwarded in September upon arrival from printer. Credit line given. Buys second reprint and promotional rights. Simultaneous submissions and previously published work OK.
Tips: "Send photos with brief cover letter describing the background of the sale. If sending more than one photo, make sure that photos are clearly identified with name and a code that corresponds to a comprehensive list. Slides should be enclosed in plastic slide sleeves, and original prints should be reinforced with cardboard. Cannot return material if SASE is not included. Tearsheets will be considered disposable unless SASE is provided and return is requested. Because photos are printed in black and white on newsprint stock, some photos, especially color shots, may not reproduce well. Photos should have strong contrast and not too much fine detail that will fill in when photo is reduced to fit our small page format."

PLAYBOY, 680 North Lake Shore Dr., Chicago IL 60611. (312)751-8000. Fax: (312)587-9046. Photography Director: Gary Cole. Circ. 3.4 million. Estab. 1954. Monthly magazine. Readers are 75% male and 25% female, ages 18-70; come from all economic, ethnic and regional backgrounds.
• This is a premiere market that demands photographic excellence. *Playboy* does not use freelance photographers per se, but if you send images they like they may use your work and/or pay a finder's fee.
Needs: Uses 50 photos/issue. Needs photos of fashion, merchandise, travel, food, personalities and glamour. Model release required. Models must be at least 18 years old.
Making Contact & Terms: Interested in receiving work from newer, lesser-known photographers. Contact through rep. Submit portfolio for review. Query with résumé of credits. Send unsolicited photos by mail for consideration. Provide résumé, business card, brochure, flier or tearsheets to be kept on file for possible assignments. Send color 35mm, 2¼×2¼, 4×5, 8×10 transparencies. Reports in 1-2 weeks. Pays $300 and up/job. Pays on acceptance. Buys all rights.
Tips: Lighting and attention to detail is most important when photographing women, especially the ability to use strobes indoors. Refer to magazine for style and quality guidelines.

POLO MAGAZINE, 656 Quince Orchard Rd., Gaithersburg MD 20878. (301)977-0200. Fax: (301)990-9015. Editor: Ami Shinitzky. Circ. 7,000. Estab. 1975. Publishes monthly magazine 10 times/year with combined issues for January/February and June/July. Emphasizes the sport of polo and its lifestyle. Readers are primarily male; average age is 40. 90% of readers are professional/managerial levels, including CEO's and presidents. Sample copy free with 10×13 SASE. Photo guidelines free with SASE.
Needs: Uses 50 photos/issue; 70% supplied by freelance photographers; 20% of this by assignment. Needs photos of polo action, portraits, travel, party/social and scenics. Most polo action is assigned, but freelance needs range from dynamic action photos to spectator fashion to social events. Photographers may write and obtain an editorial calendar for the year, listing planned features/photo needs. Captions preferred, where necessary include subjects and names.
Making Contact & Terms: Query with list of stock photo subjects. Provide résumé, business card, brochure, flier or tearsheets to be kept on file for possible assignments. SASE. Reports in 2 weeks. Pays $25-150/b&w photo, $30-300/color photo, $150/half day, $300/full day, $200-500/complete package. Pays on publication. Credit line given. Buys one-time or all rights; negotiable. Simultaneous submissions and previously published work OK "in some instances."
Tips: Wants to see tight focus on subject matter and ability to capture drama of polo. "In assigning action photography, we look for close-ups that show the dramatic interaction of two or more players rather than a single player. On the sidelines, we encourage photographers to capture emotions of game,

pony picket lines, etc." Sees trend toward "more use of quality b&w images." To break in, "send samples of work, preferably polo action photography."

✦**POOL & SPA LIVING MAGAZINE**, (formerly *Pool and Spa Magazine*), 270 Esna Park Dr., Unit 12, Markham, Ontario L3R 1H3 Canada. (905)513-0090. Editor: David Barnsley. Circ. 40,000. Published twice a year. Emphasizes swimming pools, spas, hot tubs, outdoor entertaining, landscaping (patios, decks, gardens, lawns, fencing). Readers are homeowners and professionals 30-55 years old. Equally read by men and women.
Needs: Uses 20-30 photos/issue; 30% supplied by freelance photographers. Looking for shots of models dressed in bathing suits, people swimming in pools/spas, patios. Plans annual bathing suit issue late in year. Model release required.
Making Contact & Terms: Send unsolicited photos by mail for consideration. Send 8×10 glossy color prints; 35mm transparencies. SASE. Reports in 2 weeks. NPI; will negotiate payment. Pays on publication. Credit line given. Buys all rights; negotiable. Simultaneous submissions and previously published work OK.
Tips: Looking for "photos of families relaxing outdoors around a pool, spa or patio. We are always in need of visual material, so send in whatever you feel is appropriate for the magazine. Photos will be returned."

POPULAR PHOTOGRAPHY, 1633 Broadway, New York NY 10019. (212)767-6578. Fax: (212)767-5629. Send to: Your Best Shot/Hard Knocks. Circ. 700,000. Estab. 1937. Monthly magazine. Readers are male and female photographers, amateurs to professionals of all ages. Photo guidelines free with SASE.
Needs: Uses many photos/issue; many supplied by freelancers, mostly professionals. Uses photos for monthly contest feature, Your Best Shot. Needs scenics, nature, portraits. Hard Knocks.
Making Contact & Terms: Interested in receiving work from newer, lesser-known photographers. Send unsolicited photos by mail for consideration. Send prints size 8×12 and under, color and b&w; any size transparencies. Does not keep samples on file. SASE. Reports in 3 months. Pays prize money for contest: $300 (first), $200 (second), $100 (third) and honorable mention. **Pays on acceptance.** Credit line given. Buys one-time rights.

PORTLAND-THE UNIVERSITY OF PORTLAND MAGAZINE, 5000 N. Willamette Blvd., Portland OR 97203. (503)283-7202. Fax: (503)283-7110. Editor: Brian Doyle. Estab. 1985. 40-page magazine published quarterly.
Needs: Buys 20 photos/year; offers 3 assignments/year. Subjects include people. Model release preferred.
Making Contact & Terms: Interested in receiving work from newer, lesser-known photographers. Query with résumé of credits. Query with list of stock photo subjects. Solicits photos by assignment only. Uses 8×10 glossy b&w prints; b&w contact sheets; 35mm and 2½×2½ transparencies. SASE. Reports in 2 weeks. Pays $100-300/b&w and color photo. Credit line given. Buys one-time rights.
Tips: "Our needs are fairly specific. Tell me how you can help me. We want strong, creative photos. No mugs and 'grip and grins.' " In portfolio of samples wants to see "interpretive ability more than photojournalistic work. Also show work with other magazines. Strong composition and color is important. Often buy already completed work. University magazines are a growing market for first-rate photography. Our best work in recent years has been on assignment. There are more than 500 university and college magazines—a little-known niche. Our needs are not extensive. A good promotional brochure gives me someone to contact in various areas on various subjects."

PRAYING, P.O. Box 419335, Kansas City MO 64141. (800)821-7926. Editor: Art Winter. Photo Editor: Rich Heffern. Circ. 15,000. Estab. 1986. Bimonthly. Emphasizes spirituality for everyday living. Readers include mostly Catholic laypeople. Sample copy and photo guidelines free with SASE.
Needs: Uses 1 photo/issue; all supplied by freelance photographers. Needs quality photographs which stand on their own as celebrations of people, relationships, ordinary events, work, nature, etc. "We are looking for photos for a feature called Prayer-Starter. The pictures should lead readers to reflect on an aspect of their lives. The images can be abstract, but they must be natural—we don't go for

The First Markets Index preceding the General Index in the back of this book provides the names of those companies/ publications interested in receiving work from newer, lesser-known photographers.

'trick' photography. Close-ups tend to work better than panoramic shots." Reviews photos with or without accompanying ms.

Making Contact & Terms: Query with samples. Send 8 × 10 b&w prints by mail for consideration. SASE. Reports in 2 weeks. Pays $50/b&w photo. **Pays on acceptance.** Credit line given. Buys one-time rights. Simultaneous submissions and previously published work OK.

Tips: Looking for "good *printing* composition. We get a lot of really *poor* stuff! Know how to take and print a quality photograph. Don't try to add holy element or reflective moment. Natural, to us, is holy. We have one rule: never to run a picture of someone praying."

***PRE-VUE ENTERTAINMENT MAGAZINE**, 7825 Fay Ave., La Jolla CA 92037. (619)456-5577. Fax: (619)542-0114. Photo Director/Editor: Penny Langford. Circ. 100,000. Estab. 1991. Monthly magazine distributed nationally in fine arts theaters. Emphasizes movies/celebrities. Readers are 51% male. Sample copy free with 6 × 9 SAE and 2 first-class stamps.

Needs: Uses 35 photos/issue; 10 supplied by freelancers. Needs photos of celebrities at play/events. Reviews photos with or without ms. Captions preferred.

Making Contact & Terms: Interested in receiving work from newer, lesser-known photographers. Send unsolicited photos by mail for consideration. Provide résumé, business card, brochure, flier or tearsheets to be kept on file for possible assignments. Send any size, 3 × 3 and up, matte color and b&w prints; 35mm, 2¼ × 2¼, 4 × 5, 8 × 10 transparencies. Keeps samples on file. SASE. Reports in 1 month. Pays $50/color photo. Pays on publication. Credit line given. Buys all rights; negotiable. Simultaneous submissions and/or previously published work OK, "if I know where it was published previously."

Tips: "We need shots of celebrities at play, working, premieres, stars traveling with family (identified). Movie stars, foreign film stars, directors, music celebrities (not in concert) are preferred. The best photos are of relaxed, friendly subjects looking straight into the lens (head and shoulders to torso and full length)."

PRIMAVERA, Box 37-7547, Chicago IL 60637. (312)324-5920. Contact: Board of Editors. Annual magazine. "We publish original fiction, poetry, drawings, paintings and photographs that deal with women's experiences." Sample copy $5. Photo guidelines free with SASE.

Needs: Uses 2-12 photos/issue; all supplied by freelancers.

Making Contact & Terms: Interested in receiving work from newer, lesser-known photographers. Send unsolicited photos or photocopies by mail for consideration. Send b&w prints. SASE. Reports in 1 month. Pays on publication 2 copies of volume in which art appears. Credit line given. Buys one-time rights.

PRIME TIME SPORTS & FITNESS, Dept. PM, P.O. Box 6097, Evanston IL 60204. (708)864-8113. Fax: (708)864-1206. Editor: Dennis Dorner. Magazine publishes 8 times/year. Emphasizes sports, recreation and fitness. Readers are professional males (50%) and females (50%), 19-45. Photo guidelines on request.

Needs: Uses about 70 photos/issue; 60 supplied by freelancers. Needs photos concerning women's fitness and fashion, swimwear and aerobic routines. Special photo needs include women's workout and swimwear photos. Upcoming short-term needs: summer swimwear, women's aerobic wear, portraits of women in sports. "Don't send any photos that would be termed 'photobank access." Model/property release required. Captions preferred; include names, the situation and locations.

Making Contact & Terms: Interested in reviewing work from newer, lesser-known photographers. Send unsolicited photos by mail for consideration. SASE. Reports in 2 months. Pays $200/color and b&w cover photo; $20/color and b&w inside photo; $20/color page rate; $50/b&w page rate; $30-60/hour. Time of payment negotiable. Credit line given. Buys all rights; negotiable. Simultaneous submissions and previously published work OK.

Tips: Wants to see "tight shots of personalities, people, sports in action, but only tight close ups." There are a "plethora of amateur photographers who have trouble providing quality action or fashion shots and yet call themselves professionals. However, bulk of photographers are sending in a wider variety of photos. Photographers can best present themselves by letting me see their work in our related fields (both published and unpublished) by sending us samples. Do not drop by or phone, it will not help."

PRISON LIFE MAGAZINE, 505 Eighth Ave, 14th Floor, New York NY 10018. (212)967-9760. Fax: (212)967-7101. Photo Editor: Chris Cozzone. Circ. 100,000. Estab. 1992. Bimonthly magazine. Emphasizes prison life and prison-related topics. Readers are male and female prisoners ages 16-80, and families of the incarcerated. Sample copy $3.95 with #10 SAE and 1 first-class stamp. Photo guidelines available.

Needs: Uses 40-50 photos/issue; 10-20 supplied by freelancers. Needs photos of prison. Model/property release preferred for prisoners. Captions preferred.

Making Contact & Terms: Interested in receiving work from newer, lesser-known photographers. Send unsolicited photos by mail for consideration. Send any size color or b&w prints; 35mm transparencies. Keeps samples on file. SASE. Reports in 2 weeks. Pays $200/color cover photo; $100/b&w cover photo; $50/color inside photo; $40/b&w inside photo; $200/photo/text package. Pays on publication. Credit line given. Buys one-time rights; negotiable. Previously published work OK.

PRIVATE PILOT, P.O. Box 6050, Mission Viejo CA 92690. (714)855-8822. Fax: (714)855-3045. Managing Editor: Chuck Stewart. Circ. 90,000. Estab. 1965. Monthly magazine. Emphasizes aircraft, avionics, aviation-related materials. Readers are 90% male, age 45 and over. Sample copy free with SASE. Photo guidelines free with SASE.
Needs: Uses 80-100 photos/issue; 50-75 supplied by freelancers. Needs photos of aircraft—air-to-air and details. Model/property release preferred. Captions required; include date, location, names of people.
Making Contact & Terms: Interested in receiving work from newer, lesser-known photographers. Submit portfolio for review. Query with résumé of credits. Query with stock photo list. Send unsolicited photos by mail for consideration. Provide résumé, business card, brochure, flier or tearsheets to be kept on file for possible assignments. Send 3×5, 8×10 color prints; 35mm transparencies. Keeps samples on file. SASE. Reports in 2 weeks. Pays $350/color cover photo; $25-50/color inside photo; $15-25/b&w inside photo; $75-100/photo/text package. Pays on publication. Credit line given. Buys one-time rights. Simultaneous submissions and/or previously published work OK.

THE PROGRESSIVE, 409 E. Main St., Madison WI 53703. Art Director: Patrick JB Flynn. Circ. 35,000. Estab. 1909. Monthly. Emphasizes "political and social affairs—international and domestic." Free sample copy and photo guidelines upon request.
Needs: Uses 10 or more b&w photos/issue; generally supplied by freelance photographers. Looking for images documenting the human condition and the social/political structures of contemporary society. Special photo needs include "Third World countries, labor activities, environmental issues and political movements." Captions (name, place, date) and credit information required.
Making Contact & Terms: Query with photocopies to be kept on file for possible future assignments. SASE. Reports once every month. Pays $300/color cover photo; $40-100/b&w inside photo; $150/b&w full-page. Pays on publication. Credit line given. Buys one-time rights. Simultaneous submissions and previously published work OK.
Tips: "Interested in photo essays and in images that make a visual statement."

***PSYCHOLOGY TODAY**, 49 E. 21st St., 11th Floor, New York NY 10010. (212)260-3214. Fax: (212)260-7445. Photo Editor: Elisabeth Sinsabaugh. Estab. 1992. Bimonthly magazine. Emphasizes latest research in psychology useful to people in their everyday lives. Readers are male and female, highly educated, active professionals. Photo guidelines free with SASE.
Needs: Uses 19-25 photos/issue; all supplied by freelancers. Needs photos of humor, photo montage, symbolic, environmental, portraits, conceptual. Model/property release preferred.
Making Contact & Terms: Interested in receiving work from "upcoming" photographers. Submit portfolio for review. Send promo card with photo. Call before you drop off portfolio. Keeps samples on file. Cannot return material. Reports back only if interested. For assignments, pays $1,000/cover plus expenses; $350-750/inside photo plus expenses; for stock, pays $150/¼ page; $300/full page.

***RACQUETBALL MAGAZINE**, 1685 W. Uintah, Colorado Springs CO 80904-2921. (719)635-5396. Fax: (719)635-0685. Production Manager: Rebecca Maxedon. Circ. 45,000. Estab. 1990. Publication of American Amateur Racquetball Association. Bimonthly magazine. Emphasizes racquetball. Sample copy $4. Photo guidelines available.
Needs: Uses 20-40 photos/issue; 20-40% supplied by freelancers. Needs photos of action racquetball. Model/property release preferred. Captions required.
Making Contact & Terms: Interested in receiving work from newer, lesser-known photographers. Provide résumé, business card, brochure, flier or tearsheets to be kept on file for possible assignments. Deadlines: 1 month prior to each publication date. Keeps samples on file. SASE. Reports in 1 month. Pays $200/color cover photo; $25-75/color inside photo; $3-5/b&w inside photo. Pays on publication.

The asterisk before a listing indicates that the market is new in this edition. New markets are often the most receptive to freelance submissions.

Credit line given. Buys all rights; negotiable. Previously published work OK.

RADIANCE, The Magazine for Large Women, P.O. Box 30246, Oakland CA 94604. Phone/fax: (510)482-0680. Publisher/Editor: Alice Ansfield. Circ. 10,000. Estab. 1984. Quarterly magazine. "We're a positive/self-esteem magazine for women all sizes of large. We have diverse readership, 90% women, ages 25-70 from all ethnic groups, lifestyles and interests." Sample copy $3.50. Writer's guidelines free with SASE. Photo guidelines not available.
Needs: Uses 20 photos/issue; all supplied by freelance photographers. Needs portraits, cover shots, fashion photos. Model release preferred. Captions preferred.
Making Contact & Terms: Send unsolicited photos by mail for consideration. Provide résumé, business card, brochure, flier or tearsheets to be kept on file for possible assignments. SASE. Reports in 4 months. Pays $50-200/color cover photo; $15-25/b&w inside photo; $8-20/hour; $400/day. Pays on publication. Credit line given. Buys one-time rights. Simultaneous submissions OK.
Tips: In photographer's portfolio or samples wants to see "clear, crisp photos, creativity, setting, etc." Recommends freelancers "get to know the magazine. Work with the publisher (or photo editor) and get to know her requirements. Try to help the magazine with its goals."

RAG MAG, Box 12, Goodhue MN 55027. (612)923-4590. Editor: Beverly Voldseth. Circ. 300. Estab. 1982. Magazine. Emphasizes poetry and fiction, but is open to good writing in an genre. Sample copy $6 with 6¼×9¼ SAE and 4 first-class stamps.
Needs: Uses 3-4 photos/issue; all supplied by freelancers. Needs photos that work well in a literary magazine; faces, bodies, stones, trees, water, etc. Reviews photos without a manuscript. Uses photos on covers.
Making Contact & Terms: Interested in receiving work from newer, lesser-known photographers. Send up to 8 unsolicited photocopies of photos by mail for consideration; include name on back of copies with brief bio. Always supply your name and address and add an image title or number on each photo for easy reference. Do not send originals. 6×9 vertical shots are best. Does not keep samples on file. SASE. Reports in 2 weeks-2 months. Pays in copies. Pays on publication. Buys one-time rights. Simultaneous submissions and previously published work OK.
Tips: "I do not want anything abusive, sadistic or violent."

RANGER RICK, 8925 Leesburg Pike, Vienna VA 22184-0001. Photo Editor: Steve Freligh. Circ. 850,000. Estab. 1967. Monthly magazine. Readers are children, ages 6-12, interested in the natural world, wildlife, conservation and ecology. Sample copy $2. Photo guidelines free with SASE.
Needs: Buys 400 photos annually; 90% supplied by freelancers; 0-10% on assignment. Needs photos of wild animals (U.S. and foreign birds, mammals, insects, reptiles, etc.); humorous (wild animals in funny poses or situations); photo essay/photo feature (with captions); celebrity/personality; and children (especially girls or racial minorities) doing things involving wild animals, outdoor activities, crafts, recycling and helping the environment. No plants, weather or scenics. No soft focus, grainy, or weak color shots. Reviews photos with or without accompanying ms, but query first on articles.
Making Contact & Terms: Interested in receiving work from newer, lesser-known photographers. Submit portofolio of 20-40 photos for review and a list of available material. Uses original color transparencies; vertical format on cover. "Allow space in upper left corner or across the top for insertion of masthead." SASE. Reports in 2 weeks. Pays $290/half page or less; $825/2-page spread; $635/color cover photo. Pays 3 months before publication. Buys first serial rights and right to reuse for promotional purposes at half the original price. Previously published work OK.
Tips: "Come in close on subjects." Wants no "obvious flash." Mail transparencies inside 20-pocket plastic viewing sheets, backed by cardboard, in a manila envelope. "Do your own editing. We don't want to see 20 shots of almost the same pose. We pay by reproduction size. Check printed issues to see our standards of quality, which are high. Looking for fresh, colorful, clean images. New approaches to traditional subject matter welcome."

REAL PEOPLE, 950 Third Ave., 16th Floor, New York NY 10022. (212)371-4932. Fax: (212)838-8420. Editor: Alex Polner. Circ. 130,000. Estab. 1988. Bimonthly magazine. Emphasizes celebrities. Readers are women 35 and up. Sample copy $3.50 with 6×9 SAE.
Needs: Uses 30-40 photo/issue; 10% supplied by freelancers. Needs celebrity photos. Reviews photos with accompanying ms. Model release preferred where applicable. Photo captions preferred.
Making Contact & Terms: Interested in receiving work from newer, lesser-known photographers. Query with résumé of credits and/or list of stock photo subjects. Provide résumé, business card, brochure, flier or tearsheets to be kept on file for possible assignments. Send samples or tearsheets, perhaps even an idea for a photo essay as it relates to entertainment field. SASE. Reports only when interested. Pays $100-200/day. Pays on publication. Credit line given. Buys one-time rights.

REDBOOK, 224 W. 57th St., New York NY 10019. Prefers not to share information.

***RELIX MAGAZINE**, P.O. Box 94, Brooklyn NY 11229. (718)258-0009. Fax: (718)692-4345. Editor: Toni A. Brown. Circ. 60,000. Estab. 1974. Bimonthly. Emphasizes rock and roll music and classic rock. Readers are music fans, ages 13-50. Sample copy $4.

Needs: Uses about 50 photos/issue; "about 30%" supplied by freelance photographers; 20% on assignment; 80% from stock. Needs photos of "music artists—in concert and candid, backstage, etc." Special needs: "photos of rock groups, especially the Grateful Dead, San Francisco-oriented groups and sixties related bands." Captions preferred.

Making Contact & Terms: Interested in receiving work from newer, lesser-known photographers. Send 5×7 or larger b&w and color prints by mail for consideration. SASE. Reports in 1 month. "We try to report immediately; occasionally we cannot be sure of use." Pays $15-75/b&w photo; $25-300/color. Pays on publication. Credit line given. Buys all rights; negotiable. Simultaneous submissions and previously published work OK.

Tips: "Black and white photos should be printed on grade 4 or higher for best contrast."

***REMEMBER: The People and News We Can't Forget**, 6 Prowitt St., Norwalk CT 06855. (203)866-6688. Fax: (203)854-5962. Photo Researcher: Valerie Therrien. Circ. 100,000. Estab. 1994. Bimonthly magazine. Emphasizes events and celebrities of the past 75 years. Readers are male and female, ages 25-65. Sample copy $3.25.

Needs: Uses 100 photos/issue. Needs historical photos, celebrities, TV/movie stars, sports—all mostly from the past, but we do use some contemporary shots. Captions required; include date, name(s) of subjects, place.

Making Contact & Terms: Query with résumé of credits. Provide résumé, business card, brochure, flier or tearsheets to be kept on file for possible assignments. SASE. Reports in 1 month. Pays $100-150/color cover photo; $100-150/b&w cover photo; $50-100/color inside photo; $50-100/b&w inside photo; $100-150/color page rate; $100-150/b&w page rate. Pays on publication. Credit line given. Buys one-time rights; negotiable. Previously published work OK.

REMINISCE, 5400 S. 60th St., Greendale WI 53129. (414)423-0100. Fax: (414)423-1143. Editorial Assistant: Trudi Bellin. Estab. 1990. Bimonthly magazine. "For people who love reliving the good times." Readers are male and female, interested in nostalgia, ages 55 and over. "*Reminisce* is supported entirely by subscriptions and accepts no outside advertising." Sample copy $2. Photo guidelines free with SASE.

Needs: Uses 130 photos/issue; 30% supplied by freelancers. Needs photos with people interest— "we need high-quality color shots with nostalgic appeal." Model/property release required. Captions preferred; season, location.

Making Contact & Terms: Interested in receiving work from newer, lesser-known photographers. Query with list of stock photo subjects. Send unsolicited photos by mail for consideration. Send 35mm, 2¼×2¼, 4×5, 8×10 transparencies. Submit seasonally. Tearsheets filed but not dupes. SASE. Reports ASAP; "anywhere from a few days to a couple of months." Pays $200/color cover photo; $50-125/color inside photo; $150/color page (full page bleed); $10-50/b&w photo. Pays on publication. Credit line given. Buys one-time rights. Previously published work OK.

Tips: "We are continually in need of authentic color taken in the 40s, 50s and 60s and b&w stock photos. Technical quality is extremely important; focus must be sharp, no soft focus; colors must be vivid so they 'pop off the page.' Color photos of nostalgic subjects stand the best chance of making our covers. Study our magazine thoroughly—we have a continuing need for sharp, colorful images, and those who can supply what we need can expect to be regular contributors."

REPTILE & AMPHIBIAN MAGAZINE, RD3, Box 3709-A, Pottsville PA 17901. (717)622-6050. Fax: (717)622-5858. Editor: Erica Ramis. Circ. 14,000. Estab. 1989. Bimonthly magazine. Specializes in reptiles and amphibians only. Readers are college-educated, interested in nature and animals, familiar with basics of herpetology, many are breeders and conservation oriented. Sample copy $4. Photo guidelines with SASE.

Needs: Uses 50 photos/issue; 80% supplied by freelance photographers. Needs photos of related subjects. Photos purchased with or without ms. Model/property releases preferred. Captions required; clearly identify species with common and/or scientific name on slide mount.

Making Contact & Terms: Interested in receiving work from newer, lesser-known photographers. Send cover letter describing qualifications with representative samples. Must identify species pictured. Provide résumé, business card, brochure, flier or tearsheets to be kept on file for possible assignments. Send b&w and glossy prints; 35mm transparencies. Originals returned in 3 months. SASE. Reports in 1 month. Pays $25-50/color cover photo; $25/color inside photo; and $10/b&w inside photo. Pays on acceptance if needed immediately, or publication if the photo is to be filed for future use. Credit line given. Buys one-time rights. Previously published work OK.

Tips: In photographer's samples, looks for quality—eyes in-focus; action shots—animals eating, interacting, in motion. "Avoid field-guide type photos. Try to get shots with action and/or which have 'personality.'" All animals should be clearly identified with common and/or scientific name.

***REQUEST MAGAZINE**, 7630 Excelsior Blvd., Minneapolis MN 55108. (612)932-7740. Fax: (612)932-7797. Art Director: Scott Anderson. Assistant Editor: Vickie Gilmep. Circ. 600,000. Estab. 1989. Monthly magazine. Emphasizes music, all types: rock, metal, rap, country, blues, world, reggae, techno/rave, blues, jazz, etc. Readers are male 54%, female 46%, median age 23.6. Free sample copy.
Needs: Uses 20-100 photos/issue; 50% supplied by freelancers. Needs music photos: color or b&w, live, studio or location. Frequent requests for archival photos. Special photo needs include more exclusive photos of well-known musicians, different styles, "arty" photos, unusual locations or processing techniques." Model release issues dealt with as they arise, no predetermined policy at this point. I.D.'s of band members, etc. required."
Making Contact & Terms: Interested in receiving work from newer, lesser-known photographers. Submit portfolio for review. Query with stock photo list. Deadlines: 2 month lead time; "we do not review concerts but frequently need live photos for features." Keeps samples on file. Cannot return material. Reports in 1-2 weeks or as photos are needed. Pays $700-1,300/color cover photo; $150-300/color inside photo; $200-500/color page rate. Pays on publication. Buys one-time rights. Previously published work OK.

REVIEW OF OPTOMETRY, Chilton Way, Radnor PA 19089. (215)964-4371. Editor: Rich Kirkner. Circ. 31,500. Estab. 1891. Monthly. Emphasizes optometry. Readers include 31,000 practicing optometrists nationwide; academicians, students.
Needs: Uses 40 photos/issue; 3-8 supplied by freelance photographers. "Most photos illustrate news stories or features. Ninety-nine percent are solicited. We rarely need unsolicited photos. We will need top-notch freelance news photographers in all parts of the country for specific assignments." Model and property releases preferred; captions required.
Making Contact & Terms: Provide résumé, business card, brochure, flier or tearsheets to be kept on file for possible assignments; tearsheets and business cards or résumés preferred. NPI; payment varies. Credit line given. Rights negotiable. Simultaneous submissions and previously published work OK.

***RHODE ISLAND MONTHLY**, 18 Imperial Place, Providence RI 02903. (401)421-2552. Fax: (401)831-5624. Art Director: Donna Chludzinski. Circ. 32,000. Estab. 1988. Monthly magazine. Emphasizes local personalities, current events, consumer pieces, beautiful photo essays. Readers are predominantly affluent women, ages 40-55. Sample copy $1.
Needs: Uses 35-45 photos/issues; 30-40 supplied by freelancers. Needs photos of scenics, local personalities. Captions required; include identify names (correct spelling) and places.
Making Contact & Terms: Send unsolicited photos by mail for consideration. Send 35mm, 2¼ × 2¼, 4 × 5, 8 × 10 transparencies. Keeps samples on file. SASE. Reports in 3 weeks. Pays $200-800/job; $300-500/color cover photo; $75-300/color inside photos. The above amounts are an average. Pays on publication. Credit line given. Buys one-time rights. Simultaneous submissions and previously published work OK.
Tips: "We need photographers who have a good rapport with people as we photograph many Rhode Islanders from politicians, celebrity personalities, business men and women. We also need good nature photographers, Rhode Island has many beautiful natural resources, especially its 300 mile coastline. Please familiarize yourself with our magazine to give you an idea of our needs."

***RIFLE & SHOTGUN SPORT SHOOTING**, 2448 E. 81st St., 5300 CityPlex Tower, Tulsa OK 74137-4207. (918)491-6100. Fax: (918)491-9424. Executive Editor: Mark Chesnut. Circ. 100,000. Estab. 1994. Bimonthly magazine. Emphasizes shooting sports, including hunting. Readers are primarily male over 35. Sample copy $2.50. Photo guidelines free with SASE.
Needs: Uses 40-50 photos/issue; all supplied by freelancers. Needs photos of various action shots of shooting sports. Special photo needs include action shots for cover, skeet, trap, sporting clays, rifle shooting. Model/property release preferred. Captions preferred.
Making Contact & Terms: Interested in receiving work from newer, lesser-known photographers. Send unsolicited photos by mail for consideration. Send 35mm, 2¼ × 2¼ transparencies. Keeps samples on file. SASE. Reports in 3 weeks. Pays $400-600/color cover photo; $75-200/color inside photo; $300-450/photo/text package. **Pays on acceptance.** Credit line given. Buys first North American serial rights. Simultaneous submissions OK.

THE ROANOKER, P.O. Box 21535, Roanoke VA 24018. (703)989-6138. Fax: (703)989-7603. Editor: Kurt Rheinheimer. Circ. 14,000. Estab. 1974. Monthly. Emphasizes Roanoke and western Virginia. Readers are upper income, educated people interested in their community. Sample copy $2.
Needs: Uses about 40 photos/issue; most are supplied on assignment by freelance photographers. Needs "travel and scenic photos in western Virginia; color photo essays on life in western Virginia." Model/property releases preferred. Captions required.
Making Contact & Terms: Interested in receiving work from newer, lesser-known photographers. Send any size glossy b&w or color prints and transparencies (preferred) by mail for consideration.

SASE. Reports in 1 month. Pays $15-25/b&w photo; $20-35/color photo; $100/day. Pays on publication. Credit line given. Rights purchased vary; negotiable. Simultaneous submissions and previously published work OK.

ROCK & ICE, P.O. Box 3595, Boulder CO 80307. (303)499-8410. Editor-in-Chief: George Bracksieck. Circ. 45,000. Estab. 1984. Bimonthly magazine. Emphasizes rock and ice climbing and mountaineering. Readers are predominantly professional, ages 10-80. Sample copy for $6.50. Photo guidelines free with SASE.
- Photos in this publication usually are outstanding action shots. Make sure your work meets the magazine's standards. Do not limit yourself to climbing shots from the U.S.
Needs: Uses 90 photos/issue; all supplied by freelance photographers; 20% on assignment, 80% from stock. Needs photos of climbing action, personalities and scenics. Buys photos with or without ms. Captions required.
Making Contact & Terms: Interested in receiving work from newer, lesser-known photographers. Query with list of stock photo subjects. Send unsolicited photos by mail for consideration. Send b&w prints; 35mm, 2¼×2¼ and 4×5 transparencies. SASE. Pays $500/cover photo; $200/color and b&w page rate. Pays on publication. Credit line given. Buys one-time rights and first North American serial rights. Previously published work OK.
Tips: "Samples must show some aspect of technical rock climbing, ice climbing, mountain climbing or indoor climbing, scenics of places to climb or images of people who climb or who are indigenous to the climbing area. Climbing is one of North America's fastest growing sports."

***ROLLER HOCKEY**, 12327 Santa Monica Blvd., Los Angeles CA 90025. (310)442-6660. Fax: (310)442-6663. Editor: Michael Scarr. Circ. 20,000. Estab. 1992. Magazine published 9 times/year. Emphasizes roller hockey, specifically inline hockey. Readers are male and female, ages 12-45. Sample copy $2.95. Photo guidelines free with SASE.
Needs: Uses 50 photos/issue; 35 supplied by freelancers. Needs photos of roller hockey. Special photo needs include play from local and professional roller hockey leagues. Model/property release preferred for professionals in staged settings. Captions preferred; include who, what, where, when, why, how.
Making Contact & Terms: Interested in receiving work from newer, lesser-known photographers. Send unsolicited photos by mail for consideration. Query with stock photo list. Send 3×5, 5×7 glossy color b&w prints; 35mm transparencies. Deadlines: 3 months prior to any season. SASE. Reports in 1 month. Pays $100/color cover photo; $25/color inside photo; $15/b&w inside photo. Pays on publication. Credit line given. Buys all rights; negotiable. Previously published work OK.

ROLLING STONE, Dept. PM, 1290 Avenue of the Americas, New York NY 10104. (212)484-1616. Associate Photo Editor: Jodi Peckman. Emphasizes all forms of entertainment (music, movies, politics, news events).
Making Contact & Terms: "All our photographers are freelance." Provide brochure, calling card, flier, samples and tearsheet to be kept on file for future assignments. Needs famous personalities and rock groups in b&w and color. No editorial repertoire. SASE. Reports immediately. Pays $150-350/ day.
Tips: "Drop off portfolio at mail room any Wednesday between 10 am and noon. Pickup same day between 4 pm and 6 pm or next day. Leave a card with sample of work to keep on file so we'll have it to remember."

RUNNER'S WORLD, 135 N. Sixth St., Emmaus PA 18049. (610)967-5171. Fax: (610)967-7725. Executive Editor: Amby Burfoot. Photo Editor: Chuck Johnson. Circ. 435,000. Monthly magazine. Emphasizes running. Readers are median aged: 37, 65% male, median income $40,000, college-educated. Photo guidelines free with SASE.
Needs: Uses 100 photos/issue; 25% freelance, 75% assigned; features are generally assigned. Needs photos of action, features, photojournalism. Model release and captions preferred.
Making Contact & Terms: Query with samples. Contact photo editor before sending portfolio or submissions. Pays as follows: color—$350/full page, $250/half page, $210/quarter page, $580/2-page spread. Cover shots are assigned. Pays on publication. Credit line given. Buys one-time rights. Simultaneous submissions and previously published work OK.
Tips: "Become familiar with the publication and send photos in on spec. Also send samples that can be kept in our source file. Show full range of expertise; lighting abilities—quality of light—whether strobe sensitivity for people—portraits, sports, etc.. Both action and studio work if applicable, should be shown." Current trend is non-traditional treatment of sports coverage and portraits. Call prior to submitting work. Be familiar with running as well as the magazine."

RURAL HERITAGE, 281 Dean Ridge Lane, Gainesboro TN 38562-5039. (615)268-0655. Editor: Gail Damerow. Circ. 2,500. Estab. 1975. Bimonthly magazine. Readers live the rural lifestyle and maintain its traditional values in the modern world. Sample copy $6 ($6.50 outside the U.S.).

Needs: "Most of the photos we purchase illustrate stories or poems. Exceptions are back cover, for which we need well-captioned, humorous scenes related to rural life, and front cover where we use draft animals in harness. We're especially looking for rural humor."

Making Contact & Terms: Interested in receiving work from newer, lesser-known photographers. "For covers we prefer color horizontal shots, 5×7 glossy (color or 35mm slide). Interior is b&w. Please include SASE for the return of your material, and put your name and address on the back of each piece. Pays $10/photo to illustrate a story or poem; $15/photo for captioned humor; $25/back cover, $50/front cover. Also provides 2 copies of issue in which work appears. Pays on publication.

Tips: "Animals usually look better from the side than from the front. We like to see all the animal's body parts, including hooves, ears and tail. For animals in harness, we want to see the entire implement or vehicle. We prefer action shots (plowing, harvesting hay, etc.). Look for good contrast that will print well in black and white; watch out for shadows across animals and people. Please include the name of any human handlers involved, the farm, the town (or county), state, and the animal's names (if any) and breeds."

SACRAMENTO MAGAZINE, Dept. PM, 4471 D St., Sacramento CA 95814. (916)452-6200. Fax: (916)452-6061. Editor: Krista Hendricks Minard. Managing Editor: Darlena Belushin. Art Director: Rebecca McKee. Circ. 30,000. Monthly magazine. Emphasizes culture, food, outdoor recreation, home and garden and personalities for middle to upper middle class, urban-oriented Sacramento residents with emphasis on women.

Needs: Uses about 40-50 photos/issue; most supplied by freelance photographers. "Photographers are selected on the basis of experience and portfolio strength. No work assigned on speculation or before a portfolio showing. Photographers are used on an assignment only basis. Stock photos used only occasionally. Most assignments are to area photographers and handled by phone. Photographers with studios, mobile lighting and other equipment have an advantage in gaining assignments. Darkroom equipment desirable but not necessary." Needs news photos, essay, avant-garde, still life, landscape, architecture, human interest and sports. All photography must pertain to Sacramento and environs. Captions required.

Making Contact & Terms: Arrange a personal interview to show portfolio. Also query with résumé of photo credits. Pays $5-45/hour. Average payment is $15-20/hour; all assignments are negotiated to fall within that range. **Pays on acceptance.** Credit line given. Buys one-time rights. Will consider simultaneous submissions and previously published work, providing they are not in the northern California area.

SAIL MAGAZINE, 275 Washington St., Newton MA 02158-1630. (617)630-3726. Fax: (617)630-3737. Photo Editor: Allison Peter. Circ. 200,000. Estab. 1970. Monthly magazine. Emphasizes all aspects sailing. Readers are managers and professionals, average age 44. Photo guidelines free with SASE.

● This publication no longer publishes b&w images.

Needs: Uses 40 photos/issue; 100% supplied by freelancers. "We are particularly interested in photos for 'Under Sail' section. Photos for this section should be original 35mm transparencies only and should humorously depict some aspect of sailing." Photo captions preferred.

Making Contact & Terms: Interested in receiving work from newer, lesser-known photographers. Send unsolicited 35mm and 2¼×2¼ transparencies by mail for consideration. SASE. Pays $600/cover photo; $75-250/color inside photo; also negotiates prices on a per day, per hour, and per job basis. Pays on publication. Credit line given. Buys one-time rights.

SAILING, Dept. PM, 125 E. Main St., Box 248, Port Washington WI 53074. (414)284-3494. Editor: Micca L. Hutchins. Circ. 50,000. Monthly magazine. Emphasizes sailing. Our theme is "the beauty of sail." Readers are sailors with great sailing experience—racing and cruising. Sample copy free with 11×15 SAE and 9 first-class stamps. Photo guidelines free with SASE.

Needs: "We are a photo journal-type publication so about 50% of issue is photos." Needs photos of exciting sailing action, onboard deck shots; sailor-type boat portraits seldom used. Special needs include high quality color—mainly good *sailing*. Captions required. "We must have area sailed, etc., identification."

Making Contact & Terms: Query with samples. Send 35mm transparencies by mail for consideration. "Request guidelines first—a big help." SASE. Reports in 1 month. Payment varies from $150 and up. Pays 30 days after publication. Credit line given. Buys one-time rights. Simultaneous submissions and previously published work OK "if not with other sailing publications who compete with us."

Tips: "We are looking for good, clean, sharp photos of sailing action—exciting shots are for us. Please request a sample copy to become familiar with format. Knowledge of the sport of sailing a requisite for good photos for us."

Photographer Roger Archibald of Philadelphia, Pennsylvania, says he didn't even get wet while taking this shot that graced the cover of Sail magazine's December 1994 issue. The image sold for $600 and has generated additional sales of Archibald's photos and increased interest in the book American Photographers at the Turn of the Century: Travel & Trekking. *Self-published through Five Corners Publications, the book was mentioned by Sail because it contains a photo essay by Archibald.*

SAILING WORLD, 5 John Clarke Rd., Newport RI 02840. (401)847-1588. Fax: (401)848-5048. Asst. Art Director: Maureen Mulligan. Circ. 62,000. Estab. 1962. Monthly magazine. Emphasizes sailboat racing and performance cruising for sailors, upper income. Readers are males 35-45, females 25-35 who are interested in sailing. Sample copy $5. Photo guidelines free with SASE.
Needs: "We will send an updated photo letter listing our needs on request. Freelance photography in a given issue: 20% assignment and 80% freelance stock. Covers most sailing races.
Making Contact & Terms: Uses 35mm and 2¼×2¼ transparencies for covers. Vertical and square (slightly horizontal) formats. Reports in 1 month. Pays $500 for cover shot; regular color $50-300 (varies with use). Pays on publication. Credit line given. Buys first N.A. serial rights.
Tips: "We look for photos that are unusual in composition, lighting and/or color that feature performance sailing at its most exciting. We would like to emphasize speed, skill, fun and action. Photos must be of high quality. We prefer Fuji Velvia or Kodachrome 64 film. We have a format that allows us to feature work of exceptional quality. A knowledge of sailing and experience with on-the-water photography is really a requirement." Please call with specific questions or interests. "We cover current events and generally only use photos taken in the past 30-60 days."

SALT WATER SPORTSMAN, 77 Frankin St., Boston MA 02110. (617)439-9977. Fax: (617)439-9357. Editor: Barry Gibson. Circ. 140,000. Estab. 1939. Monthly magazine. Emphasizes all phases of salt water sport fishing for the avid beginner-to-professional salt water angler. "Number-one monthly marine sport fishing magazine in the U.S." Sample copy free with 9×12 SAE and 7 first-class stamps. Free photo and writer's guidelines.
Needs: Buys photos (including covers) without ms; 20-30 photos/issue with ms. Needs salt water fishing photos. "Think scenery, mood, fishing action, storytelling close-ups of anglers in action. Make it come alive—and don't bother us with the obviously posed 'dead fish and stupid fisherman' back at the dock. Wants, on a regular basis, cover shots (verticals depicting salt water fishing action)." For accompanying ms needs fact/feature articles dealing with marine sportfishing in the US, Canada, Caribbean, Central and South America. Emphasis on how-to.
Making Contact & Terms: Send material by mail for consideration or query with samples. Provide résumé and tearsheets to be kept on file for possible future assignments. Holds slides for 1 year and will pay as used. Uses b&w and color glossy prints and 35mm or 2¼×2¼ transparencies; cover transparency vertical format required. SASE. Reports in 1 month. Pay included in total purchase price with ms, or pays $20-200/b&w photo; $50-400/color photo; $1,000 minimum/cover photo; $250-up/text-photo package. **Pays on acceptance.**
Tips: "Prefers to see a selection of fishing action and mood; must be sport fishing oriented. Read the magazine! Example: no horizontal cover slides with suggestions it can be cropped etc. Don't send Ektachrome. We're using more 'outside' photography—that is, photos not submitted with ms package. Take lots of verticals and experiment with lighting. Most shots we get are too dark."

***SAN DIEGO FAMILY PRESS**, P.O. Box 23960, San Diego CA 92193. (619)685-6970. Editor: Sharon Bay. Circ. 72,000. Estab. 1982. Monthly magazine. Emphasizes families with children. Readers are mothers, ages 25-45. Sample copy 10×13 SAE and $3.50 postage/handling.
Needs: Uses 4-6 photos/issue. Needs photos of children and families participating in all activities.
Making Contact & Terms: Send unsolicited photos by mail for consideration. Query with stock photo list. Send 3×5, 4×5, 5×7 color b&w prints. Deadlines: first of each month. Keeps samples on file. SASE. Reports in 1 month. Pays $5-1/b&w inside photo. Pays on publication. Credit line given. Buys one-time rights; negotiable. Simultaneous submissions and previously published work OK.

***SANDLAPPER MAGAZINE**, P.O. Box 1108, Lexington SC 29071. (803)359-9941. Fax: (803)957-8226. Managing Editor: Dan Harmon. Estab. 1989. Quarterly magazine. Emphasizes South Carolina topics.
Needs: Uses about 5 photographers/issue. Needs photos of South Carolina subjects. Model release preferred. Captions required; include places and people.
Making Contact & Terms: Interested in receiving work from newer, lesser-known photographers. Query with samples. Send 8×10 color and b&w prints; 35mm, 2¼×2¼, 4×5, 8×10 transparencies. Keeps samples on file. SASE. Reports in 1 month. Pays $25-100/color inside photo; $25-75/b&w inside photo. Pays on publication. Credit line given. Buys first rights plus right to reprint.
Tips: Looking for any south Carolina topic—scenics, people, action, mood, etc.

SANTA BARBARA MAGAZINE, Dept. PM, 226 E. Canon Perdido, Suite H, Santa Barbara CA 93101. (805)965-5999. Fax: (805)965-7627. Editor: Daniel Denton. Photo Editor: Kimberly Kavish. Circ. 12,000. Estab. 1975. Quarterly magazine. Emphasizes Santa Barbara community and culture. Sample copy $3.50 with 9×12 SASE.

Needs: Uses 50-60 photos/issue; 40% supplied by freelance photographers. Needs portrait, environmental, architectural, travel, celebrity, et al. Reviews photos with accompanying ms only. Model release required. Captions preferred.

Making Contact & Terms: Provide résumé, business card, brochure, flier or tearsheets to be kept on file for possible future assignments; "portfolio drop off Thursdays, pick up Fridays." Cannot return unsolicited material. Reports in 4-6 weeks. Pays $75-250/b&w or color photo. Pays on publication. Credit line given. Buys first North American serial rights.

Tips: Prefers to see strong personal style and excellent technical ability. "Work needs to be oriented to our market. Know our magazine and its orientation before contacting me."

THE SATURDAY EVENING POST SOCIETY, Dept. PM, Benjamin Franklin Literary & Medical Society, 1100 Waterway Blvd., Indianapolis IN 46202. (317)634-1100. Editor: Cory SerVaas, M.D. Photo Editor: Patrick Perry. Magazine published 6 times annually. For family readers interested in travel, food, fiction, personalities, human interest and medical topics—emphasis on health topics. Circ. 500,000. Sample copy $4; free photo guidelines with SASE.

Needs: Prefers the photo essay over single submission. Model release required.

Making Contact & Terms: Send photos for consideration; 8 × 10 b&w glossy prints; 35mm or larger transparencies. Provide business card to be kept on file for possible future assignments. SASE. Reports in 1 month. Pays $50 minimum/b&w photo or by the hour; pays $150 minimum for text/photo package; $75 minimum/color photo; $300/color cover photo. Pays on publication. Prefers all rights. Simultaneous submissions and previously published work OK.

***SCHOLASTIC MAGAZINES**, 555 Broadway, New York NY 10012. (212)343-6100. Fax: (212)343-6185. Manager of Picture Services: Grace How. Estab. 1920. Publication of magazine varies from weekly to monthly. Emphasizes current events, children's projects, science, general interest. Readers are children pre-school through high school. Sample copy free with 8 × 10 SASE with 3 first-class stamps.

Needs: Uses 15 photos/issue. Needs photos of various subjects depending upon educational topics planned for academic year. Model release preferred. Captions required.

Making Contact & Terms: Interested in receiving work from newer, lesser-known photographers. Query with résumé, business card, brochure, flier or tearsheets to be kept on file for possible assignments. Material cannot be returned. Pays $400/color cover photo; $100/b&w inside photo (⅛ page); $125/color inside photo (¼ page). Pays on publication. Buys one-time rights. Previously published work OK.

SCIENTIFIC AMERICAN, 415 Madison Ave., New York NY 10017. (212)754-0474. Fax: (212)755-1976. E-mail: geller@sciam.com. Photography Editor: Nisa Geller. Circ. 600,000. Estab. 1854. Emphasizes science technology and people involved in science. Readers are ages 35-65. Samples copies $3.95.

Needs: Uses 50-100 photos/issue; 90% supplied by freelancers. Needs photos of animals, scenics, science and technology, personalities, photojournalism and how-to shots. Reviews photos only on request. Model release required. Property release preferred. Captions required.

Making Contact & Terms: Interested in receiving work from newer, lesser-known photographers. Submit portfolio for review. Query with stock photo list. Provide résumé, business card, brochure, flier or tearsheets to be kept on file for possible assignments. Does not keep samples on file. Cannot return material. Reports in 1 month. Pays $350/day; $1,000/color cover photo. Pays on publication. Credit line given. Buys one-time rights; negotiable.

Tips: Wants to see strong natural and artificial lighting, location portraits and location shooting. "Send business cards and promotional pieces frequently when dealing with magazine editors. Find a niche."

♣SCORE, Canada's Golf Magazine, 287 MacPherson Ave., Toronto, Ontario M4V 1A4 Canada. (416)928-2909. Fax: (416)928-1357. Managing Editor: Bob Weeks. Circ. 125,000. Estab. 1980. Magazine published 7 times/year. Emphasizes golf. "The foundation of the magazine is Canadian golf and golfers." Readers are affluent, well-educated, 80% male, 20% female. Sample copy $2 (Canadian). Photo guidelines free with SAE with IRC.

Needs: Uses between 30 and 40 photos/issue; approximately 95% supplied by freelance photographers. Needs "professional-quality, golf-oriented color and b&w material on prominent Canadian male and female pro golfers on the US PGA and LPGA tours, as well as the European and other international circuits, scenics, travel, close-ups and full-figure." Model releases (if necessary) required. Captions required.

Making Contact & Terms: Query with samples and with list of stock photo subjects. Send 8 × 10 or 5 × 7 glossy b&w prints and 35mm or 2¼ × 2¼ transparencies by mail for consideration. Provide résumé, business card, brochure, flier or tearsheets to be kept on file for possible future assignments. SASE with IRC. Reports in 3 weeks. Pays $75-100/color cover photo; $30/b&w inside photo; $50/

314 Photographer's Market '96

color inside photo; $40-65/hour; $320-520/day; and $80-2,000/job. **Pays on acceptance.** Credit line given. Buys all rights. Simultaneous submissions OK.

Tips: "When approaching *Score* with visual material, it is best to illustrate photographic versatility with a variety of lenses, exposures, subjects and light conditions. Golf is not a high-speed sport, but invariably presents a spectrum of location puzzles: rapidly changing light conditions, weather, positioning, etc. Capabilities should be demonstrated in query photos. Scenic material follows the same rule. Specific golf hole shots are certainly encouraged for travel features, but wide-angle shots are just as important, to 'place' the golf hole or course, especially if it is located close to notable landmarks or particularly stunning scenery. Approaching *Score* is best done with a clear, concise presentation. A picture is absolutely worth a thousand words, and knowing your market and your particular strengths will prevent a mutual waste of time and effort. Sample copies of the magazine are available and any photographer seeking to work with *Score* is encouraged to investigate it prior to querying."

SEA, The Magazine of Western Boating, 17782 Cowan, Suite C, Irvine CA 92714. (714)660-6150. Fax: (714)660-6172. Senior Editor: Eston Ellis. Art Director: Jeffrey Fleming. Circ. 60,000. Monthly magazine. Emphasizes "recreational boating in 13 western states (including some coverage of Mexico and British Columbia) for owners of recreational power boats." Sample copy and photo guidelines free with 9½ × 13 SAE.

Needs: Uses about 50-75 photos/issue; most supplied by freelance photographers; 10% assignment; 70% requested from freelancers existing photo files or submitted unsolicited. Needs people enjoying boating activity and scenics shots; shots which include parts or all of a boat are preferred." Special needs include "vertical-format shots involving power boats for cover consideration." Photos should have West Coast angle. Model release required. Captions required.

Making Contact & Terms: Query with samples. SASE. Reports in 1 month. Pays $250/color cover photo; inside photo rate varies according to size published. Range is from $25 for b&w and $50-150 for color. Pays on publication. Credit line given. Buys one-time North American rights.

Tips: "We are looking for sharp color transparencies with good composition showing pleasureboats in action, and people having fun aboard boats in a West Coast location. We also use studio shots of marine products and do personality profiles. Black & white also accepted, for a limited number of stories. Color preferred. Send samples of work with a query letter and a résumé or clips of previously published photos."

SEA KAYAKER, P.O. Box 17170, Seattle WA 98107. (206)789-1326. Fax: (206)781-1141. Editor: Christopher Cunningham. Circ. 18,000. Estab. 1984. Quarterly magazine. Emphasizes sea kayaking— kayak cruising on coastal and inland waterways. Sample copy $5.30. Photo guidelines free with SASE.

Needs: Uses 50 photos/issue; 85% supplied by freelancers. Needs photos of sea kayaking locations, coastal camping, paddling techniques. Reviews photos with or without ms. Always looking for cover images (to be translated into paintings, etc. Model/property release preferred. Captions preferred.

Making Contact & Terms: Interested in receiving work from newer, lesser-known photographers. Submit portfolio for review. Send unsolicited photos by mail for consideration. Send 5 × 7 color and b&w prints; 35mm transparencies. Keeps samples on file. SASE. Reports in 1 month. Pays $100/color cover photo; $25-50/color inside photo; $15-35/b&w inside photo. Pays on publication. Credit line given. Buys one-time rights, first North American serial rights.

Tips: Subjects "must relate to sea kayaking and cruising locations."

SENTIMENTAL SOJOURN, 11702 Webercrest, Houston TX 77048. (713)733-0338. Editor: Charlie Mainze. Circ. 1,000. Estab. 1993. Annual magazine. Sample copy $12.50.

Needs: Uses photos on almost every page. Needs sensual images evocative of sentimental emotions, usually including at least one human being, suitable for matching with sentimental poetry. Delicate, refined, romantic, nostalgic, emotional idealism can be erotic, but must be suitable for a general readership. Model/property release required for any model not shot in public places.

Making Contact & Terms: Interested in receiving work from newer, lesser-known photographers. Send unsolicited photos by mail for consideration. Provide résumé, business card, brochure, flier or tearsheets to be kept on file for possible assignments. Send color and b&w prints; 35mm, 2¼ × 2¼, 4 × 5 transparencies. Keeps samples on file. SASE, but generally keep for a few years. Reports when need for work arises, could be 2 years. Pays $50-200/color cover photo; $50-200/b&w cover photo; $10-100/color inside photo; $10-100/b&w inside photo; also pays a percentage of page if less than full page. Credit line given. Buys one-time rights, first North American serial rights. Previously published work OK.

Tips: "Symbols of the dead and dying had better be incomparably delicate. Send a celebration of emotions."

SEVENTEEN MAGAZINE, 850 Third Ave., 9th Floor, New York NY 10022. (212)407-9723. Fax: (212)935-4236. Photo Editor: Margaret Kemp. Circ. 1.9 million. Estab. 1944. Publication of K-III

Magazines. Monthly magazine. Emphasizes young women's beauty and fashion. Readers are young females between 12-18 year old.
Needs: Uses 30 photos/issue; close to 80% supplied by freelancers. Needs photos of fashion, celebrities, beauty. Model release required. Captions required.
Making Contact & Terms: Interested in receiving work from newer, lesser-known photographers. Contact through rep. Arrange personal interview to show portfolio. Submit portfolio for review. Provide résumé, business card, brochure, flier or tearsheets to be kept on file for possible assignments. Reports in 2 weeks. Pays $250/day; $175/¼ page or less; $350/full page. Pays on publication. Credit line given. Buys one-time rights; negotiable. Previously published work OK.

SHOWBOATS INTERNATIONAL, 1600 SE 17th St., Suite 200, Ft. Lauderdale FL 33316. (305)525-8626. Fax: (305)525-7954. Executive Editor: Marilyn Mower. Circ. 60,000. Estab. 1981. Bimonthly magazine. Emphasizes exclusively large yachts (100 feet or over). Readers are mostly male, 40 plus years of age, incomes above $1 million, international. Sample copy $5.
• This publication received 18 Florida Magazine Association Awards plus two Ozzies since 1989.
Needs: Uses 90-150 photos/issue; 80-90% supplied by freelancers. Needs photos of very large yachts and exotic destinations. "Almost all shots are commissioned by us." Model/property releases required. Color photography only. Captions preferred.
Making Contact & Terms: Arrange personal interview to show portfolio. Submit portfolio for review. Query with résumé of credits. Provide résumé, business card, brochure, flier or tearsheets to be kept on file for possible assignments. Does not keep samples on file. SASE. Reports in 3 weeks. Pays $400-500/color cover photo; $75-300/color page rate; $450-850/day. Pays on publication. Credit line given. Buys first serial rights, all rights; negotiable. Previously published work OK, however, exclusivity is important.
Tips: Looking for excellent control of lighting; extreme depth of focus; well-saturated transparencies. Prefer to work with photographers who can supply both exteriors and beautiful, architectural quality interiors. "Don't send pictures that need any excuses. The larger the format, the better. Send samples. Know about yachts."

SIMPLY SEAFOOD, 5305 Shilshole Ave. NW, Suite 200, Seattle WA 98107. (206)789-6506. Fax: (206)789-9193. Photo Editor: Scott Wellsandt. Estab. 1991. Quarterly magazine. Emphasizes seafood recipes, step-by-step cooking of seafood, profiles of chefs. Sample copy $1.95.
Needs: Uses 40 photos/issue; 25% supplied by freelancers. Needs "mainly food shots, a few travel, historic and fishing shots, chefs in different locations." Model/property release preferred. Captions preferred.
Making Contact & Terms: Interested in receiving work from newer, lesser-known photographers. Query with list of stock photo subjects. Provide résumé, business card, brochure, flier or tearsheets to be kept on file for possible assignments. Keeps samples on file. SASE. Reports as needed. Pays $100/color cover photo; $50/color inside photo. Pays on publication. Credit line given. Buys one-time rights; negotiable. Simultaneous submissions and previously published work OK.
Tips: Review the magazine before contacting.

***SKATING**, 20 First St., Colorado Springs CO 80906-3697. (719)635-5200. Fax: (719)635-9548. Editor: Jay Miller. Circ. 40,000. Estab. 1923. Publication of The United States Figure Skating Association. Monthly magazine. Emphasizes competitive figure skating. Readers are primarily pre-teen and teenage girls who spend up to 15 hours a week skating. Sample copy $3.
Needs: Uses 50 photos/issue; 90% supplied by freelancers. Needs sports action shots of national and world-class figure skaters; also casual, off-ice shots of skating personalities. Model/property release required. Captions preferred; include who, what, when where. Send unsolicited photos by mail for consideration. Send 3½×5, 4×6, 5×7 glossy color prints; 35mm transparencies. Deadlines: 15th of every month. Keeps samples on file. Cannot return material. Reports in 2 weeks. Pays $50/color cover photo; $35/color inside photo; $15/b&w inside photo. Pays on publication. Credit line given. Buys one-time rights; negotiable.
Tips: "We look for a mix of full-body action shots of skaters in dramatic skating poses and tight, close-up or detail shots that reveal the intensity of being a competitor. Shooting in ice arenas can be tricky. Flash units are prohibited during skating competitions, therefore, photographers need fast, zoom lenses that will provide the proper exposure, as well as stop the action."

♣SKI CANADA, 117 Indian Rd., Toronto, Ontario M6R 2V5 Canada. (416)538-2293. Fax: (416)538-2475. Editor: Iain MacMillan. Monthly magazine published 7 times/year. Readership is 65% male, ages 25-44, with high income. Circ. 55,000. Sample copy free with SASE.
Needs: Uses 40 photos/issue; 100% supplied by freelance photographers. Needs photos of skiing—competition, equipment, travel (within Canada and abroad), instruction, news and trends. Model release required; photo captions preferred.

Making Contact & Terms: Send unsolicited photos by mail for consideration. Provide résumé, business card, brochure, flier or tearsheets to be kept on file for possible assignments. Send color and 35mm transparencies. SASE. Reports in 1 month. Pays $100/photo/page; cover $300; rates are for b&w or color. Pays within 30 days of publication. Credit line given. Buys first North American serial rights. Simultaneous submissions OK.

Tips: "Please request in writing (or by fax), an editorial lineup, available in late fall for the following year's publishing schedule. Areas covered: travel, equipment, construction, competition, fashion and general skiing stories and news."

***SKIPPING STONES: A Multicultural Children's Magazine**, P.O. Box 3939, Eugene OR 97403. (503)342-4956. Managing Editor: Arun N. Toke. Circ. 3,000. Estab. 1988. Magazine published 5 times/year. Emphasizes multicultural and ecological issues. Readers are youth ages 8-15, their parents and teachers, schools and libraries. Sample copy $5 (including postage). Photo guidelines free with SASE.

Needs: Uses 25-40 photos/issue; most supplied by freelancers. Needs photos of animals, wildlife, children 8-16, cultural celebrations, international, travel, school/home life in other countries or cultures. Model release preferred. Captions preferred; include site, year, names of people in photo.

Making Contact & Terms: Interested in receiving work from newer, lesser-known photographers. Send unsolicited photos by mail for consideration. Send 4×6, 5×7 glossy color or b&w prints. Keeps samples on file. SASE. Reports in 1 month. Pays contributor's copy; "we're a labor of love." For photo essays; "we provide 5 copies to contributors. Additional copies at a 25% discount. Sometimes, a small honorarium of up to $50. Credit line given. Buys one-time and first North American serial rights; negotiable. Simultaneous submission OK.

Tips: "We publish only b&w. Should you send color photos, choose the ones with good contrast which can translate well into b&w photos. We are seeking meaningful, humanistic and realistic photographs."

SKY (Inflight Magazine of Delta Air Lines), 600 Corporate Dr., Suite 300, Ft. Lauderdale FL 33334. (305)776-0066. (800)523-6809. Fax: (305)493-8969. Photo Editor: Natasha Blumenfeld. Circ. 500,000 (print run). Estab. 1971. Monthly magazine. Emphasizes general interest and business/finance topics. Sample copy $3 and 9×12 SAE.

Needs: Uses about 70 photos/issue; 35% supplied by freelance photographers. Needs photos of travel, consumer, entertainment, business, lifestyle, sports, technology, collectibles. Reviews photos with accompanying ms only unless submitting for "Places" department. "We are actively seeking materials for 'Places' department, our photo end page that features interesting perspectives on Delta destination cities." Model release required. Captions required, include in travel photos.

Making Contact & Terms: Interested in receiving work from newer, lesser-known photographers. Send 35mm and 2¼×2¼ transparencies by mail for consideration. Provide résumé, buisness card, brochure, flier or tearsheets to be kept on file for possible future assignments. SASE. Reports in 1 month. Pays $600/color cover photo; $150 and up/color inside photo; $1,000/text/photo package. Pays on publication. Credit line given. Buys one-time rights. Simultaneous submissions and previously published work OK.

Tips: Request guidelines and include SASE. Follow up and send samples. No posed travel shots.

SNOW COUNTRY MAGAZINE, 5520 Park Ave., Trumbull CT 06611. (203)373-7029. Fax: (203)373-7111. Photo Editor: Douglas Wheeler. Circ. 465,000. Estab. 1988. Magazine published 8 times/year. Emphasizes skiing, mountain sports and living. Readers are 70% male, 39 years old, professional/managerial with average household income of $90,000. Sample copy $5.

Needs: Uses 90 photos/issue; 95% supplied by freelancers. Needs photos of downhill skiing, cross-country skiing, telemark skiing, snowboarding, mountain biking, in-line skating, hiking, scenic drives, ski area resorts, ice/rock climbing, people profiles, Heli skiing, snowcat skiing, rafting, camping. Special photo needs include good ski area resort shots showing family interaction, scenic drives going into white-capped mountains. Also b&w and color photos to be used as a photo essay feature in each issue. The photos should have a theme and relate to the mountains. Model/property release preferred. Captions preferred.

Making Contact & Terms: Interested in receiving work from newer, lesser-known photographers. Query with stock photo list. Provide résumé, business card, brochure, flier or tearsheets to be kept on file for possible assignments. Keeps samples on file. SASE. Reports in 1 month. Pays $250/½ day; $400/day; $800/color cover photo; $100-400/color space rate. Pays on publication. Buys first North American serial rights; negotiable. Simultaneous submissions and/or previously published work OK.

Tips: "Looking for unique shots that put our readers in snow country, a place in the mountains."

SOAP OPERA DIGEST, 45 W 25th St., New York NY 10010. (212)645-2100. Fax: (212)645-0683. Editor-in Chief: Lynn Leahey. Art Director: Catherine Connors. Photo Editor: Christina Bonichi. Circ. 1 million. Estab. 1975. Biweekly. Emphasizes daytime and nighttime TV serial drama. Readers are mostly women, all ages. Sample copy free with 5×7 SAE and 3 first-class stamps.

Needs: Needs photos of people who appear on daytime and nighttime TV soap operas; special events in which they appear. Uses mostly color and some b&w photos.

Making Contact & Terms: Interested in receiving work from new photographers. Query with résumé of credits to photo editor. Provide business card and promotional material to be kept on file for possible future assignments. SASE. Reports in 1 month. Pays $50-175/b&w photo; $100-400/color photo; $350-1,000/complete package. Pays on publication. Credit line given. Buys all rights; negotiable.

Tips: "Have photos of the most popular stars and of good quality." Sharp color quality is a must. "I look for something that's unusual in a picture, like a different pose instead of head shots. We are not interested in people who happened to take photos of someone they met. Show variety of lighting techniques and creativity in your portfolio."

***SOCCER ACTION MAGAZINE**, 5380 Clairemont Mesa Blvd., San Diego CA 92117. (619)569-8482. Fax: (619)569-7139. Senior Editor: Paul Martinez. Circ. 110,000. Estab. 1994. Bimonthly magazine. Emphasizes soccer. Readers are soccer fans/players; average age is 18. Sample copies free with 9 × 12 SASE and 4 first-class stamps.

Needs: Uses 50 photos/issue; 50% supplied by freelancers. Need action photos of top-level soccer: international, club, college, indoor CISL and NPSL, and feature photos pertaining to soccer. Model/property release required for feature photos. Captions required; include players' names, teams involved, date.

Making Contact & Terms: Interested in receiving work from newer, lesser-known photographers. Send unsolicited photos by mail for consideration with SASE. Provide résumé, business card, brochure, flier or tearsheets to be kept on file for possible assignments. Query with stock photo list. Send 5 × 7, 8 × 10 b&w prints; 35mm transparencies. Deadlines: January 21, March 21, May 21, July 21, September 21, November 21. SASE. Reports in 2 weeks. Pays $150/color cover photo; $15-75/color inside photo; $15-25/b&w inside photo; $150-300/photo/text package. Pays on publication. Credit line given. Buys one-time rights; negotiable.

***SOCCER MAGAZINE**, 5211 S. Washington Ave., Titusville FL 32780. (407)268-5010. Fax: (407)267-1894. Photo Editor: J. Brett Whitesell. Circ. 30,000. Estab. 1993. Magazine published 9 times/year. Emphasizes soccer. Readers are male and female, ages 15-50, players, fans, coaches, officials. Photo guidelines free with SASE.

Needs: Uses 45-50 photos/issue; 25-30% supplied by freelancers. Needs photos of game action. Reviews photos purchased with accompanying ms only. Captions required; include player identification, event.

Making Contact & Terms: Provide résumé, business card, brochure, flier or tearsheets to be kept on file for possible assignments. Keeps samples on file. SASE. Reports in 2 weeks. Pays $300/color cover photo; $75-100/color inside photo; $50/b&w inside photo; photo/text package rate negotiated. Pays on publication. Credit line given. buys one-time rights.

Tips: "The photographers I use know the sport of soccer. They are not just sports photographers. I will know the difference. I use photographer's files who keep me informed on events they are covering. Rarely do I give specific assignments. Those that are given out go to proven photographers."

***SOCIETY**, Rutgers University, New Brunswick NJ 08903. (201)932-2280. Fax: (201)932-3138. Editor: Irving Louis Horowitz. Circ. 31,000. Estab. 1962. Bimonthly magazine. Readers are interested in the understanding and use of the social sciences and new ideas and research findings from sociology, psychology, political science, anthropology and economics. Free sample copy and photo guidelines.

Needs: Buys 75-100 photos/annually. Human interest, photo essay and documentary. Needs photo essays—"no random photo submissions." Essays (brief) should stress human interaction; photos should be of people interacting (not a single person) or of natural surroundings. Include an accompanying explanation of photographer's "aesthetic vision."

Making Contact & Terms: Send 8 × 10 b&w glossy prints for consideration. SASE. Reports in 3 months. Pays $250/photo essay. Pays on publication. Buys all rights to one-time usage.

***SOLDIER OF FORTUNE MAGAZINE**, P.O. Box 693, Boulder CO 80306. (303)449-3750. Editor: Tom Slizewski. Monthly magazine. Emphasizes adventure, combat, military units and events. Readers are mostly male—interested in adventure and military related subjects. Circ. 175,000. Estab. 1975. Sample copy $5.

Needs: Uses about 60 photos/issue; 33% on assignment, 33% from stock. Needs photos of combat—under fire, or military units, military—war related. "We always need front-line combat photography." Not interested in studio or still life shots. Model/property release preferred. Captions required, include as much tech information as possible.

Making Contact & Terms: Contact Tom Slizewski, by phone with queries; send 8 × 10 glossy b&w, color prints, 35mm transparencies, b&w contact sheets by mail for consideration. SASE. Reports in 3 weeks. Pays $50-150/b&w photo; $50-500/color cover; $150-2,000/complete job. Will negotiate

a space-rate payment schedule for photos alone. **Pays on acceptance.** Credit line given. Buys one-time rights.

Tips: "Combat action photography gets first consideration for full-page and cover layouts. Photo spreads on military units from around the world also get a serious look, but stay away from 'man with gun' shots. *Give us horizontals and verticals!* The horizontal-shot syndrome handcuffs our art director. *Get close!* Otherwise, use telephoto. Too many photographers send us long distance shots that just don't work for our audience. *Give us action!* People sitting, or staring into the lens, mean nothing. *Consider using b&w* along with color. It gives us options in regard to layout; often, b&w better expresses the combat/military dynamic."

SOUTHERN BOATING, 1766 Bay Rd., Miami Beach FL 33139. (305)538-0700. Executive Editor: David Strickland. Circ. 30,000. Estab. 1972. Monthly magazine. Emphasizes "boating (mostly power, but also sail) in the southeastern U.S. and the Caribbean." Readers are "concentrated in 30-50 age group; male and female; affluent—executives mostly." Sample copy $4.

Needs: Number of photos/issue varies; all supplied by freelancers. Needs "photos to accompany articles about cruising destinations, the latest in boats and boat technology, boating activities (races, rendezvous); cover photos of a boat in a square format (a must) in the context of that issue's focus (see editorial calendar)." Model release preferred. Captions required.

Making Contact & Terms: Query with list of stock photo subjects. SASE. Reporting time varies. Pays $150 minimum/color cover photo; $50 minimum/color inside photo; $25 minimum/b&w inside photo; $75-150/photo/text package. Pays on publication. Credit line given. Buys one-time rights. Simultaneous submissions and previously published work OK.

Tips: "Photography on the water is very tricky. We are looking for first-rate work, preferably Kodachrome or Fujichrome, and prefer to have story *and* photos together, except in the case of cover material."

***SOUTHERN EXPOSURE**, P.O. Box 531, Durham NC 27702. (919)419-8311. Fax: (919)419-8315. Editor: Pat Arnow. Estab. 1972. Quarterly. Emphasizes the politics and culture of the South, with special interest in women's issues, African American affairs and labor. Sample copy $5 with 9×12 SASE. Photo guidelines free with SASE.

Needs: Uses 30 photos/issue; most supplied by freelance photographers. Needs news and historical photos; photo essays. Model/property release preferred. Captions required.

Making Contact & Terms: Interested in receiving work from newer, lesser-known photographers. Query with samples. Send glossy b&w prints by mail for consideration. SASE. Reports in 6 weeks. Pays $25-100/color photo; $100/color cover photo; $25-50/b&w inside photo. Pays on publication. Credit line given. Buys all rights "unless the photographer requests otherwise." Simultaneous submissions and previously published work OK.

***SPARE TIME MAGAZINE**, 5810 W. Oklahoma Ave., Milwaukee WI 53219. (414)543-8110. Fax: (414)543-9767. Publisher: Dennis Wilk. Circ. 301,500. Estab. 1955. Published 9 times yearly (monthly except June, July, December). Emphasizes income-making opportunities. Readers are income opportunity seekers with small capitalization. People who want to learn new techniques to earn extra income. Sample copy $2.50 with 9 first-class stamps.

Needs: Uses one photo/issue. Needs photos that display money-making opportunities. Model/property release required.

Making Contact & Terms: Interested in receiving work from newer, lesser-known photographers. Send unsolicited photos by mail for consideration. Send color or b&w prints; 2¼×2¼ transparencies. Keeps samples on file. Contacts photographer if photo accepted. NPI; payment negotiable. Pays on publication. Buys one-time rights, all rights; negotiable. Simultaneous submissions and previously published work OK.

SPORT FISHING, 330 W. Canton, Winter Park FL 32789. (407)628-4802. Fax: (407)628-7061. Photo Editor: Doug Olander. Circ. 110,000 (paid). Estab. 1986. Publishes 9 issues/year. Emphasizes off-shore fishing. Readers are upscale boat owners and off shore fishermen. Sample copy $2.50 with 9×12 SAE and 6 first-class stamps. Photo guidelines free with SASE.

Needs: Uses 50 photos/issue; 85% supplied by freelance photographers. Needs photos of off shore fish and fishing—especially big boats/big fish, action shots. "We are working more from stock—good opportunities for extra sales on any given assignment." Model release preferred; releases needed for subjects (under "unusual" circumstances) in photo. Captions preferred.

Making Contact & Terms: Interested in receiving work from newer, lesser-known photographers. Query with samples. Send unsolicited photos by mail for consideration. Provide résumé, business card, brochure, flier or tearsheets to be kept on file for possible future assignments. Send 35mm, 2¼×2¼ and 4×5 transparencies by mail for consideration. "Kodachrome 64 and Fuji 100 are preferred." Reports in 3 weeks. Pays $20-100/b&w page; $50-500/color page; $750/cover. Buys one-time rights unless otherwise agreed upon.

Tips: "Tack-sharp focus critical; avoid 'kill' shots of big game fish, sharks; avoid bloody fish in/at the boat. The best guideline is the magazine itself. Get used to shooting on, in or under water. Most of our needs are found there. If you have first rate photos and questions: call."

SPORT MAGAZINE, Dept. PM, 6420 Wilshire Blvd., Los Angeles CA 90048. (213)782-2830. Photo Director: Catherine Doyle. Monthly magazine. Emphasizes sports, both professional and collegiate. Readers are ages "9-99, male and female." Circ. 1 million. Photo guidelines free with SASE.
Needs: Uses 80 photos/issue; 20% supplied by freelance photographers. Needs photos of sports action, strobed basketball, hockey, football, baseball. "Always need good editorial (nonaction) photographers for portrait work, especially photographers who can work on location."
Making Contact & Terms: Interested in receiving work from newer, lesser-known photographers. Query with résumé of credits or stock photo subjects. "No unsolicited work accepted." Reports in 1 month. Pays $600/color cover photo or $350/day. Pays on publication. Credit line given. Buys one-time rights.
Tips: In portfolio or samples looking for "tight, sharp, action—hockey and basketball must be strobed, color transparencies preferred, well-lighted portraits of athletes. No prints. Assignments are being given to those who continue to excel and are creative."

SPORTS CARD TRADER, 155 E. Aimes Court, Plainview NY 11803. (516)349-9494. Fax: (516)349-9516. Editor: Doug Kale. Circ. 225,000. Estab. 1990. Monthly magazine. Emphasizes baseball cards, basketball, football, hockey sports cards, memorabilia, all sports. Readers are male ages 9-99. Free sample copy.
Needs: Uses 1-2 photos/issue; all supplied by freelancers. Needs photos of studio shots, action shots. Model/property release required.
Making Contact & Terms: Interested in receiving work from newer, lesser-known photographers. Send unsolicited photos by mail for consideration. Send 8×10 glossy color prints. Keeps samples on file. Cannot return material. Reports in 2 weeks. Pays $100-150/job. Pays on publication. Credit line given. Buys all rights; negotiable. Simultaneous submissions OK.

SPORTS ILLUSTRATED, Time Life Building, 1271 Avenue of the Americas, New York NY 10020. Prefers not to share information.

SPOTLIGHT MAGAZINE, 126 Library Lane, Mamaroneck NY 10543. (914)381-4740. Fax: (914)381-4641. Editor-in-Chief: Susan Meadow. Circ. 500,000. Monthly magazine. Readers are largely upscale, about 60% female. Sample copy $3.
Needs: Uses 25-30 photos/issue; 5-10 supplied by freelancers. Reviews photos purchased with accompanying ms only. Model release required. Captions required.
Making Contact & Terms: Interested in receiving work from newer, lesser-known photographers. Query with résumé of credits. Does not keep samples on file. SASE. Reports in 1 month. Pays $25 per photo minimum. Pays on publication. Credit line given. Buys all rights "but flexible on reuse."

STAR, 660 White Plains Rd., Tarrytown NY 10591. (914)332-5000. Editor: Richard Kaplan. Photo Director: Alistair Duncan. Circ. 2.8 million. Weekly. Emphasizes news, human interest and celebrity stories. Sample copy and photo guidelines free with SASE.
Needs: Uses 100-125 photos/issue; 75% supplied by freelancers. Reviews photos with or without accompanying ms. Model release preferred. Captions required.
Making Contact & Terms: Interested in receiving work from newer, lesser-known photographers. Query with samples and with list of stock photo subjects. Send 8×10 b&w prints; 35mm, 2¼×2¼ transparencies by mail for consideration. SASE. Reports in 2 weeks. NPI. Pays on publication. Credit line sometimes given. Simultaneous submissions and previously published work OK.

THE STATE: Down Home in North Carolina, 128 S. Tryon St., Suite 2200, Charlotte NC 28202. (704)371-3268. Editor: Scott Smith. Circ. 25,000. Estab. 1933. Monthly magazine. Regional publication, privately owned, emphasizing travel, history, nostalgia, folklore, humor, all subjects regional to North Carolina for residents of, and others interested in, North Carolina. Sample copy $3. "Send for our photography guidelines."
Needs: Freelance photography used; 5% assignment and 5% stock. Photos on travel, history and human interest in North Carolina. Captions required.
Making Contact & Terms: Send material by mail for consideration. Uses 5×7 and 8×10 glossy b&w prints; also glossy color prints and slides. Uses b&w and color cover photos, vertical preferred. SASE. Pays $25/b&w photo; $25-150/color photo; $125-150/complete job. Credit line given. Pays on publication.
Tips: Looks for "North Carolina material; solid cutline information."

STOCK CAR RACING MAGAZINE, 47 S. Main St., P.O. Box 715, Ipswich MA 01938. (508)356-7030. Fax: (508)356-2492. Editor: Dick Berggren. Circ. 400,000. Estab. 1966. Monthly magazine.

Emphasizes all forms of stock car competition. Read by fans, owners and drivers of race cars and those with racing businesses. Photo guidelines free with SASE.

Needs: Buys 50-70 photos/issue. Documentary, head shot, photo essay/photo feature, product shot, personality, crash pictures, special effects/experimental, technical and sport. No photos unrelated to stock car racing. Photos purchased with or without accompany ms and on assignment. Model release required unless subject is a racer who has signed a release at the track. Captions required.

Making Contact & Terms: Send material by mail for consideration. Uses 8 × 10 glossy b&w prints; 35mm or 2¼ × 2¼ transparencies. Kodachrome 64 or Fuji 100 preferred. Pays $20/b&w photo; $35-250/color photo; $250/cover photo. Pays on publication. Credit line given. Buys one-time rights.

Tips: "Send the pictures. We will buy anything that relates to racing if it's interesting, if we have the first shot at it, and it's well printed and exposed. Eighty percent of our rejections are for technical reasons—poorly focused, badly printed, too much dust, picture cracked, etc. We get far fewer cover submissions than we would like. We look for full bleed cover verticals where we can drop type into the picture and position our logo."

STRAIGHT, 8121 Hamilton Ave., Cincinnati OH 45231. (513)931-4050. Fax: (513)931-0904. Editor: Carla J. Crane. Circ. 35,000. Estab. 1950. Weekly. Readers are ages 13-19, mostly Christian; a conservative audience. Sample copy free with SASE and 2 first-class stamps. Photo guidelines for SASE.

Needs: Uses about 4 photos/issue; all supplied by freelance photographers. Needs color and b&w photos of teenagers involved in various activities such as sports, study, church, part-time jobs, school activities, classroom situations. Outside nature shots, groups of teens having good times together are also needed. "Try to avoid the sullen, apathetic look—vital, fresh, thoughtful, outgoing teens are what we need. Any photographer who submits a set of quality b&w glossies or color transparencies for our consideration, whose subjects are teens in various activities and poses, has a good chance of selling to us. This is a difficult age group to photograph without looking stilted or unnatural. We want to purport a clean, healthy, happy look. No smoking, drinking or immodest clothing. We especially need masculine-looking guys and minority subjects." Submit photos coinciding with the seasons (i.e., winter scenes in December through February, spring scenes in March through May, etc.). Model release required. Photo captions preferred.

Making Contact & Terms: Interested in receiving work from newer, lesser-known photographers. Send 5 × 7 or 8 × 10 b&w photos and color transparencies by mail for consideration. Enclose sufficient packing and postage for return of photos. Reports in 6 weeks. Pays $30-50/b&w photo; $75-125/color photo. **Pays on acceptance.** Credit line given. Buys one-time rights. Simultaneous submissions and previously published work OK.

Tips: "Our publication is almost square in shape. Therefore, 5 × 7 or 8 × 10 prints that are cropped closely will not fit our proportions. Any photo should have enough 'margin' around the subject that it may be cropped square. This is a simple point, but absolutely necessary. Look for active, contemporary teenagers with light backgrounds for photos. For our publication, keep up with what teens are interested in. Due to design changes, we will be purchasing more photographs. Subjects should include teens in school, church, sports and other activities. Although our rates may be lower than the average, we try to purchase several photos from the same photographer to help absorb mailing costs. Review our publication and get a feel for our subjects."

THE STRAIN, P.O. Box 330507, Houston TX 77233-0507. (713)738-4887. For articles contact: Alicia Adler; for columns, Charlie Mainze. Circ. 1,000. Estab. 1987. Monthly magazine. Emphasizes interactive arts and 'The Arts'. Readers are mostly artists and performers. Sample copy $5 with 9 × 12 SAE and 7 first-class stamps. Photo guidelines free with SASE.

Needs: Uses 5-100 photos/issue; 95% supplied by freelance photographers. Needs photos of scenics, personalities, portraits. Model release required. Captions preferred.

Making Contact & Terms: Send any format b&w and color prints or transparencies by mail for consideration. SASE. The longer it is held, the more likely it will be published. Reports in 1 year. Pays $50/color cover photo; $100/b&w cover photo; $5 minimum/color inside photo; $5 minimum/b&w inside photo; $5/b&w page rate; $50-500/photo/text package. Pays on publication. Credit line given. Buys one-time rights or first North American serial rights. Simultaneous submissions and previously published work OK.

SUMMIT, The Mountain Journal, 1221 May St., Hood River OR 97031. Art Director: Adele Hammond. Circ. 30,000. Estab. 1990. Quarterly magazine. Features news related to the world of mountains. Readers are mostly male professionals, ages 35-45. Sample copy for $6 with 10 × 13 SAE and 7 first-class stamps.

Needs: Uses up to 40 photos/issue; all supplied by freelancers. Needs "landscape shots of mountains, flowers, mountain people, animals and mountain environments from all over the world. All imagery must have strong interpretative element as well as being graphically powerful. Both abstract and figurative photos welcome." Photos must be high-quality b&w or color only. Model release preferred (when applicable). Captions required.

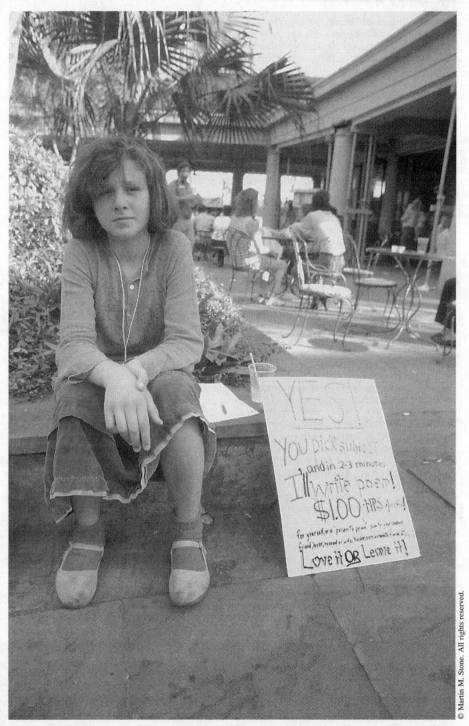

Martin Stone of Beachwood, Ohio, found this "poet-for-hire" sitting outside a cafe. The photo was requested by The Sun *as a feature for the October 1994 issue. Since appearing in the magazine the image has sold numerous times to private art collectors.*

Making Contact & Terms: Interested in receiving work from newer, lesser-known photographers. Query with list of stock photo subjects. Provide résumé, business card, brochure, flier or tearsheets to be kept on file for possible assignment. Reports in 3 weeks. Pays $300/color cover photo; $50-170/ various page rates. Pays on publication. Credit line given. Buys one-time rights.

THE SUN, 107 N. Roberson, Chapel Hill NC 27516. (919)942-5282. Editor: Sy Safransky. Circ. 25,000. Estab. 1974. Monthly magazine. Sample copy $3.50. Photo guidelines free with SASE.
Needs: Uses about 6 photos/issue; all supplied by freelance photographers. Model release preferred.
Making Contact & Terms: Interested in receiving work from newer, lesser-known photographers. Send cover letter and b&w prints by mail for consideration. SASE. Reports in 2 months. Pays $25-50/ b&w cover and inside photos. Pays on publication. Credit line given. Buys one-time rights; negotiable. Previously published work OK.
Tips: Looks for "artful and sensitive photographs that are not overly sentimental. We use many photos of people. All the photographs we publish come to us as unsolicited submissions."

SUPER CYCLE, 9171 Wilshire Blvd., #300, Beverly Hills CA 90210. (310)258-7155. Fax: (310)247-1708. Managing Editor: Marla S. Garber. Monthly magazine. Emphasizes motorcyles—American only. Readers are male and female bike enthusiasts, builders, riders, ages 18-80. Sample copy free with 9×12 SASE. Photo guidelines free with SASE.
Needs: Uses 100 photos/issue; 100 supplied by freelancers. Needs photos of motocycling only. Model release for topless women required; include name and address on each photo.
Making Contact & Terms: Interested in receiving work from newer, lesser-known photographers. Send unsolicited photos by mail for consideration. Send 4×6 glossy color prints; 35mm transparencies. Does not keep samples on file. SASE. Reports immediately or within 3 months. Pays $200-300/job; $300/color cover photo; $50/color inside photo; $35/b&w inside photo; $200-500/photo/text package. Pays on publication. Credit line given. Buys first North American serial rights; negotiable.
Tips: "Be patient! We have many photos and not enough pages."

***SUPER FORD**, 3816 Industry Blvd., Lakeland FL 33811. (813)644-0449. Managing Editor: Steve Turner. Circ. 65,000. Estab. 1977. Monthly magazine. Emphasizes high-performance Ford automobiles. Readers are males, ages 18-40, all occupations. Sample copy free with 11×14 SASE and 7 first-class stamps.
Needs: Uses 75 photos/issue; 30-40 supplied by freelancers. Needs photos of high performance Fords. Model/property release preferred. Captions required.
Making Contact & Terms: Interested in receiving work from newer, lesser-known photographers. Send unsolicited photos by mail for consideration. Provide résumé, business card, brochure, flier or tearsheets to be kept on file for possible assignments. Send 5×7 glossy color or b&w prints; 35mm, 2¼×2¼ transparencies. Does not keep samples on file. SASE. Reports in 1 month, "can be longer." Pays $200/day; $65/color inside photo; $45/b&w inside photo. Pays on publication. Credit line given. Buys one-time rights; negotiable.
Tips: "Do not park/pose cars on grass."

***SURFING MAGAZINE**, P.O. Box 3010, San Clemente CA 92672. (714)492-7873. Photo Editor: Larry Moore. Monthly. Circ. 120,000. Emphasizes "surfing and bodyboarding action and related aspects of beach lifestyle. Travel to new surfing areas covered as well. Average age of readers is 18 with 92% being male. Nearly all drawn to publication due to high quality, action packed photographs." Free photo guidelines with SASE. Sample copy free with legal size SAE and 9 first-class stamps.
Needs: Uses about 80 photos/issue; 35% supplied by freelance photographers. Needs "in-tight, front-lit surfing and bodyboarding action photos as well as travel-related scenics. Beach lifestyle photos always in demand."
Making Contact & Terms: Send by mail for consideration 35mm or 2¼×2¼ transparencies; b&w contact sheet and negatives. SASE. Reports in 1 month. Pays $750/color cover photo; $30-225/color inside photo; $20-100/b&w inside photo; $600/color poster photo. Pays on publication. Credit line given. Buys one-time rights.
Tips: Prefers to see "well-exposed, sharp images showing both the ability to capture peak action as well as beach scenes depicting the surfing and bodyboarding lifestyle. Color, lighting, composition and proper film usage are important. Ask for our photo guidelines prior to making any film/camera/ lens choices."

SWANK, 210 Route 4 East, Paramus NJ 07652. (201)843-4004. Fax: (201)843-8636. Circ. 350,000. Estab. 1954. Published 13 times a year magazine. Emphasizes adult entertainment. Readers are mostly male of all backgrounds, ages 22 to 55. Sample copy $5.95. Photo guidelines free with SASE.
Needs: Needs photos of new models for explicit, all nude photo shoots. Reviews photos with or without a manuscript. Model/property release required.

Making Contact & Terms: Send unsolicited photos by mail for consideration. Send color prints, 35mm transparencies. SASE. Reports in 2 weeks. Average pay for one set $1,600. Rates vary. Pays on publication. Buys all rights.

Tips: "We mostly work with established erotic photographers, but always looking for new talent. Make sure there are enough photos submitted for us to have a good idea of your ability."

TAMPA REVIEW, The University of Tampa, 19F, Tampa FL 33606-1490. Editor: Richard B. Mathews. Circ. 500. Estab. 1988. Literary magazine. Semiannual magazine. Emphasizes literature and art. Readers are intelligent, college level. Sample copy $5. Photo guidelines free with SASE.

• In December 1994 this publication received the Phoenix Award from the Council of Editors of Learned Journals for "Significant Editorial Achievement."

Needs: Uses 6 photos/issue; 100% supplied by freelancers. Needs photos of artistic, museum quality images. Photographer must hold right, or release. "We have our own release form if needed." Photo captions required.

Making Contact & Terms: Interested in receiving work from newer, lesser-known photographers. Provide résumé, business card, brochure, flier or tearsheets to be kept on file for possible assignments. Send b&w, color prints "suitable for vertical 6×8 or 6×9 reproduction." SASE. Reports by end of April. Pays $10/image. Pays on publication. Credit line given. Buys first North American serial rights.

Tips: "We are looking for artistic photography, not for illustration, but to generally enhance our magazine. We will consider paintings, prints, drawings, photographs, or other media suitable for printed reproduction. Submissions should be made in February and March for publication the following year."

A photo rep helped Sarasota, Florida, photographer Woody Walters land a sale of this image to Tampa Review. Editor Richard Mathews says he admired Walters's work after seeing it in art shows. This photo was used in the magazine as an illustration for a short story by Stephen March entitled "A Good Gravedigger" about a corpse that refused to stay buried.

TENNIS WEEK, 341 Madison Ave., New York NY 10016. (212)808-4750. Publisher: Eugene L. Scott. Managing Editors: Cherry Masih, Kim Kohl and Merrill Chapman. Circ. 80,000. Biweekly. Readers are "tennis fanatics." Sample copy $3.

Needs: Uses about 16 photos/issue. Needs photos of "off-court color, beach scenes with pros, social scenes with players, etc." Emphasizes originality. Subject identification required.

Making Contact & Terms: Send actual 8×10 or 5×7 b&w photos by mail for consideration. SASE. Reports in 2 weeks. Pays $25/b&w photo; $50/cover; $100/color cover. Pays on publication. Credit line given. Rights purchased on a work-for-hire basis.

TEXAS FISH & GAME, 7600 W. Tidwell, Suite 708, Houston TX 77040. (713)690-3474. Fax: (713)690-4339. Editor: Marvin Spivey. Circ. 120,000. Estab. 1983. Magazine published monthly, 10 times/year. Features all types of hunting and fishing. Must be Texas only. Photo guidelines free with SASE.

Needs: Uses 20-30 photos/issue; 95% supplied by freelance photographers. Needs photos of fish: action, close up of fish found in Texas; hunting: Texas hunting and game of Texas. Model release preferred. Captions required.

Making Contact & Terms: Interested in receiving work from newer, lesser-known photographers. Query with list of stock photo subjects. SASE. Reports in 1 month. Pays $200-300/color cover photo and $50-100/color inside photos. Pays on publication. Credit line given. Buys one-time rights.
Tips: "Query first. Ask for guidelines. No b&w used. For that 'great' shot, prices will go up. Send best shots and only subjects the publication you're trying to sell, uses."

TEXAS GARDENER, P.O. Box 9005, Waco TX 76714. (817)772-1270. Editor/Publisher: Chris S. Corby. Circ. 35,000. Bimonthly. Emphasizes gardening. Readers are "65% male, home gardeners, 98% Texas residents." Sample copy $1.
Needs: Uses 20-30 photos/issue; 90% supplied by freelance photographers. Needs "color photos of gardening activities in Texas." Special needs include "photo essays on specific gardening topics such as 'weeds in the garden.' Must be taken in Texas." Model release preferred. Captions required.
Making Contact & Terms: Query with samples. SASE. Reports in 3 weeks. Pays $100-200/color cover photo; $5-15/b&w inside photo; $10-200/color inside photo. **Pays on acceptance.** Credit line given. Buys all rights.
Tips: "Provide complete information on photos. For example, if you submit a photo of watermelons growing in a garden, we need to know what variety they are and when and where the picture was taken."

TEXAS HIGHWAYS, P.O. Box 141009, Austin TX 78714. (512)483-3675. Editor: Jack Lowry. Photo Editor: Michael A. Murphy. Circ. 430,000. Monthly. *"Texas Highways* interprets scenic, recreational, historical, cultural and ethnic treasures of the state and preserves the best of Texas heritage. Its purpose is to educate and entertain, to encourage recreational travel to and within the state, and to tell the Texas story to readers around the world." Readers are 45 and over (majority); $24,000 to $60,000/year salary bracket with a college education. Sample copy and photo guidelines free.
• This publication only publishes photographs shot in Texas.
Needs: Uses about 60-70 photos/issue; 50% supplied by freelance photographers. Needs "travel and scenic photos in Texas only." Special needs include "fall, winter, spring and summer scenic shots and wildflower shots (Texas only)." Captions required; include location, names, addresses and other useful information.
Making Contact & Terms: Interested in receiving work from newer, lesser-known photographers. Query with samples. Provide business card and tearsheets to be kept on file for possible future assignments. We take only color originals, 35mm or larger transparencies. No negatives. SASE. Reports in 1 month. Pays $120/half page color inside photo; $170/full-page color photo; $400/front cover photo. Pays on publication. Credit line given. Buys one-time rights. Simultaneous submissions OK.
Tips: "Know our magazine and format. We accept only high-quality, professional level work—no snapshots. Interested in a photographer's ability to edit their own material and the breadth of a photographer's work. Look at 3-4 months of the magazine. Query not just for photos but with ideas for new/ unusual topics."

THANATOS, P.O. Box 6009, Tallahassee FL 32314. (904)224-1969. Fax: (904)224-7965. Editor: Jan Scheff. Circ. 6,000. Estab. 1975. Quarterly journal. Covers death, dying and bereavement. Readers include healthcare professionals, thanatologists, clergy, funeral directors, counselors, support groups, volunteers, bereaved family members, students, et al. Photo guidelines free with SASE.
Needs: Uses 6 photos/issue; all supplied by freelancers. Needs many b&w scenic and people shots to accompany articles. Also, full-color scenics to illustrate seasons for each quarterly edition. Model release required. Captions preferred.
Making Contact & Terms: Query with list of stock photo subjects. Provide résumé, business card, brochure, flier or tearsheets to be kept on file for possible assignment. Cannot return material. Reports in 1 month. Pays $100/color cover photo; $50/b&w inside photo. Buys all rights. Simultaneous submissions OK.

***THRASHER MAGAZINE,** P.O. Box 884570, San Francisco CA 94188-4570. (415)822-3083. Fax: (415)822-8359. Photo Editor: Bryce Kanights. Circ. 250,000. Estab. 1981. Monthly magazine. Emphasizes skateboarding, snowboarding and alternative music. Readers are primarily male between ages 12-24. Sample copy $3.25. Photo guidelines free with SASE.
• *Thrasher* scans 35mm b&w negatives and color transparencies inhouse and uses Photoshop 3.0 to correct color, density and manipulate images to be published.
Needs: Uses 55 photos/issue; 20 supplied by freelancers. Needs photos of skateboarding, snowboarding and alternative music. Reviews photos with or without a manuscript. Special needs are b&w action sequences. Model/property release preferred; release needed for minors. Captions preferred; include name of subject, location and date of shoot.
Making Contact & Terms: Interested in receiving work from newer, lesser-known photographers. Send unsolicited photos by mail for consideration. Send 5×7, 8×10 b&w prints; 35mm, 2¼×2¼ transparencies. Keeps samples on file. SASE. Reports in 2 weeks. Pays $250/color cover photo; $200/

b&w cover photo; $65/color inside photo; $50/b&w inside photo; $110/color page rate; $85/b&w page rate. Pays on publication. Credit line given. Buys all rights.
Tips: "Get to know the sports of skateboarding and snowboarding, the lifestyles and current trends."

TIDE MAGAZINE, 4801 Woodway, Suite 220 W, Houston TX 77056. (713)626-4222. Fax: (713)961-3801. Editor: Doug Pike. Circ. 40,000. Estab. 1979. Publication of the Coastal Conservation Association. Bimonthly magazine. Emphasizes coastal fishing, conservation issues. Readers are mostly male, ages 25-50, coastal anglers and professionals.
Needs: Uses 16-20 photos/issue; 12-16 supplied by freelancers. Needs photos of coastal activity, recreational fishing, coastal scenics, tight shots of fish (saltwater only). Model/property release preferred. Captions required; include names, dates, places and specific equipment or other key information.
Making Contact & Terms: Interested in receiving work from newer, lesser-known photographers. Query with stock photo list. SASE. Reports in 1 month. Pays $100/color cover photo; $50/color inside photo; $25/b&w inside photo; $250/photo/text package. Pays on publication. Credit line given. Buys one-time rights; negotiable. Simultaneous submissions and/or previously published work OK.
Tips: Wants to see "fresh twists on old themes—unique lighting, subjects of interest to my readers. Take time to discover new angles for fishing shots. Avoid the usual poses, i.e. man holding fish. We see too much of that already."

***TIME**, Time/Life Building, 1271 Avenue of the Americas, New York NY 10020. (212)522-1212. Picture Editor: Michele Stephenson. Weekly magazine.
Needs: Needs photos of news—national and international— government, portrait, celebrities, international figures. Model release preferred for minors (young children). Property release required. Captions required.
Making Contact & Terms: Interested in photographers who have been published in magazines. Contact through rep. Submit portfolio for review. Provide résumé, business card, brochure, flier or tearsheets to be kept on file for possible assignments. Deadlines: Thursday (back of book), Friday (news events). Reports in 1-2 weeks. Pays $500/full page color or b&w photo; $250/½ page color or b&w photo; $175/¼ or smaller color or b&w photo. Rates vary on assignments. Cover assignment is $3,000 plus expenses. Pickup cover is $1,500. Assigned inside photo used as cover is $2,000. Expenses: day rate, $400; ½-day rate, $200. **Pays on acceptance** or publication. Rights negotiable.

TODAY'S PHOTOGRAPHER INTERNATIONAL, P.O. Box 18205, Washington DC 20036. (910)945-9867. Photography Editor: Vonda H. Blackburn. Circ. 131,000. Estab. 1986. Bimonthly magazine. Emphasizes making money with photography. Readers are 90% male photographers. For sample copy, send 9×12 SAE. Photo guidelines free with SASE.
Needs: Uses 40 photos/issue; all supplied by freelance photographers. Model release required. Photo captions preferred.
Making Contact & Terms: Send 35mm, 2¼×2¼, 4×5, 8×10 b&w and color prints or transparencies by mail for consideration. SASE. Reports at end of the quarter. NPI; payment negotiable. Credit line given. Buys one-time rights, per contract. Simultaneous submissions and previously published work OK.
Tips: Wants to see "consistently fine quality photographs and good captions or other associated information. Present a portfolio which is easy to evaluate—keep it simple and informative. Be aware of deadlines. Submit early."

***TODAY'S TRAVELER**, 68 E. Wacker Place, Suite 800, Chicago IL 60601. (312)853-4775. Fax (312)782-7367. Associate Editor: Lisa Smith. Circ. 65,000. Estab. 1991. Bimonthly magazine. Emphasizes travel. Readers are of all ages and backgrounds. Sample $4 with 9×12 SASE. Photo guidelines free with SASE.
Needs: Uses 40-50 photos; 20-25 supplied by freelancers. Needs photos of travel, scenics, personalities, how-to (i.e., how to pack luggage; how to dress for certain climates, cruises, safaris, etc.). Model release required for children, close-up shots of people; celebrities. Property release preferred. Captions preferred.
Making Contact & Terms: Interested in receiving work from newer, lesser-known photographers. Query with résumé of credits, stock photo list. Provide résumé, business card, brochure, flier or tearsheets to be kept on file for possible assignments. Does not keep samples on file. SASE. Reports

 A bullet has been placed within some listings to introduce special comments by the editor of Photographer's Market.

in 1 month. Pays $500-1,000/color cover photo. **Pays on acceptance.** Credit line given. Buys first North American serial rights; negotiable. Previously published work OK.

Tips: Looking for photo essays, character studies, candid shots, mood shots, unusual angles, creativity, action shots. "Since we are relatively new and small in size, we naturally look for highly creative people who do not command high fees. We want people who are willing to grow with us."

TOURING AMERICA, P.O. Box 6050, Mission Viejo CA 92690. (714)855-8822. Fax: (714)855-0654. Editor: Bob Carpenter. Circ. 100,000. Estab. 1991. Bimonthly magazine. Emphasizes travel in US, Canada and Mexico. Readers are male and female, 30-55 primarily.

Needs: Uses 100-150 photos/issue; 99% supplied by freelancers. Needs travel photos, scenics with people in frame. "Our covers seem to be difficult to find." Model/property release preferred. Captions required; include "location, what's going on."

Making Contact & Terms: Query with list of stock photo subjects; "explain story idea." Keeps samples on file. Does not review unsolicited portfolios. SASE. Reports in 3 weeks. Pays $250 minimum/color cover photo; $50-150/color inside photo; $250-750/photo/text package, "preferred." Credit line given. Buys one-time rights; first North American serial rights for text; and anthology rights for text. Previously published work OK for photos only.

Tips: "We prefer story/photo packages. Writing must be excellent, with a lead that grabs the reader. Photos must have people in them, no Sierra Club scenics. Request our Authors' Guide which includes photo guidelines, then do what it says."

TRACK AND FIELD NEWS, 2570 El Camino Real, Suite 606, Mountain View CA 94040. (415)948-8417. Fax: (415)948-9445. Associate Editor (Features/Photography): Jon Hendershott. Circ. 35,000. Estab. 1948. Monthly magazine. Emphasizes national and world-class track and field competition and participants at those levels for athletes, coaches, administrators and fans. Sample copy free with 9 × 12 SAE. Free photo guidelines.

Needs: Buys 10-15 photos/issue; 75% of freelance photos on assignment, 25% from stock. Wants on a regular basis photos of national-class athletes, men and women, preferably in action. "We are always looking for quality pictures of track and field action as well as offbeat and different feature photos. We always prefer to hear from a photographer before he/she covers a specific meet. We also welcome shots from road and cross-country races for both men and women. Any photos may eventually be used to illustrate news stories in *T&FN*, feature stories in *T&FN* or may be used in our other publications (books, technical journals, etc.). Any such editorial use will be paid for, regardless of whether material is used directly in *T&FN*. About all we don't want to see are pictures taken with someone's Instamatic or Polaroid. No shots of someone's child or grandparent running. Professional work only." Captions required; include subject name, meet date/name.

Making Contact & Terms: Interested in receiving work from newer, lesser-known photographers. Query with samples or send material by mail for consideration. Uses 8 × 10 glossy prints; contact sheet preferred; 35mm transparencies. SASE. Reports in 1 week. Pays $20/b&w inside photo; $50/color inside photo; $150/color cover photo. Payment is made bimonthly. Credit line given. Buys one-time rights.

Tips: "No photographer is going to get rich via *T&FN*. We can offer a credit line, nominal payment and, in some cases, credentials to major track and field meets to enable on-the-field shooting. Also we can offer the chance for competent photographers to shoot major competitions and competitors up close as well as the most highly regarded publication in the track world as a forum to display a photographer's talents."

TRAILER BOATS MAGAZINE, Poole Publications Inc., 20700 Belshaw Ave., Carson CA 90746. (310)537-6322. Fax: (310)537-8735. Editor: Randy Scott. Circ. 90,000. Estab. 1971. Monthly magazine. "Only magazine devoted exclusively to legally trailerable boats and related activities" for owners and prospective owners. Sample copy $1.25. Free writer's guidelines.

Needs: Uses 15 photos/issue with ms. 95-100% of freelance photography comes from assignment; 0-5% from stock. Scenic (with ms), how-to, humorous (monthly "Over-the-Transom" funny or weird shots in the boating world), travel (with ms). For accompanying ms, articles related to trailer boat activities. Photos purchased with or without accompanying ms. Photos must relate to trailer boat activities. No long list of stock photos or subject matter not related to editorial content. Captions preferred; include location of travel pictures.

Making Contact & Terms: Interested in receiving work from newer, lesser-known photographers. Query or send photos or contact sheet by mail for consideration. Uses transparencies. SASE. Reports in 1 month. Pays per text/photo package or on a per-photo basis. Pays $25-200/color photo; $150-400/cover photo; additional for mss. **Pays on acceptance.** Credit line given. Buys one-time and all rights; negotiable.

Tips: "Shoot with imagination and a variety of angles. Don't be afraid to 'set-up' a photo that looks natural. Think in terms of complete feature stories; photos and mss. It is rare any more that we publish

freelance photos only, without accompanying manuscripts; with one exception, 'Over the Transom'— a comical, weird or unusual boating shot."

TRAILER LIFE, Dept. PM, 3601 Calle Tecate, Camarillo CA 93012. Publisher: Bill Estes. Editorial Director: Barbara Leonard. Circ. 300,000. Monthly magazine. Emphasizes the why, how and how-to of owning, using and maintaining a recreational vehicle for personal vacation or full-time travel. Send for editorial guidelines.
Needs: Human interest, how-to, travel and personal experience. The editors are particularly interested in photos for the cover; an RV must be included.
Making Contact & Terms: Send material by mail for consideration or query with samples. Uses 8×10 b&w glossy prints; 35mm and 2¼×2¼ transparencies. SASE. Reports in 3 weeks. Pays $50-150/b&w photo; $75-300/color photo; $500 for cover. **Pays on acceptance.** Credit line given. Buys first North American rights.

TRANSITIONS ABROAD, 18 Hulst Rd., P.O. Box 1300, Amherst MA 01004. Fax: (413)256-0373. E-mail: chubbs@hamp.hampshire.edu. Editor: Clay Hubbs. Circ. 20,000. Estab. 1977. Bimonthly magazine. Emphasizes travel. Readers are people interested in traveling, learning, living, or working abroad, all ages, both sexes. Sample copy $5. Photo guidelines free with SASE.
Needs: Uses 20 photos/issue; all supplied by freelancers. Needs photos of travelers in international settings or the people of other countries. Each issue has an area focus: January/February—Asia and the Pacific Rim; March/April—Europe and the former Soviet Union; May/June—The Americas and Africa (South of the Sahara); November/December—The Mediterranean Basin and the Near East. Captions preferred.
Making Contact & Terms: Interested in receiving work from newer, lesser-known photographers. Query with list of stock photo subjects. Send unsolicited 8×10 b&w prints by mail for consideration. Prefers b&w; sometimes uses color photos; rarely uses transparencies. SASE. Reports in 6 weeks. Pays $25-250/inside photo; $125/b&w cover photo. Pays on publication. Credit line given. Buys one-time rights. Simultaneous submissions and previously published work OK.
Tips: In freelance photographer's samples, wants to see "mostly people in action shots—travelers and people of other countries. We use very few landscapes or abstract shots."

TRAVEL & LEISURE, 1120 Avenue of the Americas, New York NY 10036. (212)382-5600. Editor: Nancy Novogrod. Art Director: Giovanni C. Russo. Circ. 1.2 million. Monthly magazine. Emphasizes travel destinations, resorts, dining and entertainment. Free photo guidelines with SASE.
Needs: Nature, still life, scenic, sport and travel. Model release required. Captions required.
Making Contact & Terms: Uses 8×10 semigloss b&w prints; 35mm, 2¼×2¼, 4×5 and 8×10 transparencies, vertical format required for cover. Pays $200-500/b&w photo; $200-500/color photo; $1,000/cover photo or negotiated. Sometimes pays $450-1,200/day; $1,200 minimum/complete package. Pays on publication. Credit line given. Buys first world serial rights, plus promotional use. Previously published work OK.
Tips: Seeing trend toward "more editorial/journalistic images that are interpretive representations of a destination."

‡TRAVELLER, 45-49 Brompton Road, London SW3 1DC Great Britain. (071)581-4130. Fax: (071)581-1357. Managing Editor: Caroline Brandenburger. Circ. 35,000. Quarterly. Readers are predominantly male, professional, age 35 and older. Sample copy £2.50.
Needs: Uses 30 photos/issue; all supplied by freelancers. Needs photos of travel, wildlife. Reviews photos with or without ms. Captions preferred.
Making Contact & Terms: Interested in receiving work from newer, lesser-known photographers. Arrange personal interview to show portfolio. Submit portfolio for review. Provide résumé, business card, brochure, flier or tearsheets to be kept on file for possible future assignments. Send 35mm transparencies. Does not keep samples on file. SASE. Reports in 1 month. Pays £50/color cover photo; £25/color inside photo. Pays on publication. Buys one-time rights.
Tips: Looks for "original, quirky shots with impact, which tell a story."

TROUT: The Journal of Coldwater Fisheries Conservation, 1500 Wilson Blvd., Suite 310, Arlington VA 22209-2310. (703)522-0200. Fax: (703)284-9400. Editor: Peter Rafle. Circ. 75,000. Estab. 1959. Quarterly magazine. Emphasizes conservation and restoration of America's trout and salmon species and the streams and rivers they inhabit. Readers are conservation-minded anglers, primarily male, with an average age of 46. Sample copy free with 9×12 SASE and 4 first-class stamps. Photo guidelines free with SASE.
Needs: Uses 25-50 photos/issue; 100% supplied by freelancers. Needs photos of trout and salmon, trout and salmon angling, conservation issues. Special photo needs include endangered species of trout and salmon; Pacific and Atlantic salmon; historical (19th-early 20th century) photos of salmon. Model/

property release required. Captions preferred; include species of fish; if angling shot: location (river/ stream, state, name of park or wilderness area).
Making Contact & Terms: Interested in receiving work from newer, lesser-known photographers. Query with résumé of credits. Deadlines: Spring, 2/20; Summer, 5/20; Fall, 8/20; Winter, 11/20. Does not keep samples on file. SASE. Reports in 2 months. Pays $500/color cover photo; $500/b&w cover photo; $150-500/color inside photo; $150-500/b&w inside photo. Pays on publication. Credit line given. Buys first North American serial rights; negotiable. Simultaneous submissions OK.
Tips: "If the fish in the photo could not be returned to the water alive with a reasonable expectation it would survive, we will not run the photo. The exception is when the photo is explicitly intended to represent 'what not to do.' "

TRUE WEST, P.O. Box 2107, Stillwater OK 74076. (405)743-3370. Fax: (405)743-3374. Editor: John Joerschke. Circ. 30,000. Estab. 1953. Monthly magazine. Emphasizes "history of the Old West (1830 to about 1915)." Readers are "people who like to read the history of the West, mostly male, age 45 and older." Sample copy $2 with 9 × 12 SAE. Photo guidelines free with SASE.
Needs: Uses about 50 or more photos/issue; almost all are supplied by freelance photographers. Needs "mostly Old West historical subjects, some travel, some scenic, (ghost towns, old mining camps, historical sites). We prefer photos with ms." Special needs include western wear; cowboys, rodeos, western events. Captions required; include name and location of site.
Making Contact & Terms: Interested in receiving work from newer, lesser-known photographers. Query with samples—b&w only for inside; color for covers. Query with stock photo list. Send unsolicited photos by mail for consideration. SASE. Reports in 1 month. Pays $100-175/color cover photo; $10-25/color inside photo; $10-25/b&w inside photo. **Pays on acceptance**; cover photos on publication. Credit line given. Buys first North American serial rights.
Tips: Prefers to see "transparencies of existing artwork as well as scenics for cover photos. Scenics should be free of modern intrusions such as buildings, powerlines, highways, etc. Inside photos need to tell story associated with the Old West. Most of our photos are used to illustrate stories and come with manuscripts; however, we will consider other work, scenics, historical sites, old houses. Even though we are Old West history, we do need current photos, both inside and for covers—so don't hesitate to contact us."

TV GUIDE, Four Radnor Corporate Center, Radnor PA 19088. Did not want to be listed. Uses staff members to shoot photos.

***TWINS MAGAZINE**, 6740 Antioch, Suite 155, Merriam KS 66204. (913)722-1090. Fax: (913)722-1767. Editor: Barbara Unell. Art Director: Cindy Himmelberg. Circ. 55,000. Estab. 1984. Bimonthly magazine. Emphasizes parenting twins, triplets, quadruplets, or more and being a twin, triplet, quadruplet or more. Readers include the parents of multiples. Sample copy $4.50. Free photo guidelines with SASE.
Needs: Uses about 10 photos/issue; all supplied by freelance photographers. Needs family related—children, adults, family life. Usually needs to have twins, triplets or more included as well. Reviews photos with or without accompanying ms. Model release required. Property release preferred. Captions preferred.
Making Contact & Terms: Interested in receiving work from newer, lesser-known photographers. Query with résumé of credits and samples. Provide résumé, business card, brochure, flier or tearsheets to be kept on file for possible assignments. SASE. Reports in 1 month. Pays $100 minimum/cover photo. Pays on publication. Credit line given. Buys all rights. Simultaneous submissions OK.

U. THE NATIONAL COLLEGE MAGAZINE, 1800 Century Park E., Suite 820, Los Angeles CA 90067. (310)551-1381. Fax: (310)551-1659. E-mail: umag@well.sf.ca.us; umagazine@aol.com. Managing Editor: Frances Huffman. Circ. 1.5 million. Estab. 1987. Monthly magazine. Emphasizes college. Readers are college students at 400 schools nationwide. Sample copy free for 9 × 12 SAE with 3 first-class stamps.
Needs: Uses 15 photos/issue; all supplied by student freelancers. Needs color feature shots of students, college life and student-related shots. Model release preferred. Captions required that include name of subject, school.
Making Contact & Terms: Interested in receiving work from newer, lesser-known photographers. Send unsolicited photos by mail for consideration. Provide résumé, business card, brochure, flier or tearsheets to be kept on file for possible assignments. Send any size color prints; 35mm, 2¼ × 2¼, 4 × 5, 8 × 10 transparencies, but prefer color slides. Also uses photo illustrations, collages, etc. "Send samples and we will commission shots as needed." Keeps sample on file. Reports in 3 weeks. Pays $100/color cover photo; $25/color inside photo. Pays on publication. Credit line given. Buys all rights; negotiable. Simultaneous submissions and previously published work OK.

Tips: "We look for photographers who can creatively capture the essence of life on campus. Also, we need light, bright photos since we print on newspaper. We are looking for photographers who are college students."

UNITY, 1901 NW Blue Pkwy. , Unity Village MO 64065. Editor: Philip White. Associate Editor: Janet McNamara. Circ. 120,000. Estab. 1889. Monthly magazine. Emphasizes spiritual, metaphysical, self-help, healing articles and poetry. Free sample copy and photo guidelines.
Needs: Uses 6-10 photos/issue. Buys 100 photos/year, 10% from freelancers. Wants on a regular basis people and nature scenics. Model release required. Captions required, include location for scenics and ethnic clothed people. Stock numbers required.
Making Contact & Terms: Interested in receiving work from newer, lesser-known photographers. Send insured material by mail for consideration. No calls in person or by phone. Uses 4×5 or 2×2 color transparencies. Vertical format required for cover. Send SAE and check or money order for return postage. Do not send stamps or stamped envelopes. There is a 7-8 month lead time for seasonal material. Reports in 2 months. Pays $200/cover, $65-125 inside color photo. **Pays on acceptance.** Credit line given. Buys first North American serial rights.
Tips: "Don't overwhelm us with hundreds of submissions at a time. We look for nature scenics, human interest, photos of active people. We are looking for photos with a lot of color and contrast."

♣**UP HERE**, P.O. Box 1350, Yellowknife, Northwest Territories X1A 2N9 Canada. (403)920-4652. Fax: (403)873-2844. Editor: R. Allerston. Circ. 35,000. Estab. 1984. Bimonthly magazine. Emphasizes Canada's north. Readers are white collar men and women ages 30 to 60. Sample copy $3 and 9×12 SAE. Photo guidelines free with SASE.
Needs: Uses 20-30 photos/issue; 90% supplied by freelance photographers. Purchases photos with and without accompanying ms. Captions required.
Making Contact & Terms: Provide résumé, business card, brochure, flier or tearsheets to be kept on file for possible assignments. SASE. Reports in 2 months. Pays $35-100/b&w photo; $50-150/color photo; $150-500/cover. Pays on publication. Credit line given. Buys one-time rights.
Tips: "We are a *people* magazine. We need northern subjects—lots of faces. We're moving more into outdoor adventure—soft type, as they say in the industry—and wildlife. Few scenics as such. We approach local freelancers for given subjects, but are building a library. We can't always make use of photos alone, but a photographer could profit by sending sheets of dupes for our stock files." Wants to see "sharp, clear photos, good color and composition. We always need verticals to consider for the cover, but they usually tie in with an article inside."

UPSIDE MAGAZINE, 143 11th Ave., San Mateo CA 94401. (415)570-5193. Fax: (415)570-5083. Art Director: Amparo del Rio. Circ. 50,000. Estab. 1978. Monthly magazine. Emphasizes people who build companies in the computer industry. Readers are male executives.
Needs: Uses 10 photos/issue; 10 supplied by freelancers. Wants photos of people only.
Making Contact & Terms: Interested in receiving work from newer, lesser-known photographers. Send unsolicited photos by mail for consideration. Keeps samples on file. Cannot return material. NPI. Credit line given. Buys one-time rights.
Tips: Make sure your work is creative and has strong composition with impact.

*****VANITY FAIR**, Condé Nast Building, 350 Madison Ave., New York NY 10017. (212)880-8800. Photography Director: Susan White. Monthy magazine.
Needs: 50% of photos supplied by freelancers. Needs portraits. Model/property release required for everyone. Captions required for photographer, styles, hair, makeup, etc.
Making Contact & Terms: Interested in receiving work from newer, lesser-known photographers. Contact through rep. Submit portfolio for review. Provide résumé, business card, brochure, flier or tearsheets to be kept on file for possible assignments. Reports in 1-2 weeks. NPI. Pays on publication.
Tips: "We solicit material after a portfolio drop. So really we don't want unsolicited material."

VEGETARIAN TIMES, Dept. PM, 4 Highridge Park, Stanford CT 06905. Art Director: Joe Ulatowski. Published 12 times annually. Circ. 250,000. Sample copy $4.
Needs: Buys 80 photos/year; 90% specific, 10% stock. Primary: food (with styling) to accompany articles. Celebrity/personality (if vegetarians), sport, spot news, how-to (cooking and building), humorous. Model release and captions preferred.
Making Contact & Terms: Send material by mail for consideration. SASE. Reports in 6 weeks. Uses 8×10 glossy prints. Prefers color transparencies. Pays $40 minimum b&w/photos. Pays $300 up/(color slide) cover. Pays 30 days after acceptance. Rights vary. Credit line given. Simultaneous submissions OK.
Tips: "We consider composition, color usage, flair with food when reviewing photographer's samples."

VENTURE, P.O. Box 150, Wheaton IL 60189. (708)665-0630. Fax: (708)665-0372. Editor: Deborah Christensen. Art Director: Robert Fine. Circ. 20,000. Estab. 1959. Magazine published 6 times/year. "We aim to inform, entertain and challenge from a Christian perspective. Our readers are boys 8-11 years old." Sample copy $1.85 with 9 × 12 SAE and 4 first-class stamps. Photo guidelines available (SASE).
Needs: Buys 2-3 color photos/issue; all from freelance stock. Photos of boys involved in sports, hobbies, camping, family life and just having fun. Also need photos of interest to boys: ecology, nature, adventure, occupations, etc.
Making Contact & Terms: Fax your stock list to Art Director or send photos for consideration. Send 8 × 10 color prints or duplicate transparencies with. SASE. Reports in 6 weeks. Pays $50-150/ b&w photo; $100-250/cover photo. Pays on publication. Buys one-time rights. Simultaneous submissions and previously published work OK.

VERMONT LIFE, 6 Baldwin St., Montpelier VT 05602. (802)828-3241. Editor: Tom Slayton. Circ. 95,000. Estab. 1946. Quarterly magazine. Emphasizes life in Vermont: its people, traditions, way of life, farming, industry and the physical beauty of the landscape for "Vermonters, ex-Vermonters and would-be Vermonters." Sample copy $4 with 9 × 12 SAE. Free photo guidelines.
Needs: Buys 30 photos/issue; 90-95% supplied by freelance photographers, 5-10% from stock. Wants on a regular basis scenic views of Vermont, seasonal (winter, spring, summer, autumn), submitted 6 months prior to the actual season; animal; documentary; human interest; humorous; nature; photo essay/photo feature; still life; travel; and wildlife. "We are using fewer, larger photos and are especially interested in good shots of wildlife, birds." No photos in poor taste, nature close-ups, cliches or photos of places other than Vermont. Model/property releases preferred. Captions required.
Making Contact & Terms: Interested in receiving work from newer, lesser-known photographers. Query first. Send 35mm or 2¼ × 2¼ color transparencies. SASE. Reports in 3 weeks. Pays $75-200/ b&w photo; $75-200/color photo; $200/day; $400-800 job. Pays on publication. Credit line given. Buys one-time rights; negotiable. Simultaneous submissions OK.
Tips: "We look for clarity of focus; use of low-grain, true film (Kodachrome is best); unusual composition or subject."

VERMONT MAGAZINE, P.O. Box 288, 14 School St., Bristol VT 05443. (802)453-3200. Art Director: Susan Romanoff. Circ. 50,000. Estab. 1989. Bimonthly magazine. Emphasizes all facets of Vermont and nature, politics, business, sports, restaurants, real estate, people, crafts, art, architecture, etc. Readers are people interested in Vermont, including residents, tourists and summer home owners. Sample copy $3 with 9 × 12 SAE and 5 first-class stamps. Photo guidelines free with SASE.
Needs: Uses 30-40 photos/issue; 75% supplied by freelance photographers. Needs animal/wildlife shots, travel, Vermont scenics, how-to, portraits, products and architecture. Special photo needs include Vermont activities such as skiing, ice skating, biking, hiking, etc. Model release preferred. Captions required.
Making Contact & Terms: Interested in receiving work from newer, lesser-known photographers. Query with résumé of credits and samples of work. Send 8 × 10 b&w prints or 35mm or larger transparencies by mail for consideration. Submit portfolio for review. Provide tearsheets to be kept on file for possible assignments. SASE. Reports in 2 months. Pays $450/color cover photo; $200/color page rate; $75-200/color or b&w photo; $275/day. Pays on publication. Credit line given. Buys one-time rights and first North American serial rights; negotiable. Previously published work OK, depending on "how it was previously published."
Tips: In portfolio or samples, wants to see tearsheets of published work, and at least 40 35mm transparencies. Explain your areas of expertise. Looking for creative solutions to illustrate regional activities, profiles and lifestyles. "We would like to see more illustrative photography/fine art photography where it applies to the articles and departments we produce."

***VERMONT PARENT & CHILD MAGAZINE,** P.O. Box 4446, Burlington VT 05406. (802)229-5442. Editor: Susan Youngwood. Circ. 18,000. Estab. 1990. Bimonthly magazine. Emphasizes parenting. Readers are parents of infants to pre-teens. Sample copy free with 9 × 12 SASE and 3 first-class stamps.
Needs: Uses 2-5 photos/issue; 50% supplied by freelancers. Needs photos of children and parents with children—variety of settings. Model release preferred for children.
Making Contact & Terms: Interested in receiving work from newer, lesser-known photographers. Send unsolicited photos by mail for consideration. Query with stock photo list. SASE. Reports in 1 month. Pays $100/color cover photo; $25/b&w inside photo. Pays on publication. Credit line given. Buys one-time rights. Simultaneous submissions and previously published work OK.

VICTORIA MAGAZINE, 224 W. 57th St., New York NY 10019. Fax: (212)757-6109. Photography Editor: Bryan McCay. Circ. 900,000. Estab. 1987. Monthly magazine. Emphasizes women's interests, lifestyle. Readers are females, 60% married, average age 37. Photo guidelines free with SASE.

© Joseph Sackman

Unity magazine needed an image to illustrate a poem titled "Meditation," so editors selected this one by Joseph Sackman of Margate, New Jersey. Sackman says he typically submits 20 slides, a cover letter, résumé and business card when approaching new markets. He received $65 for one-time usage by Unity; he found the magazine's submission policies in **Photographer's Market.**

Needs: Uses "hundreds" of photos/issue; most supplied by freelancers. "We hire freelancers to shoot 99% of our stories. Occasionally a photographer will submit work that we consider exceptional and wish to publish. This is rare, and an exception to the rule." Needs beauty, fashion, home furnishings, lifestyle, children's corner, gardens, food, collections. Model/property release required.

Making Contact & Terms: Interested in receiving work from newer, lesser-known photographers. Submit portfolio for review. Provide tearsheets to be kept on file for possible future assignments. SASE. Reports in 2 weeks. Pays $750-850/day. **Pays on acceptance.** Credit line given. Usually buys all rights, one-time rights; negotiable. Previously published work OK.

Tips: Looking for beautiful photos, wonderful lighting, elegance of style, simplicity.

VISIONS, 106 W. 11th St., #250, Kansas City MO 64105-1806. (816)221-4404. Fax: (816)221-1112. Editor: Neoshia Michelle Paige. Circ. 100,000. Semi-annual magazine. Emphasizes Native Americans in high school, college, vocational-technical, careers. Readers are Native American students 16-22. Sample copy free with 9×12 SAE and 4 first-class stamps.

Needs: Uses 30 photos/issue. Needs photos of students in-class, at work, on campus, in vocational/technical training in health, engineering, technology, computers, law, science, general interest. Model/property release required. Captions required; include name, age, location, what's going on in photo.

Making Contact & Terms: Interested in receiving work from newer, lesser-known photographers. Query with ideas and SASE. Reports in 1 month. Pays $10-50/color photo; pays $5-25/b&w inside photo. Pays on publication. Buys first North American serial rights. Simultaneous submissions and previously published work OK.

***VISTA,** 999 Ponce, Suite 600, Coral Gables FL 33134. (305)442-2462. Fax: (305)443-7650. Editor: Julia Bencomo Lobaco. Circ. 1.2 million. Estab. 1985. Monthly newspaper insert. Emphasizes Hispanic life in the US. Readers are Hispanic-Americans of all ages. Sample copy available.

Needs: Uses 10-50 photos/issue; all supplied by freelancers. Needs photos mostly of personalities with story only. No "stand-alone" photos. Reviews photos with accompanying ms only. Special photo needs include events in the Hispanic American communities. Model/property release preferred. Captions required.

Making Contact & Terms: Provide résumé, business card, brochure, flier or tearsheets to be kept on file for possible assignments. Keeps samples on file. SASE. Reports in 3 weeks. Pays $300/color cover photo; $150/color inside photo; $75/b&w inside photo; day assignments are negotiated. Pays on publication. Credit line given. Buys one-time rights. Previously published work OK.

Tips: "Build a file of personalities and events. Hispanics are America's fastest-growing minority."

***VOICE OF SOUTH MARION,** P.O. Box 700, Belleview FL 32620. (904)245-3161. Editor: Jim Waldron. Circ. 1,800. Estab. 1969. Weekly tabloid. Readers are male and female, ages 12-65, working in agriculture and various small town jobs. Sample copy $1.

Needs: Uses 5-10 photos/issue; 2 supplied by freelance photographers. Features pictures that can stand alone with a cutline. Captions required.

Making Contact & Terms: Send b&w or color prints by mail for consideration. SASE. Reports in 2 weeks. Pays $10/b&w cover photo; $5/b&w inside photo. Pays on publication. Credit line given. Buys one-time rights.

WASHINGTONIAN, 1828 L St. NW, Suite 200, Washington DC 20036. (202)296-3600. Fax: (202)785-1822. Photo Editor: Jay Sumner. Monthly city/regional magazine emphasizing Washington metro area. Readers are 40-50, 54% female, 46% male and middle to upper middle professionals. Circ. 160,000. Estab. 1965.

Needs: Uses 75-150 photos/issue; 100% supplied by freelance photographers. Needs photos for illustration, portraits, reportage; tabletop of products, food; restaurants; nightlife; house and garden; fashion; and local and regional travel. Model release preferred; captions required.

Making Contact & Terms: Submit portfolio for review. Provide résumé, business card, brochure, flier or tearsheets to be kept on file for possible assignments. Pays $125-250/b&w photo; $150-300/color photo; $175-$350/day. Credit line given. Buys one-time rights ("on exclusive shoots we share resale").

The asterisk before a listing indicates that the market is new in this edition. New markets are often the most receptive to freelance submissions.

Tips: "Read the magazine you want to work for. Show work that relates to its needs. Offer photo-story ideas. Send samples occasionally of new work."

***WATERFRONT SOUTHERN CALIFORNIA NEWS**, 17782 Cowan, Suite C, Irvine CA 92714. (714)660-6150. Fax: (714)660-6172. Assistant Editor: Erin McNiff. Circ. 40,000. Estab. 1979. Monthly magazine. Emphasizes sailing and power boating in Southern California. Sample copy $5. Photo guidelines free with SASE.
Needs: Uses 15-20 photos/issue; 5-10 supplied by freelancers. Needs photos of people having fun in boats for cover; current boating events. Special photo needs include America's Cup. Model release required. Captions preferred; include place, date, identify people if possible.
Making Contact & Terms: Interested in receiving work from newer, lesser-known photographers. Query with résumé of credits. Provide résumé, business card, brochure, flier or tearsheets to be kept on file for possible assignments. Query with stock photo list. Deadlines: 15th of the month preceeding publication. SASE. Reports in 1 month. Pays $50/color cover photo; $15/b&w inside photo. Pays on publication. Credit line given. Buys first North American serial rights. Simultaneous submissions OK.

WATERSKI MAGAZINE, 330 W. Canton Ave., Winter Park FL 32789. (407)628-4802. Fax: (407)628-7061. Editor: Rob May. Circ. 105,000. Estab. 1978. Published 10 times/year. Emphasizes water skiing instruction, lifestyle, competition, travel. Readers are 31-year-old males, average household income $65,000. Sample copy $2.95. Photo guidelines free with SASE.
Needs: Uses 75 photos/issue; 20 supplied by freelancers. 30% of photos in each issue comes from assigned work; 30% from freelance stock. Needs photos of instruction, travel, personality. Special photo needs include travel, personality. Model/property release preferred. Captions preferred; include person, trick described.
Making Contact & Terms: Interested in receiving work from newer, lesser-known photographers. Arrange a personal interview to show portfolio. Keeps samples on file. Reports in 1 month. Pays $150-300/day; $500/color cover photo; $75-200/color inside photo; $50-75/b&w inside photo; $75-250/color page rate; $50-75/b&w page rate. Pays on publication. Credit line given. Buys first North American serial rights.
Tips: "Clean, clear, large images. Plenty of vibrant action, colorful travel scenics and personality. Must be able to shoot action photography."

WATERWAY GUIDE, 6151 Powers Ferry Rd. NW, Atlanta GA 30339. Fax: (404)618-0349. Editor: Judith Powers. Circ. 50,000. Estab. 1947. Cruising guides with 3 annual regional editions. Emphasizes recreational boating. Readers are men and women ages 25-65, management or professional, with average income $95,000 a year. Sample copy $33.95 and $3 shipping. Photo guidelines free with SASE.
Needs: Uses 10-15 photos/issue; all supplied by freelance photographers. Needs photos of boats, Intracoastal Waterway, bridges, landmarks, famous sights and scenic waterfronts. Expects to use more coastal shots from Maine to the Bahamas; also, Hudson River, Lake Champlain and Gulf of Mexico. Model release required. Captions required.
Making Contact & Terms: Send unsolicited photos by mail for consideration. Send b&w and color prints or 35mm transparencies. SASE. Reports in 2 months. Pays $600/color cover photo; $25/b&w inside photo; $50/color photo. Pays on publication. Credit line given. Buys first North American serial rights.

***WEEKENDS**, 481 Bronson Rd., Southport CT 06490. (203)255-0064. Fax: (203)255-4281. Associate Publisher: Zach Chouteau. Circ. 260,000. Estab. 1991. Bimonthly magazine. Emphasizes travel—primarily in the Northeast and Mid-Atlantic regions, with occasional exotic escapes. Readers are top executives, male and female, with an average age of 43.6. Sample copy free with 9×12 SASE and 6 first-class stamps.
Needs: Uses 10-15 photos/issue; 0-10 supplied by freelancers. Needs photos primarily of travel. Special photo needs include Bar Harbor, ME; Atlanta, GA; Detroit, MI. Property release preferred. Captions preferred; include what it is, where it is.
Making Contact & Terms: Interested in receiving work from newer, lesser-known photographers. Query with stock photo list. Send unsolicited photos by mail for consideration. Send color or b&w prints; 35mm transparencies. SASE. Reports in 3 weeks. Pays $50-75/color cover photo; $25-50/b&w cover photo; $25-35/color inside photo; $20-40/b&w inside photo. Pays on publication. Credit line given. Buys one-time rights. Simultaneous submissions and previously published work OK.
Tips: "Extreme clarity is a necessity; lighting is also crucial." Suggests that photographers who want to sell to publications should "look over the periodicals you are considering submitting photos to. Be willing to work for whatever you can get in order to build portfolio/résumé etc."

***WESTERN HORSEMAN**, P.O. Box 7980, Colorado Springs CO 80933. (719)633-5524. Editor: Pat Close. Monthly magazine. Circ. 227,000. Estab. 1936. Readers are active participants in horse activi-

ties, including pleasure riders, ranchers, breeders and riding club members. Model/property release preferred. Captions required; include name of subject, date, location.
Needs: Articles and photos must have a strong horse angle, slanted towards the western rider—rodeos, shows, ranching, stable plans, training. "We also buy 35mm color slides for our annual cowboy calendar. Slides must depict ranch cowboys/cowgirls at work."
Making Contact & Terms: Interested in receiving work from newer, lesser-known photographers. Submit material by mail for consideration. Pays $20/b&w photo; $50-75/color photo; $400-500 maximum. "We buy mss and photos as a package." Payment for 1,500 words with b&w photos ranges from $100-400. Buys one-time rights; negotiable.
Tips: "For color, we prefer 35mm slides. For b&w, either 5×7 or 8×10 glossies. We can sometimes use color prints if they are of excellent quality. In all prints, photos and slides, subjects must be properly dressed. Baseball caps, T-shirts, tank tops, shorts, tennis shoes, bare feet, etc., are unacceptable."

WESTERN OUTDOORS, 3197-E Airport Loop, Costa Mesa CA 92626. (714)546-4570. Editor: Jack Brown. Circ. 131,000. Estab. 1961. Magazine published 9 times/year. Emphasizes fishing and boating for Far West states. Sample copy $2. Editorial and photo guidelines free with SASE.
Needs: Uses 21 photos/issue; 70 supplied by freelancers; 25% comes from assignments, 75% from stock. Cover photos of fishing in California, Oregon, Washington, Baja. "We are moving toward 100% four-color books, meaning we are buying only color photography. A special subject need will be photos of boat-related fishing, particularly small and trailerable boats and trout fishing cover photos." Most photos purchased with accompanying ms. Model/property release preferred for women and men in brief attire. Captions required.
Making Contact & Terms: Interested in receiving work from newer, lesser-known photographers. Query or send photos for consideration. Send 35mm Kodachrome II transparencies. SASE. Reports in 3 weeks. Pays $25-100/b&w photo; $50-150/color photo; $250/cover photo; $400-600 for text/photo package. **Pays on acceptance.** Buys one-time rights; negotiable.
Tips: "Submissions should be of interest to Western fishermen, and should include a 1,120-1,500 word ms; a Trip Facts Box (where to stay, costs, special information); photos; captions; and a map of the area. Emphasis is on fishing and hunting how-to, somewhere-to-go. Submit seasonal material 6 months in advance. Make your photos tell the story and don't depend on captions to explain what is pictured. Avoid 'photographic cliches' such as 'dead fish with man.' Get action shots, live fish. In fishing, we seek individual action or underwater shots. For cover photos, use vertical format composed with action entering picture from right; leave enough left-hand margin for cover blurbs, space at top of frame for magazine logo. Add human element to scenics to lend scale. Get to know the magazine and its editors. Ask for the year's editorial schedule (available through advertising department) and offer cover photos to match the theme of an issue. In samples, looks for color saturation, pleasing use of color components; originality, creativity; attractiveness of human subjects as well as fish or game; above all—sharp, sharp, sharp focus! Send duplicated transparencies as samples, but be prepared to provide originals." Sees trend toward electronic imagery, computer enhancement and electronic transmission of images.

WHERE CHICAGO MAGAZINE, 1165 N. Clark St., Chicago IL 60610. (312)642-1896. Fax: (312)642-5467. Editor: Margaret Doyle. Circ. 100,000. Estab. 1985. Monthly magazine. Emphasizes shopping, dining, nightlife and entertainment available in Chicago and its suburbs. Readers are male and female traveling executives and tourists, ages 25-55. Sample copy $3.
Needs: Uses 1 photo/issue; 90% supplied by freelancers. Needs scenic, seasonal shots of Chicago, must include architecture or landmarks that identify a photo as being shot in Chicago. Reviews photos with or without ms. "We look for seasonal shots on a monthly basis." Model/property release required. Captions required.
Making Contact & Terms: Send unsolicited photos by mail for consideration. Provide résumé, business card, brochure, flier or tearsheets to be kept on file for possible assignments. Send 35mm, 2¼×2¼, 4×5, 8×10 transparencies. SASE. Reports in 1 month. Pays $300/color cover photo. **Pays on acceptance.** Credit line given. Buys one-time rights; negotiable. Simultaneous submissions and previously published work OK.
Tips: "We only consider photos of downtown Chicago, without people in them. Shots should be colorful and current, in a vertical format. Keep our deadlines in mind. We look for covers two months in advance of issue publication."

WHERE MAGAZINE, 15th Floor, 600 Third Ave., New York NY 10016. (212)687-4646. Fax: (212)687-4661. Editor-in-Chief: Lois Anzelowitz-Tanner. Circ. 119,000. Estab. 1936. Monthly. Emphasizes points of interest, shopping, restaurants, theater, museums, etc. in New York City (specifically Manhattan). Readers are visitors to New York staying in the city's leading hotels. Sample copy available in hotels.
Needs: Buys cover photos only. Covers showing New York scenes; color photos only. Vertical compositions preferred. Model release preferred. Captions preferred.

Making Contact & Terms: Interested in receiving work from newer, lesser-known photographers. Arrange a personal interview to show portfolio. Does not return unsolicited material. Pays $300-500/color photo. Pays on publication. Credit line given. Rights purchased vary. Simultaneous submissions and previously published work OK.

THE JAMES WHITE REVIEW, P.O. Box 3356, Butler Quarter Station, Minneapolis MN 55403. (612)339-8317. Art Editor: Ed Mikola. A gay men's literary quarterly. Emphasizes gay men's writing, poetry and artwork. Readers are mostly gay men. Estab. 1983. Sample copy $3.
Needs: Uses 8-10 photos/issue; 100% supplied by freelancers. Reviews photos with or without a manuscript. Photo captions preferred; include title of work and media used.
Making Contact & Terms: Send unsolicited photos by mail for consideration. Send 5×7 or 8×10 glossy b&w prints. Keeps samples on file. SASE. Reports in 1 month. Pays $25/b&w cover photo; $25-50/photo package. Pays on publication. Credit line given. Buys one-time rights. Simultaneous submissions and previously published work OK.
Tips: "We are seeking work by emerging and established gay male artists, any style and theme. Please include biographical information."

***WIN MAGAZINE**, 120 S. San Fernando Blvd., Suite 439, Burbank CA 91302. Editor: Cecil Suzuki. Monthly magazine. Circ. 50,000. Emphasizes gambling.
Needs: Buys 6-12 photos/issue. Celebrity/personality (in a gambling scene, e.g., at the track); sport (of football, basketball, jai alai and all types of racing); and gambling scenes. Model release not required if photo is of a general scene; photo captions preferred. Uses 5×7 or 8×10 b&w prints; contact sheet OK. Also uses transparencies or color prints. Vertical format preferred.
Making Contact & Terms: Send material by mail for consideration. SASE. Reports in 1 month. Credit line given. Pays on publication. Buys all rights. Pays $5-25/b&w photo; $75/color cover.

WINDSURFING, 330 W. Canton Ave., Winter Park FL 32789. (407)628-4802. Fax: (407)628-7061. Editor: Debbie Snow. Circ. 75,000. Monthly magazine published 8 times/year. Emphasizes boardsailing. Readers are all ages and all income groups. Sample copy free with SASE. Photo guidelines free with SASE.
Needs: Uses 80 photos/issue; 60% supplied by freelance photographers. Needs photos of boardsailing, flat water, recreational travel destinations to sail. Model/property release preferred. Captions required, include who, what, where, when, why.
Making Contact & Terms: Query with samples. Send unsolicited photos by mail for consideration. Provide résumé, business card, brochure, flier or tearsheets to be kept on file for possible future assignments. Send 35mm, 2¼×2¼ and 4×5 transparencies by mail for consideration. Kodachrome and slow Fuji preferred. SASE. Reports in 3 weeks. Pays $450/color cover photo; $40-150/color inside; $25-100/b&w inside. Pays on publication. Credit line given. Buys one-time rights unless otherwise agreed on. Previously published work OK.
Tips: Prefers to see razor sharp, colorful images. The best guideline is the magazine itself. "Get used to shooting on, in or under water. Most of our needs are found there."

***WINE & SPIRITS**, 1 Academy St., RD #6, Princeton NJ 08540. (609)921-1060. Fax: (609)921-2566. Art Director: Johanna Wirtz. Circ. 60,000. Estab. 1985. Bimonthly magazine. Emphasizes wine. Readers are male, ages 39-60, married, parents, children, $70,000 plus income, wine consumers. Sample copy $2.95.
Needs: Uses 6-15 photos/issue; all supplied by freelancers. Needs photos of food, wine, travel, people. Captions preferred; include date, location.
Making Contact & Terms: Interested in receiving work from newer, lesser-known photographers. Submit portfolio for review. Provide résumé, business card, brochure, flier or tearsheets to be kept on file for possible assignments. Reports in 1-2 weeks, if interested. Pays $250-600/job; $250/color cover photo. Pays on publication. Credit line given. Buys one-time rights. Simultaneous submissions OK.
Tips: "I prefer working with natural light whenever possible and I find these photographers very hard to come by."

♦WINE TIDINGS, 5165 Sherbrooke St. W., #414, Montreal, PQ H4A 1T6 Canada. (514)481-5892. Circ. 16,000. Estab. 1973. Published 8 times/year. Emphasizes "wine for Canadian wine lovers, 85% male, average age 45, high education and income levels." Sample copy free on request.
Needs: Uses about 10 photos/issue; occasionally supplied by freelance photographers. Needs "wine scenes, grapes, vintners, pickers, vineyards, bottles, decanters, wine and food; from all wine producing countries of the world." Photos usually purchased with accompanying ms. Captions preferred.
Making Contact & Terms: Send any size color prints; 35mm or 2¼×2¼ transparencies by mail for consideration. SAE and IRC. Reports in 6 weeks. Pays $300 (Canadian)/color cover photo; $25-100/color used inside. Pays on publication. Credit line given. Buys "all rights for one year from date of publication."

WISCONSIN SNOWMOBILE NEWS, 112 Market St., Sun Prairie WI 53590. (608)837-5161. Fax: (608)825-3053. General Manager: John Weishar. Circ. 23,000. Estab. 1960. Publication of the Wisconsin Snowmobile Clubs. Magazine published 7 times/year. Emphasizes snowmobiling. Sample copy free with 9×12 SAE and 4 first-class stamps.
Needs: Uses 20-24 photos/issue; 85% supplied by freelancers. Needs photos of snowmobile action, posed snowmobiles, travel, new products. Model/property release preferred. Captions preferred; include where, what, when.
Making Contact & Terms: Interested in receiving work from newer, lesser-known photographers. Submit portfolio for review. Send unsolicited photos by mail for consideration. Provide résumé, business card, brochure, flier or tearsheets to be kept on file for possible assignments. Send 8×10 glossy color and b&w prints; 35mm, 2¼×2¼, 4×5, 8×10 transparencies. Keeps samples on file. SASE. Reports in 1-2 weeks. NPI. Pays on publication. Credit line given. Buys one-time rights, all rights; negotiable. Simultaneous submissions and/or previously published work OK.

WITH, The Magazine for Radical Christian Youth, P.O. Box 347, Newton KS 67114. (316)283-5100. Co-editors: Eddy Hall, Carol Duerksen. Circ. 6,100. Estab. 1968. Magazine published eight times a year. Emphasizes "Christian values in lifestyle, vocational decision making, conflict resolution for US and Canadian high school students." Sample copy free with 9×12 SAE and 4 first-class stamps. Photo and writer's guidelines free with SASE.
Needs: Buys 75 photos/year; 8-10 photos/issue. Buys 65% of freelance photography from assignment; 35% from stock. Documentary (related to concerns of high school youth "interacting with each other, with family and in school environment; intergenerational"); head shot; photo essay/photo feature; scenic; human interest; humorous. Particularly interested in action shots of teens, especially of ethnic minorities. We use some mood shots and a few nature photos. Prefers candids over posed model photos. Few religious shots, e.g., crosses, steeples, etc. Photos purchased with or without accompanying ms and on assignment. For accompanying mss wants issues involving youth—school, peers, family, hobbies, sports, community involvement, sex, dating, drugs, self-identity, values, religion, etc. Model release preferred.
Making Contact & Terms: Interested in receiving work from newer, lesser-known photographers. Send material by mail for consideration. Uses 8×10 glossy b&w prints. SASE. Reports in 2 months. Pays $25-40/b&w inside photo; $40-50/b&w cover photo; 5¢/word for text/photo packages, or on a per-photo basis. **Pays on acceptance.** Credit line given. Buys one-time rights. Simultaneous submissions and previously published work OK.
Tips: "Candid shots of youth doing ordinary daily activities and mood shots are what we generally use. Photos dealing with social problems are also often needed. Needs to relate to teenagers—either include them in photos or subjects they relate to; using a lot of 'nontraditional' roles, also more ethnic and cultural diversity. Use models who are average-looking, not obvious model-types. Teenagers have enough self-esteem problems without seeing 'perfect' teens in photos."

WOMAN ENGINEER, Equal Opportunity Publications, Inc., 150 Motor Parkway, # 420, Hauppage NY 11788-5145. (516)273-8743. Fax: (516)273-8936. Editor: Anne Kelly. Circ. 16,000. Estab. 1979. Published three times a year. Emphasizes career guidance for women engineers at the college and professional levels. Readers are college-age and professional women in engineering. Sample copy free with 9×12 SAE and 6 first-class stamps.
Needs: Uses at least one photo per issue (cover); planning to use freelance work for covers and possibly editorial; most of the photos are submitted by freelance writers with their articles. Model release preferred. Captions required.
Making Contact & Terms: Query with list of stock photo subjects or call to discuss our needs. SASE. Reports in 6 weeks. Pays $25/color cover photo; $15/b&w photo; $15/color photo. Pays on publication. Credit line given. Buys one-time rights. Simultaneous submissions and previously published work OK, "but not in competitive career-guidance publications."
Tips: "We are looking for strong, sharply focused photos or slides of women engineers. The photo should show a woman engineer at work, but the background should be uncluttered. The photo subject should be dressed and groomed in a professional manner. Cover photo should represent a professional woman engineer at work, convey a positive and professional image. Read our magazine, and find

The First Markets Index preceding the General Index in the back of this book provides the names of those companies/ publications interested in receiving work from newer, lesser-known photographers.

actual women engineers to photograph. We're not against using cover models, but we prefer cover subjects to be women engineers working in the field."

WOMEN'S GLIB™, P.O. Box 259, Bala Cynwyd PA 19004. (215)668-4252. Editor: Roz Warren. Estab. 1991.
• This company publishes material in book form, although articles are magazine style.
Needs: "I'll buy as many photos as I can get if they suit my format." Needs humorous photos by women with a feminist outlook. Will review stock photos.
Making Contact & Terms: Interested in receiving work from newer, lesser-known photographers. Query with samples. Send various sized b&w prints. SASE. Reports in 2 weeks. Must send SASE for reply. Pays $20/b&w photo plus two copies. Pays on publication. Credit line given. Buys one-time rights; negotiable. Simultaneous submissions and/or previously published work OK. Sample copy available for $10, payable to Roz Warren (not Women's Glib).
Tips: "Be outrageous!! Rock the boat! I need laugh-out-loud (not subtle) humor by women. I am a terrific break-in market. I do not get nearly enough submissions of photos and photo essays. I would love to publish more. For an example of the kind of work I need take a look at the photo essay 'Morsels & Memories' which appears in *Women's Glib: A Collection of Women's Humor* (The Crossing Press) or at the material in *The Best Contemporary Women's Humor* (The Crossing Press). Either book is available at your local bookstore or library or can be ordered directly from my publisher by phoning 1-800-777-1048."

WOMEN'S SPORTS AND FITNESS MAGAZINE, 2025 Pearl St., Boulder CO 80302. (303)541-3695. Fax: (303)440-3313. Photo Editor: Laurie Jennings. Art Director: Janis Llewelyn. Circ. 150,000. Estab. 1974. Published 8 times/year. Readers want to celebrate an active lifestyle through the spirit of sports. Recreational interests include participation in two or more sports, particularly cycling, running and swimming. Sample copy and photo guidelines free with SASE.
• This publication is just now considering the possibility of storing and using PhotoCD images. They do some photo manipulation with PhotoShop.
Needs: 80% of photos supplied by freelance photographers. Needs photos of indoor and outdoor fitness, product shots (creative approaches as well as straight forward), outdoor action and location. Model release preferred. Captions preferred.
Making Contact & Terms: Interested in receiving work from newer, lesser-known photographers. Call or write before submitting material to receive photo schedule. Provide résumé, business card, brochure, flier or tearsheets to be kept on file for possible future assignments. "I prefer to see promo cards and tearsheets first to keep on file. Then follow up with a call for specific instructions." SASE. Reports in 1 month. Pays $125-400/b&w or color photo; $200-400/day; $200-3,000 (fees and expenses)/job. Pays on publication. Credit line given. Buys one-time rights.
Tips: Looks for "razor sharp images and nice light. Check magazine before submitting query. We look especially for photos of women who are genuinely athletic in active situations that actually represent a particular sport or activity. We want to see less set-up, smiling-at-the-camera shots and more spontaneous, real-action shots. We are always interested in seeing new work and new styles of photography."

WOODENBOAT MAGAZINE, P.O. Box 78, Brooklin ME 04616. (207)359-4651. Fax: (207)359-8920. Editor: Matthew P. Murphy. Circ. 105,000. Estab. 1974. Bimonthly magazine. Emphasizes wooden boats. Sample copy $4.95. Photo guidelines free with SASE.
Needs: Uses 100-125 photos/issue; 95% supplied by freelancers. Needs photos of wooden boats: in use, under construction, maintenance, how-to. Captions required; include identifying information, name and address of photographer on each image.
Making Contact & Terms: Interested in receiving work from newer, lesser-known photographers. Query with stock photo list. Keeps samples on file. SASE. Reports in 1 month. Pays $350/day; $350/color cover photo; $25-125/color inside photo; $15-75/b&w page rate. Pays on publication. Credit line given. Buys first North American serial rights. Simultaneous submissions and/or previously published work OK with notification.

‡WOODTURNING. 166 High St., Lewes E. Sussex BN7 1XU United Kingdom. (01273)477374. Fax: (01273)486300. Editor: Nick Hough. Circ. 30,000. Estab. 1990. Published 10 times per year. Emphasizes woodturning. Readers are mostly male age 30 and older. Samples copy £2.95 (English currency), $6.50, £1, $2 (US) first-class stamps.
Needs: Reviews photos with accompanying ms only. "Photos nearly all sent by writers with articles." Some gallery photos of work, rest how-to with projects. Captions required.
Making Contact & Terms: Provide résumé, business card, brochure, flier or tearsheets to be kept on file for possible future assignments. Keeps samples on file sometimes. SASE. Reports in 2 weeks. Pays £50/color page rate; £50/per page. Pays on publication. Credit line given if requested. Buys one-time rights. Considers simultaneous submission and/or previously published work (photos).

Tips: "We normally only consider articles on woodturning or woodturners with photos. Occasionally we use unusual photos with captions of woodturnings."

WORKBENCH MAGAZINE, 700 W. 47th St., Suite 310, Kansas City MO 64112. (816)531-5730. Fax: (816)531-3873. Executive Editor: A. Robert Gould. Senior Editor: Lawrence F. Okrend. Managing Editor: Ami B. Johnson. Circ. 750,000. Estab. 1957. Bimonthly magazine. Emphasizes do-it-yourself projects for the woodworker and home remodeler. Free sample copy. Free photo guidelines and writer's guidelines.
Needs: Looks for residential architecture (interiors and exteriors of homes), wood crafts, furniture, wood toys and folk art. How-to; needs step-by-step shots. Photos are purchased with accompanying ms. "We also purchase photos to illustrate articles, including 'beauty' lead photographs." Model/property release required for product shots, homeowner's or craftspeople's projects and profile shots. Captions required; include people's names and what action is shown in photo.
Making Contact & Terms: Interested in receiving work from newer, lesser-known photographers. Ask for guidelines, then send material by mail for consideration. Uses 5×7 or 8×10 glossy b&w prints; 2¼×2¼ or 4×5 transparencies and 8×10 glossy color prints; 4×5 color transparencies for cover, vertical format required. SASE. Reports in 1 month. Pay for b&w photos included in purchase price of ms; $125 minimum/color photo; $450 minimum/cover photo; $150-300/published page. **Pays on acceptance.** Credit line given with ms. Buys all rights; negotiable.
Tips: Prefers to see "sharp, clear photos; they must be accompanied by story with necessary working drawings. See copy of the magazine. We are happy to work with photographers in developing story ideas."

THE WORLD & I, 3600 New York Ave. NE, Washington DC 20002. (202)635-4037. Fax: (202)269-9353. Photo Essay Editor: Adri de Groot. Contact department editors. Circ. 30,000. Estab. 1986. Monthly magazine. Sample copy $10. Photo guidelines free with 9×12 SASE.
Needs: Uses 250 photos/issue; 50% supplied by freelancers. Needs news photos, head shots of important political figures; important international news photos of the month; scientific photos, new products, inventions, research; reviews of concerts, exhibitions, museums, architecture, photography shows, fine art; travel; gardening; adventure; food; human interests; personalities; activities; groups; organizations; anthropology, social change, folklore, Americana; photo essay: Life and Ideals, unsung heroes doing altruistic work. Reviews photos with or without ms—depends on editorial section. Model release required for special features and personalities. Captions required.
Making Contact & Terms: Interested in receiving work from newer, lesser-known photographers. "Send written query or call photo essay editor before sending photos. Photographers should direct themselves to editors of different sections (Current Issues, Natural Science, Arts, Life, Book World, Modern Thought, and Photo Essays). If they have questions, they can ask the photo director or the photo essay editor for advice. All unsolicited material must be accompanied by a SASE and unsolicited delivery memos will not be honored. We will try to give you a quick reply, within 2 weeks." For color, pays $75/¼ page, $125/½ page, $135/¾ page, $200/full page, $225/1¼ page, $275/1½ page, $330/1¾ page, $375/double page; for b&w, pays $45/¼ page, $95/½ page, $110/¾ page, $150/full page, $165/1¼ page, $175/1½ page, $185/1¾ page, $200/double page. Commissioned photo essays are paid on package deal bases. Pays on publication. Buys one-time rights. Previously published work OK.
Tips: "To be considered for the Photo Essay department, study the guidelines well, and then make contact as described above. You must be a good and creative photographer who can tell a story with sufficient attention paid to details and the larger picture. Images must work well with the text, but all tell their own story and add to the story with strong captions. Do NOT submit travel pieces as Patterns photo essays, nor sentimental life stories as Life & Ideals photo essays."

WRESTLING WORLD, Sterling/MacFadden, 233 Park Ave. S. New York NY 10003. (212)780-3500. Fax: (212)780-3555. Editor: Stephen Ciacciarelli. Circ. 50,000. Bimonthly magazine. Emphasizes professional wrestling superstars. Readers are wrestling fans. Sample copy $2.95 with 9×12 SAE and 3 first-class stamps.
Needs: Uses about 60 photos/issue; all supplied by freelance photographers. Needs photos of wrestling superstars, action and posed, color slides and b&w prints.
Making Contact & Terms: Query with representative samples, preferably action. SASE. Reports ASAP. Pays $150/color cover photo; $75/color inside photo; $50-125/text/photo package. **Pays on acceptance.** Credit line given on color photos. Buys one-time rights.

***YANKEE MAGAZINE**, Main St., Dublin NH 03444. (603)563-8111. Fax: (603)563-8252. Picture Editor: Ann Card. Circ. 700,000. Estab. 1935. Monthly magazine. Emphasizes general interest within New England. Readers are of all ages and backgrounds, majority are actually outside of New England. Sample copy $1.95. Photo guidelines free with SASE.
Needs: Uses 50 photos/issue; 70% supplied by freelancers (on assignment). Needs environmental portraits, travel, food, still lifes, photojournalistic essays. "Always looking for outstanding photo

packages shot in New England." Model/property release preferred. Captions required; include name, locale, pertinent details.

Making Contact & Terms: Interested in receiving work from newer, lesser-known photographers. Submit portfolio for review. Keeps samples on file. SASE. Reports in 1 month. Pays $300/day; $100-400/color inside photo; $100-400/b&w inside photo; $200/color page rate; $200/b&w page rate. Credit line given. Buys one-time rights; negotiable. Simultaneous submissions and previously published work OK.

Tips: "Submit only top-notch work. I don't need to see development from student to pro. Show me you can work with light to create exciting images."

YELLOW SILK: Journal of Erotic Arts, P.O. Box 6374, Albany CA 94706. (510)644-4188. Editor: Lily Pond. Circ. 16,000. Quarterly magazine. Emphasizes literature, arts and erotica. Readers are well educated, creative, liberal. Sample copy $7.50

Needs: Uses about 15-20 photos "by one artist" per issue. Have published the work of Judy Dater, Jan Saudek, Tee Corinne, Stephen John Phillips and Sandra Russell Clark. "All photos are erotic; none are cheesecake or sexist. No porn. We define 'erotic' in its widest sense. They are fine arts." Model release required.

Making Contact & Terms: Query with samples. Send prints, transparencies, contact sheets or photocopies by mail for consideration. Submit portfolio for review. SASE. Reports in 3 months. NPI; payment to be arranged. Pays on publication. Credit line given. Buys one-time and additional rights; "use for promotional and/or other rights arranged."

Tips: "Get to know the publication you are submitting work to and enclose SASE in all correspondence. Interested in color work at this time."

***YOGA JOURNAL**, 2054 University Ave., Berkeley CA 94704. (510)841-9200. Fax: (510)644-3101. Art Director: Tricia McGillis. Circ. 80,000. Estab. 1975. Bimonthly magazine. Emphasizes yoga, holistic health, bodywork and massage, meditation, and Eastern spirituality. Readers are female, college educated, median income, $60,000, and median age, 42. Sample copy $5.

Needs: Uses 20-30 photos/issue; 5-10 supplied by freelancers. Needs photos of travel, editorial by assignment. Special photo needs include botanicals, foreign landscapes. Model release preferred. Captions preferred; include name of person, location.

Making Contact & Terms: Interested in receiving work from newer, lesser-known photographers. Send unsolicited photos by mail for consideration. Provide samples or tearsheets for files. Send all sizes and finishes color b&w prints. 35mm, 2¼×2¼, 4×5, 8×10 transparencies. Keeps samples on file. SASE. Reports in 1 month only if requested.Pays $800/color cover photoo; $100-250/color inside photo; $100/b&w inside photo. **Pays on acceptance**. Buys one-time rights. Previously published work OK.

Tips: Seeking electronic files. Also searching for photographers who use exceptional lighting and exceptional outdoor scenes when photographing models. Photographers should be familiar with shooting human form in yoga poses.

YOUR HEALTH, 5401 NW Broken Sound Blvd., Boca Raton FL 33487. (800)233-7733, (407)997-7733. Editor: Susan Gregg. Photo Editor: Judy Browne. Circ. 40,000. Estab. 1963. Biweekly magazine. Emphasizes healthy lifestyles: aerobics, sports, eating, celebrity fitness plans, plus medical advances and the latest technology. Readers are consumer audience; males and females 20-70. Sample copy free with 9×12 SASE. Call for photo guidelines.

Needs: Uses 40-45 photos/issue; all supplied by freelance photographers. Needs photos depicting nutrition and diet, sports (runners, tennis, hiking, swimming, etc.), food, celebrity workout, pain and suffering, arthritis and bone disease, skin care and problems. Also any photos illustrating exciting technological or scientific breakthroughs. Model release required.

Making Contact & Terms: Interested in receiving work from newer, lesser-known photographers. Provide résumé, business card, brochure, flier or tearsheets to be kept on file for possible future assignments, and call to query interest on a specific subject. SASE. Reports in 2 weeks. Pay depends on photo size and color. Pays $25-75/b&w photo; $75-200/color photo; $75-150/photo/text package. Pays on publication. Buys one-time rights. Simultaneous submissions and previously published work OK.

Tips: "Pictures and subjects should be interesting; bright and consumer-health oriented. We are using both magazine-type mood photos, and hard medical pictures. We are looking for different, interesting, unusual ways of illustrating the typical fitness, health nutrition story; e.g. an interesting concept for fatigue, insomnia, vitamins. Send prints or dupes to keep on file. Our first inclination is to use what's on hand."

YOUR HOME, Meridian International, Inc., P.O. Box 10010, Ogden UT 84409. (803)394-9446. Attention: Editorial Staff. Distributed to businesses to be used with their inserts, as their house magazine. A monthly pictorial magazine with emphasis on home decor, buying, home construction, financing,

landscaping and working with realtors. Send SASE for guidelines. Sample copy $1 plus 9 × 12 envelope.

Needs: "We prefer manuscripts (800 to 1,200 words) with color transparencies." No do-it-yourself pieces, emphasize using professionals. Model release required. Captions preferred.

Making Contact & Terms: Interested in receiving work from newer, lesser-known photographers. Responds to SASE within 1 month. Pays 15¢/word; $25/b&w; $35 for color transparencies. Also needed are vertical transparencies for covers; pays $50/cover, negotiable for outstanding work. "These should have dramatic composition with sharp, contrasting colors." Six-month lead time. **Pays on acceptance.** Credit line given. Buys first North American rights.

Tips: Prefers to see "interior and exterior views of homes; good interior decor ideas; packages (photos with text) on home, garden, decorating and improvement ideas." Photos and text are commonly purchased as a package. About 50% of work is assigned. Send clear sharp pictures with contrasting colors for review. The photo department is very strict about the quality of pictures chosen for the articles.

YOUR MONEY MAGAZINE, 5705 N. Lincoln Ave., Chicago IL 60659. Art Director: Beth Ceisel. Circ. 450,000. Estab. 1979. Bimonthly magazine. Emphasizes personal finance.

Needs: Uses 18-25 photos/issue, 130-150 photos/year; all supplied by freelance assignment. Considers all styles depending on needs. "Always looking for quality location photography, especially environmental portraiture. We need photographers with the ability to work with people in their environment, especially people who are not used to being photographed." Model/property release required.

Making Contact & Terms: Interested in receiving work from newer, lesser-known photographers. Arrange a personal interview to show portfolio. Provide a business card, flier or tearsheets to be kept on file. Transparencies, slides, proofs or prints returned after publication. Samples not filed are returned with SASE. Reports only when interested. Pays up to $1,000/color cover photo; $450/b&w page; $200-500/b&w photo; $400-700/day; $600/color page. **Pays on acceptance.** Credit line given.

Tips: "Show your best work. Include tearsheets in portfolio."

ZUZU'S PETALS ANNUAL, P.O. Box 4476, Allentown PA 18105. (610)821-1324. Editor: T. Dunn. Circ. 300. Estab. 1992. Annual magazine. Emphasis on literature and the visual arts. Back issues (quarterly) $5.

Needs: Uses 20 photos/issue; 50% supplied by freelancers. Needs photos of unusual scenics (technological and natural), people and "especially artsy" shots. Reviews photos with or without accompanying ms. Model/property release preferred. Captions preferred; include location of subject.

Making Contact & Terms: Interested in receiving work from newer, lesser-known photographers. Send 8 × 10 or smaller glossy b&w prints by mail for consideration. Does not keep samples on file. SASE. Reports in 2 months. Pays in copies. Pays on publication. Credit line given. Buys one-time rights; negotiable. Simultaneous submissions and previously published work OK.

Tips: "We're looking for freshness, a different perspective on the everyday and the commonplace. We hope to provide a showcase for talented yet undiscovered photographers."

Consumer Publications/'95-'96 changes

The following markets appeared in the 1995 edition of *Photographer's Market*, but are not listed this year. The majority did not respond to our request to update their listings. If a reason was given for a market's exclusion it appears in parentheses below.

Al Buraq
Alaska Photographer Outdoor and Travel
American Visions
Arizona Highways
Art & Antiques
Atlanta Jewish Times
Autograph Collector Magazine
Automobile Magazine
Bicycling Plus Mt Bike
Biker
Billiards Digest
Bird Talk
Blade Magazine
The Bloomsbury Review
B'nai B'rith International Jewish Monthly
Boat Pennsylvania
Boca Raton
British Heritage
Hubie Brown's Pro Basketball

Business Journal of New Jersey (suspended publication)
Buzzworm's Earth Journal
California Angler Magazine (sold to Western Angler)
Canadian Gardening Magazine
Caribbean Sports & Travel (no longer published)
Changing Men
Chicago District Golfer (phone disconnected)
Climax (no longer published)
The Climbing Art
Columbus Monthly
Cosmopolitan
Dakota Outdoors
Dallas Life Magazine (suspended publication)
Dance Magazine
Darts World
The Diamond (suspended publi-

cation)
Down Beat Magazine
Earthkeeper (no longer published)
Event
Freedom Magazine
Gates: Magazine for College Students (requested deletion)
Gay Times
Gent
Golden Falcon
Golf Digest
Gulfshore Life
Handball Magazine
Hawai'i Review
Health & Beauty Magazine
Alfred Hitchcock Mystery Magazine
Horses International
Horses West
Hot Rod Magazine
House of White Birches

In the Wind
Islands (requested deletion)
Jazziz Magazine
Journey
Journeymen
Lotus, Journal for Personal Transformation (no longer accepting freelance work)
Master of Life Winners
Mirabella (sold to Hachette Filipacchi Magazines)
Missouri Alumnus
Moment
Monitoring Times
Mopar Muscle Magazine
Multinational Monitor
Natural History Magazine
Neil Sperry's Gardens
New Age Journal
New Choices for Retirement Living
New Hampshire Editions
New Jersey Monthly
New York Magazine

Off Duty Magazine
Offshore
Ohio Week Magazine (out of business)
Old Bike Journal
Open Wheel Magazine
Opera News
Organic Gardening
Orlando Magazine
Outdoor Photographer
Outside
Penthouse
Pets Magazine
Play Magazine
Popular Electronics
Portfolio (no longer published— see listing for *Photo Editors Review*)
Prevention Magazine
Quilt World, Quick & Easy Quilting, Stitch 'n Sew Quilts
Rand McNally Road Atlas
Rebel Yell Magazine (suspended publication)

Redbook
Rider
Score
Scripts and Scribbles
Scuba Times Magazine
Secure Retirement
Senior Magazine
Singles Almanac
Sinister Wisdom
Ski
Skin Diver
Smithsonian
This: A Serial Review
TV Guide
TWA Ambassador Magazine
Vauhdin Maailma
Videomaker Magazine
Volleyball Monthly (merged with Volleyball Magazine)
Voluptuous
Wisconsin Trails
World Trade Magazine
You Magazine

Newspapers & Newsletters

When working with newspapers always remind yourself that time is of the essence. Newspapers have various deadlines for each section that is produced. An interesting feature or news photo has a better chance of getting in the next edition if the subject is timely and has a local appeal. Most of the markets in this section are interested in regional coverage. Find publications near you and contact editors to get an understanding of their deadline schedules.

Also, ask editors if they prefer certain types of film or if they want color slides or b&w prints. Many smaller newspapers do not have the capability to run color images, so b&w prints are preferred. However, color slides can be converted to b&w. Editors who have the option of running color or b&w photos often prefer color film because of its versatility.

Although most newspapers rely on staff photographers, some hire freelancers as stringers for certain stories. Act professionally and build an editor's confidence in you by supplying innovative images. For example, don't get caught in the trap of shooting "grip-and-grin" photos when a corporation executive is handing over a check to a nonprofit organization. Turn the scene into an interesting portrait. Capture some spontaneous interaction between the people receiving the money and the firm donating the funds. By planning ahead you can be creative.

When you receive assignments it is always good to think about the image before you snap your first photo. If you are scheduled to meet someone at a specific location, arrive early and scout around. Find a proper setting or locate some props to use in the shoot. Do whatever you can to show the editor that you are willing to make that extra effort to give him something unique.

Always try to retain resale rights to shots of major news events. High news value means high resale value, and strong news photos can be resold repeatedly. If you have an image with a national appeal, search for those larger markets, possibly through the wire services. You also may find buyers among national news magazines, such as *Time* or *Newsweek*.

While most newspapers offer low payment for images, they are willing to negotiate if the image will have a major impact. Front page artwork often sells newspapers, so don't underestimate the worth of your images.

THE ADVOCATE/PKA PUBLICATIONS, 301A Rolling Hills Park, Prattsville NY 12468. (518)299-3103. Art Editor: C.J. Karlie. Circ. 12,000. Estab. 1987. Bimonthly tabloid. Literary arts-oriented magazine geared toward the pre-professional. Readers are male and female, ages 12-90, all professions. Sample copy $4. Photo guidelines free with SASE.
Needs: Uses 3-6 photos/issue; 100% supplied by freelancers. Needs photos of animals, wildlife, scenics, humor. Reviews photos with or without ms. Model/property release required. Captions required; include where shot, people and subject of photo, location, anything which describes shot.
Making Contact & Terms: Interested in receiving work from newer, lesser-known photographers. Send unsolicited photos by mail for consideration. Send prints no larger than 8 × 10, color and b&w. Does not keep samples on file. SASE. Reports in 1 month. Pays contributor's copy and byline. Pays on publication. Credit line given. Buys one-time rights.
Tips: "We like to publish pretty, positive and expressive photos. Work should look good in black and white format. We do not print in color, but do accept both b&w and color prints. Just send prints with SASE, unpublished and not simultaneous submissions."

AMERICAN METAL MARKET, 825 Seventh Ave., New York NY 10019. (212)887-8550. Fax: (212)887-8520. Capital Cities/ABC, Inc. Diversified Publishing Group. Editor: Michael G. Botta. Circ. 11,500. Estab. 1882. Daily newspaper. Emphasizes metals production and trade. Readers are top level management (CEOs, chairmen, and presidents) in metals and metals-related industries. Sample copies free with 10 × 13 SASE.
Needs: 90% of photos supplied by freelancers. Needs photos of press conferences, executive interviews, industry action shots and industry receptions. Photo captions required.
Making Contact & Terms: Provide résumé, business card, brochure, flier or tearsheets to be kept on file for possible assignments. Cannot return material. NPI. Credit line given. Buys all rights; negotiable. Simultaneous submissions OK.
Tips: "We tend to avoid photographers who are unwilling to release all rights. We produce a daily newspaper and maintain a complete photo file. We cover events worldwide and often need to hire freelance photographers. Best bet is to supply business card, phone number and any samples for us to keep on file. Keep in mind action photos are difficult to come by. Much of the metals industry is automated and it has become a challenge to find good 'people' shots."

■**AMERICAN SPORTS NETWORK**, Box 6100, Rosemead CA 91770. (818)292-2222. President: Louis Zwick. Associate Producer: Jesús Morando. Circ. 809,000. Publishes 4 newspapers covering "general collegiate, amateur and professional sports, i.e., football, baseball, basketball, track and field, wrestling, boxing, hockey, powerlifting and bodybuilding, fitness, health contests, etc."
Needs: Uses about 10-85 photos/issue in various publications; 90% supplied by freelancers. Needs "sport action, hard-hitting contact, emotion-filled photos. Have special bodybuilder annual calendar, collegiate and professional football pre- and post-season editions." Model release and captions preferred.
Making Contact & Terms: Send 8 × 10 glossy b&w prints and 4 × 5 transparencies or video demo reel or film work. by mail for consideration. Provide résumé, business card, brochure, flier or tearsheets to be kept on file for possible future assignments. SASE. Reports in 1 week. Pays $1,000/color cover photo; $250/inside b&w photo; negotiates rates by the job and hour. Pays on publication. Buys first North American serial rights. Simultaneous submissions and previously published work OK.

ANCHORAGE DAILY NEWS, Dept. PM, 1001 Northway Dr., Anchorage AK 99508. (907)257-4347. Editor: Howard Weaver. Photo Editor: Richard Murphy. Daily newspaper. Emphasizes all Alaskan subjects. Readers are Alaskans. Circ. 70,000. Estab. 1946. Sample copy free with 11 × 14 SAE and 8 first-class stamps.
Needs: Uses 10-50 photos/issue; 0-5% supplied by freelance photographers; most from assignment. Needs photos of all subjects, primarily Alaskan subjects. In particular, looking for freelance images for travel section; wants photos of all areas, especially Hawaii. Model release preferred. Captions required.
Making Contact & Terms: Contact photo editor with specific ideas. SASE. Reports in 1-3 weeks. Interested only in color submissions. Pays $35 minimum/color photo: photo/text package negotiable. Pays on publication. Credit line given. Buys one-time rights. Simultaneous submissions OK.
Tips: "We, like most daily newspapers, are primarily interested in timely topics, but at times will use dated material." In portfolio or samples, wants to see "eye-catching images, good use of light and active photographs."

AVSC NEWS, 79 Madison Ave., New York NY 10016. (212)561-8000. Fax: (212)779-9439. Director of Communications: Pam Harper. Circ. 7,000. Estab. 1962. Publication of the AVSC International. Quarterly newsletter. Emphasizes health care, contraception. Readers are health care professionals in the US and abroad. Sample copies for 4 × 9 SASE.

Needs: Uses 2-3 photos/issue; 1 supplied by freelancer. Needs photos of mothers and fathers with children in US and developing worlds. Photos only; does not accept mss. Special needs include annual report 15-20 photos, brochures throughout the year. Model release required. Captions preferred.
Making Contact & Terms: Interested in receiving work from newer, lesser-known photographers. Query with list of stock photo subjects. Reports in 2 weeks. Pays $200 maximum/b&w cover photo; $50-150/b&w inside photo. Pays on publication. Buys one-time rights. Previously published work OK.
Tips: Prefers to see a "sharp, good range of tones from white through all greys to black, and appealing pictures of people."

CALIFORNIA SCHOOL EMPLOYEE, P.O. Box 640, San Jose CA 95106. (408)263-8000, ext. 298. Fax: (408)954-0948. Senior Designer: Lisa Yordy. Publication of the California School Employees Association (CSEA). Monthly (October-July) newspaper. Circ. 100,000. Estab. 1932. Sample copy free upon request.
Needs: Uses freelance photos on assignment (70%) and from stock (30%). Needs photos of people and kids. Special photo needs include school work sites; classroom shots; crowds; elementary, middle and high school and college related. Wants to see facial emotion, action—cultural diversity, different ethnic backgrounds. Model release required; captions required including subject names.
Making Contact & Terms: Interested in receiving work from newer, lesser-known photographers. Prefers b&w, candid style photos. Provide résumé, business card, brochure, flier or tearsheets to be kept on file for possible assignments. SASE. NPI; payment negotiable. Pays on publication. Credit line given. Rights purchased are negotiable. Simultaneous submissions and previously published work OK.
Tips: "Know publisher's subject matter."

***THE CALLER**, P.O. Box 530, Edgefield SC 29824. (803)637-3106. Fax: (803)637-0034. Editor: Jay Langston. Circ. 102,000. Estab. 1990. Publication of National Wild Turkey Federation, Inc. Quarterly tabloid. Emphasizes wildlife conservation, hunting (turkey). Readers are college-educated male, ages 35-60. Sample copy free with 9×12 SASE and 4 first-class stamps. Photo guidelines available.
Needs: Uses 15 photos/issue; 50% supplied by freelancers. Needs photos of wild turkeys in natural habitat. "We have opportunities to cover photo assignments. The NWIF does approximately 1,000 habitat restoration projects each year throughout the U.S." Model release preferred. Captions preferred; include species of animals.
Making Contact & Terms: Interested in receiving work from newer, lesser-known photographers. Provide résumé, business card, brochure, flier or tearsheets to be kept on file for possible assignments. Send 35mm transparencies. SASE. Reports in 1 month. Pays $100-300/color cover photo; $75-100/ color inside photo; $20-75/b&w inside photo. **Pays on acceptance.** Credit line given. Buys one-time rights. Previously published work OK.
Tips: "We know the difference between truly wild turkeys and pen-raised birds. Don't waste any time photographing a turkey unless it's a wild bird."

♦CANADIAN RODEO NEWS, 2116 27th Ave. NE, #223, Calgary, Alberta T2E 7A6 Canada. (403)250-7292. Fax: (403)250-6926. Editor: P. Kirby Meston. Circ. 4,000. Estab. 1963. Monthly tabloid. Emphasizes professional rodeo in Canada. Readers are male and female rodeo contestants and fans—all ages. Free sample copy. Photo guidelines free with SASE.
Needs: Uses 15-20 photos/issue; 2-5 supplied by freelancers. Needs photos of professional rodeo action or profiles. Captions preferred; include identity of contestant/subject, date taken and place.
Making Contact & Terms: Interested in receiving work from newer, lesser-known photographers. Send unsolicited photos by mail for consideration. Send 4×6 or larger, glossy or matte, color or b&w prints. Keeps samples on file. SASE. Reports in 1 month. Pays $15/color cover photo; $10/color inside photo; $10/b&w inside photo; $35-60/photo/text package. Pays on publication. Credit line given. Rights negotiable. Simultaneous submissions and/or previously published work OK.
Tips: "Photos must be from or pertain to professional rodeo in Canada. Phone to confirm if subject/ material is suitable before submitting. *CRN* is very specific in subject."

CAPPER'S, Dept. PM, 1503 SW 42nd St., Topeka KS 66609-1265. (800)678-5779. Editor: Nancy Peavler. Estab. 1879. Biweekly tabloid. Emphasizes human-interest subjects. Readers are "mostly Midwesterners in small towns and on rural routes." Circ. 370,000. Sample copy $1.

 The maple leaf before a listing indicates that the market is Canadian.

Needs: Uses about 20-25 photos/issue, 3-4 supplied by freelance photographers. "We make no photo assignments. We select freelance photos with specific issues in mind." Needs "35mm color slides or larger transparencies of human-interest activities, nature (scenic), etc., in bright primary colors. We often use photos tied to the season, a holiday or an upcoming event of general interest." Captions preferred.

Making Contact & Terms: Interested in receiving work from newer, lesser-known photographers. "Send for guidelines and a sample copy (SAE, 85¢ postage). Study the types of photos in the publication, then send a sheet of 10-20 samples with caption material for our consideration. Although we do most of our business by mail, a phone number is helpful in case we need more caption information. Phone calls to try to sell us on your photos don't really help." Reporting time varies. Pays $10-15/b&w photo; $35-40/color photo; only cover photos receive maximum payment. Pays on publication. Credit line given. Buys one-time rights.

Tips: "Generally, we're looking for photos of everyday people doing everyday activities. If the photographer can present this in a pleasing manner, these are the photos we're most likely to use. Season shots are appropriate for Capper's, but they should be natural, not posed. We steer clear of dark, mood shots; they don't reproduce well on newsprint. Most of our readers are small town or rural Midwesterners, so we're looking for photos with which they can identify. Although our format is tabloid, we don't use celebrity shots and won't devote an area much larger than 5×6 to one photo."

***CATHOLIC HEALTH WORLD**, 4455 Woodson Rd., St. Louis MO 63134. (314)427-2500. Fax: (314)427-0029. Editor: Suzy Farren. Publication of Catholic Health Association. Semimonthly newspaper emphasizing healthcare—primary subjects dealing with our member facilities. Readers are hospital and long-term care facility administrators, public relations staff people. Circ. 6,000. Estab. 1985. Sample copy free with 9×12 SASE.
Needs: Uses 4-15 photos/issue; 1-2 supplied by freelancers. Any photos that would help illustrate health concerns (i.e., pregnant teens, elderly). Model release required.
Making Contact & Terms: Send unsolicited photos by mail for consideration. Uses 5×7 or 8×10 b&w glossy prints. SASE. Reports in 2 weeks. Pays $40-60/photo. Pays on publication. Credit line given. Buys one-time rights. Simultaneous submissions OK.

❖CHILD CARE FOCUS, 364 McGregor St., Winnipeg, Manitoba R2W 4X3 Canada. (204)586-8587. Fax: (204)589-5613. Communication Officer: Debra Mayer. Circ. 2,200. Estab. 1974. Quarterly newspaper. Trade publication for the child care industry. Emphasizes anything pertaining to child care field. Readers are male and female, 18 years of age and up. Sample copy available. Photo guidelines available.
Needs: Uses 8-10 photos/issue; all supplied by freelancers; 10% from assignments; 90% from stock. Needs photos of children, life shots, how-to, personalities. Make sure work isn't too cute. Material should contain realistic interaction between adults and children. Reviews photos with or without a ms. Model release required. Property release preferred. Captions preferred.
Making Contact & Terms: Interested in receiving work from newer, lesser-known photographers. Send unsolicited photos by mail for consideration. Provide résumé, business card, brochure, flier or tearsheets to be kept on file for possible future assignments. Uses 3×5 or larger b&w prints; 35mm transparencies. Keeps samples on file. SASE. Reports in 1 month. "We do not publish photos we must pay for. We are non-profit and *may* print photos offered for free." Credit line given. Buys one-time rights. Previously published work OK.

***COUNSELING TODAY**, (formerly *Counseling News*), 5999 Stevenson Ave., Alexandria VA 22304. (703)823-9800, ext. 358. Fax: (703)823-0252. Photo Editor: Mary Morrissey. Circ. 60,000. Estab. 1952. Publication of the American Counseling Association. Monthly tabloid. Emphasizes mental health counseling. Readers are male and female mental health professionals, ages 25 and older. Sample copy $2.
Needs: Uses 5-10 photos/issue; 50% supplied by freelancers. Needs human interest shots (i.e., people in conversation or counseling situations, groups, children, medical professionals, students, people with disabilities). Reviews photos with or without ms. Special photo needs include people with disabilities, group therapy, counseling with professionals. Model/property release preferred. Captions preferred; include names of subjects, location, special circumstances.
Making Contact & Terms: Interested in receiving work from newer, lesser-known photographers. Query with stock photo list. Keeps samples on file. SASE. Reports in 1 month. Pays $75-150/color cover photo; $75-100/b&w cover photo; $50-75/b&w inside photo. Pays on publication. Credit line given. Buys one-time rights/negotiable. Simultaneous submissions and/or previously published work OK.
Tips: "We often write about current popular issues from a mental health angle—gays in the military, the gender and generation gap, familial abuse—and we need photos to accompany those articles. It is easiest for us to evaluate your work if you send a pamphlet with reproductions of your stock photos. We often choose directly from catalogs or pamphlets."

CRAIN'S CLEVELAND BUSINESS, 700 W. St. Clair, Suite 310, Cleveland OH 44113. (216)522-1383. Fax: (216)522-0625. Graphics Editor: Christine Gordillo. Circ. 26,000. Weekly tabloid emphasizing business. Readers are Northeast Ohio business and industry workers. Sample copy free for 9×12 SASE. Photo guidelines free with SASE.
Needs: Uses about 10 photos/issue; all supplied by freelancers. Needs photos of office and manufacturing environments. Model release preferred. Captions required.
Making Contact & Terms: Arrange a personal interview to show portfolio. SASE. Reports in 2 weeks. $75-100/job plus 29¢/mile. **Pays on acceptance.** Credit line given. Buys all rights. Previously published work OK.
Tips: "Show me that you can make even the blandest CEO sitting behind a desk look interesting. Show experimentation with lines, lighting and angles. Be different."

CYCLE NEWS, Dept. PM, P.O. Box 498, Long Beach CA 90801. (310)427-7433. Publisher/Editor: Paul Carruthers. Art Director: Ree Johnson. Weekly tabloid. Emphasizes motorcycle news for enthusiasts and covers nationwide races. Circ. 45,000. Estab. 1964.
Needs: Needs photos of motorcycle racing accompanied by written race reports; prefers more than one bike to appear in photo. Wants current material. Buys 1,000 photos/year. Buys all rights, but may revert to photographer after publication.
Making Contact & Terms: Send photos or contact sheet for consideration or call for appointment. Reports in 3 weeks. SASE. For b&w: send contact sheet, negatives (preferred for best reproduction) or prints (5×7 or 8×10, glossy or matte), captions required, pays $10 minimum. For color: send transparencies, captions required, pays $50 minimum. For cover shots: send contact sheet, prints or negatives for b&w; transparencies for color, captions required, payment negotiable. "Payment on 15th of the month for issues cover-dated the previous month."
Tips: Prefers sharp action photos utilizing good contrast. Study publication before submitting "to see what it's all about." Primary coverage area is nationwide.

DAILY BUSINESS REVIEW, 1 SE Third Ave., Ninth Floor, Miami FL 33131. (305)347-6622. Art Director: Michael Cole. Staff Photographers: Aixa Montero-Green, Melanie Bell. Circ. 11,000. Estab. 1926. Daily newspaper. Emphasizes law, business and real estate. Readers are 25-55 years, average net worth of $750,000, male and female. Sample copy for $3 with 9×11 SASE.
Needs: Uses 8 photos/issue; 10% supplied by freelance photographers. Needs mostly portraits, however we use live news events, sports and building mugs. Photo captions "an absolute must."
Making Contact & Terms: Arrange a personal interview to show portfolio. Submit portfolio for review. Send 35mm, 8×10 b&w and color prints. Accepts all types of finishes. Cannot return unsolicited material. If used, reports immediately. Pays $50-75 for most photos; pays more if part of photo/ text package. Credit line given. Buys all rights; negotiable. Previously published work OK.
Tips: In photographer's portfolio, looks for "a good grasp of lighting and composition; the ability to take an ordinary situation and make an extraordinary photograph. We work on daily deadlines, so promptness is a must and extensive cutline information is needed."

DEKALB DAILY CHRONICLE, 1586 Barber Greene Rd., DeKalb IL 60115. (815)756-4841. Head Photographer: Kathleen Fox. Circ. 15,000. Estab. 1869. Daily newspaper. Emphasizes agriculture and features on DeKalb people. Sample copy for 50¢.
Needs: Feature pages run every week on Sunday—must pertain to DeKalb County. Photos purchased with accompanying ms only. Model release preferred; photo captions required.
Making Contact & Terms: Query with résumé of credits. Send unsolicited 8×10 glossy b&w photos by mail for consideration. Also, call to query. Cannot return material. Reports in 1 month. NPI. **Pays on acceptance.** Credit line given. Buys one-time rights.
Tips: "No 'set' pay scale per se; payment negotiable depending on several factors including quality of photo and need."

❖**FARM & COUNTRY**, 100 Broadview Ave., #402, Toronto, Ontario M4M 3H3 Canada. (416)463-8080. Fax: (416)463-1075. Managing Editor: John Muggeridge. Circ. 56,000. Estab. 1935. Tabloid published 18 times/year. Emphasizes agriculture. Readers are farmers, ages 20-70. Sample copy free with SASE. Photo guidelines available.
Needs: Uses 50 photos/issue; 5 supplied by freelancers. Needs photos of farm livestock, farmers farming, farm activities. *No rural scenes.* Special photo needs include food processing, shoppers, rural development, trade, politics. Captions preferred; include subject name, location, description of activity, date.
Making Contact & Terms: Interested in receiving work from newer, lesser-known photographers. Submit portfolio for review. Query with résumé of credits. Query with stock photo list. Send unsolicited photos by mail for consideration. Provide résumé, business card, brochure, flier or tearsheets to be kept on file for possible assignments. Send 2¼×2¼ transparencies. Published second and fourth Tuesdays—2 weeks earlier. Keeps samples on file. SASE. Reports in 1 month. Pays $100-300/color

cover photo. Pays on publication. Buys all rights; negotiable. Previously published work OK.
Tips: Looking for "Action, color, imaginative angles, vertical. Be able to offer wide range of color—on disk, if possible."

FISHING AND HUNTING NEWS, Dept. PM, 511 Eastlake Ave. E., Box C-19000, Seattle WA 98109. (206)624-3845. Managing Editor: Patrick McGann. Biweekly tabloid. Emphasizes how-to material, fishing and hunting locations and new products for hunters and fishermen. Circ. 133,000. Free sample copy and photo guidelines.
Needs: Buys 300 or more photos/year. Wildlife—fish/game with successful fishermen and hunters. Captions required.
Making Contact & Terms: Send samples of work for consideration. Uses 5×7 or 8×10 glossy b&w prints or negatives for inside photos. Uses color covers and some inside color photos—glossy 5×7 or 8×10 color prints, 35mm, 2¼×2¼ or 4×5 color transparencies. When submitting 8×10 color prints, negative must also be sent. SASE. Reports in 2 weeks. Pays $5-15 minimum/b&w print, $50-100 minimum/cover and $10-20 editorial color photos. Credit line given. **Pays on acceptance.** Buys all rights, but may reassign to photographer after publication. Submit model release with photo.
Tips: Looking for fresh, timely approaches to fishing and hunting subjects. Query for details of special issues and topics. "We need newsy photos with a fresh approach. Looking for near-deadline photos from Oregon, California, Utah, Idaho, Wyoming, Montana, Colorado, Texas, Alaska and Washington (sportsmen with fish or game)."

THE FRONT STRIKER BULLETIN, P.O. Box 18481, Asheville NC 28814. (704)254-4487. Fax: (704)254-1066. Owner: Bill Retskin. Circ. 800. Estab. 1986. Publication of The American Matchcover Collecting Club. Quarterly newsletter. Emphasizes matchcover collecting. Readers are male, blue collar workers, average age 55 years. Sample copy $3.50.
Needs: Uses 2-3 photos/issue; none supplied by freelancers. Needs table top photos of older match covers or related subjects. Reviews photos with accompanying ms only.
Making Contact & Terms: Interested in receiving work from newer, lesser-known photographers. Send unsolicited photos by mail for consideration. Send 5×7 matte b&w prints. Keeps samples on file. SASE. Reports in 1 month. NPI, negotiable. Pays on publication. Credit line given. Buys one-time rights; negotiable.

FULTON COUNTY DAILY REPORT, Dept. PM, 190 Pryor St. SW, Atlanta GA 30303. (404)521-1227. Advertising Director: Beverly Davis. Daily newspaper, 5 times/week. Emphasizes legal news and business. Readers are male and female professionals age 25 up, involved in legal field, court system, legislature, etc. Sample copy $1, with 9½×12½ SAE and 6 first-class stamps.
Needs: Uses 5-10 b&w photos/issue; 30% supplied by freelancers. Needs informal environmental photographs of lawyers, judges and others involved in legal news and business. Some real estate, etc. Photo captions preferred; complete name of subject and date shot, along with other pertinent information. Two or more people should be identified from left to right.
Making Contact & Terms: Submit portfolio for review—call first. Query with list of stock photo subjects. Keeps samples on file. SASE. Reports in 1 month. "Freelance work generally done on an assignment-only basis." Pays $100/assignment. Credit line given. Simultaneous submissions and previously published work OK.
Tips: Wants to see ability with "casual, environmental portraiture, people—especially in office settings, urban environment, courtrooms, etc.; and photojournalistic coverage of people in law or courtroom settings." In general, needs "competent, fast freelancers from time to time around the state of Georgia who can be called in at the last minute. We keep a list of them for reference. Good work keeps you on the list." Recommends that "when shooting for FCDR, it's best to avoid law-book-type photos if possible, along with other overused legal cliches."

GLOBE, Dept. PM, 5401 NW Broken Sound Blvd., Boca Raton FL 33487. (407)997-7733. Photo Editor: Ron Haines. Circ. 2 million. Weekly tabloid. "For everyone in the family. *Globe* readers are the same people you meet on the street, and in supermarket lines—average, hard-working Americans."
Needs: Buys all photos from freelancers. Needs human interest photos, celebrity photos, humorous animal photos, anything unusual or offbeat. Captions required.
Making Contact & Terms: Send 8×10 b&w glossy transparencies or color prints for consideration. SASE. Reports in 1 week. Pays $75/b&w photo (negotiable); $125/color photo (negotiable); day and package rates negotiable. Buys first serial rights. Pays on publication unless otherwise arranged. Previously published work OK.
Tips: Advises beginners to look for the unusual, offbeat shots. "Do **NOT** write for photo guidelines. Study the publication instead. Tailor your submission to my market." Use of color is increasing.

***GRAND RAPIDS BUSINESS JOURNAL**, 549 Ottawa NW, Grand Rapids MI 49503. (616)459-4545. Fax: (616)459-4800. Editor: Carole Valade. Circ. 6,000. Estab. 1983. Weekly tabloid. Emphasizes West Michigan business community. Sample copy $1.

After initially contacting Farm & Country by cold calling, Michael Courtney obtained a portfolio review and, subsequently, an assignment for the publication. During the assignment, Courtney, of Etobicoke, Ontario, created this image that appeared on the cover to illustrate a story on ethanol.

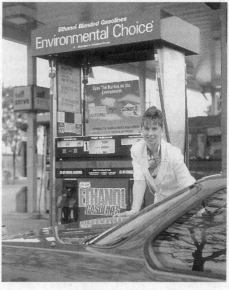

© Michael Courtney

Needs: Uses 10 photos/issue; 100% supplied by freelancers. Needs photos of local community, manufacturing, world trade, stock market, etc. Model/property release required. Captions required.
Making Contact & Terms: Interested in receiving work from newer, lesser-known photographers. Query with résumé of credits. Query with stock photo list. Deadlines: two weeks prior to publication. SASE. Reports in 1 month. Pays $25-35/b&w cover photo; $35/color inside photo; $25/b&w inside photo. Pays on publication. Credit line given. Buys one-time rights, first North American serial rights; negotiable. Simultaneous submissions and previously published work OK.

GULF COAST GOLFER, 9182 Old Katy Rd., Suite 212, Houston TX 77055. (713)464-0308. Editor: Steve Hunter. Circ. 32,000. Monthly tabloid. Emphasizes golf below the 31st parallel area of Texas. Readers average 48.5 years old, $72,406 income, upscale lifestyle and play golf 2-5 times weekly. Sample copy free with SASE and 9 first-class stamps.
Needs: "Photos are bought only in conjunction with purchase of articles." Model release preferred. Captions preferred.
Making Contact & Terms: "Use the telephone." SASE. Reports in 2 weeks. NPI. Pays on publication. Credit line given. Buys one-time rights or all rights, if specified.

HARAMBEE NEWSPAPER/JUST US BOOKS, 356 Glenwood Ave, 3rd Floor, East Orange NJ 07017. (201)676-4345. Publicity Director: Wade Hudson. Estab. 1988. Consumer newspaper. "*Harambee* is a newspaper for young readers that focuses on the African-American experience." Photo guidelines for 75¢ postage and SAE.
Needs: Uses 60 photos/year. Needs 8×10 b&w of Africans, African-Americans and other. Model/property release required. Captions required; include activity in photo, location, date and names if available.
Making Contact & Terms: Interested in receiving work from newer, lesser-known photographers. Query with stock photo list. Provide résumé, business card, brochure, flier or tearsheets to be kept on file for possible assignments. SASE. Reports in 2 months. Pays $5-35/b&w inside photo. Pays on publication. Credit line given, depending on nature of use and layout. Buys one-time rights. Previously published work OK.
Tips: Looks at quality of print and photo's content.

INSIDE TEXAS RUNNING, Dept. PM, 9514 Bristlebrook, Houston TX 77083. (713)498-3208. Fax: (713)879-9980. Publisher/Editor: Joanne Schmidt. Circ. 10,000. Estab. 1977. Monthly tabloid. Emphasizes running and jogging with biking insert. Readers are Texas runners and joggers of all abilities. Sample copy 9 first-class stamps.
Needs: Uses about 20 photos/issue; 10 supplied by freelancers; 80% percent of freelance photography in issue comes from assignment from freelance stock. Needs photos of "races, especially outside of Houston area; scenic places to run; how-to (accompanying articles by coaches); also triathlon and bike tours and races." Special needs include "top race coverage; running camps (summer); variety of Texas running terrain." Captions preferred.

Making Contact & Terms: Interested in receiving work from newer, lesser-known photographers. Send glossy b&w or color prints by mail for consideration. SASE. Reports in 1 month. Pays $10-15/ b&w or color photo; $25 per photo/text package. Pays on publication. Credit line given. Buys one-time rights; negotiable. Simultaneous submissions outside Texas and previously published work OK.
Tips: Prefers to see "human interest, contrast and good composition" in photos. Must use color prints for covers. "Look for the unusual. Race photos tend to look the same." Wants "clear photos with people near front; too often photographers are too far away when they shoot and subjects are a dot on the landscape." Wants to see road races in Texas outside of Houston area.

ITS REVIEW, 109 McLaughlin Hall, Berkeley CA 94720. (510)642-3593. Fax: (510)642-1246. Editor: Betsy Wing. Circ. 5,000. Government publication: Univ. of California Institute of Transportation Studies. Quarterly newsletter. Emphasizes transportation—current issues, research in progress. Readers range from professors and transportation professionals to individuals with interest in transportation. Sample copy free, call for copy.
Needs: Uses 5-6 photos/issue; 2-3 supplied by freelancers. Needs photos of technology, people, events that illustrate certain stories. Reviews photos with or without ms. "We need good airport/aircraft/ people during air travel photos." Model release required for any close-ups of faces in the foreground. Captions required; include type of aircraft, technology or airport being shown, plus names of any people in the foreground.
Making Contact & Terms: Interested in receiving work from newer, lesser-known photographers. Call before submitting work. Does not keep samples on file. Cannot return material. Reports in 1 month. Pays $75-250/b&w cover photo; $10-100/b&w inside photo. **Pays on acceptance.** Credit line given. Buys one-time rights; all rights; negotiable. Simultaneous submissions and previously published work OK.

✦**THE LAWYERS WEEKLY**, 75 Clegg Rd., Markham, Ontario L6G 1A1 Canada. (905)479-2665. Fax: (905)479-3758. Copy Coordinator: Ann Macaulay. Circ. 8,000. Estab. 1983. Weekly newspaper. Emphasizes law. Readers are male and female lawyers and judges, ages 25-75. Sample copy $8. Photo guidelines free with SASE.
Needs: Uses 12-20 photos/issue; 5 supplied by freelancers. Needs head shot photos of lawyers and judges mentioned in story.
Making Contact & Terms: Interested in receiving work from newer, lesser-known photographers. Provide résumé, business card, brochure, flier or tearsheets to be kept on file for possible assignments. Deadlines: 1-2 day turnaround time. Does not keep samples on file. SASE. Reports only when interested. NPI. **Pays on acceptance.** Credit line not given.
Tips: "We need photographers across Canada to shoot lawyers and judges on an as-needed basis. Send a résumé and we will keep your name on file. Mostly b&w work."

*LONG ISLAND PARENTING NEWS, P.O. Box 214, Island Park NY 11558. (516)889-5510. Fax: (516)889-5513. Director: Andrew Elias. Circulation: 50,000. Estab. 1989. Monthly newspaper. Emphasizes parenting issues and children's media. Readers are mostly women, ages 25-45, with kids, ages 0-12. Sample copy $3 and 9×12 SASE with 5 first-class stamps. Model release required.
Needs: Uses 4-8 photos/issue; 1-2 supplied by freelancers. Needs photos of kids, families, parents. Model release required.
Making Contact & Terms: Interested in receiving work from newer, lesser-known photographers. Send unsolicited photos by mail for consideration. Send 5×7 or 8×10 color or b&w prints. Keeps samples on file. SASE. Reports in 6 weeks. Pays $50/color cover photo; $25-50/color inside photo; $25-50/b&w inside photo. Pays on publication. Credit line given. Buys one-time rights.

MARKETING HIGHER EDUCATION, 280 Easy St., Suite 114, Mountain View CA 94043-3736. (415)962-1105. Publisher: Bob Topor. Estab. 1986. Monthly newsletter. Emphasizes higher education. Readers are professionals working in higher education.
Needs: Uses 1-6 photos/issue. Needs photos of schools, community colleges, colleges, universities, people and facilities. Reviews photos with or without a ms. Special photo needs include b&w shots. Model release preferred. Captions preferred.
Making Contact & Terms: Interested in receiving work from newer, lesser-known photographers. Provide résumé, business card, brochure, flier or tearsheets to be kept on file for possible future assignments. Pays $10-25/b&w page rate. **Pays on acceptance.** Credit line given. Buys all rights.
Tips: Wants photos of good quality with strong composition.

METRO, 550 S. First St., San Jose CA 95113. (408)298-8000. Chief Photographer: Christopher Gardner. Circ. 91,000. Alternative newspaper, weekly tabloid format. Emphasis on news, arts and entertainment. Readers are adults ages 25-44, in Silicon Valley. Sample copy $3.
Needs: Uses 15 photos/issue; 10% supplied by freelance photographers. Model release required for model shots. Captions preferred.

Making Contact & Terms: Query with résumé of credits, list of stock photos subjects. Provide résumé, business card, brochure, flier or tearsheets to be kept on file for possible assignments. Does not return unsolicited material. Pays $75-100/color cover photo; $50-75/b&w cover photo; $50/b&w inside photo. Pays on publication. Credit line given. Buys one-time rights. Simultaneous submissions and/or previously published work OK "if outside of San Francisco Bay area."

***THE MILITARY PRESS NEWSPAPER**, 6910-A Miramar Rd., #101, San Diego CA 92121. (619)537-2284. Fax: (619)578-3882. Editor: Louise Craig. Production Manager: Roger Baquil. Circ. 40,000. Biweekly tabloid. Emphasizes military, Navy and Marines, veteran affairs, sports. Readers are primarily military personnel stationed throughout California. Sample copy free with 8½ × 11 SASE and 3 first-class stamps. Photo guidelines available.
Needs: Uses 15-20 photos/issue. Emphasizes military planes, installations, personnel, also personalities, human interest, weird or unusual. Model release required. Property release preferred. Captions preferred.
Making Contact & Terms: Interested in receiving work from newer, lesser-known photographers. Send unsolicited photos by mail for consideration. Send any color b&w prints. Keeps samples on file. SASE. Reports in 1 month. NPI. Pays on publication. Credit line given. Rights negotiable. Simultaneous submissions and previously published work OK.
Tips: "Looking for photos that tell a story—without needing accompanying stories. Looking for humorous photos."

THE MILWAUKEE JOURNAL SENTINEL, (formerly *Wisconsin, The Milwaukee Journal Magazine*), 333 W. State St., P.O. Box 371, Milwaukee WI 53201-0371. (414)223-5515. Fax: (414)224-2047. Editor: Carol Guensberg. Circ. 495,000. Estab. 1921. Weekly magazine. General-interest Sunday magazine focusing on the places and people of Wisconsin or of interest to Wisconsinites. Free sample copy with SASE.
Needs: Uses about 12 photos/issue; 1 supplied by freelancer. About 90% of photos are on assignment; very little stock. Needs "human-interest, wildlife, adventure, still life and scenic photos, etc." Model release preferred. Captions required.
Making Contact & Terms: Interested in receiving work from newer, lesser-known photographers. Query with samples. SASE. Reports in 3 months. Pays $125/color cover photo; $50-100/b&w inside photo, $50-125/color inside photo. Pays on publication. Buys one-time rights, "preferably first-time rights; negotiable."
Tips: "We're primarily interested in people and, to a lesser extent, nature. Our emphasis is strongly on Wisconsin themes."

MISSISSIPPI PUBLISHERS, INC., Dept. PM, 311 E. Pearl St., Jackson MS 39205. (601)961-7073. Photo Editors: Chris Todd and Jennifer Laird. Circ. 115,000. Daily newspaper. Emphasizes photojournalism: news, sports, features, fashion, food and portraits. Readers are in very broad age range of 18-70 years; male and female. Sample copy for 11 × 14 SAE and 54¢.
Needs: Uses 10-15 photos/issue; 1-5 supplied by freelance photographers. Needs news, sports, features, portraits, fashion and food photos. Special photo needs include food and fashion. Model release and captions required.
Making Contact & Terms: Provide résumé, business card, brochure, flier or tearsheets to be kept on file for possible assignments. Uses 8 × 10 matte b&w and color prints; 35mm, 2¼ × 2¼, 4 × 5, 8 × 10 transparencies. SASE. Reports 1 week. Pays $50-100/color cover photo; $25-50/b&w cover photo; $25/b&w inside photo; $20-50/hour; $150-400/day. Pays on publication. Credit line given. Buys one-time or all rights; negotiable.

MODEL NEWS, 244 Madison Ave., Suite 393, New York NY 10016-2817. (212)969-8715 or (516)764-3856. Publisher: John King. Circ. 250,000. Estab. 1975. Monthly newspaper. Emphasizes celebrities and talented models, beauty and fashion. Readers are male and female, ages 15-80. Sample copy $1.50 with 8 × 10 SAE and 1 first-class stamp. Photo guidelines $1.50.
Needs: Uses 1-2 photos/issue; 1-2 supplied by freelancers. Review photos with accompanying ms only. Special photo needs include new celebrities, famous faces, VIP's, old and young. Model release preferred. Captions preferred.

The First Markets Index preceding the General Index in the back of this book provides the names of those companies/ publications interested in receiving work from newer, lesser-known photographers.

Making Contact & Terms: Interested in receiving work from newer, lesser-known photographers. Contact through rep. Arrange personal interview to show portfolio. Submit portfolio for review. Send unsolicited photos by mail for consideration. Provide résumé, business card, brochure, flier or tearsheets to be kept on file for possible future assignments. Send 8×10 b&w prints. Keeps samples on file. SASE. Reports in 3 weeks. Pays $60/b&w cover photo; $30/b&w inside photo. Pays on publication. Credit line given. Buys all rights. Considers simultaneous submissions.

MOM GUESS WHAT NEWSPAPER, 1725 L St., Sacramento CA 95814. (916)441-6397. Editor: Linda Birner. Circ. 21,000. Estab. 1978. Weekly tabloid. Gay newspaper that emphasizes political, entertainment, etc. Readers are gay and straight people. Circ. 21,000. Estab. 1978. Sample copy $1. Photo guidelines free with SASE.
• This tabloid has gone from biweekly to weekly publication and, therefore, doubled its photo needs.
Needs: Uses about 8-10 photos/issue; all supplied by freelancers, 80% from assignment and 20% from stock. Model release required. Captions required.
Making Contact & Terms: Interested in receiving work from newer, lesser-known photographers. Arrange a personal interview to show portfolio. Send 8×10 glossy b&w prints by mail for consideration. SASE. Pays $5-200/b&w photo; $10-15/hour; $25-50/day; $5-200 per photo/text package. Pays on publication. Credit line given. Buys one-time rights; negotiable. Previously published work OK.
Tips: Prefers to see gay related stories/human rights/civil rights and some artsy photos in portfolio; *no* nudes or sexually explicit photos.

NATIONAL ENQUIRER, 600 S. E. Coast Ave., Lantana FL 33464. (407)586-1111. Photo Editor: Valerie Virga. Weekly tabloid. Readers are mostly female, ages 18-45.
Needs: Uses 150-200 photos/issue; all supplied by freelancers. Needs celebrity shots, funny animal photos, spectacular stunt photos, human interest. Model release required. Captions preferred.
Making Contact & Terms: Interested in receiving work from newer, lesser-known photographers. Arrange personal interview to show portfolio. Submit portfolio for review. Query with résumé of credits. Query with stock photo list. Provide résumé, business card, brochure flier or tearsheets to be kept on file for possible future assignments. SASE. "Must have proper postage." Reports in 3 weeks. NPI. Payment varies according to photo. Credit line sometimes given. Buys one-time rights, first North American serial rights. If work is not published in competitive publication it will be considered.

NATIONAL EXAMINER, 5401 NW Broken Sound Blvd., Boca Raton FL 33487. (407)997-7733. Editor: Dan Dolan. Photo Editor: Rochelle Pallar. Weekly tabloid. General interest. Circ. 1 million.
Needs: Uses 80-100 photos/issue. Needs color and b&w: human interest, humorous animal/children pictures, action sequences, celebrities. Special photo needs include color photo stories related to women. Model release preferred. Captions required.
Making Contact & Terms: Query with samples or send photos for consideration. SASE. Pays $125/ color and $50/b&w; some fees are negotiable. Pays on publication; assignments paid upon completion of work. Previously published work OK.

NATIONAL MASTERS NEWS, P.O. Box 50098, Eugene OR 97405. (503)343-7716. Fax: (503)345-2436. Editor: Al Sheahen. Circ. 6,000. Estab. 1977. Monthly tabloid. Official world and US publication for Masters (age 35 and over) track and field, long distance running and race walking. Sample copy free with 9×12 SASE.
Needs: Uses 25 photos/issue; 20% assigned and 80% from freelance stock. Needs photos of Masters athletes (men and women over age 35) competing in track and field events, long distance running races or racewalking competitions. Captions preferred.
Making Contact & Terms: Send any size matte or glossy b&w print by mail for consideration, "may write for sample issue." SASE. Reports in 1 month. NPI. Pays on publication. Credit line given. Buys one-time rights. Simultaneous submissions and previously published work OK.

NATIONAL NEWS BUREAU, P.O. Box 43039, Philadelphia PA 19129. (215)546-8088. Editor: Andy Edelman. Circ. 300 publications. Weekly syndication packet. Emphasizes entertainment. Readers are leisure/entertainment-oriented, 17-55 years old.
Needs: "Always looking for new female models for our syndicated fashion/beauty columns." Uses about 20 photos/issue; 15 supplied by freelance photographers. Captions required.
Making Contact & Terms: Arrange a personal interview to show portfolio. Query with samples. Submit portfolio for review. Send 8×10 b&w prints, b&w contact sheet by mail for consideration. SASE. Reports in 1 week. Pays $50-1,000/job. Pays on publication. Credit line given. Buys all rights.

NEW HAVEN ADVOCATE, 1 Long Wharf Dr., New Haven CT 06511. (203)789-0010. Publisher: Gail Thompson. Photographer: Kathleen Cei. Circ. 55,000. Estab. 1975. Weekly tabloid. Emphasizes general interest. Readers are male and female, educated, ages 20-50.

Needs: Uses 7-10 photos/issue; 0-1 supplied by freelancers. Reviews photos with or without ms. Model release required. Captions required.
Making Contact & Terms: Interested in receiving work from newer, lesser-known photographers. Provide résumé, business card, brochure, flier or tearsheets to be kept on file for possible assignments. Does not keep samples on file. SASE. Reports in 1 month. NPI. Pays on publication. Credit line given. Buys one-time rights. Simultaneous submissions and/or previously published work OK.

RAY NITSCHKE'S PACKER REPORT, 1317 Lombardi Access Rd., Green Bay WI 54304. (414)490-6500. Fax: (414)497-6519. Contact: Editor. Circ. 25,000. Estab. 1972. Weekly tabloid. Emphasizes Green Bay Packer football. Readers are 94% male, all occupations, ages. Sample copy free with SASE and 3 first-class stamps.
Needs: Uses 6-10 photos/issue; all supplied by freelancers. Needs photos of Green Bay Packer football.
Making Contact & Terms: Interested in receiving work from newer, lesser-known photographers. Query with résumé of credits. Provide résumé, business card, brochure, flier or tearsheets to be kept on file for possible assignments. Does not keep samples on file. SASE. Reports in 1 month. Pays $50/color cover photo; $10-50/color inside photo; $10-20/b&w page rate. Pays on publication. Credit line given. Buys one-time rights; negotiable. Simultaneous submissions and previously published work OK.

NORTH TEXAS GOLFER, 9182 Old Katy Rd., Suite 212, Houston TX 77055. (713)464-0308. Editor: Steve Hunter. Monthly tabloid. Emphasizes golf in the northern areas of Texas. Readers average 48.5 years old, $72,406 income, upscale lifestyle and play golf 2-5 times weekly. Circ. 29,000. Sample copy $2.50 with SAE.
Needs: "Photos are bought only in conjunction with purchase of articles." Model release and captions preferred.
Making Contact & Terms: "Use the telephone." SASE. Reports in 2 weeks. NPI. Pays on publication. Credit line given. Buys one-time rights or all rights, if specified.

THE PATRIOT LEDGER, 400 Crown Colony Dr., Quincy MA 02169. (617)786-7084. Fax: (617)786-7025. Photo Editor: Joe Lippincott. Circ. 100,000. Estab. 1837. "Daily except Sunday" newspaper. General readership. Photo guidelines free with SASE.
Needs: Uses 15-25 photos/issue; most photos used come from staff; some freelance assigned. Needs general newspaper coverage photos—especially spot news and "grabbed" features from circulation area. Model release preferred. Captions required.
Making Contact & Terms: Query with résumé of credits. SASE. Reports as needed. Pays $15-75/b&w inside photo or more if material is outstanding and especially newsworthy, $10-15/hour. Pays on publication. Credit line given. Rights negotiable. Simultaneous submissions and previously published work OK "depending on time and place."
Tips: Looks for "diversity in photojournalism: use NPPA pictures of the year categories as guidelines. Dynamite grabber qualities: unique, poignant images properly and accurately identified and captioned which concisely tell what happened. We want images we're unable to get with staff due to immediacy of events, shot well and in our hands quickly for evaluation and possible publication. To break in to our publication call and explain what you can contribute to our newspaper that is unique. We'll take it from there, depending on the results of the initial conversation."

***PITTSBURGH CITY PAPER**, 911 Penn Ave., Pittsburgh PA 15236. (412)560-2489. Fax: (412)281-1962. Editor: Alan Wallace. Art Director: Kevin Shepherd. Circ. 80,000. Estab. 1991. Weekly tabloid. Emphasizes Pittsburgh arts, news, entertainment. Readers are active, educated young adults, ages 29-54, with disposable incomes. Sample copy free with 12×15 SASE.
Needs: Uses 3-5 photos, all supplied by freelancers. Model/property release preferred. Captions preferred. "We can write actual captions but we need all the pertinent facts."
Making Contact & Terms: Interested in receiving work from newer, lesser-known photographers. Arrange personal interview to show portfolio. Query with résumé of credits. Provide résumé, business card, brochure, flier or tearsheets to be kept on file for possible assignments. Does not keep samples on file. SASE. Reports 2 weeks. Pays $25-125/job. Pays on publication. Buys one-time rights; negotiable. Previously published work OK.
Tips: Provide "something beyond the sort of shots typically seen in daily newspapers. Consider the long-term value of exposing your work through publication. In negotiating prices, be honest about your costs, while remembering there are others competing for the assignment. Be reliable and allow time for possible re-shooting to end up with the best pic possible."

PRORODEO SPORTS NEWS, 101 Pro Rodeo Dr., Colorado Springs CO 80919. (719)593-8840. Fax: (719)548-4899. Staff Writer: Clay Gaillard. Circ. 40,000. Publication of Professional Rodeo Cowboys Association. Biweekly newspaper, weekly during summer (12 weeks). Emphasizes professional rodeo.

Sample copy free with SAE and 8×10 envelope and 4 first-class stamps. Photo guidelines free with SASE.
Needs: Uses about 25-50 photos/issue; all supplied by freelancers. Needs action rodeo photos. Also uses behind-the-scenes photos, cowboys preparing to ride, talking behind the chutes—something other than action. Model/property release preferred. Captions required.
Making Contact & Terms: Interested in receiving work from newer, lesser-known photographers. Send 5×7, 8×10 glossy b&w and color prints by mail for consideration. SASE. Pays $85/color cover photo; $30/color inside photo; $15/b&w inside photo. Other payment negotiable. Pays on publication. Credit line given. Buys one-time rights.
Tips: In portfolio or samples, wants to see "the ability to capture a cowboy's character outside the competition arena, as well as inside. In reviewing samples we look for clean, sharp reproduction—no grain. Photographer should respond quickly to photo requests. I see more PRCA sponsor-related photos being printed."

REGISTER CITIZEN, 190 Water St., Torrington CT 06790. (203)489-3121. Fax: (203)489-6790. Chief Photographers: Sonja Blass, John Acerbi. Circ. 17,000. Daily newspaper. Covers all Northwestern Connecticut.
Needs: Uses 10-12 photos/issue. Less than 10% supplied by freelance photographers. Needs photos of spot news, fires, accidents and rescues. Special photo needs include spot news. Captions required.
Making Contact & Terms: "Call when you have a 'hot' photo. We use only negatives." NPI. Pays on publication. Credit line given. Buys one-time rights.
Tips: "Be in the right place at the right time and have film in your camera."

ROLL CALL NEWSPAPER, 900 Second St. NE, Suite 107, Washington DC 20002. (202)289-4900. Fax: (202)289-5337. Photo Editor: Laura Patterson. Circ. 25,000. Estab. 1955. Semiweekly newspaper. Emphasizes US Congress and politics. Readers are politicians, lobbyists and congressional staff. Sample copy free with 9×12 SAE with 4 first-class stamps.
Needs: Uses 20-30 photos/issue; up to 5 supplied by freelancers. Needs photos of anything involving current congressional issues, good or unusual shots of congressmen. Captions required.
Making Contact & Terms: Interested in receiving work from newer, lesser-known photographers. Query with samples or list of stock photo subjects. Send unsolicited photos by mail for consideration. Uses 8×10 glossy b&w prints; 35mm transparencies. Does not return unsolicited material. Reports in 1 month. Pays $25-125/b&w photo; $50-300/color photo (if cover); $50-100/hour; $100-200/day. Pays on publication. Credit line given. Buys one-time rights. Simultaneous submissions OK.
Tips: "We're always looking for unique candids of congressmen or political events. In reviewing photographer's samples, we like to see good use of composition and light for newsprint."

RUBBER AND PLASTICS NEWS, 1725 Merriman Rd., Akron OH 44313. (216)836-9180. Editor: Edward Noga. Circ. 17,000. Weekly tabloid. Emphasizes rubber industry. Readers are rubber product makers. Sample copy free.
Needs: Uses 5-10 photos/issue. Needs photos of company officials, in-plant scenes, etc. to go with stories staff produces.
Making Contact & Terms: Query with samples. SASE. Reports in 2 weeks. Pays $50-200/b&w or color cover photo; $50-100/b&w or color inside photo. Pays on publication. Credit line given. Buys all rights; negotiable. Simultaneous submissions OK.
Tips: Prefers to see "news photos; mood shots suitable for cover; business-related photos. Call us. We'd like to use more freelance photographers throughout the US and internationally to produce photographs that we'd use in stories generated by our staff."

***SATIN SHEETS**, P.O. Box 427, Whitehall PA 18052-0427. Phone/fax: (610)821-1324. Editorial Assistant: Daniel Parisi. Monthly newsletter. Emphasizes romance novels. Readers are voracious readers of romance novels, females of ages 16-60. Sample copy $5. Photo guidelines available.
Needs: Uses 20 photos/issue; 100% supplied by freelancers. Needs photos of romance novelists, Fabio, massmarket book authors. Model release required. Captions preferred; include location of photo shoot.
Making Contact & Terms: Interested in receiving work from newer, lesser-known photographers. Send unsolicited photos by mail for consideration. Provide résumé, business card, brochure, flier or tearsheets to be kept on file for possible assignments. Send 5×7, 8×11 glossy b&w prints. SASE. Reports in 1 month. Pays $10/b&w cover photo; $10/b&w inside photo; $10/photo/text package and free subscription. Pays on publication. Buys one-time rights; negotiable. Simultaneous submissions and previously published work OK.
Tips: "We like fairly high contrast head shots of authors, tasteful cheesecake of Fabio and other typical 'hunks' as well as more traditional shots."

SENIOR VOICE OF FLORIDA, Suite F, 6281 39th St. N., Pinellas Park FL 34665. (813)521-3837. Managing Editor: Nancy Yost. Circ. 50,000. Estab. 1981. Monthly newspaper. Emphasizes lifestyles

of senior citizens. Readers are Florida residents and tourists, 50 years old and older. Sample copy $1. Photo guidelines free with SASE.
Needs: Uses 6 photos/issue; 1-2 supplied by freelancers. Needs photos of recreational activities, travel, seasonal, famous persons (only with story). Reviews photos purchased with accompanying ms only. Model/property release required. Captions required.
Making Contact & Terms: Send photos with manuscript. Samples kept on file. SASE. Reports in 2 months. Pays $10/color cover photo; $5/color inside photo; $5/b&w inside photo. Pays on publication. Credit line given. Buys one-time rights; negotiable. Simultaneous submissions and previously published work OK.
Tips: "We look for crisp, clean, clear prints. Photos that speak to us rate special attention. We use photos only to illustrate manuscripts."

***SERVICE REPORTER**, 651 W. Washington, Chicago IL 60661. (312)993-0929. Editorial Director: Ed Schwenn. Circ. 48,000. Monthly tabloid. Emphasizes heating, air conditioning, ventilating and refrigeration. Sample copy $3.
Needs: Uses about 12 photos/issue; no more than one supplied by freelance photographers, others manufacturer-supplied. Needs photos pertaining to the field of heating, air conditioning, ventilating and refrigeration. Special needs include cover photos of personnel installing and servicing. Model release required. Captions required.
Making Contact & Terms: Query with stock photo list. Query on needs of publication. SASE. Reports in 2 weeks. Pays $50-100/color cover photo; $10/b&w photo; $25/color inside photo. Pays on publication. Credit line given. Buys one-time rights.

SHOW BIZ NEWS, 244 Madison Ave., New York NY 10016-2817. (212)969-8715 or (516)764-3856. Publisher: John King. Circ. 250,000. Estab. 1975. Monthly newspaper. Emphasizes model and talent agencies coast to coast. Readers are male and female, ages 15-80. Sample copy $1.50 with 8×10 SAE and 1 first-class stamp. Photo guidelines $1.50.
Needs: Uses 1-2 photos/issue; 1-2 supplied by freelancers. Reviews photos with accompanying ms only. Needs photos of new celebrities, famous faces, VIP's, old and young. Model release preferred. Captions preferred.
Making Contact & Terms: Interested in receiving work from newer, lesser-known photographers. Contact through rep. Arrange personal interview to show portfolio. Submit portfolio for review. Send unsolicited photos by mail for consideration. Send 8×10 b&w prints. Keeps samples on file. SASE. Reports in 3 weeks. Pays $60/b&w cover photo; $30/b&w inside photo. Pays on publication. Gives credit line. Buys all rights. Considers simultaneous submissions.

SINGER MEDIA CORP., INC., Seaview Business Park, 1030 Calle Cordillera, Unit #106, San Clemente CA 92673. (714)498-7227. President: Kurt Singer. Worldwide circulation. Estab. 1940. Newspaper syndicate (magazine, journal, books, newspaper, newsletter, tabloid). Emphasizes books and interviews.
Needs: Needs photos of celebrities, movies, TV, rock/pop music pictures, fitness, jigsaw puzzles, posters, postcards, greeting cards, text features with transparencies (35mm, 2¼×2¼, 4×5). Will use dupes or photocopies, cannot guarantee returns. No models. Usually requires releases on interview photos. Photo captions required.
Making Contact & Terms: Interested in receiving work from newer, lesser-known photographers, depending on subject. Query with list of stock photo subjects or tearsheets of previously published work. Color preferred. Reports in 3 weeks. Pays $25-1,000/b&w photo; $50-1,000 plus royalties/color photo. Pays 50/50% of all syndication sales. Pays after collection. Credit line given. Buys one-time rights, foreign rights; negotiable. Previously published work OK.
Tips: "Worldwide, mass market, text essential. Trend is toward international interest. Survey the market for ideas."

***SLO-PITCH NEWS, VARSITY PUBLICATIONS**, 13540 Lake City Way NE, Suite 3, Seattle WA 98125. (206)367-2420. Fax: (206)367-2636. Editor: Dick Stephens. Circ. 25,000. Estab. 1985. Publication of United States Slo-Pitch Softball Association (USSSA). Monthly tabloid. Emphasizes slo-pitch

Market conditions are constantly changing! If you're still using this book and it's 1997 or later, buy the newest edition of Photographer's Market *at your favorite bookstore or order directly from* Writer's Digest Books.

softball. Readers are men and women, ages 13-70. Sample copy for 10×14 SASE and $2. Photo guidelines free with SASE.
Needs: Uses 10-30 photos/issue; 90% supplied by freelancers. Needs stills and action softball shots. Special photo needs include products, tournaments, general, etc. Model/property release preferred for athletes. Captions required.
Making Contact & Terms: Interested in receiving work from newer, lesser-known photographers. Send unsolicited photos by mail for consideration. Provide résumé, business card, brochure, flier or tearsheets to be kept on file for possible assignments. Send color and b&w prints. Deadlines: 1st of every month. Keeps samples on file. Cannot return material. Reports in 1 month. Pays $10-30/b&w cover photo; $10-30/color inside photo; $10-25/b&w inside photo; $10-25/color page rate; $10-25/ b&w page rate. Pays on publication. Credit line given. Rights negotiable. Simultaneous submissions and previously published work OK.
Tips: Looking for good sports action and current stock of subjects. "Keep sending us recent work and call periodically to check in."

SOUTHERN MOTORACING, P.O. Box 500, Winston-Salem NC 27102. (910)723-5227. Associate: Greer Smith. Editor/Publisher: Hank Schoolfield. Circ. 15,000. Biweekly tabloid. Emphasizes autoracing. Readers are fans of auto racing. Sample copy for 3 first-class stamps.
Needs: Uses about 10-15 photos/issue; some supplied by freelance photographers. Needs "news photos on the subject of Southeastern auto racing." Captions required.
Making Contact & Terms: Query with samples; send 5×7 or larger matte or glossy b&w prints; b&w negatives by mail for consideration. SASE. Reports in 1 month. Pays $25-50/b&w cover photo; $5-25/b&w inside photo; $50-100/page. Pays on publication. Credit line given. Buys first North American serial rights. Simultaneous submissions OK.
Tips: "We're looking primarily for *news* pictures, and staff produces many of them—with about 25% coming from freelancers through long-standing relationships. However, we're receptive to good photos from new sources, and we do use some of those. Good quality professional pictures only, please!"

THE SPORTING NEWS, 1212 N. Lindberg Blvd., St. Louis MO 63132. Does not accept unsolicited photographs.

THE STAR NEWSPAPERS, Dept PM, 1526 Otto Blvd., Chicago Heights IL 60411. (708)755-6161. Fax: (708)755-0095. Photo Director: Carol Dorsett. Publishes 20 weekly newspapers in south suburban Chicago. Circ. 100,000. Estab. 1920.
Needs: Buys 100 stock photos and offers 1,000 assignments annually. Uses photos for features, news, spot news and sports coverage. Captions required; include description of subject, especially of towns or events.
Making Contact & Terms: Arrange personal interview to show portfolio. Accepts color or b&w prints, any size over 5×7. Also uses 35mm and 2¼×2¼ transparencies. Works with local freelancers on assignment only. Does not keep samples on file. SASE. Pays $19-25/assignment. Credit line given. Buys one-time and all rights; negotiable.
Tips: Wants to see "variety of photojournalism categories." Also, show "ability both to utilize and supplement available light." To break in, "be ready to hustle and work lousy hours." Sees a trend toward more use of "a documentary style."

STREETPEOPLE'S WEEKLY NEWS (Homeless Editorial), P.O. Box 270942, Dallas TX 75227-0942. Newspaper publisher. Publisher: Lon G. Dorsey, Jr. Estab. 1977. For a copy of the paper send $3 to cover immediate handling (same day as received) and postage.
● *SWN* wishes to establish relationships with corporations interested in homeless issues that can also provide photography regarding what their company is doing to combat the problem.
Needs: Uses photos for newspapers. Subjects include: photojournalism on homeless or street people. Model/property release required. Captions required.
Making Contact & Terms: Interested in receiving work from newer, lesser-known photographers. "Hundreds of photographers are needed to show national view of America's homeless." Send unsolicited photos by mail for consideration with SASE for return of all materials. Reports promptly. Pays $30/b&w photo; $20/color photo; $15/hour; $20-500/job. Pays on acceptance or publication. Credit line sometimes given. Buys all rights; negotiable.
Tips: In freelancer's demos, wants to see "professionalism, clarity of purpose, without sex or negative atmosphere which could harm purpose of paper." The trend is toward "kinder, gentler situations, the 'let's help our fellows' attitude." To break in, "find out what we're about so we don't waste time with exhausting explanations. We're interested in all homeless situations. Inquiries not answered without SASE."

SUN, 5401 NW Broken Sound Blvd., Boca Raton FL 33487. (407)997-7733. Photo Editor: Maureen Scozzaro. Weekly tabloid. Readers are housewives, college students, middle Americans. Sample copy free with extra large SAE and $1.70 postage.

Needs: Uses about 60 photos/issue; 50% supplied by freelance photographers. Wants varied subjects: action, unusual pets, offbeat medical, human interest, inventions, spectacular sports action; b&w human interest and offbeat pix and stories; and b&w celebrity photos. "Also—we are always in need of interesting, offbeat color photos for the center spread." Model release preferred. Captions preferred.
Making Contact & Terms: Query with stock photo list. Send 8×10 b&w prints, 35mm transparencies, b&w contact sheet or b&w negatives by mail for consideration. Send through mail with SASE. Reports in 2 weeks. Pays $100/b&w cover photo; $200/color cover photo; $75/b&w inside photo; $125/color inside photo. Pays on publication. Buys one-time rights. Simultaneous submissions and previously published work OK.
Tips: "We are specifically looking for the unusual, offbeat, freakish true stories and photos. *Nothing is too far out for consideration.* We would suggest you send for a sample copy and take it from there."

SUNSHINE: THE MAGAZINE OF SOUTH FLORIDA, 200 E. Las Olas Blvd., Ft. Lauderdale FL 33301-2293. (305)356-4685. Editor: John Parkyn. Art Director: Greg Carannante. "*Sunshine* is a Sunday newspaper magazine emphasizing articles of interest to readers in the Broward and Palm Beach counties region of South Florida." Readers are "the 800,000 readers of the Sunday edition of the *Sun-Sentinel.*" Sample copy and guidelines free with SASE.
Needs: Uses about 12-20 photos/issue; 30% supplied by freelancers. Needs "all kinds of photos relevant to a South Florida readership." Photos purchased with accompanying ms. Model release sometimes required. Captions preferred.
Making Contact & Terms: Query with samples. Provide résumé, business card, brochure, flier or tearsheets to be kept on file for possible future assignments. SASE. Reports in 1 month. "All rates negotiable; the following are as a guide only." Pays $200/color cover photo; $75-150/color inside photo; $500-1,000 for text/photo package. Pays within 2 months of acceptance. Credit line given. Buys one-time rights. Simultaneous and previously published submissions OK.

***TECH TRANSFER**, 109 McLaughlin Hall, Berkeley CA 94720. (510)642-3593. Fax: (510)642-1246. Editor: Betsy Wing. Circ. 5,000. Government publication. Quarterly newsletter. Emphsizes transportation, public works and technology. Readers work in transportation and public works departments of local governments. Sample copy for 9×12 SAE. "We pay postage."
Needs: Uses 2 or 3 photos/issue; all on assignment. Needs photos of state-of-the-art equipment being used by workers. Reviews photos with or without ms. Model release required. Captions required: include what technology is being used, in what location, and names of any people.
Making Contact & Terms: Interested in receiving work from newer, lesser-known photographers. Call editor to see if specific photo is of interest. Does not keep samples on file. Cannot return material. Reports in 1 month. Pays $50-200/b&w cover photo; $0-50/b&w inside photo. **Pays on acceptance.** Credit line given. Buys one-time rights, all rights; negotiable. Considers simultaneous submissions and/or previously published work.

TODAY'S MODEL, P.O. Box 205-454, Brooklyn NY 11220. (718)439-0889. Fax: (718)439-0226. Publisher: Sumit Arya. Circ. 100,000. Estab. 1993. Monthly newspaper. Emphasizes modeling and performing arts. Readers are male and female ages 13-28, parents of kids 1-12. Sample copy $3 with 9×12 SAE and 10 first-class stamps.
Needs: Uses various number photos/issue. Needs photos of fashion—studio/on location/runway; celebrity models, performers, beauty and hair—how-to; photojournalism—modeling, performing arts. Reviews photos with or without ms. Needs models of all ages. Model/property release required. Captions preferred; include name and experience (résumé if possible).
Making Contact & Terms: Interested in receiving work from newer, lesser-known photographers. Provide résumé, business card, brochure, flier or tearsheets to be kept on file for possible future assignments. Keeps samples on file. Reports only when interested. NPI. Pays on publication. Buys all rights; negotiable. Considers simultaneous submissions and/or previously published work.

U.S. YOUTH SOCCER, 3333 S. Wadsworth, Suite A-106, Lakewood CO 80227. (303)987-3994. Fax: (303)987-3998. Editor: Jon DeStefano. Circ. 110,000. Estab. 1982. Publication of the United States Youth Soccer Association. Quarterly newspaper. Emphasizes soccer and kids. Readers are coaches and club officers.
Needs: Uses 40 photos/issue; 90% supplied by freelancers. Reviews photos with or without ms. Captions required; include names of players and teams.
Making Contact & Terms: Interested in receiving work from newer, lesser-known photographers. Send unsolicited photos by mail for consideration. Send color prints. Does not keep samples on file. Cannot return material. Reports in 2 weeks. NPI. Pays on publication. Buys one-time rights. Considers simultaneous submissions.
Tips: "Have fun, show emotion, humor or intensity."

VELONEWS, 1830 N. 55th, Boulder CO 80301-2700. (303)440-0601. Fax: (303)444-6788. Managing Editor: Tim Johnson. Paid circ. 45,000. The journal of competitive cycling. Covers road racing and

mountain bike events on a national and international basis. Sample copy free with 9×12 SAE and 4 first-class stamps.
Needs: Bicycle racing and nationally important races. Looking for action shots, not just finish-line photos with the winner's arms in the air. No bicycle touring. Photos purchased with or without accompanying ms. Uses news, features, profiles. Captions and identification of subjects required.
Making Contact & Terms: Send samples of work or tearsheets with assignment proposal. Query first on mss. Send glossy b&w prints and transparencies. SASE. Reports in 3 weeks. Pays $16.50-50/b&w inside photo; $33-100/color inside photo; $75/b&w cover; $150/color cover; $15-100/ms. Credit line given. Pays on publication. Buys one-time rights.
Tips: "We're a newspaper; photos must be timely. Use fill flash to compensate for harsh summer light."

VENTURA COUNTY & COAST REPORTER, Dept. PM, 1563 Spinnaker Dr., #202, Ventura CA 93001. (805)658-2244. Editor: Nancy S. Cloutier. Circ. 35,000. Estab. 1977. Weekly tabloid newspaper.
Needs: Uses 12-14 photos/issue; 40-45% supplied by freelancers. Photos purchased with accompanying ms only. Model release required.
Making Contact & Terms: Send sample b&w original photos. SASE. Reports in 2 weeks. Pays $10/b&w cover photo; $10/b&w inside photo. Pays on publication. Credit line given. Buys one-time rights. Simultaneous submissions OK.
Tips: "We prefer locally slanted photos (Ventura County, CA)."

WARNER PRESS, INC., 1200 E. 5th St., Anderson IN 46012. (317)644-7721. Contact: Millie Corzine. Specializes in weekly church bulletins and calendars.
Needs: Buys 250 photos/year. Needs photos for four bulletin series; one is of "conventional type; another is meditative, reflective, life- or people-centered. The third is catering to the needs of the African-American worshipper. The fourth line features special occurrences, holidays and events, such as Easter, baptism, Father's and Mother's Day, confirmation, etc." Submit only in August. Present model release on acceptance of photo.
Making Contact & Terms: Submit material by mail for consideration. Uses transparencies (any size 35mm-8×10). Reports when selections are finalized. Pays $150-200.
Tips: "Send only a few (20-40) transparencies at one time. Identify *each* transparency with a number and your name and address. Concentrate on *verticals*—many horizontals eliminate themselves.

THE WASHINGTON BLADE, 1408 U St. NW, Washington DC 20009-3916. (202)797-7000. Fax: (202)797-7040. Senior Editor: Lisa M. Keen. Circ. 40,000. Estab. 1969. Weekly tabloid. For and about the gay community. Readers are gay men and lesbians; moderate- to upper-level income; primarily Washington DC metropolitan area. Sample copy free with 9×12 SAE plus 11 first-class stamps.
Needs: Uses about 6-7 photos/issue; only out-of-town photos are supplied by freelance photographers. Needs "gay-related news, sports, entertainment events; profiles of gay people in news, sports, entertainment, other fields." Photos purchased with or without accompanying ms. Model release preferred. Captions preferred.
Making Contact & Terms: Interested in receiving work from newer, lesser-known photographers. Query with résumé of credits. Provide résumé, business card and tearsheets to be kept on file for possible future assignments. SASE. Reports in 1 month. Pays minimum of $25/inside photo. Pays within 45 days of publication. Credit line given. Buys all rights when on assignment, otherwise one-time rights. Simultaneous submissions and previously published work OK.
Tips: "Be timely! Stay up-to-date on what we're covering in the news and call if you know of a story about to happen in your city that you can cover. Also, be able to provide some basic details for a caption (*tell* us what's happening, too)." Especially important to "avoid stereotypes."

WATERTOWN PUBLIC OPINION, Box 10, Watertown SD 57201. (605)886-6903. Fax: (605)886-4280. Editor: Gordon Garnos. Circ. 17,500. Estab. 1887. Daily newspaper. Emphasizes general news of this area, state, national and international news. Sample copy 25¢.
Needs: Uses up to 8 photos/issue. Reviews photos with or without ms. Model release required. Captions required.
Making Contact & Terms: Interested in receiving work from newer, lesser-known photographers. Send unsolicited photos by mail for consideration. Send b&w or color prints. Does not keep samples on file. SASE. Reports in 1-2 weeks. Pays minimum $5/b&w or color cover photo; $5/b&w or color inside photo; $5/color page rate. Pays on publication. Credit line given. Buys one-time rights; negotiable. Simultaneous submissions OK.

***WELCOMAT NEWSPAPER**, 1701 Walnut St., Philadelphia PA 19103. (215)563-7400. Fax: (215)563-7778. Art Director: Cyndi Shattuck. Circ. 90,000. Estab. 1971. Free alternative weekly newspaper. Emphasizes all subjects. Readers are male and female, ages 18 and over. Sample copy free with 9½×12 SASE.

Needs: Uses 20-30 photos/issue; 1-2 supplied by freelancers. Needs creative, editorial type of illustrative photography and photo essays. Model release required. Captions required.
Making Contact & Terms: Send unsolicited photos by mail for consideration. Provide résumé, business card, brochure, flier or tearsheets to be kept on file for possible assignments. Send any color or b&w prints; 35mm transparencies. Keeps samples on file. Reports in 1 month. Pays $75/color cover photo; $75/b&w cover photo; $30/color inside photo; $30/b&w inside photo; $100/photo text package. Pays on publication. Credit line given. Rights negotiable. Simultaneous submissions and previously published work OK.
Tips: "We are only looking for photo—illustration work because we have a staff photographer to cover all other bases. Focus on a specific style and be very clear in the way you see—know your downfalls as well as what you excel in."

WESTART, Box 6868, Auburn CA 95604. (916)885-0969. Editor-in-Chief: Martha Garcia. Circ. 5,000. Emphasizes art for practicing artists, artists/craftsmen, students of art and art patrons, collectors and teachers. Free sample copy and photo guidelines.
Needs: Uses 20 photos/issue, 10 supplied by freelancers. "We will publish photos if they are in a current exhibition, where the public may view the exhibition. The photos must be b&w. We treat them as an art medium. Therefore, we purchase freelance articles accompanied by photos." Wants mss on exhibitions and artists in the western states. Captions required.
Making Contact & Terms: Send 5×7 or 8×10 b&w prints by mail for consideration. SASE. Reports in 2 weeks. Payment is included with total purchase price of ms. Pays $25 on publication. Buys one-time rights. Simultaneous and previously published submissions OK.

♣THE WESTERN PRODUCER, PO Box 2500, Saskatoon, Sasketchewan S7K 2C4 Canada. Fax: (306)934-2401. E-mail: shein@plink.geis.com. Editor: Garry Fairbairn. Circ. 105,000. Estab. 1923. Weekly newspaper. Emphasizes agriculture and rural living in western Canada. Photo guidelines free with SASE.
● This publication accesses images through computer networks and is examining the storage of images on CD.
Needs: Buys up to 10 photos/issue; about 50-80% of photos supplied by freelancers. Livestock, nature, human interest, scenic, rural, agriculture, day-to-day rural life and small communities. Model/property release preferred. Captions required; include person's name and description of activity.
Making Contact & Terms: Interested in receiving work from newer, lesser-known photographers. Send material by mail for consideration. SASE. Pays $20-40/photo; $35-100/color photo; $50-250 for text/photo package. Pays on publication. Credit line given. Buys one-time rights. Previously published work OK.
Tips: Needs current photos of farm and agricultural news. "Don't waste postage on abandoned, derelict farm buildings or sunset photos. We want modern scenes with life in them—people or animals, preferably both. Farm kids are always a good bet." Also seeks mss on agriculture, rural Western Canada, history, fiction and contemporary life in rural western Canada.

THE WICHITA EAGLE, Dept. PM, 825 E. Douglas, Wichita KS 67201. (316)268-6468. Director of Photography: Bo Rader. Daily newspaper. Emphasizes news. General readership. Circ. 190,000. Estab. 1900.
Needs: Occasionally needs freelance submissions. "We have our own staff, so we don't require much freelance work. What little we do want, however, has to do with Kansas people." Model release preferred. Captions required.
Making Contact & Terms: Query with list of stock photo subjects. Submit portfolio for review. Provide résumé, business card, brochure, flier or tearsheets to be kept on file for possible assignments. Send 35mm b&w and color prints, or transparencies by mail for consideration. SASE. Reports in 3 weeks. NPI. Pays on publication. Credit line given. Buys one-time rights. Simultaneous and previously published work OK.
Tips: In photographer's portfolio or samples, wants to see "20 or so images that show off what the shooter does best, i.e., news spots, fashion." To break in with newspapers, "work hard, shoot as much as possible, and *never* give up!"

YACHTSMAN, Dept. PM, 2033 Clement Ave., Suite 100, Alameda CA 94501. (510)865-7500. Editor: Connie Skoog. Circ. 25,000. Estab. 1965. Monthly tabloid. Emphasizes recreational boating for boat owners of northern California. Sample copy $3. Writer's guidelines free with SASE.
● *Yachtsman* scans b&w or color photos for the inside of its magazine.
Needs: Buys 5-10 photos/issue. Sport; power and sail (boating and recreation in northern California); spot news (about boating); travel (of interest to boaters). Seeks mss about power boats and sailboats, boating personalities, locales, piers, harbors, and how-tos in northern California. Photos purchased with or without accompanying ms. Model release required. Captions preferred.

Making Contact & Terms: Interested in receiving work from newer, lesser-known photographers. "We would love to give a newcomer a chance at a cover." Send material by mail for consideration. Uses any size b&w or color glossy prints. Uses color slides for cover. Vertical (preferred) or horizontal format. SASE. Reports in 1 month. Pays $5 minimum/b&w photo; $150 minimum/cover photo; $1.50 minimum/inch for ms. Pays on publication. Credit line given. Buys one-time rights. Simultaneous submissions or previously published work OK but must be exclusive in Bay Area (nonduplicated).

Tips: Prefers to see action b&w, color slides, water scenes. "We do not use photos as stand-alones; they must illustrate a story. The exception is cover photos, which must have a Bay Area application—power, sail or combination; vertical format with uncluttered upper area especially welcome."

Photographer Patrick Short of San Francisco, California, says he has had an ongoing relationship with Recreation Publications for years. So, when he shot a roll of black & white film during a San Francisco regatta, he felt comfortable submitting this image. It was used in Yachtsman, published by Recreation Publications, to illustrate an article on the event.

***YOUTH SOCCER NEWS, VARSITY PUBLICATIONS**, 13540 Lake City Way NE, Suite 3, Seattle WA 98125. (206)367-2420. Fax: (206)367-2636. Editor: Dick Stephens. Circ. 200,000. Estab. 1987. Publication of United States Youth Soccer Association (USYSA). Monthly tabloid. Emphasizes soccer. Readers are children ages 6-19 and adults (coaches, referees, administrators). Sample copy free with 10×14 SASE and $2. Photo guidelines free with SASE.

Needs: Uses 5-15 photo/issue; 90% suppied by freelancers. Needs stills and action soccer shots. Special photo needs include tournament, product, general, etc. Model/property release preferred for athletes. Captions reuired.

Making Contact & Terms: Interested in receiving work from newer, lesser-known photographers. Send unsolicited photos by mail for consideration. Provide résumé, business card, brochure, flier or tearsheets to be kept on file for possible assignments. Send color and b&w prints. Deadlines: 1st of every month. Cannot return material. Reports in 1 month. Pays $10-30/b&w cover photo; $10-30/color inside photo; $10-25/b&w inside photo; $10-25/color page rate; $10-25/b&w page rage. Pays on publication. Credit line given. Rights negotiable. Simultaneous submissions and/or previously published work OK.

Tips: Looking for good sports action and current stock of subjects. "Keep sending us recent work and call periodically to check in."

Newspapers & Newsletters/'95-'96 changes

The following markets appeared in the 1995 edition of *Photographer's Market*, but are not listed this year. The majority did not respond to our request to update their listings.

If a reason was given for a market's exclusion it appears in parentheses below.

Arizona Business Gazette
Baja Times (suspended publication)
Crain's Detroit Business
East Bay Express (requested deletion)

Jewish Exponent
Medical Tribune
New York Times Magazine
North Island News (no longer published)
Skiing Trade News

Sporting News
Texas Affiliated Publishing Company
Travel News

Special Interest Publications

As with most magazines, breaking in with special interest publications will probably happen in stages. You may be assigned smaller projects at first, but once you supply quality material—on time and within budget—you may become a regular contributor. Editors will ask you to complete larger assignments as they become more comfortable with your talents.

Though the subject matter, readerships and circulations of these publications vary, their photo editors share a need for top-notch images. Normally these publications are affiliated with certain organizations that are trying to reach a clearly defined readership. These associations generally will be described with the phrase, "Publication of the (Name) Association," or, "Company publication for the (Name) Corporation."

As you build a rapport with photo editors in these markets, you might find yourself being asked to complete noneditorial projects for a periodical's parent company or association. Among these would be shooting publicity materials, executive portraits, product advertising and documentation of company or organization events. Keep your eyes open for such opportunities and when you approach these editors remember there is potential for some of these higher paying projects.

There also are certain publications interested in text/photo packages and photographers who have an ability to write can benefit from these listings. Editors often turn down photo submissions because they do not have an article to coincide with the artwork. By providing the full package you can make work more attractive to editors. The key is to cover a topic that is unique and focuses on the magazine's audience. If you do not have talent as a writer, team up with writers who need artwork for their stories.

One photographer who knows how to tell a story with his images is James Balog of Boulder, Colorado. If you aren't familiar with his name, you might be familiar with his work, which regularly appears in *National Geographic*, *Time* and *Smithsonian*. He also has published several books and has images hanging in galleries worldwide. Balog discusses his approach to photo projects as our Insider Report subject on page 374.

AAA MICHIGAN LIVING, 1 Auto Club Dr., Dearborn MI 48126. (313)336-1506. Fax: (313)336-1344. Executive Editor: Ron Garbinski. Managing Editor: Larry Keller. Monthly magazine. Emphasizes auto use, as well as travel in Michigan, US, Canada and foreign countries. Circ. 1 million. Estab. 1918. Free sample copy and photo guidelines.
Needs: Scenic and travel. "We buy photos without accompanying ms. Seeks mss about travel in Michigan, US and Canada. We maintain a file on stock photos and subjects photographers have available." Captions required.
Making Contact & Terms: Interested in receiving work from newer, lesser-known photographers. Query with list of stock photo subjects. Uses 35mm, 2¼×2¼ or 4×5 transparencies. For covers in particular, uses 35mm, 4×5 or 8×10 color transparencies. SASE. Reports in 6 weeks. Pays up to $500/color photo depending on quality and size; $350/cover photo; $55-500/ms. Pays on publication for photos, on acceptance for mss. Buys one-time rights. Simultaneous submissions and previously published work not accepted.

ADVENTURE CYCLIST, Box 8308, Missoula MT 59807. (406)721-1776. Editor: Dan D'Ambrosio. Circ. 30,000. Estab. 1974. Publication of Adventure Cycling Association. Magazine published 9 times/year. Emphasizes bicycle touring. Readers are mid-30s, mostly male, professionals. Samples copy free with 9×12 SAE and 4 first-class stamps.

Needs: Uses 20 photos/issue; 80% supplied by freelancers. Needs scenics with bicycles. Model release preferred. Captions required.
Making Contact & Terms: Submit portfolio for review. SASE. Reports in 3 weeks. NPI; payment negotiable. Pays on publication. Credit line given. Buys one-time rights. Simultaneous submissions and previously published work OK.

AI MAGAZINE, 445 Burgess Dr., Menlo Park CA 94025. (415)328-3123. Fax: (415)853-0197. Publishing Consultant: David Hamilton. Circ. 10,000. Estab. 1980. Publication of American Association of Artificial Intelligence (AAAI). Quarterly. Emphasizes artificial intelligence. Readers are research scientists, engineers, high-technology managers, professors of computer science. Sample copy with 9 × 12 SAE and 9 first-class stamps.
Needs: Uses about 1-2 photos/issue; all supplied by freelancers. Needs photo of specialized computer applications. Model release required. Captions preferred.
Making Contact & Terms: Interested in receiving work from newer, lesser-known photographers. Arrange a personal interview to show portfolio. Query with list of stock photo subjects. Provide résumé, business card, brochure, flier or tearsheets to be kept on file for possible future assignments. SASE. Reports in 6 weeks. Pays $100-800/color cover photo; $25-250/color inside photo. Pays on publication. Credit line given. Buys one-time and first North American serial rights. Simultaneous submissions and previously published work OK.
Tips: Looks for "editorial content of photos, not artistic merit."

AIR LINE PILOT, 535 Herndon Pkwy., Box 1169, Herndon VA 22070. (703)689-4171. Fax: (703)689-4370. Managing Editor: Gary DiNunno. Circ. 65,000. Estab. 1933. Publication of Air Line Pilots Association. Monthly. Emphasizes news and feature stories for commercial airline pilots. Photo guidelines for SASE.
Needs: Uses 12-15 photos/issue; 25% comes from freelance stock. Needs dramatic 35mm Kodachrome transparencies of commercial aircraft, pilots and co-pilots performing work-related activities in or near their aircraft. Special needs include dramatic 35mm Kodachromes technically and aesthetically suitable for full-page magazine covers. Especially needs vertical composition scenes. Model release required. Captions required; include aircraft type, airline, location of photo/scene, description of action, date, identification of people and which airline they work for.
Making Contact & Terms: Interested in receiving work from newer, lesser-known photographers. Query with samples. Send unsolicited photos by mail for consideration. Uses 35mm transparencies. SASE. Pays $35/b&w photo; $35-350/color photo. **Pays on acceptance.** Buys all rights; negotiable. Simultaneous submissions and previously published work OK.
Tips: In photographer's samples, wants to see "strong composition, poster-like quality and high technical quality. Photos compete with text for space so they need to be very interesting to be published. Be sure to provide brief but accurate caption information and send in only professional quality work. For our publication, cover shots do not need to tie in with current articles. This means that the greatest opportunity for publication exists on our cover."

ALFA OWNER, 3105 E. Skelly Dr., #607, Tulsa OK 74105. (918)743-7866. Editor and Publisher: Doug Darling. Circ. 5,000. Publication of the Alfa Romeo Owners Club association. Monthly magazine. Emphasizes Alfa Romeo automobiles. Audience is upscale with median household income of $65,000. Majority hold executive, technical or professional positions. Average age is 37, with 75% male readership. Sample copy free with 9 × 12 SAE and 4 first-class stamps.
Needs: Uses 12 photos/issue; 25% supplied by freelancers. Needs shots of Alfa Romeos on the road, under-the-hood tech shots, photos of historical figures related to Alfa and "glamour" shots of Alfas. Model/property release preferred. Captions preferred.
Making Contact & Terms: Submit portfolio for review. Send a combination of color slides and/or 5 × 7 prints (if possible), plus some b&w prints. SASE. Reports in 2 weeks. Pays $75-100/color cover photo; $10/b&w inside photo. Negotiates hour and day rate. Pays on publication. Credit line given. Simultaneous submissions and previously published work OK.
Tips: "We would like to see the photographer's background in automotive photography. Experience in automotive photography is preferable, though such a background isn't crucial if the person's work is good enough. For *Alfa Owner*, knowledge of the tech aspects of automobiles is very valuable, as we need technical shots almost as much as we need glamour and 'on-the-road' photos."

AMERICAN CRAFT, 72 Spring St., New York NY 10012. (212)274-0630. Editor/Publisher: Lois Moran. Managing Editor: Pat Dandignac. Circ. 45,000. Estab. 1941. Bimonthly magazine of the American Craft Council. Emphasizes contemporary creative work in clay, fiber, metal, glass, wood, etc. and discusses the technology, materials and ideas of the artists who do the work. Free sample copy with 9 × 12 SAE and 5 first-class stamps.

Needs: Visual art. Shots of crafts: clay, metal, fiber, etc. Captions required.
Making Contact & Terms: Arrange a personal interview to show portfolio. Uses 8 × 10 glossy b&w prints; 4 × 5 transparencies and 35mm film; 4 × 5 color transparencies for cover, vertical format preferred. SASE. Reports in 1 month. Pays according to size of reproduction; $40 minimum/b&w and color photos; $175-500/cover photos. Pays on publication. Buys one-time rights. Previously published work OK.

AMERICAN FITNESS, Dept. PM, 15250 Ventura Blvd., Suite 200, Sherman Oaks CA 91403. (818)905-0040. Managing Editor: Rhonda J. Wilson. Circ. 30,000. Estab. 1983. Publication of the Aerobics and Fitness Association of America. Publishes 6 issues/year. Emphasizes exercise, fitness, health, sports nutrition, aerobic sports. Readers are fitness enthusiasts and professionals, 75% college educated, 66% female, majority between 20-45. Sample copy $2.50.
Needs: Uses about 20-40 photos/issue; most supplied by freelancers. Assigns 90% of work. Needs action photography of runners, aerobic classes, swimmers, bicyclists, speedwalkers, in-liners, volleyball players, etc. Special needs include food choices, male and female exercises, people enjoying recreation, dos and don'ts. Model release required.
Making Contact & Terms: Query with samples or with list of stock photo subjects. Send b&w prints; 35mm, 2¼ × 2¼ transparencies; b&w contact sheets by mail for consideration. SASE. Reports in 2 weeks. Pays $10-35/b&w or color photo; $50-100 for text/photo package. Pays 4-6 weeks after publication. Credit line given. Buys first North American serial rights. Simultaneous submissions and previously published work OK.
Tips: Looks for "firsthand fitness experiences—we frequently publish personal photo essays." Fitness-oriented outdoor sports are the current trend (i.e. mountain bicycling, hiking, rock climbing). Over-40 sports leagues, youth fitness, family fitness and senior fitness are also hot trends. Wants high-quality, professional photos of people participating in high-energy activities—anything that conveys the essence of a fabulous fitness lifestyle. Also accepts highly stylized studio shots to run as lead artwork for feature stories. "Since we don't have a big art budget, freelancers usually submit piggyback projects from their larger photo assignments."

AMERICAN FORESTS MAGAZINE, Dept. PM, 1516 P St. NW, Washington DC 20005. (202)667-3300. Fax: (202)667-2407. Editor: Bill Rooney. Circ. 25,000. Estab. 1895. Publication of American Forests. Bimonthly. Emphasizes use, enjoyment and management of forests and other natural resources. Readers are "people from all walks of life, from rural to urban settings, whose main common denominator is an abiding love for trees, forests or forestry." Sample copy and free photo guidelines with magazine-size envelope and 7 first-class stamps.
Needs: Uses about 40 photos/issue, 80% supplied by freelance photographers (most supplied by article authors). Needs woods scenics, wildlife, woods use/management and urban forestry shots. Model release preferred. Captions required, include who, what, where, when and why.
Making Contact & Terms: Interested in receiving work from newer, lesser-known photographers. Query with résumé of credits. SASE. Reports in 2 months. $300/color cover photo; $50-75/b&w inside; $75-200/color inside; $350-800 for text/photo package. Pays on acceptance. Credit line given. Buys one-time rights.
Tips: Seeing trend away from "static woods scenics, toward more people and action shots." In samples wants to see "overall sharpness, unusual conformation, shots that accurately portray the highlights and 'outsideness' of outdoor scenes."

AMERICAN HUNTER, 11250 Waples Mill Rd., Fairfax VA 22030-7400. (703)267-1300. Editor: Tom Fulgham. Circ. 1.4 million. Publication of the National Rifle Association. Monthly magazine. Sample copy and photo guidelines free with 9 × 12 SAE. Free writer's guidelines with SASE.
Needs: Uses wildlife shots and hunting action scenes. Photos purchased with or without accompanying ms. Seeks general hunting stories on North American game. Captions preferred.
Making Contact & Terms: Send material by mail for consideration. Uses 8 × 10 glossy b&w prints and 35mm color transparencies. (Uses 35mm transparencies for cover). Vertical format required for cover. SASE. Reports in 1 month. Pays $25/b&w print; $75-275/transparency; $300/color cover photo; $200-500 for text/photo package. Pays on publication for photos. Credit line given. Buys one-time rights.

Can't find a listing? Check at the end of each market section for the " '95-'96 Changes" lists. These lists include any market listings from the '95 edition which were either not verified or deleted in this edition.

AMERICAN MOTORCYCLIST, Dept. PM, P.O. Box 6114, Westerville OH 43081-6114. (614)891-2425. Vice President of Communication: Greg Harrison. Managing Editor: Bill Wood. Circ. 175,000. Publication of the American Motorcyclist Association. Monthly magazine. For "enthusiastic motorcyclists, investing considerable time in road riding or competition sides of the sport. We are interested in people involved in, and events dealing with, all aspects of motorcycling." Sample copy and photo guidelines for $1.50.
Needs: Buys 10-20 photos/issue. Subjects include: travel, technical, sports, humorous, photo essay/feature and celebrity/personality. Captions preferred.
Making Contact & Terms: Query with samples to be kept on file for possible future assignments. Reports in 3 weeks. SASE. Send 5×7 or 8×10 semigloss prints; transparencies. Pays $20-50/photo; $30-100/slide; $150 minimum/cover photo. Also buys photos in photo/text packages according to same rate; pays $6/column inch minimum for story. Pays on publication. Buys all rights.
Tips: Uses transparencies for covers. "The cover shot is tied in with the main story or theme of that issue and generally needs to be with accompanying ms. Show us experience in motorcycling photography and suggest your ability to meet our editorial needs and complement our philosophy."

THE AMERICAN MUSIC TEACHER, 441 Vine St., Suite 505, Cincinnati OH 45202-2814. (513)421-1420. Art Director: Stacy Clark. Circ. 26,000. Publication of Music Teachers National Association. Bimonthly magazine. Emphasizes music teaching. Readers are music teachers operating independently from conservatories, studios and homes.
Needs: Uses about 4 photos/issue; 3 supplied by freelancers. Needs photos of musical subject matter. Model release preferred. Captions preferred.
Making Contact & Terms: Query with résumé of credits. Query with samples. Query with list of stock photo subjects. Send unsolicited photos by mail for consideration. Provide résumé, business card, brochure, flier or tearsheets to be kept on file for possible future assignments. Uses 3×5 to 8×10 glossy b&w prints; 35mm, 2¼×2¼, 4×5 and 8×10 transparencies; b&w contact sheets. SASE. Pays $150 maximum/b&w photo; $250 maximum/color photo. **Pays on acceptance.** Credit line given. Buys one-time rights. Simultaneous submissions and previously published work OK.
Tips: In portfolio or samples, wants to see "teaching subjects, musical subject matter from classical to traditional, to computers and electronics, children and adults."

AMERICAN SAILOR, P.O. Box 209, Newport RI 02840. (401)849-5200. Fax: (401)849-5208. Managing Editor: Dana Marnane. Circ. 30,000. Estab. 1897. Publication of the US Sailing Association. Publishes 10 issues/year. Magazine. Emphasizes sailing. Readers are male and female sailors ages 15-70. Sample copy free with SASE.
Needs: Uses 15 photos/issue; most supplied by freelancers. Needs photos of one-design, big boat, multihull and/or windsurfing. Reviews photos with or without ms. Captions preferred; include date, location of event, name(s) of boats pictured.
Making Contact & Terms: Interested in receiving work from newer, lesser-known photographers. Send unsolicited photos by mail for consideration. Provide résumé, business card, brochure, flier or tearsheets to be kept on file for possible future assignments. Send slides or standard photograph. Does not keep samples on file. SASE. Reports in 1 month. "Small payment given. We are a nonprofit organization."
Tips: Looks for "vertical, colorful shots. No technicals, no power boats, no bikini-clad women; only sailing or sailboats."

ANCHOR NEWS, 75 Maritime Dr., Manitowoc WI 54220. (414)684-0218. Fax: (414)684-0219. Editor: Isco Valli. Circ. 1,900. Publication of the Wisconsin Maritime Museum. Quarterly magazine. Emphasizes Great Lakes maritime history. Readers include learned and lay readers interested in Great Lakes history. Sample copy free with 9×12 SAE and $1 postage. Guidelines free with SASE.
Needs: Uses 8-10 photos/issue; infrequently supplied by freelance photographers. Needs historic/nostalgic, personal experience and general interest articles on Great Lakes maritime topics. How-to and technical pieces and model ships and shipbuilding are OK. Special needs include historic photography or photos that show current historic trends of the Great Lakes. Photos of waterfront development, bulk carriers, sailors, recreational boating, etc. Model release required. Captions required.
Making Contact & Terms: Query with samples. Send 4×5 or 8×10 glossy b&w prints by mail for consideration. SASE. Reports in 1 month. Pays in copies only on publication. Credit line given. Buys first North American serial rights. Simultaneous submissions and previously published work OK.
Tips: "Besides historic photographs I see a growing interest in underwater archaeology, especially on the Great Lakes, and underwater exploration—also on the Great Lakes. Sharp, clear photographs are a must. Our publication deals with a wide variety of subjects; however, we take an historical slant with our publication. Therefore photos should be related to a historical topic in some respect. Also current trends in Great Lakes shipping. A query is most helpful. This will let the photographer know exactly what we are looking for and will help save a lot of time and wasted effort."

***ANGUS JOURNAL**, Dept. PM, 3201 Frederick Blvd., St. Joseph MO 64506. (816)233-0508. Fax: (816)233-0563. Editor: Jerilyn Johnson. Publication of the American Angus Association. Monthly. Circ. 20,000. Estab. 1979. Emphasizes purebred Angus cattle. Readers are Angus cattle breeders. Sample copy and photo guidelines free with 10×14 SAE and 7 first-class stamps.
Needs: "Only cover shots" are supplied by freelancers; 10% assigned and 10% from freelance stock. Needs scenic color shots of Angus cattle. Special needs include "cover shots, especially those depicting the four seasons. Winter scenes especially needed—vertical shots only." Identify as to farm's location.
Making Contact & Terms: Send slides and 8×10 color prints; 35mm, color contact sheet; and color negatives (all vertical shots). Provide résumé, business card, brochure, flier or tearsheets to be kept on file for possible future assignments. SASE. Pays $25-50/b&w photo; $200-350 color photo (cover); $150-250 photo/text package (photo story). **Pays on acceptance.** Credit line given. Buys all rights; rights purchased are negotiable.
Tips: "For covers: looks for creativity, pleasing-to-the eye scenery and compositions. Professional work *only*; perfect lighting, sharpness and composition. Would like to see more people (Angus farmers—kids, grandpa or grandma shots). Angus cattle shots should be purebred animals (black only) and quality animals preferred. Send us letter, sample of work and photo you would like to submit. Follow-up with a phone call or letter. We are often busy and may put letter aside. Be patient—allow us at least two months to reply."

ANIMALS, 350 S. Huntington Ave., Boston MA 02130. (617)522-7400. Fax: (617)522-4885. Photo Editor: Dietrich Gehring. Publication of the Massachusetts Society for the Prevention of Cruelty to Animals. Circ. 80,000. Estab. 1868. Bimonthly. Emphasizes animals, both wild and domestic. Readers are people interested in animals, conservation, animal welfare issues, pet care and wildlife. Sample copy $2.95 with 9×12 SAE. Photo guidelines free with SASE.
Needs: Uses about 45 photos/issue; approximately 95% supplied by freelance photographers. "All of our pictures portray animals, usually in their natural settings, however some in specific situations such as pets being treated by veterinarians or wildlife in captive breeding programs." Needs vary according to editorial coverage. Special needs include clear, crisp shots of animals, wild and domestic, both close-up and distance shots with spectacular backgrounds, or in the case of domestic animals, a comfortable home or backyard. Model release required in some cases. Captions preferred; include species, location.
Making Contact & Terms: Interested in receiving work from newer, lesser-known photographers. Query with résumé of credits; query with list of stock photo subjects. Provide résumé, business card, brochure, flier or tearsheets to be kept on file for possible future assignments. SASE. Reports in 6 weeks. Fees are usually negotiable; pays $50-150/b&w photo; $75-300/color photo; payment depends on size and placement. Pays on publication. Credit line given. Buys one-time rights.
Tips: Photos should be sent to Dietrich Gehring, Photo Editor, P.O. Box 740, Altamont NY 12009. Gehring does first screening. "Offer original ideas combined with extremely high-quality technical ability. Suggest article ideas to accompany your photos, but only propose yourself as author if you are qualified. We have a never-ending need for sharp, high-quality portraits of mixed-breed dogs and cats for both inside and cover use. Keep in mind we seldom use domestic cats outdoors; we often need indoor cat shots."

APA MONITOR, American Psychological Association, 750 First St. NE, Washington DC 20002. (202)336-6100. Editor: Sara Martin. Circ. 100,000. Monthly newspaper. Emphasizes "news and features of interest to psychologists and other behavioral scientists and professionals, including legislation and agency action affecting science and health, and major issues facing psychology both as a science and a mental health profession." Sample copy with $3 and 9×12 envelope.
Needs: Buys 60-90 photos/year. Photos purchased on assignment. Needs portraits, feature illustrations and spot news.
Making Contact & Terms: Arrange a personal interview to show portfolio or query with samples. Uses 5×7 and 8×10 glossy b&w prints; contact sheet OK; some 4-color use. SASE. Pays by the job; $60-75/hour; $250-400/day. Pays on receipt of invoice. Credit line given. Buys first serial rights.
Tips: "Become good at developing ideas for illustrating abstract concepts and innovative approaches to clichés such as meetings and speeches. We look for quality in technical reproduction and innovative approaches to subjects."

APERTURE, Dept. PM, 20 E. 23rd St., New York NY 10010. (212)505-5555. Managing Editor: Michael Sand. Circ. 16,000. Quarterly. Emphasizes fine art and contemporary photography, as well as social reportage. Readers include photographers, artists, collectors.
Needs: Uses about 60 photos/issue; issues are generally thematic—regular portfolio review. Model release required. Captions required.
Making Contact & Terms: Submit portfolio for review. SASE. Reports in 1 month. No payment. Credit line given.
Tips: "We are a nonprofit foundation and do not pay for photos."

APPALACHIAN TRAILWAY NEWS, Box 807, Harpers Ferry WV 25425. (304)535-6331. Fax: (304)535-2667. Editor: Judith Jenner. Circ. 26,000. Estab. 1939. Publication of the Appalachian Trail Conference. Bimonthly. Emphasizes the Appalachian Trail. Readers are conservationists, hikers. Sample copy $3 (includes postage and guidelines). Guidelines free with SASE.
Needs: Uses about 20-30 b&w photos/issue; 4-5 supplied by freelance photographers (plus 13 color slides each year for calendar). Needs scenes from/on the Appalachian Trail; specifically of people using or maintaining the trail. Special needs include candids—people/wildlife/trail scenes. Photo information required.
Making Contact & Terms: Query ideas. Send 5×7 or larger glossy b&w prints; b&w contact sheet; or 35mm transparencies by mail for consideration. SASE. Reports in 3 weeks. **Pays on acceptance.** Pays $150/cover photo; $200 minimum/color slide calendar photo; $10-50/b&w inside photo. Credit line given. Rights negotiable. Simultaneous submissions and/or previously published work OK.

APPALOOSA JOURNAL, P.O. Box 8403, Moscow ID 83843. (208)882-5578. Fax: (208)882-8150. Editor: Debbie Moors. Circ. 14,000. Estab. 1946. Association publication of Appaloosa Horse Club. Monthly magazine. Emphasizes Appaloosa horses. Readers are Appaloosa owners, breeders and trainers, child through adult. Sample copy $3. Photo guidelines free with SASE.
Needs: Uses 30 photos/issue; 10% supplied by freelance photographers. Needs photos (color and b&w) to accompany features and articles. Special photo needs include photographs of Appaloosas (high quality horses) in winter scenes. Model release required. Captions required.
Making Contact & Terms: Send unsolicited 8×10 b&w and color prints or 35mm and 2¼×2¼ transparencies by mail for consideration. Reports in 3 weeks. Pays $100-300/color cover photo; $25-50/color inside photo; $25-50/b&w inside photo. **Pays on acceptance.** Credit line given. Buys first North American serial rights. Previously published work OK.
Tips: In photographer's samples, wants to see "high-quality color photos of world class, characteristic Appaloosa horses with people in appropriate outdoor environment. We often need a freelancer to illustrate a manuscript we have purchased. We need specific photos and usually very quickly."

ARMY MAGAZINE, 2425 Wilson Blvd., Arlington VA 22201. (703)841-4300. Fax: (703)525-9039. Art Director: Patty Zukerowski. Circ. 110,000. Publication of the U.S. Army. Monthly magazine. Emphasizes military events, topics, history (specifically U.S. Army related). Readers are male/female military personnel—active and retired; defense industries. Sample copy free with 8×10 SASE.
Needs: Uses 20-40 photos/issue; 10-20% supplied by freelancers. Needs photos of military events, news events, famous people and politicans, military technology. Model release required. Captions required.
Making Contact & Terms: Interested in receiving work from newer, lesser-known photographers. Query with résumé of credits. Send unsolicited photos by mail for consideration. Provide résumé, business card, brochure, flier or tearsheets to be kept on file for possible assignments. Send 5×7—8×10 color or b&w prints; 35mm, 2¼×2¼, 4×5, 8×10 transparencies. Keeps samples on file. SASE. Reports in 3 weeks. Pays $125-600/color cover photo; $100-400/b&w cover photo; $75-250/color inside photo; $50/b&w inside photo; $100-400/color page rate; $75-200/b&w page rate. Pays on publication. Buys one-time rights; negotiable.

ARMY RESERVE MAGAZINE, 1815 N. Fort Myer Dr., Room 305, Arlington VA 22209-1805. (703)696-6212. Fax: (703)696-3745. Editor: Lt. Col. James M. Nielsen. Circ. 665,000. Estab. 1955. Publication for U.S. Army Reserve. Quarterly magazine. Emphasizes training and employment of Army Reservists. Readers are ages 17-60, 60% male, 40% female, all occupations. No particular focus on civilian employment. Sample copy free. Write for guidelines.
 ● *Army Reserve Magazine* won the NAGC International "Blue Pencil" award for outstanding governmental magazine.
Needs: Uses 35-45 photos/issue; 85% supplied by freelancers. Needs photos related to the mission or function of the U.S. Army Reserve. "We're looking for well-written feature stories accompanied by high-quality photos." Model release preferred (if of a civilian or non-affiliated person). Captions required.
Making Contact & Terms: Interested in receiving work from newer, lesser-known photographers. "Call the editor to discuss your idea." Uses 5×7 b&w prints; 35mm or 2¼×2¼ transparencies. Reports in 1 month. "No pay for material; credit only since we are a government publication." Unable to purchase rights, but consider as "one-time usage." Simultaneous submissions and previously published work OK.
Tips: "High quality color transparencies and prints of Army Reserve related training or community activities are in demand."

***ARTHRITIS TODAY**, 1314 Spring St., NW, Atlanta GA 30309. (404)872-7100. Fax: (404)872-9559. Art Director: Deb Gaston. Circ. 500,000. Estab. 1994. Bimonthly magazine. Emphasizes arthritis. Readers are primarily female, over 50 with interest in travel, crafts, foods (diets) and research into the

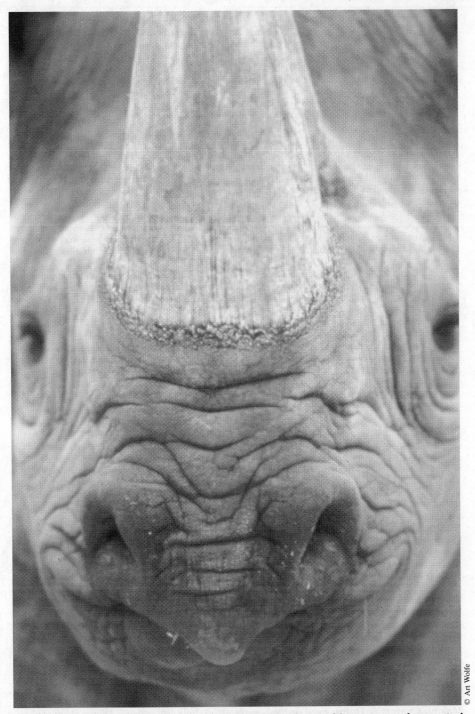

© Art Wolfe

Nature and wildlife photographer Art Wolfe of Seattle, Washington, says he wanted to show an ''in-your-face'' attitude when photographing this black rhinoceros. The image was used by Animals magazine for $125 to illustrate text on endangered species.

cure for arthritis. Sample copy available on a limited basis. Photo guidelines available.
Needs: Uses 7-20 photos/issue; 75-100% supplied by freelancers. Needs photos of people, lifestyles, research, doctor-patient. Model/property release required for people, locations, other publications or photographs.
Making Contact & Terms: Interested in receiving work from newer, lesser-known photographers. Provide résumé, business card, brochure, flier or tearsheets to be kept on file for possible assignments. SASE. Samples are kept on file until a need arises for a particular photographer's location or style. NPI. Payment based on individual assignment and budget. **Pays on acceptance.** Credit line given. Buys first North American serial rights with unlimited reprint rights for Arthritis Foundation affiliated publications.

AUTO TRIM NEWS, 6255 Barfield Rd., Suite 200, Atlanta GA 30328-4300. (404)252-8831. Fax: (404)252-4436. Associate Publisher/Editor: Gary Fong. Circ. 8,503. Estab. 1951. Publication of National Association of Auto Trim and Restyling Shops. Monthly. Emphasizes automobile restoration and restyling. Readers are upholsterers for auto/marine trim shops; body shops handling cosmetic soft goods for vehicles.
Needs: Uses about 15 photos/issue; 6-10 supplied by freelance photographers, all on assignment. Needs "how-to photos; photos of new store openings; restyling showcase photos of unusual completed work." Special needs include "restyling ideas for new cars in the aftermarket area; soft goods and chrome add-ons to update Detroit." Also needs feature and cover-experienced photographers. Captions required.
Making Contact & Terms: Interested in receiving work from photographers with a minimum of 5 years experience. Provide résumé, business card, brochure, flier or tearsheets to be kept on file for possible future assignments. Call first with ideas for photo assignments in local area. Photographer should be in touch with a cooperative shop locally. SASE. Reports in 1 week. Pays $35/b&w photo; assignment fees negotiable. **Pays on acceptance.** Credit line given if desired. Buys all rights. Simultaneous submissions and previously published work OK.
Tips: "First learn the needs of a market or segment of an industry. Then translate it into photographic action so that readers can improve their businesses. In samples we look for experience in shop photography, ability to photograph technical subject matter within automotive and marine industries."

THE BACKSTRETCH, 19899 W. Nine Mile Rd., Southfield MI 48075. (810)354-3232. Fax: (810)354-3157. Editor-in-Chief: Harriet H. Dalley. Circ. 12,000. Estab. 1962. Publication of United Thoroughbred Trainers of America, Inc. Bimonthly magazine. Emphasizes Thoroughbred racing. Readers are Thoroughbred trainers, owners, breeders, and racing fans of all ages. Sample copy $3.
 • In 1994 *The Backstretch* won 3rd Place for Service to the Reader, as well as an honorable mention.
Needs: Uses 60-75 photos/issue. Needs photos of racing personalities, current and historic famous Thoroughbred horses, racing tracks, other locations associated with racing and current editorial topics. Special photo needs include cover photos and photographic needs to fulfill specific editorial requirements. Model release preferred. Captions preferred; include photo subject names (correctly spelled), location of photo, date of photo.
Making Contact & Terms: Interested in receiving work from newer, lesser-known photographers. Query with résumé of credits. Send unsolicited photos by mail for consideration. Provide résumé, business card, brochure, flier or tearsheets to be kept on file for possible assignments. Send 3×5 or larger glossy color or b&w prints; 35mm transparencies. SASE. "Response time may be longer than 1 month due to staff limitations." NPI. Pays on publication. Credit line given. Buys first North American serial rights; "depends upon publication needs."
Tips: "*Backstretch* is not looking for the traditional Thoroughbred-crossing-the-finish-line photo, but for good, stock photos (color prints preferable) that can be used b&w or color."

THE BIBLE ADVOCATE, P.O. Box 33677, Denver CO 80233. (303)452-7973. Fax: (303)452-0657. Editor: Roy A. Marrs. Circ. 12,500. Estab. 1863. Publication of the Church of God (Seventh Day). Monthly magazine; 11 issues/year. Emphasizes Christian and denominational subjects. Sample copy free with 9×12 SAE and 4 first-class stamps.
Needs: Needs scenics and some religious shots (Jerusalem, etc.). Captions preferred, include name, place.
Making Contact & Terms: Interested in receiving work from newer, lesser-known photographers. Submit portfolio for review. SASE. Reports as needed. No payment offered. Rights negotiable. Simultaneous submissions and previously published work OK.
Tips: "We especially need fall and winter slides for the front cover." Wants to see "b&w prints for inside and 35mm color transparencies for front cover—religious, nature, people." To break in, "be patient—right now we use material on an as-needed basis. We will look at all work, but please realize we don't pay for photos or cover art. Send samples and we'll review them. We are working several

months in advance now. If we like a photographer's work, we schedule it for a particular issue so we don't hold it indefinitely."

BOWLING MAGAZINE, 5301 S. 76th St., Greendale WI 53129. (414)421-6400. Fax: (414)421-1194. Editor: Bill Vint. Circ. 150,000. Estab. 1938. Published by the American Bowling Congress. Bimonthly. Emphasizes bowling for readers who are bowlers, bowling fans or media. Free sample copy. Photo guidelines with SASE.
Needs: Uses about 20 photos/issue, 1 of which, on the average, is supplied by a freelancer. Model/property release preferred. Captions required.
Making Contact & Terms: Interested in receiving work from newer, lesser-known photographers. Provide calling card and letter of inquiry to be kept on file for possible future assignments. "In almost all cases we like to keep photos. Our staff takes almost all photos as they deal mainly with editorial copy published. Rarely do we have a photo page or need freelance photos. No posed action." Send 5×7 or 8×10 b&w or color photos by mail for consideration. SASE. Reports in 2 weeks. Pays $20-25/b&w photo; $25-50/color photo. Pays on publication. Credit line given. Buys one-time rights, but photos are kept on file after use. No simultaneous submissions or previously published work.

CALIFORNIA NURSE, 1145 Market St., Suite 1100, San Francisco CA 94103-1545. Fax: (415)431-1011. Managing Editor: Jennifer Watson. Circ. 28,000. Estab. 1904. Publication of California Nurses Association. Monthly tabloid. Emphasizes nursing. Readers are adults, male and female nurses. Sample copy free with SASE.
Needs: Uses 15-20 photos/issue; 10% supplied by freelancers. Needs photos of nurses, medical technology and populations served by health professionals, (e.g. elderly, infants, uninsured). Model release and photo descriptions required.
Making Contact & Terms: Interested in receiving work from newer, lesser-known photographers. Send unsolicited 4×5 or 5×7 glossy b&w prints by mail for consideration. Provide résumé, business card, brochure, flier or tearsheets to be kept on file for possible assignments. Phone calls acceptable. SASE. Reports in 3 weeks. Pays $25-50/b&w cover photo; $20/b&w inside photo. Pays on publication. Buys one-time rights. Simultaneous submissions OK.
Tips: "Best choices are sensitive shots of people needing or receiving health care or RNs at work. Send sample photos, well-tailored to individual publication."

CALYPSO LOG, 870 Greenbrier Circle, Suite 402, Chesapeake VA 23320. (804)523-9335. Editor: Paul Clancy. Circ. 200,000. Publication of The Cousteau Society. Bimonthly. Emphasizes expedition activities of The Cousteau Society; educational/science articles; environmental activities. Readers are members of The Cousteau Society. Sample copy $2 with 9×12 SAE and $1 postage. Photo guidelines free with SASE.
Needs: Uses 10-14 photos/issue; 1-2 supplied by freelancers; 2-3 photos/issue from freelance stock.
Making Contact & Terms: Query with samples and list of stock photo subjects. Uses color prints; 35mm and 2¼×2¼ transparencies (duplicates only). SASE. Reports in 5 weeks. Pays $50-200/color photo. Pays on publication. Buys one-time rights and "translation rights for our French publication." Previously published work OK.
Tips: Sharp, clear, good composition and color; unusual animals or views of environmental features. Prefers transparencies over prints. "We look for ecological stories, food chain, prey-predator interaction and impact of people on environment. Please request a copy of our publication to familiarize yourself with our style, content and tone and then send samples that best represent underwater and environmental photography."

✦CANADA LUTHERAN, 1512 St. James St., Winnipeg, Manitoba R3H 0L2 Canada. (204)786-6707. Fax: (204)783-7548. Art Director: Darrell Dyck. Editor: Kenn Ward. Circ. 25,000. Estab. 1986. Publication of Evangelical Lutheran Church in Canada. Monthly. Emphasizes faith/religious content; Lutheran denomination. Readers are members of the Evangelical Lutheran Church in Canada. Sample copy for $1.50 with 9×12 SAE and $1 postage (Canadian).
Needs: Uses 4-10 photos/issue; most supplied though article contributors; 1 or 2 supplied by freelancers. Needs photos of people (in worship/work/play etc.).
Making Contact & Terms: Interested in receiving work from newer, lesser-known photographers. Send 5×7 glossy prints or 35mm transparencies by mail for consideration. SASE. Pays $15-50/b&w photo; $40-75/color photo. Pays on publication. Credit line given. Buys one-time rights.
Tips: "Trend toward more men and women in non-stereotypical roles. Do not restrict photo submissions to just the categories you believe we need. Sometimes a surprise shot works perfectly for a subject. Give us many photos that show your range. We prefer to keep them on file for at least a year. We have a short term turnaround and turn to our file on a monthly basis to illustrate articles or cover concepts."

CAR & TRAVEL, (formerly *AAA World*), 1000 AAA Dr., Heathrow, FL 32746-5063. (407)444-8544. Editor and Publisher: Doug Damerst. Art Director: Emilie Whitcomb. Circ. 4,600,000. Estab. 1995.

Steve Skjold of St. Paul, Minnesota, initially submitted this photo to Canada Lutheran *magazine along with 60 other slides focusing on teens. Editor Darrell Dyck says he kept the image on file and found it when he began searching for a cover shot. "We didn't need to dig around for it or assign the photo in advance," says Dyck. In all, the image has sold a dozen times; eight times it was used in color and four in black & white.*

© Skjold Photographs

Member publication of AAA (ABC member). Bimonthly magazine (except monthly in Metro New York) emphasizing how to drive, car care, how to travel and travel destinations. Readers are above average income and age. Sample copy free.
Needs: Uses 60 photos/issue; 20 supplied by freelancers. Needs photos of people enjoying domestic and international vacation settings. Model release required. Captions preferred.
Making Contact & Terms: Provide résumé, business card, brochure, flier or tearsheets to be kept on file for possible future assignments. Cannot return material. Reports in 3 weeks. Pays $75/color inside photo. **Pays on acceptance.** Credit line given. Buys one-time rights. Simultaneous submissions and previously published submissions OK.
Tips: "Our need is for travel photos, but not of places as much as of Americans enjoying travel."

CEA ADVISOR, Dept. PM, Connecticut Education Association, 21 Oak St., Hartford CT 06106. (203)525-5641. Managing Editor: Michael Lydick. Circ. 30,000. Monthly tabloid. Emphasizes education. Readers are public school teachers. Sample copy free with 6 first-class stamps.
Needs: Uses about 20 photos/issue; 1 or 2 supplied by freelancers. Needs "classroom scenes, students, school buildings." Model release preferred. Captions preferred.
Making Contact & Terms: Send b&w contact sheet by mail for consideration. Provide résumé, business card, brochure, flier or tearsheets to be kept on file for possible future assignments. Cannot return material. Reports in 1 month. Pays $50/b&w cover photo; $25/b&w inside photo. Pays on publication. Credit line given. Buys all rights. Simultaneous submissions and/or previously published work OK.

CHESS LIFE, Dept. PM, 186 Route 9W, New Windsor NY 12553. (914)562-8350. Fax: (914)561-CHES (2437). Editor-in-Chief: Glenn Petersen. Art Director: Jami Anson. Circ. 70,000. Estab. 1939. Publication of the U.S. Chess Federation. Monthly. *Chess Life* covers news of all major national and international tournaments; historical articles, personality profiles, columns of instruction, occasional fiction, humor . . . for the devoted fan of chess. Sample copy and photo guidelines free with SAE and 3 first-class stamps.
Needs: Uses about 10 photos/issue; 7-8 supplied by freelancers. Needs "news photos from events around the country; shots for personality profiles." Special needs include "Chess Review" section. Model release preferred. Captions preferred.
Making Contact & Terms: Interested in receiving work from newer, lesser-known photographers. Query with samples. Provide business card and tearsheets to be kept on file for possible future assignments. SASE. Reports in "2-4 weeks, depending on when the deadline crunch occurs." Pays $150-300/b&w or color cover photo; $25/b&w inside photo; $35/color inside photo; $15-30/hour; $150-

250/day. Pays on publication. Credit line given. Buys one-time rights; "we occasionally purchase all rights for stock mug shots." Simultaneous submissions and previously published work OK.
Tips: Using "more color, and more illustrative photography. The photographer's name and date should appear on the back of all photos. 35mm color transparencies are preferred for cover shots." Looks for "clear images, good composition and contrast—with a fresh approach to interest the viewer. Increasing emphasis on strong portraits of chess personalities, especially Americans. Tournament photographs of winning players and key games are in high demand."

CHILDREN'S DEFENSE FUND, 25 E St. NW, Washington DC 20001. (202)628-8787. Fax: (202)662-3530. Production Manager: Janis Johnston. Specializes in newsletters and books.
Needs: Buys 50 photos/year. Buys stock and assigns work. Wants to see children of all ages and ethnicity, serious, playful, poor, middle class, school setting, home setting and health setting. Does not want to see studio portraits. Domestic photos only. Model/property release required.
Making Contact & Terms: Provide résumé, business card, self-promotion piece or tearsheets to be kept on file for possible future assignments. Uses b&w prints only. Keeps photocopy samples on file. SASE. Reports in 1-2 weeks. Pays $50-75/hour; $125-500/day; $50-150/b&w photo. Pays on usage. Credit line given. Buys one-time rights. Previously published work OK.
Tips: Looks for "good, clear focus, nice composition, variety of settings and good expressions on faces."

CHRISTIAN HOME & SCHOOL, 3350 E. Paris Ave. SE, Grand Rapids MI 49512-3054. (616)957-1070. Senior Editor: Roger Schmurr. Circ. 57,000. Estab. 1922. Publication of Christian Schools International. Published 6 times a year. Emphasizes Christian family issues. Readers are parents who support Christian education. Sample copy free with 9 × 12 SAE with 4 first-class stamps. Photo guidelines free with SASE.
Needs: Uses 10-15 photos/issue; 7-10 supplied by freelancers. Needs photos of children, family activities, school scenes. Model release preferred.
Making Contact & Terms: Query with samples. Query with list of stock photo subjects. Send b&w prints or contact sheets by mail for consideration. SASE. Reports in 3 weeks. Pays color: $125/inside editorial; $250/cover; b&w: $50/b&w inside spot usage. Pays on publication. Credit line given. Buys one-time rights. Simultaneous submissions and previously published work OK.
Tips: Assignment work is becoming rare. Freelance stock most often used. "Photographers who allow us to hold duplicate photos for an extended period of time stand more chance of having their photos selected for publication than those who require speedy return of submitted photos."

CIVITAN MAGAZINE, P. O. Box 130744, Birmingham AL 35213-0744. (205)591-8910. Editor: Dorothy Wellborn. Circ. 36,000. Estab. 1920. Publication of Civitan International. Bimonthly magazine. Emphasizes work with mental retardation/developmental disabilities. Readers are men and women, college age to retirement and usually managers or owners of businesses. Sample copy free with 9 × 12 SAE and 2 first-class stamps. Photo guidelines not available.
Needs: Uses 8-10 photos/issue; 50% supplied by freelancers. Always looking for good cover shots (travel, scenic and how-tos). Model release preferred. Captions preferred.
Making Contact & Terms: Send unsolicited 2¼ × 2¼ or 4 × 5 transparencies or b&w prints by mail for consideration. Provide résumé, business card, brochure, flier or tearsheets to be kept on file for possible assignments. Reports in 1 month. Pays $50/color cover photo; $10 b&w inside photo. **Pays on acceptance.** Buys one-time rights. Simultaneous submissions and previously published work OK.

COMMERCIAL INVESTMENT REAL ESTATE JOURNAL, 430 N. Michigan Ave., Suite 600, Chicago IL 60611. (312)321-4464. Fax: (312)321-4530. Editor: Catherine Simpson. Circ. 9,000. Estab. 1983. Publication of Commercial-Investment Real Estate Institute. Published 5 times/year. Emphasizes commercial real estate brokerage and consulting. Readers are commercial real estate brokers, consultants, developers, mortgage bankers, attorneys. Sample copy free with 9 × 12 SAE and 6 first-class stamps.
Needs: Uses 3-6 photos/issue; occasionally supplied by freelance photographers. Photo needs vary; may be office scenes, buildings, high-resolution close-ups for special effects, etc.
Making Contact & Terms: Provide résumé, business card, brochure, flier or tearsheets to be kept on file for possible assignments. Pays $800-900/color cover photo; $150-250/b&w inside photo. **Pays on acceptance.** Credit line given. Buys first North American serial rights. Previously published work OK.

The Subject Index, located at the back of this book, can help you find publications interested in the topics you shoot.

COMPANY: A MAGAZINE OF THE AMERICAN JESUITS, Dept. PM, 3441 N. Ashland Ave., Chicago IL 60657. (312)281-1534. Fax: (312)281-2667. Editor: Martin McHugh. Circ. 128,000. Estab. 1983. Published by the Jesuits (Society of Jesus). Quarterly magazine. Emphasizes people; "a human interest magazine about people helping people." Sample copy free with 9 × 12 SAE and 4 first-class stamps. Photo guidelines free with SASE.

Needs: All photos supplied by freelancers. Needs photo-stories of Jesuit and allied ministries and projects, only photos related to Jesuit works. Photos purchased with or without accompanying ms. Model release required. Captions required.

Making Contact & Terms: Interested in receiving work from newer, lesser-known photographers. Query with samples. Provide résumé, business card, brochure, flier or tearsheets to be kept on file for possible future assignments. SASE. Reports in 1 month. Pays $300/color cover photo; $100-400/job. Pays on publication. Credit line given. Buys one-time rights; negotiable.

Tips: "Avoid large-group, 'smile-at-camera' photos. We are interested in people photographs that tell a story in a sensitive way—the eye-catching look that something is happening."

CURRENTS, Voice of the National Organization for River Sports, Box 6359, Ketchum ID 83340. (208)726-8865. Editor: Greg Moore. Circ. 10,000. Estab. 1979. Quarterly magazine. Membership publication of National Organization for River Sports, for canoeists, kayakers and rafters. Emphasizes river conservation and river access, also techniques of river running. Sample copy $1. Writer's and photographer's guidelines free with #10 SASE.

Needs: Buys 10 photos/issue; 25% assigned, 75% unsolicited. Photo essay/photo feature (on rivers of interest to river runners). Need features on rivers that are in the news because of public works projects, use regulations, wild and scenic consideration or access prohibitions. Sport newsphotos of canoeing, kayaking, rafting and other forms of (whitewater) river paddling, especially photos of national canoe and kayak races; nature/river subjects, conservation-oriented; travel (river runs of interest to a nationwide membership). Wants on a regular basis close-up action shots of whitewater river running and shots of dams in progress, signs prohibiting access. Especially needs for next year shots of whitewater rivers that are threatened by dams, showing specific stretch to be flooded and dam-builders at work. No "panoramas of river runners taken from up on the bank or the edge of a highway. We must be able to see their faces, front-on shots. We always need photos of the twenty (most) popular whitewater river runs around the US." Photos purchased with or without accompanying ms. "We are looking for articles on whitewater rivers that are in the news regionally and nationally—for example, rivers endangered by damming; access is limited by government decree; rivers being considered for wild and scenic status; rivers offering a setting for unusual expeditions and runs; and rivers having an interest beyond the mere fact that they can be paddled. Also articles interviewing experts in the field about river techniques, equipment and history." Captions required.

Making Contact & Terms: Interested in receiving work from newer, lesser-known photographers. Send material or photocopies of work by mail for consideration. "We need to know of photographers in various parts of the country." Provide tearsheets or photocopies of work to be kept on file for possible future assignments. Uses 5 × 7 and 8 × 10 glossy b&w prints. Occasional color prints. Query before submitting color transparencies. SASE. Reports in 2 weeks. Pays $30-50/b&w print or color prints or transparencies; $50-150 text/photo package; $35 minimum/interview article. Credit line given. Buys one-time rights. Simultaneous submissions and previously published work OK if labeled clearly as such.

Tips: "Needs more squirt boating photos, photos of women and opening canoeing photos. Looks for close-up action shots of whitewater river runners in kayaks, rafts, canoes or dories. Little or no red. Show faces of paddlers. Photos must be clear and sharp. Tell us where the photo was taken—name of river, state and name of rapid, if possible."

***❧ CYCLING: BC**, Dept. PM, 332-1367 W. Broadway, Vancouver, British Columbia V6H 4A9 Canada. Fax: (604)738-7175. Office Manager: Nele Blaton. Circ. 2,600. Estab. 1974. Monthly newsletter. Publication of Cycling BC. Emphasizes bicycling. Readers are 14-75 years old, male and female. Sample copy free with #10 SAE and IRC.

Needs: Uses all types of cycling photos, regional and current context necessary. Action photos preferred.

Making Contact & Terms: Send b&w and color prints by mail for consideration. SAE and IRC. No payment. Reports in 2 weeks. Credit line given. Previously published work OK.

Tips: "Our readers prefer detail: riders' expressions, musculature, equipment. To capture movement, compose around center of gravity, the contact surfaces of wheels."

DEFENDERS, 1101 14th St. NW, Suite 1400, Washington DC 20005. (202)682-9400. Fax: (202)682-1334. Editor: James G. Deane. Circ. 90,000. Membership publication of Defenders of Wildlife. Quarterly magazine. Emphasizes wildlife and wildlife habitat. Sample copy free with 9 × 12½ SAE and 6 first-class stamps. Photo guidelines free with SASE.

Needs: Uses 35 or more photos/issue; "almost all" from freelancers. Captions required.
Making Contact & Terms: Query with list of stock photo subjects. In portfolio or samples, wants to see "wildlife group action and behaviorial shots in preference to static portraits. High technical quality." SASE. Reports ASAP. Pays $50-100/b&w photo; $75-450/color photo. Pays on publication. Credit line given. Buys one-time rights.
Tips: "*Defenders* focuses heavily on endangered species and destruction of their habitats, wildlife refuges and wildlife management issues, primarily North American, but also some foreign. Images must be sharp. Cover images must be vertical (unless in a wrap), able to take the logo up top, and be arresting and *simple*. Think twice before submitting anything but low speed (preferably Kodachrome) transparencies."

DIVERSION MAGAZINE, 1790 Broadway, 6th Floor, New York NY 10019. (212)969-7542. Fax: (212)969-7557. Photo Editor: Ericka Camastro. Circ. 176,000. Monthly magazine. Emphasizes travel. Readers are doctors/physicians. Sample copy free with SASE.
 • Editor for *Diversion* sometimes conducts photo research by using Kodak Picture Exchange.
Needs: Uses varying number of photos/issue; all supplied by freelancers. Needs a variety of subjects, "mostly worldwide travel. Hotels, restaurants and people." Model/property release preferred. Captions preferred; include precise locations.
Making Contact & Terms: Interested in receiving work from newer, lesser-known photographers. Query with list of stock photo subjects. Keeps samples on file. SASE. Reports in 3 weeks. Pays $350/color cover photo; $135/quarter color page inside photo; $225/color full page rate; $200-250/day. Pays on publication. Credit line given. Buys one-time rights. Simultaneous submissions and/or previously published work OK.
Tips: "Send updated stock list and photo samples regularly."

***DOLL READER, Cowles Magazines**, 6405 Flank Dr., Harrisburg PA 17112. (717)540-6656. Fax: (717)540-6169. Managing Editor: Deborah Thompson. Estab. 1972. Magazine published 9 times/year. Emphasizes doll collecting. Photo guidelines free with SASE.
Needs: Buys 100-250 photos/year; 50 photos/year supplied by freelancers. "We need photos of specific dolls to accompany our articles." Model/property release required. Captions required; include name of object, height, medium, edition size, costume and accessory description; name, address, telephone number of artist or manufacturer; price.
Making Contact & Terms: Interested in receiving work from newer, lesser-known photographers. Send unsolicited photos by mail for consideration. Provide résumé, business card, brochure, flier or tearsheets to be kept on file for possible assignments. Submit portfolio for review. Query with stock photo list. Query with sample. Send 3½×5 glossy color prints; 35mm, 2¼×2¼, 4×5 trapnsparencies. Transparencies are preferred. Keeps samples on file.SASE. Reports in 1 month. NPI. "If photos are accepted, we pay on receipt of invoice." Credit line given. Buys all rights. Simultaneous submissions OK.

THE DOLPHIN LOG, 870 Greenbrier Circle, Suite 402, Chesapeake VA 23320. (804)523-9335. Fax: (804)523-2747. Editor: Liz Foley. Circ. 80,000. Estab. 1981. Publication of The Cousteau Society, Inc., a nonprofit organization. Bimonthly magazine. Emphasizes "ocean and water-related subject matter for children ages 7 to 13." Sample copy $2.50 with 9×12 SAE and 3 first-class stamps. Photo guidelines free with SASE.
Needs: Uses about 20 photos/issue; 2-6 supplied by freelancers; 10% stock. Needs "selections of images of individual creatures or subjects, such as architects and builders of the sea, how sea animals eat, the smallest and largest things in the sea, the different forms of tails in sea animals, resemblances of sea creatures to other things. Also excellent potential for cover shots or images which elicit curiosity, humor or interest." No aquarium shots. Model release required if person is recognizable. Captions preferred, include when, where and, if possible, scientifically accurate identification of animal.
Making Contact & Terms: Query with samples or list of stock photos. Send 35mm, 4×5 transparencies or b&w contact sheets by mail for consideration. Send duplicates only. SASE. Reports in 1 month. Pays $75-200/color photo. Pays on publication. Credit line given. Buys one-time rights and worldwide translation rights. Simultaneous and previously published submissions OK.
Tips: Prefers to see "rich color, sharp focus and interesting action of water-related subjects" in samples. "No assignments are made. A large amount is staff-shot. However, we use a fair amount of freelance photography, usually pulled from our files, approximately 45-50%. Stock photos purchased only when an author's sources are insufficient or we have need for a shot not in file. These are most often hard-to-find creatures of the sea." To break in, "send a good submission of dupes in keeping with our magazine's tone/content; be flexible in allowing us to hold slides for consideration."

DUCKS UNLIMITED, One Waterfowl Way, Memphis TN 38120. (901)758-3825. Production Coordinator: Diane Jolie. Circ. 520,000. Estab. 1937. Association publication of Ducks Unlimited. Bimonthly

magazine. Emphasizes waterfowl conservation. Readers are professional males, ages 40-50. Sample copy $3. Guidelines free with SASE.

Needs: Uses 20-30 photos/issue; 70% supplied by freelance photographers. Needs wildlife shots (waterfowl/waterfowling), scenics and personalities. Special photo needs include dynamic shots of waterfowl interacting in natural habitat.

Making Contact & Terms: Send 20-40 35mm or larger transparencies with ideas for consideration. SASE. Reports in 1 month. Pays $100 for images less than half page; $125/half page; $150/full page; $225/2-page spread; $400/cover photo; $600/photo essay. **Pays on acceptance.** Credit line given. Buys one-time rights plus permission to reprint in our Mexican and Canadian publications. Previously published work OK.

EASTERN CHALLENGE, P.O. Box 14866, Reading PA 19612-4866. (610)375-0300. Fax: (610)375-6862. Editor: Dr. Osborne Buchanan, Jr. Circ. 22,000. Estab. 1967. Publication of the International Missions, Inc. Quarterly magazine. Emphasizes "church-planting ministry in a number of countries." Sample copy free with SASE.

• *Eastern Challenge* is beginning to use photos that are available on CD-ROM discs.

Needs: Uses 2 photos/issue. Needs photos of scenics and personalities. Reviews photos with or without accompanying ms. Model/property release preferred. Captions preferred.

Making Contact & Terms: Send unsolicited photos by mail for consideration. Provide résumé, business card, brochure, flier or tearsheets to be kept on file for possible assignments. Keeps samples on file. SASE. Reports in 1 month. Pays "minimal or nominal amount; organization is nonprofit." Pays on publication. Credit line given. Buys all rights; negotiable. Simultaneous submissions and/or previously published work OK.

Tips: Looks for "color and contrast; relevance to program of organization."

ENVIRONMENTAL ACTION, 6930 Carroll Ave., Suite 600, Takoma Park MD 20910. (301)891-1106. Fax: (301)891-2218. Editor: Barbara Ruben. Circ. 14,000. Estab. 1970. Association publication of Environmental Action, Inc. Quarterly magazine. Emphasizes environmental subjects for activists of all ages. Sample copies $2.50.

Needs: Uses up to 10 photos/issue; 40% supplied by freelancers. 20% of photos come from assignments; 60% from stock. Needs photos that "illustrate environmental problems and issues, including solid waste, toxic waste and energy." Model/property release preferred. Captions preferred.

Making Contact & Terms: Interested in receiving work from newer, lesser-known photographers. Query with résumé of credits. Send stock photo list. Provide résumé, business card, brochure, flier or tearsheet to be kept on file for possible assignments. Does not keep samples on file. Cannot return material. Reports in 1 month. Pays $40-150/b&w cover photo; $25-75/b&w inside photo. Pays on publication. Credit line given. Buys one-time rights. Simultaneous submissions and previously published work OK.

Tips: "We only publish in b&w, but we will consider both color and b&w original photos."

FAMILY MOTOR COACHING, Dept. PM, 8291 Clough Pike, Cincinnati OH 45244. (513)474-3622. Editor: Pamela Wisby Kay. Circ. 99,000. Estab. 1963. Publication of Family Motor Coach Association. Monthly. Emphasizes motor homes. Readers are members of national association of motor home owners. Sample copy $2.50. Writer's/photographer's guidelines free with SASE.

Needs: Uses about 45-50 photos/issue; 40-45 supplied by freelance photographers. Each issue includes varied subject matter—primarily needs travel and scenic shots and how-to material. Photos purchased with accompanying ms only. Model release preferred. Captions required.

Making Contact & Terms: Query with résumé of credits. SASE. Reports in 6 weeks. Pays $100-500/text/photo package. **Pays on acceptance.** Credit line given if requested. Prefers first North American rights, but will consider one-time rights on photos *only*.

FELLOWSHIP, Box 271, Nyack NY 10960. (914)358-4601. Fax: (914)358-4924. Editor. Richard Deats. Circ. 8,500. Estab. 1935. Publication of the Fellowship of Reconciliation. Publishes 32-page b&w magazine 6 times/year. Emphasizes peace-making, social justice, nonviolent social change. Readers are religious peace fellowships—interfaith pacifists. Sample copy free with SASE.

Needs: Uses 8-10 photos/issue; 90% supplied by freelancers. Needs stock photos of monuments, civil disobedience, demonstrations—Middle East, Latin America, Caribbean, prisons, anti-nuclear, children, farm crisis, the former Soviet Union. Also natural beauty and scenic; b&w only. Captions required.

Making Contact & Terms: Provide résumé, business card, brochure, flier or tearsheets to be kept on file for possible future assignments. "Call on specs." SASE. Reports in 3 weeks. Pays $25/b&w cover photo; $13.50/b&w inside photo. Pays on publication. Credit line given. Buys one-time rights. Simultaneous submissions and/or previously published work OK.

Tips: "You must want to make a contribution to peace movements. Money is simply token (our authors contribute without tokens)."

FFA NEW HORIZONS, Box 15160, Alexandria VA 22309. (703)360-3600. Fax: (703)360-5524. Managing Editor: Lawinna McGary. Circ. 450,000. Estab. 1953. Publication of the National FFA Organization. Bimonthly magazine; 4-color. Emphasizes careers in agriculture/agribusiness, members and their successes and topics of general interest to youth. Readers are members of the FFA who are students of agricultural education in high school, ages 14-21. Photo guidelines free with SASE.
Needs: Uses 45 photos/issue; 18 supplied by freelancers. "We need exciting shots of our FFA members in action." Has continuing need for national coverage. Model/property release preferred. Photo captions required; include names, hometowns.
Making Contact & Terms: Provide résumé, business card, brochure, flier or tearsheets to be kept on file for possible assignments. Keeps samples on file. SASE. Reports in 1 month. Pays $100/color cover photo; $35/color inside photo; $20/b&w inside photo. **Pays on acceptance.** Credit line given. Buys all rights.
Tips: "We want to see energy and a sense that the photographer knows how to work with teenagers." Contact editor before doing any work. "We have specific needs and need good shooters."

***FIGURINES & COLLECTIBLES, Cowles Magazines**, 6405 Flank Dr., Harrisburg PA 17112. (717)540-6656. Fax: (717)540-6169. Managing Editor: Deborah Thompson. Estab. 1994. Emphasizes figurine collecting. Photo guidelines free with SASE.
Needs: "New project, but we have already used freelance photography in putting together first issue. We need photos of specific figurines to accompany our article." Model/property release required. Captions required; include name of object, height, medium, edition size and accessory description, name, address, telephone number of artist or manufacturer; price.
Making Contact & Terms: Interested in receiving work from newer, lesser-known photographers. Send unsolicited photos by mail for consideration. Provide résumé, business card, brochure, flier or tearsheets to be kept on file for possible assignments. Submit portfolio for review. Query with stock photo list. Query with samples. Send 3½×5 glossy color prints; 35mm, 2¼×2¼, 4×5 transparencies. Transparencies are preferred. Keeps samples on file. SASE. Reports in 1 month. NPI. "If photos are accepted, we pay on receipt of invoice." Credit line given. Buys all rights. Simultaneous submissions OK.

FLORIDA WILDLIFE, 620 S. Meridian St., Tallahassee FL 32399-1600. (904)488-5563. Fax: (904)488-6988. Editor: Dick Sublette. Circ. 29,000. Estab. 1947. Publication of the Florida Game & Fresh Water Fish Commission. Bimonthly magazine. Emphasizes wildlife, hunting, fishing, conservation. Readers are wildlife lovers, hunters and fishermen. Sample copy $2.95. Photo guidelines free with SASE.
● *Florida Wildlife* won the Silver Award Excellence, F.M.A., in 1994 for Design Excellence and Best Illustration.
Needs: Uses about 20-40 photos/issue; 75% supplied by freelance photojournalists. Needs Florida fishing and hunting, all flora and fauna of Southeastern US; how-to; covers and inside illustration. Do not feature products in photographs. No alcohol or tobacco. Special needs include hunting and fishing activities in Florida scenes; showing ethical and enjoyable use of outdoor resources. "Must be able to ID species and/or provide accurate natural history information with materials." Model release preferred. Captions required; include location and species.
Making Contact & Terms: Interested in receiving work from newer, lesser-known photographers. Query with samples. Send 35mm color transparencies by mail for consideration. "Do not send negatives." SASE. Keeps materials on file, or will review and return if requested. Pays $50-75/color back cover; $100/color front cover; $20-50/color inside photos. Pays on publication. Credit line given. Buys one-time rights; "other rights are sometimes negotiated." Simultaneous submissions OK "but we prefer originals over duplicates." Previously published work OK but must be mentioned when submitted.
Tips: "Study back issues to determine what we buy from freelancers (no saltwater species as a rule, etc.) Use flat slide mounting pages or individual sleeves. Show us your best. Annual photography contest often introduces us to good freelancers. Rules printed in March-April issue. Contest form must accompany entry; available in magazine or by writing/calling; winners receive honorarium and winning entries are printed in September-October and November-December issues."

GREEN BAY PACKER YEARBOOK, P.O. Box 1773, Green Bay WI 54305. (414)435-5100. Publisher: John Wemple. Sample copy free with 9×12 SASE.
Needs: Needs photos of Green Bay Packer football action shots in NFL cities other than Green Bay. Captions preferred.
Making Contact & Terms: Query with résumé of credits. Query with samples. Provide résumé, business card, brochure, flier or tearsheets to be kept on file for possible future assignments. Works with freelance photographers on assignment basis only. SASE. Reports in 2 weeks. Pays $50 maximum/color photo. Pays on acceptance or receipt of invoice. Credit line given on table of contents page. Buys all rights.

INSIDER REPORT

Challenge Yourself and Viewers

When James Balog of Boulder, Colorado, discusses *the art* of photography, it's obvious he thinks in grand visions. There's a passion for what he does, a drive that motivates him during a project. "I try to reach the complacency inside people who really don't think about the bigger issues of society," he says. "I want to challenge the viewer's preconceptions about his place in the natural order."

James Balog

Ambitious goals and a unique style generate Balog's inspired imagery. Photo editors all over the world are attracted to his work. *National Geographic*, *Life*, *American Photo* and *Geo* are just a few of the magazines in which his photos appear. He also has shown in galleries worldwide, including the Fahey/Klein Gallery in Los Angeles, the Corcoran Gallery of Art in Washington DC, and the Centre Nationale de la Photographie in Paris.

Balog believes that, in order to attract editors to your work, it is essential to have fresh ideas. "The photography schools and the art schools turn out more talented technicians every year than there are jobs in the marketplace of magazine photography. Creativity is the difference."

For Balog this means presenting issues in innovative ways. Take, for example, two of his books, *Anima* (Arts Alternative Press), an exploration of humans and nature, and *Survivors: A New Vision of Endangered Wildlife* (Harry N. Abrams Inc.). "I get excited about shooting projects that seem impossible. With *Survivors*, I knew it was a great idea and I knew it profoundly appealed to me, but I also had no idea if I could do it technically. How the hell do you get a rhino into the studio? How do you deal with crocodiles on white backgrounds?"

Actually, overcoming technical details, such as photographing endangered animals in a studio, was only half his battle. He also had to sell the ideas. When marketing the *Survivors* concept, Balog says most people didn't understand. *National Geographic*, in which he saw photo essay possibilities, turned him down three times. "I wound up shooting the entire thing, before they were interested."

Another hurdle is funding. While Balog believes in his ideas, funds aren't easy to acquire for major projects like the ones he tackles. He says photographers working on projects that cost $100,000-200,000 are lucky to receive $10,000-$15,000 worth of funding up front, either through grants, book advances or private donations. "There are no institutions out there that are eager to give money to fuel creative photography. Nobody cares, because there's not enough

money attached to it in the long run for anybody to have a vested interest," he says.

Therefore, it's important to avoid soaking too much time and money into ideas that won't sell. A photographer must know when he's reached a dead end. "You get interested in a project because the idea hooks you. And the pictures that you see in your head hook you and won't let you go. Then as you get into it, the hooks get deeper and you get more committed. . . . It's like a hound chasing a fox. You're really after this thing that's forever elusive and fleeting in front of you and you keep running along after it. The more you run, the more money you're spending and the more dangerous that gets financially.

"I'm convinced you really have to have a masochistic, martyr-like tendency to keep doing the kinds of projects I'm talking about."
—*Michael Willins*

© James Balog

This beautiful image of actress Isabella Rossellini in the arms of a chimpanzee comes from James Balog's book Anima (Arts Alternative Press). *Balog prides himself on large projects that he hopes make viewers examine their place in the world.*

Tips: "We are looking for Green Bay Packer pictures when they play in other NFL cities—action photos. Contact me directly." Looks for "the ability to capture action in addition to the unusual" in photos.

THE GREYHOUND REVIEW, P.O. Box 543, Abilene KS 67410. (913)263-4660. Contact: Gary Guccione or Tim Horan. Circ. 6,000. Publication of the National Greyhound Association. Monthly. Emphasizes greyhound racing and breeding. Readers are greyhound owners and breeders. Sample copy with SAE and 11 first-class stamps.
Needs: Uses about 5 photos/issue; 1 supplied by freelance photographers. Needs "anything pertinent to the greyhound that would be of interest to greyhound owners." Captions required.
Making Contact & Terms: Query first. After response, send b&w or color prints and contact sheets by mail for consideration. Submit portfolio for review. Provide résumé, business card, brochure, flier or tearsheets to be kept on file for possible future assignments. Can return unsolicited material if requested. Reports within 1 month. Pays $75/color cover photo; $10-50/b&w; and $25-100/color inside photo. **Pays on acceptance.** Credit line given. Buys one-time and North American rights. Simultaneous submissions and previously published work OK.
Tips: "We look for human-interest or action photos involving greyhounds. No muzzles, please, unless the greyhound is actually racing. When submitting photos for our cover, make sure there's plenty of cropping space on all margins around your photo's subject; full bleeds on our cover are preferred."

GUERNSEY BREEDERS' JOURNAL, Dept. PM, P.O. Box 666, Reynoldsburg OH 43068-0666. (614)864-2409. Managing Editor: Becky Goodwin. Associate Editor: Beth Littlefield. Circ. 2,200. Publication of American Guernsey Association. Magazine published 10 times a year. Emphasizes Guernsey dairy cattle, dairy cattle management. Readership consists of male and female dairymen, 20-70 years of age. Sample copy free with 8½×11 SASE.
Needs: Uses 40-100 photos/issue; uses less than 5% of freelance photos. Needs scenic photos featuring Guernsey cattle. Model release preferred. Captions preferred.
Making Contact & Terms: Query with résumé of credits, business card, brochure, flier or tearsheets to be kept on file for possible assignments. SASE. Reports in 1 month. Pays $100/color cover photo and $50/b&w cover photo. Pays on publication. Credit line given. Buys all rights; negotiable. Simultaneous submissions and previously published work OK.

HADASSAH MAGAZINE, 50 W. 58th St., New York NY 10019. (212)688-0558. Fax: (212)446-9521. Editorial Assistant: Chava Boylan. Circ. 300,000. Publication of the Hadassah Women's Zionist Organization of America. Monthly magazine. Emphasizes Jewish life, Israel. Readers are 85% females who travel and are interested in Jewish affairs, average age 59. Sample copies free with 9×11 SAE and 5 first-class stamps. Photo guidelines free with SASE.
Needs: Uses 10 photos/issue; most supplied by freelancers. Needs photos of travel and Israel. Captions preferred, include where, when, who and credit line.
Making Contact & Terms: Interested in receiving work from newer, lesser-known photographers. Submit portfolio for review. Send unsolicited photos by mail for consideration. Keeps samples on file. SASE. Reports in 1 month. Pays $400/color cover photo; $100-125/¼ page color inside photo; $100-125/¼ page b&w inside photo. Pays on publication. Credit line given. Buys one-time rights.
Tips: "We're looking for kids of all ethnic/racial make up. Cute, upbeat kids are a plus. Photos of families are also needed."

HISTORIC PRESERVATION, 1785 Massachusetts Ave. NW, Washington DC 20036. (202)673-4042. Art Director: Jeff Roth. Circ. 224,000. Publication of National Trust for Historic Preservation. Bimonthly. Emphasizes historic homes, towns, neighborhoods, restoration. Readers are upper income with an average age in the fifties. Also restoration professionals, architects, etc. Sample copy $2.50 with 9×12 SASE. Photo guidelines free with SASE.
Needs: Uses about 80 photos/issue; almost all supplied by freelancers. Assigns photos of historic homes, restoration in progress, exteriors and interiors. Needs strong photo portfolio ideas, b&w or color, relating to the preservation of buildings, craftspeople, interiors, furniture, etc. Using an increasing number of environmental portraits. Model release required. Property release preferred. Captions preferred.
Making Contact & Terms: Arrange a personal interview to show portfolio. Query with samples. SASE. Reports in 1 month. Pays $75-300/b&w or color photo; $300-500/day. Other terms negotiable. **Pays on acceptance.** Credit line given. Buys first North American serial rights and one-time rights; negotiable.
Tips: Prefers to see "interestingly or naturally lit architectural interiors and exteriors. Environmental portraits, artfully done. Become familiar with our magazine. Suggest suitable story ideas. Will use stock when applicable."

HOOF BEATS, Dept. PM, 750 Michigan Ave., Columbus OH 43215. (614)224-2291. Fax: (614)224-4575. Executive Editor: Dean Hoffman. Design/Production Manager: Jenny Scranton. Circ. 18,000.

Estab. 1933. Publication of the US Trotting Association. Monthly. Emphasizes harness racing. Readers are participants in the sport of harness racing. Sample copy free.
Needs: Uses about 30 photos/issue; about 20% supplied by freelancers. Needs "artistic or striking photos that feature harness horses for covers; other photos on specific horses and drivers by assignment only."
Making Contact & Terms: Query with samples. SASE. Reports in 3 weeks. Pays $25-150/b&w photo; $50-200/color photo; $150 and up/color cover photo; freelance assignments negotiable. Pays on publication. Credit line given if requested. Buys one-time rights. Simultaneous submissions OK.
Tips: "We look for photos with unique perspective and that display unusual techniques or use of light. Send query letter first. Know the publication and its needs before submitting. Be sure to shoot pictures of harness horses only, not Thoroughbred or riding horses." There is "more artistic use of b&w photography instead of color. More use of fill-flash in personality photos. We always need good night racing action or creative photography."

HORSE SHOW MAGAZINE, % AHSA, 220 E. 42nd St., New York NY 10017-5876. (212)972-2472, ext. 250. Fax: (212)983-7286. Editor: Norine Dworkin. Circ. 57,000. Estab. 1937. Publication of National Equestrian Federation of US. Monthly magazine. Emphasizes horses and show trade. Majority of readers are upscale women, median age 31.
Needs: Uses up to 25 photos/issue; most are supplied by equine photographers; freelance 100% on assignment only. Needs shots of competitions. Reviews photos with or without accompanying ms. Especially looking for "excellent color cover shots" in the coming year. Model release required. Property release preferred. Captions required; include name of owner, rider, name of event, date held, horse and summary of accomplishments.
Making Contact & Terms: Interested in receiving work from newer, lesser-known photographers. Arrange personal interview to show portfolio. Cannot return material. Reports in 2 weeks. Pays $250/color or b&w cover photo; $30/color and b&w inside photo. **Pays on acceptance.** Credit line given. Buys one-time rights; negotiable. Previously published work OK.
Tips: "Get best possible action shots. Call to set up interview. Call to see if we need coverage of an event."

HSUS NEWS, 700 Professional Dr., Gaithersburg MD 20879-3418. Art Director: T. Tilton. Circ. 500,000. Estab. 1954. Publication of The Humane Society of the US association. Quarterly magazine. Emphasizes animals. Sample copy free with 10×14 SASE.
Needs: Uses 60 photos/issue. Needs photos of animal/wildlife shots. Model release required.
Making Contact & Terms: Query with list of stock photo subjects. Send unsolicited transparencies by mail for consideration. Provide résumé, business card, brochure, flier or tearsheets to be kept on file for possible assignments. Reports in 3 weeks. Pays $500/color cover photo; $225/color inside photo; $150/b&w inside photo. **Pays on acceptance.** Credit line given. Buys one-time rights. Previously published work OK.
Tips: To break in, "don't pester us. Be professional with your submissions."

"IN THE FAST LANE", ICC National Headquarters, 2001 Pittston Ave., Scranton PA 18505. (717)585-4082. Editor: D.M. Crispino. Circ. 2,000. Publication of the International Camaro Club. Bimonthly, 20-page newsletter. Emphasizes Camaro car shows, events, cars, stories, etc. Readers are auto enthusiasts/Camaro exclusively. Sample copy $2.
Needs: Uses 20-24 photos/issue; 90% assigned. Needs Camaro-oriented photos only. "At this time we are looking for photographs and stories on the Camaro pace cars 1967, 1969, 1982 and the Camaro Z28s, 1967-1981." Reviews photos with accompanying ms only. Model release required. Captions required.
Making Contact & Terms: Send 3½×5 and larger b&w or color prints by mail for consideration. SASE. Reports in 2 weeks. Pays $5-20 for text/photo package. Pays on publication. Credit line given. Buys one-time rights. Previously published work OK.
Tips: "We need quality photos that put you at the track, in the race or in the midst of the show. Magazine is bimonthly; timeliness is even more important than with monthly."

INTERNATIONAL OLYMPIC LIFTER, Box 65855, 3602 Eagle Rock, Los Angeles CA 90065. (213)257-8762. Editor: Bob Hise II. Circ. 1,000. Estab. 1973. Bimonthly international magazine. Emphasizes Olympic-style weightlifting. Readers are athletes, coaches, administrators, enthusiasts of all ages. Sample copy $4.50 and 5 first-class stamps.

The code NPI (no payment information given) appears in listings that have not given specific payment amounts.

Needs: Uses 20 or more photos/issue; all supplied by freelancers. Needs photos of weightlifting action. Reviews photos with or without ms. Captions preferred.
Making Contact & Terms: Send unsolicited photos by mail for consideration. Send 5×7, 8×10 b&w prints. Does not keep samples on file. SASE. Reports in 1-2 weeks. Pays $25/b&w cover photo; $2-10/b&w inside photo. **Pays on acceptance.** Credit line given. Rights negotiable.
Tips: "Good, clear, b&w still and action photos of (preferably outstanding) olympic-style (overhead/ lifting) weightlifters. Must know sport of weightlifting, not bodybuilding or powerlifting."

INTERVAL INTERNATIONAL TRAVELER, 6262 Sunset Dr., Miami FL 33143. (305)666-1861. Photo Editor: Margaret Swiatek. Circ. 390,000. Estab. 1982. Publication of Interval International. Quarterly. Emphasizes vacation exchange and travel. Readers are members of the Interval International vacation exchange club. Sample copy free with 9×12 SASE.
Needs: Uses 50 photos/issue. 80% supplied by freelancers. Needs photos of travel destinations, vacation activities. Model/property release required. Captions required; all relevant to full identification.
Making Contact & Terms: Interested in receiving work from newer, lesser-known photographers. Query with stock photo list. Provide résumé, business card, brochure, flier or tearsheets to be kept on file for possible assignments. Keeps samples on file. Cannot return materials. Reports in 1 month. NPI. Pays on publication. Credit line given. Buys one-time rights; negotiable. Simultaneous submissions and previously published work OK.
Tips: Looking for beautiful scenics; family-oriented, fun travel shots. Superior technical quality.

ITE JOURNAL, 525 School St. SW, #410, Washington DC 20024. (202)554-8050. Fax: (202)863-5486. Publications Director: Eduardo F. Dalere. Circ. 11,000. Estab. 1930. Publication of Institute of Transportation Engineers. Monthly journal. Emphasizes surface transportation, including streets, highways and transit. Readers are transportation engineers and professionals.
Needs: One photo used for cover illustration per issue. Needs "strikingly scenic shots of streets, highways, bridges, transit systems." Model release required. Captions preferred, include location, name or number of road or highway and details.
Making Contact & Terms: Interested in receiving work from newer, lesser-known photographers. Query with list of stock photo subjects. Send 35mm or 2¼×2¼ transparencies by mail for consideration. Provide résumé, business card, brochure, flier or tearsheets to be kept on file for possible assignments. Send originals; no dupes please. Pays $250/color cover photo; $50/b&w inside photo. Pays on publication. Credit line given. Buys one-time rights. Simultaneous submissions and/or previously published work OK.

***JOURNAL OF ENVIRONMENTAL HEALTH**, 720 S. Colorado Blvd., Suite 970 S. Tower, Denver CO 80222. (303)756-9090. Fax: (303)691-9490. Journal Manager: Simonne Gallaty. Circ. 20,000. Estab. 1936. Publication of National Environmental Health Association. Monthly journal. Emphasizes environmental health. Readers are male and female professionals, ages 20-60. Sample copy free with 9×12 SASE and 6 first-class stamps.
Needs: Uses 5 photos/issue; 4 supplied by freelancers. Needs photos of environmental, health, concepts. Subjects involve air quality, food protection, hazardous waste, occupational health and safety, water quality, recreational areas, radiation and toxic substances, etc. . . . Model/property release preferred. Captions preferred; include subject matter, location.
Making Contact & Terms: Interested in receiving work from newer, lesser-known photographers. Query with stock photo list. Keeps samples on file. SASE. Reports in 1 month. NPI. **Pays on acceptance.** Credit line given. Rights negotiable. Simultaneous submissions and previously published work OK.

JOURNAL OF PHYSICAL EDUCATION, RECREATION & DANCE, American Alliance for Health, Physical Education, Recreation & Dance, Reston VA 22091. (703)476-3400. Fax: (703)476-9527. Managing Editor: Frances Rowan. Circ. 35,000. Estab. 1896. Monthly magazine. Emphasizes "teaching and learning in public school physical education, youth sports, youth fitness, dance on elementary, secondary or college levels (not performances; classes only), recreation for youth, children, families, girls and women's athletics and *physical* education and fitness." Sample copy free with 9×12 SAE and 7 first-class stamps. Photo guidelines free with SASE.
Needs: Freelancers supply cover photos only; 80% from assignment. Model release required. Captions preferred.
Making Contact & Terms: Interested in receiving work from newer, lesser-known photographers. Query with list of stock photo subjects. Buys 5×7 or 8×10 color prints; 35mm transparencies. Buys b&w by contract. SASE. Reports in 2 weeks. Pays $30/b&w photo; $250/color photo. Credit line given. Buys one-time rights. Previously published work OK.
Tips: "Innovative transparencies relating to physical education, recreation and sport are considered for publication on the cover—vertical format." Looks for "action shots, cooperative games, no competitive sports and classroom scenes. Send samples of *relevant* photos."

JUDICATURE, 25 E. Washington, Suite 1600, Chicago IL 60602. (312)558-6900. Editor: David Richert. Circ. 14,000. Estab. 1917. Publication of the American Judicature Society. Bimonthly. Emphasizes courts, administration of justice. Readers are judges, lawyers, professors, citizens interested in improving the administration of justice. Sample copy free with 9×12 SAE and 6 first-class stamps.
Needs: Uses 2-3 photos/issue; 1-2 supplied by freelancers. Needs photos relating to courts, the law. "Actual or posed courtroom shots are always needed." Model/property releases preferred. Captions preferred.
Making Contact & Terms: Interested in receiving work from newer, lesser-known photographers. Send 5×7 glossy b&w prints by mail for consideration. Provide résumé, business card, brochure, flier or tearsheets to be kept on file for possible future assignments. SASE. Reports in 2 weeks. Pays $200/ b&w cover photo; $125/b&w inside photo. Pays on publication. Credit line given. Buys one-time rights. Simultaneous submissions and previously published work OK.

KEYNOTER, Dept. PM, 3636 Woodview Trace, Indianapolis IN 46268. (317)875-8755. Fax: (317)879-0204. Art Director: Jim Patterson. Circ. 160,000. Publication of the Key Club International. Monthly magazine through school year (7 issues). Emphasizes teenagers, above average students and members of Key Club International. Readers are teenagers, ages 14-18, male and female, high GPA, college bound, leaders. Sample copy free with 9×12 SAE and 3 first-class stamps. Photo guidelines free with SASE.
Needs: Uses varying number of photos/issue; varying percentage supplied by freelancers. Needs vary with subject of the feature article. Reviews photos purchased with accompanying ms only. Model release required. Captions preferred.
Making Contact & Terms: Query with résumé of credits. Pays $500/color cover photo; $350/b&w cover photo; $200/color inside photo; $100/b&w inside photo. **Pays on acceptance.** Credit line given. Buys first North American serial rights and first international serial rights.

KIWANIS MAGAZINE, 3636 Woodview Trace, Indianapolis IN 46268. (317)875-8755. Fax: (317)879-0204. Managing Editor: Chuck Jonak. Art Director: Jim Patterson. Circ. 285,000. Estab. 1915. Published 10 times/year. Emphasizes organizational news, plus major features of interest to business and professional men and women involved in community service. Free sample copy and writer's guidelines with SAE and 5 first-class stamps.
Needs: Uses photos with or without ms.
Making Contact & Terms: Send résumé of stock photos. Provide brochure, business card and flier to be kept on file for future assignments. Assigns 95% of work. Uses 5×7 or 8×10 glossy b&w prints; accepts 35mm but prefers 2¼×2¼ and 4×5 transparencies. Pays $50-700/b&w photo; $75-1,000/color photo; $400-1,000/text/photo package. Buys one-time rights.
Tips: "We can offer the photographer a lot of freedom to work *and* worldwide exposure. And perhaps an award or two if the work is good. We are now using more conceptual photos. We also use studio set-up shots. When we assign work, we want to know if a photographer can follow a concept into finished photo without on-site direction." In portfolio or samples, wants to see "studio work with flash and natural light."

***KPBS ON AIR MAGAZINE**, San Diego State University, San Diego CA 92182-5400. (619)594-3766. Fax: (619)265-6417. Editor: Michael Good. Circ. 63,000. Estab. 1967. Monthly magazine. Emphasizes public television and radio programs and San Diego arts and entertainment events. Sample copy free with 9×12 SASE and 3 first-class stamps.
Needs: Uses 25 photos/issue; 4 supplied by freelancers. Needs photos of public television and radio personalities or San Diego arts and entertainment events. Model/property release preferred.
Making Contact & Terms: Interested in receiving work from newer, lesser-known photographers. Provide résumé, business card, brochure, flier or tearsheets to be kept on file for possible assignments. Query with stock photo list. Deadlines: 2 months ahead of issue date. Keeps samples on file. Cannot return material. Reports in 1 month. Pays $50/hour; $500/day; $450/color cover photo; $75-150/color inside photo. Pays on publication. Buys one-time rights. Simultaneous submissions and previously published work OK.

LANDSCAPE ARCHITECTURE, 4401 Connecticut Ave. NW, 5th Floor, Washington DC 20008. (202)686-2752. Managing Editor: Lee Fleming. Circ. 35,000. Estab. 1910. Publication of the American Society of Landscape Architects. Monthly magazine. Emphasizes "landscape architecture, urban design, parks and recreation, architecture, sculpture" for professional planners and designers. Sample copy $7. Photo guidelines free with SASE.
Needs: Uses about 50-75 photos/issue; 50% supplied by freelance photographers. Needs photos of landscape- and architecture-related subjects as described above. Special needs include aerial photography and portraits (head shots). Model release required. Credit, caption information required.
Making Contact & Terms: Query with samples or list of stock photo subjects. Provide résumé, business card, brochure, flier or tearsheets to be kept on file for possible future assignments. SASE.

Reporting time varies. Pays $500/color cover photo; $50-300/color inside; $500/day; $250/half day. Pays on publication. Credit line given. Buys one-time rights. Previously published work OK. If commissioned, photographer agrees not to let other publishers use for 1 year.
Tips: "We look for dramatic compositions, interesting/revealing details and a personal touch. There should be no flaw in any of the work shown in a portfolio. The compositions should be distinctive, not run-of-the-mill, not ordinary, not bloodless."

LAW PRACTICE MANAGEMENT, Box 11418, Columbia SC 29211-1418. (803)754-3563. Editor/Art Director: Delmar L. Roberts. Circ. 22,005 (BPA). Estab. 1975. Published 8 times/year. Publication of the Section of Law Practice Management, American Bar Association. For practicing attorneys and legal administrators. Sample copy $7 (make check payable to American Bar Association).
Needs: Uses 1-2 photos/issue; all supplied by freelance photographers. Needs photos of some stock subjects such as group at a conference table, someone being interviewed, scenes showing staffed office-reception areas; *imaginative* photos illustrating such topics as time management, employee relations, trends in office technology, alternative billing, implementing TQM, lawyer compensation. Computer graphics of interest. Abstract shots or special effects illustrating almost anything concerning management of a law practice. "We'll exceed our usual rates for exceptional photos of this latter type." No snapshots or Polaroid photos. Model release required. Captions required.
Making Contact & Terms: Uses 5×7 glossy b&w prints; 35mm, 2¼×2¼, 4×5 transparencies. Send unsolicited photos by mail for consideration. They are accompanied by an article pertaining to the lapida "if requested." SASE. Reports in 3 months. Pays $200-300/color cover photo (vertical format); $75-100/b&w inside photo; $200-300/job. Pays on publication. Credit line given. Usually buys all rights, and rarely reassigns to photographer after publication.

THE LION, 300 22nd St., Oak Brook IL 60521-8842. (708)571-5466. Editor: Robert Kleinfelder. Circ. 600,000. Estab. 1918. For members of the Lions Club and their families. Monthly magazine. Emphasizes Lions Club service projects. Free sample copy and photo guidelines available.
Needs: Uses 50-60 photos/issue. Needs photos of Lions Club service or fundraising projects. "All photos must be as candid as possible, showing an activity in progress. Please, no award presentations, meetings, speeches, etc. Generally photos purchased with ms (300-1,500 words) and used as a photo story.We seldom purchase photos separately." Model release preferred for young or disabled children. Captions required.
Making Contact & Terms: Interested in receiving work from newer, lesser-known photographers. Works with freelancers on assignment only. Provide résumé to be kept on file for possible future assignments. Query first with résumé of credits or story idea. Send 5×7, 8×10 glossy b&w and color prints; 35mm transparencies. SASE. Reports in 2 weeks. Pays $10-25/photo; $100-600/text/photo package. **Pays on acceptance.** Buys all rights; negotiable.

LOYOLA MAGAZINE, 820 N. Michigan, Chicago IL 60611. (312)915-6157. Fax: (312)915-6215. E-mail: loyolamag@luc.edu. Editor: Mary Nowesnick. Circ. 98,500. Estab. 1971. Loyola University Alumni Publication. Magazine published 3 times/year. Emphasizes issues related to Loyola University Chicago. Readers are Loyola University Chicago alumni—professionals, ages 22 and up. Sample copy free with 9×12 SAE and 3 first-class stamps.
● This publication received the Astrid Award for Design Excellence in 1993 and in 1994 the Apex Award for Best Nonprofit magazine.
Needs: Uses 50 photos/issue; 40% supplied by freelancers. Needs Loyola-related or Loyola alumni-related photos only. Model release preferred. Captions preferred.
Making Contact & Terms: Interested in receiving work from newer, lesser-known photographers. Send unsolicited photos by mail for consideration. Provide résumé, business card, brochure, flier or tearsheets to be kept on file for possible assignments. Send 8×10 b&w/color prints; 35mm and 2¼×2¼ transparencies. SASE. Reports in 3 months. Pays $300/b&w and color cover photo; $85/b&w and color inside photo; $50-150/hour; $400-1,200/day. **Pays on acceptance.** Credit line given. Buys one-time rights. Simultaneous submissions and previously published work OK.
Tips: "Send us information, but don't call."

THE LUTHERAN, 8765 W. Higgins Rd., Chicago IL 60631. (312)380-2546. Art Director: Jack Lund. Publication of Evangelical Lutheran Church in America. Circ. 800,000. Estab. 1988. Monthly magazine. Sample copy 75¢ with 9×12 SASE.
Needs: Assigns 35-40 photos/issue; 4-5 supplied by freelancers. Needs current news, mood shots. "We usually assign work with exception of 'Reflections' section." Model release required. Captions preferred.
Making Contact & Terms: Interested in receiving work from newer, lesser-known photographers. Query with list of stock photo subjects. Provide résumé, brochure, flier or tearsheets to be kept on file for possible future assignments. SASE. Reports in 3 weeks. Pays $50-200/color photo; $175-300/day. Pays on publication. Credit line given. Buys one-time rights.

Tips: Trend toward "more dramatic lighting. Careful composition." In portfolio or samples, wants to see "candid shots of people active in church life, preferably Lutheran. Churches-only photos have little chance of publication. Submit sharp well-composed photos with borders for cropping."

MAINSTREAM—ANIMAL PROTECTION INSTITUTE, P.O. Box 22505, Sacramento CA 95822, or 2831 Fruitridge Rd., Sacramento CA 95820. (916)731-5521. Fax: (916)731-4467. Art Director: Barbara Tugaeff. Circ. 65,000. Estab. 1970. Official Publication of the Animal Protection Institute. Quarterly. Emphasizes "humane education toward and about animal issues and events concerning animal welfare." Readers are "all ages; people most concerned with animals." Sample copy and photo guidelines available with 9×12 SAE and 5 first-class stamps.
Needs: Uses approximately 30 photos/issue; 15 supplied by freelancers. Needs images of animals in natural habitats. Especially interested in "one of a kind" situational animal slides. All species, wild and domestic: marine mammals, wild horses, primates, companion animals (pets), farm animals, wildlife from all parts of the world, and endangered species. Animals in specific situations: factory farming, product testing, animal experimentation and their alternatives; people and animals working together; trapping and fur ranching; animal rescue and rehabilitation; animals in abusive situations (used/abused) by humans; entertainment (rodeos, circuses, amusement parks, zoos); etc. *API* also uses high quality images of animals in various publications besides its magazine. Submissions should be excellent quality—sharp with effective lighting. Prefer tight to medium shots with good eye contact. Vertical format required for *Mainstream* covers. Model release required for vertical shots and any recognizable faces.
Making Contact & Terms: Interested in receiving work from newer, lesser-known photographers. Query with résumé, credits, stock list and sample submission of no more than 20 of best slides; originals are preferred unless dupes are *high quality*. Provide business card, brochure, flier or tearsheets for *API* files for future reference. "We welcome all 'excellent quality' contacts with SASE." Black and white rarely used. However, will accept b&w images of outstanding quality of hard-to-get, issue-oriented situations: experimentation, product testing, factory farming etc. Original transparencies or high-quality dupes only; 35mm Kodachrome 64 preferred; larger formats accepted. Reports in 1 month. Pays $150/color cover; $35-50/b&w (from slide or photo) inside; $50-150/color inside. Pays on publication. Credit line given; please specify. Buys one-time rights. Simultaneous submissions and previously published work OK.
Tips: "The images used in *Mainstream* touch the heart. We see a trend toward strong subject, eye contact, emotional scenes, mood shots, inspirational close-ups and natural habitat shots."

MANAGEMENT ACCOUNTING, 10 Paragon Dr., Montvale NJ 07645. (201)573-9000. Fax: (201)573-0639. Editor: Kathy Williams. Circ. 95,000. Estab. 1919. Publication of Institute of Management Accountants. Monthly. Emphasizes management accounting. Readers are financial executives.
Needs: Uses about 25 photos/issue; 40% from stock houses. Needs stock photos of business, high-tech, production and factory. Model release required for identifiable people. Captions required.
Making Contact & Terms: Query with samples. Provide résumé, business card, brochure, flier or tearsheets to be kept on file for possible future assignments. Uses prints and transparencies. SASE. Reports in 2 weeks. Pays $100-200/b&w photo; $150-250/color photo. **Pays on acceptance.** Credit line given. Buys one-time rights. Simultaneous submissions and previously published work OK.
Tips: Prefers to see "ingenuity, creativity, dramatics (business photos are often dry), clarity, close-ups, simple but striking. Aim for a different slant."

✤THE MANITOBA TEACHER, 191 Harcourt St., Winnipeg, Manitoba R3J 3H2 Canada. (204)888-7961. Communications Officer: Janice Armstrong. Managing Editor: Raman Job. Production Editor/Advertising: Joy Montgomery. Circ. 16,800. Publication of The Manitoba Teachers' Society. Published nine times per year. Emphasizes education in Manitoba—emphasis on teachers' interest. Readers are teachers and others in education. Circ. 17,000. Sample copy free with 10×14 SAE and Canadian stamps.
Needs: Uses approximately 4 photos/issue; 80% supplied by freelancers. Needs action shots of students and teachers in education-related settings. "Good cover shots always needed." Model release required. Captions required.
Making Contact & Terms: Send 8×10 glossy b&w prints by mail for consideration. Submit portfolio for review. Provide résumé, business card, brochure, flier or tearsheets to be kept on file for possible assignments. SASE. Reports in 1 month. Pays $20/photo for single use.
Tips: "Always submit action shots directly related to major subject matter of publication and interests of readership of that publication."

 The maple leaf before a listing indicates that the market is Canadian.

MATERIALS PERFORMANCE, P.O. Box 218340, Houston TX 77218-8340. (713)492-0535, ext 207. Fax: (713)492-8254. Managing Editor: Theresa Baer. Circ. 16,000. Publication of NACE International. Monthly magazine. Emphasizes corrosion control and prevention applications. Readers are male and female professionals, engineers to field technicians. Sample copy $10.

Needs: Uses at least 11 photos, cover and features/issue. Needs photos of materials technology: lab, field, office. Reviews photos with or without ms. Special photo needs include infrastructure, transportation, water distribution systems pipelines. Model/property release required. Captions required; include application and owner.

Making Contact & Terms: Query with stock photo list. Send unsolicited photos by mail for consideration. Send color prints; 35mm transparencies. Does not keep samples on file. Reports in 1 month. NPI. Credit line given. Simultaneous submissions and/or previously published work OK.

THE MIDWEST MOTORIST, Dept. PM, Auto Club of Missouri, 12901 N. Forty Dr., St. Louis MO 63141. (314)523-7350. Editor: Michael Right. Circ. 385,000. Bimonthly. Emphasizes travel and driving safety. Readers are "members of the Auto Club of Missouri, ranging in age from 25-65 and older." Free sample copy and photo guidelines with SASE; use large manila envelope.

Needs: Uses 8-10 photos/issue, most supplied by freelancers. "We use four-color photos inside to accompany specific articles. Our magazine covers topics of general interest, historical (of Midwest regional interest), humor (motoring slant), interview, profile, travel, car care and driving tips. Our covers are full color photos mainly corresponding to an article inside. Except for cover shots, we use freelance photos only to accompany specific articles." Captions required.

Making Contact & Terms: Send by mail for consideration 35mm, 2¼×2¼ or 4×5 color transparencies. Query with résumé of credits. Query with list of stock photo subjects. SASE. Reports in 6 weeks. Pays $100-250/cover; $10-25/photo with accompanying ms; $50-200/color photo; $75-200 text/photo package. Pays on publication. Credit line given. Rights negotiable. Simultaneous submissions and previously published work OK.

Tips: "Send an 8½×11 SASE for sample copies and study the type of covers and inside work we use."

MODERN MATURITY, 3200 E. Carson St., Lakewood CA 90712. (310)496-2277. Photo Editor: M.J. Wadolny. Circ. 20 million. Bimonthly. Readers are age 50 and older. Sample copy free with 9×12 SASE. Guidelines free with SASE.

Needs: Uses about 50 photos/issue; 45 supplied by freelancers; 75% from assignment and 25% from stock.

Making Contact & Terms: Arrange a personal interview to show portfolio. SASE. Pays $50-200/ b&w photo; $150-1,000/color photo; $350/day. **Pays on acceptance.** Credit line given. Buys one-time and first North American serial rights.

Tips: Portfolio review: Prefers to see clean, crisp images on a variety of subjects of interest. "Present yourself and your work in a professional manner. Be familiar with *Modern Maturity*. Wants to see creativity and ingenuity in images."

THE MORGAN HORSE, P.O. Box 960, Shelburne VT 05482. (802)985-4944. Editor: Suzy Lucine. Circ. 8,500. Estab. 1941. Publication is official breed journal of The American Morgan Horse Association Inc. Monthly magazine. Emphasizes Morgan horses. Readers are all ages. Sample copy.

Needs: Uses 25 photos/issue; 50% supplied by freelancers. Needs photos of Morgan horses—farm scenes, "showing," trail riding, how-to and photos with owners. Special photo needs include covers and calendars. Model release preferred. Captions preferred.

Making Contact & Terms: Send unsolicited glossy b&w or color prints; 35mm, 2¼×2¼, 4×5, 8×10 transparencies by mail for consideration. SASE. Reports in 3 weeks. Pays $150/color cover photo; $25/color inside photo; $5/b&w inside photo. Pays on publication. Credit line given. Buys either one-time or all rights; negotiable.

Tips: "Artistic color photographs of Morgan horses in natural settings, with owners, etc., are needed for calendars and covers."

MUZZLE BLASTS, P.O. Box 67, Friendship IN 47021. (812)667-5131. Fax: (812)667-5137. Art Director: Sharon Pollard. Circ. 25,000. Estab. 1939. Publication of the National Muzzle Loading Rifle Association. Monthly magazine emphasizing muzzleloading. Sample copy free. Photo guidelines free with SASE.

Needs: Interested in North American wildlife, muzzleloading hunting, primitive camping. Model/ property release required. Captions preferred.

Making Contact & Terms: Interested in receiving work from newer, lesser-known photographers. Query with stock photo list. Deadlines: 15th of the month—4 months before cover date. Keeps samples on file. SASE. Reports in 1-2 weeks. Pays $300/color cover photo; $25/b&w inside photo. Pays on publication. Credit line given. Buys one-time rights. Simultaneous submissions OK.

NACLA REPORT ON THE AMERICAS, 475 Riverside Dr., Room 454, New York NY 10115. (212)870-3146. Photo Editor: Deidre McFadyen. Circ. 11,500. Association publication of North American Congress on Latin America. Bimonthly journal. Emphasizes Latin American political economy; US foreign policy toward Latin America and the Caribbean; and development issues in the region. Readers are academic, church, human rights, political activists, foreign policy interested. Sample copy $5.75 (includes postage).
Needs: Uses about 25 photos/issue; most supplied by freelancers. Model release preferred. Captions preferred.
Making Contact & Terms: Arrange a personal interview to show portfolio or send a query with list of countries and topics covered. Black & white prints preferred. SASE. Reports in 2 weeks. Pays $35/b&w photo. Pays on publication. Credit line given. Buys one-time rights. Simultaneous submissions and previously published work OK.

NATIONAL GARDENING, Dept. PM, 180 Flynn Ave., Burlington VT 05401. (802)863-1308. Fax: (802)863-5962. Editor: Michael MacCaskey. Managing Editor: Vicky Congdon. Circ. 200,000. Estab. 1979. Publication of the National Gardening Association. Bimonthly. Covers fruits, vegetables, herb and ornamentals. Readers are home and community gardeners. Sample copy $3.50. Photo guidelines free with SASE.
Needs: Uses about 50-60 photos/issue; 80% supplied by freelancers. "Most of our photographers are also gardeners or have an avid interest in gardening or gardening research." Ongoing needs include: "people gardening; special techniques; how to; specific varieties (please label); garden pests and diseases; soils; unusual (or impressive) gardens in different parts of the country. We sometimes need someone to photograph a garden or gardener in various parts of the country for a specific story."
Making Contact & Terms: "We send out a photo needs list for each issue." Query with samples or list of stock photo subjects. SASE. Reports in 1 month. Pays $350/color cover photo; $30/b&w and $50-100/color inside photo. Also negotiates day rate against number of photos used. Pays on publication. Credit line given. Buys first North American serial rights.
Tips: "We need top-quality work. Most photos used are color. We look for general qualities like sharp focus, good color balance, good sense of lighting and composition. Also interesting viewpoint, one that makes the photos more than just a record (getting down to ground level in the garden, for instance, instead of shooting everything from a standing position). Look at the magazine carefully and at the photos used. When we publish a story on growing broccoli, we love to have photos of people planting or harvesting broccoli, in addition to lush close ups. We like to show process, step-by-step, and, of course, inspire people."

THE NATIONAL NOTARY, 8236 Remmet Ave., Box 7184, Canoga Park CA 91309-7184. (818)713-4000. Editor: Charles N. Faerber. Circ. 80,000. Bimonthly. Emphasizes "Notaries Public and notarization—goal is to impart knowledge, understanding and unity among notaries nationwide and internationally." Readers are employed primarily in the following areas: law, government, finance and real estate. Sample copy $5.
Needs: Uses about 20-25 photos/issue; 10 supplied by non-staff photographers. "Photo subject depends on accompanying story/theme; some product shots used." Unsolicited photos purchased with accompanying ms only. Model release required.
Making Contact & Terms: Query with samples. Provide business card, tearsheets, résumé or samples to be kept on file for possible future assignments. Prefers to see prints as samples. Cannot return material. Reports in 6 weeks. Pays $25-300 depending on job. Pays on publication. Credit line given "with editor's approval of quality." Buys all rights. Previously published work OK.
Tips: "Since photography is often the art of a story, the photographer must understand the story to be able to produce the most useful photographs."

THE NATIONAL RURAL LETTER CARRIER, Dept. PM, 1630 Duke St., Alexandria VA 22314-3465. (703)684-5545. Managing Editor: RuthAnn Saenger. Circ. 80,000. Biweekly magazine. Emphasizes Federal legislation and issues affecting rural letter carriers and the activities of the membership for rural carriers and their spouses and postal management. Sample copy 34¢. Photo guidelines free with SASE.
 • This magazine uses a limited number of photos in each issue, usually only a cover photograph and some promotional headshots or group photos. Photo/text packages are used on occasion and if you present an interesting story you should have better luck with this market.
Needs: Photos purchased with accompanying ms. Buys 24 photos/year. Animal; wildlife; sport; celebrity/personality; documentary; fine art; human interest; humorous; nature; scenics; photo essay/photo feature; special effects and experimental; still life; spot news; and travel. Needs scenes that combine subjects of the Postal Service and rural America; "submit photos of rural carriers on the route." Model release required. Captions required.
Making Contact & Terms: Interested in receiving work from newer, lesser-known photographers. Send material by mail for consideration. Query with list of stock photo subjects. Uses 8 × 10 b&w or

color glossy prints, vertical format preferred for cover. SASE. Reports in 1 month. Pays $60/photo. Pays on publication. Credit line given. Buys first serial rights. Previously published work OK.
Tips: "Please submit sharp and clear photos with interesting and pertinent subject matter. Study the publication to get a feel for the types of rural and postal subject matter that would be of interest to the membership. We receive more photos than we can publish, but we accept beginners' work if it is good."

NATURE CONSERVANCY MAGAZINE, 1815 N. Lynn St., Arlington VA 22209. (703)841-8742. Fax: (703)841-8742. Photo Editor: Connie Gelb. Circ. 790,000. Estab. 1951. Publication of The Nature Conservancy. Bimonthly. Emphasizes "nature, rare and endangered flora and fauna, ecosystems in North and South America, Indonesia, Micronesia and South Pacific and sustainable development." Readers are the membership of The Nature Conservancy. Sample copy free with 9×12 SAE and 5 first-class stamps. Write for guidelines. Articles reflect work of the Nature Conservancy and its partner organizations.
Needs: Uses about 20-25 photos/issue; 70% from freelance stock. The Nature Conservancy welcomes permission to make duplicates of slides submitted to the *Magazine* for use in slide shows only and internegs for proposals. Model release required. Property release preferred. Captions required; include location and names (common and Latin) of flora and fauna. Proper credit should appear on slides.
Making Contact & Terms: Interested in receiving work and photo driven story ideas from newer, lesser-known photographers. Many photographers contribute the use of their slides. Uses color transparencies. Pays $300/color cover photo; $150-225/color inside photo; $50-100/b&w photo; negotiable day rate. Pays on publication. Credit line given. Buys one-time rights; starting to consider all rights for public relations purposes; negotiable.
Tips: Seeing more large-format photography and more interesting uses of motion and mixing available light with flash and b&w. "Photographers must familiarize themselves with our organization. We only run articles reflecting our work or that of our partner organizations in Latin America and Asia/Pacific. Membership in the Nature Conservancy is only $25/year and the *Magazine* will keep photographers up to date on what the Conservancy is doing in your state. Many of the preserves are open to the public. We look for rare and endangered species, wetlands and flyways, indigenous/traditional people, including Latin America, South Pacific, Caribbean and Canada."

NEVADA FARM BUREAU AGRICULTURE AND LIVESTOCK JOURNAL, 1300 Marietta Way, Sparks NV 89431. (702)358-7737. Contact: Norman Cardoza. Circ. 7,200. Monthly tabloid. Emphasizes Nevada agriculture. Readers are primarily Nevada Farm Bureau members and their families; men, women and youth of various ages. Members are farmers and ranchers. Sample copy free with 10×13 SAE with 3 first-class stamps.
Needs: Uses 5 photos/issue; 30% occasionally supplied by freelancers. Needs photos of Nevada agriculture people, scenes and events. Model release preferred. Captions required.
Making Contact & Terms: Send 3×5 and larger b&w prints, any format and finish by mail for consideration. SASE. Reports in 1 week. Pays $10/b&w cover photo; $5/b&w inside photo. **Pays on acceptance.** Credit line given. Buys one-time rights.
Tips: "In portfolio or samples, wants to see newsworthiness, 50%; good composition, 20%; interesting action, 20%; photo contrast, resolution, 10%. Try for new angles on stock shots: awards, speakers, etc., We like 'Great Basin' agricultural scenery such as cows on the rangelands and high desert cropping. We pay little, but we offer credits for your résumé."

NEW ERA MAGAZINE, 50 E. North Temple St., Salt Lake City UT 84150. (801)240-2951. Fax: (801)240-1727. Art Director: Lee Shaw. Circ. 200,000. Estab. 1971. Association publication of The Church of Jesus Christ of Latter-day Saints. Monthly magazine. Emphasizes teenagers who are members of the Mormon Church. Readers are male and female teenagers, who are members of the Latter-day Saints Church. Sample $1 with 9×12 SAE and 2 first-class stamps. Photo guidelines free with SASE.
Needs: Uses 60-70 photos/issue; 35-40 supplied by freelancers. Anything can be considered for "Photo of the Month," most photos of teenage Mormons and their activities. Model/property release preferred. Captions preferred.
Making Contact & Terms: Arrange personal interview to show portfolio. Submit portfolio for review. Query with stock photo list. Send unsolicited photos by mail for consideration. Send any b&w or color print; 35mm, 2¼×2¼, 4×5 transparencies. Keeps samples on file. SASE. Reports in 6-8 weeks. Pays $150-300/day; "rates are individually negotiated, since we deal with many teenagers, non-professionals, etc." Credit line given. Buys all rights; negotiable.
Tips: "Most work consists of assignments given to photographers we know and trust, or of single item purchases for 'Photo of the Month.'"

NEW WORLD OUTLOOK, 475 Riverside Dr., Room 1351, New York NY 10115. (212)870-3765. Fax: (212)870-3940. Editor: Alma Graham. Circ. 33,000. Estab. 1911. Four-color magazine published

6 times/year. Features United Methodist mission and mission projects and personnel around the world. Sample copy $2.50 with 9 × 12 SAE.

Needs: Interested in photographers who are planning trips to countries and regions in which there are United Methodist mission projects. Query first for interest and needs. Model release required for closeups and for "people in difficult situations." Captions required; include who, what, where, when, why.

Making Contact & Terms: Query first, by phone or letter. Cannot return material. If an appointment is made, bring samples of published photos, slides and b&w prints. Color preferred. Most photos used are by in-house or United Methodist-related photographers. Credit line given. Pays $25-75/b&w photo; $50-100/color photo; $150-250/color cover. Pays on publication. Buys one-time rights. Previously published work OK.

Tips: Wants to see strong images, good composition, human interest, geographic setting, religious themes. Follow current ecumenical mission study themes (Friendship Press); world events and religious trends for spotting photo opportunities.

NEWS PHOTOGRAPHER, Dept. PM, 1446 Conneaut Ave., Bowling Green OH 43402. (419)352-8175. Fax: (419)354-5435. Editor: James R. Gordon. Circ. 11,000. Estab. 1946. Publication of National Press Photographers Association, Inc. Monthly magazine. Emphasizes photojournalism and news photography. Readers are newspaper, magazine, television freelancers and photojournalists. Sample copy free with 9 × 12 SAE and 9 first-class stamps.

Needs: Uses 50 photos/issue. Needs photos of photojournalists at work; photos which illustrate problems of photojournalists. Special photo needs include photojournalists at work, assaulted, arrested; groups of news photographers at work; problems and accomplishments of news photographers. Captions required.

Making Contact & Terms: Send glossy b&w or color prints; 35mm, 2¼ × 2¼ transparencies by mail for consideration. Provide résumé, business card, brochure, flier or tearsheets to be kept on file for possible assignments; make contact by telephone. "Collect calls accepted." Reports in 3 weeks. Pays $75/color page rate; $50/b&w page rate; $50-150/photo/text package. **Pays on acceptance.** Credit line given. Buys one-time rights. Simultaneous submissions and previously published work OK.

NORTH AMERICAN HUNTER, P.O. Box 3401, Minnetonka MN 55343. (612)936-9333. Fax: (612)936-9755. Publisher: Mark LaBarbera. Editor: Bill Miller. Senior Editors: Gregg Gutshow and Michael Faw. Circ. 665,000. Estab. 1978. Publication of North American Hunting Club. Bimonthly. Emphasizes hunting. Readers are all types of hunters with an eye for detail and an appreciation of wildlife. Sample copy $5.

Needs: Uses about 12-15 photos/issue; all supplied by freelance photographers. For covers, needs "action wildlife centered in vertical format. Inside, needs North American big game, small game, gamebirds and waterfowl only. Always looking for trophy white-tailed deer." Model release preferred. Captions preferred.

Making Contact & Terms: Interested in receiving work from newer, lesser-known photographers. Send 35mm, 2¼ × 2¼, 4 × 5 or 8 × 10 transparencies by mail for consideration or submit list of photos in your file. SASE. Reports in 1 month. Pays $350/color cover photo; $100/b&w photo; $100-350/ color photo; and $325-400 for text/photo package. **"Pays promptly on acceptance."** Credit line given. Buys one-time rights; negotiable.

Tips: "We want top quality photos of North American big game that depict a particular behavior pattern that members of the North American Hunting Club might find useful in pursuing that animal. Action shots are especially sought. Get a copy of the magazine and check out the type of photos we are using."

NORTH AMERICAN WHITETAIL MAGAZINE, P.O. Box 741, Marietta GA 30061. (404)953-9222. Fax: (404)933-9510. Photo Editor: Gordon Whittington. Circ. 170,000. Estab. 1982. Published 8 times/ year (July-February) by Game & Fish Publications, Inc. emphasizing trophy whitetail deer hunting. Sample copy $3. Photo guidelines free with SASE.

Needs: Uses 20 photos/issue; 40% supplied by freelancers. Needs photos of large, live whitetail deer, hunter posing with or approaching downed trophy deer, or hunter posing with mounted head. Also use photos of deer habitat and sign. Model release preferred. Captions preferred; include where scene was photographed and when.

Making Contact & Terms: Interested in receiving work from newer, lesser-known photographers. Query with résumé of credits and list of stock photo subjects. Send unsolicited 8 × 10 b&w prints; 35mm transparencies (Kodachrome preferred). Will return unsolicited material in 1 month if accompanied by SASE. Pays $250/color cover photo; $75/inside color photo; $25/b&w photo. Tearsheets provided. Pays 75 days prior to publication. Credit line given. Buys one-time rights. Simultaneous submissions not accepted.

Tips: "In samples we look for extremely sharp, well composed photos of whitetailed deer in natural settings. We also use photos depicting deer hunting scenes. Please study the photos we are using before

making submission. We'll return photos we don't expect to use and hold the remainder. Please do not send dupes. Use an 8× loupe to ensure sharpness of images and put name and identifying number on all slides and prints. Photos returned at time of publication or at photographer's request."

OAK RIDGE BOYS "TOUR BOOK" AND FAN CLUB NEWSLETTER, 329 Rockland Rd., Hendersonville TN 37075. (615)824-4924. Fax: (615)822-7078. Art Director: Kathy Harris. Circ. newsletter 5,000; tour book 25,000. Publication of The Oak Ridge Boys, Inc. 3 times/year newsletter, tour book published "every 1-3 years." Tour book: 24 pages, full color. Emphasizes The Oak Ridge Boys (music group) exclusively. Readers are fans of Oak Ridge Boys and country music. Free sample copies available of newsletter; tourbook $10.
Needs: Uses 4-5 photos/issue of newsletter, 0-2 supplied by freelance photographers; 20-150/tour book, 1-50 supplied by freelance photographers. Needs photos of Oak Ridge Boys. Will review photos with or without accompanying ms; subject to change without notice. "We need *good* live shots or candid shots—not interested in just average shots." Model release required. Captions preferred.
Making Contact & Terms: Interested in receiving work from newer, lesser-known photographers. Send 8×10 or smaller color or b&w prints with any finish by mail for consideration. Samples kept on file. Sometimes returns material if SASE is enclosed. Reports vary, 2 months. Newsletter: Pays $50/photo. Tour Book: for color photos, pays $500/page; $250/half page; $125/quarter page. For b&w photos, pays $250/page; $125/half page; $60-70/quarter page. Price is negotiable depending on usage. Pays on publication. Credit line usually given. Buys all rights; negotiable. Simultaneous submissions and previously published work OK.
Tips: "We are interested in Oak Ridge Boys photos only! Send only a few good shots at one time—send prints only. No original slides or negatives please."

OKLAHOMA TODAY, Box 53384, Oklahoma City OK 73152. (405)521-2496. Fax: (405)521-3992. Editor-in-Chief: Jeanne M. Devlin. Circ. 45,000. Estab. 1956. Bimonthly magazine. "We cover all aspects of Oklahoma, from history to people profiles, but we emphasize travel." Readers are "Oklahomans, whether they live in-state or are exiles; studies show them to be above average in education and income." Sample copy $4.95. Photo guidelines free with SASE.
Needs: Uses about 50 photos/issue; 90-95% supplied by freelancers. Needs photos of "Oklahoma subjects only; the greatest number are used to illustrate a specific story on a person, place or thing in the state. We are also interested in stock scenics of the state." Other areas of focus are adventure—sport/travel, reenactment, historical and cultural activities. Model release required. Captions required.
Making Contact & Terms: Interested in receiving work from newer, lesser-known photographers. Query with samples. Send 8×10 glossy b&w prints; 35mm, 2¼×2¼, 4×5, 8×10 transparencies or b&w contact sheets by mail for consideration. No color prints. SASE. Reports in 2 months. Pays $50-200/b&w photo; $50-200/color photo; $50-750/job. Payment for text material on acceptance; payment for photos on publication. Buys one-time rights with a six-month from publication exclusive, plus right to reproduce photo in promotions for magazine, without additional payment with credit line. Simultaneous submissions and/or previously published work OK (on occasion).
Tips: To break in, "read the magazine. Subjects are normally activities or scenics (mostly the latter). I would like good composition and very good lighting. I look for photographs that evoke a sense of place, look extraordinary and say something only a good photographer could say about the image. Look at what Ansel Adams and Eliot Porter did and what Muench and others are producing and send me that kind of quality. We want the best photographs available and we give them the space and play such quality warrants."

✦THE ONTARIO TECHNOLOGIST, 10 Four Seasons Place, Suite 404, Etobicoke, Ontario M9B 6H7 Canada. (416)621-9621. Fax: (416)621-8694. Editor-in-Chief: Ruth M. Klein. Circ. 19,200. Publication of the Ontario Association of Certified Engineering Technicians and Technologists. Bimonthly. Emphasizes engineering technology. Sample copy free with SAE and IRC.
Needs: Uses 10-12 photos/issue. Needs how-to photos—"building and installation of equipment; similar technical subjects." Model release preferred. Captions preferred.
Making Contact & Terms: Prefers business card and brochure for files. Send 5×7 glossy b&w or color prints for consideration. SASE. Reports in 1 month. Pays $25/b&w photo; $50/color photo. Pays on publication. Credit line given. Buys one-time rights. Previously published work OK.

OUTDOOR AMERICA, 707 Conservation Lane, Gaithersburg MD 20878-2983. (301)548-0150. Fax: (301)548-0146. Editor: Denny Johnson. Circ. 45,000. Estab. 1922. Published quarterly. Emphasizes natural resource conservation and activities for outdoor enthusiasts, including hunters, anglers, hikers and campers. Readers are members of the Izaak Walton League of America and all members of Congress. Sample copy $1.50 with 9×12 envelope. Guidelines free with SASE.
Needs: Needs vertical wildlife or shots of anglers or hunters for cover. Buys pictures to accompany articles on conservation and outdoor recreation for inside. Model release preferred. Captions required; include date taken, model info, location and species.

Making Contact & Terms: Query with résumé of photo credits. Send stock photo list. Tearsheets and non-returnable samples only. Uses 35mm and 2¼×2¼ slides. Not responsible for return of unsolicited material. SASE. Pays $200/color cover; $50-100/inside photo. **Pays on acceptance.** Credit line given. Buys one-time rights. Simultaneous and/or previously published work OK.

Tips: "*Outdoor America* seeks vertical photos of wildlife (particular game species); outdoor recreation subjects (fishing, hunting, camping or boating) and occasional scenics (especially of the Chesapeake Bay and Upper Mississippi river). We also like the unusual shot—new perspectives on familiar objects or subjects—for use on inside covers. We do not assign work. Approximately one half of the magazine's photos are from freelance sources." Points out that cover has moved from using a square photo format to full bleed.

PACIFIC UNION RECORDER, Box 5005, Westlake Village CA 91359. (805)497-9457. Editor: C. Elwyn Platner. Circ. 60,000. Estab. 1901. Company publication of Pacific Union Conference of Seventh-day Adventist. Monthly except twice a month in February, April, June, August, October and December. Emphasizes religion. Readers are primarily age 18-90 church members. Sample copy free with 8½×11 SAE and 3 first-class stamps. Photo guidelines free with SASE.

Needs: Uses photos for cover only; 80% supplied by freelance photographers. Needs photos of animal/wildlife shots, travel, scenics, limited to subjects within Nevada, Utah, Arizona, California and Hawaii. Model release required. Captions required.

Making Contact & Terms: Send unsolicited 35mm, 2¼×2¼, 4×5, 8×10 transparencies by mail for consideration. Limit of 10 transparencies or less/year per photographer. SASE. Reports in 1-2 months after contest. Pays $50/color cover photo. Pays on publication. Credit line given. Buys first one-time rights.

Tips: "Avoid the trite, Yosemite Falls, Half Dome, etc." Holds annual contest November 1 each year; submit entries in October only.

PENNSYLVANIA ANGLER, Dept. PM, P.O. Box 67000, Harrisburg PA 17106-7000. (717)657-4518. Editor: Art Michaels. Monthly. "*Pennsylvania Angler* is the Keystone State's official fishing magazine, published by the Pennsylvania Fish and Boat Commission." Readers are "anglers who fish in Pennsylvania." Sample copy and photo guidelines free with 9×12 SAE and 4 first-class stamps.

Needs: Uses about 25 photos/issue; 80% supplied by freelancers. Needs "action fishing and boating shots." Model release preferred. Captions required.

Making Contact & Terms: Query with résumé of credits. Send 8×10 glossy b&w prints; 35mm or larger transparencies by mail for consideration. SASE. Reports in 2 weeks. Pays up to $200/color cover photo; $25-100/b&w inside photo; $25 up/color inside photo; $50-250 for text/photo package. **Pays on acceptance.** Credit line given. Buys variable rights.

PENNSYLVANIAN MAGAZINE, Dept. PM, 2941 N. Front St., Harrisburg PA 17110. (717)236-9526. Fax: (717)236-8164. Editor: Suzanne L. Kellner. Circ. 7,000. Estab. 1962. Monthly magazine of Pennsylvania State Association of Boroughs (and other local governments). Emphasizes local government in Pennsylvania. Readers are officials in small municipalities in Pennsylvania. Sample copy free with 9×12 SAE and 5 first-class stamps.

Needs: Number of photos/issue varies with inside copy. Needs "color photos of scenics (Pennsylvania), local government activities, Pennsylvania landmarks, ecology—for cover photos only; authors of articles supply their own photos." Special photo needs include photos of street and road maintenance work; wetlands scenic. Model release preferred. Captions preferred that include identification of place and/or subject.

Making Contact & Terms: Interested in receiving work from newer, lesser-known photographers. Query with résumé of credits. Query with list of stock photo subjects. Send unsolicited photos by mail for consideration. Provide résumé, business card, brochure, flier or tearsheets to be kept on file for possible assignments. Send color prints and 35mm transparencies. Does not keep samples on file. SASE. Reports in 1 month. Pays $25-30/color cover photo. Pays on publication. Buys one-time rights.

Tips: "We're looking for a variety of scenic shots of Pennsylvania which can be used for front covers of the magazine, especially special issues such as engineering, winter road maintenance or park and recreation. Photographs submitted for cover consideration should be vertical shots; horizontal shots receive minimal consideration."

PENTECOSTAL EVANGEL, 1445 Boonville, Springfield MO 65802. (417)862-2781. Fax: (417)862-0416. Editor: Hal Donaldson. Managing Editor: John T. Maempa. Circ. 280,000. Official voice of the Assemblies of God, a conservative Pentecostal denomination. Weekly magazine. Emphasizes denomination's activities and inspirational articles for membership. Free sample copy and photographer's/writer's guidelines.

Needs: Uses 25 photos/issue; 5 supplied by freelance photographers. Human interest (very few children and animals). Also needs seasonal and religious shots. "We are interested in photos that can be used to illustrate articles or concepts developed in articles. We are not interested in merely pretty

pictures (flowers and sunsets) or in technically unusual effects or photos. We use a lot of people and mood shots." Model release preferred. Captions preferred.

Making Contact & Terms: Interested in receiving work from newer, lesser-known photographers. Send material by mail for consideration. Uses 8×10 b&w and color prints; 35mm or larger transparencies; color 2¼×2¼ to 4×5 transparencies for cover; vertical format preferred. SASE. Reports in 1 month. Pays $35-50/b&w photo; $50-200/color photo; $100-300/job. **Pays on acceptance.** Credit line given. Buys one-time rights; simultaneous rights; or second serial (reprint) rights. Simultaneous submissions and previously published work OK if indicated.

Tips: "Send seasonal material 6 months to a year in advance—especially color."

PERSIMMON HILL, 1700 NE 63rd, Oklahoma City OK 73111. (405)478-6404. Fax: (405)478-4714. Editor: M. J. Van Deventer. Circ. 15,000. Estab. 1970. Publication of the National Cowboy Hall of Fame museum. Quarterly magazine. Emphasizes the West, both historical and contemporary views. Has diverse international audience with an interest in preservation of the West. Sample copy $7 with 9×12 SAE and 6 first-class stamps. Photo guidelines free with SASE.

● This magazine has received Outstanding Publication honors from the Oklahoma Museums Association and the International Association of Business Communicators.

Needs: Uses 60 photos/issue; 95% supplied by freelancers; 90% of photos in each issue come from assigned work. "Photos must pertain to specific articles unless it is a photo essay on the West." Model release required for children's photos. Photo captions required including location, names of people, action. Proper credit is required if photos are of an historical nature.

Making Contact & Terms: Interested in receiving work from newer, lesser-known photographers. Submit portfolio for review. SASE. Reports in 6 weeks. Pays $350/color cover photo; $50/color inside photo; $25-100/b&w inside photo; $200/photo/text package; $40-60/hour; $250-500/day; $300-750/job. Credit line given. Buys first North American serial rights.

Tips: "Make certain your photographs are high quality and have a story to tell. We are using more contemporary portraits of things that are currently happening in the West and using fewer historical photographs. Work must be high quality, original, innovative. Photographers can best present their work in a portfolio format and should keep in mind that we like to feature photo essays on the West in each issue. Study the magazine to understand its purpose. Show only the work that would be beneficial to us or pertain to the traditional Western subjects we cover."

PLANNING, American Planning Association, 1313 E. 60th St., Chicago IL 60637. (312)955-9100. (312)955-8312. Editor: Sylvia Lewis. Photo Editor: Richard Sessions. Circ. 30,000. Estab. 1972. Monthly magazine. "We focus on urban and regional planning, reaching most of the nation's professional planners and others interested in the topic." Free sample copy and photo guidelines with 9½×12½ SASE and 4 first-class stamps. Writer's guidelines included on photo guidelines sheet.

Needs: Buys 50 photos/year, 95% from freelance stock. Photos purchased with accompanying ms and on assignment. Photo essay/photo feature (architecture, neighborhoods, historic preservation, agriculture); scenic (mountains, wilderness, rivers, oceans, lakes); housing; and transportation (cars, railroads, trolleys, highways). "No cheesecake; no sentimental shots of dogs, children, etc. High artistic quality is very important. We publish high-quality nonfiction stories on city planning and land use. Ours is an association magazine but not a house organ, and we use the standard journalistic techniques: interviews, anecdotes, quotes. Topics include energy, the environment, housing, transportation, land use, agriculture, neighborhoods and urban affairs." Captions required.

Making Contact & Terms: Interested in receiving work from newer, lesser-known photographers. Query with samples. Uses 8×10 glossy and semigloss b&w prints; contact sheet OK; 4-color prints; 35mm or 4×5 transparencies. SASE. Reports in 1 month. Pays $50-100/b&w photo; $50-200/color photo; up to $350/cover photo; $200-600/ms. Pays on publication. Credit line given. Previously published work OK.

Tips: "Just let us know you exist. Eventually, we may be able to use your services. Send tearsheets or photocopies of your work, or a little self-promo piece. Subject lists are only minimally useful. How the work looks is of paramount importance."

***PN/PARAPLEGIA NEWS**, 2111 E. Highland Ave., Suite 180, Phoenix AZ 85016-4702. (602)224-0500. Fax: (602)224-0507. Director of Art & Production: Susan Robbins. Circ. 27,000. Estab. 1946. Monthly magazine. Emphasizes all aspects of living for people with spinal-chord injuries or diseases.

A bullet has been placed within some listings to introduce special comments by the editor of Photographer's Market.

Readers are primarily well-educated males, 40-55, who use wheelchairs for mobility. Sample copy free with 9×12 SASE and 7 first-class stamps. Photo guidelines free with SASE.
Needs: Uses 30 photos/issue; 10% supplied by freelancers. Articles/photos must deal with accessibility or some aspect of wheelchair living. "We do not accept photos that do not accompany manuscript." Model/property release preferred. Captions required; include who, what, when, where.
Making Contact & Terms: Interested in receiving work from newer, lesser-known photographers. Provide résumé, business card, brochure, flier or tearsheets to be kept on file for possible assignments. "OK to call regarding possible assignments in their locales." Deadlines: will be communicated on contact. Keeps samples on file. SASE. Reports in 1 month. Pays $25-200/color cover photo; $10-25/color inside photo; $10-25/b&w inside photo; $50-200/photo/text package; other forms of payment negotiate with editor. Pays on publication. Credit line given. Buys one-time, all rights; negotiable. Simultaneous submissions and previously published work OK.
Tips: "Feature a person in a wheelchair in photos whenever possible. Person should preferably be involved in some activity."

POPULATION BULLETIN, 1875 Connecticut Ave., Suite 520, Washington D.C. 20009. (202)483-1100. Fax: (202)328-3937. Production Manager: Jacqueline Guenther. Circ. 15,000. Estab. 1929. Publication of the Population Reference Bureau. Quarterly journal. Publishes other population-related publications, including a monthly newsletter. Emphasizes demography. Readers are educators (both high school and college) of sociology, demography and public policy.
Needs: Uses 8-10 photos/issue; 70% supplied by freelancers. Needs vary widely with topic of each edition—people, families, young, old, all ethnic backgrounds—everyday scenes, world labor force, working people, minorities. Special photo needs include environmental related scenes with or without people. Everyday scenes, closeup pictures of locals in developing countries in S. America, Asia, Africa and Europe. Model/property release required. Captions preferred.
Making Contact & Terms: Interested in receiving work from newer, lesser-known photographers. Query with list of stock photo subjects. Send unsolicited photos by mail for consideration. Send b&w prints or photocopies. SASE. Reports in 2 weeks. Pays $50-100/b&w photo; $150-250/color photo. **Pays on acceptance.** Buys one-time rights. Simultaneous submissions and previously published work OK.
Tips: "Looks for subjects relevant to the topics of our publications, quality photographs, composition, artistic value and price."

❧**PRESBYTERIAN RECORD**, 50 Wynford Dr., North York, Ontario M3C 1J7 Canada. (416)441-1111. Fax: (416)441-2825. Editor: Rev. John Congram. Circ. 60,000. Estab. 1875. Monthly magazine. Emphasizes subjects related to The Presbyterian Church in Canada, ecumenical themes and theological perspectives for church-oriented family audience. Photos purchased with or without accompanying ms. Free sample copy and photo guidelines with 9×12 SAE and $1 postage minimum.
Needs: Religious themes related to features published. No formal poses, food, nude studies, alcoholic beverages, church buildings, empty churches or sports. Captions preferred.
Making Contact & Terms: Interested in receiving work from newer, lesser-known photographers. Send photos. Uses prints only for reproduction; 8×10, 4×5 glossy b&w or color prints and 35mm and 2¼×2¼ color transparencies. Usually uses 35mm color transparency for cover or ideally, 8×10 transparency. Vertical format used on cover. SAE, IRCs for return of work. Reports in 1 month. Pays $15-35/b&w print; $60 minimum/cover photo; $30-60 for text/photo package. Pays on publication. Credit line given. Buys one-time rights; negotiable. Simultaneous submissions and/or previously published work OK.
Tips: "Unusual photographs related to subject needs are welcome."

*****PRINCETON ALUMNI WEEKLY**, 194 Nassau St., Princeton NJ 08542. (609)258-4885. Editor-in-Chief: J.I. Merritt. Art Director: Stacy Wszola. Circ. 58,000. Biweekly. Emphasizes Princeton University and higher education. Readers are alumni, faculty, students, staff and friends of Princeton University. Sample copy $1.50 with 8½×11 SAE and 2 first-class stamps.
Needs: Uses about 15 photos/issue (not including class notes section); 10 supplied by freelance photographers. Needs b&w photos of "people, campus scenes; subjects vary greatly with content of each issue. Show us photos of Princeton." Captions required.
Making Contact & Terms: Arrange a personal interview to show portfolio. Provide brochure to be kept on file for possible future assignments. SASE. Reports in 1 month. Payment is negotiated depending on editorial needs and usage. Pays on publication. Buys one-time rights. Simultaneous submissions and previously published work OK.

PRINCIPAL MAGAZINE, Dept. PM, 1615 Duke St., Alexandria VA 22314-3483. (703)684-3345. Editor: Lee Greene. Circ. 25,000. Estab. 1921. Publication of the National Association of Elementary School Principals. Bimonthly. Emphasizes public education—kindergarten to 8th grade. Readers are mostly principals of elementary and middle schools. Sample copy free with SASE.

Needs: Uses 5-10 b&w photos/issue; all supplied by freelancers. Needs photos of school scenes (classrooms, playgrounds, etc.), teaching situations, school principals at work, computer use and technology and science activities. The magazine sometimes has theme issues, such as back to school, technology and early childhood education. *No posed groups.* Close-ups preferred. Reviews photos with or without accompanying ms. Model release preferred. Captions preferred.

Making Contact & Terms: Interested in receiving work from newer, lesser-known photographers. Query with samples and list of stock photo subjects. Send b&w prints, b&w contact sheet by mail for consideration. SASE. "We hold submitted photos indefinitely for possible stock use, so send dupes or photocopies." Reports in 1 month. Pays $50/b&w photo. Pays on publication. Credit line given. Buys one-time rights; negotiable. Simultaneous submissions and previously published work OK.

***PROCEEDINGS/NAVAL HISTORY**, US Naval Institute, Annapolis MD 21402. (410)268-6110. Fax: (410)269-7940. Contact: Picture Editor. Circ. 110,000. Estab. 1873. Association publications. *Proceedings* is a monthly magazine and *Naval History* is a bimonthly publication. Emphasizes Navy, Marine Corps, Coast Guard. Readers are age 18 and older, male and female, naval officers, enlisted, retirees, civilians. Sample copy free with 9×12 SASE. Photo guidelines free with SASE.

Needs: Uses 50 photos/issue; 40% supplied by freelancers. Needs photos of foreign and US Naval, Coast Guard and Marine Corps vessels, personnel and aircraft. Captions required.

Making Contact & Terms: Send unsolicited photos by mail for consideration: 8×10 glossy or matte, b&w or color prints; 35mm transparencies. SASE. Reports in 1 month. Pays $200/color or b&w cover photo; $25/color inside photo; $25/b&w page rate; $250-500/photo/text package. Pays on publication. Credit line given. Buys one-time rights. Simultaneous submissions and previously published work OK.

***PUBLIC POWER**, 2301 M. St. NW, Third Floor, Washington DC 20037. (202)467-2948. Editor: Jeanne LaBella. Circ. 12,000. Publication of the American Public Power Association. Bimonthly. Emphasizes electric power provided by cities, towns and utility districts. Circ. 12,000. Sample copy and photo guidelines free.

Needs: "We buy photos on assignment only."

Making Contact & Terms: Query with samples. Provide résumé, business card, brochure, flier or tearsheets to be kept on file for possible future assignments. Reports in 2 weeks. Pay varies—$25-75/photo—more for covers. **Pays on acceptance.** Credit line given. Buys one-time rights. Simultaneous submissions and previously published work OK.

QST, 225 Main St., Newington CT 06111. (203)666-1541. Fax: (203)665-7531. Features Editor: Brian Battles. Circ. 172,000. Estab. 1915. Publication of the American Radio Relay League. Monthly magazine. Emphasizes amateur radio. Readers are generally male, ages 25 to 70. Sample copy free with SASE. Photo guidelines free with SASE.

Needs: Uses 30 photos/issue; 20-25 supplied by freelancers. "Shots must involve people enjoying ham radio or feature ham radio novelty or humorous pictures." Reviews photos purchased with or without accompanying ms; "manuscript preferred, though." Model release preferred. Captions required.

Making Contact & Terms: Interested in receiving work from newer, lesser-known photographers. Query with résumé of credits. Query with stock photo list. Send unsolicited photos by mail for consideration. Provide résumé, business card, brochure, flier or tearsheets to be kept on file for possible assignments. Send any size color or b&w prints; 35mm, $2\frac{1}{4} \times 2\frac{1}{4}$, 4×5 transparencies. SASE. Reports in 3 weeks. Pays $75-100/color cover photo; $20-30/color inside photo; $65 b&w page rate; $65-300/photo/text package. Pays on acceptance or publication; "usually on publication." Credit line given. Buys all rights; negotiable. Previously published work OK if from a non-competing market.

Tips: "Stay in focus, work people having fun into your picture. Read *QST*! The photos/stories we look for will be evident."

***RECREATIONAL ICE SKATING**, 355 W. Dundee Rd., Buffalo Grove IL 60089-3500. (708)808-7528. Fax: (708)808-8329. Managing Editor: Lara Lowery. Circ. 40,000. Estab. 1976. A publication of Ice Skating Institute of America. Quarterly magazine. Emphasizes figure skating, hockey and speedskating—recreational aspects of these sports. Readers are male and female skating enthusiasts—all professions; ages 6-80. Sample copy free with 9×12 SASE and 3 first-class stamps.

Needs: Uses 50 photos/issue; 68% supplied by freelancers. Needs photos travel (ISIA event venues); art with stories—skating, hockey. Model/property release required for skaters, bystanders, organization property (i.e. Disney World, etc.) Any photo not directly associated with story content. Captions preferred; include name(s) of person/people locations, ages of people—where they are from, skate, etc.

Making Contact & Terms: Interested in receiving work from newer, lesser-known photographers. Query with stock photo list. Provide résumé, business card, brochure, flier or tearsheets to be kept on file for possible assignments. Deadlines: July 1, September 1, January 1, February 15. Keeps samples

on file. SASE. Reports in 1 month. Pays $25-50/hour; $100-200/day; $100-1,000/job; pays $10-35/ color cover photo; $10-15/b&w inside photo; $15-35/color page rate; $10-35/photo/text package. Pays on publication. Credit line given. Buys one-time rights and all rights; negotiable. Previously published work OK.
Tips: Show an ability to produce lean action photos within indoor rinks that have poor lighting conditions.

REFORM JUDAISM, 838 Fifth Ave., New York NY 10021. (212)249-0100. Managing Editor: Joy Weinberg. Circ. 300,000. Estab. 1972. Publication of the Union of American Hebrew Congregations. Quarterly magazine. Emphasizes Reform Judaism. Readers are members of Reform congregations in North America. Sample copy $3.50.
Needs: Uses 35 photos/issue; 10% supplied by freelancers. Needs photos relating to Jewish life or Jewish issues, Israel, politics. Captions required.
Making Contact & Terms: Provide résumé, business card, brochure, flier or tearsheets to be kept on file for possible assignments. Reports in 1 month. Pays on publication. Credit line given. Buys one-time rights; first North American serial rights. Simultaneous submissions and/or previously published work OK.
Tips: Wants to see "excellent photography: artistic, creative, evocative pictures that involve the reader."

RELAY MAGAZINE, P.O. Box 10114, Tallahassee FL 32302-2114. (904)224-3314. Editor: Stephanie Wolanski. Circ. 1,800. Estab. 1957. Association publication of Florida Municipal Electric. Monthly magazine. Emphasizes municipally owned electric utilities. Readers are city officials, legislators, public power officials and employees. Sample copy free with 9×12 SAE and 3 first-class stamps.
Needs: Uses various amounts of photos/issue; various number supplied by freelancers. Needs b&w photos of electric utilities in Florida (hurricane/storm damage to lines, utility workers, etc.). Special photo needs include hurricane/storm photos. Model/property release preferred. Captions required.
Making Contact & Terms: Query with letter, description of photo or photocopy. Uses 5×7 or 8×10 b&w prints. Keeps samples on file. SASE. Reports in 3 months. NPI. Rates negotiable. **Pays on acceptance.** Credit line given. Buys one-time rights, repeated use (stock); negotiable. Simultaneous submissions and/or previously published work OK.
Tips: "Must relate to our industry. Clarity and contrast important. Query first if possible. Always looking for good hurricane, lightning-storm and Florida power plant shots."

ROCKFORD REVIEW, P.O. Box 858, Rockford IL 61105. Editor: David Ross. Association publications of Rockford Writers' Guild. Quarterly magazine. Circ. 1,000. Estab. 1982. Emphasizes poetry and prose of all types. Readers are of all stages and ages who share an interest in quality writing and art. Sample copy $5.
 • This publication is literary in nature and publishes very few photographs. However, the photos on the cover tend to be experimental (e.g. solarized images, photograms, etc.).
Needs: Uses 1-5 photos/issue; all supplied by freelancers. Needs photos of scenics and personalities. Model/property release preferred. Captions preferred; include when and where of the photos and biography.
Making Contact & Terms: Interested in receiving work from newer, lesser-known photographers. Send unsolicited photos by mail for consideration. Send 8×10 or 5×7 glossy b&w prints. Does not keep samples on file. SASE. Reports in 6 weeks. Pays in one copy of magazine, but work is eligible for *Review*'s $25 Editor's Choice prize. Pays on publication. Credit line given. Buys first North American serial rights. Simultaneous submissions OK.
Tips: "Experimental work with a literary magazine in mind will be carefully considered. Avoid the 'news' approach." Sees more opportunities for artsy photos.

THE ROTARIAN, 1560 Sherman Ave., Evanston IL 60201. (312)866-3000. Fax: (708)866-9732. Editor: Willmon L. White. Photo Editor: Judy Lee. Circ. 523,650. Estab. 1911. Monthly magazine. For Rotarian business and professional men and women and their families in 151 countries and 34 geographic regions. Free sample copy and photo guidelines with SASE.
Needs: "Our greatest need is for the identifying face or landscape, one that says unmistakably, 'This is Japan, or Minnesota, or Brazil, or France or Sierra Leone,' or any of the other states, countries and geographic regions this magazine reaches." Captions preferred.
Making Contact & Terms: Interested in receiving work from newer, lesser-known photographers. Query with résumé of credits or send photos for consideration. Uses 8×10 glossy b&w or color prints; contact sheet OK; 8×10 color glossy prints; for cover uses transparencies "generally related to the contents of that month's issue." SASE. Reports in 2 weeks. **Pays on acceptance.** NPI; payment varies. Buys one-time rights; occasionally all rights; negotiable.
Tips: "We prefer vertical shots in most cases. The key words for the freelance photographer to keep in mind are *internationality* and *variety*. Study the magazine. Read the kinds of articles we publish.

Think how your photographs could illustrate such articles in a dramatic, story-telling way. Key submissions to general interest, art-of-living material." Plans special pre-convention promotion coverage of June 1995 Rotary International convention in Nice, France.

SCOUTING MAGAZINE, Boy Scouts of America, 1325 Walnut Hill Lane, Irving TX 75038. (214)580-2358. Fax: (214)580-2079. Photo Editor: Brian Payne. Circ. 1 million. Bimonthly magazine. For adults within the Scouting movement. Free photo guidelines.
Needs: Assigns 90% of photos; uses 10% from stock. Needs photos dealing with success and/or personal interest of leaders in Scouting. Wants no "single photos or ideas from individuals unfamiliar with our magazine." Captions required.
Making Contact & Terms: "No assignments will be considered without a portfolio review by mail or in person." Call to arrange a personal appointment, or query with ideas. SASE. Reports in 10 working days. Pays $350 minimum/day. **Pays on acceptance.** Buys one-time rights.
Tips: Study the magazine carefully. In portfolio or samples, wants to see "diversity and ability to light difficult situations."

SEA FRONTIERS INC., UM Knight Center, 400 SE Second Ave., 4th Floor, Miami FL 33131. (305)375-8498. Fax: (305)375-9188. Editor: Bonnie Gordon. Art Director: Phoebe Diftler. Circ. 47,000. Estab. 1954. Quarterly magazine. For anyone with an interest in any aspect of the sea, the life it contains and its conservation. Sample copy $5 postpaid. Photo guidelines free with SASE.
Needs: Buys 350 photos/year. Animal, nature, photo feature, scenic, wildlife, industry, vessels, structures and geological features. Ocean-related subjects only. Captions required.
Making Contact & Terms: Send photos for consideration. Send 35mm or 2¼×2¼ transparencies. Uses vertical format for cover. Allow space for insertion of logo. SASE. Reports in 1 month. Pays $50-100/color photo. Pays on publication. Credit line given. Buys one-time rights.

THE SECRETARY, 2800 Shirlington Rd., Suite 706, Arlington VA 22206. (703)998-2534. Publisher: Debra J. Stratton. Circ. 45,000. Estab. 1942. Association publication of the Professional Secretaries International. Published 9 times a year. Emphasizes secretarial profession—proficiency, continuing education, new products/methods and equipment related to office administration/communications. Readers include career secretaries, 98% women, in myriad offices, with wide ranging responsibilities. Sample copy free with SASE.
Needs: Uses1 or 2 feature photos and several "Product News" photos/issue; freelance photos 100% from stock. Needs secretaries (predominately women, but occasionally men) in appropriate and contemporary office settings using varied office equipment or performing varied office tasks. Must be in good taste and portray professionalism of secretaries. Especially interested in photos featuring members of minority groups. Reviews photos with or without accompanying ms. Model release preferred.
Making Contact & Terms: Interested in receiving work from newer, lesser-known photographers. Query with samples. Send unsolicited photos by mail for consideration. Uses 3½×4½, 8×10 glossy prints; 35mm, 2¼×2¼, 4×5 and 8×10 transparencies. SASE. Reports in 1 month. Pays $150 maximum/b&w photo; $500 maximum/color photo. Pays on publication. Credit line given. Buys first North American serial rights. Simultaneous submissions and previously published work OK.

SIGNPOST FOR NORTHWEST TRAILS MAGAZINE, Dept. PM, 1305 Fourth Ave., #512, Seattle WA 98101. (206)625-1367. Editor: Dan Nelson. Circ. 3,800. Estab. 1966. Publication of the Washington Trails Association. Monthly. Emphasizes "backpacking, hiking, cross-country skiing, all nonmotorized trail use, outdoor equipment and minimum-impact camping techniques." Readers are "people active in outdoor activities, primarily backpacking; residents of the Pacific Northwest, mostly Washington; age group: 9-90, family-oriented, interested in wilderness preservation, trail maintenance." Photo guidelines free with SASE.
Needs: Uses about 20-25 photos/issue; 50% supplied by freelancers. Needs "wilderness/scenic; people involved in hiking, backpacking, canoeing, skiing, wildlife, outdoor equipment photos, all with Pacific Northwest emphasis." Captions required.
Making Contact & Terms: Send 5×7 or 8×10 glossy b&w prints by mail for consideration. SASE. Reports in 1 month. No payment for inside photos. Pays $25/b&w cover photo. Pays on publication. Credit line given. Buys one-time rights. Simultaneous submissions and previously published work OK.
Tips: "We are a b&w publication and prefer using b&w originals for the best reproduction. Photos must have a Pacific Northwest slant. Photos that meet our cover specifications are always of interest to us. Familiarity with our magazine would greatly aid the photographer in submitting material to us. Contributing to *Signpost* won't help pay your bills, but sharing your photos with other backpackers and skiers has its own rewards."

SKYDIVING, 1725 N. Lexington Ave., DeLand FL 32724. (904)736-4793. Fax: (904)736-9786. Editor: Sue Clifton. Circ. 10,200. Estab. 1979. Monthly magazine. Readers are "sport parachutists worldwide, dealers and equipment manufacturers." Sample copy $3. Photo guidelines for SASE.

Needs: Uses 50 photos/issue; 5 supplied by freelancers. Selects photos from wire service, photographers who are skydivers and freelancers. Interested in anything related to skydiving—news or any dramatic illustration of an aspect of parachuting. Model release preferred. Captions preferred; include who, what, why, when, how.
Making Contact & Terms: Interested in receiving work from newer, lesser-known photographers. Send actual 5×7 or larger b&w or color photos or 35mm or 2¼×2¼ transparencies by mail for consideration. Keeps samples on file. SASE. Reports in 1 month. Pays $50-100/color cover photo; $25-50/color inside photo; $15-50/b&w inside photo. Pays on publication. Credit line given. Buys one-time rights.

SOARING, Box E, Hobbs NM 88241-7504. (505)392-1177. Fax: (505)392-8154. Art Director: Steve Hines. Circ. 16,000. Estab. 1937. Monthly magazine. Emphasizes the sport of soaring in sailplanes and motorgliders. Readership consists of white collar and professional males and females, ages 14 and up. Sample copy and photo guidelines free with SASE.
Needs: Uses 25 or more photos/issue; 95% supplied by freelancers. "We hold freelance work for a period of usually 6 months, then it is returned. If we have to keep work longer, we notify the photographer. The photographer is always updated on the status of his or her material." Needs sharply focused transparencies, any format. Especially needs aerial photography. "We need a good supply of sailplane transparencies for our yearly calendar." Model release preferred. Captions required.
Making Contact & Terms: Send unsolicited photos by mail for consideration. Uses b&w prints, any size and format. Also uses transparencies, any format. SASE. Reports in 2 weeks. Pays $50/color cover photo. Pays $100 for calendar photos. Pays on publication. Credit line given. Buys one-time rights. Simultaneous submissions OK.
Tips: "Exciting air-to-air photos, creative angles and techniques are encouraged. We pay only for the front cover of our magazine and photos used in our calendars. We are a perfect market for photographers that have sailplane photos of excellent quality. Send work dealing with sailplanes only and label all material."

SOUTHERN CALIFORNIA BUSINESS, 350 S. Bixel St., Los Angeles CA 90017. (213)580-7571. Fax: (213)580-7511. Editor: Christopher Volker. Circ. 7,000. Estab. 1898. Association publication of L.A. Chamber of Commerce. Monthly newspaper. Emphasizes business. Readers are mostly business owners, male and female, ages 21-65. Sample copy $2. Photo guidelines not available.
Needs: Uses 10-20 photos/issue; 5-8 supplied by freelance photographers and public relations agencies. Needs photos of events, editorial, technology, business people and new products. Special photo needs include specialty shots on various subjects (mainly business-oriented).
Making Contact & Terms: Interested in receiving work from newer, lesser-known photographers. Query with list of stock photo subjects. Send b&w prints by mail for consideration. Provide résumé, business card, brochure, flier or tearsheets to be kept on file for possible assignments. SASE. Reports in 3 weeks. Pays $4-5/b&w photo; $100/b&w cover photo; $80-100/hour; $100-150/day; $100-250/photo/text package. Pays on publication. Credit line given. Buys first North American serial rights and all rights; negotiable. Model release required. Captions required. Simultaneous submissions OK.
Tips: In photographer's samples, wants to see "a variety of different subject matter but prefer people shots. Present new ideas, how photography could be more exciting. Send in detailed letter and description of work."

SPORTSCAR, 1371 E. Warner, Suite E, Tustin CA 92680. (714)259-8240. Editor: Rich McCormack. Circ. 50,000. Estab. 1944. Publication of the Sports Car Club of America. Monthly magazine. Emphasizes sports car racing and competition activities. Sample copy $2.95.
Needs: Uses 75-100 photos/issue; 75% from assignment and 25% from freelance stock. Needs action photos from competitive events, personality portraits and technical photos.
Making Contact & Terms: Interested in receiving work from newer, lesser-known photographers. Query with résumé of credits or send 5×7 color or b&w glossy/borders prints or 35mm or 2¼×2¼ transparencies by mail for consideration. Provide résumé, business card, brochure, flier or tearsheets to be kept on file for possible assignments. SASE. Reports in 1 month. Pays $25/color inside photo; $10/b&w inside photo; $250/color cover. Negotiates all other rates. Pays on publication. Credit line given. Buys first North American serial rights. Simultaneous submissions OK.
Tips: To break in with this or any magazine, "always send only the absolute best work; try to accommodate the specific needs of your clients. Have a relevant subject, strong action, crystal sharp focus, proper contrast and exposure. We need good candid personality photos of key competitors and officials."

STUDENT LAWYER, 750 N. Lake Shore Dr., Chicago IL 60611. Editor: Sarah Hoban. Circ. 30,000. Estab. 1972. Publication of the American Bar Association. Magazine published 9 times a school year. Emphasizes social and legal issues for law students. Sample copy $4.
Needs: Uses about 3-5 photos/issue; all supplied by freelancers. "All photos are assigned, determined by story's subject matter." Model release preferred. Captions required.

Making Contact & Terms: Interested in receiving work from newer, lesser-known photographers. Arrange a personal interview to show portfolio or send samples. SASE. Reports in 3 weeks. Pays $400/color cover photo; $75-200/b&w; $100-250/color inside photo. **Pays on acceptance.** Credit line given. Buys one-time rights. Previously published work OK.

THE SURGICAL TECHNOLOGIST, 7108-C S. Alton Way, Englewood CO 80112. (303)694-9130. Editor: Sharon Pellowe. Circ. 16,452. Publication of the Association of Surgical Technologists. Monthly. Emphasizes surgery. Readers are "20-60 years old, operating room professionals, well educated in surgical procedures." Sample copy free with 9×12 SASE and 5 first-class stamps. $1.25 postage. Photo guidelines free with SASE.
Needs: Uses 1 photo/issue. Needs "surgical, operating room photos that show members of the surgical team in action." Model release required.
Making Contact & Terms: Query with samples. Submit portfolio for review. Send 5×7 or 8½×11 glossy or matte prints; 35mm, 2¼×2¼ or 4×5 transparencies; b&w or color contact sheets; b&w or color negatives by mail for consideration. Provide résumé, business card, brochure, flier or tearsheets to be kept on file for possible future assignments. SASE. Reports in 4 weeks after review by Editorial Board. Pays $25/b&w inside photo; $50/color inside photo. **Pays on acceptance.** Credit line given. Buys one-time rights. Simultaneous submissions and previously published work OK.

TANK TALK, 570 Oakwood Rd., Lake Zurich IL 60047. (708)438-TANK. Fax: (708)438-8766. Contact: Tom Schwerman. Circ. 9,800. Publication of Steel Tank Institute. Bimonthly. Emphasizes matters pertaining to the underground and aboveground storage tank industry. Readers are tank owners, installers, government officials, regulators, manufacturers, engineers. Sample copy free with 9×12 SAE and 3 first-class stamps.
Needs: Uses about 4-6 photos/issue; 50-75% supplied by freelancers. Needs photos of installations, current developments in the industry, i.e., new equipment and features for tanks, author photos, fiberglass tank leaks. Photos purchased with accompanying ms only. Model/property release required. Captions required.
Making Contact & Terms: Interested in receiving work from newer, lesser-known photographers. "Call if you have photos of interest to the tank industry." Uses at least 5×7 glossy b&w prints. SASE. Reports in 2 weeks. NPI. Pays on publication. Buys all rights; negotiable. Simultaneous submissions and previously published work OK.

TEAM MAGAZINE, P.O. Box 7259, Grand Rapids MI 49510. (616)241-5616. Fax: (616)241-5558. Editor: Judy Blain. Publication of the Young Calvinist Federation. *Team Magazine* is a quarterly digest for volunteer church youth leaders. It promotes shared leadership for holistic ministry with high school young people. Contributor's guidelines and sample issue of *Team* for SASE.
Needs: Buys 25-30 photos/year. Photos used in magazines and books—"We produce 1-2 books annually for youth leaders, an additional 5-25 pictures." High school young people in groups and as individuals in informal settings—on the street, in the country, at retreats, at school, having fun; racial variety; discussing in two's, three's, small groups; studying the Bible; praying; dating; doing service projects; interacting with children, adults, the elderly.
Making Contact & Terms: Query with samples. Query with list of stock photo subjects. Send unsolicited photos by mail for consideration. "We like to keep those packages that have potential on file for two months. Others (with no potential) returned immediately." Uses 5×7 or 8×10 b&w glossy prints. Also uses color for cover. SASE. Pays $35-75/b&w photo; $50-300/color photo. Credit line given. Buys one-time rights.
Tips: In samples, looks for "more than just faces. We look for activity, unusual situations or settings, symbolic work. No out-of-date fashion or hair." To break in, "send us a selection of photos. We will photocopy and request as needed. We expect good contrast in b&w."

***TEDDY BEAR AND FRIENDS, Cowles Magazine,** 6405 Flank Dr., Harrisburg PA 17112. (717)540-6656. Fax: (717)540-6169. Managing Editor: Deborah Thompson. Estab. 1983. Bimonthly magazine. Emphasizes teddy bear collecting. Photo guidelines free with SASE.
Needs: Buys 100-250 photos/year; 50 photo/year supplied by freelancers. "We need photos of specific teddy bears to accompany our articles." Model/property release required. Captions required; include

Market conditions are constantly changing! If you're still using this book and it's 1997 or later, buy the newest edition of Photographer's Market *at your favorite bookstore or order directly from Writer's Digest Books.*

name of object, height, medium, edition size, costume and accessory description; name, address, telephone number of artist or manufacturer; price.
Making Contact & Terms: Interested in receiving work from newer, lesser-known photographers. Send unsolicited photos by mail for consideration. Provide résumé, business card, brochure, flier or tearsheets to be kept on file for possible assignments. Submit portfolio for review. Query with stock photo list. Query with samples. Send 3½×5 glossy color prints; 35mm, 2¼×2¼, 4×5 transparencies. Transparencies are preferred. Keeps samples on file. SASE. Reports in 1 month. NPI. "If photos are accepted, we pay on receipt of invoice." Credit line given. Buys all rights. Simultaneous submissions OK.

TEEN LIFE, Sunday Curriculum and Literature Department, Church School Literature Department, 1445 Boonville Ave., Springfield MO 65802. (417)862-2781. Editor: Tammy L. Bicket. Circ. 80,000. Estab. 1936. Publication of The General Council of the Assemblies of God. Thirteen weekly, 2-page issues published quarterly. Readers are primarily high school students (but also junior high). Sample copy free with 9×12 SAE and 50¢ postage. Photo guidelines free with SASE.
Needs: Uses 10-20 photos/quarter; 95% from freelance stock. Does not assign. Needs photos of teens in various moods (joy, loneliness, surprise). Some scenics used, including teens in the photo; high school settings and activities. Reviews photos with or without accompanying ms. Model release preferred.
Making Contact & Terms: Interested in receiving work from newer, lesser-known photographers. Send 8×10 glossy b&w prints; 35mm, 2¼×2¼ and 4×5 transparencies by mail for consideration. SASE. Pays $35-50/b&w photo; $50-100/color photo. **Pays on acceptance.** Credit line given. Buys one-time rights. Simultaneous submissions and previously published work OK.
Tips: Wants to see "sharp, clear, colorful, usually close-up shots of teens involved in various activities and with other people." For submission, wants good "composition and contrast of teens working, playing, eating, partying, relaxing, at school, home, church, etc. Also, mood shots, closeups." Be able to show emotion in subjects.

TEXAS ALCALDE MAGAZINE, P.O. Box 7278, Austin TX 78713. (512)471-3799. Fax: (512)471-8088. Editor: Avrel Seale. Circ. 52,000. Estab. 1913. Publication of the University of Texas Ex-Students' Association. Bimonthly magazine. Emphasizes University alumni. Readers are graduates, former students and friends who pay dues in the Association. Sample copy free with 9×12 SAE and 5 first-class stamps.
Needs: Uses 65 photos/issue; 2-3 supplied by freelance photographers. Needs University of Texas (UT) campus shots, professors, students, buildings, city of Austin, UT sports. Will review photos with accompanying ms only. Model release preferred. Captions required.
Making Contact & Terms: Interested in receiving work from newer, lesser-known photographers. Query with list of stock photo subjects. Send 5×7 or 8×10 glossy b&w and color prints; 35mm, 2¼×2¼ or 4×5 transparencies by mail for consideration. SASE. Reports in 1 month. Fee negotiable. NPI. Pays on publication. Credit line given. Buys one-time rights. Simultaneous submissions and/or previously published work OK if details of use are supplied.

TEXAS REALTOR MAGAZINE, P.O. Box 2246, Austin TX 78768. (512)370-2286. Fax: (512)370-2390. Art Director: Lauren Levi. Circ. 45,000. Estab. 1972. Publication of the Texas Association of Realtors. Monthly magazine. Emphasizes real estate sales and related industries. Readers are male and female realtors, ages 20-70. Sample copy free with SASE.
Needs: Uses 10 photos/issue; all supplied by freelancers. Needs photos of architectural details, business, office management, telesales, real estate sales, commercial real estate, nature, sales. Especially wants to see architectural detail and landscape for covers. Property release required.
Making Contact & Terms: Interested in receiving work from newer, lesser-known photographers. Pays $75-300/color photo; $1,500/job. Buys one-time rights; negotiable.

TEXTILE RENTAL MAGAZINE, Dept. PM, P.O. Box 1283, Hallandale FL 33008. (305)457-7555. Editor: Christine Seaman. Circ. 6,000. Publication of the Textile Rental Services Association of America. Monthly magazine. Emphasizes the "linen supply, industrial and commercial laundering industry." Readers are "heads of companies, general managers of facilities, predominantly male audience; national and international readers."
Needs: Photos "needed on assignment basis only." Model release preferred. Captions preferred or required "depending on subject."
Making Contact & Terms: "We contact photographers on an as-needed basis selecting from a directory of photographers." Cannot return material. Pays $350/color cover plus processing; "depends on the job." **Pays on acceptance.** Credit line given if requested. Buys all rights. Previously published work OK.

TIKKUN, 251 W 100 St., New York NY 10025. (212)864-4110. Fax: (212)864-4137. E-mail: tikkun@ panix.com. Production Manager: Eric Goldhagen. Circ. 40,000. Estab. 1986. Bimonthly journal. Publi-

cation is a political, social and cultural Jewish critique. Readers are 75% Jewish, white, middle-class, literary people ages 30-60.

Needs: Uses 10 photos/issue; 50% supplied by freelancers. Needs political; social; commentary; Middle Eastern; U.S. photos. Reviews photos with or without ms.

Making Contact & Terms: Send unsolicited photos by mail for consideration. Uses b&w "or good photo copy" prints. Keeps samples on file. SASE. Reporting time varies. "Turnaround is 4 months, unless artist specifies other." Pays $40/b&w inside photo. Pays on publication. Credit line given. Buys all rights; negotiable. Simultaneous submissions and/or previously published work OK.

Tips: "Read or look at magazine before sending photos."

TOUCH, P.O. Box 7259, Grand Rapids MI 49510. (616)241-5616. Fax: (616)241-5558. Managing Editor: Carol Smith. Circ. 15,500. Estab. 1970. Publication of Calvinettes. Monthly. Emphasizes "girls 7-14 in action. The magazine is a Christian girls' publication geared to the needs and activities of girls in the above age group." Readers are "Christian girls ages 7-14; multiracial." Sample copy and photo guidelines for $1 with 9 × 12 SASE. "Also available is a theme update listing all the themes of the magazine for one year."

Needs: Uses about 5-6 photos/issue; 50-75% from freelancers. Needs photos suitable for illustrating stories and articles: photos of girls aged 7-14 from multicultural backgrounds involved in sports, Christian service and other activities young girls would be participating in." Model/property release preferred.

Making Contact & Terms: Interested in receiving work from newer, lesser-known photographers. Send 5×7 glossy b&w prints by mail for consideration. SASE. Reports in 2 months. Pays $20-35/b&w photo; $50/cover. Pays on publication. Credit line given. Buys one-time rights. Simultaneous submissions OK.

Tips: "Make the photos simple. We prefer to get a spec sheet rather than photos and we'd really like to hold photos sent to us on speculation until publication. We select those we might use and send others back. Freelancers should write for our annual theme update and try to get photos to fit the theme of each issue." Recommends that photographers "be concerned about current trends in fashions and hair styles and that all girls don't belong to 'families.'" To break in, "a freelancer can present a selection of his/her photography of girls, we'll review it and contact him/her on its usability."

TRAFFIC SAFETY, 1121 Spring Lake Dr., Itasca IL 60143. (708)775-2284. Fax: (708)775-2285. Publisher: Kevin Axe. Executive Editor: Carrie Fearn. Managing Editor: John Jackson. Publication of National Safety Council. Bimonthly. Emphasizes highway and traffic safety, accident prevention. Readers are professionals in highway-related fields, including traffic engineers, fleet managers, state officials, driver improvement instructors, trucking executives, licensing officials, community groups, university safety centers. Circ. 20,000.

Needs: Uses about 10 photos/issue; most supplied by freelancers. Needs photos of road scenes, vehicles, driving; specific needs vary.

Making Contact & Terms: Query with four-color and/or b&w prints. SASE. Reports in 2 weeks. NPI; prices decided on individual basis. **Pays on acceptence**. Credit line given.

TRANSPORT TOPICS, 2200 Mill Rd., Alexandria VA 22314. (703)838-1780. Fax: (703)548-3662. Chief Photographer: Michael James. Circ. 31,000. Estab. 1935. Publication of the American Trucking Associations. Weekly tabloid. Emphasizes the trucking industry. Readers are male executives 35-65.

Needs: Uses approximately 12 photos/issue; amount supplied by freelancers "depends on need." Needs photos of truck transportation in all modes. Model/property release preferred. Captions preferred.

Making Contact & Terms: Interested in receiving work from newer, lesser-known photographers. Send unsolicited 35mm or 2¼ × 2¼ transparencies by mail for consideration. Provide résumé, business card, brochure, flier or tearsheets to be kept on file for possible assignments. Does not keep samples on file. SASE. Reports in 1 month. NPI. Pays standard "market rate" for color cover photo. **Pays on acceptance**. Credit line given. Buys one-time rights; negotiable. Simultaneous submissions and previously published work OK.

Tips: "Trucks/trucking must be dominant element in the photograph—not an incidental part of an environmental scene."

TURKEY CALL, P.O. Box 530, Edgefield SC 29824. Parcel services: 770 Augusta Rd. (803)637-3106. Fax: (803)637-0034. Publisher: National Wild Turkey Federation, Inc. (nonprofit). Editor: Gene Smith. Circ. 78,000. Estab. 1973. Bimonthly magazine. For members of the National Wild Turkey Federation—people interested in conserving the American wild turkey. Sample copy $3 with 9 × 12 SASE. Contributor guidelines free with SASE.

Needs: Buys at least 50 photos/year. Needs photos of "wild turkeys, wild turkey hunting, wild turkey management techniques (planting food, trapping for relocation, releasing), wild turkey habitat." Captions required.

Making Contact & Terms: Interested in receiving work from newer, lesser-known photographers. Send copyrighted photos to editor for consideration. Send 8 × 10 glossy b&w prints; color transparencies, any format. SASE. Reports in 6 weeks. Pays $25/b&w photo; $50-75/inside color photo; $200/cover. **Pays on acceptance.** Credit line given. Buys one-time rights.

Tips: Wants no "poorly posed or restaged shots, mounted turkeys representing live birds, domestic turkeys representing wild birds or typical hunter-with-dead-bird shots. Photos of dead turkeys in a tasteful hunt setting are considered. Keep the acceptance agreement/liability language to a minimum. It scares off editors and art directors." Sees a trend developing regarding serious amateurs who are successfully competing with pros. "Newer equipment is partly the reason. In good light and steady hands, full auto is producing good results. I still encourage tripods, however, at every opportunity."

V.F.W. MAGAZINE, 406 W. 34th St., Kansas City MO 64111. (816)756-3390. Fax: (816)968-1169. Editor: Richard Kolb. Managing Editor: Gary Bloomfield. Circ. 2.2 million. Monthly magazine, except July. For members of the Veterans of Foreign Wars (V.F.W.)—men and women who served overseas, and their families. Sample copy free with SAE and 2 first-class stamps.

Needs: Photos illustrating features on current defense and foreign policy events, veterans issues and, accounts of "military actions of consequence." Photos purchased with or without accompanying ms. Present model release on acceptance of photo. Captions required.

Making Contact & Terms: Interested in receiving work from newer, lesser-known photographers. Send 8 × 10 glossy b&w or color prints; transparencies. "Cover shots must be submitted with a ms. Price for cover shot will be included in payment of manuscript." SASE. Reports in 4 weeks. Pays $250 minimum. Pays $25-50/b&w photo; $35-250/color photo. **Pays on acceptance.** Buys one-time and all rights; negotiable.

Tips: "Go through an issue or two at the local library (if not a member) to get the flavor of the magazine." When reviewing samples "we look for familiarity with the military and ability to capture its action and people. We encourage military photographers to send us their best work while they're still in the service. Though they can't be paid for official military photos, at least they're getting published by-lines, which is important when they get out and start looking for jobs."

VIRGINIA TOWN & CITY, P.O. Box 12164, Richmond VA 23241. (804)649-8471. Fax: (804)343-3758. Editor: David Parsons. Circ. 5,000. Estab. 1965. Monthly magazine of Virginia Municipal League concerning Virginia local government. Readers are state and local government officials in Virginia.

Needs: Wants photos of Virginia locations/topics only. "B&w photos illustrating scenes of local government and some color work for covers." Special photo needs include "illustrations of environmental issues, computer uses, development, transportation, schools and law enforcement." Captions preferred.

Making Contact & Terms: Query with list of stock photo subjects. Send unsolicited photos by mail for consideration. Send b&w prints. Keeps samples on file. SASE. Reports "when we can." Pays $100-125/color cover photo. Pays on publication. Credit line given. Buys one-time rights; negotiable. Simultaneous submissions and previously published work OK.

VIRGINIA WILDLIFE, Dept. PM, P.O. Box 11104, Richmond VA 23230. (804)367-1000. Art Director: Emily Pels. Circ. 55,000. Monthly magazine. Emphasizes Virginia wildlife, as well as outdoor features in general, fishing, hunting and conservation for sportsmen and conservationists. Free sample copy and photo/writer's guidelines.

Needs: Buys 350 photos/year; about 95% purchased from freelancers. Photos purchased with accompanying ms. Good action shots relating to animals (wildlife indigenous to Virginia), action hunting and fishing shots, photo essay/photo feature, scenic, human interest outdoors, nature, outdoor recreation (especially boating) and wildlife. Photos must relate to Virginia. Accompanying mss: features on wildlife; Virginia travel; first-person outdoors stories. Pays 15¢/printed word. Model release preferred for children. Property release preferred for private property. Captions required; identify species and locations.

Making Contact & Terms: Send 35mm and 2¼ × 2¼ or larger transparencies. Vertical format required for cover. SASE. Reports (letter of acknowledgment) within 30 days; acceptance or rejection within 45 days of acknowledgement. Pays $30-50/color photo; $125/cover photo; $75/back cover. Pays on publication. Credit line given. Buys one-time rights.

Tips: "We don't have time to talk with every photographer who submits work to us, since we do have a system for processing submissions by mail. Our art director will not see anyone without an appointment. In portfolio or samples, wants to see a good eye for color and composition and both vertical and horizontal formats. We are seeing higher quality photography from many of our photographers. It is a very competitive field. Show only your best work. Name and address must be on each slide. Plant and wildlife species should also be identified on slide mount. We look for outdoor shots (must relate to Virginia); close-ups of wildlife."

VOCATIONAL EDUCATION JOURNAL, 1410 King St., Alexandria VA 22314. (703)683-3111. Fax: (703)683-7424. Circ. 45,000. Estab. 1926. Monthly magazine for American Vocational Association. Emphasizes education for work and on-the-job training. Readers are teachers and administrators in high school and colleges. Sample copy free with 10×13 SASE.

● This publication has begun to use computer manipulated images.

Needs: Uses 8-10 photos/issue, 1-2 supplied by freelancers. "Students in classroom and job training settings; teachers; students in work situations." Model release preferred for children. Captions preferred; include location, explanation of situation.

Making Contact & Terms: Interested in receiving work from newer, lesser-known photographers. Query with list of stock photo subjects. Send unsolicited photos by mail for consideration. Provide résumé, business card, brochure, flier or tearsheets to be kept on file for possible assignments. Send 5×7 b&w prints and 35mm transparencies. Keeps samples on file. SASE. Reports as needed. Pays $400 up/color cover photo; $50 up/color inside photo; $30 up/b&w inside photo; $500-1,000/job. Pays on publication. Credit line given. Buys one-time rights; sometimes buys all rights; negotiable. Simultaneous submissions and previously published work OK.

THE WATER SKIER, 799 Overlook Dr., Winter Haven FL 33884. (813)324-4341. Fax: (813)325-8259. Editor: Greg Nixon. Circ. 25,000. Estab. 1950. Publication of the American Water Ski Association. Magazine published 7 times a year. Emphasizes water skiing. Readers are male and female professionals ages 20-45. Sample copy $2.50. Photo guidelines available.

Needs: Uses 25-35 photos/issue. 1-5 supplied by freelancers. Needs photos of sports action. Model/property release required. Captions required.

Making Contact & Terms: Interested in receiving work from newer, lesser-known photographers. Call first. SASE. Reports in 1 month. NPI. Pays on publication. Credit line given. Buys all rights.

♣WFCD COMMUNICATOR, 2734 Lorne Ave., Brandon, Manitoba R7B 0L3 Canada. (204)726-4778. Editor: Monique Perey. Circ. 3,200. Estab. 1980. Publication of the Western Fertilizer and Chemical Dealers Association. Quarterly magazine. Emphasizes fertilizer and chemicals, related equipment and products. Audience consists of independent fertilizer and chemical dealers who are primarily male (although this is changing) of various ages.

Needs: Uses approximately 10 photos/issue; 20% supplied by freelance photographers. Looking for agricultural shots related to fertilizer and chemical industry, e.g., application equipment and field work in progress. Written release and captions preferred.

Making Contact & Terms: Provide résumé, business card, brochure, flier or tearsheets to be kept on file for possible assignments. SASE. Reports in 1 month. Pays $25/b&w inside photo. Pays on publication. Credit line given. Buys one-time rights.

Tips: "Be very specific in the shots you take; match them exactly to the requirements of the publication. For example, a picture of a tractor and hay baler is useless to a publication that focuses on chemical application."

WOMENWISE, CFHC, Dept. PM, 38 S Main St., Concord NH 03301. (603)225-2739. Editor: Luita Spangler. Circ. 3,000. Estab. 1978. Publication of the Concord Feminist Health Center. Quarterly tabloid. Emphasizes women's health from a feminist perspective. Readers are women, all ages and occupations. Sample copy $2.95.

Needs: All photos supplied by freelancers; 80% assignment; 20% or less stock. Needs photos of primarily women, women's events and demonstrations, etc. Model release required. Captions preferred.

Making Contact & Terms: Interested in receiving work from newer, lesser-known photographers, "if it's excellent quality and supports our editorial stance." Arrange a personal interview to show portfolio. Send b&w prints. Pays $15/b&w cover photo; sub per b&w inside photo. Pays on publication. Credit line given. Buys first North American serial rights.

Tips: "We don't publish a lot of 'fine-arts' photography now. We want photos that reflect our commitment to empowerment of all women. We prefer work by women. Do not send originals to us, even with SASE. We are small (staff of three) and lack the time to return original work."

WOODMEN, 1700 Farnam St., Omaha NE 68102. (402)342-1890. Editor: Scott J. Darling. Assistant Editor: Billie Jo Foust. Circ. 500,000. Estab. 1890. Official publication for Woodmen of the World/Omaha Woodmen Life Insurance Society. Bimonthly magazine. Emphasizes American family life. Free sample copy and photographer guidelines.

Needs: Buys 15-20 photos/year. Historic, animal, fine art, photo essay/photo feature, scenic, special effects and experimental, how-to, human interest, humorous; nature, still life, travel and wildlife. Model release required. Captions preferred.

Making Contact & Terms: Send material by mail for consideration. Uses 8×10 glossy b&w prints on occasion; 35mm, 2¼×2¼ and 4×5 transparencies; 4×5 transparencies for cover, vertical format preferred. SASE. Reports in 1 month. Pays $50/b&w inside photo; $75 minimum/color inside photo;

$300/cover photo.**Pays on acceptance.** Credit line given on request. Buys one-time rights. Previously published work OK.

Tips: "Submit good, sharp pictures that will reproduce well."

YOUNG CHILDREN, 1509 16th St. NW, Washington DC 20036-1426. (202)232-8777. Photo Editor: Roma White. Circ. 90,000. Bimonthly journal. Emphasizes education, care and development of young children and promotes education of those who work with children. Read by teachers, administrators, social workers, physicians, college students, professors and parents. Free photo and writer's guidelines.

Needs: Buys photos on continuing basis. Also publishes 8 books/year with photos. Children (from birth to age 8) unposed, with/without adults. Wants on a regular basis "children engaged in educational activities: dramatic play, scribbling/writing, playing with blocks—typical nursery school activities. Especially needs photos of minority children and children with disabilities." No posed, "cute" or stereotyped photos; no "adult interference, sexism, unhealthy food, unsafe situations, old photos, children with workbooks, depressing photos, parties, religious observances. Must provide copies of model releases for all individuals in photos." Accompanying mss: professional discussion of early childhood education and child development topics.

Making Contact & Terms: Interested in receiving work from newer, lesser-known photographers. Query with samples. Send glossy b&w and color prints; transparencies. SASE. Pays $25/inside photo; $75/posters and covers; no payment for ms. Pays on publication. Credit line given. Buys one-time rights; negotiable. Simultaneous submissions and/or previously published work OK.

Tips: "Write for our guidelines. We are using more photos per issue and using them in more creative ways, such as collages and inside color." Looks for "photos that depict children actively learning through interactions with the world around them; sensitivity to how children grow, learn and feel."

Special Interest Publications/'95-'96 changes

The following markets appeared in the 1995 edition of *Photographer's Market*, but are not listed this year. The majority did not respond to our request to update their listings. If a reason was given for a market's exclusion it appears in parentheses below.

AFSCME Public Employee
Alabama Municipal Journal (does not buy freelance photos)
American Bar Association Journal
American Libraries
Asta Agency Management Magazine
Black Writer
California Lawyer
Coal Voice
Construction Specifier
HR Magazine (overwhelmed by submissions)
Journal of Soil and Water Conser-

vation
LACMA Physician
Magazine For Christian Youth (out of business)
Meeting Manager (does not buy freelance photos)
National Business Woman
New Physician
NFPA Journal
Pacific Discovery
Pennsylvania Heritage
Pentecostal Messenger (does not buy freelance photos)
PTA Today
Public Citizen

Retired Officer Magazine
Science and Children
Science Scope
Scrap Processing and Recycling
Sentinel
Sharing the Victory
Shooting Sports USA
Single Parent
Spectrum
State Government News
STL
War Cry
Woman Bowler

Trade Publications

Just as special interest publications fill a specific need, so too do trade magazines. This section contains 192 listings with 44 new markets. Most trade publications are directed toward the business community in an effort to keep readers abreast of the ever-changing trends and events in their specific professions. For photographers, shooting for these professions can be financially rewarding and can serve as a stepping stone toward acquiring future jobs.

As often happens with this category, the number of trade publications produced increases or decreases as professions develop or deteriorate. In recent years, for example, magazines involving computers have flourished as the technology continues to grow. In this year's edition of *Photographer's Market* there are numerous trade publication listings covering a variety of professions.

Primarily, photos in trade publications, as in other publication markets, serve to attract the reader to the articles and illustrate the text in an informative way. Trade

publication readers are usually well-educated and very knowledgeable about their businesses or professions. The editors and photo editors, too, are often experts in their particular fields. So, with both the readers and the publications' staffs, you are dealing with a much more discriminating audience. To be taken seriously, your photos must not be merely technically good pictures, but also should communicate a solid understanding of the subject and reveal greater insights.

In particular, photographers who can communicate their knowledge in both verbal and visual form will often find their work more in demand. If you have such expertise, you may wish to query about submitting a photo/text package that highlights a unique aspect of working in that particular profession or that deals with a current issue of interest to that field.

Many photos purchased by these publications come from stock—both that of freelance inventories and of stock photo agencies. Generally, these publications are more conservative with their freelance budgets and use stock as an economical alternative. For this reason, listings in this section will often advise sending a stock list as an initial method of contact. Some of the more established publications with larger circulations and advertising bases will sometimes offer assignments as they become familiar with a particular photographer's work. For the most part, though, stock remains the primary means of breaking in and doing business with this market.

***AAP NEWS**, 141 Northwest Pt. Blvd., Elk Grove Village IL 60007. (708)981-6755. Fax: (708)228-5097. Graphic Designer/Production Coordinator: Felicia McGurren. Estab. 1928. Publication of American Academy of Pediatrics. Monthly newspaper.
Needs: Uses 100 photos/year. 30-40 freelance assignments offered/year. Needs photos of children, health care providers—news photos. Model/property release preferred. "Those we would keep on hand for stock use." Captions required; include names, dates, places and situations.
Making Contact & Terms: Arrange personal interview to show portfolio. Provide résumé, business card, brochure, flier or tearsheets to be kept on file for possible assignments. Submit portfolio for review. Send 5×7 or 8×10 color or b&w prints; Keeps samples on file. Cannot return material. Reports in 1 month. Pays $35-65/hour; $50-100/color inside photo; $50-100/b&w inside photo. Pays on publication. Buys one-time or all rights; negotiable. Simultaneous submissions and previously published work OK.
Tips: Photojournalists welcome. "Look at our paper."

ABA BANKING JOURNAL, 345 Hudson St., New York NY 10014. (212)620-7256. Art Director: John McLaughlin. Circ. 30,000. Estab. 1909. Monthly magazine. Emphasizes "how to manage a bank better. Bankers read it to find out how to keep up with changes in regulations, lending practices, investments, technology, marketing and what other bankers are doing to increase community standing."
Needs: Buys 12-24 photos/year; freelance photography is 50% assigned, 50% from stock. Personality, and occasionally photos of unusual bank displays or equipment. "We need candid photos of various bankers who are subjects of articles." Photos purchased with accompanying ms or on assignment.
Making Contact & Terms: Query with samples. For b&w: contact sheet preferred; uses 8×10 glossy prints "if prints are ordered." For color: uses 35mm transparencies and 2¼×2¼ transparencies. For cover: uses color transparencies, square format required. SASE. Reports in 1 month. Pays $100-500/photo; $100 minimum/job; $200/printed page for photo/text package. **Pays on acceptance.** Credit line given. Buys one-time rights.
Tips: "I look for the ability to take a portrait shot in a different and exciting way—not just 'look at the camera and smile.'"

***ACCOUNTING TODAY**, 11 Penn Plaza, New York NY 10001. (212)631-1594. Fax: (212)564-9896. Contact: Managing Editor. Circ. 35,000. Estab. 1987. Biweekly tabloid. Emphasizes finance. Readers are CPAs in public practice.
Needs: Uses 2-3 photos/issue; all supplied by freelancers. "We assign news subjects, as needed." Captions required.
Making Contact & Terms: Interested in receiving work from newer, lesser-known photographers. Provide résumé, business card, brochure, flier or tearsheets to be kept on file for possible assignments.

Keeps samples on file. Cannot return material. Pays $250/shoot. **Pays on acceptance.** Credit line given. Buys all rights; negotiable.

ACROSS THE BOARD MAGAZINE, published by The Conference Board, 845 Third Ave., New York NY 10022-6601. (212)339-0454. Picture Editor: Marilyn Stern. Circ. 30,000. Estab. 1976. General interest business magazine with 10 monthly issues (January/February and July/August are double issues). Readers are senior executives in large corporations. Recent articles have covered pollution in Eastern Europe, working conditions in Korea, US design, healthcare.
Needs: Use 10-15 photos/issue some supplied by freelancers. Wide range of needs, including location portraits, industrial, workplace, social topics, environmental topics, government and corporate projects, foreign business (especially east and west Europe, former USSR and Asia). Needs striking, unusual or humorous photos with newsworthy business themes for "Sightings" department. Captions required.
Making Contact and Terms: Interested in receiving promos from newer, lesser-known photographers. Query *by mail only* with résumé of credits, list of stock photo subjects and clients, and brochure or tearsheets to be kept on file. Cannot return material. "No phone queries please. We pay $125-300 inside, up to $500 for cover or $300/half-day for assignments. We buy one-time rights, or six-month exclusive rights if we assign the project."
Tips: "Our style is journalistic. We sometimes assign locally around the USA and internationally. We keep a regional file of photographers. Also interested in seeing computer manipulated photo illustration."

***AG PILOT INTERNATIONAL MAGAZINE**, P.O. Box 1607, Mt. Vernon WA 98273. (206)336-9737. Fax: (206)336-2506. Publisher: Tom J. Wood. Circ. 7,200. Estab. 1978. Monthly magazine. Emphasizes agricultural aviation and aerial fire suppression (airborne fire fighting). Readers are male cropdusters, ages 20-70. Sample copy $3.
Needs: Uses 20-30 photos/issue; 20% supplied by freelancers. Needs photos of small, less than 400 hp,ag aircraft suitable for cover shots. Model/property preferred. Captions preferred; include who, what, where, when, why.
Making Contact & Terms: Interested in receiving work from newer, lesser-known photographers. Send unsolicited photos by mail for consideration. Send 3×5 any finish color b&w prints. Keeps samples on file. SASE. Usually reports in 1 month, but may be 2-3 months. Pays $30-150/color cover photo; $10-30/color inside photo; $5-20/b&w inside photo; $50-250/photo/text package. Pays on publication. Credit line given. Buys all rights; negotiable.
Tips: "Subject must be cropdusting and aerial fire suppression (airborne fire fighting). Learn about the aerial application business before submitting material."

AMERICAN AGRICULTURIST, 2389 N. Triphammer Rd., Ithaca NY 14850. (607)257-8670. Fax: (607)257-8238. Editor: Eleanor Jacobs. Circ. 37,000. Estab. 1842. Monthly. Emphasizes agriculture in the Northeast—specifically New York and New England. Photo guidelines free with SASE.
Needs: Occasionally photos supplied by freelance photographers; 90% on assignment, 25% from stock. Needs photos of farm equipment, general farm scenes, animals. Geographic location: only New York and New England. Reviews photos with or without accompanying ms. Model release required. Captions preferred.
Making Contact & Terms: Interested in receiving work from newer, lesser-known photographers. Query with samples and list of stock photo subjects. Send 35mm transparencies by mail for consideration. SASE. Reports in 3 months. Pays $200/color cover photo and $75-150/inside color photo. **Pays on acceptance.** Credit line given. Buys one-time rights.
Tips: "We need shots of modern farm equipment with the newer safety features. Also looking for shots of women actively involved in farming and shots of farm activity. We also use scenics. We send out our editorial calendar with our photo needs yearly."

***AMERICAN BANKER**, Dept. PM, 1 State St. Plaza, New York NY 10004. (212)803-8313. Fax: (212)843-9600. Photo Editor: Lois Wadler. Circ. 17,000. Estab. 1835. Daily tabloid. Emphasizes banking industry. Readers are male and female, senior executives in finance, ages 35-59.

The asterisk before a listing indicates that the market is new in this edition. New markets are often the most receptive to freelance submissions.

● This publication scans its photos on computer.
Needs: "We are a daily newspaper and we assign a lot of pictures throughout the country. We mostly assign environmental portraits with an editorial, magazine style to them."
Making Contact & Terms: Arrange a personal interview to show portfolio. Send unsolicited b&w or color prints by mail for consideration. Provide résumé, business card, brochure, flier or tearsheets to be kept on file for possible assignments. Keeps samples on file. SASE. Pays $225/assignment plus expenses. Credit line given. Buys one-time rights.
Tips: "We look for photos that offer a creative insight to corporate portraiture and technically proficient photographers who can work well with stuffy businessmen in a limited amount of time—30 minutes or less is the norm. Photographers should send promo cards that indicate their style and ability to work with executives. Portfolio should include 5-10 samples either slides or prints, with well-presented tearsheets of published work. Portfolio reviews by appointment only. Samples are kept on file for future reference."

AMERICAN BEE JOURNAL, Dept. PM, 51 S. 2nd St., Hamilton IL 62341. (217)847-3324. Fax: (217)847-3660. Editor: Joe M. Graham. Circ. 13,000. Estab. 1861. Monthly trade magazine. Emphasizes beekeeping for hobby and professional beekeepers. Sample copy free with SASE.
Needs: Uses about 25 photos/issue; 1-2 supplied by freelance photographers. Needs photos of beekeeping and related topics, beehive products, honey and cooking with honey. Special needs include color photos of seasonal beekeeping scenes. Model release preferred. Captions preferred.
Making Contact & Terms: Interested in receiving work from newer, lesser-known photographers. Query with samples. Send 5×7 or 8½×11 b&w and color prints by mail for consideration. SASE. Reports in 2 weeks. Pays $50/color cover photo; $10/b&w inside photo. Pays on publication. Credit line given. Buys all rights.

AMERICAN BREWER MAGAZINE, Box 570, Hayward CA 94541. (510)538-9500 (AM only). President: Bill Owens. Circ. 10,000. Estab. 1986. Quarterly magazine. Emphasizes micro-brewing and brewpubs. Readers are males ages 25-35. Sample copy $5.
Needs: Uses 5 photos/issue; 5 supplied by freelancers. Reviews photos with accompanying ms only. Captions required.
Making Contact & Terms: Contact by phone. Reports in 2 weeks. NPI; pays per job. **Pays on acceptance.** Credit line given. Buys one-time rights; negotiable. Simultaneous submissions OK.

AMERICAN FARRIERS JOURNAL, P.O. Box 624, Brookfield WI 53008-0624. (414)782-4480. Fax: (414)782-1252. Editor: Frank Lessiter. Circ. 7,000 (paid). Estab. 1974. Magazine published 7 times/ year. Emphasizes horseshoeing and horse health for professional horseshoers. Sample copy free with SASE.
Needs: Looking for horseshoeing photos, documentary, how-to (of new procedures in shoeing), photo/ essay feature, product shot and spot news. Photos purchased with or without accompanying ms. Captions required.
Making Contact & Terms: Interested in receiving work from newer, lesser-known photographers. Query with printed samples. Uses 4-color transparencies for covers. Vertical format. Artistic shots. SASE. Pays $25-50/b&w photo; $30-100/color photo; up to $150/cover photo. Pays on publication. Credit line given.

AMERICAN FIRE JOURNAL, Dept. PM, 9072 Artesia Blvd., Suite 7, Bellflower CA 90706. (310)866-1664. Fax: (310)867-6434. Editor: Carol Carlsen Brooks. Monthly magazine. Emphasizes fire protection and prevention. Circ. 6,000. Estab. 1952. Sample copy $3 with 10×12 SAE and 6 first-class stamps. Free photo and writer's guidelines.
Needs: Buys 5 or more photos/issue; 90% supplied by freelancers. Documentary (emergency incidents, showing fire personnel at work); how-to (new techniques for fire service); and spot news (fire personnel at work). Captions required. Seeks short ms describing emergency incident and how it was handled by the agencies involved.
Making Contact & Terms: Interested in receiving work from newer, lesser-known photographers. Query with samples. Provide résumé, business card or letter of inquiry. SASE. Reports in 1 month. Uses b&w semigloss prints; for cover uses 35mm color transparencies; covers must be verticals. Pays $10-25/b&w photo, negotiable; $25-100/color photo; $30/cover photo; $1.50-2/inch for ms.
Tips: "Don't be shy! Submit your work. I'm always looking for contributing photographers (especially if they are from outside the Los Angeles area). I'm looking for good shots of fire scene activity with captions. The action should have a clean composition with little smoke and prominent fire and show good firefighting techniques, i.e., firefighters in full turnouts, etc. It helps if photographers know something about firefighting so as to capture important aspects of fire scene. We like photos that illustrate the drama of firefighting—large flames, equipment and apparatus, fellow firefighters, people

in motion. Write suggested captions. Give us as many shots as possible to choose from. Most of our photographers are firefighters or 'fire buffs.' "

AMERICAN OIL & GAS REPORTER, Dept. PM, P.O. Box 343, Derby KS 67037. (316)788-6271. Publisher: Charlie Cookson. Circ. 12,000. Estab. 1957. "A monthly business publication serving the domestic exploration, drilling and production markets within the oil/gas industry. The editorial pages are designed to concentrate on the domestic independent oilman. Readers are owners, presidents and other executives." Sample copy free with SASE.
Needs: Uses 1 color photo for cover/issue; virtually all from stock. Needs "photos dealing with oil and gas drilling and production. We prefer to use only independent oil and gas photos; we discourage anything that would have to do with a major oil company, i.e., Standard, Exxon, Shell, etc." Property release preferred. Captions required; include company name, description and location.
Making Contact & Terms: Interested in receiving work from newer, lesser-known photographers. Send 35mm transparencies and unsolicited photos by mail for consideration. Returns unsolicited material with SASE. Pays $50-100/color cover photo. Pays on publication. Credit line given. Buys one-time rights. Simultaneous submissions OK.
Tips: Prefers to see "any picture that depicts a typical or picturesque view of the domestic oil and gas industry." Prefers shots depicting "drilling rigs at work and working well sites, not abandoned well sites or equipment 'graveyards.' Wants to show active industry, people in the shots. Do not have special assignments. Need stock photos that match editorial material in issue." Prefers action shots with people as opposed to scenics.

***APPLIANCE MANUFACTURER**, 5900 Harper Rd., Suite 105, Solon OH 44139. (216)349-3060. Fax: (216)498-9121. Senior Editor: Joe Jancsurak. Circ. 38,000. Monthly magazine. Emphasizes design for manufacturing in the global consumer, commercial and business appliance industry. Primary audience is the "engineering community." Sample copy free with 10×12 SASE.
Needs: Uses 20-25 photos/issue. Needs technological photos. Reviews photos purchased with accompanying ms only. Captions preferred.
Making Contact & Terms: Interested in receiving work from newer, lesser-known photographers. Provide résumé, business card, brochure, flier or tearsheets to be kept on file for possible assignments. Keeps samples on file. SASE. Reports in 2 weeks. NPI. Payment negotiable. **Pays on acceptance**. Credit line given.

ART DIRECTION, 10 E. 39th St., 6th Floor, New York NY 10016. (212)889-6500. Fax: (212)889-6504. Contact: Andrea Fridley. Circ. 10,125. Monthly magazine. Emphasis is on advertising design for art directors of ad agencies. Sample copy $4.50 and 4 first-class stamps.
Needs: Buys 5 photos/issue. Photos purchased with accompanying mss only.
Making Contact & Terms: Works with freelance photographers on assignment only basis. Provide tearsheets to be kept on file for possible future assignments. SASE. Reports in 2 weeks. Pays $50/b&w photo. Pays on publication. Credit line given. Buys one-time rights.

ATHLETIC BUSINESS, % Athletic Business Publications Inc., 1846 Hoffman St., Madison WI 53704. (608)249-0186. Fax: (608)249-1153. Art Director: Paul Graff. Monthly magazine. Emphasizes athletics, fitness and recreation. "Readers are athletic, park and recreational directors and club managers, ages 30-65." Circ. 45,000. Estab. 1977. Sample copy $5.
Needs: Uses 4 or 5 photos/issue; 50% supplied by freelancers. Needs photos of sporting shots, athletic equipment, recreational parks and club interiors. Model and/or property release and photo captions preferred.
Making Contact & Terms: Send unsolicited color prints or 35mm transparencies by mail for consideration. Does not keep samples on file. SASE. Reports in 1-2 weeks. Pays $250/color cover photo; $75/color inside photos; $125/color page rate. Pays on publication. Credit line given. Buys all rights; negotiable. Simultaneous submissions and previously published work OK, but should be explained.
Tips: Wants to see ability with subject, high quality and reasonable price. To break in, "shoot a quality and creative shot from more than one angle."

***ATLANTIC PUBLICATION GROUP INC.**, 2430 Mall Dr., Suite 315, Charleston SC 29406. (803)747-0025. Fax: (803)744-0816. Vice President of Editorial Services: Jack Bacot. Circ. 5,000-10,000. Estab. 1985. Publication of the Charlotte, NC Chamber of Commerce and Charleston, SC Chamber of Commerce. Quarterly magazine. Emphasizes business. Readers are male, female business people who are members of chambers of commerce, ages 30-60. Sample copy free with 9×12 SASE and 7 first-class stamps.
Needs: Uses 10 photos/issue; all supplied by freelancers. Needs photos of business scenes, manufacturing, real estate, lifestyle. Model/property release required. Captions preferred.
Making Contact & Terms: Provide résumé, business card, brochure, flier or tearsheets to be kept on file for possible assignment. Query with stock photo list. Deadlines: quarterly. Keeps samples on

file. SASE. Reports in 1 month. Pays $100-400/color cover photo; $100-250/b&w cover photo; $50-100/color inside photo; $50/b&w inside photo. **Pays on acceptance.** Credit line given. Buys one-time rights; negotiable. Simultaneous submissions and previously published work OK.

AUTOMATED BUILDER, Dept. PM, P.O. Box 120, Carpinteria CA 93014. (805)684-7659. Editor and Publisher: Don Carlson. Circ. 26,000. Estab. 1964. Monthly. Emphasizes home and apartment construction. Readers are "factory and site builders and dealers of all types of homes, apartments and commercial buildings." Sample copy free with SASE.
Needs: Uses about 40 photos/issue; 10-20% supplied by freelance photographers. Needs in-plant and job site construction photos and photos of completed homes and apartments. Photos purchased with accompanying ms only. Captions required.
Making Contact & Terms: Interested in receiving work from newer, lesser-known photographers. "Call to discuss story and photo ideas." Send 35mm or 2¼ × 2¼ transparencies by mail for consideration. Will consider dramatic, preferably vertical cover photos. Send color proof or slide. SASE. Reports in 2 weeks. Pays $300/text/photo package; $150/cover photo. Credit line given "if desired." Buys first time reproduction rights.
Tips: "Study sample copy. Query editor on story ideas related to industrialized housing industry."

***AUTOMOTIVE COOLING JOURNAL**, P.O. Box 97, E. Greenville PA 18041. (215)541-4500. Fax: (215)679-4977. Managing Editor: Richard Krisher. Circ. 10,500. Estab. 1956. Publication of National Automotive Radiator Service Association/Mobile Air Conditioning Society. Monthly magazine. Emphasizes cooling system repair, mobile air conditioning service. Readers are mostly male shop owners and employees.
Needs: Uses 25-30 photos/issue; 50% supplied by freelancers. Needs shots illustrating service techniques, general interest auto repair emphasizing cooling system and air conditioning service. Model/property release preferred. Captions required.
Making Contact & Terms: Interested in receiving work from newer, lesser-known photographers. Send unsolicited photos by mail for consideration. Provide résumé, business card, brochure, flier or tearsheets to be kept on file for possible assignments. Send any glossy prints; 35mm, 1¼ × 2¼, 4 × 5, 8 × 10 transparencies. Keeps samples on file. SASE. Reports in 1 month. NPI. Pays on publication. Credit line given. Buys one-time rights.

***AUTOMOTIVE NEWS**, 1400 Woodbridge, Detroit MI 48207-3187. (313)446-6000. Fax: (313)446-0383. Staff Photographer: Joe Wilssens. Circ. 77,000. Estab. 1926. Published by Crain Communications. Weekly tabloid. Emphasizes the global automotive industry. Readers are automotive industry executives including people in manufacturing and retail. Sample copies available.
Needs: Uses 30 photos/issue; 5 supplied by freelancers. Needs photos of automotive executive environmental portraits, auto plants, new vehicles, auto dealer features. Captions required; include identification of individuals and event details.
Making Contact & Terms: Interested in receiving work from newer, lesser-known photographers. Send unsolicited photos by mail for consideration. Provide résumé, business card, brochure, flier or tearsheets to be kept on file for possible assignments. Send 8 × 10 color or b&w prints; 35mm, 2¼ × 2¼, 4 × 5 transparencies. Deadlines: daily. Keeps samples on file. SASE. Reports in 2 weeks. Pays on publication. Credit line given. Buys one-time rights, possible secondary rights for other Crain publications. Simultaneous submissions and previously published work OK.

AVIONICS MAGAZINE, 1201 Seven Locks Rd., Potomac MD 20854. (301)340-7788, ext. 2840. Fax: (301)340-0542. Editor: David Robb. Circ. 24,000. Estab. 1978. Monthly magazine. Emphasizes aviation electronics. Readers are avionics engineers, technicians, executives. Sample copy free with 9 × 12 SASE.
Needs: Uses 15-20 photos/issue; 10% supplied by freelancers. Reviews photos with or without ms. Captions required.
Making Contact & Terms: Interested in receiving work from newer, lesser-known photographers. Send unsolicited photos by mail for consideration. Provide résumé, business card, brochure, flier or tearsheets to be kept on file for possible assignments. Send 8½ × 11 glossy color prints; 35mm, 2¼ × 2¼, 4 × 5, 8 × 10 transparencies. Keeps samples on file. SASE. Reports in 1-2 months. Pays $150-200/color cover photo. **Pays on acceptance.** Credit line given. Rights negotiable. Simultaneous submissions OK.

***BANK INVESTMENT REPRESENTATIVE**, P.O. Box 4364, Logan UT 84323-4364. (801)752-1173. Fax: (801)752-1193. Art Director: Tamara Pluth. Circ. 25,000. Estab. 1991. Monthly magazine. Emphasizes interests and concerns of investment representatives working for financial institutions. Readers are male and female investment representatives and managers, ages 30-60. Sample copy $5. Photo guidelines free with SASE.

Needs: Uses 5-10 photos/issue; 50% supplied by freelancers. Needs photos of business, finance, personalities in field, insurance. Model/property release preferred.
Making Contact & Terms: Interested in receiving work from newer, lesser-known photographers. Query with résumé of credits. Query with stock photo list. Send unsolicited photos by mail for consideration. Provide résumé, business card, brochure, flier or tearsheets to be kept on file for possible assignments. Send 2¼ × 2¼ transparencies. Keeps samples on file. Reports in 3 weeks. Pays $50-150/job; $200/color cover photo; $100/color inside photo; $50/b&w inside photo. Pays on publication. Credit line given. Buys one-time rights. Previously published work OK.

***BANK TECHNOLOGY NEWS**, 11 Penn Plaza, New York NY 10001. Managing Editor: Sue Sandler. Circ. 33,000. Estab. 1987. Monthly tabloid. Emphasizes banking/bank technology specifically. Readers are male and female bankers of all ages.
Needs: Uses 2-3 photos/issue; all supplied by freelancers. Needs photos of personalities. Captions preferred; include name (correct spelling), title.
Making Contact & Terms: Interested in receiving work from newer, lesser-known photographers. Provide résumé, business card, brochure, flier or tearsheets to be kept on file for possible assignments. Keeps samples on file. Cannot return material. Pays $175-200/job and expenses. Pays on publication. Credit line not given. Buys all rights.

BARTENDER MAGAZINE, P.O. Box 158, Liberty Corner NJ 07938. (908)766-6006. Fax: (908)766-6607. Art Director: Erica DeWitte. Circ. 147,000. Estab. 1979. Quarterly magazine. *Bartender Magazine* serves full-service drinking establishments (full-service means able to serve liquor, beer and wine). "We serve single locations including individual restaurants, hotels, motels, bars, taverns, lounges and all other full-service on-premises licensees." Sample copy $2.50.
Needs: Number of photos/issue varies. Number supplied by freelancers varies. Needs photos of liquor related, drinks, bars/bartenders. Reviews photos with or without ms. Model/property release required. Captions preferred.
Making Contact & Terms: Interested in receiving work from newer, lesser-known photographers. Provide résumé, business card, brochure, flier or tearsheets to be kept on file for possible assignments. SASE. NPI. Pays on publication. Credit line given. Buys all rights; negotiable. Previously published work OK.

BEEF TODAY, Farm Journal Publishing, Inc., 230 W. Washington Sqare, Philadelphia PA 19106. (215)829-4865. Photo Editor: Tom Dodge. Circ. 220,000. Monthly magazine. Emphasizes American agriculture. Readers are active farmers, ranchers or agribusiness people. Sample copy and photo guidelines free with SASE.
• This company also publishes *Farm Journal, Top Producer, Hogs Today* and *Dairy Today.*
Needs: Uses 20-30 photos/issue; 75% supplied by freelance photographers. "We use studio-type portraiture (environmental portraits), technical, details, scenics." Model release preferred. Captions required.
Making Contact & Terms: Arrange a personal interview to show portfolio. Query with résumé of credits along with business card, brochure, flier or tearsheets to be kept on file for possible assignments. SASE. Reports in 2 weeks. NPI. "We pay a cover bonus." **Pays on acceptance.** Credit line given. Buys one-time rights. Simultaneous submissions OK.
Tips: In portfolio or samples, likes to "see about 20 slides showing photographer's use of lighting and photographer's ability to work with people. Know your intended market. Familiarize yourself with the magazine and keep abreast of how photos are used in the general magazine field."

***BETTER ROADS**, 6301 Gaston Ave., Suite 541, Dallas TX 75214. (214)827-4630. Fax: (214)827-4758. Associate Publisher: Ruth W. Stidges. Circ. 40,000. Estab. 1935. Monthly magazine. Emphasizes highway and street construction, repair, maintenance. Readers are mostly male engineers and public works managers, ages 30-65. Sample copy for 9 × 12 SASE and 4 first-class stamps.
Needs: Uses 12 photos/issue; 20% supplied by freelancers. Needs vertical 4-color shots of workers and/or equipment in bridge, street, road repair or maintenance situations. Special photo needs include work-zone photos, winter road maintenance photos, bridge painting, roadside vegetation maintenance. "Releases not needed if photos shot in public locations." Captions preferred; include names of workers in photos, location, highway department and contractor names.
Making Contact & Terms: Interested in receiving work from newer, lesser-known photographers. Send unsolicited photos by mail for consideration. Send 8 × 10 color prints; 35mm, 2¼ × 2¼, 4 × 5, 8 × 10 transparencies. Keeps samples on file. SASE. Reports in 2 weeks. Pays $200-300/color cover photo; $200-300/color inside photo. **Pays on acceptance.** Buys first North American serial rights; negotiable. Simultaneous submissions and previously published work OK.

BEVERAGE & FOOD DYNAMICS, (formerly *Beverage Dynamics*), Dept. PM, 100 Avenue of the Americas, New York NY 10013. Fax: (212)431-0500. Editor: Richard Brandes. Art Director: Jeanne

DeMata. Circ. 67,000. Nine times/year magazine. Emphasizes distilled spirits, wine and beer and all varieties of non-alcoholic beverages (soft drinks, bottled water, juices, etc.), as well as gourmet and specialty foods. Readers are national—retailers (liquor stores, supermarkets, etc.), wholesalers, distillers, vintners, brewers, ad agencies and media.

• This magazine received an Ozzie Award in 1994 for Best Overall Design (trade magazine under 50,000 circulation) and also the Graphic Design: USA Award.

Needs: Uses 30-50 photos/issue; 5 supplied by freelance photographers and photo house (stock). Needs photos of retailers, product shots, concept shots and profiles. Special needs include good retail environments; interesting store settings; special effect photos. Model release required. Captions required.

Making Contact & Terms: Interested in receiving work from newer, lesser-known photographers. Query with samples and list of stock photo subjects. Send non-returnable samples, slides, tearsheets, etc. with a business card. "An idea of their fee schedule helps as well as knowing if they travel on a steady basis to certain locations." SASE. Reports in 2 weeks. Pays $550-750/color cover photo; $450-950/job. Pays on publication. Credit line given. Buys one-time rights or all rights on commissioned photos. Simultaneous submissions OK.

Tips: "We're looking for good location photographers who can style their own photo shoots or have staff stylists. It also helps if they are resourceful with props. A good photographer with basic photographs is always needed. We don't manipulate other artists work, whether its an illustration or a photograph. If a special effect is needed, we hire a photographer who manipulates photographs."

BUILDINGS: The Facilities Construction and Management Magazine, 427 Sixth Ave. SE, P.O. Box 1888, Cedar Rapids IA 52406. (319)364-6167. Fax: (319)364-4278. Editor: Linda Monroe. Circ. 42,000. Estab. 1906. Monthly magazine. Emphasizes commercial real estate. Readers are building owners and facilities managers. Sample copy $6.

Needs: Uses 50 photos/issue; 10% supplied by freelancers. Needs photos of concept, building interiors and exteriors, company personnel and products. Model/property release preferred. Captions preferred.

Making Contact & Terms: Provide résumé, business card, brochure, flier or tearsheets to be kept on file for possible assignments. Send 3×5, 8×10, b&w, color prints; 35mm, 2¼×2¼, 4×5 transparencies upon request only. SASE. Reports as needed. Pays $350/color cover photo; $200/color inside photo. Pays on publication. Credit line given. Rights negotiable. Simultaneous submissions OK.

BUSINESS NH MAGAZINE, 404 Chestnut St., #201, Manchester NH 03101. (603)626-6354. Fax: (603)626-6359. Art Director: Nikki Bonenfant. Circ. 13,000. Estab. 1984. Monthly magazine. Emphasizes business. Readers are male and female—top management, average age 45. Sample copy free with 9×12 SASE and 5 first-class stamps.

Needs: Uses 3-6 photos/issue. Needs photos of people, high-tech, software and locations. Model/property release preferred. Captions required; include names, locations, contact phone number.

Making Contact & Terms: Interested in receiving work from newer, lesser-known photographers. Arrange personal interview to show portfolio. Provide résumé, business card, brochure, flier or tearsheets to be kept on file for possible assignments. Keeps samples on file. SASE. Reports in 3 weeks. Pays $300-500/color cover photo; $60/color inside photo; $40/b&w inside photo. Pays on publication. Credit line given. Buys one-time rights.

Tips: Looks for "people in environment shots, interesting lighting, lots of creative interpretations, a definite personal style. If you're just starting out and want excellent statewide exposure to the leading executives in New Hampshire, you should talk to us."

✽**CANADIAN GUERNSEY JOURNAL**, 368 Woolwich St., Guelph, Onatrio N1H 3W6 Canada. (519)836-2141. Editor: V.M. Macdonald. Circ. 500. Estab. 1927. Publication of the Canadian Guernsey Association. Bimonthly magazine. Emphasizes dairy cattle, purebred and grade guernseys. Readers are dairy farmers. Sample copy $5.

Needs: Uses 10 photos/issue; 1 supplied by freelancer. Needs photos of guernsey cattle; posed,informal, scenes. Photo captions preferred.

Making Contact & Terms: Interested in receiving work from newer, lesser-known photographers. Contact through rep. Keeps samples on file. SASE (IRCs). Reports in 2 weeks. Pays $10/b&w inside photo. Pays on publication. Credit line given. Rights negotiable. Previously published work OK.

The maple leaf before a listing indicates that the market is Canadian.

CAREER PILOT MAGAZINE, 4959 Massachusetts Blvd., Atlanta GA 30337. (404)997-8097, ext. 142. Fax: (404)997-8111. Graphic Designer: Kellie Frissell. Circ. 14,000. Estab. 1983. Monthly magazine. Emphasizes career advancement for pilots. Sample copy available.
• This graphic designer is interested in computer manipulated images as long as the quality is high.
Needs: Uses 2 photos/issue minimum; all supplied by freelancers. Needs photos of airline airplanes, lifestyle, financial and health related topics. Model/property release required.
Making Contact & Terms: Interested in receiving work from newer, lesser-known photographers. Provide résumé, business card, brochure, flier or tearsheets to be kept on file for possible assignments. No phone calls. Keeps samples on file. SASE. Pays $100-500/job; $300/color cover photo; $100-200/color inside photo. Pays on publication. Buys one-time rights. Previously published work OK.
Tips: "No fashion photography, wildlife or scenics. Still-lifes preferred. Let us know if you prefer concepting ideas or if you prefer us to give you the idea. We need both types. Attention to detail and variety of styles are very important."

CASINO JOURNAL, 3100 W. Sahara Ave., #205, Las Vegas NV 89102. (702)253-6230. Fax: (702)253-6804. Editor: Adam Fine. Circ. 35,000. Estab. 1990. Monthly journal. Emphasizes casino operations. Readers are casino executives, employees and vendors. Sample copy free with 11×14 SAE and 9 first-class stamps.
Needs: Uses 40-60 photos/issue; 5-10 supplied by freelancers. Needs photos of gaming tables and slot machines, casinos and portraits of executives. Model release required for gamblers, employees. Captions required.
Making Contact & Terms: Interested in receiving work from newer, lesser-known photographers. Query with résumé of credits. Query with stock photo list. Reports in 2-3 months. Pays $100 minimum/color cover photo; $10-35/color inside photo; $10-25/b&w inside photo. Pays on publication. Credit line given. Buys all rights; negotiable.
Tips: "Read and study photos in current issues."

***CED MAGAZINE**, 600 S. Cherry St., Suite 400, Denver CO 80222. (303)393-7449. Fax: (303)393-6654. Editor: Roger Brown. Art Director: Don Ruth. Circ. 18,500. Estab. 1975. Monthly magazine. Emphasizes cable TV or video networking. Readers are typically male, ages 30-50, who are technical and engineering oriented.
Needs: Uses 2-3 photos/issue. Needs photos of technology. Model/property release preferred.
Making Contact & Terms: Interested in receiving work from newer, lesser-known photographers. Provide résumé, business card, brochure, flier or tearsheets to be kept on file for possible assignments. Keeps samples on file. SASE. Reports in 3 weeks. Pays $400-1,700/job; $250-600/color cover photo; $50-200/color inside photo. **Pays on acceptance**. Credit line given. Buys one-time rights; negotiable. Previously published work OK.

THE CHRISTIAN MINISTRY, 407 S. Dearborn St., Chicago IL 60605-1150. (312)427-5380. Fax: (312)427-1302. Managing Editor: Victoria A. Rebeck. Circ. 12,000. Estab. 1969. Bimonthly magazine. Emphasizes religion—parish clergy. Readers are 30-65 years old, 80% male, 20% female, parish clergy and well-educated. Sample copy free with 9×12 SAE and 4 first-class stamps. Photo guidelines free with SASE.
Needs: Uses 8 photos/issue; all supplied by freelancers; 75% comes from stock. Needs photos of clergy (especially female clergy), church gatherings, school classrooms and church symbols. Future photo needs include social gatherings and leaders working with groups. Candids should appear natural. Model release preferred. Captions preferred.
Making Contact & Terms: Interested in receiving work from newer, lesser-known photographers. Send 8×10 b&w prints by mail for consideration. SASE. Reports in 3 weeks. Pays $50/b&w cover photo; $25/b&w inside photo. On solicited photography, pays $50/photo plus expenses and processing. Pays on publication. Credit line given. Buys one-time rights. Will consider simultaneous submissions.
Tips: "We're looking for up-to-date photos of clergy, engaged in preaching, teaching, meeting with congregants, working in social activities. We need photos of women, African-American and Hispanic clergy. We print on newsprint, so images should be high in contrast and sharply focused."

THE CHRONICLE OF PHILANTHROPY, 1255 23rd St. NW, 7th Floor, Washington DC 20037. (202)466-1205. Fax: (202)466-2078. Art Director: Sue LaLumia. Circ. 35,000. Estab. 1988. Biweekly tabloid. Readers come from all aspects of the nonprofit world such as charities (large or small grant maker/giving), foundations and relief agencies such as the Red Cross. Sample copy free.
Needs: Uses 20 photos/issue; 50-75% supplied by freelance photographers. Needs photos of people (profiles) making the news in philanthropy and environmental shots related to person(s)/organization. Most shots arranged with freelancers are specific. Model release required. Captions required.
Making Contact & Terms: Arrange a personal interview to show portfolio. Send unsolicited photos by mail for consideration. Send 35mm, 2¼×2¼ transparencies and prints by mail for consideration.

Provide résumé, business card, brochure, flier or tearsheets to be kept on file for possible assignments. Will send negatives back via certified mail. Reports in 1-2 days. Pays (color and b&w) $225 plus expenses/half day; $350 plus expenses/full day; $75/reprint. Pays on publication. Buys one-time rights. Previously published work OK.

CLAVIER, Dept. PM, 200 Northfield Rd., Northfield IL 60093. (708)446-5000. Editor: Elizabeth Hintch. Circ. 20,000. Estab. 1962. Magazine published 10 times/year. Readers are piano and organ teachers. Sample copy $2.
Needs: Human interest photos of keyboard instrument students and teachers. Special needs include synthesizer photos and children performing.
Making Contact & Terms: Send material by mail for consideration. Uses glossy b&w prints. For cover: Kodachrome, glossy color prints or 35mm transparencies. Vertical format preferred. SASE. Reports in 1 month. Pays $100-150/color cover; $10-25/b&w inside photo. Pays on publication. Credit line given. Buys all rights.
Tips: "We look for sharply focused photographs that show action and for clear color that is bright and true. We need photographs of children and teachers involved in learning music at the piano. We prefer shots that show them deeply involved in their work rather than posed shots. Very little is taken on specific assignment except for the cover. Authors usually include article photographs with their manuscripts. We purchase only one or two items from stock each year."

CLEANING & MAINTENANCE MANAGEMENT MAGAZINE, 13 Century Hill Dr., Latham NY 12110. (518)783-1281. Senior Editor: Tom Williams. Managing Editor: Anne Dantz. Circ. 40,000. Estab. 1963. Monthly. Emphasizes management of cleaning/custodial/housekeeping operations for commercial buildings, schools, hospitals, shopping malls, airports, etc. Readers are middle- to upper-level managers of in-house cleaning/custodial departments, and managers/owners of contract cleaning companies. Sample copy free (limited) with SASE.
Needs: Uses 10-15 photos/issue. Needs photos of cleaning personnel working on carpets, hard floors, tile, windows, restrooms, large buildings, etc. Model release preferred. Captions required.
Making Contact & Terms: Provide résumé, business card, brochure, flier or tearsheets to be kept on file for possible assignments. "Query with specific ideas for photos related to our field." SASE. Reports in 1-2 weeks. Pays $25/b&w inside photo. Credit line given. Rights negotiable. Simultaneous submissions and previously published work OK.
Tips: "Query first and shoot what the publication needs."

CLIMATE BUSINESS MAGAZINE, Dept. PM, P.O. Box 13067, Pensacola FL 32591. (904)433-1166. Fax: (904)435-9174. Publisher: Elizabeth A. Burchell. Circ. 15,000. Estab. 1990. Quarterly magazine. Emphasizes business. Readers are executives, ages 35-54, with average annual income of $80,000. Sample copy $4.75.
Needs: Uses 50 photos/issue; 20 supplied by freelancers. Needs photos of Florida topics: technology, government, ecology, global trade, finance, travel and life shots. Model/property release required. Captions preferred.
Making Contact & Terms: Send unsolicited photos by mail for consideration. Provide résumé, business card, brochure, flier or tearsheets to be kept on file for possible assignments. Send 5×7 b&w or color prints; 35mm, 2¼×2¼ transparencies. Keeps samples on file. SASE. Reports in 3 weeks. Pays $75/color cover photo; $25/color inside photo; $25/b&w inside photo; $75/color page. Pays on publication. Buys one-time rights.
Tips: "Don't overprice yourself and keep submitting work."

***CLUB INDUSTRY MAGAZINE**, 1300 Virginia Dr., Suite 400, Fort Washington PA 19034. (215)643-8036. Fax: (215)643-1705. Art Director: Al Feuerstein. Circ. 35,000. Estab. 1980. Monthly magazine. Readers are energetic, goal-oriented male and female fitness executives, ages 25-60. Sample copy free with SASE.
Needs: Uses 5-10 photos/issues; 1-4 supplied by freelancers. Needs photos of health-fitness related, nutrition, active lifestyle. Model release required. Captions required.
Making Contact & Terms: Interested in receiving work from newer, lesser-known photographers. Provide résumé, business card, brochure, flier or tearsheets to be kept on file for possible assignments. Keeps samples on file. Reports based on interest in samples and current needs. Pays $600-1,000/day. Pays on publication. Credit line given. Buys one-time rights; negotiable. Previously published work OK.

COLLISION, Box M, Franklin MA 02038. (508)528-6211. Editor: Jay Kruza. Circ. 20,000. Magazine published every 5 weeks. Emphasizes "technical tips and management guidelines" for auto body repairmen and dealership managers in eastern US. Sample copy $3. Photo guidelines free with SASE.
Needs: Buys 100 photos/year; 12/issue. Photos of technical repair procedures, association meetings, etc. A regular column called "Stars and Cars" features a national personality with his/her car. Prefers

at least 3 b&w photos with captions as to why person likes this vehicle. If person has worked on it or customized it, photo is worth more. Special needs include: best looking body shops in US, includes exterior view, owner/manager, office, shop, paint room and any special features (about 6-8 photos). In created or set-up photos, which are not direct news, requires photocopy of model release with address and phone number of models for verification. Captions required
Making Contact & Terms: Query with résumé of credits and representational samples (not necessarily on subject) or send contact sheet for consideration. Send b&w glossy or matte contact sheet or 5×7 prints. SASE. Reports in 3 weeks. Pays $135; $25 for first photo; $10 for each additional photo in the series; pays $50 for first photo and $25 for each additional photo for "Stars and Cars" column. Prefers to buy 5 or 7 photos per series. Extra pay for accompanying mss. **Pays on acceptance.** Buys all rights, but may reassign to photographer after publication. Simultaneous submissions OK.
Tips: "Don't shoot one or two frames; do a sequence or series. It gives us choice, and we'll buy more photos. Often we reject single photo submissions. Capture how the work is done to solve the problem."

COMMERCIAL CARRIER JOURNAL, Dept. PM, Chilton Way, Radnor PA 19089. (610)964-4513. Editor-in-Chief: Gerald F. Standley. Managing Editor: Paul Richards. Circ. 79,000. Estab. 1911. Monthly magazine. Emphasizes truck and bus fleet maintenance operations and management.
Needs: Spot news (of truck accidents, Teamster activities and highway scenes involving trucks). Photos purchased with or without accompanying ms, or on assignment. Model release required. *Detailed* captions required.
Making Contact & Terms: Send material by mail for consideration. For color photos, uses prints and 35mm transparencies. For covers, uses color transparencies. Uses vertical cover only. Needs accompanying features on truck fleets and news features involving trucking companies. SASE. Reports in 3 weeks. NPI; payment varies. Pays on a per-job or per-photo basis. **Pays on acceptance.** Credit line given. Buys all rights.

THE COMMERCIAL IMAGE, (formerly *Industrial Photography*), PTN Publications, 445 Broad Hollow Rd., Melville NY 11747. (516)845-2700. Fax: (516)845-7109. Editorial Director: George Schaub. Editor: Steve Shaw. Circ. 46,000. Monthly magazine. "Our emphasis is on the commercial photographer who produces images for a company or organization." Free sample copy and writer's/photo guidelines.
Needs: All mss and photos must relate to the needs of commercial photographers. Photos purchased with accompanying ms. Seeks mss that offer technical or general information of value to commercial photographers, including applications, techniques, case histories. Model/property release required. Captions required.
Making Contact & Terms: Interested in receiving work from newer, lesser-known photographers. Query with story/photo suggestion. Provide letter of inquiry and samples to be kept on file for possible future assignments. Uses 4×5, 5×7 or 8×10 glossy b&w and color prints or 35mm transparencies; allows other kinds of photos. SASE. Reports in 1 month. Pays $150 minimum/ms, including all photos and other illustrations. Pays on publication. Credit line given. Buys first North American serial rights except photo with text.
Tips: Trend toward "photo/text packages only." In samples wants to see "technical ability, graphic depiction of subject matter and unique application of technique." To break in, "link up with a writer" if not already a writer as well as photographer. Photographers with previously published work in advertising or public relations campaigns have best chance. "We also are looking for top cover shots."

***CONSTRUCTION BULLETIN,** 9443 Science Center Dr., Minneapolis MN 55428. (612)537-7730. Fax: (612)537-1363. Editor: G.R. Rekela. Circ. 5,000. Estab. 1893. Weekly magazine. Emphasizes construction in Minnesota, North Dakota and South Dakota *only*. Readers are male and female executives, ages 23-65. Sample copy $3.50.
Needs: Uses 25 photos/issue; 1 supplied by freelancers. Needs photos of construction equipment in use on Minnesota, North Dakota, South Dakota job sites. Reviews photos purchased with accompanying ms only. Captions required; include who, what, where, when.
Making Contact & Terms: Send unsolicited photos by mail for consideration. Send 8×10 matte color prints. Keeps samples on file. SASE. Reports in 1 month. NPI. Pays on publication. Credit line given. Buys one-time rights. Previously published work OK.
Tips: "Be observant, keep camera at hand when approaching construction sites in Minnesota, North Dakota and South Dakota."

✤CONSTRUCTION COMMENT, 920 Yonge St., 6th Floor, Toronto, Ontario M4W 3C7 Canada. (416)961-1028. Fax: (416)924-4408. Executive Editor: Lori Knowles. Circ. 5,000. Estab. 1970. Semi-annual magazine. Emphasizes construction and architecture. Readers are builders, contractors, architects and designers. Sample copy and photo guidelines available.

Needs: Uses 25 photos/issue; 50% supplied by freelance photographers. Needs "straightforward, descriptive photos of buildings and projects under construction, and interesting people shots of workers at construction sites." Model release preferred. Captions preferred.
Making Contact & Terms: Arrange a personal interview to show portfolio. Query with résumé of credits or list of stock photo subjects. Provide résumé, business card, brochure, flier or tearsheets to be kept on file for possible assignments. SASE (IRCs). Reports in 1 month. Pays $125/color cover photo; $75/b&w cover photo; $25/color or b&w inside photo. Pays on publication. Credit line given. Buys all rights to reprint in our other publications; rights negotiable. Simultaneous submissions and previously published work OK.
Tips: Looks for "representative photos of Ottawa building projects and interesting construction-site people shots."

***CONTEMPORARY DIALYSIS & NEPHROLOGY**, 6300 Variel Ave., Suite 1, Woodland Hills CA 91367. (818)704-5555. Fax: (818)704-6500. Assistant Publisher: Susan Sowmer. Circ. 16,300. Estab. 1980. Monthly magazine. Emphasizes renal care (kidney disease). Readers are medical professionals involved in kidney care. Sample copy $4.
Needs: Uses various number of photos/issue. Model release required. Captions required.
Making Contact & Terms: Interested in receiving work from newer, lesser-known photographers. Contact through rep. Send unsolicited photos by mail for consideration. Send 35mm transparencies. Keeps samples on file. SASE. Reports in 2 weeks. NPI. Credit line given.

CORPORATE DETROIT MAGAZINE, 3031 W. Grand Blvd., Suite 264, Detroit MI 48202. (313)872-6000. Fax: (313)872-6009. Editor: Claire Hinsberg. Circ. 33,000. Monthly independent circulated to senior executives. Emphasizes Michigan business. Readers include top-level executives. Sample copy free with 9 × 12 SASE. Call Art Director for photo guidelines.
Needs: Uses variable number of photographs; most supplied by freelance photographers; 40% come from assignments. Needs photos of business people, environmental, feature story presentation, mug shots, etc. Reviews photos with accompanying ms only. Special needs include photographers based around Michigan for freelance work on job basis. Model/property release preferred. Captions required.
Making Contact & Terms: Interested in receiving work from newer, lesser-known photographers. Arrange a personal interview to show portfolio. Query with résumé of credits and samples. SASE. NPI; pay individually negotiated. Pays on publication.

THE CRAFTS REPORT, 300 Water St., Wilmington DE 19801. (302)656-2209. Fax: (302)656-4894. Art Director: John E. Thompson. Circ. 20,000. Estab. 1975. Monthly tabloid. Emphasizes business issues of concern to professional craftspeople. Readers are professional working craftspeople. Sample copy $3.
Needs: Uses 15-25 photos/issue; 0-10 supplied by freelancers. Needs photos of professionally-made crafts, craftspeople at work, studio spaces, craft schools—also photos tied to issue theme; i.e. environment, women, etc. Model/property release required; shots of artists and their work. Captions required; include artist, location.
Making Contact & Terms: Interested in receiving work from newer, lesser-known photographers. Arrange personal interview to show portfolio. Query with résumé of credits. Provide résumé, business card, brochure, flier or tearsheets to be kept on file for possible assignments. Keeps samples on file. SASE. Reports in 3 weeks. Pays $250-400/color cover photo; $25/published photo; assignments negotiated. Pays on publication. Credit line given. Buys one-time and first North American serial rights; negotiable. Simultaneous submissions and previously published work OK.
Tips: "Shots of craft items must be professional-quality images. For all images be creative—experiment. Color, b&w and alternative processes considered."

CRANBERRIES, Dept. PM, P.O. Box 858, South Carver MA 02366. (508)866-5055. Fax: (508)866-2970. Publisher/Editor: Carolyn Gilmore. Circ. 850. Monthly, but December/January is a combined issue. Emphasizes cranberry growing, processing, marketing and research. Readers are "primarily cranberry growers but includes anybody associated with the field." Sample copy free.
Needs: Uses about 10 photos/issue; half supplied by freelancers. Needs "portraits of growers, harvesting, manufacturing—anything associated with cranberries." Captions required.
Making Contact & Terms: Send 4 × 5 or 8 × 10 b&w or color glossy prints by mail for consideration; "simply query about prospective jobs." SASE. Pays $25-60/b&w cover photo; $15-30/b&w inside photo; $35-100 for text/photo package. Pays on publication. Credit line given. Buys one-time rights. Simultaneous submissions and previously published work OK.
Tips: "Learn about the field."

DAIRY TODAY, Farm Journal Publishing, Inc., 230 W. Washington Square, Philadelphia PA 19106. (215)829-4865. Photo Editor: Tom Dodge. Circ. 111,000. Monthly magazine. Emphasizes American

agriculture. Readers are active farmers, ranchers or agribusiness people. Sample copy and photo guidelines free with SASE.
- This company also publishes *Farm Journal, Beef Today, Hogs Today* and *Top Producer.*

Needs: Uses 20-30 photos/issue; 75% supplied by freelancers. "We use studio-type portraiture (environmental portraits), technical, details, scenics." Model release preferred. Captions required.

Making Contact & Terms: Arrange a personal interview to show portfolio. Query with résumé of credits along with business card, brochure, flier or tearsheets to be kept on file for possible assignments. SASE. Reports in 2 weeks. NPI. "We pay a cover bonus." **Pays on acceptance.** Credit line given. Buys one-time rights. Simultaneous submissions OK.

Tips: In portfolio or samples, likes to "see about 20 slides showing photographer's use of lighting and ability to work with people. Know your intended market. Familiarize yourself with the magazine and keep abreast of how photos are used in the general magazine field."

DANCE TEACHER NOW, 3101 Poplarwood Court, Suite 310, Raleigh NC 27604-1010. (919)872-7888. Fax: (919)872-6888. E-mail: dancenow@aol.com. Editor: K.C. Patrick. Circ. 8,000. Estab. 1979. Magazine published 10 times per year. Emphasizes dance, business, health and education. Readers are dance instructors and other related professionals, ages 15-80. Sample copy free with 9×12 SASE. Guidelines free with SASE.

Needs: Uses 20 photos/issue; all supplied by freelancers. Needs photos of action shots (teaching, etc.). Reviews photos with accompanying ms only. Model/property release preferred. Model releases required for minors and celebrities. Captions preferred; include date and location.

Making Contact & Terms: Interested in receiving work from newer, lesser-known photographers. Provide résumé, business card, brochure, flier or tearsheets to be kept on file for possible assignments. Keeps samples on file. SASE. Pays $50 minimum/color cover photo; $20/color inside photo; $20/b&w inside photo. Pays on publication. Credit line given. Buys one-time rights plus publicity rights; negotiable. Simultaneous submissions and/or previously published work OK.

DARKROOM & CREATIVE CAMERA TECHNIQUES, Dept. PM, Preston Publications, 7800 Merrimac Ave., P.O. Box 48312, Niles IL 60714. (708)965-0566. Fax: (708)965-7639. Publisher: Tinsley S. Preston, III. Editor: Mike Johnston. Circ. 40,000. Estab. 1979. Bimonthly magazine. Covers darkroom techniques, creative camera use, photochemistry and photographic experimentation/innovation, plus general user-oriented photography articles aimed at advanced amateurs and professionals. Sample copy $4.50. Photography and writer's guidelines free with SASE.

Needs: "The best way to publish photographs in *Darkroom Techniques* is to write an article on photo or darkroom techniques and illustrate the article. The exceptions are: cover photographs—we are looking for striking poster-like images that will make good newsstand covers; and the Portfolio feature—photographs of an artistic nature; most of freelance photography comes from what is currently in a photographer's stock." Model/property release preferred. Captions required if photo is used.

Making Contact & Terms: Interested in receiving work from newer, lesser-known photographers. "We do not want to receive more than 10 or 20 in any one submission. We ask for submissions on speculative basis only. Except for portfolios, we publish few single photos that are not accompanied by some type of text." Send dupe slides first. All print submissions should be 8×10. Pays $300/covers; $100/page and up for text/photo package; negotiable. Pays on publication only. Credit line given. Buys one-time rights.

Tips: "We are looking for exceptional photographs with strong, graphically startling images. No run-of-the-mill postcard shots please. We are the most technical general-interest photographic publication on the market today. Authors are encouraged to substantiate their conclusions with experimental data. Submit samples, article ideas, etc. It's easier to get photos published with an article."

■**DELTA DESIGN GROUP, INC.**, 409 Washington Ave., Box 112, Greenville MS 38702. (601)335-6148. Fax: (601)378-2826. President: Noel Workman. Publishes magazines dealing with cotton marketing, dentistry, health care, casino, travel and Southern agriculture.

Needs: Photos used for text illustration, promotional materials and slide presentations. Buys 25 photos/year; offers 10 assignments/year. Southern agriculture (cotton, rice, soybeans, sorghum, forages, beef and dairy, and catfish); California and Arizona irrigated cotton production; all aspects of life and labor on the lower Mississippi River; Southern historical (old photos or new photos of old subjects); recreation (boating, water skiing, fishing, canoeing, camping), casino gambling. Model release required. Captions preferred.

Making Contact & Terms: Query with samples or list of stock photo subjects or mail material for consideration. SASE. Reports in 1 week. Pays $50 minimum/job. Credit line given, except for photos used in ads or slide shows. Rights negotiable. Simultaneous submissions and previously published work OK.

Tips: "Wide selections of a given subject often deliver a shot that we will buy, rather than just one landscape, one portrait, one product shot, etc."

DENTAL ECONOMICS, Box 3408, Tulsa OK 74101. (918)835-3161. Editor: Dick Hale. Circ. 10,000. Monthly magazine. Emphasizes dental practice administration—how to handle staff, patients and bookkeeping and how to handle personal finances for dentists. Free sample copy. Photo and writer's guidelines free with SASE.
Needs: The mss relate to the business side of a practice: scheduling, collections, consultation, malpractice, peer review, closed panels, capitation, associates, group practice, office design, etc." Also uses profiles of dentists.
Making Contact & Terms: Send material by mail for consideration. Uses 8 × 10 b&w glossy prints; 35mm or 2¼ × 2¼ transparencies. "No outsiders for cover." SASE. Reports in 5-6 weeks. NPI. Pays in 30 days. Credit line given. Buys all rights but may reassign to photographer after publication.
Tips: "Write and think from the viewpoint of the dentist—not as a consumer or patient. If you know of a dentist with an unusual or very visual hobby, tell us about it. We'll help you write the article to accompany your photos. Query please."

DISTRIBUTOR, 651 W. Washington, Suite 300, Chicago IL 60661. (312)993-0929. Editorial Director: Ed Schwenn. Circ. 15,000. *Distributor* is a supplement to *Service Reporter* magazine. Published 12 times/year. Emphasizes heating, air conditioning, ventilating, refrigeration and appliance parts. Readers are wholesalers. Sample copy $4.
Needs: Uses about 12 photos/issue; 1-2 supplied by freelance photographers. Needs photos pertaining to the wholesaling of heating, air conditioning, ventilating and refrigeration. Special needs include cover photos of interior and exteriors of wholesaling businesses. Most photos accompany mss. Model release required. Captions required.
Making Contact & Terms: Contact editor by phone first. Query with list of stock photo subjects; "query on needs of publication." SASE. Reports in 2 weeks. Pays $100-250/color cover photo; $10/ b&w and $25/color inside photo. Pays on publication. Credit line given. Buys one-time rights. Simultaneous and previously published submissions OK "if not within industry."

DM NEWS, 19 W. 21st St., New York NY 10010. (212)741-2095. Fax: (212)924-6305. Editor-in-Chief: Jane Trolson. Circ. 35,000. Estab. 1979. Company publication for Mill Hollow Corporation. Weekly newspaper. Emphasizes direct marketing. Readers are male and female professionals ages 25-55. Sample copy $2.
● This publication was redesigned and now needs more photos.
Needs: Uses 20 photos/issue; 3-5 supplied by freelancers. Needs photos of news head shots, product shots. Reviews photos purchased with accompanying ms only. Captions required.
Making Contact & Terms: Interested in receiving work from newer, lesser-known photographers. Provide résumé, business card, brochure, flier or tearsheets to be kept on file for possible assignments. Does not keep samples on file. SASE. Reports in 1-2 weeks. NPI. **Pays on acceptance**. Buys one-time rights.
Tips: "News and business background are a prerequisite."

***EDUCATION WEEK**, Dept. PM, 4301 Connecticut Ave. NW, Suite 250, Washington DC 20008. (202)364-4114. Fax: (202)364-1039. Editor-in-Chief: Ronald A. Wolk. Photo Editor: Benjamin Tice Smith. Circ. 65,000. Estab. 1981. Weekly. Emphasizes elementary and secondary education.
Needs: Uses about 20 photos/issue; most supplied by freelance photographers; 90% on assignment, 10% from stock. Model/property release preferred. Model release usually needed for children (from parents). Captions required; include names, ages, what is going on in the picture.
Making Contact & Terms: Interested in receiving work from newer, lesser-known photographers. Query with samples. Provide résumé and tearsheets to be kept on file for possible future assignments. Cannot return material. Reports in 2 weeks. Pays $50-150/b&w photo; $100-300/day; $50-250/job; $50-300 for text/photo package. **Pays on acceptance.** Credit line given. Buys all rights; negotiable. Simultaneous submissions and previously published work OK.
Tips: "When reviewing samples we look for the ability to make interesting and varied images from what might not seem to be photogenic. Show creativity backed up with technical polish."

The solid, black square before a listing indicates that the market uses various types of audiovisual materials, such as slides, film or videotape.

***ELECTRIC PERSPECTIVES**, 701 Pennsylvania Ave. N.W., Washington DC 20004. (202)508-5714. Fax: (202)508-5759. Associate Editor: Eric Blume. Circ. 20,000. Estab. 1976. Publication of Edison Electric Institute. Bimonthly magazine. Emphasizes issues and subjects related to investor-owned electric utilities. Sample copy available on request.
Needs: Uses 20-25 photos/issue; 60% supplied by freelancers. Needs photos relating to the business and operational life of electric utilities—from customer service to engineering, from executive to blue collar. Model release required. Captions preferred.
Making Contact & Terms: Interested in receiving work from all photographers, including newer, lesser-known photographers. Query with stock photo list. Send unsolicited photos by mail for consideration. Provide résumé, business card, brochure, flier or tearsheets to be kept on file for possible assignments. Send 8×10 glossy color prints; 35mm, 2¼×2¼, 4×5 transparencies. Keeps samples on file. SASE. Reports in 1 month. Pays $200-400/color cover photo; $100-300/color inside photo; $200-350/color page rate; $750-1,500/photo/text package. Pays on publication. Buys one-time rights; negotiable (for reprints).
Tips: "We're interested in annual-report quality transparencies in particular. Quality and creativity is often more important than subject."

ELECTRICAL APPARATUS, Barks Publications, Inc., 400 N. Michigan Ave., Chicago IL 60611-4198. (312)321-9440. Associate Publisher: Elsie Dickson. Circ. 17,000. Monthly magazine. Emphasizes industrial electrical machinery maintenance and repair for the electrical aftermarket. Readers are "persons engaged in the application, maintenance and servicing of industrial and commercial electrical and electronic equipment." Sample copy $4.
Needs: "Assigned materials only. We welcome innovative industrial photography, but most of our material is staff-prepared." Photos purchased with accompanying ms or on assignment. Model release required "when requested." Captions preferred.
Making Contact & Terms: Query with résumé of credits. Contact sheet or contact sheet with negatives OK. SASE. Reports in 3 weeks. Pays $25-100/b&w or color. Pays on publication. Credit line given. Buys all rights, but exceptions are occasionally made.

ELECTRICAL WHOLESALING, 9800 Metcalf, Overland Park KS 66212-2215. (913)341-1300. Fax: (913)967-1904. Art Director: Ruth Seagraves. Monthly magazine. Emphasizes electrical wholesale business. Readers are male and female executives, electrical distributors and contractors, salespeople (ages 30-65) in the electrical wholesale business. Sample copy free with 9×12 SAE and 10 first-class stamps.
Needs: Uses 15 photos/issue; 3 supplied by freelancers. Needs photos of executive portraits, photo/illustration. Special photos include executive portraits, company profile photos, photo/illustration. Model release required. Property release preferred.
Making Contact & Terms: Interested in receiving work from newer, lesser-known photographers. Provide résumé, business card, brochure, flier or tearsheets to be kept on file for possible assignments. Keeps samples on file. SASE. Reports in 3 weeks. Pays $400-1,000/job; $700-900/color cover photo; $500-700/b&w cover photo; $400-500/color inside photo; $300-400/b&w inside photo. Credit line given. Rights negotiable. Simultaneous submissions and previously published work OK.
Tips: Looks for "a natural sense of working with people, location capability, good color sense, an ability to make mundane subjects seem interesting using mood, color, composition, etc. We run a small operation, which often forces us to be ingenious and flexible and creative. We look for similar characteristics in the people we hire."

ELECTRONIC BUSINESS BUYER, 275 Washington St., Newton MA 02158. (617)964-3030. Fax: (617)558-4705. Art Director: Michael Roach. Assistant Art Director: Dave Brown. Circ. 75,000. Estab. 1993. Monthly. Emphasizes the electronic industry. Readers are CEOs, managers and top executives.
Needs: Uses 25-30 photos/issue; 25% supplied by freelancers, most on assignment. Needs corporate photos and people shots. Model/property release preferred. Captions required.
Making Contact & Terms: Interested in receiving work from newer, lesser-known photographers. Arrange a personal interview to show portfolio. Provide résumé, business card, brochure, flier or tearsheets to be kept on file for possible future assignments. Cannot return material. Pays $300-500/b&w photo; $300-500/color photo; $50-100/hour; $400-800/day; $200-500/photo/text package. **Pays on acceptance.** Credit line given. Buys one-time rights. Simultaneous submissions and previously published work OK.
Tips: In photographer's portfolio looks for informal business portrait, corporate atmosphere.

ELECTRONICS NOW MAGAZINE, 500 B Bi-County Blvd., Farmingdale NY 11735. (516)293-3000. Fax: (516)293-3115. Editor: Brian C. Fenton. Circ. 171,679. Estab. 1929. Monthly magazine. Emphasizes electronics. Readers are electrical engineers and technicians, both male and female, ages 25-60. Sample copy free with 9×12 SAE.

Needs: Uses 25-50 photos/issue; 2-3 supplied by freelance photographers. Needs photos of how-to, computer screens, test equipment and digital displays. Purchases photos with accompanying ms only. Model release required. Captions preferred.
Making Contact & Terms: Submit portfolio for review. Provide résumé, business card, brochure, flier or tearsheets to be kept on file for possible assignments. SASE. Reports in 2 weeks. Pays $400/ color cover photo. **Pays on acceptance.** Credit line given. Buys all rights; negotiable. Simultaneous submissions OK.

EMERGENCY, The Journal of Emergency Services, 6300 Yarrow Dr., Carlsbad CA 92009. (619)438-2511. Fax: (619)931-5809. Editor: Doug Fiske. Circ. 26,000. Estab. 1969. Monthly magazine. Emphasizes prehospital emergency medical and rescue services for paramedics, EMTs and firefighters to keep them informed of latest developments in the emergency medical services field. Sample copy $5.
Needs: Buys 200 photos/year; 12 photos/issue. Documentary and spot news dealing with prehospital emergency medicine. Needs shots to accompany unillustrated articles submitted and cover photos; year's calendar of themes forwarded on request with #10 SASE. "Try to get close to the action; both patient and emergency personnel should be visible. All medics pictured *must* be wearing gloves and using any other necessary universal precautions." Photos purchased with or without accompanying ms. Model and property releases preferred. Captions required; include the name, city and state of the emergency rescue team and medical treatment being rendered in photo. Also needs color transparencies for "Action," a photo department dealing with emergency personnel in action. Accompanying mss: instructional, descriptive or feature articles dealing with emergency medical services.
Making Contact & Terms: Interested in receiving work from newer, lesser-known photographers. Uses 5×7 b&w or color glossy prints; 35mm or larger transparencies. For cover: Prefers 35mm; 2¼×2¼ transparencies OK. Vertical format preferred. Send material by mail for consideration, especially shots of EMTs/paramedics in action. SASE. Pays $30/inside photo; $100/color cover photo; $100-400/ms. Pays for mss/photo package, or on a per-photo basis. **Pays on acceptance.** Credit line given. Buys all rights, "nonexclusive."
Tips: Wants well-composed photos with good overall scenes and clarity that say more than "an accident happened here. We're going toward single-focus, uncluttered photos." Looking for more color photos for articles. "Good closeups of actual treatment. Also, sensitive illustrations of the people in EMS— stress, interacting with family/pediatrics etc. We're interested in rescuers, and our readers like to see their peers in action, demonstrating their skills. Make sure photo is presented with treatment rendered and people involved.

EMPIRE STATE REPORT, 3/F, 4 Central Ave., Albany NY 12210. (518)465-5502. Fax: (518)465-9822. Editor: Jeff Plungis. Circ. 15,000. Estab. 1982. Monthly magazine. Emphasizes New York state politics and public policy. Readers are state policy makers and those who wish to influence them. Sample copy with 8½×11 SAE and 6 first-class stamps.
Needs: Uses 10-20 photos/issue; 5-10 supplied by freelancers. Needs photos of New York state personalities (political, government, business); issues; New York state places, cities, towns. Model/ property release preferred. Captions preferred; include subject matter of photo.
Making Contact & Terms: Interested in receiving work from newer, lesser-known photographers. Send unsolicited photos by mail for consideration. Provide résumé, business card, brochure, flier or tearsheets to be kept on file for possible assignments. Keeps samples on file. SASE. Reports in 3 weeks. Pays $200-300/color cover photo; $50-75/b&w inside photo. Pays on publication. Credit line given. Buys one-time rights. Simultaneous submissions and previously published work OK.
Tips: "Subject matter is the most important consideration at ESR. The subject must have a New York connection. But, on some occasions, a state issue can be illustrated with a more general photograph."

ENTERTAINMENT EXPRESS INTERNATIONAL, INC., Suite 112, 4747 Hollywood Blvd., Hollywood FL 33021. Editor: Evan Resnick. Quarterly magazine. Emphasizes entertainment, party planning, theatrical productions and corporate. Estab. 1989. Sample copy free with SASE.
Needs: Uses 6-12 photos/issue. Needs photos of travel, scenics, personalities, entertainment-related musical groups, celebrities and some animal shots. Especially wants to see shots of "celebrities, musical groups and entertainment-related." Model/property release required. Captions required; include who, what, when, where, why and how.
Making Contact & Terms: Arrange personal interview to show portfolio. Query with résumé of credits and list of stock photo subjects. Provide résumé, business card, brochure, flier or tearsheets to be kept on file for possible assignments. Keeps samples on file. Cannot return material. Reports as needed. Pays $25/color or b&w cover or inside photo; $25/color or b&w page rate; $25-50/hour; $100-200/day. Pays on publication. Credit line given. Rights negotiable. Simultaneous submissions and previously published work OK.
Tips: "Our company looks for quality, photo clarity, composition and life! It's also important that the photographer is an amicable person who's easy to do business with and able to respond to specific

photo needs." To break in, "nothing ventured, nothing gained . . . always give your work opportunity to exposure whether it be to our publication or anyone else's."

***ERGONOMICS IN DESIGN**, P.O. Box 1369, Santa Monica CA 90406-1369. (310)394-1811. Fax: (310)394-2410. Managing Editor: Lois Smith. Circ. 6,000. Estab. 1993. Publication of Human Factors and Ergonomics Society. Quarterly magazine. Emphasizes how ergonomics research is applied to tools, equipment and systems people use. Readers are BA/MA/PhDs in psychology, engineering and related fields. Sample copy $8.
Needs: Needs photos of technology areas, medicine, transportation, consumer products. Model/property release preferred. Captions preferred.
Making Contact & Terms: Interested in receiving work from newer, lesser-known photographers. Query with stock photo list. Keeps samples on file. SASE. Reports in 2 weeks. Pays on publication. Credit line given. Buys one-time rights. Simultaneous submissions and previously published work OK.
Tips: Wants to see high-quality color work for strong (sometimes subtle) cover that can also be modified in b&w for lead feature opener inside book.

***EUROPE**, 2100 M St. NW, Suite 700, Washington DC 20037. (202)862-9557. Editor-in-Chief: Robert J. Guttman. Managing Editor: Peter Gwin. Photo Editor: Anne Alvarez. Circ. 25,000. Magazine published 10 times a year. Covers the Europe Union with "in-depth news articles on topics such as economics, trade, US-EU relations, industry, development and East-West relations." Readers are "business people, professionals, academics, government officials." Free sample copy.
Needs: Uses about 20-30 photos/issue, most of which are supplied by stock houses and freelance photographers. Needs photos of "current news coverage and sectors, such as economics, trade, small business, people, transport, politics, industry, agriculture, fishing, some culture, some travel. No traditional costumes. Each issue we have an overview article on one of the 15 countries in the European Union. For this we need a broad spectrum of photos, particularly color, in all sectors. If a photographer queries and lets us know what he has on hand, we might ask him to submit a selection for a particular story. For example, if he has slides or b&w's on a certain European country, if we run a story on that country, we might ask him to submit slides on particular topics, such as industry, transport or small business." Model release preferred. Captions preferred; identification necessary.
Making Contact & Terms: Interested in receiving work from newer, lesser-known photographers. Query with list of stock photo subjects. Initially, a list of countries/topics covered will be sufficient. SASE. Reports in 1 month. Pays $75-150/b&w photo; $100 minimum/color transparency for inside; $400/cover; per job negotiable. Pays on publication. Credit line given. Buys one-time rights. Simultaneous submissions and previously published work OK.
Tips: "For certain articles, especially the Member States' Reports, we are now using more freelance material than previously. We need good photo and color quality, but not touristy or stereotypical. We want to show modern Europe growing and changing. Feature business or industry if possible."

FACILITIES DESIGN & MANAGEMENT, 1515 Broadway, 34th Floor, New York NY 10036. (212)626-2516. Fax: (212)302-2905. Art Director: Lyndon Lorenz. Circ. 35,000. Estab. 1981. Monthly magazine. Emphasizes corporate space planning, real estate and office furnishings. Readers are executive-level management. Free sample copy.
Needs: Uses 30-50 photos/issue; 3-5 supplied by freelancers. Needs photos of executive-level decision makers photographed in their corporate environments. Special photo needs include monthly photo shots. Model release preferred.
Making Contact & Terms: Interested in receiving work from newer, lesser-known photographers. Arrange personal interview to show portfolio. Keeps samples on file. Cannot return material. Reports in 1-2 weeks. Pays $700-900/day. **Pays on acceptance.** Credit line given. Buys one-time rights. Simultaneous submissions OK.
Tips: Looking for "a strong combination of architecture and portraiture."

FARM CHEMICALS, Dept. PM, 37733 Euclid Ave., Willoughby OH 44094. (216)942-2000. Fax: (216)942-0662. Editorial Director: Charlotte Sine. Editor: Dale Little. Circ. 32,000. Estab. 1896. Monthly magazine. Emphasizes application and marketing of fertilizers and protective chemicals for crops for those in the farm chemical industry. Free sample copy and photo guidelines with 9×12 SAE.
Needs: Buys 6-7 photos/year; 5-30% supplied by freelancers. Photos of agricultural chemical and fertilizer application scenes (of commercial—not farmer—applicators). Model release preferred. Captions required.
Making Contact & Terms: Query first with résumé of credits. Uses 8×10 glossy b&w and color prints or transparencies. SASE. Reports in 3 weeks. Pays $25-50/b&w photo; $50-125/color photo. **Pays on acceptance.** Buys one-time rights. Simultaneous submissions and previously published work OK.

FARM JOURNAL, INC., 230 W. Washington Sq., Philadelphia PA 19106. (215)829-4865. Editor: Earl Ainsworth. Photo Editor: Tom Dodge. Circ. 800,000. Estab. 1877. Monthly magazine. Emphasizes the

business of agriculture: "Good farmers want to know what their peers are doing and how to make money marketing their products." Free sample copy upon request.
• This company also publishes *Top Producer, Hogs Today, Beef Today* and *Dairy Today. Farm Journal* received the Best Use of Photos/Design, 1994 award, from the American Agricultural Editors' Association (AAEA).
Needs: Freelancers supply 60% of the photos. Photos having to do with the basics of raising, harvesting and marketing of all the farm commodities. People-oriented shots are encouraged. Also uses human interest and interview photos. All photos must relate to agriculture. Photos purchased with or without accompanying ms. Model release required. Captions required.
Making Contact & Terms: Arrange a personal interview or send photos by mail. Provide calling card and samples to be kept on file for possible future assignments. Uses glossy or semigloss color or b&w prints; 35mm or 2¼ × 2¼ transparencies, all sizes for covers. SASE. Reports in 1 month. Pays by assignment or photo. Pays $200-400/job. Cover bonus. **Pays on acceptance.** Credit line given. Buys one-time rights; negotiable. Simultaneous submissions OK.
Tips: "Be original, take time to see with the camera. Be selective. Look at use of light—available or strobed—and use of color. I look for an easy rapport between photographer and subject. Take as many different angles of subject as possible. Use fill where needed."

***FIRE CHIEF,** 35 E. Wacker, Suite 700, Chicago IL 60601. (312)726-7277. Fax: (312)726-0241. Editor: Scott Baltic. Circ. 45,000. Estab. 1956. Monthly magazine. Emphasizes fire department management and operations. Readers are overwhelmingly fire officers and predominantly chiefs of departments. Free sample copy. Photo guidelines free with SASE.
Needs: Uses 1 photo/issue; 1 supplied by freelancers. Needs photos of a fire chief in action at an emergency scene. "Contact us for a copy of our current editorial calendar." Model/property release preferred. Captions required; include names, dates, brief description of incident.
Making Contact & Terms: Interested in receiving work from newer, lesser-known photographers. Send unsolicited photos by mail for consideration. Send any glossy color prints; 35mm, 2¼ × 2¼ transparencies. Keeps samples on file. SASE. Reports in 1 month. Pays $75/color cover photo; $20-25/color inside photo. Pays on publication. Buys first serial rights; negotiable.
Tips: "We want a photo that captures a chief officer in command at a fire or other incident, that speaks to the emotions (the burden of command, stress, concern for others). Most of our cover photographers take dozens of fire photos every month. These are the guys who keep radio scanners on in the background most of the day. Timing is everything."

***FIRE ENGINEERING,** Park 80 West Plaza 2, 7th Floor, Saddle Brook NJ 07663. (201)845-0800. Fax: (201)845-6275. Editor: Bill Manning. Estab. 1877. Magazine. Training magazine for firefighters. Photo guidelines free with SASE.
Needs: Uses 50 photos/year. Needs action photos of firefighters working. Captions required; include date, what is happening, location.
Making Contact & Terms: Interested in receiving work from newer, lesser-known photographers. Send unsolicited photos by mail for consideration. Send prints; 35mm transparencies. SASE. Reports in up to 3 months. Pays $50-300/color inside photo; $50-100/b&w inside photo. Pays on publication. Credit line given. Rights negotiable.
Tips: "Firefighters must be doing something. Our focus is on training and learning lessons from photos."

FIREHOUSE MAGAZINE, 445 Broad Hollow Rd., Suite 21, Melville NY 11747. (516)845-2700. Fax: (516)845-7109. Editor-in-Chief: Harvey Eisner. Circ. 110,000. Estab. 1973. Monthly. Emphasizes "firefighting—notable fires, techniques, dramatic fires and rescues, etc." Readers are "paid and volunteer firefighters, EMT's." Sample copy $3 with 9 × 12 SAE and approximately 6 first-class stamps. Photo guidelines free with SASE.
Needs: Uses about 30 photos/issue; 20 supplied by freelance photographers. Needs photos in the above subject areas. Model release preferred.
Making Contact & Terms: Send 8 × 10 matte or glossy b&w or color prints; 35mm, 2¼ × 2¼, 4 × 5, 8 × 10 transparencies or b&w or color negatives with contact sheet by mail for consideration. "Photos must not be more than 30 days old." SASE. Reports ASAP. Pays $200/color cover photo; $15-45/b&w photo; $15-75/color photo. Pays on publication. Credit line given. Buys one-time rights.
Tips: "Mostly we are looking for action-packed photos—the more fire, the better the shot. Show firefighters in full gear, do not show spectators. Fire safety is a big concern. Much of our photo work is freelance. Try to be in the right place at the right time as the fire occurs."

■FLORAL MANAGEMENT MAGAZINE, (formerly The Society of American Florists), 1601 Duke St., Alexandria VA 22314. (703)836-8700. Fax: (703)836-8705. Editor and Publisher: Kate Penn. Estab. 1894. National trade association magazine representing growers, wholesalers and retailers of flowers and plants. Photos used in magazine and promotional materials.

Needs: Offers 15-20 assignments/year. Needs photos of floral business owners and employees on location. Reviews stock photos. Model release required. Captions preferred.
Audiovisual Needs: Uses slides (with graphics) for convention slide shows.
Making Contact & Terms: Interested in receiving work from newer, lesser-known photographers. Query with samples. Provide résumé, business card, brochure, flier or tearsheets to be kept on file for possible future assignments. Uses b&w prints, or transparencies. SASE. Reports in 1 week. Pays $600-800/cover shot; $75-150/hour; $125-250/job; $75-500/color photo. Credit line given. Buys one-time rights.
Tips: "We shoot a lot of tightly composed, dramatic shots of people so we look for these skills. We also welcome input from the photographer on the concept of the shot. Our readers, as business owners, like to see photos of other business owners. Therefore, people photography, on location, is particularly popular."

FLORIDA UNDERWRITER, Dept. PM, 9887 Fourth St. N., Suite 230, St. Petersburg FL 33702. (813)576-1101. Editor: James E. Seymour. Circ. 10,000. Estab. 1984. Monthly magazine. Emphasizes insurance. Readers are insurance professionals in Florida. Sample copy free with 9 × 12 SASE.
Needs: Uses 10-12 photos/issue; 1-2 supplied by freelancers; 80% assignment and 20% freelance stock. Needs photos of insurance people, subjects, meetings and legislators. Captions preferred.
Making Contact & Terms: Query first with list of stock photo subjects. Send b&w prints, 35mm, 2¼ × 2¼, 4 × 5, 8 × 10 transparencies by mail for consideration. Provide résumé, business card, brochure, flier or tearsheets to be kept on file for possible assignments. SASE. Reports in 3 weeks. Pays $50-150/b&w cover photo; $15-35/b&w inside photo; $5-20/color page rate. Pays on publication. Credit line given. Buys all rights; negotiable. Simultaneous submissions and previously published work OK (admission of same required).
Tips: "Like the insurance industry we cover, we are cutting costs. We are using fewer freelance photos (almost none at present)."

FOOD & SERVICE, P.O. Box 1429, Austin TX 78767-1429. Art Director: Neil Ferguson. Circ. 6,500. Estab. 1940. Publication of the Texas Restaurant Association. Monthly magazine. Emphasizes restaurant owners and managers in Texas—industry issues, legislative concerns, managment techniques. Readers are restaurant owners/operators in Texas. Sample copy free with 10 × 13 SAE and 6 first-class stamps. Photo guidelines free with SASE.
• In 1994 *Food & Service* won the Award for Excellence for 4-color Magazine and the Award of Merit for Graphic Design from the International Association of Business Communicators/ Central Texas Chapter.
Needs: Uses 1-3 photos/issue; 1-3 supplied by freelancers. Needs editorial photos illustrating business concerns (i.e. health care issues, theft in the workplace, economic outlooks, employee motivation, etc.) Reviews photos purchased with or without a manuscript (but prefers with). Model release required for paid models. Property release preferred for paid models.
Making Contact & Terms: Interested in receiving work from newer, lesser-known photographers. Provide résumé, business card, brochure, flier or tearsheets to be kept on file for possible assignments. Deadlines: 2-3 week turnaround from assignment date. Keeps samples on file. SASE. Reports in 2 months. Pays $75-450/job; $200-450/color cover photo; $200-300/b&w cover photo; $200-300/color inside photo; $100-250/b&w inside photo. **Pays on acceptance**. Credit line given. Buys one-time rights. Previously pubished work OK.
Tips: "Please don't send food shots—even though our magazine is called *Food & Service*. We publish articles about the food service industry that interest association members—restaurant owners and operators (i.e. legislative issues like health care; motivating employees; smokers' vs. non-smokers rights; proper food handling; plus, occasional member profiles. Avoid clichés and over-used trends. Don't be weird for weird's sake. Photos in our magazines must communicate (and complement the editorial matter)."

FOOD PRODUCT DESIGN MAGAZINE, 3400 Dundee Rd., Suite 100, Northbook IL 60062. (708)559-0385. Fax: (708)559-0389. Art Director: Barbara Weeks. Circ. 26,000. Estab. 1991. Monthly. Emphasizes food development. Readers are research and development people in food industry.
Needs: Needs food shots (4-color). Special photo needs include food shots—pastas, cheese, reduced fat, meat products, sauces, etc.; as well as group shots of people, lab shots, focus group shots.
Making Contact & Terms: Interested in receiving work from newer, lesser-known photographers. Query with stock photo list. Send unsolicited photos by mail for consideration. Call. Send color prints; 35mm, 4 × 5, 8 × 10 transparencies. SASE. Reports in 1-2 weeks. Pays $400 minimum/job; negotiable based on job, time, etc. "Depends on job and way photo will be used." Pays on publication; expenses/ materials paid. Credit line given. Buys all rights for use in magazine. Simultaneous submissions and/ or previously published work OK.
Tips: "Know your stuff. Submit work or call me—I keep in very close contact with my photographers, food stylists and writers."

FORD NEW HOLLAND NEWS, Dept. PM, P.O. Box 1895, New Holland PA 17557. (717)355-1276. Editor: Gary Martin. Circ. 400,000. Estab. 1960. Published 8 times a year. Emphasizes agriculture. Readers are farm families. Sample copy and photo guidelines free with 9×12 SASE.
Needs: Buys 30 photos/year. 50% freelance photography/issue from assignment and 50% freelance stock. Needs photos of scenic agriculture relating to the seasons, harvesting, farm animals, farm management and farm people. Model release required. Captions required.
Making Contact & Terms: "Show us your work." SASE. Reports in 2 weeks. "Collections viewed and returned quickly." Pays $50-500/color photo, depends on use and quality of photo; $400-1,500/photo/text package; $500/cover. Payment negotiable. **Pays on acceptance.** Buys first North American serial rights. Previously published work OK.
Tips: Photographers "must see beauty in agriculture and provide meaningful photojournalistic caption material to be successful here. It also helps to team up with a good agricultural writer and query us on a photojournalistic idea."

***FOREST FARMER**, P.O. Box 95385, Atlanta GA 30347. (404)325-2954. Fax: (404)325-2955. Managing Editor: Steve Newton. Circ. 6,000. Estab. 1950. Publication of Forest Farmers Association. Bimonthly magazine. Emphasizes forest management and forest policy issues for private forest landowners. Readers are forest landowners and consultants, 80% male, average age 55. Sample copy $3 (magazine), $25 (manual).
Needs: Uses 15-25 photos/issue; 3-4 supplied by freelancers. Needs photos of unique or interesting southern forests. Model/property release preferred. Captions preferred.
Making Contact & Terms: Send unsolicited photos by mail for consideration. Query with stock photo list. Send 5×7 color prints; 35mm transparencies. Deadlines: "The 10th of all even numbered months." Keeps samples on file. SASE. Reports in 3 weeks. Pays $200-300/hour; $100-200/b&w cover photo; $75-100/b&w inside photo. Pays on publication. Credit line given. Buys one-time and all rights; negotiable. Simultaneous submissions and previously published work OK.
Tips: "We are a small shop with limited resources. Consequently we use more computer images to save time. Digitized images are acceptable."

FUTURES MAGAZINE, 219 Parkade, Cedar Falls IA 50613. Fax: (319)277-5803. Managing Editor: Kristin Beane-Sullivan. Circ. 70,000. Monthly magazine. Emphasizes futures and options trading. Readers are individual traders, institutional traders, brokerage firms, exchanges. Sample copy $4.50.
Needs: Uses 1-5 photos/issue; 80% supplied by freelance photographers. Needs mostly personality portraits of story sources, some mug shots, trading floor environment. Model release required. Captions preferred.
Making Contact & Terms: Arrange a personal interview to show portfolio. Query with list of stock photo subjects. Provide résumé, business card, brochure, flier or tearsheets to be kept on file for possible future assignments. SASE. Reports in 2 weeks. NPI. Pays on publication. Credit line given.
Tips: All work is on assignment. Be competitive on price. Shoot good work without excessive film use.

***GAS INDUSTRIES**,6301 Gaston Ave., Suite 541, Dallas TX 75214. (214)827-4630. Fax: (214)827-4758. Associate Publisher: Ruth W. Stidger. Circ. 11,000. Estab. 1956. Monthly magazine. Emphasizes natural gas utilities and pipelines. Readers are mostly male managers and engineers, ages 30-65. Sample copy free with 9×12 SASE and 4 first-class stamps.
Needs: Uses 12 photos/issue; 20% supplied by freelancers. Needs photos of workers laying, repairing pipelines; gas utility crews on the job. Special photo needs include plastic pipe cover; new gas meter technology cover; assigned industry figure shots. Model release required. "Releases required unless photo is shot in public place. Captions required; include names of people in photos; names of contractors or utilities' crews in pictures.
Making Contact & Terms: Interested in receiving work from newer, lesser-known photographers. Send unsolicited photos by mail for consideration. Send 8×10 color prints; 35mm, 2¼×2¼, 4×5, 8×10 transparencies. Does not keep samples on file. SASE. Reports in 2 weeks. Pays $200-300/color cover photo. **Pays on acceptance.** Credit line given. Buys first North American serial rights; negotiable. Simultaneous submissions and previously published work OK.

GEOTECHNICAL FABRICS REPORT, 345 Cedar St., Suite 800, St. Paul MN 55101. (612)222-2508. Fax: (612)222-8215. Editor: Danette. R. Fettig. Circ. 14,000. Estab. 1983. Published 9 times/year. Emphasizes geosynthetics in civil engineering application. Readers are male and female civil engineers, professors and consulting engineers. Sample copies available. Photo guidelines available.
Needs: Uses 10-15 photos/issue; various number supplied by freelancers. Needs photos of finished applications using geosynthetics, photos of the application process. Reviews photos with or without ms. Model release required. Captions required; include project, type of geosynthetics used and location.
Making Contact & Terms: Interested in receiving work from newer, lesser-known photographers. Send unsolicited photos by mail for consideration. Send any size color and b&w prints. Keeps samples

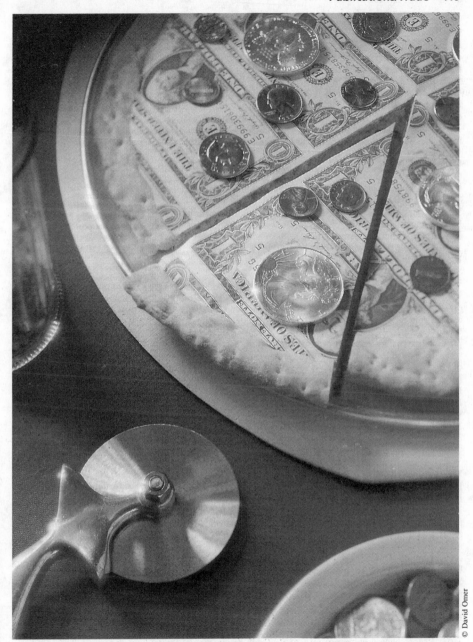

© David Omer

The Texas Restaurant Association needed a creative image to illustrate a story on markets in the food industry. The photo, taken by Austin, Texas, photographer David Omer, appeared in Food & Service magazine. "David's very easy-going and fun to work with. That counts," says Neil Ferguson, art director.

on file. SASE. Reports in 1 month. NPI. Credit line given. Buys all rights; negotiable. Simultaneous submissions OK.

Tips: "Contact manufacturers in the geosynthetics industry and offer your services."

GOVERNMENT TECHNOLOGY, 9719 Lincoln Village, #500, Sacramento CA 95827. (916)363-5000. Fax: (916)363-5197. Creative Director: William Widmaier. Circ. 55,000. Estab. 1988. Monthly tabloid. Emphasizes technology in state and local government—no federal. Readers are male and female state

and local government executives. Sample copy free with tabloid-sized SAE and 10 first-class stamps.
Needs: Uses 20-30 photos/issue; 1-5 supplied by freelancers. Needs photos of action or aesthetic—technology in use in state and local government, ex: fire department, city hall, etc. Model/property release required; model and government agency. Captions preferred; who, what and where.
Making Contact & Terms: Interested in receiving work from newer, lesser-known photographers. Send unsolicited photos by mail for consideration. Send 35mm, 2¼ × 2¼, 4 × 5, 8 × 10 transparencies. Cannot return materials. Reports back when used. Pays $100-200/color cover photo; $25-75/color inside photo; $10-50/b&w inside photo. Pays on publication. Credit line given. Buys all rights; negotiable. Simultaneous submissions and previously published work OK.
Tips: Looking for "before and after shots." Photo sequences that tell the story. Get copies of our magazine. Tell me their location if they are willing to do assignments on spec."

GRAIN JOURNAL, Dept. PM, 2490 N. Water St., Decatur IL 62526. (217)877-9660. Fax: (217)877-6647. Editor: Ed Zdrojewski. Circ. 11,303. Bimonthly. Emphasizes grain industry. Readers are "elevator managers primarily as well as suppliers and others in the industry." Sample copy free with 10 × 12 SAE and 3 first-class stamps.
Needs: Uses about 6 photos/issue. "We need photos concerning industry practices and activities. We look for clear, high-quality images without a lot of extraneous material." Captions preferred.
Making Contact & Terms: Query with samples and list of stock photo subjects. SASE. Reports in 1 week. Pays $100/color cover photo; $30/b&w inside photo. Pays on publication. Credit line given. Buys all rights; negotiable.

***THE GROWER**, 10901 W. 84th Terrace, Lenexa KS 66214. (913)438-8700. Fax: (913)438-0697. Managing Editor: Steve Buckner. Circ. 27,500. Estab. 1967. Monthly magazine. Emphasizes commercial fruit and vegetable production. "*The Grower* targets male and female fruit and vegetable growers, ages 21 and older." Free sample copy. Photo guidelines free with SASE.
Needs: Uses 15-40 photos/issue; 5-10 supplied by freelancers. Needs vegetable field shots (irrigation, planting, harvesting, packing); orchard-related shots (growing, pruning, harvesting, spraying). Model/property release required for all posed shots. Captions preferred; include where shot was taken, name of crop.
Making Contact & Terms: Interested in receiving work from newer, lesser-known photographers. Provide résumé, business card, brochure, flier or tearsheets to be kept on file for possible assignments. Keeps samples on file. SASE. Reports in 2 weeks. Pays $10-15/hour; $200-300/color cover photo; $50-100/color inside photo. **Pays on acceptance.** Buys all rights.
Tips: "We are looking only for shots pertaining to fruit and vetetable production—not shots of fruit in baskets. We'd consider odd angles, different perspectives. Know our magazine and our audience. Call us with questions or for sample issues."

THE GROWING EDGE, 215 SW Second St., P.O. Box 1027, Corvallis OR 97333. (503)757-2511. Fax: (503)757-0028. E-mail: tcoene@csos.orst.edu. Editor: Trisha Coene. Circ. 20,000. Estab. 1989. Published quarterly. Emphasizes "new and innovative techniques in gardening indoors, outdoors and in the greenhouse—hydroponics, artificial lighting, greenhouse operations/control, water conservation, new and unusual plant varieties." Readers are serious amateurs to small commercial growers.
Needs: Uses about 20 photos per issue; most supplied with articles by freelancers. Occasional assignment work (5%); 80% from freelance stock. Model release required. Captions preferred; include plant types, equipment used.
Making Contact & Terms: Interested in receiving work from newer, lesser-known photographers. Send query with samples. Accepts b&w or color prints; transparencies (any size); b&w or color negatives with contact sheets. SASE. Reports in 6 weeks or will notify and keep material on file for future use. Pays $175/cover photo; $25-50/b&w photos; $25-175/color; $75-400/text/photo package. Pays on publication. Credit line given. Buys first world and one-time anthology rights; negotiable. Simultaneous submissions and/or previously published work OK.
Tips: "Most photographs are used to illustrate processes and equipment described in text. Some photographs of specimen plants purchased. Many photos are of indoor plants under artificial lighting. The ability to deal with tricky lighting situations is important." Expects more assignment work in the future.

Market conditions are constantly changing! If you're still using this book and it's 1997 or later, buy the newest edition of Photographer's Market *at your favorite bookstore or order directly from Writer's Digest Books.*

***HEARTH AND HOME**, Dept. PM, P.O. Box 2008, Laconia NH 03247. (603)528-4285. Fax: (603)258-3772. Editor: Richard Wright. Monthly magazine. Emphasizes new and industry trends for specialty retailers and manufacturers of solid fuel and gas appliances, hearth accessories and casual furnishings. Circ. 22,000. Sample copy $5.
• This publication scans images and stores them electronically.
Needs: Uses about 30 photos/issue; 30% supplied by freelance photographers. Needs "shots of energy and patio furnishings stores (perferably a combination store), retail displays, wood heat installations, fireplaces, wood stoves and lawn and garden shots (installation as well as final design). Assignments available for interviews, conferences and out-of-state stories." Model release required; captions preferred.
Making Contact & Terms: Interested in receiving work from newer, lesser-known photographers. Query with samples or list of stock photo subjects. Send color glossy prints, transparencies by mail for consideration. SASE. Reports in 2 weeks. Pays $75-500/color photo, $250-500/job. Pays within 60 days. Credit line given. Buys various rights. Simultaneous and photocopied submissions OK.
Tips: "Call and ask what we need. We're *always* on the lookout for material."

❖HEATING, PLUMBING & AIR CONDITIONING (HPAC), 1370 Don Mills Rd., Suite 300, Don Mills, Ontario M3B 3N7 Canada. (416)759-2500. Fax: (416)759-6979. Publisher: Bruce Meacock. Circ. 17,000. Estab. 1927. Bimonthly magazine plus annual buyers guide. Emphasizes heating, plumbing, air conditioning, refrigeration. Readers are predominantly male, mechanical contractors ages 30-60. Sample copy $4.
Needs: Uses 10-15 photos/issue; 2-4 supplied by freelancers. Needs photos of mechanical contractors at work, product shots. Model/property release preferred. Captions preferred.
Making Contact & Terms: Interested in receiving work from newer, lesser-known photographers. Send unsolicited photos by mail for consideration. Send 4×6, glossy/semi-matte color b&w prints; 35mm transparencies. Cannot return material. Reports in 1 month. NPI. Pays on publication. Credit line given. Buys one-time rights; negotiable. Simultaneous submissions and/or previously published work OK.

HEAVY DUTY TRUCKING, P.O. Box W, Newport Beach CA 92658-8910. (714)261-1636. Managing Editor: Deborah Whistler. Circ. 105,000. Monthly magazine. Emphasizes trucking. Readers are mostly male—corporate executives, fleet management, supervisors, salesmen and drivers—ages 30-65. Photo guidelines free with SASE.
Needs: Uses 30 photos/issue; 30-100% supplied by freelancers. Needs photos of scenics (trucks on highways), how-to (maintenance snapshots). Model release is "photographer's responsibility." Captions preferred.
Making Contact & Terms: Query with résumé of credits. Send unsolicited photos by mail for consideration. Send 35mm transparencies. SASE. Pays $200/color cover photo; $100/color or b&w inside photo. Pays on publication; sends check when material is used. Buys one-time rights.

‡HELICOPTER INTERNATIONAL, 75 Elm Tree Rd., Locking, Weston-S-Mare, Avon BS24 8EL England. (0934)822524. Editor: E. apRees. Circ. 23,000. Bimonthly magazine. Emphasizes helicopters and autogyros. Readers are helicopter professionals. Sample copy $4.50.
Needs: Uses 25-35 photos/issue; 50% supplied by freelance photographers. Needs photos of helicopters, especially newsworthy subjects. Model release preferred. Captions required.
Making Contact & Terms: Send unsolicited photos by mail for consideration. Send 8×10 or 4×5 glossy b&w, color prints or slides. Cannot return material. Reports in 1 month. Pays $20/color cover photo; $5/b&w inside photo. Pays on publication. Credit line given. Buys one-time rights. Simultaneous submissions or previously published work OK.
Tips: Magazine is growing. To break in, submit "newsworthy pictures. No arty-crafty pix; good clear shots of helicopters backed by newsworthy captions, e.g., a new sale/new type/new color scheme/accident with dates."

HISPANIC BUSINESS, 360 S. Hope Ave., Suite 300C, Santa Barbara CA 93105. (805)682-5843. Managing Editor: Hector Cantu. Circ. 200,000. Estab. 1979. Monthly publication. Emphasizes Hispanics in business (entrepreneurs and executives), the Hispanic market. Sample copy $5.
Needs: Uses 25 photos/issue; 20% supplied by freelancers. Needs photos of personalities and action shots. No mug shots. Captions required; include name, title.
Making Contact & Terms: Query with résumé of credits. Keeps samples on file. Reports in 2 weeks. Pays $450/color cover photo; $150/color inside photo. Pays on publication. Credit line given. Rights negotiable.
Tips: Wants to see "unusual angles, bright colors, hand activity. Photo tied to profession."

HOGS TODAY, Farm Journal Publishing, Inc., 230 W. Washington Square, Philadelphia PA 19106. (215)829-4965. Photo Editor: Tom Dodge. Circ. 125,000. Monthly magazine. Sample copy and photo guidelines free with SASE.

• This company also publishes *Farm Journal*, *Beef Today*, *Dairy Today* and *Top Producer*.
Needs: Uses 20-30 photos/issue; 75% supplied by freelancers. "We use studio-type portraiture (environmental portraits), technical, details, scenics." Model release preferred. Captions required.
Making Contact & Terms: Arrange a personal interview to show portfolio. Query with résumé of credits along with business card, brochure, flier or tearsheets to be kept on file for possible assignments. SASE. Reports in 2 weeks. NPI. "We pay a cover bonus." **Pays on acceptance.** Credit line given. Buys one-time rights. Simultaneous submissions OK.
Tips: In portfolio or samples, likes to "see about 20 slides showing photographer's use of lighting and ability to work with people. Know your intended market. Familiarize yourself with the magazine and keep abreast of how photos are used in the general magazine field."

HOME FURNISHINGS EXECUTIVE, 1301 Carolina St., Greensboro NC 27401. (910)378-6065. Fax: (910)275-2864. Editor: Patricia Bowling. Monthly magazine. "We are an issue-oriented business journal that tries to provide a forum for constructive dialogue between retailers and manufacturers in the home furnishings industry. Our readers include industry retailers, manufacturers and suppliers." Sample copy and photo guidelines free with SASE.
Needs: Uses 15-20 photos/issue; 50% supplied by freelancers. Needs personality photos, shots of store interiors.
Making Contact & Terms: Query with résumé of credits. Provide résumé, business card, brochure, flier or tearsheets to be kept on file for possible assignments. Reports only when interested. Pays $500/color cover photo; $250/color inside photo. **Pays on acceptance.** Credit line given. Buys first N.A. serial rights.
Tips: Looks for "ability to capture personality in business subjects for profiles; ability to handle diverse interiors."

IB (INDEPENDENT BUSINESS): AMERICA'S SMALL BUSINESS MAGAZINE, Group IV Communications, 125 Auburn Court, Suite 100, Thousand Oaks CA 91362. (805)496-6156. Fax: (805)496-5469. Editor: Daniel Kehrer. Editorial Director: Don Phillipson. Photo Editor: Ethan Blumen. Circ. 600,000. Estab. 1990. Bimonthly magazine. Emphasizes small business. All readers are small business owners throughout the US. Sample copy $4. Photo guidelines free with SASE.
Needs: Uses 25-35 photos/issue; all supplied by freelancers. Needs photos of "people who are small business owners. All pictures are by assignment; no spec photos." Special photo needs include dynamic, unusual photos of offbeat businesses and their owners. Model/property release required. Captions required; include correct spelling on name, title, business name, location.
Making Contact & Terms: Query with résumé of credits. Provide résumé, business card, brochure, flier or tearsheets to be kept on file for possible assignments. Keeps samples on file. SASE. Reports in 6 weeks. Pays $350/color inside photo plus expenses. **Pays on acceptance.** Credit line given. Buys first plus non-exclusive reprint rights.
Tips: "We want colorful, striking photos of small business owners that go well above-and-beyond the usual business magazine. Capture the essence of the business owner's native habitat."

***IEEE SPECTRUM**, 345 E. 47th St., New York NY 10017. (212)705-7568. Fax: (212)705-7453. Art Director: Mark Montgomery. Circ. 300,000. Publication of Institute of Electrical and Electronics Engineers, Inc. (IEEE). Monthly magazine. Emphasizes electrical and electronics field and high technology. Readers are male/female; educated; age range: 24-60.
• This magazine should be available on the Internet by January 1996.
Need: Uses 3-6 photos/issue; 3 provided by freelancers. Special photo needs include portrait photography and high technology photography. Model/property release required. Captions preferred.
Making Contact & Terms: Interested in receiving work from newer, lesser-known photographers. Arrange personal interview to show portfolio. Provide résumé, business card, brochure, flier or tearsheets to be kept on file for possible assignments. Pays $400/day. $1,000-1,500/color cover photo; $200-400/color inside photo. **Pays on acceptance.** Credit line given. Buys one-time rights. Previously published work OK.
Tips: Wants photographers who are consistant, have an ability to shoot color and b&w, display a unique vision and are receptive to their subjects.

ILLINOIS LEGAL TIMES, Dept. PM, 222 Merchandise Mart Plaza, Suite 1513, Chicago IL 60654. (312)644-4378. Managing Editor: Kelly Fox. Circ. 14,194. Estab. 1987. Monthly trade publication, tabloid format. Covers the business of law. Readers are Illinois-based lawyers and other legal professionals. Sample copy free with 10×13 SASE.
Needs: Uses 30-35 photos/issue; 33% supplied by freelancers. Needs photos of personalities in the profession.
Making Contact & Terms: Query with résumé of credits. Provide résumé, business card, brochure, flier or tearsheets to be kept on file for possible assignment. SASE. Reports in 3 weeks. Pays $100/

color or b&w cover photo; $50/color or b&w inside photo. Pays on 15th of month of cover date in which photos appear. Credit line given. Buys all rights; negotiable.

INDEPENDENT BANKER, P.O. Box 267, Sauk Centre MN 56378. (612)352-6546. Editor: Dave Bordewyk. Circ. 10,000. Estab. 1950. Publication of Independent Bankers Association of America. Monthly magazine. Emphasizes independent commercial banking. Readers are male and female chief executives, ages 35-65. Sample copy $3.
Needs: Uses 15 photos/issue; 5 supplied by freelancers. Needs shots of bankers at work in the bank with fellow bankers or customers, shots of bank buildings. Reviews photos with or without accompanying ms. Model release preferred. Captions preferred.
Making Contact & Terms: Interested in receiving work from newer, lesser-known photographers. Provide résumé, business card, brochure, flier or tearsheets to be kept on file for possible assignments. Keeps samples on file. Cannot return material. Reports in 1 month. Pays $50-150/job; $50-100/color cover photo; $40 minimum/color inside photo; $25 minimum/b&w inside photo. **Pays on acceptance**. Buys one-time rights; negotiable. Simultaneous submissions and/or previously published work OK.
Tips: "Get to know our publication first—what our needs are, etc."

INDOOR COMFORT NEWS, 606 N. Larchmont Blvd., Suite 4A, Los Angeles CA 90004. (213)467-1158. Fax: (213)461-2588. Managing Editor: Chris Callard. Circ. 23,000. Estab. 1955. Publication of Institute of Heating and Air Conditioning Industries. Monthly magazine. Emphasizes news, features, updates, special sections on CFC's, Indoor Air Quality, Legal. Readers are predominantly male—25-65, HVAC/R/SM contractors, wholesalers, manufacturers and distributors. Sample copy free with 9½×12½ SAE and 10 first-class stamps.
Needs: Interested in photos with stories of topical projects, retrofits, or renovations that are of interest to the heating, venting, and air conditioning industry. Property release required. Captions required; include what it is, where and what is unique about it.
Making Contact & Terms: Interested in receiving work from newer, lesser-known photographers. Send unsolicited photos by mail for consideration. Provide résumé, business card, brochure, flier or tearsheets to be kept on file for possible assignments. Send 3×5 glossy color b&w prints. Deadlines: first of the month, 2 months prior to publication. Keeps samples on file. SASE. Reports in 1-2 weeks. NPI. Credit line given.
Tips: Looks for West Coast material—projects and activities with quality photos of interest to the HVAC industry. "Familiarize yourself with the magazine and industry before submitting photos."

INDUSTRIAL SAFETY AND HYGIENE NEWS, Dept. PM, 1 Chilton Way, Radnor PA 19089. (215)964-4057. Editor: Dave Johnson. Circ. 60,000. Monthly magazine. Emphasizes industrial safety and health for safety and health management personnel in over 36,000 large industrial plants (primarily manufacturing). Free sample copy.
Needs: Occasionally use freelance photography for front covers. Magazine is tabloid size, thus front cover photos must be powerful and graphic with the dramatic impact of a poster.
Making Contact & Terms: Send material by mail for consideration. Uses color, 35mm and 2¼×2¼ transparencies. Photographer should request editorial schedule and sample of publication. SASE. Reports in 2 weeks. Pays $300-400/color photo. Credit line given. Pays on publication. Buys all rights on a work-for-hire basis. Previously published work OK.

***INFO-SECURITY NEWS**, 498 Concord St., Framingham MA 01701-2357. (508)879-9792. Fax: (508)879-0348. Art Director: Maureen Joyce. Circ. 30,000. Estab. 1988. Bimonthly magazine. Emphasizes computer security. Readers are male and female executives, managers. Sample copy $8.
Needs: Uses 5-15 photos; 1-5 supplied by freelancers. Needs photos of technology (computers), business, people. Model/property release required. Captions preferred.
Making Contact & Terms: Interested in receiving work from newer, lesser-known photographers. Arrange personal interview to show portfolio. Query with résumé of credits. Provide résumé, business card, brochure, flier or tearsheets to be kept on file for possible assignments. Keeps samples on file (printed samples or tearsheets only). Reports in 1 month. Pays $200-1,300 (depending on use, position). Pays on publication. Credit line given. Buys one-time rights.

IN-PLANT PRINTER AND ELECTRONIC PUBLISHER, Dept. PM, P.O. Box 1387, Northbrook IL 60065. (708)564-5940. Editor: Steve Klebba. Circ. 41,000. Bimonthly. Emphasizes "in-plant printing; print and graphic shops housed, supported, and serving larger companies and organizations and electronic publishing applications in those locations." Readers are management and production personnel of such shops. Sample copy $5. Photo guidelines free with SASE.
Needs: Uses about 5-10 photos/issue. Needs "working/shop photos, atmosphere, interesting equipment shots, how-to." Model release required. Captions preferred.
Making Contact & Terms: Query with samples or with list of stock photo subjects. Send b&w and color (any size or finish) prints; 35mm, 2¼×2¼, 4×5, 8×10 slides, b&w and color contact sheet or

b&w and color negatives by mail for consideration. SASE. Reports in 1 month. Pays $200 maximum/ b&w or color cover photo; $25 maximum/b&w or color inside photo; $200 maximum text/photo package. Pays on publication. Credit line given. Buys one-time rights with option for future use. Previously published work OK "if previous publication is indicated."

Tips: "Good photos of a case study—such as a printshop, in our case—can lead us to doing a follow-up story by phone and paying more for photos. Photographer should be able to bring out the hidden or overlooked design elements in graphic arts equipment." Trends include artistic representation of common objects found in-plant—equipment, keyboard, etc.

INSTANT AND SMALL COMMERCIAL PRINTER, Dept. PM, P.O. Box 368, Northbrook IL 60065. (708)564-5940. Fax: (708)564-8361. Editor: Anne Marie Mohan. Circ. 61,000. Estab. 1982. Published 10 times/year. Emphasizes the "instant and retail printing industry." Readers are owners, operators and managers of instant and smaller commercial (less than 20 employees) print shops. Sample copy $3. Photo guidelines free with SASE.

Needs: Uses about 15-20 photos/issue. Needs "working/shop photos, atmosphere, interesting equipment shots, some how-to." Model release required. Captions preferred.

Making Contact & Terms: Interested in receiving work from newer, lesser-known photographers. Query with samples or with list of stock photo subjects or send b&w and color (any size or finish) prints; 35mm, 2¼×2¼, 4×5 or 8×10 slides; b&w and color contact sheet or b&w and color negatives by mail for consideration. SASE. Reports in 1 month. Pays $300 maximum/b&w and color cover photo; $50 maximum/b&w and color inside photo; $200 maximum text/photo package. Pays on publication. Credit line given. Buys one-time rights with option for future use; negotiable. Previously published work OK "if previous publication is indicated."

JOURNAL OF PROPERTY MANAGEMENT, 430 N. Michigan Ave., 7th Floor, Chicago IL 60611. (312)329-6058. Fax: (312)661-0217. Associate Editor: Katherine Anderson. Circ. 19,600. Estab. 1934. Bimonthly magazine. Emphasizes real estate management. Readers are mid- and upper-level managers of investment real estate. Sample copy free with SASE. Photo guidelines available.

Needs: Uses 6 photos/issue; 50% supplied by freelancers. Needs photos of buildings, building operations and office interaction. Model/property release preferred.

Making Contact & Terms: Pays $50-150/b&w photo; $75-200/color photo.

JOURNAL OF PSYCHOACTIVE DRUGS, Dept. PM, 409 Clayton St., San Francisco CA 94117. (415)565-1904. Fax: (415)621-7354. Editor: Jeffrey H. Novey. Circ. 1,400. Estab. 1967. Quarterly. Emphasizes "psychoactive substances (both legal and illegal)." Readers are "professionals (primarily health) in the drug abuse treatment field."

Needs: Uses 1 photo/issue; supplied by freelancers. Needs "full-color abstract, surreal, avant garde or computer graphics."

Making Contact & Terms: Query with samples. Send 4×6 color prints or 35mm slides by mail for consideration. SASE. Reports in 2 weeks. Pays $50/color cover photo. Pays on publication. Credit line given. Buys one-time rights. Simultaneous submissions and previously published work OK.

JR. HIGH MINISTRY MAGAZINE, 2890 N. Monroe, Loveland CO 80539. (303)669-3836. Fax: (303)669-3269. Photo Editor: Karlin Waldner. Published 5 times a year. Interdenominational magazine that provides ideas and support to adult workers (professional and volunteer) with junior highers in Christian churches. Sample copy $1 and 9×12 SASE. Photo guidelines free with SASE.

Needs: Uses 20-25 photos/issue; 3-6 supplied by freelancers. Needs photos of activities and settings relating to families, teenagers (junior high school age), adults and junior high youth together. Model release required.

Making Contact & Terms: Interested in receiving work from newer, lesser-known photographers. Send unsolicited photos by mail for consideration. "Must include SASE." Send 8×10 b&w prints; 35mm, 2¼×2¼, 4×5 transparencies, will also accept PhotoCD. Reports in 1 month. Pays $300 and up/color cover photo; $300 & up/b&w cover photo; $65 & up/color inside photo; $35 & up/b&w inside photo. **Pays on acceptance.** Credit line given. Buys one-time rights. Simultaneous submissions and previously published work OK.

Tips: "We seek to portray people in a variety of ethnic, cultural and racio-economic backgrounds in our publications and the ability of a photographer to portray emotion in photos. One of our greatest ongoing needs is for good contemporary photos of black, Hispanic and American and Native American, as well as photos portraying a mix of group ethnic. Also candid, real life shots are preferable to posed ones."

LAND LINE MAGAZINE, 311 R.D. Mize Rd., Grain Valley MO 64029. (816)229-5791. Fax: (816)229-0518. Managing Editor: Sandi Laxson. Circ. 110,000. Estab. 1975. Publication of Owner Operator Independent Drivers Association. Bimonthly magazine. Emphasizes trucking. Readers are male and female independent truckers, with an average age of 44. Sample copy $2.

• This company may have started using CD-ROM in late 1995.

Needs: Uses 18-20 photos/issue; 50% supplied by freelancers. Needs photos of trucks, highways, truck stops, truckers, etc. "We prefer to have truck owners/operators in photos." Reviews photos with or without ms. Model/property release preferred for company trucks, drivers. Captions preferred.

Making Contact & Terms: Interested in receiving work from newer, lesser-known photographers. Provide résumé, business card, brochure, flier or tearsheets to be kept on file for possible assignments. Send glossy color or b&w prints; 2¼×2¼ transparencies. Pays $100/color cover photo; $50/b&w cover photo; $50/color inside photo; $30/b&w inside photo. Credit line given. Buys one-time rights. Previously published work OK.

LLAMAS MAGAZINE, P.O.Box 100, Herald CA 95638. (209)223-0469. Fax: (209)223-0466. Circ. 5,500. Estab. 1979. Publication of The International Camelid Journal. Magazine published 7 times a year. Emphasizes llamas, alpacas, vicunas, gunacos and camels. Readers are llama and alpaca owners and ranchers. Sample copy $5.75. Photo guidelines free with SASE.

Needs: Uses 30-50 photos/issue; all supplied by freelancers. Wants to see "any kind of photo with llamas, alpacas, camels in it. Always need good verticals for the cover. Always need good action shots." Model release required. Captions required.

Making Contact & Terms: Send unsolicited b&w or color 35mm prints or 35mm transparencies by mail for consideration. Provide résumé, business card, brochure, flier or tearsheets to be kept on file for possible assignments. Reports in 2 weeks. Pays $100/color cover photo; $25/color inside photo; $15/b&w inside photo. Pays on publication. Credit line given. Buys one-time rights. Simultaneous submissions and previously published work OK.

Tips: "You must have a good understanding of llamas and alpacas to submit photos to us. It's a very specialized market. Our rates are modest, but our publication is a very slick 4-color magazine and it's a terrific vehicle for getting your work into circulation. We are willing to give photographers a lot of free tearsheets for their portfolios to help publicize their work."

MANAGING OFFICE TECHNOLOGY, 1100 Superior Ave., Cleveland OH 44114. (216)696-7000. Fax: (216)696-7648. E-mail: luraromei@aol.com. Editor: Lura K. Romei. Circ. 128,000. Estab. 1957. Monthly magazine. Emphasizes office automation, data processing. Readers are middle and upper management and higher in companies of 100 or more employees. Sample copy free with 11 × 14 SAE and 2 first-class stamps.

Needs: Uses 15 photos/issue; 1 supplied by freelancers. Needs office shots, office interiors, computers, concept shots of office automation and networking; "any and all office shots are welcome." Model/property release preferred. Captions required; include non-model names, positions.

Making Contact & Terms: Interested in receiving work from newer, lesser-known photographers. Provide résumé, business card, brochure, flier or tearsheets to be kept on file for possible future assignments. Reports in 3 weeks. Pays $500/color cover photo; $50-100/b&w or color inside photo. Pays on publication. Credit line given. Buys one-time rights.

Tips: "Good conceptual (not vendor-specific) material about the office and office supplies is hard to find. Crack that and you're in business." In reviewing a photographer's samples, looks for "imagination and humor."

MARKETERS FORUM, 383 E. Main St., Centerport NY 11721. (516)754-5000. Fax: (516)754-0630. Publisher: Martin Stevens. Circ. 70,000. Estab. 1981. Monthly magazine. Readers are entrepreneurs and retail store owners. Sample copy $5.

Needs: Uses 3-6 photos/issue; all supplied by freelancers. "We publish trade magazines for retail variety goods stores and flea market vendors. Items include: jewelry, cosmetics, novelties, toys, etc. (five and dime type goods). We are interested in creative and abstract impressions—not straight-on product shots. Humor a plus" Model/property release required.

Making Contact & Terms: Send unsolicited photos by mail for consideration. Send color prints; 35mm, 4×5 transparencies. Does not keep samples on file. SASE. Reports in 2 weeks. Pays $100/color cover photo; $50/color inside photo. **Pays on acceptance.** Buys one-time rights. Simultaneous submissions and/or previously published work OK.

***MARKETING & TECHNOLOGY GROUP**, 1415 N. Dayton, Chicago IL 60622. (312)266-3311. Fax: (312)266-3363. Art Director: Neil Ruffolo. Circ. 18,000. Estab. 1993. Publishes 3 monthly magazines: *Carnetec*, *Meat Marketing & Technology*, and *Poultry Marketing & Technology*. Emphasizes meat and poultry processing. Readers are predominantly male, ages 35-65, generally conservative. Sample copy $4.

Needs: Uses 15-30 photos/issue; 1-3 supplied by freelancers. Needs photos of food, processing plant tours, product shots, illustrative/conceptual. Model/property release preferred. Captions preferred.

Making Contact & Terms: Provide résumé, business card, brochure, flier or tearsheets to be kept on file for possible assignments. Submit portfolio for review. Keeps samples on file. Reports in 1 month.

NPI. Pays on publication. Credit line given. Buys all rights; negotiable. Simultaneous submissions and previously published work OK.

Tips: "Work quickly and meet deadlines. Follow directions when given; and when none are given, be creative while using your best judgment."

MASONRY MAGAZINE, 1550 Spring Rd., Oak Brook IL 60521. (708)782-6767. Fax: (708)782-6786. Editor: Gene Adams. Circ. 7,200. Estab. 1960. Publication of the Mason Contractors Association of America and Canadian Masonry Contractors. Bimonthly magazine. Emphasizes masonry contracting. Readers are mason and general contractors, ages 30-70. Free sample copy. Free photo guidelines.
Needs: Uses 15-20 photos/issue; 1-2 supplied by freelancers. Needs photos of technology/how-to masonry buildings/personalities in industry. Model/property release preferred for individuals/plant technolgists. Captions required.
Making Contact & Terms: Interested in receiving work from newer, lesser-known photographers. Query with stock photo list. Send unsolicited photos by mail for consideration. Provide résumé, business card, brochure, flier or tearsheets to be kept on file for possible assignments. Send 5×7 or 8×10 color or b&w matte finish prints; 35mm transparencies. SASE. Reports in 1 month. Pays $50 and up/color cover photo; $10 and up/b&w inside photo. Pays on acceptance. Credit line given. Buys all rights; negotiable. Simultaneous submissions and previously published work OK.
Tips: Looks for "grasp of subject/clarity/illustration of points-succinctly. Be available for assignment/flexible, keep work before prospects/work and submit possibilities list/keep in constant touch."

MEXICO EVENTS & DESTINATIONS, P.O. Box 188037, Carlsbad CA 92009. (619)929-0707. Fax: (619)929-0714. Art Director: Gabriela Flores. Circ. 100,000. Estab. 1992. Quarterly magazine. Emphasizes travel to Mexico for travel professionals and consumers. Readers are consumers, travel agents and travel industry people. Sample copy $2. Photo guidelines free with SASE.
Needs: Uses 30-40 photos/issue; 10 supplied by freelancers. Needs destination and travel industry shots—hotels, resorts, tourism officials, etc. in Mexico for US travel pros. Model/property release preferred. Captions required; include correct spelling of people's names, location, time of day/year.
Making Contact & Terms: Interested in receiving work from newer, lesser-known photographers. Call. Does not keep samples on file. SASE. Reports in 1 month. Pays $200/color cover photo; $20-50/color inside photo. Pays 30 days from publication. Buys one-time rights. Previously published work OK.
Tips: Wants technically sound, inventive, creative shots.

MIDWEST AUTOBODY MAGAZINE, P.O. Box 570, Hudson IA 50643-0570. (319)988-4544. Fax: (319)988-4438. Publishing Director: Martin Stoakes. Circ. 10,000. Estab. 1984. Bimonthly magazine. Emphasizes automotive collision repair. Readers are male, business owners/managers interested in auto sports, classic restorations. Sample copy $5.
Needs: Uses 10-40 photos/issue. Needs photos of automobiles, especially wrecked cars and collision repair.
Making Contact & Terms: Interested in receiving work from newer, lesser-known photographers. Query with stock photo list. Send unsolicited photos by mail for consideration. Submit a selection of your automotive work for evaluation. Send 8×10 glossy color prints; 4×5 transparencies. Deadlines: 15th of February, April, June, August, October and December. SASE. Reports in 2 weeks. Pays $50-250/color cover photo; $50-100/color inside photo; $20-50/b&w inside photo. Pays on publication. Credit line given. Buys one-time rights. Simultaneous submissions and/or previously published work OK.

MINORITY BUSINESS ENTREPRENEUR, 3528 Torrance Blvd., Suite 101, Torrance CA 90503. (310)540-9398. Fax: (310)792-8263. Executive Editor: Jeanie Barnett. Circ. 40,000. Estab. 1984. Bimonthly magazine. Emphasizes minority, small, disadvantaged businesses. Sample copy free with 9½×12½ SAE and 5 first-class stamps. "We have editorial guidelines and calendar of upcoming issues available."
Needs: Uses 5-10 feature photos/issue. Needs "good shots for cover profiles and minority features of our entrepreneurs." Model/property release required. Captions preferred; include name, title and company of subject, and proper photo credit.
Making Contact & Terms: Interested in receiving work from newer, lesser-known photographers. Query with résumé of credits. Provide résumé, business card, brochure, flier or tearsheets to be kept on file for possible assignments. "Never submit unsolicited photos." SASE. Reports in 5 weeks. NPI; payment negotiable. Pays on publication. Credit line given. Buys first North American serial rights; negotiable.
Tips: "We're starting to run color photos in our business owner profiles. We want pictures that capture them in the work environment. Especially interested in minority and women photographers working for us. Our cover is an oil painting composed from photos. It's important to have high quality b&ws which show the character lines of the face for translation into oils. Read our publication and have a

good understanding of minority business issues. Never submit photos that have nothing to do with the magazine."

MODERN BAKING, Dept. PM, 2700 River Rd., Suite 418, Des Plaines IL 60018. (708)299-4430. Fax: (708)296-1968. Editor: Ed Lee. Circ. 27,000. Estab. 1987. Monthly. Emphasizes on-premise baking, in supermarkets, foodservice establishments and retail bakeries. Readers are owners, managers and operators. Sample copy for 9×12 SAE with 10 first-class stamps.
Needs: Uses 30 photos/issue; 1-2 supplied by freelancers. Needs photos of on-location photography in above-described facilities. Model/property release preferred. Captions required; include company name, location, contact name and telephone number.
Making Contact & Terms: Interested in receiving work from newer, lesser-known photographers. Provide résumé, business card, brochure, flier or tearsheets to be kept on file for possible future assignments. SASE. Reports in 2 weeks. Pays $50 minimum; negotiable. **Pays on acceptance.** Credit line given. Buys all rights; negotiable.
Tips: Prefers to see "photos that would indicate person's ability to handle on-location, industrial photography."

***MODERN CASTING**, 505 State St., Des Plaines IL 60016. (708)824-0181. Fax: (708)824-7848. Editor: Mike Lessiter. Circ. 25,000. Estab. 1938. Publication of American Foundrymen's Association. Monthly magazine. Emphasizes metal casting and the North American foundry industry. Readers are management and technical officials of foundries.
Needs: Uses 30 photos/issue; few supplied by freelancers. Needs photos of metal poured into sand/ permanent molds; mold making; coremaking; foundry workers (at work); casting handling; shipments; some general industry. Captions necessary.
Making Contact & Terms: Interested in receiving work from newer, lesser-known photographers. Send unsolicited photos by mail for consideration. Query with stock photo list. Send any color prints. Keeps samples on file. Reports in 3 weeks. NPI. Credit line given.

MODERN PLASTICS, 1221 Sixth Ave., New York NY 10020. (212)512-3491. Art Director: Bob Barravecchia. Circ. 65,000. Monthly magazine. Readers are male buyers in the plastics trade.
Needs: Needs photos of how-to, etc. Purchases photos with accompanying ms only. Model release required. Property release preferred. Captions required; include manufacturer's name and model number.
Making Contact & Terms: Interested in receiving work from newer, lesser-known photographers. Arrange a personal interview to show portfolio. Cannot return material. Reports in 1 week. Pays $500/ color cover photo and $100/color inside photo. **Pays on acceptance.** Credit line given. Buys first North American serial rights.
Tips: In portfolio or samples looks for concept covers.

MUSHING MAGAZINE, P.O. Box 149, Ester AK 99725. Phone/fax: (907)479-0454. Publisher: Todd Hoener. Circ. 6,000. Estab. 1987. Bimonthly magazine. Readers are dog drivers, mushing enthusiasts, dog lovers, outdoor specialists, innovators and history lovers. Sample copy $4 in US. Photo guidelines free with SASE.
Needs: Uses 20 photos/issue; most supplied by freelancers. Needs action photos: all-season and wilderness; also still and close-up photos: specific focus (sledding, carting, dog care, equipment, etc). Special photo needs include skijoring, feeding, caring for dogs, summer carting or packing, 1-3 dog-sledding and kids mushing. Model release preferred. Captions preferred.
Making Contact & Terms: Interested in receiving work from newer, lesser-known photographers. Send unsolicited photos by mail for consideration. Reports in 6 months. Pays $130 maximum/color cover photo; $35 maximum/color inside photo; $15-30/b&w inside photo. Pays on publication. Credit line given. Buys first North American serial rights and second reprint rights.
Tips: Wants to see work that shows "the total mushing adventure/lifestyle from environment to dog house." To break in, one's work must show "simplicity, balance and harmony. Strive for unique, provocative shots that lure readers and publishers."

NAILPRO, 7628 Densmore Ave., Van Nuys CA 91406-2088. (818)782-7328. Fax: (818)782-7450. Executive Editor: Linda Lewis. Circ. 45,000. Estab. 1989. Published by Creative Age Publications.

The First Markets Index preceding the General Index in the back of this book provides the names of those companies/ publications interested in receiving work from newer, lesser-known photographers.

Monthly magazine. Emphasizes topics for professional manicurists and nail salon owners. Readers are females of all ages. Sample copy $2 with 8½×11 SASE.

Needs: Uses 10-12 photos/issue; all supplied by freelancers. Needs photos of beautiful nails illustrating all kinds of nail extensions and enhancements; photographs showing process of creating and decorating nails, both natural and artificial. Model release required. Captions required; identify people and process if applicable.

Making Contact & Terms: Interested in receiving work from newer, lesser-known photographers. Send color prints; 35mm, 2¼×2¼, 4×5. Keeps samples on file. SASE. Reports in 1 month. Pays $500/color cover photo; $50-200/color inside photo; $50/b&w inside photo. **Pays on acceptance.** Credit line given. Buys one-time rights. Previously published work OK.

Tips: "Talk to the person in charge of choosing art about photo needs for the next issue and try to satisfy that immediate need; that often leads to assignments."

NATIONAL BUS TRADER, 9698 W. Judson Rd., Polo IL 61064-9049. (815)946-2341. Fax: (815)946-2347. Editor: Larry Plachno. Circ. 5,600. Estab. 1977. "The Magazine of Bus Equipment for the United States and Canada—covers mainly integral design buses in the United States and Canada." Readers are bus owners, commercial bus operators, bus manufacturers, bus designers. Sample copy free (no charge—just write or call).

Needs: Uses about 30 photos/issue; 22 supplied by freelance photographers. Needs photos of "buses; interior, exterior, under construction, in service." Special needs include "photos for future feature articles and conventions our own staff does not attend."

Making Contact & Terms: "Query with specific lists of subject matter that can be provided and mention whether accompanying mss are available." SASE. Reports in 1 week. Pays $3-5/b&w photo; $100-3,000/photo/text package. **Pays on acceptance.** Credit line given. Buys rights "depending on our need and photographer." Simultaneous submissions and previously published work OK.

Tips: "We don't need samples, merely a list of what freelancers can provide in the way of photos or ms. Write and let us know what you can offer and do. We often use freelance work. We also publish *Bus Tours Magazine*—a bimonthly which uses many photos but not many from freelancers; *The Bus Equipment Guide*—infrequent, which uses many photos; and *The Official Bus Industry Calendar*—annual full-color calendar of bus photos. We also publish historical railroad books and are looking for historical photos on midwest interurban lines and railroads. Due to publication of historical railroad books, we are purchasing many historical photos. In photos looks for subject matter appropriate to current or pending article or book. Send a list of what is available with specific photos, locations, bus/interurban company and fleet number."

NEW JERSEY CASINO JOURNAL, 2524 Arctic Ave., Atlantic City NJ 08401. (609)344-9000. Fax: (609)345-3469. Photo Editor: Rick Greco. Circ. 25,000. Estab. 1985. Monthly. Emphasizes casino operations. Readers are casino executives, employers and vendors. Sample copy free with 11×14 SAE and 9 first-class stamps.

Needs: Uses 40-60 photos/issue; 5-10 supplied by freelancers. Needs photos of gaming tables and slot machines, casinos and portraits of executives. Model release required for gamblers, employees. Captions required.

Making Contact & Terms; Interested in receiving work from newer, lesser-known photographers. Query with résumé of credits. Query with stock photo list. Reports in 3 months. Pays $100 minimum/color cover photo; $10-35/color inside photo; $10-25/b&w inside photo. Pays on publication. Credit line given. Buys all rights; negotiable.

Tips: "Read and study photos in current issues."

NEW METHODS, P.O. Box 22605, San Francisco CA 94122-0605. (415)664-3469. Art Director: Ronald S. Lippert, AHT. Circ. 5,600. Estab. 1981. Monthly. Emphasizes veterinary personnel, animals. Readers are veterinary professionals and interested consumers. Sample copy $3.20 (20% discount on 12 or more). Photo guidelines free with SASE.

Needs: Uses 12 photos/issue; 2 supplied by freelance photographers. Assigns 95% of photos. Needs animal, wildlife and technical photos. Most work is b&w. Model/property releases preferred. Captions preferred.

Making Contact & Terms: Interested in receiving work from newer, lesser-known photographers. Arrange a personal interview to show portfolio. Query with résumé of credits, samples or list of stock photo subjects. Provide résumé, business card, brochure, flier or tearsheets to be kept on file for possible assignments. SASE. Reports in 2 months. Payment is rare, negotiable; will barter. Credit line given. Buys one-time rights. Simultaneous submissions and previously published work OK.

Tips: Ask for photo needs before submitting work. Prefers to see "technical photos (human working with animal(s) or animal photos (*not cute*)" in a portfolio or samples. On occasion, needs photographer for shooting new products and local area conventions.

911 MAGAZINE, P.O. Box 11788, Santa Ana CA 92711. (714)544-7776. Fax: (714)838-9233. Editor: Randall Larson. Circ. 22,000. Estab. 1988. Bimonthly magazine. Emphasizes publisher-safety communications and emergency response—police, fire, paramedic, dispatch, utilities, etc. Readers are ages 20-65, mostly male. Sample copy free with 9×12 SAE and 7 first-class stamps. Photo guidelines free with SASE.
Needs: Uses up to 25 photos/issue; 75% supplied by freelance photographers; 20% comes from assignment, 80% from stock. "From the Field" department photos are needed of incidents involving emergency agencies in action from law enforcement, fire suppression, paramedics, dispatch, etc., showing proper techniques and attire. Model release preferred. Captions preferred; if possible include incident location by city and state, agencies involved, duration, dollar cost, fatalities and injuries.
Making Contact & Terms: Interested in receiving work from newer, lesser-known photographers. Query with list of stock photo subjects. Send unsolicited photos by mail for consideration. Provide résumé, business card, brochure, flier or tearsheets to be kept on file for possible assignments. Uses 35mm, 2¼×2¼, 4×5, 8×10 glossy contacts, b&w or color prints; 35mm, 2¼×2¼, 4×5, 8×10 transparencies. SASE. Reports in 3 weeks. Pays $100-300/color cover photo; $50-150/b&w cover photo; $25-75/color inside photo; $20-50/b&w inside photo. Pays on publication. Credit line given. Buys one-time rights. Simultaneous submissions and previously published work OK.
Tips: "We need photos for unillustrated cover stories and features appearing in each issue. Topics include rescue, traffic, communications, training, stress, media relations, crime prevention, etc. Calendar available. Assignments possible."

***♥OH&S CANADA**, Dept. PM, 1450 Don Mills Rd., Don Mills ON M3B 2X7 Canada. (416)445-6641. Fax: (416)442-2200. Art Director: Catherine Goard. Bimonthly magazine. Emphasizes occupational health and safety. Readers are health and safety professionals, median age of 40. Circ. 10,000. Estab. 1985.
Needs: Uses 3 photos/issue; 70% supplied by freelancers. Primarily uses photos of business, industry on-site, etc. Model release and photo captions preferred.
Making Contact & Terms: Provide résumé, business card, brochure, flier or tearsheets to be kept on file for possible assignments. Pays $800-1,000/color cover photo; $400-600/color inside photo. "Rates of payment vary quite substantially according to photographer experience." **Pays on acceptance.** Credit line given. Buys one-time rights.
Tips: In portfolio or samples, looking for "industry shots."

OHIO TAVERN NEWS, 329 S. Front St., Columbus OH 43215. (614)224-4835. Fax: (614)224-8649. Editor: Chris Bailey. Circ. 8,200. Estab. 1939. Biweekly. Emphasizes beverage alcohol/hospitality industries in Ohio. Readers are liquor permit holders: restaurants, bars, distillers, vintners, wholesalers. Sample copy free for 9×12 SASE.
Needs: Uses 1-4 photos/issue. Needs photos of people, places, products covering the beverage alcohol/ hospitality industries in Ohio. Captions required; include who, what, where, when and why.
Making Contact & Terms: Interested in receiving work from newer, lesser-known photographers. Send unsolicited photos by mail for consideration. Send up to 8×10 glossy b&w prints. Deadlines: first and third Friday of each month. Keeps samples on file. SASE. Reports in 1 month. Pays $15/ photo. Pays on publication. Credit line given. Buys one-time rights; negotiable. Simultaneous submissions OK.

PACIFIC BUILDER & ENGINEER, Vernon Publications Inc., Suite 200, 3000 Northup Way, Bellevue WA 98004. (206)827-9900. Editor: Carl Molesworth. Circ. 14,500. Estab. 1902. Biweekly magazine. Emphasizes non-residential construction in the Northwest and Alaska. Readers are construction contractors. Sample copy $7.
Needs: Uses 8 photos/issue; 4 supplied by freelancers. Needs photos of ongoing constructing projects to accompany assigned feature articles. Reviews photos purchased with accompanying ms only. Photo captions preferred; include name of project, general contractor, important subcontractors, model/make of construction equipment, what is unusual/innovative about project.
Making Contact & Terms: Interested in receiving work from newer, lesser-known photographers. Query with résumé of credits. Does not keep samples on file. SASE. Reports in 1 month. Pays $25-125/color cover photo; $15-50/b&w inside photo. Pays on publication. Buys first North American serial rights.
Tips: "All freelance photos must be coordinated with assigned feature stories."

PACIFIC FISHING, 1515 NW 51st, Seattle WA 98107. (206)789-5333. Fax: (206)784-5545. Editor: Steve Shapiro. Circ. 11,000. Estab. 1979. Monthly magazine. Emphasizes commercial fishing on West Coast—California to Alaska. Readers are 80% owners of fishing operations, primarily male, ages 25-55; 20% processors, marketers and suppliers. Sample copy free with 11×14 SAE and 8 first-class stamps. Photo guidelines free with SASE.

Needs: Uses 15 photos/issue; 10 supplied by freelancers. Needs photos of *all* aspects of commercial fisheries on West Coast of US and Canada. Special needs include "high-quality, active photos and slides of fishing boats and fishermen working their gear, dockside shots and the processing of seafood." Model/property release preferred. Captions required; include names and locations.

Making Contact & Terms: Query with résumé of credits. Query with list of stock photo subjects. Keeps samples on file. SASE. Reports in 2-4 weeks. Pays $150/color cover photo; $50-100/color inside photo; $25-50/b&w inside photo. Pays on publication. Credit line given. Buys one-time rights, first North American serial rights. Previously published work OK "if not previously published in a competing trade journal."

Tips: Wants to see "clear, close-up and active photos."

THE PARKING PROFESSIONAL, 701 Kenmore, Suite 200, Fredericksburg VA 22401. (703)371-7535. Fax: (703)371-8022. Editor: Marie E. Witmer. Circ. 2,000. Estab. 1984. Publication of the Instutional & Municipal Parking Congress Association. Monthly magazine. Emphasizes parking: public, private, institutional, etc. Readers are male and female public parking managers, ages 30-60. Free sample copy.

Needs: Uses 12 photos/issue; 4-5 supplied by freelancers. Model release required. Captions preferred; include location, purpose, type of operation.

Making Contact & Terms: Interested in receiving work from newer, lesser-known photographers. Contact through rep. Arrange personal interview to show portfolio for review. Query with résumé of credits. Provide résumé, business card, brochure, flier or tearsheets to be kept on file for possible assignments. Send 5×7, 8×10 color or b&w prints; 35mm, 2¼×2¼, 4×5, 8×10 transparencies. Keeps samples on file. SASE. Reports in 1-2 weeks. Pays $100-300/color cover photo; $25-100/color inside photo; $25-100/b&w inside photo; $100-500/photo/text package. Pays on publication. Credit line given. Buys one-time, all rights; negotiable. Previously published work OK.

PEDIATRIC ANNALS, Dept. PM, 6900 Grove Rd., Thorofare NJ 08086. (609)848-1000. Editor: Mary L. Jerrell. Circ. 36,000. Monthly journal. Emphasizes "the pediatrics profession." Readers are practicing pediatricians. Sample copy free with SASE.

Needs: Uses 1 cover photo/issue; all supplied by freelance photographers. Needs photos of "children in medical settings, some with adults." Written release required. Captions preferred.

Making Contact & Terms: Query with samples. Provide résumé, business card, brochure, flier or tearsheets to be kept on file for possible future assignments. Reports in 6 weeks. Pays $350/color cover photo. Pays on publication. Credit line given. Buys all rights. Simultaneous submissions and previously published work OK.

PERSONAL SELLING POWER, INC., Box 5467, Fredericksburg VA 22405. (703)752-7000. Editor-in-Chief: Laura B. Gschwandtner. Magazine for sales and marketing professionals. Uses photos for magazine covers and text illustration. Recent covers have featured leading personalities such as Margaret Thatcher, Donald Trump and Tom Peters.

Needs: Buys about 35 freelance photos/year; offers about 6 freelance assignments/year. Business, sales, motivation, etc. Subject matter and style of photos depend on the article. Most photos are business oriented, but some can also use landscape.

Making Contact & Terms: Query with résumé of credits, samples and list of stock photo subjects. Uses transparencies, or in some cases b&w; formats can vary. Report time varies according to deadlines. NPI. Payment and terms negotiable. **Pays on acceptance.** Credit line given. Buys one-time rights. Previously published work OK.

Tips: Photographers should "send only their best work. Be reasonable with price. Be professional to work with. Also, look at our magazine to see what types of work we use and think about ways to improve what we are currently doing to give better results for our readers." As for trends, "we are using more and better photography all the time, especially for cover stories."

***PERSONNEL JOURNAL**, 245 Fischer Ave., #B-2, Costa Mesa CA 92626. (714)751-1883. Fax: (714)751-4106. Art Director: Steve Stewart. Circ. 30,000. Estab. 1921. Monthly magazine. Emphasizes human resources. Readers are male and female business leaders in the hiring profession, ages 30-65. Sample copies can be viewed in libraries.

Needs: Uses 2-5 photos/issue; all supplied by freelancers. "We purchase business, news stock and assign monthly cover shoots." Model release required. Property release preferred. Captions preferred.

Making Contact & Terms: Interested in receiving work from newer, lesser-known photographers. Provide résumé, business card, brochure, flier or tearsheets to be kept on file for possible assignments. Query with stock photo list. Keeps samples on file. SASE. Reports in 1 month. NPI. Pays on publication. Credit line given. Buys one-time rights. Simultaneous submissions and previously published work OK.

PET BUSINESS, 5400 NW 84th Ave., Miami FL 33166. Editorial Director: Elizabeth McKey. Circ. 19,000. Estab. 1974. Monthly news magazine for pet industry professionals. Sample copy $3. Guidelines free with SASE.

Needs: Photos of well-groomed pet animals (preferably purebred) of any age in a variety of situations. Identify subjects. Animals: dogs, cats, fish, birds, reptiles, amphibians, small animals (hamsters, rabbits, gerbils, mice, etc.) Also, can sometimes use shots of petshop interiors—but must be careful not to be product-specific. Good scenes would include personnel interacting with customers or caring for shop animals. Model/property release preferred. Captions preferred; include essential details regarding animal species.

Making Contact & Terms: Interested in receiving work from newer, lesser-known photographers. Submit photos for consideration. Reports within 3 months with SASE. Pays $20/color print or transparency for inside use; $100 for cover use. Pays on publication. Credit line given. Buys all rights; negotiable.

Tips: Uncluttered background. Portrait-style always welcome. Close-ups best. News/action shots if timely. "Make sure your prints have good composition, and are technically correct, in focus and with proper contrast. Avoid dark pets on dark backgrounds! Send only 'pet' animal, not zoo or wildlife, photos."

***PET PRODUCT NEWS MAGAZINE**, P.O. Box 6050, Mission Viejo CA 92690. (714)855-8822. Fax: (714)855-3045. Associate Editor: Stacy N. Hackett. Estab. 1950. Monthly tabloid. Emphasizes pets and business subjects. Readers are pet store owners and managers. Sample copy $4.50. Photo guidelines free with SASE.

Needs: Uses 15-25 photos/issue; 75-100% supplied by freelancers. Needs photos of people interacting with pets, pets doing "pet" things, pet stores and vets examining pets. Reviews photos with or without ms. Model/property release preferred. Captions preferred; include type of animal, name of pet store, name of well-known subjects, any procedures being performed on an animal that are not self-explanatory.

Making Contact & Terms: Interested in receiving work from newer, lesser-known photographers. Send unsolicited photos by mail for consideration. Send 5×7 or 8×10 glossy color and b&w prints; 35mm transparencies. SASE. Reports in 2 months. Pays $50-75/color cover photo; $50 minimum/b&w cover photo; $35 minimum/color inside photo; $35 minimum/b&w inside photo; $150-250/photo/text package. Pays on publication. Credit line given; must appear on each slide or photo. Buys one-time rights. Previously published work OK.

Tips: Looks for "appropriate subjects, clarity and framing, sensitivity to the subject. No avant garde or special effects. We need clear, straight-forward photography. Definitely no 'staged' photos, keep it natural. Read the magazine before submission. We are a trade publication and need business-like, but not boring, photos that will add to our subjects."

PETROLEUM INDEPENDENT, 1101 16th St. NW, Washington DC 20036. (202)857-4774. Fax: (202)857-4799. Editor: Bruce Wells. Circ. 6,200. Estab. 1930. Monthly magazine. Emphasizes independent petroleum industry. "Don't confuse us with the major oil companies, pipelines, refineries, gas stations. Our readers explore for and produce crude oil and natural gas in the lower 48 states. Our magazine covers energy politics, regulatory problems, the national outlook for independent producers."

Needs: Photo essay/photo feature; scenic; and special effects/experimental, all of oil field subjects. Please send your best work.

Making Contact & Terms: Interested in receiving work from newer, lesser-known photographers. Uses 35mm or larger transparencies. Pays $35-100/photo; payment negotiable for cover. Buys one-time and all rights.

Tips: "We want to see creative use of camera—scenic, colorful or high contrast-studio shots. Creative photography to illustrate particular editorial subjects (natural gas decontrol, the oil glut, etc.) is always wanted. We've already got plenty of rig shots—we want carefully set-up shots to bring some art to the oil field."

***PICKWORLD**, 1691 Browning, Irvine CA 92714. (714)261-7425. Fax: (714)250-8187. Editor: Denis Hill. Circ. 25,000. Estab. 1984. Bimonthly magazine. Emphasizes the nested relational database market: vendors and users. Readers are managers, technical staff, of vendors or user entities in the nested relational database market. Sample copy $8.

Needs: Uses 50 photos/issue; 25 supplied by freelancers. Needs photos of people and businesses, computers and related objects. Model release preferred.

Making Contact & Terms: Query with résumé of credits. Does not keep samples on file. SASE. Reports in 3 weeks. Pays $200/job; $300-500/color cover photo; $50/color inside photo. **Pays on acceptance**. Credit line given. Buys first North American serial rights. Simultaneous submissions and previously published work OK.

PIPELINE AND UTILITIES CONSTRUCTION, P.O. Box 219368, Houston TX 77218-9368. (713)558-6930. Fax: (713)558-7029. Editor: Robert Carpenter. Circ. 29,000. Estab. 1945. Monthly. Emphasizes construction of oil and gas, water and sewer underground pipelines and cable. Readers are contractor key personnel and company construction managers. Sample copy $3.
Needs: "Uses photos of pipeline construction, but must have editorial material on project with the photos."
Making Contact & Terms: Send unsolicited photos by mail for consideration. Accepts color prints and transparencies. SASE. Reports in 1 month. NPI. Pay rates negotiable. Buys one-time rights.
Tips: "We rarely use freelance photography. Freelancers are competing with staff as well as complimentary photos supplied by equipment manufacturers. Subject matter must be unique, striking and 'off the beaten track' (i.e., somewhere we wouldn't travel ourselves to get photos)."

PIZZA TODAY, Dept. PM, P.O. Box 1347, New Albany IN 47151. (812)949-0909. Fax: (812)941-5329. Editor: Jim Reed. Circ. 52,000. Estab. 1983. Monthly. Emphasizes pizza trade. Readers are pizza shop owner/operators. Sample copy free with 9½×12½ SAE.
Needs: Uses 40 photos/issue; 10 supplied by freelancers; 100% from assignment. Needs how-tos of pizza making, product shots, profile shots. Special needs include celebrities eating pizza, politicians eating pizza. Captions required.
Making Contact & Terms: Provide résumé, business card, brochure, flier or tearsheets to be kept on file for possible assignments. SASE. Reports in 1 month. Pays $5-15/b&w photo; $20-30/color photo (prefer 35mm slides); all fees are negotiated in advance. Pays on publication. Credit line given. Buys all rights; negotiable. Previously published work OK.
Tips: Accept samples by mail only. "Team up with writer/contributor and supply photos to accompany article. We are not looking for specific food shots—looking for freelancers who can go to pizza shops and take photos which capture the atmosphere, the warmth and humor; 'the human touch.' "

PLANTS SITES & PARKS MAGAZINE, 10100 W. Sample Rd., #201, Coral Springs FL 33065-3938. (800)753-2660. Fax: (305)755-7048. Art Director: David Lepp. Circ. 40,000. Estab. 1973. Bimonthly magazine. Emphasizes economic development and business. Readers are executives involved in selecting locations for their businesses.
Needs: Uses 15-20 photos/issue; 5-10 supplied by freelancers. General business subjects, locations, industrial, food processing and people. Model and/or property release required. Captions preferred.
Making Contact & Terms: Query with list of stock photo subjects. Provide résumé, business card, brochure, flier or tearsheets to be kept on file for possible assignments. Keeps samples on file. Reports in 3 weeks. Pays $500/color cover photo; $100-150/color inside photo. Pays on acceptance and publication; negotiable. Buys one-time rights; negotiable. Simultaneous submissions and/or previously published work OK.
Tips: Wants to see "only very good quality work. Original slides, *no* dupes; no research fees."

***PLASTICS NEWS**, 1725 Merriman Rd., Akron OH 44313. (216)836-9180. Fax: (216)836-2322. Managing Editor: Ron Shinn. Circ. 60,000. Estab. 1989. Weekly tabloid. Emphasizes plastics industry business news. Readers are male and female executives of companies that manufacture a broad range of plastics products; suppliers and customers of the plastics processing industry. Sample copy $1.95.
Needs: Uses 10-20 photos/issue; 1-3 supplied by freelancers. Needs photos of technology related to use and manufacturing of plastic products. Model/property release preferred. Captions required.
Making Contact & Terms: Send unsolicited photos by mail for consideration. Provide résumé, business card, brochure, flier or tearsheets to be kept on file for possible assignments. Query with stock photo list. Keeps samples on file. SASE. Reports in 2 weeks. Pays $125-175/color cover photo; $125-175/color inside photo; $100-150/b&w inside photo. Pays on publication. Credit line given. Buys one-time and all rights. Simultaneous submissions and previously published work OK.

PLUMBING & MECHANICAL, 3150 River Rd., Suite 101, Des Plaines IL 60018. (708)297-3757. Fax: (708)297-8371. Art Director: Wendy Calcaterra. Circ. 37,755. Estab. 1984. Monthly magazine. Emphasizes mechanical contracting, plumbing, hydronic heating, remodeling. Readers are company owners, presidents, CEOs, vice presidents, general managers, secretaries and treasurers.
Needs: Uses 10-12 photos/issue; 2-5 supplied by freelancers. Interested in showroom shots, job sites, personalities. Model/property release preferred. Captions preferred.
Making Contact & Terms: Interested in receiving work from newer, lesser-known photographers. Provide résumé, business card, brochure, flier or tearsheets to be kept on file for possible assignments. Deadlines: Photos are due during the first week of the month. Keeps samples on file. Cannot return material. Reports in 1 month. Pays $950/color cover photo. Pays on publication. Credit line given. Buys all rights.

POLICE MAGAZINE, 6300 Yarrow Dr., Carlsbad CA 92009. (619)438-2511. Fax: (619)931-9809. Managing Editor: Dan Burger. Estab. 1976. Monthly. Emphasizes law enforcement. Readers are various

members of the law enforcement community, especially police officers. Sample copy $2 with 9×12 SAE and 6 first-class stamps. Photo guidelines free with SASE.

Needs: Uses about 15 photos/issue; 99% supplied by freelance photographers. Needs law enforcement related photos. Special needs include photos relating to daily police work, crime prevention, international law enforcement, police technology and humor. Model release required. Property release preferred. Captions preferred.

Making Contact & Terms: Interested in receiving work from newer, lesser-known photographers. Arrange a personal interview to show portfolio. Send b&w prints, 35mm transparencies, b&w contact sheet or color negatives by mail for consideration. SASE. Pays $100/color cover photo; $30/b&w photo; $30 (negotiable)/color inside photo; $150-300/job; $150-300/text/photo package. **Pays on acceptance.** Buys all rights; rights returned to photographer 45 days after publication. Simultaneous submissions OK.

Tips: "Send for our editorial calendar and submit photos based on our projected needs. If we like your work, we'll consider you for future assignments. A photographer we use can grasp the conceptual and the action shots."

POLICE TIMES/CHIEF OF POLICE, 3801 Biscayne Blvd., Miami FL 33137. (305)573-0070. Fax: (305)573-9819. Editor-in-Chief: Jim Gordon. Circ. 50,000. Bimonthly magazines. Readers are law enforcement officers at all levels. Sample copy $2.50. Photo guidelines free with SASE.

Needs: Buys 60-90 photos/year. Photos of police officers in action, civilian volunteers working with the police and group shots of police department personnel. Wants no photos that promote other associations. Police-oriented cartoons also accepted on spec. Model release preferred. Captions preferred.

Making Contact & Terms: Send photos for consideration. Send glossy b&w and color prints. SASE. Reports in 3 weeks. Pays $5-10 upwards/inside photo; $25-50 upwards/cover photo. **Pays on acceptance.** Credit line given if requested; editor's option. Buys all rights, but may reassign to photographer after publication. Simultaneous submissions and previously published work OK.

Tips: "We are open to new and unknowns in small communities where police are not given publicity."

POLLED HEREFORD WORLD, 11020 NW Ambassador Dr., Kansas City MO 64153. (816)891-8400. Editor: Ed Bible. Circ. 8,500. Estab. 1947. Monthly magazine. Emphasizes Polled Hereford cattle for registered breeders, commercial cattle breeders and agribusinessmen in related fields.

Making Contact & Terms: Interested in receiving work from newer, lesser-known photographers. Query. Uses b&w prints and color transparencies and prints. Reports in 2 weeks. Pays $5/b&w print; $100/color transparency or print. Pays on publication.

Tips: Wants to see "Polled Hereford cattle in quantities, in seasonal and/or scenic settings."

POWERLINE MAGAZINE, 10251 W. Sample Rd., Suite B, Coral Springs FL 33065-3939. (305)755-2677. Fax: (305)755-2679. Editor: James McMullen. Photos used in trade magazine of Electrical Generating Systems Association and PR releases, brochures, newsletters, newspapers and annual reports.

Needs: Buys 40-60 photos/year; gives 2 or 3 assignments/year. "Cover photos, events, award presentations, groups at social and educational functions." Model release required. Property release preferred. Captions preferred; include identification of individuals only.

Making Contact & Terms: Interested in receiving work from newer, lesser-known photographers. Provide résumé, business card, brochure, flier or tearsheets to be kept on file for possible future assignments. Solicits photos by assignment only. Uses 5×7 glossy b&w and color prints; b&w and color contact sheets; b&w and color negatives. SASE. Reports as soon as selection of photographs is made. NPI. Buys all rights; negotiable.

Tips: "Basically a freelance photographer working with us should use a photojournalistic approach, and have the ability to capture personality and a sense of action in fairly static situations. With those photographers who are equipped, we often arrange for them to shoot couples, etc., at certain functions on spec, in lieu of a per-day or per-job fee."

THE PREACHER'S MAGAZINE, E. 10814 Broadway, Spokane WA 99206. (509)226-3464. Editor: Randal E. Denny. Circ. 18,000. Estab. 1925. Quarterly professional journal for ministers. Emphasizes the pastoral ministry. Readers are pastors of large to small churches in five denominations; most pastors are male. No sample copy available. No photo guidelines.

Needs: Uses one photo/issue; all supplied by freelancers. Large variety needed for cover, depends on theme of issue. Model release preferred. Captions preferred.

Making Contact & Terms: Send 35mm b&w/color prints by mail for consideration. Reports ASAP. Pays $60/color cover photo. **Pays on acceptance.** Credit line given. Buys one-time rights. Simultaneous submissions and previously published work OK.

Tips: In photographer's samples wants to see "a variety of subjects for the front cover of our magazine. We rarely use photos within the magazine itself."

***PRO SOUND NEWS**, 2 Park Ave., New York NY 10016. (212)213-3444. Editor: Debra Pagan. Managing Editor: Andrea Rotondo. Circ. 21,000. Monthly tabloid. Emphasizes professional recording and sound and production industries. Readers are recording engineers, studio owners and equipment manufacturers worldwide. Sample copy free with SASE.
Needs: Uses about 24 photos/issue; all supplied by freelance photographers. Needs photos of recording sessions, sound reinforcement for concert tours, permanent installations. Model release required. Captions required.
Making Contact & Terms: Query with samples. Send 8 × 10 glossy color prints by mail for consideration. SASE. Reports in 2 weeks. NPI; pays by the job or for text/photo package. Pays on publication. Credit line given. Buys one-time rights. Simultaneous submissions and previously published work OK.

***THE PROFESSIONAL COMMUNICATOR**, 3717 Columbia Pike, Suite 310, Arlington VA 22204-4255. (703)920-5555. Fax: (703)920-5556. Director of Communications: Leslie Sansom. Publication of Women in Communications, Inc. (WICI). Magazine published 5 times/year. Emphasizes communications industry news and issues, professional development. Readers are women (and men) in communications industry, average age is 39. Sample copy $4.
Needs: Uses 5-10 photos/issue; all supplied by freelancers. Needs photos of WICI events, members, conference coverage, and photos to accompany stories. Captions preferred; include who, where, when, why.
Making Contact & Terms: Interested in receiving work from newer, lesser-known photographers. Query with stock photo list. Provide résumé, business card, brochure, flier or tearsheets. Does not keep samples on file. Cannot return material. Reports in 4-6 weeks. NPI. Pays on publication. Rights negotiable. Simultaneous submissions and previously published work OK.

***PROGRESSIVE ARCHITECTURE**, Dept. PM, 600 Summer St., P.O. Box 1361, Stamford CT 06904. (203)348-7531. Fax: (203)348-4023. Editor: John Morris Dixon. Art Director: Julie Yee. Monthly magazine. Emphasizes current information on building design and technology for professional architects. Circ. 75,000.
 ● In 1994 *Progressive Architecture* won Jesse Neal Awards for Editorial Excellence and Ozzie Awards for Publication Design Excellence.
Needs: Photos purchased with or without accompanying ms and on assignment; 90% assigned. Architectural and interior design. Captions preferred. Accompanying mss: interesting architectural or engineering developments/projects.
Making Contact & Terms: Interested in receiving work from newer, lesser-known photographers. Send material by mail for consideration. Uses 8 × 10 b&w glossy prints; 4 × 5 transparencies. Vertical format preferred for cover. SASE. Reports in 1 month. Pays $500/1-day assignment, $1,000/2-day assignment; $250/half-day assignment or on a per-photo basis. Pays $25 minimum/b&w photo; $50/ color photo; $50/color cover photo. NPI for ms.; varies. Pays on publication. Credit line given. Buys one-time rights.
Tips: In samples, wants to see "straightforward architectural presentation. Send us regular updates (cards/samples) of new work, brief listing of future travel to coordinate with possible commissions on projects in those locations."

QUICK FROZEN FOODS INTERNATIONAL, 2125 Center Ave., Suite 305, Fort Lee NJ 07024-5898. (201)592-7007. Fax: (201)592-7171. Editor: John M. Saulnier. Circ. 13,000. Quarterly magazine. Emphasizes retailing, marketing, processing, packaging and distribution of frozen foods around the world. Readers are international executives involved in the frozen food industry: manufacturers, distributors, retailers, brokers, importers/exporters, warehousemen, etc. Review copy $8.
Needs: Buys 20-30 photos/year. Plant exterior shots, step-by-step in-plant processing shots, photos of retail store frozen food cases, head shots of industry executives, product shots, etc. Captions required.
Making Contact & Terms: Query first with résumé of credits. Uses 5 × 7 glossy b&w and color prints. SASE. Reports in 1 month. NPI. Pays on publication. Buys all rights, but may reassign to photographer after publication.
Tips: A file of photographers' names is maintained; if an assignment comes up in an area close to a particular photographer, he may be contacted. "When submitting names, inform us if you are capable of writing a story, if needed."

THE RANGEFINDER, 1312 Lincoln Blvd., Santa Monica CA 90401. (310)451-8506. Fax: (310)395-9058. Editor: Arthur Stern. Circ. 50,000. Estab. 1952. Monthly magazine. Emphasizes topics, developments and products of interest to the professional photographer. Readers are professionals in all phases of photography. Sample copy free with 11 × 14 SAE and 2 first-class stamps. Photo guidelines free with SASE.
Needs: Uses 20-30 photos/issue; 70% supplied by freelancers. Needs all kinds of photos; almost always run in conjunction with articles. "We prefer photos accompanying 'how-to' or special interest stories from the photographer." No pictorials. Special needs include seasonal cover shots (vertical

format only). Model release required. Property release preferred. Captions preferred.
Making Contact & Terms: Interested in receiving work from newer, lesser-known photographers.
Query with résumé of credits. Keeps samples on file. SASE. Reports in 1 month. Pays $60 minimum/
printed editorial page with illustrations. Covers submitted gratis. Pays on publication. Credit line given.
Buys first North American serial rights; negotiable. Previously published work occasionally OK; give
details.

RECOMMEND WORLDWIDE, Dept. PM, 5979 NW 151st St., Suite 120, Miami Lake FL 33014.
(305)828-0123. Art Director: Janet Rosemellia. Managing Editor: Rick Shively. Circ. 55,000. Estab.
1985. Monthly. Emphasizes travel. Readers are travel agents, meeting planners, hoteliers, ad agencies.
Sample copy free with 8½×11 SAE and 10 first-class stamps.
Needs: Uses about 40 photos/issue; 70% supplied by freelance photographers. "Our publication
divides the world up into seven regions. Every month we use travel destination-oriented photos of
animals, cities, resorts and cruise lines. Features all types of travel photography from all over the
world." Model/property release required. Captions preferred; identification required.
Making Contact & Terms: Interested in receiving work from newer, lesser-known photographers.
"We prefer a résumé, stock list and sample card or tearsheets with photo review later." SASE. Pays
$150/color cover photo; up to 20 square inches: $25; 21-35 square inches $35; 36-80 square inches
$50; over 80 square inches $75; supplement cover: $75; front cover less than 80 square inches $50.
Pays 30 days upon publication. Credit line given. Buys one-time rights. Simultaneous submissions and
previously published work OK.
Tips: Prefers to see "transparencies—either 2¼×2¼ or 35mm first quality originals, travel oriented."

REFEREE, P.O. Box 161, Franksville WI 53126. (414)632-8855. Fax: (414)632-5460. Editor: Tom
Hammill. Circ. 35,000. Estab. 1976. Monthly magazine. Readers are mostly male, ages 30-50. Sample
copy free with 9×12 SAE and 5 first-class stamps. Photo guidelines free with SASE.
Needs: Uses up to 50 photos/issue; 75% supplied by freelancers. Needs action officiating shots—all
sports. Photo needs are ongoing. Captions preferred.
Making Contact & Terms: Send unsolicited photos by mail for consideration. Any format is ac-
cepted. Reports in 2 weeks. Pays $100/color cover photo; $75/b&w cover photo; $35/color inside
photo; $20/b&w inside photo. Pays on publication. Credit line given. Rights purchased negotiable.
Simultaneous submissions and previously published work OK.
Tips: Prefers photos which bring out the uniqueness of being a sports official. Need photos primarily
of officials at high school level in baseball, football, basketball, soccer and softball in action. Other
sports acceptable, but used less frequently. "When at sporting events, take a few shots with the officials
in mind, even though you may be on assignment for another reason. Don't be afraid to give it a try.
We're receptive, always looking for new freelance contributors. We are constantly looking for offbeat
pictures of officials/umpires. Our needs in this area have increased."

REGISTERED REPRESENTATIVE, 18818 Teller Ave., Suite 280, Irvine CA 92715. (714)851-2220. Art
Director: Chuck LaBresh. Circ. 80,000. Estab. 1976. Monthly magazine. Emphasizes stock brokerage
industry. Magazine is "requested and read by 90% of the nation's stock brokers." Sample copy for
$2.50.
Needs: Uses about 8 photos/issue; 5 supplied by freelancers. Needs environmental portraits of finan-
cial and brokerage personalities, and conceptual shots of financial ideas, all by assignment only. Model/
property release preferred. Captions required.
Making Contact & Terms: Interested in receiving work from newer, lesser-known photographers.
Provide brochure, flier or tearsheets to be kept on file for possible future assignments. Cannot return
material. Pays $250-600/b&w or color cover photo; $100-250/b&w or color inside photo. Pays 30 days
after publication. Credit line given. Buys one-time rights. Simultaneous submissions and previously
published work OK.
Tips: "I usually give photographers free reign in styling, lighting, camera lenses, whatever. I want
something that is unusual enough to provide interest but not so strange that the subject can't be
identified."

REMODELING, 1 Thomas Circle NW, Suite 600, Washington DC 20005. (202)737-0717. Managing
Editor: Cheryl Weber. Circ. 95,000. Published 12 times/year. "Business magazine for remodeling
contractors." Readers are "small contractors involved in residental and commercial remodeling."
Sample copy free with 8×11 SASE.
Needs: Uses 10-15 photos/issue; number supplied by freelancers varies. Needs photos of remodeled
residences, both before and after. Reviews photos with "short description of project, including archi-
tect's or contractor's name and phone number. We have three regular photo features: *Double Take* is
photo caption piece about an architectural photo that fools the eye. *Snapshots* is a photo caption
showing architectural details. *Before and After* describes a whole-house remodel."

Making Contact & Terms: Interested in receiving work from newer, lesser-known photographers. Provide résumé, business card, brochure, flier or tearsheets to be kept on file for possible future assignments. Reports in 1 month. Pays $100/color cover photo; $25/b&w inside photo; $50/color inside photo; $300 maximum/job. **Pays on acceptance.** Credit line given. Buys one-time rights.

Tips: Wants "interior and exterior photos of residences that emphasize the architecture over the furnishings."

RESCUE MAGAZINE, Dept. PM, Jems Communications, P.O. Box 2789, Carlsbad CA 92018. Fax: (619)431-8176. Director of Design and Production: Harriet Wilcox. Circ. 25,000. Estab. 1988. Bimonthly. Emphasizes techniques, equipment, action stories with unique rescues; paramedics, EMTs, rescue divers, fire fighters, etc. Rescue personnel are most of our readers. Sample copy free with 9×12 SAE and 7 first-class stamps. Photo guidelines free with SASE.

● *Rescue* is currently being tested on the newsstand.

Needs: Uses 20-25 photos/issue; 5-10 supplied by freelance photographers. Needs rescue scenes, transport, injured victims, equipment and personnel, training, earthquake rescue operations. Special photo needs include strong color shots showing newsworthy rescue operations, including a unique or difficult rescue/extrication, treatment, transport, personnel, etc. b&w showing same. Model release preferred. Captions required.

Making Contact & Terms: Interested in receiving work from newer, lesser-known photographers. Query with samples. Send 5×7 or larger glossy b&w or color prints or b&w or color contacts sheets by mail for consideration. Slide/transparencies preferred format. Don't send originals. SASE. Pays $150-200/color cover photo; $75/b&w inside photo; $125/color inside photo; $10-95/hour; $80-795/day. Pays on publication. Credit line given. Buys one-time rights. Previously published work OK (must be labeled as such).

Tips: "Ride along with a rescue crew or team. This can be firefighters, paramedics, mountain rescue teams, dive rescue teams, and so on. Get in close." Looks for "photographs that show rescuers in action, using proper techniques and wearing the proper equipment. Submit timely photographs that show the technical aspects of rescue."

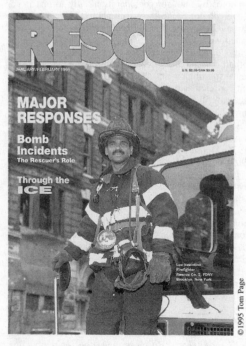

In order to gain perspective on the jobs of emergency medical technicians, Vista, California, photographer Tom Page participated in EMT training in the late 1970s. Since then he has maintained a strong working relationship with Rescue magazine, shooting cover portraits like this one. This assignment, which included a photo essay, earned him $1,200.

RESOURCE RECYCLING, P.O. Box 10540, Portland OR 97210. (503)227-1319. Editor: Meg Lynch. Circ. 16,000. Estab. 1982. Monthly. Emphasizes "the recycling of post-consumer waste materials (paper, metals, glass, plastics etc.) and composting." Readers are "recycling company managers, local government officials, waste haulers and environmental group executives." Sample copy free with 11 first-class stamps plus 9×12 SASE.

Needs: Uses about 5-15 photos/issue; 1 supplied by freelancers. Needs "photos of recycling facilities, curbside recycling collection, secondary materials (bundles of newspapers, soft drink containers), etc." Model release preferred. Captions required.

Making Contact & Terms: Send glossy color prints and contact sheet. SASE. Reports in 1 month. NPI; payment "varies by experience and photo quality." Pays on publication. Credit line given. Buys first North American serial rights. Simultaneous submissions OK.

Tips: "Because *Resource Recycling* is a trade journal for the recycling and composting industry, we are looking only for photos that relate to recycling and composting issues."

***RESTAURANT HOSPITALITY**, 1100 Superior Ave., Cleveland OH 44114. (216)696-7000. Fax: (216)696-0836. E-mail: rheditors@aol.com. Editor-in-Chief: Michael DeLuca. Art Director: Christopher Roberto. Circ. 100,000. Estab. 1919. Monthly. Emphasizes "hands-on restaurant management ideas and strategies." Readers are "restaurant owners, chefs, foodservice chain executives."
 • *Restaurant Hospitality* won the Ozzie Award for best design (circulation over 50,000) in 1993 and 1994 and the *Folio* Editorial Excellence Award for best written/edited magazine in foodservice, 1994.

Needs: Uses about 30 photos/issue; 50% supplied by freelancers. Needs "people with food, restaurant and foodservice interiors and occasional food photos." Special needs include "subject-related photos; query first." Model release preferred. Captions preferred.

Making Contact & Terms: Send résumé of credits or samples, or list of stock photo subjects. Provide résumé, business card, brochure, flier or tearsheets to be kept on file for possible future assignments. Pays $50-275/b&w or color photo; $350/half day; $150-450/job includes normal expenses. **Pays on acceptance.** Credit line given. Buys one-time rights plus reprint rights in all media. Previously published work OK "if exclusive to foodservice press."

Tips: "Let us know you exist. We can't assign a story if we don't know you. Send résumé, business card, samples, etc. along with introductory letter to Art Director Christopher Roberto."

***RISTORANTE MAGAZINE**, P.O. Box 73, Liberty Corner NJ 07938. (908)766-6006. Fax: (908)766-6607. Art Director: Erica Lynn DeWitte. Circ. 50,000. Estab. 1994. Quarterly magazine. *Ristorante*, the magazine for the Italian connoisseur and Italian restaurants with liquor licenses; appears on newstands.

Needs: Number of photos/issue varies. Number supplied by freelancers varies. "Think Italian!" Reviews photos with or without ms. Model/property release required. Captions preferred.

Making Contact & Terms: Interested in receiving work from newer, lesser-known photographers. Provide résumé, business card, brochure, flier or tearsheets to be kept on file for possible assignments. SASE. NPI. Pays on publication. Credit line given. Buys all rights; negotiable. Previously published work OK.

ROOFER MAGAZINE, 12734 Kenwood Lane, Bldg. 73, Ft. Myers FL 33907. (813)489-2929. Fax: (813)489-1747. Associate Publisher: Angela M. Williamson. Art Director: Alex Whitehair. Circ. 19,000. Estab. 1981. Monthly. Emphasizes the roofing industry and all facets of the roofing business. Readers are roofing contractors, manufacturers, architects, specifiers, consultants and distributors. Sample copy free with 9×12 SAE and 7 first-class stamps.

Needs: Uses about 25 photos/issue; few are supplied by freelancers. 20% of photos from assignment; 40-50% from stock. Needs photos of unusual roofs or those with a humorous slant (once published a photo with a cow stranded on a roof during a flood). Needs several photos of a particular city or country to use in photo essay section. Also, photographs of buildings after major disasters, showing the destruction to the roof, are especially needed. "Please indicate to us the location, time and date taken, and cause of destruction (i.e., fire, flood, hurricane)." Model release required. Captions required; include details about date, location and description of scene.

Making Contact & Terms: Interested in receiving work from newer, lesser-known photographers. Query with samples. Provide résumé, brochure and tearsheets to be kept on file for possible future assignments. Cannot return material. Reports in 1 month. Pays $25 maximum/b&w photo; $50 maximum/color photo; $125 maximum/page for photo essays. Pays on publication. Usually buys one-time rights, "exclusive to our industry."

Tips: "Good lighting is a must. Clear skies, beautiful landscaping around the home or building featured add to the picture. Looking for anything unique, in either the angle of the shot or the type of roof. Humorous photos are given special consideration and should be accompanied by clever captions or a

A bullet has been placed within some listings to introduce special comments by the editor of Photographer's Market.

brief, humorous description. No photos of reroofing jobs on your home will be accepted. Most of the photos we publish in each issue are contributed by our authors. Freelance photographers should submit material that would be useful for our photographic essays, depicting particular cities or countries. We've given assignments to freelance photographers before, but most submissions are the ideas of the freelancer."

SATELLITE COMMUNICATIONS, 6300 S. Syracuse Way, Suite 650, Englewood CO 80111. (303)220-0600. Editorial Director: Bob Chapin. Circ. 18,000. Monthly. Covers the international satellite communications industries. Readers are all professionals involved with business satellite communications. Sample copy free with SASE. Focus calendar available.
• Published by Argus Business, this magazine thrives on cutting edge material and editors are interested in computer manipulated work. Argus Business also publishes *Communications, Cellular Marketing* and *Voz Y Datos*.
Needs: Uses 15-20 photos/issue; 1-5 supplied by freelance photographers. Wants to see dramatic shots of high-tech satellite images, from terrestrial equipment, such as dishes, to orbiting space segment images.
Making Contact & Terms: Query with list of stock photo subjects; provide résumé, business card, brochure, flier or tearsheets to be kept on file for possible future assignments. Does not return unsolicited material. Reports in 3 weeks. Pays $300-500/color cover photo. Pays on publication. Credit line given. Buys one-time rights. Previously published work OK.

***THE SCHOOL ADMINISTRATOR**, 1801 N. Moore St., Arlington VA 22209. (703)875-0753. Fax: (703)528-2146. Managing Editor: Liz Griffin. Circ. 16,500. Publication of American Association of School Administrators. Monthly magazine. Emphasizes K-12 education. Readers are school administrators including superintendents and principals, ages 50-60, largely male though this is changing. Sample copy $7.
Needs: Uses 23 photos/issue. Needs classroom photos, photos of school principals and superintendents and school board members interacting with parents and students. Model/property release preferred for physically handicapped students. Captions required; include name of school, city, state, grade level of students and general description of classroom activity.
Making Contact & Terms: Interested in receiving work from newer, lesser-known photographers. Send unsolicited photos by mail for consideration (photocopy of b&w prints). Provide résumé, business card, brochure, flier or tearsheets to be kept on file for possible assignments. Photocopy of prints should include contact information including fax number. "Send a SASE for our editorial calendar. In cover letter include mention of other clients. Familiarize yourself with topical nature and format of magazine before submitting prints." Send 5×7, 8×10 matte or glossy color b&w prints; 35mm, 2¼×2¼, 4×5, 8×10 transparencies. Work assigned is 3-4 months prior to publication date. Keeps samples on file. SASE. Reports in 3 weeks. Pays $300 (maximum)/color cover photo. $50-75/color inside photo; $50-75/b&w inside photo. Credit line given. Buys one-time rights. Simultaneous submissions and previously published work OK.
Tips: "Prefer photos with interesting, animated faces and hand gestures. Always looking for unusual human connection where the photographer's presence has not made subjects stilted."

SECURITY DEALER, Dept. PM, 445 Broad Hollow Rd., Suite 21, Melville NY 11747. (516)845-2700. Fax: (516)845-7109. Editor: Susan Brady. Circ. 28,000. Estab. 1967. Monthly magazines. Emphasizes security subjects. Readers are blue collar businessmen installing alarm, security, CCTV and access control systems. Sample copy free with SASE.
Needs: Uses 2-5 photos/issue; none at present supplied by freelance photographers. Needs photos of security-application-equipment. Model release preferred. Captions required.
Making Contact & Terms: Interested in receiving work from newer, lesser-known photographers. Send b&w and color prints by mail for consideration. SASE. Reports "immediately." Pays $25-50/b&w photo; $200/color cover photo; $50-100/inside color photos. Pays 30 days after publication. Credit line given. Buys one-time rights in security trade industry. Simultaneous submissions and/or previously published work OK.
Tips: "Do not send originals, dupes only, and only after discussion with editor."

SHEEP! MAGAZINE, Dept. PM, W. 2997 Market Rd., Helenville WI 53137. (414)593-8385. Fax: (414)593-8384. Editor: Dave Thompson. Circ. 13,000. Estab. 1982. Monthly tabloid. Emphasizes sheep and wool. Readers are sheep and wool producers across the US and Canada. Sample copy $2. Photo guidelines available.
Needs: Uses 30 photos/issue; 50% supplied by freelancers. Needs photos of sheep, lambs, sheep producers, wool, etc. Model release preferred. Captions preferred.
Making Contact & Terms: Send unsolicited photos by mail for consideration. Provide résumé, business card, brochure, flier or tearsheets to be kept on file for possible assignments. Uses b&w and color prints; 35mm transparencies. SASE. Reports in 3 weeks. Pays up to $200/color cover photo;

$100-150/b&w cover photo; $50-100/color inside photo; $25/b&w inside photo. Credit line given. Buys one-time and all rights; negotiable. Previously published work OK.

SHELTER SENSE, Humane Society of the US, 2100 L St. NW, Washington DC 20037. (202)452-1100. Fax: (301)258-3081. Editor: Geoffrey Handy. Circ. 3,500. Estab. 1978. Monthly newsletter. Emphasizes animal protection. Readers are animal control and shelter workers, men and women, all ages. Sample copy free with 9 × 12 SAE and 2 first-class stamps.
Needs: Uses 15 photos/issue; 50% supplied by freelance photographers. Needs photos of domestic animals interacting with people/humane workers; animals during the seasons; animal care, obedience; humane society work and functions, other companion animal shots. "We do not pay for manuscripts." Model release required for cover photos only. Captions preferred.
Making Contact & Terms: Interested in receiving work from newer, lesser-known photographers. Provide résumé, business card, brochure, flier or tearsheets to be kept on file for possible assignments. SASE. Reports in 3 weeks. Pays $45/b&w cover photo; $35/b&w inside photo. **Pays on acceptance.** Credit line given. Buys one-time rights.
Tips: "We almost always need good photos of people working with animals in an animal shelter, in the field, or in the home. We do not use photos of individual dogs, cats and other companion animals as much as we use photos of people working to protect, rescue or care for dogs, cats and other companion animals."

***SIDEKICKS INTERNATIONAL MAGAZINE**, 19 W. 21st, Suite 1101, New York NY 10010. (212)647-9301. Fax: (212)647-9308. Editor: Steven Saltzman. Circ. 100,000. Estab. 1993. Publication of Sidekicks International Inc. Bimonthly magazine. Emphasizes soccer. Readers are male and female, ages 16-35. Sample copy $2.95.
Needs: Uses 50 photos/issue; 20 supplied by freelancers. Needs photos of soccer. Captions preferred.
Making Contact & Terms: Interested in receiving work from newer, lesser-known photographers. Query with stock photo list. Keeps samples on file. SASE. Reports in 2 weeks. NPI; pays by photo size. Pays on publication. Credit line given. Buys all rights.

SIGNCRAFT MAGAZINE, P.O. Box 60031, Fort Myers FL 33906. (813)939-4644. Editor: Tom McIltrot. Circ. 21,000. Estab. 1980. Bimonthly magazine. Readers are sign artists and sign shop personnel. Sample copy $5. Photo guidelines free with SASE.
Needs: Uses over 100 photos/issue; few at present supplied by freelancers. Needs photos of well-designed, effective signs. Captions preferred.
Making Contact & Terms: Query with samples. Send b&w or color prints; 35mm, 2¼ × 2¼ transparencies; b&w, color contact sheet by mail for consideration. SASE. Reports in 1 month. NPI. Pays on publication. Credit line given. Buys first North American serial rights. Previously published work possibly OK.
Tips: "If you have some background or past experience with sign making, you may be able to provide photos for us."

SOCIAL POLICY, 25 W. 43rd St., Room 620, New York NY 10036. (212)642-2929. Managing Editor: Audrey Gartner. Circ. 3,500. Estab. 1970. Quarterly. Emphasizes "social policy issues—how government and societal actions affect people's lives." Readers are academics, policymakers, lay readers. Sample copy $2.50.
Needs: Uses about 9 photos/issue; all supplied by freelance photographers. Needs photos of social consciousness and sensitivity. Model release preferred.
Making Contact & Terms: Arrange a personal interview to show portfolio. Query with samples. Provide résumé, business card, brochure, flier or tearsheets to be kept on file for possible future assignments. Reports in 2 weeks. Pays $100/b&w cover photo; $30/b&w inside photo. Pays on publication. Credit line given. Buys one-time rights. Simultaneous submissions and previously published work OK.
Tips: "Be familiar with social issues. We're always looking for relevant photos."

SOUTHERN LUMBERMAN, 128 Holiday Ct., Suite 116, P.O. Box 681629, Franklin TN 37068-1629. (615)791-1961. Fax: (615)790-6188. Managing Editor: Nanci Gregg. Circ. 12,000. Estab. 1881. Monthly. Emphasizes forest products industry—sawmills, pallet operations, logging trades. Readers are predominantly owners/operators of midsized sawmill operations nationwide. Sample copy $2 with 9 × 12 SAE and 5 first-class stamps. Photo guidelines free with SASE.
● This publication has begun to digitally store and manipulate images for advertising purposes.
Needs: Uses about 3-4 photos/issue; 25% supplied by freelancers. "We need b&ws of 'general interest' in the lumber industry. We need photographers from across the country to do an inexpensive b&w shoot in conjunction with a phone interview. We need 'human interest' shots from a sawmill scene—just basic 'folks' shots—a worker sharing lunch with the company dog, sawdust flying as a

new piece of equipment is started; face masks as a mill tries to meet OSHA standards, etc." Looking for photo/text packages. Model release required. Captions required.

Making Contact & Terms: Interested in receiving work from newer, lesser-known photographers. Query with samples. Send 5×7 or 8×10 glossy b&w prints; 35mm, 4×5 transparencies, b&w contact sheets or negatives by mail for consideration. SASE. Reports in 6 weeks. Pays minimum $20-35/b&w photos; $25-50/color photo; $100-150/photo/text package. Pays on publication. Credit line given. Buys first North American serial rights.

Tips: Prefers b&w capture of close-ups in sawmill, pallet, logging scenes. "Try to provide what the editor wants—call and make sure you know what that is, if you're not sure. Don't send things that the editor hasn't asked for. We're all looking for someone who has the imagination/creativity to provide what we need. I'm not interested in 'works of art'—I want and need b&w feature photos capturing essence of employees working at sawmills nationwide. I've never had someone submit anything close to what I state we need—try that. *Read* the description, shoot the pictures, send a contact sheet or a couple 5×7's."

SOUTHERN PLUMBING, HEATING AND COOLING MAGAZINE, Box 18343, Greensboro NC 27419. Phone/fax: (910)454-3516. Managing Editor: Day Atkins. Circ. 9,000. Estab. 1946. Bimonthly magazine. Emphasizes plumbing, heating and cooling news, events and industry trends. Readers are male and female heads of companies (in plumbing, heating and cooling industry) ages 35-65. Sample copies free with 9×12 SASE and 5 first-class stamps.

Needs: Uses 20 photos/issue. Interested in photos of technology, business, industrial, how-to. Model/property release preferred. Captions preferred.

Making Contact & Terms: Interested in receiving work from newer, lesser-known photographers. Send 5×7, 8×10 glossy color or b&w prints. Deadlines: 15th of the month prior to publication. Keeps samples on file. SASE. Reports in 1-2 weeks. **Pays on acceptance.** Credit line given. Buys one-time rights. Simultaneous submissions and/or previously published work OK.

Tips: "We don't need mug shots, people shaking hands or group photos of people standing in front of something. We want vitality and strong visual interest. We are open to new directions and we will work with you on what you want to accomplish."

SPEEDWAY SCENE, P.O. Box 300, North Easton MA 02356. (508)238-7016. Editor: Val LeSieur. Circ. 70,000. Estab. 1970. Weekly tabloid. Emphasizes auto racing. Sample copy free with 8½×11 SAE and 4 first-class stamps.

Needs: Uses 200 photos/issue; all supplied by freelancers. Needs photos of oval track auto racing. Reviews photos with or without ms. Captions required.

Making Contact & Terms: Send unsolicited photos by mail for consideration. Send b&w, color prints. Reports in 1-2 weeks. NPI. Credit line given. Buys all rights. Simultaneous submissions and/or previously published work OK.

STEP-BY-STEP GRAPHICS, 6000 N. Forest Park Dr., Peoria IL 61614-3592. (309)688-2300. Fax: (309)688-8515. Managing Editor: Catharine Fishel. Circ. 45,000. Estab. 1985. Bimonthly. How-to magazine for traditional and electronic graphics. Readers are graphic designers, illustrators, art directors, studio owners, photographers. Sample copy $7.50.

Needs: Uses 130 photos/issue; all supplied by freelancers. Needs how-to ("usually tight") shots taken in artists' workplaces. Assignment only. Model release required. Captions required.

Making Contact & Terms: Query with samples. Provide résumé, business card, brochure, flier or tearsheets to be kept on file for possible future assignments. SASE. Reports in 1 month. NPI; pays by the job on a case-by-case basis. **Pays on acceptance.** Credit line given. Buys one-time rights or first North American serial rights.

Tips: In photographer's samples looks for "color and lighting accuracy particularly for interiors." Most shots are tight and most show the subject's hands. Recommend letter of inquiry plus samples.

SUCCESSFUL MEETINGS, 355 Park Ave. S., New York NY 10010. (212)592-6401. Fax: (212)592-6409. Art Director: Don Salkaln. Monthly. Circ. 75,000. Estab. 1955. Monthly. Emphasizes business group travel for all sorts of meetings. Readers are business and association executives who plan meetings, exhibits, conventions and incentive travel. Sample copy $10.

Needs: Special needs include *good*, high-quality corporate portraits, conceptual, out-of-state shoots (occasionally).

Making Contact & Terms: Arrange a personal interview to show portfolio. Query with résumé of credits and list of stock photo subjects. SASE. Reports in 2 weeks. Pays $500-750/color cover photo; $50-150/inside b&w photo; $75-200/inside color photo; $150-250/b&w page; $200-300/color page; $200-600/text/photo package; $50-100/hour; $175-350/½ day. **Pays on acceptance.** Credit line given. Buys one-time rights. Simultaneous submissions and previously published work OK "only if you let us know."

TEACHING TOLERANCE MAGAZINE, 400 Washington Ave., Montgomery AL 36104. Creative Director: Paul Forrest Newman. Circ. 300,000. Estab. 1992. National education magazine published by Southern Poverty Law Center. Quarterly. Emphasizes teaching racial/cultural tolerance. Readers are male/female teachers and educators, adult.
Needs: Uses approximately 36 photos/issue; all supplied by freelancers on assignment.
Making Contact & Terms: Story photographers only. Send tearsheets of previously published story photography. No stock photos. No items returned. Absolutely no phone calls. Keeps samples on file. Pays $600-1,000/day; $600-1,000/job; $100-300/color inside photo. Rates depend on usage/negotiation. **Pays on acceptance.** Credit line given. Buys one-time rights, all rights; negotiable. Simultaneous submissions and/or previously published work OK.

TOBACCO INTERNATIONAL, 130 W. 42 St., Suite 2200, New York NY 10036. (212)391-2060. Fax: (212)827-0945. Editor: Frank Bocchino. Circ. 5,000. Estab. 1886. Monthly international business magazine. Emphasizes cigarettes, tobacco products, tobacco machinery, supplies and services. Readers are executives, ages 35-60. Sample copy free with SASE.
Needs: Uses 20 photos/issue. "Prefer photos of people smoking, processing or growing tobacco products from all around the world, but any interesting news-worthy photos relevant to subject matter is considered." Model and/or property release preferred.
Making Contact & Terms: Query with photocopy of photos. Send unsolicited color positives, slides or prints by mail for consideration. Does not keep samples on file. Reports in 3 weeks. Pays $50/color photo. Pays on publication. Credit line may be given. Simultaneous submissions OK (not if competing journal).

TOP PRODUCER, Farm Journal Publishing, Inc., 230 W. Washington Square, Philadelphia PA 19105. (215)829-4865. Photo Editor: Tom Dodge. Circ. 250,000. Monthly. Emphasizes American agriculture. Readers are active farmers, ranchers or agribusiness people. Sample copy and photo guidelines free with SASE.
Needs: Uses 20-30 photos/issue; 75% supplied by freelance photographers. "We use studio-type portraiture (environmental portraits), technical, details and scenics." Model release preferred. Captions required.
Making Contact & Terms: Arrange a personal interview to show portfolio. Query with résumé of credits along with business card, brochure, flier or tearsheets to be kept on file for possible assignments. SASE. Reports in 2 weeks. NPI. "We pay a cover bonus." **Pays on acceptance.** Credit line given. Buys one-time rights. Simultaneous submissions and previously published work OK.
Tips: In portfolio or samples, likes to "see about 20 slides showing photographer's use of lighting and photographer's ability to work with people. Know your intended market. Familiarize yourself with the magazine and keep abreast of how photos are used in the general magazine field."

TRUCK SALES & LEASING, P.O. Box W, Newport Beach CA 92658-8910. (714)261-1636. Managing Editor: Deborah Whistler. Circ. 15,000. Bimonthly magazine. Emphasizes trucking. Readers are mostly male truck dealers and salesmen, ages 30-65. Photo guidelines free with SASE.
Needs: Uses 30 photos/issue; 30-100% supplied by freelancers. Needs photos of truck dealerships, truck salesmen with customers, scenics (trucks on highways), how-to (maintenance snapshots). Model release is "photographer's responsibility." Captions preferred.
Making Contact & Terms: Query with résumé of credits. Send unsolicited photos by mail for consideration. Send 35mm transparencies. SASE. Pays $200/color cover photo; $100/color or b&w inside photo. Pays on publication; sends check when material is used. Buys one-time rights.

TRUCKERS NEWS, P.O. Box W, Newport Beach CA 92658-8910. (714)261-1636. Managing Editor: Deborah Whistler. Circ. 200,000. Monthly magazine. Emphasizes trucking. Readers are over-the-road truck drivers, male and female, ages 30-65. Photo guidelines free with SASE.
Needs: Uses 40 photos/issue; 50-100% supplied by freelancers. Needs photos of scenics (trucks on highways), drivers at work. Model release is "photographer's responsibility." Captions preferred.
Making Contact & Terms: Query with résumé of credits. Send unsolicited photos by mail for consideration. Send 35mm transparencies. SASE. Pays $200/color cover photo; $100/color or b&w inside photo. Pays on publication. Sends check when material is used. Buys one-time rights.

TRUCKSTOP WORLD, P.O. Box W, Newport Beach CA 92658-8910. (714)261-1636. Managing Editor: Deborah Whistler. Circ. 12,000. Quarterly magazine. Emphasizes trucking. Readers are truck-stop managers, mostly male, ages 30-65. Photo guidelines free with SASE.
Needs: Uses 10 photos/issue; 30-100% supplied by freelancers. Needs photos of truckstops. Model release is "photographer's responsibility." Captions preferred.
Making Contact & Terms: Query with résumé of credits. Send unsolicited photos by mail for consideration. Send 35mm transparencies. SASE. Pays $200/color cover photo; $100/color or b&w inside photo. Pays on publication. Sends check when material is used. Buys one-time rights.

TURF MAGAZINE, 50 Bay St., P.O. Box 391, St. Johnsbury VT 05819. (800)422-7147. Fax: (802)748-1866. Managing Editor: Bob Hookway. Circ. 61,000. Estab. 1988. Monthly magazine. Emphasizes Turf and the green industry. Readers are all turf grass professionals—landscapers, golf course superintendents, groundskeepers, lawn care service and others, as well as university researchers, etc. Sample copy free with SASE.
Needs: 75% of photos come from assigned work. Needs good cover photos that are turf-related: sports, professionals working on turf, landscapes, must have some green grass, our large format requires sharp focus. Model release preferred.
Making Contact & Terms: Interested in receiving work from newer, lesser-known photographers. Send unsolicited photos by mail for consideration. Provide résumé, business card, brochure, flier, or tearsheets to be kept on file for possible assignments. Send 35mm, 2¼ × 2¼ transparencies; "must be vertical format." SASE. Reports in 3 weeks. Pays $100-200/color cover photo; $225-275/photo/text package. Pays on publication. Credit line given. Buys one-time rights. Previously published work OK.
Tips: "We are always looking for shots of professionals at work—mowing grass, laying sod, using leaf blowers, etc. Subjects must have proper safety equipment."

UTILITY AND TELEPHONE FLEETS, P.O. Box 183, Cary IL 60013. (708)639-2200. Fax: (708)639-9542. Editor & Associate Publisher: Alan Richter. Circ. 18,000. Estab. 1987. Magazine published 8 times a year. Emphasizes equipment and vehicle management and maintenance. Readers are fleet managers, maintenance supervisors, generally 35 and older in age and primarily male. Sample copy free with SASE. No photo guidelines.
Needs: Uses 30 photos/issue; 3-4% usually supplied by a freelance writer with an article. Needs photos of vehicles and construction equipment. Special photo needs include alternate fuel vehicles and eye-grabbing colorful shots of utility vehicles in action as well as utility construction equipment. Model release preferred. Captions required; include person's name, company and action taking place.
Making Contact & Terms: Interested in receiving work from newer, lesser-known photographers. Provide résumé, business card, brochure, flier or tearsheets to be kept on file for possible assignments. SASE. Reports in 2 weeks. Pays $50/color cover photo; $10/b&w inside photo; $50-200/photo/text package ($50/published page). Pays on publication. Credit line given. Buys one-time rights; negotiable.
Tips: "Be willing to work cheap and be able to write; the only photos we have paid for so far were part of an article/photo package." Looking for shots focused on our market with workers interacting with vehicles, equipment and machinery at the job site.

UTILITY CONSTRUCTION AND MAINTENANCE, P.O. Box 183, Cary IL 60013. (708)639-2200. Fax: (708)639-9542. Editor: Alan Richter. Circ. 25,000. Estab. 1990. Quarterly magazine. Emphasizes equipment and vehicle management and maintenance. Readers are fleet managers, maintenance supervisors, generally 35 and older in age and primarily male. Sample copy free with SASE. No photo guidelines.
Needs: Uses 80 photos/issue; 1-2% usually supplied by a freelance writer with an article. Needs photos of vehicles and construction equipment. Special photo needs include eye-grabbing colorful shots of utility construction equipment. Model release preferred. Captions required.
Making Contact & Terms: Provide résumé, business card, brochure, flier or tearsheets to be kept on file for possible assignments. SASE. Reports in 2 weeks. Pays $50/color cover photo; $10/b&w inside photo; $50-200/photo/text package ($50/published page). Pays on publication. Credit line given. Buys one-time rights.
Tips: "Be willing to work cheap and be able to write as the only photos we have paid for so far were part of an article/photo package."

VEHICLE LEASING TODAY, 800 Airport Blvd., Suite 506, San Francisco CA 94128. Fax: (415)548-9155. Art Director: Deborah Dembek. Circ. 4,000. Estab. 1979. Publication of National Vehicle Leasing Association. Bimonthly magazine. Emphasizes leasing industry. Readers are leasing companies and their affiliates, financial institutions, dealers. Sample copy free with SASE.
Needs: Uses 3-5 photos/issue; 1-3 supplied by freelancers. Interested mostly in automotive photos, some conceptual, legislative, city views and local conferences. Captions preferred.
Making Contact & Terms: Interested in receiving work from newer, lesser-known photographers. Query with stock photo list. Keeps samples on file. SASE. Reports in 2 weeks. Pays $400/color cover

Can't find a listing? Check at the end of each market section for the " '95-'96 Changes" lists. These lists include any market listings from the '95 edition which were either not verified or deleted in this edition.

photo; $75/color inside photo. Pays on publication. Credit line given. Rights negotiable. Previously published work OK.

WATER CONDITIONING & PURIFICATION MAGAZINE, 2800 E. Ft. Lowell Rd., Tucson AZ 85716-1518. (602)323-6144. Fax: (602)323-7412. Editor: Michele Williams. Circ. 17,800. Estab. 1959. Monthly magazine. Emphasizes water treatment. Readers are water treatment professionals. Sample copy free with 9 × 12 SASE.
Needs: Uses 20-30 photos/issue; 60% supplied by freelancers. Most photos are used for cover illustrations. "Cover shots vary from water scenes to technology involving water treatment." Wants to see "mostly cover shots" in the coming year. Model/property release preferred. Captions preferred.
Making Contact & Terms: Interested in receiving work from newer, lesser-known photographers. Send unsolicited color prints or 35mm, 2¼ × 2¼, 4 × 5 or 8 × 10 transparencies by mail for consideration. Provide résumé, business card, brochure, flier or tearsheets to be kept on file for possible assignments. SASE. Reports as needed. Pays $150/color or b&w cover photo; $100/b&w inside photo. Pays on publication. Credit line given. Buys one-time rights.
Tips: "Looking for active water shots—cascading brooks, nature, technology."

WATER WELL JOURNAL, 6375 Riverside Dr., P.O. Box 9050, Dublin OH 43017-0950. (614)761-3222. Fax: (614)761-3446. Senior Editor: Gloria J. Swanson. Circ. 30,886. Estab. 1946. Monthly. Emphasizes construction of water wells, development of ground water resources and ground water cleanup. Readers are water well drilling contractors, manufacturers, suppliers and ground water scientists. Sample copy $3 (US); $6 (foreign).
Needs: Uses 1-3 freelance photos/issue plus cover photos. Needs photos of installations and how-to illustrations. Model release preferred. Captions required.
Making Contact & Terms: Interested in receiving work from newer, lesser-known photographers. Contact with résumé of credits; inquire about rates. "We'll contact." Pays $10-50/hour; $200/color cover photo; $50/b&w inside photo; "flat rate for assignment." Pays on publication. Credit line given "if requested." Buys all rights.

THE WHOLESALER, 1838 Techny Court, Northbrook IL 60062. (708)564-1127. Fax: (708)564-1264. Editor: John Schweizer. Circ. 29,600. Estab. 1946. Monthly news tabloid. Emphasizes wholesaling, distribution in the plumbing, heating, air conditioning, piping (inc. valves), fire protection industry. Readers are owners and managers of wholesale distribution businesses, also manufacturers and manufacturer representatives. Sample copy free with 11 × 15½ SAE and 5 first-class stamps.
Needs: Uses 1-5 photos/issue; 3 supplied by freelancers. Interested in field and action shots in the warehouse on the loading dock, at the job site. Model release required. Property release preferred. Captions preferred. "Just give us the facts."
Making Contact & Terms: Interested in receiving work from newer, lesser-known photographers. Query with stock photo list. Send unsolicited photos by mail for consideration. Send any size glossy print, color and b&w. SASE. Reports in 2 weeks. Pays on publication. Buys one-time rights. Simultaneous and/or previously published work OK.

WILSON LIBRARY BULLETIN, 950 University Ave., Bronx NY 10452. (718)588-8400. Fax: (718)681-1511. E-mail: graceann@wlb.hwwilson.com. Editor: Grace Anne A. DeCandido. Circ. 14,000. Estab. 1914. Monthly (except July and August) magazine. Emphasizes the issues and the practice of librarianship. For librarians and information professionals.
Needs: Buys 10-15 photos/year; 2-5 photos assigned. "We need cover images and art that can be used to highlight articles—from books and reading to people and computers."
Making Contact & Terms: Interested in receiving work from newer, lesser-known photographers. Send photos for consideration with SASE for return. Provide business card and brochure to be kept on file for possible future assignments. Send 5 × 7 or 8 × 10 glossy b&w prints, color slides or transparencies. Reports in 6 weeks. Pays $25-50/b&w photo; $50-100/color photo; $300-400/color cover or text/photo package. Pays on publication. Credit line given. Buys one-time rights; may also use images for illustration electronically on the World Wide Web.
Tips: "We look for eye-catching covers with all kinds of images: in the past year we've had photos of a silk-scarf detail, a single flower, and a batik cityscape window. Imagination and flair are paramount."

***WINES & VINES**, 1800 Lincoln Ave., San Rafael CA 94901. (415)453-9700. Contact: Philip E. Hiaring. Circ. 5,000. Estab. 1919. Monthly magazine. Emphasizes winemaking in the US for everyone concerned with the wine industry, including winemakers, wine merchants, suppliers, consumers, etc.
Needs: Wants color cover subjects on a regular basis.
Making Contact & Terms: Interested in receiving work from newer, lesser-known photographers. Query or send material by mail for consideration. Provide business card to be kept on file for possible future assignments. SASE. Reports in 3 months. Pays $10/b&w print; $50-100/color cover photo. Pays on publication. Credit line given. Buys one-time rights. Previously published work OK.

WINGS WEST, 7009 S. Potomac St., Englewood CO 80112-4029. (303)397-7600. Fax: (303)397-7619. Editor: Sparky J. Imeson. Bimonthly western-region magazine on aviation. Circ. 20,000. Estab. 1985. Published by Wisner Publishing Inc. Emphasizes aviation, travel. Readers are mid-life male, affluent, mobile. Sample copy free with SASE.
Needs: Uses both assignment and stock photos. Model release and photo captions required.
Making Contact & Terms: Provide résumé, business card, brochure, flier or tearsheets to be kept on file for possible assignments: contact by phone. SASE. Reports in 1 month. Pays $10-35/b&w; $35-75/color; $25-100/photo/text package. Pays on publication. Credit line given. Buys all rights; negotiable. Simultaneous submissions and previously published work OK.
Tips: Looks for "unusual destination pictures, general aviation oriented." Trend is "imaginative." Make shot pertinent to an active pilot readership. Query first. Don't send originals—color copies acceptable. Copy machine reprints OK for evaluation.

WISCONSIN ARCHITECT, 321 S. Hamilton St., Madison WI 53703. (608)257-8477. Managing Editor: Cheryl Seurinck. Circ. 3,700. Estab. 1931. Publication of American Institute of Architects Wisconsin. Bimonthly magazine. Emphasizes architecture. Readers are design/construction professionals.
Needs: Uses approximately 35 photos/issue. "Photos are almost exclusively supplied by architects who are submitting projects for publication. Of these approximately 65% are professional photographers hired by the architect."
Making Contact & Terms: "Contact us through architects." Keeps samples on file. SASE. Reports in 1-2 weeks when interested. Pays $50-100/color cover photo when photo is specifically requested. Pays on publication. Credit line given. Rights negotiable. Simultaneous submissions and/or previously published work OK.

WOODSHOP NEWS, 35 Pratt St., Essex CT 06426. (203)767-8227. Senior Editor: Thomas Clark. Circ. 100,000. Estab. 1986. Monthly tabloid. Emphasizes woodworking. Readers are male, ages 20-60, furniture makers, cabinetmakers, millworkers and hobbyist woodworkers. Sample copy and photo guidelines free with 11×13 SAE.
Needs: Uses 40 photos/issue; up to 10% supplied by freelancers. Needs photos of people working with wood. Model release required. Captions required.
Making Contact & Terms: Provide résumé, business card, brochure, flier or tearsheets to be kept on file for possible assignments. SASE. Reports in 1 month. Pays $250/color cover photo; $30/b&w inside photo. Pays on publication. Credit line given. Buys one-time rights.

WORLD FENCE NEWS, Dept. PM, 6301 Manchaca Rd., Suite M, Austin TX 78745. (800)231-0275. Fax: (512)445-3496. Managing Editor: Rick Henderson. Circ. 13,000. Estab. 1983. Monthly tabloid. Emphasizes fencing contractors and installers. Readers are mostly male fence company owners and employees, ages 30-60. Sample copy free with 10×12 SASE.
Needs: Uses 35 photos/issue; 20 supplied by freelancers. Needs photos of scenics, silhouettes, sunsets which include all types of fencing. Also, installation shots of fences of all types. "Cover images are a major area of need." Model/property release preferred mostly for people shots. Captions required; include location, date.
Making Contact & Terms: "If you have suitable subjects, call and describe." SASE. Reports in 3 weeks. Pays $100/color cover photo; $25/b&w inside photo. **Pays on acceptance.** Credit line given. Buys one-time rights. Previously published work OK.

Trade Publications/'95-'96 changes

The following markets appeared in the 1995 edition of *Photographer's Market*, but are not listed this year. The majority did not respond to our request to update their listings. If a reason was given for a market's exclusion it appears in parentheses below.

A/C Flyer
Alumi-News
Apartment News Publications
Athletic Management
Black Employment & Education
California Business
Cellular Marketing
Communications
Corporate Cashflow
Corporate Cleveland
Food Distribution Magazine
General Aviation News & Flyer
Ground Water Age

Group Magazine
Human Resources Professional
IGA Grocergram
Marine Business Journal (no longer soliciting freelancers)
Members Magazine (no longer published)
National Fisherman
Pacific Boating Almanac
PCI-Paint & Coatings Industry Magazine
Professional Photographer
Public Works Magazine

Quality Digest
Servistar's Successful Contractor
Shooter's Rag
Sunshine Artist (requested deletion)
Technical Analysis of Stocks & Commodities
Technology & Learning
Voz Y Datos
Wisconsin Restaurateur
Writer's Digest/Writer's Yearbook

Record Companies

Unless you have been stuck on a deserted island for the past ten years you have witnessed the CD explosion that has taken place in the music industry. The move away from traditional albums has not only changed the way music is packaged, but also affected the way it appears. Designers, for example, are using more photo and art collages to pump up the visual appeal of CDs and cassettes. Record producers want photos with odd angles and high-tech computer enhancements.

In many instances this signals a move meant to appeal to the Generation X crowd. As a photographer you have to adapt to this trend if you plan to market your work to the music industry. When working with record companies you will be asked to supply images for all kinds of uses. Assignments are made for album, cassette or CD covers, but frequently images are used in promotional pieces to sell the work of recording artists. As always, you should try to retain rights to images for future sales and the usage should help you establish a fair price during negotiations.

Building your portfolio

A good portfolio for record companies shows off your skills and style in an imaginative way, but especially illustrates your ability to solve creative problems facing art directors. Such problems may include coming up with fresh concepts for record art, working within the relatively limited visual format of the 5-inch compact disc liner sheet or assembling a complex shot on a limited budget. If you have not worked for a record company client, you still can study the needs of various companies in this section and shoot a series of self-assignments which clearly show your problem-solving abilities.

Shooters who go on to long-term, high-profile success often start working with smaller, independent music companies, or "indies." Larger companies typically rely on stables of photographers who are either on staff or work through art studios that deal with music companies. Because of this tendency, it can be difficult for newcomers to break in when these companies already have their pick of talented, reliable photographers. Start out slowly and develop a portfolio of outstanding images. Eventually the larger companies will become familiar with your work and they will seek you out when looking for images or handing out assignments.

Freelancers also must be alert when dealing with the independent market. Some newer companies have not learned the various aspects of professionalism and ethics in doing business, and, in a few cases, companies deliberately deceive freelancers in terms of payment and copyright. When trying to attract new clients in this field, query prospective companies and request copies of their various forms and contracts for photographers. Seeing the content of such material can tell you a great deal about how well organized and professional a company is. Also talk to people within the music industry to get a better understanding of the company with which you want to do business.

■**AFTERSCHOOL PUBLISHING COMPANY**, P.O. Box 14157, Detroit MI 48214. (313)571-0363. President: Herman Kelly. Estab. 1977. Handles all forms of music. Freelancers used for portraits, in-concert shots, studio shots and special effects for publicity, brochures, posters and print advertising. **Needs:** Buys 5-10 images annually. Offers 5-10 assignments annually. Examples of recent uses: "Garden of Garments," "Funk-A-Ma-Taz," and "Festival of Culture" (all album covers). Interested in animation, love. Reviews stock photos. Model/property release preferred. Captions preferred.

Audiovisual Needs: Uses videotape, prints, papers for reproductions. Subjects include: love, fun, comedy, life.
Specs: Uses prints, all sizes and finishes, and videotape, all sizes.
Making Contact & Terms: Interested in receiving work from newer, lesser-known photographers. Submit portfolio for review. Keeps samples on file. SASE. Reports in 1 month. Pays $5-500/b&w photo; $5-500/color photo; $5-500/hour; $5-500/day; payment negotiable. Credit line given. Buys one-time, exclusive product and all rights, negotiable.

‡ALPHABEAT, Box 12 01, D-97862 Wertheim/Main, Germany. Phone: 9342-841 55. Managing Director: Stephan Dehn. Handles disco, dance, pop, soft ballads, wave, synth-pop, electro-disco and funk. Photographers used for portraits, studio shots and special effects for album covers, publicity, brochures, posters and product advertising.
Specs: Uses color prints.
Making Contact & Terms: Send unsolicited photos by mail for consideration. Submit portfolio for review. Provide résumé, business card, brochure, flier or tearsheets to be kept on file for possible future assignments. Works with freelancers on assignment only. SAE, IRC. Reports in 2 weeks. NPI. Pays according to type of order. Credit line given. Buys all rights; negotiable.

APON RECORD COMPANY, INC., Steinway Station, P.O. Box 3082, Long Island NY 11103. (212)721-5599. President: Andre M. Poncic, Ph.D. Handles classical, folklore and international. Photographers used for portraits and studio shots for album covers and posters.
Needs: Offers 50 assignments/year.
Specs: Uses b&w prints and 4×5 transparencies.
Making Contact & Terms: Send photos by mail for consideration. Provide brochure and samples to be kept on file for possible future assignments. Cannot return material. Reports in 3 months. NPI; payment negotiable. Credit line given. Buys all rights.

ART ATTACK RECORDINGS/CARTE BLANCHE/MIGHTY FINE RECORDS, Dept. PM, Fort Lowell Station, P.O. Box 31475, Tucson AZ 85751. (602)881-1212. President: William Cashman. Handles rock, pop, country and jazz. Photographers used for portraits, in-concert shots, studio shots and special effects for album covers, inside album shots, publicity and brochures.
Needs: Offers 10-15 assignments/year.
Specs: "Depends on particular project."
Making Contact & Terms: Arrange a personal interview to show portfolio. Provide résumé, business card, brochure, flier or tearsheets to be kept on file for possible future assignments. Works with freelancers on assignment only. "We will contact only if interested." NPI; payment negotiable. Credit line given.
Tips: Prefers to see "a definite and original style—unusual photographic techniques, special effects" in a portfolio. "Send us samples to refer to that we may keep on file."

***AZRA INTERNATIONAL**, (formerly Azra Records), Dept. PM, 4343 E. 58 St., Maywood CA 90270. Phone/fax: (213)560-4223. President: David Richards. Estab. 1980. Handles rock, heavy metal, novelty and seasonal. Photographers used for special effects and "anything unique and unusual" for picture records and shaped picture records. Also needs photos for CD and album covers.
Needs: Model release required. Property release preferred. Captions preferred.
Specs: Uses 8×10 b&w or color glossy prints and 35mm transparencies.
Making Contact & Terms: Interested in receiving work from newer, lesser-known photographers. Query with résumé of credits or send "anything unique in photo effects" by mail for consideration. Works with freelancers on assignment only; "all work is freelance-assigned." SASE. Reports in 2 weeks. Pays $50-250/b&w photo; $50-1,000/color photo; payment "depends on use of photo, either outright pay or percentages." Credit line given. Buys one-time rights; negotiable.
Tips: Wants to see unique styles or photo angles. "Query first, in writing or by phone. We have a wide variety of projects going at all times."

B-ATLAS & JODY RECORDS INC., 2557 E. First St., Brooklyn NY 11223. (718)339-8047. Vice President A&R Department: Vincent Vallis. Public Relations: Cynthia Leavy. Handles rock, rap, pop, country. Freelancers used for portraits, in-concert shots and studio shots for cover/liner shots.

The solid, black square before a listing indicates that the market uses various types of audiovisual materials, such as slides, film or videotape.

Needs: Buys 10 images annually; 10 supplied by freelancers.
Making Contact & Terms: Interested in receiving work from newer, lesser-known photographers. Query with samples. SASE. Reports in 1-2 weeks. NPI; payment on assignment. Credit line given. Buys first rights; negotiable.
Tips: "Keep trying."

ROBERT BATOR & ASSOCIATES, Dept. PM, 170 Stafford Rd., Wales MA 01081. (413)245-7764. Fax: (413)267-3538. Art Director: Joan Bator. Estab. 1969. Handles rock and country. Photographers used for in-concert shots and studio shots for album covers, inside album shots, publicity and posters.
Needs: Buys 5,000 photos/year. Offers 400 assignments/year. Model release preferred. Captions preferred.
Specs: Uses 4×5 and 8×10 glossy ("mostly color") prints.
Making Contact & Terms: Send unsolicited photos by mail for consideration. Provide résumé, business card, brochure, flier or tearsheets to be kept on file for possible future assignments. "You can submit female suggestive photos for sex appeal, or male, but in good taste." Works with freelancers on assignment only. SASE. Reports in 1 week. Pays $100-150/b&w photo; $150-250/color photo; $150-189/hour; $400-500/day; $375-495/job. Credit line given. Buys one-time rights; other rights negotiable.
Tips: Looks "for good clear photos of models. Show some imagination. Would like some sexually-oriented prints—because advertising is geared for it. Also fashion shots—men's and women's apparel, especially swimsuits and casual clothing."

■**BLACK DIAMOND RECORDS, INC.**, P.O. Box 8073, Pittsburg CA 94565. (510)980-0893. Fax: (510)458-0915. Associate Director of Marketing: Addington Williams III. Estab. 1987. Handles rhythm & blues, rap, hip-hop, jazz hip-hop, rock dance, blues rock, jazz. Freelancers used for portraits and studio shots for cover/liner shots, publicity, brochures, posters, print advertising.
Needs: Buys 50 images annually; 10% supplied by freelancers. Offers 2-3 assignments annually. Interested in clean, creative shots. Reviews stock photos. Model release required. Property release preferred. Captions preferred.
Audiovisual Needs: Uses videotape for reviewing artist's work. Wants to see style, creativity, uniqueness, avant garde work.
Specs: Uses 8×11 b&w prints; 35mm transparencies.
Making Contact & Terms: Interested in receiving work from newer, lesser-known photographers. Submit portfolio for review. Provide résumé, business card, brochure, flier or tearsheets to be kept on file for possible assignments. Works with freelancers on assignment only. Keeps samples on file. SASE. Reports in 1-2 weeks, possibly 2 months to one year. NPI. Payment negotiable. Pays upon usage. Credit line given. Buys all rights; negotiable.
Tips: "Be flexible. Look for the right project. Create a memory."

BLASTER-BOXX HITS/MARICAO RECORDS/HARD HAT RECORDS, 519 N. Halifax Ave., Daytona Beach FL 32118. Phone/fax: (904)252-0381. CEO: Bobby Lee Cude. Estab. 1978. Handles country, MOR, pop, disco and gospel. Photographers used for portraits, in-concert shots, studio shots and special effects for album covers, inside album shots, publicity, brochures, posters, event/convention coverage and product advertising.
Needs: Offers 12 assignments/year. Model/property release required. Captions preferred.
Specs: Uses b&w and color photos.
Making Contact & Terms: Interested in receiving work from newer, lesser-known photographers. Submit portfolio for review. Provide résumé, business card, brochure, flier, tearsheets or samples to be kept on file for possible future assignments. Works with freelancers on assignment only. SASE. Reports in 2 weeks. NPI; pays "standard fees." Credit line sometimes given. Buys all rights.
Tips: "Submit sample photo with SASE along with introductory letter stating fees, etc. Read *Mix Music* magazine."

BOUQUET-ORCHID ENTERPRISES, P.O. Box 1335, Norcross GA 30091. (404)798-7999. President: Bill Bohannon. Photographers used for live action and studio shots for publicity fliers and brochures.
Making Contact & Terms: Provide brochure and résumé to be kept on file for possible future assignments. Works with freelancers on assignment only. SASE. Reports in 1 month. Pays $200 minimum/job.
Tips: "We are using more freelance photography in our organization. We are looking for material for future reference and future needs."

■**CAREFREE RECORDS GROUP**, Box 2463, Carefree AZ. (602)230-4177. Vice President: Doya Fairbains. Estab. 1991. Handles rock, jazz, classical, country, New Age and heavy metal. Freelancers used for portraits, in-concert shots, studio shots and special effects for cover/liner shots, publicity, brochures, posters, event/convention coverage, print advertising, CD covers, cassette covers.

Needs: Buys 45-105 images annually. Offers 2-8 assignments/month. Interested in all types of material. Reviews stock photos. Model/property release required. Captions required.
Audiovisual Needs: Uses slides, film, videotape. Subjects include: outdoor scenes—horses, lakes, trees, female models.
Specs: Uses all sizes of glossy color or b&w prints; 8×10 transparencies; all sizes of film; all types of videotape.
Making Contact & Terms: Interested in receiving work from newer, lesser-known photographers. Submit portfolio for review. Works with freelancers on assignment only. Keeps samples on file. SASE. Reports in 1 month. NPI. Pays upon usage. Credit line given. Buys all rights; negotiable.
Tips: "Keep your eyes and mind open to all types of photographs."

CMF RECORDS, INC., P.O. Box 39439, Los Angeles CA 90039. (213)663-8073. Fax: (213)669-1470. A&R: Diana Collette. Estab. 1975. Handles bluegrass, country, metal, industrial, alternative. Freelancers used for all types of photos for cover/liner shots, inside shots, publicity, brochures, posters and print advertising.
Needs: "Almost all" images supplied by freelancers.
Making Contact & Terms: Interested in receiving work from newer, lesser-known photographers. Provide résumé, business card, self-promotion pieces or tearsheets to be kept on file for possible future assignments. Pays $100/job. Buys all rights.

***COSMOTONE RECORDS**, 3350 Hwy. 6, Suite 412, Houston TX 77478. Record Producer: Rafael Brom. Handles all types of records. Photographers used for portraits, studio shots and special effects for album covers, inside album shots, brochures, posters and product advertising.
Needs: Offers 1-3 assignments/year.
Specs: Uses all sizes, all finish b&w and color photos.
Making Contact & Terms: Works on assignment only. Cannot return material. Will contact only if interested. Pays $30-200/b&w photo; $50-350/color photo; $30-1,000/job. Credit line given. Buys one-time rights and all rights; negotiable.

***DMP RECORDS**, 94 Southfield Ave., #1301, Stamford CT 06902. (203)327-3800. Fax: (203)323-9474. Marketing Director: Paul Jung. Estab. 1982. Handles jazz. Freelancers used for portraits and studio shots for cover/liner shots, inside shots and publicity.
Needs: Offers 10 assignments annually. Model/property release preferred. Captions preferred.
Audiovisual Needs: Uses slides.
Specs: Uses 2¼×2¼ transparencies.
Making Contact & Terms: Interested in receiving work from newer, lesser-known photographers. Query with samples. Keeps samples on file. SASE. Reports in 1-2 weeks. Pays $500/day. **Pays on acceptance.** Credit line given. Buys all rights; negotiable.
Tips: "The jazz industry is typically not a profitable one, especially for independent labels. While I realize that photographers aim to earn big money, there simply is not a big budget for photography."

***‡EFA-MEDIEN-GMBH**, Mousonstr. 12, 60316 Frankfurt, Germany. (69)495099. Fax: (69)445092. A&R Manager: Ulrich Vormehr. Estab. 1982. Handles rock, jazz, avant garde and pop for the Houses in Motion label. Photographers used for portraits, in-concert shots, studio shots and special effects for album covers. Also, inside album shots, publicity, brochures, posters and product advertising.
Needs: Buys 10-12 photos/year. Model release required. Property release preferred. Captions preferred.
Specs: Uses color prints.
Making Contact & Terms: Interested in receiving work from newer, lesser-known photographers. Send unsolicited photos by mail for consideration or submit portfolio for review. SAE, IRC. Reports in 1 month. Credit line given. Buys one-time rights; negotiable. Pays $100-250/b&w photo, $50-250/color photo.

***EMA MUSIC, INC.**, P.O. Box 91683, Washington DC 20090-1683. (202)319-1688. President: J. Murphy. Estab. 1993. Handles gospel. Freelancers used for portraits, in-concert shots, studio shots and special effects for cover/liner shots, publicity, brochures, posters, event/convention coverage and print advertising.

 The double dagger before a listing indicates that the market is located outside the United States and Canada.

Needs: All photos supplied by freelancers. Offers 2 assignments annually. Model/property release preferred. Captions preferred.
Making Contact & Terms: Interested in receiving work from newer, lesser-known photographers. Provide résumé, business card, self-promotion pieces or tearsheets to be kept on file for possible future assignment. Does not keep samples on file. Cannot return material. NPI. Pays on usage. Buys first, one-time and all rights; negotiable.

■**EMPEROR OF EMPERORS**, P.O. Box 3387, Fontana CA 92334-3387. Phone/fax: (909)355-2372. President: Stephen V. Mann. Estab. 1989. Handles rock, jazz, pop, classical, rap, heavy metal and country, future film—commercial music video, doc* materials, TV series. Freelancers used for portraits, in-concert shots, studio shots and special effects for cover/liner shots, publicity, brochures and print advertising.
Needs: Number of images bought annually varies. 50% supplied by freelancers. Offers 3 assignments annually. Examples of recent releases: "Canciones Del Peru Profundo," "Music of Peru," "Creator of Universe." Interested in landscapes, all kinds of musical instruments and products. "We need 800-1,000 new transparencies for coming CDs." Model/property release required. Captions required.
Audiovisual Needs: Uses slides and film.
Specs: Uses 35mm, 4×5 transparencies.
Making Contact & Terms: Interested in receiving work from newer, lesser-known photographers. Provide résumé, business card, self-promotion pieces or tearsheets to be kept on file for possible future assignments. Works on assignment only. Keeps samples on file. SASE. Reports in 1 month. Pays $10-50/b&w photo; $10-50/color photo; $10-25/hour; $80-200/day; $250-350/job. Pays upon usage. Buys all rights; negotiable.

FINER ARTISTS RECORDS, 2170 S. Parker Rd., Suite 115, Denver CO 80231. (303)755-2546. President: R.J. Bernstein. Estab. 1960. Handles rock, classical and country. Uses portraits, in-concert shots, studio shots and special effects for album covers, inside album shots, publicity, brochures and posters.
Needs: Uses 6 freelancers/year.
Making Contact & Terms: Query with résumé of credits. Send unsolicited photos by mail for consideration. Submit portfolio for review. Provide résumé, business card, brochure, flier or tearsheets to be kept on file for possible future assignments. Works with freelancers on assignment only. Reports in 1 month. NPI; payment negotiable. Credit line given. Buys one-time or all rights; negotiable.

GLOBAL PACIFIC RECORDS, 1275 E. MacArthur St., Sonoma CA 95476. (707)996-2748. Fax: (707)996-2658. Senior Vice President: Howard L. Morris. Handles jazz, World, New Age, modern rock. Photographers used for portraits, in-concert shots, studio shots and special effects for album covers, inside album shots, publicity, brochures, posters and product advertising.
Needs: Buys 12-18 images annually.
Specs: Uses 8×10 glossy b&w and color prints or transparencies.
Making Contact & Terms: Submit portfolio for review. Provide résumé, business card, brochure, flier or tearsheets to be kept on file for possible future assignments. SASE. Reports in 2 weeks. NPI. Buys all rights; negotiable.
Tips: Prefers "technically excellent (can be blown up, etc.), excellent compositions, emotional photographs. Be familiar with what we have done in the past. Study our music, album packages, etc., and present material that is appropriate."

GM RECORDINGS, INC., #167 Dudley Rd., Newton Centre MA 02159. Manager: Bruce Millara. Estab. 1982. Handles jazz, classical, third stream, ethnic/world. Freelancers used for portraits, in-concert shots, studio shots and special effects for cover/liner shots, inside shots, publicity, brochures, posters, event/convention coverage and print advertising.
Needs: Buys 10-15 images/annually; all supplied by freelancers. Offers 10 assignments annually. "We are a contemporary, classical, avant-garde jazz label. Use your instinct." Model release required. Property release preferred.
Specs: "Anything that fits in a file."
Making Contact & Terms: Interested in receiving work from newer, lesser-known photographers. Provide résumé, business card, self-promotion pieces or tearsheets to be kept on file for possible future assignments. Keeps samples on file. Cannot return material. Reports in 1-2 months. NPI; payment is "extremely variable." **Pays on acceptance**. Credit line given; "space permitting—almost always." Buys all rights; negotiable.
Tips: "Please understand that we are besieged by potential photographers, and don't call incessantly. Send samples for file, and we will contact you, if there's a need."

HIGHER OCTAVE MUSIC, 23715 W. Malibu Rd., Suite 358, Malibu CA 90265. (310)589-1515. Fax: (310)589-1525. Vice President, Creative Services: Dee Westlund. Handles New Age. Photographers used for studio shots and special effects for album covers, inside album shots, publicity and brochures.

Needs: Examples of recent releases: "Acoustic Planet," by Craig Chaquico (Grammy nominee); "One Thousand & One Nights," Shahin & Sepehr; "Richochet Sun," by Opafire.
Specs: Uses b&w and color prints.
Making Contact & Terms: Interested in receiving work from newer, lesser-known photographers. Submit portfolio for review. Provide résumé, business card, brochure, flier or tearsheets to be kept on file for possible future assignments. SASE. Reports in 3-4 weeks. NPI. Credit line given. Buys exclusive product rights; negotiable.
Tips: "New Age album covers are finally getting away from lovely landscapes and into a more progressive look—I look for clean elegance for our covers. Freelancers are in demand with small independent record companies that don't have lots of money to spend, but have the time to work with the photographer—for the right shot at the right price."

■**HIT CITY RECORDS**, P.O. Box 64895, Baton Rouge LA 70896. (504)925-0288. Owner: Henry Turner. Estab. 1984. Handles reggae, funk, country and rap. Freelancers used for portraits, in-concert shots, studio shots for cover/liner shots, publicity and posters.
Needs: Buys 25 images annually; all supplied by freelancers. Offers 30 assignments annually. Interested in clean b&w gloss. Property release required.
Audiovisual Needs: Uses film and videotape for promotion of artist. Subjects include music video.
Specs: Uses 8×10 prints; broadcast quality film for TV; Super 8 ¾" videotape.
Making Contact & Terms: Interested in receiving work from newer, lesser-known photographers. Submit portfolio for review. "You must send a $5 fee. Attn: Reviewing Department for a review." Works with freelancers on assignment only. Does not keep samples on file. Reports in 3 weeks. NPI; determined by the project. Pays on usage. Credit line given. Buys first rights, one-time rights, all rights; negotiable.
Tips: "Send a portfolio at least once every 2 months and be patient because we can only use photos as they are needed for projects." Noticing that "Amiga work is increasing."

*****HOUSTONE RECORDS**, P.O. Box 8305, Houston TX 77288. (713)893-2400. Fax: (713)537-2619. General Manager: Sirron Kyles. Estab. 1979. Handles rock, jazz, world beat, blues. Freelancers used for in-concert shots and special effects for cover/liner shots, inside shots, publicity, brochures, posters, event/convention coverage and print advertising.
Needs: Interested in entertainment shots. Reviews stock photos. Model/property release preferred.
Audiovisual Needs: Uses slides, film, videotape for review. Subjects include: entertainment.
Making Contact & Terms: Interested in receiving work from newer, lesser-known photographers. Submit portfolio for review. Query with samples. Query with stock photo list. Provide résumé, business card, self-promotion pieces or tearsheets to be kept on file for possible future assignments. Keeps samples on file. SASE. Reports in 4-6 weeks. NPI. Pays on usage. Credit line given. Rights negotiable.

IRS RECORDS, 3939 Lankershim Blvd., Universal City CA 91604. Prefers not to share information.

■**JAZZAND**, 12 Micieli Place, Brooklyn NY 11218. (718)972-1220. President: Rick Stone. Handles jazz, acoustic and bebop. Freelancers used for portraits, in-concert shots and studio shots for cover/liner, publicity, posters, event/convention coverage and print advertising.
Needs: Buys 3-4 images annually; all supplied by freelancers. Offers 1-2 assignments annually. Interested in shots that have been used for covers. Good live and studio shots, portraits.
Audiovisual Needs: Uses videotape.
Specs: Uses 8×10 glossy color and b&w prints; VHS videotape.
Making Contact & Terms: Interested in receiving work from newer, lesser-known photographers. Arrange personal interview to show portfolio. Provide résumé, business card, self-promotion pieces or tearsheets to be kept on file for possible future assignments. Works with local freelancers only. Keeps samples on file. Cannot return material. Reports in 1 month. Pays $50-100/hour; $100-200/job; negotiable—depends on use. **Pays on acceptance.** Credit line given. Buys all rights; negotiable.
Tips: "We are a very small label with a miniscule budget. If you are good at location shots and want to establish a portfolio of cover shots, etc., we will be more than happy to supply you with copies of CD jackets, etc., which may help you to approach other labels."

KIMBO EDUCATIONAL, 10 N. Third Ave., P.O. Box 477, Long Branch NJ 07740. (908)229-4949. Production Manager: Amy Laufer. Handles educational—early childhood movement-oriented records, tapes and videocassettes. General entertainment songs for young children. Physical fitness programs for all ages. Photographers used for album and catalog covers, brochures and product advertising.
Needs: Offers 5 assignments/year.
Specs: Uses transparencies.
Making Contact & Terms: Provide résumé, business card, brochure, flier or tearsheets to be kept on file for possible future assignments. Cannot return material. "We keep samples on file and contact

photographer if in need of their services." Payment for each job is different—small advertising job, $75 minimum; album covers, $200-400." Buys all rights; negotiable.

Tips: "We are looking for top quality work but our budgets do not allow us to pay New York City prices (need reasonable quotes). Prefer local photographers—communication easier. We are leaning a little more toward photography, especially in our catalog. In the educational marketplace, it's becoming more prevalent to actually show our products being used by children."

***L.R.J. RECORDS**, Box 3, Belen NM 87002. (505)864-7441. Fax: (505)864-7442. President: Little Richie Johnson. Estab. 1959. Handles country and bilingual records. Photographers used for record album photos.
Making Contact & Terms: Send material by mail for consideration. NPI; payment negotiable. Pays on receipt of completed job. Credit line given. Buys all rights, but may reassign to photographer.

***‡LASER RECORDS & MUSIC PTY LTD**, Box 38, Balmain, 2041 N.S.W. Australia. (02)555-7333. Fax: (02)555-7070. Publicity Manager: Kymberlie Harrison. Handles jazz, big band, Broadway, 50's, 60's rock. Photographers used for portraits, in-concert shots, studio shots, special effects "reconstruction of antique photos and memorabilia" for album covers/CD's, inside album shots, publicity, brochures, posters and product advertising.
Needs: Buys 70-150 photos/year. Offers 40-60 assignments/year. Looks for "8×10 or proof sheets color or b&w of nostalgia artists and bands. Also stills of beautiful scenery for New Age audio products."
Specs: Uses 8×10 b&w glossy prints; 2¼×2¼ and 35mm transparencies.
Making Contact & Terms: Send unsolicited photos by mail for consideration. Submit portfolio for review. Provide business card, brochure, flier or tearsheets to be kept on file for possible future assignments. SASE. Reports in 3 weeks. Pays $80-150/b&w photo; $125 minimum/hour; $250/3 hour session. Credit line given. Buys all rights; negotiable.

***PATTY LEE RECORDS**, 6034 Graciosa Dr., Hollywood CA 90068. Phone/fax: (213)469-5431. Assistant to the President: Susan Neidhart. Estab. 1985. Handles New Orleans rock and western. Freelancers used for cover/liner shots, posters.
Needs: "We look for artwork that works best for the genre of music we are promoting."
Making Contact & Terms: Interested in receiving work from newer, lesser-known photographers. Query with résumé of credits. Works with freelancers on assignment only. Keeps samples on file. SASE. Reports in 1 month. NPI; payment based on project. Credit line given. Buys one-time rights.

■LEE MAGID, P.O. Box 532, Malibu CA 90265. (213)463-5998. President: Lee Magid. Operates under Grass Roots Records label. Handles R&B, jazz, C&W, gospel, rock, blues, pop. Photographers used for portraits, in-concert shots, studio shots and candid photos for album covers, publicity, brochures, posters and event/convention coverage.
Needs: Offers about 10 assignments/year.
Specs: Uses 8×10 buff or glossy b&w or color prints and 2¼×2¼ transparencies.
Making Contact & Terms: Send print copies by mail for consideration. Works with freelancers on assignment only. SASE. Reports in 2 weeks. NPI. Credit line given. Buys all rights.

***■MIA MIND MUSIC**, 500½ E. 84 St., New York 10028. Phone/fax: (212)861-8745. Promotions Director: Ashley Wilkes. Estab. 1982. Freelancers used for cover/liner shots, posters, direct mail, newspapers and videos.
Needs: Offers 3 assignments annually. Interested in photos of recording artists. Reviews stock photos appropriate for album/CD covers. Model/property release preferred. Captions preferred.
Audiovisual Needs: Uses slides and video to present an artist to record labels to obtain a record deal.
Specs: Uses 8×10 matte color and b&w prints.
Making Contact & Terms: Interested in receiving work from newer, lesser-known photographers. Arrange personal interview to show portfolio. Submit portfolio for review. Provide résumé, business card, self-promotion pieces or tearsheets to be kept on file for possible future assignments. Contact through rep. Works with freelancers on assignment only. Keeps samples on file. SASE. Reports in 1-

2 weeks. Pays $200-1,500/job; $200-500/color photo; $200-500/b&w photo. **Pays on acceptance.** Credit line given.
Tips: Looking for conceptual, interesting, edgy borderline controversial photography. Seeing a trend toward conceptual, art photography.

■MIRAMAR PRODUCTIONS, 200 Second Ave. W., Seattle WA 98119. (206)284-4700. Fax: (206)286-4433. Production Manager: David Newsom. Estab. 1985. Handles rock and New Age. Free-lancers used for portraits, in-concert shots and studio shots for cover/liner, inside shots, publicity, brochure, posters and print advertising.
Needs: Buys 10-20 images annually; 10-20 supplied by freelancers. Offers 10-20 assignments annually. Reviews stock photos. Model/property release required. Captions preferred.
Audiovisual Needs: Uses slides, film and videotape.
Specs: Uses 35mm, 2¼×2¼, 4×5 transparencies; 35mm, 16mm film; no less than Betacam videotape.
Making Contact & Terms: Interested in receiving work from newer, lesser-known photographers. Query with samples. Works on assignment only. Keeps samples on file. SASE. Pays $100-2,500/job. **Pays on acceptance.** Credit line given. Buys all rights; negotiable.

NIGHTSTAR RECORDS, INC., Dept. PM, P.O. Box 602, Yarmouthport MA 02675. (508)362-3601. President: David M. Robbins. Estab. 1990. Handles New Age and easy listening. Photographers used for portraits, studio shots, special effects and landscape for album covers, inside album shots, publicity and brochures.
Needs: Gives 4-6 freelance assignments/year. Wants to see panoramic shots of natural scene subjects such as mountains, plains, rivers and ocean/beach scenes.
Specs: Uses any glossy, b&w and color prints.
Making Contact & Terms: Send unsolicited photos by mail for consideration; provide résumé, business card, brochure, flier or tearsheets to be kept on file for possible future assignments. Works on assignment only. Does not return unsolicited material. Reports in 1 month. NPI. "Payment depends on usage. Album covers pay more than brochures." Credit line given in liner notes. Buys all rights.
Tips: "If you live in the general area of Massachusetts, we would also be interested in your portfolio work. Submit photos that you would consider your best. If we feel we can use a photo, you will be contacted. We would never use any photo without written consent and making payment." To break in, realize that "beautiful photos speak for themselves. If you have what people want, then they will use it. Nightstar uses photos quite frequently on album covers as opposed to artwork."

NUCLEUS RECORDS, P.O. Box 111, Sea Bright NJ 07760. President: Robert Bowden. Estab. 1979. Handles rock, country. Photographers used for portraits, studio shots for publicity, posters and product advertising.
Needs: Send still photos of people for consideration. Model release preferred. Property release required. Captions preferred.
Making Contact & Terms: Interested in receiving work from newer, lesser-known photographers. Works with freelance photographers on assignment basis only. SASE. Reports in 3 weeks. Pays $25-50/b&w photo; $75-150/color photo; $50-75/hour; $100-200/day; $400-500/job. Credit line given. Buys one-time rights.

***■ORINDA RECORDS**, P.O. Box 838, Orinda CA 94568. (510)462-0333. A&R Director: H. Balk. Estab. 1978.
Needs: Interested in material for album/CD covers. Reviews stock photos. Model release required.
Audiovisual Needs: Uses slides.
Specs: Uses 3×5 color prints.
Making Contact & Terms: Interested in receiving work from newer, lesser-known photographers. Query with stock photo list. Works with freelancers on assignment only. Keeps samples on file. Reports as project needs arise. Pays on publication. Credit line given. Buys first rights.

***THE PRESCRIPTION CO.**, 70 Murray Ave., Port Washington NY 11050. (516)767-1929. President: David F. Gasman. VP (A&R): Kirk Nordstrom. Tour Coordinator: Bill Fearn. Handles rock, soul and country & western. Uses photos for portraits, in-concert/studio shots and special effects for album covers, inside album shots, publicity fliers, brochures, posters, event/convention coverage and product advertising.
Specs: Uses b&w/color prints.
Making Contact & Terms: Arrange interview to show portfolio. "Send a flier or tearsheets to be kept on file. Works on assignment only. Cannot return material. "We want no original photos submitted." NPI; payment negotiable. Rights negotiable.
Tips: "We're only a small company with sporadic needs. If interested we will set up an in-person meeting. There is always need for good photography in our business, but like most fields today,

competition is growing stiffer. Art and technique are important, of course, but so is a professional demeanor when doing business."

PRO/CREATIVES, 25 W. Burda Pl., New City NY 10956-7116. President: David Rapp. Handles pop and classical. Photographers used for record album photos, men's magazines, sports, advertising illustrations, posters and brochures.
Making Contact & Terms: Query with examples, résumé of credits and business card. SASE. Reports in 1 month. NPI. Buys all rights.

‡R.T.L. MUSIC/SWOOP RECORDS, Stewart House, Hill Bottom Rd., Sands-IND-EST, Highwycombe, Bucks, HP124HJ England. (01630)647374. Fax: (01630)647612. Owner: Ron Lee. Estab. 1970. Uses portraits, in-concert shots, studio shots and special effects for album covers, inside album shots, publicity, brochures, posters, event/convention coverage and product advertising.
Needs: Wants to see all types of photos. Examples of recent uses: "Nothin Like a Motor Bike," "One More Night," "Questions" (all CD covers). Model/property release required. Photo captions required.
Specs: Uses 8×10 glossy or matte, b&w or color prints.
Making Contact & Terms: Interested in receiving work from newer, lesser-known photographers. Reports in 3 weeks. NPI. Payment always negotiated. Credit line given. Buys exclusive product and all rights; negotiable.
Tips: Depending on the photographer's originality, "prospects can be very good."

RECORD COMPANY OF THE SOUTH, 5220 Essen Lane, Baton Rouge LA 70809. (504)766-3233. Fax: (504)768-9191. Art Director: Jay Ruiz. Handles rock, jazz. Freelancers used for portraits, studio shots, special effects for cover/liner, posters.
Needs: Buys 1-2 images annually; 1-2 supplied by freelancers. Offers 1-2 assignments annually. Interested in special effects or uniquely composed photos. Reviews stock photos of scenes or special effects. Model release required. Property release preferred. Captions preferred.
Specs: Uses 8×10 matte color and b&w prints; 35mm, 4×5 transparencies.
Making Contact & Terms: Provide résumé, business card, self-promotion pieces or tearsheets to be kept on file for possible future assignments. Works on assignment only. Keeps samples on file. SASE. **Pays on acceptance.** Buys all rights; negotiable.
Tips: "Experiment with unique compositions and effects."

RELATIVITY RECORDINGS, INC., 79 Fifth Ave., New York NY 10003. (212)337-5200. Fax: (212)337-5374. Art Director: David Bett. Estab. 1979. Handles primarily rap and rock. Freelancers used for portraits, in-concert shots, studio shots and special effects for cover/liner, inside shots, publicity, posters, print advertising.
Needs: Buys 30-50 images annually; all supplied by freelancers. Offers 30-50 assignments annually. Interested in "creative, original, intelligent" material.
Specs: Uses "any and all."
Making Contact & Terms: Interested in receiving work from newer, lesser-known photographers as well as established professionals. Submit portfolio for review. Provide résumé, business card, brochure, flier or tearsheets to be kept on file for possible future assignments. Contact by phone to arrange submission of portfolio or send card to be kept on file. Works on assignment only. SASE. Reports "when we want to hire a photographer." Pays publicity photo; $250-1,500; album cover photo $500-2,500; back cover $250-1,500. "Depends on level of the recording artist, sales potential." Credit line given. Buys one-time rights; all rights; negotiable.
Tips: "We're always looking for photographers with imagination and good rapport with musicians. We probably use photography on about 75% of our covers, and somewhere on all our albums. Photo must have good concept or a 'look' to be on cover."

ROCKWELL RECORDS, 227 Concord St., Haverhill MA 01830. (508)373-5677. President: Bill Macek. Produces top 40 and rock 'n' roll records. Photographers used for live action shots, studio shots and special effects for album covers, inside album shots, publicity, brochures and posters. Photos used for jacket design and artist shots.
Needs: Buys 1-2 photos and offers 1-2 assignments/year. Freelancers supply 100% of photos. Interested in seeing all types of photos. "No restrictions. I may see something in a portfolio I really like and hadn't thought about using."
Making Contact & Terms: Arrange a personal interview. Submit b&w and color sample photos by mail for consideration. Submit portfolio for review. Provide brochure, calling card, flier or résumé to be kept on file for possible future assignments. Local photographers preferred, but will review work of photographers from anywhere. SASE. NPI; payment varies.

SIRR RODD RECORD & PUBLISHING CO., 2453 77th Ave., Philadelphia PA 19150-1820. President/ A&R: Rodney Jerome Keitt. Handles R&B, jazz, top 40, rap, pop, gospel and soul. Uses photographers

for portraits, in-concert shots, studio shots and special effects for album covers, inside album shots, publicity, posters, event/convention and product advertising.

Needs: Buys 10 (minimum) photos/year.

Specs: Uses 8 × 10 glossy b&w or color prints.

Making Contact & Terms: Submit portfolio for review. Provide résumé, business card, brochure, flier or tearsheets to be kept on file for possible future assignments. SASE. Reports in 1 month. Pays $40-200/b&w photo; $60-250/color photo; $75-450/job. Credit line given. Buys all rights, negotiable.

Tips: "We look for the total versatility of the photographer. Of course, you can show us the more common group photos, but we like to see new concepts in group photography. Remember that you are freelancing. You do not have the name, studio, or reputation of 'Big Time' photographers, so we both are working for the same thing—exposure! If your pieces are good and the quality is equally good, your chances of working with record companies are excellent. Show your originality, ability to present the unusual, and what 'effects' you have to offer."

***‡SPHEMUSATIONS**, 12 Northfield Rd., One House, Stomarket Suffolk 1P14 3HF England. 01449-613388. General Manager: James Butt. Handles classical, country and western. Photographers used for portraits, in-concert shots, studio shots, special effects and ensemble portraits for album covers, inside album shots, publicity, brochures, posters, event/convention coverage and product advertising.

Needs: Gives 2-6 assignments/year. "Prefers to see good portraits of artists, and album cover to which the photographer has contributed work. Especially wants to see pictures which show a sense of character and culture."

Specs: Uses glossy b&w or color prints.

Making Contact & Terms: Send unsolicited photos by mail for consideration. Submit portfolio for review. Provide résumé, business card, brochure, flier or tearsheets to be kept on file for possible future assignments. Works with freelance photographers on assignment basis only. SAE, IRC. Reports in 1 month. Pays $10-1,000/b&w photo; $50-2,000/color photo; $5-25/hour; $30-175/day; $25-2,500/job. Credit line given. Buys all rights but may reassign rights; negotiable.

Tips: Chances of working with record companies are many, varied, and excellent. There is a trend toward visually sensitive, perceptive photography, which reveals something more than simple surface—values.

***TRANSWORLD RECORDS**, 2170 S. Parker Rd., Suite 115, Denver CO 80231. (303)755-2546. President: R.J. Bernstein. Estab. 1960. Handles rock, classical and country. Uses portraits, in-concert shots, studio shots and special effects for album covers, inside album shots, publicity, brochures and posters.

Needs: Gives 6 assignments/year.

Making Contact & Terms: Query with résumé of credits. Send unsolicited photos by mail for consideration. Submit portfolio for review. Provide résumé, business card, brochure, flier or tearsheets to be kept on file for possible future assignments. Works with freelancers on assignment only. Does not return unsolicited material. Reports in 1 month. NPI; payment negotiable. Credit line given. Buys all rights; negotiable.

UAR RECORDS, P.O. Box 1264, Peoria IL 61654. Phone/fax: (309)673-5755. Owner: Jerry Hanlon. Estab. 1968. Handles country, country rock, Christian. Freelancers used for portraits for cover/liner shots and publicity.

Needs: Reviews stock photos. Scenery (country scenes, water scenes), churches.

Specs: Uses color and/or b&w prints; 4 × 5 transparencies.

Making Contact & Terms: Interested in receiving work from newer, lesser-known photographers. Submit portfolio for review. Provide résumé, business card, self-promotion pieces or tearsheets to be kept on file for possible future assignments. Works with freelancers on assignment only. Keeps samples on file. Cannot return material. Reports in 1 month. NPI. Pays upon usage.

WINDHAM HILL RECORDS, 75 Willow Rd., Menlo Park CA 94025. (415)329-0647. Art Director: Candace Upman. Handles mostly jazz-oriented, acoustic and vocal music. Uses freelance photographers for portraits and art shots (including natural subjects) for album packaging.

The double dagger before a listing indicates that the market is located outside the United States and Canada.

Needs: Buys 20-30 freelance photos/year.
Specs: Uses 35mm, 2¼×2¼, 4×5 and 8×10 transparencies as well as b&w prints.
Making Contact & Terms: For portrait work, submit portfolio for review, including Fed Ex account number (or similar) if necessary for return. For album packaging imagery, send duplicate images only with SASE for eventual return of unwanted images; originals not accepted. NPI; payment varies. Credit given. Buys one-time rights or all rights.
Tips: "For both portrait photography and cover imagery, we are looking for something with a creative twist or unusual point of view. Become acquainted with our covers before submitting materials. Send materials that have personal significance—work with heart."

Record Companies/'95-'96 changes

The following markets appeared in the 1995 edition of *Photographer's Market*, but are not listed this year. The majority did not respond to our request to update their listings. If a reason was given for a market's exclusion it appears in parentheses below.

A Company Called W
August Productions Inc.
BMX Entertainment
Creative Network, Inc. (editorial decision)
Kaizan Music (editorial decision)
Landmark Communications Group

Lin's Lines
Lucifer Records, Inc.
Luke Records Inc.
Must Rock RSNY Productionz (editorial decision)
Next Plateau Records, Inc.
One Step To Happiness Music (editorial decision)

Roadrunner Records
Shaolin Film & Records
Sound Ceremony Records
Mick Taylor Music (editorial decision)
Time-Life Music

Stock Photo Agencies

Unless you're interested in taking stock photography seriously, you probably shouldn't read beyond this sentence. Stock agencies want photographers who produce quality images, and lots of them. They expect periodic submissions that have been edited and often consist of hundreds of photos. Most agencies demand model and property releases that take time to acquire. They, in short, want professionals.

Now, if you're still reading, this section has a lot to offer you. There are nearly 200 agencies listed here and more than 40 are new to this edition. They range from agencies with small staffs and archives of a couple thousand images, to worldwide image providers with millions of images, like FPG International, Tony Stone Images and Westlight. Incidentally, Westlight owner Craig Aurness expresses his opinions about the stock industry as our Insider Report subject on page 522.

One of the subjects Aurness covers in his interview is the proliferation of digital technology that has taken hold of the stock world. If you've read the photo trade magazines over the past five years, you've seen the birth of CD storage and online presentation of images. Many agencies are just now starting to adopt these and other technologies to their businesses.

As you read through these markets you will find information on new technology and its effects on stock agencies. Much of this material is new this year. We asked agencies how the new technology is changing the way they conduct business because photographers certainly will face some new challenges in the near future. Information that explains how an agency is adapting to the new technology is set off by a bullet (●). Turn to the listing for Viesti Associates Inc. to see what we mean.

Because of all these changes you should closely study agency contracts and find out how agency owners plan to market your work. For example, some agencies are willing to place images on clip art discs while others have campaigned against such practices. Most agencies are reputable, but some are either unethical in their practices or have not yet adopted professional attitudes. By knowing how various agencies operate you will know which ones should market your work.

You can learn even more about contracting with an agency in our Insider Report on page 478. In it, photographer John Gerlach of Chatham, Michigan, explains the proper way to approach a stock agency. Gerlach and his wife, Barbara, have over 300,000 images with 16 agencies worldwide and they operate a workshop for nature photographers (see listing in Workshop section).

Finally, there are a number of helpful references and organizations that will assist you in learning more about the stock industry and its standard practices. The following sources also can help you stay in touch with industry trends: *Taking-Stock*, a newsletter published by stock photo expert Jim Pickerell (301)251-0720; the *ASMP Stock Photography Handbook,* published by the American Society of Media Photographers (609)799-8300; and the Picture Agency Council of America, contact PACA Executive Administrator Lonnie Schroeder at (800)457-7222.

■✳**AAA IMAGE MAKERS**, 337 W. Pender St., Suite 301, Vancouver, British Columbia V6B 1T3 Canada. (604)688-3001. Owner: Reimut Lieder. Art Director: Joy Huston. Estab. 1981. Stock photo agency. Has 200,000 photos. Clients include: advertising agencies, public relations firms, audiovisual firms, businesses, book/encyclopedia publishers, magazine and textbook publishers, postcard publishers, calendar companies and greeting card companies.

Ethical guidelines for stock

Before a photographer signs a contract with a stock photo agency, he needs some guarantee of fair treatment. The Picture Agency Council of America (PACA) has established a set of ethical guidelines to which all members in the council must adhere in order to retain their memberships. These guidelines are a good checklist for the photographer to use when prospecting for an agency or negotiating his contract.

PACA members will openly and freely discuss with photographers:
- *Ownership of agency, and/or change thereof.*
- *Editing, inventory and refiling procedures.*
- *Disposition of any suit or settlement pertaining to a specific photographer's work, including documentation if requested.*
- *International representation policies.*
- *Policies regarding free or reduced rate usages for charitable organizations.*
- *Sub agency or franchise representation policies.*

Membership agencies should also offer photographers a fair and straightforward written contract, which should address such items as:
- *Payment schedule.*
- *Right to inspect agency records as they pertain to the individual photographer.*
- *Contract period and renewal.*
- *Charges, deductions or assessments related to the photographer's account.*
- *Procedure and schedule for return of photographs upon termination of contract.*

Also royalty statements should include:
- *An adequate photo description.*
- *A description or code for the usage.*
- *The amount of the photographer's share.*
- *An itemization of any deductions that are made.*

Needs: People, families, business, travel and "much more. We provide our photographers with a current needs list on a regular basis."
Specs: Uses 8×10 glossy or pearl b&w prints; 35mm, 2¼×2¼, 4×5 and 8×10 transparencies.
Payment & Terms: Pays 50% commission on color and b&w. Average price per image: $300-500/b&w; $400/color. Enforces minimum prices. Offers volume discount to customers; terms specified in photographer's contract. Discount sales terms not negotiable. Works on contract basis only. Offers limited regional exclusivity, guaranteed subject exclusivity. Charges 50% duping fee, 50% catalog insertion. Statements issued quarterly. Payment made quarterly. Photographers allowed to review account records. Rights negotiated by client needs. Does not inform photographer or allow him to negotiate when client requests all rights. Model release preferred. "All work must be marked 'MR' or 'NMR' for model release or no model release. Photo captions required.
Making Contact: Interested in receiving work from established, especially commercial, photographers. Arrange personal interview to show portfolio. Submit portfolio for review. Query with résumé of credits. Query with samples. Send SASE (IRCs) with letter of inquiry, résumé, business card, flier, tearsheets or samples. Samples kept on file. Expects minimum initial submission of 200 images. Reports in 2-3 weeks. Photo guideline sheet free with SASE (IRC). Market tips sheet distributed quarterly to all photographers on contract; free with SASE (IRCs).
Tips: "As we do not have submission minimums, be sure to edit your work ruthlessly. We expect quality work to be submitted on a regular basis. Research your subject completely and shoot shoot!"

■‡ACE PHOTO AGENCY, Satellite House, 2 Salisbury Rd., Wimbledon, London SW19 4EZ United Kingdom. (181)944-9944. Fax: (181)944-9940. Chief Editor: John Panton. Stock photo agency. Has approximately 300,000 photos. Clients include: ad agencies, audiovisual firms, businesses, book/encyclopedia publishers, magazine publishers, postcard companies, calendar companies, greeting card companies, design companies and direct mail companies.

Needs: People, sport, corporate, industrial, travel (world), seas and skies, still life and humor.

Specs: Uses 35mm, 2¼×2¼, 4×5 and 8×10 transparencies.

Payment & Terms: Pays 50% commission on color photos, 30% (overseas sales). General price range: $135-1,800. Works on contract basis only; offers limited regional exclusivity and contracts. Contracts renew automatically for 2 years with each submission. Charges catalog insertion fee, $100 deducted from first sale. Statements issued quarterly. Payment made quarterly. Photographers permitted to review sales records with 1 month written notice. Offers one-time rights, first rights or mostly non-exclusive rights. Informs photographers when client requests to buy all rights, but agency negotiates for photographer. Model/property release required for people and buildings. Photo captions required; include place, date and function.

Making Contact: Arrange a personal interview to show portfolio. Query with samples. SASE (IRCs). Reports in 2 weeks. Photo guidelines free with SASE. Distributes tips sheet twice yearly to "ace photographers under contract."

Tips: Prefers to see "total range of subjects in collection. Must be commercial work, not personal favorites. Must show command of color, composition and general rules of stock photography. All people must be mid-Atlantic to sell in UK. Must be sharp and also original. No dupes. Be professional and patient."

ADVENTURE PHOTO, 24 E. Main St., Ventura CA 93001. (805)643-7751. Fax: (805)643-4423. Estab. 1987. Stock agency. Member of Picture Agency Council of America (PACA). Has 250,000 photos. Clients include: advertising agencies, public relations firms, businesses, magazine publishers, calendar and greeting card companies.

Needs: Adventure Photo offers its clients 5 principal types of images: adventure sports (sailing, windsurfing, rock climbing, skiing, mountaineering, mountain biking, etc.), adventure travel (all 50 states as well as Third World and exotic locations.), landscapes, environmental and wildlife.

Specs: Uses 35mm, 2¼×2¼ and 4×5 transparencies.

Payment & Terms: Pays 50% commission on color photos. Works on contract basis only. Offers nonexclusive contract. Contracts renew automatically with each submission; time period not specified. Statements issued monthly. Payment made monthly. Photographers allowed to review sales figures. Offers one-time rights; occasionally negotiates exclusive and unlimited use rights. "We notify photographers and work to settle on acceptable fee when client requests all rights." Model and property release required. Captions required, include description of subjects, locations and persons.

Making Contact: Write to photo editor for copy of submission guidelines. SASE. Reports in 1 month. Photo guidelines free with SASE.

Tips: In freelancer's portfolio or samples, wants to see "well-exposed, well-lit transparencies (reproduction quality). Unique outdoor sports, travel and wilderness images. We love to see shots of this subject matter that portray metaphors commonly used in ad business (risk taking, teamwork, etc.)." To break in, "we request new photographers send us 2-4, 20-image sheets they feel are representative of their work. Then when we sign a photographer, we pass ideas to them regularly about the kinds of shots our clients are requesting, and we pass them any ideas we get too. Then we counsel our photographers always to look at magazines and advertisements to stay current on the kinds of images art directors and agencies are using."

***■AIRBORNE,** P.O. Box 2878, Alameda CA 94501. (510)769-9766. President: Jordan Coonrad. Estab. 1981. Stock photo agency. Has 50,000 photos. Clients include: advertising agencies, public relations firms, designers, audiovisual firms, businesses, book/encyclopedia publishers, magazine publishers, newspapers, and postcard and calendar companies.

Needs: Needs photos of aviation, military, commercial, general. Aerials of all subjects.

Specs: Uses 35mm, 2¼×2¼, 4×5, 8×10 transparencies.

Payment & Terms: Sometimes buys photos outright. Pays 30-60%; "50% is average." General price range: $200-5,000. Works with or without contract, negotiable. Charges various fees; types and amounts not specified. Statements issued monthly. Payment made monthly. Photographers allowed to review

 The double dagger before a listing indicates that the market is located outside the United States and Canada.

account records to verify sales figures. Offers one-time rights, electronic media rights and various negotiable rights. "Rights are negotiated based on client needs." Informs photographer and allows him to negotiate when client requests all rights. Model release required for "people in advertising or corporate use." Photo captions are required; include description of subject and noteworthy facts.

Making Contact: Query with résumé of publication credits. Query with samples. Also "send photos when requested after initial contact." SASE. Reports in 1 month. Photo guidelines not available. Tips sheet sometimes distributed.

Tips: In freelancer's samples, wants to see high quality, sharp, graphic images. "Prefer Kodachrome. Other film OK in 2¼ and larger formats. Submit 100-200 well-edited images in pages. *No yellow boxes.*" Sees trend toward "increased use of stock photos."

■AMERICAN STOCK PHOTOGRAPHY, Dept. PM, 6255 Sunset Blvd., Suite 716, Hollywood CA 90028. (213)469-3900. Fax: (213)469-3909. President: Christopher C. Johnson. Manager: Sandra Capelli. Stock photo agency. Has 2 million photos. Clients include: advertising agencies, public relations firms, audiovisual firms, businesses, book/encyclopedia publishers, magazine publishers, newspapers, postcard companies, calendar companies, greeting card companies and TV and movie production companies.

• American Stock Photography is a subsidiary of Camerique, which is also listed in this section.

Needs: General stock, all categories. Special emphasis upon California scenics and lifestyles.

Specs: Uses 35mm, 2¼×2¼, 4×5 transparencies; b&w contact sheets; b&w negatives.

Payment & Terms: Buys photos outright; pays $5-20. Pays 50% commission. General price range: $100-750. Works on contract basis only. Offers non-exclusive contracts. Contracts renew automatically with additional submissions. Charges 50% for catalog insertion, advertising, CD disks and online services. Statements issued monthly. Payment made monthly. Photographers allowed to review account records. Offers one-time, electronic and multi-use rights. Informs photographer and allows him to negotiate when client requests all rights. Model/property release required for people, houses and animals. Captions required: include date, location, specific information on image.

Making Contact: Contact Camerique Inc., 1701 Skippack Pk., P.O. Box 175, Blue Bell, PA 19422. (610)272-4000. SASE. Reports in 1 week. Photo guidelines free with SASE. Tips sheet distributed quarterly to all active photographers with agency; free with SASE.

***■‡THE ANCIENT ART & ARCHITECTURE COLLECTION**, 6 Kenton Rd., Harrow-on-the-Hill, Middlesex HA1 2BL London, England. (181)422-1214. Fax: (181)426-9479. Contact: The Librarian. Picture library. Has 200,000 photos. Clients include: public relations firms, audiovisual firms, book/encyclopedia publishers, magazine publishers and newspapers.

Specs: Uses 35mm, 2¼×2¼, 4×5 or 8×10 transparencies.

Payment & Terms: Pays 50% commission. Works with photographers on contract basis only. Offers non-exclusive rights. Contracts renew automatically with additional submissions. Statements issued quarterly. Payment made quarterly. Offers one-time rights. Fully detailed captions required.

Making Contact: Query with samples and list of stock photo subjects. SASE. Reporting time not specified.

Tips: "Material must be suitable for our specialist requirements. We cover historical and archeological periods from 25,000 BC to the 19th century AD, worldwide. All civilizations, cultures, religions, objects and artifacts as well as art are includable. Pictures with tourists, cars, TV aerials, and other modern intrusions not accepted."

■‡ANDES PRESS AGENCY, 26 Padbury Ct., London E2 7EH England. (071)739-3159. Director: Carlos Reyes. Picture library and news/feature syndicate. Has 500,000 photos. Clients include: audiovisual firms, book/encyclopedia publishers, magazine publishers and newspapers.

Needs: "We have a large collection of photographs on social, political and economic aspects of Latin America, Africa, Asia, Europe and Britain, specializing in contemporary world religions."

Specs: Uses 8×10 glossy b&w prints; 35mm and 2¼×2¼ transparencies; b&w contact sheets and negatives.

Payment & Terms: Pays 50% commission for b&w and color photos. General price range: £50-200/b&w photo; £50-300/color photo; (British currency). Enforces minimum prices. Works on contract basis only. Offers nonexclusive contract. Statements issued quarterly. Payment made quarterly. Photographers allowed to review account records to verify sales figures. Offers one-time rights. Informs photographer and allows him to negotiate when client requests all rights. "We never sell all rights, photographer has to negotiate if interested." Model/property release preferred. Captions required.

Making Contact: Interested in receiving work from newer, lesser-known photographers. Query with samples. Send stock photo list. SASE. Reports in 1 week. Photo guidelines free with SASE.

Tips: "We want to see that the photographer has mastered one subject in depth. Also, we have a market for photo-features as well as stock photos."

■**ANIMALS ANIMALS/EARTH SCENES,** 17 Railroad Ave., Chatham NY 12037. (518)392-5500. Branch office: 580 Broadway, Suite 1102, New York NY 10012. (212)925-2110. President: Eve Kloepper. Member of Picture Agency Council of America (PACA). Has 850,000 photos. Clients include: ad agencies, public relations firms, businesses, audiovisual firms, book publishers, magazine publishers, encyclopedia publishers, newspapers, postcard companies, calendar companies and greeting card companies.

• This agency has joined the Kodak Picture Exchange, an online photo network.

Needs: "We specialize in nature photography with an emphasis on all animal life."

Specs: Uses 8 × 10 glossy or matte b&w prints; 35mm and some larger format color transparencies.

Payment & Terms: Pays 50% commission. Works on contract basis only. Offers exclusive contracts. Contracts renew automatically for five years. Charges catalog insertion fee of 50%. Photographers allowed to review account records to verify sales figures "if requested and with proper notice and cause." Statements issued quarterly. Payment made quarterly. Offers one-time and electronic media rights; other uses negotiable. Informs photographer and allows him to negotiate when client requests all rights. Model release required if used for advertising. Captions required, include Latin names, and "they must be correct!"

Making Contact: Interested in receiving work from newer, lesser-known photographers. Send material by mail for consideration. SASE. Reports in 1-2 months. Free photo guidelines with SASE. Tips sheet distributed regularly to established contributors.

Tips: "First, pre-edit your material. Second, know your subject."

■‡**(APL) ARGUS PHOTOLAND, LTD.,** Room 2106 Goldmark, 502 Hennessy Rd., Hong Kong. (852)2890-6970. Fax: (852)2881-6979. Director: Joan Li. Estab. 1992. Stock photo agency. Has 120,000 photos. Has one branch office. Clients include: advertising agencies, graphic houses, public relations firms, book/encyclopedia publishers, magazine publishers, postcard publishers, calendar companies, greeting card companies and mural printing companies, trading firms/manufacturers.

Needs: "We cover general subject matters with urgent needs of people (baby, children, woman, couple, family and man, etc.) in all situations; business and finance; industry; living facilities; flower arrangement/bonsai; waterfall/streamlet; securities; interior (including office/hotel lobby and shopping mall); cityscape and landscape; and highlight of Southeast Asian countries."

Specs: Any of 120mm transparencies.

Payment & Terms: Pays 50% commission. Offers volume discounts to customers. Works on contract basis only. Offers regional exclusivity. Contracts renew automatically with additional submissions. Charges 100% duping fees. Statements issued quarterly. Payment made quarterly. Offers one-time rights. Informs photographer and allows him to negotiate when client requests all rights. Model/property releases preferred. Photo captions required: include name of event(s), name of building(s), location and geographical area.

Making Contact: Interested in receiving work from newer, lesser-known photographers. Submit portfolio for review. Expects minimum initial submission of 300 pieces with periodic submission of at least 300 images quarterly. Reports in 1-2 weeks. Photo guidelines free with SASE.

APPALIGHT, Clay Rt. Griffith Run Rd., Box 89-C, Spencer WV 25276. Phone/fax: (304)927-2978. Director: Chuck Wyrostok. Estab. 1988. Stock photo agency. Has 20,000 photos. Clients include advertising agencies, public relations firms, businesses, book/encyclopedia publishers, magazine publishers, calendar companies, greeting card companies and graphic designers.

Needs: General subject matter with emphasis on child development and natural history, inspirational, cityscapes, travel. Special need for African-American and Hispanic people/lifestyles, active seniors, teens, handicapped people coping, US vacation spots. "Presently we're building comprehensive sections on animals, birds, flora and on positive solutions to environmental problems of all kinds."

Specs: Uses 8 × 10, glossy b&w prints; 35mm, 2¼ × 2¼, 4 × 5 transparencies.

Payment & Terms: Pays 50% commission. General price range: $150 and up. Works on contract basis only. Offers nonexclusive rights. Charges 100% duping rate. Statements issued quarterly. Payment made quarterly. Photographers allowed to review account records during regular business hours or by appointment. Offers one-time rights, electronic media rights. "When client requests all rights photographer is contacted for his consent, but we handle all negotiations." Model release preferred. Captions required; include who, what, where.

Making Contact: Interested in receiving work from newer, lesser-known photographers. Query with stock photo list. Expects minimum initial submission of 300-500 images with periodic submissions of 200-300 several times/year. Reports in 1 month. Photo guidelines sheet free with SASE. Market tips sheet distributed "periodically" to contracted photographers.

Tips: "We look for a solid blend of topnotch technical quality, style, content and impact contained in images that portray metaphors applying to ideas, moods, business, endeavors, risk-taking, teamwork and winning."

■**AQUINO PRODUCTIONS**, P.O. Box 15760, Stamford CT 06901-0760. (203)967-9952. Director: Andres Aquino. Stock photo agency, picture library. Has 300,000+ photos. Clients include: advertising agencies, public relations firms, audiovisual firms, businesses, book/encyclopedia publishers, magazine publishers, newspapers, postcard publishers, calendar companies, greeting card companies.
• This agency markets images via CD-ROM.
Needs: Photos of all subjects; heavy on people, travel, glamour, beauty and fashion.
Specs: Uses b&w prints; 35mm, 2¼×2¼, 4×5, 8×10 transparencies; VHS and ¾″ videotape.
Payment & Terms: Pays 50% commission on b&w and color photos. Also buys photographs in bulk. Average price per image (to clients): b&w $150-2,000; color $150-3,000. Enforces minimum prices. Offers volume discounts to customers; terms specified in photographer's contract. Photographers can choose not to sell images on discount terms. Works with or without signed contract. Offers exclusive and non-exclusive contracts. Contracts renew automatically with additional submissions for two years. Charges filing fee of $4/shipment; catalog insertion fee of 15%, 30% or 50%, "based on royalty desired by photographer." Statements issued bimonthly. Payment made monthly. Photographer is allowed to review account records pertaining to his/her sales from catalogs only. Offers one-time rights. Informs photographer and permits him to negotiate when client requests all rights. Model/property release required. Captions required; include description and location.
Making Contact: Interested in receiving work from newer, lesser-known photographers. Query with samples. Query with stock photo list. Samples kept on file. SASE. Expects minimum initial submission of 20-100 images, with additional submission of 20/month or more. Reports in 3 weeks. Photo guidelines free with SASE. Market tips sheet distributed from time to time in the form of newsletter. Send $4 for sample requests and guidelines.
Tips: "We prefer sharp, carefully edited images in your area of specialization. Trends: images with specific commercial applications and images that evoke emotions and intellectual responses."

*****ARCHIVE PHOTOS**, 530 W. 25th St., New York NY 10001. (212)620-3955. Fax: (212)645-2137. Contact: Photo Editor. Estab. 1989. Picture library, news/feature syndicate. Member of the Picture Agency Council of America (PACA). Has 20 million photos; 14,000 hours of film. Has 8 branch offices. Clients include: advertising agencies, public relations firms, audiovisual firms, businesses, book/encyclopedia publishers, magazine publishers, newspapers, postcard publishers, calendar companies, greeting card companies, multimedia publishers.
• This agency markets images on KPX, PNI, Presslink, Wieck Photo Database and CompuServe.
Needs: All types of historical and new photos.
Specs: Uses 8×10 color and b&w prints; 35mm transparencies.
Payment & Terms: Pays 60% commission on b&w and color photos; 50% commission on film and videotape. Average price per image (to clients): $125-5,000/b&w; $125-5,000/color; $20-100/sec of film. Enforces minimum prices. Offers volume discounts to customers; inquire about specific terms. Discount sales terms not negotiable. Works with or without contract. Offers nonexclusive contract. Contracts renew automatically with additional submissions. Statements issued monthly. Payment made monthly within 15 days. Photographers allowed to review account records. Offers one-time rights, electronic media rights, agency promotion rights. Does not inform photographer and allow him to negotiate when client requests all rights. Caption required.
Making Contact: Interested in receiving work from newer, lesser-known photographers. Query with résumé of credits. Does not keep samples on file. SASE. Expects minimum initial submission of 100 images. Reports in 3 weeks.

*****ARMS COMMUNICATIONS**, 1517 Maurice Dr., Woodbridge VA 22191. (703)690-3338. Fax: (703)490-3298. President: Jonathan Arms. Estab. 1989. Stock photo agency. Has 80,000 photos. Clients include: advertising agencies, public relations firms, businesses and magazine publishers.
Needs: Interested in photos of military/aerospace—US/foreign ships, foreign weapon systems (land, air and sea), weaponry being fired.
Specs: Uses 35mm transparencies.
Payment & Terms: Pays 50% commission on b&w and color photos. Average price per image (to clients): $200. Enforces minimum price of $100. Offers volume discounts to customers; terms specified in photographer's contract. Discount terms not negotiable. Works on contract basis only. Offers nonexclusive contracts. Contracts renew automatically with additional submissions for three years. Payment made within 60 days of invoice payment. Photographers allowed to review account records. Offers one-time rights. Does not negotiate when client requests all rights. Model release preferred. Captions required.
Making Contact: Interested in receiving work from newer, lesser-known photographers. Reports in 1-2 weeks.

*****‡ARQUIVO INTERNACIONAL DE COR, COMUNICAÇAO PELA IMAGEM, LDA.**, R.D. Cristovão da Gama, 138, 4150 Porto Portugal. (2)610 39 67. Fax: (2)610 89 50. Contact Manager: Maria

Guimaraes. Estab. 1986. Stock photo agency. Has 100,000 photos. Clients include: advertising agencies, public relations firms, audiovisual firms, businesses, magazine publishers, newspapers, postcard publishers, calendar companies, greeting card companies and packaging companies.

Subject Needs: "As a stock photo agency, we deal with general subjects. We are, however, deeply interested in starting to work on representing video and films."

Specs: Uses b&w, color prints; 35mm, 2¼×2¼, 4×5, 8×10 transparencies; European PAL System videotape.

Payment & Terms: Pays agencies 40-60% commission on b&w and color photos; pays photographers 50% commission. Average price per image (to clients): $330/b&w or color photo depending on usage. Works with or without a signed contract, negotiable; offers exclusive contracts. Contracts renew automatically with additional submissions every year. Statements issued quarterly. Payment made quarterly. Photographers permitted to review account records to verify sales figures or account for various deductions "whenever they want to check." Offers one-time rights or non-exclusive rights. Informs photographer and allows him to negotiate when client requests all rights. Model/property release required. Captions required; include reference number, site, situation.

Making Contact: Submit portfolio for review. Query with samples. Query with stock photo list. Samples kept on file. SASE. Expects minimum initial submission of 50-100 images. Reports in 1-2 months. Photo guidelines available. Market tips sheet distributed infrequently.

Tips: "As a stock photo agency, we should be prepared to provide any kind of image. Therefore we do have interest on general themes such as: men, architecture and art, economy, industry, traffic, science, technology and nature (animal and geography)."

■**ART RESOURCE**, 65 Bleecker St., 9th Floor, New York NY 10012. (212)505-8700. Fax: (212)420-9286. Permissions Director: Joanne Greenbaum. Estab. 1970. Stock photo agency specializing in fine arts. Member of the Picture Agency Council of America (PACA). Has access to 3 million photos. Clients include: advertising agencies, public relations firms, audiovisual firms, businesses, book/encyclopedia publishers, magazine publishers, newspapers, postcard publishers, calendar companies, greeting card companies and all other publishing and scholarly businesses.

Needs: Painting, sculpture, architecture *only.*

Specs: Uses 8×10 b&w prints; 35mm, 4×5, 8×10 transparencies.

Payment & Terms: NPI. Average price per image: $75-500/b&w photo; $185-10,000/color photo. Negotiates fees below standard minimum prices. Offers volume discounts to customers; terms specified in photographer's contract. Discount sales terms not negotiable. Offers exclusive only or nonexclusive rights. Contracts renew automatically with additional submissions. Statements issued quarterly. Payment made quarterly. Photographers allowed to review account records. Offers one-time rights, electronic media rights, agency promotion and other negotiated rights. Photo captions required.

Making Contact: Query with stock photo list. "Only fine art!"

Tips: "We only represent European fine art archives and museums in US and Europe, but occasionally represent a photographer with a specialty in certain art."

■‡**BARNABY'S PICTURE LIBRARY**, Barnaby House, 19 Rathbone St., London W1P 1AF England. (071)636-6128. Fax: (071)637-4317. Contact: Mrs. Mary Buckland. Stock photo agency and picture library. Has 4 million photos. Clients include: ad agencies, public relations firms, audiovisual firms, businesses, book/encyclopedia publishers, magazine publishers, newspapers, film production companies, BBC, all TV companies, record companies, etc.

Specs: Uses 8×10 b&w prints; 35mm, 2¼×2¼, 4×5 and 8×10 transparencies.

Payment & Terms: Pays 50% commission on b&w and color photos. Works on contract basis only. Offers nonexclusive rights. "Barnaby's does not mind photographers having other agents as long as there are not conflicting rights." Statements issued semi-annually. Payment made semi-annually. "Very detailed statements of sales for photographers are given to them biannually and tearsheets kept." Offers one-time rights. "The photographer must trust and rely on his agent to negotiate best price!!" Model release required. Captions required.

Making Contact: Interested in receiving work from newer, lesser-known photographers. Arrange a personal interview to show portfolio. Send unsolicited photos by mail for consideration. Submit portfolio for review. SASE. "Your initial submission of material must be large enough for us to select a minimum of 200 pictures in color or b&w and they must be your copyright." Reports in 3 weeks. Photo guidelines free with SASE. Tips sheet distributed quarterly to anyone for SASE.

Tips: "Please ask for 'photographer's information pack' which (we hope) tells it all!"

■**ROBERT J. BENNETT, INC.**, 310 Edgewood St., Bridgeville DE 19933. (302)337-3347, (302)270-0326. Fax: (302)337-3444. President: Robert Bennett. Estab. 1947. Stock photo agency.

Needs: General subject matter.

Specs: Uses 8×10 glossy b&w prints; 35mm, 2¼×2¼ and 4×5 transparencies.

Payment & Terms: Pays 50% commission US; 40-60% foreign. Pays $5-50/hour; $40-400/day. Pays on publication. Works on contract basis only. Offers limited regional exclusivity. Charges filing fees

and duping fees. Statements issued monthly. Payment made monthly. Photographers allowed to review account records to verify sales figures. Buys one-time, electronic media and agency promotion rights. Informs photographer and allows him to negotiate when client requests all rights. Model/property release required. Captions required.

Making Contact: Interested in receiving work from newer, lesser-known photographers. Query with résumé of credits. Query with stock photo list. Provide résumé, business card, brochure or tearsheets to be kept on file for possible future assignments. Works on assignment only. Keeps samples on file. Reports in 1 month.

BIOLOGICAL PHOTO SERVICE, P.O. Box 490, Moss Beach CA 94038. (415)726-6244. Photo Agent: Carl W. May. Stock photo agency. Has 90,000 photos. Clients include: ad agencies, businesses, book/encyclopedia publishers and magazine publishers.
- This agency may begin CD storage of images in late 1995, but May says he is uncertain whether his agency will get involved with networking of images. "The network situation is still too unproven for us," he says.

Needs: All subjects in the life sciences, including agriculture, natural history and medicine. Stock photographers must be scientists. Subject needs include: color enhanced scanning electron micrographs; biotechnology; contemporary medical problems; MRI, CAT scan, PET scan, ultrasound, and X-ray images; animal behavior; tropical biology; and biological conservation. All aspects of general and pathogenic microbiology. All aspects of normal human biology and the basic medical sciences, including anatomy, human embryology and human genetics. Computer-generated images of molecules (structural biology).

Specs: Uses 4×5 through 11×14 glossy, high-contrast b&w prints; 35mm, $2\frac{1}{4} \times 2\frac{1}{4}$, 4×5, 8×10 transparencies. "Dupes acceptable for rare and unusual subjects, but we prefer originals."

Payment & Terms: Pays 50% commission on b&w and color photos. General price range: $90-500, sometimes higher for advertising uses. Works with or without contract. Offers exclusive contracts. Statements issued quarterly. Payment made quarterly; "one month after end of quarter." Photographers allowed to review account records to verify sales figures "by appointment at any time." Offers one-time, electronic media, promotion rights; negotiable. Informs photographer and allows him to negotiate when client requests all rights. "Photographer is consulted during negotiations for 'buyouts,' etc." Model or property release required for photos used in advertising and other commercial areas. Photo captions required; include complete identification of subject and location.

Making Contact: Interested in receiving work from newer, lesser-known photographers if they have the proper background. Query with list of stock subjects and résumé of scientific and photographic background. SASE. Reports in 2 weeks. Photo guidelines free with query, résumé and SASE. Tips sheet distributed intermittently to stock photographers only.

Tips: "When samples are requested, we look for proper exposure, maximum depth of field, adequate visual information and adequate technical and general information in captions. Requests fresh light and electron micrographs of traditional textbook subjects; applied biology such as biotechnology, agriculture, industrial microbiology, and medical research; biological careers; field research. We avoid excessive overlap among our photographer/scientists. We are experiencing an ever-growing demand for photos covering environmental problems of all sorts—local to global, domestic and foreign. Tropical biology, marine biology, and forestry are hot subjects. Our three greatest problems with potential photographers are: 1) inadequate captions; 2) inadequate quantities of *good* and *diverse* photos; 3) poor sharpness/depth of field/grain/composition in photos."

■D. DONNE BRYANT STOCK PHOTOGRAPHY, P.O. Box 80155, Baton Rouge LA 70898. (504)763-6235. Fax: (504)763-6894. President: Douglas D. Bryant. Stock photo agency. Currently represents 110 professional photographers. Has 400,000 photos. Clients include: ad agencies, audiovisual firms, book/encyclopedia publishers and magazine publishers.

Needs: Specializes in picture coverage of Latin America with emphasis on Mexico, Central America, South America, the Caribbean Basin and the Southern USA. Eighty percent of picture rentals are for editorial usage. Important subjects include agriculture, anthropology/archeology, art, commerce and industry, crafts, education, festivals and ritual, geography, history, indigenous people and culture, museums, parks, political figures, religion, scenics, sports and recreation, subsistence, tourism, transportation, travel and urban centers.

A bullet has been placed within some listings to introduce special comments by the editor of **Photographer's Market.**

Specs: Accepts 35mm, 2¼×2¼ and 4×5 color transparencies.
Payment & Terms: Pays 50% commission; 30% on foreign sales through foreign agents. General price range: $85-1,600. Works with or without a signed contract, negotiable. Offers nonexclusive contracts. Statements issued immediately after lease. Payment made immediately after lease. Does not allow photographers to review account records to verify sales figures. "We are a small agency and do not have staff to oversee audits." Offers one-time, electronic media, world and all language rights. Informs photographer and allows him to negotiate when client requests all rights. Offers $1,500 per image for all rights. Model/property release preferred, especially for ad set-up shots. Captions required; include location and brief description.
Making Contact: Interested in receiving work from newer, lesser-known professional photographers. Query with résumé of credits and list of stock photo subjects. SASE. Reports in 1 month. Photo guidelines free with SASE. Tips sheet distributed every 3 months to agency photographers.
Tips: "Speak Spanish and spend 1 to 6 months shooting in Latin America every year. Follow our needs list closely. Shoot Fuji transparency film and cover the broadest range of subjects and countries. We have an active duping service where we provide European and Asian agencies with images they market in film and on CD."

■**CALIFORNIA VIEWS/Pat Hathaway Historical Collection**, 469 Pacific St., Monterey CA 93940. (408)373-3811. Fax: (408)373-3733. Photo Archivist: Pat Hathaway. Picture library; historical collection. Has 70,000 b&w images, 8,000 35mm color. Clients include: ad agencies, public relations firms, audiovisual firms, book/encyclopedia publishers, magazine publishers, museums, postcard companies, calendar companies, television companies, interior decorators, film companies.
Needs: Historical photos of California from 1860-1990.
Payment & Terms: NPI.
Making Contact: "We accept donations of photographic material in order to maintain our position as one of California's largest archives." Does not return unsolicited material. Reports in 3 months.

■**CAMERIQUE INC. INTERNATIONAL**, Main office: Dept. PM, 1701 Skippack Pike, P.O. Box 175, Blue Bell PA 19422. (610)272-4000. Fax: (610)272-7651. Representatives in Boston, Los Angeles, Chicago, New York City, Montreal, Sarasota, Florida; and Tokyo. Photo Director: Christopher C. Johnson. Estab. 1973. Has 1 million photos. Clients include: advertising agencies, public relations firms, audiovisual firms, businesses, book/encyclopedia publishers, magazine publishers, newspapers, postcard companies, calendar companies, greeting card companies.
 • Don't miss the listing in this section for American Stock Photography, which is a subsidiary of Camerique.
Needs: General stock photos, all categories. Emphasizes people activities all seasons. Always need large format color scenics from all over the world. No fashion shots. All people shots, including celebrities, must have releases.
Specs: Uses 35mm, 2¼, 4×5 transparencies; b&w contact sheets; b&w negatives; "35mm accepted if of unusual interest or outstanding quality."
Payment & Terms: Sometimes buys photos outright; pays $10-25/photo. Also pays 50-60% commission on b&w/color after sub-agent commissions. General price range: $300-500. Works on contract basis only. Offers nonexclusive contracts. Contracts are valid "indefinitely until cancelled in writing." Charges 50% of cost of catalog insertion fee; for advertising, CD and online services. Statements issued monthly. Payment made monthly; within 10 days of end of month. Photographers allowed to review account records. Offers one-time rights, electronic media and multirights. Informs photographer and allows him to negotiate when client requests all rights. Model/property release required for people, houses, pets. Captions required; include "date, place, technical detail and any descriptive information that would help to market photos."
Making Contact: Query with list of stock photo subjects. Send unsolicited photos by mail for consideration. "Send letter first, we'll send our questionnaire and spec sheet." SASE. Reports in 2 weeks. "You must include correct return postage for your material to be returned." Tips sheet distributed periodically to established contributors.
Tips: Prefers to see "well-selected, edited color on a variety of subjects. Well-composed, well-lighted shots, featuring contemporary styles and clothes. Be creative, selective, professional and loyal. Communicate openly and often."

CATHOLIC NEWS SERVICE, 3211 Fourth St. NE, Washington DC 20017-1100. Photos/Graphics Manager: Nancy Wiechec. Photos/Graphics Researcher: Sarah Davis. Wire service transmitting news, features and photos to Catholic newspapers and stock to Catholic publications.
Needs: News or feature material related to the Catholic Church or Catholics; head shots of Catholic newsmakers; close-up shots of news events, religious activities. Also interested in photos aimed toward a general family audience and photos depicting modern lifestyles, e.g., family life, human interest, teens, poverty, active senior citizens, families in conflict, unusual ministries, seasonal and humor.

Specs: Uses 8 × 10 glossy prints.
Payment & Terms: Pays $25/photo; $75-200/job. Charges 50% on stock sales. Statements never issued. Payment made monthly. Offers one-time rights. Informs photographer and allows him to negotiate when client requests all rights. Model/property release preferred. Captions preferred; include who, what, when, where, why.
Making Contact: Send material by mail for consideration. SASE.
Tips: Submit 10-20 good quality prints covering a variety of subjects. Some prints should have relevance to a religious audience. "Knowledge of Catholic religion and issues is helpful. Read a Diocesan newspaper for ideas of the kind of photos used. Photos should be up-to-date and appeal to a general family audience. No flowers, no scenics, no animals. As we use more than 1,000 photos a year, chances for frequent sales are good. Send only your best photos."

‡**CEPHAS PICTURE LIBRARY**, 20 Bedster Gardens, West Molesey, Surrey KT8 1SZ United Kingdom. (0181)979-8647. Fax: (0181)224-8095. Director: Mick Rock. Picture library. Has 80,000 photos. Clients include: ad agencies, public relations firms, businesses, book/encyclopedia publishers, magazine publishers, postcard companies and calendar companies.
Needs: "We are a general picture library covering all aspects of all countries. Wine industry, food and drink are major specialties."
Specs: Prefers 2¼ × 2¼ transparencies, 35mm accepted.
Payment & Terms: Pays 50% commission for color photos. General price range: £50-500 (English currency). Offers one-time rights. Model release preferred. Captions required.
Making Contact: Send best 40 photos by mail for consideration. SASE. Reports in 1 week. Photo guidelines for SASE.
Tips: Looks for "transparencies in white card mounts with informative captions and names on front of mounts. Only top-quality, eye-catching transparencies required."

CHINASTOCK PHOTO LIBRARY, 22111 Cleveland, #211, Dearborn MI 48124-3461. Phone/fax: (313)561-1842. Director: Dennis Cox. Estab. 1993. Stock photo agency. Has 10,000 photos. Has branch office in Beijing, China. Clients include: advertising agencies, public relations firms, book/encyclopedia publishers, magazine publishers, newspapers, calendar companies.
Needs: Only handles photos of China (including Hong Kong and Taiwan) including tourism, business, historical, cultural relics, etc. Need hard-to-locate photos of all but tourism and exceptional images of tourism subjects.
Specs: Uses 5 × 7 to 8 × 10 glossy b&w prints; 35mm transparencies. Pays 50% commission on b&w and color photos. Negotiates fees below standard minimum prices. "Prices are based on usage and take into consideration budget of client." Offers volume discounts to customers. Photographers can choose not to sell images on discount terms. Works with or without a signed contract. "Will negotiate contract to fit photographer's and agency's mutual needs." Photographers are paid quarterly. Photographers allowed to review account records. Offers one-time rights and electronic media rights. Informs photographer and allows him to negotiate when client requests all rights. Model/property release preferred. Captions required; include where image was shot and what is taking place.
Making Contact: Query with stock photo list. "Let me know if you have unusual material." Keeps samples on file. SASE. Agency is willing to accept one great photo and has no minimum submission requirements. Reports in 1-2 weeks. Market tips sheet available upon request.
Tips: Agency "represents mostly veteran Chinese photographers. We're not interested in usual photos of major tourist sites. We have those covered. We plan to offer catalog on CD-ROM in the future."

■**BRUCE COLEMAN PHOTO LIBRARY**, 117 E. 24th St., New York NY 10010. (212)979-6252. Fax: (212)979-5468. Photo Director: Linda Waldman. Estab. 1970. Stock photo agency. Member of Picture Agency Council of America (PACA). Has 1 million photos. Clients include: advertising agencies, public relations firms, audiovisual firms, businesses, book/encyclopedia publishers, magazine publishers, newspapers, postcard publishers, calendar companies, greeting card companies, zoos (installations), TV.
Needs: Nature, travel, science, people, industry.
Specs: Uses 35mm, 2¼ × 2¼, 4 × 5 color transparencies.
Payment & Terms: Pays 50% commission on color film. Average price per image (to clients): color $175-975. Works on exclusive contract basis only. Contracts renew automatically for 5 years. Statements issued quarterly. Payment made quarterly. Does not allow photographer to review account records; any deductions are itemized. Offers one-time rights. Informs photographer and allows him to negotiate when client requests all rights. Model/property release preferred for people, private property. Captions required; location, species, genus name, Latin name, points of interest.
Making Contact: Query with résumé of credits. Samples kept on file. SASE. Expects minimum initial submission of 300 images with annual submission of 2,000. Reports in 3 months on completed submission; 1 week acknowledgement. Photo guidelines free with SASE. Catalog available. Want lists distributed to all active photographers monthly.

Tips: "We look for strong dramatic angles, beautiful light, sharpness. No gimmicks (prism, color, starburst filters, etc.). We like photos that express moods/feelings and show us a unique eye/style. We like work to be properly captioned. Caption labels should be typed or computer generated and they should contain all vital information regarding the photograph." Sees a trend "toward a journalistic style of stock photos. We are asked for natural settings, dramatic use of light and/or angles. Photographs should not be contrived and should express strong feelings toward the subject. We advise photographers to shoot a lot of film, photograph what they really love and follow our want lists."

■‡**COLORIFIC PHOTO LIBRARY,** The Innovation Centre, 225 Marsh Wall, London E14 9FX England. (071)515-3000. Fax: (071)538-3555. Editorial Director: Christopher Angeloglou. Estab. 1970. Picture library, news/feature syndicate. Has 300,000 photos. Clients include: advertising agencies, public relations firms, audiovisual firms, book/encyclopedia publishers, magazine publishers, newspapers, calendar companies.
Specs: Uses 35mm, 2¼×2¼ transparencies.
Payment & Terms: Pays 50% commission on color photos. Average price per image (to clients): $150-350/color photo. Enforces minimum prices. "Prices vary according to type of market." Photographers have option of not allowing their work to be discounted. Works with or without contract. Offers limited regional exclusivity and nonexclusive contracts. Contracts renew automatically with additional submissions every three-five years. Statements issued quarterly. Payment made quarterly. Offers one-time rights. Informs photographer and allows him to negotiate when client requests all rights. Model/property release preferred. Captions required.
Making Contact: Query with résumé of credits. SASE. Expects minimum initial submission of 250 images. Review held after first submission received. Reports as needed. Photo guidelines free with SASE (IRCs).

‡**EDUARDO COMESANA-AGENCIA DE PRENSA,** Casilla de Correo 178 (Suc.26), Buenos Aires 1426 Argentina. (541)771-9418, 773-5943. Fax: (541)777-3719. Director: Eduardo Comesana. Stock photo agency, picture library and news/feature syndicate. Has 500,000 photos. Clients include: ad agencies, book/encyclopedia publishers, magazine publishers and newspapers.
Needs: Personalities, entertainment, politics, science and technology, expeditions, archeology, travel, industry, nature, human interest, education, medicine, foreign countries, agriculture, space, ecology, leisure and recreation, couples, families and landscapes. "We have a strong demand for science-related subjects like shown in *Discover, Smithsonian* and *National Geographic* magazines."
Specs: Uses 8×10 glossy b&w prints; 35mm, 2¼×2¼ and 4×5 transparencies.
Payment & Terms: Pays $80/b&w photo; $100-300/color photo; 60% commission. Works with or without contract; negotiable. Offers limited regional exclusivity. Contracts continue "indefinitely unless terminated by either party with not less than 90 days written notice." Statements issued quarterly. Payment made quarterly. Photographers allowed to review account records to verify sales figures. Offers one-time and electronic media rights. Informs photographer and allows him to negotiate when client requests all rights. Model/property release preferred. Photo captions required; include "who, what, where, when, why and how."
Making Contact: "Send introductory letter or fax stating what photographer wants to syndicate. Do not send unsolicited material without previous approval. We would like to know as much as possible about the prospective contributor. A complete list of subjects will be appreciated." Include IRCs or check for postage in US dollars. Reports in 1 month.
Tips: Represents Black Star in South America; Woodfin Camp & Associates, Outline Press Syndicate from New York City; and Shooting Star from Los Angeles. "We would like to review magazine-oriented stories with a well-written text and clear captions. In case of hot news material, please fax or phone before sending anything. Freelancer should send us an introductory letter stating the type of photography he intends to sell through us. In our reply we will request him to send at least 5 stories of 10 to 20 colors each, for review. We would like to have some clippings of his photography."

COMPIX PHOTO AGENCY, 3621 NE Miami Court, Miami FL 33137. (305)576-0102. Fax: (305)576-0064. President: Alan J. Oxley. Estab. 1986. News/feature syndicate. Has 1 million photos. Clients include: advertising agencies, public relations firms, book/encyclopedia publishers, magazine publishers and newspapers.
Needs: Wants news photos and news/feature picture stories, human interest, celebrities and stunts.
Specs: Uses 35mm, 2¼×2¼, 4×5, 8×10 transparencies.
Payment & Terms: Pays 50% commission. Average price per image $175-up. Will sometimes negotiate fees below standard minimum, "if client is buying a large layout." Works with or without contract. Statements issued monthly. Payment made monthly. Photographers allowed to review account records "if showing those records does not violate privacy of other photographers." Offers one-time or negotiated rights based on story, quality and exclusivity. Photographer will be consulted when client wants all rights, but agency does negotiating. Photo captions required; include basic journalistic info.

Making Contact: "Show us some tearsheets."
Tips: "This is an agency for the true picture journalist, not the ordinary photographer. We are an international news service which supplies material to major magazines and newspapers in 30 countries and we shoot hard news, feature stories, celebrity, royalty, stunts, animals and things bizarre. We offer guidance, ideas and assignments but work *only* with experienced, aggressive photojournalists who have good technical skills and can generate at least some of their own material."

■**COMSTOCK, INC.**, 30 Irving Place, New York NY 10003. (212)353-8600. Contact: Stacia Meryl. Member of Picture Agency Council of America (PACA). Has 4 million photos. Clients include: ad agencies, public relations and audiovisual firms, businesses, book/encyclopedia and magazine publishers, newspapers, and postcard, calendar and greeting card companies.
Needs: Write for subject guidelines.
Specs: Uses 35mm, 2¼×2¼, 4×5 or 8×10 prints.
Payment & Terms: General price range: $150-20,000. Works on contract basis only. Offers exclusive contract only. Contracts renew automatically with each submission for one year after first 5-year base period. Statements issued monthly. Payment made monthly. Offers one-time rights and nonexclusive rights. "We do not sell all rights and discourage the practice. If client does ask, the photographer is informed." Model and/or property release preferred; "must have model releases for commercial files." Photo captions required; include "who, what, when, where, why."
Making Contact: Query with résumé of credits or list of stock photo subjects. SASE. Reports in 3 weeks.
Tips: "We represent very few photographers, all of whom are extremely productive, most of whom make their living from stock photography. We could use more coverage in the science and hi-tech areas, child-development from birth to adulthood. We also need more coverage of general industry, food and sports. We look for creativity, originality, a recognizable point of view, consistent technical excellence. Have an area of specialty and expertise. Present a scrupulously *edited* portfolio. Know and understand what stock is and what competition is out there; have a specialty that you care about passionately."

■**CUSTOM MEDICAL STOCK PHOTO**, Dept. PM, 3819 N. Southport Ave., Chicago IL 60613. (312)248-3200. Fax: (312)248-7427. E-mail: CMSP@delphi.com. Medical Archivist: Mike Fisher. Member of Picture Agency Council of America (PACA). Clients include: ad agencies, magazines, journals, textbook publishers, design firms, audiovisual firms and hospitals. All commercial and editorial markets that express interest in medical and scientific subject area.
Needs: Biomedical, scientific, healthcare environmentals and general biology for advertising illustrations, textbook and journal articles, annual reports, editorial use and patient education.
Specs: Uses 35mm, 2¼×2¼ and 4×5 transparencies. Negatives for electron microscopy. 4×5 copy transparencies of medical illustrations.
Payment & Terms: Pays per shot or commission. Per-shot rate depends on usage. Commission: 50% on domestic leases; 30% on foreign leases. Works on contract basis only. Offers nonexclusive contracts. Contracts renew automatically with additional submissions; for 1 year. Charges $5.50/70mm duping fees. Statements issued bimonthly. Payment made bimonthly. Credit line given if applicable, client discretion. Offers one-time, electronic media and agency promotion rights; other rights negotiable. Does not inform photographer and permit him to negotiate when a client requests all rights.
Making Contact: Query with list of stock photo subjects and request current want list and submission packet. "PC captioning disk available for database inclusion, please request. Do not send uncaptioned unsolicited photos by mail." SASE. Reports on average 1 month. Monthly want list available by US mail, and by fax. Model and property release copies required. "Information to contributors is available through our own online system. Windows or Macintosh dial (312)975-4262; download software for Mac or PC."
Tips: "Our past want lists are a valuable guide to the types of images requested by our clients. Past want lists are available. Environmentals of researchers hi-tech biomedicine, physicians, nurses and patients of all ages in situations from neonatal care to mature adults are requested frequently. Almost any image can qualify to be medical if it touches an area of life: breakfast, sports, etc. Trends also follow newsworthy events found on newswires. Photos should be good clean images that portray a single idea, whether it is biological, medical or scientific. Photographers should possess the ability to recognize the newsworthiness of subjects. Put together a minimum of 50 images for submission. Call before shipping to receive computer disk and caption information and return information. Contributing to our agency can be very profitable if a solid commitment can exist."

CYR COLOR PHOTO AGENCY, Box 2148, Norwalk CT 06852. (203)838-8230. Contact: Judith A. Cyr. Has 125,000 transparencies. Clients include: ad agencies, businesses, book publishers, magazine publishers, encyclopedia publishers, calendar companies, greeting card companies, poster companies and record companies.

Needs: "As a stock agency, we are looking for all types. There has been a recent interest in family shots (with parents and children) and people in day-to-day activities. Also modern offices with high-tech equipment and general business/professional settings. Mood shots, unusual activities, etc. are always popular—anything not completely 'standard' and common. Photos must be well-exposed and sharp, unless mood shots."

Specs: Uses 35mm to 8 × 10 transparencies.

Payment & Terms: Pays 50% commission. Works on contract basis only. Offers nonexclusive contract. Statements are never issued. Payment made upon payment from client. Photographers can inquire about their own accounts only. Offers one-time rights, all rights, first rights or outright purchase; price depending upon rights and usage. Informs photographer and allows him to negotiate when client requests all rights. Model release preferred. Captions required, include location and, if it is a flower or animal, include species.

Making Contact: Interested in receiving work from newer, lesser-known photographers. Send material by mail for consideration. SASE. "Include postage for manner of return desired." Reports in 1 month. Distributes tips sheet periodically to active contributors; "usually when returning rejects."

Tips: Each submission should be accompanied by an identification sheet listing subject matter, location, etc., for each photo included in the submission. All photos should be in vinyl holders and properly numbered, with photographer's initials. "We have received more requests from clients to use 35mm in a slide presentation only (i.e., one time) and/or in a video presentation. Thus, there are more uses of a photo with limited copyright agreements."

■**LEO DE WYS INC.**, 1170 Broadway, New York NY 10001. (212)689-5580. Fax: (212)545-1185. President: Leo De Wys. Office Manager: Laura Diez. Member of Picture Agency Council of America (PACA). Has 1 million photos. Clients include: ad agencies, public relations and AV firms; business; book, magazine and encyclopedia publishers; newspapers, calendar and greeting card companies; textile firms; travel agencies and poster companies.

Needs: Travel and destination (over 2,000 categories); and released people pictures in foreign countries (i.e., Japanese business people, German stockbrokers, English nurses, Mexican dancers, exotic markets in Asia, etc.).

Specs: Uses 35mm, medium format and 4 × 5 transparencies.

Payment & Terms: Price depends on quality and quantity. Usually pays 50% commission; 33⅓% for foreign sales. General price range: $125-6,500. Works with photographers on contract basis only. Offers exclusive and limited regional exclusive contracts; prefers to offer exclusive contract. Contracts renew automatically for five years. Offers to clients "any rights they want to have; payment is calculated accordingly." Charges 50% catalog insertion fee. "Company advances duping cost and deducts after sale has been made." Statements issued bimonthly and quarterly. Payment made bimonthly and quarterly. Photographers allowed to review account records to verify their sales figures. Offers one-time rights. Informs photographers and permits them to negotiate when client requests all rights; some conditions. Model release required; "depends on subject matter." Captions preferred.

Making Contact: Query with samples—"(about 40 pix) is the best way." Query with list of stock photo subjects or submit portfolio for review. SASE. Reporting time depends; often the same day. Photo guidelines free with SASE.

Tips: "Photos should show what the photographer is all about. They should show technical competence—photos that are sharp, well-composed, have impact; if color they should show color. Company now uses bar coded computerized filing system." Seeing trend toward more use of food shots tied in with travel such as "key lime pie for Key West and Bavarian beer for Germany. Also more shots of people—photo-released and in local costumes. Currently, the destinations most in demand are the USA, Canada, Mexico and the Caribbean."

DESIGN CONCEPTIONS, 112 Fourth Ave., New York NY 10003. (212)254-1688. Owner: Elaine Abrams. Picture Agent: Joel Gordon. Estab. 1970. Stock photo agency. Has 500,000 photos. Clients include: book/encyclopedia publishers, magazine publishers, advertising agencies.

Needs: "Real people."

Specs: Uses 8 × 10 RC b&w prints; 35mm transparencies.

Payment & Terms: Pays 50% commission on b&w and color photos. Average price per image (to clients): $160/b&w; $185/color. Enforces minimum prices. Offers volume discounts to customers; terms specified in photographer's contract. Works with or without contract. Offers limited regional exclusivity, nonexclusive. Statements issued "after check has cleared—next day with check to photographer." Payment made "after check has cleared—next day." Photographers allowed to review account records. Offers one-time rights. Offers electronic media and agency promotion rights. Informs photographer when client requests all rights. Model/property release preferred. Captions preferred.

Making Contact: Interested in receiving work from newer, lesser-known photographers. Arrange personal interview to show portfolio. Query with samples.

Tips: Looks for "real people doing real, not set up, things."

DEVANEY STOCK PHOTOS, 755 New York Ave., Suite 306, Huntington NY 11743. (516)673-4477. Fax: (516)673-4440. President: William Hagerty. Photo Editors: Carole Boccia and Kathleen Bob. Has over 500,000 photos. Clients include: ad agencies, book publishers, magazines, corporations and newspapers. Previous/current clients: Young & Rubicam, BBD&O, Hallmark Cards, *Parade* Magazine, MacMillan Publishing, Harcourt Brace & Jovanovich, *Newsday.*
Needs: Accidents, animals, education, medical, artists, elderly, scenics, assembly lines—auto and other, entertainers, schools, astronomy, factory, science, automobiles, family groups, aviation, finance, babies, fires, shipping, movies, shopping, flowers, food, beaches, oceans, skylines, foreign, office, birds, sports, gardens, operations, still life, pets, business, graduation, health, police, teenagers, pollution, television, children, history, hobbies, travel, churches, holidays, cities, weddings, communications, houses, women, writing, zoos, computers, housework, recreation, religion, couples, crime, crowds, dams, industry, laboratories, law, lawns, lumbering, restaurants, retirement, romance, etc.—virtually all subjects.
Specs: Uses all sizes of transparencies.
Payment & Terms: Does not buy photos outright. Pays 50% commission on color. Works with photographers with a signed contract. Contracts automatically renew for a 3-year period. Offers nonexclusive contract. Statements issued upon sale. Payment made monthly. Offers one-time rights. Model release preferred. Captions required.
Making Contact: Interested in receiving work from newer, lesser-known photographers. Query with list of stock photo subjects or send material by mail for consideration. SASE. Reports in 1 month. Free photo guidelines with SASE. Distributes monthly tips sheet free to any photographer. Model/property release preferred. Captions required. "Releases from individuals and homeowners are most always required if photos are used in advertisements."
Tips: "An original submission of 200 original transparencies in vinyl sheets is required. We will coach."

‡DIANA PHOTO PRESS AB, Box 6266, S-102 34 Stockholm Sweden. (46)8 314428. Fax: (46)8 314401. Manager: Diana Schwarcz. Estab. 1973. Clients include: magazine publishers and newspapers.
Needs: Personalities and portraits of well-known people.
Specs: Uses 18 × 24 b&w prints; 35mm transparencies.
Payment & Terms: Pays 30% commission on b&w and color photos. Average price per image (to clients): $150/b&w and color image. Enforces minimum prices. Works on contract basis only. Statements issued monthly. Payment made in 2 months. Offers one-time rights. Informs photographer and allows him to negotiate when client requests all rights. Captions required.
Making Contact: Query with samples. Samples kept on file. SASE. Does not report; "Wait for sales report."

■‡DINODIA PICTURE AGENCY, 13 Vithoba Lane, Vithalwadi, Kalbadevi, Bombay India 400 002. (91)22-2018572. Fax: (91)22-2067675. Owner: Jagdish Agarwal. Estab. 1987. Stock photo agency. Has 300,000 photos. Clients include: advertising agencies, public relations firms, audiovisual firms, businesses, book/encyclopedia publishers, magazine publishers, newspapers, postcard companies, calendar companies and greeting card companies.
Needs: "We specialize in photos on India—people and places, fairs and festivals, scenic and sports, animals and agriculture."
Specs: Uses 35mm, 2¼ × 2¼ and 4 × 5 transparencies.
Payment & Terms: Pays 50% commission on b&w and color photos. General price range: US $50-300. Negotiate fees below stated minimum prices. Offers volume discounts to customers; inquire about specific terms. Discount sales terms not negotiable. Works on contract basis only. Offers limited regional exclusivity. "Prefers exclusive for India." Contracts renew automatically with additional submissions for 5 years. Statement issued monthly. Payment made monthly. Photographers permitted to review sales figures. Informs photographer and allows him to negotiate when client requests all rights. Offers one-time rights. Model release preferred. Captions required.
Making Contact: Interested in receiving work from newer, lesser-known photographers. Query with résumé of credits, samples and list of stock photo subjects. SASE. Reports in 1 month. Photo guidelines free with SASE. Market tips sheet distributed monthly to contracted photographers.
Tips: "We look for style, maybe in color, composition, mood, subject-matter; whatever, but the photos should have above-average appeal." Sees trend that "market is saturated with standard documentary-type photos. Buyers are looking more often for stock that appears to have been shot on assignment."

■DRK PHOTO, 265 Verde Valley School Rd., Sedona AZ 86351. (602)284-9808. Fax: (602)284-9096. President: Daniel R. Krasemann. "We handle only the personal best of a select few photographers—not hundreds. This allows us to do a better job aggressively marketing the work of these photographers." Member of Picture Agency Council of America (PACA) and A.S.P.P. Clients include: ad agencies; PR and AV firms; businesses; book, magazine, textbook and encyclopedia publishers; newspapers; post-

card, calendar and greeting card companies; branches of the government, and nearly every facet of the publishing industry, both domestic and foreign.

Needs: "Especially needs marine and underwater coverage." Also interested in S.E.M.'s, African, European and Far East wildlife, and good rainforest coverage.

Specs: Uses 35mm, 2¼×2¼ and 4×5 transparencies.

Payment & Terms: Pays 50% commission on color photos. General price range: $100 "into thousands." Works on contract basis only. Offers nonexclusive contracts. Contracts renew automatically. Statements issued quarterly. Payment made quarterly. Offers one-time rights; "other rights negotiable between agency/photographer and client." Model release preferred. Captions required.

Making Contact: "With the exception of established professional photographers shooting enough volume to support an agency relationship, we are not soliciting open submissions at this time. Those professionals wishing to contact us in regards to representation should query with a brief letter of introduction and tearsheets."

■**DYNAMIC GRAPHICS INC., CLIPPER & PRINT MEDIA SERVICE**, 6000 N. Forest Park Dr., Peoria IL 61614. (309)688-8800. Photo Editor: Kim Gittrich. Clients include: ad agencies, printers, newspapers, companies, publishers, visual aid departments, TV stations, etc.

Needs: Generic stock photos (all kinds). "Our needs are somewhat ambiguous and require that a large number of photos be submitted for consideration. We will send a 'photo needs list' and additional information if requested."

Specs: Majority of purchases are b&w. Send 8×10 prints, contact sheets and high contrast conversions. Minimal use of 35mm and 4×5 transparencies.

Payment & Terms: Pays $50 and up/b&w photo (negotiable and competitive); $100 and up/color photo. **Pays on acceptance.** Rights are specified in contract. Model release required.

Making Contact: Interested in receiving work from newer, lesser-known photographers. Send tearsheets or folio of 8×10 b&w photos by mail for consideration; supply phone number where photographer may be reached during working hours. Reports in 6-8 weeks.

*****EARTHVIEWS, A Subsidiary of the Marine Mammal Fund**, Fort Mason Center, E205, San Francisco CA 94123. (415)775-0124. Fax: (415)921-1302. Librarian: Marilyn Delgado. Estab. 1971. Nonprofit stock photo agency. Has 8,000 photos. Clients include: advertising agencies, book/encyclopedia publishers, magazine publishers, newspapers, postcard publishers, calendar companies, exhibits and advocacy groups.

Needs: Wildlife (no captive animals) with emphasis on marine mammals.

Specs: Uses 35mm, 2¼×2¼, 4×5 transparencies; 16mm, 35mm film, Betacam SP, Hi-8, S-VHS videotape.

Payment & Terms: Pays 50% commission. Offers nonexclusive contract. Statements issued upon request. Payment made semiannually. Offers one-time rights. Informs photographer and allows him to negotiate when client requests all rights. Captions required; include species, location.

Making Contact & Terms: Interested in receiving work from newer, lesser-known photographers. Query with samples. Does not keep samples on file. SASE. Expects minimum initial submission of 20 images. Reports in 1-2 weeks.

Tips: "We do not hold originals. EarthViews will produce repro-quality duplicates and return all originals to the photographer. Contact us for more information."

■**ELITE PHOTOGRAPHY, INC.**, Box 14498, Toledo OH 43614. (419)385-9018. Director: Lori T. Cramer. Clients include: advertising agencies, public relations firms, audiovisual firms, businesses, magazine publishers, postcard companies, calendar and greeting card companies, book/encyclopedia publishers, video distributors.

Needs: "We are a stock agency that is specializing in photography of men and women, be it pretty pictures, cheesecake, nude, exotic, or erotic. Although we are strict on such rules as focusing and exposures, our needs are as varied as the marketplace—if it is saleable, we will sell it."

Specs: Uses 35mm and 2¼×2¼ transparencies. "Don't send larger transparencies or b&w unless she is a special subject."

Payment & Terms: Rarely buys photos/film outright. Pays 50% commission on b&w and color photos. General price range: $150-1,500, complete sets higher. Works on contract basis only. Contracts renew automatically with additional submissions; all for one-year extensions. Statements issued after sales within 45 days of receiving payment. Buys "any rights the photographers will sell." Model release required. Captions preferred.

Making Contact: Interested in receiving work from newer, lesser-known photographers. Query with samples. Send unsolicited photos by mail for consideration. "Send a professional-looking package certified to us. Make sure it is sent requesting a return receipt." SASE. Reports in 2 weeks. Photo guidelines, tip sheet free with SASE *and* samples. (No phone calls please.)

Tips: "Be able to compose, focus and expose a photograph properly. Remember that we specialize in photographs of men and women, with cheesecake and nude/erotic the biggest and fastest sales. Show

us you can produce marketable images, and we'll do the rest. Almost all of our magazine buyers are screaming for cover shots—shoot them! In addition, we also direct market sets overseas to publishers. This creates a very lucrative market for those with sets that have already sold in the US. We can still market them to the rest of the world. For those with such talent, Elite now deals in video and is interested in seeing sample VHS tapes that fall within our subject guidelines. We are very interested in seeing much more photography involving men and women working in all career fields and in various forms of play such as sports and other leisure activities. We also want more mother and child and family photography."

■**ENVISION**, 220 W. 19th St., New York NY 10011. (212)243-0415. Director: Sue Pashko. Estab. 1987. Stock photo agency. Member of the Picture Agency Council of America. Has 125,000 photos. Clients include: advertising agencies, public relations firms, businesses, book/encyclopedia publishers, magazine publishers, newspapers, calendar and greeting card companies and graphic design firms.
Needs: Professional quality photos of food, commercial food processing, fine dining, American cities (especially the Midwest), crops, Third World lifestyles, marine mammals, European landmarks, tourists in Europe and Europe in winter looking lovely with snow, and anything on Africa and African-Americans.
Specs: Uses 35mm, 2¼ × 2¼, 4 × 5 or 8 × 10 transparencies. "We prefer large and medium formats."
Payment & Terms: Pays 50% commission on b&w and color photos. General price range: $200 and up. Works on contract basis only. Statements issued monthly. Payment made monthly. Offers one-time rights; "each sale individually negotiated—usually one-time rights." Model/property release required. Captions required.
Making Contact: Arrange personal interview to show portfolio. Query with résumé of credits "on company/professional stationery." Regular submissions are mandatory. SASE. Reports in 1 month.
Tips: "Clients expect the very best in professional quality material. Photos that are unique, taken with a very individual style. Demands for traditional subjects *but* with a different point of view; African- and Hispanic-American lifestyle photos are in great demand. We have a need for model-released, professional quality photos of people with food—eating, cooking, growing, processing, etc."

■‡**GREG EVANS INTERNATIONAL**, 91 Charlotte St., London W1P ILB England. (0171)636-8238. Fax: (0171)637-1439. Manager: Greg Evans. Picture library. Has 250,000 photos. Clients include: ad agencies; public relations and audiovisual firms; businesses; book/encyclopedia and magazine publishers; newspapers; and postcard, calendar, greeting card and travel companies.
Specs: Uses 35mm, 2¼ × 2¼, 4 × 5, 2¼ × 2¾ and 8 × 10 transparencies.
Payment & Terms: Buys photos outright. Pays 50% commission on color photos. Offers one-time rights. Model release required.
Making Contact: Arrange a personal interview to show portfolio. Send unsolicited photos by mail for consideration. SASE. Reports in 1 week. Quarterly tips sheet free with SASE.
Tips: Wants to see "creativity, sharpness, clarity, perfect exposure, precise captions."

■**EWING GALLOWAY**, 100 Merrick Rd., Rockville Centre NY 11570. (516)764-8620. Fax: (516)764-1196. Photo Editor: Tom McGeough. Estab. 1920. Stock photo agency. Member of Picture Agency Council of America (PACA), American Society of Media Photographers (ASMP). Has 3 million photos. Clients include: advertising agencies, public relations firms, audiovisual firms, businesses, book/encyclopedia publishers, magazine publishers, newspapers, postcard companies, calendar companies, greeting card companies and religious organizations.
 • This agency is a charter member of the Kodak Picture Exchange, with more than 10,000 digital images online.
Needs: General subject library. Does not carry personalities or news items. Lifestyle shots (model released) are most in demand.
Specs: Uses 8 × 10 glossy b&w prints; 35mm, 2¼ × 2¼ and 4 × 5 transparencies.
Payment & Terms: Pays 30% commission on b&w photos; 50% on color photos. General price range: $400-450. Charges catalog insertion fee of $400/photo. Statements issued monthly. Payment made monthly. Offers one-time rights; also unlimited rights for specific media. Model/property release required. Photo captions required; include location, specific industry, etc.
Making Contact: Interested in receiving work from newer, lesser-known photographers. Query with samples. Send unsolicited photos by mail for consideration; **must include return postage.** SASE. Reports in 3 weeks. Photo guidelines with SASE (55¢). Market tips sheet distributed monthly; SASE (55¢).
Tips: Wants to see "high quality—sharpness, subjects released, shot only on best days—bright sky and clouds. Medical and educational material is currently in demand. We see a trend toward photography related to health and fitness, high-tech industry, and mixed race in business and leisure."

■**FINE PRESS SYNDICATE**, Box 22323, Ft. Lauderdale FL 33335. Vice President: R. Allen. Has 49,000 photos and more than 100 films. Clients include: ad agencies, public relations firms, businesses,

audiovisual firms, book publishers, magazine publishers, postcard companies and calendar companies worldwide.

Needs: Nudes, figure work and erotic subjects (female only).

Specs: Uses glossy color prints; 35mm, 2¼ × 2¼ transparencies; 16mm film; videocasettes: VHS and Beta.

Payment & Terms: Pays 50% commission on color photos and film. Price range "varies according to use and quality." Enforces minimum prices. Works on contract basis only. Offers exclusivity only. Statements issued monthly. Payment made monthly. Offers one-time rights. Does not inform photographer or permit him to negotiate when client requests all rights. Model/property release preferred.

Making Contact: Interested in receiving work from newer, lesser-known photographers. Send unsolicited material by mail for consideration or submit portfolio for review. SASE. Reports in 2 weeks.

Tips: Prefers to see a "good selection of explicit work. Currently have European and Japanese magazine publishers paying high prices for very explicit nudes. Clients prefer 'American-looking' female subjects. Send as many samples as possible. Foreign magazine publishers are buying more American work as the value of the dollar makes American photography a bargain. More explicit poses are requested."

***FIRST IMAGE WEST, INC.**, 921 W. Van Buren #201, Chicago IL 60607. (812)733-3239. Contact: Tom Neiman. Estab. 1985. Stock photo agency. Member of Picture Agency Council of America (PACA). Clients include: advertising agencies, public relations firms, businesses, book/encyclopedia publishers, magazine publishers, and newspapers. Clients include Bank of America, Wrangler Jeans, Jeep, America West Airlines.

Needs: Needs photos of lifestyles and scenics. Also general travel and model-released lifestyles.

Specs: Uses 35mm to panoramic.

Payment & Terms: Pays 50% commission on domestic photos. General price range: editorial, $185 and up; advertising, $230 base rate. Works on contract basis only. Offers limited regional exclusive and catalog exclusive contracts. Statements issued when payment is due. Payment made monthly. Photographers allowed to review account records to verify sales figures. Offers one-time rights and specific print and/or time usages. When client requests all rights, "we inform photographer and get approval of 'buyout' but agency is sole negotiator with client." Model/property release required for people, homes, vehicles, animals. Photo captions required.

Making Contact: Contact by telephone for photographer's package. SASE. Reports in 1 month. Photo guidelines free with SASE.

***FOLIO, INC.**, 3417½ M St., Washington DC 20007. President: Susan Soroko. Estab. 1983. Stock photo agency. Types of clients: newspapers, textbooks, education, industrial, retail, fashion, finance.

Needs: Works with 30-50 photographers/month. Photos used for billboards, consumer magazines, trade magazines, direct mail, P-O-P displays, catalogs, posters, signage and newspapers.

Specs: Uses 35mm, 2¼ × 2¼ and 4 × 5 transparencies.

Payment & Terms: Pays "50% of sales." Pays on publication or on receipt of invoice. Works on contract basis only. Offers one-time rights. Model release required. Photo captions required.

Making Contact: Arrange a personal interview to show portfolio. Provide résumé, business card, brochure, flier or tearsheets to be kept on file for possible future assignments. SASE. Reports in 3 weeks. Credit line given.

Tips: "Call first, send in requested information."

■✿FOTO EXPRESSION INTERNATIONAL (Toronto), Box 1268, Station "Q", Toronto, Ontario M4T 2P4 Canada. (905)935-2887. Fax: (905)935-2770. Director: John Milan Kubik. Selective archive of photo, film and audiovisual materials. Clients include: ad agencies; public relations and audiovisual firms; TV stations and networks; film distributors; businesses; book, encyclopedia, trade and news magazine publishers; newspapers; postcard, calendar and greeting card companies.

Needs: City views, aerial, travel, wildlife, nature/natural phenomena and disasters, underwater, aerospace, weapons, warfare, industry, research, computers, educational, religions, art, antique, abstract, models, sports. Worldwide news and features, personalities and celebrities.

Specs: Uses 8 × 10 b&w; 35mm and larger transparencies; 16mm, 35mm film; VHS, Beta and commercial videotapes (AV). Motion picture, news film, film strip and homemade video.

Payment & Terms: Sometimes buys transparencies outright. Pays 40% for b&w; 50% for color and 16mm, 35mm films and AV (if not otherwise negotiated). Offers one-time rights. Model release required for photos. Captions required.

Making Contact: Submit portfolio for review. The ideal portfolio for 8 × 10 b&w prints includes 10 prints; for transparencies include 60 selections in plastic slide pages. With portfolio you must send SASE with return postage (out of Canada—either money-order or International Reply Coupon). Reports in 3 weeks. Photo guidelines free with SASE. Tips sheet distributed twice a year only "on approved portfolio."

Tips: "We require photos, slides, motion picture films, news film, homemade video and AV that can fulfill the demand of our clientele." Quality and content is essential. Photographers, cameramen, reporters, writers, correspondents and representatives are required worldwide by FOTOPRESS, Independent News Service International, (905)935-2770, fax: (905)935-2770.

■‡**FOTO-PRESS TIMMERMANN**, Speckweg 34A, D-91096 Moehrendorf, Germany. 9131/42801. Fax: 9131/450528. Contact: Wolfgang Timmermann. Stock photo agency. Has 100,000 slides. Clients include: ad agencies, audiovisual firms, businesses, book/encyclopedia publishers, magazine publishers, newspapers and calendar companies.
Needs: All themes: landscapes, countries, travel, tourism, towns, people, business, nature.
Specs: Uses 2¼×2¼, 4×5 and 8×10 transparencies.
Payment & Terms: Pays 50% commission on color prints. Average price per image to clients: $130-300. Enforces strict minimum prices. Works on nonexclusive contract basis only. First period: three years, automatically renewed for one year. Offers one-time rights. Model/property release preferred. Captions required, include state, country, city, subject, etc.
Making Contact: Interested in receiving work from newer, lesser-known photographers. Query with list of stock photo subjects. Send unsolicited photos by mail for consideration. SASE. Reports in 1 month.

■**FOTOS INTERNATIONAL**, 4230 Ben Ave., Studio City CA 91604. (818)508-6400. Fax: (818)762-2181. Manager: Max B. Miller. Has 4 million photos. Clients include: ad agencies, public relations firms, businesses, book publishers, magazine publishers, encyclopedia publishers, newspapers, calendar companies, TV and posters.
Needs: "We are the world's largest entertainment photo agency. We specialize exclusively in motion picture, TV and popular music subjects. We want color only! The subjects can include scenes from productions, candid photos, rock, popular or classical concerts, etc., and must be accompanied by full caption information."
Specs: Uses 35mm color transparencies only.
Payment & Terms: Buys photos outright; no commission offered. Pays $5-200/photo. Offers one-time rights and first rights. Model release optional. Captions required.
Making Contact: Query with list of stock photo subjects. SASE. Reports in 1 month.

FPG INTERNATIONAL CORP., 32 Union Square E., New York NY 10003. (212)777-4210. Director of Photography: Rebecca Taylor. Affiliations Manager: Claudia Micare. A full service agency with emphasis on images for the advertising, corporate, design and travel markets. Member of Picture Agency Council of America (PACA).
Needs: High-tech industry, model-released human interest, foreign and domestic scenics in medium formats, still life, animals, architectural interiors/exteriors with property releases.
Specs: Minimum submission requirement per year—1,000 original color transparencies, exceptions for large format, 250 b&w full-frame 8×10 glossy prints.
Payment & Terms: Pays 50% commission upon licensing of reproduction rights. Works on contract basis only. Offers exclusive contract only. Contracts renew automatically upon contract date; 5-year contract. Charges catalog insertion fee; rate not specified. Statements issued monthly. Payment made monthly. Photographers allowed to review account records to verify sales figures. Licenses one-time rights. "We sell various rights as required by the client." When client requests all rights, "we will contact a photographer and obtain permission."
Making Contact: "Initial approach should be by mail. Tell us what kind of material you have, what your plans are for producing stock and what kind of commercial work you do. Enclose reprints of published work." Photo guidelines and tip sheets provided for affiliated photographers. Model/property releases required and must be indicated on photograph. Captions required.
Tips: "Submit regularly; we're interested in committed, high-caliber photographers only. Be selective and send only first-rate work. Our files are highly competitive."

FRANKLIN PHOTO AGENCY, 85 James Otis Ave., Centerville MA 02632. President: Nelson Groffman. Has 35,000 transparencies. Clients include: publishers, advertising and industrial.
Needs: Scenics, animals, horticultural subjects, dogs, cats, fish, horses, antique and classic cars, and insects.

 The maple leaf before a listing indicates that the market is Canadian.

Specs: Uses 35mm, 2¼×2¼ and 4×5 color transparencies. "More interest now in medium size format—2¼×2¼."

Payment & Terms: Pays 50% commission. General price range: $100-300; $60/b&w photo; $100/ color photo. Works with or without contract, negotiable. Offers nonexclusive contract. Statements issued when pictures are sold. Payment made within a month after sales when we receive payment. Offers one-time and one-year exclusive rights. Informs photographer and allows him to negotiate when client requests all rights. Model/property release required for people, houses; present release on acceptance of photo. Captions preferred.

Making Contact: Interested in receiving work from newer, lesser-known photographers. Query first with résumé of credits. SASE. Reports in 1 month.

Tips: Wants to see "clear, creative pictures—dramatically recorded."

***‡FRONTLINE PHOTO PRESS AGENCY**, P.O. Box 162, Kent Town, South Australia 5071. 61-8-333-2691. Fax: 61-8-364-0604. Director: Carlo Irlitti. Estab. 1988. Stock photo agency and picture library. Has 300,000 photos. Clients include: advertising agencies, book/encyclopedia publishers, magazine publishers, newspapers, postcard publishers, calendar companies, poster companies, graphic designers.

Needs: Wants photos of people, lifestyles, sports, cities and landscapes, travel, industrial and agricultural, natural history, enviromental, celebrities and important people, social documentary, concepts, science and medicine.

Specs: Uses 8×12 glossy color and b&w prints; 35mm, 2¼×2¼, 4×5, 8×10 transparencies.

Payment & Terms: Pays 60% commission on all images. Average price per image: b&w $175, color $225 (Australian currency). Enforces minimum prices. "Our lowest price is now fixed at $85 for AVs ($51 to the photographer) for all uses where reproductions are no bigger than 40mm or 1½" across." Stock for AVs is charged at a lower rate (depending on the amount to be used) and includes duping costs (client to pay). Works on contract basis but can work without if necessary. Offers non-exclusive contracts. Contracts renew automatically with additional submissions. Contracts are for a minimum of 3 years and are automatically renewed 6 months before the expiration date (if not advised in writing). Contracts concerning sports pictures are for a minimum of 1 year and are renewable at expiration date. No charges for filing or duping. Charges 50% catalog or photo CD insertion rate. Statements issued monthly. Payment made monthly and inside 30 days. Offers one-time rights and first-time rights, but also promotional rights, serial rights and exclusive rights. Under certain considerations photographers will be informed and allowed to negotiate when client requests all rights. Model/property release required.

Making Contact: Interested in receiving work from newer, lesser-known photographers. Query with samples or list of stock subjects. Send unsolicited photos for consideration. Works mostly with local freelancers but is willing to work with overseas freelancers on assignment. Samples not kept on file. SASE (include insurance and IRC). Expects minimum initial submission of 100-200 images with periodic submissions of 250-1,000 images/year. Reports in 1-2 weeks. Photo guidelines free with SASE. Market tips sheet distributed quarterly to photographers on contract; free upon request.

Tips: "We are looking for the creative freelance photographer who is dedicated to his/her work, who can provide unique and technically sound images and who is considering a long-term relationship with an Australian photo agency. We prefer our photographers to specialize in their subject coverage (one or two fields). All work submitted must be original, well-composed, well-lit (depending on the mood), sharp and meticulously edited with quality in mind. Remember the three Cs: color, composition and clarity. In the submission we prefer to see 100-200 of the photographer's best work. Send slides in 20-slide clear plastic files and not in glass mounts or loose in boxes. All material should be captioned or attached to an information sheet and indicate if model/property released. Model and property releases are mostly requested for advertising and are essential for quick sales. Please package work appropriately, we do not accept responsibility for losses or damage during transit. Before going on assignment research your subject, plan ahead and when photographing pre-visualize its final use. If needed, shoot it to fit various layout shapes. We direct our stock sales towards all media but the majority of our stock sales are now in the advertising and corporate fields where the markets are more lucrative. We would like all subjects covered equally but the ones mostly sought after are: environmental issues, people at work and at leisure, dramatic landscapes/scenics (captioned), general travel and concepts depicting real-life situations. We also need more pictures of sport (up and coming and established athletes who are making the news worldwide) and of celebrities and other important people (politicians, etc.) for our editorial clients. Freelancers who work for us or for any other stock photo agency or library must be hard, dedicated workers and professional and loyal in their outlook. Stock is constantly in demand and for the freelancer who is highly imaginative, who wants to make money out of his/her photography, there is always plenty of work. The agency provides regular advice for its contributors and will direct freelancers to photograph specific, market-oriented subjects as well as help in coordinating the photographer's own private assignments to assure saleable subjects."

■**FROZEN IMAGES, INC.**, 400 First Ave. N., Suite 512, Minneapolis MN 55401. (612)339-3191. Director of Photo Services: David Niebergall. Stock photo agency. Has approximately 175,000 photos. Clients include: ad agencies, public relations firms, audiovisual firms, graphic designers, businesses, book/encyclopedia publishers, magazine publishers, newspapers and calendar companies.
Needs: All subjects including abstracts, scenics, industry, agriculture, US and foreign cities, high tech, businesses, sports, people and families.
Specs: Uses transparencies.
Payment & Terms: Pays 50% commission on color photos. Works on contract basis only. Offers limited regional exclusivity. Contracts renew automatically with each submission; time period not specified. Charges catalog insertion fee; rate not specified. Statements issued monthly. Payment made monthly; within 10 days of end of month. Photographers allowed to review account records to verify sales figures "with notice and by appointment." Offers one-time rights. Informs photographers when client requests all rights, but agency negotiates terms. Model/property release required for people and private property. Photo captions required.
Making Contact: Query with résumé of credits. Query with list of stock photo subjects. SASE. Reports in 1 month or ASAP (sometimes 6 weeks). Photo guidelines free with SASE. Tips sheet distributed quarterly to photographers in the collection.
Tips: Wants to see "technical perfection, graphically strong, released (when necessary) images in all subject areas."

*****F-STOCK INC.**, P.O. Box 3956, Ketchum ID 83340. (208)726-1378. Fax: (208)726-8456. President: Kate Ryan. Vice President: Caroline Woodham. Estab. 1989. Stock photo agency. Member of the Picture Agency Council of America (PACA). Has 100,000 photos. Works with 3 agencies in France, Italy and Japan. Clients include: advertising agencies, public relations firms, audiovisual firms, businesses, book/encyclopedia publishers, magazine publishers, newspapers, postcard publishers, calendar companies, greeting card companies.
Needs: General stock agency—mostly specializing in outdoor sports, lifestyle, large format scenics, wildlife, adventure and travel.
Specs: Uses 35mm, 2¼×2¼, 4×5 transparencies (medium and large format); b&w images (chromes or however you can present).
Payment & Terms: Pays 50% on b&w; 50% on color. Enforces minimum prices . "We try to get the current market price." Works on contract basis only. Offers nonexclusive contract. Charges 25% duping fees, 50% separation fee for *Stock Workbook*. Statements issued monthly. Payment made monthly. Photographers allowed to review account records. Offers one-time rights. Does not inform photographer or allow him to negotiate when client requests all rights. Model/property release required. Captions required.
Making Contact: Interested in receiving work from newer, lesser-known photographers. "Write letter and we will send you guidelines." SASE. Expects minimum initial submission of 100 images for review with additional 2,000/year. Reports in 1-2 weeks. Photo guidelines free with SASE. Workbook ad available with SASE. Market tips sheet distributed once/week on our answering machine.
Tips: "We do not like too much inter-agency competition. We also need all material released so they can be used for commercial market."

F/STOP PICTURES INC., P.O. Box 359, Springfield VT 05156. (802)885-5261. Fax: (802)885-2625. President: John Wood. Estab. 1984. Stock photo agency. Member of Picture Agency Council of America (PACA). Has 140,000 photos. Clients include: advertising agencies, public relations firms, audiovisual firms, businesses, book/encyclopedia publishers, magazine publishers, newspapers, postcard companies, calendar companies and greeting card companies.
Needs: "We specialize in New England and rural America, but we also need worldwide travel photos and model-released people and families."
Specs: Uses 35mm, 2¼×2¼, 4×5, 8×10 transparencies.
Payment & Terms: Pays 50% commission on color photos. Average price per image: $225. Enforces minimum prices, minimum of $100, exceptions for reuses. Works on contract basis only. Offers nonexclusive contract, exclusive contract for some images only. Contracts renew automatically for four years. Statements issued monthly. Payment made monthly by 31st of statement month. Photographers allowed to review account records to verify sales figures. Offers one-time rights. Informs photographer and allows him to negotiate when client requests all rights. Model/property release required for recognizable people and private property. Captions required; include complete location data and complete identification (including scientific names) for natural history subjects.
Making Contact: Arrange a personal interview to show portfolio. Query with list of stock photo subjects. Submit portfolio for review. SASE. Reports in 2 weeks. Photo guidelines free with SASE. Market tips sheet distributed quarterly to contracted photographers only.
Tips: Especially wants to work with "professional full-time photographers willing to shoot what we need." Send minimum of 500 usable photos in initial shipment, and 500 usable per quarter thereafter."

Sees trend toward "more realistic people situations, fewer staged looking shots; more use of electronic manipulation of images."

FUNDAMENTAL PHOTOGRAPHS, Dept. PM, 210 Forsyth St., New York NY 10002. (212)473-5770. Fax: (212)228-5059. E-mail: 70214.3663@compuserve.com. Partner: Kip Peticolas. Estab. 1979. Stock photo agency. Applied for membership into the Picture Agency Council of America (PACA). Has 50,000 photos. Clients include: advertising agencies, book/encyclopedia publishers.
Needs: Science-related topics.
Specs: Uses 35mm, 2¼×2¼, 4×5 and 8×10 transparencies.
Payment & Terms: Pays on commission basis; b&w 40%, color 50%. General price range: $100-500/b&w photo; $150-1,200/color photo, depends on rights needed. Enforces minimum prices. Offers volume discount to customers. Informs photographer but does not allow him to negotiate when client requests all rights. Works on contract basis only. Offers guaranteed subject exclusivity. Contracts renew automatically with additional submissions. Charges duping fees $25/4×5 dupe. Payment made quarterly. Photographers allowed to review account records. Offers one-time and electronic media rights. Model release preferred. Captions required; include date and location.
Making Contact: Interested in receiving work from newer, lesser-known photographers. Arrange a personal interview to show portfolio. Submit portfolio for review. Query with résumé of credits, samples or list of stock photo subjects. Keeps samples on file. SASE. Expects minimum initial submission of 100 images. Reports in 1-2 weeks. Photo guidelines free with SASE. Tips sheet distributed.
Tips: "Our primary market is science textbooks. Photographers should research the type of illustration used and tailor submissions to show awareness of saleable material. We are looking for science subjects ranging from nature and rocks to industrials, medicine, chemistry and physics; macrophotography, stroboscopic, well lit still life shots are desirable. The biggest trend that affects us is the increased need for images that relate to the sciences and ecology."

■**GAMMA LIAISON**, 11 E. 26th St., New York NY 10010. (212)447-2525. Executive Vice President/Director: Jennifer Coley. Photographer Relations: Carlo Montali. Has 5 million plus photographs. Extensive stock files include news (reportage), human interest stories, movie stills, personalities/celebrities. Clients include: newspapers and magazines, book publishers, audiovisual producers and encyclopedia publishers.
● This agency has a second division, Liaison International, which specializes in corporate assignment work and stock files for advertising agencies and graphic designers.
Specs: Uses 35mm transparencies.
Payment & Terms: Pays 50% commission. Works on contract basis only. Statements issued monthly. Payment made monthly. Leases one-time rights. Captions required.
Making Contact: Submit portfolio with description of past experience and publication credits.
Tips: Involves a "rigorous trial period for first 6 months of association with photographer." Prefers previous involvement in publishing industry.

■‡**GEOSLIDES & GEO AERIAL (Photography)**, 4 Christian Fields, London SW16 3JZ England. Phone/fax: (0181)764-6292. Library Directors: John Douglas (Geoslides); Kelly White (Geo Aerial). Picture library. Has approximately 120,000 photos. Clients include: ad agencies, public relations firms, audiovisual firms, businesses, book/encyclopedia publishers, magazine publishers, newspapers, calendar companies and television.
Needs: Only from: Africa (South of Sahara); Asia; Arctic and Sub-Arctic; Antarctic. Anything to illustrate these areas. Accent on travel/geography and aerial (oblique) shots.
Specs: Uses 8×10 glossy b&w prints; 35mm and 2¼×2¼ transparencies.
Payment & Terms: Pays 50% commission. General price range $70-1,000. Works with or without contract; negotiable. Offers nonexclusive contract. Statements issued monthly. Payment made upon receipt of client's fees. Offers one-time rights and first rights. Does not inform photographer or allow him to negotiate when client requests all rights. Model release required. Photo captions required; include description of location, subject matter and sometimes the date.
Making Contact: Query with résumé of credits and list of stock photo subjects. SASE. Reports in 1 month. Photo guidelines for SASE (International Reply Coupon). No samples until called for. Leaflets available.
Tips: Looks for "technical perfection, detailed captions, must suit lists (especially in areas). Increasingly competitive on an international scale. Quality is important. Need for large stocks with frequent renewals." To break in, "build up a comprehensive (i.e., in subject or geographical area) collection of photographs which are well documented."

*****GLACIER BAY PHOTOGRAPHY**, P.O. Box 97, Gustavus AK 99826-0097. (907)697-2416. President: Pamela Jean Miedtke.
Needs: Alaska scenics, people in nature and wildlife. "We deal only with natural subjects in their natural habitats. No filters or manipulation of any sort is used."

Specs: Uses 35mm, 2¼×2¼, 4×5, 8×10 transparencies.
Payment & Terms: Usually charges 50% commission. Terms negotiated with photographer.
Making Contact: Query by mail only with list of stock photo subjects, samples and dupe slides to be kept on hand for future reference. Slides returned only if requested and SASE is enclosed.
Tips: When applying, dupes must be individually labeled. Originals must be readily available, razor sharp and free from distortions. "We need to be able to trust you for every image you offer. If even one is slightly blurry you won't make it."

JOEL GORDON PHOTOGRAPHY, 112 Fourth Ave., New York NY 10003. (212)254-1688. Picture Agent: Joel Gordon. Stock photo agency. Clients include: ad agencies, designers and textbook/encyclopedia publishers.
Specs: Uses 8×10 b&w prints, 35mm transparencies, b&w contact sheets and b&w negatives.
Payment & Terms: "Usually" pays 50% commission on b&w and color photos. Offers volume discounts to customers; terms specified in contract. Photographers can choose not to sell images on discount terms. Works with or without a contract. Offers nonexclusive contract. Payment made after customer's check clears. Photographers allowed to review account records to verify sales figures. Informs photographer and allows him to negotiate when client requests all rights. Offers one-time, electronic media and agency promotion rights. Model/property release preferred. Captions preferred.
Making Contact: Interested in receiving work from newer, lesser-known photographers.

***GEORGE HALL/CHECK SIX**, 426 Greenwood Beach, Tiburon CA 94920. (415)381-6363. Fax: (415)383-4935. Owner: George Hall. Estab. 1980. Stock photo agency. Member of the Picture Agency Council of America (PACA). Has 50,000 photos. Clients include advertising agencies, public relations firms, businesses, magazine publishers, calendar companies.
Needs: All modern aviation and military.
Specs: Uses 35mm, 2¼×2¼, 4×5 transparencies.
Payment & Terms: Pays 50% commission on color photos. Average price per stock sale: $1,000. Has minimum price of $300 (some lower fees with large bulk sales, rare). Offers volume discounts to customers; terms specified in photographer's contract. Photographers can choose not to sell images on discount terms. Works on contract basis only. Offers nonexclusive contract. Payment made within 5 days of each sale. Photographers allowed to review account records. Offers one-time rights. Does not inform photographer or allow him to negotiate when client requests all rights. Model release preferred. Captions preferred; include basic description.
Making Contact: Interested in receiving work from newer, lesser-known photographers. Call or write. SASE. Reports in 3 days. Photo guidelines available.

***GEORGE HALL/CODE RED**, 426 Greenwood Beach, Tiburon CA 94920. (415)381-6363. Fax: (415)383-4935. Owner: George Hall. Stock photo agency. Member of the Picture Agency Council of America (PACA). Has 5,000 photos (just starting). Clients include: advertising agencies, public relations firms, businesses, book/encyclopedia publishers, magazine publishers, calendar companies.
Needs: Interested in firefighting, emergencies, disasters, hostile weather: hurricanes, quakes, floods, etc.
Specs: Uses color prints; 35mm, 2¼×2¼, 4×5 transparencies.
Payment & Terms: Pays 50% commission. Average price (to clients) $1,000. Enforces minimum prices of $300. Offers volume discounts to customers; terms specified in photographer's contract. Photographers can choose not to sell images on discount terms. Works on contract basis only. Offers nonexclusive contract. Payment made within 5 days of each sale. Photographers allowed to review account records. Offers one-time rights. Does not inform photographer or allow him to negotiate when client requests all rights. Model release preferred. Captions required.
Making Contact: Interested in receiving work from newer, lesser-known photographers. Call or write with details. SASE. Reports in 3 days. Photo guidelines available.

■**HILLSTROM STOCK PHOTO, INC.**, Dept. PM, 5483 N. Northwest Hwy., (Box 31100), Chicago IL 60630 (60631 for Box No.). (312)775-4090. Fax: (312)775-3557. President: Ray F. Hillstrom, Jr. Stock photo agency. Has 1 million color transparencies; 50,000 b&w prints. "We have a 22-agency network." Clients include: ad agencies, public relations firms, audiovisual firms, businesses, book/encyclopedia publishers, magazine publishers, newspapers, calendar companies, greeting card companies and sales promotion agencies.
Needs: "We need hundreds of 35mm color model-released sports shots (all types); panoramic 120mm format worldwide images. Model-released: heavy industry, medical, high-tech industry, computer-related subjects, family-oriented subjects, foreign travel, adventure sports and high-risk recreation, Midwest festivals (country fairs, parades, etc.), the Midwest. We need more color model released family, occupation, sport, student, senior citizen, high tech and on-the-job shots."

Invest in Your Future

OK. You're a nature/wildlife photographer who has spent countless hours patiently waiting in blinds, rising before dawn and experimenting with films and filters. You have amassed thousands of images and sold many of them. Now you want a stock agency to help you in the marketing process. But do they want your images?

This year we decided to present a first-hand account from a photographer who knows what stock agencies desire. The photographer we chose is John Gerlach of Chatham, Michigan. His career has spanned more than 18 years and his work has appeared in magazines such as Backpacker, Ranger Rick *and* Audubon. *Gerlach and his wife, Barbara, have placed more than 300,000 nature photos with 16 stock agencies around the world. The couple also operates Gerlach Nature Photography Seminars, which is listed in the Workshops section of this edition.*

—Editor

Making a substantial income by selling nature photos through stock agencies is possible, but certainly not easy. Like anything worth doing, it takes a lot of hard work, dedication, and honesty to succeed. Selling photos through stock agencies won't make you rich overnight, but there are long-term rewards.

I consider stock agencies to be like a mutual fund investment. By investing quality photographs in a stock agency's files at regular intervals I can have financial returns that pay off quite nicely over ten years or more. Now, how can you get such an investment started for yourself?

John Gerlach

• First, be honest with your agency. If you sign an exclusive contract stick to it. I have known photographers who signed "exclusive" agreements with several agencies. Most stock agencies communicate with each other and eventually they hear about photographers who break contractual obligations.

Also, some photographers hate to split sales with agencies. Normally, this split is 50-50. I've heard of photographers who learn of potential clients through their agencies and then the photographers contact those clients directly in order to make sales. If sales are made these photographers cut their agencies out of commissions. You can imagine what this does to the agent-photographer relationship once the agency finds out! Honesty always pays in the long run.

• Always keep shooting to add images to an agency's files. Selling lots of photos through stock photo agencies is a numbers game. The more images you provide, the more money you will make. It's unlikely that 1,000 photos in a stock agency's files will generate much income. It takes thousands of photos to generate regular

and dependable income. Once you have placed 10,000 good photos with stock agencies, you should expect to receive regular paychecks. But, it will probably take at least 50,000 good photos to provide the kind of money you want.

• Quality photographs are essential in today's competitive marketplace. Wildlife photographs must be sharp, unless you are trying to show motion. You also must provide images with proper exposure, exciting composition, excellent subject matter, non-distracting backgrounds and great light. And, shoot a variety of subjects.

• Patience is crucial for long-term success. Don't expect money to start flowing in two weeks after you sign a contract with an agency. Often your photos must be at an agency for more than a year before they start earning money.

Let's examine a typical scenario. Let's say you send a stock agency an initial submission of 300 photos. It takes about two months for the agency to sort through your photos and select 125 of them. The rest are returned to you. Now the agency must get a request for a subject that you provided. This could be right away, in a few years, or never.

Suppose the agency held five of your Eastern Bluebird photos and after two months a wildlife magazine requests Eastern Bluebird photos. The agent picks 40 different shots, four of which are yours, and quickly sends them off to the magazine. The magazine editors spend two months choosing three images, including one of yours. Unfortunately, the magazine pays on publication, which is four months down the road. After four months they send a $250 check to your agency. Your agency gets a 50% commission on the sale and pays quarterly. Since the quarter just passed, the agency hangs onto your $125 for another four months before sending it to you. Approximately 14 months have passed from the time you sent the initial submission until the time you received a paycheck.

—*John Gerlach*

Photographer John Gerlach of Chatham, Michigan, has been building his stock portfolio for over 18 years. To date he and his wife, Barbara, have snapped over 300,000 images, including this one of an Atlantic puffin getting ready to snack. The couple operates a series of nature photography seminars listed in the Workshops section of this book.

© John Gerlach

Specs: Uses 8 × 10 b&w prints; 35mm, 2¼ × 2¼ and 4 × 5 transparencies.
Payment & Terms: Pays $50-5,000/b&w and color photo. Pays 50% commission on b&w and color photos. Works with or without contract, negotiable. Offers non-exclusive contracts. Statements issued periodically; time period not specified. Payment made quarterly. Photographers allowed to review account records to verify sales figures. Offers one-time rights. Informs photographer and allows him to negotiate when client requests all rights. Model/property release required for people and private property. Captions required; include location, subject and description of function.
Making Contact: Interested in receiving work from newer, lesser-known photographers. Include three business cards and detailed stock photo list. Call or write before submitting slides or prints. Reports in 3 weeks. Photo guidelines free with SASE.
Tips: Prefers to see good professional images, proper exposure, mounted, and name IDs on mount. In photographer's samples, looks for "large format, model and property release, high-tech, people on the job, worldwide travel and environment. Show us at least 200 different images with 200 different subjects."

■‡HOLT STUDIOS INTERNATIONAL, LTD., The Courtyard, 24 High St., Hungerford, Berkshire, RG17 0NF United Kingdom. (01488)683523. Fax: (01488)6835111. Director: Nigel D. Cattlin. Picture library. Has 70,000 photos. Clients include: ad agencies, public relations firms, audiovisual firms, businesses, book/encyclopedia publishers, magazines, newspapers and commercial companies.
Needs: Photographs of world agriculture associated with crop production and crop protection including healthy crops and relevant weeds, pests, diseases and deficiencies. Farming, people and machines throughout the year including good landscapes. Livestock and livestock management, horticulture, gardens, ornamental plants and garden operations. Worldwide assignments undertaken.
Specs: Uses 35mm, 2¼ × 2¼ and 4 × 5 transparencies.
Payment & Terms: Occasionally buys photos outright. Pays 50% commission. General price range: $100-1,500. Offers photographers non-exclusive contract. Contracts renew automatically with additional submissions; for 3 years. Photographers allowed to review account records. Statements issued quarterly. Payment made quarterly. Offers one-time rights. Model release preferred. Captions required; identity of biological organisms is critically important.
Making Contact: Interested in receiving work from newer, lesser-known photographers. Send unsolicited photos by mail for consideration. SASE. Reports in 2 weeks. Photo guidelines free with SASE. Distributes tips sheets every 3 months to all associates.
Tips: "Holt Studios looks for high quality, technically well-informed and fully labeled color transparencies of subjects of agricultural and horticultural interest." Currently sees "expanding interest particularly conservation and the environment, gardening and garden plants."

■❤HOT SHOTS STOCK SHOTS, INC., 341 Lesmill Rd., Toronto, Ontario M3B 2V1 Canada. (416)441-3281. Fax: (416)441-1468. Attention: Editor. Member of Picture Agency Council of America (PACA). Clients include: advertising and design agencies, publishers, major printing houses and product manufacturers.
Needs: People and human interest/lifestyles, business and industry, wildlife, historic and symbolic Canadian.
Specs: Color transparency material any size.
Payment & Terms: Pays 50% commission, quarterly upon collection; 30% for foreign sales through sub-agents. Price ranges: $200-5,000. Works on contract basis only. Offers exclusive, limited regional exclusivity and nonexclusive contracts. Most contracts renew automatically for 3-year period with each submission. Statements issued quarterly. Payment made quarterly. Photographers allowed to review account to verify sales figures. Offers one-time, electronic media, and other rights to clients. Allows photographer to negotiate when client requests all rights. Requests agency promotion rights. Model/property release preferred. Photo captions required; include where, when, what, who, etc.
Making Contact: Must send a minimum of 300 images. Unsolicited submissions must have return postage. Reports in 1 week. Photo guidelines free with business SASE.
Tips: "Submit colorful, creative, current, technically strong images with negative space in composition." Looks for people, lifestyles, variety, bold composition, style, flexibility and productivity. "People should be model released for top sales. Prefer medium format." Photographers should "shoot for business, not for artistic gratification; tightly edited, good technical points (exposure, sharpness, etc.) professionally mounted, captioned/labeled and good detail."

***■‡I.C.P. INTERNATIONAL COLOUR PRESS**, Via Alberto Da Giussano 9, Milano 20145 Italy. (02)468689 or 48008493. Fax: (02)48195625. Marketing Assistant: Mrs. Annamaria James. Estab. 1970. Stock photo agency. Has 1.2 million transparencies. Clients include: advertising agencies, public relations firms, audiovisual firms, businesses, book/encyclopedia publishers, magazine publishers, postcard publishers, calendar companies and greeting card companies.

© Inga Spence/Holt Studios International Ltd.

The best stock photos are those that can be used to express a wide variety of themes. This shot by Inga Spence of Carson City, Nevada, does just that. The image has sold seven times through Holt Studios, including sales to ad agencies, an agriculture magazine and a bank.

Specs: Uses 35mm, 2¼×2¼, 4×5 and 8×10 transparencies only.
Payment & Terms: Pays 50% commission on color photos. Average price per image (to clients): $400/color image. Offers volume discounts to customers; terms specified in photographer's contract. Discount sales terms not negotiable. Works on exclusive contract basis only. Contracts renew automatically with additional submissions, for three years. Charges 100% duping, postage and packing fees. Statements issued monthly. Payment made monthly. Photographers permitted to review account records to verify sales figures or deductions. Offers one-time, first and sectorial exclusive rights. Model/property release required. Captions required.
Making Contact: Arrange personal interview to show portfolio. Query with samples and stock photo list. Works on assignment only. SASE. No fixed minimum for initial submission. Reports in 3 weeks.

***■THE IMAGE BANK/WEST**, 2400 Broadway, Suite 220, Santa Monica CA 90404. (310)264-4850. Fax: (310)264-1482. General Manager: Mary Sue Robinson. Maintains over 2 million slides in Los Angeles and 4 million in New York. Clients include: ad agencies, design and public relations firms, corporations, audiovisual firms, publishers, retailers, and film/TV. Also, postcard, calendar and greeting card companies.
Specs: Uses 35mm color transparencies; "some larger formats."
Payment & Terms: Pays 50% commission for photos. Works with photographers on exclusive contract basis only. Statements issued quarterly. Payment made quarterly. Photographers allowed to review account records to verify sales figures. Offers one-time electronic media and agency promotion rights; negotiable, "however, photographers do not negotiate directly with the client." Model/property release required. Captions required; include date, location, description of image, especially for hi-tech imagery.
Making Contact: Interested in receiving work from newer, lesser-known photographers. When reviewing freelancer's portfolio and/or demos, looks for people, industry and an awareness of what's currently selling in the stock industry.
Tips: "Study the stock marketplace—present work which is currently relevant and present a vision for future work. All images must be originals."

‡THE IMAGE FACTORY, 7 Green Walks, Prestwich, Manchester M25 1DS England. (061)798-0435. Fax: (0161)247-6394. Principal: Jeff Anthony. Estab. 1988. Picture library. Has 350,000 photos. Has 2 branch offices. Clients include: advertising agencies, public relations firms, audiovisual firms, businesses, book/encyclopedia publishers, magazine publishers, newspapers, postcard publishers, calendar companies and greeting card companies.

Needs: Needs photos from all over the world.
Specs: Uses 35mm, 2¼×2¼, 4×5, 8×10 transparencies.
Payment & Terms: Pays 60% commission. Works on contract basis only. Offers guaranteed subject exclusivity. Contracts renew automatically with additional submissions; originally for 3 years and then annually. Statements issued annually. Photographers allowed to review account records. Offers one-time rights. Informs photographer and allows him to negotiate when client requests all rights. Model/property release preferred. Captions required, include as many details as possible.
Making Contact: Interested in receiving work from newer, lesser-known photographers. Submit portfolio for review. SASE. Expects minimum initial submission of 100 images. Reports in 1 month. Photo guidelines free with SASE. Market tips sheet distributed annually; free with SASE.
Tips: Looks for "good color saturation, clarity and good description. We will look at anything if the quality is good." All mounts should be clearly captioned.

***THE IMAGE FINDERS**, 812 Huron, Suite 314, Cleveland OH 44115. (216)781-7729. Fax: (216)781-7729. Owner: Jim Baron. Estab. 1988. Stock photo agency. Has 100,000 photos. Clients include: advertising agencies, public relations firms, audiovisual firms, businesses, book/encyclopedia publishers, magazine publishers, calendar companies, greeting card companies.
● This agency posts images on the Kodak Picture Exchange.
Needs: General stock agency. Needs more people images. Always interested in good Ohio images.
Specs: Uses 35mm, 2¼×2¼. 4×5 transparencies. Pays 50% commission on b&w and color photos. Average price per image (to clients): $250-350/color. This is a small agency and we will, on occasion, go below stated minimum prices. Offers volume discounts to customers; terms specified in photographer's contract. Works on contract basis only. Offers limited regional exclusivity. Statements issued quarterly. Payment made monthly. Photographers allowed to review account records. Offers one-time rights; negotiable depending on what the client needs and will pay for. Informs photographer and allows him to negotiate when client requests all rights. "This is rare for us. I would inform photographer of what client wants and work with photographer to strike best deal." Model release required. Property release preferred. Captions required; include location, city, state, country, type of plant or animal, etc.
Making Contact: Interested in receiving work from newer, lesser-known photographers. Query with stock photo list. Call before you send anything. SASE. Expects minimum initial submission of 100 images with periodic submission of at least 100-500 images. Reports in 3 weeks. Photo guidelines free with SASE. Market tips sheet distributed 2-4 times/year to photographers under contract.
Tips: Photographers must be willing to build their file of images. We need more people images, industry, lifestyles, medical, etc. Scenics and landscapes must be outstanding to be considered.

■THE IMAGE WORKS, P.O. Box 443, Woodstock NY 12498. (914)246-8800. Directors: Mark Antman, Vice President of ASPP, and Alan Carey, President of PACA. Stock photo agency. Member of Picture Agency Council of America (PACA). Has 500,000 photos. Clients include: ad agencies, audiovisual firms, book/encyclopedia publishers, magazine publishers and newspapers.
● The Image Works is marketing the Kodak Picture Exchange and is also in the process of producing a CD-ROM.
Needs: "We specialize in documentary style photography of worldwide subject matter. People in real life situations that reflect their social, economic, political, leisure time and cultural lives." Topic areas include health care, education, business, family life and travel locations.
Specs: Uses 8×10 glossy/semi-glossy b&w prints; 35mm and 2¼×2¼ transparencies.
Payment & Terms: Pays 50% commission on b&w and color photos. General price range: $160-900. Works on contract basis only. Offers nonexclusive contract. Charges duping fee of $1.75. Charges catalog insertion fee of 50%. Statements issued monthly. Payment made monthly. Photographers allowed to review account records to verify sales figures by appointment. Photographer must also pay for accounting time. Offers one-time and electronic media rights. Informs photographer and allows him to negotiate when client requests all rights. Model release preferred. Captions required.
Making Contact: Query with list of stock photo subjects or samples. SASE. Reports in 1 month. Tips sheet distributed monthly to contributing photographers.
Tips: "We want to see photographs that have been carefully edited, that show technical control and a good understanding of the subject matter. All photographs must be thoroughly captioned and indicate if they are model released. The Image Works is known for its strong multicultural coverage in the United States and around the world. Photographs should illustrate real-life situations, but not look contrived. They should have an editorial/photojournalistic feel, but be clean and uncluttered with strong graphic impact for both commercial and editorial markets. We are actively expanding our collection of humor photographs and are interested in seeing new work in this area. Photographers who work with us must be hard workers. They have to want to make money at their photography and have a high degree of self-motivation to succeed. As new digital-based photographic and design technology forces changes in the industry there will be a greater need for experienced photo agencies who know how to service a broad range of clients with very different needs. The agency personnel must be versed, not only in the quality and subject matter of its imagery, but also in the various new options for getting

photos to picture buyers. As new uses of photography in new media continue to evolve, the need for agencies from the perspective of both photographers and picture buyers will continue to grow."

IMAGES PICTURES CORP., Dept. PM, 89 Fifth Ave., New York NY 10003. (212)675-3707. Fax: (212)243-2308. Managers: Peter Gould and Barbara Rosen. Has 100,000 photos. Clients include: public relations firms, book publishers, magazine publishers and newspapers.
Needs: Current events, celebrities, feature stories, pop music, pin-ups and travel.
Specs: Uses b&w prints, 35mm transparencies, b&w contact sheets and b&w negatives.
Payment & Terms: Pays 50% commission on b&w and color photos. General price range: $50-1,000. Offers one-time rights or first rights. Captions required.
Making Contact: Query with résumé of credits or with list of stock photo subjects. Also send tearsheets or photocopies of "already published material, original story ideas, gallery shows, etc." SASE. Reports in 2 weeks.
Tips: Prefers to see "material of wide appeal with commercial value to publication market; original material similar to what is being published by magazines sold on newsstands. We are interested in ideas from freelancers that can be marketed and assignments arranged with our clients and sub-agents." Wants to see "features that might be of interest to the European or Japanese press, and that have already been published in local media. Send copy of publication and advise rights available." To break in, be persistent and offer fresh perspective.

■**INDEX STOCK PHOTOGRAPHY**, 126 Fifth Ave., New York NY 10011. (212)929-4644. Fax: (212)633-1914. Senior Photo Editor: Lindsey Nicholson. Has 500,000 tightly edited photos. Branch Office: Suite 500, 6500 Wilshire Blvd., Los Angeles CA 90048. (213)658-7707. Fax: (213)651-4975. Clients include: ad agencies; corporate design firms; graphic design and in-house agencies; direct mail production houses; magazine publishers; audiovisual firms; calendar, postcard and greeting card companies.
 • Index Stock is an information provider to Kodak Picture Exchange, PressLink and Compu-
 Serve. The agency markets images for use in multimedia projects, software packages and other
 electronic uses, and has taken care to arrange contracts that protect photographers' rights.
 Agency photographers are given the option to participate or not in these electronic ventures.
Needs: Up-to-date, model-released, images of people, lifestyles, corporate and business situations. Also looking for industry, technology, science and medicine, sports, family, travel and location and nature images. "We are seeking stock photography with a fresh look, be sure to keep up with current advertising themes."
Specs: Uses all sizes; 35mm, 2¼×2¼, 4×5 and 8×10 transparencies, including panoramas.
Payment & Terms: Pays 50% commission on general file images; 25% on catalog shots. General price range: $125-5,000. Sells one-time rights plus some limited buyouts (all rights) and exclusives. Model/property releases required. Captions required.
Making Contact: Query with list of stock photo subjects. Reports in 2 weeks with submission guidelines. All portfolios done on mail in or drop off basis. "We like to see 200 originals representing your best work."
Tips: "The stock photography industry has become increasingly more competitive. Keep up with current trends in advertising and print photography. Educate yourself to the demands and realities of the stock photography marketplace, find out where your own particular style and expertise fit in, edit your work tightly. Index offers worldwide representation through its many overseas affiliates as well as an East Coast office."

INTERNATIONAL COLOR STOCK, INC., Dept. PM, 3841 NE Second Ave., Suite 304, Miami FL 33137. (305)573-5200. Contact: Dagmar Fabricius or Randy Taylor. Estab. 1989. Stock photo syndicate. Clients include: foreign agencies distributing to all markets.
Needs: "We serve as a conduit, passing top-grade, model-released production stock to foreign agencies. We have no US sales and no US archives." Currently testing online and CD-ROM promotion.
Specs: Uses 35mm, 2¼×2¼ transparencies.
Payment & Terms: Pays 75% commission. Works on contract basis only. Offers exclusive foreign contract only. Contracts renew automatically on annual basis. Charges duping fee of 100%/image. Also charges catalog insertion fee of 100%/image. Statements issued monthly. Payment made monthly. Photographers allowed to review account records to verify sales figures "upon reasonable notice, during normal business hours." Offers one-time rights. Requests agency promotion rights. Informs photographer and allows him to negotiate when client requests all rights; "if notified by subagents." Model/property release required. Captions preferred; include "who, what, where, when, why and how."
Making Contact: Query with résumé of credits. Reports "only when photographer is of interest" to them. Photo guidelines sheet not available. Tips sheet not distributed.
Tips: Has strong preference for experienced photographers. "Our percentages are extremely low. Because of this, we deal only with top shooters seeking long-term success. If you are not published

20 times a month or have not worked on contract for two or more photo agencies or have less than 15 years experience, please do not call us."

INTERNATIONAL PHOTO NEWS, Dept. PM, 193 Sandpiper Ave., Royal Palm Beach FL 33411. (407)793-3424. Fax: (407)585-5434. Photo Editors: Jay Kravetz and Elliott Kravetz. News/feature syndicate. Has 50,000 photos. Clients include: newspapers, magazines and book publishers. Previous/current clients include: *Lake Worth Herald*, *S. Florida Entertainment Guide* and *Prime-Time*; all 3 celebrity photos with story.
Needs: Celebrities of politics, movies, music and television at work or play.
Specs: Uses 5×7, 8×10 glossy b&w prints.
Payment & Terms: General price range: $5. Works on non-exclusive contract basis only. Contracts renew automatically with additional submissions; 1 year renewal. Photographers allowed to review account records. Statements issued monthly. Payments made monthly. Pays $5/b&w photo; $10/color photo; 5-10% commission. Offers one-time rights. Model/property release preferred. Captions required.
Making Contact: Query with résumé of credits. Solicits photos by assignment only. SASE. Reports in 1 week.
Tips: "We use celebrity photographs to coincide with our syndicated columns. Must be approved by the celebrity."

***INTERNATIONAL SPORTS**, 1078 Route 33, P.O. Box 614, Farmingdale NJ 07727. (908)938-3533. Director: Robert J. Hack. Estab. 1993. Stock photo agency. Clients include: advertising agencies, public relations firms, book/encyclopedia publishers, magazine publishers and calendar companies.
Needs: Model released action, leisure and adventure sports, all professional and college sports.
Specs: Uses 35mm, 2¼×2¼, 4×5, 8×10 transparencies.
Payment & Terms: Pays 50% commission on color photos. Average price per image (to clients): $150-4,000/color photo. Works on contract basis only Offers exclusive and nonexclusive contracts. Statements issued quarterly. Payment made quarterly. Photographers allowed to review account records. Model/property release preferred for all subjects except professional athletes.
Making Contact: Interested in receiving work from newer, lesser-known photographers. Query with samples. SASE. Expects minimum initial submission of 500 images. Reports in 1-2 weeks. Photo guidelines free with SASE. Market tips sheets distributed quarterly to contracted photographers free upon request.

INTERPRESS OF LONDON AND NEW YORK, 400 Madison Ave., New York NY 10017. Editor: Jeffrey Blyth. Has 5,000 photos. Clients include: magazine publishers and newspapers.
Needs: Offbeat news and feature stories of interest to European editors. Captions required.
Specs: Uses 8×10 b&w prints and 35mm color transparencies.
Payment & Terms: NPI. Offers one-time rights.
Making Contact: Send material by mail for consideration. SASE. Reports in 1 week.

***BRUCE IVERSON PHOTOMICROGRAPHY**, 31 Boss Ave., Portsmouth NH 03801. Phone/fax: (603)433-8484. Owner: Bruce Iverson. Estab. 1981. Stock photo agency. Has 10,000 photos. Clients include: advertising agencies, book/encyclopedia publishers.
● This agency uses Kodak Photo CD for demos/portfolios and has placed images on the Stock Connection CD, produced by stock expert Jim Pickerell.
Needs: Currently only interested in submission of scanning electron micrographs and transmission electron micrographs—all subjects.
Specs: Uses 8×10 glossy or matte color and b&w prints; 35mm, 2¼×2¼, 4×5 transparencies; 6×17 panoramic.
Payment & Terms: Pays 50% commission on b&w and color photos. There is a minimum use fee of $175; maximum 10% discount. Terms specified in photographer's contract. Works on contract basis only. Offers nonexclusive contracts. Photographer paid within 1 month of agency's receipt of payment. Offers one-time rights. " 'Buy-outs' are not an alternative through this agency." Captions required; include magnification and subject matter.
Making Contact: "Give us a call first. Our subject matter is very specialized." SASE. Reports in 1-2 weeks.
Tips: "We are a specialist agency for science photos and technical images taken through the microscope."

JEROBOAM, 120-D 27th St., San Francisco CA 94110. Phone/fax: (415)824-8085. Contact: Ellen Bunning. Estab. 1972. Has 150,000 b&w photos, 150,000 color slides. Clients include: text and trade books, magazine and encyclopedia publishers and editorial.
Needs: "We want people interacting, relating photos, artistic/documentary/photojournalistic images, especially ethnic and handicapped. Images must have excellent print quality—contextually interesting and exciting, and artistically stimulating." Needs shots of school, family, career and other living

situations. Child development, growth and therapy, medical situations. No nature or studio shots.
Specs: Uses 8 × 10 double weight glossy b&w prints with a ¾" border. Also uses 35mm transparencies.
Payment & Terms: Works on consignment only; pays 50% commission. Works without a signed contract. Statements issued monthly. Payment made monthly. Photographers allowed to review account records to verify sales figures. Offers one-time rights. Informs photographer and allows him to negotiate when client requests all rights. Model/property release preferred for people in contexts of special education, sexuality, etc. Captions preferred; include "age of subject, location, etc."
Making Contact: Interested in receiving work from newer, lesser-known photographers. Call if in the Bay area; if not, query with samples; query with list of stock photo subjects; send material by mail for consideration or submit portfolio for review. SASE. Reports in 2 weeks.
Tips: "The Jeroboam photographers have shot professionally a minimum of 5 years, have experienced some success in marketing their talent and care about their craft excellence and their own creative vision. Jeroboam images are clear statements of single moments with graphic or emotional tension. We look for people interacting, well exposed and printed with a moment of interaction. New trends are toward more intimate, action shots even more ethnic images needed. Be honest in regards to subject matter (what he/she *likes* to shoot)."

■‡**KEYSTONE PRESSEDIENST GMBH**, Kleine Reichenstr. 1, 20457 Hamburg 11, 2 162 408 Germany. (040)33 66 97-99. Fax: (040)32 40 36. President: Constanze Martin. Stock photo agency, picture library and news/feature syndicate. Has 3.5 million color transparencies and b&w photos. Clients include: ad agencies, public relations firms, audiovisual firms, businesses, book/encyclopedia publishers, magazine publishers, newspapers, postcard companies, calendar companies, greeting card companies and TV stations.
Needs: All subjects excluding sports events.
Specs: Uses b&w prints; 35mm, 2¼ × 2¼, 4 × 5 and 8 × 10 transparencies.
Payment & Terms: Pays 50% commission on b&w and color photos. General price range: $30-1,000. Works on contract basis only. Offers guaranteed subject exclusivity (within files). Contracts renew automatically for one year with additional submissions. Does not charge duping, filing or catalog insertion fees. Payment made one month after photo is sold. Offers one-time and agency promotion rights. "We ask the photographer if client requests exclusive rights." Model release preferred. Captions required; include who, what, where, when and why.
Making Contact: Interested in receiving work from newer, lesser-known photographers. Send unsolicited photos by mail for consideration. Deals with local freelancers by assignment only. SASE. Reports in 2 weeks. Distributes a monthly tip sheet.
Tips: Prefers to see "American way of life—people, cities, general features—human and animal, current events—political, show business, scenics from the USA—travel, touristic, personalities—politics, TV. An advantage of working with KEYSTONE is our wide circle of clients and very close connections to all leading German photo users." Especially wants to see skylines of all US cities. Send only highest quality works.

■**JOAN KRAMER AND ASSOCIATES, INC.**, 10490 Wilshire Blvd., Suite 1701, Los Angeles CA 90024. (310)446-1866. Fax: (310)446-1856. President: Joan Kramer. Member of Picture Agency Council of America (PACA). Has 1 million b&w and color photos dealing with travel, cities, personalities, animals, flowers, lifestyles, underwater, scenics, sports and couples. Clients include: ad agencies, magazines, recording companies, photo researchers, book publishers, greeting card companies, promotional companies and AV producers.
Needs: "We use any and all subjects! Stock slides must be of professional quality."
Specs: Uses 8 × 10 glossy b&w prints; any size transparencies.
Payment & Terms: Pays 50% commission. Offers all rights. Model release required.
Making Contact: Query or call to arrange an appointment. Do not send photos before calling. SASE.

***KYODO PHOTO SERVICE**, 250 E. First St., Suite 1107, Los Angeles CA 90012. (213)680-9448. Fax: (213)680-3547. Business Manager: Shige Higashi. Estab. 1946. Photo department of a national news agency. Has 3 million photos in Tokyo. Has 1 branch office. Clients include: newspapers.

Market conditions are constantly changing! If you're still using this book and it's 1997 or later, buy the newest edition of Photographer's Market *at your favorite bookstore or order directly from Writer's Digest Books.*

Needs: News photos in Japan and Asia.
Specs: Uses 5×7 color prints; 35mm transparencies.
Payment & Terms: Buys photos, buys film, buys photos/film outright. Pays $50-500/color photo; $50-500/b&w photo. Average price per image (to clients): $75-300/b&w; $250-500/color. Offers volume discounts to customers; inquire about specific terms. Discount sales terms not negotiable. Works with or without a signed contract, negotiable. Offers limited regional exclusivity. Statements issued monthly. Payment made monthly. Offers one-time rights. Captions required.
Making Contact: Query with samples. Works with local freelancers only. Does not keep samples on file. Cannot return material. Reports in 1 month. Catalog free, but not always available.

***‡laenderpress/UNIVERSAL-STOCK AGENCY,** (formerly Universal-Stock Agency), Friedrich Lau Str. 26, 4000 Düsseldorf 30 Germany. (211)431-1557. Fax: (211)454 1631. Director: Ralf Dietrich. Estab. 1953. Stock photo agency. Has 1 million photos. Clients include: advertising agencies, public relations firms, businesses, book/encyclopedia publishers, magazine publishers, newspapers, postcard publishers, calendar companies, greeting card companies, TV industry.
Needs: "We handle all topics apart from well-known personalities and politics. Our needs are: people, business, industry and geography worldwide."
Specs: Uses 35mm, 2¼×2¼, 4×5, 8×10 transparencies.
Payment & Terms: Pays 50% commission on color photos. Average price per image (to clients): $100-150. Offers volume slide discounts to customers; terms specified in photographer's contract. Discount sales terms not negotiable. Works on contract basis only; offers guaranteed subject exclusivity; contracts renew without assignment for period of one year. Statements issued quarterly. Payment made quarterly. Photographers allowed to review account records. Offers one-time rights. Informs photographer and allows him to negotiate when client requests all rights. Model/property release required for portraits, people in foregrounds, inside private buildings, museums, if applicable. Captions required; include name of country, region; city/village, rivers, seas, waterfalls. The more information the better.
Making Contact: Interested in receiving work from newer, lesser-known photographers. Submit portfolio for review. Samples kept on file. SASE. Expects minimum initial submission of not less than 100 images with about 600 to 1,000 slides annually. "Send original slides for review." Reports in 3 months. Photo guidelines free with SASE. Market tips sheet distributed upon request.
Tips: "Look at the way advertisements are made in magazines. Sales are more likely in mid-size formats. Read books with motives of cities, landscapes, etc. Look for postcards to get an idea of how to take photos and what to take photos of."

LANDMARK STOCK EXCHANGE, Dept. PM, 51 Digital Dr., Novato CA 94949. (415)883-1600. Fax: (415)382-6613. Photo Editor: Michelle Doublier. Estab. 1979. Stock photo agency and licensing agents. Clients include: advertising agencies, design firms, book publishers, magazine, postcard, greeting card, poster publishers, T-shirts, design firms and "many" gift manufacturers.
Needs: Scenics, model-released people (women/men in swimsuits, children, Afro-American), cars, still-life, illustration, unique photographs, i.e., abstracts, hand-colored, b&w images.
Specs: Uses 35mm, 2¼×2¼, 4×5 transparencies.
Payment & Terms: Pays 50% commission for licensed photos. Enforces minimum prices. "Prices are based on usage." Payment made monthly. Offers one-time rights. Model/property release required. Captions preferred for scenics and animals.
Making Contact: Arrange personal interview to show portfolio. Submit portfolio for review. Query with nonreturnable samples. Query with stock photo list. Samples kept on file. SASE. Photo guidelines free on request.
Tips: "We are always looking for innovative, creative images in all subject areas, and strive to set trends in the photo industry. Many of our clients are gift manufacturers. We look for images that are suitable for publication on posters, greeting cards, etc. We consistently get photo requests for outstanding scenics, swimsuit shots (men and women) and wildlife."

LIAISON INTERNATIONAL, 11 E. 26th St., New York NY 10010. (212)447-2514. Director Photographer Relations: Susan Carolonza. Extensive stock material with the following categories: people, scenic/nature, animals, food, sports, travel, industry and abstract/art. Clients include: graphic designers and advertising agencies. For corporate assignments contact Pat Hugg.
 • For editorial photography, see the listing for Gamma Liaison is in this section.
Specs: Uses 35mm or 2¼×2¼ transparencies.
Payment & Terms: Pays 50% commission. Works on contract basis only. Offers exclusive contract only; works on assignment. Statements issued monthly. Payment made monthly. Model release required. Captions required.
Making Contact: Submit portfolio with description of past experience and publication credits.
Tips: Involves a "rigorous trial period for first 6 months of association with photographer." Previous experience with corporate assignments or stock photography requested.

LIGHT SOURCES STOCK, 23 Drydock Ave., Boston MA 02210. (617)261-0346. Fax: (617)261-0358. Editor: Sonja L. Rodrigue. Estab. 1989. Stock photo agency. Has 50,000 photos. Clients include: advertising agencies, book/encyclopedia publishers, magazine publishers, calendar companies, greeting card companies.
Needs: Children, families, educational, medical and scenics (travel).
Specs: Uses 35mm and $2\frac{1}{4} \times 2\frac{1}{4}$ transparencies.
Payment & Terms: Pays 50% commission. Average price per image (to clients): $100-250/b&w photo; $100-450/color photo. Enforces minimum prices. Offers volume discounts to customers; inquire about specific terms. Photographers can choose not to sell images on discount terms. Works on contract basis only. Offers nonexclusive contracts. Contracts renew automatically with additional submissions. Statements issued semiannually. "Payment is made when agency is paid by the client." Offers one-time rights. Informs photographer and allows him to negotiate when client requests all rights. Model/property release preferred. Captions required.
Making Contact: Interested in receiving work from newer, lesser-known photographers. Arrange personal interview to show portfolio. Samples kept on file. SASE. Expects minimum initial submission of 200 images with periodic submission of at least 100 images every six months. Reports in 1-2 weeks. Photo guidelines available.

LIGHTWAVE, 58 Fairfax St., Somerville MA 02144. Phone/fax: (617)628-1052. (800)628-6809 (outside 617 area code). E-mail: lightwave1@delphi.com. Contact: Paul Light. Has 250,000 photos. Clients include: ad agencies and textbook publishers.
Needs: Candid photos of people in school, work and leisure activities.
Specs: Uses color transparencies.
Payment & Terms: Pays $210/photo. 50% commission. Works on contract basis only. Offers nonexclusive contract. Contracts renew automatically each year. Statements issued annually. Payment made "after each usage." Offers one-time rights. Informs photographer and allows him to negotiate when client requests all rights. Model/property release preferred. Captions preferred.
Making Contact: Interested in receiving work from newer, lesser-known photographers. Send SASE for guidelines.
Tips: "Photographers should enjoy photographing people in everyday activities. Work should be carefully edited before submission. Shoot constantly and watch what is being published. We are looking for photographers who can photograph daily life with compassion and originality."

‡LINEAIR DERDE WERELD FOTOARCHIEF, van der Helllaan 6, Arnhem 6824 HT Netherlands. (00.31)26.4456713. Fax: (00.31)26.3511123. Manager: Ron Giling. Estab. 1990. Stock photo agency. Has 75,000 photos. Clients include advertising agencies, public relations firms, book/encyclopedia publishers, magazine publishers.
 • This agency has been examining the possibilities of marketing its images via computer networks.
Needs: Interested in everything that has to do with the development of countries in Asia, Africa and Latin America.
Specs: Uses 8×10 b&w prints; 35mm, $2\frac{1}{4} \times 2\frac{1}{4}$ transparencies. Pays 50% commission on color and b&w prints. Average price per image (to clients): $50-100/b&w; $100-400/color. Enforces minimum prices. Offers volume discounts to customers; inquire about specific terms. Photographers can choose not to sell images on discount terms. Works with or without a signed contract, negotiable. Offers limited regional exclusivity. Charges 50% duping fees. Statements issued quarterly. Payment made quarterly. Photographers allowed to review account records. "They can review bills to clients involved." Offers one-time rights. Informs photographer and allows him to negotiate when client requests all rights. Captions required; include country, city or region, description of the image.
Making Contact: Interested in receiving work from newer, lesser-known photographers. Submit portfolio for review. SASE. There is no minimum for initial submissions. Reports in 3 weeks. Brochure free with SASE (IRC). Market tips sheet available upon request.
Tips: "We like to see high-quality pictures in all aspects of photography. So we'd rather see 50 good ones, than 500 for us to select the 50 out of."

***✷MASTERFILE**, 175 Bloor St. E., South Tower, 2nd Floor, Toronto, Ontario M4W 3R8 Canada. (416)929-3000. Fax: (416)929-2104. Artist Liaison: Linda Crawford. Stock photo agency. Has 250,000 photos. Clients include: advertising agencies, public relations firms, audiovisual firms, book/encyclopedia publishers, magazine publishers, newspapers, postcard publishers, calendar companies, greeting card companies, all media.
 • This agency has "complete electronic imaging capabilities," including scanning, manipulation and color separations. Masterfile is also researching CD-ROM technology as a storage and cataloging medium.

Lineair Derde Wereld Fotoarchief has "a few thousand" images from French photographer Jean-Leo Dugast. "All of his work is bright, sharp and very useful," says Lineair Manager Ron Giling. This image of a workshop in Vietnam was used by the Ministry of Foreign Affairs in the Netherlands for $125 to illustrate an article discussing the plundering of cultural wealth from Third World countries.

Specs: Uses 35mm, 2¼×2¼, 4×5, 8×10 transparencies.
Payment & Terms: Pays commission. Enforces minimum prices. Offers volume discounts to customers; terms specified in photographer's contract. Discount sales terms not negotiable. Works on contract basis only. Offers exclusive contract only. Contracts renew automatically with additional submissions; for 1 year. Charges duping and catalog insertion fees. Statements issued monthly. Payments made monthly. Photographers allowed to review account records. Offers one-time and electronic media rights and allows him to negotiate when client requests all rights. Model release required. Property release preferred. Captions required.
Making Contact: Interested in receiving work from newer, lesser-known photographers. Ask for submission guidelines. Keeps samples on file. SASE. Expects maximum initial submission of 200 images. Reports in 1-2 weeks on portfolios; same day on queries. Photo guidelines free with SASE. Catalog $20. Market tips sheet distributed to contract photographers only.

‡MAURITIUS DIE BILDAGENTUR GMBH, Postfach 209, 82477 Mittenwald. Mühlenweg 18, 82481 Mittenwald Germany. Phone: 08823/42-0. Fax: 08823/8881. President: Hans-Jörg Zwez. Stock photo agency. Has 1.5 million photos. Has 5 branch offices in Germany, Belgium, CFSR and Austria. Clients include: advertising agencies, businesses, book/encyclopedia publishers, magazine publishers, postcard, calendar and greeting card companies.
Needs: All kinds of contemporary themes: geography, people, animals, plants, science, economy.
Specs: Uses 35mm, 2¼×2¼, 4×5 and 8×10 transparencies.
Payment & Terms: Pays 50% commission for color photos. Offers one-time rights. Model release required. Captions required.
Making Contact: Query with samples. Submit portfolio for review. SASE. Reports in 2 weeks. Tips sheet distributed once a year.
Tips: Prefers to see "people in all situations, from baby to grandparents, new technologies, transportation."

■MEDICHROME, 232 Madison Ave., New York NY 10016. Manager: Ivan Kaminoff. Has 1 million photos. Clients include: advertising agencies, design houses, publishing houses, magazines, newspapers, in-house design departments, and pharmaceutical companies.
Needs: Everything that is considered medical or health-care related, from the very specific to the very general. "Our needs include doctor/patient relationships, surgery and diagnostics processes such as CAT scans and MRIs, physical therapy, home health care, micrography, diseases and disorders, organ

transplants, counseling services, use of computers by medical personnel and everything in between."
Specs: "We accept b&w prints but prefer color, 35mm, 2¼×2¼, 4×5 and 8×10 transparencies."
Payment & Terms: Pays 50% commission on b&w and color photos. General price range: "$150 and up. All brochures are based on size and print run. Ads are based on exposure and length of campaign." Offers one-time or first rights; all rights are rarely needed—very costly. Model release preferred. Captions required.
Making Contact: Query by "letter or phone call explaining how many photos you have and their subject matter." SASE. Reports in 2 weeks. Distributes tips sheet every 6 months to Medichrome photographers only.
Tips: Prefers to see "loose prints and slides in 20-up sheets. All printed samples welcome; no carousel, please. Lots of need for medical stock. Very specialized and unusual area of emphasis, very costly/difficult to shoot, therefore buyers are using more stock."

***MIDWESTOCK**, 1925 Central, Kansas City MO 64108. (816)474-0229. Fax: (816)474-2229. Director: Susan L. Anderson. Estab. 1991. Stock photo agency. Has 100,000 photos. Clients include: advertising agencies, public relations firms, businesses, book/encyclopedia publishers, magazine publishers, newspapers, postcard publishers, calendar companies, greeting card companies.
 • "We currently use CD-ROM discs to showcase categories of our work and to provide economical scans for certain projects at standard stock prices. We do not distribute photo clip discs. We are currently seriously investigating online services—like Kodak Picture Exchange and PNI —as viable options for reaching new clients nationwide."
Needs: "We need more quality people shots depicting ethnic diversity." Also general interest with distinct emphasis in "Heartland" themes.
Specs: "Clean, stylized business and lifestyle themes are biggest sellers in 35mm and medium formats. In scenics, our clientele prefers medium and large formats. Uses 35mm, 2¼×2¼, 4×5, 8×10 transparencies.
Payment & Terms: Pays 50% commission. Average price per image (to clients): $150-350/color. Enforces minimum prices of $150, except in cases of reuse or volume purchase. Offers volume discounts to customers; inquire about specific terms. Works on contract basis only. "We negotiate with photographers on an individual basis." Prefers exclusivity. Contracts renew automatically after 2 years and annually thereafter, unless notified in writing. Statements issued monthly. Payment made monthly. Model release required. Property release preferred. Captions required.
Making Contact: Interested in receiving work from newer, lesser-known photographers. Query with stock photo list. Request submittal information first. Expects minimum initial submission of 1,000 in 35mm format. (Less if larger formats). Reports in 3 weeks. Photo guidelines free with SASE. Market tips sheet distributed monthly to photographers on contract.
Tips: "We prefer photographers who can offer a large selection of medium and large formats and who are full-time professional photographers who already understand the value of upholding stock prices and trends in marketing and shooting stock."

***MONKMEYER**, 118 E. 28th St., New York NY 10016. (212)689-2242. Fax: (212)779-2549. Owner: Sheila Sheridan. Estab. 1930s. Has 500,000-800,000 photos. Clients include: book/encyclopedia publishers.
Needs: General human interest and educational images with a realistic appearance.
Specs: Uses 8×10 matte b&w prints; 35mm transparencies.
Payment & Terms: Pays 50% commission on b&w and color photos. Average price per image (to clients): $140/b&w, $185/color. "We hold to standard rates." Offers volume discounts to customers; terms specified in photographer's contract. Discount sales terms not negotiable. Offers nonexclusive contract. "We have very few contracts—negotiable." Statements issued monthly. Payment made monthly. Photographers allowed to review account records. Buys one-time rights. Informs photographer and allows him to negotiate when client requests all rights. Model/property release preferred. Captions preferred.
Making Contact: Interested in receiving work from newer, lesser-known photographers. Arrange personal interview to show portfolio. Submit portfolio for review. Keeps samples on file. SASE. Expects minimum initial submission of 200 images. Reports in 1-2 weeks. Publishes tip sheet.
Tips: "Dealing with publishers, we need specific images that will make an impact on students."

MOTION PICTURE AND TV PHOTO ARCHIVE, 16735 Saticoy St., Van Nuys CA 91406. (818)997-8292. Fax: (818)997-3998. President: Ron Avery. Estab. 1988. Stock photo agency. Member of Picture Agency Council of America. Has 100,000 photos. Clients include: advertising agencies, book/encyclopedia publishers, magazine publishers, newspapers, postcard publishers, calendar companies, greeting card companies.

Needs: Color shots of current stars and old TV and movie stills.
Specs: Uses 8 × 10 b&w/color prints; 35mm, 2¼ × 2¼, 4 × 5 and 8 × 10 transparencies.
Payment & Terms: Buys photos/film outright. Pays 50% commission on b&w and color photos. Average price per image (to clients): $180-1,000/b&w image; $180-1,500/color image. Enforces minimum prices. Offers volume discounts to customers; terms specified in photographer's contract. Works with or without a signed contract, negotiable with limited regional exclusivity. Contracts renew automatically with additional submissions.
Making Contact: Reports in 1-2 weeks.

■**MOUNTAIN STOCK PHOTO & FILM**, P.O. Box 1910, Tahoe City CA 96145. (916)583-6646. Fax: (916)583-5935. Manager: Meg deVré. Estab. 1986. Stock photo agency. Member of Picture Agency Council of America (PACA). Has 60,000 photos; minimal films/videos. Clients include: advertising agencies, public relations firms, audiovisual firms, businesses, book/encyclopedia publishers, magazine publishers, newspapers, calendar companies, greeting card companies.
Needs: "We specialize in and always need action sports, scenic and lifestyle images."
Specs: Uses 35mm, 2¼ × 2¼, 4 × 5, transparencies.
Payment & Terms: Pays 50% commission on color photos. Enforces minimum prices. "We have a $100 minimum fee." Offers volume discounts to customers; inquire about specific terms. Discount sales terms not negotiable. Works on contract basis only. Some contracts renew automatically. Charges 50% catalog insertion fee. Statements issued quarterly. Payment made quarterly. Photographers are allowed to review account records with due notice. Offers unlimited and limited exclusive rights. Informs photographer and allows him to negotiate when client requests all rights. Model/property release required. Captions required.
Making Contact: Query with résumé of credits. Query with samples. Query with stock photo list. Samples kept on file. SASE. Expects minimum initial submission of 500 images. Reports in 1 month. Photo guidelines free with SAE and 58¢ postage. Market tips sheet distributed quarterly to contracted photographers; upon request.
Tips: "I see the need for images, whether action or just scenic, that evoke a feeling or emotion."

■‡**NATURAL SCIENCE PHOTOS**, 33 Woodland Dr., Watford, Hertfordshire WD1 3BY England. 01923-245265. Fax: 01923-246067. Partners: Peter and Sondra Ward. Estab. 1969. Stock photo agency and picture library. Members of British Association of Picture Libraries and Agencies. Has 175,000 photos. Clients include: ad agencies, public relations firms, audiovisual firms, businesses, book/encyclopedia publishers, magazine publishers, newspapers, postcard companies, calendar companies, greeting card companies and television.
Needs: Natural science of all types, including wildlife (terrestrial and aquatic), habitats (including destruction and reclamation), botany (including horticulture, agriculture, pests, diseases, treatments and effects), ecology, pollution, geology, primitive peoples, astronomy, scenics (mostly without artifacts), climate and effects (e.g., hurricane damage), creatures of economic importance (e.g., disease carriers and domestic animals and fowl). "We need all areas of natural history, habitat and environment from South and Central America, also high quality marine organisms."
Specs: Uses 35mm, 2¼ × 2¼ original color transparencies.
Payment & Terms: Pays 33-50% commission. General price range: $55-1,400. "We have minimum fees for small numbers, but negotiate bulk deals sometimes involving up to 200 photos at a time." Works on contract basis only. Offers nonexclusive contract. Statements issued semiannually. Payment made semiannually. "We are a private company, as such our books are for tax authorities only." Offers one-time rights, exclusive on calendars. Informs photographers and permits them to negotiate when a client requests all rights. Copyright not sold without written permission. Captions required include English and scientific names, location and photographer's name.
Making Contact: Interested in receiving work from newer, lesser-known photographers. Arrange a personal interview to show a portfolio. Submit portfolio for review. Query with samples. Send unsolicited photos by mail for consideration. "We require a sample of at least 20 transparencies together with an indication of how many are on offer, also likely size and frequency of subsequent submissions." Samples kept on file. SASE. Reports in 1-4 weeks, according to pressure on time.
Tips: "We look for all kinds of living organisms, accurately identified and documented, also habitats, environment, weather and effects, primitive peoples, horticulture, agriculture, pests, diseases, etc. Animals, birds, etc., showing action or behavior particularly welcome. We are not looking for 'arty' presentation, just straightforward graphic images, only exceptions being 'moody' scenics. There has been a marked increase in demand for really good images with good color and fine grain with good lighting. Pictures that would have sold a few years ago that were a little 'soft' or grainy are now rejected, particularly where advertising clients are concerned."

*****NATURAL SELECTION STOCK PHOTOGRAPHY INC.**, 183 St. Paul St., Rochester NY 14604. (716)232-1502. Fax: (716)232-6325. Manager: Deborah A. Free. Estab. 1987. Stock photo agency. Member of the Picture Agency Council of America (PACA). Has 300,000 photos. Clients include:

© 1995 Carol Farneti Foster/Natural Science Photos

Carol Farneti Foster of Belize City, Belize, says frogs are her favorite subjects. "I like to show the beauty of these creatures, of which many species are becoming extinct." This image of a red eyed tree frog is one of thousands Farneti Foster markets through Natural Science Photos.

advertising agencies, public relations firms, businesses, book/encyclopedia publishers, magazine publishers, newspapers, postcard publishers, calendar companies, greeting card companies.

Needs: Interested in photos of nature in all its diversity.

Specs: All formats.

Payment & Terms: Pays 50% commission on b&w and color photos. Works on contract basis only. Offers nonexclusive contracts. Contracts renew automatically with additional submissions for 3 years. Charges 50% duping fees; 50% advertising fee. Statements issued quarterly. Payment made monthly on fees collected. Offers one-time rights. "Informs photographer and allows him to negotiate when client requests all rights." Model/property release required. Captions required; include photographer's name, where image was taken and specific information as to what is in the picture.

Making Contact: Query with résumé of credits; include types of images on file, number of images, etc. SASE. Expects minimum initial submission of 200 images, with periodic submission of at least 200 images. Reports in 1 month. Photo guidelines free with SASE. Market tips sheet distributed quarterly to all photographers under contract.

Tips: "All images must be completely captioned, properly sleeved, and of the utmost quality."

NAWROCKI STOCK PHOTO, P.O. Box 16565, Chicago IL 60616. (312)427-8625. Fax: (312)427-0178. Director: William S. Nawrocki. Stock photo agency, picture library. Member of Picture Agency Council of America (PACA). Has over 300,000 photos and 500,000 historical photos. Clients include: ad agencies, public relations firms, editorial, businesses, book/encyclopedia publishers, magazine publishers, newspapers, postcard companies, calendar companies and greeting card companies.

Needs: Model-released people, all age groups, all types of activities; families; couples; relationships; updated travel, domestic and international; food.

Specs: Uses 35mm, 2¼×2¼, 2¼×2¾, 4×5 and 8×10 transparencies. "We look for good composition, exposure and subject matter; good color." Also, finds large format work "in great demand." Medium format and professional photographers preferred.

Payment & Terms: Buys only historical photos outright. Pays variable percentage on commission according to use/press run. Commission depends on agent—foreign or domestic 50%/40%/35%. Works on contract basis only. Offers limited regional exclusivity and nonexclusivity. Charges duping and catalog insertion fees. Statements issued quarterly. Payment made quarterly. Offers one-time media rights; other rights negotiable. Requests agency promotion rights. Informs photographer and allows him to negotiate when client requests all rights. Model release required. Captions required. Mounted images required.

Making Contact: Interested in receiving work from newer, lesser-known photographers. Arrange a personal interview to show portfolio. Query with résumé of credits, samples and list of stock photo subjects. Submit portfolio for review. Provide return Federal Express. SASE. Reports ASAP. Allow 2 weeks for review. Photo guidelines free with SASE. Tips sheet distributed "to our photographers." Suggest that you call first—discuss your photography with the agency, your goals, etc. "NSP prefers to help photographers develop their skills. We tend to give direction and offer advice to our photographers. We don't take photographers on just for their images. NSP prefers to treat photographers as individuals and likes to work with them." Label and caption images. Has network with domestic and international agencies.

Tips: "A stock agency uses just about everything. We are using more people images, all types—family, couples, relationships, leisure, the over 40s group. Looking for large format—variety and quality. More images are being custom shot for stock with model releases. Model releases are very, very important—a key to a photographer's success and income. Model releases are the most requested for ads/brochures."

***NETWORK ASPEN,** 319 Studio N, Aspen Business Center, Aspen CO 81611. (970)925-5574. Fax: (970)925-5680. Founder/Owner: Jeffrey Aaronson. Studio Manager: Becky Green. Photojournalism and stock photography agency. Has 250,000 photos. Clients include: advertising agencies, public relations, businesses, book/encyclopedia publishers, magazine publishers, newspapers, calendar companies.

• This agency is a member of the Kodak Picture Exchange and has the ability to transmit images digitally.

Needs: Reportage, world events, travel, cultures, business, the environment, sports, people, industry.

Specs: Uses 35mm transparencies.

Payment & Terms: Pays 50% commission on color photos. Works on contract basis only. Offers nonexclusive and guaranteed subject exclusivity contracts. Statements issued quarterly. Payments made quarterly. Photographers allowed to review account records. Offers one-time and electronic media rights. Model/property release preferred. Captions required.

Making Contact: "We prefer established photographers." Query with résumé of credits. Query with samples. Query with stock photo list. Keeps samples on file. SASE. Expects minimum initial submission of 250 duplicates. Reports in 3 weeks.

Tips: "Our agency focuses on world events, travel and international cultures, but we would also be interested in reviewing other subjects as long as the quality is excellent."

NEW ENGLAND STOCK PHOTO, Box 815, Old Saybrook CT 06475. (203)388-1741. Fax: (203)388-6999. President: Betty Rogers Johansen. Stock photo agency. Has 125,000 photos in files. Clients include: ad agencies; public relations firms; businesses; book/encyclopedia publishers; magazine publishers, postcard, calendar and greeting card companies.

• New England Stock Photo has 800 images on the Black Book CD-ROM catalog.

Needs: "We are a general interest agency with a wide variety of clients and subjects. Always looking for good people shots—workplace, school, families, couples, children, senior citizens—engaged in everyday life situations, including recreational sports, home life, vacation and outdoor activities. We also get many requests for animal shots—horses, dogs, cats and wildlife (natural habitat). Special emphasis on New England—specific places, lifestyle and scenics, but have growing need for other US and international subject matter. Also use setup shots of flowers, food, nostalgia."

Specs: Uses 8×10 glossy b&w prints; 35mm, 2¼×2¼, 4×5 transparencies. "We are especially interested in more commercial/studio photography, such as food and interiors, which can be used for stock purposes. Also, we get many requests for particular historical sites, annual events, and need more coverage of towns/cities, mainstreets and museums."

Payment & Terms: Pays 50% commission for b&w and color photos; 75% to photographer on assignments obtained by agency. Average price per image: $100-1,000/b&w photo; $100-3,000/color photo. Works with photographers on contract basis only. Offers nonexclusive contract. Charges catalog insertion fee. Statements issued monthly. Payments made monthly. Photographers allowed to review account records to verify sales figures. Offers one-time rights; postcard, calendar and greeting card rights. Informs photographer and allows him to negotiate when client requests all rights. Model/property release preferred (people and private property). Captions required; include who, what, where.

Making Contact: Interested in receiving work from newer, lesser-known photographers. Query with list of stock photo subjects or send unsolicited photos by mail for consideration. SASE. Reports in 3 weeks. Guidelines free with large SAE and 4 first-class stamps. Distributes monthly tip sheet to contributing photographers.

Tips: "Do a tight edit. Do not send overexposed or unmounted transparencies. We provide one of the most comprehensive photo guideline packages in the business, so write for it before submitting. Send a cross section of your best work. There has been an increased use of stock, but a demand for only top quality work. Images must have balanced lighting, great color saturation and strong focal point

mood. Social issues and family situations, with an ethnic mix, are still at the top of our list of needs. Also travel (with people) and outdoor leisure activities."

THE NEW IMAGE STOCK PHOTO AGENCY INC., 38 Quail Ct., Suite 200, Walnut Creek CA 94596. (510)934-2405. President: Tracey Prever. Estab. 1986. Stock photo agency. Has 50,000 photos. Clients include: advertising agencies, public relations firms, audiovisual firms, businesses, book/encyclopedia publishers, magazine publishers, newspapers, calendar companies and greeting card companies.
Needs: "We mainly deal with commercial clients in advertising. We look for model-released people images in all different situations . . . lifestyles, corporate, people working, etc. Also, industry, travel, technology and medical."
Payment & Terms: Pays 50% commission on color photos. General price range: $200-2,000. Offers limited regional exclusivity contract. Statements issued bimonthly. Payment made bimonthly. Offers one-time rights. Informs photographer and allows him to negotiate when client requests all rights. Model release required. Captions required.
Making Contact: Arrange a personal interview to show portfolio. SASE. Reports in 1 month. Photo guidelines free with SASE. Tips sheet distributed quarterly to contracted photographers.
Tips: Wants to see "technical quality as well as saleable subject matter, variety, model-released people images." Individual style is especially desired.

■**NEWS FLASH INTERNATIONAL, INC.**, Division of Observer Newspapers, 2262 Centre Ave., Bellmore NY 11710. (516)679-9888. Editor: Jackson B. Pokress. Has 25,000 photos. Clients include: ad agencies, public relations firms, businesses and newspapers.
Needs: "We handle news photos of all major league sports: football, baseball, basketball, boxing, wrestling, hockey. We are now handling women's sports in all phases, including women in boxing, basketball, softball, etc." Some college and junior college sports. Wants emphasis on individual players with dramatic impact. "We are now covering the Washington DC scene. There is currently an interest in political news photos."
Specs: Super 8 and 16mm documentary and educational film on sports, business and news; 8 × 10 glossy b&w prints or contact sheet; transparencies.
Payment & Terms: Pays 40-50% commission/photo and film. Pays $5 minimum/photo. Works on contract basis only. Offers limited regional exclusivity and non-exclusive contracts. Statements issued quarterly. Payment made monthly or quarterly. Photographers allowed to review account records. Offers one-time or first rights. Model release required. Captions required.
Making Contact: Interested in receiving work from newer, lesser-known photographers. Query with samples. Send material by mail for consideration or make a personal visit if in the area. SASE. Reports in 1 month. Free photo guidelines and tips sheet on request.
Tips: "Exert constant efforts to make good photos—what newspapers call grabbers—make them different than other photos, look for new ideas. There is more use of color and large format chromes." Special emphasis on major league sports. "We cover Mets, Yankees, Jets, Giants, Islanders on daily basis. Rangers and Knicks on weekly basis. We handle bios and profiles on athletes in all sports. There is an interest in women athletes in all sports."

***NONSTOCK**, 91 Fifth Ave., Suite 201, New York NY 10003. (212)633-2388. Fax: (212)989-9079. Vice President: Jerry Tavin. Stock photo agency. Clients include: advertising agencies, public relations firms, audiovisual firms, businesses, book/encyclopedia publishers, magazine publishers, newspapers, postcard publishers, calendar companies, greeting card companies.
Needs: Interested in images that are commercially applicable.
Specs: Uses 35mm transparencies.
Payment & Terms: Pays commission. All fees are negotiated, balancing the value of the image with the budget of the client. Offers volume discounts to customers; inquire about specific terms. Photographers can choose not to sell images on discount terms. Works on exclusive or nonexclusive contract. Statements issued quarterly. Payment made quarterly. Notifies photographer when client requests to buy all rights, "but we negotiate." Model/property release required. Captions preferred; include industry standards.
Making Contact: Interested in receiving work from newer, lesser-known photographers. Submit portfolio for review. Keeps samples on file. SASE. Expects minimum initial submission of 50 images. Reports in 1-2 weeks. Photo guidelines free with SASE. Catalog free with SASE.

‡**OKAPIA K.G.**, Michael Grzimek & Co., 60385 Frankfurt/Main, Roderbergweg 168 Germany; or Constanze Presse Haus, Kurfürstenstr. 72 -74 D10787 Berlin 30 Germany. 030 2640018 1. Fax: 030 2640018 2. President: Grzimek. Stock photo agency and picture library. Has 700,000 photos. Clients include: ad agencies, book/encyclopedia publishers, magazine publishers, newspapers, postcard companies, calendar companies, greeting card companies and school book publishers.

Needs: Natural history, science and technology, and general interest.
Specs: Uses 35mm, 2¼×2¼, 4×5 and 8×10 transparencies.
Payment & Terms: Pays 50% commission on b&w and color photos. Works on contract basis only. Offers nonexclusive and guaranteed subject exclusivity (within files). Contracts renew automatically with additional submissions. Statements issued quarterly, semi-annually or annually, depending on money they earn. Payment made quarterly, semi-annually or annually with statement. Photographers allowed to review account records in the case of disagreements. Offers one-time, electronic media and agency promotion rights. Does not permit photographer to negotiate when client requests all rights. Model release required. Captions required.
Making Contact: Interested in receiving work from newer, lesser-known photographers. Send unsolicited material by mail for consideration. SASE. Expects minimum initial submission of 300 slides. Distributes tips sheets on request.
Tips: "We need every theme which can be photographed." For best results, "send pictures continuously." Work must be of "high standard quality."

■**OMEGA NEWS GROUP/USA**, P.O. Box 309, Lehighton PA 18235-0309. (610)377-6420. Fax: (215)763-4015. Managing Editor: Marta Rubel. Stock photo agency and news/feature syndicate. Clients include: newspapers and magazines, book/encyclopedia publishers, audiovisual producers, paper product companies (calendars, postcards, greeting cards).
Needs: News, sports, features, personalities/celebrities, human interest, conflicts/wars. Wants material from Eastern Europe, primarily from Ukraine.
Specs: Prefers transparencies, however, all formats accepted. For film/tape, send VHS for review. Captions required. Model release, if available, should be submitted with photos.
Payment & Terms: Pays 60% commission on color and 50% on b&w. General price range: $75 and up, depending on usage. Offers first North American serial rights; other rights can be procured on negotiated fees.
Making Contact: Interested in receiving work from newer, lesser known photographers. "Submit material for consideration, preferably transparencies we can keep on file, by mail." Submissions should be made on a trial and error basis. Include return postage for material submitted if you want it returned. Provide résumé, business card, brochure, flier or tearsheet to be kept on file for possible future assignments. Photo guidelines not available. Tip sheets sometimes distributed to photographers on file.
Tips: Looking for quality and content, color saturation, clarity and good description. Comprehensive story material welcomed. "We will look at anything if the quality is good. Think vertical for covers."

■**OMNI-PHOTO COMMUNICATIONS**, 10 E. 23rd St., New York NY 10010. (212)995-0805. Fax: (212)995-0895. President: Roberta Guerette. Estab. 1979. Stock photo agency. Has 100,000 photos. Clients include: advertising agencies, public relations firms, audiovisual firms, businesses, book/encyclopedia publishers, magazine publishers, postcard publishers, calendar companies, greeting card companies.
Needs: Travel, multicultural and people.
Specs: Uses 8×10 b&w prints; 35mm, 2¼×2¼, 4×5, 8×10 transparencies.
Payment & Terms: Pays 50% commission on b&w and color photos. Works on contract basis only. Offers limited regional exclusive contracts. Contracts renew automatically with additional submissions. Statements issued with payment on a quarterly basis. Offers one-time rights. Informs photographer and allows him to negotiate when client requests all rights. Model/property release required. Captions required.
Making Contact: Interested in receiving work from newer, lesser-known photographers. Query with résumé of credits. Query with samples. SASE. Expects minimum initial submission of 200-300 images. Photo guidelines free with SASE.
Tips: "Spontaneous-looking, yet professional quality photos of people interacting with each other. Carefully thought out backgrounds, props and composition, commanding use of color. Stock photographers must produce high quality work at an abundant rate. Self-assignment is very important, as is a willingness to obtain model releases, caption thoroughly and make submissions regularly."

■‡**OXFORD SCIENTIFIC FILMS**, Lower Road, Long Hanborough, Witney, Oxfordshire OX8 8LL England. (01993)881881. Fax: (01993)882808. Assistant Manager: Suzanne Aitzetmuller. Photo Library Manager: Sandra Berry. Film Library: Jane Mulleneux. Film unit and stills and film libraries.

The double dagger before a listing indicates that the market is located outside the United States and Canada.

Has 350,000 photos; over one million feet of stock footage on 16mm, and 40,000 feet on 35mm. Clients include: ad agencies, design companies, audiovisual firms, book/encyclopedia publishers, magazine and newspaper publishers, calendar, postcard and greeting card companies.

Needs: Natural history: animals, plants, behavior, close-ups, life-histories, histology, embryology, electron microscopy. Scenics, geology, weather, conservation, country practices, ecological techniques, pollution, special-effects, high speed, time-lapse.

Specs: Uses 35mm and larger transparencies; 16 and 35mm film and videotapes.

Payment & Terms: Pays 50% commission on b&w and color photos. Enforces minimum prices. Offers volume discounts to customers; inquire about specific terms. Discount sale terms not negotiable. Works on contract basis only; prefers exclusivity, but negotiable by territory. Contracts renew automatically with additional submissions. "All contracts reviewed after 24 months initially, either party may then terminate contract, giving 3 months notice in writing." Statements issued quarterly. Payment made quarterly. Photographers permitted to review sales figures. Offers one-time rights and electronic media rights. Informs photographer and allows him to negotiate when client requests all rights. Photo captions required, Captions required; include common name, Latin name, behavior, location and country, magnification where appropriate.

Making Contact: Interested in receiving high quality work from both amateur and professional photographers. Query with stock photo list. SASE. Reports in 1 month. Distributes want lists quarterly to all photographers.

Tips: Prefers to see "good focus, composition, exposure, rare or unusual natural history subjects and behavioral shots."

OZARK STOCK, 333 Park Central East, Suite 712, Springfield MO 65806. Phone/fax: (417)862-6336. E-mail: jstewart@ozarks.sgcl.lib.mo.us. Director: John S. Stewart. Estab. 1991. Stock photo agency. Has 15,000 photos. Clients include: advertising agencies, public relations firms, businesses, book/encyclopedia publishers, magazine publishers, newspapers, postcard publishers, calendar companies.

• This market puts some of its best photos on CD-ROM so that thumbnails can be printed for samples to clients. "We do not sell clip art CDs."

Needs: Photos of people—couples of the '90s, working, teens; travel—domestic and foreign; health issues.

Specs: Uses 35mm, 2¼×2¼, 4×5 transparencies.

Payment & Terms: Pays 50% commission on b&w and color photos. Average price per image (to clients): $150-350/color photo. Negotiates fees below standard minimum prices. "$125 is generally our minimum, but volume, non-advertising rates are sometimes negotiated in the $100 range." Offers volume discounts to customers; inquire about specific terms. Discount sales terms not negotiated. Works on contract basis only. Offers nonexclusive contracts. Statements issued monthly. Payment made monthly; on the 15th of the month following payment to Ozark. Photographers allowed to review account records. Offers one-time rights. Informs photographer and allows him to negotiate when client requests all rights. "We just don't sell all rights very often." Model/property release preferred for images with people, pets, homes, hospital or healthcare settings and for images with possible advertising usage. Captions required for travel and scenics.

Making Contact: Interested in receiving work from newer, lesser-known photographers. Query with samples. Query with stock photo list. Keeps samples on file. SASE. Expects minimum initial submission of 300 images with periodic submissions of 150 images every 2-3 months. Reports in 3 weeks. Photo guidelines free with SASE. Market tips sheet distributed 4 times/year to anyone; free with SASE.

Tips: This agency has four photographers under contract. "I use a 10× loupe when viewing slides. All slides must be tack sharp and correctly exposed. Photos of people working, playing, interacting in a pretty setting sell better. We do not normally charge research fees if the client pays shipping costs and returns material in a timely manner. When research fees are charged, the client is informed first."

■**PACIFIC STOCK**, 758 Kapahulu Ave., Suite 250, Honolulu HI 96816. (808)735-5665. Fax: (808)735-7801. Owner/President: Barbara Brundage. Estab. 1987. Stock photo agency. Member of Picture Agency Council of America (PACA). Has 100,000 photos. Clients include advertising agencies, public relations firms, audiovisual firms, businesses, book/encyclopedia publishers, magazine publishers, postcard companies, calendar companies and greeting card companies. Previous/current clients: American Airlines, *Life* magazine (cover), Eveready Battery (TV commercial).

Needs: "Pacific Stock is the *only* stock photo agency worldwide specializing in Pacific-related photography. Locations include North American West Coast, Hawaii, Pacific Islands, Australia, New Zealand, Far East, etc. Subjects include: people, travel, culture, sports, marine science and industrial."

Specs: Uses 35mm, 2¼×2¼, 4×5 and 8×10 (all formats) transparencies.

Payment & Terms: Pays 50% commission on color photos. Works on contract basis only. Offers limited regional exclusivity. Charges catalog insertion rate of 50%/image. Statements issued monthly. Payment made monthly. Photographers allowed to review account records to verify sales figures. Offers one-time or first rights; additional rights with photographer's permission. Informs photographer and allows him to negotiate when client requests all rights. Model and property release required for

all people and certain properties, i.e., homes and boats. Photo captions are required; include: "who, what, where."
Making Contact: Query with résumé of credits and list of stock photo subjects. SASE. Reports in 2 weeks. Photo guidelines free with SASE. Tips sheet distributed quarterly to represented photographers; free with SASE to interested photographers.
Tips: Looks for "highly edited shots preferrably captioned in archival slide pages. Photographer must be able to supply minimum of 1,000 slides (must be model released) for initial entry and must make quarterly submissions of fresh material from Pacific area destinations from areas outside Hawaii." Major trends to be aware of include: "Increased requests for 'assignment style' photography so it will be resellable as stock. The two general areas (subject) requested are: tourism usage and economic development. Looks for focus, composition and color. As the Pacific region expands, more people are choosing to travel to various Pacific destinations, while greater development occurs, i.e., tourism, construction, banking, trade, etc. Be interested in working with our agency to supply what is on our want lists."

PAINET, 466 Loring Place, El Paso TX 79927. (915)852-4840. Fax: (915)852-3343. Owner: Mark Goebel. Estab. 1985. Picture library. Has 40,000 photos. Clients include: advertising agencies and magazine publishers.
Needs: "We publish catalogs to market our photos. Our primary emphasis is on 'people' pictures. However, we would review animals and graphic scenics."
Specs: Uses 35mm transparencies, 8 × 10 b&w prints.
Making Contact: Interested in receiving work from newer, lesser-known photographers. Query with samples. Samples not kept on file. SASE. Submit 20 of your best dupes in a 35mm slide preserver sheet. Include return postage. Reports in 1-2 weeks.
Tips: "Selected photographers will be asked to put 50 of their best images on Kodak Photo CD. Images will be immediately included in 5,000 image 4-color catalog which is distributed to over 2,000 markets. Kodak Photo CD will be returned to photographer. No original transparencies are kept by Painet, enabling photographers to market their images elsewhere. Painet only markets color images electronically or by contact with the photographer."

DOUGLAS PEEBLES PHOTOGRAPHY, 445 Iliwahi Loop, Kailua, Oahu HI 96734. (808)254-1082. Fax: (808)254-1267. Owner: Douglas Peebles. Estab. 1975. Stock photo agency. Has 50,000 photos. Clients include: advertising agencies, public relations firms, businesses, magazine publishers, newspapers, postcard companies and calendar companies.
Needs: South Pacific and Hawaii.
Specs: Uses 35mm, 2¼ × 2¼, 4 × 5 color transparencies.
Payment & Terms: Pays 50% commission on color photos. General price range: $100-5,000/color photo. Works on contract basis only. Offers nonexclusive contract. Charges 50% duping fee. Statements issued quarterly. Payment made quarterly. Photographers allowed to review account records to verify sales figures. Offers one-time rights. Model/property release required. Captions preferred.
Making Contact: Contact by telephone. SASE. Reports in 1 month. Photo guideline sheet not available.
Tips: Looks for "strong color, people in activities and model released. Call first."

PHOTO ASSOCIATES NEWS SERVICE, 3421 M. St. NW, #1636, Washington DC 20007. (202)965-4428. Fax: (202)337-1969. Bureau Manager: Peter Heimsath. Estab. 1970. News/feature syndicate. Has 15,000 photos. Clients include: public relations firms, book/encyclopedia publishers, magazine publishers, newspapers.
Needs: Needs feature and immediate news for worldwide distribution, also celebrities doing unusual things.
Specs: Uses 8 × 10 glossy or matte b&w or color prints; 35mm transparencies.
Payment & Terms: Pays $100-500/color photo; $50-100/b&w photo. Pays 60% commission on b&w and color photos. Average price per image (to clients): $150-750/b&w photo; $100-500/color photo. Negotiates fees at standard minimum prices depending on subject matter and need, reflects monies to be charged. Offers discounts to customers; terms specified in photographer's contract. Photographers can choose not to sell images on discount terms. Works on contract basis only. Offers nonexclusive contract. Statements issued monthly. Payment made "as we are paid. Photographers may review records to verify sales, but don't make a habit of it. Must be a written request." Offers one-time rights. Informs photographer and allows him to negotiate when client requests all rights. Photo Associates News Service will negotiate with client request of all rights purchase. Model/property release required. Captions required; include name of subject, when taken, where taken, competition and process instructions.
Making Contact: Interested in receiving work from newer, lesser-known photographers. Query with résumé of credits, samples or stock photo list. Samples kept on file. SASE. Expects minimum initial submission of 40 images with periodic submission of at least 50 images every two months. Reports

in 1 month. Photo guidelines free with SASE. Market tips sheet distributed to those who make serious inquiries with SASE.

Tips: "Put yourself on the opposite side of the camera, to grasp what the composition has to say. Are you satisfied with your material before you submit it? More and more companies seem to take the short route to achieve their visual goals. They don't want to spend real money to obtain a new approach to a possible old idea. Too many times, photographs lose their creativity, because the process isn't thought out correctly."

***‡PHOTO DIRECT STOCK PHOTOGRAPHY**, P.O. Box 312, Sans Souci 2219 NSW Australia. Phone/fax: (02)583-1778. Image Researcher: Goran Zdraveski. Estab. 1992. Has 12,500 photos. Has 2 branch offices. Clients include: advertising agencies, businesses, book/encyclopedia publishers, magazine publishers, postcard publishers, calendar companies.
- This agency is using Kodak Photo CD for self-promotion and cataloging, and eventually wants to produce low resolution CD-ROM catalogs.

Needs: Corporate, travel, lifestyles and industry.
Specs: 35mm, 2¼ × 2¼, 4 × 5 transparencies.
Payment & Terms: Pays 30-50% commission. Offers volume discounts to customers; inquire about specific terms. Discount sales terms not negotiable. Works on contract basis only. Offers nonexclusive contract. Contracts renew automatically with additional submissions for 5 years. Charges 50% duping fee, 50% catalog insertion rate, scanning services at 50%. Statements issued quarterly. Payment made quarterly. Offers one-time and electronic media rights. "We will seek advice from photographer on minimum price and terms." Model/property release required. Captions required; include accurate descriptions, scientific names where appropriate (i.e., flowers and animals).
Making Contact: Interested in receiving work from newer, lesser-known photographers. Query with stock photo list. SASE. Expects minimum initial submission of 100 images with periodic submissions of at least 100-500 images every 10-12 weeks. Reports in 3 weeks. Photo guidelines free with SASE. Market tips sheet distributed every 6 months to contributing photographers with SASE upon request.

■‡PHOTO INDEX, 2 Prowse St., West Perth Western Australia 6005. (09)481-0375. Fax: (09)481-6547. Manager: Lyn Woldendorp. Estab. 1979. Stock photo agency. Has 100,000 photos. Clients include: advertising agencies, public relations firms, audiovisual firms, businesses, book/encyclopedia publishers, magazine publishers, postcard publishers, calendar companies.
Needs: Needs generic stock photos, especially lifestyle, sport and business with people.
Specs: Uses 35mm, 2¼ × 2¼, 4 × 5 transparencies.
Payment & Terms: Pays 50% commission on color photos. Offers volume discounts to customers. Works on exclusive contract basis only. Five-year contract renewed automatically. Statements issued quarterly. Payment made quarterly. Photographers permitted to review account records to verify sales figures or account for various deductions "within reason." Offers one-time rights. Informs photographer and allows him to negotiate when client requests all rights. Model/property release required. Captions required.
Making Contact: Interested in receiving work from newer, lesser-known photographers. Query with samples. Expects minimum initial submission of 1,000 images with periodic submission of at least several hundred, quarterly. Reports in 1-2 weeks. Photo guidelines free with SASE. Catalog available. Market tips sheet distributed quarterly to contributing photographers.
Tips: "A photographer working in the stock industry should treat it professionally. Observe what sells of his work in each agency, as one agency's market can be very different to another's. Take agencies' photo needs lists seriously. Treat it as a business."

‡THE PHOTO LIBRARY (Photographic Library of Australia, Ltd.), Level 1, No. 7 West St., North Sydney 2060 N.S.W. Australia. (02)929-8511. Editor: Lucette Moore. Picture library. Has over 400,000 photos. Clients include: advertising agencies, public relations firms, magazines, businesses, book/encyclopedia publishers, postcard companies, calendar companies, greeting card companies, designers and government departments.
Needs: From abstracts to zoos. "We especially are looking for people pictures (families, couples, business), industrial and high tech."
Specs: Uses 35mm, 2¼ × 2¼, and 4 × 5 transparencies.
Payment & Terms: Pays 50% commission for color photos. Offers limited regional exclusivity contract following expiration of agreement: continues until photographer wants to withdraw images. Statements issued quarterly. Payment made quarterly; 10 days after end of quarter. Photographer allowed to review his own account, once per year to verify sales figures. Offers one-time rights, all rights and limited rights. Informs photographer and allows him to negotiate when client requests all rights. Requires model release (held by photographer) and photo captions.
Making Contact: Interested in receiving work from newer, lesser-known photographers. Send unsolicited photos by mail for consideration to Lucette Moore, Box 121, Cammeray N.S.W. Works with

local and overseas freelancers. SASE. Reports in 10 days. Guidelines free with SASE. Distributes tips sheet quarterly to photographers on file.
Tips: Prefers to see top quality commercial usage and good graphic images. "We see an increase in stock usage by advertising agents as they recognize a higher level of creative excellence in stock compared to previous years."

■‡**PHOTO LIBRARY INTERNATIONAL**, Box 75, Leeds LS7 3NZ United Kingdom 0532-623005. Managing Director: Kevin Horgan. Picture library. Clients include ad agencies, public relations firms, audiovisual firms, businesses, book/encyclopedia publishers, magazine publishers, newspapers, postcard companies, calendar companies and greeting card companies.
Needs: Most contemporary subjects, excluding personalities or special news events, i.e., industry, sport, travel, transport, scenics, animals, commerce, agriculture, people, etc.
Specs: Uses 35mm, 2¼×2¼ and 4×5 transparencies.
Payment & Terms: 50% commission.

■**PHOTO NETWORK**, Dept. PM, 1541J Parkway Loop, Tustin CA 92680. (714)259-1244. Fax: (714)259-0645. Owner: Cathy Aron. Stock photo agency. Member of Picture Agency Council of America (PACA). Has 500,000 photos. Clients include: ad agencies, AV producers, textbook companies, graphic artists, public relations firms, newspapers, corporations, magazines, calendar companies and greeting card companies.
Needs: Needs shots of personal sports and recreation, industrial/commercial, high-tech, families, couples, ethnics (all ages), animals, travel and lifestyles. Special subject needs include people over 55 enjoying life, medical shots (patients and professionals), children and animals.
Specs: Uses 35mm, 2¼×2¼, 4×5 transparencies.
Payment & Terms: Pays 50% commission. Works on contract basis only. Offers limited regional exclusivity. Contracts automatically renew with each submission for 3 years. Charges catalog insertion fee; rate not specified. Statements issued monthly. Payment made monthly. Photographers allowed to review account records to verify sales figures. Offers one-time rights. Informs photographer and allows him to negotiate when client requests all rights. Model/property release preferred. Captions preferred; include places—parks, cities, buildings, etc. "No need to describe the obvious, i.e., mother with child."
Making Contact: Query with list of stock photo subjects. Send a sample of 200 images for review. SASE. Reports in 1 month.
Tips: Wants to see a portfolio "neat and well-organized and including a sampling of photographer's favorite photos." Looks for "clear, sharp focus, strong colors and good composition. We'd rather have many very good photos rather than one great piece of art. Would like to see photographers with a specialty or specialties and have it covered thoroughly. You need to supply new photos on a regular basis and be responsive to current trends in photo needs. Contract photographers are supplied with quarterly 'want' lists and information about current trends."

PHOTO OPTIONS STOCK AGENCY, 3524 Decatur Hwy., Suite 101, Fultondale AL 35068. Phone/fax: (205)631-5091. President: David Haynes. Estab. 1983. Stock photo agency. Has 40,000 photos. Clients include: advertising agencies, public relations firms, businesses, book/encyclopedia publishers, magazine publishers.
Needs: "Our specialty is photos of the Southeast, but we also stock all general areas: corporate, life style, sports, etc."
Specs: Uses 35mm, 2¼×2¼, 4×5, 8×10 transparencies.
Payment & Terms: Pays 50% commission on color photos. Works on contract basis only. Offers nonexclusive contract. Charges filing fee of $100 for new photographers. Issues statement with each check. Payment made monthly at end of month payment is received. Photographer is allowed to review account records. Offers one-time rights. Informs photographer and allows him to negotiate when client requests all rights. Model/property release preferred for recognizable people and property. Captions required. "Good captions sell photos."
Making Contact: Interested in receiving work from newer, lesser-known photographers. Arrange a personal interview to show portfolio. Submit portfolio for review. Query with samples. Samples not kept on file. Expects minimum initial submission of 200-500 images. "Regular submissions of photos increase sales." Reports in 3 weeks. Photo guidelines free with SASE. Market tips sheet distributed quarterly to agency photographers; free with SASE. Samples available upon request.
Tips: In samples looks for "dynamic, professional-quality images, commercial as well as artistic; good, thorough captions and appropriate model releases. Best sellers are photos of the Southeast and images of people, especially business, corporate, medical situations. Commit yourself to providing a continuous supply of stock to an agency. Fresh images sell. If you are not friendly and cooperative, don't call us. We're a down-home, personal service agency."

PHOTO RESEARCHERS, INC., 60 E. 56th St., New York NY 10022. (212)758-3420. Fax: (212)355-0731. Stock photography agency representing over 1 million images specializing in science, wildlife, medicine, people and travel. Member of Picture Agency Council of American (PACA). Clients include:

ad agencies, graphic designers, publishers of textbooks, encyclopedias, trade books, magazines, newspapers, calendars, greeting cards and annual reports in US and foreign markets.

• Photo Researchers has 10,000 images on CD-ROM categorized by subject with Kodak Picture Exchange online service.

Needs: All aspects of natural history, science, astronomy, medicine, people (especially in contemporary shots of teens, couples and seniors). Particularly needs model-released people, European wildlife, up-to-date travel and scientific subjects.

Specs: Any size transparencies.

Payment & Terms: Rarely buys outright; works on 50% stock sales and 30% assignments. General price range: $150-7,500. Works on contract basis only. Offers limited regional exclusivity. Contracts renew automatically with additional submissions for 5 years initial term/1 year thereafter. Charges 50% foreign duping for subagents; 50% catalog insertion fee; placement cost when image sells (if no sales or sales less than 50% placement amount, 0-49%). Photographers allowed to review account records upon reasonable notice during normal business hours. Statements issued monthly, bi-monthly or quarterly, depending on volume. Offers one-time, electronic media and one-year exclusive rights. Informs photographers and allows him to negotiate when a client requests to buy all rights, but does not allow direct negotiation with customer. Model/property release required for advertising; preferred for editorial. Captions required; include who, what, where, when. Indicate model release on photo.

Making Contact: Interested in receiving work from newer, lesser-known photograhers. Query with description of work, type of equipment used and subject matter available. Send to Bug Sutton, Creative Director. Submit portfolio for review when requested. SASE. Reports in 1 month maximum.

Tips: "When a photographer is accepted, we analyze their portfolio and have consultations to give the photographer direction and leads for making sales of reproduction rights. We seek the photographer who is highly imaginative or into a specialty and who is dedicated to technical accuracy. We are looking for serious photographers who have many hundreds of photographs to offer for a first submission and who are able to contribute often."

■✦**PHOTO SEARCH LTD.**, 9909 104th St., #2002, Edmonton, Alberta T5K 2G5 Canada. (403)425-3766. Fax: (403)425-3766. Photo Editor: Gerry Boudrias. Estab. 1991. Stock photo agency. Has 75,000 photos. Clients include: advertising agencies, public relations firms, audiovisual firms, businesses, book/encyclopedia publishers, magazine publishers, newspapers, postcard publishers, calendar companies, graphic designers, government agencies.

Needs: "We are looking for, almost exclusively, top-notch lifestyle images. Couples, families, business people, industrial, and any other images that show people at work and at play. Good-looking models are a must, as are ethnic diversity, a variety of ages of models, and positive images of the disabled."

Specs: Uses 35mm, 2¼×2¼, 4×5 color transparencies. Prefers medium and large format.

Payment & Terms: Pays 50% commission on color photos. Average price per image (to clients): $100-400/color photo; editorial work ranges from $100-200; advertising work ranges from $200-500. Works on limited regional exclusivity contract basis only. "All contracts are automatically renewed for a one-year period, unless either party provides written notice." Statements issued quarterly. Payment made quarterly. Photographers permitted to review account records to verify sales figures or account for various deductions. Offers one-time and electronic media rights. Informs photographer and allows him to negotiate when client requests all rights. "While we reserve the right to final judgment, we confer with photographers about all-right sales. We insist on doing what we feel is right for the agency and the photographer." Model/property release required. "Model releases are imperative for photographers who wish to make sales in the advertising field." Captions required. "Point out information that could be important that may not be evident in the image."

Making Contact: Interested in receiving work from newer, lesser-known photographers who have adequate size collections. Submit portfolio for review. Query with samples. Query with stock photo list. SASE. Expects minimum initial submission of 200 images. Reports in 1 month. Photo guidelines free with SASE. Send international postage for mailings to U.S. (IRCs). "General list for anybody on request."

Tips: "Show as broad a range of subjects as possible, not just your best shots. Versatility is an important quality in stock photographers. Photographers should contact several agencies in the hope of finding one that can meet their needs and financial expectations. Who you sign with is a *very* important decision that could affect your career for many years to come. Marketing methods are constantly changing, due in part to the advent of electronic imaging. The way we serve our clientele, their needs, and the way we supply our images and services will continue to change in the near future."

The solid, black square before a listing indicates that the market uses various types of audiovisual materials, such as slides, film or videotape.

***PHOTO 20-20**, 435 Brannan St., San Francisco CA 94107. (415)543-8983. Fax: (415)543-2199. Principal Editor: Kimberly Parsons. Estab. 1990. Stock photo agency. Has 350,000 photos. Clients include: advertising agencies, public relations firms, book/encyclopedia publishers, magazine publishers, newspapers, calendar companies, greeting card companies, design firms.
• This agency also markets images via the Picture Network International.
Needs: Interested in all subjects.
Specs: Uses 35mm, 2¼×2¼, 4×5, 8×10 transparencies.
Payment & Terms: Pays 50% commission on b&w and color photos. Average price per image (to clients): $300/b&w; $300/color. Enforces minimum prices. Photographers can choose not to sell images on discount terms. Works on contract basis only. Offers nonexclusive and guaranteed subject exclusivity contract. Contract renews automatically. "As payment for their work arrives checks are sent with statements." Photographers allowed to review account records. Offers one-time rights; negotiable. Requests photographer's permission to negotiate when client requests all rights. Model/property release preferred. Captions required; include location and all pertinent information.
Making Contact: Interested in receiving queries from photographers. Query with stock photo list. Expects minimum initial submission of 300 images with periodic submission of at least 300 images every 2 months. Reports in 1-2 weeks. Market tips sheet distributed every 2 months to contracted photographers.
Tips: "Our agency's philosophy is to try to avoid competition between photographers within the agency. Because of this we look for photographers who are specialists in certain subjects and have unique styles and approaches to their work. Photographers must be technically proficient, productive, and show interest and involvement in their work."

■PHOTOBANK, 17952 Skypark Circle, Suite B, Irvine CA 92714. (714)250-4480. Fax: (714)752-5495. Photo Editor: Kristi Bressert. Stock photo agency. Has 750,000 transparencies. Clients include: ad agencies, public relations firms, audiovisual firms, book/encyclopedia publishers, magazine publishers, postcard companies, calendar publishers, greeting card companies, corporations and multimedia users.
Needs: Emphasis on active couples, lifestyle, medical, family and business. High-tech shots are always needed. These subjects are highly marketable, but model releases are a must.
Specs: Uses all formats: 35mm, 2¼×2¼, 4×5, 6×7 and 8×10; color only.
Payment & Terms: Pays 50% commission. Average price per image: $275-500/color photo. Negotiates fees below minimum prices. Offers volume discounts to customers; terms specified in photographer's contract. Photographers can choose not to sell images on discount terms. Works on contract basis only. Offers exclusive, limited regional exclusive, nonexclusive and guaranteed subject exclusivity contracts. Contracts renew automatically with additional submissions. Statements issued quarterly. Payment made quarterly. Photographers permitted to review account records to verify sales figures or account for various deductions. Offers one-time rights, electronic media rights and agency promotion rights. Informs photographer and allows him to negotiate when client requests all rights. Model/property release required. Captions preferred.
Making Contact: Query with samples and list of stock photos. SASE. Reports in 2 weeks. Photo guidelines free with SASE.
Tips: "Clients are looking for assignment quality and are very discerning with their selections. Only your best should be considered for submission. Please tightly edit your work before submitting. Model-released people shots in lifestyle situations (picnic, golf, tennis, etc.) sell."

PHOTOEDIT, 6056 Corbin Ave., Tarzana CA 91356. (818)342-2811. (800)860-2098. Fax: (818)343-9548. President: Leslye Borden. Estab. 1987. Stock photo agency. Member of Picture Agency Council of America (PACA). Has 500,000 photos. Clients include: advertising, public relations firms, businesses, book/encyclopedia publishers, magazine publishers.
Needs: People—seniors, teens, children, families, minorities.
Specs: Uses 35mm transparencies.
Payment & Terms: Pays 50% commission on color photos. Average price per image (to clients): $200/quarter page textbook only, other sales higher. Works on contract basis only. Offers nonexclusive contract. Charges catalog insertion fee of $400/image. Statements issued quarterly; monthly if earnings over $1,000/month. Payment made monthly or quarterly at time of statement. Photographers are allowed to review account records. Offers one-time rights; limited time use. Consults photographer when client requests all rights. Model release preferred for people.
Making Contact: Arrange a personal interview to show portfolio. Submit portfolio for review. Query with samples. Samples not kept on file. SASE. Expects minimum initial submission of 1,000 images with additional submission of 1,000 per year. Reports in 1 month. Photo guidelines free with SASE.
Tips: In samples looks for "drama, color, social relevance, inter-relationships, current (*not* dated material), tight editing. We want photographers who have easy access to models (not professional) and will shoot actively and on spec."

PHOTOLINK STOCK PHOTOGRAPHY, Dept. PM, 141 The Commons, Ithaca NY 14850. (607)272-0642. Fax: (607)272-0438. Director: Jon Reis. Estab. 1988. Stock photo agency. Has 50,000 photos. Clients include: advertising agencies, public relations firms, businesses, book/encyclopedia publishers, magazine publishers.
Needs: Up-to-date model released photos of families, children, business people; recreational sports; aviation; travel/scenics including upstate New York.
Specs: Uses 8×10 (off-beat pics), b&w prints; 35mm transparencies.
Payment & Terms: Pays 50% commission on b&w and color photos. Average price per image (to clients): b&w $150-200; color $150-200. Works on contract basis only. Offers guaranteed subject exclusivity (within files). Issues annual statements. Payment made bimonthly. Photographers are allowed to review account records. Offers one-time rights. Informs photographer and allows him to negotiate when client requests all rights. Model/property release preferred. Captions required; include what, where.
Making Contact: Interested in receiving work from newer, lesser-known photographers. Query with stock photo list. Samples not kept on file. SASE. Expects minimum initial submission of 80 images with additional submissions of at least 30-40 every 3 months. Reports in 1-2 weeks. Photo guidelines free with SASE. Market tips sheet distributed quarterly to contracted photographers.
Tips: Looks for "diversity of work with 3-5 subjects extensively covered; detailed captions and model released; strong initial editing before we see the work—just your best. It's hard to sell photos which are unreleased or uncaptioned. Get model releases and then clearly caption your slides!"

***PHOTONICA,** 141 Fifth Ave., 8 S, New York NY 10010. (212)505-9000. Fax: (212)505-2200. Director of Photography: Jane Yeomans. Estab. 1987. Stock photo agency. Member of the Picture Agency Council of America (PACA). Clients include: advertising agencies, public relations firms, audiovisual firms, businesses, book/encyclopedia publishers, magazine publishers, newspapers, postcard publishers, calendar companies, greeting card companies, graphic designers.
Needs: Travel, scenics, still life, people, sports, industry, environment, conceptual, food.
Specs: Uses 8×10 color and b&w prints; 35mm, 2¼×2¼, 4×5, 8×10 transparencies.
Payment & Terms: Pays 50% commission on b&w and color photos. Works on contract basis only. Payment made quarterly. Photographers allowed to review account records. Offers one-time rights. Model/property release preferred. Captions required.
Making Contact: Interested in receiving work from newer, lesser-known photographers, as well as established photographers. Submit portfolio for review. Keeps samples on file. SASE. Expects minimum initial submisson of 20 images with periodic submissions of at least 1-100 images quarterly. Reports within the week (2-3 days). Photo guidelines free with SASE.
Tips: "We look for high-quality work that is marketable, yet still evocative and visually interesting."

■PHOTOPHILE, 2400 Kettner Blvd., Studio 250, San Diego CA 92101. (619)595-7989. Fax: (619)595-0016. Owner: Nancy Masten. Clients include: ad agencies, public relations firms, audiovisual firms, businesses, publishers, postcard and calendar producers, and greeting card companies.
Needs: Lifestyle, vocations, sports, industry, entertainment, business and computer graphics.
Specs: Uses 35mm, 2¼×2¼, 4×5 and 6×7 original transparencies.
Payment & Terms: Pays 50% commission. NPI. Works on contract basis only. Offers limited regional exclusivity. Statements issued monthly. Payment made monthly; photographers paid 30 days after payment is received from client. Photographers are allowed to review account records to verify sales figures. Rights negotiable; usually offers one-time rights. Informs photographer and allows him to negotiate when client requests all rights. Model/property release required. Captions required, include location or description of obscure subjects; travel photos should be captioned with complete destination information.
Making Contact: Write with SASE for photographer's information. "Professionals only, please." Expects a minimum submission of 500 salable images and a photographer must be continuously shooting to add new images to files.
Tips: "Specialize, and shoot for the broadest possible sales potential. Get releases!" Points out that the "greatest need is for model-released people subjects; sharp-focus and good composition are important." If photographer's work is salable, "it will sell itself."

PHOTOREPORTERS, INC., Dept. PM, 875 Avenue of the Americas, New York NY 10001. (212)736-7602. Fax: (212)465-0651. General Manager: Roberta Boehm. Estab. 1958. Stock photo agency, news/feature syndicate. Member of the Picture Agency Council of America (PACA). Clients include: advertising agencies, public relations firms, book/encyclopedia publishers, magazine publishers and newspapers.
Needs: Celebrities, politics and photo stories such as human interest.
Specs: Uses 35mm transparencies.
Payment & Terms: Pays 50% commission on b&w and color photos. General price range: $175/quarter page color; $125/quarter page b&w. Enforces minimum prices. Photographers can choose not

to sell images on discount terms. Statements issued monthly. Payment made monthly. Photographers are allowed to review account records to verify sales figures. Offers one-time and electronic media rights. Informs photographer and allows him to negotiate when client requests all rights. Model release preferred. Captions required.
Making Contact: Query with résumé of credits. Contact by telephone. Keeps samples on file. SASE. Reports in 3 weeks.

***PHOTOSEARCH**, P.O. Box 92656, Milwaukee WI 53202. (414)271-5777. President: Nicholas Patrinos. Estab. 1970. Stock photo agency. Has 910,000 photos. Has 2 branch offices. Clients include: advertising agencies, public relations firms, audiovisual firms, businesses, book/encyclopedia publishers, magazine publishers, newspapers, postcard publishers, calendar companies, greeting card companies, network TV/nonprofit market (social services types).
Needs: Interested in all types of photos.
Specs: Uses 8×10 any finish b&w prints; 35mm, 2¼×2¼, 4×5, 8×10 transparencies.
Payment & Terms: Buys photos; pays $300-5,000/image. Pays 50% commission on b&w and color photos. Offers volume discounts to customers; terms specified in photographer's contract. Photographers can choose not to sell images on discount terms. Works with or without contract. Offers limited regional exclusivity, nonexclusive, guaranteed subject exclusivity contracts. Contracts renew automatically with additional submissions. Statements issued upon sale. Payment made immediately upon sale receipt from clients. Offers one-time, electronic media and agency promotion rights. Does not inform photographer or allow him to negotiate when client requests all rights. "This is pre-arranged and understood with the photographers." Model/property release required. Captions preferred; include basic specifics (i.e., place, date, etc.).
Making Contact: Interested in receiving work from newer, lesser-known photographers. Query with stock photo list. Keeps samples on file. SASE. Expects minimum initial submission of 250 images. Reports in 3 weeks or less. Photo guidelines free with SASE. Market tips sheet faxed directly to photographer, free with SASE.

***■PHOTOTAKE, INC.**, 224 W. 29th St., 9th Floor, New York NY 10001. (212)736-2525. (800)542-3686. Fax: (212)736-1919. Director: Leila Levy. Stock photo agency; "fully computerized photo agency specializing in science and technology in stock and on assignment." Has 250,000 photos. Clients include: ad agencies, businesses, newspapers, public relations and AV firms, book/encyclopedia and magazine publishers, and postcard, calendar and greeting card companies.
Needs: General science and technology photographs, medical, high-tech, computer graphics, special effects for general purposes, health-oriented photographs, natural history, people and careers.
Specs: Uses 8×10 prints; 35mm, 2¼×2¼, 4×5 or 8×10 transparencies; contact sheets or negatives.
Payment & Terms: Pays 50% commission on b&w and color photos. Works on contract basis only. Offers guaranteed subject exclusivity. Contracts renew automatically with additional submissions. Charges 50¢ duping fee. Charges $75-125 catalog insertion fees. Statements issued quarterly. Payment made quarterly. Photographers allowed to review account records. Offers one-time or first rights (world rights in English language, etc.). Informs photographer when client requests all rights, but agency negotiates the sale. Model/property release required. Captions required.
Making Contact: Interested in receiving work from newer, lesser-known photographers. Arrange a personal interview to show portfolio. Query with samples or with list of stock photo subjects. Submit portfolio for review. *SASE.* Reports in 1 month. Photo guidelines "given on the phone only." Tips sheet distributed monthly to "photographers that have contracted with us at least for a minimum of 500 photos."
Tips: Prefers to see "at least 100 color photos on general photojournalism or studio photography and at least 5 tearsheets—this, to evaluate photographer for assignment. If photographer has enough in medical, science, general technology photos, send these also for stock consideration." Using more "illustration type of photography. Topics we currently see as hot are: general health, computers, news on science. Photographers should always look for new ways to illustrate concepts generally."

■PHOTRI INC., 3701 S. George Maxon Dr., Suite C2 North, Falls Church VA 22041. (703)931-8600. Subagency: MGA/Photri Inc., 40 E. Ninth St., Suite 1109, Chicago IL 60605. (312)987-0078. Fax: (312)987-0134. President: Jack Novak. Member of Picture Agency Council of America (PACA). Has 1 million b&w photos and color transparencies of all subjects. Clients include: book and encyclopedia publishers, ad agencies, record companies, calendar companies, and "various media for AV presentations."
Needs: Military, space, science, technology, romantic couples, people doing things, humor, picture stories. Special needs include calendar and poster subjects. Needs ethnic mix in photos. Has sub-agents in 10 foreign countries interested in photos of USA in general.
Specs: Uses 8×10 glossy b&w prints; 35mm and larger transparencies.
Payment & Terms: Seldom buys outright; pays 35-50% commission. Pays: $45-65/b&w photo; $100-1,500/color photo; $50-100/film/ft. Negotiates fees below standard minimums. Offers volume

discounts to customers; terms specified in photographer's contract. Discount sale terms not negotiable. Works with or without contract; offers non-exclusivity. Charges $150 catalog insertion fee. Statements issued quarterly. Payment made quarterly. Photographers allowed to review records to verify sales figures or account for various deductions. Offers one-time and electronic media rights. Model release required if available and if photo is to be used for advertising purposes. Property release required. Captions required.

Making Contact: Interested in receiving work from newer, lesser-known photographers. Call to arrange an appointment or query with résumé of credits. SASE. Reports in 2-4 weeks.

Tips: "Respond to current needs with good quality photos. Take, other than sciences, people and situations useful to illustrate processes and professions. Send photos on energy and environmental subjects. Also need any good creative 'computer graphics.' Subject needs include major sports events."

■‡**PICTOR INTERNATIONAL, LTD.**, Lymehouse Studios, 30-31 Lyme St., London NW1 0EE England. (171)482-0478. Fax: (171)267-5759. Creative Director: Alberto Sciama. Stock photo agency and picture library with 17 offices including London, Paris, Munich, Milan, New York and Washington DC. Clients include: advertising agencies, public relations firms, audiovisual firms, businesses, book/encyclopedia publishers, magazine publishers, postcard companies, calendar companies, greeting card companies and travel plus decorative posters; jigsaw companies.

Needs: "Pictor is a general stock agency. We accept *all* subjects. Needs primarily people shots (released): business, families, couples, children, etc. Criteria for acceptance: photos which are technically and aesthetically excellent."

Specs: Uses 35mm, 6×6cm, 6×7cm and 4×5 transparencies.

Payment & Terms: Pays 50% commission for color photos. General price range: $100-$15,000. Statements issued monthly. Offers one-time rights, first rights and all rights. Requires model release and photo captions. Buys photos outright depending on subject.

Making Contact: Arrange a personal interview to show portfolio. Query with list of stock photo subjects. Send unsolicited photos by mail for consideration. Photo guidelines sheet available for SASE. Publishes annual catalog. Tips sheet for "photographers we represent only."

Tips: Looks for "photographs covering all subjects. Clients are getting more demanding and expect to receive only excellent material. Through our marketing techniques and PR, we advertise widely the economic advantages of using more stock photos. Through this technique we're attracting 'new' clients who require a whole different set of subjects."

■**THE PICTURE CUBE INC.**, Dept. PM, 67 Broad St., Boston MA 02109. (617)443-1113. Fax: (617)443-1114. President: Sheri Blaney. Member of Picture Agency Council of America (PACA). Has 300,000 photos. Clients include: ad agencies, public relations firms, businesses, audiovisual firms, textbook publishers, magazine publishers, encyclopedia publishers, newspapers, postcard companies, calendar companies, greeting card companies and TV. Guidelines available with SASE.

Needs: US and foreign coverage, contemporary images, agriculture, industry, energy, high technology, religion, family life, multicultural, animals, transportation, work, leisure, travel, ethnicity, communications, people of all ages, psychology and sociology subjects. "We need lifestyle, model-released images of families, couples, technology and work situations. We emphasize New England/Boston subjects for our ad/design and corporate clients."

Specs: Uses 8×10 prints; 35mm, 2¼×2¼, 4×5 and larger slides. "Our clients use both color and b&w photography."

Payment & Terms: Pays 50% commission. General price range: $150-400/b&w; $175-500/color photo. "We negotiate special rates for nonprofit organizations." Offers volume discounts to customers; inquire about specific terms. Discount sales terms not negotiable. Works on nonexclusive contract basis only. Contracts renew automatically for three years. Charges catalog insertion fee. Statements issued monthly. Payment made bimonthly. Photographers allowed to review account records to verify sales figures. Offers one-time rights. Informs photographer and allows him to negotiate when a client requests all rights. Model/property release preferred. Captions required; include event, location, description, if model released.

Making Contact: Request guidelines before sending any materials. Arrange a personal interview to show portfolio. SASE. Reports in 1 month.

Tips: "Black & white photography is being used more and we will continue to stock it." Serious freelance photographers "must supply a good amount (at least a thousand images per year, sales-oriented subject matter) of material, in order to produce steady sales. All photography submitted must be high quality, with needle-sharp focus, strong composition, correctly exposed. All of our advertising clients require model releases on all photos of people, and often on property (real estate)."

■**PICTURE LIBRARY ASSOCIATES**, 4800 Hernandez Dr., Guadalupe CA 93434. (805)343-1844. Fax: (805)343-6766. Director of Marketing: Robert A. Nelson. Estab. 1991. Stock photo agency. Has 25,000 photos. Clients include: advertising agencies, public relations firms, audiovisual firms, businesses, book/encyclopedia publishers, magazine publishers, newspapers, postcard publishers, cal-

endar companies, greeting card companies, electronic publishing companies.
Needs: All subjects. Specifically senior activities, health-related subjects; black, Hispanic, Asian and other ethnic people in everyday activities, animals, birds (other than North American). Write with SASE for want lists.
Specs: Uses 8×10 glossy b&w prints; 35mm, 2¼×2¼, 4×5 transparencies; videotape (contact agency for specifics).
Payment & Terms: Photographer specifies minimum amount to charge. Pays 50% commission on b&w and color photos; and videotape. Negotiates fees based on both media's published price schedule, minimum stated in photographer's contract, if any; and type of usage. This agency uses ASMP contract. Offers volume discounts to customers; terms specified in photographer's contract. Photographers can choose not to sell images on discount terms. Works on contract basis only. All renewal clauses are tailored to meet needs of a specific client, usually one time renewal option at a stated price. Charges 100% duping fees. Catalog insertion—rate being determined. Charges shipping costs of images to and from Picture Library Associates and photographer. Statements issued bimonthly under terms listed in photographer/agency contract. Payment made within a few days of agency's receipt of payment. Photographers may review their sales records at any time during business hours. Offers electronic media rights, one-time North American rights, one-time world-wide rights, renewal rights based on original license fee. Photographer and agency negotiate with client on requests to buy all rights. Model/property release required for recognizable persons and recognizable property. Captions required; include who, what, when and where of principal subject in each image.
Making Contact: Interested in receiving work from newer, lesser-known photographers as well as established ones. Submit portfolio for review. Contact agency for guidelines before submission. Samples not kept on file. SASE. Expects minimum initial submission of 40-60 images. No required minimum. Prefer frequency of 60 days or less. Reports in 3 weeks. Photo guidelines free with SASE. Computer printout of subject categories to clients on request. Publishes newsletter. No regular schedule. Distributed to photographers under contract and anyone requesting it; free with SASE. Established photographers asked to consider PLA as an additional agency.
Tips: "Primarily look at technical quality for reproduction, subject matter, similars with varied composition, color choices. Increased need for ethnic people. Need people doing things. Need senior citizen activity. Need health-related subject matter with people involved. Shoot for a theme when possible. Submit new stock regularly. Every image must be numbered. Arrange images on a slide page. Group images by category. Pre-edit images to include only technically excellent ones. Planning to market images via online bulletin boards. Would like to download images to clients as images to review and use in comps."

PICTURES INTERNATIONAL, P.O. Box 470685, Tulsa OK 74147-0685. (918)664-4909. Picture Editor: Jim Wray. Has 50,000 images. Clients include: ad agencies, public relations firms, magazine publishers, and paper product (calendars, postcards, greeting cards) companies.
Specs: Uses 2¼×2¼ and larger transparencies; also 8×10 glossy b&w and color prints.
Payment & Terms: Pays 50% commission on b&w and color photos. Model releases required. Captions required.
Making Contact: Submit photos by mail for consideration. Send SASE for photo guidelines and tip sheet.

***■PICTURESQUE STOCK PHOTOS**, 1520 Brookside Drive #3, Raleigh NC 27604. (919)828-0023. Manager: Syd Jeffrey. Estab. 1987. Stock photo agency. Member of Picture Agency Council of America (PACA). Has 300,000 photos. Clients include: advertising agencies, design firms, corporations, book/encyclopedia publishers and magazine publishers.
Needs: Travel/destination, model-released people, lifestyle, business, industry and general topics.
Specs: Uses 35mm, 2¼×2¼, 4×5 and 8×10 transparencies.
Payment & Terms: Pays 40-50% commission. Works on contract basis only. Contracts renew automatically. Payment made monthly. Photographers allowed to review account records. Offers various rights depending on client needs. Model/property release required. Captions required.
Making Contact: Interested in receiving work from newer, lesser-known photographers. Contact by telephone for submissions guidelines. SASE. Reports in 1 month. Tips sheet distributed quarterly to member photographers.
Tips: Submission requirements include 200-300 original transparencies; wide range of subjects.

***■‡PRO-FILE**, 2B Winner Commercial Building, 401-403 Lockhart Rd., Wanchai Hong Kong. (852)2574-7788. Fax: (852)2574-8884. Director: Neil Farrin. Stock photo agency. Has 100,000 photos. Clients include: advertising agencies, public relations firms, audiovisual firms, businesses, book/encyclopedia publishers, magazine publishers and calendar companies.

Needs: General stock, emphasis on Asian destinations and Asian model-released pictures.
Specs: Uses 35mm, $2\frac{1}{4} \times 2\frac{1}{4}$ and 4×5 transparencies.
Payment & Terms: Pays 50% commission; 70% on films. Works on contract basis only. Guarantees subject exclusivity within files and limited regional exclusivity. Charges duping and catalog insertion fees. Statements issued quarterly. Payment made quarterly. Photographers allowed to review account records to verify sales figures. Offers one-time, electronic media and agency promotion rights. Requests agency promotion rights. Informs photographer and allows him to negotiate when client requests all rights. Model/property release required. Captions required.
Making Contact: Interested in receiving work from newer, lesser-known photographers. Query with résumé of credits and list of stock photo subjects. SASE. Reports in 3 months. Distributes tips sheet "as necessary" to current photographers on file.
Tips: Has second office in Singapore; contact main office for information.

■❋**REFLEXION PHOTOTHEQUE**, 1255 Square Phillips, Suite 307, Montreal, Quebec H3B 3G1 Canada. (514)876-1620. President: Michel Gagne. Estab. 1981. Stock photo agency. Has 100,000 photos. Clients include: advertising agencies, public relations firms, audiovisual firms, businesses, book/encyclopedia publishers, magazine publishers, newspapers, postcard companies, calendar companies and greeting card companies.
Needs: Model-released people of all ages in various activities. Also, beautiful homes, recreational sports, North American wildlife, industries, U.S. cities, antique cars, hunting and fishing scenes, food, and dogs and cats in studio setting.
Specs: Uses 35mm, $2\frac{1}{4} \times 2\frac{1}{4}$, 4×5, 8×10 transparencies.
Payment & Terms: Pays 50% commission on color photos. Average price per image: $150-500. Enforces minimum prices. Offers volume discounts to customers; inquire about specific terms. Discount sales terms not negotiable. Works on contract basis only. Offers limited regional exclusive and non-exclusive contracts. Contracts renew automatically for five years. Charges 100% duping fee and 75% catalog insertion fee. Statements issued quarterly. Payment made monthly. Offers one-time rights. Informs photographer and allows him to negotiate when client requests all rights. Model/property release preferred. Photo captions required; include country, place, city, or activity.
Making Contact: Interested in receiving work from newer, lesser-known photographers. Arrange a personal interview to show portfolio. Query with list of stock photo subjects. Submit portfolio for review. SASE. Reports in 1 month. Photo guidelines available.
Tips: "Limit your selection to 200 images. Images must be sharp and well exposed. Send only if you have high quality material on the listed subjects."

RETNA LTD., Third Floor, 18 E. 17th St., New York NY 10013. (212)255-0622. Contact: Julie Grahame. Estab. 1979. Member of the Picture Agency of America (PACA). Stock photo agency, assignment agency. Has 1 million photos. Clients include advertising agencies, public relations firms, book/encyclopedia publishers, magazine publishers, newspapers and record companies.
 • Retna wires images worldwide to sub agents.
Needs: Handles photos of musicians (pop, country, rock, jazz, contemporary, rap, R&B) and celebrities (movie, film, television and politicians). Covers Paris fashion shows; has file on royals.
Specs: Uses 8×10 b&w prints; 35mm and $2\frac{1}{4} \times 2\frac{1}{4}$ transparencies; b&w contact sheets; b&w negatives.
Payment & Terms: Pays 50% commission on b&w and color photos. General price range: $125-1,500. Works on contract basis only. Contracts renew automatically with additional submissions all-for five years. Statements issued monthly. Payment made monthly. Offers one-time rights; negotiable. When client requests all rights photographer will be consulted, but Retna will negotiage. Model/property release required. Captions required.
Making Contact: Works on contract basis only. Arrange a personal interview to show portfolio. Primarily concentrating on selling stock, but do assign on occasion. Does not publish "tips" sheets, but makes regular phone calls to photographers.
Tips: Wants to see a variety of musicians/actors shot in studio, as well as concert. Photography must be creative, innovative and of the highest aesthetic quality possible.

■**REX USA LTD (incorporating RDR)**, 351 W. 54th St., New York NY 10019. (212)586-4432. Fax: (212)541-5724. Manager: Charles Musse. Estab. 1935. Stock photo agency, news/feature syndicate. Affiliated with Rex Features in London. Member of Picture Agency Council of America (PACA). Has 1.5 million photos. Clients include: advertising agencies, public relations firms, audiovisual firms, businesses, book/encyclopedia publishers, magazine publishers, newspapers, postcard companies, calendar companies, greeting card companies and TV, film and record companies.
Needs: Primarily editorial material: celebrities, personalities (studio portraits, candid, paparazzi), human interest, news features, movie stills, glamour, historical, geographic, general stock, sports and scientific.

Specs: Uses all sizes and finishes of b&w and color prints; 35mm, 2¼×2¼, 4×5, and 8×10 transparencies; b&w and color contact sheets; b&w and color negatives; VHS videotape.
Payment & Terms: Pays 50% commission; payment varies depending on quality of subject matter and exclusivity. "We obtain highest possible prices, starting at $100-100,000 for one-time sale." Pays 50% commission on b&w and color photos. Works with or without contract. Offers nonexclusive contracts. Statements issued monthly. Payment made monthly. Photographers allowed to review account records. Offers one-time rights, first rights and all rights. Informs photographer and allows him to negotiate when client requests all rights. Model release required. Captions required.
Making Contact: Interested in receiving work from newer, lesser-known photographers. Arrange a personal interview to show portfolio. Query with samples. Query with list of stock photo subjects. SASE of mailing photos, send no more than 40. Reports in 1-2 weeks.

■**H. ARMSTRONG ROBERTS**, Dept. PM, 4203 Locust St., Philadelphia PA 19104. (800)786-6300. Fax: (800)786-1920. President: Bob Roberts. Estab. 1920. Stock photo agency. Member of the Picture Agency Council of America (PACA). Has 2 million photos. Has 2 branch offices. Clients include: advertising agencies, public relations firms, audiovisual firms, businesses, book/encyclopedia publishers, magazine publishers, newspapers, postcard publishers, calendar companies and greeting card companies.
Needs: Uses images on all subjects in depth except personalities and news.
Specs: Uses b&w negatives only; 35mm, 2¼×2¼, 4×5 and 8×10 transparencies.
Payment & Terms: Buys only b&w negatives outright. NPI; rate varies. Pays 35% commission on b&w photos; 45-50% on color photos. Works with or without a signed contract, negotiable. Offers various contracts including exclusive, limited regional exclusivity, and nonexclusive. Guarantees subject exclusivity within files. Charges duping fee 5%/image. Charges .5%/image for catalog insertion. Statements issued monthly. Payment made monthly. Payment sent with statement. Photographers allowed to review account records to verify sales figures "upon advance notice." Offers one-time rights. Informs photographer and allows him to negotiate when client requests all rights. Model release and captions required.
Making Contact: Interested in receiving work from newer, lesser-known photographers. Query with résumé of credits. Does not keep samples on file. SASE. Expects minimum initial submission of 250 images with quarterly submissions of 250 images. Reports in 1 month. Photo guidelines free with SASE.

■**RO-MA STOCK**, 3101 W. Riverside Dr., Burbank CA 91505-4741. (818)842-3777. Fax: (818)566-7380. Owner: Robert Marien. Estab. 1989. Stock photo agency. Member of Picture Agency Council of America (PACA). Has more than 100,000 photos. Clients include: advertising agencies; public relations firms; multimedia firms; corporations; textbook, encyclopedia and magazine publishers; postcard, calendar, greeting card, design and film/video production companies.
● As an active provider of images to the new Kodak Picture Exchange, RO-MA Stock is marketing its best images through this online computer marketing system nationwide.
Needs: Shots of wild and domestic baby animals; people (young adults, elderly, children and babies) involved with nature and/or with animals; outdoor leisure, and outdoor action sports involving every age range. Also looking for outerspace fictional images of earth and the universe, microscopic images of everything, general situations in sciences (botany, ecology, geology, astronomy, weather, natural history, medicine). People depicting their occupations, like technology, manufacturing, science, medical, business, etc. Most well-known landmarks and skylines around the world are needed.
Specs: Primarily uses 35mm, 2¼×2¼, 4×5 and 70mm dupes. Prefers medium format mounted and its matching slide dupe for scanning into Photo CD.
Payment & Terms: Pays 50% commission on b&w and color; international sales, 40% of gross. General price range: $200. Offers volume discounts to customers; terms specified in photographer's contract. Contract renews automatically with each submission for 1 year. Charges 100% duping fees; 50% catalog insertion fee from commissions and $3.50/each image in the Kodak Picture Exchange. Statements issued with payment. Photographers allowed to review account records to verify sales figures. Offers one-time rights and first rights. Informs photographer when client requests all rights to obtain permission to proceed with negotiation. Model/property release required for recognizable people and private places. Captions required for animals/plants; include common name, scientific name, habitat, photographer's name; for others include subject, location, photographer's name.

A bullet has been placed within some listings to introduce special comments by the editor of Photographer's Market.

Making Contact: Interested in receiving work from newer, lesser-known photographers. Query with résumé of credits, tearsheets or samples and list of specialties. No unsolicited original work. Responds with tips sheet, agency profile and questionnaire for photographer with SASE. Photo guidelines and tips distributed periodically to contracted photographers.

Tips: Wants photographers with "ability" to produce excellent competitive photographs for the stock photography market on specialized subjects and be willing to learn, listen and improve agency's file contents. Looking for well-composed subjects, high sharpness and color saturation. Emphasis on action outdoor sports, people involved with the environment, manufacturing, medical and laboratory situations, and industry. Also, photographers with collections of patterns in nature, in art and in architecture and macro/micro imagery are welcome.

***∎‡S & I WILLIAMS POWER PIX,** Castle Lodge, Wenvoe, Cardiff CF5 6AD Wales, United Kingdom. (01222) 595163. Fax: (01222)593905. President: Steven Williams. Picture library. Has 100,000 photos. Clients include: ad agencies, public relations firms, audiovisual firms, businesses, book/encyclopedia publishers, magazine publishers, postcard companies, calendar companies, greeting card companies and music business, i.e., records, cassettes and CDs.

Specs: Uses 35mm, 2¼×2¼, 4×5 and 8×10 transparencies.

Payment & Terms: Pays 50% commission on b&w and color photos. General price range: £50-£500 (English currency). Model release required. Captions required.

Making Contact: Arrange a personal interview to show portfolio. Query with résumé of credits, samples or stock photo list. SASE. Reports in 1-2 weeks. Photo guidelines available for SASE. Distributes a tips sheet every 3-6 months to photographers on books.

Tips: Prefers to see "a photographer who knows his subject and has done his market research by looking at pictures used in magazines, record covers, books, etc.—bright, colorful images and an eye for something just that little bit special."

∎S.K. STOCK, P.O. Box 460880, Garland TX 75046-0880. (214)494-5915. Photo Manager: Sam Copeland. Estab. 1985. Stock photo agency. Has 1,500 photos. Clients include: public relations firms, book/encyclopedia publishers, magazine publishers, calendar companies and greeting card companies.

Needs: Wants to see nudes, flowers, sunsets, animals, all subjects.

Specs: Uses 4×6, 4×4, color and/or b&w prints; 35mm 2¼×2¼, 4×5 and 8×10 transparencies; film; VHS videotape.

Payment & Terms: Buys photos when needed; pays $50/color photo; $50/b&w photo; $80/minute of videotape footage. Pays 50% commission on b&w, color, film and videotape. Average price per image: $100-300/b&w; $75-150/color; $100-400/film. Negotiates fees below standard minimum prices. Works on contract basis only. Offers nonexclusive contract. Statements issued quarterly. Payment made at time of sale. Photographers allowed to review account records "so that they can see they are not being cheated." Offers one-time rights. Informs photographer and allows him to negotiate when client requests all rights "as long as I get 10 percent." Model/property release required. Captions required; include title, what, when, where and send a list of all work.

Making Contact: Interested in receiving work from newer, lesser-known photographers. Query with samples. Query with stock photo list. Keeps samples on file. SASE. Expects minimum initial submission of 30 images with periodic submission of at least 30 images every other month. Reports in 3 weeks. Photo guidelines free with SASE. Market tips sheet distributed every 3 months; free with SASE upon request.

Tips: "Your work must be sharp. We need people who will submit work all the time, clear and sharp."

∎‡SCIENCE PHOTO LIBRARY, LTD., 112 Westbourne Grove, London W2 5RU England. (071)727-4712. Fax: (071)727-6041. Research Director: Rosemary Taylor. Stock photo agency. Has 100,000 photos. Clients include: ad agencies, public relations firms, audiovisual firms, businesses, book/encyclopedia publishers, magazine publishers, newspapers, postcard companies, calendar companies and greeting card companies.

Needs: SPL specializes in all aspects of science, medicine and technology. "Our interpretation of these areas is broad. We include earth sciences, landscape, and sky pictures; and animals. We have a major and continuing need of high-quality photographs showing science, technology and medicine *at work*: laboratories, high-technology equipment, computers, lasers, robots, surgery, hospitals, etc. We are especially keen to sign up American freelance photographers who take a wide range of photographs in the fields of medicine and technology. We like to work closely with photographers, suggesting subject matter to them and developing photo features with them. We can only work with photographers who agree to our distributing their pictures throughout Europe, and preferably elsewhere. We duplicate selected pictures and syndicate them to our agents around the world."

Specs: Uses color prints and 35mm, 2¼×2¼, 4×5, 6×7, 6×5 and 6×9 transparencies.

Payment & Terms: Pays 50% commission for b&w and color photos. General price range: $80-1,000; varies according to use. Only discount below minimum for volume or education. Offers volume discounts to customers; inquire about specific terms. Discount sales terms not negotiable. Works on

contract basis only. Offers exclusivity; exceptions are made; subject to negotiation. Agreement made for four years; general continuation is assured unless otherwise advised. Statements issued quarterly. Payment made quarterly. Photographers allowed to review account records to verify sales figures; fully computerized accounts/commission handling system. Offers one-time and electronic media rights. Model release required. Captions required.

Making Contact: Interested in receiving work from newer, lesser-known photographers. Query with samples or query with list of stock photo subjects. Send unsolicited photos by mail for consideration. Returns material submitted for review. Reports in 3 weeks.

Tips: Prefers to see "a small (20-50) selection showing the range of subjects covered and the *quality*, style and approach of the photographer's work. Our bestselling areas in the last two years have been medicine and satellite imagery. We see a continuing trend in the European market towards very high-quality, carefully-lit photographs. This is combined with a trend towards increasing use of medium and large-format photographs and decreasing use of 35mm (we make medium-format duplicates of some of our best 35mm); impact of digital storage/manipulation; problems of copyright and unpaid usage. The emphasis is on an increasingly professional approach to photography."

SHARPSHOOTERS, INC., 4950 SW 72 Ave., Suite 114, Miami FL 33155. (305)666-1266. Manager, Photographer Relations: Edie Tobias. Estab. 1984. Stock photo agency. Member of Picture Agency Council of America (PACA). Has 500,000 photos. Clients include: advertising agencies.

Needs: Model-released people for advertising use. Well-designed, styled photographs that capture the essence of life: children; families; couples at home, at work and at play; also beautiful landscapes geared toward advertising, large format preferred.

Specs: Uses transparencies only, all formats.

Payment & Terms: Pays 50% commission on color photos. General price range: $275-15,000. Works on contract basis only. Offers exclusive contract only. Statements issued monthly. Payments made monthly. Photographers allowed to review account records; "monthly statements are derived from computer records of all transactions and are highly detailed." Offers one-time rights usually, "but if clients pay more they get more usage rights. We never offer all rights on photos." Model/property release required. Photo captions preferred.

Making Contact: Interested in receiving work from newer, lesser-known photographers. Query along with nonreturnable printed promotion pieces. Cannot return unsolicited material. Reports in 1 week.

Tips: Wants to see "technical excellence, originality, creativity and design sense, excellent ability to cast and direct talent and commitment to shooting stock." Observes that "photographer should be in control of all elements of his/her production: casting, styling, props, location, etc., but be able to make a photograph that looks natural and spontaneous."

SILVER IMAGE PHOTO AGENCY, INC., 4104 NW 70th Terrace, Gainesville FL 32606. (904)373-5771. President/Owner: Carla Hotvedt. Estab. 1988. Stock photo agency. Assignments in Florida/S. Georgia. Has 20,000 color/b&w photos. Clients include: public relations firms, book/encyclopedia publishers, magazine publishers and newspapers.

Needs: Florida-based travel/tourism, Florida cityscapes and people, nationally oriented topics such as drugs, environment, recycling, pollution, etc. Humorous people, celebrities and animal photos.

Specs: Uses 35mm transparencies.

Payment & Terms: Pays 50% commission on b&w/color photos. General price range: $150-600. Works on contract basis only. Offers nonexclusive contract. Statements issued monthly. Payment made monthly. Offers one-time rights. Informs photographer and allows him to negotiate when client requests all rights. Model release preferred. Captions required: include name, year shot, city, state, etc.

Making Contact: Query with list of stock photo subjects. SASE; will return if query first. Reports on queries in 2 weeks; material up to 2 months. Photo guidelines free with SASE. Tips sheets distributed as needed. SASE. Do not submit material unless requested first.

Tips: Looks for ability to tell a story in one photo. "I will look at photographer's work if they seem to have images outlined on my stock needs list which I will send out after receiving a query letter with SASE. Because of my photojournalistic approach my clients want to see people-oriented photos, not just pretty scenics. I also get many calls for drug-related photos and unique shots from Florida."

SILVER VISIONS, P.O. Box 2679, Aspen CO 81612. (313)923-3137. Owner: Joanne M. Johnson. Estab. 1987. Stock photo agency. Has 10,000 photos. Clients include: book/encyclopedia publishers, magazine publishers, postcard companies, calendar companies and greeting card companies.

• Silver Visions is in the process of creating a CD-ROM catalog of low resolution images for distribution to publishers.

Needs: Emphasizes lifestyles—people, families, children, couples involved in work, sports, family outings, pets, etc. Also scenics of mountains and deserts, horses, dogs, cats, cityscapes—Denver, L.A., Chicago, Baltimore, NYC, San Francisco, Salt Lake City, capitol cities of the USA.

We Outgrew Our Old Location!!

John Moran / SILVER IMAGE

SILVER IMAGE
904 • 373-5771

When Carla Hotvedt, president/owner of Silver Image Photo Agency, wanted to announce a new location for her company, she knew right away which image she wanted to use for a direct mail piece. Photographer John Moran of Gainesville, Florida, snapped the shot while the pigs were attempting to warm up on a cold day. Hotvedt says the image sold to Avanti Press after the greeting card/calendar producer received the direct mail piece.

Specs: Uses 8×10 or 5×7 glossy or semigloss b&w prints; 35mm, 2¼×2¼ or 4×5 transparencies.
Payment & Terms: Pays 50% commission on b&w and color photos. General price range: $35-750. Offers one-time rights and English language rights. Model/property release required for pets, people, upscale homes. Captions required; include identification of locations, species.
Making Contact: Query with samples. SASE. Reports in 2 weeks. Photo guidelines free with SASE.
Tips: Wants to see "emotional impact or design impact created by composition and lighting. Photos must evoke a universal human interest appeal. Sharpness and good exposures—needless to say." Sees growing demand for "minority groups, senior citizens, fitness."

‡**THE SLIDE FILE,** 79 Merrion Square, Dublin 2 Ireland. (0001)6766850. Fax: (0001)6608332. Director/Picture Editor: George Munday. Stock photo agency and picture library. Has 70,000 photos. Clients include: ad agencies, public relations firms, businesses, book/encyclopedia publishers, magazine publishers, newspapers and designers.
Needs: Overriding consideration is given to Irish or Irish-connected subjects. Has limited need for overseas locations, but is happy to accept material depicting other subjects, particularly people.
Specs: Uses 35mm, 2¼×2¼ and 4×5 transparencies.
Payment & Terms: Pays 50% commission on color photos. General price range: £60-1,000 English currency ($90-1,500). Works on contract basis only. Offers exclusive contracts and limited regional exclusivity. Contracts renew automatically with additional submissions. Statements issued quarterly. Payment made quarterly. Photographers allowed to review account records. Offers one-time rights. Informs photographer when client requests all rights, but "we take care of negotiations." Model release preferred. Captions required.
Making Contact: Interested in receiving work from newer, lesser-known photographers. Query with list of stock photo subjects. Works with local freelancers only. Does not return unsolicited material. Expects minimum initial submission of 250 transparencies; 1,000 images annually. "A return shipping fee is required: important that all similars are submitted together. We keep our contributor numbers down and the quantity and quality of submissions high. Send for information first." Reports in 1 month.
Tips: "Our affiliation with international picture agencies provides us with a lot of general material of people, overseas travel, etc. However, our continued sales of Irish-oriented pictures need to be kept supplied. Pictures of Irish-Americans in Irish bars, folk singing, Irish dancing, would prove to be

useful. They would be required to be beautifully lit, carefully composed and good-looking, model-released people."

■**SOUTHERN STOCK PHOTO AGENCY,** 3601 W. Commercial Blvd., Suite 33, Ft. Lauderdale FL 33309. (800)486-7118. Fax: (305)486-7118. Contact: Victoria Ross. Estab. 1976. Stock photo agency. Member of Picture Agency Council of America (PACA). Has 750,000 photos. Clients include: advertising agencies, design firms, businesses, book/encyclopedia publishers, magazine publishers, newspapers, calendar and greeting card companies.
Needs: Needs photos of "southern U.S. cities, Bahamas, Caribbean, South America, and model-released lifestyle photos with young families and active seniors, as well as all general categories."
Specs: Uses color, 35mm, 2¼×2¼, 4×5 transparencies.
Payment & Terms: Pays 50% commission on color photos. General price range: $225-5,000. Works on contract basis only. Offers nonexclusive contract. Contracts renew automatically. Statements issued bimonthly. Payment made bimonthly. Photographers allowed to review account records. Offers one-time rights, first time rights and all rights. Informs photographer and allows him to negotiate when client requests all rights. Model release and photo captions required.
Making Contact: Query with samples/phone call. SASE. Reports in 1 month. Photo guidelines free with SASE.
Tips: In portfolio or samples, wants to see approximately 200 transparencies of a cross section of work. Photographers "must be willing to regular new work on a consistent basis."

SOUTHWEST STOCK SHOTS, 4100 Knollcrest Dr., P.O. Box 6402, Farmington NM 87499. Phone/fax: (505)325-7699. President: Chris Henderson. Estab. 1994. Stock photo agency. Has 3,500 photos. Clients include: advertising agencies, public relations firms, book/encyclopedia publishers, magazine publishers, postcard publishers, calendar and greeting card companies.
 • This market is examining CD-ROM storage of images and Internet marketing. They hope to have something online in late 1995 or early 1996.
Needs: Photos of the Southwest portion of the United States.
Specs: Uses 8×10 glossy b&w prints; 35mm, 2¼×2¼, 4×5 transparencies.
Payment & Terms: Pays 50% commission on b&w and color photos. Enforces minimum price of $50/image. Offers volume discounts to customers; terms specified in photographer's contract. Photographers can choose not to sell images on discount terms. Works with or without contract. Offers nonexclusive contracts. Statements issued monthly. Payment made within 30 days of client payment. Photographers allowed to review account records. Offers one-time rights; will negotiate other rights, but photographer has final approval. Informs photographer and allows him to negotiate when client requests all rights. Model/property release preferred. Captions required, "get the five 'Ws' in."
Making Contact: Interested in receiving work from newer, lesser-known photographers. Query with stock photo list. Send unsolicited slides in archival quality pages. Keeps samples on file. SASE. Reports in 3 weeks. Photo guidelines free with SASE. Market tips sheet distributed quarterly to photographers with images on file; cost is $1.
Tips: "Leave good negative space for copy. We're new and still building our image files, so we need all Southwestern images. Be creative; we can shoot pretty sunsets 300 days a year from our office."

■**SOVFOTO/EASTFOTO, INC.,** 48 W. 21 St., 11th Floor, New York NY 10010. (212)727-8170. Fax: (212)727-8228. Director: Victoria Edwards. Estab. 1935. Stock photo agency. Has 1 million photos. Clients include: audiovisual firms, book/encyclopedia publishers, magazine publishers, newspapers.
 • This agency markets images via the Picture Network International.
Needs: Interested in photos of Eastern Europe, Russia, China, CIS republics.
Specs: Uses 8×10 glossy b&w and color prints; 35mm transparencies.
Payment & Terms: Pays 50% commission. Average price per image to clients $150-250/b&w photo; $150-250/color photo. Negotiates fees below standard minimum prices. Offers exclusive contracts, limited regional exclusivity and non-exclusivity. Statements issued quarterly. Payment made quarterly. Photographers permitted to review account records to verify sales figures or account for various deductions. Offers one-time, electronic media and nonexclusive rights. Model/property release preferred. Captions required.
Making Contact: Arrange personal interview to show portfolio. Query with samples. Query with stock photo list. Samples kept on file. SASE. Expects minimum initial submission of 50-100 images. Reports in 1-2 weeks.
Tips: Looks for "news and general interest photos (color) with human element."

SPECTRUM PHOTO, 3127 W. 12 Mile Rd., Berkley MI 48072. Phone: (313)398-3630. Fax: (313)398-3997. Owner: Laszlo Regos. Estab. 1990. Stock photo agency. Has 300,000 images. Clients include: ad agencies, public relations firms, businesses, magazine publishers, postcard publishers, calendar companies and display companies.

Needs: All subjects, but especially "high-tech, business, industry, lifestyles, food and backgrounds."
Specs: Uses 8×10 glossy b&w prints; 35mm, 2¼×2¼, 4×5 transparencies, 70mm and panoramic.
Payment & Terms: Pays 50% commission on b&w and color film. General price range: $50-300/
b&w photo; $150-1,500/color photo. Works on contract basis only. Offers limited regional exclusivity.
Contracts renew automatically with each submission; time period not specified. Charges duping fee
of 50%/image. Statements issued monthly. Payment made bimonthly. Photographers allowed to review
account records to verify sales figures. Offers one-time and electronic media rights. Requires agency
promotion rights. Informs photographer and permits negotiation when client requests all rights, with
some conditions. Model/property release required. Captions required.
Making Contact: Query with samples. Does not keep samples on file. SASE. Submit maximum of
50-75 images in initial query. Expects periodic submissions of 300-600 images each year. Reports
in 3 weeks. Photo guidelines sheet free with SASE. Tips sheet available periodically to contracted
photographers.
Tips: Wants to see "creativity, technical excellence and marketability" in submitted images. "We have
many requests for business-related images, high-tech, and lifestyle photos. Shoot as much as possible
and send it to us."

■‡**SPORTING PICTURES (UK), LTD.**, 7A Lambs Conduit Passage, London WC1R 4RG England.
(071)405-4500. Fax: (071)831-7991. Picture Editor: Mark Whitmore. Estab. 1972. Stock photo agency,
picture library. Has 3 million photos. Clients include: advertising agencies, public relations firms,
audiovisual firms, businesses, book/encyclopedia publishers, magazine publishers, newspapers, post-
card companies, calendar companies and greeting card companies.
Needs: Sport photos: gridiron, basketball, baseball, ice hockey, boxing and athletics, especially leisure
sports, children in sports, amateur sports, adventure sports.
Specs: Uses 35mm transparencies.
Payment & Terms: Pays 50-60% commission. Enforces minimum prices. Works with or without a
signed contract, negotiable; offers guaranteed subject exclusivity. Statements issued quarterly. Payment
made quarterly. Does not inform photographer or allow him to negotiate when client requests all rights.
Model/property release preferred. Captions preferred.
Making Contact: Interested in receiving work from newer, lesser-known photographers. Submit
portfolio for review. Samples kept on file "if pictures are suitable." SASE. Expects minimum initial
submission of 50 images. Reports ASAP.

SPORTSLIGHT PHOTO, 127 W. 26 St., Suite 800, New York NY 10001. Director: Roderick Beebe.
Stock photo agency. Has 250,000 photos. Clients include: ad agencies, public relations firms, busi-
nesses, book/encyclopedia publishers, magazine publishers, newspapers, postcard companies, calendar
companies, greeting card companies and design firms.
Needs: "We specialize in every sport in the world. We deal primarily in the recreational sports such
as skiing, golf, tennis, running, canoeing, etc., but are expanding into pro sports, and have needs for
all pro sports, action and candid close-ups of top athletes. We also handle adventure-travel photos,
e.g., rafting in Chile, trekking in Nepal, dogsledding in the Arctic, etc."
Specs: Uses 35mm transparencies.
Payment & Terms: Pays 50% commission. General price range: $100-6,000. Contract negotiable.
Offers limited regional exclusivity. Contract is of indefinite length until either party (agency or photog-
rapher) seeks termination. Statements issued quarterly. Payment made quarterly. Photographers allowed
to review account records to verify sales figures "when discrepancy occurs." Offers one-time rights,
rights depend on client, sometimes exclusive rights for a period of time. Informs photographer and
consults with him when client requests all rights. Model release required for corporate and advertising
usage. (Obtain releases whenever possible.) Strong need for model-released "pro-type" sports. Cap-
tions required; include who, what, when, where, why.
Making Contact: Interested in receiving work from newer, and known photographers. Query with
list of stock photo subjects, "send samples *after* our response." SASE must be included. Cannot return
unsolicited material. Reports in 2-4 weeks. Photo guideline sheet free with SASE.
Tips: In reviewing work looks for "range of sports subjects that show photographer's grasp of the
action, drama, color and intensity of sports, as well as capability of capturing great shots under all
conditions in all sports. Well edited, perfect exposure and sharpness, good composition and lighting
in all photos. Seeking photographers with strong interests in particular sports. Shoot variety of action,
singles and groups, youths, male/female—all combinations. Plus leisure, relaxing after tennis, lunch
on the ski slope, golf's 19th hole, etc. Clients are looking for all sports these days. All ages, also.
Sports fashions change rapidly, so that is a factor. Art direction of photo shoots is important. Avoid
brand names and minor flaws in the look of clothing. Attention to detail is very important. Shoot with
concepts/ideas such as teamwork, determination, success, lifestyle, leisure, cooperation and more in
mind. Clients look not only for individual sports, but for photos to illustrate a mood or idea. There is
a trend toward use of real-life action photos in advertising as opposed to the set-up slick ad look. More
unusual shots are being used to express feelings, attitude, etc."

STOCK IMAGERY, INC., 711 Kalamath, Denver CO 80204. (303)592-1091. Fax: (303)592-1278. Contact: Heather Hill. Estab. 1981. Stock photo agency. Member of Picture Agency Council of America (PACA). Has over 150,000 photos. "With representation in over 30 countries worldwide, our highly competitive catalogs receive maximum exposure." Clients include: advertising agencies, public relations firms, audiovisual firms, book/encyclopedia publishers, magazine publishers, newspapers, postcard publishers, calendar companies, greeting card companies, TV and a variety of businesses. Quarterly newsletter gives market tips, agency updates, etc.
Needs: All subjects, color and b&w.
Specs: Uses 35mm, 2¼×2¼, 4×5, 8×10 transparencies.
Payment & Terms: Pays 50% commission on image sales. NPI. "We have set prices, but under special circumstances we contact photographer prior to negotiations." Works on contract basis only. Offers exclusive and nonexclusive contracts. Statements and payments issued monthly. Model/property release required. Captions required.
Making Contact: "We are always willing to review new photographers' work; please call for a photographer information packet that includes submission guidelines and other pertinent information. Photographer must have 250 images on file to be put under contract. Submit a well edited sample of your work. Selection must be a good representation of the type and caliber of work that you can supply on a regular basis."

■**THE STOCK MARKET**, 360 Park Ave. S., New York NY 10010. (212)684-7878. Fax: (212)532-6750. Contact: Gerry Thies or Catherine DeMaria. Estab. 1981. Stock photo agency. Member of Picture Agency Council of America (PACA). Has 2 million images. Clients include: advertising agencies, public relations firms, corporate design firms, book/encyclopedia publishers, magazine publishers, newspapers, postcard companies, calendar companies and greeting card companies.
• This agency markets more than 6,000 low resolution images on CD-ROM and plans to produce even more.
Needs: Topics include lifestyle, corporate, industry, nature, travel and digital concepts.
Specs: Uses color, all formats.
Payment & Terms: Pays 50% gross sale on color photos. Works on exclusive contract basis only. Charges catalog insertion fee of 50%/image for US edition only. Statements issued monthly. Payment made monthly. Photographers allowed to review account records to verify sales figures. Offers one-time rights. When client requests to buy all rights, "we ask permission of photographer, then we negotiate." Model/property release required for all people, private homes, boats, cars, property. Captions are required; include "what and where."
Making Contact: Call or write with printed samples. Arrange a personal interview or send portfolio of 250 transparencies. SASE. Reports in 2-3 weeks. Tips sheet distributed as needed to contract photographers only.
Tips: "The Stock Market represents work by some of the world's best photographers. Producing work of the highest caliber, we are always interested in reviewing work by dedicated professional photographers who feel they can make a contribution to the world of stock."

STOCK OPTIONS, Dept. PM, 4602 East Side Ave., Dallas TX 75226. (214)826-6262. Fax: (214)826-6263. Owner: Karen Hughes. Estab. 1985. Stock photo agency. Member of Picture Agency Council of America (PACA). Has 100,000 photos. Clients include: advertising agencies, public relations firms, audiovisual firms, corporations, book/encyclopedia, magazine publishers, newspapers, postcard companies, calendar and greeting card companies.
• This agency hopes to market work on CD-ROM in the near future.
Needs: Emphasizes the southern US. Files include Gulf Coast scenics, wildlife, fishing, festivals, food, industry, business, people, etc. Also western folklore and the Southwest.
Specs: Uses 35mm, 2¼×2¼ and 4×5 transparencies.
Payment & Terms: Pays 50% commission on b&w or color photos. General price range: $300-3,000. Works on contract basis only. Offers nonexclusive contract. Contract automatically renews with each submission to 5 years from expiration date. When contract ends photographer must renew within 60 days. Charges catalog insertion fee of $300/image and marketing fee of $5/hour. Statements issued upon receipt of payment from client. Payment made immediately. Photographers allowed to review account records to verify sales figures. Offers one-time and electronic media rights. "We will inform photographers for their consent only when a client requests all rights, but we will handle all negotiations." Model/property release preferred for people, some properties, all models. Captions required; include subject and location.
Making Contact: Interested in receiving work from newer, lesser-known photographers. Arrange a personal interview to show portfolio. Query with list of stock photo subjects. Contact by "query and submit 200 sample photos." Works with local freelancers only. SASE. Reports in 1 month. Tips sheet distributed annually to all photographers.

Tips: Wants to see "clean, in focus, relevant and current materials." Current stock requests include: industry, environmental subjects, people in up-beat situations, minorities, food, cityscapes and rural scenics.

■‡STOCK PHOTOS, Serrano, 85 3 DCHA, Madrid 28006 Spain. 34 1 564 4095. Fax: 34 1 564 4353. Director: Carmen Taibo. Estab. 1988. Stock photo agency and news/feature syndicate. Has 300,000 photos. Clients include: advertising agencies, audiovisual firms, businesses, book/encyclopedia publishers, magazine publishers and newspapers.
 • Latin Stock is a network of eight Latin agencies, based in Madrid (Stock Photos), Buenos Aires (Focus), Sao Paulo (Stock Photos), Santiago de Chile (Fotobanco Internacional), Mexico (BIF), Caracas, Bogotá and Lima. It is also affiliated with West Light and The Stock Market in the U.S.
Needs: Stock photography for advertising with model-released people, top quality magazine stories with short text and people.
Specs: "We specialize in advertising in our ad section and we also handle magazine photography in our editorial section." Uses 35mm b&w prints; 35mm, 2¼×2¼, 4×5, 8×10 transparencies.
Payment & Terms: Pays 50-60% commission. General price range: Minimum $90-1,500. Works on contract basis only. Contracts renew automatically with additional submissions. Statements issued bimonthly. Photographers allowed to review account records. Informs photographer and allows him to negotiate when client requests all rights. Offers one-time and electronic media rights. Model release required for advertising materials. Captions required.
Making Contact: Query with samples. Reports in 3 weeks. Tips sheet distributed once a year to working photographers; free with SASE.
Tips: Looks for "transparencies of technical excellence, professionalism in producing stock and knowledge of the needs of this market, whether editorial or advertising. We need high-tech imagery, high-tech stories/reportage for magazines, pictures with models, teenagers, people consuming, people working at their professions, medicine, etc. Portraits of celebrities have another area of the market and we also sell them very well in Spain. We are currently preparing our first stock catalog, which will be centered in Latin images, that is model-released stock photography with Latin-looking models, travel and economic images of Latin America and Spain, and all sorts of images that are related to the Latin culture, especially the ones that are related with the Latino culture within the USA, since those images are very much requested and we do have most of our picture suppliers in Latin America."

■STOCK PILE, INC., Main office: Dept. PM, 2404 N. Charles St., Baltimore MD 21218. (410)889-4243. Branch: P.O. Box 30168, Grand Junction CO 81503. (303)243-4255. Vice President: D.B. Cooper. Picture library. Has 28,000 photos. Clients include: ad agencies, art studios, slide show producers, etc.
Needs: General agency looking for well-lit, properly composed images that will attract attention. Also, people, places and things that lend themselves to an advertising-oriented marketplace.
Specs: Transparencies, all formats. Some b&w 8×10 glossies.
Payment & Terms: Pays 50% commission on b&w and color photos. Works on contract basis only. Contracts renew automatically with additional submissions. Payment made monthly. Offers one-time rights. Informs photographer and permits him to negotiate when client requests all rights. Model release preferred. Captions required.
Making Contact: Interested in receiving work from newer, lesser-known photographers. Inquire for guidelines, submit directly (minimum 200) or call for personal interview. All inquiries and submissions must be accompanied by SASE. *Send all submissions to Colorado address.* Periodic newsletter sent to all regular contributing photographers.

■STOCK SOUTH, 75 Bennett St. NW, Suite P-1, Atlanta GA 30309. (404)352-0538. Fax: (404)352-0563. President: David Perdew. Estab. 1989. Stock photo agency. Has 250,000 photos; color and b&w. Clients include: advertising agencies, public relations firms, audiovisual firms, businesses, book/encyclopedia publishers, magazine publishers and newspapers. Holds photographs on consignment.
 • This agency is a member of the Picture Network International, an online database network.
Needs: Lifestyles, corporate, leisure, travel (southeastern particularly). All should be model- and property-released.
Specs: Uses 8×10 glossy b&w prints; 35mm, 2¼×2¼, and 4×5 transparencies.
Payment & Terms: Pays 50% commission on b&w and color photos. General price range: $250-1,000. Works on contract basis only. Offers nonexclusive contracts. Contracts renew automatically for five years. Charges duping fees and catalog insertion fees. Statements issued monthly. Payment made monthly. Photographers allowed to review account records. Offers one-time and electronic media rights. Photographer notified when client requests all rights. Model/property release required. Captions required.
Making Contact: Query with samples. SASE. Reports in 3 weeks. Photo guidelines free with SASE. Market tips sheet distributed monthly to contracted photographers.

Tips: Wants to see photos that are "model-released, clean, dramatic and graphic. In all situations, we're looking for outstanding photographs that are better than anything we've seen. Edit tightly."

■**THE STOCKHOUSE, INC.**, Box 540367, Houston TX 77254-0367. (713)942-8400. Fax: (713)526-4634. Sales and Marketing Director: Celia Jumonville. Stock photo agency. Member of Picture Agency Council of America (PACA). Has 500,000 photos. Clients include: advertising agencies, public relations firms, audiovisual firms, businesses, book/encyclopedia publishers, magazine publishers, newspapers, postcard companies, calendar companies and greeting card companies.
Needs: Needs photos of general topics from travel to industry, lifestyles, nature, US and foreign countries. Especially interested in Texas and petroleum and medical.
Specs: Uses 35mm, 2¼×2¼, 4×5, 8×10 transparencies; "originals only."
Payment & Terms: Pays 50% commission on color photos. General price range: $200-1,000. Works on contract basis only. Offers limited regional exclusivity. Statements issued monthly. Payment made following month after payment by client. Photographers allowed to review account records to verify sales figures by appointment. Offers one-time rights; other rights negotiable. Informs photographer and allows him to negotiate when client requests all rights; must be handled through the agency only. Model/property release preferred for people and personal property for advertising use; photographer retains written release. Photo captions required; include location, date and description of activity or process.
Making Contact: Interested in receiving work from newer, lesser-known photographers. Query with samples; request guidelines and tipsheet. Send submissions to 3301 W. Alabama, Houston TX 77098. SASE. Photo guidelines free with SASE. Tips sheet distributed quarterly to contract photographers.
Tips: In freelancers' samples, wants to see "quality of photos—color saturation, focus and composition. Also variety of subjects and 200-300 transparencies on the first submission. Trends in stock vary depending on the economy and who is needing photos. Quality is the first consideration and subject second. We do not limit the subjects submitted since we never know what will be requested next. Industry and lifestyles and current skylines are always good choices."

■**TONY STONE IMAGES, INC.**, 6100 Wilshire Blvd., #1250, Los Angeles CA 90048. (213)938-1700. (Offices in 25 locations worldwide). Director of Photography: Sarah Stone. Estab. in US 1988, Worldwide 1968. Stock photo agency. Member of Picture Agency Council of America (PACA). Clients include: advertising agencies, public relations firms, audiovisual firms, businesses, book/encyclopedia publishers, magazine publishers, newspapers, calendar, greeting card and travel companies.
● This agency has worked hard to accommodate digital submissions. Tony Stone Images accepts work in any form, including digital. As technology improves so does the agency's capabilities. Keep in touch with them to know what digital formats are accepted.
Needs: Very high quality, technically and creatively excellent stock imagery on all general subjects for worldwide and US distribution.
Specs: Wants to see great images in any format—print, transparencies or digital. "Large and medium format transparencies are always put into our custom mounts, so you do not have to mount them. We do, however, want them submitted (with acetate sleeves) in appropriately-sized viewing sheets." As for digital submissions "at the moment, only high resolution drum scans will yield image files of the quality and resolution to meet our standards. We are not accepting digital imagery which originate from Kodak's Photo CD's or the new desktop scanners."
Payment & Terms: Pays 50% commission on b&w and color photos. Price ranges vary according to usage. "Minimum price in the United States is $100 unless very exceptional circumstances, e.g., very specialized, low-level usage or limited exposure of imagery." Offers volume discounts to customers, "but *maximum* 10% and then rarely"; inquire about specific terms. Works on contract basis only. "We ask for exclusivity on a photographer's best work only." Charges catalog insertion fee. "No upfront charges are required; deductions are made if image sells." Statements and payment issued monthly. Offers various rights. "When client requests all rights, we ask photographer's permission and negotiate accordingly." Model/property release required. "Call us if you need samples of release forms designed for stock photography. Too often we have to reject perfectly good images for lack of releases." Photo captions required with as much detail as possible. Print captions on the front of each mount, or number each mount and print the captions on a separate sheet of paper.
Making Contact: "Please do not send unsolicited images. Call our Creative Department for free submission guidelines." Expects minimum initial submission of 50 images.
Tips: Wants to see "technical ability, creativity. Commitment to high standards." Sees increased demand for high quality. "If you can't shoot better imagery than that already available, don't bother at all."

✤**TONY STONE IMAGES/VANCOUVER**, (formerly Image Finders Photo Agency, Inc.), 134 Abbott St., 7th Floor, Vancouver, British Columbia V6B 2K4 Canada. (604)688-9818. President: Pindar Azad. Has 300,000 photos of all subjects. Clients include: ad agencies, graphic designers, public relations firms, businesses, audiovisual firms, book publishers, magazine publishers, encyclopedia publishers,

newspapers, postcard companies, calendar companies and greeting card companies.
Needs: Business, education, medical, hospitality, service and industrial, and general worldwide stock.
Specs: Uses transparencies only.
Payment & Terms: Pays 50% commission. General price range: $400 and up; more for ad campaigns. Works on contract basis only. Offers limited regional exclusivity. Some contracts renew automatically with each submission; time periods of 1 and 2 years according to contract. Statements issued quarterly. Payment made quarterly. Offers one-time rights, all rights or first rights. Informs photographer and allows him to negotiate when client requests all rights; "requires photographer's written approval." Model/property release required for people and houses. Captions required; include description, technical data, etc.
Making Contact: "Send SASE for questionnaire and description of agency. Please do not send unsolicited material. Tearsheets OK." Photo guidelines free with SAE and International Reply Coupons. "*Please no* foreign stamps—*stamps must be Canadian.*" Distributes quarterly want list to established contributors.
Tips: "Show the very best work. Ask lots of questions, and review monthly magazine and stock catalogs."

■**SUPERSTOCK INC.**, 7660 Centurion Parkway, Jacksonville FL 32256. (904)565-0066. Photographer Liaison: Kai Chiang. International stock photo agency represented in 38 countries. Extensive vintage and fine art collection available for use by clients. Clients include: ad agencies, public relations firms, audiovisual firms, businesses, book/encyclopedia publishers, magazine publishers, newspapers, postcard companies, calendar companies, greeting card companies and major corporations.
Needs: "We are a general stock agency involved in all markets. Our files are comprised of all subject matter."
Specs: Uses 35mm, 2¼×2¼, 4×5 and 8×10 transparencies.
Payment & Terms: "We work on a contract basis." Statements issued monthly. Payment made monthly. Photographers allowed to review account records to verify sales figures. Rights offered "varies, depending on client's request." Informs photographer and allows him to negotiate when client requests all rights. Model release required. Captions required.
Making Contact: Query with résumé of credits. Query with tearsheets only. Query with list of stock photo subjects. Submit portfolio for review "when requested." SASE. Reports in 3 weeks. Photo guidelines sheet free with SASE or sent if requested via phone. Newsletter distributed bimonthly to contracted photographers.
Tips: "The use of catalogs as a buying source is a very effective means of promoting photographs, and a continuing trend in the industry is the importance of bigger, comprehensive catalogs. We produce the SuperStock Photo Catalog in the US. Space is available to professional photographers regardless of any of their other photographic affiliations. Participation in this catalog provides an excellent opportunity for photographers to take advantage of the growing international market for stock, and receive the highest royalty percentage for internationally distributed photographs."

SWANSTOCK AGENCY INC., P.O. Box 2350, Tucson AZ 85701. (602)622-7133. Fax: (602)622-7180. Contact: Submissions. Estab. 1991. Stock photo agency. Has 100,000 photos. Clients include: advertising agencies, public relations firms, book/encyclopedia publishers, magazine publishers, newspapers, postcard publishers, calendar companies, greeting card companies, design firms, record companies and inhouse agencies.
Needs: Swanstock's image files are artist-priority, not subject-driven. Needs range from photo-illustration to realistic family life in the '90s. (Must be able to provide releases upon request.)
Specs: Uses 8×10 or smaller color and b&w prints; 35mm, 2¼×2¼, 4×5, 8×10 transparencies. *Send dupes only.*
Payment & Terms: Pays 50% commission on b&w and color photos. Average price per image (to clients): $200-1,000. Negotiates fees below standard minimum prices if agreeable to photographer in exchange for volume overrun of piece for promotional needs. Offers volume discounts to customers; terms specified in photographer's contract. Photographers can choose not to sell images on discount terms. Works on contract basis only. Offers nonexclusive contracts. Photographers provide all dupes for agency files. Statements issued upon sales only, within one month of payment by client. Photographers allowed to review account records by appointment only. "We sell primarily one-time rights, but clients frequently want one of the following arrangements: one year, domestic only; one year, international; one year with an option for an immediate second year at a predetermined price; one year, unlimited usage for a specific market only; one year, unlimited usages within ALL markets; all rights for the life of that specific edition only (books) and so forth." Informs photographer when client requests all rights and allows photographer to negotiate if they have experience with negotiation and have a prior relationship with the client. Model release often required. Captions preferred; include where and when.

Making Contact: Interested in receiving work from lesser-known photographers with accomplished work. Query with samples. Include SASE to receive submission details. Keeps samples on file. SASE. Reporting time may be longer than 1 month.

Tips: "We look for bodies of work that reflect the photographer's consistent vision and sense of craft—whether their subject be the landscape, still lifes, family, or more interpretive illustration. Alternative processes are encouraged (i.e., Polaroid transfer, hand-coloring, infrared films, photo montage, pinhole and Diana camera work, etc.). Long-term personal photojournalistic projects are of interest as well. We want to see the work that you feel strongest about, regardless of the quantity. Artists are not required to submit new work on any specific calendar, but rather are asked to send new bodies of work upon completion. We do not house traditional commercial stock photography that was created by fine art photographers for personal reasons or for the gallery/museum arena. The majority of requests we receive require images to illustrate an emotion, a gesture, a season rather than a specific place geographically or a particular product. Our goal with each submission to clients is to send as many different photographer's interpretation of their need, in as many photographic processes as possible. We communicate with our clients in order to keep the usages within the original intent of the photographer (i.e., submitting proofs of desired placement of copy, wrapping an image around a book jacket, etc.) and frequently place the artist in communication with the client with regard to creative issues. Swanstock offers a non-exclusive contract and encourages photographers to place specific bodies of their work with the appropriate agency(s) for maximum return. We do NOT publish a catalog and ask that photographers supply us with appropriate promotional materials to send to clients. Under no circumstances should artists presume they will make a living on fine art stock in the way that commercial stock shooters do. However, we are confident that this 'niche' market will continue to improve, and encourage artists who previously felt there was no market for their personal work to contact us."

TAB STOCK INC., 6306 Ducketts Lane, Baltimore MD 21227. Phone/fax: (410)796-0545. President: Tabatha Adams-Baker. Estab. 1993. Stock photo agency. Has 250,000 photos. Clients include: advertising agencies, public relations firms, businesses, book/encyclopedia publishers, magazine publishers, newspapers, postcard publishers, calendar companies, greeting card companies.

Needs: "General subject matter, subjects with an ethnic mix—doing everything! especially families (in every situation)." Business, medical, environment, children, animals, Washington DC, Baltimore, Ocean City, Annapolis. Uses all formats. Color only.

Payment & Terms: Pays 50% commission on b&w and color photos. Average price per image (to clients): $100-20,000/color. Enforces minimum prices. Offers volume discounts to customers; inquire about specific terms. Photographers can choose not to sell images on discount terms. Works on contract basis only. Offers nonexclusive contract. Statements issued monthly. Payment made monthly. Photographers allowed to review account with 2 weeks notice. Offers one-time rights, agency promotion rights, one year exclusive calendar rights. Informs photographer of client request to buy all rights "but the agency will do the negotiation of price." Model/property release preferred for medical, business, some education. Captions preferred.

Making Contact: Interested in receiving work from newer, lesser-known photographers. Query with samples. Query with stock photo list. Samples kept on file. SASE. Expects minimum initial submission of 100-500 images with quarterly submission of at least 100-500. Reports in 1-2 weeks. Photo guidelines free with SASE. Market tips sheet distributed to photographers on file monthly free with SASE.

Tips: "We look for photographers who are well versed in their work, but our agency will not accept anything that is not top quality. Our agency is of general subject matters. Such as business, medical, environment, children, animals, etc. We would, however, like to see more of Washington DC, Baltimore, Ocean City and Annapolis, especially Baltimore. We are seeing more of an ethnic mix in all people subjects. More and more clients are demanding a model and/or property release—so get them when you can—all you have to do is ask. We want to see what a photographer can do, so we can show him/her what we can do."

■✦**TAKE STOCK INC.**, 516 15th Ave. SW, Calgary, Alberta T2R 0R2 Canada. (403)229-3458. Fax: (403)541-9104. Estab. 1987. Stock photo agency. Clients include: advertising agencies, public relations firms, audiovisual firms, corporate, book/encyclopedia publishers, magazine publishers, newspapers, postcard companies, calendar companies and greeting card companies.

Needs: Model-released people, lifestyle images (all ages), Canadian images, arts/recreation, industry/occupation, business, high-tech.

Specs: Uses 35mm, medium to large format transparencies.

Payment & Terms: Pays 50% commission on transparencies. General price range: $150-600. Works on contract basis only. Offers limited regional exclusivity. Contracts renew automatically with additional submissions with "1-year review, then every 3 years." Charges 100% duping fees. Statements issued monthly. Payment made monthly. Photographers allowed to review account records to verify sales figures, "anytime by appointment." Offers one-time rights, exclusive rights. Model/property release required. Captions required.

Making Contact: Query with list of stock photo subjects. SASE. Reports in 3 weeks. Photo guidelines free with SASE. Tips sheet distributed every 2 months to photographers on file.

■‡**TANK INCORPORATED**, Box 212, Shinjuku, Tokyo 160-91, Japan. T81-3-3239-1431. Fax: T81-3-3230-3668. Telex: 26347 PHTPRESS. President: Masayoshi Seki. Has 500,000 slides. Clients include: advertising agencies, encyclopedia/book publishers, magazine publishers and newspapers.
Needs: "Women in various situations, families, special effect and abstract, nudes, scenic, sports, animal, celebrities, flowers, picture stories with texts, humorous photos, etc."
Specs: Uses 8×10 b&w prints; 35mm, 2¼×2¼ and 4×5 slides; b&w contact sheets; videotape.
Payment & Terms: Pays 40% commission on b&w and color photos. "As for video, we negotiate at case by case basis." General price range: $70-1,000. Works on contract basis only. Offers limited regional exclusivity within files. Contracts renew automatically with each submission for 3 years. Statements issued monthly. Payment made monthly; within 45 days. Photographers allowed to review account records to verify sales figures. Offers one-time rights. Informs photographer and allows him to negotiate when client requests all rights. Model and property release is required for glamour/nude sets. Photo captions required.
Making Contact: Interested in receiving work from newer, lesser-known photographers. Query with samples, with list of stock photo subjects or send unsolicited material by mail for consideration. SASE. Reports in 1 month. Photo guidelines free with International Reply Coupons.
Tips: "We need some pictures or subjects which strike viewers. Pop or rock musicians are very much in demand. If you want to make quick sales, give us some story ideas with sample pictures which show quality, and we will respond to you very quickly. Also, give us brief bio. Color transparencies with sample stories to accompany—no color prints at all. Stock photography business requires patience. Try to find some other subjects than your competitors. Keep a fresh mind to see saleable subjects." Remarks that "photographers should have eyes of photo editor. Try to take photos which make editors use them easily. Also, give a little background of these photos."

TERRAPHOTOGRAPHICS, Box 490, Moss Beach CA 94038. (415)726-6244. Photo Agent: Carl May. Stock photo agency. Has 25,000 photos on hand; 70,000 on short notice. Clients include: ad agencies, businesses, book/encyclopedia publishers and magazine publishers.
Needs: All subjects in the earth sciences: paleontology, volcanology, seismology, petrology, oceanography, climatology, mining, petroleum industry, civil engineering, meteorology, worldwide geography, astronomy. Stock photographers must be scientists. "Currently, we need more on energy resource conservation, natural and cut gems, economic minerals, recent natural disasters and severe weather." Environmental issues are hot topics. Much more needed from the Third World, formerly Communist countries and the Middle East.
Specs: Uses 8×10 glossy b&w prints; 35mm, 2¼×2¼, 4×5 and 8×10 transparencies.
Payment & Terms: Pays 50% commission on all photos. General price range: $90-500. Works with or without a signed contract, negotiable. Offers exclusive contract only. Statements issued quarterly. Payment quarterly within one month of end of quarter. Photographers allowed to review account records to verify sales figures. Offers one-time rights; other rights negotiable. However, "this rarely happens at our agency." Informs photographer and allows participation when client requests all rights. Model release required for any commercial use, but not purely editorial. Photo captions required; include "all information necessary to identify subject matter and give geographical location."
Making Contact: Will consider work from newer, lesser-known scientist-photographers as well as established professionals. Query with list and résumé of scientific and photographic background. SASE. Reports in 2 weeks. Photo guidelines free with query, résumé and SASE. Tips sheet distributed intermittently only to stock photographers.
Tips: Prefers to see proper exposure, maximum depth of field, interesting composition, good technical and general information in caption. Natural disasters of all sorts, especially volcanic eruptions, storms and earthquakes; scientists at work using modern equipment. "We are a suitable agency only for those with both photographic skills and sufficient technical expertise to identify subject matter. We only respond to those who provide a rundown of their scientific and photographic background and at least a brief description of coverage. Captions must be neat and contain precise information on geographical locations. Don't waste your time submitting images on grainy film. Our photographers should be able to distinguish between dramatic, compelling examples of phenomena and run-of-the-mill images in

Market conditions are constantly changing! If you're still using this book and it's 1997 or later, buy the newest edition of Photographer's Market *at your favorite bookstore or order directly from Writer's Digest Books.*

the earth and environmental sciences. We need more on all sorts of weather phenomena; the petroleum and mining industries from exploration through refinement; problems and management of toxic wastes; environmental problems associated with resource development; natural areas threatened by development; and oceanography."

***TEXSTOCKPHOTO INC.**, 5320 Gulfton, #8, Houston TX 77081. (713)661-1411. Fax: (713)661-2597. President: Hal Lott. Estab. 1993. Stock photo agency. Member of Picture Agency Council of America (PACA). Has 200,000 photos. Has 1 branch office. Clients include: advertising agencies, public relations firms, audiovisual firms, businesses, book/encyclopedia publishers, magazine publishers, postcard publishers, calendar companies and greeting card companies.
● "We are either using currently, or will be using in the future, all digital and/or electronic means of marketing at our disposal."
Needs: Interested in photos of people, Texas, Southwest, lifestyle, general interest.
Specs: Uses 5×7 fiber b&w prints; 35mm, 2¼×2¼, 4×5 transparencies.
Payment & Terms: Pays 50% commission on b&w photos. Enforces minimum price of $150. Offers volume discounts to customers; inquire about specific terms. Photographers can choose not to sell images on discount terms. Works on contract basis only. Offers nonexclusive contract. Charges 50% catalog insertion fee; one-time initial submission fee $125. Statements issued quarterly. Payment made monthly. Photographers allowed to review account records. Model release required. Property release preferred. Captions required; include specifics that add value to the image.
Making Contact: Interested in receiving work from newer, lesser-known photographers. Query with samples. Query with stock photo list. Keeps samples on file. SASE. Expects minimum initial submission of 200-300 images. Reports in 1-2 weeks. Market tips sheet distributed bimonthly to contracted photographers only.

■THIRD COAST STOCK SOURCE, P.O. Box 92397, Milwaukee WI 53202. (414)765-9442. Fax: (414)765-9342. Director: Paul Henning. Managing Editor: Mary Ann Platts. Sales and Research Manager: Paul Butterbrodt. Member of Picture Agency Council of America (PACA). Has over 125,000 photos. Clients include: ad agencies, public relations firms, audiovisual firms, corporations, book/encyclopedia publishers, magazine publishers, newspapers, calendar companies and greeting card companies.
Needs: People in lifestyle situations, business, industry, sports and recreation, medium format scenics (domestic and foreign), traditional stock photo themes with a new spin.
Specs: Uses 35mm, 2¼×2¼, 4×5 and 8×10 transparencies (slow and medium speed color transparency film preferred).
Payment & Terms: Pays 50% commission on color photos. General price range: $200 and up. Enforces minimum prices. Works on contract basis only. Offers various levels of exclusivity. Contracts with photographers renew automatically for 3 or 5 years. Charges duping and catalog insertion fee. Statements issued bimonthly. Payment made bimonthly. Photographers allowed to review account records to verify sales figures. Offers one-time rights. Informs photographer when client requests all rights. Model release required. Captions required.
Making Contact: Interested in receiving work from any photographer with professional-quality material. Submit 200-300 images for review. SASE. Reports in 1 month. Photo guidelines free with SASE. Tips sheet distributed 2 times/year to "photographers currently working with us."
Tips: "We are looking for technical expertise; outstanding, dramatic and emotional appeal. We are anxious to look at new work. Learn what stock photography is all about. Our biggest need is for photos of model-released people: couples, seniors, business situations, recreational situations, etc. Also, we find it very difficult to get great winter activity scenes (again, with people) and photos which illustrate holidays: Christmas, Thanksgiving, Easter, etc."

■‡TROPIX PHOTOGRAPHIC LIBRARY, 156 Meols Parade, Meols, Merseyside L47 6AN England. Tel/Fax: 51-632-1698. Proprietor: Veronica Birley. Picture library specialist. Has 60,000 transparencies. Clients include: book/encyclopedia publishers, magazine publishers, newspapers, ad agencies, public relations firms, audiovisual firms, businesses, television/film companies and travel agents.
Needs: "All aspects of the developing world and the natural environment. Detailed and accurate captioning according to Tropix guidelines is essential. Tropix documents the Third World from its economy and environment to its society and culture. Education, medicine, agriculture, industry, technology and other Third World topics. Plus the full range of environmental topics worldwide."
Specs: Uses 35mm and medium format transparencies; some large format.
Payment & Terms: Pays 50% commission. General price range: £60-250 (English currency). Works on contract basis only. Charges cost of returning photographs by insured/registered post, if required. Payment made quarterly. Photographers allowed to have qualified auditor review account records to verify sales figures in the event of a dispute but not as routine procedure. Offers one-time rights. Other rights only by special written agreement. Informs photographer when a client requests all rights but agency handles negotiation. Model release preferred, especially for medical images. Full photo captions

required; accurate, detailed data, to be supplied on disk. Guidelines are available from agency.

Making Contact: Interested in receiving work from both established and newer, lesser-known photographers. Query with list of stock photo subjects and SASE (International Reply Paid Coupon to value of £3). *No* unsolicited photographs, please. Reports in 1 month, sooner if material is topical. "On receipt of our leaflets, a very detailed reply should be made by letter. Transparencies are requested only after receipt of this letter, if the collection appears suitable. When submitting transparencies, always screen out those which are technically imperfect."

Tips: Looks for "special interest topics, accurate and informative captioning, sharp focus always, correct exposure, strong images and an understanding of and involvement with specific subject matters. Travel scenes, views and impressions, however artistic, are not required except as part of a much more informed, detailed collection. Not less than 150 saleable transparencies per country photographed should be available." Sees a trend toward electronic image grabbing and development of a pictorial data base.

UNICORN STOCK PHOTO LIBRARY, 7809 NW 86th Terrace, Kansas City MO 64153-1769. (816)587-4131. Fax: (816)741-0632. President/Owner: Betts Anderson. Has 250,000 color slides. Clients include: ad agencies, corporate accounts, textbooks, magazines, calendars and religious publishers.

Needs: Ordinary people of all ages and races doing everyday things: at home, school, work and play. Current skylines of all major cities, tourist attractions, historical, wildlife, seasonal/holiday, and religious subjects. "We particularly need images showing two or more races represented in one photo and family scenes with BOTH parents. There is a critical need for more minority shots including Hispanics, Orientals and blacks. We also need ecology illustrations such as recycling, pollution and people cleaning up the earth."

Specs: Uses 35mm color slides.

Payment & Terms: Pays 50% commission. General price range: $50-400. Works on contract basis only. Offers nonexclusive contract. Contracts renew automatically with additional submissions for 3 years. Charges duping fee; rate not specified. Statement issued quarterly. Payment made quarterly. Offers one-time rights. Informs photographer and allows him to negotiate when client requests all rights. Model release preferred; increases sales potential considerably. Photo captions required; include: location, ages of people, dates on skylines.

Making Contact: Write first for guidelines. "We are looking for professionals who understand this business and will provide a steady supply of top-quality images. At least 500 images are required to open a file. Contact us by letter including $10 for our 'Information for Photographers' package."

Tips: "We keep in close, personal contact with all our photographers. Our monthly newsletter is a very popular medium for doing this. Our biggest need is for minorities and interracial shots. If you can supply us with this subject, we can supply you with checks. Because UNICORN is in the Midwest, we have many requests for farming/gardening/agriculture/winter and general scenics of the Midwest."

***UNIPHOTO PICTURE AGENCY**, a Pictor Group company, 3307 M St. NW, Suite 300, Washington DC 20007. (202)333-0500. Fax: (202)338-5578. Art Director: Page Carr. Estab. 1977. Stock photo agency. Has more than 750,000 photos. Has 22 other branch offices worldwide. US photographers contact Washington DC. European photographers please see Pictor International in this section. Clients include: advertising agencies, public relations firms, audiovisual firms, businesses, book/encyclopedia publishers, magazine publishers, postcard publishers, calendar companies, greeting card companies and travel.

• This agency plans to provide digital transmission of images in the future.

Needs: Uniphoto is a general library and requires all stock subjects.

Specs: Uses 35mm, 2¼×2¼, 4×5 transparencies.

Payment & Terms: Buys photos outright only occasionally. Payment "depends on the pictures." Takes 50% commission on licensing revenues received by Uniphoto. Average fee per image (to clients): $250-30,000. Enforces minimum prices. Works on contract basis only. Offers exclusive contract. "Under special circumstances, contract terms may be negotiated." Contracts renew automatically with additional submissions for 5 years. Charges various rates for catalog insertion fees. Statements issued monthly. Payment made monthly within 3½ months. Offers one-time and all other commercial rights. When client requests all rights we negotiate with photographer's permission. Model/property release required. Captions required.

Making Contact: Interested in receiving work from newer, lesser-known photographers. Query with résumé of credits and non-returnable samples. Keeps samples on file. SASE. Reports in 4 months on queries; up to 2 weeks on portfolio submissions. Portfolio submission guidelines free with SASE. Market tips sheet distributed to Uniphoto photographers only.

Tips: "Portfolios should demonstrate the photographer's creative and technical range. We seek professional photographers and accomplished fine artists with commercial potential as well as experienced stock photographers."

■**U.S. NAVAL INSTITUTE**, 118 Maryland Ave., Annapolis MD 21402. (410)268-6110. Fax: (410)269-7940. E-mail: straight@pensacola.nadn.navy.mil. Photo Archivist: Mary Beth Straight. Picture library. Has 450,000 photos. Clients include: advertising agencies, public relations firms, audiovisual firms, businesses, book/encyclopedia publishers, magazine publishers, newspapers, calendar companies, greeting card companies. "Anyone who may need military photography. We are a publishing press, as well."

• At press time, the U.S. Naval Institute was working with PressLink on a contract for networking of images. The contract would extend for a trial basis only.

Needs: US and foreign ships, aircraft, equipment, weapons, personalities, combat, operations, etc. Anything dealing with military.

Specs: Uses 5×7, 8×10 color and/or b&w prints; 35mm transparencies.

Payment & Terms: Buys photos outright. Works with or without contract. Offers contracts on a case-by-case basis. Payment made 1 month after usage. Offers rights on a case-by-case basis. Informs photographer and allows him to negotiate when client requests all rights, "if requested in advance by photographer." Model/property release preferred. Captions required; include date taken, place, description of subject.

Making Contact: Interested in receiving work from newer, lesser-known photographers. Query with samples. Samples kept on file. SASE and Social Security number. Expects minimum initial submission of 5 images. Reports in 1 month. Photo guidelines free with SASE.

Tips: "We do not look for posed photography. Want dramatic images or those that tell story. The U.S. Naval Institute is a nonprofit agency and purchases images outright on a very limited basis. However, we do pay for their use within our own books and magazines. Prices are somewhat negotiable, but lower than what the profit-making agencies pay."

■**VIESTI ASSOCIATES, INC.**, P.O. Box 20424, New York NY 10021. (212)787-6500 or 0-700-VST-FOTO. Fax: (212)595-6303. President: Joe Viesti. Estab. 1987. Stock photo agency. Has 20 affiliated foreign sub-agents. Clients include: advertising agencies, businesses, book/encyclopedia publishers, magazine publishers, calendar companies, greeting card companies, design firms.

• This agency distributed two catalogs totaling 476 pages in 1995. Viesti is also involved with CD-ROM and modem transmission of images. The images contain a watermark to protect copyright. Viesti is "dead set against clip art sales."

Needs: "We are a full service agency."

Specs: Uses 35mm, 2¼×2¼, 4×5, 6×7, 8×10 transparencies; both color and b&w transparencies; all formats film and videotape.

Payment & Terms: NPI; "We negotiate fees above our competitors on a regular basis." Works on contract basis only. "Catalog photos are exclusive." Contract renews automatically upon expiration unless photographer or agency opts for termination. Charges duping fees "at cost. Many clients now require submission of dupes only." Catalog insertion rate varies. Statements issued monthly. "Payment is made the month after payment is received." Rights vary. Informs photographer and allows him to negotiate when client requests all rights. Model/property release preferred. Captions required.

Making Contact: Interested in receiving work from newer, lesser-known (but serious) photographers as well as from established photographers. Query with samples. Send no originals. Send dupes or tearsheets only with bio info and size of available stock; include return postage if return desired. Samples kept on file. Expects minimum submissions of 500 edited images; 100 edited images per month is average. Submissions edited and returned usually within one week. Catalog available for fee, depending upon availability and size.

Tips: There is an "increasing need for large quantities of images from interactive, multimedia clients and traditional clients. No need to sell work for lower prices to compete with low ball competitors. Our clients regularly pay higher prices if they value the work."

*❖**VISUAL CONTACT INC.**, 67 Mowat Ave., Suite 247, Toronto, Ontario M6K 3E3 Canada. (416)532-8131. Fax: (416)532-3792. E-mail: 75363.1724@compuserve.com. President: Thomas Freda. Library Administrator: Laura Chen. Estab. 1990. Stock photo agency. In January 1995 applied to become PACA member. Has 30,000 photos. Clients include: advertising agencies, public relations firms, businesses, book/encyclopedia publishers, magazine publishers, calendar companies, greeting card companies.

• This agency expected to be offering images via online networks by the fall of 1995.

Needs: Interested in photos of people/lifestyle, people/corporate, industry, nature, travel, science and technology, medical, food.

Specs: Uses transparencies.

Payment & Terms: Pays 50% commission on color photos. Offers volume discounts to customers; inquire about specific terms. Works with or without signed contract, negotiable. Offers exclusive only, limited regional, nonexclusive, or guaranteed subject exclusivity contracts. Contracts renew automatically with additional submissions. Charges 100% duping fee, 100% mounting, 100% CD/online service. Statements issued quarterly. Payment made quarterly. Offers one-time rights. Informs photographer

and allows him to negotiate when client requests all rights. Model/property release required. Captions required; include location, specific names, i.e., plants, animals.

Making Contact: Interested in receiving work from newer, lesser-known photographers. Arrange personal interview to show portfolio. Submit portfolio for review. Query with résumé of credits. Query with samples. Query with stock photo list. Keeps samples on file. SASE. Expects minimum initial submission of 100-200 images. Reports in 3 weeks. Photo guidelines free with SASE. Market tips sheet distributed free with SASE.

■**VISUALS UNLIMITED**, Dept. PM, P.O. Box 146, East Swanzey NH 03446-0146. (603)352-6436. Fax: (603)357-7931. President: Dr. John D. Cunningham. Stock photo agency and photo research service. Has 500,000 photos. Clients include: ad agencies, public relations firms, audiovisual firms, businesses, book/encyclopedia publishers, magazine publishers, postcard companies, calendar companies and greeting card companies.

Needs: All fields: (biology, environmental, medical, natural history, geography, history, scenics, chemistry, geology, physics, industrial, astronomy and "general."

Specs: Uses 5×7 or larger b&w prints; 35mm, $2\frac{1}{4} \times 2\frac{1}{4}$, 4×5 and 8×10 transparencies; b&w contact sheets; and b&w negatives.

Payment & Terms: Pays 50% commission for b&w and color photos. Negotiates fees based on use, type of publication, user (e.g., nonprofit group vs. publisher). Average price per image (to clients): $30-90/b&w photo; $50-190/color photo. Offers volume discounts to customers; terms specified in contract. Photographers can choose not to sell images on discount terms. Works on contract basis only. Offers non-exclusive contract. Contracts renew automatically for an indefinite time unless return of photos is requested. Statements issued monthly. Payment made monthly. Photographers not allowed to review account records to verify sales figures; "All payments are exactly 50% of fees generated." Offers one-time rights. Informs photographer and allows him to negotiate when client requests all rights. Model release preferred. Captions required.

Making Contact: Interested in receiving work from newer, lesser-known photographers. Query with samples or send unsolicited photos for consideration. Submit portfolio for review. SASE. Reports in 1 week. Photo guidelines sheet is free with SASE. Distributes a tip sheet several times/year as deadlines allow, to all people with files.

Tips: Looks for "focus, composition and contrast, of course. Instructional potential (e.g., behavior, anatomical detail, habitat, example of problem, living conditions, human interest). Increasing need for exact identification, behavior, and methodology in scientific photos; some return to b&w as color costs rise. Edit carefully for focus and distracting details; submit anything and everything from everywhere that is geographical, biological, geological, environmental, and people oriented."

■**WESTLIGHT**, 2223 S. Carmelina Ave., Los Angeles CA 90064. (310)820-7077. Owner: Craig Aurness. Estab. 1978. Stock photo agency. Member of Picture Agency Council of America (PACA). Has 2½ million photos. Clients include: advertising agencies, public relations firms, audiovisual firms, corporations, book/encyclopedia publishers, magazine publishers, newspapers, postcard companies, calendar companies, greeting card companies and TV.

• Westlight is working with Kodak's Photo CD technology in the development of Photo CD catalog products.

Needs: Needs photos of all top quality subjects.

Specs: Uses 35mm, $2\frac{1}{4} \times 2\frac{1}{4}$, 4×5 transparencies.

Payment & Terms: Pays 50% commission. General price range: $600 and up. Offers exclusive contract. Contracts renew automatically for 1 year at the end or 5 years if no notice is given. Charges duping fees of 100%/image. Also charges catalog insertion fee 50%/image. Statements issued quarterly. Payment made quarterly; within 45 days of end of quarter. Photographers allowed to review account records to verify sales figures. Offers one-time rights, electronic media and agency promotion rights. Informs photographer and allows him to negotiate when client requests all rights. Model/property release required for recognizable people and private places. Captions required.

Making Contact: Query with résumé of credits. Query with tearsheet samples. Query with list of stock photo subjects; show a specialty. Cannot return material. Reports in 1 month. Photo guidelines free with SASE. Tips sheet distributed monthly to contract photographers. Send tearsheets only, no unsolicited photos.

Tips: Photographer must have "ability to regularly produce the best possible photographs on a specialized subject, willingness to learn, listen and fill agency file needs. Photographers must request application in writing only. All other approaches will not be answered."

■‡**DEREK G. WIDDICOMBE**, Worldwide Photographic Library, Oldfield, High Street, Clayton West, Huddersfield, Great Britain HD8 9NS. Phone/fax: (011)44 1484 862638. Proprietor: Derek G. Widdicombe. Picture library. Has over 150,000 photos. Clients include: ad agencies, public relations firms, audiovisual firms, businesses, book/encyclopedia publishers, magazine publishers, newspapers, post-

INSIDER REPORT

Digital Media: Changing the Face of Stock

"Get ready!" says Craig Aurness, owner of the Los Angeles stock agency, Westlight. Digital media are revolutionizing the stock photo marketplace. And, as this veteran stock professional explains, this presents special challenges for both aspiring and veteran stock shooters.

"In the next five years, the majority of (stock) images sold will be those produced for the computer/TV format," says Aurness. "If you're going to survive as a photographer, you have to be comfortable designing visuals for this medium."

With the removal of international trade barriers, the world is rapidly evolving toward a global economy. But an even more important factor behind the sharp increase in demand for stock images is the explosive use of both online information networks and Photo CD technologies, he says.

© Jim Mendenhall/Westlight

Craig Aurness

The potential for stock is overwhelming, especially with Photo CDs, which are considered nearly universally compatible with most computer systems, Aurness claims. "Photo CD is the optimum global format for a number of reasons, including its resolution and compatibility."

Although exchange of images over networks will become commonplace, more end uses—because they'll be heavily consumer-oriented—will be on Photo CD, Aurness says. CD-ROM-based multimedia products will be in high demand, too.

"Whole new industries will use digital images, but not transparencies," he explains. "I'm not saying you shouldn't shoot for print usage. But if you shoot only for print, you're going to trap yourself out of the largest market in the future."

This former *National Geographic* photographer plunged into the stock business 16 years ago because of the market he saw for his own work. Incorporating the files of his partners with those of contracted photographers, he has brought Westlight's inventory to almost two million images.

Aurness says he saw the need in the early 1990s to increase Westlight's efficiency. So with continual improvements in, and worldwide usage of, digital technology, the agency committed itself to pioneering electronic systems.

From its experience in converting film-based images to digital, Westlight has encountered several major limitations. In particular, Aurness cites "horrendous graphic problems" related to the dimensions of computer/television monitors. These problems result in roughly a 30 percent loss of visual information when images are put onto a monitor, he says.

"You have to make sure all the important information is in the center of the image," Aurness says. The monitor format demands well-composed, simpler, more graphic images. It's also better to supply horizontal images because verticals are less suitable for monitor formats. He adds that even with images centered, there's a noticeable loss in sharpness around the edges of images.

"On-screen media generally show fewer color variations than do high-quality print media," Aurness says, explaining how digital scans drastically compress detail. "The visual information needs to be easily readable without a subtle color range or shadow details," he says.

Anyone who's serious about shooting images for this new market must consider and deal with all these factors.

"You don't need to be 'computer literate,' but 'monitor literate,' " Aurness says, noting the importance of understanding how images translate to the electronic "page." He maintains that all stock agencies will get into digital imaging to some extent. So serious stock photographers should review their agencies to ensure that a good fit exists.

A "good" agency, Aurness says, should have a sizable collection, with a moderate volume of unique images, a high level of digital expertise, a verifiable level of profitability, and—most important—a strong team spirit among owners, staff and photographers.

"Because we're more intense about technology than most agencies, we understand that the bond between (the stock) agent and photographer is critical in this new era," Aurness says.

—*Sam A. Marshall*

Taken by Lee White, this photo is typical of traditional film-based stock imagery. However, Craig Aurness of Westlight in Los Angeles, California, sees a photo industry that's being inundated with clients who want images in digital form. Photographers who want to succeed in the future should investigate online networks and CD-ROM presentation/ storage of photos.

© Lee White/Westlight

card companies, calendar companies, greeting card companies, television, packaging, exhibition and display material, posters, etc.

Needs: "The library covers many thousands of different subjects from landscape, architecture, social situations, industrial, people, moods and seasons, religious services, animals, natural history, travel subjects and many others. We have some archival material. These subjects are from worldwide sources."

Specs: Uses 20.3×24.4 cm. glossy b&w prints. Also, all formats of transparencies; 35mm preferred.

Payment & Terms: Pays 50% commission for b&w and color photos. General price range: reproduction fees in the range of £25-200 (English currency); pays $52-333 or higher/b&w photo; $73-500 or higher/color photo. Works with or without contract; negotiable. Offers limited regional exclusivity and nonexclusive contract. Statements issued quarterly. Payment made quarterly. Photographers not allowed to review account records to verify sales figures. Offers one-time and electronic media rights. Requests agency promotion rights. Does not inform photographer or allow him to negotiate when client requests all rights. Model/property release required for portraits of people and house interiors. Photo captions required.

Making Contact: Interested in receiving work from newer, lesser-known photographers. "Send letter first with details on what you have to offer. If invited, send small selection at own risk with return postage/packing." SASE.

Tips: Looks for "technical suitability (correct exposure, sharpness, good tonal range, freedom from defects, color rendering [saturation] etc.). Subject matter well portrayed without any superfluous objects in picture. Commercial suitability (people in pictures in suitable dress, up-to-date cars—or none, clear-top portions for magazine/book cover titles). Our subject range is so wide that we are offering the whole spectrum from very traditional (almost archival) pictures to abstract, moody, out-of-focus shots. Always send details of what you have to offer first. When invited we normally require small batches of around 100 pictures."

THE WILDLIFE COLLECTION, a division of Cranberry Press Inc., 69 Cranberry St., Brooklyn NY 11201. (718)935-9600. Fax: (718)935-9031. Director: Sharon A. Cohen. Estab. 1987. Stock photo agency. Has 175,000 photos. Clients include: advertising agencies, public relations firms, businesses, book/encyclopedia publishers, magazine publishers, newspapers, postcard companies, calendar companies, greeting card companies, zoos and aquariums.

Needs: "We handle anything to do with nature—animals, scenics, vegetation, underwater. We are in particular need of coverage from India, South America, Europe and Antarctica, as well as endangered animals, in particular chimpanzees, bonobos, and California Condors."

Specs: Uses 35mm, 2¼×2¼, 4×5, 6×4½ transparencies.

Payment & Terms: Pays 50% commission on color photos. General price range: $100-6,000. Works on contract basis only. Offers limited regional exclusivity but prefers world exclusivity. Contracts renew automatically "until either party wishes to terminate." There are no charges to be included in catalogs or other promotional materials. Statements issued monthly. Payment made monthly. Photographers permitted to review sales figures. Offers one-time rights. Informs photographers and allows them to negotiate when client requests all rights, "but they can only negotiate through us—not directly." Model release "not necessary with nature subjects." Photo captions required; include common, scientific name and region found.

Making Contact: Interested in receiving work from newer, lesser-known photographers, as well as more established photographers. Query with samples. Printed samples kept on file. SASE. Expects minimum initial submission of 200 images. "We would like 2,000 images/year; this will vary." Reports in 2 weeks. Photo guidelines and free catalog with 6½×9½ SAE with 78¢ postage. Market tips sheet distributed quarterly to signed photographers only.

Tips: In samples wants to see "great lighting, extreme sharpness, *non-stressed* animals, large range of subjects, excellent captioning, general presentation. Care of work makes a large impression. The effect of humans on the environment is being requested more often as are unusual and endangered animals."

***‡WILDLIGHT PHOTO AGENCY**, 87 Gloucester St., The Rocks, NSW 2000 Australia. (02)251-5852. Fax: (02)251-5334. Contact: Manager. Estab. 1985. Stock photo agency, picture library. Has 300,000 photos. Clients include: advertising agencies, public relations firms, audiovisual firms, businesses, book/encyclopedia publishers, magazine publishers, newspapers, postcard publishers, calendar companies, greeting card companies.

Specs: Uses 35mm, 2¼×2¼, 4×5, 8×10, 6×12, 6×17 transparencies.

Payment & Terms: Pays 50% commission on color photos. Works on exclusive contract basis only. Statements issued monthly. Payment made monthly. Offers one-time rights. Model/property release required. Captions required.

Making Contact: Arrange personal interview to show portfolio. Expects minimum initial submission of 1,000 images with periodic submission of at least 250/month. Reports in 1-2 weeks. Photo guidelines available.

■‡**WORLD VIEW-HOLLAND BV**, A.J. Ernststraat 181, Amsterdam, 1083 GV Holland. 31-20-6420224. Fax: 31-20-6611355. Managing Director: Bert Blokhuis. Estab. 1985. Stock photo agency. Has 150,000 transparencies. Clients include: advertising agencies, audiovisual firms, businesses, calendar companies and corporations.
Needs: Wants to see "sizes bigger than 35mm, only model-released commercial subjects."
Specs: Uses 2¼×2¼, 4×5, 8×10 transparencies only.
Payment & Terms: Pays 50% commission on transparencies. General price range: US $300/color photos, minimum $100. Offers volume discounts to customers; inquire about specific terms. Discount sales terms not negotiable. Works on contract basis only. Offers limited regional exclusivity. Contracts renew automatically for 4 years. Statements issued monthly. Payment made quarterly. Photographers permitted to review sales figures. Offers one-time rights. Informs photographer and allows him to negotiate when client requests all rights. Model release required. Captions required.
Making Contact: Interested in receiving work from newer, lesser-known photographers. Query with samples. SASE. Reports in 3 weeks.
Tips: In freelancer's samples, wants to see "small amount of pictures (20 or 30) plus a list of subjects available and list of agents." Work must show quality.

■**WORLDWIDE IMAGES**, P.O. Box 150547, San Rafael CA 94915. (415)459-0627. Owner: Norman Buller. Estab. 1988. Stock photo agency. Has 4,000 photos. Clients include: advertising agencies, businesses, book/encyclopedia publishers, magazine publishers, postcard companies, calendar companies, greeting card companies and men's magazines, foreign and domestic.
Needs: Nude layouts for men's magazines, foreign and domestic; celebrities, rock stars, college and professional sports teams, amateur X-rated videos and photos.
Specs: Uses all size prints, slides and transparencies, VHS videos.
Payment & Terms: Pays 50% commission on all sales. Works without a signed contract, negotiable. Offers nonexclusive contract. Statements issued upon request. Payment made immediately upon payment from client. Photographers allowed to review account records to verify sales figures. Offers one-time or first rights and all rights. Informs photographer and allows him to negotiate when client requests all rights but handles all negotiation. Model release required. Captions required.
Making Contact: Interested in receiving work from newer, lesser-known photographers. Query with samples and list of stock photo subjects. Send unsolicited photos by mail for consideration. Reports immediately.
Tips: "Work must be good. We have worldwide clientele, don't edit too tightly, let me see 90% of your material on hand and critique it from there! We're getting new clients around the world every week! We have more clients than photos!"

■‡**ZEFA ZENTRALE FARBBILD AGENTUR GmbH**, Schanzenstrasse 20, 40549 Duesseldorf 11, Germany. (211)55061. Fax: (211)55 06 29. Managing Director: Max Oberdorfer. Stock photo agency. Has 8 branch offices in 5 European countries. Clients include: ad agencies, public relations firms, audiovisual firms, industrial, businesses, book/encyclopedia publishers, magazine publishers, postcard companies, calendar companies, greeting card companies.
Needs: All kinds of transparencies like geography (landscapes), people, industry, traffic, nature, botany and zoology.
Specs: Uses 35mm, 2¼×2¼, 4×5 and 8×10 transparencies.
Payment & Terms: Pays 40% commission. General price range from DM150-10,000 (German currency). Works on contract basis only. Offers guaranteed subject exclusivity contracts. Contracts renew automatically with additional submissions for 5 years. Does not charge for catalog insertions, but requires transfer of exclusive world rights to include any images in catalogs. Photographers allowed to review account records. Model release and captions required. Statements issued quarterly. Payment made quarterly. Offers one time rights. Informs photographer and allows him to negotiate when a client requests all rights.
Making Contact: Interested in receiving work from newer, lesser-known photographers. Arrange a personal interview to show portfolio. Query with samples or list of stock photo subjects. Send unsolicited photos by mail for consideration. SASE. Reports in 1 month. Photo guidelines free with SASE. Distributes tips sheet upon request.
Tips: Prefers to see "a first picture selection of approximately 150 images showing the spectrum of your photographic work."

■**ZEPHYR PICTURES**, 339 N. Highway 101, Solana Beach CA 92075-1130. (619)755-1200. Fax: (619)755-3723. Owner: Leo Gradinger. Estab. 1982. Stock photo agency. Member of Picture Agency Council of America (PACA). Also commercial photo studio. Has 200,000 photos. Clients include: advertising agencies, public relations firms, audiovisual firms, businesses, book/encyclopedia publishers, magazine publishers, newspapers, postcard and calendar companies, developers, corporate, finance, education, design studios and TV stations.

Needs: "We handle everything from A to Z. We specialize in people (model-released) for advertising. New material is shot on a weekly basis. We also have lots of great material for the textbook and editorial markets."

Specs: Uses 35mm, 2¼×2¼, 4×5, 8×10, 6×7 transparencies.

Payment & Terms: Pays 50% commission for b&w and color photos. Average price per image: $400. Enforces minimum prices. Sub-agency agreement 50% domestic, 40% to photographer on foreign sales. Offers volume discounts to customers; inquire about specific terms. Discount sales terms not negotiable. Works on contract basis only. Offers limited regional exclusivity. Contracts renew automatically for three years, auto-renewal each year thereafter. Charges 25% catalog insertion fee. Statements issued monthly. Payment made monthly. Photographers allowed to review account records to verify sales figures. Offers one-time rights; other rights negotiable. Model/property release required. Captions required.

Making Contact: Interested in receiving work from newer, lesser-known photographers. Arrange a personal interview to show portfolio. Query with list of stock photo subjects. SASE. Reports in 2-3 weeks, according to time demands. Photo guidelines available occasionally. Tips sheet distributed twice a year to any photographers who are contracted for submissions.

Tips: "I am looking for a photographer who *specializes* in one, maybe two, areas of expertise. Be professional. Call or write to let us know who you are and what you specialize in. If we are interested, we ask you to send 20 to 40 of your very best images with a SAE and return postage. We are shooting at the highest level of sophistication for stock since our beginning 10 years ago. The market demands it and we will continue to try and provide a high level of creativity in our images."

Stock Photo Agencies/'95-'96 changes

The following markets appeared in the 1995 edition of *Photographer's Market*, but are not listed this year. The majority did not respond to our request to update their listings. If a reason was given for a market's exclusion it appears in parentheses below.

Action Press
Anthro-Photo File
Bavaria Bildagentur GmbH
Black Star Publishing Co. Inc.
John Blake Picture Library (merged with J Allan Cash Library)
Colotheque S.P.R.L.
Das Photo
Echo Image (out of business)
Ekofoto Slovakia
Fashions in Stock
Fern-Wood Designs & Photo Marketing Agency
First Light Associated Photographers
Fotoconcept Inc.

Geoscience Features Picture Library
High Country Images (discontinuing stock business from outside photographers)
The Hutchison Library
Impact Visuals Photo & Graphics, Inc.
Harold M. Lambert Studios, Inc.
LGI Photo Agency
Mach 2 Stock Exchange Ltd.
Medical Images Inc.
Mega Productions, Inc.
Megapress Images
Outline
Panoramic Images
Picture Perfect USA, Inc.

Picture That, Inc.
Planet Earth Pictures/Seaphot Ltd.
Profiles West
Rainbow
Shashinka Photo Library
Tom Stack & Associates
Stock Boston Inc.
The Stock Broker
The Stock Shop
The Stock Solution
Visions Photo, Inc.
West Stock, Inc. (requested deletion)
Worldwide Press Agency

Resources

Art/Photo Representatives

The 63 listings in this section are perfect for anyone who is either unable to market themselves, uncomfortable with the marketing process or just plain uninterested in the marketing of their photography. If you fall into any of these categories, or if you want to do a little research to see what kind of professional marketing help exists, this section is for you.

Many photographers find that having a rep helps their business grow. Photographers can concentrate on shooting, while reps concentrate on finding new clients and marketing the skills of their photographers. In the early stages of the rep-photographer relationship, the better reps are extremely helpful in creating innovative direct mail pieces and they assist photographers in the organization and presentation of portfolios.

If you sign on with a rep, listen to their suggestions. The simple fact is reps deal with art directors every day and they know what buyers prefer. If they advise you to cut down the number of photos you have in your portfolio or they suggest adding black and white images and removing some color shots, take their advice. That's why you hired them. More about packaging and marketing your skills through a rep can be found on page 542 in our interview with Elyse Weissberg of New York City. Weissberg reps such talent as former Pulitzer Prize winner Eddie Adams and people/illustration photographer Jack Reznicki.

As you examine these listings you will see that some reps are members of SPAR, the Society of Photographer and Artist Representatives. This organization sponsors educational programs and maintains a code of ethics to which all members must adhere. For more information on the group, contact SPAR, 60 E. 42nd St., Suite 1166, New York NY 10165. (212)779-7464.

***ANNE ALBRECHT AND ASSOCIATES**, 68 E. Wacker Place, Suite 800, Chicago IL 60601. (312)853-4830. Fax: (312)629-5656. Contact: Anne Albrecht. Commercial photography and illustration representative. Estab. 1991. Member of C.A.R. (Chicago Artists Representatives) and Graphic Artists Guild. Represents 3 photographers and 7 illustrators. Markets include advertising agencies, corporations/clients direct, design firms, editorial/magazines, publishing/books and sales/promotion firms.
Handles: Illustration, photography.
Terms: Agent receives 25% commission. Advertises in *American Showcase*, *Creative Black Book* and *The Workbook*.
How to Contact: For first contact, send tearsheets. Reports only if interested. After initial contact drop off or mail materials for review. Portfolios should include photographs, tearsheets and/or photocopies.

ARTIST DEVELOPMENT GROUP, 21 Emmett St., Suite 2, Providence RI 02903-4503. (401)521-5774. Fax: (401)521-5776. Contact: Rita Campbell. Represents photography, fine art, graphic design, as well as performing talent. Staff includes Rita Campbell. Estab. 1982. Member of Rhode Island Women's Advertising Club. Markets include: advertising agencies; corporations/clients direct.
Handles: Illustration, photography.
Terms: Rep receives 20-25% commission. Advertising costs are split: 50% paid by talent; 50% paid by representative. For promotional purposes, talent must provide direct mail promotional piece; samples in book for sales meetings.

How to Contact: For first contact, send résumé, bio, direct mail flier/brochure. Reports in 3 weeks. After initial contact, drop off or mail in appropriate materials for review. Portfolios should include tearsheets, photographs.
Tips: Obtains new talent through "referrals as well as inquiries from talent exposed to agency promo."

***ARTIST REPRESENTATIVE OF TEXAS**, 3352 Walnut Bend Lane, Houston TX 77042. (713)781-6226. Fax: (713)781-0957. Contact: Mary Loos. Commercial photography, illustration, fine art representative. Estab. 1992. Member of Society of Illustrators. Represents 1 photographer, 9 illustrators, 1 designer and 2 fine artists. "We are in the business of producing art for the business world." Fine art markets include advertising agencies, corporations/clients direct, design firms, publishing books and sales/promotion firms. Fine art markets include art publishers, private collections and publishing/books.
Handles: Illustration, photography and fine art; also technical illustrators.
Terms: Agent receives 25% commission. Exclusive area representation required. Advertising costs are split 75% paid by talent; 25% paid by representative. For promotional purposes, talent must provide portfolio, leave behind sheets, 8 × 10 photo book, 2 rep pages. Advertises in *Texas Source Book*.
How to Contact: For first contact, send query letter, bio, tearsheets, photos and SASE. Reports in 5 days. After initial contact, call to schedule an appointment. Portfolios should include original art, tearsheets, slides, photographs.
Tips: "We look for talent all the time, but must fit a need."

***BEATE WORKS**, 7916 Melrose Ave., #2, Los Angeles CA 90046. (213)653-5088. Fax: (213)653-5089. Contact: Beate Chelette. Commercial photography, illustration and graphic design representative. Estab. 1992. Represents 5 photographers, 2 illustrators and 2 designers. Staff includes Larry Bartholomew (fashion); Rick Steil (fashion); Lorraine Day (beauty, celebrities); Basia Kenton (architecture, portraits); and Maura McCarthy (graphic design). A full service agency that covers preproduction to final product. Markets include advertising agencies, corporations/clients direct, design firms and editorial/magazines.
Handles: Photography. Only interested in established photographers. "Must have a client base."
Terms: Agent receives 25-30% commission. Exclusive area representation required. Advertising costs are split: 75% paid by talent; 25% paid by representative. For promotional purposes, talent must provide at least 3 portfolios.
How to Contact: For first contact, sent query letter and direct mail flier/brochure. Reports in several days if interested. After initial contact, call to schedule an appointment. Portfolios should include tearsheets, photographs and photocopies.
Tips: Typically obtains new talent through recommendations and referrals. "Do your research on a rep before you approach him."

BERENDSEN & ASSOCIATES, INC., 2233 Kemper Lane, Cincinnati OH 45206. (513)861-1400. Fax: (513)861-6420. Contact: Bob Berendsen. Commercial illustration, photography, graphic design representative. Estab. 1986. Represents 24 illustrators, 4 photographers, 4 Mac designers/illustrators. Specializes in "high-visibility consumer accounts." Markets include: advertising agencies; corporations/clients direct; design firms; editorial/magazines; paper products/greeting cards; publishing/books; sales/promotion firms.
Handles: Illustration, photography. "We are always looking for illustrators that can draw people, product and action well. Also, we look for styles that are unique."
Terms: Rep receives 25% commission. Charges "mostly for postage but figures not available." No geographic restrictions. Advertising costs are split: 75% paid by talent; 25% paid by representative. For promotional purposes, "artist must co-op in our direct mail promotions, and sourcebooks are recommended. Portfolios are updated regularly." Advertises in *RSVP*, *Creative Illustration Book*, *The Ohio Source Book* and *American Showcase*.
How to Contact: For first contact, send query letter, résumé, tearsheets, slides, photographs, photocopies and SASE. Reports in weeks. After initial contact, drop off or mail in appropriate materials for review. Portfolios should include tearsheets, slides, photographs, photostats, photocopies.
Tips: Obtains new talent "through recommendations from other professionals. Contact Bob Berendsen, president of Berendsen and Associates, Inc. for first meeting."

The asterisk before a listing indicates that the market is new in this edition. New markets are often the most receptive to freelance submissions.

BERNSTEIN & ANDRIULLI INC., 60 E. 42nd St., New York NY 10165. (212)682-1490. Fax: (212)286-1890. Contact: Sam Bernstein. Commercial illustration and photography representative. Estab. 1975. Member of SPAR. Represents 54 illustrators, 16 photographers. Staff includes Tony Andriulli; Howard Bernstein; Fran Rosenfeld; Molly Birenbaum; Craig Haberman; Randi Fiat; Ivy Glick; Liz McCann; Fiorenzo Nisi; Michele Schiavone; Susan Wells; Helen Goon. Markets include: advertising agencies; corporations/clients direct; design firms; editorial/magazines; paper products/greeting cards; publishing/books; sales/promotion firms.
Handles: Illustration and photography.
Terms: Rep receives a commission. Exclusive career representation is required. No geographic restrictions. Advertises in *Creative Black Book, The Workbook, Bernstein & Andriulli International Illustration, CA Magazine, Archive Magazine, Creative Illustration Book.*
How to Contact: For first contact, send query letter, direct mail flier/brochure, tearsheets, slides, photographs, photocopies. Reports in 1 week. After initial contact, drop off or mail in appropriate materials for review. Portfolio should include tearsheets, slides, photographs.

***BYRNES BRADY BARBER**, 500 West End Ave., New York NY 10024. (212)875-0226. Fax: (212)787-5058. Contact: Evelyn Brady. Commercial photography representative. Member of Art Directors, The One Club, Advertising Women of NY. Represents 5 photographers. Staff includes Chris Bailey (automotive); Chris Kahley (still life); Rich Dublin (animals, humor); Jim Fiscus (portraits); David Maisel (location, sports). Markets include advertising agencies.
Handles: Photography. "Photographers must currently be billing a minimum of $250,000 in creative fees. We will not carry photographers whose area of expertise is in competition with our photographers."
Terms: Agent receives 25-30% commission. Photographers pay messenger and Federal Express where necessary. Exclusive representation preferred. Advertising costs are split: 75% paid by talent; 25% paid by representative. For promotional purposes, talent must provide 3-4 portfolios (preferably). Advertises in *Creative Black Book, The Work Book.*
How to Contact: For first contact, send direct mail flier/brochure and SASE. Reports in 2 weeks only if interested. Portfolios should include tearsheets and photographs.

MARIANNE CAMPBELL, Pier 9 Embarcadero, San Francisco CA 94111. (415)433-0353. Fax: (415)433-0351. Contact: Marianne Campbell or Quinci Payne. Commercial photography representative. Estab. 1989. Member of APA, SPAR, Western Art Directors Club. Represents 4 photographers. Markets include: advertising agencies; corporations/clients direct; design firms; editorial/magazines.
Handles: Photography.
Terms: Rep receives 25% commission. Charges a percentage for FedEx charges. Advertising costs are split: 75% paid by talent; 25% paid by representative. For promotional purposes, talent must provide direct mail pieces "in which we share cost. Portfolio must consistently be updated with new, fresh work."
How to Contact: For first contact, send direct mail flier/brochure, printed samples of work. Reports in 2 weeks, only if interested. After initial contact, call for appointment to show portfolio of tearsheets, slides, photographs.
Tips: Obtains new talent through recommendations from art directors and designers, outstanding promotional materials. "Be considerate of rep's time."

STAN CARP, INC., 2166 Broadway, New York NY 10024. (212)362-4000. Contact: Stan Carp. Commercial photography representative and producer. Estab. 1959. Represents 3 photographers. Markets include: advertising agencies; corporations/clients direct; design firms; editorial/magazines; paper products/greeting cards; publishing/books; sales/promotion firms.
Handles: Photography and "commercial directors."
Terms: Rep receives 25% commission. Exclusive area representation is required. No geographic restrictions. Advertising costs are split: 75% paid by talent; 25% paid by representative. Advertises in *Creative Black Book, The Workbook,* and other publications.
How to Contact: For first contact, send photographs. Reporting time varies. After initial contact, call for appointment to show a portfolio of tearsheets, slides, photographs.
Tips: Obtains new talent through recommendations from others.

***CORPORATE ART PLANNING**, 16 W. 16th St., 6th Floor, New York NY10011. (212)645-3490. Fax: (212)645-3490. Contact: Maureen McGovern. Fine art representative. Estab. 1986. Specializes in art management expertise, curatorial services. Markets include advertising agencies, corporations/ clients direct. Fine art markets include architects, corporate collections.
Handles: Photography, fine art.
Terms: Agent receives 50% commission. Advertising costs are split: 50% paid by talent; 50% paid by the representataive. Advertises in *Creative Black Book* and *The Workbook.*

How to Contact: For first contact, send query letter, résumé and color photocopies. Reports in 10 days. After initial contact, call to schedule an appointment. Portfolios should include tearsheets, slides, photographs and photocopies.

***KATIE DALEY REPRESENTS**, 245 W. 29th St., New York NY 10001. (212)465-2420. Fax: (212)268-2650. Contact: Katie Daley. Commercial photography and illustration representative. Estab. 1985. Represents 4 photographers and 1 illustrator. Specializes in fashion and interiors. Markets include advertising agencies, corporations/clients direct, design firms, editorial/magazines, publishing/books and sales/promotion firms.
Handles: Illustration and photography.
Terms: Agent receives 25% commission. Charges messenger and promotional card fees. Exclusive area representation required. Advertising costs are split: 75% paid by the talent; 25% paid by the representative. For promotional purposes, talent must provide promotional cards (4 times/year); 2-6 portfolios.
How to Contact: For first contact, send promotional card. Reports in 2-3 days only if interested. After initial contact drop off or mail materials for review. Portfolios should include tearsheets, photographs and photostats.
Tips: Advises photographers to know "what your goals are and be ready to discuss how you and your rep can achieve them."

LINDA DE MORETA REPRESENTS, 1839 Ninth St., Alameda CA 94501. (510)769-1421. Fax: (510)521-1674. Contact: Linda de Moreta. Commercial illustration and photography representative; also portfolio and career consultant. Estab. 1988. Member of San Francisco Creative Alliance, Western Art Directors Club. Represents 13 illustrators, 4 photographers. Markets include: advertising agencies; corporations/clients direct; design firms; editorial/magazines; paper products/greeting cards; publishing/books; sales/promotion firms.
Handles: Photography, illustration, calligraphy.
Terms: Rep receives 25% commission. Exclusive representation requirements vary. Advertising costs are split: 75% paid by talent; 25% paid by representative. Materials for promotional purposes vary with each artist. Advertises in *The Workbook, American Showcase, The Creative Black Book, California Creative Sourcebook*.
How to Contact: For first contact, send direct mail flier/brochure, tearsheets, slides, photocopies, photostats and SASE. "Please do *not* send original art. SASE for any items you wish returned." Responds to any inquiry in which there is an interest. Portfolios are individually developed for each artist and may include tearsheets, prints, transparencies.
Tips: Obtains new talent primarily through client and artist referrals, some solicitation. "I look for a personal vision and style of illustration or photography and exceptional creativity, combined with professionalism, maturity and a willingness to work hard."

***RHONI EPSTEIN/Photographer's Representative**, 11711 Goshen Ave., #5, Los Angeles CA 90049-6119. (310)207-5937. Contact: Rhoni Epstein. Advertising photography representative. Estab. 1983. Member of APA. Represents 8 photographers. Specializes in advertising/entertainment photography.
Handles: Photography.
Terms: Agent receives 30% commission. Exclusive representation required in geographic area. Advertising costs are paid by talent. For promotional purposes, talent must have a spread in a national book, portfolio to meet requirements of agent. Advertises in *The Workbook*.
How to Contact: For first contact, send direct mail flier/brochure. Reports in 1 week, only if interested. After initial contact, call for appointment or drop off or mail in appropriate materials for review. Portfolio should demonstrate own personal style.
Tips: Obtains new talent through recommendations. "Research the rep and her agency the way you would research an agency before soliciting work!"

***FORTUNI**, 2508 E. Belleview Place, Milwaukee WI 53211. (414)964-8088. Fax: (414)332-9629. Contact: Marian Deegan. Commercial photography and illustration representative. Estab. 1990. Member of Graphic Artists Guild and ASMP. Represents 1 photographer and 3 illustrators. Fortuni handles artists with unique, distinctive styles appropriate for commercial markets. Markets include advertising agencies, corporations/clients direct, design firms, editorial/magazines, publishing/books.
Handles: Illustration and photography. "I am interested in artists with a thorough professional approach to their work."
Terms: Agent receives 25-30% commission. Exclusive area representation required. Advertising costs are split: 75% paid by the talent; 25% paid by the representative. For promotional purposes, talent must provide 4 duplicate transparency portfolios, leave behinds and 4-6 promo pieces per year. "All artist materials must be formatted to my promotional specificaitons." Advertises in *American Showcase, Workbook* and *Directory of Illustration*.

How To Contact: For first contact, send query letter, résumé, bio, direct mail flier/brochure, tear-sheets, photocopies and SASE. Reports in 2 weeks only if interested. After initial contact, call to schedule an appointment. Portfolios should include roughs, tearsheets, slides, photographs, photocopies and transparencies.
Tips: "I obtain new artists through referrals. Organize your work in a way that clearly reflects your style, and the type of projects you most want to handle; and then be professional and thorough in your initial contact and follow-through."

JEAN GARDNER & ASSOCIATES, 444 N. Larchmont Blvd., Suite 108, Los Angeles CA 90004. (213)464-2492. Fax: (213)465-7013. Contact: Jean Gardner. Commercial photography representative. Estab. 1985. Member of APA. Represents 6 photographers. Specializes in photography. Markets include: advertising agencies; design firms.
Handles: Photography.
Terms: Rep receives 25% commission. Exclusive representation is required. No geographic restrictions. Advertising costs are paid by the talent. For promotional purposes, talent must provide promos, *Workbook* advertising, a quality portfolio. Advertises in *The Workbook*.
How to Contact: For first contact, send direct mail flier/brochure.
Tips: Obtains new talent through recommendations from others.

***MICHAEL GINSBURG & ASSOCIATES, INC.**, 240 E. 27th St., Suite 24E, New York NY 10016. (212)679-8881. Fax: (212)679-2053. Contact: Michael Ginsburg. Commercial photography representative. Estab. 1978. Represents 6 photographers. Specializes in advertising and editorial photographers. Markets include advertising agencies, corporations/clients direct, design firms, editorial/magazines, sales/promotion firms.
Handles: Photography.
Terms: Rep receives 25% commission. Charges for messenger costs, Federal Express charges. Exclusive area representation is required. Advertising costs are split: 75% paid by talent; 25% paid by representative. For promotional purposes, talent must provide a minimum of 5 portfolios—direct mail pieces 2 times per year—and at least 1 sourcebook per year. Advertises in *Creative Black Book* and other publications.
How to Contact: For first contact, send query letter, direct mail flier/brochure. Reports in 2 weeks, only if interested. After initial contact, call for appointment to show portfolio of tearsheets, slides, photographs.
Tips: Obtains new talent through personal referrals and solicitation.

BARBARA GORDON ASSOCIATES LTD., 165 E. 32nd St., New York NY 10016. (212)686-3514. Fax: (212)532-4302. Contact: Barbara Gordon. Commercial illustration and photography representative. Estab. 1969. Member of SPAR, Society of Illustrators, Graphic Artists Guild. Represents 9 illustrators, 1 photographer. "I represent only a small select group of people and therefore give a great deal of personal time and attention to the people I represent."
Terms: Agent receives 25% commission. No geographic restrictions in continental US.
How to Contact: For first contact, send direct mail flier/brochure. Reports in 2 weeks. After initial contact, drop off or mail in appropriate materials for review. Portfolio should include tearsheets, slides, photographs; "if the talent wants materials or promotion piece returned, include SASE."
Tips: Obtains new talent through recommendations from others, solicitation, at conferences, etc. "I have obtained talent from all of the above. I do not care if an artist or photographer has been published or is experienced. I am essentially interested in people with a good, commercial style. Don't send résumés and don't call to give me a verbal description of your work. Send promotion pieces. *Never* send original art. If you want something back, include a SASE. Always label your slides in case they get separated from your cover letter. And always include a phone number where you can be reached."

***T.J. GORDON/ARTIST REPRESENTATIVE**, P.O. Box 4112, Montebello CA 90640. (213)887-8958. Contact: Tami Gordon. Commercial illustration, photography and graphic design representative; also illustration or photography broker. Estab. 1990. Member of SPAR. Represents 8 illustrators, 3 photographers. Looking for digital artists. Markets include: advertising agencies; corporations/clients direct; design firms; editorial/magazines.

Handles: Illustration, photography, design.

Terms: Rep receives 30% commission. Advertising costs are paid by talent (direct mail costs, billable at end of each month). Represents "illustrators from anywhere in US; designers and photographers normally LA only, unless photographer can deliver a product so unique that it is unavailable in LA." For promotional purposes, talent must provide "a minimum of three pieces to begin a 6-month trial period. These pieces will be used as mailers and leave behinds. Portfolio is to be professional and consistent (pieces of the same size, etc.) At the end of the trial period agreement will be made on production of future promotional pieces."

How to Contact: For first contact, send résumé, direct mail flier/brochure, tearsheets, photocopies. Reports in 2 weeks, if interested. After initial contact, call for appointment to show portfolio of tearsheets.

Tips: Obtains new talent "primarily through recommendations and as the result of artists' solicitations. Have an understanding of what it is you do, do not be afraid to specialize. If you do everything, then you will always conflict with the interests of the representatives' other artists. Find your strongest selling point, vocalize it and make sure that your promos and portfolio show that point."

CAROL GUENZI AGENTS, INC., 1863 S. Pearl St., Denver CO 80210. (303)733-0128. Contact: Carol Guenzi. Commercial illustration, film and animation representative. Estab. 1984. Member of Denver Advertising Federation and Art Directors Club of Denver. Represents 23 illustrators, 3 photographers, 1 computer designer. Specializes in a "wide selection of talent in all areas of visual communications." Markets include: advertising agencies; corporations/clients direct; design firms; editorial/magazine, paper products/greeting cards, sales/promotions firms.

Handles: Illustration, photography. Looking for "unique style application."

Terms: Rep receives 25% commission. Exclusive area representative is required. Advertising costs are split: 75% paid by talent; 25% paid by the representation. For promotional purposes, talent must provide "promotional material after six months, some restrictions on portfolios." Advertises in *American Showcase, Creative Black Book, The Workbook,* "periodically."

How to Contact: For first contact, send direct mail flier/brochure. Reports in 2-3 weeks, only if interested. After initial contact, call or write for appointment to drop off or mail in appropriate materials for review, depending on artist's location. Portfolio should include tearsheets, slides, photographs.

Tips: Obtains new talent through solicitation, art directors' referrals, an active pursuit by individual. "Show your strongest style and have at least 12 samples of that style, before introducing all your capabilities. Be prepared to add additional work to your portfolio to help round out your style."

HALL & ASSOCIATES, 1010 S. Robertson Blvd, #10, Los Angeles CA 90035. (310)652-7322. Fax: (310)652-3835. Contact: Marni Hall. Commercial illustration and photography representative. Estab. 1983. Member of SPAR, APA. Represents 7 illustrators and 8 photographers. Markets include: advertising agencies; design firms. Member agent: Wendy Jones (artist representative).

Handles: Illustration, photography.

Terms: Rep receives 25-30% commission. Exclusive area representation is required. No geographic restrictions. Advertising costs are paid by talent. For promotional purposes, talent must advertise in "one or two source books a year (double page), provide two direct mail pieces and one specific, specialized mailing. No specific portfolio requirement except that it be easy and light to carry and send out." Advertises in *Creative Black Book, The Workbook.*

How to Contact: For first contact, send direct mail flier/brochure. Follow with a call before 7 days. After initial contact, drop off (always call first) or mail in appropriate materials for review. Portfolios should include tearsheets, transparencies, prints (4×5 or larger).

Tips: Obtains new talent through recommendations from clients or artists' solicitations. "Don't show work you think should sell but what you enjoy shooting. Only put in tearsheets of great ads, not bad ads even if they are a highly visible client."

HAMILTON GRAY, (formerly Keswick Hamilton), 3519 W. Sixth St., Los Angeles CA 90020. (213)380-3933. Fax: (213)380-2906. Contact: Maggie Hamilton. Commercial photography. Estab. 1990. Member of AIGA, APA. Represents 12 photographers. Specializes in entertainment, editorial, advertising. Markets include: advertising agencies; corporations/clients direct; editorial/magazines.

Handles: Illustration, photography.

Terms: Rep receives 30% commission. Charges for messengers or FedEx if photographer has requested sending. Exclusive area representation required. Advertising costs are paid by talent. For promotional materials, talent must provide current portfolios (2-4 books), mailing pieces and open to sourcebooks. Advertises in *American Showcase, Creative Black Book, The Workbook* and *California Sourcebooks* (Black Book Publishing).

How to Contact: For first contact, send query letter with direct mail flier/brochure. Reports in 1 week. After initial contact, call for appointment to show portfolio of tearsheets, slides, photographs.

Tips: "Obtains new talent through my own awareness and recommendations from others. Think about if you were a rep, what you would want in photographer? Portfolio—2-4 books; material—mailers,

etc.; and a good sense of how hard it is to accomplish success without vision and commitment."

BARB HAUSER, ANOTHER GIRL REP, P.O.Box 421443, San Francisco CA 94142-1443. (415)647-5660. Fax: (415)285-1102. Estab. 1980. Represents 10 illustrators and 1 photographer. Markets include: primarily advertising agencies and design firms; corporations/clients direct.
Handles: Illustration and photography.
Terms: Rep receives 25-30% commission. Exclusive representation in the San Francisco area is required. No geographic restrictions.
How to Contact: For first contact, send direct mail flier/brochure, tearsheets, slides, photographs, photocopies and SASE. Reports in 3-4 weeks. After initial contact call for appointment to show portfolio of tearsheets, slides, photographs, photostats, photocopies.

***ICEBOX**, 2401 Central Ave. NE, Minneapolis MN 55418. (612)788-1790. Contact: Howard Christopherson. Fine art representative. Estab. 1988. Represents photographers and fine artists, includes sculptors. Specializes in "thought-provoking art work and photography, predominantly Minnesota artists." Markets include: corporate collections; interior decorators; museums; private collections.
Handles: Fine art and fine art photographs. Looking for "new photography and thought-provoking works."
Terms: Agent receives 33-50% commission. Exclusive representation in Minnesota is required. For promotional purposes, talent must provide slides.
How to Contact: For first contact, send résumé, bio, slides and SASE. Reports in 2 months. After initial contact, drop off or mail in appropriate materials for review. Portfolio should include slides.

***THE TRICIA JOYCE CO.**, 80 Warren St., New York NY 10007. (212)962-0728. Send to: Tricia Joyce. Commercial photography representative and stylist. Estab. 1988. Represents 7 photographers and 9 stylists. Specializes in architecture, interiors, still life, fashion, portraiture. Markets include advertising agencies, corporations/clients direct, design firms, editorial/magazines and sales/promotion firms.
Handles: Photography and fine art.
Terms: Agent receives 25% commission. Advertising costs are split 75% paid by talent; 25% paid by the representative. For promotional purposes, talent must provide 3-6 portfolios, promotional card/booklet. Advertises in *The Workbook* and *NY Gold*.
How to Contact: For first contact, send query letter. Reports only if interested. After initial contact "wait to hear—please don't call."
Tips: "Write/send work to reps whose clients' work you respect."

KIRCHOFF/WOHLBERG, ARTISTS REPRESENTATION DIVISION, 866 United Nations Plaza, #525, New York NY 10017. (212)644-2020. Fax: (212)223-4387. Director of Operations: John R. Whitman. Estab. 1930s. Member of SPAR, Society of Illustrators, AIGA, Assn. of American Publishers, Bookbuilders of Boston, New York Bookbinders' Guild. Represents over 50 illustrators. Artist's Represenative: Elizabeth Ford (juvenile and young adult trade book and textbook illustrators). Specializes in juvenile and young adult trade books and textbooks. Markets include: publishing/books.
Handles: Illustration and photography (juvenile and young adult). Please send all illustration correspondence to the attention of Elizabeth Ford and all photography correspondence to Judith Greene.
Terms: Rep receives 25% commission on all illustrations sold. Exclusive representation to book publishers is usually required. Advertising costs paid by representative ("for all Kirchoff/Wohlberg advertisements only"). "We will make transparencies from portfolio samples; keep some original work on file." Advertises in *American Showcase*, *Art Directors' Index*; *Society of Illustrators Annual*, children's book issue of *Publishers Weekly*.
How to Contact: For first contact, send query letter and "any materials artists feel are appropriate." Reports in 4-6 weeks. "We will contact you for additional materials." Portfolios should include "whatever artists feel best represents their work. We like to see children's illustration in any style."

ELLEN KNABLE & ASSOCIATES, INC., 1233 S. LaCienega Blvd., Los Angeles CA 90035. (310)855-8855. (310)657-0265. Contact: Ellen Knable, Kathee Toyama. Commercial illustration, photography and production representative. Estab. 1978. Member of SPAR, Graphic Artists Guild. Represents 6 illustrators, 5 photographers. Markets include: advertising agencies; corporations/clients direct; design firms.
Terms: Rep receives 25-30% commission. Exclusive West Coast/Southern California representation is required. Advertising costs split varies. Advertises in *The Workbook*.
How to Contact: For first contact, send query letter, direct mail flier/brochure and tearsheets. Reports within 2 week. Call for appointment to show portfolio.
Tips: Obtains new talent from creatives/artists. "Have patience and persistence!"

KORMAN & COMPANY, PHA, 135 W. 24th St., New York NY 10011. (212)727-1442. Fax: (212)727-1443. Contact: Alison Korman. Commercial photography representative. Estab. 1984. Member of

SPAR. Represents 3 photographers. Markets include: advertising agencies; corporations/clients direct; editorial/magazines; publishing/books; sales/promotion firms.
Handles: Photography.
Terms: Rep receives 25-30% commission. "Talent pays for messengers, mailings, promotion." Exclusive area representation is required. Advertising costs are paid by talent "for first two years, unless very established and sharing house." For promotional purposes, talent must provide portfolio, directory ads, mailing pieces. Advertises in *Creative Black Book, The Workbook, Gold Book*.
How to Contact: For first contact, send direct mail flier/brochure. Reports in 1 month if interested. After initial contact, write for appoinment or drop off or mail in portfolio of tearsheets, photographs.
Tips: Obtains new talent through "recommendations, seeing somebody's work out in the market and liking it. Be prepared to discuss how you can help a rep to help you."

***CAROYL LABARGE REPRESENTING**, 161 E. 89th St., #4B, New York NY 10128. (212)831-6701. Fax: (212)831-6050. Contact: Carol LaBarge. Commercial photography representative. Estab. 1990. Represents 4 photographers. Specializes in commercial and editorial photography. Markets include advertising agencies, corporations/clients direct, design firms, editorial/magazines, publishing/books, sales/promotion firms and catalogs.
Handles: Photography. Searching for photographers with experience in fashion, still life, food and lifestyle photography.
Terms: Agent receives 25% commission. Charges 75% of monthly incidentals (messengers cabs, mailings, etc.). Advertising costs are split: 75% paid by talent; 25% paid by the representative. For promotional purposes, talent must provide a professional portfolio and leave-behind promo pieces. Advertises in *New York Gold*.
How to Contact: For first contact, send direct mail flier/brochure, photostats and promo cards. Reports only if interested. After initial contact, write to schedule an appointment. Portfolios should include tearsheets, slides, photographs and print books.
Tips: Usually obtains new talent through recommendations, but often tracks down photographers after seeing their editorial work.

SHARON LANGLEY REPRESENTATIVES!, 4300 N. Narragansett, Chicago IL 60634. (708)670-0912. Fax: (708)670-0926. Contact: Sharon Langley. Commercial illustration and photography representative. Estab. 1988. Member of CAR (Chicago Artists Representatives). Represents 10 illustrators and 1 photographer. Markets include: advertising agencies; corporations/clients direct; design firms; editorial/magazines; publishing/books.
Handles: Illustration and photography. Although representative prefers to work with established talent, "I am always receptive to reviewing work."
Terms: Rep receives 25% commission. Exclusive area representation is preferred but not necessary. Advertising costs are split: 75% paid by talent; 25% paid by representative. For promotional purposes, talent must provide printed promotional piece, well organized portfolio. Advertises in *Creative Black Book, The Workbook, Chicago Source Book, Creative Illustration, American Showcase*.
How to Contact: For first contact, send printed promotional piece, tearsheets, slides, photos, photocopies. Reports in 1 month if interested. After initial contact, call for appointment to show portfolio of tearsheets, transparencies.
Tips: Obtains new talent through art directors, clients, referrals. "When an artist starts freelancing it's a good idea to represent yourself for a while. Only then are you able to appreciate and respect a professional agent. Don't be discouraged when one rep turns you down. Contact the next one on your list!"

***LEE + LOU PRODUCTIONS INC.**, 8522 National Blvd., #108, Culver City CA 90232. (310)287-1542. Fax: (310)287-1814. Commercial illustration and photography representative, digital and traditional photo retouching. Estab. 1981. Represents 10 illustrators, 5 photographers. Specializes in automotive. Markets include: advertising agencies.
Handles: Photography.
Terms: Rep receives 25% commission. Charges shipping, entertainment. Exclusive area representation required. Advertising costs are paid by talent. For promotional purposes, talent must provide direct mail advertising material. Advertises in *Creative Black Book, The Workbook* and *Single Image*.
How to Contact: For first contact, send direct mail flier/brochure, tearsheets. Reports in 1 week. After initial contact, call for appointment to show portfolio of photographs.
Tips: Obtains new talent through recommendations from others, some solicitation.

LEIGHTON & COMPANY, 4 Prospect St., Beverly MA 01915. (508)921-0887. Fax: (508)921-0223. Contact: Leighton O'Connor. Commercial illustration and photography representative. Estab. 1986. Member of Graphic Artists Guild, ASMP. Represents 8 illustrators and 2 photographers. Staff includes Jodie Sinclair (fashion and lifestyle photography), Jeffrey Coolidge (still life photography). Markets

include: advertising agencies; corporations/clients direct; design firms; editorial/magazines; publishing/books.

Handles: Illustration, photography. "Looking for photographers and illustrators who can create their work on computer."

Terms: Rep receives 25% commission. Advertising costs are split: 75% paid by talent; 25% paid by representative. For promotional purposes, "talent is required to supply me with 6×9 color mailer(s). Photographers and illustrators are required to supply me with laminated portfolio as well as two 4×5 color transparency portfolios." Advertises in *Creative Illustration, Graphic Artist Guild Directory of Illustration.*

How to Contact: For first contact, send query letter, direct mail flier/brochure, tearsheets and SASE. Reports in 1 week if interested. After initial contact, drop off or mail in appropriate materials with SASE for review. Portfolio should include tearsheets, slides, photographs.

Tips: "My new talent is almost always obtained through referrals. Occasionally, I will solicit new talent from direct mail pieces sent to me. It is best to send work first, i.e., tearsheet or direct mail pieces. Only send a portfolio when asked to. If you need your samples returned, always include a SASE. Follow up with one phone call. It is very important to get the correct spelling and address of the representative. Also, make sure you are financially ready for a representative, having the resources available to create a portfolio and direct mail campaign."

LEVIN•DORR, 1123 Broadway, Suite 1015, New York NY 10010. (212)627-9871. Fax: (212)243-4036. Contact: Bruce Levin or Chuck Dorr. Commercial photography representative. Estab. 1982. Member of SPAR. Represents 6 photographers. Markets include: advertising agencies; design firms; editorial/magazines; sales/promotion firms.

Handles: Photography.

Terms: Rep receives 25% commission. Exclusive area representation is required. Advertising costs are split: 75% paid by talent; 25% paid by representative. For promotional purposes, "talent must have a minimum of five portfolios which are lightweight and fit into Federal Express boxes." Advertises in *Creative Black Book, The Workbook, Gold Book.*

How to Contact: For first contact, send "portfolio as if it were going to advertising agency." After initial contact, call for appointment to show portfolio of tearsheets, slides, photographs.

Tips: Obtains new talent through recommendations, word-of-mouth, solicitation. "Don't get discouraged."

JIM LILIE ARTIST'S REPRESENTATIVE, 110 Sutter St., #706, San Francisco CA 94104. (415)441-4384. Fax: (415)395-9809. Commercial illustration and photography representative. Estab. 1977. Represents 7 illustrators, 1 photographer. Markets include: advertising agencies; design firms.

Handles: Illustration and photography.

Terms: Rep receives 25% commission. Exclusive area representation is required. Advertising costs are split: 75% paid by talent; 25% paid by representative. For promotional purposes, talent must provide portfolio of either transparencies or laminated pieces: 8×10. Advertises in *American Showcase, Creative Black Book.*

How to Contact: For first contact send direct mail flier/brochure, tearsheets and SASE. Portfolio should include tearsheets, photocopies.

Tips: Obtains new talent through recommendations from others.

***LULU CREATIVES**, 4645 Colfax Ave. S., Minneapolis MN 55409. Phone/fax: (612)825-7564. Contact: LuLu Z. Zabowski. Commercial photography and illustration representative. Estab. 1986. Represents 1 photographer and 12 illustrators. Markets include advertising agencies, corporations/clients direct, design firms, editorial/magazines, publishing/books and sales/promotion firms.

Handles: Illustration and photography.

Terms: Agent receives 25% commission. Exclusive area representation required. Advertising costs are split: 75% paid by the talent; 25% paid by the representative. For promotional purposes, talent must provide portfolio. Advertises in *American Showcase, Creative Black Book, The Workbook* and direct mailers.

How to Contact: For first contact, send tearsheets. Reports in 2 weeks. After initial contact call for appointment. Portfolios should include 4×5 transparencies.

The First Markets Index preceding the General Index in the back of this book provides the names of those companies/publications interested in receiving work from newer, lesser-known photographers.

FRANK MEO, 54 Morningside Dr., Suite 54, New York NY 10025. (212)932-9236. Fax: (212)932-3280. Contact: Frank Meo. Commercial photography representative. Estab. 1983. Member of SPAR. Represents 2 photographers. Markets include: advertising agencies; corporations/client direct; design firms.
Handles: Photography.
Terms: Rep receives 25% commission. Exclusive representation required. Advertising costs are split: 25% paid by talent; 75% paid by representative. Advertises in *Creative Black Book*.
How to Contact: For first contact, send query letter, photographs, direct mail flier/brochure. Reports in 5 days. After initial contact, drop off or mail in appropriate materials for review. Portfolio should include tearsheets, photographs.
Tips: Obtains new talent through recommendations and solicitations.

■**MIDWEST TALENT/CREATIVE TALENT**, 1102 Neil Ave., Columbus OH 43201. (614)294-7827. Fax: (614)294-3396. Talent Developer: Gary Aggas. Also 700 W. Pete Rose Way, Cincinnati OH 45203. (513)241-7827. Contact: Betty Aggas. Types of clients: talent and advertising agencies, production companies.
Needs: Works with 2-3 freelance photographers/month. Uses photographers for slide sets and videotapes. Subjects include portfolios and promotional shots of models and actors.
Specs: Uses 5×7 and 11×14 b&w prints; 35mm transparencies; and U-matic ¾" videotape.
Making Contact & Terms: Query with samples or résumé. Works with freelancers by assignment only. SASE. Reports in 2-3 weeks. Pays $4-10/b&w photo, $4-25/color photo, $25-65/hour and $100-275/job. **Pays on acceptance.** Buys all rights. Credit line given.
Tips: "Be concise, to the point and have good promotional package. We like to see well lit subjects with good faces."

SUSAN MILLER REPRESENTS, 1641 Third Ave., Suite 29A, New York NY 10128. (212)427-9604. Fax: (212)427-7777. Contact: Susan Miller. Commercial photography representative. Estab. 1983. Member of SPAR. Represents 15 photographers. "Firm deals mainly in advertising photography." Markets include: advertising agencies; sales/promotion firms, design firms, some editorial.
Handles: Photography.
Terms: Rep receives 25-30% commission in US; 33% in Europe. Advertising costs are paid by talent. "Talent must be able to self-promote in a directory page and possibly other mailers if possible." Advertises in *Creative Black Book*, *The Workbook*, *New York Gold*.
How to Contact: For first contact, send query letter, direct mail flier/brochure, photocopies and SASE. Reports in 2 weeks. After initial contact, call for appointment to show portfolio of slides, photographs.
Tips: "New talent comes to us through a variety of means. Recommendation from art buyers and art directors is one way, solicitation is another way. Photographers and illustrators sending portfolio must pay courier both ways. Talent should please check directory ads to see if we have conflicting talent before contacting us. Most people calling us do not take the time to do any research, which is not wise."

MONTAGANO & ASSOCIATES, 211 E. Ohio St., #2123, Chicago IL 60611-3254. (312)527-3283. Fax: (312)527-9091. Contact: David Montagano. Commercial illustration, photography and television production representative and broker. Estab. 1983. Member of Chicago Artist Representatives. Represents 7 illustrators, 2 photographers. Markets include: advertising agencies; corporations/clients direct; design firms; editorial/magazines; paper products/greeting cards.
Handles: Illustration, photography, design. Looking for tabletop food photography.
Terms: Rep receives 30% commission. No geographic restrictions. Advertises in *American Showcase*, *The Workbook*, *Creative Illustration Book*.
How to Contact: For first contact, send direct mail flier/brochure, tearsheets, photographs. Reports in 5 days. After initial contact, call to schedule an appointment. Portfolio should include original art, tearsheets, photographs.
Tips: Obtains new talent through recommendations from others.

*****THE NEIS GROUP**, 11440 Oak Dr., Shelbyville MI 49344. (616)672-5756. Fax: (616)672-5757. Contact: Judy Neis. Commercial illustration and photography representative. Estab. 1982. Represents 30 illustrators, 7 photographers. Markets include: advertising agencies; design firms; editorial/magazines; publishing/books.
Handles: Illustration, photography.
Terms: Rep receives 25% commission. Advertising costs are split: 75% paid by talent; 25% paid by representative. Advertises in *The American Showcase*.
How to Contact: For first contact, send direct mail flier/brochure, tearsheets, photographs. Reports in 5 days. After initial contact, drop off or mail in appropriate materials for review. Portfolio should include tearsheets, photographs.

Tips: "I am mostly sought out by the talent. If I pursue, I call and request a portfolio review."

***PACIFIC DESIGN STUDIO**, P.O. Box 1396, Hilo HI 96721. (808)966-8280. Fax: (808)933-4815. Contact: Francine H. Pearson. Commercial illustration and photography representative. Also handles fine art, graphic design and is an illustration and photography broker. Estab. 1980. "This is a small 2-person office." Specializes in "art and design of the Hawaiian Islands, the Big Island in particular." Markets include advertising agencies, editorial/magazines, paper products/greeting cards, T-shirt manufacturers, resorts, architects and interior designers.
Handles: Illustration, photography, fine art. Looking for "underwater ocean and sea life, Pacific Rim, Hawaiiana design."
Terms: Rep receives 15-20% commission. Charges for "real costs of freight, etc., which come off the top of a sale." Exclusive area representation is "preferred, but not required." For promotional purposes, "transparencies, full-color tearsheet or mailer is preferred; artist must have minimum of ten pieces for sale."
How to Contact: For first contact, send query letter, résumé, bio, direct mail flier/brochure, tearsheets, slides and SASE. Reports in 2 weeks, only if interested, "depending on what is sent for first contact." After initial contact, write for appointment to show portfolio or drop off or mail in portfolio of original art, slides, photographs, transparencies.
Tips: Obtains new talent through studio visits, recommendations, client reference, architect reference, local news and print media. "Send only your best work and be patient. Good representation requires good timing and creativity as well as client contacts."

JACKIE PAGE, 219 E. 69th St., New York NY 10021. (212)772-0346. Commercial photography representative. Estab. 1987. Member of SPAR and Ad Club. Represents 10 photographers. Markets include: advertising agencies.
Handles: Photography.
Terms: "Details given at a personal interview." Advertises in *The Workbook*.
How to Contact: For first contact, send direct mail flier/brochure. After initial contact, call for appointment to show portfolio of tearsheets, slides, photographs.
Tips: Obtains new talent through recommendations from others and mailings.

MARIA PISCOPO, 2038 Calvert Ave., Costa Mesa CA 92626-3520. (714)556-8133. Fax: (714)556-0899. Contact: Maria Piscopo. Commercial photography representative. Estab. 1978. Member of SPAR, Women in Photography, Society of Illustrative Photographers. Markets include: advertising agencies; design firms; corporations.
Handles: Photography. Looking for "unique, unusual styles; handles only established photographers."
Terms: Rep receives 25-30% commission. Exclusive area representation is required. No geographic restrictions. Advertising costs are split. For promotional purposes, talent must provide 1 show portfolio, 3 travelling portfolios, leave-behinds and at least 6 new promo pieces per year. Advertises in *American Showcase*, *The Workbook*, *New Media*.
How to Contact: For first contact, send query letter, direct mail flier/brochure and SASE. Reports in 2 weeks, if interested.
Tips: Obtains new talent through personal referral and photo magazine articles. "Be very business-like, organized, professional and follow the above instructions!"

KERRY REILLY: REPS, 1826 Asheville Place, Charlotte NC 28203. Phone/fax: (704)372-6007. Contact: Kerry Reilly. Commercial illustration and photography representative. Estab. 1990. Represents 16 illustrators, 3 photographers. Markets include: advertising agencies; corporations/clients direct; design firms; editorial/magazines.
Handles: Illustration, photography.
Terms: Rep receives 25% commission. Exclusive area representation is required. No geographic restrictions. Advertising costs are split: 75% paid by talent; 25% paid by representative. For promotional purposes, talent must provide at least 2 pages printed leave-behind samples. Preferred format is 9×12 pages, portfolio work on 4×5 transparencies. Advertises in *American Showcase*, *Workbook*.
How to Contact: For first contact, send direct mail flier/brochure or samples of work. Reports in 2 weeks. After initial contact, call for appointment to show portfolio or drop off or mail tearsheets, slides, 4×5 transparencies.
Tips: Obtains new talent through recommendations from others. "It's essential to have printed samples—a lot of printed samples."

***REPRESENTED BY KEN MANN INC.**, 20 W. 46th St., New York NY 10036. (212)944-2853. Fax: (212)921-8673. Contact: Ken Mann. Commercial photography representative. Estab. 1974. Member of SPAR. Represents 3 photographers. Specializes in "highest quality work!" Markets include: advertising agencies.

Handles: Photography.
Terms: Rep receives 25% commission in US; 30% international. Exclusive area representation is required. Advertising costs are split in US. 75% paid by talent; 25% paid by representative. International: photographer pays all advertising costs. Advertises in *Creative Black Book*.
How to Contact: For first contact, send query letter, résumé, bio, direct mail flier/brochure, photocopies, photostats, "nothing that needs to be returned." Reports in 1 week if interested. After initial contact, call for appointment to show portfolio of tearsheets and photographs; drop off or mail materials for review.
Tips: Obtains new talent through editorial work, recommendations. "Put together the best portfolio possible because knowledgable reps only want the best!"

RIDGEWAY ARTISTS REPRESENTATIVE, 71 Terminal Rd., Lansing MI 48906. (517)321-2777. Fax: (517)321-2815. Contact: Edwin Bonnen. Commercial illustration and photography representative. Estab. 1984. Member of AAF, AIGA. Represents 2 illustrators, 1 photographer. Markets include: advertising agencies; corporations/clients direct; design firms; editorial/magazines.
Handles: Illustration, photography, fine art. "We are primarily looking for individuals who have developed a distinctive style, whether they be a photographer or illustrator. Photographers must have an area they specialize in. We want artists who are pros in the commercial worlds; i.e., working with tight deadlines in sometimes less than ideal situations. We would consider a fine artist looking for commercial outlet if it was a good fit."
Terms: Rep receives 25-35% commission in the state of Michigan, 35% out of state. Exclusive area representation is required. Advertising costs are split: 75% paid by talent; 25% paid by representative. For promotional purposes, talent must provide portfolio of laminated color prints. "Direct mail is primary method of advertising; use of sourcebooks is secondary."
How to Contact: For first contact, send query letter, résumé, tearsheets, slides, direct mail flier/brochure; "whatever artist thinks best represents his abilities." Reports in 3 weeks, only if interested. After initial contact, call for appointment to show portfolio of photographs.
Tips: Obtains talent through recommendations, sourcebooks and solicitations.

***THE ROLAND GROUP INC.**, 4948 St. Elmo Ave., #201, Bethesda MD 20814. (301)718-7955. Fax: (301)718-7958. Contact: Rochel Roland. Commercial photography and illustration representative and illustration or photography broker. Estab. 1988. Member of SPAR, Society of Illustrators and ASMP. Represents 40 photographers, 20 illustrators and 6 designers. Markets include advertising agencies, corporations/clients direct, design firms and sales/promotion firms.
Handles: Illustration, photography and design. Searching for photographers and illustrators who are "computer oriented."
Terms: Agent receives 25% commission. Charges $150 marketing fee. Exclusive area representation required. Advertising costs are 100% paid by talent. For promotional purposes, talent must provide transparencies, slides, Kodak Photo CD. Advertises in *American Showcase*, *Creative Black Book*, *The Workbook* and local sourcebook for Mid-Atlantic.
How to Contact: For first contact, send résumé, photos and photocopies. Reports only if interested. After initial contact, drop off or mail materials for review. Portfolios should include tearsheets, slides, photographs, photocopies.

KEVIN R. SCHOCHAT, 150 E. 18th St., #14-N, New York NY 10003. (212)475-7068. Fax: (212)475-1040. Contact: Kevin R. Schochat. Commercial photography representative. Estab. 1982. Represents 4 photographers. Markets include: advertising agencies; corporations/clients direct; design firms; editorial/magazines; publishing/books; sales/promotion firms.
Handles: Photography.
Terms: Rep receives 25% commission. Advertising costs are split: 75% paid by talent; 25% paid by representative. "Talent must be willing to do regular promotions and mailings. Also, portfolio must be up-to-date, with new ideas and tests added frequently. A photographer should love to take pictures, therefore, adding new work to his/her portfolio." Advertises in *Creative Black Book*, *New York Gold* and *Workbook*.
How to Contact: For first contact, "phone call is fine." Reports in 2 days. After initial contact, call for appointment to show portfolio of tearsheets, slides, photographs; "his/her best work."
Tips: Obtains new talent through "recommendations from people in my field, review of various publications, attending portfolio reviews, notice of award shows, solicitation of people who interest me, etc. Show only your best work and be truly passionate about what you do."

FREDA SCOTT, INC., 1015-B Battery St., San Francisco CA 94111. (415)398-9121. Fax: (415)398-6136. Contact: Wendy Fuchs or Freda Scott. Commercial illustration and photography representative. Estab. 1980. Member of SPAR. Represents 10 illustrators, 10 photographers. Markets include: advertising agencies; corporations/clients direct; design firms; editorial/magazines; paper products/greeting cards; publishing/books; sales/promotion firms.

Handles: Illustration, photography.

Terms: Rep receives 25% commission. No geographic restrictions. Advertising costs are split: 75% paid by talent; 25% paid by representative. For promotional purposes, talent must provide "promotion piece and ad in a directory. I also need at least three portfolios." Advertises in *American Showcase*, *Creative Black Book*, *The Workbook*.

How to Contact: For first contact, send direct mail flier/brochure, tearsheets and SASE. If you send transparencies, reports in 1 week, if interested. "You need to make follow up calls." After initial contact, call for appointment to show portfolio of tearsheets, photographs, 4×5 or 8×10.

Tips: Obtains new talent sometimes through recommendations, sometimes solicitation. "If you are seriously interested in getting repped, keep sending promos—once every six months or so. Do it yourself a year or two until you know what you need a rep to do."

SHARPE + ASSOCIATES, 7536 Ogelsby Ave., Los Angeles, CA 90045. (310)641-8556. Fax: (310)641-8534. Contact: John Sharpe (LA), Colleen Hedleston (NY: (212)595-1125). Commercial illustration and photography representative. Estab. 1987. Member of APA, ADLA. Represents 6 illustrators, 5 photographers. Not currently seeking new talent but "always willing to look at work." Staff includes: John Sharpe, Jodi Pais and Colleen Hedleston (general commercial—advertising and design), "all have ad agency marketing backgrounds. We tend to show more non-mainstream work." Markets include: advertising agencies; corporations/clients direct; design firms; editorial/magazines; music/publishing; sales/promotion firms.

Handles: Illustration, photography.

Terms: Agent recieves 25% commission. Exclusive area representation is required, Advertising costs are split: 75% paid by talent; 25% paid by representative. For promotional purposes, "promotion and advertising materials are a shared responsibility, though the talent must be able to afford 75% of the material/media. The portfolios are 100% the talent's responsiblity and we like to have at least two complete books per market." Advertises in *The Workbook*, Music Industry Sourcebook, *AR Directory*, select magazines and through direct mail.

How to Contact: For first contact, call, then follow up with printed samples. Reports in 2 weeks. After initial contact, call for appointment to show portfolio.

Tips: Obtains new talent mostly through referrals, occasional solicitations. "Once they have a professional portfolio together and at least one representative promotional piece, they should target reps along with potential buyers of their work as if the two groups are one and the same. They need to market themselves to reps as if the reps are potential clients."

DANE SONNEVILLE ASSOC. INC., 67 Upper Mountain Ave., Montclair NJ 07042. (201)744-4465. Fax: (201)744-4467. Contact: Dane. Commercial illustration, photography and graphic design representative, illustration or photography broker, paste up, printing, hair and make up, all type stylists, computer image artists, writers. Estab. 1971. Represents 20 illustrators, 10 photographers, 10 designers, 40 writers in all disciplines. Specializes in "resourcefulness and expeditious service." Markets include: advertising agencies; corporations/clients direct; design firms; editorial/magazines; publishing/books; sales/promotion firms.

Handles: Illustration, photography, design, writing, all creative support personnel.

Terms: Rep receives 25% commission. Advertising costs are paid by talent. For promotional purposes, talent must provide unlimited promo pieces (leave behinds). Advertises in *American Showcase*, *Creative Black Book*, *RSVP*, *The Workbook*.

How to Contact: For first contact, send résumé, direct mail flier/brochure, tearsheets. Reports in 1 week if interested. After initial contact, call for appointment to show portfolio of original art, tearsheets, slides, photographs.

Tips: Obtains new talent through recommendations from others. "Knock on every door."

SULLIVAN & ASSOCIATES, 3805 Maple Ct., Marietta GA 30066. (404)971-6782. Fax: (404)973-3331. Contact: Tom Sullivan. Commercial illustration, commercial photography and graphic design representative. Estab. 1988. Member of Creative Club of Atlanta, Atlanta Ad Club. Represents 14 illustrators, 7 photographers and 7 designers, including computer graphic skills in illustration/design/production and photography. Staff includes Tom Sullivan (sales, talent evaluation, management), Debbie Sullivan (accounting, administration). Specializes in "providing whatever creative or production resource the client needs." Markets include: advertising agencies, corporations/client direct; design firms; editorial/magazines; publishing/books; sales/promotion firms.

Handles: Illustration, photography. "Open to what is marketable; computer graphics skills."

Terms: Rep receives 25% commission. Exclusive area representation in Southeastern US is required. Advertising costs are split: 75-100% paid by talent; 0-25% paid by representative. "Negotiated on individual basis depending on: (1) length of time worked with; (2) area of representation; (3) scope of exclusive representation." For promotional purposes, talent must provide "direct mail piece, portfolio in form of 8½×11 (8×10 prints) pages in 22 ring presentation book." Advertises in *American Showcase*, *The Workbook*.

How to Contact: For first contact, send bio, direct mail flier/brochure; "follow up with phone call." Reports in 2 weeks if interested. After initial contact, call for appointment to show portfolio of tearsheets, photographs, photostats, photocopies, "anything appropriate in nothing larger than 8½×11 print format."
Tips: Obtains new talent through referrals and direct contact from creative person. "Have direct mail piece or be ready to produce it immediately upon reaching an agreement with a rep. Be prepared to immediately put together a portfolio based on what the rep needs for that specific market area."

T & M ENTERPRISES, 270 N. Canon Dr., Suite 2020, Beverly Hills CA 90210. (310)281-7504. Fax: (310)274-7957. Contact: Tony Marques. Commercial photography representative and photography broker. Estab. 1985. Represents 50 photographers. Specializes in women photography only: high fashion, swimsuit, lingerie, glamour and fine (good taste) *Playboy*-style pictures. Markets include: advertising agencies; corporations/clients direct; editorial/magazines; paper products/greeting cards; publishing/books; sales/promotion firms; medical magazines.
Handles: Photography.
Terms: Rep receives 50% commission. Exclusive area representation is not required. Advertising costs are paid by representative. "We promote the standard material the photographer has available, unless our clients request something else." Advertises in Europe, South and Central America and magazines not known in the US.
How to Contact: For first contact, send slides, photographs, transparencies and printed work, if any. Reports in 2 days. After initial contact, drop off or mail in appropriate materials for review. Portfolio should include slides, photographs, transparencies, printed work.
Tips: Obtains new talent through worldwide famous fashion shows in Paris, Rome, London and Tokyo; participating in well-known international beauty contests; recommendations from others. "Send your material clean. Send your material organized (neat). Do not borrow other photographers' work in order to get representation. Protect—always—yourself by copyrighting your material. Get releases from everybody who is in the picture (or everything owned by somebody)."

■**TWO STEPS UP, INC.**, 26 Bedford St., #1A, New York NY 10014. (212)675-1892. Fax: (212)691-3627 ("write my name and phone on fax"). Contact: Amy Cohen. Commercial photography representative. Estab. 1989. Markets include: advertising agencies; corporations/clients direct; design firms (least); editorial/magazines.
Handles: Photography. "I am looking for 1-2 photographers; anything except fashion and beauty: portrait, still life, lifestyle, food; open to other categories."
Terms: Rep receives 20% commission with a monthly draw. Exclusive area representation is required. Advertising costs are paid by talent (at present only). For promotional purposes, "need minimum two portfolios with cases, tearsheets optional, and at least four leave-behinds. Direct mail not mandatory. Must supply a minimum of three new printed promo pieces annually." Advertises in *The Workbook*, *Single Image*.
How to Contact: For first contact, send query letter, direct mail flier/brochure. Reports in 1 week if interested.
Tips: Obtains new talent through recommendations from *The Workbook*, recommendations from art directors, solicitation from sourcebooks. "The right photographer/rep relationship sometimes seems as elusive as the perfect tiramisu! Communication is as important as good work; if we aren't working toward the same goal(s), we are working separately. I'm looking for someone who doesn't mind frequent testing, someone established and responsible, with a great sense of humor. My best working relationship is friendly and honest. Growth is a continual process for us both."

*****TY REPS**, 920¼ N. Formosa Ave., Los Angeles CA 90046. (213)850-7957. Fax: (213)850-0245. Contact: Ty Methfessel. Commercial photography and illustration representative. Specializes in automotive photography, portfolio reviews and marketing advice. Markets include advertising agencies, corporations/clients direct, design firms.
Handles: Illustration and photography. Searching for automotive photographers.
Terms: Agent receives 25-30% commission. Exclusive area representation required. Advertising costs 100% paid by talent. For promotional purposes, talent must provide a minimum of 3 portfolios, 4 new promos per year and a double-page ad in a national directory. Advertises in *American Showcase*, *Creative Black Book* and *The Workbook*.
How to Contact: For first contact, send query letter, direct mail flier/brochure and tearsheets. Reports in 2 weeks only if interested.

*****WARNER & ASSOCIATES**, 1425 Belleview Ave., Plainfield NJ 07060. (908)755-7236. Contact: Bob Warner. Commercial illustration and photography representative. Estab. 1986. Represents 4 illustrators, 4 photographers. "My specialized markets are advertising agencies that service pharmaceutical, medical, health-care clients."

Handles: Illustration, photography. Looking for medical illustrators: microscope photographers (photomicrography), science illustrators, special effects photographers.
Terms: Rep receives 25% commission. "Promo pieces and portfolios obviously are needed; who makes up what and at what costs and to whom, varies widely in this business."
How to Contact: For first contact, send query letter "or phone me." Reports back in days. Portfolio should include "anything that talent considers good sample material."
Tips: Obtains new talent "by hearsay and recommendations. Also, specialists in my line of work often hear about my work from art directors and they call me."

ELYSE WEISSBERG, 420 Lexington Ave., 10th Floor, New York NY 10170. (212)406-2566. Fax: (212)867-1865. Contact: Elyse Weissberg. Commercial photography representative, photography creative consultant. Estab. 1982. Member of SPAR. Markets include: advertising agencies; corporations/clients direct; design firms; editorial/magazines; publishing/books; sales/promotion firms.
Handles: Photography. "I'm not looking for talent at this time."
Terms: "Each talent contract is negotiated separately." No geographic restrictions. No specific promotional requirements. "My only requirement is ambition." Advertises in *KIK*, *Creative Black Book*, *The Workbook*.
How to Contact: Send mailers.
Tips: Obtains new talent through recommendations, direct mail. "Don't give up! Someone is always looking for new talent. Elyse is available on a consultation basis. She reviews photography portfolios and gives direction in marketing and promotion."

DAVID WILEY, ARTISTS' AGENCY, 282 Second St., 2nd Floor, San Francisco CA 94105. (415)442-1822. Fax: (415)442-1823. Contact: David Wiley. Commercial illustration and photography representative. Estab. 1984. Member of AIP (Artists in Print). Represents 7 illustrators, 1 photographer. Specializes in "Going beyond expectations!"
Terms: Artist fee is divided, 75% artist and 25% agent. No geographical restriction. Artist is responsible for 100% of portfolio costs. Promotional materials and expenses including portfolio courier costs, 75% artist, 25% agent. Each year the artists are promoted in *American Showcase* and through direct mail (bimonthly mailings).
How to Contact: For first contact, send direct mail flier/brochure, tearsheets, slides, photographs, and SASE ("very important"). Will call back if requested within 48 hours. After initial contact, call for appointment or drop off appropriate materials. "To find out what's appropriate, just ask!" Portfolio should include, roughs, original art, tearsheets—color and b&w if possible.
Tips: "Generate new clients through creative directories, direct mail and a rep relationship. To create new images that will hopefully sell, consult an artist rep or someone qualified to suggest ideas keeping in alignment with your goals. I suggest working with a style that will allow quick turnaround, 1-2 weeks, preferably within 10 days (this includes pencils and making changes). Present portfolios with examples of roughs and finished commissioned work. Show color and b&w imagery, concepts to finish process, i.e., paper napkin sketches through finish. Ask questions and then sit back and listen! and take notes. Three key words I work with: 'vision, action and manifestation.' Learn how to work with these and new discoveries will unfold! Remember to give yourself permission to make mistakes, 'it's just another way of doing something.' "

■**WINSTON WEST, LTD.**, 195 S. Beverly Dr., Beverly Hills CA 90212. (310)275-2858. Fax: (310)275-0917. Contact: Bonnie Winston. Commercial photography representative (fashion/entertainment). Estab. 1986. Represents 8 photographers. Specializes in "editorial fashion and commercial advertising (with an edge)." Markets include: advertising agencies; client direct; editorial/magazines.
Handles: Photography.
Terms: Rep receives 25% commission. Charges for courier services. Exclusive area representation is required. No geographic restrictions. Advertising costs are split: 75% paid by talent; 25% paid by representative. Advertises by direct mail and industry publications.
How to Contact: For first contact, send direct mail flier/brochure, photographs, photocopies, photostats. Reports in days, only if interested. After initial contact, call for appointment to show portfolio of tearsheets.
Tips: Obtains new talent through "recommendations from the modeling agencies. If you are a new fashion photographer or a photographer who has relocated recently, develop relationships with the modeling agencies in town. They are invaluable sources for client leads and know all the reps."

WORLDWIDE IMAGES, P.O. Box 150547, San Rafael CA 94915. (415)459-0627. Contact: Norman Buller. Commercial photography representative. Estab. 1988. Represents 36 photographers. Specializes in nudes, all pro sports, celebrities, rock stars, men's magazine layouts, calendars, posters. Markets include: advertising agencies; clients direct; magazines; paper products/greeting cards; publishing/books; amateur x-rated videos.

INSIDER REPORT

Success Takes More Than Talent

"When people say 'Times are tough,' I don't believe it," says New York City-based photo agent/consultant Elyse Weissberg. "There's work everywhere. And there's always a way to find someone who needs a photographer."

The owner of the agency Expose Yourself (Properly), Weissberg says talent isn't the only requirement for success in today's intensely competitive market. "If you have a good amount of talent, you'll get business. But if you have a fair amount of talent or you're working on bettering it, then it often comes down to packaging."

Weissberg draws her insight into photography from working on "high-end" advertising/commercial assignments. She has been a photo rep for more

© Jack Reznicki

Elyse Weissberg

than 13 years and a creative consultant for the last six. Her stable of photographers includes Jack Reznicki (people illustration photography), Markow Southwest (location photography), Paul Lachenauer (still life photography) and former Pulitzer Prize winner Eddie Adams.

The key to a positive professional appearance is doing "your homework," she says. This includes carefully choosing your company name, having your business card and stationery professionally designed, and developing a well-polished presentational style. "How you conduct business tells others how professional you are."

Taking a personal inventory of your strengths and weaknesses is a valuable first "assignment," Weissberg says. In particular, she recommends making a list of your top five attributes. Such qualities might include creativity, experience, confidence, flexibility and resourcefulness. "The client never sees your list, but these qualities need to be on your own internal list. They will empower you and become something you live by."

Weissberg says self-evaluation often shows photographers that they seem to be doing everything right. Yet, she adds, they don't always get work because they overlook other important factors. One common oversight is failing to identify the real photo buyers in a client's organization.

"When you first contact a client and go in to show your [portfolio], make sure you're getting work in front of the person who makes the decisions about photography purchases."

In the case of beginners, or of established shooters needing a drastic overhaul of their portfolios, developing a quality portfolio from self-assignments can be

costly. "Reworking a portfolio does involve some costs," Weissberg says. "But ingenuity and creativity sometimes can take the place of money."

Fortunately for most photographers, images they have already captured often provide many suitable options when developing new portfolios. "All photographers have jewels in their files. They just never crack open the safe." Such was the case for one of Weissberg's clients. "We started grouping his images, and a new portfolio evolved. But the funny thing is, he didn't shoot anything new. The only money he spent was on new boards and pages for his book."

Also, vary print sizes according to the impact you want the different photos to have, especially with a series. "This shows the client that you have a lot to offer, that there's more than one side to you."

Especially for photographers who aspire to the "big leagues" of commercial photography, a commissioned photo rep can become an indispensable ally. But first, as Weissberg points out, the photographer must establish his business. "When you're established and you have a good amount of work, then you're ready for a rep. A rep doesn't want to work with an unknown talent. It's too hard to make money with someone who isn't already established."

Photographers may find that a good alternative to a rep during their expansion phase is a part-time support person, says Weissberg. "You wouldn't hire three reps to divide the job of a rep, but a part-time person can do some of those things and help you to expand your business." Making cold calls, organizing promotional mailings, and handling other office work are just some of the tasks that a part-timer can do at minimum wage, she adds.

—*Sam A. Marshall*

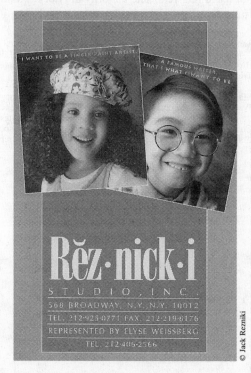

One of the keys to attracting new clients is putting together strong promotional pieces for direct mail, like this one by Jack Reznicki of New York City. Photo rep/consultant Elyse Weissberg says such pieces show art directors that you are professional and take your work seriously.

Handles: Photography (all formats); videos of all kinds.
Terms: Rep receives 50% commission. Advertising costs are paid by the representative.
How to Contact: For first contact send résumé, slides, photographs and SASE. Reports immediately. Portfolio should include slides, photographs.
Tips: Obtains new clients through recommendations from others, solicitation. "I am advertised all over the world! Have doubled my clients in the last six months."

***ZACCARO PRODUCTIONS INC.,** 315 E. 68th St., New York NY 10021. (212)744-4000. Fax: (212)744-4442. Contact: Jim Zaccaro. Commercial photography and fine art representative. Estab. 1961. Member of SPAR, DGA. Represents 4 photographers.
Terms: Agent receives 25% commission.
How to Contact: For first contact send query letter, direct mail flier/brochure. Reports in 10 days. After initial contact, call for appointment to show portfolio.

DAVID ZAITZ ARTIST REPRESENTATIVE, 11830 Darlington Ave., #10, Los Angeles CA 90049. (310)207-4806. Fax: (310)207-6368. Contact: D. Zaitz. Commercial photo rep. Estab. 1985. Represents 5 photographers. Specializes in advertising. Markets include: advertising agencies; design firms.
Handles: Photography.
Terms: Rep receives 25% commission. Exclusive area representation is required. Advertising cost split varies. For promotional purposes, talent must provide promo cards and/or sourcebook ad reprints to use as leave-behinds or mailers. Advertises in *The Workbook*.
How to Contact: For first contact, send direct mail flier/brochure. Reports in 1 week. Call for appointment to show portfolio of photographs.
Tips: Obtains new talent through referral through art directors, contact from photographers. "Learn to represent yourself *first*, then delegate that responsibility to a rep that best reflects your personal/business style. A rep should augment, embellish and help direct your business—not a quick fix to the problem: 'no work.' "

Art/Photo Representatives/'95-'96 changes

The following markets appeared in the 1995 edition of *Photographer's Market*, but are not listed this year. The majority did not respond to our request to update their listings. If a reason was given for a market's exclusion it appears in parentheses below.

Ceci Bartels Associates
Sam Brody, Artists & Photographers Representative
Brooke & Company
Tricia Burlingham/Artist Representation (requested deletion)
Marilyn Cadenbach Associates
Woody Coleman Presents Inc. (only represents illustrators)
Conrad Represents
Corcoran Fine Arts Limited, Inc.
CVB Creative Resource

Steven Edsey & Sons
Elliott/Oreman Artists' Representatives (requested deletion)
Randi Fiat & Associates
Giannini & Talent
Tom Goodman Inc.
Jedell Productions Inc.
Kastaris & Associates
Elaine Korn Associates, Ltd.
Peter Kuehnel & Associates
L.A. Art Exchange (requested deletion)

McConnell McNamara & Co.
Colleen McKay Photography
The Newborn Group (only takes illustrators)
Gerald & Cullen Rapp Inc.
Pamela Reid
Linda Ruderman
Dario Sacramone
Soodak Represents
Paul Willard Associates Ltd.

Contests

The proliferation of photo contests around the world tells us a lot about the photography industry. First, there are thousands of amateurs and professionals shooting huge quantities of film every year. And second, associations, magazines and businesses are eager to sponsor contests because of photography's popularity. For photographers this shows the good (a popular industry filled with money-making possibilities) and the bad (a glut of professionals). Eventually competition will weed out the less-skilled photographers who consider themselves "professionals," but in the meantime there is a fierce battle for recognition.

This section contains 62 competitions and 12 are new this year. They range in scope from the tiny juried county fairs to the massive international competitions. Whether you're a seasoned veteran or a newcomer still cutting your teeth, you may want to enter a few to see how you match up against other shooters. When possible we've included entry fees and other pertinent information, but our space is limited and, therefore, you should ask sponsors for an entry form for more details.

Once you receive rules and an entry form, pay particular attention to the section describing rights. Regrettably, some sponsors retain all rights to winning entries or even *submitted* images. Don't get lured into such traps. While you can benefit from the publicity and awards connected with winning prestigious competitions, you do not want to unknowingly forfeit copyright. Granting limited rights for publicity is reasonable, but never assign rights of any kind without adequate financial compensation or a written agreement. If such terms are not stated in contest rules, ask sponsors for clarification.

If you are satisfied with the contest's copyright rules, check with contest officials to see what types of images won in previous years. By scrutinizing former winners you might notice a trend in judging that could help when choosing your entries. If you can't view the images, ask what styles and subject matters have been popular.

For more on entering contests, pick up the book *Winning Photo Contests*, by Jeanne Stallman (Images Press, 1990).

■**AMERICAN INTERNATIONAL FILM/VIDEO FESTIVAL**, P.O. Box 4034, Long Beach CA 90804. Festival Chairman: George Cushman. Sponsored by the American Motion Picture Society. Sponsors worldwide annual competition in its 66th consecutive year for film and videotape.

ANACORTES ARTS & CRAFTS FESTIVAL, 819 Commercial, Anacortes WA 98221. (206)293-6211. Director: Joan Tezak. Two-day festival, first weekend in August. An invitational, juried fine art show with over 250 booths. Over $1,500 in prizes awarded for fine arts.

*****ART OF CARING PHOTOGRAPHY CONTEST**, Caring Institute, 320 "A" St. NE, Washington DC 20002-5940. (301)493-6125. Director: Marian Brown. Image must relate to the subject of caring. Photos must be 8 × 10, color or b&w and must be submitted with a completed entry blank which may be obtained from Caring Institute.

ART ON THE GREEN, P.O. Box 901, Coeur d'Alene ID 83816. (208)667-9346. Outdoor art and crafts festival including juried show first August weekend each year.

ART SHOW AT THE DOG SHOW, 11301 W. 37 North, Wichita KS 67205. (316)722-6181. Chairman: Joe Miller. Entry fee of $20 for up to 3 entries. A national juried fine arts competition devoted to canine art. All entries must include a dog. Entry deadline for 1996 competition is January 13, 1996.

*■**BACA'S ANNUAL FILM AND VIDEO FESTIVAL**, 195 Cadman Plaza West, Brooklyn NY 11201. (718)625-0080. Festival Coordinator: Mark Dannat. Sponsors annual festival for filmmakers. Call for application and regulations information.

■**BALTIMORE ANNUAL INDEPENDENT FILM & VIDEO MAKERS' COMPETITION**, % The Baltimore Film Forum, 10 Art Museum Dr., Baltimore MD 21218. (410)889-1993. Annual international competition. Applications available in summer, entries due in fall. Winners screened in April during International Film Festival.

■**CAMERA BUG INTERNATIONAL,** Camera Bug World Headquarters, 2106 Hoffnagle St., Philadelphia PA 19152. (215)742-5515. Director: Leonard Freidman. Annual contest open to all 35mm photographers and amateur videographers. Provide SASE or 32¢ postage for submission guidelines.

COUNTERPOINT: ANNUAL NATIONAL JURIED DRAWING, PHOTOGRAPHY, AND PRINT-MAKING EXHIBITION, Hill Country Arts Foundation, Dept. CP-PM, P.O. Box 1169, Ingram TX 78025. (210)367-5120. Cost: Handling fee to enter competition $22 for 3 slides. Send SASE for prospectus. Awards $3,200 in cash and purchase awards.

■**THE CREATIVITY AWARDS SHOW**, 10 E. 39th St., 6th Floor, New York NY 10016. (212)889-6500. Show Director: Dan Barron. Sponsor: *Art Direction* magazine. Annual show for photos and films appearing in advertising and mass communication media, annual reports, brochures, etc.

*****ECLIPSE AWARDS**, Thoroughbred Racing Associations, 420 Fair Hill Dr., Suite 1, Elkton MD 21921-2573. (410)392-9200. Fax: (410)398-1366. Director of Services: Conrad Sobkowiak. Sponsor: Thoroughbred Racing Associations, Daily Racing Form and National Turf Writers Association. Annual event for photographers. Given for outstanding achievement in the coverage of thoroughbred racing.

FINE ARTS WORK CENTER IN PROVINCETOWN, 24 Pearl St., Provincetown MA 02657. (508)487-9960. Contact: Visual Coordinator. Seven-month residency program for artists and writers. Housing, monthly stipend and materials allowance provided from October 1 through May 1. Send SASE for application. Deadline February 1.

47th INTERNATIONAL EXHIBITION OF PHOTOGRAPHY, 2260 Jimmy Durante Blvd., Del Mar CA 92014-2216. (619)792-4207. Sponsor: Del Mar Fair (22nd District Agricultural Association). Annual event for still photos/prints. April 26, 1996—pre-registration deadline. Send #10 SASE for brochure, available March 1.

GALLERY MAGAZINE, 401 Park Ave. S., New York NY 10016-8802. Contest Editor: Judy Linden. Sponsors monthly event for still photos of nudes. Offers monthly and annual grand prizes. Write for details or buy magazine.

GEORGIA COUNCIL FOR THE ARTS INDIVIDUAL ARTISTS GRANT PROGRAM, 530 Means St. NW, Suite 115, Atlanta GA 30318-5793. (404)651-7926. Visual Arts Manager: Richard Waterhouse. Open to individual artists, who must have been legal residents of Georgia for at least 1 year prior to the application date. To be funded the artist must complete a specific project during the 1996 fiscal year. The award will be based on the quality of the artist's work.

GOLDEN ISLES ARTS FESTIVAL, P.O. Box 20673, Saint Simons Island GA 31522. (912)638-8770. Contact: Registration Chairman. Sponsor: Glynn Art Association. Annual 2-day festival for still photos/prints; all fine art and craft. Deadline: August 30.

GREATER MIDWEST INTERNATIONAL XI, CMSU Art Center Gallery, Clark St., Warrensburg MO 64093-5246. (816)543-4498. Gallery Director: Morgan Dean Gallatin. Sponsor: CMSU Art Center Gallery/Missouri Arts Council. Sponsors annual competition for all media. Send SASE for current prospectus. Entry deadline October 13.

IDAHO WILDLIFE, P.O. Box 25, Boise ID 83707-0025. (208)334-3746. Fax: (208)334-2148. Editor: Diane Ronayne. Annual contest; pays cash prizes of $20-150. Rules in summer and fall issues of *Idaho Wildlife* magazine. Deadline October 1. Winners published. Freelance accepted in response to want list. Pays b&w or color inside $40; cover $80. Fax request for submission guidelines.

The solid, black square before a listing indicates that the market uses various types of audiovisual materials, such as slides, film or videotape.

‡INTERNATIONAL DIAPORAMA FESTIVAL, Auwegemvaart 79, B-2800 Mechelen, Belgium. President: J. Denis. Sponsor: Koninklijke Mechelse Fotokring. Competition held every other year (even years) for slide/sound sequences.

INTERNATIONAL WILDLIFE PHOTO COMPETITION, 280 E. Front St., Missoula MT 59802. (406)728-9380. Chairman: Susanna Gaunt. Professional and amateur catagories, color and b&w prints, color slides accepted; $1,700 in cash and prizes. Entry deadline-March 4. Co-sponsored by the 17th Annual International Wildlife Film Festival and the Rocky Mountain School of Photography.

JURIED PHOTOGRAPHY EXHIBITION, 5601 South Braeswood, Houston TX 77096. (713)729-3200. Cultural Arts Director: Marilyn Hassid. Sponsor: Jewish Community Center of Houston. Competition held every other year for still photos/prints (slide entry format). For next exhibition, write for information.

LARSON GALLERY ANNUAL PHOTO EXHIBITION, P.O. Box 1647, Yakima WA 98907. (509)575-2402. Director: Carol Hassen. Cost: $5/entry (limit 4 entries). National juried competition with approximately $2,000 in prize money. Held annually in April. Write for prospectus in January.

MATRIX INTERNATIONAL, Matrix Gallery and Workshop of Women Artists, 1725 I St., Sacramento CA 95814. (916)441-4818. Director: Sheri Tatsch. Cost: $5/work with limit of 5 entries. Send SASE for details. Open to all media except installation, video, film and performance. Pays $25 honorarium to each accepted artist, plus substantial cash awards.

MAYFAIR JURIED PHOTOGRAPHY EXHIBITION, 2020 Hamilton St., Allentown PA 18104. (215)437-6900. Maximum 3 entries, $10 non-refundable fee to enter. May juried exhibition open to all types of original photographs by artists within 75-mile radius of Allentown. Send for prospectus; entry deadline March 1.

MINNESOTA INK, 3585 N. Lexington Ave., Suite 328, Arden Hills MN 55126. (612)486-7818. Contact: Valerie Hockert. Cost: $3/entry. Deadlines: June 15 and November 30. Photos can be scenic, with or without people. Send SASE for guidelines.

***∎THE "MOBIUS"™ ADVERTISING AWARDS**, 841 N. Addison Ave., Elmhurst IL 60126-1291. (708)834-7773. Fax: (708)834-5565. Chairman: J.W. Anderson. Executive Director: Patricia Meyer. Sponsor: The United States Festivals Association. Annual international awards competition for print advertising, package design, TV and radio commericals. Annual October 1st entry deadline. Awards in early February each year.

MOTHER JONES INTERNATIONAL FUND FOR DOCUMENTARY PHOTOGRAPHY AWARDS, 731 Market St., Suite 600, San Francisco CA 94103. Fax: (415)665-6696. E-mail: stewart@mojones. com. Contact: Lorelei Stewart. Sponsors awards programs for in-depth (lasting more than 1 year) in-progress social documentary projects. Awards four grants of $7,000 each and the Leica Medal of Excellence of $10,000. Write, fax or e-mail for guidelines.

***MYSTIC ART ASSOCIATION**, P.O. Box 259, 9 Water St., Mystic CT 06355. (203)536-7601. Executive Director: Marjorie Ciminera. Sponsors annual juried show held each year in Fine Arts Gallery.

NATURAL WORLD PHOTOGRAPHIC COMPETITION & EXHIBITION, The Carnegie Museum of Natural History, 4400 Forbes Ave., Pittsburgh PA 15213. (412)622-3283. Contact: Division of Education. Held each fall, contest accepts color and b&w prints depicting the "natural world." Prizes totaling $1,650 are awarded and a juried show is selected for exhibition in the museum.

NAVAL AND MARITIME PHOTO CONTEST, U.S. Naval Institute, 118 Maryland Ave., Annapolis MD 21402. (410)268-6110. Picture Editor: Charles Mussi. Sponsors annual competition for still photos/prints and 35mm slides. December 31 deadline.

NEW YORK STATE FAIR PHOTOGRAPHY COMPETITION AND SHOW, New York State Fair, Syracuse NY 13209. (315)487-7711. Program Manager: Janet J. Edison. Fee: $5/entrant for 1 or 2 works. Open to amateurs and professionals in both b&w and color. Two prints may be entered per person. Prints only, no transparencies. Entry deadline August 1.

∎NEW YORK STATE YOUTH MEDIA ARTS SHOWS, Media Arts Teachers Association, 1401 Taylor Rd., Jamesville NY 13078. (315)469-8574. Co-sponsored by the New York State Media Arts Teachers Association and the State Education Department. Annual regional shows and exhibitions for

still photos, film, videotape and computer arts. *Open to all New York state, public and non-public elementary and secondary students.*

NIKON SMALL WORLD COMPETITION, 1300 Walt Whitman Rd., Melville New York 11747. (516)547-8500. Advertising Manager: B. Loechner. International contest for photography through the microscope, 35mm—limit 3 entries. First prize $4,000.

1996 PHOTOGRAPHY ANNUAL, 410 Sherman, P.O. Box 10300, Palo Alto CA 94303. (415)326-6040. Executive Editor: Jean A. Coyne. Sponsor: *Communication Arts* magazine. Annual competition for still photos/prints. Write or call for entries. Deadline: March 16, 1996.

NOVELLO PHOTO COMPETITION, The Light Factory Photographic Arts Center, P.O. Box 32815, Charlotte NC 28232. (704)333-9755. Director of Education: Nancy Stanfield. Cost: $5/entry (make checks payable to PLCMC). Cosponsor with the Public Library of Charlotte-Mecklenburg County. Two categories—Advanced and Snapshot divisions on the theme of "Lifelong Learning." The photos will be displayed in public space at the Main Library in Charlotte, NC from October-November. The cost of shipping to and from The Light Factory is the responsibility of the artist.

GORDON PARKS PHOTOGRAPHY COMPETITION, Fort Scott Community College, 2108 S. Horton, Fort Scott KS 66701. (316)223-2700. Chair, Lucile James Fine Arts Committee: Johnny Bennett. Cost $15 for 2 photos; maximum of 2 additional photos for $5 each. Prizes of $1,000, $500, $250; winners and honorable mentions will be featured in annual nationwide traveling exhibition. Entry deadline September 30; write for entry form.

PHOTO COMPETITION U.S.A., 3900 Ford Rd., Philadelphia PA 19131. (215)878-6211. Publisher: Allan K. Marshall. Quarterly contests in 5 categories, sponsored by magazine for amateur photographers. Cost: $4-18/entry. Write for more information.

PHOTO METRO MAGAZINE ANNUAL CONTEST, 17 Tehama St., San Francisco CA 94105. (415)243-9917. Photography contest with cash prizes, publication and exhibition. Send SASE for information. Call for entries goes out in July. Contest deadline is around September.

PHOTO REVIEW ANNUAL COMPETITION, 301 Hill Ave., Langhorne PA 19047. (215)757-8921. Editor: Stephen Perloff. Cost: $18 for up to 3 prints or slides, $5 each for up to 2 more. National annual photo competition; all winners reproduced in summer issue of *Photo Review* magazine. One entrant selected for 1-person show at the Print Club Center for Prints and Photographs, Philadelphia, PA. Awards $1,000 cash prizes.

PHOTOGRAPHIC ALLIANCE U.S.A., 1864 61st St., Brooklyn NY 11204-2352. President: Henry Mass. Sole US representative of the International Federation of Photographic Art. Furnishes members with entry forms and information regarding worldwide international salons as well as other information regarding upcoming photographic events.

PHOTOGRAPHIC COMPETITION ASSOCIATION QUARTERLY CONTEST, P.O. Box 53550-B, Philadelphia PA 19105. (610)828-2773. Contact: Competition Committee. Sponsor: Photographic Competition Association (PCAA). Quarterly competition for still photos/prints.

PHOTOGRAPHY 14, Perkins Center for the Arts, 395 Kings Hwy., Moorestown NJ 08057. (609)235-6488. Director: Alan Willoughby. Juried regional photography exhibition. Past jurors include Merry Foresta, curator from the Smithsonian and Buzz Hartshorn, International Center of Photography. Write for prospectus. Held from late January through February.

PHOTOGRAPHY NOW, % the Center for Photography at Woodstock, 59 Tinker St., Woodstock NY 12498. (914)679-9957. Sponsors annual competition. Call for entries. Juried annually by renowned photographers, critics, museums. Call or write for prospectus in August and January.

Market conditions are constantly changing! If you're still using this book and it's 1997 or later, buy the newest edition of Photographer's Market at your favorite bookstore or order directly from Writer's Digest Books.

PHOTOSPIVA 96, Spiva Center for the Arts, 222 W. Third St., Joplin MO 64801. (417)623-0183. Director: James A. Martin. National photography competition. Send SASE for prospectus.

PICTURE PERFECT, P.O. Box 15760, Stamford CT 06901. (203)967-9952. Publisher: Andres Aquino. Ongoing photo contest in many subjects. Offers publishing opportunities, cash prizes and outlet for potential stock sales. Send SAE with 2 first-class stamps for details.

PICTURES OF THE YEAR, 27 Neff Annex, Ninth and Elm, Columbia MO 65201. (314)882-4442. Coordinator: Lisa Barnes. Photography competition for professional magazine, newspaper and freelance photographers.

***PRO FOOTBALL HALL OF FAME PHOTO CONTEST**, 2121 George Halas Dr. NW, Canton OH 44708. (216)456-8207. Curator/Director of Research Information: Joe Horrigan. Sponsor: Canon USA, Inc. Annual event for still photos. Open to professional photographers on NFL coverage assignments only.

PULITZER PRIZES, 702 Journalism, Columbia University, New York NY 10027. (212)854-3841 or 3842. Costs: $20/entry. Annual competition for still photos/prints published in American newspapers. February 1 deadline for work published in the previous year.

***SCHOLASTIC ART & WRITING AWARDS**, 555 Broadway, New York NY 10012. Art awards include photography. Purpose is to provide scholarship grants to college-bound high school seniors; program open to students in the 7th-12th grades.

■SINKING CREEK FILM/VIDEO FESTIVAL, 402 Sarratt, Vanderbilt University, Nashville TN 37240. (615)322-2471. Director: Meryl Truett. Sponsors annual competition for 35mm, 16mm film and ½″ videotape. All genres judging on ½″ video. Holds screening of winners from its national film/video competition. Festival held in November at Vanderbilt University, Nashville, TN. May deadline. Now accepting Canadian and international entries.

SISTER KENNY INSTITUTE INTERNATIONAL ART SHOW BY DISABLED ARTISTS, 800 E. 28th St., Minneapolis MN 55407-3799. (612)863-4630. Art Show Coordinator: Linda Frederickson. Show is held once a year usually in April and May for disabled artists. Deadline for entries, February-March.

TAYLOR COUNTY FAIR PHOTO CONTEST, P.O. Box 613, Grafton WV 26354-0613. Co-Chairman: K.M. Bolyard. Entry fee: $3 each print (maximum of 10). Color and b&w.

33RD ANNUAL INTERNATIONAL UNDERWATER PHOTOGRAPHIC COMPETITION, P.O. Box 2401, Culver City CA 90231. (310)437-6468. Competition Chairperson: Cory Gray. Cost: $7.50 per image, maximum 4 images per category. Offers annual competition in 9 categories (8 underwater, 1 water related). Thousands of dollars worth of prizes. Deadline mid-October 14.

■THREE RIVERS ARTS FESTIVAL, 207 Sweetbriar St., Pittsburgh PA 15211. (412)481-7040. Assistant Director, Visual Arts: Jamie Gruzska. Annual competition for still photos/prints and videotape. Early February deadline.

***■U.S. INTERNATIONAL FILM AND VIDEO FESTIVAL**, 841 N. Addison Ave., Elmhurst IL 60126-1291. (708)834-7773. Fax: (708)834-5565. Chairman: J.W. Anderson. Executive Director: Patricia Meyer. Sponsor: The United States Festivals Association. Annual international awards competition for sponsored, business, television and industrial film and video. Founded 1968. Annual March entry deadline.

UNLIMITED EDITIONS INTERNATIONAL JURIED PHOTOGRAPHY COMPETITIONS, % Competition Chairman, P.O. Box 1509, Candler NC 28715-1509. (704)665-7005. President/Owner: Gregory Hugh Leng. Sponsors juried photography contests offering cash and prizes. Also offers opportunity to sell work to Unlimited Editions.

WELCOME TO MY WORLD, P.O. Box 20673, Saint Simons Island GA 31522. (912)638-8770. Contact: Registration Chairman. Sponsored by the Glynn Art Association. Call or write for application. Cash awards. Deadline June.

WORLD IMAGE PHOTOGRAPHERS ASSOCIATION, P.O. Box 7369, Aloha OR 97007. Director: Bernie Wilt. Monthly contest for still photos, 35mm slides and computer images. Provide SASE for entry form.

YOUR BEST SHOT, % *Popular Photography*, P.O. Box 1247, Teaneck NJ 07666. Monthly photo contest, 2-page spread featuring 5 pictures: first ($300), second ($200), third ($100) and two honorable mention ($50 each).

Workshops

Unless your head has been buried in the sand you certainly have noticed that photography is headed in a new direction, one filled with computer manipulation and compact discs. Technological advances are no longer the wave of the future—they're here.

Even if you haven't invested a lot of time and money into electronic cameras, computers or software, you should understand what you're up against if you plan to succeed as a professional photographer. Although outdoor and nature photography still are popular with instructors, technological advances are examined closely in some of the nearly 133 workshops listed in this section.

As you peruse these pages take a good look at the quality of workshops and the level of photographers the sponsors want to attract. It is important to know if a workshop is for beginners, advanced amateurs or professionals and information from a workshop organizer can help you make that determination.

These workshop listings contain only the basic information needed to make contact with sponsors and a brief description of the styles or media covered in the programs. We also include information on workshop costs.

The workshop experience can be whatever the photographer wishes it to be—a holiday from his working routine, or an exciting introduction to new skills and perspectives on the craft. Some photographers who start out by attending someone else's workshops come away so inspired that eventually they establish their own. Maybe you, too, can learn enough to become a workshop instructor.

***AERIAL AND CREATIVE PHOTOGRAPHY WORKSHOPS**, P.O. Box 470455, San Francisco CA 94147. (415)771-2555. Fax: (415)771-5077. Director: Herb Lingl. Offers Polaroid sponsored seminars covering creative uses of Polaroid films and aerial photography workshops in unique locations from helicopters, light planes and balloons.

ALASKA ADVENTURES, P.O. Box 111309, Anchorage AK 99511. (907)345-4597. Contact: Chuck Miknich. Offers photo opportunities for Alaska wildlife and scenery on remote fishing/float trips and remote fish camp.

AMBIENT LIGHT WORKSHOPS, 5 Tartan Ridge Rd., Burr Ridge IL 60521. (708)325-5464. Contact: John J. Mariana. $45-125/day. In-the-field and darkroom. One-week travel workshops.

***THE AMERICAN SAFARI**, P.O. Box 4085, Naperville IL 60567. (708)369-0438. Executive Director: Joe Speno. Cost: varies. Nature study and photography workshops from 1-14 days devoted to natural areas of the Midwest. Beginners are welcomed and encouraged to participate. "Groups study and observe everything from black bears to wildflowers."

AMERICAN SOUTHWEST PHOTOGRAPHY WORKSHOPS, P.O. Box 220450, El Paso TX 79913. (915)757-2800. Director: Geo. B. Drennan. Offers intense field and darkroom workshops for the serious b&w photographer.

♣AMPRO PHOTO WORKSHOPS, 636 E. Broadway, Vancouver BC V5T 1X6 Canada. (604)876-5501. Fax: (604)876-5502. Course tuition ranges from under $100 for part-time to $5,900 for fulltime. Approved trade school. Offers part-time and fulltime career courses in commercial photography and photofinishing technician. "Twenty-nine different courses in camera, darkroom and studio lighting—from basic to advanced levels. Special seminars with top professional photographers. Career

courses in photofinishing, camera repair, photojournalism, electronic imaging and commercial photography.''

ANDERSON RANCH ARTS CENTER, P.O. Box 5598, Snowmass Village CO 81615. (303)923-3181 or (800)595-2722. Fax: (303)923-3871. Cost: $215 and up. Weekend to 2-week workshops run June to August with such recognized photographers/teachers as Sam Abell, Richard Benson, Jim Bones, Linda Connor, Judy Dater, Ralph Gibson, Mark Klett, Jay Maisel, Richard Misrach, Holly Roberts, Meridel Rubenstein, John Sexton, Clarissa Sligh, Maggi Steber, John Szarkowski and Jerry Uelsmann. Program highlights include portrait, dance and landscape photography; technical themes;photojournalism and advanced techniques. Special field expeditions offer trips to the Grand Canyon, Death Valley and Monument Valley.

ARROWMONT SCHOOL OF ARTS AND CRAFTS, P.O. Box 567, Gatlinburg TN 37738. (615)436-5860. PR Head: Cynthia Huff. Tuition is $195 per week. Room and board packages start at $170. Offers 1-week summer workshops in various techniques.

***AS WE ARE NUDE FIGURE PHOTOGRAPHY WORKSHOP**, 5666 La Jolla Blvd., Suite 111, La Jolla CA 92037. (619)551-2705. Vice President/Executive Director: Bob Stickel. Cost: $100-185/day. AWA offers a range of studio and location (mountain, beach, desert, etc.) workshops on the subject of photographing the male nude figure . . . for both members and non-members of the nonprofit organization.

NOELLA BALLENGER & ASSOCIATES PHOTO WORKSHOPS, P.O. Box 457, La Canada CA 91012. (818)954-0933. Fax: (818)954-0910. Contact: Noella Ballenger. Three-day travel and nature photo workshops in California. Individual instruction in small groups emphasizes visual awareness and problem solving in the field. All formats and levels of expertise welcome.

BIXEMINARS, 919 Clinton Ave. SW, Canton OH 44706-5196. (216)455-0135. Founder/Instructor: R.C. Bixler. Offers 3-day, weekend seminars for beginners through advanced amateurs. Usually held third weekend of February, June and October. Covers composition, lighting, location work and macro.

BODIE, CALIFORNIA STATE HISTORIC PARK PHOTOGRAPHY WORKSHOPS, P.O. Box 515, Bridgeport CA 93517. (800)674-8444, ext. 2174. Instructor: Clinton Smith. Cost: $200 for 3-day workshops (meals and lodging not included). Workshop participants are allowed to explore inside and out, before, during and after normal park hours, the best preserved gold mining ghost town in the American West. The general public is not allowed inside the buildings.

HOWARD BOND WORKSHOPS, 1095 Harold Circle, Ann Arbor MI 48103. (313)665-6597. Owner: Howard Bond. Offers 1-day workshop: View Camera Techniques; and two 2-day workshops: Zone System for All Formats and Refinements in B&W Printing. Also offers b&w field workshops: 5 days at Lake Superior Provincial Park and 3 days at Colorado's Great Sand Dunes.

MATT BRADLEY PHOTOGRAPHY WORKSHOPS, 15 Butterfield Ln., Little Rock AR 72212. (501)224-0692. Workshop Director: Marcia Hartmann. *National Geographic* freelance photographer teaches his ''Creative Image'' workshop two times a year at various scenic Arkansas locations.

NANCY BROWN HANDS-ON WORKSHOPS, 6 W. 20 St., New York NY 10011. (212)924-9105. Fax: (212)633-0911. Contact: Nancy Brown. $1,000 for week, breakfast and lunch included. Offers two 1-week workshops in New York City studio; workshops held 1 week each month in August and September.

CAMERA-IMAGE WORKSHOPS, P.O. Box 1501, Downey CA 90240. Instructors: Craig Fucile and Jan Pietrzak. Offers 3- and 4-day workshops during winter, spring and fall in California desert, Sierra Nevada Mountains and the California central coast. Workshop fees are approximately $60/day and cover tuition only. Instruction in color, b&w techniques, exposure, Ilfochrome and hand-coated printmaking. All camera formats welcome. Moderately priced motels and campgrounds are nearby. College credit is available.

 The maple leaf before a listing indicates that the market is Canadian.

JOHN C. CAMPBELL FOLK SCHOOL, Rt. 1, Box 14-A, Brasstown NC 28902. (704)837-2775 or (800)365-5724. Cost: $125-225 tuition; room and board available for additional fee. The Folk School offers weekend and week-long courses in photography year-round (b&w, color, wildlife and plants, image transfer, darkroom set-up, abstract landscapes). Please call for free schedule.

❖**A CANVAS WITHOUT AN EASEL IS LIKE A CAMERA WITHOUT A TRIPOD**, 10430 Hollybank Dr., Richmond, British Columbia V7E 4S5 Canada. (604)277-6570. Teacher: Dan Propp. Cost: $200/ day (group of 5 maximum). "An old-fashioned scenic and postcard photographer will provide a fun day in scenic Vancouver showing you how to 'see' as opposed to simply 'look,' via the good old-fashioned, steady tripod!"

*****CANYONLANDS FIELD INSTITUTE PHOTO WORKSHOPS**, P.O. Box 68, Moab UT 84532. (801)259-7750. Contact: Director of Programs. Program fees range from $265-415. Offers programs in landscape photography in Monument Valley (Bluff, UT residential workshops for Elderhostel, age 55 and older).

CENTER FOR PHOTOGRAPHY, 59 Tinker St., Woodstock NY 12498. (914)679-9957. Contact: Director. Offers monthly exhibitions, a summer and fall workshop series, annual call for entry shows, library, darkroom, fellowships, memberships, and photography magazine, classes, lectures. Has interns in workshops and arts administration.

CHINA PHOTO WORKSHOP TOURS, 22111 Cleveland, #211, Dearborn MI 48124-3461. (313)561-1842. Director: Dennis Cox. Offers annual photo tours to China's major cities and scenic countryside. Top Chinese photographers guide participants to special photo opportunities.

CLOSE-UP EXPEDITIONS, 1031 Ardmore Ave., Oakland CA 94610. (510)465-8955 or (800)995-8482. Guide and Outfitter: Donald Lyon. Sponsored by the Photographic Society of America. World-wide, year-round travel and nature photography expeditions, 7-25 days. Professional photographer guides put you in the right place at the right time to create unique marketable images.

CORY NATURE PHOTOGRAPHY WORKSHOPS, 1629 Rustic Homes Lane, Signal Mountain TN 37377. (615)886-1004 or (800)495-6190. Contact: Tom or Pat Cory. Small workshops with some formal instruction, but mostly one-on-one instruction tailored to each individual's needs. "We spend the majority of our time in the field. Cost and length vary by workshop. Many of our workshop fees include single occupancy lodging and some also include home-cooked meals and snacks. We offer special prices for two people sharing the same room and, in some cases, special non-participant prices. Workshops include spring and fall workshops in Smoky Mountain National Park and Chattanooga, TN, and a fall workshop in the Upper Peninsula of Michigan. Our western workshops vary from year to year but include locations such as the High Sierra of California, Olympic National Park, Arches National Park and Glacier National Park." Write or call for a brochure or more information.

CREATIVE ADVENTURES, 67 Maple St., Newburgh NY 12550. (914)561-5866. Contact: Richie Suraci. Photographic adventures to "exotic, sensual, beautiful international locations to photograph beautiful nude women and men."

CREATIVE ARTS WORKSHOP, 80 Audubon St., New Haven CT 06511. (203)562-4927. Photography Department Head: Harold Shapiro. Offers advanced workshops and exciting courses for beginning and serious photographers.

❖■**DAWSON COLLEGE CENTRE FOR IMAGING ARTS AND TECHNOLOGIES**, (formerly Dawson Institute of Photography), 4001 de Maisonneuve Blvd. W., Suite 2G.2, Montreal, Quebec H3Z 3G4 Canada. (514)933-0047. Director: Donald Walker. Cost: Ranges from $160-400. Workshop subjects include imaging arts and technologies, animation, photography, computer imaging, desktop publishing and video.

*****DJERASSI RESIDENT ARTISTS PROGRAM**, 2325 Bear Gulch Rd., Woodside CA 94062-4405. (415)747-1250. Program Assistant: Judy Freeland. Cost: $20 application fee. One month residencies April-October, in country setting, open to international artists in dance, music, visual arts, literature, media arts/new genres.

CHARLENE FARIS WORKSHOPS, 9524 Guilford Dr., #A, Indianapolis IN 46240. (317)848-2634. Director: Charlene Faris. Offers 1-day programs for beginners in marketing and learning to shoot marketable photos. Seven-week courses taught 2 or 3 times annually at IU-PUI Continuing Studies Division. Send SASE for schedule and information.

ROBERT FIELDS PHOTOGRAPHIC WORKSHOPS, P.O. Box 3516, Ventura CA 93006. (805)641-2150. Instructor: Robert Fields. Cost: $79-198 per person. California photo workshops to Yosemite, Death Valley, Mono Lake, San Francisco, Morro Bay and Anza Borrego Desert. Practical application—not theory.

FINDING & KEEPING CLIENTS, 2038 Calvert Ave., Costa Mesa CA 92626-3520. (714)556-8133. Fax: (714)556-0899. Instructor: Maria Piscopo. "How to find commercial photo assignment clients and get paid what you're worth! Call for schedule and leave address or fax number."

FOCUS ADVENTURES, P.O. Box 771640, Steamboat Springs CO 80477. Phone/fax: (303)879-2244. Owner: Karen Schulman. Workshops in the art of seeing, self-discovery through photography and hand coloring photographs. Field trips to working ranches and wilderness areas. Customized private and small group lessons available year round. Workshops are summer and fall.

FOCUS SEMINAR IN HYBRID IMAGING AND NEW TECHNOLOGIES, 5210 Photo/Lansing Community College, P.O. Box 40010, Lansing MI 48901-7210. (517)483-1673. A 3-day series of workshops, seminars, forums and demonstrations related to hybrid imaging, new technologies in photography, imaging and computer graphics.

***FORT SCOTT COMMUNITY COLLEGE PHOTO WORKSHOP & TOURS**, 2108 S. Horton, Fort Scott KS 66701. (800)874-3722. Photography Instructor: John W. Beal. Cost: $85-150 workshops; $250-900 tours. Weekend nature photo workshops spring and fall. Other workshops cover Zone System, color printing, b&w fine printing, etc. Photo tours (2-7 days) of Ozarks, Kansas prairie, Rocky Mountains.

FOUR SEASONS NATURE PHOTOGRAPHY, 2292 Shiprock Rd., Grand Junction CO 81503. (800)20-PHOTO. Co-directors: Daniel Poleschook, Jr. and Joseph K. Lange. Specializes in small-group nature-photography tours to nature's finest locations in the western United States, Alaska, Florida, Canada and Africa. Features wildlife and scenery photography with instructional slide shows included.

FRIENDS OF ARIZONA HIGHWAYS PHOTO WORKSHOPS, P.O. Box 6106, Phoenix AZ 85005-6106. (602)271-5904. Offers photo adventures to Arizona's spectacular locations with top professional photographers whose work routinely appears in *Arizona Highways*.

FRIENDS OF PHOTOGRAPHY, 250 Fourth St., San Francisco CA 94103. (415)495-7000. Education and Workshop Coordinator: Julia Brashares. "One one- and two-day workshops are conducted by a faculty of well-known photographers and provide artistic stimulation and technical skills in a relaxed, focused environment."

GERLACH NATURE PHOTOGRAPHY SEMINARS, P.O. Box 259, Chatham MI 49816. (906)439-5991. Fax: (906)439-5144. President: John Gerlach. Professional nature photographers John and Barbara Gerlach conduct intensive 1-day seminars and week-long field workshops around the US. They also lead wildlife photo expeditions to the Galapagos, Kenya and Antarctica every year. Write for their informative color catalog.

GETTING & HAVING A SUCCESSFUL EXHIBITION, 163 Amsterdam Ave., # 201, New York NY 10023. (212)838-8640. Speaker: Bob Persky. Cost: 1995 tuition—$75. Course manual $24.95. A 1-day seminar.

THE GLACIER INSTITUTE PHOTOGRAPHY WORKSHOPS, P.O. Box 7457. Kalispell MT 59904. (406)756-3911. General Manager: Khris Bruninga. Cost: $130-175. Workshops sponsored in the following areas: nature photography, advanced photography, wildlife photography and photographic ethics. All courses take place in beautiful Glacier National Park.

***GLAMOUR WORKSHOPS**, Box 4085, Naperville IL 60567. (708)369-0438. Contact: Workshop Registrar. Cost: from $95. These are intensive glamour photo workshops and shoots in many various cities and locations. Beginners are welcomed. Length varies from half day to full weekends.

GLOBAL PRESERVATION PROJECTS, P.O. Box 30866, Santa Barbara CA 93130. (805)682-3398. Fax: (805)563-1234. Director: Thomas I. Morse. Offers workshops promoting the preservation of environmental and historic treasures. Produces international photographic exhibitions and publications.

GOLDEN GATE SCHOOL OF PROFESSIONAL PHOTOGRAPHY, P.O. Box 187, Fairfield CA 94533. (800)442-0319. Director: Jim Inks. Offers short courses in photography annually.

HEART OF NATURE PHOTOGRAPHY WORKSHOPS, 14618 Tyler Fte Rd., Nevada City CA 95959. (916)292-3839. Contact: Robert Frutos. Cost: $125/weekend workshop. "Deepening the View, the fine art of nature photography workshop, will help you deepen the quality of your personal vision and photographic awareness."

HILL COUNTRY ARTS FOUNDATION, P.O. Box 1169, Ingram TX 78025. (210)367-5120. Instructor: Dan Burkholder. Platinum/Palladium Printing Workshop, $225 plus $70 material fee. Instructors: Dan Burkholder and Jerry Townsend. Digital Imaging Workshop, tuition $165 for 1 day, $300 for both days, $10 materials fee. Send SASE for brochure.

HORIZONS: The New England Craft Program, 108 North Main St., Sunderland MA 01375. (413)665-0300. Director: Jane Sinauer. International programs: week-long workshops in Tuscany, Italy in October; Oaxaca, Mexico in January. Also two 3-week summer sessions in b&w for high school students.

IN FOCUS WITH MICHELE BURGESS, 20741 Catamaran Lane, Huntington Beach CA 92646. (714)536-6104. President: Michele Burgess. Tour prices range from $3,000 to $5,000 from US. Offers overseas tours to photogenic areas with expert photography consultation, at a leisurely pace and in small groups (maximum group size 20).

INTERNATIONAL CENTER OF PHOTOGRAPHY, 1130 Fifth Ave., New York NY 10128. (212)860-1776. Education Associate: Donna Ruskin. "The cost of our weekend workshops range from $255 to $325 plus registration and lab fees. Our five- and ten-week courses range from $220 to $380 plus registration and lab fees." ICP offers photography courses, lectures and workshops for all levels of experience—from intensive beginner classes to rigorous professional workshops.

INTERNATIONAL PHOTO TOURS (VOYAGERS INTERNATIONAL), P.O. Box 915, Ithaca NY 14851. (607)257-3091. Managing Director: David Blanton. Emphasizes techniques of nature photography.

IOWA SEMINARS, 10 E. 13th St., Atlantic IA 50022. Director: Jane Murray. Offers workshops in developing personal vision for beginning and intermediate photographers.

IRISH PHOTOGRAPHIC & CULTURAL EXCURSIONS, Voyagers, P.O. Box 915, Ithaca NY 14851. (607)257-3091. Cost: $2,195 (land). Offers 2-week trip in County Mayo in the west of Ireland.

THE LIGHT FACTORY, 311 Arlington Ave., P.O. Box 32815, Charlotte NC 28232. (704)333-9755. Education Director: Nancy Stanfield. Gallery and non-profit organization dedicated to fine art photography since 1972. Offers classes, workshops and outreach programs.

JOE McDONALD'S WILDLIFE PHOTOGRAPHY WORKSHOPS AND TOURS, RR#2, Box 1095, McClure PA 17841-9340. (717)543-6423. Owner: Joe McDonald. Offers small groups, quality instruction with emphasis on wildlife. Workshops and tours range from $400-2,000.

McNUTT FARM II/OUTDOOR WORKSHOP, 6120 Cutler Lake Rd., Blue Rock OH 43720. (614)674-4555. Director: Patty L. McNutt. 1994 Fees: $140/day/person, included lodging. Minimum of 2 days. Outdoor shooting of livestock, pets, wildlife and scenes in all types of weather.

MACRO TOURS PHOTO WORKSHOPS, P.O. Box 460041, San Francisco CA 94146. (800)369-7430. Director: Bert Banks. Fees range from $45-1,995 for 1-10-day workshops. Offers travel workshops for wildflowers, scenics, wildlife in California, Alaska, Southwest, western National Parks and New England fall color. Brochure available; call or write.

■**THE MAINE PHOTOGRAPHIC WORKSHOPS**, Rockport ME 04856. (207)236-8581. Fax: (207)236-2558. Director: David H. Lyman. Offers more than 200 one-week workshops for professionals and serious amateurs in photography, film and television, digital imaging from May through October. Also professional year-round resident programs in photography and film and video production. Associate of Arts and Bachelor of Fine Arts Degrees also available. Request materials by mail, phone or fax. Specify primary area of interest.

MENDOCINO COAST PHOTOGRAPHY SEMINARS, P.O. Box 1629, Mendocino CA 95460. (707)937-2805. Program Director: Hannes Krebs. Offers a variety of workshops, including a foreign expedition to Chile.

MEXICO PHOTOGRAPHY WORKSHOPS, Otter Creek Photography, Hendricks WV 26271. (304)478-3586. Instructor: John Warner. Cost: $1,300. Intensive week-long, hands-on workshops held throughout the year in the most visually rich regions of Mexico. Photograph snow-capped volcanos, thundering waterfalls, pre-Columbian ruins, fascinating people, markets and colonial churches in jungle, mountain, desert and alpine environments.

***MIDWEST MEDIA ARTISTS ACCESS CENTER**, 2388 University Ave., St. Paul MN 55114. (612)644-1912. Directors: Steve Westerlund and Althea Faricy. Offers basic through intermediate level courses in photography, film/video production and sound design.

MIDWEST PHOTOGRAPHIC WORKSHOPS—MPW INTERNATIONAL, 28830 W. Eight Mile Rd., Farmington Hills MI 48336. (810)471-7299. Fax: (810)542-3441. Directors/Instructors: Alan Lowy, C.J. Elfont and Bryce Denison. Workshops, seminars and lectures dealing with classical nude figures (Victorian House), nude figure in the environment (Ludington Dunes), boudoir and fashion photography, nature photography on location, still-life and product photography, wedding and portraits, and weeklong travel workshops to Smoky Mountains, Tobermory, Canada and Belize, Central America.

MISSISSIPPI VALLEY WRITERS CONFERENCE, 3403 45th St., Moline IL 61265. Director: David R. Collins. Registration $25, plus individual workshop expenses. Open to the basic beginner or polished professional, the MVWC provides a week-long series of workshops in June, including 5 daily sessions in photography.

MISSOURI PHOTOJOURNALISM WORKSHOP, 27 Neff Annex, Ninth and Elm, Columbia MO 65201. (314)882-4442. Coordinator: Lisa Barnes. Workshop for photojournalists. Participants learn the fundamentals of documentary photo research, shooting, editing and layout.

NATURE IMAGES, INC., P.O. Box 2037, West Palm Beach FL 33402. (407)586-7332. Director: Helen Longest-Slaughter. Photo workshops offered in Yellowstone National Park, Little St. Simons Island, Costa Rica and Everglades National Park.

NATURE PHOTOGRAPHY EXPEDITIONS, 418 Knottingham Dr., Twin Falls ID 83301. (800)574-2839. Contact: Douglas C. Bobb. Cost: $1,200/person, includes room, meals and transportation during the tour; requires a $300 deposit. Offers week-long trips in the Yellowstone Ecosystem, from June to October.

NEVER SINK PHOTO WORKSHOP, P.O. Box 641, Woodbourne NY 12788. (212)929-0008; (914)434-0575. Fax: (212)929-2689. Owner: Louis Jawitz. Offers weekend workshops in scenic, travel, location and stock photography from late July through early September in Catskill Mountains.

NEW ENGLAND SCHOOL OF PHOTOGRAPHY, 537 Commonwealth Ave., Boston MA 02215. (617)437-1868. Academic Director: Martha Hassell. Instruction in professional and creative photography.

NEW MEXICO ARTISTS' ASSOCIATION, 2801 Rodeo Rd., Suite 239B, Santa Fe NM 87505. (505)982-5639. Director: Winona Garmhausen, Ph.D. Cost: $775 plus tax per week. Year-round individualized instruction in chosen or selected photo instructor's studio and darkroom. All levels, color and b&w. All photo instruction takes place in Santa Fe, NM. Allow 3-6 weeks for arrangements to be made.

***NEW SCHOOL/PARSONS INTERNATIONAL PHOTO WORKSHOPS**, Photo Department, 66 Fifth Ave., New York NY 10011. (212)229-8923. Chairperson: Michelle Bogre. Assistant Chairperson: Geoffrey Biddle. Summer workshops in New York City and Paris bring together diverse groups of photography students and professionals in a variety of fields, including photojournalism, fashion and electronic imaging.

The First Markets Index preceding the General Index in the back of this book provides the names of those companies/ publications interested in receiving work from newer, lesser-known photographers.

NORTHEAST PHOTO ADVENTURE SERIES WORKSHOPS, 55 Bobwhite Dr., Glemont NY 12077. (518)432-9913. President: Peter Finger. Price ranges from $99 for a weekend to $600 for a week-long workshop. Offers over 20 weekend and week-long photo workshops, held in various locations. Recent locations have included: Cape Cod, Maine, Acadia National Park, Vermont, The Adirondacks, The Catskills, Block Island, Martha's Vineyard, Nantucket, Prince Edward Island, Nova Scotia and New Hampshire. "Small group instruction from dawn till dusk." Write for additional information.

OKLAHOMA FALL ARTS INSTITUTES, P.O. Box 18154, Oklahoma City OK 73154. (405)842-0890. Fax: (405)848-4538. Tuition: $450 for 4 days. October photography workshop at Quartz Mountain Arts and Conference Center in Southwest Oklahoma.

ON LOCATION SEMINARS, P.O. Box 1653, Ross CA 94957. (415)927-4579. President: Brenda Tharp. Offers multi-day photography tours and workshops in exciting locations worldwide. Small group sizes with one-on-one instruction. Specializes in creative outdoor and travel photography with an emphasis on low-impact travel, unique cultural and wilderness experiences. Brenda Tharp leads all workshops/tours which are designed tor provide maximum photographic opportunity. Destinations (1996) include: Alaska, Arizona, California, Galapagos, India, Indonesia, Maine, Montana, Utah.

***OREGON PHOTO TOURS**, 745 E. Eighth, Coquille OR 97423. Contact: Tony Mason. Personalized photographic tours throughout Oregon and the American West.

OREGON SCHOOL OF ARTS AND CRAFTS, 8245 SW Barnes Rd., Portland OR 97225. (503)297-5544. Offers workshops and classes in photography throughout the year: b&w, color and alternative processes. Call or write for a schedule.

OSPREY PHOTO WORKSHOPS & TOURS, 2719 Berwick Ave., Baltimore MD 21234-7615. (410)426-5071. Workshop Operator: Irene Hinke-Sacilotto. Cost: varies with program. Programs for '95/'96 include: Bryce/Zion/Arches/Canyonlands; the Allegheny Mountains; Brigantine/Pine Barrens/ Delaware Bay shorebird migration; Puffins/Acadia/Campobello; Canadian Rockies; Kenya; Yellowstone; polar bears at Churchill; Chincoteague; the Galapagos Islands; plus in '96 the Falklands and Chile; South Florida; Rio Grande Valley in Texas; the Smokies; the White Mountains; Argentina; Glacier National Park and more. Classes are small with personal attention and practical tips given.

OUTBACK PHOTO TOURS AND WORKSHOPS, % Bob Grytten, Inc., P.O. Box 8792, St. Petersburg FL 33738. (813)397-3013. President: Bob Grytten. Offers weekend tours and workshops in 35mm nature photography, emphasizing Florida flora and fauna. Also offers programs on marketing one's work.

***OUTBACK RANCH OUTFITTERS**, P.O Box 384, Joseph OR 97846. (503)426-4037. Owner: Ken Wick. Offers photography trips by horseback or river raft into Oregon wilderness areas.

OZARK PHOTOGRAPHY WORKSHOP FIELDTRIP, 40 Kyle St., Batesville AR 72501. (501)793-4552. Conductor: Barney Sellers. Cost: 2-day trip, $100; participants furnish own food, lodging and transportation. Limited to 12 people. Offers opportunities for all-day, outdoor subject shooting. No slides shown, fast moving, looking at subjects through the camera lens.

‡PAN HORAMA, Puskurinkatu 2, FIN-33730 Tampere Finland. Fax: 110-358-31-3645 382. Chairman: Rainer K. Lampinen. Cost: FIM 900. Annual Pan Horama (panoramic photography) workshops. Tampere, Finland; Tallinn, Estonia; Prague, Czech Republic.

♣FREEMAN PATTERSON/DORIS MOWRY PHOTO WORKSHOP, Rural Route 2, Clifton Royal, New Brunswick E0G 1N0 Canada. (506)763-2271. Partner: Doris J. Mowry. Cost: $600 (Canadian) for 6-day course. All workshops are for anybody interested in photography, from the complete novice to the experienced amateur or professional. "Our experience has consistently been that a mixed group functions best and learns the most."

PETERS VALLEY CRAFT CENTER, 19 Kuhn Rd., Layton NJ 07851. (201)948-5200. Fax: (201)948-0011. Offers workshops June, July and August, 3-5 days long. Offers instruction by talented photographers as well as gifted teachers in a wide range of photographic disciplines as well as classes in blacksmithing/metals, ceramics, fibers, fine metals and woodworking. Located in northwest New Jersey in the Delaware Water Gap National Recreation Area, 1½ hours west of New York City. Write, call or fax for catalog.

PHOTO ADVENTURE TOURS, 2035 Park St., Atlantic Beach NY 11509-1236. (516)371-0067. Fax: (516)371-1352. Manager: Pamela Makaea. Offers photographic tours to Iceland, India, Nepal, Russia,

China, Scandinavia and domestic locations such as New Mexico, Navajo Indian regions, Hawaiian Islands, Michigan, Albuquerque Balloon Festival and New York.

PHOTO ADVENTURES, P.O. Box 591291, San Francisco CA 94159. (415)221-3171. Instructor: Jo-Ann Ordano. Offers practical workshops covering creative and documentary photo technique in California nature subjects and San Francisco by moonlight.

PHOTO FOCUS/COUPEVILLE ARTS CENTER, P.O. Box 171 MP, Coupeville WA 98239. (360)678-3396. Director: Judy Lynn. Cost: $235-330. Workshops on Whidbey Island, Washington, in b&w, photojournalism, stock photography, portraiture, nature photography and more with nationally respected faculty, during June, July, August and October.

PHOTOCENTRAL/INFRARED WORKSHOP, 1099 E St., Hayward CA 94541. (510)278-7705. Coordinators: Geir and Kate Jordahl. One-day workshops, $56-76; 2- and 3-day, $110-150. Intimate workshops for travel and technical topics—dedicated to seeing more. Led by Geir and Kate Jordahl, specialists in infrared and panoramic photography. Workshops are open in all formats to photographers wanting to grow visually.

PHOTOGRAPHIC ARTS WORKSHOPS, P.O. Box 1791, Granite Falls WA 98252. (206)691-4105. Director: Bruce Barnbaum. Offers wide range of workshops across US, Mexico and Canada. Workshops feature instruction in composition, exposure, development, printing, photographic goals and philosophy. Includes critiques of student portfolios. Sessions are intense, held in field, darkroom and classroom with various instructors. Ratio of students to instructor is always 8:1 or fewer, with detailed attention to the problems the student wants to solve.

PHOTOGRAPHY AT THE SUMMIT: JACKSON HOLE, 3200 Cherry Creek Dr. S., Suite 650, Denver CO 80209. (303)744-2538 or (800)745-3211. Administrator: Chip Garofalo. A week-long workshop and weekend conferences with top journalistic, fine art and illustrative photographers and editors.

PHOTOGRAPHY WORKSHOPS INTERNATIONAL, (formerly Block Island Photography Workshops), 319 Pheasant Dr., Rocky Hill CT 06067. (800)563-9156. Directors: Stephen Sherman and Jack Holowitz. Workshops take place on Block Island, Rhode Island and also in the deserts of California, the canyons of the Southwest, the Pacific Northwest and Scotland. Offers workshop programs in b&w zone system, portraiture and landscapes. "We also conduct one portrait/figure and darkroom workshop each summer."

PT. REYES FIELD SEMINARS, Pt. Reyes National Seashore, Pt. Reyes CA 94956. (415)663-1200. Director: Julie Milas. Fees range from $40-150. Offers weekend photography seminars taught by recognized professionals.

PORT TOWNSEND PHOTOGRAPHY IMMERSION WORKSHOP, 1005 Lawrence, Port Townsend WA 98368. (604)469-1651. Instructor: Ron Long. Cost: $450. Six-day workthops include lectures, critiques, overnight processing, individual instruction, field trips and lots of shooting. All levels welcome.

***PORTRAITURE WITH WAH LUI**, % Daytona Beach Community College, P.O. Box 2811, Daytona Beach FL 32120-2811. (904)254-4475. Museum Director: Alison Nordstrom. Offers spring workshops at the Southeast Museum of Photography.

PROFESSIONAL PHOTOGRAPHER'S SOCIETY OF NEW YORK PHOTO WORKSHOPS, 121 Genesee St., Avon NY 14414. (716)226-8351. Director: Lois Miller. Cost is $475. Offers week-long, specialized, hands-on workshops for professional photographers.

ROCKY MOUNTAIN SCHOOL OF PHOTOGRAPHY, P.O. Box 7605, Missoula MT 59807. (406)543-0171 or (800)394-7677. Vice President: Jeanne Chaput de Saintonge. Offers workshops throughout US and abroad and a 10-week career training program each summer in Montana.

***ROCKY MOUNTAIN SEMINARS**, Rocky Mountain National Park, Estes Park CO 80517. (303)586-1258. Seminar Coordinator: Kris Marske. Cost: $40-170, day-long to 5½-day seminars. Workshops covering photgraphic techniques of wildlife and scenics in Rocky Mountain National Park. Professional instructors include Willard Clay, David Halpern and Perry Conway.

RON SANFORD, P.O. Box 248, Gridley CA 95948. (916)846-4687. Contact: Ron or Nancy Sanford. Travel and wildlife workshops and tours.

PETER SCHREYER PHOTOGRAPHIC TOURS, P.O. Box 533, Winter Park FL 32790. (407)671-1886. Tour Director: Peter Schreyer. Specialty photographic tours to the American West, Europe and the backroads of Florida. Travel in small groups of 10-15 participants.

"SELL & RESELL YOUR PHOTOS" SEMINAR, by Rohn Engh, Pine Lake Farm, Osceola WI 54020. (715)248-3800. Seminar Coordinator: Sue Bailey. Offers half-day workshops in major cities. 1996 cities include: Baltimore, Washington DC, Detroit, Minneapolis, San Diego, Atlanta, Charlotte, Orlando, St. Louis, Las Vegas, Denver and Houston. Workshops cover principles based on methods outlined in author's best-selling book of the same name. Marketing critique of attendee's slides follows seminar. Phone for free 1996 schedule.

***JOHN SEXTON PHOTOGRAPHY WORKSHOPS**, 291 Los Agrinemsors, Carmel Valley CA 93924. (408)659-3130. Director: John Sexton. Offers a selection of intensive workshops with master photographers.

SHENANDOAH PHOTOGRAPHIC WORKSHOPS, P.O. Box 54, Sperryville VA 22740. (703)937-5555. Directors: Frederick Figall and John Nenbauer. Three days to one week photo workshops in the Virginia Blue Ridge foothills, held in summer and fall. Weekend workshop held year round in Washington DC area.

SIERRA PHOTOGRAPHIC WORKSHOPS, 3251 Lassen Way, Sacramento CA 95821. (800)925-2596. In Canada, phone: (916)974-7200. Contact: Sierra Photographic Workshops. Offers week-long workshops in various scenic locations for "personalized instruction in outdoor photography, technical knowledge useful in learning to develop a personal style, learning to convey ideas through photographs."

***BOB SISSON'S MACRO/NATURE PHOTOGRAPHY**, P.O. Box 1649, Englewood FL 34295. (813)475-0757. Cost: $200/day. Special one-on-one course; "you will be encouraged to take a closer look at nature through the lens, to learn the techniques of using nature's light correctly and to think before exposing film."

CLINTON SMITH PHOTOGRAPHY WORKSHOPS, P.O. Box 1761, Mendocino CA 95460. (800)674-8444, ext. 2174. Instructor: Clinton Smith. Cost: $250-500. Landscape workshops conducted at Mono Lakd/Eastern Sierra, Mendocino Coast, Redwood National Park, Glacier National Park and Zion National Park. Color printing workshops are conducted in Sacramento CA.

SOUTHAMPTON MASTER PHOTOGRAPHY WORKSHOP, % Long Island University-Southampton Campus, Southampton NY 11968-9822. (516)287-8349. Contact—Summer Director: Carla Caglioti. Offers a diverse series of 1-week photo workshops through the month of July.

***SOUTHEASTERN CENTER FOR THE ARTS, INC.**, (SCA), 1935 Cliff Valley Way, Atlanta GA 30329. (404)633-1990. Director: Fred W. Rich. Offers professional career program and adult education classes.

***SPECIAL EFFECTS FOR BACKGROUNDS**, P.O. Box 1745, San Marcos TX 78667. (512)353-3111. Director of Photography: Jim Wilson. Offers 3-day programs in background projection techniques. Open to all levels of photographic education; participants are limited to 12/workshop.

SPLIT ROCK ARTS PROGRAM, University of Minnesota, 306 Wesbrook Hall, 77 Pleasant St. SE, Minneapolis MN 55455. (612)624-6800. Fax: (612)625-2568. Registrar: Vivien Oja. Tuition: $346. One-week, intensive summer residential workshops; nature and documentary photography as well as other arts. Duluth campus on Lake Superior. On-campus housing and food services available at reasonable cost. College credit available. Registration opens in April.

SPORTS PHOTOGRAPHY WORKSHOP, 3200 Cherry Creek Dr. S., Suite 650, Denver CO 80209. (303)744-2538 or (800)745-3211. Administrator: Chip Garofalo. There is a tuition fee of $700 and a $250 deposit must accompany your application. Balance is due upon acceptance into workshop. A week-long workshop in sports photography with photographers and editors from *Sports Illustrated*. Held in conjunction with the US Olympic Festival.

***SPRING AND FALL COLOR PRINTING WORKSHOP**, 707 Myrtle Ave., St. Joseph MI 49085. (616)983-5893. Contact: Bob Mitchell. Offers biannual workshops with intensive exercises in shooting, processing and printing and annual summer photo tour to Europe.

***STONE CELLAR DARKROOM WORKSHOPS**, 51 Hickory Flat Rd., Buckhannon WV 26201. (304)472-1669. Photographer/Printmaker: Jim Stansbury. Master color printing and color field work, small classes with Jim Stansbury. Work at entry level or experienced level.

SUPERIOR/GUNFLINT PHOTOGRAPHY WORKSHOPS, P.O. Box 19286, Minneapolis MN 55419. Director: Layne Kennedy. Prices range from $585-650. Write for details on session dates. Fee includes all meals/lodging and workshop. Offers wilderness adventure photo workshops twice yearly. Winter session includes driving your own dogsled team in northwestern Minnesota. Fall session includes canoe trips into border waters of Canada-Minnesota. All trips professionally guided. Workshop stresses how to shoot effective and marketable magazine photos.

SYNERGISTIC VISIONS WORKSHOPS, Gallery 412, 412 Main St., Grand Junction CO 81501. (303)245-6700. Fax: (303)245-6767. Director: Steve Traudt. Costs vary. Offers a variety of photo trips, workshops and classes including Wildflowers in Ouray, Colorado; Slot Canyons in Arizona; Marketing; Macro Photography; Galapagos Islands; Tahiti; Costa Rica; and more. All skill levels welcome. "Traudt's trademark is enthusiasm and his workshops promise a true synergy of art, craft and self." Call or write for brochures.

TOUCH OF SUCCESS PHOTO SEMINARS, P.O. Box 194, Lowell FL 32663. (904)867-0463. Director: Bill Thomas. Costs vary from $250-895 US to $5,000 for safaris. Offers workshops on nature scenics, plants, wildlife, stalking, building rapport and communication, composition, subject selection, lighting, marketing and business management. Workshops held at various locations in US. Photo safaris led into upper Amazon, Andes, Arctic, Alaska, Africa and Australia. Writer's workshops for photographers who wish to learn to write.

***TOUCHSTONE CENTER FOR THE CRAFTS**, P.O. Box 2141, Uniontown PA 15401. (412)438-2811. Executive Director: Julie Greene. Offers week-long and weekend photography workshops featuring master level photographers as instructors.

***UC-BERKELEY EXTENSION PHOTOGRAPHY PROGRAM**,% University of California Berkeley Extension, 55 Laguna St., San Francisco CA 94102. (415)252-5249. Director, Photography Program: Michael Lesser. Offers courses and workshops for beginning, advanced and professional photographers.

***UNIVERSITY OF CALIFORNIA EXTENSION PHOTOGRAPHY WORKSHOPS**, 740 Front St., Suite 155, Santa Cruz CA 95060. (408)427-6620. Contact: Photography Program. Ongoing program of workshops in photography throughout California, also international study tours in photography. Call or write for details.

UNIVERSITY OF NEVADA, Imaging Center, #278, University of Nevada, Reno NV 89557-0029. (702)784-6298. Director: Phillip M. Padellford. "On Assignment Freelance Photojournalism," co-sponsored by Polaroid. Emphasizes techniques and procedures needed to become a consistently published freelancer. Work is assigned and critiqued by panel of experts. Also, "On Location Freelance Photojournalism," co-sponsored by Polaroid. Photography for publication in Nevada and California Sierra Nevada mountain locations. Sessions led by professional photographers, art directors, editors.

UNIVERSITY OF WISCONSIN SCHOOL OF THE ARTS AT RHINELANDER, 726 Lowell Hall, 610 Langdon St., Madison WI 53703. (608)263-3494. Coordinator: Kathy Berigan. One-week interdisciplinary arts program held during July in northern Wisconsin.

JOSEPH VAN OS PHOTO SAFARIS, INC., P.O. Box 655, Vashon Island WA 98070. (206)463-5383. Fax: (206)463-5484. Director: Joseph Van Os. Offers photo tours and workshops worldwide.

VENTURE WEST, P.O. Box 7543, Missoula MT 59807. (406)825-6200. Owner: Cathy Ream. Offers various photographic opportunities, including wilderness pack and raft trips, ranches, housekeeping cabins, fishing and hunting.

Market conditions are constantly changing! If you're still using this book and it's 1997 or later, buy the newest edition of Photographer's Market *at your favorite bookstore or order directly from* Writer's Digest Books.

MARK WARNER NATURE PHOTO WORKSHOPS, P.O. Box 142, Ledyard CT 06339. (203)376-6115. Offers 1-4-day workshops on nature and wildlife photography by nationally published photographer and writer at various East Coast locations.

WFC ENTERPRISES, P.O. Box 5054, Largo FL 34649. (813)581-5906. Owner: Wayne F. Collins. Cost: $300. Photo workshops (glamour), January through December, all on weekend (2 days long). Free brochure on request.

WILD HORIZONS, INC., P.O. Box 5118-PM, Tucson AZ 85703. (602)622-0672. Fax: (602)798-1514. President: Thomas A. Wiewandt. Average all-inclusive costs: domestic travel $1,400/week; foreign travel $2,000/week. Offers workshops in field techniques in nature/travel photography at vacation destinations in the American Southwest selected for their outstanding natural beauty and wealth of photographic opportunities. Customized learning vacations for small groups are also offered in E. Africa and Ecuador/Galápagos.

WILDERNESS ALASKA, Box 113063, Anchorage AK 99511. (907)345-3567. Contact: MacGill Adams. Offers custom photography trips featuring natural history and wildlife to small groups.

WILDERNESS PHOTOGRAPHY EXPEDITIONS, 402 S. Fifth, Livingston MT 59047. (406)222-2302. President: Tom Murphy. Offers programs in wildlife and landscape photography in Yellowstone Park and Montana.

WILDLIFE PHOTOGRAPHY SEMINAR, LEONARD RUE ENTERPRISES, 138 Millbrook Rd., Blairstown NJ 07825. (908)362-6616. Program Support: Barbara. This is an indepth all day seminar covering all major aspects of wildlife photography. Based on a slide presentation format with question and answer periods. Topics covered include animal, bird, closeup, reptile and landscape photography as well as exposure and equipment.

WINSLOW PHOTO TOURS, INC., P.O. Box 334, Durango CO 81302-0334. (303)259-4143. President: Robert Winslow. Cost: varies from workshop to workshop and photo tour to photo tour. "We conduct wildlife model workshops in totally natural settings. Also run various domestic and international photo tours concentrating mostly on intense wildlife photography."

WOMEN'S PHOTOGRAPHY WORKSHOP, P.O. Box 3998, Hayward CA 94540. (510)278-7705. Coordinator: Kate Jordahl. Cost: $150/intensive 2-day workshop. Workshops dedicated to seeing more through photography. Specializing in women's concerns in photography.

WOMEN'S STUDIO WORKSHOP, P.O. Box 489, Rosendale NY 12472. (914)658-9133. Program Director: Laura Moriarty. WSW offers weekend and week-long classes in our comprehensive fully-equipped studios throughout the summer. Photographers may also spend 2-4 weeks here November-May as part of our fellowship program. SASE for specific information.

WOODSTOCK PHOTOGRAPHY WORKSHOPS, 59 Tinker St., Woodstock NY 12498. (914)679-9957. Fax: (914)679-6337. Offers annual lectures and workshops in creative photography from June through October. Faculty includes numerous top professionals in fine art and commercial photography. Interviews workshop interns each April. Topics include still life, landscape, portraiture, lighting, alternative processes. Offers 1-, 2- and 3-day events as well as travel workshops in the US and overseas.

WORKSHOPS IN THE WEST, P.O. Box 1261, Manchaca TX 78652. (512)295-3348. Contact: Joe Englander. Costs: $275-2,500. Photographic instruction in beautiful locations throughout the world, all formats, color and b&w, darkroom instruction.

***YELLOWSTONE INSTITUTE**, P.O. Box 117, Yellowstone National Park WY 82190. (307)344-2294. Registrar: Pam Gontz. Offers workshops in nature and wildlife photography during the summer, fall and winter. Custom courses can be arranged.

YOSEMITE FIELD SEMINARS, P.O. Box 230, El Portal CA 95318. (209)379-2646. Seminar Coordinator: Penny Otwell. Costs: $60-250. Offers small (8-15 people) workshops in outdoor field photography throughout the year. Write or call for free brochure. "We're a nonprofit organization."

YOUR WORLD IN COLOR, % Stone Cellar Darkroom, P.O. Box 253, Buckhannon WV 26201. (304)472-1669. Director: Jim Stansbury. Offers workshops in color processing, printing and related techniques. Also arranges scenic field trips. Work at entry or advanced level, one-on-one with a skilled printmaker. "Reasonable fees, write for info on variety of workshops."

Schools

Whether you are a long-time professional or a newcomer to photography, continuing education is very important to your success. Earlier in this book we listed dozens of workshops. This section lists schools that specialize in photography. Because of space constraints we chose not to include the numerous colleges and universities throughout the world that offer academic degrees in photography. For information about university degrees in photography, check your local library for the most recent edition of *Peterson's Guide to Four-Year Colleges*.

THE AEGEAN CENTER FOR THE FINE ARTS, *Paros, Cyclades 84400, Greece. Director: John A. Pack. American art school in Greece.*

ANTONELLI INSTITUTE OF ART AND PHOTOGRAPHY, *In Ohio: 124 E. Seventh St., Cincinnati OH 45202. (513)241-4338. In Pennsylvania: P.O. Box 570, 2910 Jolly Rd., Plymouth Meeting PA 19462. (610)275-3040.*

BROOKS INSTITUTE OF PHOTOGRAPHY, *801 Alston Rd., Santa Barbara CA 93108. (805)966-3888.*

CENTER FOR IMAGING ARTS & TECHNOLOGY, *4001 de Maisonneuve Blvd. W., Suite 2G2, Montreal, Quebec H3Z 3G4 Canada. (514)933-0047.*

HALLMARK INSTITUTE OF PHOTOGRAPHY, *P.O. Box 308, Turners Falls MA 01376. (413)863-2478.*

INTERNATIONAL CENTER OF PHOTOGRAPHY, *Education Dept., 1130 Fifth Ave. at 94th Street, New York NY 10128. (212)860-1776.*

THE MAINE PHOTOGRAPHIC WORKSHOPS, *2 Central St., Rockport ME 04856. (207)236-8581.*

NEW ENGLAND SCHOOL OF PHOTOGRAPHY (NESOP), *537 Commonwealth Ave., Kenmore Square, Boston MA 02215. (617)437-1868.*

OHIO INSTITUTE OF PHOTOGRAPHY AND TECHNOLOGY (OIPT), *2029 Edgefield Rd., Dayton OH 45439. (513)294-6155.*

PORTFOLIO CENTER, *Admissions Department, 125 Bennett St. NW, Atlanta GA 30309. (800)255-3169 or (404)351-5055.*

ROCHESTER INSTITUTE OF TECHNOLOGY, *Bausch & Lomb Center, 60 Lomb Memorial Dr., Rochester NY 14623-5604. Admissions Office: (716)475-6631.*

SOUTHEASTERN CENTER FOR THE ARTS (SCA), *1935 Cliff Valley Way, Suite 210, Atlanta GA 30329. (404)633-1990.*

WEST DEAN COLLEGE, *West Dean, Chichester, West Sussex P.O. 18 0QZ, England. Public Relations Manager: Heather Way.*

THE WESTERN ACADEMY OF PHOTOGRAPHY, *755A Queens Ave., Victoria, British Columbia V8T 1M2 Canada. (604)383-1522. Fax: (604)383-1534.*

WINONA INTERNATIONAL SCHOOL OF PROFESSIONAL PHOTOGRAPHY, *57 Forsyth St. NW, Suite 1500, Atlanta GA 30303. (404)522-3030.*

Professional Organizations

The organizations in the following list can be valuable to photographers who are seeking to broaden their knowledge and contacts within the photo industry. Typically, such organizations have regional or local chapters and offer regular activities and/or publications for their members. To learn more about a particular organization and what it can offer you, call or write for more information.

ADVERTISING PHOTOGRAPHERS OF NEW YORK (APNY), *27 W. 20th St., Room 601, New York NY 10011. (212)807-0399.*

AMERICAN SOCIETY OF MEDIA PHOTOGRAPHERS (ASMP), *14 Washington Rd., Suite 502, Princeton Junction NJ 08550-1033. (609)799-8300.*

AMERICAN SOCIETY OF PHOTOGRAPHERS (ASP), *Box 3191, Spartanburg SC 29304. (803)582-3115.*

AMERICAN SOCIETY OF PICTURE PROFESSIONALS (ASPP), *ASPP Membership, Woodfin Camp, 2025 Pennsylvania Ave. NW, Suite 226, Washington DC 20006. Or call President Larry Levin at (202)463-5447, or Vice President Mark Antman (914)246-8800.*

THE CENTER FOR PHOTOGRAPHY AT WOODSTOCK (CPW), *59 Tinker St., Woodstock NY 12498. (914)679-9957. Executive Director: Colleen Kenyon.*

EVIDENCE PHOTOGRAPHERS INTERNATIONAL COUNCIL (EPIC), *600 Main St., Honesdale PA 18431. (717)253-5450.*

THE FRIENDS OF PHOTOGRAPHY, *250 Fourth St., San Francisco CA 94103. (415)495-7000.*

INTERNATIONAL CENTER OF PHOTOGRAPHY (ICP), *1130 Fifth Ave., New York NY 10128. (212)860-1781.*

INTERNATIONAL FIRE PHOTOGRAPHERS ASSOCIATION (IFPA), *P.O. Box 8337, Rolling Meadows IL 60008. (708)394-5835.*

THE LIGHT FACTORY (TLF) PHOTOGRAPHIC ARTS CENTER, *311 Arlington at South Blvd., Charlotte NC 28203. Mailing Address: P.O. Box 32815, Charlotte NC 28232. (704)333-9755.*

NATIONAL PRESS PHOTOGRAPHERS ASSOCIATION (NPPA), *3200 Croasdaile Dr., Suite 306, Durham NC 27705. (800)289-6772. NPPA Executive Director: Charles Cooper.*

NORTH AMERICAN NATURE PHOTOGRAPHY ASSOCIATION (NANPA), *10200 W. 44th Ave., Suite 304, Wheat Ridge CO 80033. (303)422-8527. Contact: Mark Lukes.*

PHOTOGRAPHIC ART & SCIENCE FOUNDATION, *111 Stratford Rd., Des Plaines IL 60016-2105. (708)824-6855. President: Frederick Quellmalz.*

PHOTOGRAPHIC SOCIETY OF AMERICA (PSA), *3000 United Founders Blvd., Suite 103, Oklahoma City OK 73112. (405)843-1437.*

PICTURE AGENCY COUNCIL OF AMERICA (PACA), *P.O. Box 308, Northfield MN 55057-0308. (800)457-7222.*

PROFESSIONAL PHOTOGRAPHERS OF AMERICA (PPA), *57 Forsyth St. NW, Suite 1600, Atlanta GA 30303. (404)522-8600.*

PROFESSIONAL PHOTOGRAPHERS OF INDIANA, INC., *P.O. Box 848, Shelbyville IN 46176.*

PROFESSIONAL WOMEN PHOTOGRAPHERS, *% Photographics Unlimited, 17 W. 17 St., 4th Floor, New York NY 10011-5510. (212)289-6072. President: Katherine Criss.*

SF CAMERAWORK, INC., *70 12th St., San Francisco CA 94103. (415)621-1001.*

SOCIETY OF PHOTOGRAPHER AND ARTIST REPRESENTATIVES, INC. (SPAR), *60 E. 42nd St., Suite 1166, New York NY 10165. (212)779-7464.*

VOLUNTEER LAWYERS FOR THE ARTS, *1 E. 53rd St., 6th Floor, New York NY 10022. (212)319-2787.*

WEDDING PHOTOGRAPHERS INTERNATIONAL (WPI), *P.O. Box 2003, 1312 Lincoln Blvd., Santa Monica CA 90406. (310)451-0090.*

WHITE HOUSE NEWS PHOTOGRAPHERS' ASSOCIATION, INC. (WHNPA), *P.O. Box 7119, Ben Franklin Station, Washington DC 20044-7119. (202)785-5230.*

WORLD COUNCIL OF PROFESSIONAL PHOTOGRAPHERS, *654 Street Rd., Bensalem PA 19020.*

Recommended Books & Publications

Photographer's Market recommends the following additional reading material to stay informed of market trends as well as to find additional names and addresses of photo buyers. Most are available either in a library or bookstore or from the publisher. To insure accuracy of information, use copies of these resources that are no older than a year.

ADVERTISING AGE, *740 N. Rush St., Chicago IL 60611-2590. (312)649-5200. Weekly advertising and marketing tabloid.*

ADWEEK, *Adweek Advertising, 1515 Broadway, New York NY 10036. (212)536-5336. Weekly advertising and marketing magazine.*

AMERICAN PHOTO, *1633 Broadway, 43rd Floor, New York NY 10019. (212)767-6086. Monthly magazine, emphasizing the craft and philosophy of photography.*

ART CALENDAR, *P.O. Box 199, Upper Fairmont MD 21867-0199. (410)651-9150. Monthly magazine listing galleries reviewing portfolios, juried shows, percent-for-art programs, scholarships and art colonies, among other art-related topics.*

ART DIRECTION, *10 E. 39th St., 6th Floor, New York NY 10016-0199. (212)889-6500. Monthly magazine featuring art directors' views on advertising and photography.*

ASMP BULLETIN, *14 Washington Rd., Suite 502, Princeton Junction NJ 08550-1033. (609)799-8300. Monthly newsletter of the American Society of Media Photographers. Subscription comes with membership in ASMP.*

COMMUNICATION ARTS, *410 Sherman Ave., Box 10300, Palo Alto CA 94303. Magazine covering design, illustration and photography. Published 8 times a year.*

CREATIVE BLACK BOOK, *10 Astor Place, 6th Floor, New York NY 10003. (800)841-1246. Sourcebook used by photo buyers to find photographers.*

DIRECT STOCK, *10 E. 21st St., 14th Floor, New York NY 10010. (212)979-6560. Sourcebook used by photo buyers to find photographers.*

EDITOR & PUBLISHER, *The Editor & Publisher Co., Inc., 11 W. 19th St., New York NY 10011. (212)675-4380. Weekly magazine covering latest developments in journalism and newspaper production. Publishes an annual directory issue listing syndicates and another directory listing newspapers.*

ENCYCLOPEDIA OF ASSOCIATIONS, *Gale Research Co., 835 Penobscot Building, Detroit MI 48226-4094.(313)961-2242. Annual directory listing active organizations.*

F8 and BEING THERE, *P.O. Box 8792, St. Petersburg FL 33738. (813)397-3013. A bimonthly newsletter for nature photographers who enjoy travel.*

FOLIO, *911 Hope St., P.O. Box 4949, Stamford CT 06907-0949. (203)358-9900. Monthly magazine featuring trends in magazine circulation, production and editorial.*

GREEN BOOK, *% AG Editions, 41 Union Square West, #523, New York NY 10003. (212)929-0959. Annual directory of nature and stock photographers for use by photo editors and researchers.*

GREETINGS MAGAZINE, *MacKay Publishing Corp., 307 Fifth Ave., 16th Floor, New York NY 10016. (212)679-6677. Monthly magazine featuring updates on the greeting card and stationery industry.*

GUIDE TO TRAVEL WRITING & PHOTOGRAPHY, *by Ann and Carl Purcell, published by Writer's Digest Books, 1507 Dana Ave., Cincinnati OH 45207. (513)531-2222.*

GUILFOYLE REPORT, % AG Editions, 41 Union Square West, #523, New York NY 10003. (212)929-0959. *Quarterly market tips newsletter for nature and stock photographers.*

HOW TO SHOOT STOCK PHOTOS THAT SELL, *by Michal Heron, published by Allworth Press, distributed by Writer's Digest Books, 1507 Dana Ave., Cincinnati OH 45207. (513)531-2222.*

HOW YOU CAN MAKE $25,000 A YEAR WITH YOUR CAMERA, *by Larry Cribb, published by Writer's Digest Books, 1507 Dana Ave., Cincinnati OH 45207. (513)531-2222. Newly revised edition of the popular book on finding photo opportunities in your own hometown.*

INDUSTRIAL PHOTOGRAPHY, PTN Publishing, 445 Broad Hollow Rd., Melville NY 11747. (516)845-2700. *Monthly magazine for photographers in various types of staff positions in industry, education and other institutions.*

LIGHTING SECRETS FOR THE PROFESSIONAL PHOTOGRAPHER, *by Alan Brown, Tim Grondin and Joe Braun, published by Writer's Digest Books, 1507 Dana Ave., Cincinnati OH 45207. (513)531-2222.*

LITERARY MARKET PLACE, R.R. Bowker Company, 121 Chanlon Rd. New Providence NJ 07974. (908)464-6800.

MADISON AVENUE HANDBOOK, Peter Glenn Publications, 42 W. 38th St., New York NY 10018. (212)869-2020. *Annual directory listing advertising agencies, audiovisual firms and design studios in the New York area.*

NEGOTIATING STOCK PHOTO PRICES, *by Jim Pickerell. Available through American Society of Media Photographers, 14 Washington Rd., Suite 502, Princeton Junction NJ 08550-1033. (609)799-8300. Hardbound book which offers pricing guidelines for selling photos through stock photo agencies.*

NEWS PHOTOGRAPHER, 1446 Conneaut Ave., Bowling Green OH 43402. (419)352-8175. *Monthly news tabloid published by the National Press Photographers Association.*

NEWSLETTERS IN PRINT, Gale Research Co., 835 Penobscot Building, Detroit MI 48226-4094. (313)961-6083. *Annual directory listing newsletters.*

O'DWYER DIRECTORY OF PUBLIC RELATIONS FIRMS, J.R. O'Dwyer Company, Inc., 271 Madison Ave., New York NY 10016. (212)679-2471. *Annual directory listing public relations firms, indexed by specialties.*

OUTDOOR PHOTOGRAPHER, 12121 Wilshire Blvd., Suite 1220, Los Angeles CA 90025. (310)820-1500. *Monthly magazine emphasizing equipment and techniques for shooting in outdoor conditions.*

PETERSEN'S PHOTOGRAPHIC MAGAZINE, 6420 Wilshire Blvd., Los Angeles CA 90048-5515. (213)782-2200. *Monthly magazine for beginning and semi-professional photographers in all phases of still photography.*

PHOTO DISTRICT NEWS, 1515 Broadway, New York NY 10036. *Monthly trade magazine for the photography industry.*

THE PHOTOGRAPHER'S BUSINESS & LEGAL HANDBOOK, *by Leonard Duboff, published by Images Press, distributed by Writer's Digest Books, 1507 Dana Ave., Cincinnati OH 45207. (513)531-2222. A guide to copyright, trademarks, libel law and other legal concerns for photographers.*

PHOTOGRAPHER'S SOURCE, *by Henry Horenstein, published by Fireside Books, % Simon & Schuster Publishing, Rockefeller Center, 1230 Avenue of the Americas, New York NY 10020. (212)698-7000.*

PHOTOSOURCE INTERNATIONAL, Pine Lake Farm, 1910 35th Rd., Osceola WI 54020. (715)248-3800. *This company publishes several helpful newsletters, including PhotoLetter, PhotoMarket, Photo-Bulletin and PhotoStockNotes.*

PRICING PHOTOGRAPHY: THE COMPLETE GUIDE TO ASSIGNMENT & STOCK PRICES, *by Michal Heron and David MacTavish, published by Allworth Press, 10 E. 23rd St., New York NY 10010. (212)777-8395.*

PRINT, RC Publications Inc., 104 Fifth Ave., 19th Floor, New York NY 10011. (212)463-0600. *Bimonthly magazine focusing on creative trends and technological advances in illustration, design, photography and printing.*

PROFESSIONAL PHOTOGRAPHER, *published by Professional Photographers of America (PPA), 57 Forsyth St. NW, Suite 1600, Atlanta GA 30303. (404)522-8600. Monthly magazine, emphasizing technique and equipment for working photographers.*

PROFESSIONAL PHOTOGRAPHER'S GUIDE TO SHOOTING & SELLING NATURE & WILDLIFE PHO-TOS, *by Jim Zuckerman, published by Writer's Digest Books, 1507 Dana Ave., Cincinnati OH 45207. (513)531-2222.*

PROFESSIONAL PHOTOGRAPHER'S SURVIVAL GUIDE, *by Charles E. Rotkin, published by Writer's Digest Books, 1507 Dana Ave., Cincinnati OH 45207. (513)531-2222. A guide to becoming a professional photographer, making the first sale, completing assignments and earning the most from photographs.*

PUBLISHERS WEEKLY, *Bowker Magazine Group, Cahners Publishing Co., 249 W. 17th St., New York NY 10011. (212)645-0067. Weekly magazine covering industry trends and news in book publishing, book reviews and interviews.*

THE RANGEFINDER, *1312 Lincoln Blvd., Santa Monica CA 90406. (310)451-8506. Monthly magazine on photography technique, products and business practices.*

SELL & RESELL YOUR PHOTOS, *by Rohn Engh, published by Writer's Digest Books, 1507 Dana Ave., Cincinnati OH 45207. (513)531-2222. Newly revised edition of the classic volume on marketing your own stock images.*

SHUTTERBUG, *Patch Communications, 5211 S. Washington Ave., Titusville FL 32780. (407)268-5010. Monthly magazine of photography news and equipment reviews.*

STANDARD DIRECTORY OF ADVERTISING AGENCIES, *A Reed Reference Publishing Co., 121 Chanlon Rd., New Providence NJ 07974. (908)464-6800. Annual directory listing advertising agencies.*

STANDARD RATE AND DATA SERVICE, *1700 W. Higgins Rd., Des Plains IL 60018. (708)256-6067. Monthly directory listing magazines, plus their advertising rates.*

STOCK PHOTOGRAPHY HANDBOOK, *by Michal Heron, published by American Society of Media Photographers, 14 Washington Rd., Suite 502, Princeton Junction NJ 08550-1033. (609)799-8300.*

STOCK PHOTOGRAPHY: The Complete Guide, *by Ann and Carl Purcell, published by Writer's Digest Books, 1507 Dana Ave., Cincinnati OH 45207. (513)531-2222.*

THE STOCK WORKBOOK, *published by Scott & Daughters Publishing, Inc., 940 N. Highland Ave., Suite A, Los Angeles CA 90038. (213)856-0008. Annual directory of stock photo agencies.*

SUCCESSFUL FINE ART PHOTOGRAPHY, *by Harold Davis, published by Images Press, distributed by Writer's Digest Books, 1507 Dana Ave., Cincinnati OH 45207. (513)531-2222.*

TAKING STOCK, *published by Jim Pickerell, 110 Frederick Ave., Suite A, Rockville MD 20850. (301)251-0720. Newsletter for stock photographers; includes coverage of trends in business practices such as pricing and contract terms.*

WRITER'S MARKET, *Writer's Digest Books, 1507 Dana Ave., Cincinnati OH 45207. (513)531-2222. Annual directory listing markets for freelance writers. Lists names, addresses, contact people and marketing information for book publishers, magazines, greeting card companies and syndicates. Many listings also list photo needs and payment rates.*

Glossary

Absolute-released images. Any images for which signed model or property releases are on file and immediately available. For working with stock photo agencies that deal with advertising agencies, corporations and other commercial clients, such images are absolutely necessary to sell usage of images. Also see Model release, Property release.

Acceptance (payment on). The buyer pays for certain rights to publish a picture at the time he accepts it, prior to its publication.

Agency promotion rights. In stock photography, these are the rights that the agency requests in order to reproduce a photographer's images in any promotional materials such as catalogs, brochures and advertising.

Agent. A person who calls upon potential buyers to present and sell existing work or obtain assignments for his client. A commission is usually charged. Such a person may also be called a *photographer's rep*.

All rights. A form of rights often confused with work for hire. Identical to a buyout, this typically applies when the client buys all rights or claim to ownership of copyright, usually for a lump sum payment. This entitles the client to unlimited, exclusive usage and usually with no further compensation to the creator. Unlike work for hire, the transfer of copyright is not permanent. A time limit can be negotiated, or the copyright ownership can run to the maximum of 35 years.

All reproduction rights. See All rights.

All subsidiary rights. See All rights.

ASMP member pricing survey. These statistics are the result of a national survey of the American Society of Media Photographers (ASMP) compiled to give an overview of various specialties comprising the photography market. Though erroneously referred to as "ASMP rates," this survey is not intended to suggest rates or to establish minimum or maximum fees.

Assignment. A definite OK to take photos for a specific client with mutual understanding as to the provisions and terms involved.

Assignment of copyright, rights. The photographer transfers claim to ownership of copyright over to another party in a written contract signed by both parties. Terms are almost always exclusive, but can be negotiated for a limited time period or as a permanent transfer.

Assign (designated recipient). A third-party person or business to which a client assigns or designates ownership of copyrights that the client purchased originally from a creator, such as a photographer.

Audiovisual. Materials such as filmstrips, motion pictures and overhead transparencies which use audio backup for visual material.

Automatic renewal clause. In contracts with stock photo agencies, this clause works on the concept that every time the photographer delivers an image, the contract is automatically renewed for a specified number of years. The drawback is that a photographer can be bound by the contract terms beyond the contract's termination and be blocked from marketing the same images to other clients for an extended period of time.

AV. See Audiovisual.

Betacam. A videotape mastering format typically used for documentary/location work. Because of its compact equipment design allowing mobility and its extremely high quality for its size, it has become an accepted standard among TV stations for news coverage.

Bimonthly. Every two months.

Biweekly. Every two weeks.

Bleed. In a mounted photograph it refers to an image that extends to the boundaries of the board.

Blurb. Written material appearing on a magazine's cover describing its contents.

Body copy. Text used in a printed ad.

Bounce light. Light that is directed away from the subject toward a reflective surface.

Bracket. To make a number of different exposures of the same subject in the same lighting conditions.

Buyout. A form of work for hire where the client buys all rights or claim to ownership of copyright, usually for a lump sum payment. Also see All rights, Work for hire.

Capabilities brochure. In advertising and design firms, this type of brochure—similar to an annual report—is a frequent request from many corporate clients. This brochure outlines for prospective clients the nature of a company's business and the range of products or services it provides.

Caption. The words printed with a photo (usually directly beneath it) describing the scene or action. Synonymous with *cutline*.

Catalog work. The design of sales catalogs is a type of print work that many art/design studios and advertising agencies do for retail clients on a regular basis. Because the emphasis in catalogs is upon selling merchandise, photography is used heavily in catalog design. Also there is a great demand for such work, so many designers, art directors and photographers consider this to be "bread and butter" work, or reliable source or income.

CD-ROM. Compact disc read-only memory; non-erasable electronic medium used for digitized image and document storage and retrieval on computers.

Cibachrome. A photo printing process that produces fade-resistant color prints directly from color slides.

Clip art. Collections of copyright-free, ready-made illustrations available in b&w and color, both line and tone, in book form or in digital form.

Clips. See Tearsheets.

CMYK. Cyan, magenta, yellow and black—refers to four-color process printing.

Collateral materials. In advertising and design work, these are any materials or methods used to communicate a client's marketing identity or promote its product or service. For instance, in corporate identity designing, everything from the company's trademark to labels and packaging to print ads and marketing brochures is often designed at the same time. In this sense, collateral design—which uses photography at least as much as straight advertising does—is not separate from advertising but supportive to an overall marketing concept.

Commission. The fee (usually a percentage of the total price received for a picture) charged by a photo agency or agent for finding a buyer and attending to the details of billing, collecting, etc.

Composition. The visual arrangement of all elements in a photograph.

Copyright. The exclusive legal right to reproduce, publish and sell the matter and form of a literary or artistic work.

C-print. Any enlargement printed from a negative. Any enlargement from a transparency is called an R-print.

Credit line. The byline of a photographer or organization that appears below or beside published photos.

Crop. To omit unnecessary parts of an image when making a print or copy negative in order to focus attention on the important part of the image.

Cutline. See Caption.

Day rate. A minimum fee which many photographers charge for a day's work, whether a full day is spent on a shoot or not. Some photographers offer a half-day rate for projects involving up to a half-day of work. This rate typically includes mark-up but not additional expenses, which are usually billed to the customer.

Demo(s). A sample reel of film or sample videocassette which includes excerpts of a filmmaker's or videographer's production work for clients.

Disclaimer. A denial of legal claim used in ads and on products.

Dry mounting. A method of mounting prints on cardboard or similar materials by means of heat, pressure, and tissue impregnated with shellac.

EFP. Abbreviation for Electronic Field Processing equipment. Trade jargon in the news/video production industry for a video recording system that is several steps above ENG in quality. Typically, this is employed when film-like sharpness and color saturation are desirable in a video format. It requires a high degree of lighting, set-up and post-production. Also see ENG.

ENG. Abbreviation for Electronic News Gathering equipment. Trade jargon in the news/video production industry for professional-quality video news cameras which can record images on videotape or transmit them by microwave to a TV station's receiver.

Exclusive property rights. A type of exclusive rights in which the client owns the physical image, such as a print, slide, film reel or videotape. A good example is when a portrait which is shot for a person to keep, while the photographer retains the copyright.

Exclusive rights. A type of rights in which the client purchases exclusive usage of the image for a negotiated time period, such as one, three or five years. Can also be permanent. Also see All rights, Work for hire.

Fee-plus basis. An arrangement whereby a photographer is given a certain fee for an assignment—plus reimbursement for travel costs, model fees, props and other related expenses incurred in filling the assignment.

First rights. The photographer gives the purchaser the right to reproduce the work for the first time. The photographer agrees not to permit any prior publication of the work for a specified amount of time.

Format. The size, shape and other traits giving identity to a periodical.

Four-color printing, four-color process. A printing process in which four primary printing inks are run in four separate passes on the press to create the visual effect of a full-color photo, as in magazines, posters and various other print media. Four separate negatives of the color photo—shot through filters—are placed identically (stripped) and exposed onto printing plates, and the images are printed from the plates in four ink colors.

Gaffer. In motion pictures, the person who is responsible for positioning and operating lighting equipment, including generators and electrical cables.

Grip. A member of a motion picture camera crew who is responsible for transporting, setting up, operating, and removing support equipment for the camera and related activities.

Holography. Recording on a photographic material the interference pattern between a direct coherent light beam and one reflected or transmitted by the subject. The resulting hologram gives the appearance of three dimensions, and, within limits, changing the viewpoint from which a hologram is observed shows the subject as seen from different angles.

In perpetuity. A term used in business contracts which means that once a photographer has sold his copyrights to a client, the client has claim to ownership of the image or images forever. Also see All rights, Work for hire.

Internegative. An intermediate image used to convert a color transparency to a b&w print.

IRC. Abbreviation for International Reply Coupon. IRCs are used instead of stamps when submitting material to foreign buyers.

Leasing. A term used in reference to the repeated selling of one-time rights to a photo; also known as *renting*.

Logo. The distinctive nameplate of a publication which appears on its cover.

Model release. Written permission to use a person's photo in publications or for commercial use.

Ms, mss. Manuscript and manuscripts, respectively. These abbreviations are used in *Photographer's Market* listings.

Multi-image. A type of slide show which uses more than one projector to create greater visual impact with the subject. In more sophisticated multi-image shows, the projectors can be programmed to run by computer for split-second timing and animated effects.

Multimedia. A generic term used by advertising, public relations and audiovisual firms to describe productions using more than one medium together—such as slides and full-motion, color video—to create a variety of visual effects. Usually such productions are used in sales meetings and similar kinds of public events.

News release. See Press release.

No right of reversion. A term in business contracts which specifies once a photographer sells his copyrights to an image or images, he has surrendered his claim to ownership. This may be unenforceable, though, in light of the 1989 Supreme Court decision on copyright law. Also see All rights, Work for hire.

NPI. An abbreviation used within listings in *Photographer's Market* that means "no payment information given." Even though we request specific dollar amounts for payment information in each listing, the information is not always provided.

Offset. A printing process using flat plates. The plate is treated to accept ink in image areas and to reject it in nonimage areas. The inking is transferred to a rubber roller and then to the paper.

One-time rights. The photographer sells the right to use a photo one time only in any medium. The rights transfer back to the photographer on his request after the photo's use.

On spec. Abbreviation for "on speculation." Also see Speculation, Assignment.

PACA. See Picture Agency Council of America.

Page rate. An arrangement in which a photographer is paid at a standard rate per page. A page consists of both illustrations and text.

Panoramic format. A camera format which creates the impression of peripheral vision for the viewer. It was first developed for use in motion pictures and later adapted to still formats. In still work, this format requires a very specialized camera and lens system.

Pans. See Panoramic format.

PICT. The saving format for bit-mapped and object-oriented images.

Picture Agency Council of America. A trade organization consisting of stock photo agency professionals established to promote fair business practices in the stock photo industry. The organization monitors its member agencies and serves as a resource for stock agencies and stock photographers.

Point-of-purchase, point-of-sale. A generic term used in the advertising industry to describe in-store marketing displays which promote a product. Typically, these colorful and highly-illustrated displays are placed near check out lanes or counters, and offer tear-off discount coupons or trial samples of the product.

P-O-P, P-O-S. See Point-of-purchase.

Portfolio. A group of photographs assembled to demonstrate a photographer's talent and abilities, often presented to buyers.

Press release. A form of publicity announcement which public relations agencies and corporate communications staff people send out to newspapers and TV stations to generate news coverage. Usually this is sent in typewritten form with accompanying photos or videotape materials. Also see Video news release.

Property release. Written permission to use a photo of private property and public or government facilities in publications or commercial use.

Publication (payment on). The buyer does not pay for rights to publish a photo until it is actually published, as opposed to payment on acceptance.

Release. See Model release, Property release.

Rep. Trade jargon for sales representative. Also see Agent.

Query. A letter of inquiry to an editor or potential buyer soliciting his interest in a possible photo assignment or photos that the photographer may already have.

Résumé. A short written account of one's career, qualifications and accomplishments.

Royalty. A percentage payment made to a photographer/filmmaker for each copy of his work sold.

R-print. Any enlargement made from a transparency. Any enlargement from a negative is called a C-print.

SAE. Self-addressed envelope. Rather than requesting a self-addressed, stamped envelope, market listings may advise sending a SAE with the proper amount of postage to guarantee safe return of sample copies.

SASE. Abbreviation for self-addressed stamped envelope. Most buyers require SASE if a photographer wishes unused photos returned to him, especially unsolicited materials.

Self-assignment. Any photography project which a photographer shoots to show his abilities to prospective clients. This can be used by beginning photographers who want to build a portfolio or by photographers wanting to make a transition into a new market.

Self-promotion piece. A printed piece which photographers use for advertising and promoting their businesses. These pieces usually use one or more examples of the photographer's best work, and are professionally designed and printed to make the best impression.

Semigloss. A paper surface with a texture between glossy and matte, but closer to glossy.

Semimonthly. Twice a month.

Serial rights. The photographer sells the right to use a photo in a periodical. Rights usually transfer back to the photographer on his request after the photo's use.

Simultaneous submissions. Submission of the same photo or group of photos to more than one potential buyer at the same time.

Speculation. The photographer takes photos on his own with no assurance that the buyer will either purchase them or reimburse his expenses in any way, as opposed to taking photos on assignment.

Stock photo agency. A business that maintains a large collection of photos which it makes available to a variety of clients such as advertising agencies, calendar firms, and periodicals. Agencies usually retain 40-60 percent of the sales price they collect, and remit the balance to the photographers whose photo rights they've sold.

Stock photography. Primarily the selling of reprint rights to existing photographs rather than shooting on assignment for a client. Some stock photos are sold outright, but most are rented for a limited time period. Individuals can market and sell stock images to individual clients from their personal inventory, or stock photo agencies can market a photographer's work for them. Many stock agencies hire photographers to shoot new work on assignment, which then becomes the inventory of the stock agency.

Stringer. A freelancer who works part-time for a newspaper, handling spot news and assignments in his area.

Stripping. A process in printing production where negatives are put together to make a composite image or prepared for making the final printing plates, especially in four-color printing work. Also see Four-color printing.

Subagent. See Subsidiary agent.

Subsidiary agent. In stock photography, this is a stock photo agent which handles marketing of stock images for a primary stock agency in certain US or foreign markets. These are usually affiliated with the primary agency by a contractual agreement rather than by direct ownership, as in the case of an agency which has its own branch offices.

SVHS. Abbreviation for Super VHS. A videotape equipment format utilizing standard VHS format tape but which is a step above consumer quality in resolution. The camera system separates the elements of the video signal into two main components of sharpness and color which can be further enhanced in post-production and used for TV broadcast.

Table-top. Still-life photography; also the use of miniature props or models constructed to simulate reality.

Tabloid. A newspaper that is about half the page size of an ordinary newspaper, and which contains many photos and news in condensed form.

Tearsheet. An actual sample of a published work from a publication.

TIFF. Tagged Image File Format—a computer format used for saving or creating certain kinds of graphics.

Trade journal. A publication devoted strictly to the interests of readers involved in a specific trade or profession, such as doctors, writers, or druggists, and generally available only by subscription.

Transparency. A color film with positive image, also referred to as a slide.

Tungsten light. Artificial illumination as opposed to daylight.

U-Matic. A trade name for a particular videotape format produced by the Sony Corporation.

Unlimited use. A type of rights in which the client has total control over both how and how many times an image will be used. Also see All rights, Exclusive rights, Work for hire.

VHS. Abbreviation for Video Home System. A standard videotape format for recording consumer-quality videotape; the format most commonly used in home videocassette recording and portable camcorders.

Video news release. A videocassette recording containing a brief news segment specially prepared for broadcast on TV new programs. Usually, public relations firms hire AV firms or filmmaker/videographers to shoot and produce these recordings for publicity purposes of their clients.

Videotape. Magnetic recording tape similar to that used for recording sound, but which also records moving images, especially for broadcast on television.

Videowall. An elaborate installation of computer-controlled television screens in which several screens create a much larger moving image. For example, with eight screens, each of the screens may hold a portion of a larger scene, or two images can be shown side by side, or one image can be set in the middle of a surrounding image.

VNR. See Video news release.

Work for hire, Work made for hire. Any work that is assigned by an employer and the employer becomes the owner of the copyright. Copyright law clearly defines the types of photography which come under the work-for-hire definition. An employer can claim ownership to the copyright only in cases where the photographer is a fulltime staff person for the employer or in special cases where the photographer negotiates and assigns ownership of the copyright in writing to the employer for a limited time period. Stock images cannot be purchased under work-for-hire terms.

World rights. A type of rights in which the client buys usage of an image in the international marketplace. Also see All rights.

Worldwide exclusive rights. A form of world rights in which the client buys exclusive usage of an image in the international marketplace. Also see All rights.

Zone System. A system of exposure which allows the photographer to previsualize the print, based on a gray scale containing nine zones. Many workshops offer classes in Zone System.

Zoom lens. A type of lens with a range of various focal lengths.

First Markets Index

The following index contains hundreds of markets which are interested in receiving work from newer, lesser-known photographers. While some of these listings are lower paying markets, many are at the top-end of the pay scale. The index has been divided into categories which coincide with the sections in this book.

Book Publishers

Paper Products

Publications

Subject Index

This index can help you find editors who are searching for the kinds of images you are producing. Consisting of markets from the Publications section, this index is broken down into 24 different subjects. If, for example, you shoot sports photos and want to find out which publishers purchase sports material, turn to that category in this index.

Animals

Architecture

Art

Erotica/Nudity

Entertainment

Fashion

Food

GET YOUR WORK INTO THE RIGHT BUYERS' HANDS!

You work hard... and your hard work deserves to be seen by the right buyers. But with the constant changes in the industry, it's not always easy to know who those buyers are. That's why you'll want to keep up-to-date and on top with the most current edition of this indispensable market guide.

Totally Updated Each Year

Keep ahead of the changes by ordering *1997 Photographer's Market* today. You'll save the frustration of getting photographs returned in the mail, stamped MOVED: ADDRESS UNKNOWN. And of NOT submitting your work to new listings because you don't know they exist. All you have to do to order the upcoming 1997 edition is complete the attached order card and return it with your payment or credit card information. Order now and you'll get the 1997 edition at the 1996 price—just $23.99—no matter how much the regular price may increase! *1997 Photographer's Market* will be published and ready for shipment in September 1996.

Keep on top of the fast-changing industry and get a jump on selling your work with help from the *1997 Photographer's Market*. Order today! You deserve it!

PHOTOGRAPHER'S MARKET

Where & How to Sell Your Photographs

2,000 places to sell your news, publicity, product, scenic, portrait, fashion, wildlife, audiovisual, sports, and travel photos!

Totally Updated! Plus **500** New Markets!

Turn over for more books to help you sell your photos ➡

More Great Books To Help You Sell What You Shoot!

Location Photography Secrets: How To Get the Right Shot Every Time
With this problems/solutions manual you'll turn adversity to your advantage and get the shots you want! You'll learn to conquer technical challenges using lenses, creative composition, filters, lighting techniques and more! #10416/$26.99/144 pages/paperback

Essential! Professional Photographer's Survival Guide
Discover everything you need to know about making it in the photography business. You'll learn how to make the crucial first sale, how to earn the most from your photographs, and more! #10327/$16.95/368 pages/paperback

Sell & Resell Your Photos
This best seller is completely revised and updated to give you the latest tips on selling your photos to nationwide markets by phone or mail! #10236/$14.99/324 pages/paperback

How You Can Make $25,000 a Year with Your Camera
You'll get hundreds of ideas for selling your photos in your own town—no matter where you live! Discover how to negotiate rights, use a computer to manage your business, and more! #10211/$13.99/224 pages/paperback

Best Seller!
Creative Techniques for Photographing Children
Discover proven techniques for capturing the charm and innocence of children on film. You'll get great advice on lighting, equipment, and more! #10358/$24.95/144 pages/paperback

Fill out order card on reverse side and mail today!

Health

History

Humor

People

Political

Product Shots/Still Lifes

Travel

General Index

H

More Great Books
to Help You Sell What You Shoot!

Professional Photographer's Survival Guide—Earn the most from your photographs! This one-of-a-kind book guides you through making your first sale to establishing yourself in a well-paying career. *#10327/$16.95/368 pages/paperback*

The Professional Photographer's Guide to Shooting & Selling Nature & Wildlife Photos—This all-in-one guide shows you the ins and outs of capturing the wonder of nature in photos. Plus, you'll get great advice on how to market your work. *#10227/$24.95/134 pages/250 color photos/paperback*

How You Can Make $25,000 a Year With Your Camera—Discover how to uncover photo opportunities in your own community! You'll get special sections on pricing, negotiating rights and boudoir photography. *#10211/$13.99/224 pages/46 b&w illus./paperback*

Sell & Re-Sell Your Photos—This best seller is completely revised and updated to give you the latest tips on selling your photos to nationwide markets by phone or mail! *#10236/$14.99/324 pages/ 40 b&w illus./paperback*

Creative Techniques for Photographing Children—Capture the innocence and charm of children in beautiful portraits and candid shots. Professionals and parents alike will create delightful photos with dozens of handy hints and loads of advice. *#10358/$24.95/144 pages/paperback*

Stock Photography: The Complete Guide—Discover how to break into this very lucrative market! Two highly successful photographers show you what to shoot, how to organize your pictures, how to make the sale, and more! *#10359/$19.95/144 pages/paperback*

How To Shoot Stock Photos That Sell—You'll build a fantastic stock photo file as you develop a keen eye for rare shots that bring in the big money. 25 step- by-step assignments show you how. *#10175/$16.95/192 pages/30 b&w illus./paperback*

Location Photography Secrets: How to Get the Right Shot Every Time—This problem-solution manual helps you overcome the many problems you may encounter while shooting on location. You'll find solutions using lenses, creative composition, filters, lighting techniques, and more. *#10416/$26.99/ 144 pages/150 color illus./paperback*

Profitable Model Photography—Any photographer—from beginner to experienced— will learn how to set up a model photography business, and how to keep their business growing. *#10300/$18.95/128 pages/paperback*

A Guide to Travel Writing & Photography—This book introduces you to the colorful and appealing opportunities that allow you to explore your interest in travel while making a living. *#10228/$32.95/ 144 pages/80 color photos/paperback*

Outstanding Special Effects Photography on a Limited Budget—Create eye-popping effects (without busting the bank)! Dozens of tips and techniques will show you how to make the most of your equipment—and how to market your dazzling shots. *#10375/$24.95/144 pages/175 + color photos/ paperback*

Lighting Secrets for the Professional Photographer—Don't be left in the dark! This problems-solutions approach gives you everything you need to know about special lighting tricks and techniques. *#10193/$24.99/134 pages/300 color illus./paperback*